JACOPO BASSANO

Published by the Kimbell Art Museum, Fort Worth, with the assistance of and in collaboration with Nuova Alfa Editoriale, Bologna, on the occasion of the four-hundredth anniversary retrospective exhibition

Museo Civico, Bassano del Grappa, 5 September – 6 December 1992

Kimbell Art Museum, Fort Worth, 23 January – 25 April 1993

Essays by M.E. Avagnina, A. Ballarin, and P. Marini translated by Robert Erich Wolf; notes for Marini, Ballarin, and Avagnina essays translated by Mark Roberts.
Essay by G. Ericani translated by Susan Scott.
Painting entries translated by Susan Scott. Drawing entries translated by Susan Scott and Janet Smith.
Appendix and chronological register of documents translated by Susan Scott.

Edited in Fort Worth with the assistance of Wendy P. Gottlieb, Katherine M. Whann, and Julie M. Harrison.

Cover: Jacopo Bassano, *The Podestà of Bassano Matteo Soranzo with His Daughter Lucia and His Brother Francesco Being Presented by Saints Lucy, Francis, and Matthew to the Madonna and Child* (detail), 1536, Museo Civico, Bassano del Grappa (cat. 2)

Distributed by Kimbell Art Museum, 3333 Camp Bowie Boulevard, Fort Worth, Texas 76107, USA. Tel. (817) 332-8451, Telefax (817) 877-1264.
Printed in Italy
ISBN 0-912804-27-0 (paper edition)
 0-912804-28-9 (cloth edition)

JACOPO BASSANO
c. 1510-1592

edited by
BEVERLY LOUISE BROWN AND PAOLA MARINI

with contributions by
Livia Alberton Vinco da Sesso, Filippa M. Aliberti Gaudioso, M. Elisa Avagnina,
Alessandro Ballarin, Giuliana Ericani, Paola Marini,
W.R. Rearick, Vittoria Romani

Kimbell Art Museum
Fort Worth, Texas

ADVISORY COMMITTEE FOR THE EXHIBITION

Filippa M. Aliberti Gaudioso, President
Livia Alberton Vinco da Sesso
M. Elisa Avagnina
Alessandro Ballarin
Alessandro Bettagno
Beverly Louise Brown
Sydney J. Freedberg
Paola Marini
† Michelangelo Muraro
Giovanna Nepi Sciré
Bruno Passamani
Terisio Pignatti
Edmund P. Pillsbury
W.R. Rearick
Fernando Rigon
David Rosand
Francesco Valcanover
Pietro Zampetti

Lenders to the Exhibition

AUSTRIA
Vienna, Graphische Sammlung Albertina
Vienna, Kunsthistorisches Museum,
Gemäldegalerie

CANADA
Ottawa, National Gallery of Canada

CZECHOSLOVAKIA
Kroměříž, Arcibiskupský Zámek a
Zahraòy
Prague, Národní galerie

DENMARK
Frederikssund, J.F. Willumsen Museum

FINLAND
Jyväskylä, Alvar Aalto Museum

FRANCE
Montpellier, Musée Fabre
Nîmes, Musée des Beaux-Arts de Nîmes
Paris, Musée du Louvre, Département
des Arts Graphiques

GERMANY
Hamburg, Hamburger Kunsthalle,
Kupferstichkabinett
Berlin, Staatliche Museen Preussischer
Kulturbesitz, Gemäldegalerie
Frankfurt, Städelsches Kunstinstitut
Kassel, Staatliche Museen Kassel,
Gemäldegalerie Alte Meister
Munich, Bayerische
Staatsgemäldesammlungen, Alte
Pinakothek
Potsdam, Stiftung Schlösser und Gärten
Potsdam-Sanssouci

GREAT BRITAIN
Berkshire, Royal Library, Windsor Castle
(Lent by Her Majesty Queen
Elizabeth II)

Cambridge, Syndics of the Fitzwilliam
Museum
Chatsworth, The Duke of Devonshire and
the Chatsworth Settlement Trustees
Edinburgh, The National Galleries of
Scotland
Hampton Court, The Royal Collection
(Lent by Her Majesty Queen
Elizabeth II)
London, Courtauld Institute Galleries
London, Hazlitt, Gooden and Fox
London, The National Gallery
Oxford, The Governing Body of Christ
Church

HUNGARY
Budapest, Szépmüvészeti Múzeum

ITALY
Asolo, Chiesa Cattedrale
Bassano del Grappa, Museo Civico
Bergamo, Accademia Carrara
Borso del Grappa, Chiesa Parrocchiale
Enego, Chiesa di Santa Giustina
Florence, Gabinetto Disegni e Stampe
degli Uffizi
Florence, Galleria degli Uffizi
Florence, Museo Horne
Genoa, Civica Galleria di Palazzo Rosso
Lusiana, Chiesa di San Giacomo
Milan, Pinacoteca di Brera
Modena, Galleria Estense
Padua, Chiesa di Santa Maria in Vanzo
Padua, Musei Civici-Museo d'Arte
Medievale e Moderna
Rome, Galleria Borghese
Rome, Galleria Corsini
Rome, Galleria Doria Pamphilj
Treviso, Museo Civico
Venice, Gallerie dell'Accademia

Verona, Fondazione Museo Miniscalchi-
Erizzo

LIECHTENSTEIN
Vaduz, Stiftung Ratjen

THE NETHERLANDS
Rotterdam, Museum Boymans-van
Beuningen

POLAND
Warsaw, Muzeum Narodowe W
Warszawie

SPAIN
Barcelona, Museu Nacional d'Art de
Catalunya
Madrid, Museo del Prado

SWITZERLAND
Kreuzlingen, Sammlung Heinz Kisters

UNITED STATES
Boston, Museum of Fine Arts, Boston
Chicago, The Art Institute of Chicago
Cleveland, The Cleveland Museum of Art
Fort Worth, Kimbell Art Museum
Hartford, Wadsworth Atheneum
Houston, Sarah Campbell Blaffer
Foundation
Malibu, Collection of The J. Paul Getty
Museum
Memphis, Memphis Brooks Museum of
Art
Providence, Museum of Art, Rhode Island
School of Design
Sarasota, John and Mable Ringling
Museum of Art
Springfield, Museum of Fine Arts
Toledo, The Toledo Museum of Art
Washington, National Gallery of Art

and private lenders

Contents

FOREWORD

*P*lans *for a Jacopo Bassano retrospective on the occasion of the fourth centenary of the painter's death in 1592 – the first exhibition devoted to the artist in some thirty-five years and the only one ever to be mounted outside Italy – developed independently on two continents. In 1988, stimulated by the Royal Academy of Arts' revealing exhibition* The Genius of Venice: 1500-1600 *in 1983 and encouraged by the initiatives of museums in America as well as Italy in organizing in the late 1980s displays of Paolo Veronese's work and that of Titian, the Kimbell Art Museum of Fort Worth engaged Professor W.R. Rearick to curate an exhibition of Jacopo Bassano's paintings and drawings; only in January of 1989 did the Texas institution acquire its first work by the cinquecento master.*

Coincidentally, in the late 1980s the Museo Civico in Bassano del Grappa, the custodian of the largest repository of the artist's work, in conjunction with the Soprintendenza ai Beni Artistici e Storici del Veneto, began exploring the idea of an exhibition to honor its famous native son in 1992.

Although initially the two projects were conceived with different ends – in America the emphasis being on the early phase of the artist's career, in Italy the concentration falling on the late work and the role of the workshop – by 1990 a consensus emerged that more would be gained than sacrificed by consolidating the two endeavors into a single undertaking. The nucleus of this joint effort became a selection of some forty-three paintings, supplemented by thirty-five drawings divided between the two expositions and additional paintings available to one or the other venue (as it turned out, some twenty-seven in Bassano and another nine in Fort Worth).

From this decision grew a close and cordial collaboration of scholars and museum officials in Italy and America. Professor Alessandro Ballarin of the Università di Padova joined his American counterpart, Professor Rearick. An advisory committee of Americans and Italians was appointed; the names of the individual committee members are listed elsewhere on these pages. Dr. Giuseppe Nardini assumed the presidency of the organizing committee in Italy, and Italian sponsors were enlisted to underwrite the costs of the Bassano exhibition. Additional funds to conserve paintings were also raised, while U.S. government indemnification for the insurance of foreign loans to the Fort Worth venue was solicited from the Federal Council on the Arts and the Humanities in Washington.

Jacopo Bassano's innovative compositions, bold use of light and color, and daring iconographical solutions all helped to earn him fame equal in his time to that of Titian, Tintoretto, and Veronese. Of particular importance was his introduction of the elements of everyday life into traditional religious subjects, which, by humanizing the canon of high art, had a decisive impact on the subsequent development of painting throughout Europe.

Son of a minor provincial painter, Jacopo dal Ponte was born around 1510; he was therefore some twenty years younger than Titian and Veronese's elder by almost the same number of years, while being some eight years older than Tintoretto. After an early

artistic education in Venice he chose to return to live in a small city of Bassano in the foothills of the Alps, along the river Brenta, in a house located beside the town's wooden bridge, from which his family took their name.

His isolation, rather than retarding his art, nourished an independent and experimental disposition that contributed to his being the least known among the great Venetian sixteenth-century painters yet made him «perhaps the most complex personality and the most important figure because of the secular aspect of his development», as Roberto Longhi has observed, following in the path of Adolfo Venturi.

In comparison with the Jacopo Bassano exhibition held in the Palazzo Ducale in Venice in 1957, curated by Piero Zampetti, the current one incorporates a great deal of basic new information about the artist, much of which has come to light in the last thirty-five years. Above all, there have been many important discoveries of paintings, drawings, and documents. The progress of critical analysis as well as the study and publication of the hitherto unedited manuscript containing the accounts of the Dal Ponte workshop, a tool of exceptional value, have led to a more systematic and plausible chronology of the artist's work. Finally, there has been a broad reevaluation of the historical importance of genre painting in European art, of which Jacopo Bassano is justly considered the legitimate inventor and for which the artist has long been appreciated by critics and collectors.

An impressive campaign of restoration and conservation work, carried out largely in collaboration with the Soprintendenza ai Beni Aristici e Storici del Veneto, has occasioned the preparation of the exhibition. As many as twenty-three paintings have undergone conservation, with support from the Veneto Region, the Italian organizing committee of the exhibition, the Kimbell Art Museum, and such private sources as the Italian Committee of the World Monuments Fund, the Libreria Scrimin in Bassano, and the Associazione Artigiani della Provincia di Vicenza-Mandamento di Bassano del Grappa. In addition, many lending institutions undertook conservation work specially for the exhibition.

For the catalogue accompanying the exhibition, Professors Ballarin and Rearick were joined by a small group of dedicated scholars consisting of Livia Alberton Vinco da Sesso, Filippa M. Aliberti Gaudioso, M. Elisa Avagnina, Giuliana Ericani, Paola Marini, and Vittoria Romani. This volume, published in its Italian edition by Nuova Alfa Editoriale, promises to occupy a place of importance in the bibliography of Renaissance art, superseding the last monographic study on Bassano published in 1960. The edition of the catalogue published by the Kimbell Art Museum with the assistance of, and in collaboration with, Nuova Alfa Editoriale for the Fort Worth venue will be the first book in English on the father of European genre painting, one of the greatest – albeit still relatively unsung – heroes of the golden age of Venetian art.

FILIPPA M. ALIBERTI GAUDIOSO PAOLA MARINI EDMUND P. PILLSBURY
Soprintendente ai Beni Artistici Direttrice del Director, Kimbell
e Storici del Veneto Museo Civico Art Museum of
di Bassano Fort Worth
del Grappa

ACKNOWLEDGMENTS

*T*hroughout his long and productive career Jacopo Bassano never strayed far from home. The roots of his style and, indeed, its fundamental strength are deeply rooted in his provincial background. He populated his works with vignettes, characters, and descriptive details derived from his own particular reality. In time he moved beyond the infusion of merely familiar motifs to invent a new mode of bucolic genre – a bucolic genre that, nevertheless, first and foremost celebrated the region around Bassano. It is only fitting, then, that this exhibition opens in Jacopo's hometown, the modern city of Bassano del Grappa.

There are many individuals to whom we owe thanks for having helped make this exhibition possible. First and foremost we are profoundly grateful to the lenders from around the world, who join us in commemorating the four-hundredth anniversary of Jacopo Bassano's death and celebrating his artistic achievement. Whether private collections or public museums, they have been enormously generous and understanding about an exhibition that changed dates and venues after the original loan requests were sent out from Fort Worth. Their staffs have been extraordinarily kind in answering myriad questions and providing optimum conditions for the teams of catalogue authors who came to study their works by Jacopo and members of his family. The success of this exhibition owes much to their understanding, flexibility, and good will.

We were blessed by support from the members of an advisory committee, whose names are listed elsewhere on these pages. They lent their time, energy, and expertise in the most willing manner. Among them the late Michelangelo Muraro should be singled out. Shortly before his death, Professor Muraro completed the transcription and annotation of Jacopo's account book, the famous Il libro secondo di dare ed avere della famiglia Dal Ponte con diversi per pitture fatte, which has only recently been acquired by the Museo Civico in Bassano del Grappa. Fortunately its contents were made available to all of the catalogue authors, so that this catalogue reflects the most accurate and up-to-date scholarship on the chronology of Jacopo's work and his many local patrons.

We gratefully acknowledge the financial support that we received for the conservation of key works in the exhibition. Many institutions undertook their own restoration campaigns; others were aided by outside funds. In particular, the organizing committee in Bassano del Grappa sponsored the work carried out by The J.F. Willumsen Museum, Frederikssund; Christ Church, Oxford; the Galleria Borghese, Rome; and the Gabinetto Disegni e Stampe degli Uffizi, Florence. The organizing committee was joined by the Kimbell Art Museum in helping to defray the cost of the restoration of works from the Szépművészeti Múzeum, Budapest; the Civica Galleria di Palazzo Rosso, Genoa; the Staatliche Museen, Kassel; and the Galleria Corsini, Rome. The Regione Veneto, the Comune di Bassano del Grappa, and the Kimbell Art Museum together supported the restoration of pictures belonging to the Museo Civico of Bassano del Grappa. A very special note of thanks is due to Paolo Marzotto, President of the World Monuments Fund's Comitato Italiano, and Stephen Eddy for arranging conservation funds for the Museo Civico in Bassano del Grappa and the Galleria Borghese in Rome. The Libre-

ria Scrimin provided additional support for the Museo Civico in Bassano del Grappa and the Chiesa Cattedrale in Asolo. Finally, the Associazione Artigiani della Provincia di Vicenza-Mandamento di Bassano del Grappa made funds available for the restoration of works coming from the Galleria Borghese, Rome. Thanks to the efforts of all of these organizations, for the first time in many decades the full power of Jacopo's chromatic brilliance can once again be experienced.

No exhibition of this magnitude and importance can be undertaken by a small provincial museum alone. In Italy, the Comune di Bassano del Grappa, the Ministero per i Beni Culturali e Ambientali, the Regione Veneto, the Provincia di Vicenza, and the Camera di Commercio Industria Artigianato Agricoltura di Vicenza, as well as a number of local businesses, joined together to promote and sustain the project. We are especially pleased to acknowledge the funding provided by the following group of sponsors: Banca Popolare Vicentina, Banco Ambrosiano Veneto, Fondazione Cassa di Risparmio di Verona Vicenza Belluno e Ancona, and Nuova Alfa Editoriale; additional funds were provided by American Express, Associazione Artigiani della Provincia di Vicenza-Mandamento di Bassano del Grappa, API Associazione Piccole e Medie Industrie della Provincia di Vicenza, Associazione Industriali della Provincia di Vicenza, Cassa di Risparmio di Venezia, Consorzio Trasportatori Montegrappa, Fidia spa, Iniziativa Centro Commerciale Bassano spa, Unione del Commercio del Turismo e dei Servizi-Mandamento di Bassano del Grappa.

Indemnification for the exhibition in Fort Worth was provided by the Federal Council on the Arts and the Humanities. We are most grateful to Alice Whelihan and her staff for their continued help before, during, and after the application process.

That this exhibition has been realized is due to the exceptional cooperation between three institutions. All of their staffs have contributed to its success. In Bassano del Grappa, Aida Ruggiero, Rita Bizzotto, and the museum's staff have ably served as the exhibition secretaries; Vittoria Romani and Enrica Pan helped with the editing and the preparation of the bibliography; and Ugo Bonato, Gianni Posocco, and Mario Ruaro made contributions to the technical aspects of the exhibition's organization. In Fort Worth, Katherine M. Whann provided invaluable assistance with organizational matters and editing and preparation of the manuscript for publication. Wendy P. Gottlieb supervised the editing of the English edition of the catalogue, with the able assistance of Julie M. Harrison, and handled the promotion of the exhibition. Jeanette Schnell helped with the manuscript preparation; Paula Phipps and Jo Vecchio also assisted. Anne C. Adams prepared the indemnity application and coordinated the shipping arrangements. In the Soprintendenza ai Beni Artistici e Storici del Veneto, M. Elisa Avagnina coordinated the efforts of many local lenders and assisted the staff of the Museo Civico, while Fabrizio Pietropoli prepared the x-radiographs of recently restored works and Guglielmo Stangherlin oversaw the restoration projects.

In addition, many scholars, dealers, colleagues, and collectors shared their knowledge of Jacopo's work, made their collections available, and graciously provided unpublished

material. Mention should be made of Luisa Attardi, Bernard Aikema, Giusi Boni, Carlo Alberto Chiesa, Keith Christiansen, Costanza Costanzi, Renata Del Sal, Carla De Martini, Ida De Stefani, Claudio Donella, Paola Donella, Chris Fisher, Tomaso Franco, Burton B. Fredericksen, Paul Joannides, Mari Kalmann Meller, Alessandro Lechi, Nino Magalini, Felicity Mallet, John Mallet, Franco Marin, Sergio Marinelli, Stefania Mason Rinaldi, Sergio Momesso, Antonio Niero, Pompeo Pianezzola, Corrado Pin, Jeremy Rex-Parkes, Scott Schaefer, Julien Stock, Alessandro Vattani, George Wachter, Edward Weiss, Adam Williams, Michael Wynn, and Fulvio Zuliani. The support of all of these individuals, plus countless others too numerous to mention here, has allowed us to realize our vision of a comprehensive exhibition devoted to Jacopo Bassano.

BEVERLY LOUISE BROWN
Assistant Director/Curator of Exhibitions
Kimbell Art Museum

PAOLA MARINI
Direttrice del Museo Civico
di Bassano del Grappa

Jacopo Bassano seen anew

Paola Marini

Jacopo Bassano is certainly the least known among the leading personalities of sixteenth-century Venetian painting and among the less well known of his time, even if, for a variety of reasons, he was properly appreciated by the most sensitive and deeply concerned critical writers of later centuries – one need only recall the illuminating pages of Adolfo Venturi and Roberto Longhi, and some by Sergio Bettini – as well as by numerous art lovers and collectors in earlier years, who were attracted by the fascinating iconography of his paintings or those of his collaborators and followers, more than by the quality of Jacopo's work. Early on, Carlo Ridolfi had placed him among the « inventors of a new manner » and perceptively stressed how much this manner appealed « not only to the experts, but also to the universal taste ».[1]

Jacopo's choice of a retired life in his very modest native town, the scarcity of documents relating to his work, his feverish pictorial experimentation, the vastness of his output stemming from collaborations – first with his father, Francesco il Vecchio, and his brother, Giambattista, and, later and above all, with his own four sons – have rendered his artistic career so complex, rich, and ever-changing that today there are still many disagreements over attributions and, even more, over dating. Indeed, a good many works Jacopo painted have for a long time been given to other artists very different from one another, ranging from Bonifazio de' Pitati to Titian, Palma il Vecchio, and Mariscalchi as well as from El Greco to Schiavone, Francesco Maffei, and the Carracci.

Faced with such knotty problems, scholars have been in a way virtually compelled to rely on stylistic exegesis, to build up sophisticated reconstructions that have had to be dismantled and built anew each time a reliable, but previously unknown fact happens to be unearthed. In so doing, they have been in a sense following the painter's own way of working, « not in a straight line, but continually quitting the high road to put to the test the most diverse experiments down to the very last possibility, only then to take up his way again, but at a point that was not the one he had started from and, indeed, which does not seem to justify the expenditure of energies, the commitment called for in each and every one of those experiments ».[2]

Quite unlike Titian, Jacopo's worth was only in part appreciated and recognized by his contemporaries. There were a few exceptions, but they were at best modest. Two centuries later, however, Jacopo would enjoy the attention of a diligent and perceptive critic such as few old masters could glory in: his compatriot Giambattista Verci, who made extensive use of the manuscripts of Giambattista Volpato, a seventeenth-century painter and highly skilled copyist of Jacopo's work. We can still take as trustworthy and perfectly acceptable the basic framework of the stylistic and technical reading proposed by Volpato in his chapter devoted to « Giacomo da Ponte » in his *No-*

1. Ridolfi 1648, 1, 384.
2. Ballarin 1973, 105.

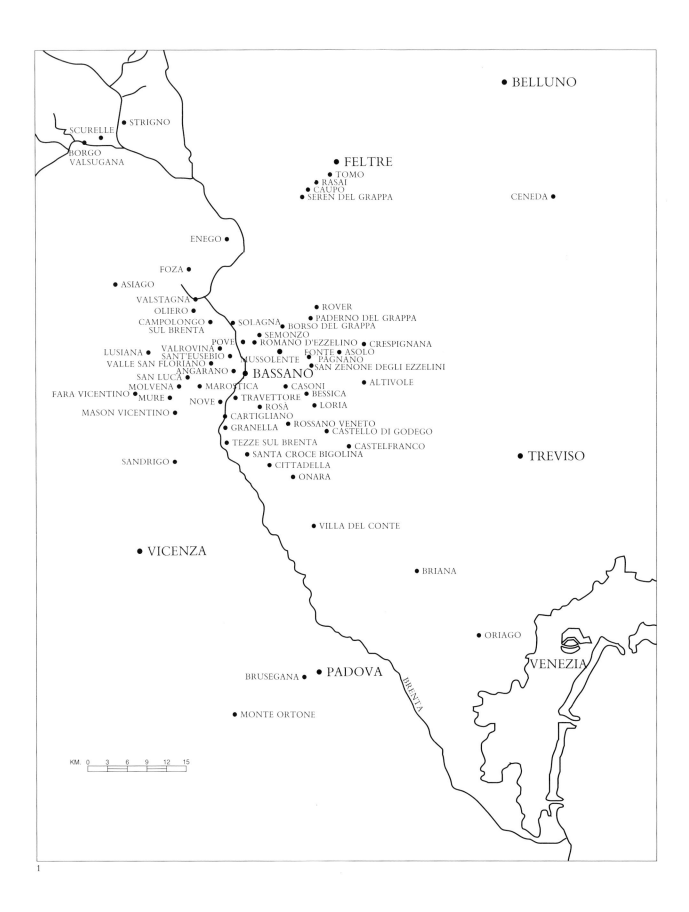

BELLUNO

SCURELLE • • STRIGNO
BORGO
VALSUGANA

FELTRE
• TOMO
• RASAI
• CAUPO
• SEREN DEL GRAPPA

CENEDA •

ENEGO •

FOZA •

ASIAGO •

VALSTAGNA
OLIERO •
CAMPOLONGO
SUL BRENTA
ROVER •
PADERNO DEL GRAPPA
SOLAGNA BORSO DEL GRAPPA
SEMONZO
POVE • ROMANO D'EZZELINO CRESPIGNANA
LUSIANA • VALROVINA FONTE • ASOLO
SANT'EUSEBIO PAGNANO
VALLE SAN FLORIANO • MUSSOLENTE SAN ZENONE DEGLI EZZELINI
SAN LUCA • ANGARANO
MOLVENA • BASSANO
MAROSTICA CASONI ALTIVOLE
FARA VICENTINO • MURE • NOVE TRAVETTORE BESSICA
ROSÀ LORIA
MASON VICENTINO • CARTIGLIANO
GRANELLA ROSSANO VENETO
CASTELLO DI GODEGO
TEZZE SUL BRENTA CASTELFRANCO
SANTA CROCE BIGOLINA
SANDRIGO • CITTADELLA
ONARA

TREVISO •

VILLA DEL CONTE •

VICENZA •

BRIANA •

ORIAGO •

VENEZIA

BRUSEGANA • PADOVA

BRENTA

MONTE ORTONE •

KM. 0 3 6 9 12 15

1. Location of the activity of the Dal Ponte shop mentioned in the *Libro secondo*

2. Francesco and Leandro Bassano, *Map of the City of Bassano del Grappa*, Museo Civico, Bassano del Grappa (next page)

tizie intorno alla vita e alle opere de' pittori, scultori e intagliatori della città di Bassano (Giovanni Gatti, Venice, 1775).

The very full census of critical comment and appreciation compiled by Arslan in our century calls for only marginal insertions today.[3] Due appreciation was scarce, or virtually nonexistent, during the sixteenth century, but in the next century, and particularly in the Veneto region, it was based on enthusiasm for Jacopo's more specifically coloristic and pictorial values, whereas elsewhere, outside the Veneto, Bellori would fancy an imagined, idealized link between Jacopo and Caravaggio on the grounds of a naturalistic pastoral tendency.[4] Bellori, indeed, went so far as to have Annibale Carracci recount the famous episode in which he was the victim of an optical illusion in Jacopo's studio when he reached out his hand to take a book that was, in fact, only painted, thus inspiring the following eulogy: « Giacomo Bassano was a highly worthy painter and deserving of praise beyond that bestowed on him by Vasari, because besides his very beautiful paintings he performed those miracles that, it is said, the ancient Greeks likewise performed, tricking the eye not only of animals, but also of men professional in art ».[5]

Between the eighteenth and nineteenth centuries, when classicistic positions came to dominate and critical judgment became entrenched in decidedly negative positions, Jacopo was charged with poverty of invention, lack of nobility, of dignity, of grace and elegance, and accused of overemphasizing themes judged to be trivial. Luigi Lanzi, in the notebook he kept of his *Viaggio del 1793 per lo Stato Veneto, e Venezia istessa*, in preparation for the first edition of his *Storia pittorica della Italia* (Raimondi, Bassano, 1795-96), notes significantly: « His masterwork, as some see it, is the Nativity with Saint Joseph, a painting replete with the graces that elsewhere are only in scattered evidence, with strong coloring, an exact copy of nature. There is an ox, two little sheep, a dog, all very lifelike. There is a relief that, from a distance, makes the figures look like small statues. There is the usual lack of decorum: a peasant with feet sticking out, and one of the best lights lavished on his breeches ».[6] In any event, if the popularity of country scenes and animals was immediately evident in painting, from the start it also invited its complement, a deprecatory critical attitude that would perhaps exhaust itself only in the romantic era. Genre scenes were a guarantee of commercial success, but at the same time they were viewed as a limitation on the universal genius of the Renaissance. And the art of Jacopo Bassano was destined, *a posteriori* and reductively, to be confined to the status of « genre », with all the inevitable consequences.

In 1966-67 Ballarin made a point of rereading the early writings on Jacopo and investigating other authors not previously considered, among them the lives of artists by Karel van Mander, and the result was exceptional critical

3. Arslan 1960 (B), I, 295 ff.
4. The observation is made in Haskell 1980, 134.
5. Bellori 1672, 35-36.
6. One of the ten notebooks of Luigi Lanzi in the Biblioteca degli Uffizi, Florence, 36 VII, has recently been published by Donata Levi; see Lanzi 1988, 20 and *passim*.

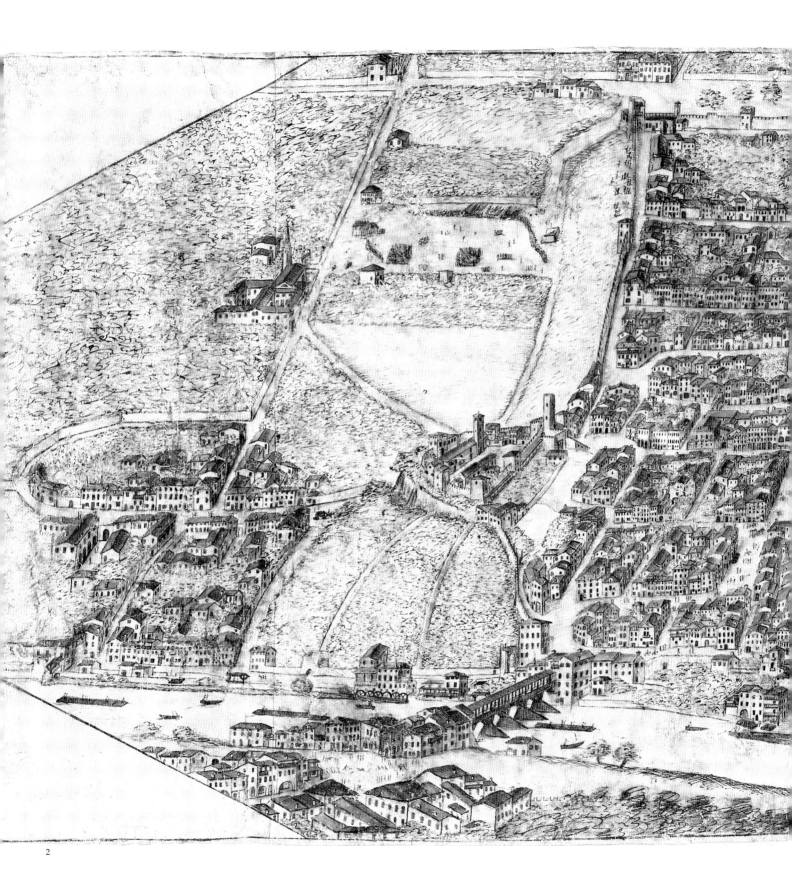

2

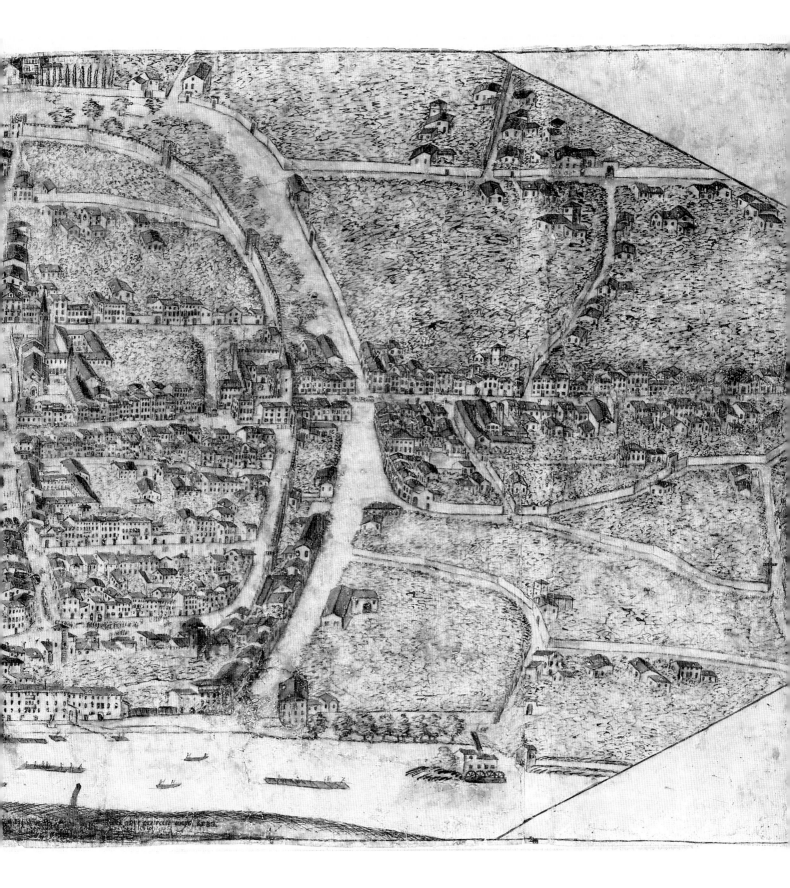

17

progress in the understanding of Jacopo. Twentieth-century writers had made much of Jacopo's mannerist period, which made him appear substantially a painter of altarpieces. Attempts to reinstate his great qualities had been hopelessly compromised by the enormous number and vast diffusion of second-rate paintings from his workshop. Such paintings cast an ever more derogatory light on the entire phenomenon of Jacopo and his art throughout the nineteenth century. Ballarin, however, turned his thinking to Jacopo as « a painter of animals, of Noah's Arks, and of biblical exoduses, of kitchens and the trivial everyday things of country life, of sunsets and moonlit nightpieces ».[7] From the interweaving and reciprocal confirmation of four of the most authoritative sources – *Il Bassano* by Lorenzo Marucini (1577); the inventory of the paintings found in the Dal Ponte house at Jacopo's death (1592), whose importance was recognized by Memmo (1754) and which was published in full by Verci (1775); the life of the painter by Van Mander (1604); and the biography by Ridolfi (1648) – Ballarin brought out in full, with clear evidence, the fundamental role of Jacopo as inventor of the genre picture between the end of the 1550s and beginning of the 1570s and of his son, Francesco, as publicist and popularizer of the genre scenes on the market.[8]

Local writers more or less mirrored the general attitudes of their time and place, adding at the most an occasional anecdote.[9] « Here everything is full of Bassanos, like Guercino in Cento », wrote Giambattista Giovio to Count Giambattista Roberti of Bassano in 1777.[10] And when Giambattista Baseggio affirmed that to know Jacopo one has to visit his home town, « inasmuch as elsewhere [his works] are either extremely rare or were not carried through by him with that loving care he deployed for his home place », he gave support to the idea of the influence of a particular society on the painter's work and explained Jacopo's thematic and iconographical choices by his having lived and worked in an environment trivial in quality and lacking in culture and spirituality, where the upper hand was held by the merchants who took special pleasure in seeing exact imitations of ordinary everyday things in images repeated over and over again. Still and all, Baseggio ended up concluding that it is precisely « to those influences we owe the Bassano school and its originality ».[11]

Now, however, new clues for a reading of Jacopo's work in terms that are not exclusively stylistic can be drawn not only from the *Libro secondo* – the only surviving volume of the workshop's four account books – but also from a thoroughgoing analysis of the sources having to do with collecting and the market, and, further, from an investigation of the success his works enjoyed when engraved for sale.

The story of Jacopo Bassano and his patrons has never been written.

3

7. Ballarin 1966-67, 158.
8. Ballarin 1966-67, 172-73.
9. Arslan 1960 (B), I, 311, n. 85, and 322-23.
10. Roberti 1777, 85.
11. Baseggio 1847, 21 and 29-30.

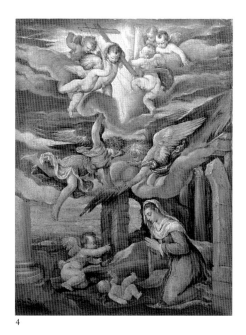

4

Among the most plausible reasons for that lacuna is the simple fact that many of the individuals concerned were of obscure status and left little or no information about their years on earth. However, the publication of the *Libro secondo* now offers a great many elements pertaining to at least the years between 1525 and 1555, with some significant information for the following years as well. It suffices to say that the account book names nine hundred individuals. Even though the manuscript represents only a segment of what was surely the much vaster financial documentation of the Dal Ponte clan, it offers a reliable source for a significant sampling of their business within the period indicated. The ledger lists the movements of works and the exchange of money, utilizing the system of double-entry bookkeeping and registering such activities under the initials of the baptismal and family names of the contracting parties. Its relative completeness is proven by the fact that it contains all the letters of the alphabet, duly compiled from A to Z.[12]

The secure data furnished by the *Libro secondo* enables us to propose here, for the years covered, certain preliminary considerations, which need to be gone into more fully, concerning the extent of the initially quite narrow social composition of the Dal Ponte clientele.

The geographical area within which Francesco il Vecchio and Jacopo dal Ponte garnered their commissions was decidedly limited, as can be verified graphically on the map drawn by David Rosand for the recent publication of the *Libro secondo* (fig. 1). It comprises roughly one hundred localities, most of them communes or fractions of communes dispersed around the town of Bassano. Altogether, they make up a kind of quadrangle of a few dozen square kilometers whose endpoints are, at the south, Sandrigo and Castelfranco, passing by way of Cittadella; and at the north, Valstagna and Paderno del Grappa. Asiago, Foza, and Enego attest their presence on the uplands of the Sette Comuni; Borgo and Strigno in the Valsugana; to the northeast, Feltre, with a few small villages, such as Belluno and Ceneda, roundabout; to the west, Fara Vicentino and Vicenza (a single commission, a Madonna with the young Saint John the Baptist ordered in 1548 by «Zuan schultor vicentino», who entrusted the advance deposit to an otherwise unidentified «*muraro*», a stonemason working for one Giacomo Angarano).[13] Farther north, Brusegana, Padua, Monte Ortone near Teolo, and then the Villa del Conte, Briana di Noale, Treviso, Oriago, and, finally, Venice. More remote places like Brescia, Lendinara, Soave near Verona, Monferrato, Naples, and Zara are named in the business ledger only as places from whence individuals entering into contact with the Dal Ponte family business hailed. If *The Flight into Egypt* (The Toledo Museum of Art, cat. 11) was done for Ancona at the start of the fifth decade, it represents an absolute exception to an otherwise restricted geographical area.[14]

12. Muraro 1992, 6.
13. *Libro secondo*, fol. 135r.
14. Costanzi 1991, and here, Ericani in cat. 10.

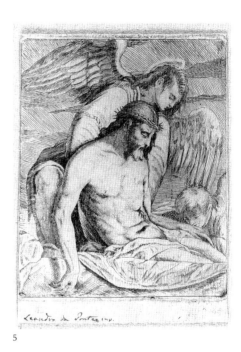

5. Anonymous, *Christ Laid to Rest by Two Angels*, engraving after Jacopo Bassano

At the center of this little world was Bassano del Grappa, faithfully depicted some time later by Francesco and Leandro dal Ponte in one of the most beautiful and accurate city views of the late Italian Renaissance (fig. 2).[15] It is worth having a look at the population (around 4,000), or at least that segment whose names appear in the ledger of the most important workshop painters in the zone. In a microcosm populated by representatives of all the artisan activities – stonemasons, smiths, woodworkers, barrel makers, wool drapers, weavers, tailors, shoemakers, millers, ferrymen – the leather workers (*pellizzari*, in the local dialect) were in the majority. From the historical information gathered by Franco Signori concerning the leading figures mentioned in the *Libro secondo*, it appears that thirty or so among those identified were leather workers.[16] In fact, Jacopo, the father of Francesco il Vecchio, was a *pellizzaro*, as were his sons Melchiorre and Baldassare. Also a former leather worker was the hermit, Fra Antonio – son of Giovanni da Colonia, who was likewise of the trade – who was certainly one of the central figures in the anxious quest for religious renewal that also pervaded Bassano in the first half of the sixteenth century. In 1537 Fra Antonio received a visit from Ignatius of Loyola, founder of the Compagnia di Gesú. Fra Antonio attracted a small community of hermits who had close contact with other personages whose names figure in the Dal Ponte account book; among them was Girolamo, Jacopo's brother who joined the priesthood.[17] The confraternity in which leather workers were most numerous was the Scuola della Beata Vergine Maria e di San Paolo, and it was for that association that Francesco il Vecchio painted *The Madonna and Child Enthroned with Saints John the Baptist and Bartholomew* to go on the altar of San Bartolomeo in the church of Santa Maria in Colle; later, in 1519, he produced a *Madonna and Child Enthroned with Saints Peter and Paul* for the church of San Giovanni.[18] According to the account book, in 1534 Francesco il Vecchio, by then well along in years, also supplied the Confraternita di San Paolo with a banner as partial payment of a long-term lease, a *livello*, for which he was indebted and which was finally paid off in 1542, with a credit in favor of Jacopo extending to the year 1551. In that latter year, the account was reopened with a *livello* assumed by Jacopo as well as numerous tasks he undertook for the confraternity: decorations for ceremonies and processions up to 1558; the painting of a Crucifix in 1554; the decoration of a large candle in 1567; an *Adam and Eve* and a job of restoration in 1568; and an *Annunciation* («two figures done after his cartoons larger than life») in 1569. The account with the confraternity – Jacopo was debtor for a *livello* and paid principally with his work – extended until 1588 and is the one with the latest dates in the ledger.[19]

To this can be added that a leather tannery is depicted in the lower right corner of the altarpiece of the *Most Holy Trinity* that Jacopo completed in 1548

15. The drawing is in the Museo Civico, Bassano del Grappa, Mappe, 10 (ink, red pencil, and watercolor on paper, 565 × 1220 mm). The inscription, though variously interpreted, bears at any rate the names of Jacopo's sons, Francesco and Leandro, and the dates 1583 and 1610, which have been considered the possible span for its execution. See Chiuppani 1904, 56-59; and *Album bassanese* 1988, 18-20. No explanation is given for the making of this splendid bird's-eye view, taken from the west, with many adjustments to make it more readable and more accurate. It should not, however, be overlooked that there are numerous points of contact (date, viewpoint, meticulous execution) with the representation of Vicenza, the so-called «pianta Angelica», made in 1580 by Giovanni Battista Pittoni as a model for the painting in the Belvedere map gallery in the Vatican that was planned by Egnazio Danti. See Ackerman 1967; and Barbieri 1973.

16. Signori, «Notizie storiche sui personaggi citati nel manoscritto», in Muraro 1992, 313-85. In particular, see the entries for Michiel Baggio, Bastian pelizaro de la Rosà, Matthio Bolognin, Chrestofano pelatario, Bortolamio de Cressini, Bernardo Cuxin, Bor-

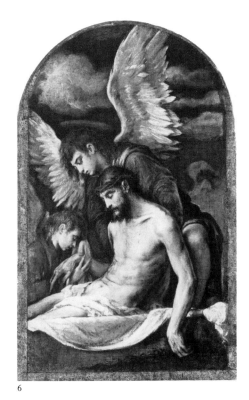

6. Jacopo Bassano, *Christ Laid to Rest by Two Angels*, private collection, Verona

6

tolamio and Domenico De la Fosa, Jeronimo De la Porta, Francesco and Paulo Dolzan, the Gardelins, Antonio, Beneto with his sons Gasparo, Zanandrea, and Zuanbattista, pre' Gasparo Gropello and his father Jeronimo, Piero Mazante, Nicolò pelizaro de Campolongo, Francesco Ottello, Piero dal Lion, Bortolamio de la Prana, Jacomo de Savio, Zuan Jacomo Scucato, Bortolamio Sossa, and Zuane Todesco.

17. The only allusions to him are in Michieli 1893 and Signori in Muraro 1992, 315 and 337.

18. Both works are now in the Museo Civico, Bassano del Grappa, invs. 1 and 2. For the Confraternita della Beata Vergine Maria e di San Paolo, see Signori in Muraro 1992, 325-26.

19. *Libro secondo*, fols. 21*v*, 41*v*, 98*v*, and 100*v*, 101*r*; Muraro 1992, *Catalogo*, nos. 68, 213-15, and 218-19. For the plausible suggestion that a painting by Jacopo depicting *Saint Paul Preaching* was intended for the Confraternita di San Paolo, see here, cat. 38.

20. Fabris 1991, 34-35.

21. *Libro secondo*, fols. 12*v*-13*r*; Muraro 1992,

for the church of the Santissima Trinità at Angarano di Bassano.[20]

On the other hand, Bortolamio de Cressini, Jacopo's brother-in-law and cousin of Cristoforo and Niccolò, both leather handlers, is identified as a «*calegaro*», or shoemaker. In 1538 Bortolamio ordered from Jacopo, and paid for partly in kind, a picture «with the story of Saint Catherine» and provided also a «*cuerta*», or painted cover, on which Jacopo painted a «*paese*», or landscape, which scholars have tried to equate with *The Martyrdom of Saint Catherine*, a painting now lost and documented only by a workshop copy.[21] Other small tasks of decoration are recorded for 1541, 1546, 1551, 1553, and 1563. Furthermore, Bortolamio puts in a personal appearance on several occasions as attendant or witness in circumstances connected with the administration of the family estate or possessions. The tasks carried out for Bortolamio are entered in the ledger in an exemplary manner: the gilding of a frame for a sign with tin foil («una forma da insegna con stagnolo»); the painting of an inkwell turned in the German style («calamaro fatto al torno tedesco») and a green bed with a single support («letiera verde con una arma»); a chest in imitation walnut («cassa fenta de nogara»); a dining table in imitation walnut and varnished («tavola da manzar fenta de nogara et in vernicada»); three benches («tre banche»); chests and *credenze* and two ceremonial staves with a lion and an eagle in the knob, done in various colors painted («con un leon e una aquila nel pomo, fati de piú colori invernichà»); a small banner in marzipan («banderola di marzapan»); and the restoration of an alabaster vase glued with mastic and gilded («incolà cun mastici e dorado») and, after a second break, further repairs.[22]

This clan of leather handlers, eager for a prominent place in the local society, was also responsible for the commission of one of the most spectacular and celebrated of Jacopo's paintings, *The Beheading of the Baptist* (Statens Museum for Kunst, Copenhagen, fig. 29). Originally there was also a lunette with a painted landscape (*paese*), which is now lost. The work was ordered in 1550 by Gasparo Ottello, a notary who resided in Padua, but who was the son of the leather handler Francesco Ottello, a native of Borso and resident of Bassano.[23]

Another son of Francesco Ottello, Giambattista, was rector of the church in Rosà and a notary public in Bassano. Together with the priest Girolamo Gropello, who also came from a family of leather workers and was himself a member of Fra Antonio's sodality of hermits, Giambattista Ottello was responsible for drawing up an interesting agreement with the Dal Ponte workshop. This was signed on 30 September 1550, in the house of the priest Evangelista of the monastery of nuns of San Girolamo, and contracted for various paintings including a *Flight into Egypt* (cat. 1) and a *Martyrdom of Saint Catherine* (cat. 13). In this contract Jacopo, having had to make do for several

years by then without the help of his brother Giambattista, agreed to take on as apprentice for eight years the young Zillio, son of his relative (« *barba* ») Battista Zilliolo: «…and I will provide his expenses and clothing and teach him the art ».[24]

Within what appears a dense web of relationships, familial and other, barter of goods and services was frequent, not only under the more old-fashioned administration of Francesco il Vecchio, but also during that of Jacopo. Thus, back in the 1540s Zuanne da Lugo, in exchange for paintings, supplied fabric for clothing for all members of the Dal Ponte family, including the apprentice Zillio.[25] Among the paintings thus bartered, there was also a portrait in 1540.[26]

Though the list of portraits contained in the *Libro secondo* is sparse, it does afford a significant cross section of humankind. Besides Zuanne da Lugo, one finds the priest Giovanni da Stringo, as well as Bartolomeo Merzari, a cousin of Jacopo's wife, plus members of well-regarded Bassano families, such as the doctor in jurisprudence Alessandro Campesano, the notary Alessandro Gardelin, the wool merchant Lazzaro Guadagnin, and Giulia Forcadura, late wife of Matteo Forcadura, who was a member of the city council, attorney, and landowner. There are also entries for the Venetian administrators of Bassano and Castelfranco such as Bernardo Morosini, Agostino Barbarigo, and Maffio Girardo.[27] The few names we know of the people who sat for their portraits are, so to speak, marginal to the grander historical events of the time. It is also true that as a rule the sitter's name was not recorded in the ledger and that the artist himself did not trouble to sign his portraits. These facts probably suffice to explain why Jacopo's production as a portraitist has virtually disappeared *in toto* and is all but unknown, despite his innate predisposition to naturalism and the praise of a Ridolfi, for one, of his gifts in this field.[28]

The picture one gets from the surviving account book is of an artisan's workshop where the carving and gilding of a frame was more profitable than the painting of an altarpiece, and where the heads of the shop were personally involved in producing objects of all sorts: wardrobe chests, coats of arms, banners and pennants, playing cards, simple firearms, candlesticks, cradles, designs for clothing and embroideries, gonfalons, along with candles (fig. 3), boxes, sculptures,[30] stoves, relief maps of the territory, and so much else.[31]

There is not a trace of patrons from Vicenza in the account book, but beginning in the 1530s there is the constant presence of Venetian gentlemen, functionaries of the Serenissima, and owners of property in the Bassano territory. This is a clear refutation of the notion that Venice became acquainted with Jacopo's art only after 1550, and then only through the new market for genre scenes and a growing interest in collecting them, an error implicitly

Catalogo, no. 94; *Notizie storiche*. The copy of the painting is in the Museo Civico, Bassano del Grappa, inv. 326. See Ballarin 1967, 77, 86, 89, and fig. 113.

22. *Libro secondo*, fols. 16 *v*-17 *r*, 18 *v*-19 *r*, 19 *v*-20 *r*, 46 *v*, 80 *r*, 98 *r*, 112 *r*, and 134 *r*.

23. *Libro secondo*, fols. 52 *v*-53 *r*; Muraro 1992, *Catalogo*, no. 189; and Signori in Muraro 1992, 365-66.

24. The name Zillio occurs frequently until 1557; see *Libro secondo*, fols. 19 *r*, 37 *r*, 80 *r*, 109 *r*, 117 *v*, 118 *r*, 119 *r*, 121 *r*, 128 *r*, 132 *r*, 134 *v*, and 136 *r*. The « contract » is registered on fol. 132 *r*. See also Puppulin in Muraro 1992, 307, n. 104. The document offers the possibility of an alternative explanation to that of the hand of Giambattista in a work such as *The Adoration of the Shepherds* (Gallerie dell'Accademia, Venice, inv. 1130); stylistically it is close to works of the second half of the 1540s, but bears the dates 1556 and 1557 (Moschini Marconi 1962, 13-14, n. 14). Its « Bassanesque » characteristics are not supported by a similarity to Jacopo's style, nor to that of Giambattista, nor, at this time, to any of those of his sons. It cannot be considered a copy. On this subject, see here, Rearick's essay, n. 115.

25. *Libro secondo*, fols. 54 *r*, 130 *v*, 131 *r*, 132 *r*-133 *r*, 134 *v*, and 135 *v*. For the commissions of Zuanne da Lugo, see here, Romani in cat. 32.

26. Muraro 1992, *Catalogo*, no. 112.

27. Muraro 1992, *Catalogo*, nos. 129-31, 133, 147, 160, 188, and 209, and the entries by Signori, nos. 323, 345, 347, 351, and 362.

28. Ridolfi 1648, I, 388: « Fu egli non meno valoroso nel far de' ritratti, riducendoli al naturale, essendo avvezzo à cavare le cose dal vivo, unde' quali è appresso del Signor Gioi Battista Cornaro di S. Luca. Ritrasse il Doge Sebastiano Veniero, Lodovico Ariosto, Torquato Tasso & altri letterati, e se stesso dallo specchio con la tavolozza e pennelli in mano… » Having mentioned the artist's propensity for portraiture, the actual list Ridolfi gives in support of his assertion is somewhat short. See also Verci 1775, *passim*. The objective and psychological « ungraspability » of Jacopo's portraiture has led to inevitable difficulties regarding attribution: among these one might mention a number in the otherwise excellent reading of Venturi 1929 (B), and the painter's absence from monographical treatments of a regional sort, for which, see Moretti 1983. Rearick 1980 (B) has made a fundamental contribution to the correct approach to this problem.

29. Muraro 1992, 14-19. The fees paid to Titian for altarpieces in themselves notably higher, quadrupled during the 1530s; see Hope 1990, 80; and Goffen 1990, 93, especially n. 23.

30. The *Libro secondo*, fols. 0*v*, 7*v*, 12*v*, 35*v*, 68*v*, 69*v*, 80*v*, and 119*v*, mentions the commissions for numerous sculptures. Among these, Muraro 1992, *Catalogo*, n. 167, identifies a Crucifix and a Saint John as part of a group, originally also including a Madonna, which was ordered by the *massari*, or stewards, of Castello di Godego in 1547. The style of the Saint John, which is still quattrocentesque, and the differences in typology and workmanship between it and the Crucifix, give rise to many objections about the proposed identification.

31. Muraro 1992, especially 16-17, and the « Indice generale delle opere e dei lavori diversi citati nel manoscritto », 437-38. The candle with Saint Anthony and floral decoration, still preserved in the parish church of Rosà, was identified by Muraro 1992, cat. 112 bis, as the one ordered by the spice-merchant Piero de Cante in 1540.

32. Vasari 1568, II, 816, says in his life of Titian that a painting by Jacopo in the house of Matteo Giustiniani is « very beautiful, as are many other works by this Bassano, which are spread about Venice, and are held in high esteem, most especially for little things, and for animals of all kinds ».

33. In 1534 Jacopo – however the note is by Francesco – received in Venice a payment for the « fazada de la Nave fata da novo », and in 1536 a payment for the door of the *brolo* with four virtues and four saints. For these and for other work, see *Libro secondo*, fols. 1*v*, 2*r*, app. v *r*; the entry by Signori in Muraro 1992, 346-47; and Bordignon Favero 1992. *The Last Supper*, commissioned on 14 September 1537, was identified and published by Joannides and Sachs 1991. Like the portrait of Torquato Tasso (Sammlung Heinz Kisters, Kreuzlingen, cat. 41), this *Last Supper* also passed through the English collection of Sir Abraham Hume.

34. The three « quadri istoriati va sopra la letiera » ordered from Francesco on 20 July 1535 – together with the painting for the ceiling of the « camera granda » in the Palazzo Pretorio, for which 200 lire were paid on 8 February 1536 – are, in fact, by Jacopo and depict *The Fiery Furnace* (fig. 11), *Christ and the Adulteress* (cat. 115), and *Susanna and the Elders*

deduced from Vasari's well-known assertion.[32]

Ambrogio Frizier de la Nave, a pharmacist in Venice, appears to have supplied paint to Francesco (yellows, azurite, various binders, gum tragacanth) in exchange for various tasks of frescoing and decorating his residence in Bassano, in the Nave district, and for whose main hall Jacopo painted the large *Last Supper* that was only recently rediscovered in the church of Saint Lawrence at Wormley in Hertfordshire.[33]

In 1535 Luca Navagero seems to have been the first Venetian podestà administering Bassano to become aware that the city housed the Dal Ponte workshop, and it is difficult not to suppose that this came about precisely because of the new importance being assumed within the shop by the young Jacopo.[34] The paintings done for Navagero remained in Bassano in the Palazzo Pretorio. Matteo Soranzo, podestà in the following year, ordered three pictures from Francesco il Vecchio (though probably executed under the direction of Jacopo), two of which perhaps returned with the official to Venice at the conclusion of his mandate: a Madonna with Saints Matthew and Lucy and a Christ at the column with a portrait, neither of which has been found.[35] The third, *The Podestà of Bassano Matteo Soranzo with His Daughter Lucia and His Brother Francesco Being Presented by Saints Lucy, Francis, and Matthew to the Madonna and Child* (cat. 2), is signed by Jacopo, who repeats, in a somewhat ingenuous key, the classical votive altarpiece of the Venetian tradition. This canvas remained in Bassano to adorn the administrative palace.[36]

Likewise Giovanni Simone Zorzi, who arrived to govern Bassano in 1537, did not fail to honor what could by then be considered a tradition and ordered from Francesco il Vecchio a painting of the three Magi for the palace (« che li va li tre Magi per la jesiola de palazo »). The identical price – 70 lire – and the format very close to that of the canvases commissioned by the two previous podestàs, as well as matters of style and the detail of the « portrait » in the center of the scene, all suggest that Zorzi's painting may well be *The Adoration of the Magi* now in the Exeter collection (Burghley House, Stamford, fig. 16).[37]

The Supper at Emmaus, together with a painting of Jacopo's choice, was requested in 1538 by Cosmo da Mosto, podestà of Cittadella, and intended for a member of the Malipiero family. It is clearly connected with the success enjoyed by a canvas on the same subject that Jacopo had just produced for the cathedral of Cittadella. The second version of this subject, the one painted for Cosmo da Mosto, is now in the Kimbell Art Museum, Fort Worth (cat. 4).[38]

Marco Pizzamano is another Venetian whose name appears among the accounts of Francesco il Vecchio for an altarpiece for Cittadella.[39] His family had a villa and land at Rosà and a house in Bassano in the Campo Marzo

neighborhood. In 1537, identified as «brother of Monsignor Pizaman», Francesco Pizzamano was elected archpriest of Bassano; in the same year he requested from Francesco a painting with quite an unusual iconography: Christ consigning the keys to Peter together with Faith, Hope, and Charity. The price of 62 lire suggests a medium-large format, and the balance of payment was made in Venice to Giambattista dal Ponte on 15 January 1538.[40] In October of the following year, Marco commissioned from Jacopo *Christ among the Doctors in the Temple* (Ashmolean Museum of Art and Archaeology, Oxford, fig. 18).[41] In 1544, the year Marco Pizzamano was podestà of Cittadella, his brother Pietro held that office in Bassano, and on that occasion he turned to the Dal Ponte workshop for *The Miraculous Draught of Fishes*, a painting recently identified in a private collection in England (cat. 15).[42]

In 1541 it was Pietro Venier who asked Jacopo for a *Nativity* (still unidentified), and who a few years earlier had acquired from him *Samson and the Philistines* (Gemäldegalerie Alte Meister, Dresden, fig. 100), which the painter himself restored in 1550.[43]

Documented in 1542 are portraits of Agostino Barbarigo with Maffio Girardo and Bernardo Morosini, podestàs of, respectively, Cittadella and Bassano.[44] Morosini, who does not seem to have belonged to the same branch of the family that had extensive properties at Cartigliano, also commissioned the *Marcus Curtius* and the *Lion* frescoed by Jacopo on the outer façade of the Porta Dieda.

The name of Luca Gradenigo, vice-podestà of Bassano in 1528 and in 1532, appears in the ledger in 1542, but only for payment of a certain quantity of wine.[45]

The high price – 117 lire – and the date of 1542 indicated for a «story of how the three Magi went to make offerings at the Manger», contracted for by a still mysterious «messer Giacomo Gisi», incline one to consider this the documentary evidence for *The Adoration of the Magi* (The National Galleries of Scotland, Edinburgh, cat. 10), but the matter is complicated and is likely to remain unresolved, because the gentleman took back the advance deposit that he had previously paid out.[46]

In 1545 there was an agreement with Alvise Masipo for a Madonna and a Saint Jerome in the Wilderness, one of which was consigned in 1550 to Masipo's widow through the intermediary Giovanni Soranzo, podestà of Bassano.[47]

Battista Erizzo – an antiquarian, a man of erudition, and a collector – was only twenty-four years old when, in 1546, he ordered the large *Last Supper* (Galleria Borghese, Rome, cat. 18). Among those who delivered the payments, which went on until 1548, was Pietro Morosini.[48]

Antonio Zentani, a Venetian patrician and diplomat, was named count

(Museo Civico, Bassano del Grappa, invs. 8, 9, 10). The first of the series is prominently signed « IACOBUS A PONTE BAS.ˢ FAC.ᵗ ». See *Libro secondo*, fols. 92*v*-93*r*; Muraro 1992, 25, *Catalogo*, no. 70; and here, Rearick's essay.

35. *Libro secondo*, fols. 94*v*-95*r*; and Muraro 1992, *Catalogo*, nos. 80-81.

36. *Libro secondo*, fols. 94*v*-95*r*; Muraro 1992, 27, *Catalogo*, no. 79; and here, Rearick's essay and cat. 2. Soranzo also links the commissions to the portrait of Francesco, brother of Matteo, mentioned by Rearick 1980 (B), 100, fig. 2, and 104, and now in the Musée des Beaux-Arts, Nancy, no. 81.

37. *Libro secondo*, fols. 95*v*-96*r*; Muraro 1992, *Catalogo*, no. 88, who does not propose the identification; and here, Rearick's essay.

38. *Libro secondo*, fol. 25*v*; and Muraro 1992, 29, *Catalogo*, no. 95. Of the two paintings, only one was in the collection of Cosmo da Mosto.

39. *Libro secondo*, fol. 25*v*.

40. *Libro secondo*, fols. 69*v*-70*r*. Details on the Pizzamano family are given by Signori in Muraro 1992, 368-69.

41. *Libro secondo*, fols. 69*v*-70*r*; and Muraro 1992, 31. The «Dispute» must have been liked, since, in fact, Jacopo notes that another unidentified gentleman had asked him for it and that Marco Pizzamano was prepared to let it go, but that it turned out to be too small for the first gentleman's house and so was finally sold to Pizzamano by Giambattista (fol. 70*r*).

42. *Libro secondo*, fols. 99*v*-100*r*; Muraro 1992, *Catalogo*, no. 154; and here, Rearick's essay and cat. 15.

43. *Libro secondo*, fols. 98*v*-99*r*; Muraro 1992, 32, *Catalogo*, no. 190.

44. *Libro secondo*, fols. 3*v*-4*r*, 5*r*, and 16*v*-17*r*; and Muraro 1992, 35, *Catalogo*, nos. 129 and 131. For the identification of the portrait of Morosini with the painting now in Kassel, see here, Rearick's essay and cat. 6. On the Morosini family «from Bassano», see Targhetta 1990.

45. *Libro secondo*, fol. 5*r*.

46. *Libro secondo*, fol. 55*r*.

47. *Libro secondo*, fols. 6*v*-7*r* and the note on this person by Aikema in Muraro 1992, 359.

48. *Libro secondo*, fol. 18*v*; Muraro 192, 36-37, *Catalogo*, no. 163, and the note by Aikema, 342; and here cat. 18.

and *cavaliere* by Pope Julius III. Governor of the Ospedale degli Incurabili in Venice, he ordered the new church to be built on Sansovino's model. A passionate enthusiast of letters and the arts, he owned an important collection of antiquities. And it is to his intellectually highly exacting commission, passed on by the priest Nicola da Pesaro, that we owe Jacopo's realization in 1548 of one of his most singular and innovative works: one of those paintings depicting only animals, in this case two dogs, which constitute one of the great preludes to the art of future centuries.[49]

The absence of the family name from the *Libro secondo* makes it impossible to give a precise physiognomy of Antonio Contarini, a relative of the previously mentioned Battista Erizzo, who in 1552 ordered from the Dal Ponte, with the mosaicist Valerio Zuccato as intermediary, a painting of an unspecified subject.[50] Thus it cannot be said with any certainty that this was the Antonio Contarini who, from 1528 to his death in 1556, was parish priest of the church of San Martino in Venice and who entrusted the reconstruction of the church to Jacopo Sansovino in a climate of «religious anxieties» that has been so well described by Manfredo Tafuri.[51]

At the request of Alvise Contarini, podestà in 1552, and his brother Albertuci, who were of a branch of the family that had property in and resided in Bassano, Jacopo executed the ceiling decoration of a small hall in the Palazzo Pretorio.[52]

In 1552, Suor Maria Pesaro, abbess of the monastery of San Sebastiano in Bassano, ordered a frame for a picture depicting the Agony in the Garden.[53]

An important patron of the mid-1550s was Domenico Priuli, proprietor of the mills at the foot of the castle in Bassano. In 1552 he ordered a painting of an unspecified subject, a small canvas with a Madonna and Saints Catherine and Joseph, that Rearick has identified as *The Mystic Marriage of Saint Catherine* (Wadsworth Atheneum, Hartford, cat. 22), and a head of Christ bearing the cross, followed in 1554 by a *Miracle of the Quails and the Manna* formerly in a private collection in Bergamo.[54]

Among the Venetian patrons should also be noted Girolamo Ingegnerio, friend of the banker Girolamo Obizzi, who requested in 1548 a picture of the artist's own choice.[55] Finally, in 1550 Giambattista Fontana, identified as a gentleman of Treviso and a physician, asked Jacopo for a small picture with the story of the Good Samaritan, possibly the canvas now in the Royal Collection at Hampton Court (fig. 25).[56]

Thus it was in large part the enlightened and cultivated Venetian aristocracy who were the first to grasp the particular character of Jacopo's art and to launch it internationally from the piazza of their metropolis, frequented as it was by merchants from all over Europe.

Besides the substantial harvest of information regarding Jacopo's early pa-

49. *Libro secondo*, fols. 6*v*-7*r*; and Muraro 1992, 43, *Catalogo*, no. 173, and the profile of Antonio Zentani by Aikema, 382.

50. *Libro secondo*, fols. 8*v*-9*r*; and Muraro 1992, *Catalogo*, no. 206, and the note by Aikema, 331. For «Valerio Zuchato dal musaicho da Venetia», see the note by Signori in Muraro 1992, 385.

51. Tafuri 1985, 82-83, and no. 85.

52. *Libro secondo*, fols. 4*r* and 7*v*-8*r*; and Muraro 1992, *Catalogo*, no. 198, and Signori's note, 331.

53. *Libro secondo*, fols. 75*v*-76*v*.

54. *Libro secondo*, fols. 7*v*-8*r*; and Muraro 1992, 43, *Catalogo*, nos. 203-4 and 211, and Signori's note, 370.

55. *Libro secondo*, fol. 74*v*; and Signori in Muraro 1992, 353.

56. *Libro secondo*, fols. 134*v*-135*r*. The identification of the painting is not proposed by Muraro 1992. Rearick is more cautious, see here, his essay, n. 107.

trons in Bassano and Venice, the *Libro secondo* also affords a fleeting, but significant, glimpse at the dealers who marketed his work, confirming Ridolfi's assertion that Jacopo appears to have painted numerous canvases with biblical scenes « that the Venetians took off his hands from time to time to sell, and others he himself sent to Venice for sale ».[57]

Jacopo's commercial connection with Alessandro Spiera, a painter in his shop in the Calle delle Acque in Venice, appears from the ledger to have been continuous from 1539 to 1543. Even if only in exchange for painting materials, Jacopo sent Spiera full-sized pictures and *quadretti*, small pictures worth only two ducati, such as, for example, a *Madonna and Saint Joseph*, along with larger « four-ducat » works, such as a *Nativity* and a *Christ Bearing the Cross*.[58]

A good many works were ordered by communes and parishes, and even more by confraternities: a full thirty-four, in fact.[59] But the religious orders also sought out Jacopo. The Eremitani of Santa Maria del Camposanto at Cittadella maintained an uninterrupted connection with the workshop between 1525 and 1541, ordering four altarpieces, a restoration, and a *Last Supper*, though it is not specified if the latter was on canvas or frescoed.[60] The Augustinian nuns of San Sebastiano at Bassano wanted only frames and gilding in 1526, 1529, 1552, and 1553.[61] Francesco supplied the Camaldolese friars of Monte Ortone with a painting of the Madonna,[62] and between 1535 and 1537, for the prior of Santa Maria in Castello di Godego, he produced a canvas with a Saint Michael and a portrait of the donor.[63] The Benedictines of San Fortunato, belonging to the congregation of Santa Giustina in Padua, gave Francesco work in 1536 and 1537, frescoing the little church of Santa Lucia at Santa Croce Bigolina,[64] while Fra Zampiero, guardian of San Francesco, requested from the young Jacopo in 1536 a painting of Saint Anthony.[65] The priest Evangelista, connected with the Benedictine nuns of San Girolamo, was one of the Dal Ponte family's most assiduous clients: in 1534 he ordered *The Flight into Egypt* (cat. 1); between 1532 and 1536 he made payments for a painting of the altar of the Corpus Christi; in 1538 he ordered a *Saint John the Baptist*; and in 1544, *The Martyrdom of Saint Catherine* (cat. 13).[66] It was perhaps in emulation of the latter acquisition that the Augustinian nuns of San Giovanni, and in particular Suor Benedetta, contracted with Jacopo in 1547 for « a picture of Christ bearing the Cross with the Madonna and Saint John the Evangelist behind the Christ », and for a price slightly lower than what the Benedictines paid for the Martyrdom: 43 lire and 8 soldi compared to 49 lire and 12 soldi.[67] Although the *Christ Bearing the Cross* is analogous in format to *The Martyrdom of Saint Catherine*, stylistic factors suggest caution in identifying it as either the version in the Christie collection at Glyndebourne (fig. 24) or *The Way to Calvary* (The National Gallery, London, cat. 14).[68] Re-

57. Ridolfi 1648, i, 390.
58. *Libro secondo*, fols. 95v-96r and 98v-99r; and the note by Puppulin in Muraro 1992, 306-7, which mentions the limitations imposed on foreign artists by the Venetian painters' guild, and the probable role Spiera played as an intermediary in putting Jacopo's works on the market.
59. Muraro 1992, « Indice dei nomi citati nel manoscritto », 427.
60. Muraro 1992, *Catalogo*, nos. 14-16, 26, 47, and 99. See also here, Ericani's essay.
61. Muraro 1992, *Catalogo*, nos. 21 and 207.
62. Muraro 1992, *Catalogo*, no. 43.
63. Muraro 1992, *Catalogo*, no. 72.
64. Muraro 1992, *Catalogo*, nos. 76 and 87. See also here, Ericani's essay.
65. Muraro 1992, *Catalogo*, no. 77.
66. Muraro 1992, *Catalogo*, nos. 48, 54, 101, and 148.
67. Muraro 1992, *Catalogo*, no. 169.
68. For a different opinion, see here, Rearick's essay, n. 113.

lations with the Reformed Franciscans of Asolo are confirmed not so much by the commission of the altarpiece depicting *Saint Anne and the Virgin Child with Saints Jerome and Francis* (Museo Civico, Bassano del Grappa, cat. 7), which was ordered in 1541 by the Confraternita della Concezione,[69] as by the contemporaneous *Franciscan Friar* (Earl of Shelburne, Bowood House, fig. 19)[70] and *The Madonna in Glory with Saint Jerome*, signed and dated 1569 (Gallerie dell'Accademia, Venice).[71]

It would be audacious in light of the information presented above – which has so far not been fully investigated – and in view of the few existing studies, to attempt to discuss Jacopo Bassano's religious attitude. A similar query, however, elicited rich and stimulating reflections on Lorenzo Lotto and Pordenone, who, like Jacopo, rendered in an anticlassical manner their « provincial » personalities and dealt chiefly with that middle, or petty bourgeois, class of artisans or modest merchants, in whom the reformed doctrine found the most favorable terrain.

Concerning the altarpiece of *Saints Justina, Sebastian, Anthony Abbot, and Roch* (cat. 31) and the decoration undertaken in the parish church at Enego, Verci wrote: « It is rumored that Giacomo had carried out all those tasks... at a time when he had fled from his home place and, for his greater safety, withdrawn to that village. Of that we have not found a grain of evidence, and therefore cannot assert it with any foundation, nor say if he did so either because he had fallen afoul of the law or, as would be more likely, to escape the risks of a raging plague that in 1576 ... invaded Bassano as well, where it wreaked frightful havoc ».[72] This passage is in itself decidedly vague and completely misleading with regards to the chronology of the works, indeed so much so as to make one suspect that its principal aim and excuse was a concern with defending the reputation of the beloved artist and fellow-citizen from the venom of the village gossips. Rearick, however – in the only study specifically devoted to the subject – took it as a point of departure to represent Jacopo, though with due caution, as open to Protestant ideas.[73] But the meager suggestions gleaned from the few elements available at the present stage of research do not permit any precise identification of the artist's religious predilections, not even for the years up to 1555, which, besides being the best documented, were – in the Veneto region, in particular – the most energetic and interesting from the point of view of the religious debate. Moreover, up to the 1540s – 1541 marked the failure of the Diet of Regensburg, in which the Venetian Gasparo Contarini had taken a leading role – a good many people within the Italian evangelistic movement did not signify a break with the church of Rome. It is also true, as Aldo Stella pertinently reminds us, that during the following decade as well, when the reform movement was in full crisis, it is not easy « to distinguish and delineate the

69. *Libro secondo*, fols. 44v-45r and 47r; and Muraro 1992, 32, and *Catalogo*, no. 121.
70. Rearick 1980 (B), 106-7, and here, Rearick's essay.
71. Moschini Marconi 1962, 12-13, n. 12.
72. Verci 1775, 106.
73. Rearick 1978 (B); Bordignon Favero and Rearick 1983; Rearick 1984; and also here, Rearick's essay.

increasing alienation of the two principal currents, one heterodox, the other remaining more or less within the bounds of orthodoxy, because in large measure they both appear inclined to a Nicodemite practice of avoiding grave suspicions ».[74]

The town of Bassano's geographical position and intense commercial activity led to frequent relations with Germany, and Bassano was certainly not immune to the more or less organized spread of Protestant sympathies, which we know won numerous adherents in Vicenza, Asolo, and especially nearby Cittadella.[75] The subject, however, has been completely neglected by scholars. One of the rare testimonies to the penetration of Lutheran tendencies into Bassano has proven to be the declarations of the archpriest Francesco Pizzamano (whose connection with the Dal Ponte shop as a client has already been noted), on the occasion of his pastoral visits on 5 September 1542 and 23 May 1544. When asked if there were heretics or their sympathizers in Bassano, he asserted that the Eremitani di Santa Caterina in Margnan took advantage of the confessional and their sermons to spread false opinions concerning the value of vows and the existence of Purgatory.[76] His declaration, however, still awaits proof and deeper investigation. Nevertheless, the *Libro secondo* records contacts with the friars of Margnan – a country town with an active population of woolworkers, dyers, and leather workers coming chiefly from northern and southern Germany – for small tasks, arranged for by the Confraternita di San Nicola da Tolentino.[77] The *Libro secondo* is equally uninformative regarding Giacomo Angaran, a resident of Bassano at the time, whose reformist positions are known, since he is named only incidentally, without evidence of any direct relationship.[78] On the other hand, verification is still totally lacking as to the duration and character of the connection between Francesco Negri and the town of Bassano. Negri, in fact, broke with the Catholic Church far from his native hometown – first in the Benedictine monastery of San Benedetto di Polirone; then in Santa Giustina in Padua and San Giorgio in Venice; subsequently at Strasbourg, where he drew close to Zwingli's doctrine; then in Chiavenna, Tirano, and, finally, in far distant Cracow.[79] More than the intransigent violence of his nonetheless successful and widely read tragedy, *Il libero Arbitrio* (1546), of interest to our subject is the short poem *Rethia*, published in Basel in 1547. Its descriptions of the Rhaetian region and the pastoral life of its inhabitants, along with the poet's nostalgia for Bassano and its landscape in the changing seasons, are imbued with an intense poetry that has been compared to the paintings of Jacopo Bassano.[80] Among the dedicatees of the poems published as an appendix to the volume appear two citizens of Bassano, Antonio Gardelin and Matteo Forcadura, the latter of whom was certainly also in contact with Jacopo Bassano.[81]

74. Stella 1983, 11.
75. Fasoli and Mantese 1980, 450. For Vicenza, see Stella 1983; and for Cittadella, see Zille 1971.
76. Mantese 1980, 108, n. 218; and Signori in Muraro 1992, 368.
77. *Libro secondo*, fols. 112v and 130v; and for the confraternity, see Signori in Muraro 1992, 328.
78. See above n. 13; and Zappa 1990, 320-22.
79. The most substantial bibliographic reference on Francesco Negri remains Zonta 1916, but see also Scremin 1976-77.
80. The parallel is suggested by Vinco da Sesso 1980, 574.
81. *Libro secondo*, fols. 76v-77r and the entry by Signori in Muraro 1992, 344-45.

82. Stella 1989, 199 ff; and Olivieri 1981. However, Stella 1989, 214, documents the furrier «Alessandro Ghecchele da Bassano» as an Anabaptist.

83. For Lorenzo Lotto's piety, see Calí 1981; and Fontana 1981. For Pordenone, see Calí 1984.

84. See here Ericani's essay. Other possibilities might be the *Trinity* altarpiece, the Lusiana *Descent of the Holy Spirit* (cat. 20), and the later *Descent of the Holy Spirit* (Museo Civico, Bassano del Grappa, cat. 119), in the context of the orthodox reaction to the anti-Trinitarian movement, which spread throughout the Veneto in the fourth and fifth decades of the sixteenth century (Stella 1969). The study by Aikema is announced in Aikema 1989, 96, n. 37.

85. The problem is already discussed in Aikema 1989, 75-76, with regard to similar choices in Flemish painting. We might apply to Jacopo the interpretation suggested by Emmens (1973). He maintains that the genre scene is not a self-sufficient entity nor does it serve to render more accessible the painting's religious content. Rather, it is a kind of admonition stressing the contrast between *voluptas* and the Christian life. Conceived as they were with this moralistic intention, these paintings gave rise to a taste for genre *per se*, under the influence of the merchant classes. This moment of artistic exploration was relatively brief, in view of the Council of Trent's teaching that the biblical message should be both clear and legible. See Emmens 1973, 78-79.

86. Ridolfi 1648, I, 375.

87. Ridolfi 1648, I, 377; and here, Ericani's essay.

Jacopo's relations with the religious orders offer little more towards deciphering his religious sentiments. More than one of the orders served by the Dal Ponte workshop – Eremitani, Reformed Franciscans, Benedictines, and canons of San Giorgio in Alga, from whom came commissions in the 1570s – made their contribution to the spread of a revitalized religiosity, one that would be more inward and less weighed down by the superstructures of the ecclesiastical apparatus. Yet, with none of these bodies does one find anything similar to an exclusive relationship with the workshop, some particular bond, that might cast light on a more profound rapport.

As for the group of leather handlers, or *pellizzari*, that Jacopo frequented and to which he was linked by family roots, the connections have never been looked into thoroughly. There is, however, proof of some such bond with similar groups in the Veneto who propagated heretical ideas.[82]

But then too, in the workshop account book one finds no traces of everyday speech, expressive comments, references to particular forms of solidarity, or mutual aide comparable to those that render Lorenzo Lotto's *Libro di spese diverse* an exceptional document of a troubled conscience, yearning for a different contact with divinity. The Dal Ponte's ledger is strictly a matter of bookkeeping, the accounts of a family business, in the nature of the *Giornale* of Paolo Farinati. It has nothing of the accessory remarks more fitting to a personal diary, such as one finds in Lotto's or Pontormo's daybooks, whose individualistic, intimate character reflects a very different social and working situation as well as the humanism and literary predispositions that distinguished the preceding generation.[83]

No research has been done on the subjects chosen by Jacopo nor on their iconography. Only recently has Ericani explored certain aspects of his youthful period, while Aikema is at work on an extensive iconological study.[84] In Jacopo's pictorial corpus the subjects are almost exclusively religious, with slightly more frequent representations of the Madonna than of Christ. Even in the very successful series of the Seasons, or at least in their prototypes, there is invariably a biblical reference, even if only in a secondary position and towards the back of the composition. Thus the paintings that at first sight would be thought of as genre or pastoral scenes are, in reality, representations – progressively richer and more elaborate stagings – of parables from the Gospels or of Old Testament episodes.[85] Among the very few profane themes and the even rarer depictions of the female nude, which, in any case, appear only when strictly necessary, are the «fables of Ariosto and the Liberal Arts and a nude Venus in a little landscape» in the courtyard of Ca' Dolfin at Rosà noted by Ridolfi,[86] the Giorgionesque nudes of Casa dal Corno in Bassano – presented here in a sketch by Cavalcaselle (Biblioteca Nazionale Marciana, Venice, fig. 9) – and of the houses of the Campesan family,[87] with

Diana and Actaeon (The Art Institute of Chicago, cat. 73) and, perhaps, *Orpheus* and *The Rape of Europa*.[88] In the case of *Susanna and the Elders* (Musée des Beaux-Arts, Nîmes, cat. 72), the nude Susanna is there to represent purity, according to Rearick, who numbers among other iconographic oddities, in the sense that concerns us here, an *Ecce Homo* in a Milanese private collection, *The Nativity with Symbols of the Passion* (Museo Civico, Vicenza, fig. 4),[89] and the *Portrait of a Man in Prayer* (Civica Galleria di Palazzo Rosso, Genoa, cat. 42).

From the pages of the workshop ledger and the images of the paintings, we see Jacopo as a man who is serene, well balanced, and harmoniously integrated in his civil and social context, of a profound faith, yet, at least apparently, without anxieties and perturbations. And yet, if in the present state of research it is hazardous to venture any concrete association on his part with the world of the Protestant Reformation, there is no evidence of any direct connection with the lively and variegated movement in the Veneto of the so-called Catholic Reform. Oddly enough, however, it was precisely this solitary individual, stubbornly devoted to his work and rather out of step with the great artistic movements of his time (though by no means unaware of them), who gave rise to certain major revolutions, in both pictorial approach and content, in sixteenth-century painting.

After having rendered the villages « no less worthy of respect than the cities by means of paintings »,[90] Jacopo received occasional commissions of a certain importance from some of the cities of the Venetian Republic. Yet these were only sporadic episodes, not in the slightest comparable in extent or importance to similar tasks awarded to Titian, nor, even, to Veronese and Tintoretto. We have very little information concerning the historical circumstances of those commissions, which should, and can, be investigated more thoroughly.

Jacopo's first public commission in Venice was for a triptych depicting *Saint Christopher and Saints*, painted in the late 1550s for the church of San Cristoforo della Pace on a small island near Murano. Later Jacopo would paint a *Saint Jerome*, now lost, for this same church.[91]

More central, important, and enriched with works by esteemed colleagues like Paolo Veronese and Tintoretto was the Jesuit church of Santa Maria dell'Umiltà for which, in the early 1560s, Jacopo painted *Saints Peter and Paul* (Galleria Estense, Modena, cat. 34).

In 1592, the year of Jacopo's death, his *Adoration of the Shepherds* (fig. 83) was installed in San Giorgio Maggiore in Venice. By then his presence in the capital was more frequent – even if indirect – since, significantly, his sons Francesco and Leandro had settled there, regardless of the prudent and reserved « provincial » distance their father had always, and almost severely, main-

88. See here, Rearick's essay, n. 375.
89. Rearick 1978 (B), 339-40.
90. Ridolfi 1648, I, 377.
91. Ridolfi 1648, I, 379. For both, see here, Rearick's essay.

tained. Far from their roots, though repeating their father's types and prototypes, the sons' art would become something very different if not openly antithetical, at least in the huge historical canvases for the Palazzo Ducale. It would suddenly also win great success: in the comments of a literary personage foreign to the Venetian world like Lomazzo (1584), Francesco was considered on a par with Jacopo, if not his outright superior.

Just as in the account book it has been impossible so far to identify any citizens of Vicenza, it may be also that the commissions for that city reached the artist by indirect channels. A plausible working hypothesis in the search for an intermediary who commissioned the altarpiece of *Saint Eleutherius Blessing the Faithful* (Gallerie dell'Accademia, Venice, cat. 40) might be to look for some confraternity whose members were artisans connected with the church named for that saint.[92] *Saint Roch Visiting the Plague Victims*, done for the church of San Rocco in Vicenza (now Pinacoteca di Brera, Milan, cat. 47), *The Madonna and Child with Saints Mark and Lawrence Being Revered by Giovanni Moro and Silvano Cappello* (fig. 54), and the *Entombment of Christ* (formerly in Santa Croce, the church of the Padri Crociferi), date from the beginning of the 1570s, when Veronese was working in Vicenza, at Monte Berico, and also for the same church of Santa Croce. If the commission for the large lunette of the rectors, which is signed and dated 1573, initiated with the Venetian patricians Giovanni Moro and Silvano Cappello, who are portrayed within, it should be remembered that the church of San Rocco belonged to the canons of San Giorgio in Alga, who would turn to the artist from Bassano for *The Entombment* (cat. 52) for the Paduan church of Santa Maria in Vanzo in 1574,[93] a work that is certainly of a later date than the version in Vicenza.

In Treviso, the monastery of Dominican nuns of San Paolo that requested a *Crucifixion* from Jacopo in 1562 (cat. 37) included among the sisters a native of Bassano. But as yet no study has been made of the works for the church of the Ognissanti in Treviso, of the altarpiece with *Saints Fabian, Roch, and Sebastian* for the cycle at Civezzano, of the canvas for Feltre,[94] of the series for the Jesuits in Brescia, carried out in collaboration with Jacopo's sons, or for other works for Cividale and Chioggia recorded by Ridolfi.[95]

Besides the sculptor Giovanni of Vicenza and the Venetian mosaicist Valerio Zuccato, other artists active in Venice appear in the account book as collectors, intermediaries, and, on occasion, dealers. These include the jeweler Marco Bellagamba and two engravers from Feltre: Girolamo, son of Vettore, and Alessandro Scienza.[96]

More significant in this context is the presence of two «landscapes» by Jacopo and a *Noah's Ark* in the collection of Alessandro Vittoria, who could pride himself on owning, besides paintings by Flemish authors, Veronese, and Titian, no less than Parmigianino's *Self-Portrait in a Mirror,* along with nu-

92. See here, cat. 40.
93. For the altarpieces of San Rocco and Santa Maria in Vanzo and their commissions, see here, cats. 45 and 52.
94. For all these, see here, Rearick's essay.
95. Ridolfi 1648, I, *passim.*
96. *Libro secondo*, fols. 75*v*, 60*v*-61*r*, and 81*v*. The contacts with Gerolamo and Alessandro Scienza are documented between 1541 and 1542, those with Marco Bellagamba in 1551.

7. Licisco Magagnato, *Sketches Made at the 1957 Jacopo Bassano Exhibition*, Museo Civico, Bassano del Grappa

7

merous engravings and drawings by that artist.[97] Even Titian, according to Ridolfi, acquired for the considerable sum of 25 scudi an *Entry into the Ark*,[98] perhaps the very one sent to Philip II of Spain.[99]

The fact is that it is only after the key date of 1550 – the year that the first edition of Vasari's *Vite* was published, in which there is no mention of Jacopo, and a period no longer documented by the account book – that there is firm evidence of Jacopo's success outside his native town. Even if, prior to that date, Jacopo had a good number of clients in Venice and a fair number of his works were to be seen there, he acquired a certain renown when he presented himself as the author of pictures in a small format with animals, pastoral scenes, and night-pieces on canvas or on the « black stones of Verona ». It was then that his name began to appear in contemporary sources: in Vasari's second edition of 1568;[100] in the *Ragguaglio* of Rocco Benedetti, recounting the celebrations in Venice for the victory at Lepanto in 1571;[101] in the biographies by Karel van Mander (compiled around 1576 and published in 1604); and in Marucini's book of 1577.[102] A good Dutchman, Karel van Mander was, of course, interested in Jacopo's genre scenes and virtuoso effects in his night-pieces, as well as in the dynamics of the market and Jan Sadeler's translation of Jacopo's paintings into engravings. A traveler who never ventured as far as the town of Bassano, Van Mander nonetheless noticed, and at quite the right time, the interest collectors were showing in Jacopo's work, noting that examples were to be found in Venice, Rome, at the royal

97. Predelli 1908, 230-36.

98. Ridolfi 1648, I, 379.

99. Muraro 1957, 379; Rearick 1980 (C), 373, and n. 19; Rearick 1984, 311, n. 29.

100. See above n. 32.

101. Rocco Benedetti, *Ragguaglio delle Allegrezze, Solennità, e feste, fatte in Venetia per la felice Vittoria, al Clariss. Sig. Girolamo Diedo, digniss. Consigliere di Corfu*, Venice 1571, published in Gombrich 1967. In describing the celebrations organized by the drapers of the Rialto, Benedetti writes: « Each shop was adorned with arms, with spoils, with trophies of the enemy taken in battle, and with marvelous paintings by Giovan Bellino, by Giorgion da Castel Franco, by Raffael d'Urbino, by Pordenone, by Sebastianello, by Titiano, by the Bassanese miraculous for painting pastoral subjects, and by many other most excellent painters » (Gombrich 1967, 63). Gombrich (1967, 64, n. 11) also draws attention to the way Sansovino (1663, 415) replaces the name of Jacopo in the list with that of Michelangelo, and he advances the view that Benedetti used the expression (« miraculous for painting… ») as a necessary explanation, which shows that at the time Jacopo was little known in Venice.

102. Borghini 1584; and Lomazzo 1585, VI, LXI.

32

8. Licisco Magagnato, *Sketches Made at the 1957 Jacopo Bassano Exhibition*, Museo Civico, Bassano del Grappa

8

court of France, in Amsterdam collections, and, in particular, in that of Ioan Ycket. Rather more peculiar was the attitude of Marucini, who himself was from Bassano and had before his eyes everything the painter had done in his youth and for various churches, yet ignored it in favor of the innovations of the « new Apelles » in the realm of genre. The natural commercial outlet for paintings of that type, and therefore their immediate and vast diffusion, set the tone for Verci's critical approach followed by that of his successors, who increasingly emphasized the altarpieces that could readily be seen *in situ*.

Ridolfi offers the most detailed and balanced view of Jacopo's production and devotes a number of densely packed pages in his biography to listing the biblical episodes the artist had depicted.[103] He does this with such precision and wealth of detail as to suggest firsthand acquaintance with the works themselves. Although he only cites certain subjects as examples known to him, many other subjects were painted for which no examples have survived or, at any rate, have been identified. From the book of Genesis, the artist derived the series of Adam and Eve, Noah, Abraham, and Jacob, and Joseph; from Exodus, those of Moses and the Hebrews in the desert; while still others were taken from Numbers, Deuteronomy, Joshua, Judges, Ruth, Kings, Chronicles, Tobias, Judith, Esther, and Job. For those subjects, dozens upon dozens of them, Ridolfi puts the accent on the naturalistic rendering of details and on the painter's skill in description, and he stresses how attractive those works were to the public as well as their possible usefulness for reli-

103. Ridolfi 1648, I, 379-82.

gious teaching. He cites as an example the case of the jeweler Antonio Maria Fontana, who ordered from the painter «many episodes in the life of the Savior» to be used in preaching and diffusing the Christian religion in the Indies.[104] Ridolfi then goes on to mention paintings based on the Gospels, giving particular attention to a long list of parables, and then mentions the *Seasons* and a series in the collection of the painter Nicolas Regnier, who also owned a *Supper at Emmaus*, adding that there was another series in the church of Santa Maria Maggiore. The growing success of such subjects can be deduced, if we read between the lines of Ridolfi's book, from the fact that some of those paintings were offered for sale alongside the church of San Moisè in Venice for an endless time, with never a sniff from a purchaser, and then, suddenly, «in our days» were snapped up for thousands of scudi, which meant that the worthy artist, by the sweat of his brow, had supplied many with the stuff by which to enrich themselves.[105]

Ridolfi further explains the invention of other series such as the *Months* and the *Elements* as the results of royal commissions from Emperor Rudolph II and another «great Prince».[106] There follows a rapid listing of highly impressive places where paintings by Jacopo were to be found – especially in England, at Rome, Antwerp, and Venice – a list amply confirmed by other independent sources.[107] Verci's vividly imagined scene of a «ship bearing pictures by the Bassani... as blithely sailing off to Prismouth [Plymouth] as if arriving laden with the wealth of Java and Borneo»,[108] finds fitting confirmation in the archival documents detailing the purchase of the collections of Bartolomeo della Nave and, in lesser measure, of Nicolas Regnier and of a certain «Gobbo» that was carried out by Basil Fielding, the English ambassador in Venice from 1634 to 1639, acting for his brother-in-law the Marquess of Hamilton, who, in all likelihood, had it in mind to sell them to King Charles I. Arriving in Britain at the outbreak of the Civil War in 1642, a good many of the paintings made their way to Belgium between 1648 and 1659, where they became the nucleus of Archduke Leopold Wilhelm's collection in Brussels.[109] As for the British royal collections, it is worth noting that in the inventory of Charles I's possessions in 1649, *The Adoration of the Shepherds* (cat. 17) was appraised at 25 pounds compared to 50 pounds for *Jacob's Journey* (cat. 33). Thus the «pastoral» painting, although of slightly smaller format, earned a decidedly higher valuation.[110]

Even from these fleeting remarks it can be concluded that, in the entirely seventeenth-century phenomenon of Jacopo dal Ponte's success among collectors, England very early won a sort of leadership. Unlike that of other countries, British taste did not predominantly or exclusively favor the so-called genre scenes, but collectors also sought out his youthful paintings and those of his mannerist period. This is borne out by the very rich presence in

104. Ridolfi 1648, I, 384.

105. Ridolfi 1648, I, 386.

106. Ridolfi 1648, I, 387. For other Dal Ponte works in Venetian collections, see Ridolfi 1648, I, 321, and II, 201.

107. Ridolfi 1648, I, 387 88, records paintings by Jacopo: in the collections of King Charles I of England; the Duke of Buckingham (a series of *The Seasons*); the Earl of Pembroke (a *Noah's Ark*); Lord Arundel (*The Expulsion of the Merchants from the Temple*); and at Rome: in the collections of the Duca di Bracciano (*The Deposition of Christ*, «painted most rarely by night»); and the Aldobrandini and Borghese families. For Rome, see Mannili 1650, who cites thirteen Dal Ponte works in the Borghese collection. For *The Rest on the Flight into Egypt*, which passed in 1618 from the collection of Cardinal Federico Borromeo to the Pinacoteca Ambrosiana in Milan, see Magagnato 1983, 147. Other examples of Jacopo's paintings in Italy and Spain in the seventeenth century appear in the manuscript inventories at present being catalogued by the Getty Art History Information Program. Burton B, Fredericksen, Director of The Provenance Index, has kindly supplied this information. For seventeenth-century English collections, see the highly accurate provenance notes in Shearman 1983. *The Beheading of the Baptist* (Statens Museum for Kunst, Copenhagen, fig. 29) was also in an English collection in the early seventeenth century. See here, Rearick's essay, n. 127. For the somewhat limited presence of Jacopo's work in seventeenth-century France, see Florisoone 1954.

108. Verci 1775, 119. The source of the episode is Abbot Giambattista Roberti.

109. Waterhouse 1952. For Dal Ponte paintings in the collection of Leopold Wilhelm, see below.

110. Shearman 1983, 21 and 25.

British collections of works from the start of Jacopo's career and early maturity, and their appreciation finds support in the fact that there are equally as many, if not more, copies of works from precisely those years.[111] Since the English were avid collectors of Jacopo's paintings, England became the center for the market that, in the nineteenth century, created a market in the United States as well. From the volumes of the Getty Art History Information Program's *Index of Paintings Sold in the British Isles During the Nineteenth Century*, one learns that between 1801 and 1810 almost four hundred paintings by Jacopo were sold, a figure which dropped to around three hundred in the next decade. The two prime pieces by Jacopo in American collections, both depicting *The Flight into Egypt* – one in The Toledo Museum of Art (cat. 11) and the other in the Norton Simon Museum, Pasadena (fig. 20) – had remained in England until the 1960s and 1970s.

The naturalistic approach, the terse and profound rendering of certain landscapes done in his youthful years, and the anti-classicism of the pastoral and genre subjects of his maturity all have often given rise to discussions of Jacopo's relationships with Flemish and Dutch painting.[112] The hypothesis, however, has not been explored in detail, nor is this the place for an exhaustive discussion. On the grounds of a suggestion by Pevsner, Ballarin has hypothesized that Jan van der Straeten (Giovanni Stradano), who was in Venice in the latter half of the 1540s, may have been the intermediary between Pieter Aertsen and Jacopo, whose Flemish inclinations would exhaust themselves between 1545 and 1550. A similar role was played by Paolo Fiammingo, Stradano's pupil, who brought to Venice the court culture of Florence, with regard to the «Flemishness» of Francesco and Leandro Bassano, whose genre paintings, once the initial enthusiasm for the pastoral style had worn itself out, would be transformed under Paolo's influence into «illustrations of high-level quality of agricultural labors, something like leaves from a highly luxurious calendar».[113] Leaving aside the well-known presence of Netherlandish and Flemish paintings in the Venetian collections, which could have influenced the background settings of Jacopo's youthful canvases, one is compelled to note an extraordinary affinity of dates, choice of themes, and moral and religious implications with the contemporary *Seasons* painted in 1565 by Pieter Brueghel the Elder for Nicolas Jonghelinck, or the displays of foodstuffs that form a prelude to the biblical events in the background of the scenes popularized by Pieter Aertsen and his pupil Joachim de Beukelaer in the 1550s.[114] Slightly later in date, and perhaps not entirely akin in spirit and, therefore, closer to the art of Paolo Fiammingo, one can mention the activity of Vincenzo Campi, also in some way connected with the artists mentioned above.[115]

In any attempt to find a place in the culture of the time for the art of Jaco-

111. Here we can only make a general reference to the catalogue entries in Shearman 1983, 17-39, and to the documentation in the Witt Library, Courtauld Institute of Art, London.

112. Baldass 1955; Baldass 1958; Pallucchini 1957, 102; Ballarin 1965 (B), 68-70; and Mason Rinaldi 1965.

113. Ballarin 1965 (B), 69.

114. Moxey 1977; and Aikema 1989, 71 ff.

115. Meijer 1985, 28 ff.

po, and in particular for the invention of genre painting, there is an open field of study – unfortunately, as of yet, unexplored – concerning the relationship with the literature of those years: from the popular theatre and the macaronic poetry of Ruzzante[116] and Folengo, and from the bucolic and arcadian fables of humanist inspiration to the pastoral elegy in the poetry of Torquato Tasso and the codification of the literary genres. Intuitively one senses multiple themes and innumerable clues to interpreting this particular sector of Jacopo's art: religious stimuli in the delicate passage from Reformation to Counter-Reformation; the first contacts with a naturalistic approach destined to develop in the next century; and literary stylization. All of these appear to interweave in giving life to one of the great, and less well known, discoveries of modern painting. Although that phenomenon was the leading factor of a success among dealers and collectors alike and was exceptionally widely diffused and enjoyed a constant popular favor, it still awaits an adequate analysis of both its content and interpretation now that the artist himself has finally, after isolated sporadic intuitions,[117] won a full critical reevaluation on artistic and formal grounds.

Having considered so far the matters of patronage and religious allegiance, and of collecting and the art market, there remains a subject that calls for deeper investigation in the interests of a more detailed and fuller comprehension of Jacopo's art: the success won by his painting when translated into engravings. One further fertile source to be looked into besides the workshop account book is the early writings about the artist, his art, and the practice of copying. The information about his engraved work is drawn from a recent exhibition catalogue by Pan.[118]

The first to transcribe Jacopo's paintings into engravings were the brothers Jan and Raphael Sadeler and their nephew Aegidius. Their work offers more than one point for reflection. On the one hand, it supplies us with a kind of map of the international interest in Jacopo's art, whose accuracy is substantially confirmed by subsequent investigation. On the other hand, it presents us with a choice of themes decidedly favoring genre scenes, with the exception of a few examples of *The Adoration of the Shepherds* and *Saint Christopher* as painted for the church on the small island of San Cristoforo della Pace in the Venetian lagoon. At the same time, it stands as an example of engraving whose success would remain surprisingly undiminished during the span of three centuries in profoundly different contexts. A key role in the success was played by the *Seasons* that the Sadeler brothers engraved in Venice toward the end of the century after paintings now unknown, yet similar to those Ridolfi described in the house of Nicolas Regnier[119] and those present since before 1659 in the collection of the Austrian Archduke Leopold Wilhelm in Brussels and documented by Jan van Ossenbeck's etchings.

116. Muraro 1992, 45 ff.
117. See, for example, Berenson 1906; and Buscaroli 1935.
118. Pan 1992.
119. Ridolfi 1648, I, 386.

9

Copied many times throughout Italy, Flanders, The Netherlands, and France, above all, during the course of the seventeenth century, the Sadeler *Seasons* were copied again in Paris in the second half of the eighteenth century by Mariette.[120] But even a century later the two Flemings' engravings continued to provide inspiration for the stippled-technique etchings of *The Annunciation to the Shepherds* and *The Adoration of the Shepherds* that Gaetano Venzo of Bassano realized after drawings by Carlo Paroli for the catalogue of the Raimondi publishing house in 1826.[121]

The dedications on Jan's and Raphael's sheets suggest possible connections between the personalities in those Venetian circles frequented by the engravers in the last five years of the cinquecento and certain of Jacopo's paintings: in particular, between Pietro Corneretti and a *Christ in the House of Mary, Martha, and Lazarus*, much like the picture now in Houston (cat. 61); between Jacob König – a German jeweler and art dealer close to Rudolph II who had been portrayed by Veronese and who had published in Venice Dürer's *Triumph* – and an *Adoration of the Shepherds* in a Parmigianesque manner; between Leonardo Mocenigo, called *patrono nostro*, « our patron », and an *Adoration of the Shepherds*, which may be the canvas now in Winterthur; between Carlo Holman, a Flemish merchant active in Venice, and a *Parable of the Sower*, whose prototype seems to have been a painting once in the collec-

120. For the versions by Giovanni Antonio de Paoli, Cornelis Galle, Jacques Callot, Lucas, Stefano Scolari (publisher), and Charles David, see Pan 1992, nos. 28-31, 32-35, 39-40, 49-52, and 100-3.

121. Pan 1992, nos. 154-55.

tion of Leopold Wilhelm and now in the Kunsthistorisches Museum of Vienna, where it is attributed to Francesco.[122] Our information is more explicit concerning *The Adoration of the Magi* (on which the painting on that subject, inv. 234 in the Galleria Borghese, Rome, is based), which was declared the property of Paolo Caggioli, prior of the convent of Santi Giovanni e Paolo,[123] and a singular small group of paintings in the Giusti del Giardino collection in Verona: an *Annunciation to Abraham*; an *Annunciation to the Shepherds at Night*,[124] identifiable as the one now in Prague (cat. 54), both engraved by Jan; and another *Annunciation to the Shepherds* (now Accademia di San Luca, Rome) that Aegidius engraved in Verona, in 1595 and 1593 respectively, before Jan and Raphael moved on to Venice and Aegidius went first to Munich and then to Prague. If to this we add the information given by Francesco Pona in his *Sileno* (1620) that in the same Giusti collection there was a small version on copper of the portrait of *Doge Sebastiano Venier*[125] (in all likelihood the one now in a private collection in Stuttgart, fig. 67), it becomes clear that the brothers Agostino and Girolamo Giusti, great enthusiasts for the poetry of Tasso, whose *Aminta* they had performed in their celebrated garden, were not only at the time the most dynamic and enterprising art collectors in Verona,[126] but also among the first to have acquired and appreciated Jacopo's pastoral and nocturnal scenes. A passage of dialogue in the *Sileno* confirms this, where admiration is expressed, «in the manner of Bassano», for «a detail perhaps not observed by everyone, that is, the knowledge of how to express light and splendor in the coloring, something quite certainly difficult to do and do well… as indeed is shown by the tops of those figures which, within the dark horror of feigned Night, appear to be touched by the Sun».[127] Thirty years later, after the Giusti pictures had been dispersed, the most conspicuous ensemble of the Dal Ponte's paintings – a full eleven examples with a prevalence of parables and biblical episodes – was the Curtoni collection in Verona, which in view of the identity of the subjects, may have included the Giusti canvases. The dedication to Alfonso Morando on the series of engravings of the *Seasons* is evidence of yet another connection with an important personality from Verona who was also the patron and protector of Felice Brusasorci.[128]

The engravings of *Lazarus and the Rich Man* and its pendant, *The Supper at Emmaus*, were probably produced around 1593 on the occasion of the renewal of Jan Sadeler's imperial privilege and its extension to Raphael.[129] Here we have confirmation of the success of such genre paintings in the circles of Rudolph II, known to be a great admirer of Jacopo's.[130] But, apart from the dedicatory inscriptions examined thus far, what is striking in the prints of those Flemish engravers is the important place accorded to citations from the Bible represented in the original painting, thus ensuring immediate recognition of the religious character of the image.

122. Pan 1992, nos. 5, 7, 8, 9-12, and 14.
123. Pan 1992, nos. 13.
124. For the interest in this subject shown by engravers, we recall that Karel van Mander (in Ballarin 1966-67, 193) indicated an oil painting of the same subject in the collection of Ioan Ychet of Amsterdam that was engraved by Jan Sadeler.
125. Pona 1620, 30.
126. On this subject, see Dillon 1991.
127. Pona 1620, 55.
128. For the Curtoni collection, see Ridolfi 1648, II, 113. For Alfonso Morando, see Magagnato 1974, 76, n. 40; and Conforti Calcagni 1987, 38 ff.
129. Pan 1992, nos. 4 and 6.
130. Ridolfi 1648, I, 387.

One of the most beautiful seventeenth-century prints after Jacopo is an otherwise anonymous *Christ Laid to Rest by Two Angels*,[131] still reminiscent of the cadences and elongations characteristic of Schiavone. This can be taken as an emblematic example of another function performed by engravings: the documentation of lost paintings. In this instance, the print recovers for us the otherwise lost image of one of Jacopo's pictorial prototypes that can be dated between the late 1550s and early 1560s, as is also borne out by an unpublished small painted version in a private collection (figs. 5 and 6).

Continuing to follow in more or less chronological order the thread of information that can be extracted from Jacopo's work in its engraved form, we must consider the painting collection put together in Venice by two Dutch merchants and shipowners, Gerrit and Jan Reynst, to whom Carlo Ridolfi dedicated the first volume of *Le Maraviglie dell'arte* and who owned a number of Jacopo's works of rather more varied character than usual. After Gerrit died in Amsterdam in 1658, his collection of paintings was engraved and published between 1660 and 1671. At that time, part of the collection was still with his widow, but another part had been donated in 1660 to Charles II Stuart by the States of Holland. Among the prints, besides two biblical-pastoral subjects – an *Exodus to the Land of Canaan* and an *Annunciation to the Shepherds* recognizably done after a painting now in Strasbourg – there is a *Deposition* similar in composition to *The Entombment* from Santa Maria in Vanzo, Padua (cat. 52), which proved a very successful religious conception that reappeared in numerous derivations in a reduced format more appropriate for private devotion. Further, there were two fundamental examples of Jacopo's great mannerist phase: *The Way to Calvary* of 1545 (The National Gallery, London, cat. 14), and *The Madonna and Child with the Infant Baptist* from the late 1550s (formerly Earl of Spencer, Althorp House, London, fig. 36).[132]

The mid-seicento increasingly proves an invaluable observation point. The simultaneous presence of documentary sources, historical-critical writings like Ridolfi's, and a major body of graphic work encourages us to make some conclusions about the way Jacopo's works circulated and to what extent they were diffused. In 1660 the Latin edition of the *Theatrum Pictorium* appeared in Brussels. Under the skillful direction of David Teniers the Younger, its 246 engraved plates illustrated the gallery of Archduke Leopold Wilhelm of Austria, who governed the Southern Netherlands from his seat in Brussels. At the Archduke's death in 1662, the paintings were bequeathed to his nephew, Emperor Leopold I, and became incorporated into the Austro-Hungarian imperial collections. As we have seen, included were works from Venetian collections, notably those of Della Nave and Regnier acquired originally for the British crown, and probably also from the collection of Jan and Jacob van Buren of Antwerp.[133] The largest group of works

131. Pan 1992, no. 24.
132. See the engravings by Jeremias Falck, Dirck Theodor Matham, and Cornelis Visscher in the *Variarum imaginum a celebris artificibus pictarum caelaturae...*, Amsterdam 1660-71, discussed in Pan 1992, nos. 54-58. On the Reynst collection, see Logan 1979, 110-15 for Dal Ponte paintings.
133. See above n. 109. For the works in the van Buren collection, see Ridolfi 1648, I, 387-88.

39

by Jacopo to be gathered in a single collection, twenty-three in all, denotes a criterion in which numbers counted, with a considerable presence also of works by his sons Francesco and Leandro, most of them explicitly acknowledged. In this ensemble such diversity appears without rhyme or reason, the sons' portraits and altarpieces being placed side by side with the father's devotional images, his *Seasons*, and an *Orpheus among the Animals*, while only a very timid *Young Shepherds with Their Flocks* was there to represent the pastoral genre. Among the works most significant for our present interests, we can mention *The Good Samaritan* derived from the lost prototype in Berlin that was once in the Venetian collection of Bartolomeo della Nave (fig. 38), *The Adoration of the Magi* (Kunsthistorisches Museum, Gemäldegalerie, Vienna, cat. 27), from the same collection and strangely assigned to «Bassano iunior», *The Martyrdom of Saint Sebastian*, which is certainly the one now in the Musée des Beaux-Arts, Dijon (fig. 55), and most especially two series of *Seasons* unconnected with those engraved by the Sadelers, but engraved respectively by Jan van Ossenbeck after drawings by Nicolaus Hoÿ and Jan van Troyen.[134] Those paintings also figure in the list of art works belonging to Della Nave and shipped in 1638 to England, finally ending up in Leopold Wilhelm's collection.[135]

A project originating in the seventeenth century, stimulated perhaps by the *Theatrum Pictorium* produced for Leopold Wilhelm, was the publication of the collection of the Grand Prince Ferdinando de' Medici, which was filled out with works by the Venetian painters appreciated by his granduncle Cardinal Leopold.[136] The names of Titian, Veronese, Jacopo Bassano, and Palma il Giovane recur in the letters the Prince wrote to Nicolò Cassana, the Genoese artist, who, beginning in 1698, acted as his agent in Venice.[137] The publishing project, however, was taken up again only after Pietro Leopoldo of the House of Lorraine became Grand Duke of Tuscany in 1765, and the *Raccolta de' quadri dipinti da' piú famosi pennelli e posseduti da S.A.R. Pietro Leopoldo* was finally brought out in 1778. Of the 148 engravings included, seven were drawn from Dal Ponte paintings, and the biblical-pastoral theme clearly prevails – conspicuous is *The Parable of the Sower* (Museum of Fine Arts, Springfield, cat. 44) – with the sole exception of Francesco's altarpiece depicting *The Martyrdom of Saint Catherine*, formerly in the Florentine church of San Giovannino dei Gesuiti.[138] Omitted is a canvas considered of singular importance by modern scholars not only for its pictorial quality, but, above all, for its iconographical innovation of representing nothing more than two dogs. Its absence from the publication, however, can be explained by the troubled history of the painting's attribution. The *Two Hunting Dogs* (Galleria degli Uffizi, Florence, cat. 26), purchased by Cardinal Giovan Carlo de' Medici, was listed without an author in the inventory of 1663 of the villa at Cas-

134. Quirin Boel, Theodor van Kessel, and Lucas Vorsterman also took part in the *Theatrum Pictorium*, of which there were also editions published in Antwerp (1658 and 1684). See Pan 1992, nos. 59-81.

135. *Young Shepherds with Their Flock* is also listed as no. 85. See Waterhouse 1952, 17.

136. Boschini 1660, 364, records, for example, that Jacopo's *Adam and Eve after the Fall* (Galleria Palatina, Palazzo Pitti, Florence, fig. 37) was in Cardinal Leopold's collection.

137. Fogolari 1937 and, especially for considerations on Jacopo and Francesco Bassano and the differences in their styles, letters 2, 5, 6, 8, 15, 80, 81, 82, 111, 115, and 116 of 15 March, 12 and 26 April, 3 May, 31 June 1698; 25 November, 9 and 16 December 1702; 6 June, 19 September, and 17 October 1705. See also Haskell 1980, 228 31.

138. The engravings, almost all after drawings by Francesco Petrucci, are by Giovanni Antonio Lorenzini, Domenico Picchianti, and Theodor Verkruis. See Pan 1992, nos. 92-98.

tello; it then passed to Giovan Carlo's brother, Leopoldo, and in 1677 it was transferred, under the name of Titian, to the Tribuna of the Uffizi, where the inventory of 1704 assigned it to the Carracci. Not before 1798 was it definitively installed in the Galleria degli Ufizzi with the correct attribution to Jacopo Bassano.[139]

Only after the 1680s do we find the first recognition of Jacopo Bassano's excellence in the graphic arts of his native city. This took the form of etchings that two modest local engravers, Pietro and Crestano Menarola, did of the most renowned altarpieces in the city's churches: *The Adoration of the Shepherds with Saints Victor and Corona, Saint John the Baptist in the Wilderness, Saints Martin and Anthony Abbot, The Descent of the Holy Spirit* (cats. 46, 29, 67, and 119), and the *Nativity* from Santa Maria in Colle, to which were added the *Saints Anthony Abbot, Virgil, and Jerome* (fig. 59) and *The Mystic Marriage of Saint Catherine*, both part of the cycle at Civezzano painted by Jacopo in collaboration with his son Francesco around 1575.[140] That token of public appreciation, expressed at rather long last, was confirmed by measures of protection for Jacopo's works decreed by the civic authorities at around the same time. As Alberton Vinco da Sesso has noted, in 1672 the Senate of the Veneto decreed that the paintings by Jacopo in churches and public edifices in Bassano were not to be sold or otherwise removed. Two years later the Confraternita di San Giuseppe ordained that *The Adoration of the Shepherds* could not be removed, for any reason whatsoever, from its original location under pain of pecuniary fine, and the officials were ordered to protect the altarpiece «both in front and in behind for its preservation». In 1678 the city council deliberated that the altarpiece depicting *Saint Lucille Baptized by Saint Valentine* (cat. 53) was to be protected against theft by «an iron grating with chains and locks». Only a century later, in 1725, was there a dogal order stating that the three canvases of the artist's early years in the Sala dell'Udienza of the Palazzo Pretorio were not to be moved to Venice, but to remain in Bassano inalienably and irremovably.[141]

It is understandable that because the first half of the eighteenth century was marked by the widest popularity of baroque and rococo taste, there was a momentary decline in interest in engraving Jacopo's work. There was, however, an exception, in the prints by Domenico Rossetti and Andrea Zucchi done after the historical scenes painted by Francesco and Leandro for the great council hall in the Palazzo Ducale in Venice. These were published in 1717 in a volume entitled *Gran teatro di Venezia ovvero raccolta delle principali vedute e pitture che in essa si conservano*, which was reprinted in 1720 and again in 1786 by Teodoro Viero.[142] A marked revival of interest occurred in 1745 when Giambattista Pasquali published in Venice the collection of chiaroscuro prints by John Baptist Jackson entitled *Titiani Vecelli, Pauli Caliari, Jacobi*

139. See here, cat. 26.
140. Pan 1992, nos. 83-90.
141. See here, Chronological Register of Documents and cat. 46.
142. Pan 1992, nos. 104-6.

Robusti et Jacoipo de Ponte, opera selectiora a Joanne Baptista Jackson, Anglo, ligno coelata et coloribus adumbrata. Proposing to illustrate in twenty-four plates seventeen masterworks of Venetian painting of the cinquecento, the English artist in reality carried out a critical operation when he placed Jacopo on the same plane as Titian, Veronese, and Tintoretto. What particularly appealed to him about Jacopo was the artist's striving for lighting effects that easily lent themselves to the engraving technique he adopted. The choice of works, in this sense emblematic, comprised *The Entombment* from Santa Maria in Vanzo, Padua (cat. 52) and an *Agony in the Garden*, without failing to document two works in the collection of Consul Smith, *Melchisedec Blessing Abraham* (which recently reppeared on the London art market) and *Lazarus and the Rich Man*, of which all trace has been lost. In addition, there was Leandro's *Resurrection of Lazarus* (formerly in the church of Santa Maria della Carità, Venice, and now in the Galleria dell'Accademia, Venice).[143] The publisher Giambattista Raimondi of Bassano promptly showed interest in Jackson's work and later, in 1784, included it in his offer of prints done after old and modern masters and of reprintings from the old plates that he had been collecting. It is in this context that Raimondi included in his catalogue of 1778 prints from seventeenth-century plates by Menarola along with new engravings by Filippo Ricci and Teodoro Viero of *Saint Lucille Baptized by Saint Valentine* and a *Nativity Scene with Saint Joseph*.[144]

The whole matter of reproduction of the Dal Ponte family's paintings in their native town proved in the long run repetitive and without exceptional results. It kept exclusively to Jacopo's work and, within that, to religious subjects. Nevertheless, there was one piquant episode in which fragments of the best-known works (the usual *Saint Martin* and *Saint Lucille*) were recombined in different ways to give them a « Rembrandt look », a feat carried off by Dominique Vivant Denon towards the end of the eighteenth century.[145] In the tiny corner of history we are looking at here, a fundamental stage is paradoxically represented by *The Flight into Egypt* of Pietro Vedovato.[146] That stippled etching (« a granito ») freely reinterprets the « wooden » painting of 1534 with the languid mellowness of a Cipriani or an Angelika Kauffmann, as if to write finis to a figurative potentiality that had been capable of remaining faithfully close to a pictorial prototype for more than two centuries, even through the most diverse kinds and techniques of translation into engraving and although the results had not all been of the highest quality.

Further observations in this context are few and marginal, with minimal documentary usefulness and not such as to affect in any way the tendencies we have traced here. The *Recueil d'estampes* promoted by Augustus III of Saxony to commemorate the finest works in his royal gallery in Dresden, printed there in 1753 and 1757, includes only two examples from the Dal Ponte

143. Pan 1992, nos. 108-13.
144. Pan 1992, nos. 128 and 129. For traces of Jacopo's presence in seventeenth-century Italian collections, it is worth looking at the earliest artistic guides to the various cities; for Venice, Padua, Ferrara, and Naples, see, for example, Agnelli 1734; Rossetti 1776, 326 29; *Catalogo dei quadri* 1785; and Haskell 1980, 222, 339-40, and 362. See also the listings of the Getty Art History Information Program, cited above in n. 107.
145. Pan 1992, no. 137. For *The Nativity* in Santa Maria in Colle, see Pan 1992, no. 138. For the portraits of Jacopo, Francesco, and Leandro in the Uffizi, see Pan 1992, nos. 139-41. For the versions by Giovanni Suntach of Vivant Denon's prints after Jacopo, see Pan 1992, nos. 142-43.
146. Pan 1992, no. 153.

147. Pan 1992, nos. 116-17. The engravings are by Philip Andreas Killian and Pierre Chenu.

148. Pan 1992, nos. 120-23.

149. Pan 1992, no. 125.

150. For the engravings by François Luis Couché, Joseph de Longueil, and Jean Baptiste Massau, see Pan 1992, nos. 133-36.

151. Pan 1992, nos. 127, 156, 157, and 173-75.

152. In the group of Venetian paintings in the *Pinacoteca del Palazzo reale delle Scienze e delle Belle Arti di Milano* published in 1812 are listed some of the paintings today in the Pinacoteca di Brera, Milan, accompanied by a critical text and engraved by Michele Bisi, Luigi Bridi, Antonio Giberti, and Pietro Locatelli: an *Annunciation to the Shepherds* and an *Adoration of the Shepherds* (lost), thought to be workshop productions, as is *The Last Supper* and *The Adoration of the Shepherds* from the Capuchins' convent in Bassano. On the other hand, *Saint Roch Visiting the Plague Victims* (cat. 47) is an important work by Jacopo from the church of San Rocco in Vicenza. It was engraved by Ignazio Fumagalli, see Pan 1992, nos. 148-49, 151-52, and 150. In the *Pinacoteca dell'Imp. Reg. Accademia Veneta delle Belle Arti*, there appears *The Raising of Lazarus*, brought to the Gallerie dell'Accademia and engraved by Marco Comirato, and also Jacopo's *Saint Eleutherius Blessing the Faithful* (cat. 40), brought from the church of that name in Vicenza, and engraved by Giannantonio Zuliani, see Pan 1992, nos. 158-59. In the volumes dealing wih the *Imperiale e reale galleria Pitti illustrata*, no less than eleven Dal Ponte paintings in the Galleria Palatina, Palazzo Pitti, Florence are documented in prints by Vincenzo Benucci, Geminiano Bruni, Achille Calzi, G. Camera, Francesco Clerici, Giuseppe Dala, Domenico Gandini, Sc. Milanese, C. Podiani, Michele Vignocchi, Antonio Viviani, and Domenico Conte; see Pan 1992, nos. 161-71. In the *Pinacoteca Veneta ossia raccolta dei migliori dipinti delle chiese veneziane*, Venice 1858-60, thanks to the engravers G. Bernsaconi and Butazzon, there are records of two paintings by Francesco from the church of San Giacomo dell'Orio, *The Virgin in Glory with Saints Nicholas and John the Baptist* (fig. 68) and *The Preaching of the Baptist*, together with *The Circumcision* by Jacopo and Francesco from the church of Santa Maria della Misericordia, see Pan 1992, nos. 176-79.

153. Verci 1775, 79, 77, and 75; and Ridolfi 1648, I, 384.

family: an *Expulsion of the Moneylenders from the Temple* attributed to Jacopo, but now lost, and an *Adoration of the Shepherds* by Francesco or Gerolamo.[147] The *Raccolta* brought out by Pietro Monaco in 1763 adds some information about the presence of works by Jacopo in Venetian collections, filling out what would be recorded in Giambattista Verci's biography of 1775. Thus, *The Good Samaritan* (The National Gallery, London, fig. 40) was noted as in the Pisani palace; a *Departure for Canaan* and a *Return of the Prodigal Son* were in the collection of Francesco Savorgnan at San Geremia; and a *Marriage at Cana* in the collection of the lawyer Giulio Crivellari.[148] The *Schola Italica* brought out by Gavin Hamilton a decade later includes a single example by Jacopo, a portrait of an unknown man (in fact, the architect Antonio dal Ponte), engraved by Domenico Cunego.[149] In the *Galerie du Palais Royal*, made up of the works owned by the duc d'Orléans and published between 1786 and 1808 with even more overtly commercial aims, not only were the measurements of each picture given, but also precise descriptions of the colors.[150]

The series of engravings published in the nineteenth century were no longer interested in transposing and interpreting the specific stylistic traits of the Dal Ponte paintings. They were restricted to conveying in a summary manner – through the almost exclusive use of outline engraving – the presence of particular works in volumes on specific subjects or collections of masterworks.[151] In addition, illustrated catalogues of masterworks in the Italian galleries and churches were made more or less indispensable because of the changes in location of art works following the suppressions of church properties and the removals, appropriations by public authorities, and sales that marked the early decades of the nineteenth century.[152]

Another paragraph in the long history of the public response to Jacopo's paintings concerns the copies of his work, executed not by his sons or workshop, but by other painters of the time or later. «[There were] extremely many copies», Verci said, of *The Flight into Egypt* (cat. 1), the *Saint John the Baptist in the Wilderness* (cat. 29), and *Saints Martin and Anthony Abbot* (cat. 67), and Ridolfi mentions many copies of *The Entombment* from Santa Maria in Vanzo, Padua (cat. 52).[153] «Counterfeits» – to use a polite word – of Jacopo's paintings are known by David Teniers, Luca Giordano, Giambattista Volpato, Francesco Maffei, and Giambattista Zampezzi;[154] others were done by Gian Antonio Guardi for Marshal Schulenberg,[155] and still others can be attributed to Piazzetta or his circle.[156] The copies were not only of pastoral inventions or the more successful altarpieces of Jacopo's mature years, but also of works of the 1540s and 1550s,[157] thus evidence of an early and lasting attention that is noteworthy and calls for further study. The phenomenon offers ulterior confirmation of how much the retiring, but very well informed painter, alien as he was to others' schemes for securing commissions and pa-

tronage, in reality understood how to satisfy the expectations of a very diversified public. From the parish priests and confraternities of his modest native town and the country places roundabout, to the Venetian intellectuals and patricians, from merchants to wealthy bourgeois and the most enlightened collectors, the circle of his patrons grew steadily broader in their appreciation of the pictorial and poetic values he propounded and of his innovations.

154. Ivanoff 1947.
155. Haskell 1980, 313.
156. See here, Rearick's essay, n. 187.
157. Longhi 1948, 44 ff; Shearman 1983, *passim*; here, cat. 14 and Rearick's essay, ns. 106, 107, 115, and *passim*.

The life and works of Jacopo dal Ponte, called Bassano c. 1510-1592

W.R. Rearick

The small town of Bassano del Grappa, some thirty miles northwest of Venice, cannot be said to have had an artistic tradition of its own in the early Renaissance. The market nucleus of a rich agrarian land on the river Brenta where it emerges from the Dolomite mountains, Bassano was a small but prosperous commercial center with its castle, encircling walls, and a scattering of medieval churches and houses.[1] Local artisans provided what was needed to furnish these sober and substantial interiors, but none found an adequate market for more sophisticated artistic enterprises in altarpieces, fresco cycles, portraits, and other work that could create and sustain an indigenous tradition in the figurative arts. When, around 1340, the church of San Francesco decided to commission a large painted crucifix (now Museo Civico, Bassano del Grappa), they invited Guariento to travel north from Padua to paint it and a few fresco decorations before he returned home, but his visit seems to have left no stylistic impact among local craftsmen. In 1449 Filarete was asked to do a silver processional cross for the cathedral, where it still remains. In 1472 an itinerant follower of Andrea Mantegna added an ambitious fresco depicting *The Madonna and Child* in the Palazzo Pretorio (now Museo Civico, Bassano del Grappa), and a scattering of private devotional pictures had been bought in Padua and Vicenza by the more prosperous of the local gentry. Although the town had pledged itself to Venice in 1404 and was administered by an appointed Venetian podestà, its citizens seem not to have ventured so far afield as the capital when in need of paintings. Prior to the end of the quattrocento, local painters were more likely to occupy themselves with painting shutters or shop signs.

Significantly, it is from within this matrix of multipurpose craftsmanship that a genuinely Renaissance artistic concept takes root shortly after 1500. Jacopo di Berto came down from the high plateau of the Sette Comuni above Bassano in 1464 to take up the trade of tanner.[2] His shop-residence was not far from the famous wooden bridge, and by 1479 he is called Dal Ponte after the district near the bridge. He married, began a family, and appears to have prospered sufficiently to have aspired to a wider range of professional activity for his son Francesco, who was probably born between 1475 and 1478.[3] We do not know where Francesco was sent to learn the craft of painting with an established painter, but it was probably in Vicenza that he served an apprenticeship with Giovanni Speranza during the years 1496 to 1499.[4] Speranza, trained by Bartolomeo Montagna and registered as « magister » by 1495, passed on to Francesco an elementary skill in architectural perspective, a dully metallic color range, an inarticulated anatomy, an arbitrary elaboration of hard-edged drapery form, and a vacuous simplicity of expression. This awkward reflection of Vicentine quattrocento modes was at least professionally respectable to clients in Bassano, and by 1500 Francesco is referred

1. For the urban development of Bassano del Grappa, see Petoello and Rigon 1980, 389-434.

2. Alberton Vinco da Sesso 1986, 171.

3. Alberton Vinco da Sesso 1986, 170-73.

4. Francesco il Vecchio is usually described as a pupil of Bartolomeo Montagna, but his true source is the more haltingly provincial reflection of Montagna's highly sophisticated style that one finds in Speranza, particularly in his earlier works such as *The Madonna in Glory with Saints Thomas and Jerome* (Museo Civico, Vicenza) painted for San Bartolomeo in Vicenza shortly before 1500. Recorded in Montagna's shop in 1488 and registered as « magister » in 1491, his earliest works remain undefined, but he would have been able to contract apprenticeships after 1491, and his San Bartolomeo altarpiece shows precisely the style he would have communicated to Francesco dal Ponte between about 1496 and 1500. See Rama 1990, II, 767, and Tanzi 1990, II, 619.

10

to as «*pictor*» in local documents. We know little of these early years in which Francesco was perhaps the only painter worthy of the name in Bassano, but he seems to have established a clientele over a wide range of the surrounding communities as well as in the town itself, where he doubtless provided craft work of every sort in addition to altarpieces. By 1504 he had married Lucia Pizzardini, and by 1510 or shortly thereafter a son was born, whom he named Jacopo after his father, the tanner. Giambattista, Gerolamo, Caterina Angelica, and Elisabetta followed, the last three probably by a second marriage already recorded in 1523.[5] Francesco was named to the Consiglio Comunale in 1522, a post of significant responsibility as well as social status. His commissions in a wide range of arts and crafts multiplied, and it was only natural that he should begin to teach little Jacopo the family trade, probably by around 1523-26, when his son was about thirteen years old. Soon Giambattista would begin to help in the workshop, but Gerolamo was encouraged to become a teacher and a cleric instead, since the Dal Ponte enterprise already had as many eager hands as it could use.

Jacopo dal Ponte doubtless grew up among the tools of his father's workshop, encouraged and disciplined in the proper handling of carpentry, terracotta, and painting equipment with which his father produced the well-crafted objects that the townspeople required. His early *Self-Portrait* (Kunsthistorisches Museum, Gemäldegalerie, Vienna, fig. 10) shows him to have been rather short, firmly built, with dark hair, slightly fleshy nose, sensuous mouth, and, most strikingly, penetrating dark eyes that fixed their subject with an intense and analytical stare.[6] This native visual inquisitiveness was directed by a natural intelligence that seems not to have had the benefit of formal learning. It is possible, however, that the boy knew local intellectuals such as the Latinist Lazzaro Bonamico or the orator Alvise dal Corno, and that he had access to learned counsel when it might serve his work.[7] He could read, write, and keep the firm's financial accounts. Like any shop apprentice, Jacopo must have started with menial tasks, gradually moving on to grinding colors, stretching canvases, and, little by little, learning to paint by executing minor passages of Francesco's pictures under his father's attentive guidance. It was not long, however, before the older man recognized that his son handled the brush and color with an ease and confidence that already produced results technically superior to anything to which the master could aspire. The result is that when the village of Valstagna, about seven and one-half miles into the mountain pass of the Brenta, commissioned an altarpiece of *The Nativity* (parish church, Valstagna) on 23 April 1525, Francesco characteristically cast about for some more sophisticated treatment that he might use as a model.[8] In what may be the earliest instance in which one of the Dal Ponte turned to a print for his composition, Francesco reversed Nicoletto da

5. Alberton Vinco da Sesso 1986, 171. Muraro (1982-83, 31-32) reported that the *Libro secondo* contained references to a third brother, Gianfrancesco, and quoted an entry in which payments were made both to him and his brother Giambattista. An attentive reading of the manuscript has not turned up this or other mention of Jacopo's presumably youngest brother. We must conclude that he did not exist.

6. Oil on canvas, 60 × 57.5 cm. Rearick 1980 (B), 104-5. Its extremely skinned state renders this subtle work unexhibitable.

7. For the culture of the early cinquecento in Bassano, see Vinco da Sesso 1980, 541-616.

8. The documents relative to the commission and delivery of the Valstagna *Nativity* are to be found in the manuscript *Il Libro secondo di dare e avere della famiglia Dal Ponte con diversi per pitture fatte*, Biblioteca Civica di Bassano del Grappa. For its publication, see Muraro 1992. See also Arslan 1960 (B), I, 26-27, and 33, and Pallucchini 1982, 11.

Modena's engraved *Nativity* as his point of departure.[9] He might, in addition, have attempted to modernize that old-fashioned model by way of an altarpiece of *The Nativity* (Museum of Fine Arts, Houston) that Titian's brother, Francesco Vecellio, had painted for the church of San Giuseppe in Belluno only a few months earlier. Although it might have been another of Vecellio's routine imitations of his sibling's work that the Dal Ponte plagiarized, Belluno is not so far from Bassano that a trip there for other business might not have brought them into contact with that picture. In any case, Francesco misunderstood that model in every respect, simplifying the composition into a rigid collage of hard and unnatural figures, stage architecture, and rather monochromatic color centered on dull dark blue and mustard. Work dragged on, and only in its later stages did Francesco turn to his son for assistance. Judging from the contrast in handling, Francesco permitted him to repaint much of the Madonna, in particular her head and striped veil. Jacopo softened and reordered her mantle to create a more natural fall, added the decorative stripes to her veil, and, finally, followed the Titianesque model in creating her handsomely noble head. The Valstagna *Nativity* is perhaps the earliest of Francesco's pictures in which Jacopo's more fluent and idealizing touch is evident; it is, prophetically, his first homage to Titian, the master he would revere above all others over the next sixty years. On 5 November 1528, Jacopo carried the altarpiece to Valstagna, where he proudly signed the receipt for its final payment.

The Dal Ponte studio kept collective accounts in four small books, of which only the second survives. *Il libro secondo del dare ed avere della famiglia Dal Ponte con diversi per pitture fatte* has recently been published by the late Michelangelo Muraro as his valedictory book.[10] Ordered alphabetically, usually by the given name of the commissioner, this volume begins with entries dated to 1512 and has a final notation from 1588. However, those notations that refer to paintings fall almost exclusively between the years 1519 and 1554 and are, in the absence of the other three volumes, which were presumably organized along the same format, only fragmentary in allowing an idea of the total activity of the family enterprise at any given point. Further, pictures produced by the Dal Ponte were generally regarded to variable degrees as collective efforts, with little or no disclosure as to their actual authorship. Distinctions of hand among the various members of the family and other associates must, therefore, be based on the concept and handling of each work or fragmentary passage of such. It is unlikely that we will find clear evidence for Jacopo's participation in Francesco's pictures much before 1528, when we believe he took a significant role in the Valstagna *Nativity*, but the following year Francesco fell ill, possibly the first of what would become frequent bouts of failing health, and by the next year Jacopo must have assumed in-

9. See Zucker 1980, 79. Other possible sources, even closer in format, are *The Nativity* by Giovanni Antonio da Brescia (Zucker 1980, 171), and Benedetto Montagna's *Nativity* altarpiece (parish church, Orgiano), which is signed and dated 1500. See Puppi 1962, 115. The Child resembles that in Giovanni Speranza's *Madonna and Saints* (formerly Gambier-Parry collection, Highnam Court). For Francesco Vecellio's Belluno altarpiece, see Fiocco 1953, 44-45.

10. Muraro (1992, 5-19) gives a summary of the format in which the Dal Ponte registered commissions.

creasing responsibilities.[11] He still probably added passages here and there in Francesco's compositions before he began to produce his own independent works around 1531. His signature and the date 1531 in gold letters were read by Giambattista Verci on a *sacra conversazione* then in the Larber collection, Bassano del Grappa, but since lost.[12] That he frequented cultivated humanist circles in these years, such as the one that centered around Lazzaro Bonamico, is suggested by his earliest known commission for a fresco, also lost, representing the arms of Ambrogio Frizier supported by a pair of classical satyrs, which he painted in 1532 on the façade of his patron's villa near Bassano. Work for Frizier continued through 1534. Although his brother Giambattista is mentioned in the accounts for work at the Frizier villa, known locally as «La Nave», Jacopo clearly painted the figural portions of the fresco cycle that covered the façade as well as significant interior paintings, including a recently identified fresco of *The Madonna and Child with the Infant Baptist* that was probably in the chapel.[13]

Limited though old Francesco's cultural horizons surely were, by 1533 he must have recognized that Jacopo's natural talent required the stimulus of wider exposure to sophisticated art beyond Bassano. It is to this moment that we believe the boy's first extended visit to Venice should be dated. Titian spent most of the early months of that year in Bologna advancing his career as court painter to the Holy Roman Emperor Charles V, but by summer he was back at work in Venice and might have received the young painter from Bassano in his studio, where he was at work on *The Adoration of the Shepherds* (Galleria Palatina, Palazzo Pitti, Florence), a composition that would have a profound impact on Jacopo for the rest of his career.[14] Titian's bad reputation for exploiting apprentices and teaching them little might have made the youth shy of closer associations with the famous master. He did not, in any case, need an apprenticeship, but rather an association with an established artist on an informal basis, an arrangement familiar in Venice in these years, especially if the beginner was from the hinterland. Bonifazio de' Pitati provided just the careful collaborative situation in which Jacopo could learn by observing and assisting the artist that ran the most orderly and productive Venetian studio of the day.[15] He was solidly professional and pedagogically unexceptionable. This rapport may not have lasted very long, but it might equally have been renewed at various times over the coming decade, since Jacopo's paintings show a continuing awareness of Bonifazio's work at several points after 1533.

The Flight into Egypt (Museo Civico, Bassano del Grappa, cat. 1) once bore Jacopo's signature and the date 1534, now effaced.[16] Commissioned on 3 October 1532, signed after an interval of two years, and paid for only on 3 November 1537, this *Flight* retains few traces of old Francesco's primitive style.

11. Muraro 1982-83, 6, and Alberton Vinco da Sesso 1986, 172.

12. Verci 1775, 86.

13. The Dal Ponte executed both artisan work and figurative painting for Frizier, see *Libro secondo*, fols. 1r-1v, and Muraro 1992, 59-60. Bordignon Favero (1992, in press) has identified a fine, if damaged, detached fresco of *The Madonna and Child with the Infant Baptist* (Azzalin collection, Bassano del Grappa) still in the chapel of La Nave in Bassano del Grappa. Since its style suggests a date close to 1538, it is probable that it was done for a position high on the back wall of the chapel at the villa simultaneously with *The Last Supper* canvas, see below n. 37. It was doubtless detached from the original chapel when the house was remodeled in 1734, at which time what remained of the arms and the façade frescoes were destroyed. Frizier, resident both in Bassano and Venice, was an important early patron of Jacopo's. I am particularly grateful to Bordignon Favero for sharing his discovery with me.

14. For this close rapport, see Rearick 1980 (C), 371-74.

15. For Bonifazio's work in the 1530s and 1540s, see Westphal 1931, and Faggin 1963, 79-95.

16. *Libro secondo*, fols. 121v-122r. Circumstantial evidence in the account book suggests that it was standard practice for the Dal Ponte to sign a contract with a stipulated consignment date and then wait until that time approached before starting work on the project. It may, therefore, be assumed that usually a painting was in progress during the months just before it was delivered. Equally, final payments were often made long, even years, after the work was completed. In the case of *The Flight into Egypt*, it was ordered late in 1532, painted in 1534, and paid for in late 1537, a span of five years.

17. For the Fara altarpiece, see *Libro secondo*, fols. 60*v*-61*r*, and Muraro 1992, 22. For the Santa Caterina di Lusiana altarpiece, see Magagnato 1952 (A), 35, no. 7, and Muraro 1992, 27. For the division of hands in these works, see Rearick 1992 (C), in press.

18. *Libro secondo*, fols. 94*v*-95*r*, and Muraro 1992, 28. The Santa Lucia cycle, the apse, the *Annunciation*, and the exterior altar fresco are clearly by Jacopo. The Prophets in the under-arch seem mostly to be by Jacopo, and the façade *Saint Lucy* has Jacopo's form, although little of its surface survives. The frieze of saints partly preserved around the hall is largely by Giambattista, but its *rinceau* pattern and the fictive stonework inside and out are mere artisan decor and might be by a lesser apprentice. On the basis of some of my suggestions, Sgarbi 1982 (A), 200-4, made a similar distribution of hands. The two large fresco fields on the façade of the Scuola di Sant'Antonio reveal a faint shadow of the paintings in the weathered plaster, but *The Dead Christ* in the lunette over the door is fairly well preserved. Clumsy though it is, it is not by Francesco and is unlikely to be by Giambattista, who may have been about eighteen at this time. The commission is recorded in the *Libro secondo*, fol. 110*v*. The commission for the early frescoes at Cartigliano is recorded in the *Libro secondo*, fols. 128*v*-129*r*. Christ cleansing the temple would again become a major theme for the Dal Ponte after 1569.

19. Gerola 1907 (B), 167-70.

20. *Libro secondo*, fols. 92*v*-93*r*, and Muraro 1992, 25-26.

Instead, the Venetian experience has enriched Jacopo's repertory of form, and his handling of the brush has become measurably more secure. From Francesco Vecellio's fresco of *The Madonna and Child* (Palazzo Ducale, Venice) of c. 1528-30, Jacopo took his Madonna and Child; from Titian's woodcut *The Triumph of Christ* of shortly before 1517, he copied Saint Joseph; and his attentive rustics who accompany the Holy Family reflect familiar Bonifacesque types. Most surprising, his monumental planar procession suggests that Jacopo looked with admiration at the composition of Giotto's frescoes in the Cappella Scrovegni, Padua. Rarely did a cinquecento artist in the Veneto show such discriminating appreciation for the austere art of this Gothic Florentine visitor. But the detail in the *Flight*, for which no source can be cited, is the freshly natural profusion of flowering plants and grass in the foreground, a striking testimony to Jacopo's precocious capacity for a loving transcription of nature into pictorial form.

To judge from the accounts and the sudden burgeoning of surviving works, 1535 marked an accelerated pace of production for the Dal Ponte family. They painted two altarpieces in a still-archaic pyramidal format with the Madonna enthroned between two saints, one between November 1534 and April 1535 for the village of Fara (now Museo Civico, Vicenza) and another that is still in the church in Santa Caterina di Lusiana.[17] In 1535 they frescoed the façade of the Scuola di Sant'Antonio in Marostica, today largely effaced except for *The Dead Christ* (fig. 84) in the lunette over the portal. The same year they painted frescoes of *The Resurrection* and *Christ Cleansing the Temple*, both lost, for the old church at Cartigliano, a project finished in 1536. They were commissioned to fresco the entire church of Santa Lucia at Tezze: the nave and triumphal arch in 1536; the illusionistic altarpieces on the interior and exterior walls, God the Father, and Saint Lucy on the façade in 1537.[18] In the midst of all this activity Jacopo was busy as a hydraulic engineer, probably already in 1531, when the Venetian government sent to Bassano for technicians to drain and fill the marshes near Marghera, but certainly by 15 January 1535, when he and two colleagues from Trent went to Venice, where the Senate awarded them patents for machinery and techniques for building water mills, raising and channeling water, and draining marshes.[19] By far the most prestigious project during this year was a complex of cabinetry, decor, and three paintings (Museo Civico, Bassano del Grappa) requested by Luca Navagero for the Palazzo del Podestà.[20] Navagero had been sent from Venice as podestà in October 1534, and on 20 July 1535 he signed the contract with the Dal Ponte for the entire cycle. Only the three pictures of judgment themes survived the seicento fire that gutted the city hall. *The Fiery Furnace* (fig. 11) included Jacopo's self-portrait, *Christ and the Adulteress* (cat. 115) documented the elegant figure of Navagero as a gentleman falconer, and *Susanna*

and the Elders was dedicated to an extended landscape. All show sharp disjunctures in quality in their execution, and it is evident that Jacopo kept about half of the work for himself, assigning the rest to a colleague. One looks in vain for old Francesco's hard-edged forms, but the *Susanna* in particular was painted by an inferior imitator of Jacopo's now richly Venetian brushwork.[21] All continue to employ figures based on prints, now including those of Albrecht Dürer, Agostino Veneziano, and Marcantonio Raimondi, but each enjoys a warmer, more sensuous color and texture that achieves a unifying pictorial harmony.

The podestà was traditionally a younger Venetian aristocrat who served a two-year term as provincial administrator before returning to higher office at home or in a more important colony. As such, he frequently brought with him a civic-minded sense of responsibility for the embellishment of the town in his charge and, more importantly, a cosmopolitan appetite for the latest bellwether in artistic taste. Navagero must have been pleased to discover in Bassano a firm capable of producing an only slightly embarrassing approximation of the canvases Bonifazio was supplying to the bureaucracy back home. The 1535 project would be the first in a long succession of commissions from the Venetian podestà, commissions which would continue the next year when his successor Matteo Soranzo took up the post. Soranzo arrived with his family in February 1536, and on 12 March he signed the contract with old Francesco for *The Podestà of Bassano Matteo Soranzo with His Daughter Lucia and His Brother Francesco Being Presented by Saints Lucy, Francis, and Matthew to the Madonna and Child* (Museo Civico, Bassano del Grappa, cat. 2), a picture put in place in the city hall on the following 15 December.[22] It is characteristic that the senior director of the business should have taken responsibility by signing the agreement, but neither its design nor its execution was due to Francesco. Instead, Jacopo adapted Titian's votive painting of Doge Gritti done for the Palazzo Ducale in Venice in 1531, which he had doubtless seen there in 1533. Adding a few details from Titian's *Pesaro Madonna* (Santa Maria Gloriosa dei Frari, Venice), he then turned most of the right side of the canvas over to a halting imitator who laid in the wooden Virgin, the sullen Child, the weightless Saint Lucy, and the faulty architectural perspective. He reserved for himself the truculent little podestà, his athletic patron Saint Matthew, the gentle Saint Francis, the charming angel who ruffles through Matthew's giant tome, and, most arresting of all, brother Francesco Soranzo, who commands reverential attention from the spectator. Finally, in blunt contrast with the clumsy saint just above her, Jacopo added the disarming portrait of little Lucia Soranzo, who plays unconcernedly with her puppy, her apricot and moss green dress the loveliest passage in the picture. As if to forestall criticism, Jacopo added his large signature under her foot, but the

21. This collaborator was probably Giambattista. The *Susanna* is based on Palma il Vecchio's *Flora* (The National Gallery, London). See Rylands 1988, 232.

22. *Libro secondo*, fols. 94v-95r, and Muraro 1992, 27-28. Soranzo was a particularly enthusiastic patron, who also commissioned Jacopo to paint a devotional *Madonna and Child with Saints Matthew and Lucy* (lost), see *Libro secondo*, fols. 94v-95r, and a *Christ at the Column with the Donor Marcantonio, Cavalier of Podestà Soranzo* (lost), see *Libro secondo*, fols. 94v-95r.

11. Jacopo Bassano, *The Fiery Furnace*, Museo
Civico, Bassano del Grappa

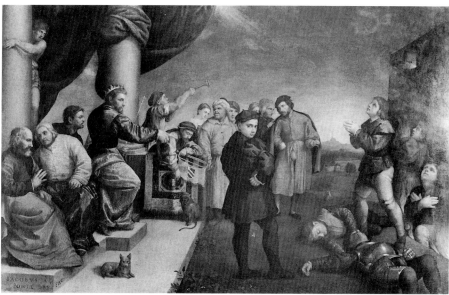

11

23. Rearick 1992 (C), in press.

24. Muraro 1992, 29-30.

25. Prior to its demolition and the erection of the present church in 1775, this ensemble included a fresco of *The Transfiguration* that was described by Ridolfi (1648, 1, 386) but is not recorded in the commission, and on the high altar a *Supper at Emmaus*. For the recently recovered fresco fragments, see Ericani's essay in this catalogue.

26. *Libro secondo*, fols. 25v-26r, 43v, 95v, and 139v, and Muraro 1992, 29, and 102-3.

27. Oil on canvas, 235 × 250 cm. See Rearick 1976 (A), 104, no. 66. For religious conflicts in Cittadella, see Muraro 1992, 29.

collaborator's work remains painfully evident. He is perhaps to be identified as Giambattista, who was probably born about 1517 and would thus at about eighteen years have graduated from apprenticeship to active collaboration in the Dal Ponte collective approach to painting.[23] He is explicitly mentioned as Jacopo's collaborator in the extensive project for the choir and apse of the cathedral at Cittadella, a small fortified town to the south on the road toward Padua.[24] There they frescoed the tribune with various subjects on the side walls, concluding with *The Supper at Emmaus* for the high altar, which, along with a fresco figure of Samson and a few other mural fragments, is all that remains today.[25] The contract was signed by Francesco on 19 August 1537, work began on 13 September, payments continue to 22 December 1537, and final settlement was made on 22 March 1539, certainly long after the program had concluded.[26] The humbly rustic *Supper at Emmaus* (fig. 12) was a rare subject for a cathedral high altar, but its emphasis on Christ's presence among mere men suggests a pertinence for Cittadella, where Protestant ideas of direct revelation of the divinity to the faithful had been for a decade the subject of bitter conflict.[27] For Jacopo it provided an ideal vehicle for his personal mixture of motives borrowed from Raphael by way of engravings: a majestic, nearly square format and a charming repertory of homely details, such as the exquisitely delicate still life on the table or the witty confrontation between the butch cat and Cleophas's coy puppy. The bored, but watchful, host scarcely betrays Jacopo's adaptation of a classical Roman bust, the so-

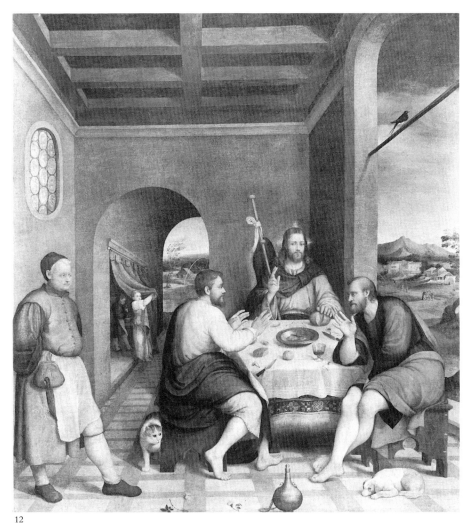

12

12. Jacopo Bassano, *The Supper at Emmaus*, cathedral, Cittadella

13. Giambattista and Jacopo Bassano, *The Way to Calvary*, private collection, London

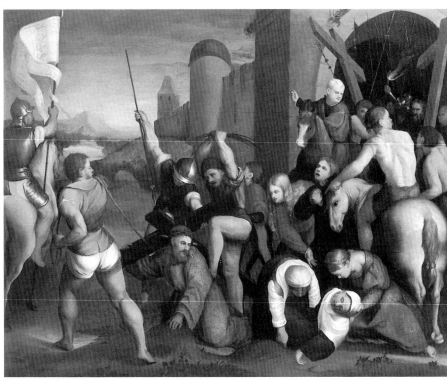

13

14

28. Perhaps the most popular antiquity
used as a model by Venetian cinquecento art-
ists, this bust is now in the Museo Archeol-
ogico, Venice.

29. Oil on canvas, 96 × 122 cm. See Rearick
1992 (C), in press.

30. Oil on canvas, 57 × 48 cm. See Rearick
1980 (B), 104.

31. Oil on canvas, 243 × 180 cm. *Libro secon-
do*, fols. 93 *v*-94 *r*. Magagnato 1952 (A), 39, no.
15, and Muraro 1992, 26, and 213-13.

32. Oil on canvas, 179 × 215 cm. *Libro secon-
do*, fols. 14 *v*-15 *r*, and 43 *v*, and Muraro 1992, 30.
For the Berlin drawing, see Rearick 1986 (B),
no. 1.

33. Oil on canvas, 187 × 187 cm. *Libro secon-
do*, fols. 62 *v*-63 *r*, and Muraro 1992, 22. For the
San Luca di Crosara *Entombment*, oil on can-
vas, 130 × 159 cm, see *Libro secondo*, fols. 95 *v*,
126 *v*-127 *r*, and 139 *v*. Cut irregularly along the
top to fit into a baroque frame, it was stolen a
decade ago and recovered in a very damaged
state.

called *Vitellius* in the Grimani collection of antiquities then in the Palazzo
Ducale, Venice.[28] Here Jacopo's hand clearly predominated; Giambattista
was doubtless assigned parts of the now-destroyed fresco cycle. By now old
Francesco seems to have become a largely inactive figurehead.

The Way to Calvary (private collection, London, fig. 13) is a seminal compo-
sition based on Agostino Veneziano's engraving after Raphael (fig. 14).[29] Be-
gun about 1536, the early stages seem to betray the stiff form, unbalanced
proportions, and approximate drawing of old Francesco, rendered even
clumsier by infirmity, but almost simultaneously a very tentative hand, prob-
ably that of the juvenile Giambattista, intervened with less than salutary ef-
fect. So things stood when the canvas was finally taken over by an impatient
Jacopo, who corrected many passages, added the touching figure of the faint-
ing Virgin and the landscape at left, and allowed it to pass muster as a Dal
Ponte product. It best represents the collaborative character of their work
around 1537. Portraiture seems from the beginning to have been considered
Jacopo's province, as his restrained, but powerfully characterized, *Francesco
Soranzo* (Musée des Beaux-Arts, Nancy, fig. 15) attests. Doubtless prompted
by the strength of his portrait in his brother Matteo's votive picture, it might
have been one of Jacopo's first pictures to arrive in Venice.[30]

Thus, this youthful phase of Jacopo's career concludes with transitional
collaborations, such as the *Saint Vigilius* altarpiece (parish church, Pove) of
1536-37, in which the richly attired titular saint is handsomely realized by
Jacopo, but his awkward colleagues below betray Giambattista's interven-
tion.[31] *The Madonna Enthroned with Saints John the Baptist and Zeno* (parish
church, Borso, cat. 3), dated 1538, was designed by Jacopo, as his disarmingly
ugly drawing (Staatliche Museen Preussischer Kulturbesitz, Kupferstichkab-
inett, Berlin) for the homely Madonna attests, and Giambattista was relegat-
ed to decorative motives on the throne.[32] Perhaps the most telling evidence
of the change in the family relationships may be found in the contrast be-
tween two versions of *The Pietà* (Museo Civico, Bassano del Grappa; parish
church, San Luca di Crosara). The first was commissioned from Francesco in
1521, delayed, and finally painted by the sick old man in 1534.[33] In 1532 Jacopo
began the San Luca di Crosara *Entombment*, in time for Francesco to see it
half-finished in 1534. Jacopo permitted Giambattista to paint about half of it
before it was consigned in 1538, but in the Bassano canvas it is the sad specta-
cle of Francesco's maladroit struggle to absorb his brilliant offspring's
achievement, vitiated though it is by his second son's equally failed efforts on
the same canvas, that sets Jacopo's originality into relief. Father and brother
could only look on with admiration and dismay as the youth moved rapidly
beyond their ken. In 1536 the senior Dal Ponte was busy constructing a mod-
el of a mountain to settle a mining rights dispute, and early sources that hint

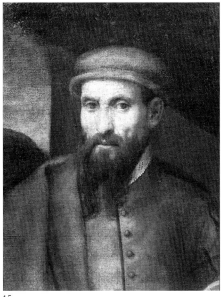

at a compulsion to alchemical experiments suggest a senile decline in his faculties, although he continued to exercise his right to sign Dal Ponte contracts nearly to the end. The account book records the disbursement for a mass in his memory on 11 December 1539.[34]

*

Giovanni Antonio de Sacchis, called Il Pordenone, mounted a fierce attack on the Venetian artistic establishment during the 1530s. After two decades of nomadic wandering in his native Friuli, to Alviano near Rome, to Genoa and Mantua, and in many Emilian and Lombard centers, he had settled primarily in Venice. There his principal target was Titian, with whom he sought repeated opportunities for comparison, as in the case of Titian's *Annunciation*, which the nuns at Santa Maria degli Angeli, Murano, rejected because the price was too high; Pordenone stepped in to provide a substitute, which is still *in situ*, at a more affordable price. Jacopo would already have seen certain of Pordenone's more showy public works when he was in Venice in 1533, and a few figures in his pictures of around 1536 seem to reflect Pordenone's aggressively large types, but their impact becomes a dominant force only in his works commissioned after 1537. It is first evident in the densely compacted *Adoration of the Magi* (Burghley House, Stamford, fig. 16), in which many elements are developed from the eponymous fresco that Pordenone painted in the Cappella Malchiostro of the cathedral in Treviso in 1521.[35] In particular, the massively planar Madonna and the disproportionately looming horse and rider at right, derived from a Pordenone drawing (Musée Condé, Chantilly), frame the more Bonifacesque group of the Magi at center. Unexpectedly, Pordenone's pallid but gloomy color has here a remarkable effect; Jacopo's chromatic emphasis has shifted from the Venetian gilded warmth of previous works to a cooler, brighter range of strong local colors with much-reduced shadow. Quite unlike Pordenone's tonality, Jacopo's emphasis on lustrous white, pale rose, apple green, and rust here assumes a personal character distinct from that of his sources. The handsome Venetian gentleman at center, evidently a portrait, might be the then Podestà Giovanni Simon Zorzi, who was in office between July 1537 and November 1538. The *Libro secondo* documents a painting of this subject commissioned by Zorzi in 1537 for the chapel of the Palazzo del Podestà in Bassano del Grappa.[36] Its execution might well have extended over the following year, since elements of its color and finely described texture are closely related to Jacopo's works of 1538. A closely related picture is *The Last Supper* (Church of Saint Lawrence, Wormley, Hertfordshire), which is probably the work commissioned by Ambrogio Frizier, one of Jacopo's most loyal patrons in these years, on 14

34. Muraro 1992, 21. Francesco was about sixty-four years old when he died, a normal age for that period, but he had been in poor health since he was about fifty-five and appears to have shown signs of senility, which caused him to relinquish most responsibility for the execution of paintings by about 1535.

35. Furlan 1988, 238, no. 102.

36. Oil on canvas, 149 × 217 cm. *Libro secondo*, fols. 95v-96r, and Rearick 1958, 197-200. Since the Burghley House picture was in the Widmann collection in Venice by the early seicento, it is probable that Zorzi took it with him when he left Bassano in November 1538. I no longer attribute the verso of Pordenone's Chantilly drawing to Jacopo Bassano, but rather to Amalteo, Pordenone's son-in-law, but I still see the figure of Saint Martin as Jacopo's source for the *Adoration* horseman.

16. Jacopo Bassano, *The Adoration of the Magi,*
Burghley House Collection, Stamford

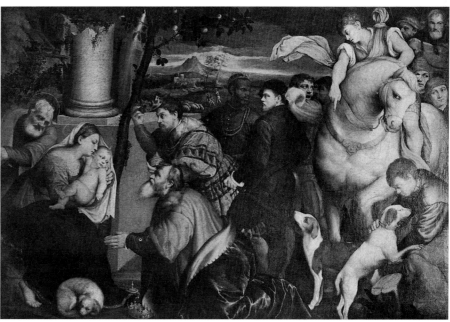

16

37. Joannides and Sachs 1991, 695-99. Muraro seems not to have communicated all of the relevant documents to the authors. *Libro secondo*, fols. 1v-2r. Jacopo knew and adapted several figures from *The Last Supper* (Museo Civico, Bassano del Grappa), which was then in San Bastiano in Bassano. Attributed to one of the Santacroce, it is directly based on a Bonifazio prototype or the related *Last Supper* (Sant'Alvise, Venice). Jacopo's patron was, once again, Ambrogio Frizier, who might have intended that it go above the altar of the chapel of his villa La Nave. *The Last Supper,* now in the chapel, is derived from Titian's picture (formerly in the refectory of Santi Giovanni e Paolo, Venice), and might have been substituted for Jacopo's picture when the latter was sold.

38. Furlan 1988, 207.

39. See Ericani's essay in this catalogue. *Libro secondo*, fols. 130v-131r. Detached by Ottorino Nonfarmale, cleaned, restored, and installed in the Museo Civico of Bassano del Grappa, this fresco retained significantly more of its original surface when it was copied by Gaspare Fontana (Museo Civico, Bassano del Grappa, inv. 77) in 1906.

September 1537, but painted and delivered only shortly before the payment of 23 January 1538.[37] Equally claustrophobic in its massed figures, the composition owes its format and a few figures to Marcantonio Raimondi's engraving after a Raphael design (fig. 17), but the calm order of that model has been transformed by way of the aggressive, Pordenone-inspired apostles into a menacingly explosive knot of figures. Already in 1538 Jacopo metamorphosizes the ideality of a classical Renaissance model through devices that, in calculated perversity, can only be described as mannerist.

If Pordenone provided the impulse to figurative acrobatics early in that year, a commission lodged with Jacopo on 19 May 1539 invited him to emulate the Friulian master's most famous painting in Venice, the illusionistic façade fresco (lost) of the Palazzo d'Anna on the Grand Canal, a work of about seven years before.[38] Zaneto dal Corno employed the Dal Ponte firm to carry out diverse embellishments of the family house at the upper end of Piazzotto del Sale, but the ambitious program for its façade was entrusted largely to Jacopo (cat. 116).[39] Lazzaro dal Corno, Latinist and orator who had been named Count Palitinate by Charles V on his visit to Bassano on 1 November 1532, was probably primarily responsible for its program, an arcane mixture of allegory and biblical themes intended to advertise the virtues of the Dal Corno clan and, perhaps, the need to root out Lutheran heresy. Covering a pair of Dal Corno emblems probably applied by the Dal Ponte shortly after

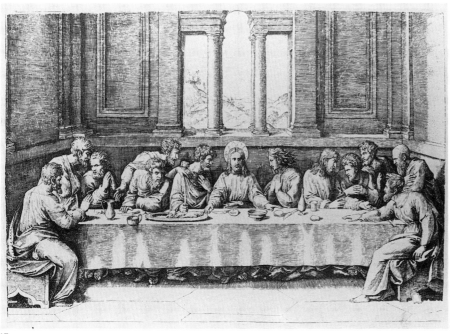

17

1532, Jacopo began with a rough indication of the oval fields in the bottom
level and the perspective balustrades at top in charcoal, the only *sinopia* he is
known to have done, and then proceeded with the fresco. Parts of the top
frieze of putti and drapery were left to Giambattista, but the lovely fictive re-
lief frieze below is entirely Jacopo's. Of the allegorical females in niches be-
tween the windows, *Industry* (fig. 102) is Jacopo's most sumptuous nude, but
Prudence and *Rhetoric* suggest Giambattista's inarticulate anatomy. The large
field at right is dedicated to *Samson Exterminating the Philistines*, a tangle of fig-
ures partly derived from prints, but composed with Jacopo's most daring il-
lusionism. Heads, arms, and feet seem to spill out of the picture space above
our heads. Its showy exhibition of foreshortened nudes is, however, lent a
human dimension by the suffering pathos of the wounded Philistines' heads,
which he prepared carefully in Pordenone-like sketches (The Duke of De-
vonshire and the Chatsworth Settlement Trustees, Chatsworth, cat. 81). The
lower four ovals, a startling mixture of biblical sex and violence, are power-
fully realized in the same vein as the Samson. The ensemble, still Gior-
gionesque in its brilliant color, athletic in its Pordenone-inspired figures, and
Titianesque in its heroic naturalism, is perhaps closest in spirit to the façade
of the Castel del Buonconsiglio in Trent, a 1531 project of Marcello Fogolino,
whom Jacopo much admired at this moment. This very range of sources sug-

gests, however, that Jacopo's capacity for assimilation has here evolved to the point where outside influence is much less significant than the artist's internal exploration of his own idiom. On 11 August Dal Corno made the final payment.

Several themes seem to have been especially congenial to Jacopo, and his success with them prompted still other patrons to request them. The Supper at Emmaus was clearly one, first noted in the account books in an important commission that came from a member of the Malipiero family by way of the podestà of Cittadella, Cosimo da Mosto. The order, dated 14 October 1533, was for a small *Emmaus* (lost), but it included a second picture, the subject to be chosen by Jacopo himself.[40] This unusual demonstration of confidence in the young painter's capacity to create original work suggests the high regard in which he was already held at home. It was followed five years later by the high altar for the cathedral of the same town, and finally, the third version (Kimbell Art Museum, Fort Worth, cat. 4) is perhaps the one mentioned in the surviving account book as commissioned in 1538. Stylistically, it more closely resembles works of 1539, just after the Casa dal Corno façade, and its execution might have been protracted.[41] Now, doubtless to meet the requirements of the private collector, Jacopo reduced and simplified the monumental Cittadella altarpiece, expanding it laterally and adding a young waiter at right and a sliver of landscape through the arch at left. The mood is intimist, the recognition of Christ in the pilgrim communicated more through a raised eyebrow than lunging gestures, and the genre detail is affectionately described with a delicacy of brushstroke that is now miniaturist in its refinement. Light is crystalline, focused, and nearly shadowless so that the optical effect of its passage through the wine glass assumes striking immediacy. In such details Jacopo demonstrates a new subtlety in metamorphosizing the broad monumentality of the Cittadella altarpiece into a precious connoisseur's treasure.

Christ among the Doctors in the Temple (Ashmolean Museum of Art and Archaeology, Oxford, fig. 18) was commissioned from Jacopo by the Venetian aristocrat Marco Pizzamano in October 1539.[42] It was not the first of Marco Pizzamano's orders, a *Christ Giving the Keys to Saint Peter* (lost) having been painted for him in 1537-38. The intermediary seems to have been his brother Francesco, who had just taken up his responsibilities as archpriest in the cathedral in Bassano del Grappa.[43] Jacopo adapted several of the figures from the small *Supper at Emmaus*, sometimes with elementary variations as in the man seated at right, for which he simply reversed the lower body from the *Emmaus* Luke. The architecture he borrowed from a Dürer engraving without excessive attention to its structural logic.[44] Here the frosty gleam of surfaces assumes a textural elaboration in passages such as the striped coat of the

40. Muraro 1982-83, 13, who mistakenly identified the *Emmaus* with the picture now in the Kimbell Art Museum (cat. 4). The account book does not identify the subject that Jacopo chose for the second canvas.

41. Rearick 1958, 199; Ballarin 1967, 78; and Joannides and Sachs 1991, 697, all date it closer to 1539.

42. Oil on canvas, 114 × 174 cm. *Libro secondo*, fols. 69v-70r, and Muraro 1992, 31.

43. Francesco Pizzamano was appointed archpriest of the cathedral in Bassano del Grappa in 1537. His brother, Marco, commissioned *Christ Giving the Keys to Saint Peter, with Hope and Charity* in 1537. *Libro secondo*, fols. 69v-70r. It was delivered in 1538.

44. Dürer's *Last Supper* woodcut (Winkler n.d., 254) provided part of the architectural setting, but Jacopo's primary inspiration was Bonifazio's *Christ among the Doctors* (Galleria Palatina, Palazzo Pitti, Florence), painted for the Casa del Consiglio dei Dieci in the Palazzo dei Camerlenghi, Venice, in 1537.

18. Jacopo Bassano, *Christ among the Doctors in the Temple*, Ashmolean Museum of Art and Archaeology, Oxford

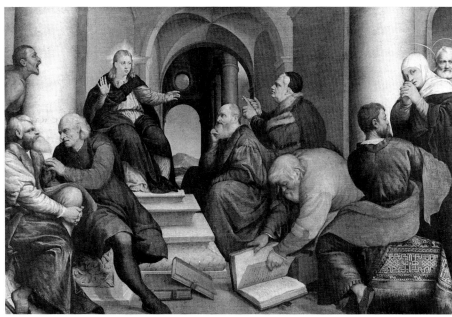

18

bald sage at left that seems almost Flemish in its concentration on visual sensation. Jacopo arrives at this, however, by way of his intense attachment to the object seen and not by way of any direct contact with transalpine painting. His delight with his achievement here was such that he asked Pizzamano if he might give the picture to another, presumably more exigent, patron. It proved, however, too small for that client's space, so it went to Pizzamano as promised. He offered a *scudo* as balance, and Giambattista closed the deal by accepting that.[45] His brother's role as collaborator seems at this point to have shifted slightly, and Giambattista began to design and execute some of his own paintings rather than simply seconding Jacopo's work in some passages of his older sibling's projects. The results in works such as *The Martyrdom of Saint Mark* (The Royal Collection, Hampton Court) must have been disheartening indeed, but Giambattista continued to paint even though his primary responsibility remained in the realm of artisan crafts, which the Dal Ponte firm continued to produce in quantity.[46]

★

Prints provided a common conduit in the Renaissance for the exchange of artists' ideas, and nowhere more than in Venice, where engravers and woodcutters collaborated with some of Europe's greatest publishers of illustrated

45. Marco Pizzamano doubtless displayed his picture in his Venetian palazzo, and it may be considered one of Jacopo's first monumental works to be known in the capital. Marco was also the brother of Jacopo's 1545 patron Pietro Pizzamano and would thus have been aware of the artist prior to his arrival in Bassano as podestà in 1544.

46. Oil on canvas, 115 × 166 cm. See Rearick 1992 (C), in press, for other paintings attributed to Jacopo, but instead entirely or in part by Giambattista.

47. Panofsky 1948, 107-31.

48. Jacopo took motives from *The Triumph of Christ*, the Brito *Adoration of the Shepherds* and his *Milkmaid*, the Boldrini *Six Saints*, and other prints after Titian's designs. See Rearick 1980 (C), 371-74; and Muraro and Rosand 1976.

49. For Jacopo's rare drawings in pen, see cats. 83 and 113. He seems never to have used wash in a traditional manner.

50. *Libro secondo*, fols. 44v-45r, and 47r. Neither Moretto nor Parmigianino is known to have worked near to Bassano, and their works in Venice were not relevant in this context. Jacopo's absorption of this mannerist variation on Raphaelesque form may in part, but only in certain respects, be attributed to his study of the mature works of Gerolamo da Treviso il Giovane, whose *Saint James* altarpiece (San Salvador, Venice) was in place by 1531. Other of Gerolamo's Venetian works of this moment, such as the frescoed *cortile* (lost) of Andrea Odoni, were probably known to Jacopo and might have influenced his Casa dal Corno façade of 1539.

books. Venice's position at the crossroads between north and south meant that it enjoyed access not only to Roman masters such as Marcantonio Raimondi, but also to the rich productions from Germany, particularly Albrecht Dürer, who recorded the avidity with which Venetian artists sought his prints during his 1505-7 sojourn there.[47] Titian, in particular, provided engravers and woodcutters with designs from about 1509 on, and it is natural that Jacopo dal Ponte's admiration for the senior master should have led him to acquire some of his prints.[48] Few of his contemporaries, however, made such a systematic practice of establishing a repertory of graphic art to serve as ready reference when new figures, motives, or compositional ideas were needed. Paradoxically, this artisan of copybook mentality also liberated Jacopo from a too partisan adherence to a native point of view. He clearly kept sheafs of prints in his studio, including works by or after Titian, Agostino Veneziano and Marcantonio Raimondi after Raphael, Niccolò Vicentino after Parmigianino, Antonio da Trento after Francesco Salviati and others, Ugo da Carpi after Pordenone and others, Albrecht Dürer, Barthel Beham, Martin Schongauer, and Lucas Cranach, as well as other Northern masters. The list is so long as to suggest a collection of impressive bulk, even by comparison with those of wealthy connoisseurs. It is significant, however, that their primary function was motivic and not stylistic, since Jacopo virtually never drew in pen and ink, the creative parallel to a line print.[49] Instead, each served as a starting point for his visual imagination, an empty contour to be filled by his pictorial inspiration. Further, exotic formal elements prompted his fantasy for color and brushwork into experimental paths with little relation to the painting on which the model print had been based. Jacopo's painting, therefore, seems entirely liberated from sources in the usual sense, and a fall of drapery, an arm, or a horse shows almost no stylistic relation to the work by Titian, Raphael, or Dürer on which it was based. As a connoisseur with a fastidious eye for useful material, Jacopo dal Ponte had few equals in the cinquecento and none in the Veneto.

Travel in these early years seems to have been limited to the occasional visit to Venice on business and perhaps short stays in Padua, Vicenza, Belluno, and Verona. We have no documentation for excursions further afield, and the Dal Ponte shop activity surely would not have extended to other regions beyond the Veneto. Nonetheless, Jacopo's painting style suggests that around 1540 he came into direct contact with works by Parmigianino and his followers in Emilia, and by Moretto in Brescia. The little altarpiece of *Saint Anne with the Virgin Child and Saints Jerome and Francis* (Museo Civico, Bassano del Grappa, on loan from the Gallerie dell'Accademia, Venice, cat. 7) is signed and dated 26 September 1541.[50] The traditional pyramidal format is here rendered slightly claustrophobic by the suppression of a landscape environ-

ment, and the Saints Jerome and Francis remain ponderously Pordenone-inspired, as in works of 1539. The Saint Anne, however, is designed with a weighty but elegant attention to the fluid play of drapery that falls in stylized parallel folds in her dress, suggests the figure's torsion in the mantle, and is worked to an elaborate pattern in the coif. Its color is a frigid contrast of cobalt blue, pallid rose, and snowy white. This sophisticated artifice suggests a direct observation of similar mannerist passages in the works of painters from Parma such as Girolamo Mazzola Bedoli. This rarefied pictorial formula contrasts amusingly with the touchingly natural gesture of the little Virgin Mary, her plain-faced mother, and delightful details such as the flowers, the goldfinch, and the illusionistic fly, perhaps observed in a Northern picture. If the *Saint Anne* hints at a westward glance to Parma, the exquisite *Madonna and Child with the Young Saint John the Baptist* (Accademia Carrara, Bergamo, cat. 9) embraces a Parmigianesque idiom in all of its elaboration.[51] The Madonna's ovoid head, her porcelain pallor, attenuated hand, and richly worked veil are integrated with an internal order of convoluted forms to create a cosmopolitan aura of sophistication not previously achieved in Jacopo's works in which his heterogeneous visual sources remained to a greater degree distinct. Still, the impasto of the lustrous veil and her golden tresses indicate that Titian's physically sensuous surfaces are lurking just beneath this arch veneer. The austere *Franciscan Friar* (Earl of Shelburne, Bowood House, fig. 19), which also dates to 1541, demonstrates that the stimulus of the real world remained constant for Jacopo; somber and admonishing in the penetrating gray light, the friar gently reminds himself and us of the inevitability of death, present in the skull gleaming in a charged luminescence that sets it into a surreal relationship with its reticent surroundings.[52] That Parma here plays no significant role in Jacopo's concept or execution simply underscores his achievement of a pictorial maturity in which influences flicker in and out of his consciousness without disruption to his personal dedication to the subject at hand.

The council of the community of Bassano del Grappa voted on 27 May 1541 to exempt Jacopo from the payment of all taxes because of the excellence of his art – a rare example of enlightened local government and its support and admiration for the man now firmly recognized as its finest artist, a talent already established throughout the territory if only sporadically recognized in Venice itself.[53] His insularity was about to give way to a new, if understated, notoriety in the capital. The new podestà, Bernardo Morosini, assigned him the major fresco project of this moment, the enormous *Lion of Saint Mark* and *Marcus Curtius Riding into the Fissure*, with which the Dal Ponte covered the outside façade of the Porta Dieda, the principal gate in the medieval city walls.[54] Although largely effaced by time and weather, enough re-

51. Although Jacopo's awareness of the elegant convolutions current in Parma was, in large measure, by way of graphics, the crisply gelid harmony of pale rose and ice blue in the Bergamo picture can only have been inspired by a painting, and most particularly one by Bedoli.

52. Oil on canvas, 79 × 65.5 cm (without the added strip of canvas above). Formerly attributed to Cariani or Sebastiano del Piombo. See Rearick 1980 (B), 106-7. The *Libro secondo*, fols. 131v-132r, records a 1542 commission for a portrait by a priest from Strigno, possibly the present picture. See Muraro 1992, 274 and 409.

53. Arslan 1960 (B), I, 91-92.

54. G. Fontana reproduced the entire façade of the Porta Dieda in a tempera of 1906 (Museo Civico, Bassano del Grappa, inv. 76). In 1956 the present writer made a reconstruction based on what was then clearly visible.

19. Jacopo Bassano, *Franciscan Friar*, Earl of
Shelburne, Bowood House

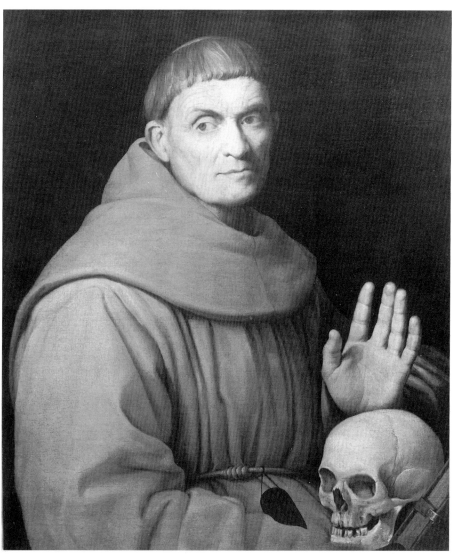

19

55. Rearick 1984, 296-97. The fragmentary
inscription reads «...MORO.../ ...JANU-
ARI...»

mains to suggest that brother Giambattista was pressed into service for *The
Lion of Saint Mark*. Jacopo himself, however, designed the dashing Roman
hero and his fervid white steed as they sacrifice themselves to save the Ro-
man Republic. His apple green cape billows after him in a motive distantly
derived from a Marcantonio engraving, but now freed of all timidly repro-
ductive character to assume a dynamic role recalling Pordenone's fresco of
this subject from a decade earlier.[55] Jacopo here strikes out on his own dra-
matic path with hardly a trace of the provincial awkwardness that gave his

prior works a disarming naïveté. If the Porta Dieda fresco could be known in Venice only through the description of its proud patron, Bernardo Morosini followed it with a commission of more portable scale. His portrait (Staatliche Museen Kassel, cat. 6) is pictorially and psychologically one of Jacopo's most subtle works.[56] Captured in a moment of self-conscious discomfort at being the subject of the artist's concentrated appraisal, Morosini sits stiffly in his splendidly described wine red robe of office, but his glance is averted and his hands are furtively hidden from our view. Faintly bemused, sly, but vaguely aware that the picture might at least hint at a vulnerability that he might have preferred to cloak in the portentous guise of the podestà, Morosini betrays internal contradictions that Jacopo set down with a candor and sympathy distantly recalling the more distressed portraits of Lorenzo Lotto, although Jacopo seems to have known little of Lotto's work and shows no direct trace of it here.[57] When Morosini returned to Venice at the conclusion of his term in Bassano in November 1542, he surely took his portrait with him, and once hung in the family palace near San Samuele it would be seen and admired by other Venetian patricians. Within a few months Jacopo would travel to Venice to paint another portrait, that of Giovanni Marcello (Brooks Museum of Art, Memphis, cat. 5), and, as if to document the significance of this venture, he signed it on the folded letter with the dual allusion to his roots in Bassano del Grappa and the execution of the picture in Venice.[58] Despite the inscription, part of the Marcello portrait must have been painted in Bassano, since the carpet was a studio prop depicted in several works that we know were carried out at home.[59] It is probable that the artist made preliminary studies in Venice, developed them on the canvas at home, and made the finishing touches back again in Venice. As in the Morosini portrait, but here with greater delicacy and warmth, Jacopo allows us to observe this shy humanist without direct confrontation. Behind the archaic Moretto motive of a turkey-carpeted barrier, Marcello distractedly leafs through his book, gazes defensively out of the picture to our right, and rather illogically grasps his glove as though he were about to hurry away to some appointment he has just remembered. Less pictorially gaudy than the Morosini picture, the refined harmonies of black, beige, and olive are modulated with even greater subtlety. If Venetian sitters expected an aggressive projection of political and social status, and they usually did, the portrait of Giovanni Marcello cannot have aroused an enthusiastic response; Jacopo is not known to have painted any further portraits in Venice during these years. Several years would pass before we know that another of his paintings was to be seen there.

The partial nature of the Dal Ponte account book permits a fairly secure documentation for certain of Jacopo's works prior to 1551, but for certain subjects that Jacopo repeated many times over, the records allow a margin of

56. *Libro secondo*, fols. 5r, and 16v 17r. See Muraro 1992, 35, and Rearick 1980 (B), 107.

57. Although Lotto's name has often been cited as an inspiration for Jacopo, there is no trace of direct influence on his art at any period except when required for his adaptation of the Asolo altarpiece (cat. 19).

58. Inscribed «Jac.ˢ a Ponte/ bassanensis. f./ in Venetiis.»

59. This turkey carpet appeared in the Oxford *Christ among the Doctors* (fig. 18) and the Rasai altarpiece (cat. 8). The book depicted in the Bowood Franciscan Friar (fig. 19), the Saint Anne altarpiece (cat. 7), and the Saint Ursula altarpiece (cat. 118) is the same studio prop. Other objects appear several times over in Jacopo's pictures, suggesting that he painted directly from this type of model.

ambiguity, since a commission might be linked with a known picture, a lost work, or a painting documented in one of the three missing account books. Conversely, we are left with splendid masterpieces that are of indisputable authenticity, but about which the surviving book of records is silent. Thus it is for the period between June 1542 and August 1543. One commission can be identified securely today; *The Madonna and Child with Saints Martin and Anthony Abbot* (Bayerische Staatsgemäldesammlungen, Alte Pinakothek, Munich, cat. 8) was commissioned in June 1542 and completed by 22 February 1543.[60] Its conservative format and somewhat lethargic touch might be the conscious choice of the artist when dealing with a patron from far-off Rasai, but it is more probably the result of a partial reuse and adaptation of the figures from the fresco of *The Madonna and Child with Saints Bassiano and Francis* (Museo Civico, Bassano del Grappa, cat. 117), which in turn is based on the Bergamo *Madonna* and thus places the Rasai altarpiece last in this sequence.[61] Almost simultaneously, but with somewhat more fluent brushstrokes and clear, stronger color, comes *The Flight into Egypt* (The Toledo Museum of Art, cat. 11).[62] Reconsidering his 1534 composition, Jacopo reversed it and expanded it laterally to a more festively animated procession, today slightly unbalanced due to the loss of a strip at right that would have placed the Madonna just to the right of center. Precise references to prints have been replaced by an internally generated amplitude and cursively graceful form, as in the majestic figure of Joseph, whose head was prepared by a remarkable drawing (private collection, New York, cat. 82) in which Jacopo used red, white, and black chalks in a decisively naturalistic evocation of the coloristic effect he envisioned for the painting. The lovely Madonna is formally developed from the Bergamo prototype, but the frosty artifice of that work now gives way to a warmer Venetian harmony, as though Jacopo had just renewed his awareness of Bonifazio's golden tonalities. The grooms are drawn with an attenuated proportion and a pointed precision of detail, and their coloring is a rarefied and burnished range of sun-bronzed muscle and touches of brilliant hue. As ever, Jacopo lends his animals a spirited character, particularly in the furtive confrontation between dog and cock at center. It is, however, the fine-grained atmosphere of the landscape with its rustic farms and misty view of Monte Grappa that would provide Jacopo with a prototype to which he would return for more than a decade thereafter.

If the Toledo *Flight* seems cheerfully informal, the successive *Adoration of the Magi* (The National Galleries of Scotland, Edinburgh, cat. 10) inspired Jacopo to his most sumptuous pictorial experiment to date.[63] A picture of this subject was commissioned from Jacopo on 29 April 1542 with a payment registered on the formal signing of the contract on 5 July following, and an undated receipt for a substantial sum was made later. The patron was Jacopo

60. *Libro secondo*, fols. 81 v-82 r. See Muraro 1992, 34-35.
61. Tempera and oil on plaster, 112 × 128 cm. This fresco is not, as has usually been alleged, unfinished, but is instead in a mixed medium, sketched alternately with a nail or in gray paint on the wet plaster, painted in tempera – or « buon fresco » – in the portions that retain color, and finished in oil – or « al secco » – in the portions where the color has dropped off. He probably took this approach on the mistaken assumption that the painting would be protected by its position under the cloister arcade.
62. The lovely Madonna and Child suggest a renewed contact with Bonifazio at this moment, although elsewhere in the picture Jacopo's color and texture are now quite personal.
63. *Libro secondo*, fol. 55 r. See Muraro 1992, 153 and 409.

Ghisi, tentatively identified as a resident of Angarano, across the river from Bassano del Grappa, but more likely to have been a member of the wealthy Venetian family of that name. Certainly, this extravagant pageant would be more at home in a Venetian palazzo on the Grand Canal than in a simple home on the banks of the Brenta. Although in the eighteenth century it was thought to be by Titian, it owes no direct debt to the master from Cadore. Instead, there is a hint of the hedonistic color and texture of Palma il Vecchio in its lovingly worked impasto, and the only clear quotation from a print comes in the ruined architecture at left, which is lifted from Dürer.[64] Surprisingly, Pordenone's influence has now virtually disappeared, but Jacopo still found the kneeling groom in the Friulian's Cappella Malchiostro *Adoration* worth adapting for his cinnamon-clad servant at front right.[65] Although one's eye wanders with intense pleasure over the infinity of fine detail, such as the violets at lower left, the ivy on the weathered wall, the dark emerald of the slashed jacket at right, and the dusty rose of the billowing banner, it is the magisterial order of refined color that finally seems Jacopo's most original achievement in *The Adoration of the Magi*. Most particularly, the unique brownish plum of Melchior's robe, the tomato red of Balthazar's jacket, and the emerald and gold stripes of Caspar's suit are conjunctions of such striking originality as to defy reference to other paintings of these years in the Veneto. They are and would remain Jacopo's own colors, his private and joyous invention after a decade of chromatic trial and occasional error.

Returning to the theme of *The Flight into Egypt* (Norton Simon Museum, Pasadena, fig. 20) seemingly late in 1542, Jacopo enriches his Toledo formulation by reducing the scale of the figures, lightening their proportions and sharpening their detail.[66] Unexpectedly, his repertory of print sources here expanded to include Mantegna, from whose *Bacchanale* he adapted the shepherd who drinks from a wooden canteen at left.[67] Color is now paler but more intense, and a nervous delicacy of touch etches detail with microscopic precision. Most prophetic is the newly created guiding angel, a vivid conjunction of natural form in the great bird wings and pure caprice in the arbitrary calligraphy of the drapery. Its color is a violent clash of ice blue, livid rose, and pale apple green. The tangible world and visionary invention have seldom been mixed to such volatile effect.

A certain caution is in order in interpreting the Dal Ponte account book records as secure evidence for the dating of paintings. One notes consistently, for example, that commissions often remained unfilled for many months and even many years, waiting for a presumed complaint on the patron's part before the project was even begun. An extreme instance is *The Trinity* (parish church, Angarano, fig. 21), commissioned in 1533, its contract renegotiated in 1546, and the picture consigned in 1547, fourteen years after the contract was

64. Dürer's *Rest on the Flight* woodcut (Winkler n.d., 273) from *The Life of the Virgin* cycle of c. 1506 provided Jacopo with the architecture at left, but he readjusted the bundle of faggots on the roof. His *Nativity* (Winkler n.d., 287) from the *Small Passion* was the source of the ruin at center, the *Great Horse* (Winkler n.d., 129) of 1505 seems to have inspired the animal at right, and other details are more freely adapted from the prints of the Nuremberg Master.

65. Furlan 1988, 92-97.

66. Oil on canvas, 119.4 × 198.1 cm. See Pallucchini 1982, no. 11.

67. For Mantegna's *Bacchanale*, see Boorsch and Landau 1992, 279-83.

20. Jacopo Bassano, *The Flight into Egypt*, Norton Simon Museum, Pasadena

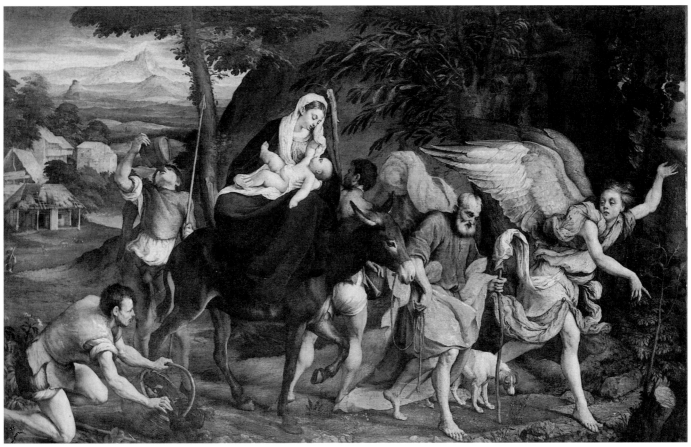

20

68. *Libro secondo*, fols. 24v-25r, and 35r. Oil on canvas, 240×156 cm (including added arched canvas at top). The original format was rectangular, but the top corners were beveled when it was reshaped for an arched frame. The iconography is partly inspired by Northern graphics, but Jacopo doubtless also knew the very similar large marble relief of *The Trinity* (Santa Corona, Vicenza) done in 1533 by Giovanni Battista Krone.

69. *Libro secondo*, fols. 49v-50r, 51r, and 98v. Oil on canvas, 168×106 cm. Rediscovered by Muraro (1957, 291) on the basis of the account book, and published by him (1992, 33). Only the top and lower corners of the clear blue sky survive, but the figures are in generally good condition.

drawn up.[68] In the years 1541-42 this is vividly illustrated by the *Saints Ursula, Valentine, and Joseph* (parish church, Mussolente, on loan to the Museo Civico, Bassano del Grappa, cat. 118), an altarpiece commissioned in September 1541 simultaneously with the termination of the *Saint Anne* altarpiece, with which it evidently has little stylistic relation.[69] Despite the loss of most of the brilliant blue sky, the surviving surfaces are freshly preserved, and the newly sparkling color has shed the last traces of the leaden tonality of a year or two before. Gone, equally, are the stubby figural proportions of works of 1541. Instead, a limpid radiance and delicately flexible figural construction lend the *Saint Ursula* a cheerful serenity of mood, an absolute command of the brush, and a refinement of sentiment that bespeaks a more advanced stage of the artist's evolution. In fact, the right side of the Pasadena *Flight* contains a Saint Joseph that is only slightly varied from the same saint in this altarpiece, and the angelic guide is only slightly more delicate than the Ursula enclosed in

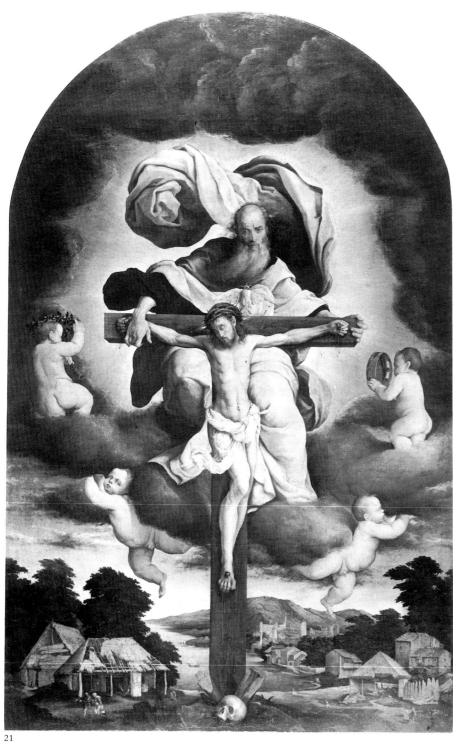

21

her flowing mantle and banner. The thinly translucent veils of clear pigment have the same effortless fluency in both paintings. In short, the *Saint Ursula* altarpiece was painted very shortly before its consignment to Mussolente in December 1542, fifteen months after it was commissioned, and this date gives, in turn, the appropriate context for the Pasadena *Flight* and a *terminus ante quem* for the Toledo and Edinburgh pictures, as well as the Morosini and Marcello portraits.

As is well known, Venetian painters were subjected to an exceptionally strong dose of Tuscan mannerism in precisely these years. Francesco Salviati arrived in Venice in 1539 to paint works for public places as well as for private patrons, and his designs for printmakers extended his influence significantly. His apprentice, Giuseppe Porta, stayed on after Francesco's departure in 1541, and his role would assume greater importance for the future. Giorgio Vasari had a lesser impact as a painter, being more significant for the commissions he left to Titian on his departure in 1542. Simultaneously, Schiavone provided a direct conduit for Parmigianino's Emilian mannerist formulation. If Tintoretto observed these exotic phenomena at close range, Jacopo Bassano took a more fastidiously distant view of them.[70]

<center>★</center>

Jacopo dal Ponte was not a mannerist in the narrowly defined historical sense of the term.[71] There is no evidence that he read any of the cosmopolitan theorists on artistic principles, such as Giorgio Vasari or Marco Pino, nor was his art known to them until well after the middle of the century.[72] The largely Tuscan impulse to formulate a canonical set of rules by which a work of art might be judged was utterly foreign to his artisan mentality. Instead, after old Francesco's death in 1539, Jacopo inherited the direction of the Dal Ponte family enterprise, sharing with his brother Giambattista as well as a corps of specialist collaborators the diverse jobs the community lodged with them. They provided processional banners, decorated lanterns, embellished Easter candles, made sculpture of religious and secular subjects, drew patterns for embroidery, and designed marzipan for parties.[73] Of course, altarpieces with their frames, devotional pictures, portraits, and other work more appropriate to an artist had become the dominant activity of all members of the shop at an early date. After about 1535 Jacopo was recognized as the best prepared to execute this kind of work on a high professional level. Recognition as a painter of pictures, however, did not exempt him from the diverse artisan products of the Dal Ponte shop, where commissions were still lodged generically with the family rather than with an individual member of the collective enterprise. Indeed, his brother and his associates continued to

70. Twentieth-century historiography has taken a deliberately simplified view of the cross-cultural artistic currents of the cinquecento, but it is true that first generation mannerists such as Pontormo, Rosso, Beccafumi, et al., remained virtually unknown in Venice except for Caraglio prints after Rosso. Conversely, Raphael and, to a lesser degree, Michelangelo were known from originals and prints from at least 1521. Jacopo's isolation and critical judgment saved him from the deleterious effect of central Italian influence, but it paradoxically also permitted him to absorb whatever he found useful at a precocious date.

71. Freedberg 1971, 114-26.

72. Schlosser 1964, 239-45.

73. Muraro 1982-83, 145-54.

paint original compositions as well as repetitions of Jacopo's pictures, and it was more the rule than the exception that all members of the clan worked cheek by jowl on many pictorial projects.[74] Jacopo, nonetheless, arrogated invention to himself with increasing frequency, and to that end he had amassed his file of graphic sources. As his technical proficiency increased, his appetite for new aesthetic experience brought him increasingly into contact with foreign artists whenever the possibility presented itself. From an early date he seems to have studied works of Jan van Scorel and, later, Lambert Sustris.[75] The work of Moretto, Romanino, and Parmigianino he must have seen on trips further to the west and south.[76] By 1540 Venice itself was the scene of Central Italian incursions, first by Francesco Salviati, who visited in 1539-41, and then by Giorgio Vasari, who worked there and researched his first edition of the *Lives* in 1541-42.[77] Needless to say, the Aretine historiographer took no notice of Jacopo and had probably not seen any of his work by 1542. Equally, of these true mannerists only Salviati seems to have interested Jacopo, and there is a hint of the Florentine's pale floral tonality in the guiding angel of the Pasadena *Flight*. In none of these instances, however, does Jacopo show any sign of interest in the doctrinaire aspect of the pictures he examined; he was exclusively concerned with discovering new ways to expand and enrich his own capacity to express his personal vision in purely pictorial terms.

Just as his repertory of sources remained voracious and compendious, as chance study of paintings and the acquisition of graphics permitted, Jacopo's adaptation of ideas derived from them did not usually follow a predictable course. Invention was not always followed by a painting executed entirely by Jacopo, nor were replicas the exclusive province of his brother. Still, it is surprising to find that Jacopo returned around 1543 to the compositional format of *The Way to Calvary* (fig. 13), painted about five years earlier. Furthermore, old Francesco and Giambattista had painted much of the picture, ceding it finally to Jacopo, who made an only partly successful effort to salvage the work through additions and corrections. Then, however, the composition of *The Way to Calvary* had doubtless been set down first by Jacopo in a free reordering of Agostino Veneziano's engraving (fig. 14). Now, in painting a refined reduced replica (Fitzwilliam Museum, Cambridge, cat. 12), Jacopo decided to carry it out nearly alone.[78] His picture returns to several Raphaelesque figures reproduced in the print, figures that he did not use in 1538. He does not correct the clumsy narrative disjunctures that made the first treatment rather episodic in action. His touch is sharply detailed as in works of 1542, but the strong local color more closely resembles the dissonant juxtapositions of 1543 and looks forward to the brilliant hues of *The Martyrdom of Saint Catherine* (Museo Civico, Bassano del Grappa, cat. 13) of the following

74. Rearick 1992 (C), in press.

75. Van Scorel was at work in various mainland towns in the Veneto as well as in Venice from 1520 to 1526. Sustris may have been in Titian's studio as early as 1538, but he was active at Luvigliano, Padua, and elsewhere in the Veneto by about 1542. In 1548 he accompanied Titian to Augsburg, a date that effectively concludes his work as it relates to Jacopo's development.

76. Jacopo's travels remain a matter of speculation, but, since his clients did not range so far afield, it would be difficult to adumbrate trips to Brescia, Bergamo, or Parma merely out of curiosity. Still, the works of these masters that are documented in the Veneto do not go far toward explaining these hypothetical contacts.

77. Vasari was in Venice between December 1541 and August 1542. The first edition of *Le vite de' più eccellenti pittori scultori e architetti* (Florence 1550) is notoriously sketchy in its report about Venetian painting and very short on information regarding contemporary events. He took no note of Jacopo, but then he was not aware of Tintoretto either. Schiavone alone of the younger generation seems to have interested him.

78. This is the smallest of Jacopo's treatments of this theme.

22. Jacopo Bassano, *Noli me tangere*, parish church, Oriago

22

79. *Libro secondo*, fols. 95 v-96 r, and 98 v-99 r. See Muraro 1992, 35 and 407-8.

80. Alessandro Spiera was first recorded in the painters' guild in Venice in 1530. See Favero 1975, 137. No signed works are known, and early sources such as Ridolfi make no reference to him. Spiera's orders for pictures, sometimes referred to as lots of diverse subjects, seem to have been concentrated between 1540 and 1543. He was probably not the only middleman to serve as conduit between the Dal Ponte and the open market in Venice.

81. Oil on canvas, 255 × 180 cm. *Libro secondo*, fols. 16 v-17 r. Ridolfi (1648, 1, 85) described it as by Francesco Vecellio. Fiocco, Valcanover, and Lucco all accepted the attribution to Francesco Vecellio. The present writer gave it to Jacopo dal Ponte in his unpublished Harvard dissertation, *The Paintings of Jacopo Bassano* (1968, 1, 578-81), and Muraro (1982-83, 70) revealed the documentary evidence for this. Since then several scholars have taken note of the Oriago altarpiece as by Jacopo, but it has only recently been extensively discussed as his by Rearick 1992 (C), in press.

82. Winkler n.d., 301.

year. Another, bluntly approximate, hand, perhaps once again Giambattista, is evident in the old woman in purple and a few passages above her, but the new fainting Virgin is one of Jacopo's most touching creations, a motive not found in any graphic source.

The circumstances under which the Fitzwilliam picture was painted suggest an aspect of Jacopo's relation to the art trade in Venice that has, until now, only been hinted at. On 5 July 1540 Jacopo recorded an order vaguely defined as for « some pictures » to be done for Alessandro Spiera, who is described in the account book as a painter living and working in Venice. A delivery was made to Spiera in Venice on 4 April 1541. Finally, on 1 August 1543, a *Way to Calvary* was consigned to Spiera in Venice.[79] One may surmise that Spiera, about whom we know nothing more, was one of a number of artist-dealers active in Venice, a shopkeeper middleman who ordered pictures from provincial painters that he in turn sold to Venetian clients at a sizable markup. Once again, the certain identification of *The Way to Calvary* as the work ordered by Spiera must remain hypothetical, but the account book records make it clear that Jacopo's paintings were already in circulation on the open market in Venice.[80]

Although Jacopo's work was beginning to be appreciated in Venice, his detachment from the ebb and flow of artistic fashion in the great world beyond Bassano is poignantly manifest in the great altarpiece for Oriago. The *Noli me tangere* (parish church, Oriago, fig. 22) was commissioned in April 1543 and delivered in March 1544, when Giambattista began to gild the frame, which was also the product of the Dal Ponte shop.[81] The painting, which has only recently been returned to the parish church, has passed unknown as Jacopo's work since 1648, when Ridolfi attributed it to Titian's brother, Francesco. For his composition Jacopo remembered the Magdalene in Titian's youthful treatment of this subject (The National Gallery, London), but, surprisingly, he took one of the little angels by the tomb from Agostino Veneziano's engraving of *The Dead Christ* after Andrea del Sarto. His primary source, however, was the *Noli me tangere* woodcut from Dürer's *Little Passion* set.[82] Given the wide range of more up-to-date treatments of this subject, why did Jacopo return to a now-archaic formulation of more than thirty years before? The answer probably lies in the print's dramatic evocation of the landscape at dawn, a vibrant environment for the pathetic Christ, but one achieved through purely linear means. In short, Jacopo responded to Dürer's expressive power without being bound to emulate a painterly model. Now, his own capacity to conjure up the frigid atmosphere of the garden as the red sun rises over the sleeping land is fully equal to the challenge, once the print had pointed the way for his pictorial imagination. Academic doctrine is irrelevant and motival sources merely provide a point of departure. For the lone-

ly craftsman by the Brenta, all that really counts is the dialogue between his hand, the brush, and the empty canvas.

If these pictures of about 1543 echo much earlier works by Raphael and Dürer, Jacopo's next masterpiece is perfectly contemporary in its source. Francesco Salviati provided drawings for the two woodcuts used to illustrate Pietro Aretino's uncharacteristically pious *Life of Saint Catherine*, a little volume published in Venice just after 1540.[83] Jacopo seems not to have found a use for the *Catherine Carried by Angels to Her Tomb*, but the *Martyrdom* came into play as he prepared his small altarpiece (Museo Civico, Bassano del Grappa, cat. 13) for the Bassano convent church of San Gerolamo.[84] Commissioned on 9 June 1544 and delivered on the following 11 August, its square format announces the artist's aspiration to monumentality, despite its modest dimensions. Indeed, he seems to have been aware of the giant altarpiece of this subject (Santa Maria Novella, Florence) commissioned from Giuliano Bugiardini in 1534. That same year Bugiardini had asked for Michelangelo's guidance for the fallen soldiers, but his execution of the altarpiece dragged on for nearly a decade.[85] Salviati himself knew and adapted the fallen soldiers for part of his woodcut, and it is possible that in 1540 he showed Jacopo drawings after the Michelangelesque figures. From Salviati Jacopo merely digested the general format, reversing it and revising the figures so that the only ideas retained from the print are the fleeing soldiers with pikes and the nude who falls head-down at center. Indeed, the nude is obviously studied from a live model, whose strenuous pose still eludes Jacopo's grasp of anatomy. The terrified, bleeding, and illogically decapitated executioners are a diverse lot; some, like the man with a shield at right, were closely based on Titian's *Triumph of Christ* woodcut; others, as the delicately contracted youth in blue and rose at lower left, were developed from Pordenone's *Goliath* fresco painted c. 1532 in the cloister of Santo Stefano, Venice; and several were adapted from Jacopo's own *Samson* fresco of 1539.[86] The flying angel comes in part from Raphael's *God the Father Appearing to Isaac* in the Vatican Logge, certainly by way of Marcantonio's engraving. The Catherine, however, is not, as is often said, borrowed from Parmigianino but is, rather, Jacopo's elaboration of the Raphael-inspired Magdalene in his own *Way to Calvary*.[87] Finally, although the complexity of Jacopo's sources encourages us to trace them, it is the dramatic pictorial unity of his painting that relegates influences to a secondary level of significance. The elegantly doll-like saint, a serpentine convolution of curved forms, is poised serenely at the nexus of a centripetal explosion of her executioners as the sulfurous cloud reveals the exterminating angel. Again, Giotto's *Kiss of Judas* (Cappella Scrovegni, Padua) inspired the device of allowing angled spears to suggest, rather than describe, the movement of a vast crowd. Although their acrobatics are rather forced and dramatically un-

83. Dillon 1981, 324, no. 178, and Rearick 1984, 299-300.

84. *Libro secondo*, fols. 37v-38r. See Muraro 1992, 36 and 118-19.

85. Pagnotta 1987, 222-23. Work on this altarpiece began in 1534 and seems to have extended over a decade, but Michelangelo's contribution of drawings for the fallen soldiers occurred in 1534.

86. Jacopo or, more probably, Giambattista painted a lost *Martyrdom of Saint Catherine* in about 1540. A copy from the late Dal Ponte shop is in the Museo Civico, Bassano del Grappa, inv. 326. See Magagnato and Passamani 1978, 38. It reused most of the elements from the Casa dal Corno *Samson* of 1539, and seems to precede Giambattista's Hampton Court *Martyrdom of Saint Mark* by a year or so.

87. The Raphael *God the Father* was engraved by Marcantonio Raimondi. See Oberhuber 1978, vol. 26, 16.

motivated, the soldiers have each been characterized in human terms, even to the frightened reflex of the mail-clad warrior at bottom left. Each bleeds and suffers as an individual, and Jacopo's sympathy extends even to the pagan statue, which seems offended by the angelic intrusion. Drawn with minute precision, but brushed with startling speed – one notes the use of the blunt end of the brush to scratch stitching into the fawn jacket at upper left – the pictorial vitality of Jacopo's touch communicates his exhilaration without academic posturing. The sharp, jewel-like color is disposed antiphonally through the picture, most strikingly the emerald and ruby, which originate in Catherine and recur throughout. Jacopo was seldom assigned a subject that was so demanding; the relish with which he attacked it is vividly evident in every detail as well as in the painterly unity of the ensemble, which seems far more monumental than its modest dimensions would suggest.

When, on 12 April 1545, the podestà of Bassano, Pietro Pizzamano, came to the Dal Ponte studio, Jacopo must have known that the picture he intended to commission would soon return with Pizzamano to his native Venice, where it would be seen by colleagues and connoisseurs in the capital. This was not, in fact, Pietro Pizzamano's first contact with Jacopo's art. His brother, Marco, had commissioned a *Christ Giving the Keys to Saint Peter* (lost) in 1537. In that instance their brother, Francesco, archpriest of the cathedral of Bassano del Grappa, probably provided the contact. Pietro's picture, *The Miraculous Draught of Fishes* (private collection, London, cat. 15), was also unusual and explicitly Petrine in subject.[88] This suggests a mildly polemical manifestation of Pizzamano's position regarding heresy, one particularly pertinent since his brother Francesco had frequently come into conflict with the Protestant sympathies of the citizenry. For his composition Jacopo once again looked to Raphael by way of Ugo da Carpi's chiaroscuro woodcut after a design for the Sistine Chapel tapestries, but here again the print provided merely a point of departure for an audacious and commanding pictorial experiment.[89] The monumental figures have been brought forward to create a planar frieze that unwinds with measured rhythm across the full width of the large canvas, the forms freely adapted to create humbly rustic types, such as the touchingly reverent Peter, or grandly heraldic profiles, such as the dynamic Andrew, whose billowing cape is entirely Jacopo's insertion to establish the unity of the two principal groups. Space is warped forward to the dark waters below, then back in a concave curve through the vast and exhilarating expanse of lake, and finally bent back as the sky darkens in a narrow strip along the top. This surreal seascape is enclosed by a castled promontory at left and on the right by perhaps Jacopo's loveliest evocation of his native town, poised illogically on the coast below a depiction of Monte Grappa. The picture was doubtless finished four months later, when Pizzamano left

88. Marco Pizzamano, brother of both the podestà of Bassano, Piero, and its archpriest, Francesco, was podestà of Cittadella in 1544. See Muraro 1992, 368-69. For the commission, given in 1537 with payment in 1538, see *Libro secondo*, fols. 69v-70r. There seems to be no subsequent record of the *Christ Giving the Keys to Saint Peter*, but it may be presumed that Marco took it with him on his return to Venice.

89. Ugo da Carpi's two-color chiaroscuro woodcut (Karpinski 1983, vol. 48, 38, no. 13) reversed the Raphael design and reproduced only its barest essentials.

office, and that autumn in Venice it is clear that artists such as Tintoretto came to look at this strange and powerful work by a provincial artist they scarcely knew. Remarkably, one of the visitors was Titian, just returned from Rome. The aging master found Jacopo's picture fascinating enough that he adapted it for the distant vignette in his *Virgin in Glory with Saints Andrew and Peter* (cathedral, Serravalle), which he brought to conclusion in 1547.[90] Titian had doubtless seen Raphael's tapestry in Rome just a year before, but specific details confirm that it was Jacopo's Pizzamano picture that he adapted. Although we have no clear indication that they knew one another personally before this, the two artists evince a clear personal contact from this time, one which would endure until the older master's death in 1576.

Raphael once again would prove a useful jumping-off point the following year, when Jacopo undertook to paint *The Last Supper* (Galleria Borghese, Rome, cat. 18).[91] Although the identification is circumstantial, this is probably the picture commissioned in 1546 by Battista Erizzo in Venice and paid for in 1547 and 1548. Just as he had in 1539, Jacopo continued to draw on Marcantonio Raimondi's engraving (fig. 17) after Raphael, but now his composition has undergone a profound metamorphosis. Like the *Miraculous Draught*, it warps space through a flared opening in which both top and bottom margins spread to force the figures forward toward the spectator, who is brought ineluctably into the midst of a turbulent rolling of form and thrashing of arms and hands. Thus compacted and thrust upon us, the harshly realistic apostles assume an almost alarming presence, enclosing the languid calm of Christ and the amusingly dozing John. The most riveting passage is, however, the dazzling still life that animates the expanse of white tablecloth. Textures, from the fabric itself through the crystal carafe, from the rough rind of the orange to the ice blue of the skinned lamb's head, make each object the focus of an intense optical analysis that magnifies its insistent reality. Each of these details could be found earlier, for example in the Kimbell *Emmaus*, but now Jacopo's concentrated eye squeezes a quintessential tactile sensation from each wrinkle and reflection. The high-keyed tonality is much like that of *The Miraculous Draught*. Although their aesthetic priorities were almost diametrically opposed, Tintoretto might have looked with a perceptive eye at the tense visual drama here evoked.[92]

A subtle shift away from the explosive skittishness of *The Last Supper* lends *The Adoration of the Shepherds* (The Royal Collection, Hampton Court, cat. 17) a more stable order.[93] Still, it resembles the earlier, Titian-inspired types in a newly massive and densely composed amalgam in which the powerful figure of the Virgin is shifted almost to the center of the great frieze of figures that converge upon the Child to form a classic pyramidal grouping backed by the animals at left and the young shepherd at right, whose distracted outward

90. Wethey 1969, 112, and Rearick 1992 (C), in press. Its recent restoration has revealed the superior quality of many passages as well as the evident shop participation.

91. *Libro secondo*, fol. 18*v*. Muraro 1992, 36-37. The *Libro secondo* records commissions for paintings of the Last Supper in 1537, 1540, and 1546.

92. Tintoretto's *Last Supper* (San Marcuola, Venice) is signed and dated 27 August 1547. See Pallucchini and Rossi 1982, 155-56, no. 127. If Erizzo received Jacopo's picture in Venice immediately on its completion, Tintoretto might have seen it prior to the completion of his canvas. See Rearick 1984, 305. Another *Last Supper* (Pallucchini and Rossi 1982, 151, no. 113) is a clumsy derivation from Tintoretto's San Marcuola canvas and may tentatively be attributed to Domenico Molin. It has no association with Jacopo.

93. This is unlikely to be the *Nativity* commissioned by Alessandro Spiera in 1540, see *Libro secondo*, fols. 95*v*-96*r*, and 98*v*, as Muraro once proposed (1982-83, 69). Comparison with the Rasai altarpiece (cat. 8), commissioned in June of that year, suggests that Spiera's picture is a different work, now apparently lost. Its price, just 24 Lire, 16 soldi, suggests that it was a small canvas. The Hampton Court picture does not appear in the *Libro secondo*, but stylistic considerations place it just prior to the Angarano *Trinity* of 1546-47.

gaze releases the central concentration. The goat, which is about to nibble the leaves just above the Child, is a reference to the *ardita capra*, the eager goat of classical pastoral allusion that took on redemptive meaning in the medieval and Renaissance periods.[94] Jacopo may not have been learned, but he was the equal of most of his contemporaries in handling symbols, sometimes even arcane conjunctions thereof. Like many of his paintings in which Jacopo exerted an especial effort to expand his stylistic range, the Hampton Court *Adoration* shows both retrospective and forward-looking passages. The pallid, high-keyed colors of the shepherds relate to the sharply dissonant tonality of his pictures of c. 1543-45. Equally, their finely drawn features have the same nervous delicacy of touch we have noted in those mannerist works. Even the Virgin and Child seem a direct development of those forms in the Pasadena *Flight*, and the Dürer-inspired architecture and tree recall those of the Edinburgh *Adoration*. However, the powerfully compressed group that crowds the foreground of this *Adoration* is substantially different from the more open disposition of attenuated figures in preceding pictures. Moreover, the left side of the painting, in particular the Joseph, is imbued with a new interest in a sober and straightforward transcription of weighty, normative forms described with a sharply focused attention to naturalistic surface detail. This realism, adumbrated in many passages of *The Last Supper* but here more assured in grasp and technique, includes a new approach to color. Still fanciful at right, the tonality at left is concentrated on darker earth tones centering on the dull lavender, rust, brown, deep rose, and a blue so dark as to seem black. These set into almost sculptural relief the radiant whites of the Virgin's coif and the swaddling wrap at the exact center of the composition. A newly emphatic rotundity of form, especially substantial in the Virgin's rose dress, looks forward to pictures that follow directly in late 1546 and 1547. This complex range of pictorial effects is held in magisterial control by Jacopo's extraordinary capacity to harmonize every aspect of the painting as it grows and evolves under his attentive brush. For all of its sophisticated range of cross references, the 1546 *Adoration of the Shepherds* does not resemble, nor does it carry a significant debt to, the work of other Venetian artists as we approach midcentury.

Jacopo's aspiration to a heroic scale, a dynamically forceful action, and a densely claustrophobic composition would be channeled into yet another version of *The Way to Calvary* (The National Gallery, London, cat. 14), one now cast in a slightly vertical format that, surprisingly, returns more directly to the Agostino Veneziano engraving (fig. 14) for some of its figures.[95] Like all of his pictures of these years that began with a glance at a print, this powerful *Way to Calvary* now makes hardly an obeisance to Raphael's invention before moving off in a strikingly personal direction. Instead, the peripheral

94. Chastel 1975, 146-49.
95. The return to the format of the engraving was doubtless occasioned by the requirements of an altarpiece rather than a private devotional image. The London *Road to Calvary* is Jacopo's only autograph treatment of this subject in the standard altarpiece format as adumbrated by Raphael.

figures have disappeared, others based on types from *The Martyrdom of Saint Catherine* or the Hampton Court *Adoration* (cat. 17) have taken their place, and outworn formulae, such as the mounted soldiers at top right, are constricted to the point of extinction. The composition has not, as has been suggested, been cut at left by more than a few centimeters, but rather depends on the compressed sensation that we are brought ineluctably to witness the propulsive drama of Christ dragged away to our left just as Saint Veronica has wiped his sweaty, bleeding face with the *sudarium*. He turns to see his image, and this invisible confrontation is seized by Jacopo as the fulcrum of visual focus. Veronica's veil is tonally almost identical to the contiguous rose robe of Christ, but its color dead white is in sharp contrast to his garment. Other rarefied pictorial passages abound. The *changeant* olive and creamy raspberry of Veronica's sleeve; the solemn archaicism of the blue and red of the Germanic Virgin; and, most exotic of all, the flickering absinthe green image of the garden of Gesthemene on the embossed shield at center all suggest a visual priority which is confirmed by the repetition of the dark-bearded men at both top left and upper right. They serve to abstract subordinate passages, just as the most intense emotional focus is brought front and center through purely pictorial and coloristic means. An intimation of a more somber range of color and texture develops a direction adumbrated in the Hampton Court *Adoration* and looks forward to works of a year later. Once again, Jacopo's isolation is an essential component of an approach to pure painting which has but scant relation to what his contemporaries were achieving elsewhere.

If Jacopo dal Ponte were a maniera artist during the decade of the 1540s in the sense in which we might apply the term to Bronzino, he would be the exponent of a rationally ordered synthesis of carefully and intellectually selected elements based on a well-formulated concept of the correct ends he intended to achieve.[96] Instead, Jacopo treats every painting as an adventure, a prospect to be explored with an unfailing sense of wonderment at the effects which his unconscious, if supremely disciplined, brush can conjure up. This is consistently true during the years 1543-46, a phase which saw exquisitely rarefied experiments in color conjoined with a newly dynamic figural power. It could not be sustained at this pitch, nor did Jacopo intend that it be. Instead, his art was in constant flux, and the shift in his concerns from stylized effect to a sober naturalism can be seen in motion in the Hampton Court *Adoration* and the London *Way to Calvary*. Thereafter, one is no longer tempted to use the word mannerist to describe his pictures.[97]

★

96. Freedberg 1971, 285-314.
97. Rearick 1984, 310-11.

74

The Dal Ponte account book now provides firm documentation for the circumstances of the commission of *The Trinity* altarpiece (parish church, Angarano, fig. 21), and they prove to be unusual on several counts.[98] The committee responsible for the provision of a new high altar for the old Gothic church in the village across the Brenta from Bassano signed a contract with old Francesco on 6 November 1533 for *The Trinity*, which was to be delivered two years hence and was to follow the format indicated in a drawing already in possession of the parish priest, Don Egidio. This seems to prove that Francesco drew, although none of his studies is known today, unless it was already Jacopo who was expected to undertake the project and was therefore assigned the sketch as well.[99] However, Francesco was taken ill in 1533, and, as we have suggested, Jacopo was in Venice for a time during that year. Both circumstances perhaps account for a delay in starting the painting. In any case, work began at once on the monumental frame, but there is no mention of the painting until 24 December 1546, when Jacopo received a new payment for it and the unusual recapitulation of an agreement for the consignment of the picture between Easter 1547 and Easter 1548. This second record is dated 6 March 1547 and clearly refers to the work as already done. The final payment was made to Jacopo and his brother. Giambattista might, as was often the case, have been occupied primarily with the peripheral artisan aspects of the project. However, here he seems to have assisted marginally with *The Trinity* itself. Distantly inspired by Northern graphics and Pordenone's 1535 *Trinity* (cathedral, San Daniele), and more directly by Giovanni Battista Krone's *Trinity* relief in marble of 1533 (Santa Corona, Vicenza), Jacopo's austere vision emphasizes the physical presence of the symbolic group by spreading their heroic forms across the foreground space and planting the cross firmly behind the bottom edge of the frame in conjunction with the emblems of death, Adam's skull and the split tree of life.[100] Fragile and deathly pale, the unnaturally small figure of Christ is protected by the massive God the Father, whose thunderous descent from a golden radiance disperses the leaden clouds with the assistance of a pair of hard-working putti. The ill-drawn infants above are evidently the work of Giambattista. The powerful swell of God the Father's rose drapery culminates in the unfurling motion of the billowing mantle, a motive developed from *The Miraculous Draught of Fishes*, which was finished only about a year before, but his weighty presence is contradicted by a deeply troubled expression of apprehension. One is again forcefully reminded of the deep religious divisions which rent Bassano del Grappa at this moment, a turbulent unrest fomented by its propinquity to the Protestant forces to the north and the increasingly ferocious counter-attack of the Church Militant, which had been gathered in nearby Trent since 1545 for the express purpose of extirpating heresy and fostering a re-

98. *Libro secondo*, fols. 24v-25r, and 35r, and Muraro 1992, 37-40.

99. The *Libro secondo* refers several times to drawings made as guides to carpenters in the preparation of frames, but no such drawings by Jacopo are known today. Since they served utilitarian purposes in the craft sector of Dal Ponte shop practice, they were doubtless considered ephemera.

100. Although the tradition of the Trinity in a natural environment is older, more recent depictions such as Mansueti's *Trinity* (San Simeone Grande, Venice) tended to include a throne and an architectural setting.

newal of faith through reform. Monte Grappa and Bassano itself preside over the rustic panorama, pristine and rainwashed after the storm, as though bucolic life were about to resume as the threatening tempest was dispelled. And yet, God's restless anxiety suggests that Jacopo's own spiritual torment had not lifted, an ambivalence that lends the image a tremulous depth of emotion.

The Dal Ponte workshop continued to function smoothly as a family enterprise, an orderly provider of whatever arts and crafts the community might require. In appearance the family remained respectable and industrious without any outward sign of stress or spiritual conflict. When another *Noli me tangere* (parish church, Onara di Tombolo) was commissioned in February 1546, Jacopo merely revised his Oriago composition, allotted most of the execution to his brother, and returned to add finishing touches such as the mallow flower at lower left.[101] In other cases he followed a different procedure. When a new *Madonna and Child with the Infant Baptist* (Galleria Palatina, Palazzo Pitti, Contini-Bonacossi bequest, Florence, fig. 23) was required, he simply recast the Bergamo format in a new, more robustly plastic style similar to that of *The Trinity*.[102] That he did not quite finish it in details such as the inserted lamb suggests that it remained in the shop for replication. In fact, a series of dull copies by Giambattista seems to confirm its function as a *modello* for his brother.[103]

Jacopo himself, insulated from the industrious hubbub of the busy shop, began, probably shortly after the completion of *The Trinity* in March 1547, to explore a new pictorial approach already hinted at in the austere rigor of that altarpiece. Its clearest harbinger is the transitional *Adoration of the Shepherds* (Gallerie dell'Accademia, Venice, cat. 16), a picture that has understandably resisted integration into the chronology of Jacopo's work.[104] Taking the Hampton Court *Adoration* as his point of departure, Jacopo reduced the figure scale by almost half, made the forms more slender, and rearranged the components according to his familiar procedure. The Madonna and Child here lose their massive bulk and are redesigned according to an elaborately stylized and convoluted linearism, that one would be tempted to call Parmigianesque were it not evolved from Jacopo's own prior types. The Virgin's head is tortuously refined into wattled features, hair as brittle as copper shavings and a coif endowed with a serpentine life of its own. Her preternaturally swollen figure enclosed in the husk of a dark mantle obeys the same elegant artifice, and Joseph is disposed with only slightly less rarefied stylization. The kneeling shepherd is repeated in a totally new pictorial key, but he has been given the second shepherd's hat, and a new rustic substitutes for the standing figure. The youth at far right is an attenuated variant of the simple shepherd in the Hampton Court picture. Most striking is the meta-

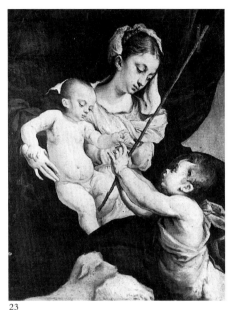

23

101. Oil on canvas, 250 × 156 cm. See *Libro secondo*, fols. 32*v*-33*v*, and Muraro 1957, 295. The price, 100 Lire, when compared with that of the Oriago version, 620 Lire, suggests that invention was not here required. It also confirms the minor role taken by Jacopo in its execution. Zampetti (1957, 78-81, no. 30) reproduced it before and during restoration. Unfortunately, that treatment concluded with an application of overpaint nearly as extensive as that which had just been removed.

102. Oil on canvas, 61 × 81 cm. Arslan 1960 (B), I, 76 and 168.

103. Berenson 1957, II, 21. This may be the picture recorded in the *Libro secondo*, fol. 135*r* as commissioned in 1548 by a Vicentine sculptor, called simply Zuan. Its price, 13 Lire 12 soldi, suggests its modest size and quality. Other replicas after the original *modello* have passed through the art market.

104. Differences remain, as the present catalogue entry suggests.

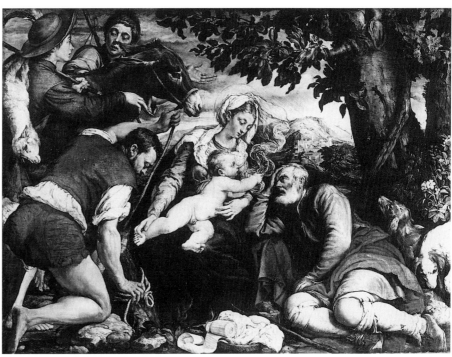

24

105. Jacobowitz 1981, vol. 12, 292, no. 158.
106. Oil on canvas, 118 × 158 cm. Of the numerous repetitions still in existence, most are later copies, but one (art market, London) appears to be the work of Giambattista.

morphosis of the massively benign animals of the earlier painting, here reversed and placed prominently to the right. Emaciated and flea-bitten, the cow might have been inspired by Lucas van Leyden's *Milkmaid* engraving, but its scruffy realism is more directly derived from an objective study of a real animal.[105] Slightly more abstracted, the donkey shares this exasperated realism, as does the dumbly reverent central shepherd, the single novelty among Jacopo's components. Behind a more spaciously disposed architectural screen, made up again of quotations from Dürer prints, a vast and barren expanse of sere straw green meadow contains only a single shepherd, who runs wildly toward the invisible angelic annunciation. Surreal in its desolation, this setting echoes the tone of the figures, a harsh conjunction of sophisticated artifice and brutal realism. It is, however, the color, a somber harmony of metallic and earth tones in which bronzey rusts predominate, that signals a profound mutation in Jacopo's chromatic repertory and would, in turn, assume a gentler tone in successive pictures.

If, as we believe, the Accademia *Adoration* was painted toward the middle of 1547, *The Rest on the Flight into Egypt* (Pinacoteca Ambrosiana, Milan, fig. 24) must date significantly later, probably to the last months of 1547.[106] Again, one is tempted to posit a trip to Brescia and a direct study of such works as Moretto's *Rovelli Madonna* (Pinacoteca Civica Tosio-Martinengo, Brescia),

25. Jacopo Bassano, *The Good Samaritan*, The
Royal Collection, Hampton Court

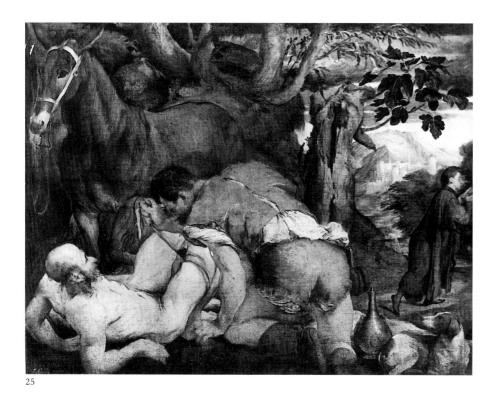

25

painted for the Brescian church of the Miracoli in 1539, but there is no record
of such a trip, and another Moretto painting closer to hand might have pro-
vided a source for the transparent blown veil. In any case, the remarkable
handling of the paint and the highly original color are Jacopo's alone. The
Ambrosiana *Rest* makes a decisive break with the discursive horizontal for-
mat of earlier treatments, concentrating instead on the monumental pyramid
formed by the groom, lifted from the Edinburgh *Adoration*, the Joseph, re-
versed from the Hampton Court *Adoration*, and the emphatically central Ma-
donna and Child. She is developed from the Contini-Bonacossi type, and the
Child is, typically, excerpted from *The Trinity* altarpiece. But the significant
aspect of the Ambrosiana picture lies in its further development of a sharp-
focus attention to realistic detail adumbrated in the Accademia *Adoration*, but
here extended to every aspect of the painting. The veil is rendered in silvery
rivulets of translucent paint, the leaves of the tree seem to be made of beaten
copper, the laundered diapers in the basket are painted with an intense con-
centration on their texture and substance, and this puritan objectivity ex-
tends to every magnified detail of the picture. Even the grooms and the don-
key, while clearly revealing their sources in the Accademia *Adoration*, are
here recast in a more normative vein. Tightly linear drawn detail and a dark-

78

er tonality have now moved decisively away from the looser bravura and exotic floral color of his works of the first half of the decade.

But Jacopo never remains settled in his restless drive to experiment, and *The Good Samaritan* (The Royal Collection, Hampton Court, fig. 25) shows both its close proximity to the Ambrosiana *Rest* and its evolution toward works of 1548.[107] For the Samaritan, Jacopo once again reversed the Pordenone-like figure from the *Rest*, here lightened in physical mass and drawn with a nervously attuned pointed brush tipped with black paint. The equally familiar recumbent and wounded robbery victim is even more delicately tensile in its line and detail. The tendency toward a crepuscular tonality now grows deeper and more somber with a predominance of metallic green and rust against subtly modulated browns. Most striking in his aspiration to a fine-tuned draftsman's approach to painting is the dilution of his medium to a translucent mobility. Light seems to float on the picture surface, a quality best appreciated in the distant priest, who is drawn in such silvery filaments of highlight that the landscape remains visible through his form. Seldom does Jacopo characterize with such delicacy and wit as in the supercilious Levite who prances away, absorbed in his book. Evidently successful with the client who commissioned it, *The Good Samaritan* would be repeated several times in the year or so that followed. For a reduced vertical variant (Pinacoteca Capitolina, Rome), Jacopo turned the figures over to his brother for mechanical replication, returning only to add the particularly wild vegetation that fills the added space above. Other repetitions were assigned to the shop with no participation at all from Jacopo.[108]

No artist can sustain such eloquent concentration without pause, and Jacopo shows evident signs of flagging energy and imagination for a brief moment that seems to fall during the first half of 1548. *The Madonna and Child with Saints James and John the Baptist* (Bayerische Staatsgemäldesammlungen, Alte Pinakothek, Munich, fig. 26) evinces this distraction.[109] Commissioned for the village of Tomo near Feltre and consigned in July 1548, its format is traditional but still original, with its low horizon and minimal landscape that throw the grandly silhouetted figures into a looming relationship with the spectator. The individual figures are, however, unusually pedestrian in following outside sources. The Madonna and Child come from Titian's votive of Doge Andrea Gritti (formerly Palazzo Ducale, Venice), a model that Jacopo had used as early as 1537 at Santa Lucia, Tezze; the Saint James is modeled in his lower drapery and feet on the Christ in Niccolò Vicentino's chiaroscuro woodcut after Parmigianino's *Christ Healing the Lepers*;[110] and the Baptist is a conflation of passages from several Schiavone etchings.[111] In fact, Schiavone seems to have come to Jacopo's attention as an etcher, draftsman, and painter at this moment. Jacopo's only known sketch in pure pen (Museo Civico, Bas-

107. Oil on canvas, 64 × 84 cm. Although this might be the *Good Samaritan* commissioned in 1550 by Zuanbattista Fontana from Treviso, *Libro secondo*, fols. 134 v-135 r, that date accords better with the style of the revision in the Pinacoteca Capitolina, Rome (see below n. 126), or Giambattista's replica (Piero Corsini, New York). See above n. 100.

108. Oil on canvas, 81.9 × 90.2 cm. See Pallucchini 1987, 135-38; and Aikema and Meijers 1989, 74. Another replica is reported to be in the Galleria Borromeo, Isola Bella, but I have been unable to confirm this.

109. Oil on canvas, 191 × 134 cm. Commissioned by Antonio and Pasquale Zatta for the parish church at Tomo in 1548, and consigned in 1549. See *Libro secondo*, fols. 7 v-8 r. See Kultzen and Eikemeier 1971, 29-31, no. 5217; Muraro 1992, 41; and Rearick 1992 (C), in press.

110. Karpinski 1983, vol. 48, 41, no. 15-1.

111. Zerner 1979, vol. 32, 65, no. 30; 67, no. 34; 68, no. 37; and 74, no. 43.

26. Jacopo Bassano, *The Madonna and Child with Saints James and John the Baptist*, Bayerische Staatsgemäldesammlungen, Alte Pinakothek, Munich

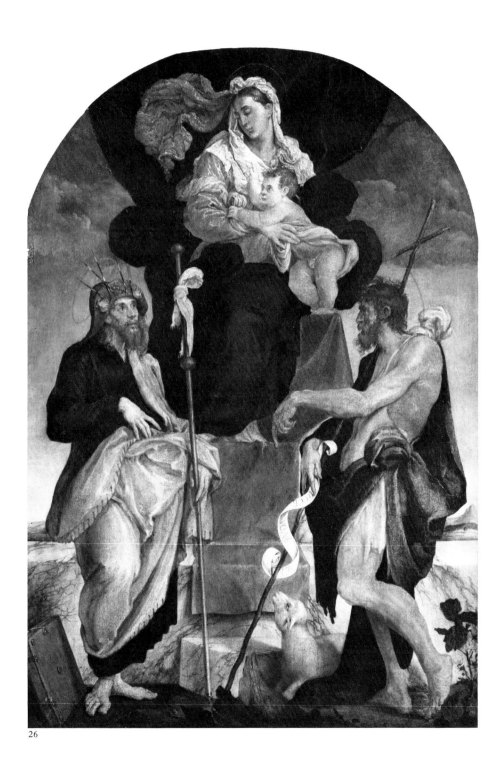

26

sano del Grappa, cat. 83) seems to be a preparation for the head of this Baptist, and it shows a patent debt to Schiavone's etchings in type and handling.[112] Schiavone enjoyed considerable success in Venice in 1547-48, particularly in the circle of artists who gravitated around Pietro Aretino, and it is tempting to suppose that Jacopo came to know him personally at this point and that he purchased prints directly from the artist himself. In any case, he demonstrates in the Tomo altarpiece that he had studied Schiavone's paintings as well as his etchings. Their effect was not salutary. The metallic earth tones of his preceding pictures turn dull here, almost monochrome in a dryly textured range of tan, moss green, ivory, and matt navy blue. The weave of the canvas, left evident by a thin application of very diluted pigment, accentuates the tapestry-like texture of its surface. This thready and impoverished surface is suddenly broken by the application of a thicker impasto in the Virgin's veil and sleeve, as though another hand had suddenly intervened to energize the pictorial effect. Indeed, much of the Tomo altarpiece seems to have been painted by an associate, probably Giambattista, but Jacopo cannot entirely be absolved of responsibility for the monotony of this essay in Schiavonesque opacity. The Baptist is drawn with power and integrity, and the light-infused rivulets of impasto in the Virgin's veil look forward to painting of the following year.

A different, and in at least one aspect surprising, type of shop practice is evident in the large *Way to Calvary* (Christie collection, Glyndebourne, Lewes, fig. 27).[113] The account book records that the nuns of the convent of San Giovanni in Bassano del Grappa commissioned an altarpiece of this subject on 25 August 1547 and that its frame was paid for on 20 March 1549. The style of the Glyndebourne painting suggests a date of mid-1548, close to that of the Tomo altarpiece.[114] Adapting the vertical format of the London altarpiece, this picture transforms the elaborately stylized secondary figures in the prototype into peasants of a rather grotesque character, adding clumsy genre details such as the rough types who carry the crucifixion spikes in a basket. Conversely, the soldier striding away at left, omitted effectively from the London composition, here returns in a particularly rubbery misinterpretation of the print after Raphael that had now served the Dal Ponte as a source for almost fifteen years. In a similar vein, if rather better drawn, the Holy Women at right revert directly to the Agostino Veneziano engraving (fig. 14) with a pedestrian fidelity that Jacopo had avoided in all three of his previous treatments of the theme. The distant landscape is lifted from the Accademia *Adoration*, the color is a nearly monochrome range of browns, dusty rose, and moss green, and the texture is so woolly as to hide the distorted drawing. It would be too easy, however, to dismiss the Glyndebourne *Way to Calvary* as yet another example of Jacopo's brother's inept efforts, because, in fact, Jaco-

112. Jacopo clearly studied and may have purchased etchings directly from Schiavone, who was at the height of his technical achievement in this medium in 1548. They may have inspired him to his unique use of pen in the Bassano sketch, a small sheet from the same source, but not originally bound into the *Libro secondo*.

113. Oil on canvas, 137 × 117 cm. Sister Benedetta of the Convent of San Giovanni in Bassano commissioned this subject in 1547, agreeing to pay 48 Lire 8 soldi, a rather modest sum considering that the Tomo altarpiece (see above n. 109) cost 200 Lire. See *Libro secondo*, fols. 73v-74r. For the Glyndebourne canvas, see Ballarin 1967, 77-78, and Rearick 1992 (C), in press.

114. The qualitative gap between the powerfully concentrated brushstroke and austere color in the weeping Virgin and the unfocused textures and mossy color of the rest of the painting is particularly evident, but refined passages such as the reticent head of Christ suggest that Jacopo intervened elsewhere.

27. Gianfrancesco and Jacopo Bassano, *The Way to Calvary*, Christie collection, Glyndebourne, Lewes

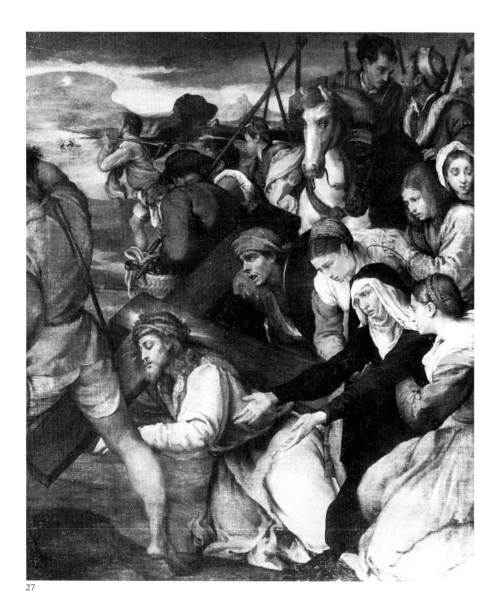

27

po suddenly intervened with a passage of striking power. Over Giambattista's figure of the Virgin, and without departing significantly from its form, Jacopo repainted the distraught mother with decisive strokes of his pigment-laden brush. A dark, almost black dress contrasts dramatically with the brilliant white coif that sets off her tear-streaked face. Its impasto is richly applied, but luminous and translucent in texture. Once again, Jacopo oversaw the quality of the pictures that issued from the Dal Ponte production line, but seldom did he limit his corrections to such an isolated passage without

115. Oil on canvas, 121 × 223 cm. Moschini Marconi (1962, 13-14, no. 14) gave an exhaustive account of this picture's complex history. Although it bears two dates, 1556 and 1557, these refer to the periods in office of the two sets of *Provveditori della Giustizia Nuova*, officials whose arms were added to the picture at the same time. The original portion of the painting is largely shop, probably Giambattista, with some participation by Jacopo in finishing details. In the meantime, Giambattista produced a replica (Johannesburg Art Gallery) of the original portion of the composition. Finally, a clumsy hand, probably not from the Dal Ponte establishment, finished the Accademia canvas and put it into condition to serve as the donation of the *Provveditori* in 1556. It must have been begun about 1547, perhaps for one or another of the original *Provveditori*, Falier, Venier, and Memmo, who eventually gave it to their headquarters at the Rialto, built by Sansovino between 1552 and 1555.

116. Jacopo seems frequently to have delayed beginning challenging projects, even beyond the terms of the contract. Usually, about four months of concentrated work would be required for an altarpiece of this type.

117. Jacopo followed the model of Lotto's altarpiece in iconography and format, and his picture was commissioned by the Confraternita dei Battuti for the altar of Santa Maria dei Battuti in the cathedral of Asolo. Since Lotto's work was first recorded in the seicento in the adjacent *scuola* of this confraternity, it is probable that Jacopo's painting was specifically planned to replace the 1506 altarpiece, which was then demoted to the *scuola* and thence to the Oratorio di Santa Caterina, which was also administered by the Battuti. It was found there and moved back to the cathedral in 1826.

118. Wethey 1969, 168-69, no. x-3. Although Titian's shop predominated in its execution, this Assunta shows the master's hand in the Virgin and the heads of the Apostles.

modifying the original design. He may, in fact, have retouched the delicately restrained face of Christ, trying there to remain closer to the surrounding thready surface. In another shop picture, his brother's work seemed so beyond help that he allowed it to remain as it was. *The Adoration of the Shepherds* (Gallerie dell'Accademia, Venice) bears the date 1557, but it must have been painted shortly after Jacopo's own version, now also in the Accademia (cat. 16), of about 1547.[115] The date represents, instead, the moment in which a group of Venetian Camerlenghi pressed it into service as their obligatory contribution to the decoration of their palazzo next to the Rialto bridge. If it was, in the interval, in Venice it can have done little to promote the Dal Ponte's status in the capital.

After this group of somewhat compromised paintings produced around 1548 in a moment of curiosity about Schiavone, it is reassuring to come to a masterpiece in which Jacopo has clearly found his own voice. *The Virgin in Glory with Saints Anthony Abbot and Louis of Toulouse* (Chiesa Cattedrale, Asolo, cat. 19) was commissioned in February 1548, but, like most Dal Ponte projects, actual work seems to have been postponed for more than a year.[116] Fortunately, the painting retains little of the dull character of the other pictures produced in 1548, and one assumes that Jacopo turned to it only a few months before it was finished and consigned in October 1549. The subject is called, even in the autograph commission, « The Assumption of the Virgin », but in the absence of the apostles and the presence of saints, who are extraneous to the legendary event in which the Madonna rose bodily from her tomb, the real subject is the Virgin in Glory with an explicit allusion to her ascent into heaven. In this Jacopo followed exactly the format set by Lorenzo Lotto in his altarpiece (Chiesa Cattedrale, Asolo) of 1506, a work which the officials of the Scuola della Madonna there might have recommended as a model for the new altarpiece, dedicated to Saint Anthony Abbot and destined to occupy an elaborate frame also ordered from the Dal Ponte for the altar on the left on entering the old cathedral at Asolo.[117] But Jacopo, who never displayed any real interest in Lotto's works, rejected the hieratic immobility of the half-century old altarpiece and turned, instead, to Titian's most recent treatment of *The Assumption* (cathedral, Dubrovnik), a work that was probably nearly finished in the master's Venetian studio in 1549.[118] The elegantly balletic pose, the contrast between the deep blue mantle and the pale rose dress, and the golden radiance that bursts through the heavy frame of gray clouds all find inspiration in Titian's picture. The technique, however, does not, since Jacopo was surely aware that the old man had largely delegated to his shop associates the execution of the dull Dubrovnik *Assumption*. In place of Titian's warm tonality, he retains the close harmonies of brown seen in pictures of 1548 only in the Saint Anthony, who is in part reversed

from the Tomo altarpiece Baptist. The dense impasto of the Virgin's veil in that altarpiece and the vibrantly expressive brushwork in the Virgin in the Glyndebourne *Way to Calvary* provided the point of departure of a new and liberated handling of pigment in the Asolo altarpiece. The nearly transparent rivulets of liquid paint now evoke a flickering play of broken highlights that energizes the surface of the Virgin's dress into a tremulously luminous pattern of visionary power. Form, too, is now more slender and pliant, even in the svelte putti who replace their solid prototypes in *The Trinity*. It is, however, Jacopo's color that has undergone the most drastic metamorphosis. Deeper and centered on sharp contrasts of chiaroscuro, it here turns to rose lavender with silvery blue shadows to create a glitteringly cool pattern of dissonances that perfectly realizes the supernatural character of the vision toward which the saints turn in tremulous awe. Seldom did Jacopo achieve a purer pictorial virtuosity than in the saturated plum of Saint Louis' cope with its radiant raspberry highlights. When the final payment was made for the Asolo *Assumption* on 4 October 1549, Jacopo had fully regained his creative momentum.

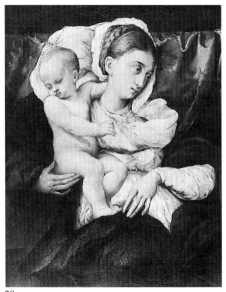

28

The same fruity, saturated color and creamy surfaces which are so vibrant in *The Assumption* appear in more appropriately prosaic terms in the charmingly intimate *Madonna and Child* (Detroit Institute of Arts, fig. 28), perhaps, given the divided attention of mother and child, a fragment of a larger canvas in which saints and a donor turned in adoration toward the central figures.[119] The ruby curtain thrown over a horizontal pole behind them suggests that Lorenzo Lotto's *sacra conversazione* (The National Galleries of Scotland, Edinburgh), painted in 1506 simultaneously with the Asolo altarpiece, which Jacopo had adapted for his *Assumption*, might have provided him with the original format for the Detroit picture.[120] Another work that shares the luminous surface gleam and volatile pathos of these paintings of 1549 is *The Portrait of a Man* (J. Paul Getty Museum, Malibu, cat. 25), the unique surviving portrait from these middle years.[121] Austere in its contrast between the dark silhouetted figure and the pale olive background, the melancholy air of resignation of its subject coalesces in the large, damp eyes, which are turned toward something unseen to our right. Once again, Lotto might have provided a stimulus toward this introspective emotionalism, perhaps by way of such portraits as that of *Fieramonte Avogaro* (Cini collection, Venice), which was painted in Treviso in 1542.[122]

In Cittadella, the walled town about six miles south of Bassano del Grappa, Jacopo signed a contract in October 1548 with a priest, Nicola da Pesaro, who was acting on behalf of Antonio Zentani, a Venetian gentleman who seems to have had a villa in the nearby countryside. The patron agreed to pay the rather modest sum of fifteen lire for a small painting of *Two Hunting Dogs*

119. Oil on canvas, 80 × 63.5 cm. Zampetti 1957, 76, no. 29. A general loss of paint surface has required rather extensive inpainting, but the picture still reveals Jacopo's hand in its entirety.

120. Berenson 1955, 24. An analogous subject to our hypothetical reconstruction of the Detroit canvas may be found in a *Madonna and Child with the Donor's Mother and Brother in Adoration* (lost), a commission received from Andrea di Guerzi in 1551. See *Libro secondo*, fol. 3r.

121. The *Portrait of an Elderly Man and His Secretary* (formerly Cook collection, now Ashmolean Museum of Art and Archeology, Oxford) has been referred to Jacopo's middle years. See Arslan 1931, 123. It is, instead, by Domenico Brusasorci.

122. Berenson 1955, 140.

123. Oil on canvas, 61 × 79.5 cm. *Libro secondo*, fols. *6v-7r*. See Ballarin 1964, 55-61; Rearick 1984, 302-5; Muraro 1992, 43.

124. Hartt 1958, I, 112-15.

125. Ridolfi (1648, I, 390) reported that Jacopo had paintings on paper of snakes and other animals that were so realistic they frightened the unwary visitor. Verci (1775, 70-72) gives extended quotations from other sources that praised Jacopo's virtuosity in trompe l'oeil pictures of animals, birds, and still-life objects. Since, in addition to the lost examples cited by early sources, three paintings of animals depicted alone survive today (see below ns. 148 and 248) – and only one of them is cited in the *Libro secondo* – it seems safe to posit that Jacopo painted a considerable number of such animal portraits over a long span of his career. Therefore, although it is now clear that Antonio Zentani's *Two Hunting Dogs* was painted a year after the nearly identical dog in Tintoretto's *Christ Washing the Feet of the Apostles* (Museo del Prado, Madrid), I remain convinced that the Venetian master took his uncharacteristically naturalistic animal from a painting by Jacopo.

126. Oil on paper, laid down on panel, 60 × 42 cm. The figural passages seem to be largely by Giambattista, but the wild underbrush on the hillock above is so vivid and precise in definition that it must be due to Jacopo's intervention. For the document and other versions of this subject, see above n. 107 and below n. 191.

127. Oil on canvas, 131 × 126 cm. The *Libro secondo*, fols. *52v-53r*, records a commission from Gasparo Ottello in Padua, dated 1550, for a painting of *The Beheading of Saint John the Baptist* for an unspecified price. It was, in addition, to have a landscape (*un paese*) in the tympanum above. In any case, the tympanum seems to have been separated from Ottello's picture at an early date. Wilks (1989, 175) is surely correct in identifying it as one of the paintings bought in the Veneto by Sir Dudley Carlton between 1611 and 1615 and included in the 1615 inventory of the collection of Robert Carr, Earl of Somerset. The literature has been exceptionally various in its dating, ranging across the entire decade between 1540 and 1550.

128. This unusual feature, especially in a picture for a private patron, suggests that the project included a frame, not specified in the contract, which concluded with a lunette in the arch above. Its subject may be interpreted

(private collection, Rome).[123] That the contract took pains to specify that the canvas was to represent « only » these two dogs makes it clear that the project was unusual and required specification. Given Zentani's situation it seems safe to assume that the dogs in question were prized hunters from his own kennel and that their picture was not expected to carry any arcane symbolic meaning. A little-noted aspect of mannerism was its conscious juxtaposition of objectively realistic images with highly stylized artifice, the former setting off all the more strikingly the artist's capacity for « artfulness ». Giulio Romano's Gonzaga horses perched improbably high up on the walls of the Palazzo Te provide a notable demonstration of the surreal effect of naturalistic portraits of animals in an unnatural ambiance.[124] Jacopo dal Ponte had spent a decade experimenting with a highly personal mannerist idiom, and in most of those pictures animals were used precisely for their realist contrast. Dogs, in particular, permitted the artist to be wittily playful in characterization, all the while remaining faithful to his innate dedication to their natural look. Now, in a gesture as unforced as it is innovative, Jacopo excerpted two perfectly straightforward canines from their familiar context and dedicated a painting to them and to them alone. Zentani must have been pleased with this portrait of his dogs when he received it twenty-five days later, but he can hardly have guessed that four centuries of animal paintings would emanate from this humble start. But then, Jacopo's art seems deceptively simple even when it is most original and prophetic. This would not be his only animal picture, and there is some reason to believe that it was not the first either.[125]

For the entire year 1549 and most of 1550 the *Libro secondo* accounts for only three paintings, of which only one, a *Good Samaritan* of 1550 done on paper (Pinacoteca Capitolina, Rome), is perhaps identifiable today.[126] In the absence of the other three Dal Ponte account books, we cannot draw firm conclusions, but it is possible that some outside influence limited Jacopo's production of paintings at this point. In any case, his next secure work stands rather alone in his development, a remarkably original flight of pictorial fantasy that defies integration into the mainstream of Venetian art at midcentury. As a subject, few precedents existed in the Veneto for *The Beheading of the Baptist* (Statens Museum for Kunst, Copenhagen, fig. 29).[127] Equally, the *Libro secondo* does not hint at the reason why Gasparo Ottello of Padua should have commissioned it in October 1550. Even stranger is the stipulation that a lunette above the picture should depict a landscape, probably a representation of the Baptist in the wilderness.[128] The sources for his composition are few and veiled; they range from a direct transcription of the mameluke in Dürer's *Pilate Washing His Hands* from the *Small Passion* woodcuts, to a much more generic nod in the direction of Antonio da Trento's chiaroscuro *Martyrdom of Saints John and Paul* after a design by Parmigianino.[129] Although he

29. Jacopo Bassano, *The Beheading of the Baptist*, Statens Museum for Kunst, Copenhagen

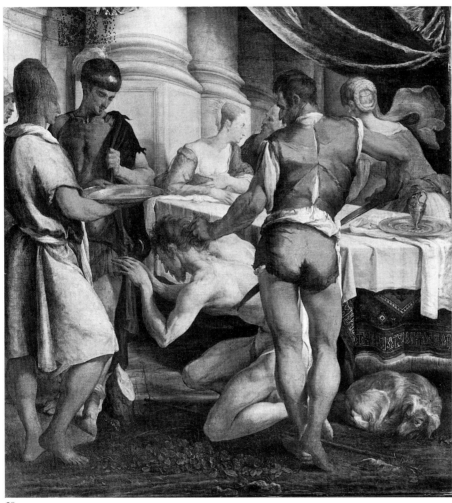

29

may distantly have remembered Sebastiano del Piombo's *Saint John Chrysostom* (San Giovanni Cristomo, Venice) with its vertical figures against a diagonal flight of columns, Jacopo's warped space is his own striking invention.[130] Establishing the picture plane with a shimmering raspberry silver curtain that seems to be tied back, trompe l'oeil fashion, from the inside edge of the frame, he flattens the principal figures into a serpentine arabesque held in place by the mameluke in profile, whose waiting salver is teasingly aligned almost with the far edge of the table and is echoed by the salver on the table at right. In sharp conflict with this planar emphasis, the table lunges diagonally back toward the left and the colonnade slides off to the right in a quite unrelated perspective. In perverse isolation from this disjunctive nonspace,

as *John the Baptist in the Wilderness*, since it was a familiar cinquecento practice to describe such pictures in which landscape is the dominant motive simply as a *paese*. It may have served as the prototype for later treatments of analogous subjects such as *Moses and the Burning Bush*, and it probably was adapted to altarpiece format in the 1558 *Saint John the Baptist in the Wilderness* (cat. 29). It is puzzling that a landscape would have been juxtaposed with the architectural colonnade that seems to rise beyond the top of the painting below.

129. Antonio da Trento cut the woodblock chiaroscuro around 1528, after Parmigianino's drawing that he had stolen from the master in Bologna in 1527. See Popham 1971, I, 12-13.

130. Sebastiano del Piombo was commissioned to paint the altarpiece just after March 1510. Its architecture is rigorously perspectival in contrast to Jacopo's malleable distortions.

the figures are drawn with a delicate attenuation, the contours elastic and the fine detail applied with a nervously pointed brush. Color plays an integral role in this hypersensitized ambiance, its dissonant juxtaposition of high-keyed cinnamon, rose, emerald, and turquoise set against metallic surfaces, which coruscate as though transfigured by an inner radiance. In this rarefied pictorial environment the figures move as though in a trance, the balletic swivel of the elegantly slim executioner perfectly attuned to the insect-like delicacy of the passive Baptist. His rising sword just grazes his victim's dorsal muscle in an expectant juxtaposition that echoes in the enigmatic stares exchanged by Herod and Herodias. Jacopo here permits himself a neurasthenic hegira into a realm of aesthetic and psychological subtlety reminiscent of an earlier phase of mannerism in Florence and Parma, but in this instance he owed nothing to the former and merely a motival start to the latter. Certainly, nothing like it was being painted in Venice at this moment, let alone by an artisan-craftsman in a small town at the edge of the Dolomites.[131] But Jacopo's introverted isolation from the vigorous novelty of Venetian painting was not destined to last beyond this brief moment.

<center>★</center>

Ever prudent and well organized in his family life as in his work, Jacopo waited until he was thirty before he married Elisabetta Merzari.[132] A son, Francesco Alessandro, was born on 15 January 1547, but died the following March.[133] On 7 January 1549, a new baby arrived and was baptized Francesco Giambattista after his late grandfather and his uncle, who seems just to have died.[134] He was the first of Jacopo's four sons, all of whom were destined to enter the family business, doubtless in part as replacements for Jacopo's modestly talented brother. But these first years as a paterfamilias seem to have been anything but tranquil. The sole surviving volume of the Dal Ponte account books contains notations about the births and baptisms of Jacopo's children as well as detailed expenses for the construction of a new family house between 1554 and 1559. This larger and more commodious structure would accomodate not only Jacopo, his wife Elisabetta, and his priest-teacher brother Gerolamo, but now his growing brood of children as well.[135] In the midst of all this domestic hubbub, Jacopo kept a weather eye on artistic developments in Venice.

As midcentury approached, Venetian painting was emerging from an infelicitous moment in which the noble sensuousness of the tonalist tradition as created by Titian and promulgated on a more popular level by Palma il Vecchio had seemingly run its course not long after the latter's death in 1528. Pordenone's turbulent compositions and slaty color would prove a prelude

131. After a somewhat erratic decade of experiment, Tintoretto's 1548 *Miracle of the Slave* established him as the primary exponent of a style that was both Venetian and innovative without being derivative of central Italian *maniera* convention. For lack of an established appellative, we may call this phenomenon Venetian post-*maniera*.

132. There seems to be no documentation for the exact date of Jacopo's marriage.

133. *Libro secondo*, fols. 136v-137r. See Muraro 1992, 284-85.

134. *Libro secondo*, fol. 136v. See Muraro 1992, 284.

135. For the births of Jacopo's remaining children, see *Libro secondo*, fols. 136v-137r. For the minute accounts relative to the construction of the new Dal Ponte house, see Muraro 1982-83, 163-68.

to the mannerist invasion of the 1540s, when even Titian's radiant harmonies underwent a metamorphosis toward a somber order of spent pastels against muddy browns and black. Schiavone's autumnal monochromes seem to be a nadir for Venetian color by the middle of the decade, and this dull phase had an impact on Jacopo dal Ponte for a brief moment around 1548. If Jacopo's paintings of this phase may be assumed to reflect his interests, he had not yet come to recognize the ferment that centered around the tempestuous early works of Tintoretto, whose epochal 1548 *Miracle of the Slave* (Gallerie dell'Accademia, Venice) remained unknown to him. However, Tintoretto's *Saint Roch Ministering to the Plague Victims* (San Rocco, Venice) of 1549 made an indelible impression on several counts.[136] First, its somber realism in the cruel depiction of the physical suffering afflicted by the plague is unified by a striking sunset light, which almost dominates Tintoretto's cheeky display of virtuoso foreshortening in the academic nudes. Second, the nocturnal atmosphere of the distant room lit by flickering torches puts artificial illumination to a new dramatic use in Venetian painting. Together, they pointed the way toward an aggressive use of light as an expressive device, a lesson not lost on Jacopo dal Ponte.

Perhaps the first painting to suggest Jacopo's curiosity about pictorial innovations in Venice follows but is in distinct contrast to *The Beheading of the Baptist* in Copenhagen. Early in 1551 Jacopo recorded the commission for a small altarpiece representing *The Descent of the Holy Spirit* (Chiesa di San Giacomo, Lusiana, cat. 20) for the hillside village of Lusiana above Bassano del Grappa to the west.[137] For it he drew on his recollection of Titian's recently renewed *Pentecost* (Santa Maria della Salute, Venice), which the master had repainted in 1544-45 after the first version turned black.[138] The colonnade he adapted from his own *Beheading of the Baptist*. The most direct font of motives was, however, Schiavone's *Pentecost* etching, which in turn followed Titian's format.[139] From the print Jacopo drew several of the more energetic poses of the lateral apostles, and from other Schiavone etchings he developed the stepped floor levels. But Jacopo's pictorial approach to this subject's psychological resonance is entirely original and, despite severely damaged passages of surface such as the Virgin, remarkably evocative. Apostles react variously to the spectral flaming tongues that hover over their heads, some rising in ecstatic greeting while others stare straight ahead in paranoid fixation. Although certain figures, such as the Saint John at left, retain an elaborate mannerist torsion, most are sharply natural in pose and detail. The electric but restrained dusty light emphasizes this haunted expression, and the color assumes a deep, but luminous tonality. More modern in his penetration of the troubled emotional states of the participants than his predecessors, Jacopo here adumbrates effects he will develop in a more volatile vein in his treat-

136. Color underwent a broad but complex change in Venetian painting during the fifth decade of the cinquecento. Jacopo's high-keyed dissonance seems only distantly to reflect Salviati and not at all Vasari at this moment. Giuseppe Porta briefly adapted Venetian tonalism to central Italian discrete passages of jewel-like color during the years 1541-45, but his result is primarily decorative without the expressive charge inherent in Jacopo's experimental juxtapositions. In this context Tintoretto at first attempted an elision from a Bonifacesque tonalism to a gloomy, monochromatic Pordenonesque range of earth tones. When that failed to satisfy his appetite for independence, he flirted with a high-keyed central Italian blocking of color that was more inspired by Raphael's *Conversion of Saul* cartoon than the Tuscan visitors present between 1539 and 1542. If *The Miracle of the Slave* proclaimed his articulation of his own approach to color, the *Saint Roch Ministering* is an even more significant manifesto for the new pictorial range on which Tintoretto would base his post-maniera style.

137. *Libro secondo*, fols. 120v-121r. See Muraro 1992, 43. Jacopo here uses the diminutive «pallesina» (little altarpiece) for a canvas 161 × 68 cm, whereas the 1541 *Saint Anne* (cat. 7) – though only a little wider than this one – is called a «palla». The rediscovery of the Lusiana picture is one of the most important additions to Jacopo's oeuvre in recent years.

138. Pilo 1990, 280-83, no. 43. Rearick 1991 (C), 23-24.

139. Richardson 1980, 85, no. 23.

30. Jacopo Bassano, *The Madonna della Misericordia*, Vassar College Art Gallery, Poughkeepsie

30

140. Traditionally ascribed to Schiavone, this picture was first given to Jacopo by Venturi 1929 (A), 117 and 121. This underscores its debt to the Dalmatian artist.

141. The *Libro secondo* records commissions for twenty-nine banners between 1532 and 1554. We do not know how many were recorded in the three lost account books, but there were evidently once many more, particularly in the possession of country churches.

142. Neither Ridolfi (1648) nor Verci (1775) seems to have known any of Jacopo's banners, but they had seen several by his sons, particularly Leandro. See Magagnato 1952 (A), 62-63, no. 54.

143. Rearick 1986 (A), 181, and Muraro 1992, figs. 45-46. The *Libro secondo*, fol. 34v, records the 1553 commission from the priest at Loria for a banner depicting *The Madonna with Saint Anthony at Right and Saint George at Left*. The reverse side is not specified, but the Saints on the front do not correspond with those on the Vassar banner.

144. The *Madonna della Misericordia* has Saint Anthony at our left and Saint John the Baptist at our right. Muraro 1992, 14, erroneously called the former Saint Peter. The Loria banner might have been a partial reprise

ment of seven or so years later (Museo Civico, Bassano del Grappa).

Tintoretto's influence is emphatic in *The Way to Calvary* (Szépmüvészeti Múzeum, Budapest, cat. 21).[140] Once again this theme is subjected to a fresh variation, but the role of Agostino Veneziano's engraving is now minimal. Instead, here Jacopo reverses the Glyndebourne composition, dropping his brother's passages, and with scant concern for classical, or for that matter mannerist convention, he freely orchestrates his tumultuous throng into a convulsively propulsive cavalcade, which rushes pell-mell across the picture space. Familiar figures, such as the Pordenone-derived kneeling groom at right and the flailing soldier at center, are left ambiguous in action so that an irrational disjuncture intensifies the aura of hysteria in the densely compacted group. Although its surface is somewhat skinned, the painting always lacked descriptive treatment of detail, allowing a diffuse granular luminosity to gleam from the increasingly nocturnal evening light. Bronze, cinnamon, copper, and moss dominate the color in a tonality that remains linked with works of 1548, such as the Tomo altarpiece, but its smudged contours, thick impasto, and vigorous brushwork all suggest a more advanced dating. Similarly, the exceptionally attenuated stylization of the holy women's heads reflects familiar Schiavonesque motives, but here the elegant profile of the Virgin is more masterfully ordered. Confirmation of a date closer to 1551 may be found in its anticipation of the dramatic chiaroscuro and richly worked surfaces of pictures that follow in 1552. Unlike the preceding treatment of this subject, this painting seems to be Jacopo's in execution as well as invention.

The Dal Ponte shop did not shirk its homely responsibility to the Bassano community's needs, and continued to provide well-crafted work in every imaginable medium. One of their most frequent tasks was to paint processional standards to be carried through the town streets by members of confraternities and religious orders on ceremonial occasions.[141] Such double-sided banners came in for hard use in all kinds of weather, and it is not surprising that almost none have survived.[142] The single exception is a rather worn canvas representing on its face *The Madonna della Misericordia* and, on the reverse, *Saints Sebastian and Roch* (Vassar College Art Gallery, Poughkeepsie, figs. 30, 31).[143] Evidently an ex voto as protection against the plague that had broken out in the countryside around Bassano in the late summer of 1551, the presence of Saints Anthony of Padua and John the Baptist flanking the Madonna suggests that it was commissioned in 1551 by a confraternity dedicated to those saints.[144] Although the Madonna's embroidered dress has almost the character of folk art and is probably by an anonymous assistant, the saints are rapidly, but securely painted and demonstrate that Jacopo himself did not disdain such ephemera. The odd juxtaposition of brusque abstraction in Sebastian's face and harsh naturalism in his torso is characteristic

of the phase of Jacopo's development around 1552, as is the granular texture of the loosely brushed paint and the increasingly dark tonality of his colors.

This and other projects of 1552 suggest that Jacopo was under pressure to produce works rapidly and with inadequate backing in the family shop. In a lost *Mystic Marriage of Saint Catherine*, he composed a traditional *sacra conversazione* using elements excerpted from compositions of a few years before, including a Joseph that had first appeared in the Hampton Court *Adoration* and the Ambrosiana *Rest on the Flight*.[145] Evidently dissatisfied, Jacopo recast that format with the substitution of a fresher idea for Joseph, repeating the *Mystic Marriage*. This second *Mystic Marriage* (Wadsworth Atheneum, Hartford, cat. 22) seems equally to have frustrated his intentions, because he abandoned it in a rapidly sketched state.[146] The Madonna is nearly finished, but Joseph and Catherine are roughed in with little attention to finish or detail, and the landscape is merely hinted at. Nonetheless, even without its cut lower quarter, the Hartford painting is a prime document for Jacopo's working method; the solid blocking out of form in the head of Catherine and the fluid looseness of luminous paint that evokes Joseph allow us a glimpse of the painter at work. Its earth-toned color orientation relates most closely to the restrained harmonies of 1552, and it would seem that Jacopo's restless shifting of color range was about to undergo another precipitous change.

If Tintoretto's impetuous directness seems to have caught Jacopo's attention around 1553, Titian remained a constant source of inspiration. Once again, however, evidence suggests that the exchange of ideas and inspiration was mutual. The glowing luminosity of the elderly master's *Man of Sorrows* (The National Gallery of Ireland, Dublin) heralds a new phase of Counter-Reformation pathos in Titian's work, an intense but restrained emotionalism and an incandescent pictorial key that suggests a date of about 1561-62. Jacopo's treatment of the same theme (private collection, Milan, fig. 32) must, on style, be seen in the context of his paintings of about 1553.[147] It seems possible, therefore, that Titian knew Jacopo's *Man of Sorrows*, and that it provided inspiration for his own treatment. Jacopo emphasizes a distressing contrast between the rustic candor with which the ugly, suffering body is evoked, an abstracted realism reminiscent of the Vassar banner, and the almost feminine delicacy of the shadowed face. These contradictory elements are unified by light, whose dual source is the phosphorescent aureola of supernatural origin and a sharply objective illumination of the figure; together they immerse the image in a transfiguring glow. Here a lyrical pathos calls forth a nocturnal pictorial key that Jacopo would find useful the following year.

A modest commission of a very different sort is the second version of *Two Hunting Dogs* (Galleria degli Uffizi, Florence, cat. 26).[148] For it Jacopo recast the standing dog from Zentani's picture in a different color range and ex-

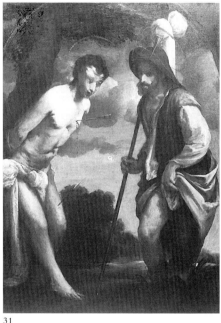

31

of this one, since we would date the Vassar canvas to c. 1551. The recto is severely damaged and is not visible in the present backed frame, but the verso is not seriously worn and retains much of its paint surface. Distortions, such as Sebastian's face, are intentional. It appeared on the London art market as by Jacopo, but was purchased by the Vassar College Art Museum as a work of Francesco Maffei.

145. The *Libro secondo*, fols. 37v-38r, records the commission for a *Madonna with Saints Joseph and Catherine* lodged by Domenico Priuli in 1552 and paid for in 1553. It was described as a «quadretto picholo» (small picture). A painting, formerly in the Brockelhurst collection in London, corresponds in theme with the Priuli picture, but its dimensions, 79.5×98.5 cm, cannot be described as small. The Madonna and Child are freely derived from Titian's *Madonna and Child with the Baptist and a Donor* (The National Galleries of Scotland, Ellesmere loan, Edinburgh), the Joseph comes from the Hampton Court *Adoration of the Shepherds* (cat. 17), probably by way of a drawing, and the Catherine is loosely based on the Virgin in the Budapest *Way to Calvary* (cat. 21). Although it is a pedestrian

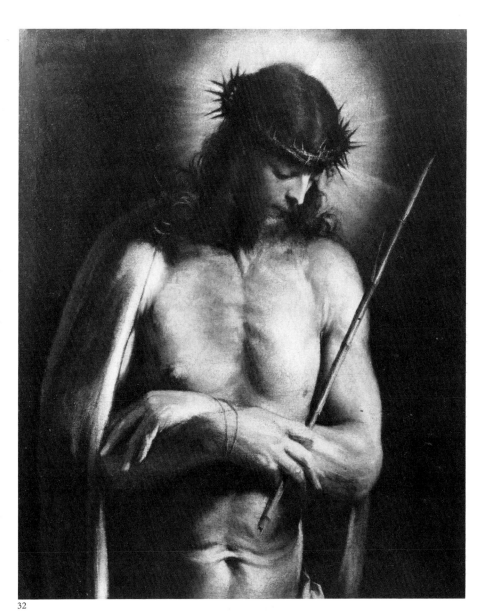

32

work of the later Bassano shop, the Brock-elhurst copy reproduces the lost original so faithfully as to permit a dating of that work to c. 1552. Therefore, if it is not the composition commissioned by Priuli in that year, it is closely related to it. An alternative identification for the Priuli «quadretto picholo» might be the little *Madonna and Child with Saints Catherine and Joseph* (formerly Thomas Agnew, London) that appeared on the market in 1944. It reversed the Brockelhurst format. Although its quality seems good, its rather timid execution does not encourage an attribution to Jacopo himself. It measures 27.9 × 46.4 cm.

146. Its original dimensions were c. 108 × 117 cm, much larger than the copy after the lost, but nearly contemporary version (see above n. 145) which, because of its more direct dependence on earlier pictures, we would date slightly before the present picture. The irregularly sketchy finish of the Hartford canvas is due to its abandonment when it was about sixty percent complete and is not a result of subsequent damage. Indeed, for a painting almost without finishing glazes, its surface is in rather good condition.

147. Oil on canvas, 82 × 67.5 cm. Rearick 1978 (B), 335-37. For the Titian *Man of Sorrows*, see Wethey 1969, 87-88.

148. Attributed to Titian when in the collection of Cardinal Leopoldo de' Medici prior to 1675, this picture was neglected until Ballarin (1964, 64-66) focused attention on Jacopo's representation of animals by publishing the earlier version of this theme.

149. According to Ridolfi (1648, 1, 390), Verci (1775, 114), and other early sources, this was but one of a rather large number of animal «portraits» Jacopo was reported to have painted.

cerpted the sleeping hunter from the lower right corner of the shop repetition of the Accademia *Adoration*. One should remember, however, that the probability that Jacopo had earlier painted other such dog portraits makes it difficult to define exact prototypes.[149] In any case, here the dark tonality, grayed light, thready texture, and somber mood contrast with the lucidity of Zentani's picture, which was painted only about four years earlier. Something of the menace of their furtive movement in the twilight

atmosphere lends these animals a mysterious aura of danger.

Two treatments of *The Adoration of the Shepherds* suggest the direction taken by Jacopo's art in the biennium 1553-54. *The Adoration of the Shepherds* (Galleria Borghese, Rome, cat. 23) retains a few details from the Accademia version, but now Jacopo departs strikingly from standard iconography.[150] Not strictly an Adoration of the Shepherds, it is instead an informal domestic moment with the Holy Family relaxing under the thatched porch of a barn. The Virgin, seen from the back in an unusual pose probably based on a Schiavone etching, turns to support the curious Child, who bends forward in response to the serenade that the reclining shepherd pipes on his recorder. Other shepherds continue unconcerned about their pastoral tasks, but an alert sheep looks toward Christ from the exact center of the composition, doubtless an allusion to the *Ecce Agnus Dei* theme. Apparently casual, the Borghese painting is instead a subtly original and innovative variant of the *Adoration* idea, one destined, like so many of Jacopo's pictures of these years, to interest artists of the next century. His painterly concerns show a distinct shift to a brighter, airier luminosity after the darker tonality of preceding pictures, but its looser brushwork develops with greater discipline the vivacity of the Hartford picture, and its delicately pointed facial types are very close to those of *The Man of Sorrows*. Powdery blues, ivory, saffron, and dusty rose evoke the warmth of a summer's day, and the effortless suavity of Jacopo's brush is seldom so freshly improvisational as in the granular texture of the pink lavender highlights that trail across the Virgin's dress. A more monumental version of the *Adoration* theme seems to be lost, but Jan Sadeler engraved it, in reverse, in Venice in 1599.[151] A revision of the first Accademia *Adoration*, its format is a massive compaction of those figures with a sharply realistic avoidance of their elegant stylization. Rustic to the point of clumsiness, these disjunctive forms seem lost in an interior reverie, barely conscious of those around them. In this it resembles the Hartford *Mystic Marriage of Saint Catherine*. It is surprising to find that this most un-Titianesque of compositions was prepared by a splendid life drawing (private collection, Padua) for the shepherd in the lower corner, a study that is powerfully original and direct in handling but which, equally, makes no attempt to hide its source in the sensuously evocative chalk drawing of Titian.[152] Drawings by Jacopo from these middle years are very rare, and this is probably the finest one we have today. Its concern with light and texture strongly suggests the emphatic chiaroscuro toward which he was working in the picture.

If works that we would date to 1553 or early 1554 seem to be a transitional interlude, by later in 1554 we find Jacopo immersed in his new idiom. The *Libro secondo* records a commission from Domenico Priuli in Bassano, the same patron who had ordered *The Mystic Marriage of Saint Catherine* two years be-

150. Arslan (1946, plate 4) published a picture (formerly Cattaneo collection, Milan; now private collection, Bassano del Grappa) as autograph. It is, instead, a copy after the Borghese original, not by Giambattista, who was by this time dead. It is so careful in reproducing Jacopo's picture that it is difficult to determine its time and place of origin. It is probably Roman mid-seventeenth century.
151. Pan 1992, no. 7.
152. Rearick 1986 (B), I, no. 6.

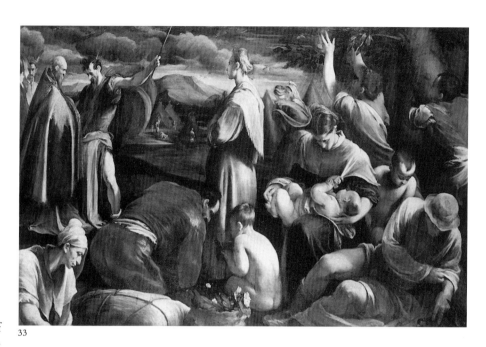

33. Jacopo Bassano, *The Miracle of the Quails and the Manna*, private collection, Florence

33

153. *Libro secondo*, fols. 37 *v*-38 *r*. The price of 25 ducats is moderate for a picture by Jacopo. Priuli's little *Mystic Marriage* had cost 5 ducats. Domenico Priuli was, on each occasion in which he is mentioned in the accounts, described as resident in Bassano, but he was probably a member of the rich and distinguished Priuli family that owned several palaces in Venice.

154. Attributed, significantly, to Tintoretto when it was in the Mapelli collection in Bergamo, it was identified as by Jacopo by Fiocco and so published by Longhi (1948, 52), who described it as the pendant to the Cleveland *Lazarus* (cat. 24) with a date close to 1550. All the subsequent literature has recognized it as one of Jacopo's masterpieces, but virtually no scholar has seen it and it has been absent from all exhibitions. Nonetheless, it remains in private hands in Florence, an ownership that has kindly provided the source for the present illustration. See Muraro 1992, 43.

155. Jacopo's habit of keeping accounts in alphabetical order based on the client's given name suggests that Domenico Priuli's commissions would all be recorded together in the *Libro secondo*, as indeed they are. Thus, the Cleveland *Lazarus* seems not to have been a Priuli project. Ridolfi (1648, 1, 384) saw in 1648 a Lazarus in the Palazzo Contarini in Venice that he described as large and in the style of Parmigianino, a possible reference to the Cleveland picture.

fore.[153] He requested a *Miracle of the Quails and the Manna* (private collection, Florence, fig. 33), a painting almost certainly to be identified with the work once in the Mapelli collection in Bergamo.[154] It seems clear that *Lazarus and the Rich Man* (The Cleveland Museum of Art, cat. 24) was painted at about the same time, but since it is not mentioned in the record of the commission it might not have been done as a pendant to Priuli's picture.[155] Nonetheless, *The Miracle of the Quails and the Manna* provides the essential contrast and release in relation to the grim *Lazarus*. Just as the denial of sustenance on the part of selfish man is the theme of the Cleveland picture, here it is God's beneficent care for his chosen people. In this hopeful key, Jacopo's range of color turns to a fresh harmony of floral rose, pallid green, chocolate brown, and lustrous white. Even the consolation of vibrant nature returns here to its usual role in the stormy drama of the landscape with its picturesque tents and a softened vista of Monte Grappa. Jacopo's brushwork has also developed the delicacy of the Borghese *Adoration* to a thinner, more fluid pattern of broad veils of improvised strokes. Concomitant with this relaxed elegance of tone and touch comes a return of a mannerist artifice in the figure types, not only in the statuesque standing female and the sinuously rhetorical Moses, but in the mythic abstraction of Aaron and the tender delicacy of the mother and child at center as well. Shapes are blocked out with audacious simplicity, from the mysteriously shadowed man who seems to roll out of the picture space at right, to the sibylline crone who rises into it at left. Their abrupt sim-

plicity lends an aura of the fabulous to what is equally, and paradoxically, a clear premonition of the pastoral genre picture to which Jacopo would dedicate his primary effort fifteen years hence. Now datable to 1554, this painting sets the tone for a decade of dusky sobriety that stands in stark contrast with the experimental freshness of his optimistic youth. For most of the previous decade Jacopo had explored a highly personal pictorial idiom based on brilliant color and precisely contained contour in a pervasive and almost shadowless illumination. Now black shadow prevails and deeply resonant color gleams from thick layers of pigment. Precisely drawn surface detail, so recently concentrated into microscopic focus in the Ambrosiana *Rest*, has blurred into roughly applied swaths of loose brushstrokes, brusque and graceless but all the more powerful for their brutal candor. *Lazarus and the Rich Man* is austere and melancholy in tone, its forms gleaming from a deepening evening gloom. Lazarus, in particular, seems a conscious rejection of elegant artifice in his cruelly observed degradation. The dramatic moment is pregnant with impending tragedy. Lazarus raises himself painfully on one elbow, his staff and water gourd cast aside, while the menacing dogs, close in character to those in the Uffizi *Dogs*, sniff his sores. His plea for succor interrupts the elegant supper, and the lute player falls silent as he and the lady, the 1553 Saint Catherine grown sensuously opulent, turn expectantly to await Dives's reply. Enigmatically expressionless, the rich man has already raised his invisible hand to dismiss the discomfiting intruder. With deep melancholy the young page senses that the sad task of turning away the miserable begger will fall to him. It is precisely this sense of still suspension of action that matches the dense pictorial atmosphere of Jacopo's paint. Seldom does an artist of the cinquecento so pungently anticipate the distilled realism of the seicento as in the harsh light that falls across the back of the lutist. One understands the confusion of critics who have insisted that the Cleveland *Lazarus* is not only a masterpiece of the baroque, but that it is in fact Dutch.[156]

Protestant ideas and ideals had circulated throughout the Veneto for more than a quarter century when Jacopo dal Ponte withdrew from his town and business for a rather long period of work in the village of Enego, high up on the alpine plateau called the Sette Comuni.[157] Bassano and neighboring villages, especially Rosà just to the south, had seen violent conflict between church authorities and proponents of Protestant principles during the decade of the 1530s, and Treviso had been the scene of cruel repression in which Lorenzo Lotto appears to have been involved, at least marginally.[158] In Bassano itself dissidents such as Francesco Negri, whose polemical tract *Il libero arbitrio* of 1546 had landed him in serious trouble with ecclesiastical authorities, elicited wide public sympathy.[159] No documentary evidence survives to prove that Jacopo dal Ponte took any particular position on the religious is-

156. Berenson suggested the name of Mariscalchi to Arslan, and in 1957 Fiocco expressed (orally) his suspicion that it was a seicento picture.

157. Bordignon Favero and Rearick 1986, 250-54.

158. For Lotto and heresy, see Fontana 1981, 279-97.

159. Francesco Negri, who was the son of a prominent family, was born in Bassano del Grappa in 1500. He entered the Benedictine order in 1517, went to San Benedetto Po near Mantua, then to Santa Giustina in Padua, and finally to San Giorgio in Venice, where the reformer Paolo Roselli introduced him to the writings of Martin Luther. Disillusioned with the Church, Negri renounced his holy orders and departed for Germany in 1525. After long peregrinations, he published his tragedy *Il libero arbitrio*, first probably in 1546, but subsequently in editions of 1547, 1550, and 1559. His *Rethia*, published in Basel in 1547, gives a poetic view of agrarian life that must have impressed Jacopo dal Ponte. Negri's works were read and discussed in Bassano, although he seems never to have dared return home, moving in 1556 to Tirano in the Valtellina. It was at about this time that Jacopo made a similar move to Enego. See Vinco da Sesso 1980, 571-74.

sues that divided his community, but he cannot have been impervious to them. His paintings were in large measure religious in subject, and his iconographic treatments were usually straightforward if not simply conventional. He depicted, however, a notable number of themes more favored by Northern artists of clear Protestant orientation, and his candid naturalism in setting biblical episodes in recognizable rustic environments has a Germanic flavor. Further, it is clear that he preferred to return to the scriptural text, depicting with straightforward honesty what was described and avoiding the doctrinaire iconographic accretions expected, and now required, by the Roman Church.[160] By inference it seems clear that the Lutheran idea of private individual conscience and a direct respect for the Bible were shared at least in spirit, if not as doctrine, by the painter. On the other hand, he observed all normal religious customs, kept his family within middle-class convention, and shared his household with his brother-priest Gerolamo.

What then are we to make of the guarded allusion made two centuries after the fact by Verci when he wrote: «… It is rumored that Jacopo took refuge at Enego for his greater safety because he was in trouble with the law».[161] Although there is no whiff of heresy here, it was a well-known fact that the Sette Comuni provided a refuge for religious dissidents who frequently fled to its welcoming isolation just out of the reach of the bishop of Vicenza, a notorious and energetic extirpator of Lutheran sympathizers.[162] In any case, probably in 1555 but perhaps extending into 1556, Jacopo left his family, including the little Marina Benedetta, who was born in March 1555. He retreated to Enego, parish of the not yet forty-year-old priest Stefano da Romano, who must have known the artist since their youth together in Bassano.[163] Once settled, Jacopo carried out an impressive cycle of work that centered on a fresco program covering the entire vaulted tribune as well as its entrance arch of the church of Santa Giustina. It was probably on the completion of these frescoes that Jacopo was asked to add the small altar to the right of the choir, a commission from the Compagnia di Santa Giustina, which was to depict *Saints Justina, Sebastian, Anthony Abbot, and Roch* (Chiesa di Santa Giustina, Enego, cat. 31).[164] The choice of these plague protectors was surely conditioned by a serious outbreak of the pestilence in the summer of 1555 and again in 1556.[165] This delicate canvas survived both the fire of 1613 and that of 1732, in which everything else perished. One of the painter's most liberated improvisations, the Enego altarpiece is but another example of the effect that a protracted bout of work in the fresco medium had on Jacopo's use of oil on canvas. The necessity for painting rapidly in very liquid pigment imposes an especial fluidity of touch and a concentrated attention to the desired pictorial effect without recourse to a layered elaboration or fussy detail. This altarpiece reflects exactly the dynamism of fresco painting without los-

160. Lutheran insistence on direct fidelity to biblical text finds an exact parallel in Jacopo's paintings where he depicts details described in the Bible but seldom, if ever, represented in traditional iconography sanctioned by the Roman Church. This direct return to sacred text is evident early in his works, becomes prominent after 1550, and dominated the genre-like pictures done after 1563. Again, Negri's writings seem directly related to this evolution, but there is little evidence that Northern painting played any role in Jacopo's formal development of a genre type.

161. Verci 1775, 106. « Corre voce, che Giacomo abbia eseguito questi lavori [at Enego] in tempo ch'esso fuggito dalla patria erasi per sua maggior sicurezza ritirato in questo Villaggio. Noi di cio non abbiamo ritrovato notizia alcuna; e perci non possiamo asserirlo con fondamento, ne dire se ci egli facesse o per esser incorso in disgrazia della Giustizia ». He then proceeds to blame the flight on the plague of 1576, although these works were not done in 1576. Verci clearly skirted what he still regarded as dangerous territory.

162. Rearick 1978 (B), II, 334.

163. Bordignon Favero and Rearick 1986, 251.

164. The Enego composition owes an unexpected debt to Titian's *Pesaro Madonna* (Santa Maria Gloriosa dei Frari, Venice) in the diagonal placement of the figures and the Saint Anthony Abbot.

165. Brentari 1884, 376-77.

ing sight of the tonal subtlety that only oil on canvas can achieve. Taking the standard axial composition of a Madonna with saints as he himself had formulated it in his youth, Jacopo here rotates the throne toward our right so that Justina swivels to look sidewise at her companions, her ruby cloth of honor caught as it twists even further around the spiral, which sets the ensemble into a gently rotary motion. There is no setting, and the sole escape lies low to our right, where Saint Roch's bread-carrying dog echoes his master's muscular contrapposto to return our attention to Anthony's ghostly pig at bottom center. Many figurative details are developed from those of immediately preceding pictures, and the color remains brightly fruity, but it is the freshly liberated transparency of the brushstroke which gives the Enego altarpiece its exhilarating visual vitality. Few passages of chromatic invention match the irridescent *changeant* wine and lime of Justina's overdress. Although he would return more than twenty years later with Francesco to add an even larger cycle of frescoes and a coffered ceiling in the church at Enego, one senses in the altarpiece that late in 1555 or in 1556 Jacopo felt not only a deep satisfaction in his work there, but also a fresh sense of mission as conditions permitted him to return home to his family and community.[166]

After 1554 and Jacopo's Enego sojourn, the *Libro secondo* ceases to record more than a few of the commissions for paintings lodged with the firm. We are, therefore, for the remainder of the sixth decade, largely dependent once again on stylistic analogy for establishing Jacopo's personal chronology as well as distinctions among the various hands at work in the shop. After Giambattista's death, the identity of Jacopo's assistants remains for more than a decade a matter of conjecture. The account book does not record the names of apprentices, but their handiwork is evident prior to the emergence of young Francesco as his father's right-hand associate around 1562.

Workshop participation does not seem to be responsible, however, for yet another phase in which Jacopo seems to have lost momentarily the creative intensity which marks his masterpieces of 1554-55. *The Adoration of the Shepherds* (Nationalmuseum, Stockholm) appears to be unfinished in its lack of detail, but here the foamy blur is due to an early excessive cleaning that removed the finishing glazes.[167] It differs, however, in its essential color range, which has become still more sharply fruity in its dissonant reds, green, rust, and bright blue than the similarly dissonant tonalities of the Enego altarpiece. A similar juicy brightness of tone, as well as the skinned surface, is evident in the *Saint Roch* (cathedral sacristy, Castelfranco), a fragment of a rather conventional *Madonna Enthroned with Saints* that, in turn, was much like the lost *Madonna with Saints Sebastian and Roch* that Jacopo's son Gerolamo copied many years later (Museo Civico, Bassano del Grappa).[168] Both repeat with minor variations the Vassar processional standard of early in the decade.

166. Jacopo seems to have gone to Enego alone. The records of commissions in the *Libro secondo* suddenly become sporadic in mid-1554 and include only minor works in 1556 and 1558. The construction of his new house began in 1554, but it was protracted through 1559. His brother Giambattista had died in 1548, but his younger brother Gerolamo, the priest and teacher, still lived at home. His wife, Elisabetta, and his young children Francesco and Giambattista were joined by a new sister, Marina Benedetta, on 21 March 1555. All things considered, 1555-56 hardly seems a propitious moment for the middle-aged artist to have withdrawn willingly to the remote mountains of the Sette Comuni.

167. Oil on canvas, 75 × 100 cm. Purchased by Queen Louisa Ulrika, probably through her Italian agent Bodissoni, this canvas first appears in her inventory of 1760 as by Jacopo. First published by Arslan (1938, 462-63), the attribution has been universally accepted, but with widely divergent dating. Its surface is severely abraded by strenuous early cleaning.

168. The Castelfranco fragment, oil on canvas, 93 × 64 cm, was noted by Zottmann (1908, 32), but it was Magagnato (1952 (A), 43, no. 23) who had it restored and brought it to general attention. Arslan (1958) suggested that it might be a fragment of the altarpiece at Crespano described by Verci (1775, 164) as representing the Madonna and Child with putti, and Saints Sebastian and Roch. Verci reported that it was much damaged by time and an incompetent restoration. Since the sacristy at Castelfranco served in the early nineteenth century as a repository for derelict paintings from the territory, it is probable that this is the surviving portion of the painting from San Pancrazio, Crespano. The small altarpiece depicting *The Madonna and Child with Saints Sebastian and Roch* (Museo Civico, Bassano del Grappa, inv. 43), oil on canvas, 133 × 93 cm, is clearly a copy after a lost work of Jacopo's executed by Gerolamo. Dalla Pozza (1943, 37-38) published a letter written by the Vicentine collector Paolo Gualdo to his brother Emilio on 1 February 1613, in which he complains that his Jacopo Bassano painting of this subject that had been sent to Gerolamo in Venice, presumably for restoration, had not been returned despite repeated solicitations. It is probable that Gerolamo copied this now missing picture, perhaps more than once since another version was

34. Jacopo Bassano, *The Adoration of the Magi*, private collection, Bassano del Grappa

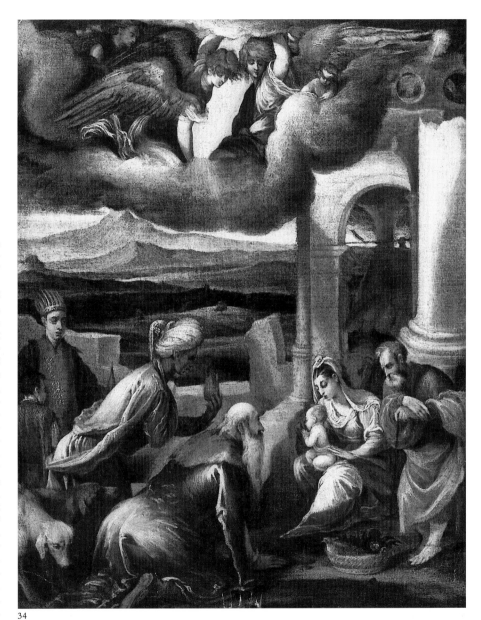

34

once in the Simonetti collection in Rome. This is consonant with the pedestrian character of Gerolamo's work, where copies after his father's compositions abound.

169. *The Madonna and Child with Saints John the Baptist and Jerome* (cathedral, Asolo), which came from the Villa Rinaldi at Casella d'Asolo, seems probably to be a copy of a lost original by Jacopo. See Bordignon Favero 1983-84, 255-72. Circumstances suggest that it was painted by Carlo Osti, a pupil of Volpato, in 1685. The Madonna and Child seem very close to the visible parts of the fragmentary altarpiece in the sacristy of the Castelfranco cathedral, and the Baptist is a source for the 1558 altarpiece (Museo Civico, Bassano del Grappa, cat. 29). The picture, oil on canvas, 215 × 118 cm, over the high altar of the parish church at Loria, between Bassano and Castelfranco, was described by Ridolfi (1648, I, 387) and Verci (1775, 107) as *The Madonna and Child Enthroned with Saints Bartholomew and John the Baptist*. Volpato substituted a copy of the original altarpiece, probably around 1685-86, in a maneuver that seems parallel to his theft and substitution of the altarpieces from Rasai and Tomo (see cat. 8). Bordignon Favero (1981, 12) first published the Loria Volpato. The Madonna and Child closely resemble those in paintings of c. 1555, but the Bartholomew provided the source for the Saint Mark in the 1573 Vicenza lunette (Museo Civico, Vicenza), and, as mentioned above, the Baptist was a source for the 1558 altarpiece. The recent Bassano literature is silent on the subject of both the Asolo and Loria altarpieces. Jacopo also painted a processional banner for Loria in 1553. See *Libro secondo*, fol. 34v.

To this list of pictures datable to about 1556-57, we might add the lost *Madonna and Child with Saints John the Baptist and Jerome* preserved in an early copy (cathedral, Asolo) not by a member of the Dal Ponte entourage.[169] Despite the rather diffuse paint technique evident in these pictures, they all seem essentially to have been executed by Jacopo, since none shows the character of a pedantic copyist.

An *Adoration of the Magi* (private collection, Bassano del Grappa, fig. 34)

opens again a complex problem of the many surviving versions of this composition.[170] One, now lost, was engraved by Raphael Sadeler in 1598 when it was in the collection of Padre Caggioli, prior of the monastery of Santi Giovanni e Paolo.[171] A copy (Galleria Borghese, Rome, no. 234), probably Flemish and based on the engraving, usually passes today as the original.[172] An alternate composition with large angels above, based on Caraglio's engraving after Titian's lost *Annunciation* of 1537, is known from what seems to be a copy (Galleria Borghese, Rome, no. 176) by the youthful Ippolito Scarsellino.[173] Now, one might introduce the small canvas reproduced here as the model for the Scarsellino copy. For this composition Jacopo adapted, in reverse, many elements from previous treatments, most notably the Edinburgh picture, but the dog comes from the Uffizi *Two Hunting Dogs*, and the Madonna and Child are formed by a conflation of those figures in the Hartford and Stockholm paintings. The angels and their cloudy setting are freely adapted from Titian's *Annunciation* by way of Caraglio's engraving. Rather roughly painted and somewhat over-restored toward the top, this *Adoration* nonetheless resembles closely in its broader brushwork and bright, fruity color other pictures datable to about 1556. It has, I believe, the best claim to being considered an autograph variant of the lost Caggioli *Adoration* and the major source for Jacopo's later treatment in Vienna (Kunsthistorisches Museum, Vienna, cat. 27).

Jacopo continued to enjoy the support and patronage not only of his fellow Bassanese, but of new patrons in Venice itself. Since 1542 his portraits were to be seen in Venice, and the Pizzamano *Miraculous Draught of Fishes*, the Erizzo *Last Supper*, and other masterpieces hung in several palazzi in the capital when, probably in 1556, he received the commission to paint an altarpiece for the church of San Cristoforo della Pace.[174] Modest in scale and isolated on an island between Venice and Murano, San Cristoforo had, nonetheless, significant works of art. Jacopo's altarpiece was in the archaic format of a central canvas depicting *Saint Christopher* (Museo Nacional de Bellas Artes, Havana, fig. 35) with *Saints Stephen and Francia* at left and *Saints Jerome and Nicholas* at right.[175] This suggests that it was a replacement for an earlier, perhaps quattrocento triptych. Only the central panel survives, and that is severely worn and pieced out by a strip at right. It is, nonetheless, an imposing work in which the giant Christopher, his size enhanced by the low horizon line and a well-constructed torsion in the figure seen from below, reflects Titian's fresco in the Palazzo Ducale, Venice, without copying it in any detail. Pictorially, the Havana altarpiece shares a blue-violet-rose harmony with the *Saint Roch* at Enego, and the billowing mantle is painted with a similar thin fluidity of medium. The general tonality is here marginally darker, a twilight in which the muscular plasticity of the leg and arm takes on a tangible presence, in

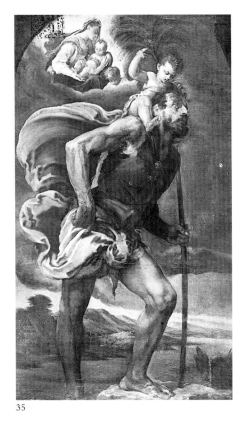

35

170. This picture is not discussed in the Bassano literature.

171. Raphael Sadeler engraved a painting during his stay in Venice in 1598 with the indication that the model was by Jacopo dal Ponte and belonged to Padre Caggioli, prior of Santi Giovanni e Paolo. See Pan 1992, no. 13.

172. Oil on panel, 50 × 47 cm. Purchased in 1787 as a work of Filippo Lauri, it has also been attributed to Giacinto Gemigniano (Venturi 1893, 132), to El Greco (Cantalamessa 1916, 266-71; Bertini Calosso 1923-24, 481-87; Mayer 1939, 28; and Camon Aznar 1950, 80), and Mariscalchi (Fiocco 1929, 213-14; Arslan 1931, 349-50). Della Pergola (1955, 101, no. 177) gave its history and called it a copy after a lost Jacopo Bassano. Longhi (1926, 142; and 1948, 54) insisted on the attribution to Jacopo, followed by Berenson (1936, 50) and, eventually, by Arslan (1960 (B), 1, 107 and 175), and Zampetti (1957, 100-1, no. 37). This range of opinion should be a danger sign, but it has

not deterred more recent writers, including Pallucchini (1982, 36) from accepting it, although he had earlier (1948, 134) thought it a derivation from a lost Jacopo. The Sadeler engraving differs from Borghese 234 in a crucial detail. The architectural sequence above the Virgin at right is clearly a sequence of a loggia, a light-toned wall behind it, and a dark wall with two oculi beyond. The painter of this panel has misunderstood the somewhat ambiguous print, mistaking the light-toned wall as sky and painting it as such, which leaves the dark wall suspended in the air above. Therefore, this panel was copied from the Sadeler engraving. Its enameled surfaces, bright colors, black shadow, and the revision of the landscape into a Patenir form all suggest that Borghese 234 is the work of a Flemish painter of an archaic bent who worked shortly after the 1598 publication of the print. I know at least twelve other paintings derived from this engraving, many of them Netherlandish, but several are French or German.

173. Oil on canvas, 58 × 49 cm. Preempted by the exportation authorities in 1923 and assigned to the Galleria Borghese, this picture was ascribed to El Greco (Bertini Calosso 1924, 486-90), but given to Jacopo Bassano (Longhi 1926, 142). It has oscillated between these two names, but recently (Zampetti 1957, 100) it has been demoted to the status of an inferior derivation from Borghese 234 (see above n. 172). This composition is distinct from the Caggioli type, and its texture, broad brushstroke, and dissonant color marks it as a free and fairly well-painted copy of the original, here identified as in a private collection in Bassano del Grappa (see above n. 170). I believe that its individual character suggests the hand of the young Scarsellino.

174. Ridolfi 1648, I, 378-79. Aegidius Sadeler engraved the *Saint Christopher* in 1605 (see Pan 1992, no. 15), and Zanetti (1771, 198) recorded that it replaced an earlier picture, which had been lost. Verci (1775, 135) named the lateral saints. Gallo (1953, 154) proved that the altarpiece was removed from the church in 1797 and dispersed.

175. Oil on canvas, 147 × 86 cm, including the added strip at right. Recommended by Bazin to the 1957 exhibition in Venice (Zampetti 1957, 114, no. 44), the *Saint Christopher* altarpiece has not been accorded a serious study since that time, although all authors have accepted it as the central part of Jacopo's

contrast with the phosphorescent vision of the Virgin and Child in the clouds above. Although Jacopo surely traveled to Venice before undertaking the project, he doubtless painted it at home in his studio and oversaw its transport and installation in the capital. A modest beginning to be sure, but the San Cristoforo altarpiece seems to have been Jacopo's first public commission in the Serenissima itself and, as such, heralds a decade in which the painter became a well-known artist to Venetian collectors.

Back home in Bassano, Jacopo turned to a local commission, *The Descent of the Holy Spirit* altarpiece (Museo Civico, Bassano del Grappa, cat. 119) for the church of San Francesco.[176] For it he drew two of the apostles' heads, to the left of the Virgin (Royal Library, Windsor Castle, Berkshire, cat. 93) in his familiar Titian-inspired black chalk; for the Saint Paul just below (Graphische Sammlung Albertina, Vienna, cat. 85) he used colored chalks, a shift which underlines the changes taking place in his art at this moment.[177] Remembering his small altarpiece painted about six years before for Lusiana (Chiesa di San Giacomo, cat. 20), he racast its format on a more monumental scale, enlarging the colonnade and, as with the *Saint Christopher*, lowering the angle of view to enhance its looming mystery. The earlier, more informal distribution of figures is here concentrated around the pivotal axis of the ecstatic Virgin, whose substantial bulk easily dominates the condensed mass of powerful apostles. Their muscular solidity, in turn, develops directly from the *Saint Christopher*. The significant change here is, however, not so much figural as painterly. In what the perceptive critic of a century later, Giovanni Battista Volpato, called Jacopo's « ashen style » (*stile cenereccio*), color here turns gray and heatless, a dim twilight in which the extraterrestrial flaming tongues flutter downward over the convulsed crowd. Surfaces glow and steam as though incandescent, and light gleams with otherworldly radiance from within the forms.[178] To achieve this transfigured effect, Jacopo diluted his medium to near transparency, much as he had in the Asolo altarpiece of almost a decade before, and used its liquid mobility in union with repeated thin glazes to achieve a unique fusion of the real and the visionary. Unhappily, it was Volpato who overcleaned this painting, revealing an eliminated apostle to the right of the Virgin, double nostrils for John the Evangelist, and other pentimenti that document the intensity with which Jacopo worked. Worse, he trimmed off frayed margins and opened up the space with baroque additions on all sides.[179] Despite these distortions, *The Descent of the Holy Spirit* suggests the degree to which Jacopo had transcended the maniera rhetoric of Titian to adumbrate a Counter-Reformation drama of mystic import.

Alvise Bon arrived from Venice as podestà in September of 1557 and, like many of his predecessors, noted the advantages of using Jacopo as an instru-

ment for making manifest his largess to the community. He restructured the old Loggia Comunale and commissioned Jacopo to embellish it with a cycle of frescoes.[180] Unhappily, a demented prisoner in the adjacent jail set fire to his straw mattress in 1682, and the frescoes as well as the prisoner perished in the conflagration. It has, however, escaped general notice that a fragmentary head of *The Madonna* (Loggia Comunale, Bassano del Grappa) does survive on the façade, probably detached and reapplied, since the space between the central arches of the loggia does not permit the inclusion of the Child.[181] Its form is the same abstracted ovoid with large features that one sees with this degree of emphasis only in the Madonna in *The Descent of the Holy Spirit.* We would, therefore, suggest that the altarpiece be dated during the first half of 1558 and the related frescoes to the summer months, when outdoor painting could more efficiently be executed. Bon attached a plaque, dated 1558, to commemorate his largess.[182]

In rapid succession Jacopo was asked to provide another, smaller altarpiece for San Francesco. The *Saint John the Baptist in the Wilderness* (Museo Civico, Bassano del Grappa, cat. 29) was probably in place when a subsidy for masses at the altar was provided on 27 December 1558.[183] Here the mood changes to one of daylight communion between the angular, emaciated saint and the radiance of divine inspiration that streams through the forest from upper right. The range of golden rust to moss green recalls the restrained harmonies of 1548, but the figure is an elegant variant of the fluting shepherd in the Borghese *Adoration*, the Baptist in the lost Asolo altarpiece, and, perhaps, the lunette of the Copenhagen *Beheading of the Baptist* for which we have hypothesized the same subject. However, the phosphorescent luminosity of the mystical light links it to the more extreme experiments of earlier in 1558. It would quickly become one of Jacopo's more popular images, the subject of shop replicas, copies, and imitations.[184]

Although the years 1557-58 seem to be fairly well documented, the three years that follow provide no precise guidelines to Jacopo's development. Stylistic considerations suggest, however, that a small group of pictures followed in 1559. Jacopo had periodically been asked to provide private devotional images of the Madonna and Child, but a surprisingly small number of them survives today. It was apparently at this moment that he painted several, one of which was in Venice at an early date and may have been painted for a patron there. The little *Madonna and Child with the Infant Baptist* (formerly Earl of Spencer, Althorp House, London, fig. 36) is a charming reduction of his standard format, now transformed into a darker, more vibrant tonality.[185] It seems subsequently to have been given a larger, but more prosaic treatment in a format that survives in two signed versions (The Art Institute of Chicago; formerly Contini-Bonacossi collection, Florence) and an unusu-

San Cristoforo triptych. A small fragment of a *Madonna and Child* (Museo Civico, Padua; see Banzato 1988, 81, no. 84) is very close to the Madonna in the *Saint Cristopher.* Although it is severely damaged, it seems too hestitant in touch to be by Jacopo. The lateral canvases of the San Cristoforo triptych remain lost.

176. Oil on canvas, 341 × 174 cm, including additions. Painted for the Santo Spirito altar in the church of San Francesco, Bassano del Grappa, this painting has been accepted as one of Jacopo's masterpieces by all authors, both early and recent. Its place in Jacopo's chronology has only recently been clarified (Ballarin 1973, 102-4). In my view, its date falls within the first half of 1558.

177. Although Ballarin (1990 (B), 138-39) considers the Windsor drawing to be Jacopo's preparation for the Vienna *Tamar Brought to the Stake* (cat. 38), I remain convinced that it is closer to the head of the apostle in *The Descent of the Holy Spirit.* A chalk study related to the Saint Peter (formerly art market, London) is by Francesco after the painting, and a compositional sketch (formerly Herbert List collection, Munich) is by a late follower.

178. Volpato 1685, fols. 66, 225, 373, and 392. See Bordignon Favero 1992, in press.

179. The canvas had been damaged around its margins when, in about 1680-87, just before Menarola's engraving of the latter year, the chapel was reconstructed and G.B. Volpato was commissioned to trim off the frayed edges and piece it out to fit a much larger baroque frame. See Bordignon Favero 1981, 4-11. Since Volpato's additions have aged differently from the original, restoration presented complex problems, in part resolved by the recent cleaning.

180. Rearick 1986 (A), 184, and Ericani's essay in this catalogue. Their subjects remain unclear since Verci (1775, 89), who knew them from hearsay, describes them simply as various subjects and admirable paintings («…varie Istorie e stimabile Pitturi»). They probably covered the spaces on the back and side walls of the Loggia Comunale.

181. The Madonna and Child might have been over the door on the back wall. Perhaps only the Madonna's head survived and was detached and placed over the arcade during a later renovation. Its complete format was probably partly repeated in the various Ma-

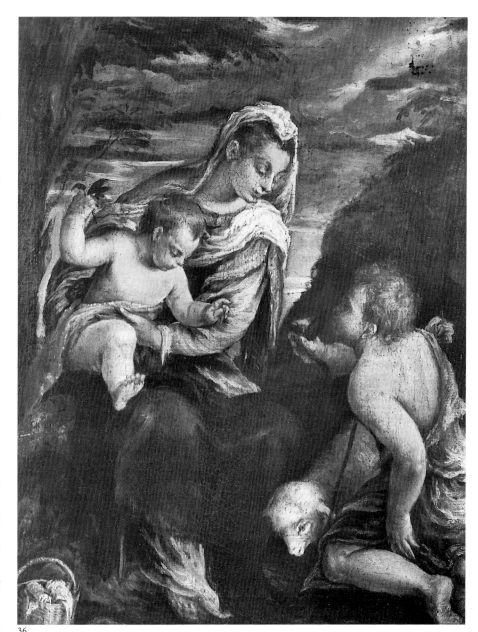

36

donna and Child pictures of a few years later. See below n. 186.

182. It reads: ALOISIUS BONO PRAET. /PRAEFQ. PRAESTANT. ET/ INTEGERRIMUS LODIAM HANC/ ERIGENDAM INSIGNISQ. PICTOR. MAN./ PINGENDAM CUR./ MDLVIII.

183. Sartori 1958 (B), 200-1. A hypothetical source might lie in the 1550 *Beheading of the Baptist* (Statens Museum for Kunst, Copenhagen) where, according to the commission, a lunette (lost) was described as simply a «paese». Since it is possible that the subject of this «landscape» was *Saint John the Baptist in the Wilderness*, the present composition might be an elaboration of that picture. The Baptist's figure here does, indeed, recall the ascetic stylization of the Baptist in the Copenhagen picture. Closer in scale is the Baptist in the lost altarpiece (copy in the cathedral, Asolo; see above n. 169), which we have dated to c. 1556-57.

184. The *Saint John the Baptist in the Wilderness* (sacristy of Il Redentore, Venice), recently restored by W. Piovan and attributed to Jacopo himself (Gramigna Dian 1991, 57-60, no. 14), reproduces the effaced signature IAC.S A/ PONTE./ BASSA.S/ F., which is recorded as being on the rock at left in the original (Museo Civico, Bassano del Grappa, cat. 29), a space where the recent restoration of Jacopo's painting has revealed a lacuna in the surface. The Redentore picture is clearly the work of Volpato. It was probably around 1680-86, when he amplified *The Descent of the Holy Spirit* (Museo Civico, Bassano del Grappa, cat. 119), then in the same church, that Volpato copied the original. He might have reproduced the signature and then scratched it off of the original with the intention of substituting his work for Jacopo's altarpiece. Later, around 1580-84, Leandro did a drawing in black and red chalk (Hugh Squire collection, London, 174×240 mm) after Jacopo's picture. He used it for his own painting of the subject (Marlborough Gallery, London) in which he added his own unmistakable rabbit at lower left. Jacopo adapted the Baptist, in reverse, for a *Moses and the Burning Bush,* of which the best of many replicas are in the Galleria degli Uffizi, Florence, and the Gallerie dell'Accademia, Venice. Both are by the young Leandro.

185. Engraved by Matham (Pan 1992, no. 56), this little picture, oil on canvas, 51.9×41 cm, was at Althorp House since the Knapton inventory of 1746, no. 296, and was published

al number of shop replicas.[186] All seem rather routine productions that might, given the publicity function of the unusual signatures, have been intended for a Venetian public.

Not all of his pictures of this moment were standardized in format and

manufacture. *The Annunciation to the Shepherds* (National Gallery of Art, Washington, cat. 30) was, as far as we know, Jacopo's first independent treatment of a subject that was normally relegated by Venetian painters to the distant background of Adoration pictures.[187] Here, the artist takes a slightly ambiguous approach to the nocturnal setting, one biblically authentic but seldom employed by Venetian painters. The landscape is an adventuresome effort at a dense dawn atmosphere, with its turbulent sky and silvery view of Monte Grappa, but his impulse to analytical clarity renders it uncertainly poised between day and night. The angel, inspired by Titian by way of Caraglio's print of *The Annunciation*, emerges from a woolly gray cloud that recalls the mystic rays of the 1558 *Baptist*, but the figures are in sharp chiaroscuro, half dark and half spotlit from our space rather than by the angel's supernatural glow. Despite, and in some measure because of, these multiple and coexistent sources of light, *The Annunciation to the Shepherds* projects a deeply evocative aura of sharp reality immersed in an otherworldly mystery. Essentially a variant of the Borghese *Adoration of the Shepherds*, the Washington composition rotates around a central void with a sinuous interrelation of its garland of figures, but as if to draw back from this mannerist stylization, Jacopo pauses to describe surfaces with loving attention to detail. The kneeling woman, who is interrupted at her milking – Jacopo's first instance of this oft-used motive freely developed from Titian's *Milkmaid* woodcut – is painted with a deft and skittering brush that trails shimmeringly silver rivulets of white highlight to evoke her veil with virtuoso ease. Only the pliant form of the dazzled shepherd retains any trace of mannerist artifice; with this picture it may be said that Jacopo is poised midway between two contrasting phases of his stylistic argosy.

Never caricaturing, but often gently amused by the human condition, Jacopo occasionally assayed subjects that he endowed with a tinge of humor. *Adam and Eve after the Fall* (Galleria Palatina, Palazzo Pitti, Florence, fig. 37) is unusual in depicting our progenitors resting after their expulsion from Paradise. Adam is a singularly realistic nude drawn from a sinewy peasant type and posed like the piping shepherd in the almost contemporary *Annunciation*, while Eve is only slightly more stylized.[188] Here deep night is relieved only by the last sunset glow on the horizon, but a harshly accusing glare picks out the figures, the skull (symbolizing death), and the enigmatic ox. The otherwise grim message of human frailty is relieved, however, by Adam's patient attention to Eve's optimistic chit-chat, her fashionable fig leaves already suggesting that she is making the best of a bad situation. Very similar in its dramatic chiaroscuro, but quite without wit, *Lazarus and the Rich Man* (Kunsthistorisches Museum, Vienna) is a rather casual vertical transformation of the Cleveland composition, in which the majestic stillness of that work is

(Garlick 1976, 4, no. 28) before Raine, Countess Spencer, sold it (Sotheby's, London, 3 July 1985, lot 8). It is now on the art market in Switzerland. Ballarin (1973, 123-24) alluded to it as the original on which the print was based, but it has otherwise been ignored in the Bassano literature. Its condition is quite worn along the right side, especially in the figure of the infant Baptist.

186. The Art Institute of Chicago, oil on canvas, 76.5 × 87.5 cm, signed at top left: IACS. A PŌTE/ BASS. P. From the collections of the Earl of Carlisle, Castle Howard, and Archibald Werner, Newlands, it was acquired by The Art Institute in 1968. It is the finest in quality among the various versions extant. Another, Galleria Palatina, Palazzo Pitti, Florence, Contini-Bonacossi bequest, oil on canvas, 75 × 78 cm, is also signed at top left: JAC.S A PŌTE/ BASSANE.S/ PINXIT. It is weaker in facture, diffuse and granular in texture, and more decorative in its rosy tonality. Although Francesco was hardly old enough to have painted it in direct sequence to the Chicago original, he might have done it on the basis of a *modello* or a *ricordo* not long afterwards. It would thus be among his earliest works, c. 1560-62. It would not have been unusual for his father to have signed it as a guarantee of its Dal Ponte origin. Other, unsigned, replicas are in a private collection in Switzerland; a private collection in Milan (Ballarin 1968 (A), 43-45); formerly Bettini collection, Padua; etc. All seem to be by Francesco.

187. The Washington painting is the original and the only autograph version of this composition. Francesco painted a very exact replica (Accademia di San Luca, Rome) and an almost equally expert repetition (Pinacoteca Ambrosiana, Milan). They probably date from shortly after Jacopo's original, c. 1560-62. The Bassano shop produced at least thirty repetitions of this composition, and Leandro made a specialty of it late in his career. Egidio Sadeler engraved it (see Pan 1992, no. 1) in a print that provided a model for later copies. The original seems to have been in Venice from an early date; it was much admired in the eighteenth century, and two fine copies (The Detroit Institute of Arts; and The Art Institute of Chicago) are by Piazzetta or an artist of his immediate circle.

188. Oil on canvas, 75 × 152 cm. Boschini (1660, 364) first noted this picture in the col-

37. Jacopo Bassano, *Adam and Eve after the Fall*, Galleria Palatina, Palazzo Pitti, Florence

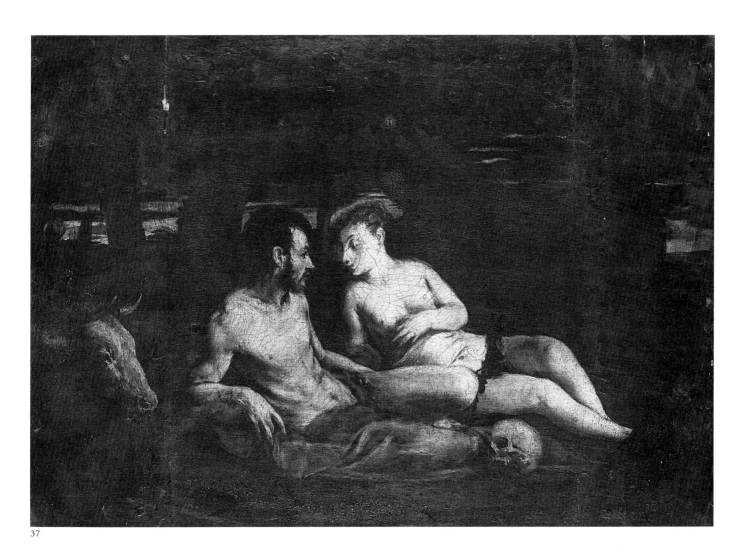

37

lection of Archduke Leopoldo de' Medici, who may have purchased it from Paolo del Sera. Longhi (1948, 54) dedicated an evocative page to it. He implied a date shortly before 1562. Berenson (1932, 518) ascribed it to Schiavone, and Arslan (1960 (B), 1, 167) thought it coeval with the Galleria Doria Pamphilj *Adam and Eve* (cat. 48).

189. Oil on canvas, 55 × 43 cm. Ballarin (1973, 111-12) first drew attention to this picture as a work of Jacopo. Its rough finish indicates that it was kept in the Bassano shop, where it served as a model for replication. An equally approximate version (Gallerie dell'Accademia, Venice) is by Francesco, but Leandro would enlarge it in several more

given a more animated and somewhat trivialized vivacity.[189] Very approximate in detail, it seems to be a *modello* that was retained in the shop for repetition. No finished version by Jacopo is known today.

A residual reminiscence of Schiavone seems to return in the unusual little painting that expands our knowledge of the working procedures of the Dal Ponte cooperative. *Saint Paul Preaching* (Musei Civici-Museo d'Art Medievale e Moderna, Padua, cat. 32) is evidently a *modello* for a larger work, probably the one commissioned in 1559 by a certain Giovanni da Lugo.[190] Painted rapidly in a liquid medium, it is improvisational, fresh, and casual, the margins remaining variably unpainted and two standing figures at left merely

38. Jacopo Bassano, *The Good Samaritan*, formerly Kaiser Friedrich Museum, Berlin

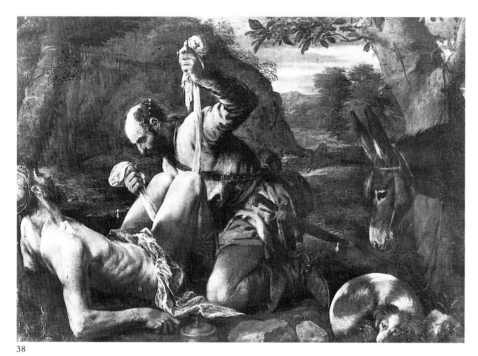

38

sketched in with the brush tipped with black paint. The composition is a free conflation of motives lifted from Schiavone's etchings, and its grainy texture, reduced chromatic range of browns, tan, moss green, and oyster reflect the Dalmatian painter's final works. This *modello* clearly remained in the shop, where several small variants were produced by assistants and a second, monumental version was developed by Jacopo himself about fifteen years later.

On another canvas, also small in dimensions but powerful in effect, Jacopo revised his earlier Hampton Court treatment of the Good Samaritan theme (formerly Kaiser Friedrich Museum, Berlin, fig. 38).[191] Destroyed in 1945, this solemn painting bore a fragmentary signature. Sharply realistic in the wounded man's anatomy and intentionally blocky in the clumsy form of the Samaritan, the strong impasto and nocturnal atmosphere from which phosphorescent highlights glow seem a development from the previous pictures. But now the chiaroscuro is broader and less contrasting, and the color equally shows a shift toward brown and olive. It should be dated at the very end of the decade.

Not all of Jacopo's paintings of about 1560 were intimate in scale, and the *Saint Jerome in the Wilderness* (Gallerie dell'Accademia, Venice, fig. 39) is cast in a monumental mode.[192] Although we do not know who commissioned this work, it was probably in Venice at an early date and may have been known

finished versions (Balbi di Piovera, Genoa; and private collection, 60.5 × 47 cm).

190. *Libro secondo*, fol. 135 *v*. Despite an echo of Schiavone, more appropriate to Jacopo's works of 1548-49, the commission of 1559 is probably the correct context for this *modello*. Its insertion in the Bassano literature is due to Ballarin (1973, 106-7), who dated it close to 1560. A derivation (formerly Morandi collection, Bologna, 52 × 37 cm) follows Jacopo's model, without the sketched figures at rear left. It is fumbling in touch, but it might well be an infantile effort of Francesco. Another replica (The Hermitage, Saint Petersburg), said to be similar in size to the Padua picture, has a new figure of a seated woman with a child at lower left and many other changes. It is coarse in quality, but a clear resemblance to Francesco's replica of the Corsini *Adoration* (cat. 36) suggests that it is a second effort on Francesco's part, c. 1561. Two later variants (Accademia Carrara, Bergamo; art market, New York) are nearly identical in handling and seem to be by Francesco, c. 1564. Finally, the large 1574 altarpiece of this theme (Sant' Antonio, Marostica) is signed jointly by Jacopo and Francesco, but is largely the work of the son. For it they adapted the woman from the Hermitage version. The so-called *modello* (formerly Kress collection, New York) is more likely a partial derivation by the young Leandro.

191. Oil on canvas, 60 × 89 cm. A fragmentary signature is detectable on the rock at lower right: IAC. A... Recorded as by Jacopo in the Prussian Royal Collections prior to 1786 (Nicolai 1779, II, 892, no. 346), this fine painting had received scant attention in the literature before it was burned in May 1945. Berenson (1932, 56) listed it as Jacopo, but Arslan (1936, 113) denied that it was by him. A drastic revision of the Hampton Court *Good Samaritan*, this format would be repeated by Francesco (Kunsthistorisches Museum, Gemäldegalerie, Vienna) and influenced Paolo Veronese's late treatment (Gemäldegalerie Alte Meister, Dresden).

192. Oil on canvas, 119 × 154 cm. This is almost certainly the picture seen by Ridolfi (1648, I, 388) in the Widmann collection in Venice. All subsequent authors, except Willumsen (1927), who characteristically gave it to El Greco, have recognized it as one of Jacopo's masterpieces. Most, however, dated it close to 1569 or later. Ballarin (1973, 112; and 1990 (B), 118-20) alone dated it to 1564, but his

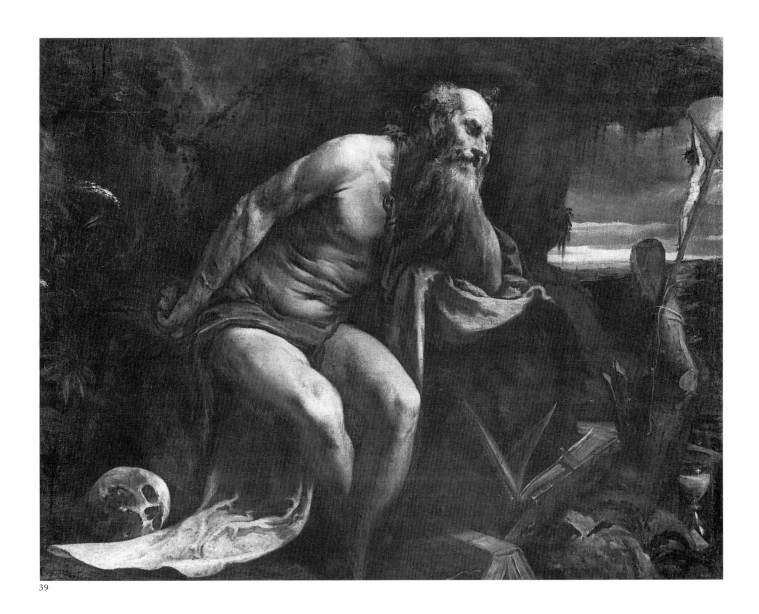

39

chronology for these years differs widely from the one proposed here.

193. Compare the anguish of the Dürer 1496-97 engraving (Winkler n.d., 109) or the serenity of Giovanni Bellini's painting of c. 1498 (Galleria Palatina, Palazzo Pitti, Florence, Contini-Bonacossi bequest). Lorenzo Lotto's various treatments of the theme might have suggested the psycho-physical vulnerability of Jacopo's saint.

to painters there from the time it was painted, that is about 1560. In forming his starkly realistic image, Jacopo was simultaneously aware of the Germanic tradition of physical punishment as well as Giovanni Bellini's ideal harmony between the hermit and wild nature by the mouth of the cave, where he has sought refuge from the temptations of the civilized world.[193] Jacopo adds a singularly modern psychological aspect in Jerome's human reluctance to continue the self-inflicted pain of chastisement; he holds the blood-stained rock behind his back as if to postpone the resumption of beating his chest as

long as possible. The stark spotlight that reveals every vein and wrinkle in the aged body only underscores the concentrated gravity of his meditation on Christ's sacrifice on the cross. But, as in the preceding pictures, the emotional focus in the saint's head elicits from Jacopo a quickened delicacy of brushstroke that is deeply affecting.

Once again, probably in 1560, Jacopo returned to his beloved theme of *The Adoration of the Shepherds* (Galleria Corsini, Rome, cat. 36), casting it now in a fresh and more natural pictorial key.[194] Using his familiar repertory of types, he here concentrates on a color range centered on brick red, navy blue, gold, deep green, and brown, relieved by touches of rose and shimmering white. The dominant and unifying element is the dazzling dawn light that suffuses the landscape in a misty glare and, as in the Washington *Annunciation*, competes with a strong vertical illumination of the foreground figures. A novel third source lies in the peasant boy at right, who blows on a firebrand. Doubtless derived from the familiar Netherlandish motive of the candle held by Saint Joseph at the nativity as a sign that Christ as the « light of the world » outshines mere worldly fire, here Jacopo adopts the firebrand for the first of many symbolic depictions of fire.[195] Solemn and evocative in its contrasts, from the opalescent grays of the tremulous Virgin's stole to the shimmering sleeve of the Hellenistic grinning shepherd, which was prepared by a typical abbreviated sketch (Galleria Estense, Modena, cat. 103), the Corsini *Adoration* effectively concludes the darkly Tintorettesque phase of Jacopo's work in the 1550s. It may well be the picture that Ridolfi described in the house of Cristoforo Orsetti in Venice as being illuminated by a dawn light, with a Madonna in the manner of Parmigianino.[196] As such, it would again emphasize Jacopo's increasing patronage from Venice itself.

If Schiavone came to Jacopo's attention, with rather negative consequences, around 1548, and if Tintoretto's dark chiaroscuro interested him after 1551, the deeply shadowed drama of his own work was, as it had always been, rooted firmly in his personal view of the real world as the most communicative conduit for his private vision. As head of the family shop, father of children destined to follows his path, and with an ever-widening fame that intruded on his provincial solitude, Jacopo could no longer view the great world that lay to the south with skeptical curiosity. However, he could, and did, absorb its lessons with fastidious discrimination.

★

Like the rising of the sun on a radiant spring morning, *The Crucifixion with Saints* (Museo Civico, Treviso, cat. 37) opens a new and limpid phase of Jacopo's pictorial development. Commissioned on 29 November 1561, this large

194. Restored in 1991-92, the resonantly deep tonality and the rich impasto make it clear that this painting shares little of the transparent luminosity of the Vienna *Adoration* (cat. 27) with which Ballarin (1990 (B), 118) would date it.

195. For the iconography of this still much-discussed motive, see Edinburgh 1989.

196. Ridolfi 1648, I, 382.

altarpiece was brought to Treviso on 9 November 1562 for trial placement in its frame over the high altar of the Dominican convent church of San Paolo. However, a final accounting, made on 29 September 1563, a week after the solemn consecration of the altar, records that the canvas had been returned at an unspecified date to Jacopo's studio in Bassano. Since the painter had traveled by coach to Treviso at the time of the commission, arranged for the frame with its carpenter, and discussed the altarpiece's placement with the architect, we have clear evidence for the care taken in considering its ambiance. Perhaps the best explanation for the picture's return to Bassano after its completion lies in Jacopo's insistence that its tonality should be even further lightened through retouching so that it would be fully legible in the church, which was not yet completed when the painting was delivered in November 1562.[197] This new search for a classical focus and high-keyed clarity of form and color has, as well, significant sources outside Jacopo's own prior work, although it was already evident in the Corsini *Adoration of the Shepherds* and other nearly contemporary works. In format, Jacopo's altarpiece shows a clear debt to Titian's equally heroic altarpiece (San Domenico, Ancona), which he might have seen in the old man's Biri Grande studio before the work left for Ancona in 1558.[198] Titian's deep chiaroscuro had, indeed, an impact at that time, but by 1562 Jacopo's priorities had shifted markedly. Hans Memling's little *Crucifixion with Saints* (Museo Civico, Vicenza) was evidently in the Veneto at an early date. From it Jacopo adopted archaic motives such as Christ's blowing loin cloth, the Magdalene who clasps the base of the cross, and, most particularly, the clear, strong color centering on a blue, red, and white triad.[199] Most significant, however, is Jacopo's delighted response to the lucidly classical painting of Paolo Veronese, who was just concluding his first decade of work in Venice. Carefully avoiding exact quotation, Jacopo nonetheless found inspiration in the sunny harmonies and serene openness of expression in *The Madonna and Saints* installed over the high altar of San Sebastiano in February 1561, just nine months before Jacopo's commission for Treviso.[200] Heterogeneous as these sources might be, Jacopo as usual has drawn on his own resources to unify the pictorial ensemble. Against the darkened vastness of the cloudy sky, the pallid body of Christ is noble but vulnerable, his wounds gushing gouts of red blood, while the chiseled definition of the Virgin sets her ashen features against the brilliant white of her coif and the translucent crystal of her tears. By contrast, the opulent Magdalene is in the spirit of Veronese, while John's ecstatic emotionalism retains the mystical aura of the second *Descent of the Holy Spirit* altarpiece. Perhaps the most arresting figure is the unstable Jerome, who pivots to consult his own volume, painted with an almost miraculous mastery of tonal subtlety. Although his head is a clear reprise of the saint painted just a year earlier, the contrast in

197. The *Memoria* (ASTv, San Paolo, Processo no. 257) of the Abbess Cornelia Meolo is dated 24 September 1563. It gives no hint of the motivation for the return of the altarpiece to Bassano and does not imply that it was the result of any disagreement between patron and painter. An infra-red examination, which has not yet been made, might reveal changes made at that time, but it may be assumed that a nearly finished picture was brought from Bassano to Treviso between 9 and 12 November 1562.

198. Wethey 1969, 85-86, no. 31.

199. The provenance of Memling's *Crucifixion* can be traced only to 1865, but its impact on Vicentine painting, most particularly Bartolomeo Montagna, suggests that it was there at least by 1490 and may have been commissioned directly from the visiting artist by a Vicentine patron. It was copied (Ca d' Oro, Galleria Franchetti, Venice) by an artist of the Venetian terra firma before 1500. Faggin 1969, 95, no. 20-D.

200. Pignatti 1976, I, 126-27, no. 132.

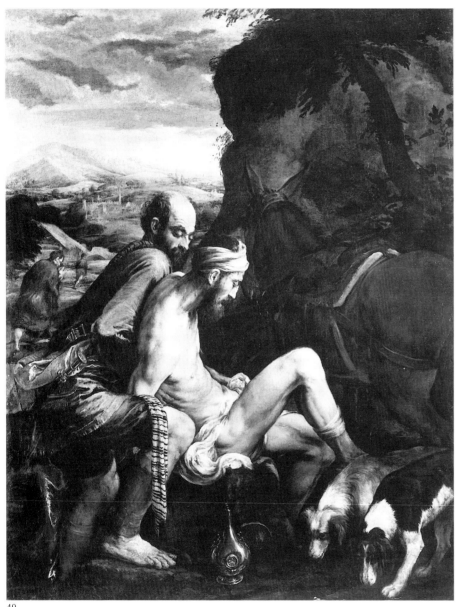

40

201. Only a technical examination can re-
solve the question of the Saint Jerome being
absent from the 1561-62 composition, an ad-
dition that might have occasioned the 1562-63
second phase of work on the canvas. The Jer-
ome is easily separable from this context, as a
long series of horizontal replicas demon-
strate. Several (Bayerische Staatsgemälde-
sammlungen, Alte Pinakothek, Munich; and
Fitzwilliam Museum, Cambridge) were
done by Francesco immediately following
the original, while later variants (High Muse-
um of Art, Atlanta; Ponce Museum of Art,
Puerto Rico; Mont collection, New York;
and unknown private collection) are Fran-
cesco's revisions of c. 1578-80. Many other
late shop repetitions after the Munich type
are known.

its radiant color aptly illustrates the rapidity with which Jacopo has shifted
his pictorial concerns.[201] Tragic but hopeful in tenor, *The Crucifixion* empha-
sizes the integrity of individual forms in a spacious and palpable atmosphere.
Its transfixed moment is subtly placed in context by the glowing dawn low at
right and the retreating cavalcade just suggested at left.

202. Oil on canvas, 101.5 × 79 cm. Engraved by Pietro Monaco in 1772 when it was in the Palazzo Pisani in Venice, this picture passed by way of Joshua Reynolds prior to 1792 and eventually to The National Gallery in 1856. Although Waagen (1857, 60) ascribed it to Francesco, Berenson (1894, 84) and virtually all subsequent scholars have agreed that it is an original by Jacopo. A damaged compositional sketch (Courtauld Institute Galleries, London, Witt Collection) was followed by a splendid study for the wounded man (private collection, Chicago, cat. 84), and a much later shop *ricordo* (The Royal Library, Windsor Castle). Francesco began to paint yet another replica of the Washington *Annunciation to the Shepherds* (cat. 30) just as Jacopo finished the London *Good Samaritan*. Responding to the challenge, he turned the canvas upside down and began a replica of *The Good Samaritan* (Narodní galerie, Prague, 107.5 × 84.5 cm). Dissatisfied, he abandoned it in a sketched state. Several good shop replicas (art market, London; and Melville collection, Cincinnati) might be early works of Francesco.

203. This study figured as nos. 23 and 74 in inventories of the Sagredo collection in Venice with an explicit attribution to Jacopo.

204. Discussed in public lectures by the present writer since 1974, and first published by Ballarin (1973, 91-124), I would now revise the date I then proposed of c. 1566 to one closer to 1563-64. Tintoretto's earliest *Susanna* (Museo del Prado, Madrid) of c. 1546 might have been known to Jacopo, but Tintoretto's monumental version (Kunsthistorisches Museum, Gemäldegalerie, Vienna) of c. 1558 seems to play no role in Jacopo's formulation. Nor is the serene monumentality of Veronese's earliest *Susanna* (Cassa di Risparmio, Genoa) of c. 1558 closely related to the Ottawa picture. Since it was painted for the Emo family for their new villa at Fanzolo, it might well have been known to Jacopo. For the symbolic meaning of this sudden proliferation of *Susanna* pictures, see Rearick 1978 (B), II, 339-41.

205. The now archaic format of the *sacra conversazione* à la Bonifazio might have been a requirement of the patron.

Almost simultaneously with this great altarpiece, Jacopo turned to less demanding projects, among them a new format for *The Good Samaritan* (The National Gallery, London, fig. 40).[202] In canting the seminude figure from the composition formerly in Berlin into a more vertical position, Jacopo drew one of his most original sketches (private collection, Chicago, cat. 84), a free mixture of pen, a medium he almost never used, and exotically colored chalks, the medium he had but recently developed in this pictorial key, to suggest the bright color, but contained form, he foresaw in the painting.[203] It remains unique within his drawing oeuvre. Doubling the dog from the Enego altarpiece and shifting the landscape opening to the left, his new *Samaritan* required an entirely different figure for the benefactor, and it is here that the more sober light and color of the first part of the painting suddenly shifts to a brilliant virtuoso display of glittering brushwork to evoke the red jacket, the scarf, and the gleaming knife. Its painterly verve is exactly parallel to that of the Magdalene's sleeve in the Treviso altarpiece, a conjunction that suggests that the London *Good Samaritan* was begun slightly before *The Crucifixion* and finished just after it.

Veronese might also have inspired Jacopo to return to the theme of *Susanna and the Elders* (National Gallery of Canada, Ottawa, cat. 28), one he had painted early in his career for the Palazzo Comunale in Bassano del Grappa, but now a theme imbued with Counter-Reformation significance.[204] It was probably intentional that Jacopo used his Eve from the Pitti *After the Fall* for Susanna, here charmingly blushing, even to her knee caps. The broad garden setting, replete with symbolic fruit and flowers, underscores the heroine's dual role as Chastity and Ecclesia assaulted by hypocritical heretics. The luxuriantly flashy fabrics of the elders suggest that this delightfully relaxed diversion follows very slightly the Treviso *Crucifixion* and the London *Good Samaritan*. Its refined and dusty harmonies of green and tan look forward to the pastoral genre soon to come.

A devotional picture of the rather archaic *sacra conversazione* type, *The Madonna and Child with Saints Anthony Abbot and John the Baptist* (Alvar Aalto Museum, Jyväskylä, cat. 35) nonetheless elicited from Jacopo the same spirited level of execution he dedicated to large altarpieces.[205] Although the figures are clearly based on types Jacopo had developed over the previous five years, his brushstroke has sharpened to clarify shimmering surfaces such as the gleaming ruby curtain, and his medium is once again thinned to veils of glazes that seem almost transparent in loosely brushed passages such as the sky. Color is clear but resonant, and form is defined and normative in proportion, so that mannerist stylization gives way to a measured, classical stasis. Still another, unusual painting seems to be contemporary with the Treviso *Crucifixion*. A small, round-topped altarpiece representing *The Flight into*

41. Jacopo Bassano, *The Flight into Egypt*, parish church, Borso del Grappa

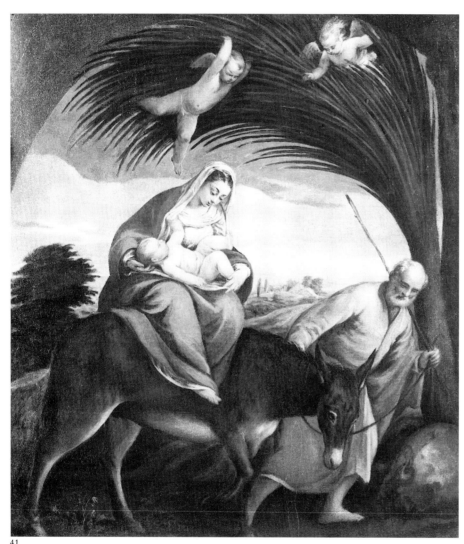

41

Egypt (parish church, Borso, fig. 41), is unfinished and might be the painting described in the inventory of Jacopo's studio made after his death in 1592.[206] Fresh in its rather pretty conjunction of bright blues, red, and bottle green, it lacks final glazes and surface detail; as a document for a painting abandoned when it was about two-thirds done, it is a useful measure of his technical procedure. We do not know why it remained in this state, but it would serve the shop as a model for about a dozen replicas carried to completion over the following thirty years.[207]

206. Verci (1775, 95) recorded from the 1592 inventory of Jacopo's studio « No. 97. Una Madonna che va in Egitto sbozzata in tela ». Elsewhere (163), he recorded an altarpiece in the old parish church of Borso del Grappa at the right of the high altar that represented *The Flight into Egypt*. He confused, however, its date with the 1538 inscribed on the earlier picture there, but he did specify that it was in the style of Parmigianino, which for him implied Jacopo's middle years up to about 1568. The placement of this *Flight* high above the door on the interior façade has impeded a correct assessment of its style and quality, and the recent literature has largely ignored it, Arslan (1960 (B), I, 333) finally calling it a copy after a lost work of Jacopo. It was restored by Ottorino Tassello in 1981. That the Borso *Flight* is unfinished is confirmed by the lack of final, detailed glazes throughout, by the overly bright blocks of color that lack chiaroscuro modeling, and by ambiguities such as the unresolved upper curve of the painted field at right.

207. Leandro in particular borrowed this format for his signed picture (formerly Wahlin collection, Stockholm) of c. 1586, but other, lesser shop associates used it as well, suggesting that the original remained in the Bassano shop. Ridolfi's (1648, I, 389) record of a *Rest on the Flight* in the possession of Jacopo's grandson, Carlo Scajaro, may refer to the present work, especially since he emphasized the putti gathering fruit from the palm tree above. Only on the dispersal of the effects of the last Dal Ponte in the mid-seventeenth century is the Borso picture likely to have arrived at its present location.

Jacopo's concern with a noble monumentality of form bathed in a spaciously atmospheric light suggests that around 1563 he kept a curious if diffident eye on the cosmopolitan developments in the capital, particularly the measured opulence of Paolo Veronese, who evidently returned the compliment by studying Bassano's rustic poetry. It was, indeed, this bucolic element that Venetian connoisseurs were coming to appreciate in Jacopo's paintings. The arcadian nostalgia of drawings, prints, and paintings done by Titian and disseminated by Giulio and Domenico Campagnola in the teens had begun to lose some of its gentle poetry in favor of a more realistic view of country life by about 1525, when Titian designed *The Milkmaid* woodcut. This transition in literary interest from Virgil's *Eclogues* to his *Georgics* finds a clear visual echo in Lambert Sustris's *Plowman* of about 1544-45, as well as in other prints in which an agrarian naturalism comes to the fore.[208] Thus, a shift in cultivated literary fashion in Venice helped to foster a market for new visual images of country folk going about their daily tasks. Connoisseur-collectors in the capital might already have come to know pictures such as Zentani's *Two Hunting Dogs*, but they surely had seen and admired rustic settings of biblical themes such as *The Annunciation to the Shepherds*. It may, therefore, be a fortunate conjunction of sophisticated taste and Jacopo's natural proclivity to depict the world around him in Bassano del Grappa that brought into being his celebrated peasant genre pictures. Neither the public nor the artist was, however, prepared to discard traditional subject matter in the costly and decorum-hedged field of painting, and Jacopo's first forays into this new genre are cautiously costumed with conventional themes. Thus, what seems to be a simple farming vignette in which a peasant family unhitches its plow-ox and prepares its picnic lunch while the farmer finishes his sowing in the field just beyond is simultaneously a depiction of *The Parable of the Sower* (Thyssen-Bornemisza Collection, Lugano) in which the biblical passage « ... and some of the seed was eaten by the birds of the air » is freshly illustrated with a device that would become a Dal Ponte trademark.[209] The primary illustration of the theme is moved to the middle ground in order to make way for casual staffage intended to provide a natural ambiance for the biblical text, as though one had opened a window on the countryside around Bassano to glimpse the actual event itself shorn of Renaissance rhetoric. The device of a devious and oblique access to a picture's true meaning is, equally, mannerist in character, a duality which places the Thyssen *Sower* at a crucial crossroad of European painting, simultaneously retrospective and avant-garde. In addition, it should be remembered that the Thyssen picture might equally, and simultaneously, illustrate the sowing treatise in Virgil's *Georgics*.[210] Jacopo casts the picture in an idiom that remains rather heroic in tone, sibylline in the powerful seated woman at right and dedicated in the solem-

208. Rearick 1992 (A), in press.

209. Oil on canvas, 140 × 129.5 cm. Traceable to the collection of Thomas Darving in London (pre-1839), where it bore a traditional attribution to Jacopo, this picture was accepted by Waagen (1854, IV, 96) and others before it came to wider attention. Zampetti (1957, 214, no. 90) included it in the 1957 exhibition on the recommendation of the present writer. Muraro (1957, 299) first called it *The Parable of the Sower*. Ballarin (1990 (B), 118) discussed it in the context of the beginnings of the pastoral genre in the 1560s. A drawing (formerly Geiger collection, Venice) for the sower is an early derivation by Francesco. Jacopo produced a later variant (Museum of Art, Springfield, Mass., cat. 44), and the later shop made many modified replicas.

210. Rearick (1980 (C), 373) saw its composition as inspired by the Brito woodcut *Milkmaid* after Titian, and suggested (1992 (A), in press) a secondary meaning related to the revival of interest in Virgil's *Georgics* around midcentury.

nity of the kneeling matriarch at left. Monumental though these passages may be, it is the pungent aroma of nature that is evoked by the poetic landscape and endows this painting with a prophetic intimation for the future.

The Adoration of the Magi (Kunsthistorisches Museum, Gemäldegalerie, Vienna, cat. 27) of about 1563-64 shows the consistent impulse toward pictorial vivacity that this subject stimulated in the painter.[211] Drawing retrospectively on works even as remote as the Edinburgh *Adoration* (cat. 10) of more than two decades before, but primarily reworking motives from his more recent small painting (private collection, Bassano del Grappa, fig. 34) of this theme, Jacopo here dedicates little attention to invention. Instead, his concern is with a fluent and virtuoso rapidity of brushstroke perfectly attuned to rarefied coloristic effect. Its dazzling brilliance of hue in the emerald, cobalt, and rose of the Magi and their entourage focuses on gleaming reflections in the burnished gold of their gifts to create a scintillant play of color recalling that of the Treviso *Crucifixion*, but now cast in a duskier light that only augments its vivacity. The Madonna is thinly brushed in luminous veils of diluted pigment, and her delicate features are accented by tiny touches of ice blue. An electric blue wash seems to float above the dove gray landscape, and the same lightly flickering brush movement energizes the mother-of-pearl in the horse's mane. Countless other subtleties make it evident why this *Adoration* quickly became a preferred model for Jacopo's sons in the production of replicas.[212] Good though Francesco's are, they never capture the apparently effortless ease of Jacopo's handling of the pigment here.

Jacopo's fame in Venice was clearly on the rise by 1564, primarily in the field of biblical themes that lent themselves to a pastoral treatment. The picturesque passage of Genesis in which Jacob gathered his family, their animals, and all they possessed in preparation for the departure from Canaan to Egypt provided an ideal subject for an ambitious painting, *Jacob's Journey* (The Royal Collection, Hampton Court, cat. 33), in which Jacopo developed ideas adumbrated in the Thyssen *Sower*.[213] Expanding the diagonal hillock that he had used at least since the Edinburgh *Adoration*, the artist simplified his setting to emphasize the magnetic draw of the shimmering distance toward which the humble family is about to depart. Indeed, the obedient sheep already follow Jacob's grandson out of the picture at right, while the patriarch remonstrates with a tearful child at center and Rachel comforts another baby in the midst of the foreground packing. As in the Vienna *Adoration*, bright passages of emerald and rose dominate the color, but the new element in this dusty tonality is a subtle play of opalescent silver gray set against diverse values of brown. Jacopo's medium achieves a new level of liquidity in the silvery rivulets of Rachel's dress. Although it is rather large in scale, this *Jacob's Journey* is intimate and precious in character, a perfect embellishment for the

211. The unaccustomed vertical format explored in the two most recent treatments (private collection, Bassano del Grappa, fig. 34; and formerly Caggioli collection, Venice) is here returned to a more familiar horizontal order. Confusion about its attribution in the early literature is due to a *lapsus* in the *Theatrum Pictorium* 1659 engraving, which ascribed it to « Bassan junior ».

212. Among the more than a dozen shop replicas of the Vienna original, the most faithful is by Francesco (The Barber Institute, Manchester), who repeated it (The Hermitage, Saint Petersburg; and formerly Oscar Bondy collection, Vienna). Leandro made replicas (Art Museum, Princeton University; Schloss Weissenstein der Grafen von Schönborn, Pommersfelden) in a coolly glittery tonality. Giambattista added his own clumsy version (Harvard University Art Museums, Cambridge, Mass.), and numerous later shop duplicates attest to its continued popularity.

213. A bright and attentive version (formerly Cobham collection, Hagley Hall) is, once again, Francesco's immediate replica after the original.

water-bound palazzo of a Venetian who yearned for the summer at his mainland villa.

Venetian connoisseurs were by now familiar with the pastoral aspect of Jacopo's work, and a few had noticed the *Saint Christopher* altarpiece on a nearby island. It must, nonetheless, have required a considerable act of faith to award this provincial artisan the commission for a major altarpiece in Venice itself. The *Saints Peter and Paul* (Galleria Estense, Modena, cat. 34) was part of the program of decoration for the small church of the Umiltà, which stood just behind the present site of the Salute.[214] In 1564 the other major component of this project was the grandiose ceiling (now Cappella del Rosario, Santi Giovanni e Paolo, Venice) by Paolo Veronese, whose work Jacopo had admired for several years. Assuming a consciously Veronesian mode, Jacopo approaches this intractable subject subtly but with candid simplicity. Peter seems bowed by the administrative responsibilities of his evangelical mission, and Paul's typical aggressive arrogance is endowed with a heroic monumentality, accentuated by the low vista toward the horizon. Gravely solemn as though transfixed by an interior vision, each is foil and complement to the other. Still, the luminous range of emerald, rose, and rust, now joined by the lovely lavender of Peter's robe, vibrates against a shimmering twilight. Diluted to watercolor thinness, the rapidly applied paint in the looming rocks and bushes bleeds and runs down the canvas in places. Similarly, Paul's head was painted before the sky; Jacopo's lightning brush added the blue above and around this head, leaving a penumbra of unpainted canvas above it. All the more commanding for its simplicity, the Umiltà altarpiece might have passed unnoticed in the noisy push and shove of the Venetian artistic milieu were it not for the sincere admiration of Paolo Veronese, who made his *Adoration of the Shepherds* ceiling overhead a clear homage to his friend from the country.

The Umiltà *Saints Peter and Paul* was not followed by any public commissions in Venice, where Tintoretto's aggressive enterprise in taking over the decoration of the Scuola di San Rocco made him the center of attention to such a degree that even Veronese retired briefly to his native Verona.[215] Conversely, the fashion for small pastoral pictures increased, and Jacopo seems to have dedicated much of his time and effort to developing prototypes for this popular genre. Surely the most unusual of these was a set of three long oval canvases representing episodes from the Genesis story of Jude and Tamar. A subject virtually unknown in Italy before Jacopo painted it, this suite illustrates *Jude and Tamar* (lost), *Hirah Searching for Tamar* (lost), and *Tamar Brought to the Stake* (Kunsthistorisches Museum, Gemäldegalerie, Vienna, cat. 38).[216] There is no record of its commission nor its original placement, but the theme of sex used for devious but just ends, fecundity, and a

214. Paolo Veronese painted his ceiling c. 1564, and it is likely that Jacopo's altarpiece followed by a matter of months or was nearly contemporary with it. It is significant that in 1566 Vasari took note of Veronese's work there, but ignored the *Saints Peter and Paul*. On the suppression of the monastery of Santa Maria della Umiltà in 1807, the picture became State property and was assigned to Modena in 1811.

215. Veronese married Elena Badile in Verona on 27 March 1566, and two months later, on 21 May, the competition for the Scuola di San Rocco ceiling was posted. While he never abandoned his Venetian studio, Veronese then turned for a few years to several major commissions in Verona. Jacopo played no role in these Venetian artistic confrontations and seems to have produced only small private commissions for Venetian clients in these years.

216. Rearick's (1986 (A), 184) reconstruction of the *Tamar* trio of canvases was in part accepted by Ballarin (1990 (B), 121-25), who, nevertheless, denied that the three scenes formed an integral set and dated the Vienna *Tamar* to 1563.

denouement in which the thwarted connubial match is achieved suggests that it was a frieze on the upper part of a bed alcove. Jacopo had done such a set in 1545 for the podestà's bedchamber in the Palazzo Pretorio in Bassano.[217] Although the exotic theme of the Tamar series did not lend itself to replication, Jacopo nonetheless made use of his newly developed technique of making finished wash drawings, or *ricordi*, after the completed pictures so that the motives could be preserved among the shop materials should they be needed again. The *ricordo* (Gabinetto Disegni e Stampe degli Uffizi, Florence, cat. 88) made after the *Jude and Tamar* survives and illustrates the refinement of Jacopo's handling of this new medium, one which he soon delegated to his sons as part of their training. This *ricordo* served as the model for numerous independent replicas. Several later versions of *Hirah Searching for Tamar* are also known, but the *Tamar Brought to the Stake* seems not to have been repeated.[218] In style, the *Tamar Brought to the Stake* most closely resembles the clear brilliance of the Vienna *Adoration of the Magi* and should be dated just subsequently in 1565.

A much more popular pairing follows fairly directly in the *Jacob and Rachel at the Well* (private collection, Turin, cat. 43) and *Jacob's Journey* (formerly Wallraf-Richartz-Museum, Cologne), the kind of moderately scaled pendants designed to face one another above a pair of *credenze* in a fine domestic interior.[219] The former would be repeated with variations dozens of times by the shop, but the latter did not find favor, perhaps because another revision that proved more marketable followed.[220] In this pair Jacopo develops still more casually the realistic depiction of the activities of country folk. In the originals, it is clear that Jacopo's palette has become more somber; a date a bit later than the *Tamar* cycle, that is close to 1566, might therefore be suggested. Venetian collectors had, from the decade of Giorgione on, favored intimately scaled cabinet pictures in which landscape was lent equal emphasis with small figures that were comfortably contained within its natural environment. Taking the still monumentally conceived Thyssen picture as a point of departure, Jacopo restudied all of its components to paint the small *Parable of the Sower* (Museum of Fine Arts, Springfield, cat. 44), an almost miniaturist evocation of country life which might equally illustrate a chapter on sowing from Virgil's *Georgics*.[221] Limpid in tone, but less brilliant in hue, the Springfield painting may also be dated to about 1566.

These and other pastoral treatments of biblical themes that Jacopo created between about 1563 and 1566 evidently brought him recognition not only among connoisseurs of fine painting, but also in literary circles where the poetic tradition of Virgil and Sannazaro was revered and debated. Torquato Tasso might have met Jacopo dal Ponte during the brief period in April 1566 when the twenty-two-year-old poet returned from the entourage of Cardi-

217. Lost, apparently in the fire of 1627. They depicted *Joseph Interprets Dreams, Joseph before Pharoah,* and *Joseph Proclaimed Savior of Egypt.* It is probable that the first two were oval and constituted the frieze at either end of the bed alcove, while the last was a longer oval and was placed high on the long wall. They were commissioned by Alvise Minotta in 1545. Ridolfi 1648, 1, 376.

218. The *Jude and Tamar* was reproduced in its figures by Jacopo in a *ricordo* drawing (cat. 88) and in a full format painting of reduced dimensions (Galleria Palatina, Palazzo Pitti, Florence, depot. inv. 927). This replica is by Gerolamo, c. 1585, as is a version of higher quality (Gallerie dell'Accademia, Venice, inv. 418), which has been cut to just the figures. A good replica of the figures alone (Musée Fabre, Montpellier, inv. 837.1.281) is also by Gerolamo, and is based on the *ricordo*. The *Hirah Searching for Tamar* was duplicated by Gerolamo in complete form in two versions, one (Gallerie dell'Accademia, Venice, inv. 409) faithful to the original, but the other (Galleria Palatina, Palazzo Pitti, Florence, inv. 920) transformed into a conventional *Annunciation to the Shepherds* by the addition of a tiny angel in a celestial radiance. The *Tamar Brought to the Stake* seems not to have found favor with later clients, but Leandro did copy the central group in a red and black chalk drawing (Musée du Louvre, Département des Arts Graphiques, Paris, inv. 5283).

219. The *Jacob's Journey*, oil on canvas, 63 × 100 cm, without the addition along the upper edge, was sold by the Wallraf-Richartz-Museum about 1943 and may have been destroyed in the bombing of Cologne in 1944. A damaged sketch (Collezione Horne, Florence, cat. 92) is Jacopo's preparation for the shepherd boy in the middle distance at right. Although several copies are known, there are no contemporary replicas. The *Jacob and Rachel at the Well*, by contrast, met with immediate success. Jacopo painted the first, rather damaged version (private collection, Baltimore, oil on canvas, 62 × 101 cm) as a pendant to the Cologne canvas. The excellent and well-preserved picture exhibited here (cat. 43) seems to be an autograph replica, but I have not seen it in the original. Francesco painted an exact repetition (Kunsthistorisches Museum, Gemäldegalerie, Vienna, inv. 5824), followed by a brilliant revision (private collection, Bassano del Grappa) in which Jacopo added the dog at lower right.

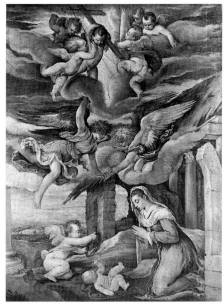

42

Leandro also painted replicas (Accademia di San Luca, Rome; and Fitzwilliam Museum, Cambridge), as did Giambattista (private collection, Bassano del Grappa) and other later shop assistants.

220. Staatliche Museen Preussischer Kulturbesitz, Gemäldegalerie, Berlin, cat. 60.

221. Rearick 1992 (C), in press. The Florentine provenance is confirmed by Picchianti's 1778 engraving. A variant was engraved by Raphael Sadeler in 1601 (Pan 1992, no. 96).

222. Ridolfi (1648, I, 388) recorded the Tasso portrait, although he did not know the location of the painting. His allegation that Jacopo portrayed Ariosto is surely mistaken, since the painter had barely begun his independent career when the poet died in 1533. The delicate impasto and dark tonality of the *Tasso* shows the type of portrait that provided Francesco with a point of departure. The younger Dal Ponte painted the *Man with Gloves* (The Royal Collection, Hampton Court) around 1567, and the *Scholar* (Galleria Colonna, Rome) perhaps a year later. Both follow the severe paternal type, but the brushstroke is more aggressive, the impasto thicker, and the characterization more extroverted as was Jacopo's wont.

223. Emiliani 1968, 131-37.

224. Oil on canvas, 100 × 75 cm. Rearick

nal Luigi d'Este to rejoin his friend and patron, Scipione Gonzaga, who had founded the *Accademia degli Eterei* in his Padua residence. The purpose of this visit was to read proofs of a small collection of his verses.[222] The portrait of *Torquato Tasso* (Sammlung Heinz Kisters, Kreuzlingen, cat. 41) bears an inscription with his name, that of the artist, and the date 1566. Restrained but courtly in format, its oval frame with trompe l'oeil strapwork suggests that the painter took engraved mannerist frontispieces as a model. It might, indeed, have been intended to serve an engraver in the preparation of such a print for the volume about to be published. The device seen in the oval space below the image is, indeed, a reference to a sonnet included in the *Rime degli Eterei*.[223] It seems, however, never to have been engraved. Witty and perceptive in capturing Tasso's proud and unstable temperament, its nearly monochrome severity of palette combines with a delicate luminosity of light and texture.

Signs of this darker, more monochromatic tendency are also to be found in one of Jacopo's most unusual small paintings, *The Nativity with the Symbols of the Passion* (Museo Civico, Vicenza, fig. 42).[224] The conjunction of symbolic elements, virtually unknown at this time in Italy, has strong Germanic and perhaps Protestant overtones. Since we do not know for whom or why it was painted, this must remain rather mysterious, but its pictorial character is equally unexpected. The Virgin's sandy red dress and the golden radiance are among the few color accents in an otherwise subtly modulated harmony of oyster, fawn, amber, and bronze, a delicately restrained tonality barely ruffled by the intense pink strip of light against the brilliant topaz of the sky near the horizon. This absence of local color suggests that it might have been conceived as a model for an engraver, but since no print exists we must assume that it was an arcane private commission. Its formal associations suggest a date near to 1566.

Periodically, Jacopo shows signs of crisis, moments in which infelicitous outside influences prompted uncertainty as to the ideal direction his restless sense of experimentation should take. The monochromatic, linear phase of 1549-50 was one such episode; the somewhat monotonous formal repetitions of 1559 signal another. The period around 1567 is tense and introverted. Here, however, the cause seems to be internally generated, a sort of schizoid dedication to intimate pastoral subjects, which rendered monumental altarpieces difficult to formulate. Large-scale commissions were, nonetheless, still forthcoming, as in the case of the request for a picture to go over the high altar of the Vicentine church of Sant'Eleuterio, which stood at the end of the main square there.[225] The *Saint Eleutherius Blessing the Faithful* (Gallerie dell'Accademia, Venice, cat. 40) might seem an ideal vehicle at this moment, since it allowed the artist to devote the major space to the common people who

kneel in veneration of the relics that the saint carries onto the columned porch of the church. But there was, equally, no chance to emphasize a stately simplicity as in the Umiltà altarpiece of only about three years before. Instead, Jacopo drew on his small *modello* for *Saint Paul Preaching* and his second *Descent of the Holy Spirit* to assemble an unintelligible, though monumental, complex of multilevel steps and giant columns around which a variegated crowd assumes uncomfortably artificial poses. Typical is the axial male in greenish bronze at center, derived from the Jacob in the Hampton Court *Jacob's Journey*, but now given an unstable half-kneeling pose intended to lead the eye up and inward toward the reverent women placed higher on the steps. Instead, he emphasizes the irrational intrusion of a reclining soldier – the patrons of the altar were *Bombardieri* – and another armed soldier, who rises Salviati-like into the picture space from below.[226] It was, ultimately, the multiple and largely unresolved internal conflicts of his composition that forced the painter to make drastic pictorial decisions aimed at enforcing visual unity. Moving beyond the shimmering, veiled tonality of the preceding pictures, Jacopo here sharpens his focus to a harsh gleam that pierces the somber gray atmosphere with unrelenting clarity. Chiaroscuro is demarcated into mysterious shadow and a heatless light that seems to come from low at left, as if from the last rays of an autumn sun. Almost monochrome, this dusty atmosphere permits rills of silvery highlight to pick out the edges of the coif, and the metallic armor is set against pallid lavender and infinite gradations of oyster gray. Grim in pictorial terms that might have impressed Caravaggio or the young Guercino, the *Saint Eleutherius* is one of Jacopo's most arresting if unconventional achievements.

Not all projects of 1567 could be subjected to such fiercely concentrated visual order, and the nearly contemporary *Supper at Emmaus* (The Royal Collection, Hampton Court, fig. 43) breaks up into fugitive narrative and visual episodes.[227] Here the dim light simply obfuscates instead of focusing attention, and modest touches of color, such as the mameluke's hat and the dark wine in the crystal cup, become isolated accents in a generally dispirited prose. Still, the sensitivity in highlights is clearly that of Jacopo, and the tender pathos of the sad faces is truly felt and tremulously expressive. A partial explanation for the apparently irreconcilable contradictions evident in the Hampton Court *Emmaus* might lie in the participation of one of the Dal Ponte sons in the first stages of execution, a halting and lethargic priming which Jacopo could not quite vitalize with an extensive application of glazes, highlight, and detail. It should be noted that several of the heads, particularly the three attendants at far left and the youth coming through the door at right, have a clear portrait character. The gloomy man who fixes us with a fierce stare from the far left does, indeed, seem to be Jacopo himself, and the deli-

1978 (B), 337-39. Sgarbi 1980, 84.

225. Thanks to the insistence of Ballarin (1969, 94-95; and 1990 (B), 118-20) the *Saint Eleutherius* has now been accepted as a work of the 1560s. I have been of this view since 1957, but still prefer to place it closer to 1567, rather than near Ballarin's date of c. 1563-64.

226. Francesco Salviati dropped the picture space below the lower margin of the painting and allowed two spectators to rise from this ambiguous lower plane in his 1538 *Visitation* (Oratorio di San Giovanni Decollato, Rome). Although none of his surviving Venetian works used it, it is here so explicitly Salviatesque as to suggest that Jacopo knew an example, perhaps by way of Schiavone who used it several times in the 1540s.

227. Oil on canvas, 169 × 237.8 cm. Although Waagen (1854, II, 356) and Berenson (1894, 83, and all subsequent editions of the *Lists*) regarded it as by Jacopo, Arslan (1960 (B), I, 345) relegated it to school status, and it has seldom been mentioned since. Ballarin (1990 (B), 125-26) and the present writer, independently, returned it to Jacopo, the former with a date of c. 1565 and the latter c. 1567. Ballarin's identification of it as the picture seen by Ridolfi (1648, I, 377) in the Guadagnini collection in Bassano is possible, but undocumented.

43. Jacopo, Giambattista il Giovane, and
Francesco il Giovane Bassano, *The Supper at
Emmaus*, The Royal Collection, Hampton
Court

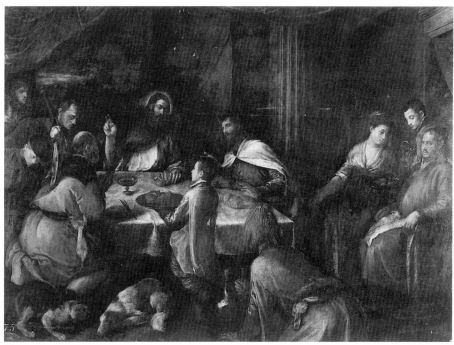

43

cate youth at right is the same as the smiling man in lavender in the *Saint
Eleutherius*, a figure we have identified as the young Francesco, who assisted
marginally there. However, the ages of Jacopo's other three sons do not cor-
respond with those of the three other youths in the *Emmaus*.[228]

This dark, but objective, phase of Jacopo's development favored portrai-
ture, as the 1566 *Tasso* attests. However, the slightly subsequent *Portrait of
a Man in Prayer* (Civica Galleria di Palazzo Rosso, Genoa, cat. 42) is also a
strange and disquieting image.[229] His expression left partly in shadow, this
gentleman – for his fur collar bespeaks a certain social level – kneels in pro-
file, his hands clasped in prayer and his eyes fixed on a simple black cross at-
tached to the cell wall. His environment is clearly a prison as the massive
stone architecture and the bars at right attest, and the reason he is confined is
easy to guess. The empty cross is usually associated with Protestants in this
period, since a Roman Catholic cross would have included the sculptured
image of Christ. We may, therefore, speculate that once again the shadow of
heresy and the Inquisition falls across Jacopo's career. The identity of the sit-
ter and whether the picture was painted in jail or was done as an ex voto up-
on the subject's release remains a mystery. Its gray and sober pictorial han-
dling was doubtless conditioned by the subject; however, the style closely re-

228. The sharp qualitative disjunctures in
this *Emmaus* are due to the early stages of ex-
ecution by a hesitant assistant, probably to be
identified as Giambattista, and an interven-
tion of another hand, probably that of Fran-
cesco, before Jacopo took over to make cor-
rections and add almost all of the heads. In
1567 Jacopo was about fifty-seven, Francesco
eighteen, Giambattista fourteen, Leandro
ten, and Gerolamo one year old. If Jacopo is
the fiercely observant man in the left back-
ground, Francesco might be the attendant to
Christ's right, Leandro would be the sallow
youth at right, the boy with the hat at left
might be Giambattista, and the child in pro-
file behind him Leandro. This must, howev-
er, remain speculative.

229. On occasion, prisoners chose to have
their portraits painted in jail, as did Thomas
More, whose portrait (private collection, Mi-
lan) was done in the Tower of London be-
fore he was beheaded.

117

44. Jacopo Bassano, reworked by Lodovico Toeput, *Saints Florian, Sebastian, and Roch,* Museo Civico, Treviso

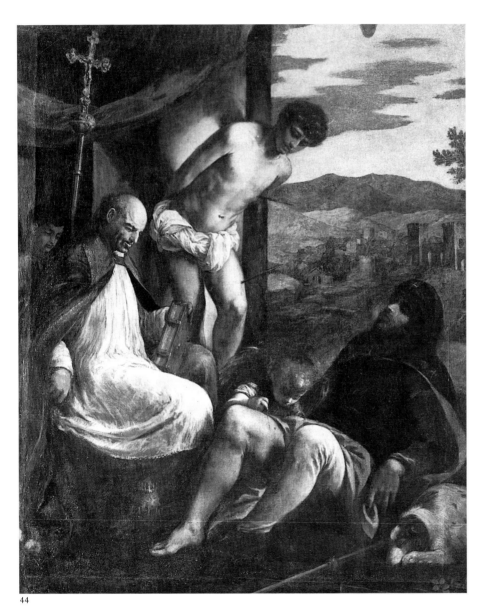

44

sembles that of the *Saint Eleutherius* altarpiece.

The *Saints Florian, Sebastian, and Roch* (Museo Civico, Treviso, fig. 44) poses still a different problem.[230] It had probably already lost some of its margins when, about 1690, Lodovico Toeput, Il Pozzoserrato, was commissioned to piece it out to fit a larger frame. He did so with an entirely new landscape background that was intended to slide into the extensive added canvas above, but as with the second *Descent of the Holy Spirit,* the original and the ad-

230. Oil on canvas, 229 × 136 cm, including additions. Painted for the church of the Ognissanti in Treviso, the canvas had apparently already been damaged around its margins when Lodovico Toeput, Il Pozzoserrato, was commissioned to piece it out to fit a larger frame. This was carried out between November 1592 and April 1594 (Torresan 1986-87, 132-33) and required the insertion of the landscape. The presumed *modello* (The Hermitage, Saint Petersburg) is a sketched *ricordo,* probably by Giambattista, which shows the original column in the right background.

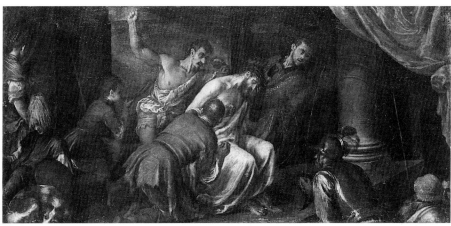

45

231. The drawing (Städelsches Kunstinstitut, Frankfurt, inv. 15216) seems to prepare the Saint Roch, but similar recumbent figures recur in several paintings of these years. It is, in any case, a precocious example of Jacopo's most aggressive use of colored chalks.

232. Oil on canvas, 53 × 111 cm. Part of the Contarini gift to the Accademia in 1836, this picture was then ascribed to Francesco and considered a derivation from one of the Bassano shop by Arslan (1931, 352; and 1960 (B), I, 375). Rearick (1962, 525-26) associated it with the sketch (formerly Goldman collection, New York) after Titian's *Death of Saint Peter Martyr* (formerly Santi Giovanni e Paolo, Venice), the compositional study (National Gallery of Art, Washington, cat. 94) dated 1 August 1568, and the detailed study of the scourger and the head of Christ (private collection, Paris). Ballarin (1990 (B), 128-31) accepted the painting and the last two drawings as by Jacopo, but dated the picture and the Paris sketch closer to 1565. It was engraved by van de Passe in 1614 (Pan 1992, no. 38) with expanded space below and, especially, above to conform to baroque taste. Several painted derivations follow the print format.

ditions aged at a different pace, so that the present effect is one of a makeshift collage of two painters and even more restorers. The original portion is a composite of figures from earlier paintings, and no restoration could give it the majestic breadth of *Saints Peter and Paul*. Nonetheless, all three figures are more solidly constructed and broadly brushed than the tensely introverted preceding paintings, and their relaxed disposition suggests a more assured frame of mind on the artist's part. Still, the colored chalk study (Städelsches Kunstinstitut, Frankfurt, cat. 90) for the Roch is harsh and aggressive, a powerful evocation of the tension that gives these works their charged atmosphere.[231]

On 1 August 1568, Jacopo inscribed the date on one of his earliest surviving compositional sketches in colored chalks, *The Scourging of Christ* (National Gallery of Art, Washington, cat. 94). A rather cautious colored chalk drawing (formerly Goldman collection, New York) after Titian's destroyed *Saint Peter Martyr* altarpiece (formerly Santi Giovanni e Paolo, Venice) preceded it and served as the point of departure for the scourger above Christ in the compositional drawing. In turn, another colored chalk *Scourger with the Head of Christ* (private collection, Paris) developed this detail toward the form it would take in the painting of *The Scourging of Christ* (Gallerie dell'Accademia, Venice, fig. 45).[232] This delicate and touching work shares elements with the *Saint Eleutherius* altarpiece of the preceding year, but its richer color and softer texture suggest that the artist's enthusiastic involvement with a more important project is here reflected by a quickened pictorial vivacity. That project was the 1568 *Adoration of the Shepherds with Saints Victor and Corona* (Museo Civico, Bassano del Grappa, cat. 46).

<div style="text-align:center">★</div>

By Christmas 1568, Jacopo dal Ponte was about fifty-eight years old – for the cinquecento well beyond maturity, if not on the threshold of old age. Jacopo could look back on a forty-year career, thirty of which were spent as the recognized head of a prosperous business in his home town. Now his status had changed, and he doubtless seldom or never dedicated his efforts to craft work such as sign painting, decorating paschal candles, or designing embroideries. Instead, his fame in faraway places had brought him more commissions than he could fill, and in Venice his pastoral easel pictures were in wide demand. His brother was now ten years dead, and the artisan side of the Dal Ponte workshop ceased to function or was left to professional associates who specialized in crafts and did not paint.[233] For the moment, these associates, who participated in some works of the 1550s, must remain anonymous. Over the previous decade a splendid new prospect for the Dal Ponte firm had opened with the first of Jacopo's four sons.[234] The baby of the clan, Gerolamo, was two and one-half, and perhaps the thought of improving his lot by sending him to the university in Padua had already occurred to his father. Leandro was not yet eleven, but might already have been initiated into minor tasks in the studio. Giambattista at fifteen would have been in the midst of his training as an apprentice, and it might already have been clear that his aptitude for painting was indeed modest. Finally, it was young Francesco who clearly promised to be a worthy successor to his father and the prime hope for family continuity into a third generation. Approaching the age of twenty, Francesco seems to have been a prodigy, learning from copying Jacopo's pictures when he was barely ten years old. *The Adoration of the Shepherds* (Sammlung Oskar Reinhart, Winterthur, fig. 46) is a rather bumbling repetition of the Corsini *Adoration* (cat. 36), which Jacopo took over, correcting its mistakes just as he had years before for his brother.[235] Soon the lad improved sufficiently to replicate the Washington *Annunciation to the Shepherds* (cat. 30) several times over and to come deceptively close to the quality of the original.[236] Francesco continued to paint replicas of the master's inventions during the 1560s until, around 1567, when he designed, executed, and proudly signed *The Miracle of the Quails* (private collection, Verona), which is a remarkably adroit composite of figures from his father's works and some of his own design.[237] His future, as well as that of the Dal Ponte establishment, seemed assured as the holiday approached.

On 18 December 1568, *The Adoration of the Shepherds with Saints Victor and Corona* (Museo Civico, Bassano del Grappa, cat. 46) was solemnly installed above the altar in the small church of San Giuseppe next to the cathedral in Bassano.[238] We may assume that the painter was present for the occasion,

233. The ample documentation afforded by the *Libro secondo* for the production of artisan objects by the Dal Ponte shop up to about 1559 is, of course, missing for the years that follow. It seems probable, however, that the seventh decade saw a shift toward a more cosmopolitan level of artistic activity in order to meet the wider demand for the private pastoral genre pictures. There is no record that any of Jacopo's sons worked in the craft sector.

234. See above n. 228.

235. Oil on canvas, 102 × 152 cm. Jan Sadeler engraved this version in 1599 (Pan 1992, no. 8), a print that Watteau reproduced in *Gersaint's Signboard* (Staatliche Museen Preussischer Kulturbesitz, Gemäldegalerie, Berlin). Jacopo intervened most noticeably in the kneeling shepherd, but, oddly, he left the ugly Madonna just as Francesco had painted it. Of the numerous paintings that survive of this composition, most are derived from the engraving and were not produced in the shop. The engraving is dedicated to Leonardo Mocenigo, who may have owned the picture by the end of the century.

236. See above ns. 107 and 202.

237. Oil on canvas, 148 × 195 cm. Signed FRANC.S A PÕTE/ BASSANO/ FE... Arslan (1960 (B), I, 184 and 219) saw Jacopo's hand in the head of the boy at center, but this is to underestimate the precocious expertise of Francesco in matching his father's brilliant technique.

46. Francesco and Jacopo Bassano, *The Adoration of the Shepherds*, Sammlung Oskar Reinhart, Winterthur

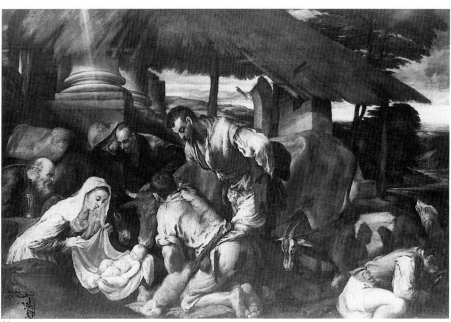

46

238. ACB, *Marieggio della Scuola di San Giuseppe*, fol. 102. The drawing (The National Galleries of Scotland, Edinburgh, inv. 2232) in black and red chalk is Leandro's derivation in preparation for the first of his ubiquitous replicas. Among the many shop replicas, one (Kunsthistorisches Museum, Gemäldegalerie, Vienna) is signed by Gerolamo and may be dated to his retraining in Bassano c. 1590, on his return from Padua.

perhaps accompanied by Francesco and other members of the clan. If his work over the previous two years shows signs of crisis, this *Adoration* shows them to have been triumphantly superseded. The challenge was not minor, since Jacopo had treated the subject previously only in a horizontal format whereas here a tall, arch-topped altarpiece was required. Further, Saints Victor and Corona had to be included as well as the donor who had paid for it. But Jacopo's major problem lay in the necessity to translate the intimate bucolic pictures on which he had focused his primary attention for a decade into a monumental altarpiece format without losing the poetry he had so tenderly evoked on a small scale. For *Saints Peter and Paul* straightforward monumentality has served, but *Saint Eleutherius* had proved intractable, and the result was full of stressful conflicts. For the San Giuseppe *Adoration* he chose again simplicity, here disposed with apparently casual informality. In fact, the format is an infinitely subtle balance of components, beginning with the majestic Madonna, whose type is familiar but whose scale has broadened so that she firmly anchors our attention around the gently sleeping Child. Joseph is brought forward to provide a solid frame at left, and the three shepherds are disposed in rotary relation to the Child, a focus balanced by the richly emotional young shepherd, who turns to welcome his invisible companions and the animals entering from the right. The extraneous saints and donor are seen as secondary attendants, Victor's splendid military banner

providing a visual link with the top of the canvas, where athletic putti separate a dense cloud for the celestial radiance that warms the reverent ensemble. Jacopo's color is now richly sensuous, a sonorous harmony undisturbed by dissonant accents, and his texture is firmly worked by brushstrokes that are alternately broad and serene, as in Joseph's mantle, or thickly impasted to a rugged surface, as in the kneeling shepherd's rough clothing. Once again Jacopo is in magisterial control of his medium and direct in achieving his ends. With the 1568 *Adoration of the Shepherds*, his intimate genre idiom and the monumental exigencies of an altarpiece are brought into ideal balance. At once the rustics from the local countryside and the sophisticated connoisseurs recognized in it his masterpiece. Such a harmonious synthesis would not again be so serenely achieved. But, given Jacopo's compulsion to experiment, would it be maintained?

The test was not long in coming, for in 1569 Jacopo was asked to paint an equally large altarpiece of *Saint Jerome in the Wilderness* (Gallerie dell'Accademia, Venice, fig. 47) for Asolo.[239] For it he took the audacious decision to allow the isolated, diminutive figure of the penitent saint to remain alone in a darkling landscape. The vision of the Madonna in glory above hardly provides a consoling force, since Jacopo assigned it to Giambattista, whose leaden prose carries no expressive impact. If one ignores her, the scene takes on a powerfully melancholy tone, one in which the human anguish of the earlier *Saint Jerome* is reduced in monumentality, but rendered more affecting by the ambiguity of the night landscape, poised between somnolent repose and hidden danger. The tormented fixation of the fierce saint elicits a sympathetic wail from his lion. Unseen for decades, this *Saint Jerome* is one of Jacopo's most unjustly neglected works.

Simultaneously with the completion of the 1568 *Adoration of the Shepherds*, Jacopo decided to recast that altarpiece on an intimate scale. In one of his most astonishing drawings (Staatliche Museen Preussischer Kulturbesitz, Kupferstichkabinett, Berlin, figs. 48, 49), Jacopo took a large sheet of blue paper and with a maelstrom of ferocious, almost random strokes restudied the composition of the altarpiece; he turned the paper over, reversed the first sketch, and with hardly less energy set down its essentials in a format he then, surprisingly, painted with a delicate preciosity quite unlike the sensuous strength of the larger picture.[240] He signed this exquisite canvas (formerly art market, London) and turned it over to Francesco, who made two fine replicas.[241] On the drawing Jacopo inscribed the date « 1569 » and the phrase *Nil mihi placet* (nothing satisfies me), a Latin motto found on another of his many drawings from 1569 and a rare insight into the restless determination with which he sought to channel his creative urge.

The exceptional number of drawings which Jacopo dated in 1568, and es-

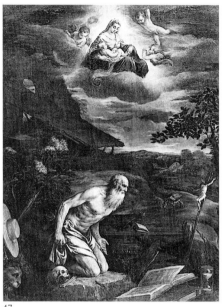

47

239. Oil on canvas, 222 × 162 cm. Signed and dated: 1569/ G.o A. P.t P.t B. Painted for the high altar of the church of the Padre Riformati in Asolo, this picture passed to the Palazzo Reale, Venice (ca. 1812), the Kunsthistorisches Museum, Gemäldegalerie, Vienna (c. 1866), and back to the Palazzo Reale, Venice (c. 1870), before entering the Gallerie dell'Accademia, Venice (c. 1930), where it was exhibited until 1957. Arslan (1931, 116, 135, and 354) thought that Leandro painted the obviously weaker Madonna and Child, even though the boy was only eleven or twelve in 1569. Rearick (1962, 529) first thought that Francesco assisted in the upper part, but I am now more inclined to see this particularly lethargic hand as that of Giambattista, who was then sixteen. Francesco was and would remain far more accomplished, as comparison of the Verona *Miracle of the Quails* of two or three years before confirms. A sketched derivation from the lower part of the finished picture (private collection, Paris, 74 × 95.5 cm) is probably a painted *ricordo* by Giambattista. See above n. 230.

240. Dreyer 1983, 145-46. Rearick 1989, III, no. 5. Dated « 1569 » twice and inscribed « *Nil mihi placet* ». Were it not for the date, it would be easy to see the recto as a sketch for the 1568 *Adoration of the Shepherds* (cat. 46).

48. Jacopo Bassano, *The Adoration of the Shepherds*, recto, Staatliche Museen Preussischer Kulturbesitz, Kupferstichkabinett, Berlin

49. Jacopo Bassano, *The Adoration of the Shepherds,* verso, Staatliche Museen Preussischer Kulturbesitz, Kupferstichkabinett, Berlin

48

241. Signed JAC. A PONTE/ BASS. The exact replicas (Bode Museum, Berlin; and formerly Gemäldegalerie Alte Meister, Dresden) are of excellent quality and might have passed as Jacopo had not the signed version appeared. Francesco's Dresden replica was engraved by Pierre Chenu (see Pan 1992, no. 116) in 1753-57 with an attribution to Francesco.

49

pecially in 1569, suggests that he was subjecting the Dal Ponte studio to an organizational reform in which a measure of order was needed so that drawings might easily be associated with particular projects. There was a special necessity for *ricordo* drawings after finished pictures, a visual repertory to be kept for reference on canvas rolls.[242] We know, from one of the last references to a painting commission in the *Libro secondo* accounts, that in 1569 Jacopo undertook to provide « *cartoni* » for an *Annunciation* in which the figures were to be larger than life. The document is vague about the type of painting required, but we know that Jacopo painted an *Annunciation* on paired canvases in which the figures are about half life-size. Of these paintings one, *The Archangel Gabriel*, survives (private collection, Baltimore), but both are preserved in particularly fresh and spontaneous *ricordo* drawings that he dated 1569 (Christ Church, Oxford; Gabinetto Disegni e Stampe degli Uffizi, Florence, cats. 99, 98).[243] The drawing of *The Visitation* (Gabinetto Disegni e Stampe degli Uffizi, Florence, cat. 97), dated 1569 with the inscription « *Nil mihi placet* », is partly in Titian's preferred black chalk medium, but its elaborate mannerist form suggests that even at this late date the artist remembered Schiavone.[244] It served the late shop when the theme was required for *The Madonna del Rosario* (parish church, Cavaso del Tomba) of 1587. Equally, the 1568 *Capture of Christ* (Musée du Louvre, Département des Arts Graphiques, Paris) and the 1569 *Presentation of the Virgin* (National Gallery of Canada, Ottawa, cat. 95) might have prepared paintings, but none survives today.[245]

Although Jacopo tended to see a clear distinction between his peasant genre compositions on a small scale and his monumental altarpieces during the preceding decade, the 1568 *Adoration* being the single completely successful fusion of these two types, from 1569 on he began to experiment by enlarging the genre scenes and filling them with many animals and smaller scale figures. Clearly intending to satisfy the Venetian market for rustic subjects while rendering them better able to hold their own in larger palace spaces, he assayed for the first time a subject occasionally depicted by Venetians, but only in the context of biblical cycles.[246] *The Expulsion of the Merchants from the Temple* (Museo del Prado, Madrid, fig. 50) employs the familiar Bassano device of relegating Christ to the upper distance, so that the scattering farmers rushing away with their animals and produce in the foreground seem part of a candid news reportage of an actual event in which they are, as it were, innocent bystanders.[247] The result, paradoxically, is that all our sympathy goes to the discomfited merchants, and only the moneychanger at lower right and the dismayed priests on the steps at left seem mildly wicked. If it occurred to Jacopo to use this subject as a Counter-Reformation tract against a Church in need of cleansing – the direction taken just a year or two

242. Verci 1775, 100. Rearick 1962, 533. Many drawings by Jacopo bear traces of the glue used to paste them to these canvas rolls.

243. Oil on canvas, 90.5 × 47.7 cm. From the Italico Brass collection, Venice. Rearick 1962, 530 and 533. Both *ricordo* drawings (Christ Church, Oxford, cat. 99; Gabinetto Disegni e Stampe degli Uffizi, Florence, cat. 98) are inscribed with the date « 1569 » in Jacopo's hand and preserve the original format of the paired paintings. The *Archangel Gabriel* was modified and, by the addition of sword and scales, turned into Saint Michael. The last entry regarding paintings in the *Libro secondo*, fol. 101 *v*, records for 1569 « *la Nontiation de l'angello e la Madonna grande più del vivo... due figure sopra li soi cartoni* ». Although the medium and function of the two separate parts of this *Annunciation*, done for the Scuola di San Paolo in Bassano del Grappa, is not defined, neither the *ricordo* drawings nor the surviving painting is larger than life. There is every probability, however, that all of these works are closely related and that the drawings might be what the accounts call cartoons, as Ballarin (1969, 85) suggested. See Muraro 1992, 415.

244. Rearick 1989, III, no. 7.

245. Rearick 1989, III, nos. 4 and 6.

246. The most visible example was the large canvas by Stefano Cernotto (Gallerie dell'Accademia, Venice, on deposit at the Fondazione Giorgio Cini), which was painted c. 1536 for the Magistrato del Monte Nuovissimo in the Palazzo dei Camerlenghi in Venice. Its patent debt to Cernotto's master, Bonifazio, opens the possibility that both he and Jacopo knew a lost work by that master, who was an ongoing source of ideas for each.

247. Oil on canvas, 149 × 233 cm. Severely damaged in the 1734 fire in the Alcázar, Madrid, this painting has always carried the name of Jacopo Bassano, but it has been accorded inadequate attention in the literature.

50. Jacopo Bassano, *The Expulsion of the Merchants from the Temple*, Museo del Prado, Madrid

51. Jacopo and Francesco Bassano, *Noah Gathering the Animals into the Ark*, Museo del Prado, Madrid

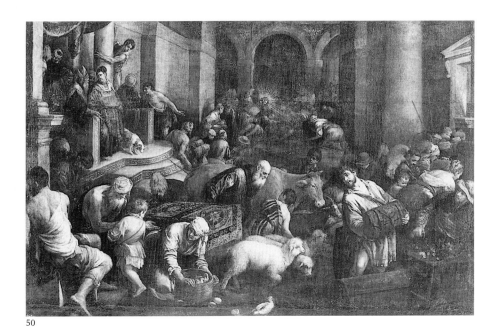

50

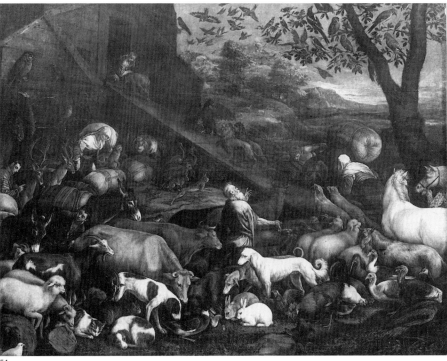

51

later by El Greco, who clearly knew this picture – he rejected the portrayal of righteous anger in favor of seeing Christ as a nuisance who creates a public disturbance. Despite old fire damage that has obscured its surface, especially toward the top, the technique here may be read as the preciously finished miniaturist style used in the 1569 *Adoration* and the *Jacob* pendants of about two years before. The head of the 1569 *Saint Jerome* served for that of the elder at center. No drawings for this important picture survive, but since so much of its staffage was destined for repetition over the next three decades, many must have been done and kept in the shop. A small painting of *A Ewe and its Lamb* (Galleria Borghese, Rome) suggests that Jacopo continued to paint small pictures of animals as he had done for Zentani's *Two Hunting Dogs* many years before, but it is equally possible that this charming canvas is a fragment of a larger picture.[248]

Perhaps encouraged by the success of *The Expulsion of the Merchants*, which is nearly as large as the 1568 *Adoration* altarpiece, Jacopo undertook his largest and most ambitious project in this genre, the *Noah Gathering the Animals into the Ark* (Museo del Prado, Madrid, fig. 51), which measures 207 × 265 cm.[249] On this scale it was certainly not part of a Noah cycle of the type Jacopo would later create with great success, nor do we know for whom it was painted. Ridolfi reports that Titian bought a fine picture of this subject from Jacopo, and although the Prado picture can be traced only to the collection of Prince Philibert of Savoy in the early seventeenth century, it is still possible that it had made its way to Turin after the dispersal of Titian's estate in 1577. For it Jacopo doubtless made many drawings of animals, of which two survive (Gabinetto Disegni e Stampe degli Uffizi, Florence, cat. 104; and Staatliche Museen Preussischer Kulturbesitz, Kupferstichkabinett, Berlin), and he certainly called on Francesco and perhaps Giambattista for assistance in painting this grand menagerie.[250] Placing his horizon rather high, he disposes his animals in two diagonals, which allows each to be clearly identified. It is, indeed, this simple delight in natural description which would have reduced the picture to a mere zoological catalogue were it not for the harmonizing unity of the dusky light and the small but commanding figure of Noah at the center. Once again, Jacopo's simple trust and delight in nature enables him to endow the humble participants with an awesome solemnity.

Among the most mysterious of Jacopo's pictures is the pastoral canvas (Szépmüvészeti Múzeum, Budapest, cat. 45) that seems simply to represent peasants and their stock in a landscape.[251] Given the improbability that in the cinquecento a fine picture on this scale would be essentially subjectless, a mere slice of agrarian life, we must search further for its subject. The clue may be found in a source that Jacopo evidently knew and had studied with care. The sumptuous breviary illuminated by the Netherlandish miniaturist

248. Oil on canvas, 30 × 51 cm. Recorded in its present format in the Borghese collection since 1650, this canvas was then ascribed to Titian, as was the Uffizi *Two Hunting Dogs* (cat. 26). Only removal of the evidently later neutral background will resolve the question of its autonomy, but the fact that these animals do not appear in any replicas and that they are a balanced composition in their present planar format suggests that this is an independent animal portrait. The qualitative analogy with the Prado *Expulsion of the Merchants* confirms Jacopo's authorship.

249. Oil on canvas, 207 × 265 cm. Titian listed this subject among the pictures he claimed to have sent to Philip II, but no painting of this theme by him survives, nor was any recorded in Spanish Royal inventories. The traditional report that the Prado picture had been sold by Titian to Emperor Charles V, who took it into retirement with him at San Yuste, is manifestly impossible, since Charles abdicated in 1556 and died in 1558. Ridolfi (1648, I, 379) recorded that Titian had purchased a painting of this subject from Jacopo for the significant sum of 25 scudi. Although the Prado canvas was bought by Philip IV from Emanuel Philibert of Savoy, its history between Titian's death and this acquisition remains unknown. Thus, although its provenance is clouded by ambiguity, it is possible that this is the canvas sold by Jacopo to Titian. I would no longer insist that the older master repainted parts of it.

250. Rearick 1989, III, nos. 10 and 11. In a pattern that would be standard for the remainder of his life, Jacopo sketched the composition onto the canvas, turned the intermediary stage of painting over to Francesco and, marginally, to Giambattista, before returning to paint all of the Noah, the son at left, the head of the youth at left center, the woman at top left, the woman at the ark door, and a scattering of finished detail in the animals. Disjunctures in scale such as that between Noah and the dogs below him are evidence for two hands at work with lapses of coordination. Surprisingly, no replicas are known.

251. The motive of the sleeping shepherd seems appropriate for an Annunciation to the Shepherds, and, indeed, the Budapest composition would be adapted for several paintings of that theme, as well as a lost *Jacob's Journey* that was engraved by Jan Sadeler (Pan 1992, no. 3). Its author was probably Leandro, c. 1578-80. Unless they have been painted

out, the essential angel and shepherds or God and Jacob are missing here. Ballarin (1990 (B), 144) ingeniously identified the subject of the Budapest picture as *Mercury Stealing the Flocks Guarded by Argos*, but the sleeping Argos has only two, rather than a hundred, eyes and the child at right can hardly be Mercury who, in any case, decapitated Argos before stealing his herd. Here he gently leads them to the water bucket in the foreground.

252. For the Grimani Breviary, see Ferrari 1971.

253. Verci (1775, 100, no. 177) lists an *August* as a sketch in chiaroscuro. Along with *January*, *February*, *March*, *April*, and *June*, it apparently served as the shop model for replicas. The *May* of this suite is simply described as having the sign of Taurus painted in the sky, a detail that suggests that they all had the appropriate zodiacal sign. It is probable, given the proliferation of replicas after about 1585, that these *bozzetti* relate to the well-known cycles preserved in Vienna, Prague, and elsewhere. See below n. 305. There seem to be no surviving painted replicas of the Budapest *August*, but a drawing after it (Teylers Museum, Haarlem) is not by a member of the Dal Ponte family and might be a preparation for a print. Another fine chiaroscuro *ricordo* (present location unknown) is after a variant in which the younger shepherd boy is omitted, thus confirming that he was not essential to its subject. Teniers painted a simplified variant of the Budapest composition (The Metropolitan Museum of Art, New York).

254. Monumental ceiling allegories of the *Seasons* survive by Bonifazio (John and Mable Ringling Museum of Art, Sarasota; Szépművészeti Múzeum, Budapest) and Tintoretto (Chrysler Museum, Norfolk; National Gallery of Art, Washington; and private collection, Bergamo). In both cases they date to the first half of the 1540s, when maniera figural complexity was at its apogee in Venice.

Simon Bening and his associates at the beginning of the century had been a jewel of the Grimani collection for many years and was shown to connoisseurs and artists alike. In the calendar section at the bottom of the page facing the month of August (folio 9 recto), the illumination depicts characteristic aspects of peasant life during late summer.[252] The principal figure is a youth in rustic garb asleep on his back at left, his knees together and his hatted head thrown back. Spread in front of him is a varied assortment of farm animals around a fountain. In short, Jacopo's painting may most likely illustrate the astrological sign of Leo, whose symbolic lion seems to have been painted out in the sky at top center at a later date. Although canvases depicting *August*, with its appropriate astrological sign in the sky, were found as models in Jacopo's studio after his death, this composition was, as far as we know, repeated only in drawn form, and the dozens of shop repetitions of the later type are better candidates for the *modelli* left in 1592.[253] Even if it is not the sole surviving piece from a full cycle of the Months painted about 1570 and destined to be superseded in 1576 by a succession of variants, this *August* or *Leo* is a work of major importance. Seasons, Months, or variations on such were familiar subjects throughout the medieval and Early Renaissance periods, and a major cycle of late Gothic murals existed in the Torre dell'Aquila at Trent, not far from Bassano del Grappa. However, the elevated formal and iconographic concerns of the High Renaissance caused the genre to pass from favor.[254] During the second half of the cinquecento the same agrarian current that lent new interest to Virgil's *Georgics* prompted a revival of Season and Month cycles, both north of the Alps and in the Veneto, where Northern graphics had long been admired and imported. Jacopo's composition shows the moment in which the grazing animals are gathered by the boy at right to be watered from the tub in the left foreground. The densely humid summer atmosphere lends the quiet assemblage a somnolent reticence, a languor subtly conveyed by the dozing youth at left. An imminent transition is, however, suggested by the sense of impending storm as well as the equipment loaded on the melancholy white horse, whose pack includes a tub of the type that will be put to use for the grape harvest in September and, presumably, in the next canvas. Jacopo's color is here restrained, rather in the same muted rose and gray of the *Saint Jerome*, but his delicate attention to texture and detail is more refined. This *August* is, in effect, such a quiet painting that one might, as the literature has until quite recently, pass over it without recognizing its exceptional potency for future painting, both Jacopo's and that of the baroque.

In pictures prior to 1570, Francesco's role had been primarily that of replicator and modest collaborator in secondary passages of Jacopo's paintings. Now he was capable of working on his own, but Jacopo evidently main-

52. Jacopo and Francesco Bassano, *Abraham's Journey*, private collection, Montreal

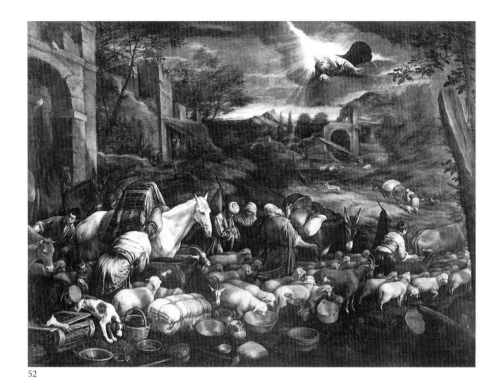

52

tained an iron hand in the family shop, and for the moment his talented son was held firmly in check. His primary outlet was the revision and expansion of his father's inventions, as with the monumental new treatment of *Abraham's Journey* (private collection, Montreal, fig. 52), almost interchangeable with *Jacob's Journey* were it not for the celestial appearance of God the Father.[255] The Prado *Noah's Ark* served for many of its motives, but others were lifted from *August* or other works of the early 1570s. Jacopo, as was his wont, made revisions and added finishing glazes and detail. It should probably be dated a bit after the works we have placed around 1570.

Large altarpieces representing tradition-bound subjects still presented difficulties for Jacopo in these years. His most original experiments were in the peasant genre idiom, an informal naturalism hardly adaptable to an altarpiece format, save on occasions when the Adoration of the Shepherds did in fact encourage such a unity. Probably in 1570, the Collegio dei Notai in Belluno commissioned Jacopo's largest altarpiece to date for the new cathedral. The resulting *Martyrdom of Saint Lawrence* (fig. 53), which is still *in situ*, provided him with just such a challenge.[256] The artist sought to resolve it in familiar ways. He consulted Cornelius Cort's engraving of the subject, circulated among artists in 1567 but not published until 1571.[257] Titian had provided the

255. Oil on canvas, 191 × 257 cm. Once in Hamilton Palace (sale Christie's, London, 17 June-20 July 1882, lot 763), this impressive picture was first published by Ballarin (1969, 101). The distinction between *Jacob's Journey* and *The Departure of Abraham* in the numerous Dal Ponte treatments is here arbitrarily based on the visible presence of God, who explicitly appears to Abraham, but is not so specified in the biblical account of Jacob's departure.

256. Oil on canvas, 327 × 209 cm. Signed and dated: JACOBUS A PONTE/ BASSANENSIS PING./ M. D. L. XXI. Commissioned by the Collegio dei Notai, it was probably begun in 1570. An elaborate *ricordo* (Gabinetto Disegni e Stampe degli Uffizi, Florence, inv. 13065 F) is clearly the work of Francesco, who also participated rather extensively in the painting.

257. Bierens de Haan 1948, 144 and 147, nos. 139 and 140. Chiari 1982, 56, no. 11.

53. Jacopo Bassano, *The Martyrdom of Saint Lawrence*, cathedral, Belluno

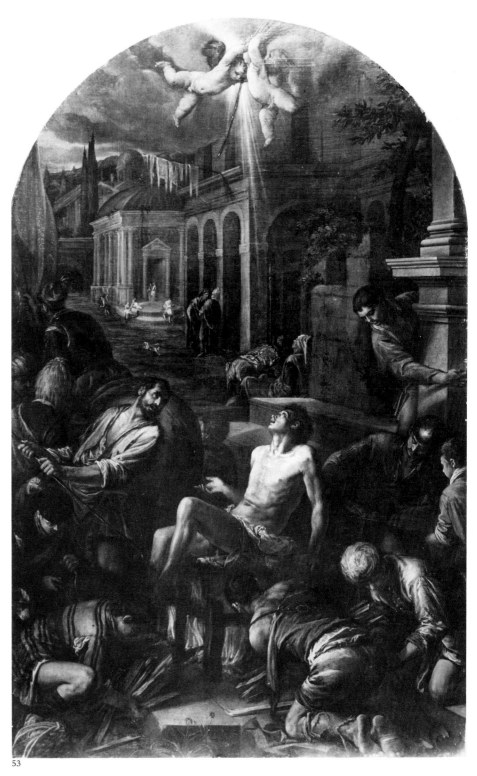

53

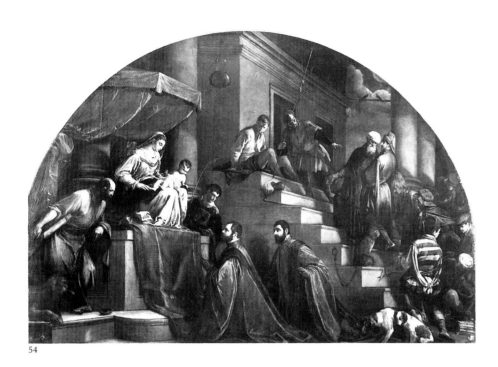

54

printmaker with the design, and although Jacopo had probably seen both nocturnal paintings that Titian had done of the theme (Church of the Gesui-ti, Venice; and Colecciones del Real Monasterio, El Escorial), he worked directly from the print. Thus, he transformed the torch-lit night scene to full daylight, gaining intelligibility but losing dramatic chiaroscuro, and, drawing on the repertory of rustic types used in recent pictures, particularly the Prado *Expulsion of Merchants from the Temple*, he set the martyrdom as though it were a routine event in the main square of a market town. The result is faintly absurd, and the painting is saved only by passages of dazzling pictorial beauty such as the iridescent cobalt and lavender of the executioner's sleeve at lower right. The artist signed and dated it in 1571.

Although such civic votive pictures existed in quantity in Venice, Jacopo seems not to have been required to paint one since his youthful votive done for Matteo Soranzo (cat. 2) thirty-four years before. Now the rectors of Vicenza needed a huge lunette for their civic council hall, and they chose as its theme their gesture of pardoning prisoners from the local jail in thanks for the town's being spared the worst of an outbreak of plague in 1572. *The Ma-donna and Child with Saints Mark and Lawrence Being Revered by Giovanni Moro and Silvano Cappello* (Museo Civico, Vicenza, fig. 54) was signed and dated 1573.[258] Veronese would have rendered it a serene civic festivity, Tintoretto would have underscored inner formal and psychological tensions, and Jaco-

258. Oil on canvas, 340 × 510 cm. Signed: JAC. A. PONTE/ BASS. F. Dated: M. D. L. XXIII. Commissioned by the Rectors of Vicenza, Giovanni Moro and Silvano Cappello whose arms, together with those of Vicenza, appear at left on the occasion of Vicenza being spared the worst of the outbreak of plague in September 1572. At right Jacopo depicted their act of thanks in granting pardons to prisoners in the local jail. Both Titian and Tintoretto inspired passages of the Vicenza lunette, but its discontinuous collage of disparate elements is Jacopo's doing, as is much of the execution. A *ricordo* painting (art market, Washington) by Leandro reproduces the finished work.

259. Oil on canvas, 178 × 119 cm. According to Magagnato (1952 (A), 45) the *Libro dei Battezzati, Libro II, 21 decembre, 1573* preserved in the parish church at Cassola records the installation of this altarpiece. Its format is archaic, recalling the Pove altarpiece of more than thirty-five years before, but the Saint Mark provided the model for several later pictures. The condition is disastrous, with almost no passage of finished surface intact. It is probable that there was significant shop participation in its execution, perhaps by Giambattista.

260. Palluchini (1982, no. 35) saw extensive participation by Francesco, especially in the landscape, but the balanced pictorial integrity of every passage of its execution suggests that here Jacopo worked virtually unassisted. Later (see below n. 345), he collaborated with Leandro in painting a revised version of the Padua composition. It was probably in anticipation of that project that Leandro painted the small *Entombment* (Kunsthistorisches Museum, Gemäldegalerie, Vienna), a loose, but rather labored work, which has sometimes passed as Jacopo's *modello* for the Santa Maria in Vanzo altarpiece. As Ridolfi (1648, 1, 384) noted, there are many later replicas of this composition, most of them based on the Vienna type and largely by Leandro or the shop.

261. Oil on canvas, 303 × 190 cm. Signed and dated: JAC. A. PŌTE BASS.is/ ET FRANC.S FILI.S/ PINGEBAT. 157[4]. This appears to be the first instance in which Jacopo signed a picture with Francesco, who was twenty-five at the time. For it Jacopo adapted his Padua *modello* (cat. 32) with more recent additions such as the Saint John, which is based on the Cassola Saint Mark. The hand of Francesco predominates throughout. A roughly painted monochromatic version (Kress collection, New York), in which the Saint John is omitted, was produced in the shop by Giambattista after the finished picture. Memmo (1754, 78) records what he called a modello in the Fantucci collection in Ravenna, perhaps the Kress painting. It probably provided the source for the large repetition (Accademia Carrara, Bergamo) produced by the late shop, perhaps again Giambattista.

po might have made it a candid vignette of life in Vicenza. Instead, he fell into the trap of juxtaposing holy figures and civic personages in a fragmented and episodic order. The result is confused and discontinuous, with the Madonna dull and prosaic, the donors fine as portraits but isolated from their environment, and the release of prisoners at right dramatically incoherent. Again, isolated passages of great virtuosity, such as the solidly constructed page in turquoise and lavender, are painted with such elan as to almost convince us that the picture is a success. Francesco and his siblings clearly collaborated in secondary passages, but they cannot be held responsible for its tiresome aspects. Nor did their more extensive participation cause the poor impression made by the *Saint Mark in Glory with Saints John the Evangelist and Bartholomew* (parish church, Cassola) installed 21 December 1573.[259] Instead, this routine product is severely damaged by restoration.

From Padua came the invitation to paint *The Entombment* (Santa Maria in Vanzo, Padua, cat. 52), a large altarpiece that Jacopo signed and dated 1574.[260] Once again, the subject permitted an ideal conjunction between the monumental exigencies of the altar format and Jacopo's pastoral concerns. A harsh white light, ambiguously poised between moonlight and a divine intervention, focuses on the tragic scene in which the ashen corpse is carried to burial by Nicodemus and Joseph of Aramathea as the grieving Virgin, her gray face lined by pain, falls into the arms of the weeping holy women. The sputtering torches pale against the merciless glare. Above, and occupying fully half the canvas, a shadowy forest stirs in the nocturnal breeze. Its woodsy depth opens to a distant glimpse of Golgotha and the first gleam of dawn on the horizon, a hopeful note, as is the goldfinch-symbol of the Resurrection – and the broken tree from which a new branch is growing – equally an augury of the release from death. All nature seems to participate with tremulous emotion in the night drama; seldom does Jacopo bring every element into play with such unity of purpose and effect.

Later in the same year an order for another large altarpiece arrived, this time from the less important village of Marostica, and for it Jacopo pressed Francesco into service, something he had avoided in *The Entombment*.[261] For *Saint Paul Preaching* (Sant'Antonio, Marostica), Jacopo returned to his small *modello* (cat. 32), expanding its staffage and setting to suggest a village square replete with hanging laundry. The vision of Saint John above was simply lifted from the already dull figure of Saint Mark in the 1573 Cassola altarpiece. Jacopo returned to add finishing highlights and detail to the foreground figures, but since Francesco had, in fact, painted most of the picture, he was permitted to sign it jointly with his father, the first of many pictures signed by both artists.

The plague broke out in several rural areas around Bassano in August

55. Jacopo Bassano, *The Martyrdom of Saint Sebastian*, Musée des Beaux-Arts, Dijon

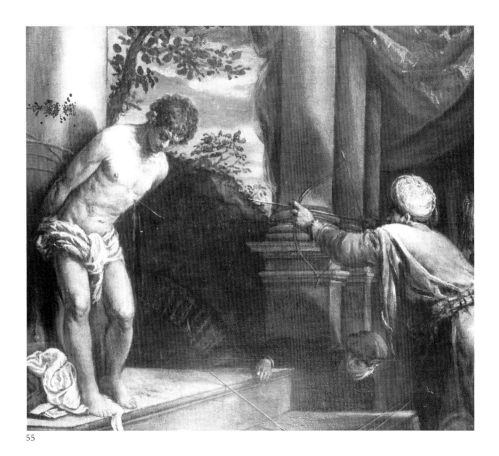

55

1574, and at least one Dal Ponte project was certainly a direct result. The small *Martyrdom of Saint Sebastian* (Musée des Beaux-Arts, Dijon, fig. 55) is not a narrative image of the event but served rather as an emblematic ex voto to the saint most often invoked for protection from the dreaded malady.[262] As such, it lacks drama, but its utility is attested by replicas for which Francesco drew on his father's delicately atmospheric *ricordo* drawing (Royal Library, Windsor Castle, Berkshire, cat. 106).[263] Not long afterward Jacopo turned over entirely to his sons the utilitarian job of making *ricordo* drawings.

Jacopo's development in the years between 1568 and 1574 is one of complex and often contrasting directions. Even after the success of the 1568 *Adoration* and the audacious *Saint Jerome* of the following year, Jacopo's discomfort with large, tradition-laden subjects continued to leave altarpieces such as the 1571 *Martyrdom of Saint Lawrence* suspended in an ambivalent duality between candor and ideality. Only the powerful *Entombment* entirely escaped this indecision by way of its unity of natural environment and sacred drama. It was, indeed, in the area of biblical themes presented in a natural imagery

262. Oil on canvas, 65 × 76 cm. Signed and dated: JAC. BASSANEN./ FACIEBAT/ AN MDLXXIV. From the collection of Archduke Leopold Wilhelm in Brussels (1659), this small picture passed through the Hapsburg royal collections (1660-1809) to the Musée Napoleon (1809-11) and, on deposit, to Dijon (1811). A prior, but not necessarily first, use of the Saint Sebastian is found in the Vassar banner (fig. 31), where the saint was paired with Saint Roch. Later, the figure appeared in the Treviso altarpiece (fig. 44), and would be repeated frequently, as in the *Saint Roch* altarpiece (cat. 47).

263. This *ricordo* remained in the shop, where Gerolamo used it for a picture (private collection, Bologna) that follows the model exactly. It dates from about 1582, but later Gerolamo and the Bassano shop excerpted the saint for several small devotional pictures.

that he made significant progress. Often large in scale, these aggregations of animals and simple folk in landscape settings seem to have occupied a place of honor in Venetian palaces. When, in late 1572, a spontaneous exhibition of masterpieces was held at the Rialto bridge to celebrate the victory over the Turks at Lepanto, a contemporary report said that among the privately owned pictures by masters long dead such as Raphael and Giorgione and living legends such as Titian, there were paintings by Bassano, described as «... miraculous in painting pastoral things».[264] The work of no other contemporary was included. Jacopo could no longer ignore the great world beyond his village, but he could and did depict his homeland with honesty and conviction, a pastoral imagery that the cosmopolitan world consumed with ever-increasing voracity.

*

If the threat of plague caused alarm in the autumn of 1574, it would loom as more dangerous a year later. In the meantime, Jacopo found himself with another, albeit modest public commission from Venice. Once again the church of San Cristoforo della Pace, located on an island between Venice and Murano, asked Jacopo to paint a small altarpiece of *Saint Jerome* (lost).[265] For at least a decade Jacopo had known Titian and was clearly a welcome guest in the master's studio at Biri Grande, just a few steps from the waterfront toward San Cristoforo. One might suppose that it was during a trip to Venice to settle matters and study the site for the altarpiece that Jacopo called on the senior painter and saw the great *Saint Jerome* (Colecciones del Real Monasterio, El Escorial), which Titian was about to ship to Philip IV in Spain.[266] With that masterpiece in mind, he took a sheet of blue paper and sketched in black and white chalks his own idea (Accademia Carrara, Bergamo, fig. 56) for the San Cristoforo altarpiece, equally based on his own 1569 *Saint Jerome* altarpiece, but new in the inclusion of the scholar's paraphernalia.[267] Turning his paper over, he studied his idea for the fresco of *The Flight into Egypt*, which he painted in the lunette over the door of San Giuseppe in Bassano del Grappa, probably during the early summer of 1575.[268] During these peregrinations the sixteen-year-old Leandro seems to have accompanied Jacopo and to have painted a replica (Museo Civico, Padua) of his now lost *Saint Jerome* altarpiece.[269]

Plague sprang up in Bassano toward the end of the summer, and this time Jacopo took the unusual precaution of retreating from the town to the village of Cartigliano on the banks of the Brenta to the south. It was there that he had painted one of his first fresco projects, *The Resurrection* and the *Christ Expelling the Merchants from the Temple* (lost) in 1535-36. Now, forty years later,

264. Benedetti 1571, unpaged, and Gombrich 1967, 62-68.

265. Ridolfi 1648, I, 379. By 1775 Verci merely quoted Ridolfi, suggesting that the painting had already disappeared from the church.

266. Wethey 1969, 136, no. 108. Clearly the picture shipped to Philip II on 25 September 1575. It would have been nearing completion in Venice in the spring of 1575, when we believe that Jacopo saw it at Biri Grande. One of the supreme masterpieces of Titian's last years, its impact would be long lasting for Jacopo.

267. Rearick 1991 (A), IV, no. 9.

268. Volpato (1685, 248-49) mentioned this fresco as in Jacopo's latest style, and Verci (1775, 89) reported its date to be 1575. Vitorelli (1833, 27) is the last to mention it as extant. It was probably in the arched lunette over the church door. Its primary source was the unfinished small altarpiece (parish church, Borso del Grappa, cat. 3) of about thirteen years before.

269. The Padua *Saint Jerome*, oil on canvas, 118 × 97 cm, came to the Museo Civico in 1864 with the Emo Capodilista collection. See Banzato 1988, 76, no. 71. It was first tentatively assigned to Leandro, later to Francesco by Arslan (1931, 347), and by Rearick (1968 (A), 241). More recently I have come to recognize Leandro's hand here and to see the eighteen-year-old third son as beginning an active role in his father's work (Rearick 1991, IV, no. 9). Leandro would soon, probably in 1576, reproduce the San Giuseppe *Flight into Egypt*, first in a drawing (Staatliche Museen Preussischer Kulturbesitz, Kupferstichkabinett, Berlin, inv. KdZ 15791) and then in a painting (canon's sacristy, cathedral, Padua).

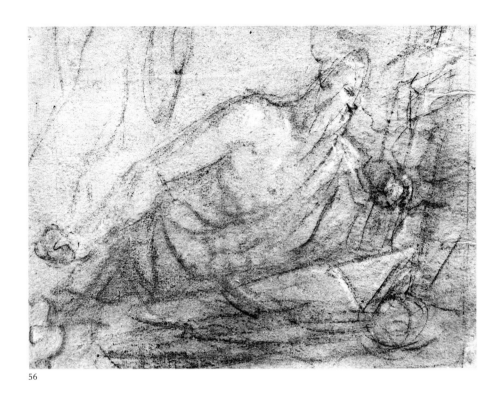

56

the parish priest there, a friend from Bassano, took advantage of the artist's
presence to commission a cycle of frescoes for the tribune of his church.
They constitute the most complete documentation for Jacopo and Francesco
as *frescanti*. Simultaneously, a canvas of *Christ on the Mount of Olives* was in
preparation, as Jacopo's drawings attest, but Francesco's replica (Museo Civi-
co, Bassano del Grappa) gives us some idea of the lost original.[270]

As winter approached and the deaths in Bassano abated, Jacopo returned
to the family shop by the bridge, where many demanding projects awaited
his attention. Doubtless the first was the imposing *Saint Roch Visiting the Plague
Victims* (Pinacoteca di Brera, Milan, cat. 47), commissioned for the church of
San Rocco in Vicenza, probably with funds left during the incursion of just a
few months before.[271] We can only speculate how much Jacopo's dedication
to this canvas was due to his personal relief that he and his family had been
spared, but the painting is one of his most incandescent achievements. Its
format is not much varied from that of *The Martyrdom of Saint Lawrence*, but
the horizon line is dropped significantly to impose a view sharply from be-
low, in which the suffering populace is brought painfully close to the specta-
tor. Apparently randomly disposed, but in effect constituted of carefully re-
vised types from his recent paintings, these figures are painted broadly, se-

270. For the drawings, see Rearick 1991
(A), IV, no. 6. For the frescoes, see Ericani's
essay in this volume.
271. The influence of Tintoretto's two pic-
tures (San Rocco, Venice) of 1549 and 1567 is
evident in the careful avoidance of any picto-
rial reference to either of them. A large
drawing (Gabinetto Disegni e Stampe degli
Uffizi, Florence, inv. 13063 F) reproduces the
lower half of the *Saint Roch* altarpiece. Jacopo
began it with a very rapid and approximate
indication of the major forms, a start almost
completely covered by Francesco's careful
chiaroscuro transcription of the finished
painting. On the verso of this ricordo a six-
teenth-century hand, probably that of Franc-
esco, wrote « *Palla/ So Rocho* ».

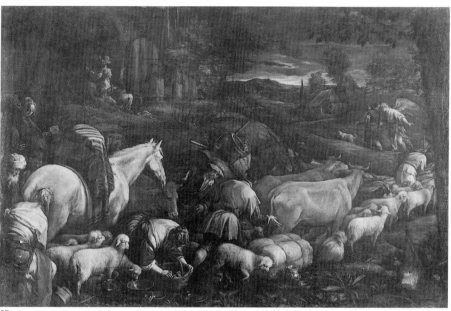

57

curely, and in resonant colors of an earthy sensuality. Most surprising, the celestial vision is conceived and executed with fervid intensity. The mature Virgin as intercessor is formulated in the same mold as the Virgin in the Asolo altarpiece of almost twenty-eight years before, but here that cool range of color is transformed into an ashen order of austere strength. If the Padua *Entombment* is a meditative masterpiece, the Brera *Saint Roch* is an authoritative pictorial ensemble that must have dominated its Gothic environment in much the same way that Titian's *Assumption* controls the space of the Frari church in Venice. Clearly Jacopo arrogated its execution to himself alone.

He was more willing to share responsibility for the two large pictures that might have been painted for the Grimani dei Servi in Venice, since they were purchased there in 1747 for the Dresden gallery. *The Return of Tobias* (Gemäldegalerie Alte Meister, Dresden, fig. 57), taking the Hampton Court *Jacob's Journey* as its point of departure, illustrated three aspects of the Tobias story.[272] At left his father-in-law, Raguel, admonishes his daughter to take the chattel given in dowry and follow Tobias, who appears at the middle right traveling toward his parents, who watch and wait at top left. Here, once again, we find Jacopo reading scripture attentively to capture the authentic spirit of the subject. Cast in a twilight landscape of rich natural pungency, the *Tobias* is painted with the same broadly secure brushstrokes and sonorous color we find in the *Saint Roch* altarpiece, which must just precede it in execution. The pendant, *The Israelites Drinking the Miraculous Water* (Gemäldegal-

272. Oil on canvas, 179 × 277 cm. Perhaps this is the picture noted by Ridolfi (1648, I, 382) in his list of subjects treated by Jacopo. It was first securely recorded by Dézallier d'Argenville (1745, 68) as in the Palazzo Grimani de' Servi, Venice. Arslan (1960 (B), I, 146, 148, 186-87, and 288) waffled between Gerolamo and Francesco. In the recent literature only Ballarin (1969, 85-114; and 1988, I) has recognized the importance of the Dresden pictures, which he ascribed entirely to Jacopo with a date of 1572-73.

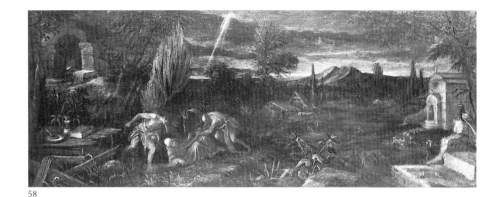

58

erie Alte Meister, Dresden), is much more episodic in its crowd of thirsty refugees that fills the foreground, several lifted with little change from the *Saint Roch* altarpiece.[273] Although Jacopo took over many passages in the foreground, Francesco was invited to do most of the painting here and perhaps a sizable part of the design, since he adapted the distant camp from his own *Miracle of the Quails* of a decade before. It is not surprising that a year later Marucini would write that Francesco was so well trained by his father that he was not merely his imitator, but might even surpass him if he were to live as long.[274] He might have been thinking of just these complementary paintings.

Portraits by Jacopo are, with rare exceptions, so candid, so artless, so devoid of derivative details that they must be dated entirely on the basis of the handling of the paint. This very simplicity is, conversely, what lends them a human immediacy that stands in contrast with the formal distance of Titian, the dramatization of Tintoretto, and the serene ideality of Veronese. *The Portrait of a Prelate* (Museum of Fine Arts, Boston, cat. 57) seems datable just subsequent to the *Saint Roch* altarpiece and close to the warmly fluent brushstroke of the Dresden *Tobias*.[275] Bluff and jovial, the pale-eyed elder turns suddenly in response to an intrusion to our right, a shadow of a smile about to warm his surprised expression. Or are his watery eyes so nearsighted that he is bemused by something he cannot quite identify? It is exactly the ambiguity of an emotion caught in transition that imbues this quiet image with warm humanity.

When the village of Civezzano ordered four large altarpieces, each with its predella, Jacopo did not hesitate to press every available member of the shop into service. All except *The Temptation of Saint Anthony* predella (Castello del Buonconsiglio, Trent, fig. 58) remain *in situ* in the parish church.[276] The finest altarpiece, *The Preaching of the Baptist* with its forest setting, is an-

273. Oil on canvas, 183 × 278 cm. For its history, see above n. 272.

274. Marucini 1577, 59-60.

275. Rearick 1980 (B), 112-13, dated it around 1570, but its richer impasto and softer focus now seems to me more closely related to works of about 1575.

276. *The Preaching of the Baptist*, oil on canvas, 185 × 115 cm; *The Beheading of the Baptist*, oil on canvas, 47 × 115 cm; *The Meeting of Joachim and Anna*, oil on canvas, 181 × 112 cm, cut irregularly at the top and signed: JAC.S BASS. et/ FRANC. FIULIUS P.; *The Madonna della Misericordia*, oil on canvas, 47 × 112 cm; *The Mystic Marriage of Saint Catherine*, oil on canvas, 185 × 115 cm; *The Martyrdom of Saint Catherine*, oil on canvas, 45 × 109 cm; and *Saint Anthony Abbot Enthroned with Saints Virgilius and Jerome*, oil on canvas, 185 × 115 cm. Although all remain in the Civezzano church, each has been reframed, sometimes cut, and differently placed in the interior. *The Temptation of Saint Anthony*, oil on canvas, 47 × 112 cm, was separated from the *Saint Anthony* altarpiece, probably during the rebuilding of the church in the eighteenth century, and was rediscovered by Borgo (1975, 603-7). It was subsequently acquired by the Castello del Buonconsiglio, Trent.

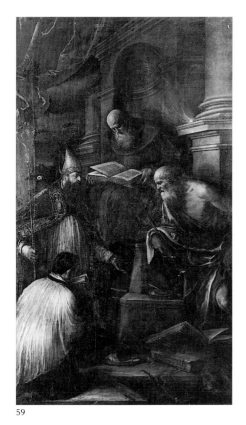

59

277. The drawing (Boymans-van Beuningen Museum, Rotterdam; Rearick, 1991 (A), IV, no. 10) by Jacopo for *The Martyrdom of Saint Catherine* survives, and a freshly rapid *ricordo* (Musée du Louvre, Département des Arts Graphiques, Paris) after *The Preaching of the Baptist* is by Francesco.

278. Oil on canvas, 176 × 115 cm. Signed and dated: JAC.S A PONTE BASSA.S FECIT/ ANNO M.D.L.XVI.

other work in which a bit more than half the execution was allotted to Francesco, who also did much of *The Meeting of Joachim and Anna* altarpiece, which he signed jointly with his father. Rather more conventional and therefore neglected is the sober *Saints Anthony Abbot, Virgil, and Jerome* altarpiece (fig. 59) with its now-separated predella. Again, Francesco laid in the first layers of glaze to structure the forms, and Jacopo added the later stages of highlight and detail. For *The Mystic Marriage of Saint Catherine* altarpiece the forces change, since it is here Leandro who began and in considerable degree finished this picture, with its characteristic cooler, more glittering light and fussy surface detail. This new direction began with Jacopo, in the nervous pattern of reflections in the Madonna and Saint Catherine, but it required Leandro to mimic its touch, and this experience profoundly conditioned Leandro's style for the rest of his career. Even Giambattista was allowed to add the secondary female saint here. The predella canvases, a uniquely archaic device that Jacopo had seldom used even at the beginning of his career, do not follow the pattern of collaboration set in the altarpieces. *The Martyrdom of Saint Catherine, The Beheading of the Baptist*, and *The Temptation of Saint Anthony* are charmingly theatrical in their spacious balance between action and landscape. Jacopo's remarkably elaborate figure study (Boymans-van Beuningen Museum, Rotterdam, cat. 110) for the first is evidence for the care he dedicated to them.[277] Francesco again assisted in the early stages of painting. *The Madonna della Misericordia* predella, however, was too tradition-bound to interest him, so he turned it over to Giambattista for the figures and Francesco for the landscape.

A natural disaster occasioned a commission that must have been awarded to Jacopo almost simultaneously with that of the Civezzano altarpieces but was carried out just after them, probably in the autumn of 1576. In the spring of that same year, torrential rains had caused the Colmeda river near Feltre to flood with significant loss of life, farm animals, and land. As an ex voto to insure against repetitions of this tragedy, the local church commissioned an altarpiece, *Saints Anthony and Crescenzio Interceding with the Virgin on Behalf of the Flood Victims* (Santa Maria degli Angeli, Feltre).[278] The Virgin and saints in the clouds above are standard types, and, although he painted the final details himself, Jacopo allowed Leandro to do most of the top half in a cold and fussy style that is an intensified variation on the Civezzano *Saint Catherine*. By contrast, the lower half of the picture is dedicated to a vista of the flood of the Colmeda, its muddy waters tossing pots, furniture, animals, and humans on its crest. More a charming still life than a terrifying drama, this landscape opens to a vast and atmospheric mountain landscape that glints in the clear light after the storm. As a hopeful promise, a rainbow rises at right, and Jacopo almost playfully uses it as a field on which to add his signature. After such

a spirited evocation of nature he was evidently in a very cheerful mood.

The year 1576 came to an end with yet another plague-motivated picture. The podestà of Bassano, Sante Moro, had taken office in August 1575, just as Jacopo and his family had taken refuge in Cartigliano, and in the autumn of the next year the terrible pestilence in Venice, that carried off Titian, was abating. Before he left Bassano to return to Venice, the podestà commissioned a small votive picture from Jacopo. *The Madonna and Child with Saint Roch and Sante Moro* (Museo Civico, Bassano del Grappa, fig. 120) is the most extreme example of the coldly dark and gleaming style that Jacopo accentuated during that year.[279] Leandro assisted with the saint, but the podestà, the Virgin, and the remarkable hanging lamp evoked by a few silvery reflections are clearly by Jacopo's hand in its most fastidious and evanescent mode. For the Virgin and Child, he made one of his rare studies in red chalk (private collection, London, cat. 112), for which he invented a new technique where he wetted and bled the pointed red chalk stick to achieve a drawn effect like the shimmering light he intended for the picture. As always, drawing was for Jacopo a stage in painting rather than a self-contained discipline.[280]

<p style="text-align:center">★</p>

Paintings in series were a familiar phenomenon in cinquecento Venice, but usually on a rather large scale and for public places. They were in most instances religious in theme, or in Titian's case they were mythological subjects that he called *poesie* and were destined for princely patrons outside Venice. From early in the century a patrician market for small pictures on a pastoral theme was fostered first by Giorgione and subsequently by Titian, Palma il Vecchio, Paris Bordone, and still later Schiavone and Tintoretto. But those in series were usually destined to ornament furniture such as *cassoni*, *credenze*, or domestic spaces such as bed alcoves. Jacopo himself had painted such works earlier in his career. Now, however, Venetian connoisseurs had developed a taste for Jacopo's rustic subjects, usually in the guise of biblical themes and occasionally in pairs. By 1576 demand for these bucolic evocations of country life had burgeoned to such a degree that Jacopo was forced to dedicate serious thought to creating several new compositions that would serve singly or in series as useful and repeatable pictures that could be sold to a much wider market. His public would remain as it had been, Venetian connoisseurs and Bassano gentry, but now a much more diverse and numerous middle class could afford and took pleasure in Jacopo's peasant genre works. For them Jacopo set about establishing a pictorial repertory, a sort of catalogue of available merchandise that could be ordered directly or disseminated by way of a new type of middle man, the commercial art dealer. Once dis-

279. Oil on canvas, 130 × 103 cm. Removed from the chapel of the Palazzo del Podestà, c. 1781, and from the Municipio to the new Museo Civico in 1840.

280. Leandro's close association in the execution of this painting extended to two drawings of the Madonna (formerly private collection, Munich; and formerly Cornet collection, Paris), which derive from Jacopo's study. Leandro is the only Dal Ponte son to use red chalk with any frequency.

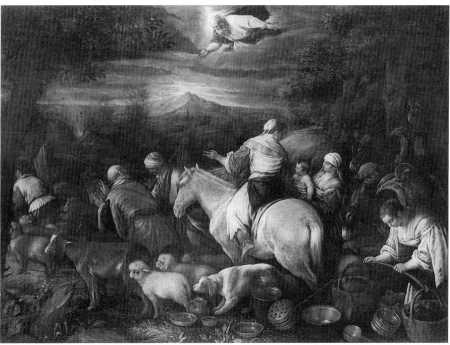

60

criminating entrepreneurs, like Jacopo Strada, who brokered masterpieces to crowned heads throughout Europe, these dealers were now a legion of marketing conduits who found a remunerative resource in popular Bassano themes at reasonable prices. Twenty years before, Jacopo had used Alessandro Spiera as such a conduit in Venice; now he may be presumed to have expanded that market many times over.[281]

It was probably during 1576 and more particularly in 1577 that new formulations were established for at least six biblical subjects, some of them familiar from earlier treatments and others apparently new to his repertory. They all measured approximately 95 × 120 cm, a convenient size for a moderately scaled room. That old standby, Jacob's Journey, was reconsidered in the guise of *Abraham's Journey* (Staatliche Museen Preussischer Kulturbesitz, Berlin, cat. 60) in a composition that reordered figures and motives from a variety of earlier pictures. In what is probably its first surviving treatment, Francesco laid in the broad areas of paint over Jacopo's design, and Jacopo returned to bring much of that surface to completion with the final glazes and details, correcting his son's preliminary work in noticeable pentimenti.[282] Both artists signed the finished picture. In this instance, however, there is a jointly signed second version (private collection, Bassano del Grappa, fig. 60)

281. We do not know the names of the art dealers who stocked Dal Ponte pictures for the open market in Venice in the last quarter of the cinquecento, but there are clear indications that their number had burgeoned since midcentury.

282. Of the fifteen replicas painted by Francesco and his shop, one (Rijksmuseum, Amsterdam) is Francesco's almost exact replica of the Berlin original. For it he drew a study (Crocker Art Gallery, Sacramento) after the woman on horseback, using the chiaroscuro technique usually reserved for *ricordi*, which, in fact, is what it is.

61. Jacopo and Francesco Bassano, *The Return of the Prodigal Son*, Galleria Doria Pamphilj, Rome

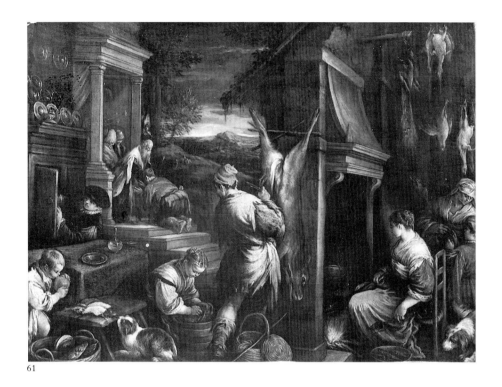

61

that shows a more developed stage of collaboration in which there are fewer corrections by Jacopo, and Francesco was permitted to substitute one of his characteristic opulent women for the boy at lower right.[283] The son then proceeded to produce replicas and variants, some of them signed, over the next fourteen years.[284] In time all of Jacopo's associates duplicated this format, persisting almost to the middle of the following century at the hands of a fifth generation of Dal Ponte painters. Quality declined steadily, especially after 1600, when only Leandro maintained a modest standard. Jacopo had repeatedly treated *The Supper at Emmaus* since the beginning of his career. Now he gave it a discursive, informal format (private collection, cat. 62) by using a new device of dividing his scene like a stage set into the kitchen interior at left and the supper under a trellis on the outdoor terrace at right. As in the first instance, Jacopo sketched the design onto the canvas, allowed Francesco to develop it, and then added his corrections and finishing details.[285] Pentimenti are particularly evident at the horizon, where the young Dal Ponte carefully defined the mountain only to have his father dab a lively and irregular contour over it. Both painters signed it on the step at left. In the case of the *Emmaus*, we have a surprising departure from this formula. A replica (art market, New York), which departs from the painting under discussion in the

283. Oil on canvas, 13 × 183 cm. Signed: JAC. A PONTE /ET FRANC.S FILIUS P. See Rearick 1986 (A), 186. Among many slight changes, the substitution of the woman for the boy at front right is the most notable.

284. Francesco's first, and enlarged (136 × 183 cm) replica (Kunsthistorisches Museum, Gemäldegalerie, Vienna, inv. 1550) was followed by many others of poorer quality.

285. Ridolfi (1648, I, 383) described this composition, if not this painting, when it was in the collection of the painter Nicholas Renier. This version was exhibited (Enniskillen 1944, no. 20; and Belfast 1961, 12, no. 16), but only later published (Rearick 1968 (A), 245). Many replicas, mostly from Francesco's later shop, survive, but none is of very fine quality. A drawing of the servant boy at right (private collection, Spilimbergo; Rearick 1982 (B), 36-38) is a rough *ricordo* done in Francesco's shop. A shop variant was engraved in 1593 by Raphael Sadeler (Pan 1992, no. 6).

62. Jacopo and Francesco Bassano, *Joachim's Vision*, The Methuen Collection, Corsham Court

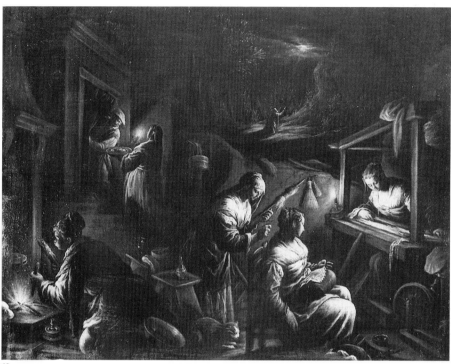

62

more conventional position of Christ's head and the omission of some of the still-life paraphernalia in the foreground, is signed by Jacopo alone.[286] It is, however, as pentimenti such as that above the head of the apostle to the left of Christ suggest, also a collaboration. This time Jacopo's amanuensis was Leandro, whose cooler tonality is distinct from that of Francesco. Since he was but twenty years old, Leandro was perhaps not yet permitted to sign pictures with his father. Francesco was accorded this honor only when he was twenty-five. If these subjects were Dal Ponte stock-in-trade, others seem to have been treated for the first time. *Christ in the House of Mary, Martha, and Lazarus* (Sarah Campbell Blaffer Foundation, Houston, cat. 61) makes somewhat irrational use of the indoors-outdoors conjunction seen in the *Emmaus*, employing much the same range of staffage and still-life detail. Its collaborative effect – it is jointly signed by Jacopo and Francesco – is much like that of the *Emmaus* picture, if perhaps slightly less vivacious in brushstroke.[287] An unsigned replica (art market, New York) in which Leandro collaborated in larger measure is the pendant to the *Emmaus*, which Jacopo signed alone.[288] Rather more monumental than its companions, *The Return of the Prodigal Son* (Galleria Doria Pamphilj, Rome, fig. 61) is more densely peopled with servants, who prepare the banquet, while the prodigal is received in the middle

286. Oil on canvas, 77 × 115 cm. Signed: JAC.S/ A. PŌTE/ BASS.S. Sold, with its pendant *Christ in the House of Mary and Martha*, in Monaco.

287. Francesco signed alone his first replica (Staatliche Museen Kassel, Gemäldegalerie Alte Meister, Kassel) after the Blaffer original, and repeated it in an autograph picture (Bayerische Staatsgemäldesammlungen, Alte Pinakothek, Munich), which his shop repeated many times. It was engraved in 1598 by Jan Sadeler (Pan 1992, no. 5).

288. Oil on canvas, 77 × 115 cm. See above n. 286.

63. Jacopo and Francesco Bassano, *The Boy Blowing on a Firebrand*, formerly art market, New York

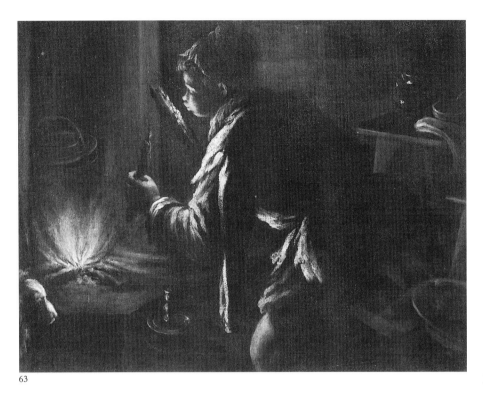

63

289. Oil on canvas, 100 × 124 cm. Signed: JAC.S ET/ FRANC.S/ FILIUS/ P.

290. In a sequence analogous to that of the Noah cycle (cats. 63-66) Francesco assisted Jacopo in the earliest examples of *The Prodigal Son*. However, after his departure for Venice in 1578, Leandro assumed the role of replicator, painting a fine version (The Art Gallery of Western Australia, Perth), a slightly varied replica of it (Museo del Prado, Madrid), and delegated others to his shop. A *ricordo* drawing (Musée du Louvre, Département des Arts Graphiques, Paris) was made in Leandro's shop after the Prado replica. In his record of the 1592 contents of Jacopo's studio, Verci (1775, 96) lists: « *110. Il figlio Prodigo, alto quarti cinque, e lungo quarti sete in circa* ». This might be the unfinished picture (private collection, Bassano del Grappa, cat. 76), that reflects the style of Leandro in its cold tonality against a black ground and Jacopo's late work in its ghostly swaths of silvery highlight. It might be by Luca Martinelli, whose work in the Dal Ponte shop around 1592 is primarily based on the example of Leandro.

291. Oil on canvas, 88 × 117 cm. Signed: JAC.S ET/ FRAN.S/ FIL. Rearick 1968 (A), 246.

292. The nocturne in the works of the Dal Ponte is the subject of a forthcoming study by Paolo Berdini.

distance in a reversion to the medieval practice of simultaneously depicting sequential events.[289] Jointly signed, it seems to have been less in demand, since fewer replicas survive.[290] Most mysterious of the set and most unusual in treatment is *Joachim's Vision* (The Methuen Collection, Corsham Court, fig. 62).[291] Drawing on his longstanding admiration of Giotto's grave and stately narrative cycle in the Scrovegni Chapel, Padua, Jacopo similarly selects simultaneous, but separate, events from the life of the Virgin, beginning with the barren Anna, who sadly spins with her servants; continuing through the symbol of fecundity in the boy blowing on a firebrand; and concluding with the vision of the coming birth of Mary as announced to Joachim in the wilderness by night, and the return of the shepherd with the news, at the door at upper left. Jacopo had experimented with genuine night scenes earlier, but here he took the opportunity to illuminate the story by three separate fire sources and the cooler celestial radiance. Although the result is somewhat forced for dramatic effect, *Joachim's Vision* is one of the first complete nocturnes in Venetian painting.[292] Jacopo and Francesco signed it, Francesco signed his own replica (Thorvaldsens Museum, Copenhagen), and most members of the shop continued to do replicas based on the *ricordo* (Royal Library, Windsor Castle, Berkshire) by Francesco, including an un-

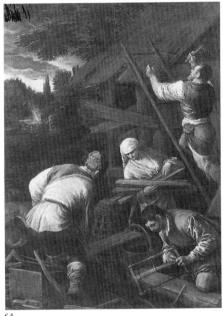

64

finished one (private collection, Bassano del Grappa) started by Gerolamo and corrected by Jacopo around 1590.[293] This composition was the source for a picture that exists in only one version, *The Boy Blowing on a Firebrand* (formerly art market, New York, fig. 63).[294] Signed by both Jacopo and Francesco, it might be an allegory of fecundity; El Greco, Georges de La Tour, and others saw it or a replica and derived their own allegories from it.[295]

Simultaneously, but apart from this suite, individual collaborations that exist in only one version were painted. Young Leandro had already begun to collaborate and to duplicate some of those compositions, but in at least one instance he was promoted to a superior role. The *Adam and Eve in the Earthly Paradise* (Galleria Doria Pamphilj, Rome, cat. 48) follows a slightly different procedure from the others in its execution, since Leandro was allowed to bring the entire landscape to a completely finished state, leaving a blank space for the figures, which Jacopo then added.[296] Leandro's contribution to the Doria picture shows that, like his older sibling, he had been well schooled to imitate his model, but in this case it is Francesco whose style he mimics with deceptive dexterity. The peacock will, in particular, become one of his preferred motifs, and in its tail he repeats the shorthand indication of the eye pattern in his more familiar paintings. The collaboration terminated, Leandro copied Jacopo's figures in a red chalk drawing (Staatliche Museen Preussischer Kulturbesitz, Kupferstichkabinett, Berlin) that he squared for repetition in a picture never painted or since lost.[297] He was the only son attracted by this medium, but even he used it sparingly and usually for copies.

Just as a variety of individual, earlier pictures provided sources for these compositions destined for seriatim repetition, Jacopo returned to his great *Animals Entering Noah's Ark* of about 1569-70 as the basis for one of his most famous and popular sets of paintings intended to be sold together. The sequence of execution of the various surviving full or partial sets of Noah pictures is complicated by the fragmentary preservation of what must have been an early version of one of its components. The *Noah Giving Thanks to God* (Walker Art Gallery, Liverpool, fig. 64) is a fragment of a large picture, about 121×175 cm, which preserves its right half.[298] There is here no signature on the foreground wooden box, the place where other versions are signed. Its quality is superior to that of any other surviving example, and its numerous pentimenti confirm that it must have formed part of the original Noah cycle. As elsewhere, Jacopo sketched the design onto the primed canvas and then turned it over to Francesco, who laid in broad areas of paint. Jacopo, however, returned before he had gone further and added or modified almost every element, reducing in scale the distant Noah and moving him lower to the left; lengthening the jacket of the carpenter seen from behind; changing the contours of the arm of the hammerer on the ladder; and,

293. A rather strong *ricordo* (The Royal Library, Windsor Castle) is now cut in half. It is probably by Francesco after the Corsham Court original, although it differs from the painting in several details. It provided the source for Francesco's fragmentarily signed first replica (Thorvaldsen Museum, Copenhagen), which Francesco repeated (Staatliche Museen Kassel, Gemäldegalerie Alte Meister, Kassel; Duke of Alba collection, Madrid; Musée des Beaux-Arts, Lille; etc.) with shop assistance. Around 1591-92 Jacopo assigned Gerolamo the job of painting a replica (private collection, Bassano del Grappa) from the *ricordo*. While it was still in progress the old man brusquely took a brush to it, correcting certain passages, such as the old woman's head at center. It may have been left in this state on Jacopo's death in 1592, although it is not specified among the paintings inventoried that April. It might have been one of the canvases simply described as *sbozzato*. Gerolamo later proceeded to paint a finished version (Museo Civico, Vicenza), although the omission of Joachim suggests that he did not understand its subject.

294. Oil on canvas, 49.5×63 cm. Signed

65. Jacopo and Leandro Bassano, *Noah Giving Thanks to God*, formerly art market, London

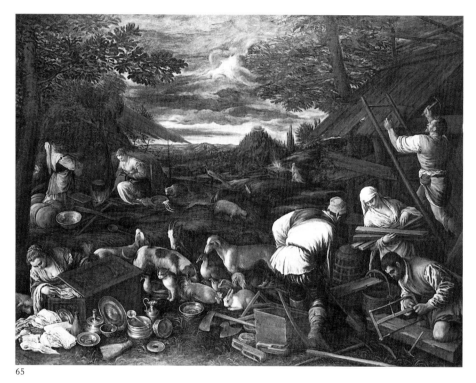

65

most significantly, adding the wooden box in front over the tools painted first. This proves that the box, the place where other versions are signed, was thought of and added here at the last stage of painting; this, therefore, must precede those replicas. The replica (Stiftung Schlösser und Gärten Potsdam-Sanssouci, Potsdam, cat. 49) that preserves the full composition is of excellent quality and seems again to follow the Jacopo-Francesco collaboration, but it follows all of the modifications made by Jacopo in the Liverpool version without second thoughts.[299] It is signed on the box by Jacopo alone. Finally, a much less satisfactory version (formerly art market, London, fig. 65) also bears Jacopo's signature, but here Leandro seems to have assumed a preponderant role in its execution.[300] It was again Jacopo's third son who assisted in the only signed complete suite to survive (Archibiskupský Zámek a Zahraòy, Kroměříž, cats. 63-66), but they date significantly later. At a date just subsequent to the original set of four *Noah* pictures, Jacopo and Francesco added a fifth canvas to the set, the *Noah's Dream*, but an odd number of pictures seems not to have sold well, and only two replicas by Francesco of this composition survive (private collection, New York, fig. 66; and Kunsthistorisches Museum, Gemäldegalerie, Vienna).[301] The inception of this major project, to judge by the deep but rich color and vibrant brushstrokes of the Liverpool

and fragmentarily dated: JAC.S BASSAN.S ET FRANC. F./ 157. Sold by Victor Spark in New York in 1948 and since then untraced. Rearick 1968 (A), 246-49. This small picture was excerpted from the *Joachim's Vision*, and therefore its significance must derive from the motive in that picture.

295. For a recent but inconclusive discussion of this theme, see Edinburgh 1989.

296. In filling the dark-primed empty space alotted to the figures, doubtless indicated in contour before the painting was begun, Jacopo shifted Eve's left arm, the angle of Adam's body, and the line of the hillock below Eve. In Adam's head he painted beyond the contour and over the adjacent landscape, and in Eve's head and below her elbow he did not quite fill the alotted space.

297. Staatliche Museen Preussischer Kulturbesitz, Kupferstichkabinett, Berlin, inv. KdZ 5109. Leandro observed Jacopo's rare use of red chalk in 1576 (see cat. 112), and he is the only Dal Ponte son to adopt it, usually for copies. Since all the visible pentimenti in the Doria Pamphilj painting are exactly reproduced to the finest details of highlight in Eve's hair, it is clear that the Berlin drawing was done after the finished picture. That it was never repeated by the shop may be due to the exigency of the patron, who wanted the unique example of this composition.

298. Oil on canvas, 119 × 86 cm. The provenance cannot be traced beyond 1952, when it belonged to the Wright collection, Skelton Hall, Newark, England.

299. It was not unusual for Jacopo to leave the canvas on which he worked out his original ideas unsigned. Subsequently, he added his signature to replicas to advertise his invention, if not the totally autograph character of the work. See above n. 286.

300. Oil on canvas, 140 × 190.8 cm. Signed: J. PONTE BASS. On the art market in New York and London in 1968, it is the pendant of *The Animals Entering Noah's Ark*, of which no photograph was available. Ballarin (1988, 2) did not indicate if it was also signed. Even in a photograph the drier, thready texture of Leandro's brushstroke seems evident in the *Noah Giving Thanks*.

301. Oil on canvas, 181 × 162.6 cm. On the New York art market in 1953. The Vienna replica is autograph, but somewhat damaged. Rearick 1986 (A), 186.

66. Francesco Bassano, *Noah's Dream*, private collection, New York

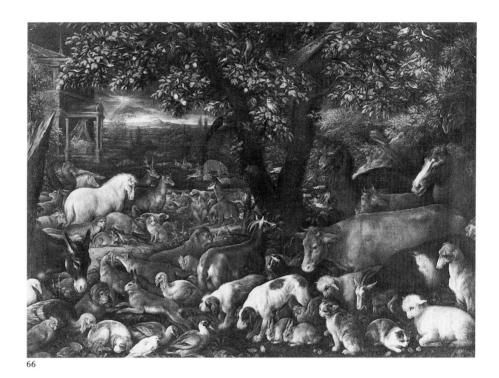

66

fragment, may probably he placed close to the Dresden *Tobias*, that is about 1576 or perhaps 1577, but the production of shop replicas went on for more than a half-century thereafter.

If the Noah pictures grew out of a single prototype, the second and probably more popular and influential set of four subjects might have had a more complex source. If, as we believe, the Budapest *August* was once either one of twelve canvases depicting the Months with their zodiacal sign, or was the Summer in a four-picture suite of the Seasons, we may assume that Jacopo had executed one or the other of these cycles around 1569-70. If this must remain speculative, it is certain that around 1577 he undertook an entirely new formulation for the Seasons, of which *Summer* and *Autumn* (Kunsthistorisches Museum, Gemäldegalerie, Vienna, cats. 50, 51) survive in the original, but the full set is known from many replicas, most of them by Francesco.[302] None is signed. Iconographically, this set is unusual in that each includes a biblical theme in the distant landscape. In the Salone in Padua the cycle of Months is interwoven into a complex of biblical and allegorical themes, but Jacopo's combinations must be based on a simpler symbolic program, one provided perhaps by the patron who ordered this first set. Since no exact literary source can be found for them, we might simply assume that the cycle of the Seasons is paralleled by the sequence of man's fall from a state of grace

302. The complete original set of four canvases passed in 1659 from the Brussels collection of Archduke Leopold Wilhelm to the Royal Palace in Prague. They were engraved by Teniers (Hoÿ) in 1660. By the time of their transfer to the Kunsthistorisches Museum in Vienna in 1894, only the *Summer* and *Autumn* were recorded.

and the stages whereby he achieves the promise of redemption. Thus, *Spring* includes Adam and Eve expelled from Paradise, *Summer* has the sacrifice of Isaac as the Old Testament prefiguration of Christ's crucifixion for man's sins, *Autumn* shows Moses receiving the Commandments as the way to salvation through law, and finally *Winter* depicts Christ carrying the cross as the promise of redemption for all mankind. These biblical episodes are not allowed to interfere with the primary purpose of the set, that is the straightforward depiction of the agrarian activities associated in Bassano with the changing seasons. Thus the fresh spring landscape with its cherry blossoms is peopled with peasants milking goats, strawberry gatherers, hunters, and a hungry goat who nibbles fresh tree sprouts, already a hopeful augury. The last is the only symbolic intrusion in an otherwise naturalistic vignette. *Summer* shows sheep shearing, the grain harvest, threshing, and a cheerful picnic. *Autumn* depicts grape gatherers and wine pressing as well as the sowing of winter wheat. *Winter* is set in a snowcovered landscape peopled by wood gatherers who bring kindling to the farm family huddled around the open fire. Monte Grappa in the distance anchors each view to the countryside around Bassano, but the foreground shifts locale in each without departing from a recognizably local environment. Even the light and color in each scene is a subtle evocation of the seasonal shift from fresh pale green and pink, to sensuously heavy green and gold, through wine-sharp chiaroscuro, to conclude in almost monochromatic tones of black and white. The execution of these Seasons follows the standard procedure for the Dal Ponte shop around 1577; Jacopo sketched in the format, Francesco laid in much of the preliminary painting, and Jacopo returned to develop final glazes and details, particularly in the foreground figures. Seldom, however, did father and son work together with such harmonious unity. Of the original cycle only the *Summer* and *Autumn* (cats. 50, 51) survive, but Francesco at once produced an excellent set of replicas of which three, the *Spring, Summer*, and *Winter* survive (Kunsthistorisches Museum, Gemäldegalerie, Vienna).[303] Later, when clients lost interest in the religious implications of the biblical episodes, Francesco eliminated them. All of Jacopo's sons and his shop followers continued to supply replicas of these compositions well into the next century, but Francesco took advantage of their popularity to expand each into a larger, more encyclopedic format (Galleria Borghese, Rome, cats. 58, 59) that, in turn, led to an eight-canvas set and eventually to a suite of twelve Months.[304] Leandro concluded this burgeoning production with a set of Months (Kunsthistorisches Museum, Gemäldegalerie, Vienna; Národní galerie, Prague; art market, London; etc.) of vast proportions.[305]

Other biblical themes were given their first formulation by Jacopo and Francesco, or more rarely his siblings at this moment; among them, *Ruth and*

303. Of the primary set, *Summer* and *Autumn* survive in Vienna. The Kunsthistorisches Museum also contains the *Spring, Summer*, and *Winter* from Francesco's first and exact set of replicas. They are irregularly damaged. The missing *Autumn* from this set of prime replicas is probably to be identified with the *Autumn* (Galleria Doria Pamphilj, Rome). About a dozen later, enlarged replicas by Francesco or his shop survive for each composition. Most of them omit the distant biblical episode. One such set was engraved by Jan and Raphael Sadeler in 1598-1600. See Pan 1992, nos. 9-12.

304. The Galleria Borghese *Autumn* and *Winter* are parts of a set of four canvases, first recorded in Rome in 1650. The *Summer* survives in a fragment depicting *The Sacrifice of Isaac* (Robert and Bertina Manning collection, New York). Although Francesco was delegated the primary responsibility for the enlarged Borghese set, where elementary insertions of figures and animals from the nearly contemporary *Noah* cycle bespeak a more pedestrian mentality, Jacopo probably intervened toward the end to enliven the effect with some freshly painted finishing touches. Francesco then, c. 1580, painted a set of *Seasons* each with three zodiac signs in the sky, of which *Summer* and *Autumn* survive (Kunsthistorisches Museum, Gemäldegalerie, Vienna), and *Spring* is known in an excellent replica (private collection, Bassano del Grappa). This cycle would be repeated by Francesco without the zodiacal signs, of which *Spring, Summer*, and *Winter* are known (Galleria Borghese, Rome). A complete set of replicas with numerous revisions (Palazzo Spinola, Genoa) is of much poorer quality and shows predominantly the participation of Francesco's shop. A set of four *Seasons* (Ancillotti collection, Poli) is reported to have the signature of Francesco, but they are not directly related to either the Viennese or Roman cycles. Much later, around 1588, Francesco painted a set of six vertical canvases with two months and their zodiacal signs in each; *January-February* and *March-April* are known (Kunsthistorisches Museum, Gemäldegalerie, Vienna). Odd remnants, which do not fit into any of these sets, are scattered about, and they do not permit a clear reconstruction of other cycles, although some certainly did exist.

305. The 1592 inventory of Jacopo's studio effects (Verci 1775, 91-100) includes the mod-

146

ello canvases of *January, February, March, April, May* (two examples), *June* (two examples), *July, August, September, October, November,* and *December,* plus seven more separate sketched months not identified by name. Ridolfi (1648, I, 387) reported that Jacopo painted twelve pictures of *Months* for Emperor Rudolph II in Prague, which so pleased the patron he invited Jacopo to be his court painter. According to Ridolfi, Jacopo preferred his Bassano workshop to the Prague palace and refused. Ridolfi implied that the cycle was no longer in Prague. Since Rudolph became Emperor in 1576 and Spranger, who is mentioned by Ridolfi as falling out of favor when Jacopo's *Months* arrived, did not arrive in Prague until 1581, this cycle is likely to date late in the ninth decade. The full set seems to have been brought from Prague to Vienna in the seventeenth century, since it was returned to Prague in 1732. Ten canvases were returned to Vienna for the Kunsthistorisches Museum in 1894. The *October* and *November* remained in the Narodní galerie in Prague (Neumann 1962, 70-73, nos. 8-9). Prior to 1894, the Vienna pictures had been damaged, cut in half, repainted to eliminate the signs of the zodiac, and otherwise suffered. The *January* (art market, London) has reappeared with a Viennese provenance, and may have come from the Hapsburg holdings in the past century. The 1592 inventory proves that the Dal Ponte shop retained the *modello* sketches for the *Months*, but it is not proof that Jacopo designed them, since the shop contained work of every member of the family. Since all of the Vienna and Prague pictures are, or were, prominently signed by Leandro, Ridolfi must have meant that the cycle was a Dal Ponte product, in this case delegated to Leandro for both design and execution. It cannot, however, be ruled out that still another twelve canvas cycle by Jacopo once existed, and that the *modelli* and the set owned by Rudolph are lost.

306. Oil on canvas, 122.8 × 167.9 cm. Kultzen and Eikemeier 1971, 37-39, inv. 2300. Much of the composition would reappear in the Borghese *Summer* with three zodiacal signs, and it is probable that Francesco had, with Jacopo's help, adumbrated it previously in the missing *Summer* from the first Borghese set. In any case, it must date from a bit later, c. 1577, and shows Francesco as the predominant executant and, in part, even as formulator of the composition.

Boaz (Bayerische Staatsgemäldesammlungen, Alte Pinakothek, Munich) is primarily a reordering of the *Summer* from the Seasons.[306] Other familiar compositions were remodeled, *The Israelites Drinking the Miraculous Water* (Museo del Prado, Madrid, cat. 39) following a slightly different course, in which Giambattista was allowed to reverse the big Dresden treatment and to add various figures from Francesco's Borghese *Summer*.[307] Here, however, Jacopo reverted to his habit with his inept brothers of impatiently intervening to repaint much of the halting start made by his second son. Giambattista, destined to get worse as a painter rather than better, may still be seen in the central horse, the figures at right, and parts of the background. A new *Animals Entering Noah's Ark* (private collection, Florence) took a higher vantage point than the Prado composition so that each zoological pairing could be clearly identified.[308] Francesco was assigned most of it, including the fine study (private collection, Padua) for the now diminutive Noah at the foot of the gangplank.[309] Predictably, it enjoyed an even greater success than the previous editions. Still other pastoral compositions, known today only from poor late shop repetitions, were recomposed from bits and pieces of this new repertory.[310]

By 1578 the Dal Ponte shop had undergone a major reorganization prompted by the ever-widening vogue for their peasant-genre pictures, which were now in demand even outside the Veneto. With the Noah and Seasons suites leading the way, followed by the diverse biblical themes, the shop had a stock of twenty or more standard compositional formats that served both for direct orders and an increasing repository of canvases available to dealers. In the early versions, in which Jacopo dominated the execution, the quality was often excellent, but inevitably it declined as the lesser minions were assigned the tiresome task of mass production. Even Jacopo's energies flagged and his attention wandered when confronted with the seventh or seventieth repetition of an old idea. These works brought the Dal Ponte to a wider attention than any family of painters had enjoyed before in the cinquecento; it equally sowed the seeds of its decline in the coming decades.

*

The Dal Ponte firm had never been asked to paint an altarpiece for the cathedral in Bassano del Grappa when, in 1577, they undertook to provide a very large *Circumcision* (Museo Civico, Bassano del Grappa, fig. 121).[311] At the top of the altarpiece an angelic radiance emanates from a vision of the infant Christ as Redeemer, in the middle range the Child is presented to the high priest in the presence of secular, symbolic observers, while below a fuming tangle of devils recoils in horror at the promise of redemption above. Jacopo

had never learned perspective, and architecture always posed a problem; here it is an unstructural melange of vaguely Palladian motifs seen from skewed angles. In any case, most of the painting of the secondary passages was turned over to Francesco, who finished the group at right, the angels, and the first stages of the devils before Jacopo returned to finish the most powerful demons and almost all of the group at left with the pope, emperor, and doge. Here contemporary events conjoin to illuminate the circumstances under which the two painters were working. Sebastiano Venier, the heroic victor over the Turkish fleet at Lepanto in 1571, was elected doge on 11 June 1577, at the age of eighty-one. Although he had already been portrayed with noble ideality by Veronese and militant energy by Tintoretto, old Venier chose Jacopo dal Ponte as his official portraitist.[312] It was probably during the summer of 1577 that the painter, himself aged about sixty-seven, journeyed to Venice, where he made a life sketch in oil on copper, transportable but durable, which he brought back home as the *modello* for the official life-size portrait that would survive only a few months before it was destroyed in the great fire that consumed the Palazzo Ducale in Venice. Jacopo's *modello* for *Doge Sebastiano Venier* (private collection, Stuttgart, fig. 67) depicts a predictable view of the frail old warrior, candid in capturing his tremulous infirmity, but sensitive to the tragic implications of the wizened lion weighed down by political trappings.[313] That autumn, when he painted the concluding passages of the *Circumcision* altarpiece, Jacopo took out his sketch, and although the pope and emperor are abstract types, the doge bears the likeness of Venier himself. As if to suggest that their collaboration in this picture held an especial portent, Jacopo portrayed Francesco just above the doge and his son depicted Jacopo peering nearsightedly from just to the left.[314] Prophetically, Francesco has a febrile expression and wears a soft traveling hat.

On 20 December 1577, fire ravaged the principal block of the Palazzo Ducale in Venice, sweeping away the Sala del Maggior Consiglio with its vast cycle of historical murals, the ducal portrait gallery, including Jacopo's recent *Sebastiano Venier*, and a treasury of Venetian art from two centuries. One suspects that Francesco had planned his transfer to the capital before this disaster opened the way for unprecedented opportunities for young painters to participate in the restoration of the Palazzo Ducale. In any case, he was already at work on his four battle scenes for the ceiling of the Sala del Maggior Consiglio by 5 April 1578, and would soon move into the studio-home left vacant by Titian's death about two years before.[315] Even before this debut into the competitive circle of Venetian painters, Francesco seems to have served as the Dal Ponte liaison with the Serenissima, providing quantities of biblical genre and Seasons pictures to the market there. Now the working procedure changed, and Jacopo visited Francesco rather frequently in his

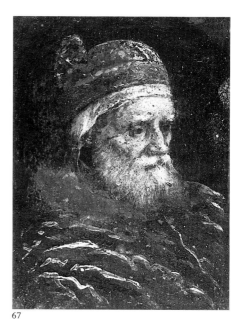

67

307. Some of the staffage, particularly the figures at right, are taken from the Borghese *Autumn*, which includes Moses, a work by Francesco of c. 1577. The first hand is particularly crude and may circumstantially be considered Giambattista. Jacopo's second son would, after Jacopo finished his corrections, be permitted to copy it in his own replica (Hood Museum of Art, Dartmouth College, Hanover).

308. Formerly in the Modiano collection, Bologna (Arslan 1931, 187), and by inheritance to its present owner. The revised composition was probably due to Jacopo, but details and most of the execution were left to Francesco. An autograph replica by Francesco (Palazzo Ducale, Venice) was followed by many repetitions.

309. A fine and characteristic early study by Francesco (private collection, Padua) prepared the figure of Noah at the foot of the gangplank. Francesco chose here to emulate the softly granular tonalist effect found in some of Jacopo's studies of c. 1575, and his drawing style remained closely tied to this mode for the remainder of his career.

310. After about 1575 Jacopo progressively delegated greater autonomy to his sons in the formulation of new variants on his familiar bucolic settings for biblical themes. It is,

68. Francesco and Jacopo Bassano, *The Virgin in Glory with Saints Nicholas and John the Baptist*, San Giacomo dell' Orio, Venice

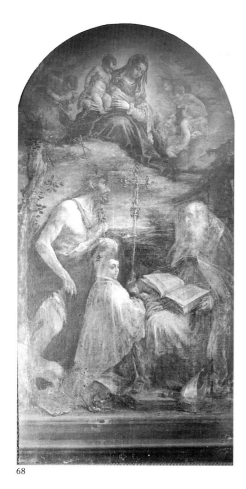

68

therefore, often impossible to determine if a type made up of motives developed from Jacopo's own prototypes was first designed by him or is the free metamorphosis of sources put together by a younger Dal Ponte.

311. Oil on canvas, 320 × 211 cm. Signed and dated: JAC.S A PŌTE/ BASS.S ET FRANC.S/ FILIUS FACIE.nt/ M.D. LXXVII. Painted for the altar of the *Nome di Gesú* in the old cathedral, it was transferred to the Museo Civico in 1870 and replaced with a copy. Volpato (1685) especially praised the Michelangelesque demons below. Portraits of Jacopo and Francesco appear below and beside the plinth with their signatures at left, and the Doge carries the likeness of Sebastiano Venier. Although early sources praised it highly, the modern literature has largely ignored it, doubtless largely due to the layered clumsi-

Venice studio, providing him with designs for commissions, participating in some of the young man's paintings, and imparting freely both advice and corrections.[316] Jacopo must have been a severe, demanding, and even irascible master-father, and it is easy to see that this new pressure of a cosmopolitan career imposed a dangerous strain on Francesco's already high-strung temperament.

Although he was occupied with work for the Palazzo Ducale and was busy settling in as provisioner of Seasons and other genre-type pictures for the local clientele, Francesco had received important commissions for church altarpieces almost from the moment of his arrival in Venice. Gaspare Dolzoni erected a family chapel in the church of San Giacomo dell'Orio in 1568, and in 1578 he ordered an altarpiece of *The Virgin in Glory with Saints Nicholas and John the Baptist* (San Giacomo dell'Orio, Venice, fig. 68), which Francesco signed alone.[317] Given the significance of the project for his son's career, Jacopo secretly or by agreement provided his son with sketches (formerly art market, London) for individual figures and then proceeded to take brush to canvas, painting most of the saints and the acolyte over Francesco's start.[318] The Filarete-inspired cross is a particularly glittering passage of his intervention, but the upper part was left to his son, whose heavier touch is evident throughout. The junior Dal Ponte was left to his own devices for the side canvas of *The Preaching of the Baptist*, doubtless a relief after the old man's return to Bassano.

Meanwhile, back in Bassano the shop made an apparently smooth adjustment to Francesco's absence. Giambattista had amply demonstrated his deficiencies as an inventor as well as an executant, and he seems already to have been relegated to modest small-scale altarpieces for country churches.[319] The *Saint Roch Visiting the Plague Victims* (parish church, Cavaso del Tomba) is a variant of the Brera altarpiece by way of Francesco's *ricordo* drawing (Gabinetto Disegni e Stampe degli Uffizi, Florence), but the adjustments are clumsy, some figures reversed and others moved without logical shifts in gesture or interrelationship, suggesting that here Jacopo did not even supervise the general composition.[320] The technique is based directly on that of Leandro in his moment of coldly sharp color in a black environment, a grim phase that followed Jacopo's *Sante Moro* votive of late 1576. Its touch is thready, linear, and formless, most particularly in the Madonna and saints above, and it is these figures which point to Giambattista's execution around 1577-79. Still later, his maladroit hand would lose even this rudimentary control and become a poor substitute for Gerolamo's woolly forms. Instead, it was Leandro who stepped into Francesco's role as Jacopo's adjutant and prime collaborator.

A characteristic example of this new collaboration may be found in Jaco-

69. Leandro and Jacopo Bassano, *The Expulsion of the Merchants from the Temple*, private collection, Bassano del Grappa

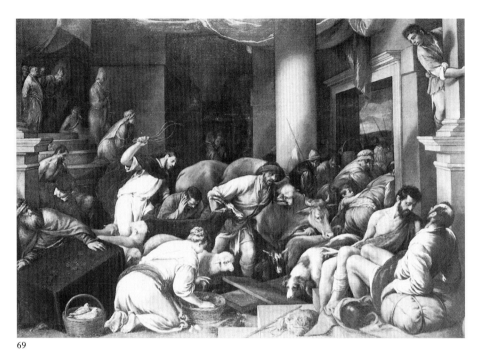

69

po's reprise of *The Expulsion of the Merchants from the Temple* (private collection, Bassano del Grappa, fig. 69).[321] Condensing the Prado composition of this theme, reducing the staffage, making the figures more monumental, and bringing Christ nearer to the foreground, Jacopo sketched onto the canvas a more energetic depiction of the expulsion itself. At once, he saw the need for two new reclining figures to anchor the lower right corner, and he sketched them (formerly private collection, Stockholm; and Hessisches Landesmuseum, Darmstadt) anew, although each was a familiar type.[322] He probably began the early phases of painting, but soon assigned specific passages to Leandro, who brought many of them to completion. Jacopo, however, executed almost all of the Christ and much of the group of figures from center to right, including the boy on the plinth and, surprisingly, the apricot red drapery above. At this point, Leandro was left to his own devices in formulating a vertical edition of the subject,[323] drawing it in a pen and wash study (Musée du Louvre, Département des Arts Graphiques, Paris), a medium Jacopo almost never used. He developed that idea in a painting (private collection) that seems not to have suited Jacopo, since his father picked up a large sheet of blue paper, and with splintered energy scratched a colored chalk version (J. Paul Getty Museum, Malibu, cat. 25) in a return to the horizontal format.[324] It is perhaps his latest surviving colored chalk compositional study, and its creative urgency is utterly personal and without parallel in Italian

ness of its disordered composition and the foamy lack of focus in the central group, where Francesco's hand predominates. Jacopo, however, painted most of the spectators at left, parts of the group at right, and the major forms of the charmingly theatrical demons.

312. Although he was not noted for his taste as an art collector, as a brusque naval person Venier might have been attracted by the candor of Jacopo's portraits. The commission must have been awarded rather soon after his election in June 1577, since it was evidently finished in time to be inserted into *The Circumcision* altarpiece, which was finished toward the end of that year.

313. Oil on copper, 23.4 × 17.5 cm. Unpublished. A few copies survive, but none was produced directly by the Dal Ponte shop.

314. We have no firm documentation for the date of Francesco's transfer to Venice, except that he was at work on the Palazzo Ducale ceiling by early April 1578. The intensity of his collaboration with his father during 1577 suggests that he moved directly after December of that year. It is possible, indeed probable, that he worked for Venetian clients prior to his immigration there. His marriage in Bassano to Giustina Como on 10 February 1578, might have been the occasion for this imminent shift.

315. With the deaths of both Titian and his son Orazio Vecellio in the early autumn of 1576, the Biri Grande house was sacked by robbers and passed to the Barbarigo family. It is not clear when Francesco moved in, but he probably rented it from the Barbarigo, since his will does not mention the property as his.

316. Ridolfi (1648, I, 396) reports that old Jacopo, too frail to mount the scaffolding, pointed out mistakes and suggested corrections to Francesco from the floor of the Sala del Maggior Consiglio in the Palazzo Ducale.

317. Oil on canvas, c. 250 × 125 cm. Signed: FRANC.S BASS.S. See Muraro 1952, 52; and Lugato Giupponi 1992 (B), in press. Gaspare Dolzoni endowed a new chapel to be constructed at San Giacomo dell'Orio in 1568, and recently discovered documents suggest that the altarpiece was completed and signed by 1578.

318. Jacopo provided Francesco with a sketch for the Saint Nicholas (formerly Colnaghi, London; see Rearick 1992 (B), in press) and intervened in finishing much of the lower part of the painting.

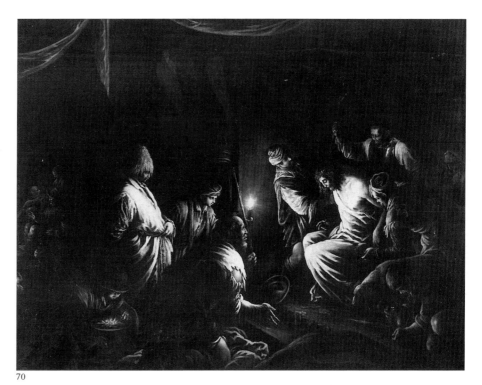

70. Jacopo and Leandro Bassano, *The Scourging of Christ*, Galleria Palatina, Palazzo Pitti, Florence

70

319. Alberton Vinco da Sesso 1986, 13-14.

320. Oil on canvas, 165 × 127 cm. Ascribed to Jacopo by early authors (Ridolfi 1648, I, 376) and dated to after 1576 (Federici 1803, II, 63), this small altarpiece was demoted (Magagnato 1952 (A), 49-50, no. 32) to the status of a collaboration in great part by Francesco. It was, instead, delegated to Giambattista and painted well after 1576. Here Giambattista makes a failed effort to emulate the coldly glittering early style of Leandro. For it he made clumsy use of Francesco's *ricordo* (Gabinetto Disegni e Stampe degli Uffizi, Florence) after the Brera altarpiece (cat. 47). Giambattista's descent into a blunt imitation of Gerolamo after 1588 is evident in the altarpieces painted in collaboration with Luca Martinelli in 1593 (parish church, Rosà); *Saints Peter, Paul, and Bartholomew* (parish church, Oliero), that is documented to 1594-95; the signed altar of c. 1596 (parish church, Serdes); *Saints Sebastian and Roch* (Museo Civico, Bassano del Grappa); the ruined altarpiece of 1598 from Gallio (Museo Civico, Bassano del Grappa); and the feeble 1612 *Madonna and Saints* (parish church, San Bartolo di Crosara).

321. Oil on canvas, 143 × 204 cm. Ballarin (1973, 113) thought it a shop replica after a lost work by Jacopo, while Pallucchini (1982, 40, no. 30) gave it to Jacopo with a date c. 1565. Rearick (1986 (A), 187) considered it a collaboration between Jacopo and Leandro datable to c. 1578.

322. Rearick 1992 (B), in press.

323. Leandro's drawing in Paris is inscribed: «1570/ a sa'to martino cio…/ divi[?] aceppi [?] salviati [?]». The date is either a misreading of 1579 inscribed elsewhere, or 1580. The painting, known to me only in a transparency without dimensions, was on the market a decade ago.

324. Rearick 1992 (B), in press.

325. The *ricordo* (Gabinetto Disegni e Stampe degli Uffizi, Florence, inv. 19107, *bozzetto* inv. 607) is a large chiaroscuro on several sheets of faded blue-green paper pasted to canvas. Crude in technique, it was probably done by Giambattista after the lost original by Leandro under Jacopo's supervision. Leandro painted several replicas (Museo del Prado, Madrid; Kunsthistorisches Museum, Gemäldegalerie, Vienna; Galleria Doria Pamphilj, Rome; etc.) over the next decade and signed a repetition (Musée des Beaux-Arts, Lille) which, be-

Renaissance draftsmanship. Still not content, Jacopo worked out another version, the format that he allowed Leandro to paint and Giambattista to reproduce in a *ricordo* drawing, which in turn was passed on to Francesco in Venice for replication.[325] This would become the standard late shop version of *The Expulsion of the Merchants from the Temple*, but there is no version of it painted entirely by Jacopo, even though he added finishing touches to several of Leandro's replicas.

The revision of *The Annunciation to the Shepherds* (Národní galerie, Prague, cat. 54) presented fewer problems. Its composition was almost entirely changed from the Washington version of twenty years before, and a singularly delicate black chalk study for the sleeping shepherd boy at center (Graphische Sammlung Albertina, Vienna, cat. 107) suggests the care and restraint that went into it.[326] Here Leandro's role was lesser and different, restricted to broad passages of the atmospheric, sulfurous nocturnal landscape. Highlights are largely Jacopo's, except for parts of the shepherds at the left and right foreground, and the angel, whose emergence from the cloud casts a curious and rather awkward shadow. All members of the shop, including Francesco, would reproduce it with a frequency that made this particular *Annunciation to the Shepherds* a key work in the dissemination throughout Europe of night

scenes with artificial or miraculous illumination.

Another influential nocturne, *The Scourging of Christ* (Galleria Palatina, Palazzo Pitti, Florence, fig. 70), is a free revision of the Accademia picture of a decade before.[327] Again, Leandro played a major role in its execution and dissemination.[328] At about the same time, shortly after 1578, Leandro participated in transforming the familiar 1568 type *Adoration of the Shepherds* into a night scene in which the Child is the primary source of illumination.[329] Both Jacopo and Francesco had explored this treatment somewhat earlier, but it was Leandro who promulgated it in an oft-repeated composition of which no original by Jacopo survives.[330]

Another reprise of a cycle that was becoming a hugh success with collectors was a new set of Noah canvases (Arcibiskupský Zámek a Zahraòy, Kroměříž, cats. 63-66).[331] Only slightly varied from Jacopo's first suite of about three years before, it was smaller in scale and more attentive to detail. Jacopo apparently regarded these works as destined for a significant patron, since he carefully signed all four pictures, even though Leandro was pressed into service in the execution of each. His sharper color, black shadow, and rather dry and thready texture is evident throughout. Given the fragmentary parts that survive from Jacopo's earlier treatment, this group holds an important place as an integral series of pictures that is fully signed.

The Dal Ponte home shop was not exclusively dedicated to producing popular pictures for an ever-widening market, even though this mass-production technique now constituted a predominant part of its activity. Altarpieces for local and provincial churches continued to be commissioned, and Jacopo remained dedicated to providing them on a high qualitative level. For the village of Valstagna north of Bassano in the narrow valley of the Brenta, he was asked to do an ex voto, now lost, for which we have Jacopo's autograph *modello*, *Saints Nicholas, Valentine, and Martha* (Museum of Art, Rhode Island School of Design, Providence, cat. 68).[332] It is not known if Jacopo made regular use of small, painted *modelli* as guides for larger projects, but since this is one of about three that survives, he may have used them primarily when another member of the shop would be delegated much of the execution of the altarpiece. Here, his touch is fresh, vivacious, and casual in leaving most of the margin outside the curved upper corners unpainted. The old-fashioned format was probably required by the Valstagna patrons. The small ex voto tablet at lower right shows a woman kneeling by a cradle, perhaps either giving thanks for the birth of a child or the survival of an infant after an illness. The finished altarpiece was reproduced in a crude *ricordo* (Staatliche Museen Preussischer Kulturbesitz, Kupferstichkabinett, Berlin), which Giambattista inscribed with the date « 1578 ».[333]

At about the same time, or perhaps into 1579, Jacopo was given a task clos-

cause of the inclusion of *EQUES*, must date after his knighthood of 1595. Francesco used the *ricordo* as a model for his first repetition (formerly Sambon collection, Paris), which he signed in a unique form: FRANC. FILIUS./ JACI. BASS./ FAC. It seems to have been intended to underscore Francesco's role as Jacopo's representative in Venice during the years 1580-84.

326. The nocturnal version was probably preceded by a transitional *Annunciation to the Shepherds* that is very close in style to the Vienna *Seasons* and survives in a version entirely by Francesco (Czernin collection, Vienna). Given its poorly coordinated format, it was probably Francesco's own invention. It was not popular and quickly disappeared from the Dal Ponte repertory. The Prague revision or a replica was engraved by Jan Sadeler (Pan 1992, no. 2). It was first brought to wide attention as Jacopo's original by Ballarin (1966, 131-35). The sketch (Rearick 1992 (B), in press) is unexpected in its refined use of continuous line and avoidance of chiaroscuro in a project for which strong constrasts of light and shade were to be his primary concern. Leandro painted several replicas (Wawel Museum, Cracow; Gemäldegalerie Alte Meister, Dresden; Museo del Prado, Madrid; Pinacoteca di Brera, Milan; Kunsthistorisches Museum, Gemäldegalerie, Vienna, in two versions), and Francesco did a signed version (formerly art market, Paris) that his shop reproduced. Jacopo returned to the theme around 1589-90 (private collection, Padua, fig. 82), and Gerolamo attempted his own revision (Museo Civico, Vicenza) c. 1595.

327. Oil on canvas, 138×182 cm. Ballarin (1966, 130) recorded that the Pitti picture is signed jointly by Jacopo and Francesco, but I have been unable to detect this in the original. It is a broad revision of the 1568 drawing (cat. 94) in a completely different pictorial key.

328. Francesco was directed to paint almost all of the Pitti picture except the passages brightly illuminated by the torches. Leandro repeated it in more than a dozen replicas, but around 1583-85 Gerolamo began to produce fuzzy replicas in which the central group is the prime focus. On occasion, Jacopo intervened in a late version such as Leandro's large picture (Rossi collection, Venice).

329. Drawing on the 1568 *Adoration* (cat. 46) and the 1569 reduced variant, Jacopo be-

gan to formulate a nocturnal version around 1575, simultaneous with the lost *Christ in the Garden of Gethsemane* done for Cartigliano. At first he and Francesco experimented with vivacious small compositions (private collection, Padua; with a replica in the Kunsthistorisches Museum, Gemäldegalerie, Vienna; etc.) in which bright passages of color are sharply contrasted with a black environment. Francesco signed his own larger version (Museo Civico, Bassano del Grappa), which was attempted as a pendant to a replica of *Christ in the Garden* (Museo Civico, Bassano del Grappa), but it was too scattered in composition and would not be repeated. It was, instead, about 1578-79 that Leandro assumed responsibility for creating a horizontal composition (Saint Symphorien, Tours) that would become the standard for a quarter century in many replicas by Leandro, Gerolamo, and the late shop. Francesco preferred to return to a daylight treatment based on the 1560 Corsini picture (cat. 36), which he had copied (fig. 46) at the beginning of his career.

330. Once again, the absence of an original by Jacopo might mean that his sons created the first version of a given picture, but the closely collaborative working process of the Bassano shop suggests that Jacopo at least supervised the execution of new formulations destined to join the standard repertory for duplication in the shop.

331. In the collection of the Archbishop of Kroměříž at least since 1667, this is the finest in quality of the few surviving *Noah* cycles that remain intact. That it was regarded as a pivotal formulation of the most popular cycle of Bassano pictures is confirmed by the fact that the great majority of replicas were painted by Leandro, by his shop, or by the younger generation of assistants in Bassano, who looked primarily to Leandro for guidance.

332. Arslan's (1960 (B), I, 364) attribution to Pietro Mariscalchi is surprising, since that artist from Feltre was strongly influenced by Jacopo's work during the years 1548-51, but by 1578 had developed in an entirely different direction, as seen in the 1576 *Feast of Herod* (Gemäldegalerie Alte Meister, Dresden).

333. Giambattista and his brothers still, on occasion, dated *ricordo* drawings. In this instance, it might indicate that he had participated in painting the now lost altarpiece as well. The Providence *modello* is, however, quite distinct from Giambattista's blunt and

er to home and closer to his heart. For the ancient church of Santa Maria delle Grazie, which was built into the city walls of Bassano del Grappa by the northeast gate, he painted the *Saint Lucille Baptized by Saint Valentine* (Museo Civico, Bassano del Grappa, cat. 53), an unusual subject showing the moment when the girl rises from her sewing to be baptized by Saint Valentine.[334] Once again, as with *The Adoration of the Shepherds* altarpiece (Museo Civico, Bassano del Grappa, cat. 46) of a decade before, the subject fell comfortably into the genre-like naturalism of his style at this moment. The happy result is another masterpiece in which the painter's skimming brush moved with apparently effortless fluency to conjure up shimmering passages of light and texture, such as the web of gleaming reflection over the silk dress of the saint. This virtuoso effect so astonished Giambattista Tiepolo almost two centuries later that he wrote to his son Domenico saying he had seen a miracle of painting, a dark drapery that appeared light. Similarly, Saint Valentine's chasuble, the Filarete cross – which had just been depicted in the Dolzoni altarpiece – and the clothing of Saint Lucille's mother are evoked with almost equal brio. Even Jacopo's perspective seems nearly accurate here. This may, however, be due to the participation in subsidiary passages of Leandro, his hand here more delicate in response to his father's high spirits. The general tonality is frosty and the touch skittering without losing definition. The *Saint Lucille* altarpiece already shows intimations of yet another transformation in Jacopo's stylistic argosy, which would lead to his last, visionary works.

Commissioned in all probability by the wealthy Contarini family in Venice, in whose palace near San Samuele it was accorded pride of place in the next century, *Jacob's Journey* (Palazzo Ducale, Venice) is perhaps Jacopo's last and grandest treatment of this favored theme.[335] For it he made a rapid sketch (private collection, Spilimbergo) in colored chalks, perhaps his latest drawing in this, his most original medium.[336] The composition is panoramic without recourse to the self-consciously high vantage point he occasionally exploited in these years. It follows, generally, the prosy format of the Dresden *Return of Tobias* (fig. 57), but is more secure in assembling an aggregation of peasant types without exploiting their picturesque potential for condescending social comment. Rarely has Jacopo seemed so sure of his ground as in this spacious twilight landscape in which his simple countrymen go diligently about their business oblivious of any milieu but their own. It shares this disarming candor with the *Saint Lucille* altarpiece, but its scintillant touches of faintly dissonant color suggest that it be dated just subsequently, close to 1579. Leandro's expert if more prosaic touch is evident in peripheral passages, particularly the charmingly described ceramics in the foreground. Jacopo would never again paint his well-loved countryside with such sensuous pleasure.

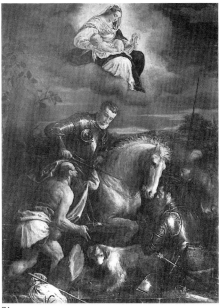

71

The *Saints Martin and Anthony Abbot* (Museo Civico, Bassano del Grappa, cat. 67) was referred to in a document of 1580 in terms that suggest that it was just recently finished.[337] Indeed, comparison with Jacopo's altarpieces of 1577-78 strongly suggests that this work should be dated to 1579. Jacopo arbitrarily juxtaposes Saints Martin and Anthony with no concern for dramatic or psychological interaction, and the ghostly appearance of the Crucifixion on the distant hillside further enhances the aura of melancholy isolation that pervades the twilight atmosphere of this magical painting. Less concerned with descriptive detail than he had been in either the Valstagna *modello* or the Saint Lucille altarpiece, Jacopo here allows his brush to skim the canvas with a feather-soft touch, leaving nervous trails of luminous highlight that assume a visual life of their own in the horse's mane and in Saint Martin's glinting armor and tremulously expressive head. Light seems to coalesce around the beggar's extended hand, but its anatomical structure is sure and decisive in touch. Indeed, the entire paint surface takes on an incandescent intensity, as though transfigured by the last rays of the setting sun. Jacopo painted it alone, but the fast approaching moment in which his sons could no longer keep pace with his restless experimentation is amply illustrated by two pictures that were developed on the basis of the *Saint Martin* altarpiece. The *Saint Martin with Brandolino V Brandolini* (Castello di Valmarino, Cison, fig. 71) is a revision of the earlier composition, omitting the Saint Anthony, adding the Virgin in Glory above, and, most importantly, inserting the donor and his page.[338] Although its quality is high, the detailed surface description and cold blue rose color clearly bespeak Leandro's hand in much of its execution. Jacopo, nonetheless, took over final finishing touches and almost all of the donor and his page. Its close relation to Leandro's *Circumcision* (parish church, Rosà) which is documented to 1582, suggests its date. Still later, close to 1583, *Saint John the Evangelist with Lodovico Tabarino* (Museo Civico, Bassano del Grappa) used the donor figure from the Brandolini votive, with the saint borrowed from the Cassola altarpiece of 1573.[339] Here almost everything except the finishing touches to the donor and the firmer modeling of the drapery over the saint's knees was given over to little Gerolamo, who was just finishing his training in the studio. In both of these derivations, which follow the *Saint Martin* altarpiece, Jacopo's participation is disciplined and professional but almost totally without the electric vitality of that work. It provides an unusual glimpse of a great painter making an effort to bring his work down to the level of his sons and assistants.

If the *Saint Martin* is a transitional work, *The Madonna in Glory with Saints Agatha and Apollonia* (Museo Civico, Bassano del Grappa, cat. 122) has moved

hesitant *ricordo* paintings, such as that in The Hermitage, Saint Petersburg, which he did after the *Saints Florian, Sebastian, and Roch* (fig. 44) of a decade earlier.

334. Leandro's sharper tonality and drier precision of finish is evident in the group of figures above Lucille and her mother, in the turbaned servant and dog at right front, and in the architecture, sky, and putti. In all of these areas, however, Jacopo added final touches of a freshly improvisational brio. Roberti (1777, 28) reported Tiepolo's vivid reaction to the white satin dress in the *Saint Lucille*.

335. Oil on canvas, 150×205 cm. Mentioned by most early sources, beginning with Ridolfi (1648, I, 380), as in the Palazzo Contarini at San Samuele, Venice, it was given to the Venetian state by Bertucci Contarini (1637-1713) and installed in the Anticollegio. Since Ridolfi, its subject has been described as *Jacob's Journey*. Contrary to the modern literature, which usually dated this picture to c. 1574 and saw Francesco's participation, the recent restoration has revealed passages of tremulously loose brushwork, confirming a later date. Since Francesco was already in Venice, Jacopo turned to Leandro, who did most of the secondary passages, especially the

72. Leandro and Jacopo Bassano, *Saint Roch in Glory with Saints Job and Sebastian*, Palazzo della Provincia, Vicenza

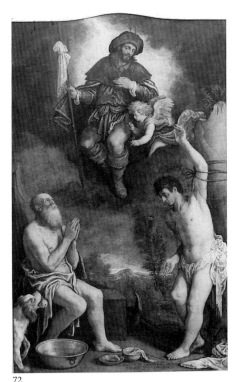

72

minutely described still-life objects in the foreground.

336. For the women at lower left, Jacopo sketched a particularly loose and expressive colored chalk drawing (formerly Furlan collection, Spilimbergo). Rearick 1992 (B), in press. No photograph of the slight and rather damaged sketch of a horse on the verso is available.

337. For the document relative to *The Madonna in Glory, with Saints Agatha and Apollonia*, see below n. 340. It records, under 3 March 1580, that the new altarpiece should follow the format of the *Saint Martin* picture. A poor, seventeenth-century copy of the *Saint Martin* (Kress collection, New York) has been called Jacopo's *modello*.

338. Oil on canvas, 151 × 103 cm, including the added strip of canvas below. Brandolini d'Adda (1945, 1) recorded the family tradition that the work was commissioned from Jacopo by Brandolini V Brandolini at a date between 1570 and 1580, presumably a date based on the appearance of the age of the donor in the picture. He alleged, convincingly, that

into a new and alarming pictorial world.[340] On 3 March 1580, it was commissioned for a side altar in the small church of San Giuseppe next to the cathedral in Bassano del Grappa, and the final payment of 21 January 1581 noted it as already in place. The composition is almost archaic in its simplicity, and the figure types propose no new forms, but the pictorial idiom is in an advanced stage of disintegration. This is only in a minor sense due to shop intervention, since Giambattista and Leandro were restricted to secondary passages which are today hardly visible. Instead, it is Jacopo who began with a dense pattern of slashing swaths of paint in the Saint Apollonia, whose sleeve has lost all but the most rudimentary rapport with identifiable surfaces and verges toward pure expression of will through movement of the wrist. Violent and forceful as it is, this passage gives way in the Saint Agatha to a spectral fragility of touch in which the fat-faced saint seems already to have decomposed into a ghostly ectoplasm conjured up in livid tones of transpicuous volatility. Finally, as though he recognized the necessity to get a firm grip on a disoriented digression, Jacopo took a harsh range of black, deep blue, rose, and dead white and blocked out the Madonna and Child with compulsive severity. Abstracted and insistent, these forms are among the most bluntly ugly Jacopo ever painted. As though he sensed that only the Madonna remained fully legible, Jacopo recorded its blocky design in a *ricordo* (Hamburger Kunsthalle, Kupferstichkabinett, Hamburg, cat. 113), which is unusual, since he had turned that labor over to his sons almost a decade before.[341] This one was doubtless intended to instruct Gerolamo in the technique, although his fourth son never learned the lesson. The fifteen-year-old boy signed a payment receipt for the altarpiece in his father's name, but he did not paint any of it as has been alleged, except possibly the dark sky, which Jacopo covered with a gloomy cloud.

Although the 1580 altarpiece announces a vertiginous departure from the orderly and conservative collaborations that characterized the works of the preceding decade, it would prove more the exception than the rule at this point. Instead, Jacopo continued to preside over the Dal Ponte establishment. Leandro provided him with expert seconding, Giambattista was delegated minor tasks and replication, and young Gerolamo struggled to learn from the increasingly impatient old man. Now, in contrast with the nearly seamless level of quality that the establishment had maintained for many years, the gaps began to become apparent between Jacopo and his variously talented offspring. Even Leandro began to falter in pictures such as the *Saint Roch in Glory with Saints Job and Sebastian* (Palazzo della Provincia, Vicenza, fig. 72), which was done for the chapel of Villa Bonin-Longare near Vicenza and bears the joint signature of Jacopo and Leandro, perhaps the first instance in which the third son was permitted a joint signature.[342] It is dated

1582. Here it was probably Gerolamo who was assigned the task of laying in basic areas of paint over Jacopo's sketched design. Leandro then developed form, bringing all of the figures near to completion. The difference in this picture lies in Jacopo's intervention at its final stage. The old man decided that Sebastian's placement was wrong, and he brusquely shifted the axis of the torso, lowered the head, and brought the raised arm to the left, a pentimento which clearly shows today. He repainted much of the body, adding the strongly naturalistic head, but turned the loin-cloth back to Leandro. He retouched Job less drastically and added the gleam to the brass basin. The rest remained as Leandro had painted it, rather ponderously mechanical in contrast to the fresher Rosà *Circumcision* of the same year, which he had, after all, good reason to favor, since it was entirely his own work and might better foster his independent career.[343]

Simplicity is by definition inimitable. Leandro was already recognized as an efficient portraitist, and it would, in a few years, become his recognized specialty in Venice. In 1582, however, Jacopo reduced his approach to portraiture to its barest essentials in the *Portrait of an Elderly Man* (Museo Civico, Vicenza, fig. 73).[344] Faintly embarrassed to be the object of such scrutiny, the old gentleman purses his lips and stares fixedly, if diffidently, at the painter. Graying beard, simple black suit with white collar, and a neutral dark space are all there is. And yet, the even older artist's austere simplicity, much like the touching pathos of the Job in the *Saint Roch* altarpiece, permits an emotional honesty to which the skittishly chic Leandro knew better than to aspire.

Raffaello Borghini came from Florence to collect information on Venetian painters for his book *Il Risposo* in the autumn of 1582. Thus, *The Entombment* (Santa Croce, Vicenza) must have been quite fresh when he described it as a fine work of Jacopo.[345] Its format is a slightly smaller simplification of the great 1574 *Entombment*, but its character is quite distinct. Narrower, round-topped, and more intimate in tone, it adds a sputtering torch at right that casts a sharper, more naturalistic light on the tragic tableau than the celestial glare that transfigures its model. This more mundane mood extends to the night landscape, which is more realistic and insistent in its detail and symbolism, such as the resprouted broken tree, here shifted to the right. As was customary, a collaborator took responsibility for the early stages of its execution, but he relinquished the canvas for almost all of the figures, particularly those on the left side, where the head of Joseph of Arimathea is nervously delicate in touch in a rapid handling that recalls the *Saint Martin* altarpiece. Jacopo's assistant seems again to have been Leandro, although much of his work was covered by the old man's finer brushwork.

Venice was, in these years, the scene of frenetic activity. The victory over

73

the *Saint Martin* was a portrait of the donor's son Francesco Maria. When it was exhibited (Zampetti 1957, 208, no. 87), Fiocco (verbally, and 1958, plate 5) defended the attribution to Jacopo and gave it priority over the *Saint Martin* altarpiece (cat. 67); Pallucchini 1957, 115) cited The Hermitage drawing as supporting Leandro's authorship, and Arslan (1960 (B), 1, 166 and 348) considered it partially autograph and after the *Saint Martin* picture. The drawing in pen and wash (The Hermitage, Saint Petersburg; Salamina 1964, 34-35, no. 34) is a characteristic *ricordo* done after the picture by Leandro, who had played a predominant role in painting the picture.

339. Oil on canvas, 110 × 78 cm. Once in the collection of Antonio Canova at Possagno. The banderole, inscribed LODOVICUS/TABARINUS, was uncovered during the 1952 restoration. The softly messy style accords well with Gerolamo's early collaborations with his father. See above n. 293.

340. Oil on canvas, 198 × 117 cm. Crivellari (1893, 10) transcribed the complete document in which the contract was signed 3 March 1580, payments were made to Jacopo on 8 March and 14 September, a payment signed for by Gerolamo on 14 September, and the final payment to Gerolamo dated 21 January 1581, with the notation that the picture was

already finished and in place. Arslan (1931, 292-93 and 303) insisted that the picture was entirely by Gerolamo, and it has not been given adequate attention in the recent literature.

341. Rearick 1992 (B), in press. The firmness of hand is exactly like that which Jacopo demonstrated in the painting.

342. Oil on canvas, 240×148 cm, slightly reshaped above to fit a later frame. Signed and dated: IACOBUS BASSAN.sis ET LEA.er/ FILIUS FACIEBANT/ MDLXXXII. Sgarbi (1980, 92) gave the first extensive discussion of this picture, although he underestimated Jacopo's role in it.

343. Leandro was twenty-five years old in 1582, and later the same year he signed alone The Circumcision (parish church, Rosà), although there again Jacopo intervened with a few highlights. Its composition came from the 1577 altarpiece (cat. 121), but much of the cool glitter of fabrics still reflects The Baptism of Saint Lucille (cat. 53).

344. Oil on canvas, 78×61 cm. Rearick (1980 (B), 113) first attributed it to Jacopo with a date toward 1580, a location I now regard as slightly too early. Many of the portraits previously assigned to Jacopo in this phase are, significantly, by Palma il Giovane and may be dated more than a decade later. See Mason Rinaldi 1984, 40-46.

345. Oil on canvas, 258×142 cm. Leandro's small reduced version (Kunsthistorisches Museum, Gemäldegalerie, Vienna) of the 1574 Entombment (cat. 52) served as the starting point for the Vicenza variant. Many details such as the torches, the broken tree at right, the sunset at distant right, etc., are already adumbrated in the small modello by Leandro. Despite this delegation of its basic format, Jacopo here assumed greater responsibility for its finishing touches than in other paintings of the years 1580-82.

346. Formiciova 1981, 89-90. Rearick 1988 (A), 103-4.

347. Oil on canvas, 237×156 cm. Major passages of the dark background in the lower half of the painting have flaked off entirely, leaving exposed canvas. Paolo Veronese must also have seen and admired it, since his Ognissanti altarpiece (Gallerie dell'Accademia, Venice) clearly shows its influence in 1585-86. Rearick 1988 (B), 190-91.

348. Although Veronese's style was entering a darker phase in 1582, and despite the fact that he sent his talented son Carletto to

the Turks at Lepanto in 1571 was followed by the great plague of 1576, during which Titian died. A year later, the Palazzo Ducale was gutted by fire, an artistic and historic loss that the government quickly set about restoring with unparalleled commissions for new paintings to cover its interior. Most prestigious of all was the giant Paradiso, which was to replace Guariento's fresco in the Sala del Maggior Consiglio. Documentation about its commission and execution is fragmentary, but it is probable that the competition to which Francesco submitted his modello (The Hermitage, Saint Petersburg) took place in 1582.[346] Jacopo, as we have seen in the case of the Dolzoni altarpiece of 1578, felt that it was incumbent on him to help his most talented offspring, especially in situations where public recognition would further the young artist's career. He took no part in the painted modello, but he did take advantage of a local commission to show Francesco the way in such subjects. The Paradiso altarpiece (Museo Civico, Bassano del Grappa, cat. 123) was based on Titian's Gloria (Museo del Prado, Madrid) by way of Cort's engraving, but its figures are a compendium of Dal Ponte stock types, including the Saints Martin and Anthony from the 1579 picture, the Saint Agatha from the 1580 altarpiece, and the Saints Roch and Sebastian from the 1582 painting.[347] It is, therefore, probable that the Paradiso altarpiece was carried out in 1582 as a kind of trial run for the Palazzo Ducale mural. Its execution was, however, a collaborative effort in which Jacopo took a very minor role, adding finishing detail only to the Saint Christopher and the nun saints at front left. The rest was left largely to Leandro, although Francesco may have returned from Venice to study it and add a few passages here and there. Francesco borrowed numerous details as well as the general concept for his modello. Its success was such that he was invited to collaborate with Paolo Veronese in the execution of the Paradiso mural, a project delayed and finally abandoned after Paolo's death in 1588.[348]

The equilibrium of the Dal Ponte firm was about to be tilted away from Bassano toward Venice. Francesco's career in the capital had catapulted him into a position of only slightly less esteem than that of Tintoretto and Veronese, and nearly on a par with, though distinct in clientele from, Palma il Giovane.[349] Jacopo seems to have visited him at Biri Grande with a certain frequency and may be presumed to have offered freely both advice and intervention in his son's works. Fifty years later Ridolfi reported with a detail certainly founded on recent legend, that Jacopo, too infirm to mount the scaffold in the Sala del Maggiore Consiglio, stood below with a mirror and a long bamboo stick to point out mistakes and suggest corrections in Francesco's four battle scenes placed in situ in 1582. Still, commissions poured in, and, at least by 1584, Leandro had begun to absorb the excess projects, painting a Saint Jerome (San Zulian, Venice) in Venice that same year.[350] Only the

74. Gerolamo and Jacopo Bassano, *The Expulsion of the Merchants from the Temple*, formerly art market, Venice

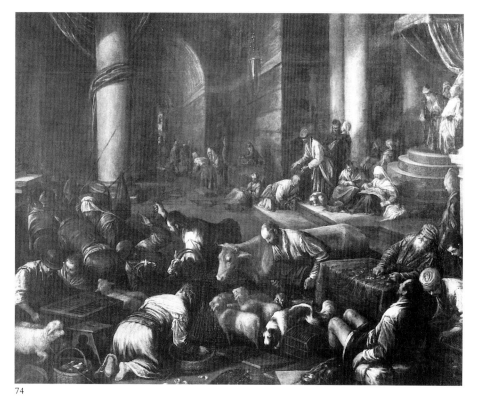

74

maladroit Giambattista remained in the Bassano shop, but by 1584 Gerolamo was eighteen years old and would have been ready to assume the role of an active collaborator.

Gerolamo's career as a painter is divided sharply into two phases, that before his medical studies began at the University of Padua around 1585 and that after his return to the Bassano workshop around 1588.[351] Born in 1566, he doubtless followed the pattern of his three older brothers in starting to learn his craft by about 1580. His early work as his father's junior collaborator is traceable to about 1583, when Jacopo decided once again to revise his *Expulsion of the Merchants from the Temple* (formerly art market, Venice, fig. 74).[352] Reversing the standard formulation of the late shop practice, he reduced the figure scale, took a high angle view, and generally dissipated drama to compile a rather episodic picture, which was turned over to Gerolamo for the selection of stock figures from the Dal Ponte repertory. Jacopo intervened only in the upper part of Christ, the man Christ is striking, the man carrying a pack at center, and a few smaller details such as the crystal lamp. It served for replication in Bassano, but Leandro and Francesco stuck by the older format. Very soon afterward, close to 1584, a new set of Genesis themes in a small

study with Francesco Bassano, it must have been evident to all concerned that their diversity of style was an unbridgeable gap in carrying out the *Paradiso*. After postponing even the purchase of canvas, each found other things to do until Paolo's death released Francesco from the daunting challenge.

349. Mason Rinaldi 1984, 28-36. Palma had not yet been given the major commissions for the refurbishment of the Palazzo Ducale, which he would assume only in 1582. He was, however, already well established with many rich and powerful old Venetian families. Despite his success in the Palazzo Ducale, Francesco seems never to have penetrated the conservative taste of families such as the Gritti, Mocenigo, Barbaro, or Venier. Instead, Francesco was already in demand among foreign patrons, who felt, justifiably, that the quality of works now issued from the shop in Bassano was, at best, variable in quality.

350. Arslan 1960 (B), 1, 237 and 272. Signed and dated 1585. Leandro certainly received commissions from Venetian patrons earlier, but in the absence of documents for his opening of a studio in Venice, this step should be placed near to 1585. Significantly, for his *Saint Jerome* Leandro drew on his own replica (Museo Civico, Padua) after his father's San Cristoforo altarpiece of exactly a decade earlier.

351. Born on 3 June 1566, Gerolamo must have begun work in the shop by 1580, the year in which he acted as his father's surrogate in signing a payment receipt. By 1583 he would have been delegated a significant role in the familiar pattern of paternal collaboration. Arslan (1960 (B), 1, 277-83) formulated a seriously flawed reconstruction of Gerolamo's career as a painter, erring especially in tracing his beginnings. For the documented facts, see Alberton Vinco da Sesso 1986, 178-79.

352. Oil on canvas, 113 × 140 cm. This version is marginally superior to the replicas (The National Galleries of Scotland, Edinburgh; and Borromeo collection, Isola Bella) painted immediately afterwards by Gerolamo alone. Although the shop repeated it several times, it would be replaced about two years later by another revision (The National Gallery, London).

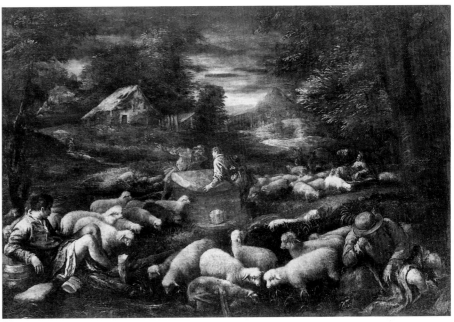

75

format was projected (Kunsthistorisches Museum, Gemäldegalerie, Vienna).[353] Small figures in spacious landscapes are barely visible in a pervasive gloom, their clothing, coifs, and beards sharply accented in white or other high-keyed colors. *The Israelites Drinking the Miraculous Water* and *The Miracle of the Manna* are recompositions of figures from prototypes, such as the Jacopo/Francesco Dresden *Miracle*, but many of the clumsier passages, such as the woman kneeling at left, in the *Israelites Drinking* are Gerolamo's inventions, as his drawing (art market, London) attests. In these only the highlights have been added by Jacopo, and not in every passage. A different approach is evident in the *Jacob and Rachel at the Well* (fig. 75) and *The Departure of Abraham*, where the compositions are reordered, but with little reference to the familiar prototypes. In them the figures are almost entirely by Jacopo, who left the disordered landscapes to Gerolamo. Although here again Gerolamo produced replicas for the market, this suite was never satisfactory. Jacopo's rapidly and roughly applied passages of luminous paint at once separate themselves from Gerolamo's woolly textured labors; there is no longer a seamless collaboration but rather a visionary old man rushing on to new experiments as his fumbling offspring struggles vainly to comprehend.

Dal Ponte shop practice must, under these difficult circumstances, have been variable, depending on the project and the forces available. Commissions to be realized entirely in Bassano suffered most, as a large but fragmen-

353. Although they all conform to an only slightly varied size and figure scale, there does not seem to be an integral iconographical thread that links them internally.

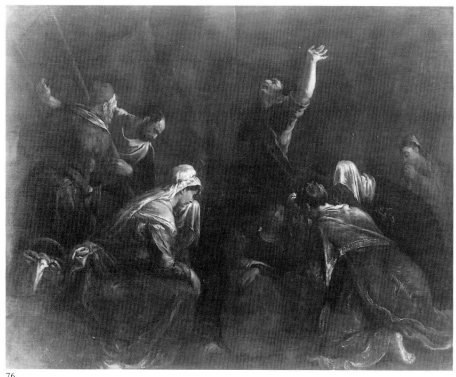

76

tary *Crucifixion* altarpiece (The Duke of Devonshire and the Chatsworth Set-
tlement Trustees, Chatsworth) attests.[354] The group below the cross, com-
posed of diverse stock elements, might have been sketched onto the canvas
by Jacopo, but it was primarily Gerolamo who carried out the rubbery,
moon-faced Holy Woman and the men with the ladder at left. Giambattista
added the ill-designed Saint John and the ugly woman at far right. Jacopo in-
tervened only in the assured top half of the weeping Magdalene. Finally,
however, it must be admitted that the rich, brown and ivory color range and
dramatic nocturnal illumination reflects Jacopo's new interest in night scenes
and must have been broadly determined by him. Another nocturne was real-
ized according to a different sequence. *The Lamentation* (Museum Nacional
de Arte Antiga, Lisbon, fig. 76) is a small *modello* of particularly nervous and
evanescent touch, the torchlight skittering over irregularly dense surfaces
with ghostly effect.[355] Jacopo seems to have sent it to Francesco in Venice,
since the majority of the larger canvases based on the *modello* issued from his
shop. Leandro did use it several times as well, but it was a Venetian Bassano
product, and no surviving finished version was touched by Jacopo himself.

For what may well have been the last time, a major commission for a cycle

354. Oil on canvas, 107 × 133 cm. The origi-
nal dimensions of this monumental *Crucifix-
ion* were c. 216 × 137 cm. It was, thus, slightly
smaller than the Treviso *Crucifixion* (cat. 37).
The replica (Muzeul National de Arta, Bu-
charest) measures 194 × 136.5 cm. It was
largely carried out by Gerolamo with mar-
ginal help from Giambattista. Unexpectedly,
the junior Dal Ponte transformed Jacopo's
somber night illumination into clear daylight
so as to concentrate on a delicate, but nig-
gling description of fabric textures and the
silvery light over trees and clouds. A drawing
(Gabinetto Disegni e Stampe degli Uffizi,
Florence; attributed to Muziano) repeats the
Bucharest version with the Evangelist shifted
into the pose of the woman at far right. Its
clumsy execution and daylight illumination
suggest that it is also by Giambattista. Re-
duced variants in which the nocturnal effect
of the Chatsworth picture is intensified
through the black surface of the slate used as
a support survive in several versions (Museu
Nacional d'Arte de Catalunya, Barcelona,
cat. 55; and private collection, Verona, 43 × 32
cm). Both are probably by Gerolamo c. 1585.

355. Oil on canvas, 59.5 × 75.5 cm. Fran-
cesco painted a monumental canvas (Musée
du Louvre, Paris, 154 × 225 cm) on the basis of
this *modello*, and later repeated it many times
as a modestly scaled devotional picture.
Leandro used it occasionally, and a number
of poor repetitions came from the late shop.

77. Jacopo and Francesco Bassano, *The Capture of Christ*, Stourhead, Stourton, Wiltshire

77

356. Documentation for the commission and its date have not yet been discovered. Since Francesco was already known in the region by about 1580, it is possible that the project was at first lodged with him and that he brought the other Dal Ponte in to collaborate. Ridolfi (1648, I, 379) first described the cycle as disposed around the choir of Sant'Antonio Abate in Brescia. Boselli (1957, 208-10) corrected details on the basis of early Brescian guidebooks. Removed before 1826, they are today scattered.

357. The *Christ in the Garden* is signed by Francesco, who executed it entirely by himself on the basis of the lost Cartigliano version of 1575. The major changes are in the foreground apostles. The *Ecce Homo* is also by Francesco, and its rather uncoordinated composition is his own invention. The *Crucifixion* is a ponderous rethinking of the Treviso composition (cat. 37), and although Francesco's hand is visible in the primary figures the added lateral soldiers are by Giambattista.

358. A horizontal *Way to Calvary* (Musée des Beaux-Arts, Quimper) by Leandro reflects a lost original by Jacopo of c. 1579-80. Gerolamo repeated it around 1583 (Musée du Louvre, Paris). Francesco's vertical composition (private collection, Florence) was prepared by a small edition on slate (Kunsthistorisches Museum, Gemäldegalerie, Vienna). For the Brescia treatment he reversed that

of paintings was distributed among virtually every member of the Dal Ponte clan for execution. The church of Sant'Antonio at Brescia ordered nine canvases depicting scenes from the Passion of Christ.[356] Francesco was given the largest role in their execution, designing and painting *Christ in the Garden of Gethsemane* (John and Mable Ringling Museum of Art, Sarasota), the *Ecce Homo* (Okresni Viastivedné Muzeum, Bruntàl), and *The Crucifixion* (Städtisches Kunstmuseum, Bonn).[357] Francesco painted much of *The Way to Calvary* (formerly De Frey collection, Paris), but Giambattista's blocky forms seem evident in peripheral passages.[358] Leandro executed *The Crowning with Thorns* (Museo d'Arte Antica, Castello Sforzesco, Milan), and *The Scourging of Christ* (Museo d'Arte Antica, Castello Sforzesco, Milan), the latter on the basis of Jacopo's nervously delicate *modello* (The J.F. Willumsen Museum, Frederikssund, cat. 69).[359] Giambattista seems to have assisted Leandro with these two scenes, and was assigned the task of making replicas of both of his brothers' pictures. Jacopo himself prepared a luminous *modello* (Stourhead, Stourton, Wiltshire, fig. 77), almost the scale of the lower part of *The Capture of Christ* (Museo Civico, Cremona), which he turned over to Gerolamo for the earlier phase of execution and then returned to add the flaming highlights.[360] He allotted a larger part of *Christ Stripped* (Museo Civico, Cremona) and *Christ Nailed to the Cross* (Museo Civico, Bassano del Grappa) to Gerolamo, but returned, in the latter case, to paint much of the central figures and the powerful reclining figure in the foreground.[361] The date of this impressive cycle of pictures is not easy to establish, because of the presence of so many hands and the use of a familiar repertory of stock figures, but it seems probable that it was produced over a rather extended period between about 1582 and 1584. Its presence in Brescia further expanded the area in which Bassano works were known, and its realism and dramatic illumination made an impression that the young Caravaggio would long remember.[362]

*

Susanna and the Elders (Musée des Beaux-Arts, Nîmes, cat. 72) is signed and dated 1585 in a casual form, which suggests that it was for a discriminating private patron who was familiar with Jacopo's work.[363] Its composition distantly recalls the Ottawa version of a quarter-century before, but its pictorial idiom is strikingly different. Although its poor state of preservation intensifies the impression of a rapidly summary execution, the Nîmes *Susanna* does mark another turning point in Jacopo's career, one which ushers in the final, powerfully expressive turn in his constant search for new pictorial horizons. The darkling landscape has atomized into a granular haze against which the burning hues of the figures vibrate with tremulous touches of the brush. A

78. Gerolamo and Jacopo Bassano, *The Expulsion of the Merchants from the Temple*, The National Gallery, London

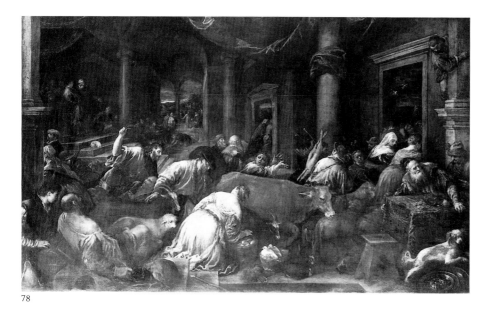

78

ghostly deer stares in from the right, and the anatomy of the central elder has lost corporeal legibility in the fiery intensity of its dominant pale rose. Most powerful of all, Susanna is evoked through jagged, irregular slashes of silvery pigment against deep, metallic blue, her terror suggested more by the nervous movement of the thick impasto than by her wide-eyed expression or gesture of rejection. The tendril of blowing veil has no natural motivation, but is a direct expression of her recoil at the assault. Leandro, Gerolamo, and others in the shop would attempt to paint replicas, but, confronted with an irrational and inimitable work, they could do no more than take refuge in prosaic description of naturalistic detail with which they coated Jacopo's forms.[364] No more revealing index of the schism that was isolating the old man from his sons can be found.

Gerolamo was the first to defect. At a date close to 1585, he was once again set the task of revising the familiar *Expulsion of the Merchants from the Temple* (The National Gallery, London, fig. 78).[365] Avoiding the most recent versions, he reverted to the standard format, which Leandro and Francesco had duplicated since about 1579 and would continue to reproduce for decades. Gerolamo carried the painting to a fairly advanced stage throughout, when Jacopo brusquely interrupted to repaint most of the strip of middle-ground figures from Christ at left to the woman in a white coif, who is about to exit through the portal at right. Jacopo's strange, fat-faced adolescent type, inserted at three points of this band, is entirely his own, and the material surface has the same spectral gleam from a dark environment that we find in the

type, added a few figures, and turned much of the execution over to Giambattista, who did a couple of drawings before he began to paint.

359. I have not studied the Willumsen *modello* in the original, but its skeins of nervously jotted white highlight seem too highstrung for Leandro. Both paintings in the Castello Sforzesco are in very poor condition and are significantly shorter than the other canvases. Their black shadows, cherry red and frosty blue tonality clearly reflect Leandro's style, but the dry execution strongly suggests that they are either poor versions from the shop of Leandro, unlikely in such an important cycle, or that they are later products of Leandro's shop.

360. Francesco himself participated in the Stourhead *modello*, but the sequence changed for the large picture, where Gerolamo's smudged brushstroke laid in the preliminary passages and Jacopo applied an incandescent scattering of highlights on top of Gerolamo's effort.

361. The visionary effect of Jacopo's tremulous brushwork in the *Christ Stripped* almost coordinates in this case with Gerolamo's diffuse and unfocused evocation of form. As was the case with the 1580 altarpiece, Jacopo fitfully exerted a strenuous effort to clarify form through a longer, more decisive brushstroke. The foreground figure, otherwise extraneous to the action of *Christ Nailed to the Cross*, is just such an aggressively plastic passage in the midst of a painting in which Gerolamo's flaccid style prevails.

362. I see no evidence that the young Caravaggio ever visited Venice. Born in 1571 and apprenticed to Peterzano in Milan in 1584, he was back in Caravaggio in 1589. He shows a clear awareness of the Brescia cycle, which was only about fifty-eight kilometers east of Caravaggio. He might already have studied it by 1584, but it was certainly in place by 1589. From the broad drama of the harsh chiaroscuro to individual details such as the dirty feet in the *Christ Stripped*, the Dal Ponte paintings in Brescia find repeated echoes in Caravaggio's work.

363. The abbreviated signature, «J. B. f. 1585», appears in no other picture and suggests an informal relationship with the patron.

364. Although it is too large to have served as a *modello*, the Nîmes picture did provide Leandro with a composition that he repeated

(Christie's, London, March 1965, lot 99; fragmentary signature) with an effortful attempt to clarify the ambiguities of the original. Later, he adapted it in a fancifully decorative version (Bayerische Staatsgemäldesammlungen, Alte Pinakothek, Munich; full signature) of great but vacuous charm. Gerolamo made several failed attempts to copy the original after 1590.

365. Oil on canvas, 159 × 265 cm. Although both Francesco and Leandro continued to repeat the standard composition (see above n. 321), Jacopo here undertook an amalgam of earlier ideas. Since Gerolamo left the Bassano shop for Padua soon after the completion of this picture, it would not be replicated. Those recorded in the 1592 shop inventory (Verci 1775, 92, no. 34; 95, no. 96; and 100, no. 187) were in the standard format, to judge by their proportions, which were not so horizontal.

366. Northern graphics had helped to disseminate the subject of the Elements in Italy prior to 1575. In 1576 Tintoretto alluded to the Elements in his four mythological canvases for the Atrio Quadrato of the Palazzo Ducale (now in the Anticollegio), but again they were given classical figurative embodiments. Venetian patrons seem not to have been interested in the realistic depiction of the Elements until Jacopo began to produce sets of four canvases of moderate size for domestic interiors. In a circular exchange of influence, the Dal Ponte pictures inspired Netherlandish artists early in the next century.

367. Oil on canvas, 123 × 182 cm. Burned in the Flakturm fire of 1945, this fine picture was repeated by Francesco alone (formerly Liechtenstein collection, Vaduz, 142 × 187.8 cm). Ballarin (1988, 5) dated the Berlin original to c. 1576. I agree in seeing the original Elements as originating in close proximity with the biblical genre pictures and perhaps closer to the 1577 Circumcision altarpiece (cat. 121).

368. Oil on canvas, 148 × 234.2 cm. Zeri 1976, 409-10, no. 281. All replicas seem to be by Leandro or his shop (private collection, Venice; private collection, Paris; etc.). For this reason, and their subsequent use by Leandro for his Months cycle (see above n. 305), this set may be dated after Francesco's move to Venice in 1578.

369. Although I had suggested (Rearick 1986 (A), 186) that Gerolamo participated in the Sarasota Elements, the secondary hand is

Nîmes Susanna. Gerolamo must have looked with dismay at the disjuncture between his clumsy prose and the poetic mystery of his father's intervention. Both painters seem to have decided at this moment that the time had come for Gerolamo to abandon the family shop and depart to undertake his medical studies at the University of Padua. Between about 1585 and 1589 Gerolamo's heavy hand is missing from products of the Bassano shop, and Jacopo remained more than ever alone in the big house by the bridge.

Since his favorite son's departure for Venice in 1578, Jacopo had made a regular practice of traveling, doubtless an uncomfortable two-day trek by wagon, to Venice, where he assisted Francesco in various roles. Earlier in the decade he had probably participated in the creation of what would prove to be the last of the Bassano suites of four pictures, the Elements.[366] Of the earliest collaboration, the last surviving canvas, Air (formerly Kaiser Friedrich Museum, Berlin), was burned in 1945.[367] In it Jacopo's role was limited to the four figures in the foreground, the rest being by Francesco in his most assured manner. Both Francesco and Leandro would repeat it, occasionally with Jacopo's slight participation, as in Leandro's Earth (Walters Art Gallery, Baltimore), where he retouched the sleeve and coif of the woman with the basket.[368] Surprisingly, the old man undertook to paint a set around 1584-85 with slight preliminary work on the part of Francesco. The Element of Water and The Element of Fire (John and Mable Ringling Museum of Art, Sarasota, cats. 70-71) survive and convey some of the melancholy intensity of the 1585 Susanna.[369] Color is somber, wine red, blue black, bottle green, with sputtering highlights in chalk, orange, and saffron. Physical details such as the bellows pumper in the Fire are deliberately coarse to the point of deformation. It was but a short step for Francesco to reshape the Fire into Venus at the Forge of Vulcan (Galleria Sabauda, Turin), a composition entirely by the son, since we have his preliminary drawings for it (Musée du Louvre, Département des Arts Graphiques, Paris; and Collezione Horne, Florence).[370] Equally an offshoot of the Fire, but more probably developed in relation to the lost earlier treatment, Venus at the Forge of Vulcan (Muzeum Narodowe, Poznan) bears the joint signatures of Jacopo and Francesco.[371] It is distinct in format, a large oval in which the grandly scaled figures are adjusted to a di sotto in su angle of view, and it was clearly intended to be seen as a slightly rougher equivalent of Paolo Veronese's mythological ceilings. Once again Bassano and Veronese are in close rapport, now probably cemented by the joint commission for the Paradiso awarded to Paolo and Francesco in collaboration, and by the enrollment of Carletto Caliari, Paolo's son, in Francesco's studio so that the Caliari and Dal Ponte styles could be harmonized.[372]

Mythologies had never constituted a significant part of the Bassano the-

79. Leandro and Jacopo Bassano, *The Death of Actaeon*, formerly Kaiser Friedrich Museum, Berlin

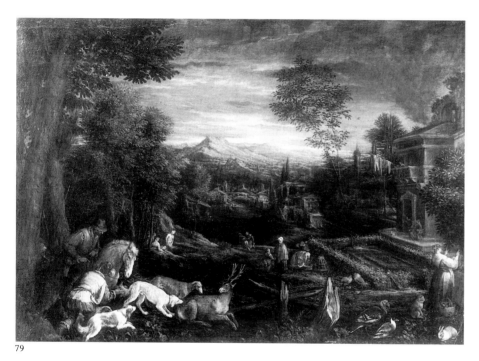

79

matic repertory. The *Venus at the Forge of Vulcan* signals an effort to take advantage of the longstanding Venetian humanist taste for the adventures of the classical gods. Jacopo might have provided a general sketch for the composition, but Francesco prepared individual figures and painted almost all of the visible surface, Jacopo adding only a few finishing touches to passages such as the boy at left, the head of Venus, and the youth at the bellows. Their signatures constitute a familiar Venetian practice of signing a work as a sort of guarantee that the firm stood behind its products. In the case of the nearly contemporary *Rape of the Sabines* (Galleria Sabauda, Turin), Jacopo provided his eldest son with a violent compositional sketch (formerly Cornet collection, Paris) of such energetic touch that it approaches indecipherability.[373] Jacopo neither participated in nor signed the finished canvas. He did, however, add a few touches to Leandro's *The Death of Actaeon* (formerly Kaiser Friedrich Museum, Berlin, fig. 79), a subject that his third and fourth sons would repeat in a reduced format.[374] He may also have contributed to the original *Orpheus* and *Rape of Europa* compositions, of which only shop replicas survive.[375]

After 1585 Francesco worked for a progressively wider and more prestigious public, including the Grand Duke of Tuscany, Ferdinando de' Medici; the French national church in Rome, San Luigi dei Francesi; and the Jesuit

far more assured and broad there, with little of the spotty dabs characteristic of Jacopo's youngest son. Since Francesco was already in Venice when they were painted, we must posit either his brief return to Bassano or a visit to his son's Venice studio by Jacopo. Because we know that Jacopo made this trip rather often around 1582 or slightly later, the latter seems more probable.

370. Oil on canvas, 123 × 182 cm. The Sambon picture, which reappeared on the Verona art market a decade ago, is spirited and secure in execution, with passages of pictorial bravura in the illumination that show a direct reflection of the Sarasota *Fire*. Although a direct study might clarify the presence of Jacopo's hand in some finishing touches of the Sambon painting, it appears so unified in facture as to suggest that it is entirely by Francesco. The drawings are in one instance secure as by Francesco (Collezione Horne, Florence) or, in another (Musée du Louvre, Département des Arts Graphiques, Paris), closer to Leandro, who painted several replicas of his sibling's original (Kunsthistorisches Museum, Gemäldegalerie, Vienna, cut in half with the central figure of Vulcan missing).

371. Oil on canvas, 177 × 264 cm. Signed: JAC. BASS.es et FRAC.us FIL.s. Its early history is unknown. Although the participants are mostly the same as those in the Sambon *Forge of Vulcan*, they are entirely recomposed, except for the tinker at right. Since the Poznan composition is clearly a somewhat effortful attempt to adapt the *Fire* and the *Vulcan* to a grandiloquent Venetian mode à la Veronese, the logical chronology places it third in that sequence. Jacopo's hand is detectable only in the head of Venus and the boy at left. The joint signature may be interpreted as a publicity device on behalf of Francesco.

372. Rearick 1987-88, 31-39. Although Carletto was responsive to Francesco dal Ponte's naturalism and developed an almost Netherlandish capacity for surface description, the deeply nocturnal tonality, which dominated the works of all the Dal Ponte, could not be coordinated with the Caliari tradition of lucid daylight. Only Paolo would, in precisely these years, develop a true tenebrist style. Rearick 1991 (B), 237-53.

373. Rearick 1992 (B), in press. Francesco interpreted as best he could Jacopo's furious jottings in detailed sketches for individual figures (Gabinetto Disegni e Stampe degli

Uffizi, Florence).

374. Oil on canvas, 123 × 182 cm. Burned in 1945, it was considered to be by Francesco (Arslan 1960 (B), I, 214) until Ballarin (1988, 5) attributed it to Jacopo alone. For the Berlin picture Leandro adapted the Doria Pamphilj *Eve* (cat. 48) for one of Diana's nymphs, and much of the staffage from the second set of *Seasons*, the Civezzano predelle (fig. 58), and particularly the Kroměříž *Noah* cycle, which he had in significant measure painted himself. Jacopo took over after most of the painting had been completed, adding finishing touches to the nymphs, the little figures at center, and much of the deer, dogs, and horse's head. It should be dated to c. 1582-84. The wide-eyed deer would be introduced into the Nîmes *Susanna* of 1585. Revisions were, naturally, largely Leandro's province, and around 1590 he painted a variant (formerly Neumann and Salzer, Vienna) in which the nymphs appear in front at the right, and the hunt is reversed to exit from the left. Gerolamo, just called home from his studies in Padua, was allowed to make a painted *ricordo* (formerly art market, New York) after the nymphs. His bluntly smudged form and texture are particularly evident in this roughly painted jotting, which is much like those done earlier by Giambattista after Jacopo's pictures. He, in turn, used this group with the hunters, which he probably also copied from Leandro's second version, to paint a particularly ugly little picture of his own (The Art Institute of Chicago, cat. 73). Its sulfurous color and dissolved form are quite distinct from the sharp colors gleaming from a black environment characteristic of Jacopo's late works.

375. *Orpheus Playing for the Animals* survives in several replicas, of which the best (Wortley collection, Hovingham Hall, York) is a long pastoral canvas that seems to be by Francesco. Gerolamo took it over and produced several more vertical editions, of which one (private collection, Baltimore) is signed. His versions, such as the one in Florence, seem all to date from after 1589 (Gallerie degli Uffizi, Florence, in deposit). Arslan (1960 (B), I, 341) listed it as shop of Leandro. This is essentially correct, but the strength of individual figures suggests that it is not the prime version of this composition. Its obvious allusion to one or another of Veronese's treatments of this theme places the

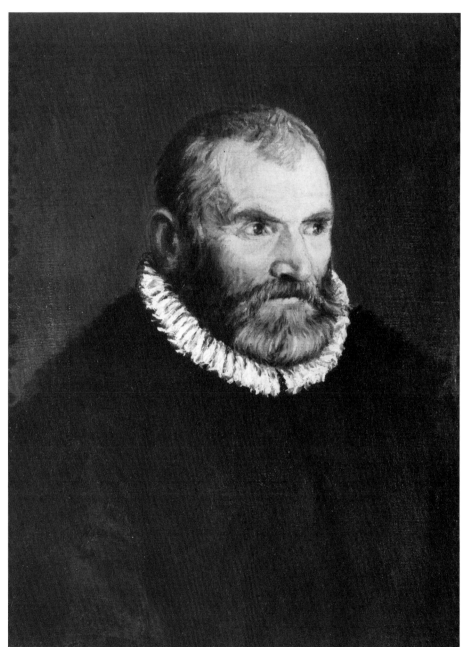

80

church, Il Gesú, also in Rome; plus diverse crowned heads further afield.[376] Although we do not know many of them by name, apprentices in considerable number must have enrolled in Francesco's shop; their participation frequently reduced the quality of its products, even those signed by Francesco himself. Leandro filled in by assuming many local commissions, particularly in the popular field of portraiture, to which his prosaic temperament was well suited. Gerolamo studied medicine in Padua. Giambattista was joined by a corps of younger apprentices in Bassano, a generally unpromising troop of which Luca Martinelli was the most original.[377] It was to him that Jacopo entrusted most of *The Madonna del Rosario* (parish church, Cavaso di Tomba), an altarpiece documented to 1587, for which the old painter added only the heads of the monastic donors and the ruby reflections on the silk cloth of honor.[378] Luca's style is marked by sharply dissonant cherry reds and cobalt blue against jet black, a chilly tonality learned from Leandro, but even this personal touch tends to dissipate after Jacopo's death. Younger apprentices, left to learn a second-hand idiom derived from Leandro, gradually lost even a reflected recollection of Jacopo's pictorial handling.

Now that the Dal Ponte manufactory was running full tilt in Venice, at home in Bassano del Grappa, Giambattista seems to have dedicated himself to minor church decoration in the rural countryside. Jacopo was thus left alone to experiment on an occasional picture that caught his fancy, but at the age of about seventy-eight his activity as a painter must have been progressively more limited to dedicating long periods of gestation to a select number of larger canvases and to providing *modello* sketches for his sons, both at home and in Venice. His *Lamentation* (Museo Nacional de Arte Antiga, Lisbon, fig. 76) served for countless replicas, none of which he painted himself.[379] Conversely, the freely sketched *Birth of the Virgin* (Museum of Art, Rhode Island School of Design, Providence, cat. 68) is not known in any full-scale repetition, although it served Leandro several times as a source of motives.[380] As a portraitist, Jacopo seems to have reduced his activity to nearly nil, the only late example to survive being the fierce *Portrait of an Old Man* (Nasjonalgalleriet, Oslo, fig. 80).[381] Both the anguished sitter and the determined painter seem to clench their teeth in an effort to get the ordeal over. Gerolamo would imitate its broad brushstrokes, but the harsh contrast of velvety black and snow white in rapid swatches of loose brushstrokes shows the same jagged energy that one finds only in Jacopo's own works of about 1588. Perhaps the only altarpiece which Jacopo undertook to paint by himself for a church in his home territory was *The Martyrdom of Saint Lawrence* (parish church, Poggiana, fig. 81), a work of the end of the decade.[382] Clearly, during one of his trips to Venice, where he stayed with Francesco at Biri Grande, he went to the nearby church of the Gesuiti, where he meditated long and in-

invention in the context of Leandro's transfer to Venice.

376. Borghini (1584, 564), on the basis of his visit to Venice in the autumn of 1582, declared that Francesco's work was widely known and admired, even in Florence and Rome. He saw in the Biri Grande studio *The Rape of the Sabines* (Galleria Sabauda, Turin) commissioned by Carlo Emanuele I of Savoy. In 1581 the artist was already painting the *Seasons* and sending drawings to the Florentine collector, Niccolò Gaddi (Bottari and Ticozzi 1822, III, 265). He traveled, probably shortly before 1587, to Florence in the company of Carletto Caliari, perhaps at the invitation of the Grand Duchess Bianca Cappello. There he painted *The Martyrdom of Saint Catherine* (Galleria Palatina, Palazzo Pitti, Florence), the *Archduke Francesco I de' Medici* (Staatliche Museen Kassel, Gemäldegalerie Alte Meister, Kassel), and his *Self-Portrait* (Gallerie degli Uffizi, Florence). Most prestigious of all was the commission for the *Assunta* for the high altar of San Luigi dei Francesi in Rome, a project that postdates the removal of Muziano's picture in 1585 and that, therefore, is probably related to and contemporary with the trip to Florence. All these were interspersed with vast pictorial projects for the Palazzo Ducale and other sizable works for Brescia, Bergamo, and other centers.

377. Luca Martinelli's date of birth is unrecorded, but since his earliest documented work is a pair of altarpieces (parish church, Rosà) done in collaboration with Giambattista dal Ponte and paid for on 10 March 1593, his birth may be placed close to c. 1570-73, his apprenticeship to c. 1584-88, and his death c. 1640 (Verci 1775, 222). His most characteristic work is *The Miraculous Apparition of the Virgin* (The Royal Collection, Hampton Court), which was strongly influenced by Leandro's black shadow and glittery red-blue color. Giulio Martinelli was younger than his brother and distinctly less talented.

378. Oil on canvas, 278 × 184 cm. The commission (Magagnato 1952 (A), 55-56) was signed 17 August 1587.

379. After 1589 Gerolamo returned to the parental shop, but he no longer made any effort to emulate Jacopo's late style. Instead, he settled into dull recapitulations of old formulae for country churches, a practice he continued even after his transfer to Venice in 1595. He appears never to have made a suc-

81. Jacopo Bassano, *The Martyrdom of Saint Lawrence*, parish church, Poggiana

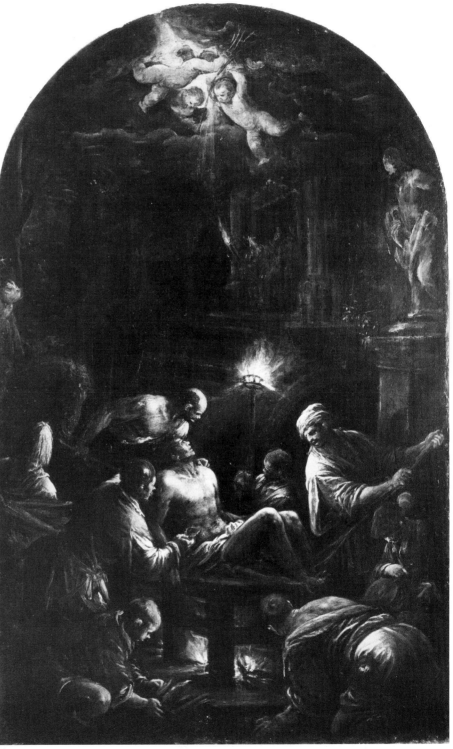

cessful career there prior to his death in 1621. Giambattista died in 1613. Leandro retained little contact with the Bassano shop after 1593 when the surviving brothers quarreled over Jacopo's estate. His death in Venice in 1622 did not, however, bring the dynasty to an end. Chiaretta, daughter of Giambattista, married the painter Antonio Scaiaro from Asiago in 1613. He assumed the name Dal Ponte and practiced a modest activity as a painter until his death in 1630. It appears that their sons Giacomo and Carlo kept the shop open until their deaths in 1650 and 1651 respectively. It was to Jacopo's grandson Carlo that Ridolfi turned for information on the Dal Ponte. It was on Carlo's death in 1651 that the remaining shop material, doubtless including the bulk of the family drawings, was sold. Thus, a century and a half passed between the first record of Francesco il Vecchio as a painter and the final, feeble activity of his great grandsons.

380. Its nocturnal illumination, format, and subject suggest that it was conceived as a pendant to the *Joachim's Vision* (fig. 62), but no finished version is known. Unfortunately, this subject does not figure in the 1592 inventory of Jacopo's studio (Verci 1775, 91-109).

381. Oil on canvas, 60 × 46 cm. Although I had attributed it to Gerolamo in a moment particularly close to Jacopo's late works (Rearick 1980 (B), 99), its secure grasp of the head's structure and the intensity of its expression are beyond Gerolamo's technical and temperamental capacities. He might, however, have been allowed to paint the ill-proportioned and dull upper torso.

382. Oil on canvas, 192 × 120 cm. Verci (1775, 166) ascribed it to Francesco, followed by the entire modern literature. Magagnato (1952 (A), 52, no. 37) saw it as related to the Cremona *Christ Stripped* and dated it to 1587. Arslan (1960 (B), 1, 221) saw Francesco's workshop in its execution. The present writer (1986 (A), 187) gave it to Jacopo with a date of 1590. Its inimitable pictorial vibrancy has left it a unicum; the shop never attempted replicas.

81

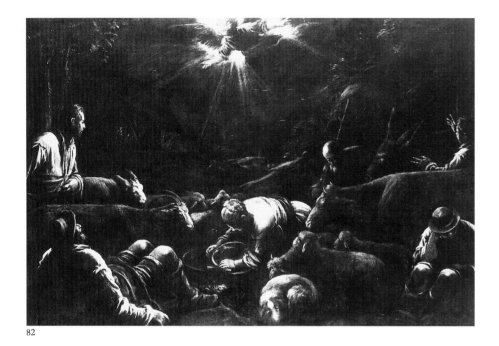

82

tently on Titian's nocturnal *Martyrdom of Saint Lawrence*. Back home he created his own variation on the multiple sources of illumination in Titian's powerful painting. But if the source was energetically dramatic, Jacopo's altarpiece is visionary in a fervently expressive idiom that owes an equal debt to the older master's last pictures such as *The Crowning with Thorns* (Bayerische Staatsgemäldesammlungen, Alte Pinakothek, Munich), which then belonged to Tintoretto. Jacopo's fiery atmosphere is, finally, an integral development of ideas that were already germinating in the 1585 *Susanna*, an interior vision significantly more closely derived from Cort's engraving after Titian than from the late master's paintings themselves. Finish, surface detail, even correct anatomy no longer interested Jacopo. Instead, a blunt cruelty informs the executioners with a terrifying force that is communicated more by the coruscating fire than by rhetorical pose or physiognomy. Lawrence, pitiable in his clumsy vulnerability, gazes toward the barely sketched putti with the martyr's palm, while his torment is presided over by a ghostly pagan goddess. Tradition held that *The Martyrdom of Saint Lawrence* was the work of Francesco, but the eldest son did not work for rural patrons near Bassano del Grappa at this moment, nor at any time did he paint a masterpiece of such vibrant concentration. Very close in handling, but perhaps slightly later on account of its even more abbreviated application of highlight, *The Annunciation to the Shepherds* (private collection, Padua, fig. 82) made only minimal

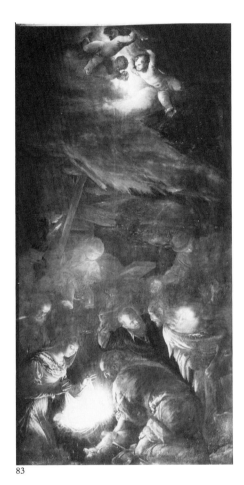

83. Jacopo Bassano, *The Adoration of the Shepherds*, San Giorgio Maggiore, Venice

83

383. Oil on canvas, 114 × 173 cm. Unpublished. Almost no element is left as it was in the Prague version (cat. 54). Most, but not all, figures, including the angel, are reversed. The standing shepherd is moved to the left edge, the sleeping boy to the front right, the recumbent youth to front left and to a different pose, and a kneeling girl reversed from *The Return of Tobias* has been inserted at center. The contrasting chiaroscuro assumes a brutal abruptness, and the transfiguring illumination is almost chalky white. Details of grotesque distortion such as the girl's profile are not mistakes, but rather the tremulous touch of an old man's brush. Jacopo has lost interest in description as he pursues his inner vision regardless of his failing manual control.

384. Like the other highly personal late

changes on the Prague composition of about a decade before.[383] Here, however, the black night is starkly contrasted with a supernatural glare that picks out faces and contours with a surreal intensity. More compact and less effervescent than the *Saint Lawrence*, this final version of *The Annunciation to the Shepherds* may have had its dark passages laid in by Giambattista, but the striking illumination is Jacopo's. The latest of these profoundly personal pictures is *Christ Crowned with Thorns* (private collection, Rome, cat. 77), a composition that is less indebted to the Willumsen *modello* or the Rossi version than it is a nostalgic recollection of the Accademia composition of more than twenty years before, by way of the richly colored chalk studies for that version, which were surely among the store of drawings kept in the shop.[384] Here again, a magical light transfigures the participants, who assume an ectoplasmic transparency in the unreal light of the torch and brazier, but it is their form, however, that vibrates with tremulous expression. Christ seems to dissolve into veils of light, the armored soldier is a dangerously disembodied apparition, and the cruel child who spits in Christ's face is characterized with an abrupt swirl of the brush. Seldom in the late cinquecento is mere impasto imbued with such density of feeling. Small in scale, this *Crowning with Thorns* must have been destined for an especial patron; it would not have been readily understood by the broad public.

One can only guess at the astonishment bordering on panic with which the eighty-year-old painter received the news that the Benedictine monks of San Giorgio Maggiore in Venice wished to commission a monumental altarpiece from him for their almost completed church.[385] Palladio's great church had been begun in 1566, and was under progress when the architect died in 1580. In 1587 the choir was still unfinished. Had Palladio and Paolo Veronese lived longer the church's decoration might have brought these two classical masters together once again, but in 1590 Jacopo Bassano would have seemed a reasonable alternative. Tintoretto, who after 1592 would ultimately execute most of the cycle of paintings in the church, seems not yet to have entered the picture. For the first altar on the right upon entering, Jacopo painted the great *Adoration of the Shepherds* (San Giorgio Maggiore, Venice, fig. 83). For it he returned to the *verso* of his 1569 Berlin drawing of *The Adoration of the Shepherds* (fig. 49) for the major figures, but since that was a horizontal composition he found it necessary to extend it above with shepherd boys who clamber about in the stable. Further up in the composition he reintroduced the thatched roof, beyond which one glimpses the night landscape and the angelic annunciation on the distant hillside. Finally, at the very top he simply repeated the trio of angels, who burst through a similar radiance in his earlier *Martyrdom of Saint Lawrence*. Perhaps the scale of the canvas was intimidating, but his composition shows Jacopo composing an oddly layered spacial se-

quence that the prevalent dark of the top two-thirds renders bottom heavy, making it difficult to grasp the whole as a pictorial unity. The variable density of the impasto has also resulted in an irregular preservation; the black passages in the upper half have sunk and turned opaque with time. The most striking aspect of the San Giorgio *Adoration* is the laborious intensity with which Jacopo worked and reworked the illuminated figures below. Using the Netherlandish idea of Christ as the light of the world, he heightened to a dazzling pink white the tonality of the infant Christ, from whom emanates a cool and brilliant radiance that defines with penetrating clarity the massive forms of the Holy Family, the shepherds, and their reverent animals. Jacopo applies layer upon layer of paint, his hand steady and his eye fixed on an ideal of austere solemnity. The Virgin's facial features assume an almost abstract ovoid order, already adumbrated in the preliminary study (Courtauld Institute Galleries, London, cat. 114), but built through impasto to a sculpturesque density.[386] Determined to rise to this awesome challenge, Jacopo has, with evidently painful effort, achieved his most heroic masterpiece. Put in place after his death in 1592, the San Giorgio *Adoration* was recorded as « opus veteris Bassani », the work of the father of the Bassano family.[387]

While Jacopo worked on his last *Adoration of the Shepherds*, family tragedy overtook the Dal Ponte in Venice. For many years Francesco's mental and physical health had deteriorated under the stress of obligations he was not by temperament able to assume. Apparently already ill, he made a will in 1587 in which he favored his youngest brother Gerolamo, who needed assistance in completing his medical studies in Padua. In 1589, he made another will dropping the bequest to Gerolamo, who had been peremptorily summoned back to Bassano del Grappa to resume work in the family shop, where Giambattista was inadequate, and Jacopo turned progressively more inward in his last works. Then, in early November 1591, someone pounded on the door of the Biri Grande house, and Francesco, alone and terrified that assassins had come to get him, threw himself out of the window over the courtyard. Mortally injured, his agony stretched on for eight months before death came on 3 July 1592.[388]

Jacopo probably had nearly completed the *Adoration* that autumn, and now he had another canvas on his easel. We do not know who commissioned the altarpiece of *The Baptism of Christ* (private collection, cat. 79), but the fact that Gerolamo substituted a finished copy (Museo del Castel Vecchio, Verona) that took the place of Jacopo's projected picture suggests that, like the *Saint Lawrence*, it had been commissioned by a provincial church.[389] The *Baptism* is normally a rather cheerful daytime subject, but at this moment it became an image of darkly melancholy power. Jacopo is not known to have treated it since 1541, and numerous pentimenti suggest that he sket-

works, this *Crowning with Thorns* would not be the subject of shop repetition.

385. Oil on canvas, 421 × 219 cm. The commission to Jacopo has not been found. The order for the frames along the right aisle of San Giorgio Maggiore of 1 March 1592 doubtless implies that the picture had already been consigned before the artist's death less than a month before.

386. Rearick 1992 (B), in press. Jacopo's source is, of course, the nocturnal *Adoration of the Shepherds* formulated around 1579 and repeated many times by Leandro, but the massively dehumanized forms in both the drawing and the painting are unique to these works and confirm that Jacopo conceived and executed them.

387. The 1594 account of the payment refers to the altarpiece as « opus veteris Bassani » and records that it cost 80 ducats. It is normal bookkeeping procedure of the time to do a summary of payments well after the actual disbursements. It appears that Tintoretto was not awarded any commissions for San Giorgio Maggiore until after Jacopo's death. Most of them were carried out by his heirs after his own death in 1594. On 16 April 1596, one altarpiece, *The Martyrdom of Saint Lucy*, was commissioned from Leandro Bassano, who promised it for the following September. Another altarpiece, *The Fall of the Rebel Angels*, was commissioned on 24 February 1597, but seems never to have been executed.

388. Gerola (1905, 103) published the death certificate, which is specific about the sequence of events. Other details, too explicit to be fabrications, are found in the sources (Ridolfi 1648, I, 399). Arslan (1960 (B), I, 204) stated that Francesco predeceased his father, but this has been corrected (Alberton Vinco da Sesso 1986, 176).

389. The copy is clearly in Gerolamo's dull and formless style of 1592. No early source mentions this copy in a provincial church, and its provenance is unknown. Ridolfi (1648, I, 389) reported seeing Jacopo's unfinished picture preserved as a relic in the house of his grandson Carlo Scaiaro in Bassano.

ched it directly onto the dark-primed canvas. Christ, pathetic in his ponderous submission to his mission, bends solemnly forward to receive the water from the Baptist's upraised hand. John moves in synchrony, his gesture at once sacramental and somnambulistic, and his face is a mask of conflicting emotions. His ghostly lamb stares in awe, while against a black sky the apparition of the white dove materializes in descent. The three angels, by contrast, seem energized by this vision, their drapery a foaming chaos of random brushstrokes. Their fat, ugly faces are a distant evocation of the elegant stylization of Jacopo's profiles of forty years before, but their troubled expressions seem barely hinted at, as though the painter had neither time nor the inclination to pause for detailed description. Although the *Baptism* is unfinished, one doubts that it would ever have been brought into sharper focus. Ghostly swaths of paint barely suggest form, and in the distance Monte Grappa fades in the harsh red of the dabs of thick paint that only allude to the setting sun. The inventory of the contents of the Bassano studio made on 27 April 1592 lists a no. 64: « The Baptism of Our Lord by Saint John the Baptist, that is an altar picture sketched ».[390]

Work became progressively more fatiguing, and on 10 February Jacopo called in the notary so that he might dictate his testament.[391] Now, like the orderly and responsible craftsman and head of the family business he had been for more than half a century, he carefully assigned his goods to his heirs, allotting two-thirds of the materials in the studio to Gerolamo, one-third to Giambattista, and a small portion to Leandro who, after all, enjoyed a prosperous career in Venice. He knew the Dal Ponte shop was destined to degenerate when he was gone, and he foresaw the squabbles over its crumbs that would follow, so he made what seemed to him an equitable distribution so that Gerolamo and Giambattista, whom he described as less naturally talented, could continue to make a living. He made no mention of Francesco, who lay dying in Venice, and one can only guess at his bitter regret and even self-recrimination as he realized he would never see his favorite again. Three days later, on 13 February 1592, Jacopo died at the age of about eighty-one and was solemnly buried in San Francesco by the townspeople for whom he had worked with simple devotion.[392]

390. Verci 1775, 94, no. 64.

391. Alberton Vinco da Sesso and Signori 1979, 161-64.

392. Although it is couched in sentimental terms, which suggest mythmaking, there is surely an element of truth in Ridolfi's report (1648, I, 390) that « ne gli increbbe il morire, diceva egli, che per non poter di nuovo imparare, incominciando all'hora ad apprendere il buono della Pittura.. » (he regretted dying since he would no longer continue to learn the secrets of painting, which he was just beginning to grasp). His quest never ended, it just stopped in mid-brushstroke.

Jacopo Bassano, *The Miracle of Saint Peter Curing the Cripple*, private collection

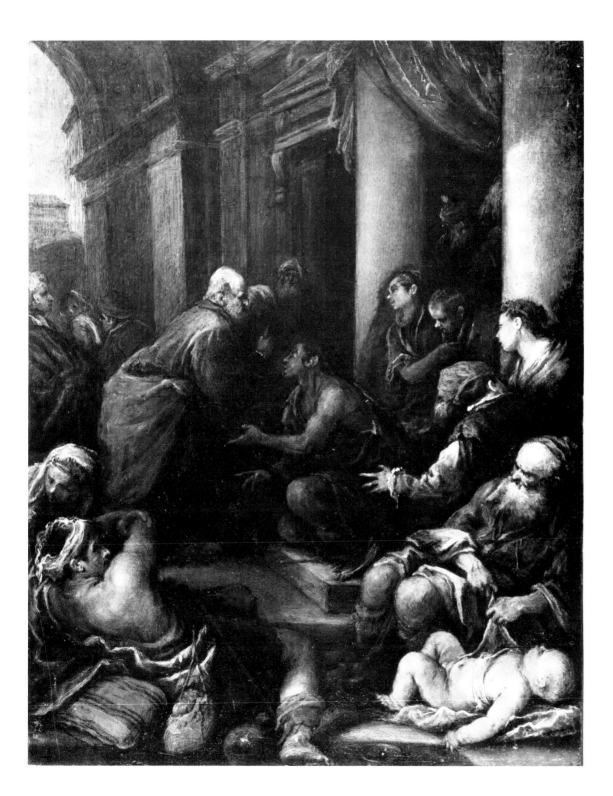

172

Jacopo Bassano 1573-1580*

Alessandro Ballarin

* Republished here is an essay by Alessandro Ballarin on the painter's activity in the 1570s, whose original title was « Jacopo Bassano. San Pietro risana lo storpio ». Written on the occasion of the exhibition *Pittori padani e toscani fra Quattro e Cinquecento* held at the Galleria di Vicenza Antichi Maestri Pittori in October and November 1988, the essay had a fairly limited circulation at the time, and we are grateful to the proprietors of the gallery for permission to republish it. Certain paintings are mentioned in the notes as scheduled for forthcoming publication, and others are to be seen in the present exhibition. For the latter, the appropriate catalogue entries can be consulted, whereas the former are discussed in Ballarin's forthcoming monograph *Jacopo Bassano*, Padua 1992. To this text, first published four years ago, an addendum has been added, which completes and corrects it on a particular point: the dating of *Saint Roch Visiting the Plague Victims* (Pinacoteca di Brera, Milan, cat. 47).

1. It measures 43.6 × 33.8 cm. For the subject, see Acts: 3: 1-11. There is no mention of a painting on this subject in the sources or the literature. Nor, as far as I know, does any copy or workshop version exist.

2. Ballarin 1966-67; Ballarin 1966; Rearick 1967; Rearick 1968 (A); Rearick 1981 (A); and Rearick 1986 (A).

3. Gemäldegalerie Alte Meister, Dresden, invs. 254 and 253 respectively. I have been convinced of these two paintings' importance for a long time, see Ballarin 1969. They are illustrated in Arslan 1960 (B), II, figs. 210-11, where they are attributed to Francesco.

4. Preto 1978, 19.

To understand *The Miracle of Saint Peter Curing the Cripple*, a painting on copper by Jacopo Bassano previously unknown, requires retracing the main lines of the artist's activity between 1573 and 1580.[1] On its own clear evidence, the work could not have been painted earlier than *Saint Roch Visiting the Plague Victims* (Pinacoteca di Brera, Milan, cat. 47) from around 1573, nor later than *The Virgin in Glory with Saints Agatha and Apollonia* (Museo Civico, Bassano del Grappa, cat. 122) of 1580. But we know that this is precisely the period in which the history of Jacopo's career begins to become so difficult to pin down, for the reason that it was increasingly not a personal endeavor, but rather a workshop activity. While more recent studies have done something to clarify it, taking as basis the artist's method and giving convincing examples, much remains to be done.[2] For my part, I should like especially to go further in what I think of as the surgical operation I began more than twenty years ago on the body of Jacopo's later production and which has not made headway because the focus of my research shifted to the periods of the artist's youth and maturity and then to entirely different fields of study. The presentation of a central element of that earlier investigation offers a happy occasion to take up the line of thought again.

The large lunette in Vicenza depicting *The Madonna and Child with Saints Mark and Lawrence Being Revered by Giovanni Moro and Silvano Cappello* (Museo Civico, Vicenza, fig. 54) was painted in the winter of 1572-73, and it assures us that the two large paintings in Dresden depicting *The Return of Tobias* (fig. 57) and *The Israelites Drinking the Miraculous Water* are from precisely that moment and are entirely autograph.[3] The central experience of 1573 must have been the altarpiece for the church of San Rocco in Vicenza, which I suppose was commissioned shortly after Jacopo set to work on the large lunette for the council hall of the Palazzo del Podestà in the same city. It has become customary to date the San Rocco altarpiece to 1575, with reference to the plague that raged between Venice and Milan in the following year. Vicenza, however, remained immune from the contagion longer than other cities in the Veneto, but « in February of 1577 the epidemic manifested itself with virulence in the Vicenza area, rapidly involved Bassano as well as other minor towns, and wore itself out only in the spring of 1578, almost a year later than in Venice and the other major towns of the mainland ».[4] But even supposing that the commission was awarded the painter in the greatest haste, at the first symptoms of contagion in the countryside around Verona and Vicenza in the summer and autumn of 1575 – the infection seems to have originated in Trento as early as March of 1574 – nothing permits us to presume that the canvas was completed before the end of the year. This means that it would have had priority over all the works we date to 1575 and to which, by all evidence, it is anterior. Moreover, an « emergency » commis-

sion is scarcely consistent with the dimensions and destination of the work itself, intended as it was for the high altar of one of the most prestigious churches in Vicenza, one dedicated precisely to the saintly protector against the plague, and where everyone at the time would have wished to see depicted the episodes of Saint Roch's curing the plague victims along with a visible sign that the city was under the protection of the Virgin in times of health as well. A case in point would be the episodes involving Saint Roch commissioned from Tintoretto years earlier for the presbytery of San Rocco in Venice. However, from a stylistic standpoint the most pertinent dating would be 1573, between the large lunette (1572-73) and *The Entombment* of 1574 for the church of Santa Maria in Vanzo in Padua (cat. 52) or, to remain in Vicenza, the replica of *The Entombment* the painter had to make immediately for the church of Santa Croce (c. 1574).

The fact that the two biblical paintings in Dresden (see above) were conceived as a pair – they have the same measurements and come from the Grimani dei Servi family of Venice – is invaluable information, because the case is that, while the *Tobias* seems very close to the large lunette, *The Miraculous Water* would appear to look toward the San Rocco altarpiece. It follows that the other extraordinary painting of that moment, the monumental *Jacob's Journey* in the Palazzo Ducale in Venice, dates later than the San Rocco altarpiece, still within 1573, or from the time of *Saint Paul Preaching* for the church of Sant' Antonio in Marostica, which was signed by both Jacopo and his son Francesco and dated 1574. I would myself, however, hold out for the beginning of 1574, because I am convinced that the artistic temperature of that year is better measured on two other signed and dated works, *The Entombment* for Santa Maria in Vanzo in Padua (cat. 52) and *The Martyrdom of Saint Sebastian* (Musée des Beaux-Arts, Dijon, fig. 55), and on certain inventions conceived purely for collectors, such as the cycle of the Seasons, specifically the series known from plates 157-60 of the *Theatrum Pictorium* and the 1601 engravings of Hendrik Hondius. Compared with the Vienna *Summer* (cat. 50),[5] one would judge that the series preceded the Padua altarpiece and the cycle of the Flood. Considering the progress made in the altarpiece, the latter appears the most consistent sequel, at least so long as it is judged not on the general character the cycle assumed three years later in the canvases now in Kroměříž (cat. 63-66), but on the earlier and more authoritative firsthand versions. For this we get support from the fine *Sacrifice of Noah* in Potsdam (cat. 49),[6] which is signed and certainly autograph. It is characterized by a minutely broken-up touch, though still graphically distinguished, and an exceptional format that enhances the landscape effect. There is support also from the no less firsthand fragment in the Walker Art Gallery, Liverpool, which depicts *Noah Giving Thanks to God* (fig. 64). This picture is a version of *The Sacrifice of*

5. Kunsthistorisches Museum Gemäldegalerie, inv. 4302. It is illustrated in Arslan 1960 (B), II, fig. 213, as « Francesco Bassano and workshop ».

6. My knowledge of this painting goes back to spring 1968. Bildergalerie, 28 (GKI 5265). It measures 100 × 168 cm. It is signed on the stone in the center: « IACˢ/ BASSANESI/ [PIN] GEBAT ». The second line lacks the abbreviation sign, and there is no room on the stone for the final « s ». The third line was partly cut away when the lower edge was reworked. On the linen-chest to the left is the coat-of-arms of the patron, yet to be identified. It was catalogued by Arslan (1960 (B), I, 364), who was unaware of the signature, as the workshop of Jacopo. It was later correctly catalogue as being by Jacopo himself, Eckardt 1975, 13, with mention of the signature. [The coat-of-arms, « argent, on a fess azure three lions or, between six barbels sable » (Frescot 1707, *ad vocem*), belongs to the Venetian family Barbarigo. A member of this same family cuts a fine figure at the base of the Virgin's throne in Giovanni Bellini's Doge Agostino altarpiece.]

Noah of which there also exists a replica signed by Jacopo, but done entirely by the workshop (fig. 65).[7] In the light of the Potsdam example, this must be considered a sort of second state of the composition (the variants are minimal) and the one, in any case, which would be repeated in the successive replicas, from the one just cited to the cycle in Kroměříž. A pair of canvases depicting *Noah Building the Ark* and *The Flood*, sold at Christie's in 1932 and then by Finarte in Milan in 1970,[8] and another pair depicting *Noah Building the Ark* and *The Animals Entering Noah's Ark* in a private collection in Milan,[9] are replicas executed more or less with the collaboration of Francesco. These pairs make it perfectly clear that the invention of this cycle must have come about not long after Jacopo completed *The Return of Tobias, Jacob's Journey,* and *Saint Paul Preaching.*

In consequence, I suppose that 1575 began with the execution of the frescoes in the Cappella del Rosario in Cartigliano and ended with the canvases for Civezzano, in both cases works carried out and signed together with Francesco. The frescoes are dated, and by chance one of the sheets of preparatory studies also contains those for an *Agony in the Garden at Night.*[10] Van Mander, who was in Rome from mid-1574 until the first months of 1576, saw scenes by Jacopo of the Passion of Christ painted on black stones, immersed in darkness, and illuminated only by torches and other artificial lights. His testimony allows us to date the invention of a series of nocturnal paintings to 1575. These pictures would become no less successful than the works of pastoral inspiration, with their landscape settings. Indeed, they must have been the sensation of the year.[11]

Submerged among the numerous replicas and workshop variants there are still splendid autograph examples: *The Annunciation to the Shepherds* (Národní galerie, Prague, cat. 54),[12] *The Nativity* (private collection, Padua),[13] *The Agony in the Garden* (Burghley House Collection, Stamford),[14] and the same subject in the Galleria Estense, Modena.[15] The first of these, with its format of a small altarpiece, is one of the pictures which, ever since my youthful peregrinations in search of Jacopo, has remained most impressed upon my memory. The second is in the usual format, and studies for it appear on the sheet in the Louvre mentioned above. There is also a *Mocking of Christ* (private collection, Venice), which in the 1970s was with Alessandro Morandotti in Rome,[16] while the example in the Galleria Palatina, Palazzo Pitti, Florence, is a reworking of the subject done together with Francesco, whose name in fact figures alongside his father's in the signature.[17] Finally, there is *The Crucifixion* (Museu Nacional d'Arte de Catalunya, Barcelona, cat. 55) on slate. The latter is another of the painter's highest achievements and certainly the finest example known so far of the production that so excited Van Mander's enthusiasm in Rome.[18]

7. Coupled with an *Animals Entering Noah's Ark*, it passed through the Knoedler Gallery in New York and Weitzner Gallery in London around 1968. Both canvases measured 55 1/8 x 75 1/8 in. The signature at the center of the *Sacrifice* reads: «J. PONTE BASS.» Julius Weitzner brought these works to my attention.

8. Mildmay sale, Christie's, London, 12 February 1932, lot 127 (copy); and Finarte, Milan, auction 98, 1 December 1970, lot 45 (copy), pls. XXIII-XXIV.

9. They were published by Arslan 1967.

10. Musée e du Louvre, Département des Arts Graphiques, Paris, 2897r and *v*. See Rearick 1968 (A), 246.

11. For the biography of Van Mander, see the translation in Ballarin 1966-67, 192-93. I do not understand why this author continues to be omitted from the sources on the artist, see Rearick 1968 (A).

12. Inv. 09026. It is illustrated in Ballarin 1966, figs. 149-51, and 153.

13. Unpublished. Soon to be published.

14. Unpublished. Not catalogued by Arslan. In Lord Exeter's collection considered to be by Leandro. Soon to be published.

15. Pallucchini 1945 (B), no. 416 (as Francesco). Arslan 1960 (B), I, 355 (as either Leandro or Francesco, more probably the latter).

16. Recognized by me as being by Jacopo in 1972 when it belonged to Morandotti, and published as such in Pallucchini 1981 (B) and Pallucchini 1982, pl. 40, where, however, it is assigned to the final decade of the painter's active life.

17. The painting has still to be restored and studied. For the discovery of the signature, see Ballarin 1966-67, 167-68.

18. Inv. 108373.

The extent to which the experiment with night scenes modified the painter's language can be seen in *Saint Lucille Baptized by Saint Valentine* (Museo Civico, Bassano del Grappa, cat. 53), which for precisely that reason is to be dated 1575. The series of four altarpieces for the parish church in Civezzano is to be evaluated particularly with respect to the one of the four which, it so happens, is the least well known and less studied, although the most fully autograph: *Saints Anthony Abbot, Virgil, and Jerome* (fig. 59). The figures of Virgil and Anthony are indebted to the drawings for the Evangelists and the Doctors of the Church that Jacopo did for the vaults at Cartigliano, while the figure of Jerome is indebted to a drawing in the Accademia Carrara, Bergamo (fig. 56), which was probably done for the saint « in prayer placed between tables with books in front of him », which Ridolfi described above an altar in the church of San Cristoforo della Pace near Murano and which, equally probable, was produced in 1575.[19] However, in the very special luminism of these works, we can detect Jacopo's recently completed experiments with light as exemplified in the *Saint Lucille*. What is more, in another canvas of the Civezzano cycle, *The Meeting of Joachim and Anna*, the result can be compared with similar renderings of biblical themes such as *The Return of Tobias*, *Jacob's Journey*, and *Noah Building the Ark* from the Flood cycle. In these pictures one sees clearly how a certain problem in treatment of form has evolved and then worn itself out with a particular solution, which can be considered the end result of such a sequence. There is no reason to suppose that these works date after 1575. The predellas of the paintings in Civezzano, which are the best known and most appreciated part of the cycle, are carried out with a graphic elegance already present in the story of Jacob, which precedes them, and that persists into the *Saint Lucille*, but not beyond. From the same year, in tune with this work and with *The Virgin Enthroned between Saints Joseph and Catherine* in Civezzano, is the small altarpiece depicting *Saint Martin with Brandolino V Brandolini* (Castello di Valmarino, Cison, fig. 71) from the Brandolini collection in Milan. That canvas is usually considered a reworking by the shop of the altarpiece depicting *Saints Martin and Anthony Abbot* (Museo Civico, Bassano del Grappa, cat. 67), but is, in fact, the first successful autograph formulation of an idea Jacopo would return to three years later in a similar work done for the church of Santa Caterina in Bassano. Finally, on the strength of Van Mander's statement that he saw one in Rome, we must consider *The Return of the Prodigal Son* to have been executed by 1575 – indeed, I would say precisely in that year, because of its obvious affinities in composition with the *Saint Lucille* and the Civezzano predellas. While that *Return of the Prodigal Son* is now lost, it is known through an engraving made by Pietro Monaco in the eighteenth century after the canvas in the Savorgnan collection in Venice.[19 bis]

19. For this interpretation of the Accademia Carrara drawing (inv. 294*r* and *v*), see Rearick 1968, 241, 2.

19 bis. [A *Return of the Prodigal Son* (canvas, 81.9 × 114.9 cm) was sold at Sotheby's New York on 10 October 1991, lot 148. It may have been the one owned by Savorgnan and engraved by Pietro Monaco. It appears to be by Francesco, and appears as such in the sale catalogue. The date should come forward two or three years, it being closer than one could guess from the engraving to the square version that was exhibited in Venice in 1957 as the work of Francesco, at that time the property of the Lloyds of Wantage (Berkshire), then on the London market in the 1970s (Agnew's), and finally acquired by the Central Museum and Art Gallery of Northampton. I have long been convinced that the Lloyd picture is by Jacopo himself, c. 1572. The Savorgnan version must derive from this one and is by the son's hand. Clearly this question will only be settled when it is possible to examine the New York picture.]

As for what followed, I think much can be deduced about the orientation of the following year, 1576, from *The Adoration of the Magi* (Galleria Borghese, Rome, cat. 56).[20] I hold this painting to be another autograph work by Jacopo on the basis of its close connection with passages in the *Saint Lucille* and the episode of the meeting of Joachim and Anna in the upper part of the canvas at Civezzano, which is from Jacopo's own hand and done at the start of 1576. For the two years of 1576-77 the points of reference – and they should be taken seriously – are, first of all, the small votive altarpiece of the Podestà Sante Moro, *The Madonna and Child with Saint Roch and Sante Moro* (Museo Civico, Bassano del Grappa, cat. 120), which, on the basis of what is known about the date of the construction of the chapel in the Palazzo Pretorio and about the donor's period of service in Bassano, must be from 1576. The second then would be the altarpiece depicting *Saints Anthony and Crescenzio Interceding with the Virgin on Behalf of the Flood Victims* (Santa Maria degli Angeli, Feltre), signed and dated 1576, followed by the large *Circumcision* (cat. 121) for the cathedral of Bassano signed by Jacopo and Francesco and dated 1577. I must add that, on the basis of recently discovered archival material, it can be stated that Francesco painted four large canvases for the ceiling of the Sala del Maggior Consiglio in the Palazzo Ducale in Venice during the spring and summer of 1578, which implies that he must have settled in Venice immediately following his marriage contracted in Bassano in February of that year, though it cannot be ruled out that he moved there some time earlier.[21] The fact that since the end of 1577 Francesco was no longer present in his father's workshop as the principal collaborator is invaluable evidence, as we shall see, for putting order into Jacopo's activity during 1576-77. The small altarpiece for Sante Moro meanwhile offers proof that all of the works mentioned here so far could not have been done after 1575, since they are manifestly earlier in style. The Sante Moro altarpiece was a result of Jacopo's experience in painting the *Saint Lucille* as well as the altarpieces depicting Saint Catherine and Saint Anthony Abbot done for Civezzano. However, it has a different style in the drawing of the figures: the same, in fact, as found in the Rome *Adoration of the Magi* (cat. 56), which means that the latter likewise dates from the start of the same year.

It is at this point that Jacopo invented his well-known manner of depicting parables and other biblical episodes, setting them in a kitchen with a hearth, pantry, copper pans lined up on shelves, a vine-covered trellis beneath which a table has been set, and a threshing floor with a well. Of these, among the many replicas we know at present, a few examples are famous, but not because they are entirely autograph, since Jacopo's signature accompanies that of Francesco, who must have had a major part in their conception and execution. These include *Joachim's Vision*, also known as *The Weavers* (The Me-

20. Della Pergola 1955, no. 172 as Francesco. Arslan 1960 (B), ii, fig. 221 as Francesco.

21. Mason Rinaldi 1980 (A), 214-19.

thuen Collection, Corsham Court, fig. 62), *Christ in the House of Mary, Martha, and Lazarus* (Sarah Campbell Blaffer Foundation, Houston, cat. 61), *The Supper at Emmaus* (private collection, cat. 62), and *The Return of the Prodigal Son* (Galleria Doria Pamphilj, Rome, fig. 61). We have no signed example of the *Lazarus and the Rich Man*, but it may have existed.[21 bis] The version owned by Consul Smith in Venice in the eighteenth century is known through the intaglio engraving on the two plates done by Jackson, through another engraving by Jan Sadeler, which is rather burdened down with additional genre elements, and from workshop replicas like the one in the Národní galerie in Prague (inv. 02952). To these can be added another version of *Abraham's Journey*, which updates the earlier ones and of which there is a version in Berlin signed by both father and son (cat. 60) and which very likely dates from this particular moment.[22] A simple comparison of the two versions of *The Return of the Prodigal Son* (Savorgnan and Rome) suffices to tell us what the major orientations of the Dal Ponte workshop were in the course of 1576. The Roman version was, as I have said, signed by both, but was produced entirely by Francesco along the compositional lines of similar paintings of that moment. One must also take for granted that certain themes and figurative conceptions, even more significant than those in the *Prodigal Son*, had already taken form: notably the cycle of the Elements and a new cycle of Seasons, which conspicuously provided motifs, especially the *Earth* and the *Winter*, that would be repeated in *The Return of the Prodigal Son*.

Meanwhile, within Jacopo's creative process the splendid *Death of Actaeon* (fig. 79), which before the war was in the Kaiser Friedrich Museum, Berlin,[23] must have been taken as a kind of grand introduction to the new landscape approach in those two cycles. Jacopo himself would produce a more foreshortened and fantastic reworking of the *Actaeon* some ten years later in a canvas depicting *Diana and Actaeon* (The Art Institute of Chicago, cat. 73). Leandro would also have this picture in mind when he attempted his own version of the theme in the 1580s in a painting which, fifty years ago, was in a Viennese private collection.[24] It is understandable that the Berlin *Actaeon* was produced after *The Adoration of the Magi* and after the small Moro altarpiece, but also that between that painting and the *Allegory of Air* from the cycle of the Elements, the step must have been extremely brief.[25] The latter likewise was destroyed in the bombing of Berlin, so for both we have only photographs to go by. But the quality of the invention of the whole as well as in the details is very high, and one senses the excellence of the execution to be compatible with the hand of Jacopo himself. Indeed, in both pictures there is a pre-eighteenth-century buoyancy in the drawing of the figures in which one still senses an echo of the elegance that marks the Civezzano predellas and the Savorgnan *Return of the Prodigal Son*. Now, however, there is

21 bis. [I found this painting, unsigned but autograph, in a private collection shortly after I wrote this article and I will soon publish it.]

22. Staatliche Museen Preussischer Kulturbesitz, Gemäldegalerie, 4/60. This and the earlier picture signed by father and son, apart from the well-known one in the Galleria Doria Pamphilj, Rome, were introduced into the discussion for the first time and analyzed by Ballarin 1966-67 and Rearick 1968 (A).

23. Gemäldegalerie, 1937. Illustrated in *Staatliche Museen Berlin* 1930, 8, as Francesco Bassano, with the title *Allegory of Autumn*. Arslan 1960 (B), I, 287, as close to Gerolamo, with the same title.

24. Illustrated in Arslan 1960 (B), II, fig. 311.

25. Illustrated in *Staatliche Museen Berlin* 1930, 8, as Francesco. Arslan 1960 (B), I, 214, as Francesco.

26. Kunsthistorisches Museum, 12. Illustrated in Arslan 1960 (B), II, fig. 272, as Leandro.

27. Suida 1949, nos. 86 and 87, as Jacopo, in large part autograph. Illustrated in Arslan 1960 (B), II, figs. 215 16, as Francesco. It is usually said that the Berlin *Air* and the Sarasota *Fire* and *Water* were part of the same series of Elements, because of their similar measurements (*Air*: 123 × 182 cm; *Fire* and *Water*: 139.7 × 182 cm) and their provenance, which for all three is the Gallery of the Prince of Liechtenstein, Vienna. This assumption is decisively disproved by the different style of *Air*. The argument from measurements is not conclusive, since it is known that the Dal Ponte family often used to duplicate the same compositions on canvases of the same size. Nor is the argument based on provenance, since in the same collection there were two other Elements, *Air* and *Fire*, signed by Francesco and with very similar measurements to the other three (*Air*: 142.1 × 187.8; *Fire*: 145 × 187). *Fire* is still in the collection at Vaduz, and was shown in the exhibition *Venezianische Kunst in der Schweiz und in Liechtenstein*, Präffikon 1978, and illustrated in the catalogue (no. 85). *Air* was sold, became the property of Harold Fitch, and later came on the English market 1970-71 (Christie's, 26 June 1970, lot 64; 11 June 1971, lot 10). So it is clear that the Liechtenstein pictures must have been from three different cycles: one by Jacopo, with the possible help of Francesco, c. 1576 (the Berlin *Air*), another by Jacopo of the early 1580s (the Sarasota *Fire* and *Air*), and one by Francesco working in Venice during the same period (the *Fire* in Vaduz, the *Air* in a private collection). [When I visited Vaduz in the fall of 1991, a check of the inventories and a conservation with the then director of the collections, Dr. Reinhold Baumstark (whom I thank), made it clear that the two paintings now in Sarasota did not come from the collection of the Princes of Liechtenstein. The assertion had been made by William Suida and was unfounded. Nor is there reason to suppose a similar provenance for the painting formerly in the Berlin Museums. There was a cycle of the Elements, the one painted by Francesco in Venice and signed by him, mentioned in Vicenzo Fanti's *Descrizione* of 1767 (*Water*, 416; *Air*, 461; *Earth*, 473; *Fire*, 488), which was unfortunately already dispersed by the time of the 1873 catalogue, when two pieces, *Water* and *Air*, were

a stripped-down quality in the structure of the figures that, to my mind, rules out any possible confusion between the two moments and that can be placed at the high level of *The Adoration of the Magi* and the Moro altarpiece. In the landscape of both pictures there is something of a neo-Giorgionesque accent that decidedly distinguishes the products of this moment from those of a mere two years earlier in the cycle of the Flood. The same buoyancy, moreover, is found in the workshop's reworking of the theme of the Good Samaritan; I have in mind the Vienna version, which I believe dates to 1576.[26] This buoyancy is notably present in the episodes added to the preexisting version of the theme – thus the idyll between the horse and the dog in the presence of a page seen from the rear – placing it between the Savorgnan *Return of the Prodigal Son* and the Berlin *Actaeon*, while the Samaritan in the woods is almost the same as in the Civezzano predellas. My contention that with the landscapes in the *Actaeon* and the *Air* one does not have to look beyond 1576 is proven by the fine landscape depicting the flooding river Colmeda, which is so prominent in the Feltre altarpiece. This altarpiece has been said to date from 1576, perhaps toward the end of that year, and was the consequence of those new experiments essayed in paintings done specifically for collectors. It is, therefore, on the *Allegory of Air* that the facts and significance of the cycle of the Elements should be evaluated, not on the versions of the *Water* and *Fire* (The John and Mable Ringling Museum of Art, Sarasota, cats. 70 and 71),[27] which are very beautiful and important replicas from the start of the 1580s of compositions originating around five years earlier. As for the new cycle of the Seasons, I judge it on three mainly autograph examples: *Spring* (cat. 58), *Autumn* (cat. 59), and *Winter*, all in the Galleria Borghese, Rome,[28] of which the latter is known by few, or perhaps no one, since for years it has been on deposit in an office of the Ministry of Public Education.[29] A comparison of *Autumn*, for example, with *The Return of Tobias* gives us the two poles of an impressive stylistic development carried through in the course of about four years and which would remain inexplicably incomplete, truncated even, if it had not culminated – beyond the Potsdam *Sacrifice of Noah* (cat. 49), beyond the Prague *Annunciation to the Shepherds* (cat. 54), to cite only those nocturnes most immersed in nature – in this cycle of Seasons arrived at by way of the *Actaeon* and the *Allegory of Air*. No less enlightening is a comparison between the cycles, for example the *Summer* of the one and the *Autumn* of the other. In the former, the figures are arranged in the foreground of the picture, while the landscape slopes away in depth through receding diagonals, which are accompanied by a diminution in scale of the small figures placed in the intermediate planes and the rigorous damping down of the lights. In *Summer*, on the other hand, the figures are immersed in the landscape through exclusively pictorial means, without artifices of perspective or abrupt changes in scale,

and spatial depth is suggested by tonal density.

In this change of approach one sees clearly a new attention on the part of Jacopo to the Venetian pictorial tradition (and we shall see further indications of this as we go along). The streaky heavy brushwork, which kneads light and air into the color and, without a framework of drawing, models the forms with the very color of the things themselves, is another chapter of Jacopo's «impressionism». It is very different, for example, from that of the San Rocco altarpiece, where the painter's touch still makes drops of light glisten on the «mute» half-tints, while making use of a structure drawn with great nobility and of a cold chromatic register. By experimenting with night scenes, Jacopo very much enhanced the constructive power of light and reduced that of the half-tint: the consequences can be seen in the *Saint Lucille*. A further step was the discovery of the warmer color range and of the use of a loaded brush to create heavy strokes in the Seasons. In this progression, *The Adoration of the Magi* and the Moro altarpiece play an important role. The replicas signed by Francesco,[30] with their profound incomprehension of the more original qualities of the paternal prototypes, suffice in themselves to demonstrate to what extent the Galleria Borghese paintings ought to be considered autograph and are significant for Jacopo's orientations after the *Saint Lucille* and the Civezzano canvases. What is the date of the Seasons? Within 1576? Or at the turn between 1576 and 1577? The reply comes from consideration of the large *Circumcision*, but even more from *Venus at the Forge of Vulcan*, which I consider without question to date to 1577 and, like the altarpiece from the cathedral in Bassano, to be later than the Seasons. The reworking of *The Expulsion of the Merchants from the Temple* that Jacopo had produced in the 1560s,[31] and which currently occupied him and his workshop, would be the point of departure for his final interpretation of the theme, the version in The National Gallery, London (fig. 78). That canvas must be considered to precede the two central works of 1577. A fragment of the composition, which depicts only the youth with the cage and the bust of the old man seen from behind, comes from what must have been, in our present state of knowledge, the most important of the many known versions. Twenty years ago this fragment was in a private collection in London.[32] Visually it could have been inserted, with no disturbance whatever, into the Galleria Borghese *Winter*.

As for *The Circumcision*, which is usually not taken too seriously by students of our artist, what matters above all are the innovations with respect to the preceding altarpieces. These involve the composition of the demons turning in various directions in a sort of frieze at the bottom of the canvas and the angels strung out at the top to form a garland, as well as the way the figures in the central episode stretch across the front and cancel out the traditional way of reading space on the diagonal, and, finally, the chromatic inter-

in Paris at Sedelmayer. As I said, *Air* appeared on the English market around 1970. In the Prince's Castle of Vaduz, next to *Fire* there is another still unpublished piece of the cycle, *Earth*. They are respectively nos. 232 and 234 in the catalogue of the collection at Vienna in the Gartenpalais der Rossau of 1885, and with the same numbers appear in the better-known catalogue of the collection, still at Vienna, by Kronfeld 1931.]

28. Della Pergola 1955, nos. 178, 179, and 181, as follower of Jacopo Bassano; Arslan 1960 (B), I, 365, as workshop of Jacopo. Soon to be published.

29. *Summer* is missing, but is known through copies by Francesco: Kunsthistorisches Museum, Vienna, inv. 4289, or Národní galerie Prague, inv. DO 196. The cycle is the one illustrated in plates 162-65 of the *Theatrum Pictorium*.

30. Kunsthistorisches Museum, Vienna, 4289 (*Summer*), inv. 4287 (*Autumn*), inv. 4288 (fragment of *Winter*). *Summer* and *Winter* are signed. *Autumn* is illustrated in Arslan 1960 (B), II, fig. 255.

31. Ballarin 1973, especially 112-17.

32. Ballarin 1966, 124, fig. 141. [The fragment has for more than fifteen years been in the Ackland Art Museum of the University of North Carolina, Chapel Hill, inv. 75.13.1.].

weave that results from a skillful modulation of zones in light and zones in shadow so as to create a decorative effect. Looking at this altarpiece on the staircase of the Museo Civico in Bassano del Grappa, I have always thought that Francesco, after having succeeded in this experiment, must have felt himself particularly well prepared to claim a place within the Venetian art world, something he could not have pretended to after completing the canvases for Marostica and Civezzano. It might be thought that it was Francesco who guided his father's hand in this direction, but I am convinced of the contrary. Participating in ventures like this in his father's workshop, Francesco was equipping himself to move undaunted into the Venice of 1580. When we look at the ceilings of the Sala del Maggior Consiglio in the Palazzo Ducale, which we now know date from 1578, it is obvious that he had behind him *The Circumcision* and *Venus at the Forge of Vulcan*, two paintings indicative – though in a different measure because of what we shall say now – of Jacopo's teaching no less than of Francesco's growth in 1577. It is in *Venus at the Forge of Vulcan* that we must study the sudden advance in Jacopo's art during the course of that year and work out the entire chronology of 1576 and 1577. The composition is of notable beauty, invented by Jacopo with his son's collaboration, and it reworks thematic and figurative material from the Elements series, from *Water* no less than *Fire*: the boy with the basket of fish becomes the one with the purse of money, the fishmonger becomes Vulcan. The work should be judged not by the canvas in the Galleria Sabauda in Turin, which is signed by Jacopo but is in reality a workshop replica,[33] but by the substantially autograph version in the University of Barcelona.[34] That canvas was without doubt produced when Francesco was still in the workshop, thus before the end of 1577. Francesco collaborated in the execution of drawings for at least a pair of figures: the stoker seen from the back and the potmaker.[35] In all likelihood this was the last undertaking Francesco had time for before departing for Venice.

The large canvas in Barcelona is a great masterwork of Jacopo's old age, impressive in its measurements as well. It is relegated, unappreciated, to the Sala de Junta in the university, where the Museo del Prado deposited it a century ago. A profound reflection on Titian and Tintoretto was evidently brought to a head during the course of 1577 and, grafted onto his deep-rooted inclination to paint from life, produced results that sometimes seem to look toward Rembrandt, sometimes toward Chardin. The *Saint Lucille* of only ten years before suddenly appears to belong to a much earlier time, while one senses the advent, still eight years off, of the artist who would paint *Susanna and the Elders* (Musée des Beaux-Arts, Nîmes, cat. 72). Although still utilizing certain artifices such as the oblique wall in the center of the picture, as in a *Supper at Emmaus* or a *Return of the Prodigal Son*, the space is no longer taken

33. Gabrielli 1971, no. 587, fig. 146, as Jacopo and Francesco Bassano. Arslan 1960 (B), I, 372, as workshop production.

34. Museo del Prado, Madrid, 5263 (inv. P. 880) as Leandro Bassano. It measures 250 × 407 cm; Alcolea 1980, no. 194, ills., as Leandro; « El Prado disperso » 1986, 122, ills., as Leandro. Soon to be published by me.

35. Musée du Louvre, Département des Arts Graphiques, Paris, inv. 5288; Collezione Horne on deposit at the Gabinetto Disegni e Stampe degli Uffizi, Florence, inv. 5664. [Another study by Francesco for the painting emerged last year in France: for the young man with coins. It was sold at Christie's, London, 7 July 1992, lot 143.]

over and ordered by a system of diagonal stage flats, but spread out across the front and seemingly hollowed out. The background emerges from the very meagerly painted warm brown shadows, while the figures and objects come to the fore modeled with summary traits, but kneaded in a warm light, like the afterglow of a conflagration, and compounded out of an extraordinary lifelike material. At the same time the twilight sky spreads out in a gelid pale blue just barely warmed by the sunset beyond the stage flats in the counter-light of the forge. It is a very beautiful idea that contrives to keep the fantastic temperature of the invention at a high level. In one sense it seems to be going back to the tension of certain engraftings of sky seen in the years around the altarpiece depicting *Saints Peter and Paul* (Galleria Estense, Modena, cat. 34) or *The Parable of the Sower* (Thyssen-Bornemisza Collection, Lugano), as if retroactively expunging the more objective treatment of landscape from the years of *The Return of Tobias* and the Flood cycle, but preluding the glimpse of sky in the *Saints Martin and Anthony Abbot*.

With Francesco departed, our point of reference for Jacopo's work becomes the altarpiece depicting *The Virgin in Glory with Saints Agatha and Apollonia* (Museo Civico, Bassano del Grappa, cat. 122) for the church of San Giuseppe, whose commission in March of 1580 is documented, as is its execution during the course of that year. It was preceded by the *Saints Martin and Anthony Abbot* (Museo Civico, Bassano del Grappa, cat. 67) for the church of Santa Caterina, which is referred to in the contract mentioned above as the model for the altarpiece being commissioned. But to what extent, one must ask. The two altarpieces belong to a phase of Jacopo's career different from that which we have seen up to 1577, and it would be interesting to know more about the old master's attitudes following the departure of his eldest son. By chance, we have a pair of altarpieces from precisely that moment, though once again works of collaboration and, even worse, now unknown except through photographs. These were formerly in the Reder collection in Brussels, and one bore an authentic inscription, almost entirely legible even in photographs, naming as authors Jacopo and one of his sons on commission from the stewards of the church under the date of 7 June 1578.[36] The early provenance is unknown, since neither Ridolfi nor Verci mention the pictures, nor do we even know the dimensions (the inscription, however, specifies « do palle », two altarpieces) or the secure identification of the six saints pictured.[37] The son whose name is not given, is Leandro. This comes as no surprise, since once Francesco had gone his way, the most authoritative collaborator in the workshop was Leandro, then aged twenty. Nor are we even sure of what paintings from the early 1580s can be looked to for comparison. The possibilities are *The Circumcision* for Rosà near Bassano, signed and datable around 1580; *Saint Roch in Glory with Saints Job and Sebastian* (now in the

36. I do not think that they have ever been studied or published or even cited. Soon to be published by me. This is the text of the inscription on the higher of the two steps of the *Three Sainted Martyrs* altarpiece: « .S (e) r Domenegha [sic] e [Se] r Zoanne Hiero. masari / De la giesia fec. far q.te do palle./. Jac[obus a] po(n)te et eiu(s) [sic] filui(s) p./ M[D] LXXVIII. VIT./juni. » In round brackets, the expansion of contractions; in square ones, letters wholly or partly obliterated but safely conjectured.

37. One altarpiece has in the center Saint James the Greater, and at the sides Saint Nicholas and a sainted deacon with a book, who might be Saint Lawrence (or Saint Stephen). The other has two young and beardless apostles with palms and books, one of whom might be Saint John, and a sainted deacon on the left with a palm and book, perhaps Saint Stephen (or Lawrence). So only in one of the altarpieces do the saints bear martyrs' palms, while all six are holding books. [The first of these two paintings has belonged at least since 1975 to the Weisgall collection. In that year it was shown in the exhibition of works from the collection held at the Crocker Art Gallery in Sacramento (*The Collecting Muse: A Selection from the Natalie and Hugo Weisgall Collection*, no. 37). In the catalogue it was attributed to Francesco Bassano. It measures 98.5 × 72 cm. The height of these two altarpieces, about a meter, leaves their true purpose uncertain: too small to stand on an altar, too big and finished, as well as being signed, to be *bozzetti*.]

Palazzo della Provincia, Vicenza, fig. 72) dated 1582 and which, though signed together with his father, is entirely Leandro's; *The Madonna Enthroned between Saints Zeno and Sebastian* for Molvena near Vicenza from about the same year (it should also be noted that the Saint Zeno is a reworking of the Saint Nicholas); but above all *Orpheus among the Animals.*

This latter can be attributed unhesitatingly to Leandro's youthful years and should be judged not by the version in the Svenonius collection in Sweden, which is of a later date, but by the one I hold to be the earliest and finest, which in 1972 was with the dealer Steffanoni in Bergamo and which, on the basis of the Reder altarpieces, can be said to also date from 1578. Orpheus is a trifle too obese and even comic, more Bacchus than divine musician, yet we remain certain that in the case of those two altarpieces Jacopo's responsibility is not to be underestimated. For one, it happens that they anticipate Jacopo's choices in altarpieces that we usually think matured only around 1580, and for another, because the two altarpieces seem to reveal, even in photographs, a different quality of drawing and painting. The drawing is more elevated in the one depicting *Three Sainted Martyrs*, especially in the rendering of saints to the sides, and in particular the drape of the apostle's habit is rendered with a very beautiful spiral movement, which exceeds the possibilities we can credit to the painter of the *Orpheus* or the Saint Job altarpiece of a few years later.

Fundamental as these works are for putting Leandro's youthful production in some order, they are no less useful for dividing Jacopo's later years into more precise periods. The altarpiece for Valstagna depicting *Saints Nicholas, Valentine, and Martha* is lost, but its *bozzetto* survives (cat. 68)[38] and is quite certainly by Jacopo himself: the fleet touches on the gleams of the dalmatic, the spills of white on the surplice, the severe tones of Saint Martha's habit, the book standing on edge, the ex voto leaning aslant at the foot of the throne where Saint Nicholas sits frontally like an archaic wooden statue venerated by the populace are all heart-warming anticipations of the new art of the seventeenth century. We would have dated it after the altarpiece with Saints Agatha and Apollonia, at the same time as *Saints Martin and Anthony Abbot*, because the heads of Martin and Valentine, or throne of Anthony Abbot and Nicholas, could be interchanged from one canvas to the other. But it happens that a drawing in the Kupferstichkabinett in Berlin, derived in the workshop from the painting for Valstagna and dated 1578, assures us that the *bozzetto* originated in precisely that year, even possibly in the spring, but not later. The two altarpieces formerly in the Reder collection must derive from a new project for an altarpiece like the one for the parish church at Valstagna, and it is easy to see, on the basis of Saints Valentine and Martha, that the sainted deacon and the apostle to the left and the right in the altarpiece depicting *Three Sainted Martyrs* are figures that could only have been conceived

38. Museum of Art, Rhode Island School of Design, Providence, inv. 57.158. The Valstagna altarpiece is mentioned by Verci 1775, 109-10: «In his late manner [Jacopo] painted moreover another altarpiece with Saint Nicholas the Bishop, who has on the right Saint Valentine, and on the left Saint Martha. Now it is to be seen above the door of the sacristy». The identification of the saints in the Providence *bozzetto* is certain. Saint Valentine, companion of Martha, has at his feet the epileptic child he has cured. The connection between the *bozzetto* and the lost altarpiece, and the dating, is Rearick's (1976 (A), 106, no. 67), who made use of the dated drawing in the Kupferstichkabinett Berlin, inv. 22720.

by Jacopo himself. The date of the pair of altarpieces therefore is quite probably valid as *ante quem* for the *bozzetto* in Providence, and it is not without significance for a better understanding of Jacopo's career between the period of the Saint Martha and the Saint Apollonia of two years later, for which the Saint Martha can be seen as the model. The date of 1578, which consequently applies to the *Saint Martin* and could also serve for the invention of the *Lamentation over the Dead Christ by Candlelight*, judging it by the touchstone of the painting in the Lansdowne collection, allows time, before the end of 1580, for the execution of the *Paradiso* for the high altar of the church of the Capuchins in Bassano (cat. 123). That altarpiece is quiet definitely posterior to the *Saint Martin*, because the entire composition of the latter is found again in the right corner. Moreover, there would have been time also for the great *Lamentation* in the Musée du Louvre, Paris.

I have said that *The Miracle of Saint Peter Curing the Cripple* definitely falls within this span of time. But exactly when? The skillful balancing of movements that converge and diverge, exit and enter the picture, endows the composition with the monumentality of an altarpiece, so much so that it would be legitimate to suspect that Jacopo had produced a major painting on the theme, although there is no mention of any such picture in any early source, and then reproduced it in smaller format on copper for some collector. Through the gap opened up by the foreground figure's withdrawal to the side, the cluster of figures at the right leads our eye to the cripple immersed in shadow in the center. The great invention of this painting consists, in fact, in having imagined the figures crowded in the foreground, which are merely accessory to the episode of the miracle, as if rotating and as if suspended in light against the penumbra of the second plane, where we find the cripple and, in part, Saint Peter himself. The staging – indeed, one needs to say the composition of lights and shadows – is elaborately worked out, almost as if the portico is traversed by a light that filters at intervals through a colonnade outside the picture itself. A beam of cold light flows into the right corner and isolates in the foreground an episode that is also exceptional for its quality of domestic sentiment expressed through the old man with his little grandchild. The result is entirely legible in the very carefully planned variation of lights and half-lights, penumbras and reflections. There is a variation in textures as well which ranges from the child's densely woven complexion, the lumpiness of brushwork on his shoulder and temple and the gleams of one of his copper pots, to the thinnish and ashen rendering of his legs in shadow, which are woven of extremely thin highpoints of light. The pinkish and gray flesh parts are bound in a winding sheet drenched with cold silvery light, but set against a wall of red lake – the cloth that descends into shadow from the old man's legs – which suffuses them with a warm reflec-

tion. The old man's large head, no less stupendous than his gnarled hands, is an aggregate of brushmarks of pink, white, and black creating an effect of high relief, but at the same time of smouldering embers over the warm brown of the garments shining with reddish reverberations against the cold blue behind him. The youth at his back stretches himself, scintillating in the richness of his orange, blue, and golden gray garments, which are set against the shadow of the interior with a very beautiful gesture of his arm suspended between light and shadow. The light flares up on his shoulder, adding new resplendence to the cold blue of his garment and the golden gray of his sleeve, flickers, then dies out on the end of the sleeve that sinks into shadow, then catches new life in the subdued silvery vibration of the cuff, in the touches of pink on the fingers. Likewise, the young woman in front of him, leaning against the temple column, is poised at the threshold of the shadow: the light touches her shoulder, but her neck and face, which are turned toward the interior, are rotated in an intensely luminous penumbra. Note especially the dab of color slashed by cold light at the base of her neck from which pours that grazing reverberation that brings to the fore, from the diaphanous ground of the flesh tone, the intermediate and « mute » rose color of the scars on her cheeks, and the more luminous effects of the brushwork on her ear. Here, as moreover in the preceding passages of the painting, we are at the very summit of excellence that can be expected from this great master. The woman's head is an example of the interweaving of the entire picture: shifting the ray of light to the margins and working the forms in a reverberated penumbra. The two figures that took out from the columns behind the cripple are, like him, entirely immersed in the tenebrous gloom of the portico: a harmony of warm browns and inks on which vibrate, subdued, touches of a colder pink.

The modernity of this way of painting, accompanied as it is by acuteness of observation and by human compassion, gives rise to a passage worthy of Goya. The cripple, accustomed to being at the door of the temple, turns to Saint Peter, who is about to enter. The light grazes the saint from the rear, touching his shoulder and the nape of his neck. On the cold grayish blue of the garment, the cranium covered with a soft down is constructed by brushstrokes of cold gray and pink freely laid over the ground, which shows through and comes to be part of the form itself, heightened finally by a forceful stroke of lead white. However terse the construction, it does not prevent the painter from suggesting the way the artery stands out on the saint's forehead. No less masterly is the variation he introduces in the left corner, where he lets us see another cripple, stretched out on the ground, who twists about in a shadow shot through with light and gives rise to a warmer and more fused chromaticism. Here then is something virtually Titianesque in relation

to a situation of light different from that of the opposite corner, with ruby reds, brownish ochers, golden whites, warm grays, and from which stand out the forceful brushstrokes of colder and more luminous pink in the face and the coils of silvery white of the turban.

The close examination we are attempting here, however, reveals that the painting is not well preserved. Saint Peter's brown mantle and the green one of the figure behind him are totally repainted. The latter's head and the two alongside are products of the restorer, and the head of the figure at the temple threshold is quite unreadable. A large part of the architecture has been redone, in particular the zone of the vault at the rear and the sky. It is fair to suppose that there were extensive paint losses in an area corresponding roughly to the upper left quarter.

The painting was quite certainly done after not only the *Saint Lucille* and the Civezzano canvases, but also the series of biblical and allegorical pictures I have dated to 1576, namely the versions of *The Supper at Emmaus* and the series of Elements and Seasons. A comparative study of the *Miracle of Saint Peter* and the large altarpiece painted for Vicenza that depicts *Saint Roch Visiting the Plague Victims* (Pinacoteca di Brera, Milan, cat. 47), of which the *Saint Peter* is to be considered a rethinking, would offer material for an ultimate summary of the brief stretch of Jacopo's career before and after 1575. The drawing of the figures in the *Miracle of Saint Peter* is profoundly changed, but above all so too are the criteria of construction of the space and of distribution of the light. The figures do not wedge themselves into the pictorial depth following the diagonal that leads into the landscape or the architectural perspective, which rapidly recedes from the margins of the window. Instead, they loiter, so to speak, and entrench themselves along those margins in clusters organized internally by a skillful equilibrium of rotations that converge and diverge. Jacopo was obviously concerned to reconcile compositionally the image's need to recede into depth with its need to unfold on the picture plane itself. In achieving this, he discovered in himself a new sensitivity to the two-dimensional reality of the support as such, something that can only have been suggested to him by another phase of reflection on Venetian painting between Veronese and Tintoretto. It is only at the time of *The Circumcision* in 1577 that we find, coming to the fore in his painting, this way of coping with the problems of form which, obviously, he was facing up to in other works as well, but with a quite different commitment: precisely in this painting on copper. It cannot be denied that the spatial organization in the large altarpiece for the cathedral of Bassano, even if it is laid out to achieve a decorative effect, shares precise affinities with the spatial organization in the *Miracle of Saint Peter*, and in particular that the composition of the demons – an innovation in Jacopo's art – is carried out in accord with the same criteria that in-

spired the groups of figures at the margin of the *Miracle of Saint Peter*, in particular the cripple on the ground and the woman looking out from behind. I should add that, speaking of *The Circumcision*, it would not be out of place to point out the first sign of a Titianesque approach in portions of the large altarpiece.

If we consider the new version of the Flood cycle that Jacopo and Francesco completed at the precise time of *The Circumcision* – I am referring to the four canvases at Kroměříž signed by Jacopo (cat. 63-66) – we can point out a very clear example of these new tendencies in the workshop. Three pictures of the cycle remain substantially unaltered, whereas *The Flood* (cat. 65) itself is appreciably recomposed. Comparing the two versions, one readily sees that now the Dal Ponte father and son no longer accept the solution of 1574 with its typical landscape traits – the diagonal recession that empties out of the foreground and inserts the figures into the landscape – but feel the need to balance that reading of space by working on the margins of the preceding composition, where they introduce figures that literally clamber upward. The result is a profound alteration to the perception of the picture's spatiality. Francesco was certainly involved in this operation, since we have his drawing for the toddling child in the foreground,[39] but it was Jacopo who presided over and inspired such essential revisions, and it is not by chance that those changes have become more comprehensible since the discovery of an entirely autograph work.[40] Faced with this conspicuous transformation of the language that Jacopo used at the time of the *Saint Lucille*, one cannot deny the importance of the experimentation of 1576, in, for example, the Seasons. It suffices to isolate the stupendous passage in the *Spring* with the old man sunk wearily on the chair like the grandfather on the steps of the temple, the large sheep on his lap, and alongside him the youth seen from the rear going off to hunt, the cold blue of the garment illuminated on the shoulder and attuned to the warm red of the cap and sleeve, against which the whippets' muzzles stand out. Here then is a comparison that induces us to reflect once again on Jacopo's new way of composing and, so to speak, setting up the figures. It will also be noted that the figure of the child introduced into the revised composition of the *Flood* was worked out in a drawing by Francesco and repeats, facing the other way, the child in the *Miracle of Saint Peter*, with the sole variant being the raised leg. Therefore, one can well ask if, at the moment of this revision, which, I repeat, must be the same time as *The Circumcision* and *Venus at the Forge of Vulcan* – the woman who comes forward in a low-necked dress with her hands joined is the same figure found at the right in the large altarpiece done for the cathedral of Bassano, though turned around here, and who reappears as Venus behind Vulcan – the *Miracle of Saint Peter* was not already known in the workshop. For myself, I doubt it.

39. Tietze and Tietze-Conrat 1944, no. 168, CXLIV, no. I, as Jacopo Bassano, used in *The Flood*. The drawing was the property of Mrs. Julia Rayner Wood (Skippe collection), Malvern, England. It was sold at Christie's, London (Skippe catalogue), 20 November 1958, lot 18, as Jacopo Bassano, and again at Sotheby's, London, 28 June 1979, lot 123, ills., as Jacopo Bassano.

40. The father's measure of responsibility in the new version of *The Flood* could be clarified by the important example (also for its provenance: the Gonzagas of Mantua) in Hampton Court, but it would be prudent to await restoration before giving judgment. Inv. 471. Shearman 1983, no. 22, plate 17, as Jacopo Bassano and workshop, but with too early a date, c. 1570. In the catalogue entry (29) we are given the important detail that the 1578 inventory of Cardinal Ferdinando de' Medici in Rome already included a series of four canvases on the *Flood* by Jacopo – more probably, I should say, a cycle in the older version, which I have placed in about 1574, rather than the one evidenced by the Kroměříž canvases of c. 1577.

We come closer to a true and proper citation of that detail from *The Miracle of Saint Peter* in the altarpiece in the parish church at Cavaso del Tomba, which depicts *Saint Roch Curing the Plague Victims with the Madonna between Saints Michael and Sebastian*.[41] At a time difficult to pin down, but I would say no later than 1578, the workshop was required to prepare a reproduction of the Vicenza altarpiece with Saint Roch in Glory (fig. 72). A series of adjustments and changes were made. The figure of the saint himself was revised on the basis of the small votive painting of Sante Moro, and that of the child on the ground was borrowed from the detail of the child in its grandfather's care in the *Miracle of Saint Peter*, which Jacopo evidently had only just reinvented on the basis of the child infected with the plague whose father entrusts him to the healing of Saint Roch in the Vicenza altarpiece.

I must nonetheless say that this *Miracle of Saint Peter Curing the Cripple*, despite the connections one can find with the later works from 1577, makes me sense how remote it is not only from the period of the great altarpieces of the years up to 1575, but also from the paintings of landscape and genre themes from the following two years, remote also from the more intense collaboration between father and son. For these reasons, I am inclined to date the *Miracle of Saint Peter* to 1578, after Francesco had left Bassano. When in fact he left I do not know for sure, but I feel certain he must have been in Venice some months before he received the commission to paint the ceiling of the Sala del Maggior Consiglio. In any case, I find it impossible to consider those battle scenes later than, or even from the same time as, the Dolzoni altarpiece in San Giacomo dell'Orio in Venice depicting *The Virgin in Glory with Saints Nicholas and John the Baptist* (fig. 68), which Francesco painted with his father's help and which was perhaps his first commission in Venice. With the rigorous luministic web of the *Saint Roch* and *Saint Lucille* shattered, the experiment of an emphasis on color and brushwork befitting landscape paintings exhausted, Jacopo now sought an instrument of language that would permit a more expressive use of light, a more fantastic and emotionally stirring way of composing. It is not surprising that he should find it by looking back at his own development, but also at that of Venetian painting, from Titian to Tintoretto. In the *Miracle of Saint Peter*, he was preparing the conditions for the precipitous apparition of the great white horse and the shining arms and armor of his Saint Martin against the dark backdrop of the natural setting, and for the way to link that image with the Saint Anthony Abbot seated withdrawn in the corner, a figure that eludes the continuity of the space in the picture as a whole and favors instead ellipsis and the anacoluthon. He was readying the way too for the luministic toning that sets afire the optical subtleties of the *Saints Martin and Anthony Abbot* and for that tightly locked concentration of notions that underpins the equestrian saint's en-

41. Magagnato 1952 (A), no. 32, ill., as Francesco, around or after 1576. Arslan 1960 (B), 1, 215, as Francesco, c. 1576.

counter with the beggar. The Saint Anthony Abbot deserves to be viewed along with the old man in the *Miracle of Saint Peter*, and there would be much to learn from a montage that would align five heads: those of the rich merchant in the *Expulsion of the Merchants* (but for this we lack an authoritative version), the grandfather in the *Miracle of Saint Peter*, the Saint Nicholas of the *bozzetto* in Providence, the Saint Anthony Abbot in the altarpiece with Saint Martin, and the Joseph of Arimathaea in the Lansdowne *Lamentation over the Dead Christ*. What, on the other hand, could be more significant of the new chapter about to open in our artist's career than that hollow of shadow in the center of the *Miracle of Saint Peter*? One needs to make a real effort, in the elliptic foreshortened montage of the old man and the youth in this picture, to visualize lying ahead not only *Saints Martin and Anthony Abbot*, but also the reinterpretation of the *Actaeon*, and in that sudden leap of light that cuts across the shadow with the youth's gesture the reinterpretation of the *Susanna and the Elders*.

The San Rocco Altarpiece: Saint Roch visiting the Plague Victims

Alessandro Ballarin

It has been the custom in studies on Jacopo Bassano to recount the history of the 1570s almost exclusively in terms of the succession of altarpieces, from *The Adoration of the Shepherds with Saints Victor and Corona* (Museo Civico, Bassano del Grappa, cat. 46) for the church of San Giuseppe in Bassano, begun at the close of 1568, to the *Saints Martin and Anthony Abbot* (Museo Civico, Bassano del Grappa, cat. 67), which, produced well within the second half of the 1570s, for long was held to be the ultimate achievement – at more than ten years' distance from his death – of Jacopo's creative career. Some of these are dated, and this has made them the even more indispensable point of departure for any critical consideration of his late years. From 1569 we have *Saint Jerome in the Wilderness* (Galleria dell'Accademia, Venice, fig. 47), which was painted for the Padri Riformati (Reformed Fathers) in Asolo; from 1571 or 1572, *The Martyrdom of Saint Lawrence* (cathedral, Belluno, fig. 53); from 1573, *Saint Mark in Glory with Saints John the Evangelist and Bartholomew* (parish church, Cassola); from 1574, *Saint Paul Preaching* (Sant'Antonio, Marostica) and *The Entombment* (Santa Maria in Vanzo, Padua, cat. 52); from 1576, the small votive altarpiece for the Podestà Sante Moro depicting *The Madonna and Child with Saint Roch and Sante Moro* (Museo Civico, Bassano del Grappa, cat. 120) and *Saints Anthony and Crescenzio Interceding with the Virgin on Behalf of the Flood Victims* (Santa Maria degli Angeli, Feltre); from 1577, the large *Circumcision* (Museo Civico, Bassano del Grappa, cat. 121) for the cathedral in Bassano; and, from a time certainly before 1580, *Saints Martin and Anthony Abbot* (Museo Civico, Bassano del Grappa, cat. 67) for the church of Santa Caterina in Bassano. In addition, we have the date of 1573 for the large lunette depicting *The Madonna and Child with Saints Mark and Lawrence Being Revered by Giovanni Moro and Silvano Cappello* (Museo Civico, Vicenza, fig. 54) painted for the Palazzo Pubblico in Vicenza, and the fresco cycle in the choir of the old parish church at Cartigliano, dated 1575.

A great effort has been made in the past thirty years to put some order into the painter's production, not only on the basis of quality, but also of chronology. This is true as well for the vast field of easel paintings, pictures for private homes meant to serve as objects of personal devotion that also gratified the individual's passion for collecting. There is reason to believe now that, at least beginning in the 1560s, Jacopo lavished the best of his creative energies on this particular field. That fact, now recognized, quite certainly shifts the center of scholarly attention from the altar paintings, though at the same time provides them with a proper context. We can now perceive those major works as the result of problems solved that often had come to a head and been worked out in the domestic easel paintings. This means that we can grasp more fully the individuality of the large works that, as we have seen from the succession of dates, closely followed one after the other, but were

also distanced by the intense creative labor expended on other works at the same time. Jacopo's activity in these years is now seen to have expanded in an extraordinary fashion, the decade itself can now be seen as particularly long and rich in the number of works produced, and the altarpieces themselves can be regarded with new eyes. We see his works as much more diversified than we did previously, both differentiated and strung out in time in relation to a stylistic discourse whose motivations appear much clearer, precisely because they are built upon the analysis of the entire production that came out of the Dal Ponte workshop in the 1570s.

On the basis of these developments in scholarly research, I think we can finally solve the problem of the exact date of the altarpiece depicting *Saint Roch Visiting the Plague Victims* (Pinacoteca di Brera, Milan, cat. 47) done for the church of San Rocco in Vicenza. The most beautiful of the altarpieces of this period, it is also one of the few neither dated nor documented. Scholars have until now proposed a date around the middle of the 1570s, thus *after* the Padua *Entombment* and only *two years before* Francesco left his father's workshop to try his fortune in Venice. But that dating rendered incomprehensible the artist's stylistic discourse in the 1570s as read through the large altarpieces, and that was the only approach those scholars had been able to envisage. It also held back and made more difficult the urgent task of putting into order the chronology of Jacopo's oeuvre as a whole. What was needed was to return to the path laid down by critics in the 1930s, scholars like Fröhlich-Bum or Baldass, and to investigate the production of what we can call the « domestic picture ». In this way we can better appreciate Jacopo's role in creating the prototypes for these domestic pictures and decipher some sort of chronology within that particular field.

Leaving aside the latter approach, the argument on which the more recent scholarly proposal centered had to do with the San Rocco altarpiece commissioned by the canons of San Giorgio in Alga in Vicenza for the high altar of their church, and its possible connection with the plague raging across northern Italy between Milan and Venice in 1576 – a weak argument, but destined to weigh heavily in the absence of a well worked-out and valid perspective on the artists's stylistic development to which one could refer and, if possible, use as a measuring rod for the series of documented facts and indices we do have. Some years back, seeking my own answer for the dissatisfaction I had always felt toward that solution, I took into serious consideration this finding of the historian Preto: « It is known that precisely Vicenza succeeded in remaining immune from the contagion longer than other cities of the Veneto and that 'in February of 1577 the epidemic manifested itself with virulence in the Vicenza area, rapidly involved Bassano as well as other minor towns, and wore itself out only in the spring of 1578, almost a year later

than in Venice and the other major towns of the mainland' (Preto 1978). But even supposing that the commission was awarded the painter in the greatest haste, at the first symptoms of contagion in the countryside around Verona and Vicenza in the summer and autumn of 1575 – the infection seems to have originated in Trento as early as March of 1574 – nothing permits us to presume that the canvas was completed before the end of the year. This means that it would have had priority over all the works we date to 1575 and to which, by all evidence, it is anterior. Moreover, an 'emergency' commission is scarcely consistent with the dimensions and destination of the work itself, intended as it was for the high altar of one of the most prestigious churches in Vicenza, one dedicated precisely to the saintly protector against the plague, and where everyone at the time would have wished to see depicted the episodes of Saint Roch's curing the plague victims along with a visible sign that the city was under the protection of the Virgin in times of health as well. A case in point would be the episodes involving Saint Roch commissioned from Tintoretto years earlier for the presbytery of San Rocco in Venice» (Ballarin 1988, reprinted here as «Jacopo Bassano 1573-1580»).

Rearick has let himself be tempted by a date of 1576 for the San Rocco altarpiece, obviously because it fits better with the time when the plague spread through the city, but this simply gives rise to more contradictions. It suffices to recall that from that same year – confining ourselves to the series of altarpieces – is the small votive altarpiece painted for the Podestà Sante Moro. To my mind, the justification and the date of the very important San Rocco altarpiece, which was the central point of the entire disposition of the church interior, as Humfrey (1990, 196) rightly observed, are to be sought not so much in external events as in the episodes connected with the construction and renovation of the church itself. As is known, that work went on until well into the century, so that precisely the preparation of the four monumental stone altars of the nave and their decoration with paintings were delayed until the years between 1560 and roughly 1570. In this context it is useful to recall that the four paintings done for the side altars were: *The Adoration of the Magi* by Agostino Galeazzi of Brescia, dated 1559; *The Martyrdom of Saint Catherine*, a work by another Brescian of uncertain identity, which dates from 1572 or 1571; *The Pool of Bethesda* by Giannantonio Fasolo (now Museo Civico, Vicenza), which is well known as a late work by the painter, who died in 1572; and *The Discovery of the True Cross* by Giambattista Zelotti, which must date from around 1570. The high altar is an integral part of the nave, so it seems reasonable to suppose that Jacopo's assignment to paint the altarpiece must have been part of the overall project, and from no later than 1570. In my preceding essay (Ballarin 1988, reprinted here as «Jacopo Bassano 1573-1580»), I had suggested the date of 1573, influenced by certain simi-

larities with the large lunette votive in Vicenza and the two «pastoral sce-
nes» in the Gemäldegalerie Alte Meister, Dresden, from the same time, *The
Return of Tobias* (fig. 57) and *The Israelites Drinking the Miraculous Water*. Imme-
diately afterward, however, those similarities proved without substance
when I learned that the pictures made use of motifs invented elsewhere
some years earlier and reutilized here in a different sense. In revising my
point of view on this painting, I saw that I would have to go, so to speak, to
rock bottom. The opportunity offered itself, in the course of some months in
1991, to examine close up the large lunette in Vicenza during its restoration
in the laboratories of the Museo Civico. At the same time the two pastoral
scenes, which ordinarily hang on the main staircase of the Dresden gallery,
were removed and stored in the Pillnitz while the Zwinger was undergoing
restoration. What emerged was a new reckoning in my investigation of Jaco-
po's production during 1573, because the two pastoral paintings were con-
firmed beyond the shadow of a doubt to be from the same exact time as the
large lunette, and this allowed me to push back in time the execution of the
San Rocco altarpiece to even before the Belluno *Martyrdom of Saint Lawrence.*
It is clear to me now that the painting reveals preoccupations with formal
choices, both in its compositional scheme and in the drawing of the individu-
al figures, which are closer to those of the 1560s than those of the 1570s. I am
referring to the way in which the artist calculated how the figures should
converge toward the central axis, which is dominated above by the appari-
tion of the Virgin, and to the skill with which he linked to that movement of
convergence the narrative nuclei that only in appearance are independent of
it. These include the foreground episodes of the youth succored by the old
woman and the child being lifted into an adult's arms. I also refer to the way
the frontal plane, where all those movements are reconciled, is welded to the
depth of the space and to the diagonal line of the street where, in fact, the en-
counter of the saint and the plague victims takes place. It is seen in the coun-
terlight against a twilight sky that makes an extraordinary support, visually as
well, for the apparition in the clouds – once again toward the front of the pic-
ture – where the supernatural light of the glory of the Virgin pours out. The
drawing of the figures is still very refined, as is evident in the members hul-
led out of subtle rotations, out of foreshortenings and just barely defined lost
profiles. The forms are filled out by the shadows and half-lights and polished
by precious drops of light. The cold and lucid chromaticism, iridescent even
in the variegated streaking of the brushwork and changeable in color in the
shadows, strives for refined harmonies in the combination of the reds and
blues, the greens and golden browns. The diaphanous sky, of a cold deep
blue tending toward green, and the counterlight of the street and of the opti-
cally perspicuous clouds underpin a situation of true light, of a twilight only

just descending and in reality still distant. It is a quality of light seen in the sixteenth century only in the backgrounds of Moretto and Savoldo.

But the transparent dusk that envelops the foreground, and in which the figures shine out, is extraordinarily colored, as if those drops and streakings of the brushwork might have dissolved and blended the most precious re-verberations into the air. The singular stylistic temperature of this picture is revealed in the portion with the Virgin. Because of the attention reserved for the drawing as such, the integrity of the form, and the neatly demarcated areas of color, this passage belongs more to Jacopo's style of the 1560s than that of the 1570s. Were it not for the « control » of the color that presupposes the central experience of the 1560s, the passage would still be distinctive enough for comparison with details of *Jacob's Journey* (The Royal Collection, Hampton Court, cat. 33) or of *The Parable of the Sower* (Thyssen-Bornemisza Collection, Lugano), where the color is precisely laid on in cold and compact fields, and the luminism is concentrated entirely on the whites; in the mid-1570s such a passage would become utterly incomprehensible.

But we have said that our *terminus ante quem* must be the concatenation of circumstances in 1573 or, better, 1572-73, because *The Martyrdom of Saint Lawrence* makes a magnificent introduction to that conjuncture. Indeed, if it was produced, as I believe, midway between the San Rocco altarpiece and the large votive lunette in Vicenza, the *Saint Lawrence* would remain open to a total reexploration of the complexity of its stylistic message, by which I mean its value as a pivotal moment between those two peaks of the painter's creative activity. The change of tack to chiaroscuro which, in that sequence of altarpieces, becomes evident in the Saint Lawrence, that kind of auda-cious, free, coruscating, forceful use of the brush, the splash of color that in-creasingly leaves behind all notion of elegant mannerist form, and in 1573 at-tains results of a pre-seventeenth-century naturalness, all these compel us to rule out the possibility that the San Rocco altarpiece could have been painted after 1572. Today I find convincing a dating poised between the 1560s and the 1570s, that is, c. 1570, which is even more apparent – and this is the other horn of the dilemma – since, in the course of this rereading of *Saint Roch Visiting the Plague Victims*, I have become aware of the extraordinary affinities it shares with a very well known drawing by Jacopo dated 1569, *The Visitation* (Gabinetto Disegni e Stampe degli Uffizi, Florence, cat. 97). The Virgin, who is about to embrace Elizabeth in the drawing, and the young mother, who implores the saint to cure her little boy of the plague, originate in one and the same formal archetype. The fracture, so to speak, between bust and lower body is the same; there is the same slight rotation of the oval head, and, within the limits in which one can say it of a drawing, there is the same su-premely virtuoso handling of brush and chalk that constructs forms, even in

the details that are still so noble and entire. Similarly, the way the meeting between the two women is calculated, the way in which the Virgin, turned three-quarters with her shoulders rotated, and Elizabeth, likewise in a three-quarters view but seen frontally from below, interlock with each other, reveals the same concern with formalizing the image as found in the San Rocco altarpiece.

If we then bring into comparison another well-known drawing dated 1569, a study for an altarpiece depicting *The Presentation of the Virgin* (National Gallery of Canada, Ottawa, cat. 95), which is done in colored chalks and is therefore more likely to capture the structural values of the composition, I see nothing that can fail to confirm the hypothesis of the dating proposed here for the *Saint Roch*. This study for a lost altarpiece exploits a compositional scheme, a skeleton, that can be read as the same as that in the San Rocco altarpiece. There are even solutions to details that are absolutely identical to those in the painting and over which I shall not linger, because the connection seems so obvious. Following through with these considerations, I now find a point becoming clarified, which I glimpsed in the past but could never bring myself to affirm publicly because there was no important painting to which I could refer. This is the special physiognomy of the year 1569 as it has been possible until now to reconstruct it on the basis of a few dated drawings: the two mentioned above, plus *The Archangel Gabriel* (Christ Church, Oxford, cat. 99) and *The Virgin Annunciate* (Gabinetto Disegni e Stampe degli Uffizi, Florence, cat. 98), which are models for a lost *Annunciation*. In an article of thirty years back, Rearick (1962) put together the paintings and drawings dated 1568 and 1569 and gave thought to that particular period of Jacopo's career, but neither he nor anyone else since seems to have recognized that the drawings of 1569 mark the advent of something new. I repeat, however, that it is difficult to describe solely on the basis of the graphic material associated with, for example, the large *Adoration of the Shepherds with Saints Victor and Corona* (Museo Civico, Bassano del Grappa, cat. 46), which was installed on the high altar of the church of San Giuseppe in Bassano on 18 December 1568. If after having admired the sublime classical breath, the naturalness stripped of all artifice in that painting, we look at the drawing for *The Presentation of the Virgin* and the two for *The Visitation*, we cannot be unaware of a return to preoccupations with form alien to those in the 1568 *Adoration*. In the Ottawa drawing we find once again, alongside the figure sprawled on his back at the threshold of the pictorial space, the device of a figure seen from the rear, turned toward the interior of that space and cut down to three-quarters length by the frame. The figure is found again in *Saint Eleutherius Blessing the Faithful* (Gallerie dell'Accademia, Venice, cat. 40), in *The Supper at Emmaus* (The Royal Collection, Hampton Court, fig. 43), and

in the small *Scourging of Christ* (Gallerie dell'Accademia, Venice, fig. 45) – all of them works from around 1565 – but also, something like two years later, in *The Miracle of the Quails and the Manna* (formerly Caspari collection, now private collection, Venice) by Francesco il Giovane, and in the study for a second version of the *The Scourging of Christ* (National Gallery of Art, Washington, cat. 94), which is dated 1 August 1568. But, the fact is, that device now appears with a different significance. In that sense, the comparison with the *Saint Eleutherius* altarpiece is of the utmost interest, because it is certain that the painter's use of this figure started there. But the fact that he now puts the emphasis on the formal interconnections that underlie the figure's composition, carrying them into the very foremost plane and renouncing the interior space, means a pronounced reinterpretation of the model that had had coherent development up to *The Adoration of the Shepherds* for the church of San Giuseppe, to the point that, judging at least from that skeleton framework constructed from colored chalks, one can legitimately imagine an altarpiece more like the *Saint Roch* than the *Saint Eleutherius*. To be clear about the temperature of the year 1568, we need to remember that *The Adoration of the Shepherds* is not an isolated case. In the Szépmüvészeti Múzeum in Budapest there is a painting, generally identified as *Sleeping Shepherd* (cat. 45), which apparently really depicts Mercury and Argus. Years ago I recognized the hand of Jacopo in this picture, and after this year's restoration it reveals itself as one of the summits of his oeuvre. It exactly repeats the moment of the great pastoral vein and of classical and monumental style achieved in *The Adoration of the Shepherds*, and, as I explained recently, must be understood as the ultimate result, on the plane of both domestic and ecclesiastical painting, of what I called the second season of biblical-pastoral painting, to distinguish it from a first phase of the years 1557-61 and from a third, and last, of 1570-73.

A while back, Dreyer (1983) wrote about a large sheet with studies on both sides for *The Adoration of the Shepherds* (Staatliche Museen Preussischer Kulturbesitz, Kupferstichkabinett, Berlin, inv. KdZ 24630 *r* and *v*, and here, figs. 48 and 49) and the date of 1569. On that occasion, I also wondered why Jacopo, returning only a year later to the same theme for the altarpiece for San Giuseppe, should have felt the need to take his distance from the result already achieved there. Given the fact that those two studies are surely no more than just jottings of an idea – it is difficult to say to what extent – a figure like that of the shepherd on the recto, who bends forward under the weight of the lamb he is carrying and who twists his legs in a scissor-like fashion, surely does not belong to the repertory of the pastoral pictures of the 1560s. Rearick (1989 and in his essay here) has proposed connecting these studies with *The Adoration of the Shepherds* formerly in Dresden and now better known through a replica by Francesco in the Bode Museum in Berlin. He

ends up dating this canvas as well to 1569. I cannot follow him in this because, above all, one cannot see how, from those first ideas – which are confused but still do tell us something, if only about the format of the work and the painter's intentions – we could have arrived at the solution found in the definitive painting. In the second place, the picture itself does not bear out such a late date. Since it was destroyed in the war, I can say nothing personal about the Dresden example. But I know another version of that composition in a Swiss private collection, perhaps even more authoritative than the one lost, and in any case signed and exceptionally well preserved. I am fortunate in being able to present it to the public in next year's exhibition in Paris, *Le siècle de Titien: De Giorgione à Veronese*, where it will be clear that this very beautiful painting from the years of *The Crucifixion* (Museo Civico, Treviso, cat. 37) and *Tamar Brought to the Stake* (Kunsthistorisches Museum, Gemäldegalerie, Vienna, cat. 38) ushers in that second phase of « pastorals » and prepares its final results, though prior to the *Saint Eleutherius* altarpiece. The Berlin studies are, moreover, memorable for the intensity of luminism that the tangle of black chalk strokes releases from the light blue paper and the other colored chalks. I do wonder if this new luministic approach, which does not dampen but instead enhances the preciosity of the color in subordinating it to a principle of unified light and is not present in the altarpiece of the preceding year, does not let us imagine a picture closer to the *Saint Roch* than to *The Adoration of the Shepherds*. There are very beautiful elements: the silvery gleams against the lilac color of the jacket of the shepherd who comes forward with the lamb; the acme of light conveyed by forceful brushstrokes of ocher and light red on the lost profile of the shepherd in red kneeling in the foreground; the brown splash of the hair against the green background of the third shepherd's vest; and the expanse of cerulean light that wells forth from the paper ground corresponding to the child's cradle. An equally refined though studied chromaticism can be admired in the Ottawa drawing, and also a few brighter notes, like the patches of luminous orange, are modulated and integrated into the overall harmony. Here, indeed, the black chalk has a particular role: it is itself color that envelops, works upon, and links the other colors, bringing about a transition compounded of nuances, transparencies, and transformations of color. Once again, I wonder if this is not precisely the chromaticism of the *Saint Roch* expressed in the medium of colored chalks in an overall study.

At this point we might venture another step on this terrain, with full awareness of the risk of error. While one can see the affinities between the drawings in Berlin and Ottawa – above all keeping in mind the verso of the Berlin sheet and, even more, the fact that they are contemporary, with the date 1569 on each of them – it is more difficult to see connections between

those two sheets and two from the previous year, which are also in colored chalks. I am referring to the Washington *Scourging of Christ* already mentioned and *The Capture of Christ* (Musée du Louvre, Département des Arts Graphiques, Paris, inv. RF 38815), both dated 1568. These are obviously two studies for a fresco cycle on the theme of the Passion of Christ, I should say, but one has to leave open the possibility that the cycle could have included narrated episodes in the childhood and adult life of Christ and that, therefore, the Berlin drawings also may have been done for the same purpose, though some time later. In this context as well, an attempt to discriminate one from the other is risky, but it is worth observing at least that the color, in the Louvre sheet for example, is applied in more compact and defined patches, but not as worked out, perfected, and interlinked as in the two drawings of the following year. In those sheets, the black chalk fulfills its more traditional role of defining the structural support of the composition and delimiting the fields of color, but this does not result from the nocturnal effect and artificial light, as in the Louvre study, because similar observations can be made about the sheet in Washington. This may suggest the possibility of re-studying the sequence of Jacopo's drawings in colored chalks in order to open another chapter, one differing from that of the years around 1560. Twenty years ago I sought to delineate the physiognomy of this other phase, distinguishing certain sheets still mannerist in their structure and coloristic treatment from those of 1575, but the question needs to be treated in a different chronological segment. There remains instead – poised between the chapter that concludes with *The Adoration of the Shepherds* in Bassano and the Budapest *Sleeping Shepherd* (*Mercury and Argus?*) and the chapter that opens with the drawings of 1569 and the *Saint Roch* altarpiece – the likelihood that the study for *The Expulsion of the Merchants from the Temple* (J. Paul Getty Museum, Malibu, cat. 96) dates from around 1569. It too is in colored chalks and on a sheet of the same huge dimensions as those in Berlin, Paris, and Washington, and one may well suspect that this drawing may be another for the hypothetical cycle of episodes from the life and Passion of Christ, if such a cycle were indeed planned or executed between 1568 and 1569. Unlike the other three, the *Expulsion* is not dated. As for the affinities with the Ottawa *Presentation in the Temple* as regards the technique of drawing in chalk and the structure of the composition, nothing needs to be said because they are self-evident. Nevertheless, it should be observed that it is only in the context of the considerations expressed so far, and in the attempt to pin down a special physiognomy for the year 1569, one distinct from that of the preceding year or years, that such a collocation of the drawings becomes plausible. One does in fact have to keep in mind that in the years between the *Saint Eleutherius* and *The Adoration of the Shepherds* for San Giuseppe, Jacopo painted *The Ex-*

pulsion of the Merchants from the Temple (Museo del Prado, Madrid, fig. 50). With respect to that canvas, the Getty drawing of the same subject mentioned above shows that, in 1569, there was an inversion of tendency even more spectacular than what we observed when comparing the *Saint Eleutherius* altarpiece and the Ottawa drawing of *The Presentation in the Temple.* Here again there was a return to formal ideas that seemed to have been put aside for good at the time of the Prado *Expulsion* in favor of looking, one would think, toward the production of the 1570s. It is not by chance that the painter returned to his first version of the subject, worked out around 1561. The reasons for such a change are to be sought, I believe, in the exigencies inherent in the technique of depicting concise and « closed light », that is, the *lume serrato* described by Volpato (see here, Avagnina's essay).

In 1973, seeking to explain the change that took place between *The Descent of the Holy Spirit* (Museo Civico, Bassano del Grappa, cat. 119) and the Enego altarpiece (cat. 31), I observed that, in the latter, « the painter explores once again his most personal and most anti-Titianesque problem, the problem of color and of the luminism of brushwork – two inseparable aspects of a single problem from the time of *The Adoration of the Magi* [Kunsthistorisches Museum, Vienna, cat. 27], because color is the support of that particular luminism and the 'touch,' the brushstroke, an attempt to synthesize color and light – together with the problem of a form once again inspired by the 'manner' of Parma ». Now, it is probable that something of the same sort came to pass in the years that concern us here, though with a form no longer connected with that of Parma, but, instead, generic. I observed further that « such a return to mannerism is not so odd, when one keeps in mind that the luminism of touch of which we are speaking – remote progenitor of that of his old age – can ignite its sparks only on the preordained haphazardness arising out of mannerist form, and that such sparks are not so much the instrument of a luministic unification of the space – a qualification still remote, even if that is its point of departure – as the vehicle of the formal choice that imprints the entire invention and exposition of the mannerist drawing ». At the point where the painter feels the need to give new force to light, its capacity for unifying color (because that is what we are dealing with now) still needs a formal scaffolding that will provide a thought-out support for the new economy and boldness of the light, while the color itself is resplendent, regulated on that unifying principle in the expanded area of the half-tones. The itinerary that culminated in the *Saint Lucille Baptized by Saint Valentine* (Museo Civico, Bassano del Grappa, cat. 53) obviously proceeded from Jacopo's renewed consideration of the problem of color and light of dawn in *The Adoration of the Shepherds* for San Giuseppe in Bassano. Another path, leading to an earlier dating for the San Rocco altarpiece and to the reconstruction of the physiog-

nomy of the year 1569, could begin with *The Martyrdom of Saint Lawrence*, for which Verci (1775) gave the date of 1572. In that painting the formal scaffolding is particularly emphasized. I refer to the way in which around the saint's «splayed» figure there are movements that converge and diverge and are reconciled on the frontal plane, as well as on a diagonal axis following in the direction of the street that rises in relation to what is here a particularly high horizon level. Much skill was deployed in linking the second plane to the knot of figures, something possible thanks to that high horizon line, which enabled the artist to decant his figures into the funnel, so to speak, of the foreground composition, but also thanks to the particular role played by a diagonal axis that emerges from the knot of figures itself and leads the eye into the pictorial depth. As for the drawing of the saint – seemingly prepared to take in the light like another Danae – it is perhaps significant that we recognize in the Saint Lawrence a reflection of the culture of Salviati that had its effect on Jacopo's youth and maturity. Indeed, one can read here, as through a transparency, inventions like the wounded man in *The Good Samaritan* (The National Gallery, London, fig. 40). This crowding in of formal interconnections, this gymnastic deployment of movements that are here and there even too mechanical, is enough in itself to create a problem warranting a new chapter in the history of the painter's career. But we have seen that, in the prospect we are opening here, the picture is not isolated, but has behind it the conjuncture of the years 1569-70, in particular the *Saint Roch*.

But now we have to mark out the distances from that painting. *The Martyrdom of Saint Lawrence* is the first altarpiece in which the overall intonation of the color turns out so lowered by a lighting effect as to make us sense that the next step will be the experiment of true and proper night pieces: an artificial light strikes the saint's thorax and keeps the figures surrounding him in shadow. Note how Jacopo's famous emerald greens now fester and decay, as it were, and how the warm reds and reddish lilac predominate. Not that his color becomes impoverished, because precisely in the kneeling figures seen from the back the yellowed green of the undervest matches well with the golden yellow of the breeches in a passage of refined chromaticism, though quite different from what we see in the *Saint Roch*. There the touch is more scintillating, the area of the half-tints more transparent and luminous, the general intonation of the color colder. This shift to chiaroscuro, which is the new factor with respect to the *Saint Roch*, goes along with a lesser refinement in the drawing of the figures and a broader and more liquid way of painting that leaves behind the virtuoso brushwork – still overly refined – of the *Saint Roch*. The result is a painting rich in episodes of a fragrant naturalness that we seek in vain in the still-too-sustained internal structure of the San Rocco altarpiece, which, instead, makes a stupendous prelude to the pre-seven-

teenth-century quality of the Vicenza lunette. In the *Saint Lawrence,* look at the youth with his red and green striped vest, bending over the firewood alongside the basket with the cloths and rope; at the other youth dressed in blue who encourages the fire with a firebrand, his face rendered in fore-shortening under the beret; or, then again, at the kneeling man seen from the back view, his feet with dirty soles toward the viewer, his large head bent over the fire with ears forcefully marked in red; and yet another behind him who scoops up the coal with a shovel whose handle is streaked with blue and pink. All of these constitute passages that could fit well into the Vicenza lunette. Wherever one isolates out details – for example, the stupendous heads of the saint and the man with a pitchfork – one sees readily how this shift to chiaroscuro meant also painting with bolder patches of color, with a broader overall scheme, and with more fragrant naturalness. While this can only mean that the technique used in the *Saint Roch* had by then been surpassed and abandoned, it did open the way to the unsurpassed peaks of pictorial modernity in the Vicenza lunette. Here one must grasp a number of points: the continuity in pictorial technique between the *Saint Lawrence* and *The Madonna and Child with Saints Mark and Lawrence Being Revered by Giovanni Moro and Silvano Cappello*; the fact that in this changeover the formal scaffolding of the *Saint Lawrence* has been dissolved in favor of recovering the dimension of the interior, through the utilization of ample pauses, in the search for a more natural ordering and management; and, finally, one must also be aware of how consistently, at this point, the painter pursued his development during the following year in two other altarpieces, *Saint Paul Preaching* (parish church, Marostica) and *The Entombment* for Padua. In *Saint Paul Preaching* the figures take their positions at the saint's feet in a scene of domestic life, which by then reflected the maturing of genre within the context of the domestic painting for private owners, while in *The Entombment* the painter plunged into nature, into the great landscape in a well-advanced twilight in which the body of Christ is carried to its resting place, with all artifice abandoned. Here too he was attuned to the experiments that arose out of the last biblical-pastoral paintings and the first allegories.

Having grasped these points, one will have to agree that beyond those two altarpieces there could be space – and here we are really and truly in the flood tide of the period of night pieces – only for the *Saint Lucille Baptized by Santa Valentine,* the other undated altarpiece that came from the church of Santa Maria delle Grazie, but not for the *Saint Roch.* The comprehension of this chronology based on the great altarpieces – from the *Saint Roch* to the *Saint Lucille* by way of the *Saint Lawrence,* Vicenza lunette, and *The Entombment* – has been made easier by the fact that some order has been established in the chronological succession of the domestic paintings.

And now, taking as a point of departure the altarpiece of 1569, the *Saint Jerome in the Wilderness*, one needs to examine that reordering more closely, deepening the track opened four years ago, and to bring other arguments to that thesis. That, however, is a task to be put off for another time.

There remains to be said that, at this point, after having brought the conviction expressed here to some maturity, I cannot resist the temptation to recognize a date in the watercolor marks on the reverse of the large sheet connected with the San Rocco altarpiece (Gabinetto Disegni e Stampe degli Uffizi, Florence, inv. 13063F), something no one has ever taken into consideration. These marks are found below the authentic, and in all probability autograph, inscription in black chalk: « Palla d[e] / S[ant]o Roccho », and can be read as « M D 70 ». Since this drawing is either a model for or a later record of the painting, it cannot be ruled out that the date of the *Saint Roch* altarpiece is given in that inscription.

Jacopo and fresco painting

Giuliana Ericani

1. Actually it is very difficult, given the limited number of extant painted cycles compared to the number recorded at the beginning of the cinquecento, to establish if the painters from the mainland (as opposed to those working mainly in Venice), specialized in one painting technique, or if all of them, indiscriminately, learned in their workshops to paint frescoes in order to fulfill the numerous commissions. Bonelli, for Pordenone, refers the large production of this particular propensity towards the technique, which would have derived from his natural « quickness and decisiveness » (Bonelli 1984 249). Our increasing knowledge in this last decade of fresco cycles executed in the first half of the sixteenth century, the result of greater awareness and conservation, leads us nonetheless to reflect on the fact that the « natural tendency » of some or many of the mainland painters derived from their having learned the technique during their apprenticeship in the workshops and from a general tendency to work in fresco.

2. Ridolfi 1648, 1, 386: « Nella Parrochiale di Cittadella… ne' fianchi della Cappella lavorò a fresco il medesimo Signore trasfigurato nel Tabor. Sopra la porta Padovana dell'istesso Castello dipinse Sansone in atto di rovinar i sostegni della Loggia de' Filistei. In Villa della Rosata, nel cortile di Casa Delfina (Rosà, ca' Dolfin) fece con simile stile alcune favole dell'Ariosto e le Arti liberali, & una Venere ignuda in un Paesino… in Bassano nella contrada de i spezzapietra la figura di nostra Donna, che ha il Bambino in seno, scherzante con San Giovannino; & in villa di Poe [Pove]… in un Capitello… la Vergine con li Santi Rocco e Sebastiano… »; 387: « … Sopra la Porta del Leone di Bassano figurò M. Curzio, ch'entra precipitoso nella voragine; & a Padri Serviti lavorò in un volto la Regina de' Cieli in gloria e Cherubinetti intorno & a piedi Frati di quella Religione e gentili donne adoranti, e nel mezzo naturale paese… », « … a Marostica nella Sala dell'Audienza, alcuni trofei di terretta gialla… », « … a Bassano. Sopra la Casa de' Micheli… un fregio di bambini nella cima, e sotto un'intreccio d'animali, di libri e di medaglie, e stromenti musicali a chiaro scuro; e di sotto Sansone sopra un monte di Filistei, il quale con la mascella dell'Asino fà di quelli horrenda strage. Tra le fenestre fece la Prudenza, la Rettorica e l'Industria; nella parte inferiore divise in cinque ovati la morte dell'innocente Abelle… Noè

Our knowledge of Jacopo Bassano's activity as a fresco painter is greatly increased by the ample documentary evidence provided by Ridolfi and Verci, who gave to this aspect of the artist's production the attention it deserved in light of the important role frescoes played in the art of the early sixteenth century.[1]

Because frescoes played an integral part in the decoration of secular buildings and the walls of churches, fresco painting constituted a major role in artists' workshops from the middle ages to the sixteenth century. Around the middle of the cinquecento, however, the custom of completely covering the interior and exterior walls of a house or a church with paintings was beginning to change and was destined to be relegated almost exclusively to country villas as painting on canvas became more and more prevalent. This change in materials was favored from midcentury on because of structural changes in the chancels and side chapels of the churches, where it was becoming popular to build marble altars against the wall, covering the space earlier reserved for frescoes, which since the middle ages had been visible because the moveable altars had stood isolated in the center of the chapels. The increasing variety of figures and themes considered suitable for painting and the evolution in style, resulting from the directives of the Council of Trent, also contributed to this change in taste. We can readily assume that Jacopo, like all the great Venetian mannerist painters active after 1560, participated fully in this evolution in the choice of technique, and sources confirm that after the fifth decade of the sixteenth century his use of fresco declined.

Ridolfi[2] and Verci[3] list among Jacopo's works some frescoes still extant and many more that are lost. These numerous indications, analyzed in 1983 by Marini,[4] are supplemented today by recent discoveries furnished by the information in the painter's account books, which exhaustively chronicle his work until at least midcentury, but from the next decade on are often only partial. The city of Bassano's very recent purchase of this manuscript and its subsequent publication means that we can now use this data, the most concrete available, to trace an acceptable chronology, correct certain imprecisions in the sources, and attempt to understand the role of wall painting in the development of Jacopo's figurative language.[5]

The *Libro secondo*, in fact, records young Jacopo's first fresco, identified by Muraro as the small outer lunette in the Scuola di Sant' Antonio Abate in Marostica (fig. 84).[6] The date of execution, 1535, allows us to compare surviving fragments with the three canvases for the Sala dell'Udienza in the Palazzo Pretorio in Bassano, executed for Luca Navagero between 1535 and 1536.[7] We can thus confirm the presence of the young artist's hand in the angels' light complexions and rosy cheeks, in the very careful attention payed to the drawing in Christ's hair, and especially in the upright lock of hair of the cher-

84. Jacopo Bassano, *The Dead Christ*, Scuola
di Sant'Antonio Abate, Marostica

84

ub on the left. These refined details of execution reveal stylistic influences
that must have reached Jacopo over land – such as Romanino's work in Pad-
ua, which was filtered through Titian's paintings for the Scuola del Santo –
rather than from the Venetian lagoon and the soft-focused, subtle gradations
of color found in the frescoes on the façade of the Fondaco dei Tedeschi in
Venice. This brief period of the artist's youth confirms a study trip to Padua,
sometime before 1534, in search of formal sources, to see again Andrea Man-
tegna – who had been evoked by his father, Francesco il Vecchio, through a
reading of Bartolomeo Montagna – and, more importantly, Giotto, whose
solid forms, paratactically placed in space, had captured his imagination. But
this visit to Padua would give Jacopo more interesting and modern sources
of stimulation than Giotto and Mantegna. He went to see the great altar-
piece by Romanino in Santa Giustina, where he also encountered the possi-
bilities offered by using a brush dipped in paint and applied directly to a
blank wall, as revealed in Titian's *Woman Taken in Adultery* in the Scuola del
Santo. The uplifted lock of hair of the little angel suggests, however, another
milestone in Jacopo's early research – the frescoes by Romanino in the loggia
of the Castello del Buonconsiglio in Trent, where we can see, together with
evidence of Titian's influence, Jacopo's interpretation of Pordenone's style,
which in this early piece was limited to a quotation, but destined to leave its

ubriaco giacente sul terreno con le parti virili
scoperte, e Sem e Giafet, che lo ricoprono col
mantello. Un fanciullo morto in iscorcio fra
teschi di cadaveri col motto *Mors omnia ae-
quat*; e la bella Giuditta, che ha reciso il capo
ad Oloferne »; 388: « ... Nel chiostro di San
Francesco ritrasse la Vergine col fanciullo in
seno, Sant'Antonio Abbate, vestito all'Epis-
copale, e 'l Serafico Santo »; 389: « in Villa
della Nove... una Cappella a fresco con le
figure degli Evangelisti; & in tre tondi li Santi
Rocco, Sebastiano e Donato, cavati di mosa-
ico... in Enico [Enego]... nella Tribuna mag-
giore Christo Crocefisso; Maria Vergine nel
viaggio dell'Egitto; gli Evangelisti; ... Santa
Giustina... tra' Santi Antonio Abbate, Rocco
e Sebastiano... a Fieta [Fietta]... intorno al-
l'Altare, la figura di San Michele e di San
Giorgio, la visita di nostra Donna alla Cogna-
ta Elisabetta, e 'l passar, ch'ella fece per timor
di Herode nell'Egitto, e gli Evangelisti ».

3. Verci 1775, 79: « ... Ammiravasi eziando
(nella chiesa di San Girolamo a Bassano) un
bellissimo S. Rocco a fresco dell'ultima sua
maniera »; 87-88: « Sopra la Casa de' Signori
Michieli... colori nella prima sua maniera un
fregio di Bambini nella cima, e sotto un in-
treccio d'animali, di Libri, di medaglie, e di
strumenti musicali d'ogni sorte a chiaro scu-
ro, e di sotto Sansone sopra un monte di Filis-
tei, il quale colla mascella dell'Asino fa di
quelli orrenda strage. Tra le finestre fece la
Prudenza, la Rettorica, e l'Industria. E nella
parte inferiore divise in cinque ovati, La
morte dell'innocente Abelle, ove appaiono
tuguri coperti di paglia. Noè ubriaco giacente
sul terreno, e Sem, e Jafet, che lo ricoprono
col mantello. Lot colle tre figlie. Un fanciullo
idropico sotto il poggiuolo fra teschi di ca-
daveri col motto: *Mors omnia aequat*. E la bella
Guiditta, che ha reciso il capo ad Oloferne »;
88: « ... tre quadri per un recinto di letto...
nel Palazzo Pretorio. Nel primo vedevasi Gi-
oseffo, che dispiegava i sogni al Coppiere di
Faraone, e al Fornaio; nel secondo interpre-
tava le visioni al Re; e nel terzo... assiso so-
pra eminente soglio acclamato dal popolo
Salvatore dell'Egitto...; ... sopra la porta del-
la Sala dell'Audienza la figura di nostra Don-
na col bambino in braccio... »; 88-89: « ... nel
Camerino della Cancelleria Pretoria rappre-
sentò Cristo in Croce, e a basso pingenti Ma-
ria Vergine, e S. Giovanni... »; 89: « ... ornò
nel 1558 la Loggia della piazza da esso [Alvise
Bon, podestà] eretta, di varie Istorie, e stima-
bili Pitture... »; 89: « ... Fuori della porta del-

206

la Chiesa di S. Giuseppe dipinse l'anno 1575 Maria Vergine che fugge in Egitto con S. Giuseppe e graziosissimi puttini… Sopra la Porta del Borgo Leone si vede ancora Curzio, ch'entra precipitoso nella voragine. Nella Chiesa delle Grazie s'ammirano in un volto sopra la strada, che serve di passalizio dalla Chiesa alle Case vicine, la Regina de' Cieli in gloria, e Cherubinetti intorno; ed a' piedi Frati della Religione de' Servi… e gentili donne adoranti, e nel mezzo naturale paese. Indi nella Cappella della Madonna miracolosa, Cristo Crocifisso colla Sacra Triade, e a' piedi il prospetto di Bassano col famoso Ponte…»; 89-90: «… Esiste ancora nel Chiostro di S. Francesco la Vergine col bambino in braccio, S. Antonio Abbate… e 'l Serafico Santo… »; 90: «…E sotto i volti vicino alla piccola porta del Sacrato, alcuni miracoli di S. Antonio, ma assai guasti da mano indotta. La vicina Chiesa di S. Bernardino era stata dipinta a fresco da Giacomo…»; 104-5: «La Tribuna maggiore della chiesa parrocchiale, ch'è dedicata a S. Giustina, è tutta dipinta a fresco da Giacomo. Dietro l'altare, da un lato si vede l'angelo Gabriele, e dall'altro M. Vergine annunziata. Queste due figure al naturale furono piú di mezze guaste da due finestre aperte dipoi per dar maggior lume alla detta Tribuna. Sotto all'Angelo sta S. Prosdocimo, e sotto la Vergine S. Antonio da Padova. Dall'una parte e dall'altra vi sono delle colonne di giusta Architettura co' capitelli d'ordine Corinzio. Sopra il lato sinistro si vede la Natività di Gesú, S. Giuseppe, gli animali, e i pastori. Divisa da una finestra segue la Fuga d'Egitto, e in alto il Padre Eterno in una nuvola attorniata da quantità di Angeli. Il lato destro rappresenta Cristo in Croce tra i due Ladroni; a basso Maria Vergine svenuta, le buone donne che la soccorrono; gli sgherri crocifissori parte a piedi, parte a cavallo con lancie in mano; due co' dadi che traggono le sorti sopra le vestimenta; tutte figure di sopra del naturale. Il volto di essa tribuna è diviso in croce da due larghe fascie composte di fogliami e frutta d'ogni sorte, per mezzo le quali vi serpeggia un nastro rosso: queste lo contornano, anche tutto, e si diffondono per i quattro angoli di essa. Ne' quattro spazi cosí formati nella volta vi sono dipinti i quattro Evangelisti. Uscendo dalla Tribuna, sul muro dell'arco in alto da una parte si vede Adamo, che osserva un arbore carico di frutta, e dall'altra Eva col pomo in mano, e il Serpente sull'arbore colla testa di donna. Sotto di Eva,

mark for the future. This small fragment presents, as well, one of Jacopo's masculine figure types, which with variations would appear in some of his paintings and frescoes of 1539: the Casa dal Corno (cat. 116), the *Samson and the Philistines* in Dresden (fig. 100), and the series of drawings at Chatsworth (cat. 81).[8]

We can establish here for the first time the direct relationship between Jacopo's preparatory drawings and their transfer to the wall. This procedure would become a constant in Jacopo's fresco production. A comparison of the technique involved in the two media has shown that the drawing on the sheet is directly linked to the mark of the charcoal on the wall. It is almost as though the two operations were born at the same time, representing the earliest formulation of the work's concept; each of them an early idea that was then finished by the application of pigment to a wall or of colored chalk and white lead to paper. In 1969 Ballarin established that starting in the sixth decade of the sixteenth century, during a central phase of his artistic activity, Jacopo made finished *modelli* for his works in fresco and, later, for those on canvas. Ballarin postulated the existence of earlier drawings of this type based on the survival of more numerous later drawings. This practice can be confirmed throughout Jacopo's entire career from its earliest phases, as our analysis here will show. Ballarin indicated that the source for this practice was to be found in the working methods of artists' shops in central Italy, beginning with the *bottega* of Raphael. He connected the presence of *modelli* in the corpus of certain artists born or naturalized in Venice, such as Pordenone, Veronese, Farinati, and Porta Salviati, with their Roman or Mantuan experiences.[9] To be sure, it is difficult to understand whether the origin of this practice as far as Jacopo is concerned derived from contact with Pordenone very early in his career, or if it was already in use in his father's workshop. The loss of so many fresco cycles means that we can only make a limited comparison between the various ways of preparing to paint a fresco. For Pordenone, nonetheless – and this has not been noticed up to now – a close connection can be made between the existence of preparatory *modelli* and the very rapid execution of figures in a single day, as is evident beginning at least with the decoration of the parish house in Travesio.[10] This is also the case for Jacopo, beginning with his Cittadella cycle.

But to get back to the small fragment in Marostica, how far Jacopo has come, despite the short lapse of time, since his apprenticeship in his father's shop! His first experience as an apprentice had been from 1529 to 1535,[11] mixing colors on site at Cartigliano, near the altarpiece by Montagna. The frescoes included the triumphal arch with the canonical representation of the *Annunciation* as well as the decoration of the entire church: «li volti de mezo», that is, the nave, with a frieze of tondi framing the twelve apostles,

85

and, between the severies (« ne li treangoli de li volti »), stories from the life of Saint Simeon. In its ornamental richness – « et depento fina su li capiteli de i pilastri » – the decoration was to echo what Francesco il Vecchio was already doing in his altarpieces, for example *The Descent of the Holy Spirit* in Oliero,[12] where the pilasters and capitals are covered with colored grotesques. The decoration, extended to the façade (« con li dodexe profeta ») and to the belltower with a Saint Christopher. In the final phase of the work, contemporary with the Marostica lunette of 1535, it included an *Expulsion of the Merchants from the Temple*, whose subject anticipated one of the frescoes that Jacopo and his son Francesco would execute for the apse of the same church in 1575, almost as the symbolic conclusion of the artist's life cycle.

Jacopo's complete emancipation from his father would occur only in the work done in the church of Santa Lucia in Santa Croce Bigolina. The chronological details furnished by the *Libro secondo*[13] and a stylistic comparison of the surviving passages visible through the whitewash permit us to divide the execution of the fresco into two distinct phases, corresponding in part to the differences in execution already pointed out by art historians.[14] On 17 October 1536, on behalf of don Mattia, prior of the mother church of San Fortunato in Bassano, Francesco il Vecchio recorded the commencement of the work for the church: « un frixo a torno con fegure 18 in tondi » (a fresco all around with 18 figures in tondi), « una Nonziata » (a Virgin Annunciate), and « 13 Profeti in tondi » (13 prophets in tondi); that is, the partial decoration of the walls, the triumphal arch, and the archivault. In the following spring, beginning on 12 April, with the scaffolding already in place at the entrance to

in un ovale, la testa di un Prete colle parole: *Presbiter Antonius de Romanis*; e sotto di Adamo, in un altro ovale, che corrisponde al primo, un'altra testa di un vecchione »; 106: « Fieta, Villa del Trivigiano. Nella vecchia Chiesa, or di ragione di Casa Zon, dipinse per asserzione del Ridolfi intorno all'altare la figura di S. Michele, e di S. Giorgio, la visita di nostra Donna alla Cognata Elisabetta; e 'l passar ch'ella fece per timor di Erode in Egitto; e i quattro Evangelisti. Queste pitture a fresco or sono interamente distrutte e dal tempo, e dall'umida situazione »; 107: « Nove, Villa del Vicentino. Per asserveranza del Ridolfi, avea colorito, seguendo la maniera del Parmigiano, una Cappella a fresco colle figure degli Evangelisti; e in tre tondi S. Rocco, S. Sebastiano e S. Donato cavati di Mosaico. Or queste pitture dall'indiscreto Parroco l'anno 1702, rinovando la Chiesa furono cancellate del tutto, e soltanto vi s'ammira in un ovato Maria Vergine con S. Giuseppe che adorano il Santo bambino »; 108: « Pove, Villa del bassanese. Seguendo lo stile medesimo scrive il Ridolfi, colorí a fresco con maniera però tratteggiata in un Capitello di nuovo la Vergine con S. Rocco, e S. Sebastiano, alla somiglianza di quello di Tiziano di S. Nicolò de' Frari di Venezia: or piú non esiste »; 109: « Rosata, grosso Villaggio del Bassanese. Nel Cortile de' N.N.H.H. Dolfini avea dipinto nella sua prima maniera alcune favole dell'Ariosto e le Arti liberali, e la Venere ignuda in un Paesino, come scrive il Ridolfi or perirono affatto miseramente ».

4. The sources were already checked by Marini 1983, 20-21.

5. *Libro secondo.* See Muraro 1992. I am grateful to the Muraro family for permitting me to study the proofs of the transcription of the volume.

6. *Libro secondo*, fol. 110v.

7. For the dates, see *Libro secondo*, fol. 110v. For a stylistic analysis, see Magagnato and Passamani 1978, 20-21, and here Rearick's essay and the introduction to the entries.

8. For an analysis of a rendition of the type in drawings, see Rearick 1978 (A), 163-64; and Rearick 1986 (B), I, 2.

9. Ballarin 1969, 85-86, and 104-8.

10. Ballarin (1969, 108) recognizes in the *Saturn as Time* at Chatsworth the « model » for the figure on the Palazzo d'Anna in Venice, executed by Pordenone in 1534. No relationship has ever been noted between the technique of execution and the existence of

86. Jacopo Bassano, *Saint in Profile*, Santa Lucia, Santa Croce Bigolina

86

these preliminary « models ». For Travesio's *giornate*, see Bonelli 1985, plates 1.1 and 1.6; for Pordenone's technique, see Bonelli 1985, 21-24; Bonelli in Furlan and Bonelli 1984; Bonelli 1982, 80; and Brambilla Barcilon and Avagnina Gostoli 1983, 1.

11. *Libro secondo*, fol. 56v.

12. For an analysis of the painting, dated 1523, see Arslan 1960 (B), 1, 23-24.

13. *Libro secondo*, fol. 94v (dated 12 April 1537) and fol. 95r (dated 12 April 1537 and 17 October 1536).

14. Muraro (1960, 114) reports the beginning of work on 17 October 1536, but does not mention the subsequent document. Sgarbi (1980, 200-4) repeats Muraro's citation, but distinguishes two moments of execution, one for the interior frescoes and the other for the exterior painting, which is now practically illegible.

15. The payments are registrered on 12 April, 24 May, and 6 June (*Libro secondo*, fol. 95r).

16. The *Deposition* of San Luca di Crosara, originally completed by a *Resurrection of Christ*, now lost, was commissioned on 8 July 1532, but delivered on 11 April 1538. The economic agreement was reached on 26 August 1537, the last payment would be made on 29 September, Saint Michael's Day, 1539 (*Libro secondo*, fols. 125r-126v). See here, Rearick's essay.

17. The contract between Francesco il

the chancel, Francesco il Vecchio recorded the agreement for the frescoes of the apse and all of the exterior decoration, which would be finished by 6 June, the date of final payment.[15] Since the original starting date coincided with the beginning of the cold weather, we can hypothesize that the work site was actually set up on 17 October, some work done on the strip below the eaves on the right, or even on the left, in the autumn – a period which is especially damp and thus favorable to a long drying time for the plaster and the proper carbonation of the fresco – and then suspended through the winter months, to be resumed in the spring with the triumphal arch and archivault, beginning with the apse in April. At the same time work was proceeding on the Benedictine cycle of Santa Lucia, Jacopo was finishing the canvases for the Sala dell'Udienza as well as the delightful *Deposition* for the little church of San Luca di Crosara in the mountains,[16] the frescoes depicting *Saints Apollonia, Sebastian, Valentine, Lucy, and Roch* for the chapterhouse in Pove, at the bottom of Monte Grappa (since destroyed), and beginning an altarpiece for the parish church in the same town.[17] The stylistic characteristics of the works done at this time show a mixture of influences, with a strong propensity for an interest in color inherited from Bonifazio, Titian, Romanino, and Lotto. In Santa Croce Bigolina, as well, the interest in color seems to prevail.

The overall decoration repeats the classical schemes tried and proven in Vicenza and Verona: saints in clypei under the beams; prophets in the archivault, as seen at Cartigliano; and the patron saints of the Benedictine church in the apse. The linear definition of the frieze under the eaves and of some figures of saints within the tondi on the right wall – *Saint John the Evangelist, Saint Jeremiah, Saint Matthew,* and a female saint (fig. 85) – shows an absorption of the achievements of a style closer to Verla and to the naturalistic linearity of Romanino in the small vaults over the entrance to the loggia of the Buonconsiglio.[18] But seen up close, the fair complexions of the sweetly modeled faces are enclosed in a red outline that gives a rhythmic elegance to their poses, as well as energy and volume to their forms. Here again, as in San Luca di Crosara, we find an attempt to compose the poetry of emotion using the refined, soft modulation of color, producing an odd combination of Lotto and Savoldo and not immune to a certain compositional *naiveté*.

The presence of Francesco il Vecchio's other son, Giambattista, in this section of the decoration of Santa Lucia, hypothesized by Rearick and repeated by Sgarbi,[19] is revealed by a careful reading of the actual application of the paint to be that of a helper to the other artists.[20] Those passages where Jacopo executes some of the painting himself, as in the saint seen in profile on the left wall (fig. 86), stand out for the imprecise drawing and strong colors.

The faces of the prophets in the archivault, instead, even with their differ-

209

87. Jacopo Bassano, *Prophet*, Santa Lucia, Santa Croce Bigolina

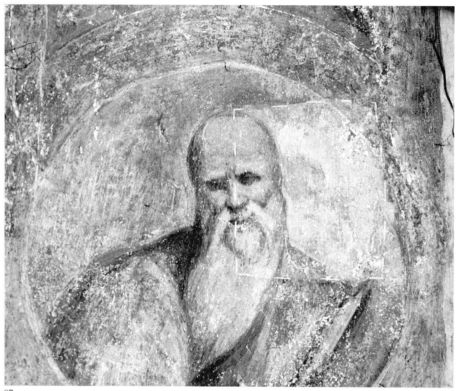

87

ent expressions and physiognomies, are painted without a definite outline, built up by repeated strokes of brick red in the shadows until precise rounded volumes constructed in pure color were obtained. The facial features – sunken eyes, flat or sharp noses, grossly outlined lips, and wrinkles in the skin – are traced with a brush dense with paint, giving a thick bright or dark red outline that almost completely hides the eyes (fig. 87). The technique used here shows a definite awareness of Romanino's frescoes in Trent, even if in some of the figures in the middle ground echoes are observable of Pordenone's frescoes in Travesio and the Cappella Malchiostro in Treviso. Nonetheless, it seems to me that the insistence on snub noses in these figures shows a greater debt to Romanino than to Pordenone. The overall influence of Pordenone detected by Sgarbi in the cycle refers, instead, mainly to the false altarpiece frescoed on the back wall of the apse (fig. 88). There is no doubt that here, in the spring of 1537, Jacopo began thinking about the possibilities offered by painting to break through the physical space of architecture and to simulate a situation different from an old-fashioned arrangement of saints lined up around the wall. We cannot say, however, that Jacopo's attempt was totally successful in this illusionistically painted altarpiece, which

Vecchio and the city administrators of 26 January 1536 (*more veneto* 1537) for the painting and the wooden altar to house it states that delivery would be taken on 29 September, Saint Michael's Day, of the same year (*Libro secondo*, fol. 93 *v*), while the execution of the chapterhouse can be traced back, given the impossibility of doing it in the winter, to the preceding fall, since it was commissioned by the rector of the church in Pove on 7 October 1536 and paid for on 2 march 1537 (*Libro secondo*, fol. 129 *v*).

18. See the frescoes published in Chini 1988, figs. 151-52. There are in actuality very few examples of fresco decoration of this type. The closest stylistically to this one could be the fragmentary frieze on the Cassa di Risparmio di Trento, dubiously attributed by Puppi (1967, 19) to Francesco Verla, c. 1514.

19. Rearick theorizes that Giambattista dal Ponte, cited by Muraro (1957, 291-99) as Jacopo's co-worker and depicted in a portrait in charcoal in the Louvre (Rearick, 1978, 162-63; note on 168; and here cat. 80), could have collaborated with him between 1536 and 1542

88. Jacopo Bassano, *The Madonna in Glory with Four Saints*, Santa Lucia, Santa Croce Bigolina

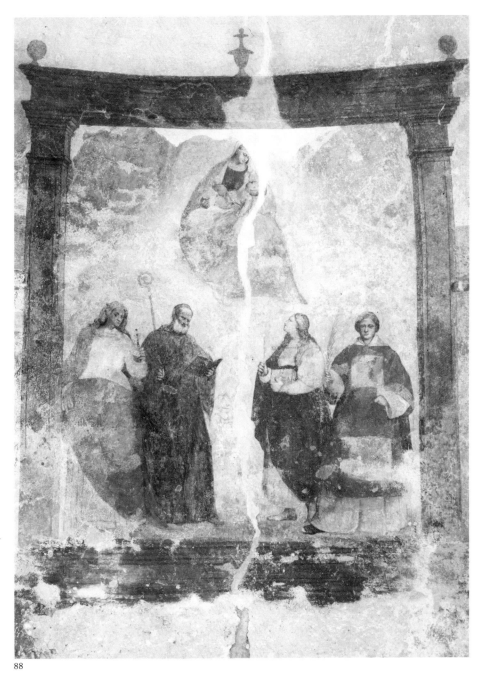

88

«as... a rather clumsy assistant». Sgarbi (1980, n. 114) agrees with the presence of Giambattista as collaborator and attempts to recognize his hand in the saints on the side walls, as well as in the general softening of the lines (which was certainly the result of an earlier restoration, as proven in the photograph, published by von Hadeln 1914 (C), where a well-defined and polished application of the paint very similar to that of the Soranzo Madonna is documented). He also finds Giambattista's hand in *Susanna and the Elders* (Museo Civico, Bassano del Grappa), the Pove altarpiece, the votive altarpiece of Matteo Soranzo (cat. 2), and in the *Deposition* for San Luca di Crosara. The role of Giambattista would seem from this range of works to be that of a factotum who intervened everywhere, both in setting up the designs and in defining the color, but leaving always behind him a negative impression.

20. A close-up view of these frescoes and definition of the differences in execution was made possible by the restoration financed by the Rotary Club of Cittadella and entrusted to Guido Botticelli with the collaboration of Alberto Felici. The work commenced at the beginning of May 1992 and will involve, in its first phase, the frescoes in the apse.

89. Pordenone, *The Adoration of the Magi*
(detail), cathedral, Cappella Malchiostro,
Treviso

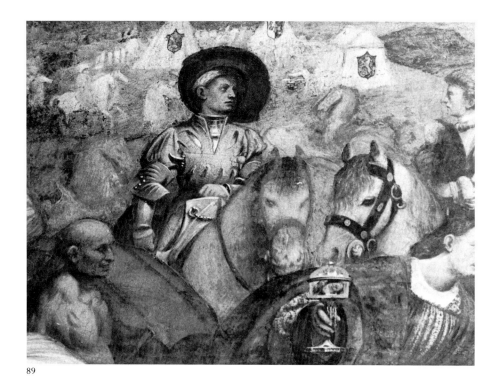

89

is distorted by the circular shape of the wall and where its frame ends near the presbytery's lantern, seeming literally to be climbing up toward God the Father! Nor was an analogous attempt successful in the archivault, where the faces of the prophets come out of their round frames in a Pordenonesque manner, yet whichever way they turn remain trapped in their circular space like miniature portraits. However, Jacopo's effort to adapt the marbles of the mountain tradition to the necessity of simulating a real environment was completely successful in the side pilasters, where he created the impression of thickness and depth with colors, rather than with drawn lines.

Nonetheless, even if in this instance Jacopo did not succeed in capturing, or at least in suggesting, the «architectonic» presence of Pordedone's work, his careful observation of the master's frescoes in the Cappella Malchiostro is revealed in this portion of the decoration. The construction of the faces of the saints, still Giorgionesque in the manner of the Fondaco dei Tedeschi, has taken on an expressive and figurative boldness absolutely unprecedented to this point. His *Saint Lucy*, who proudly exhibits her eyeballs as the symbol of her martyrdom, has the same characteristics as the young horseman in the background of *The Adoration of the Magi* in the Cappella Malchiostro in the Treviso cathedral (fig. 89), who almost seems to have served as the young Jacopo's cartoon for the construction of Saint Lucy's face, so similar are the

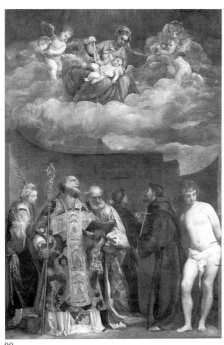

90. Titian, *The Madonna in Glory with Six Saints*, Pinacoteca Vaticana, Vatican City

90

21. See cat. 1.

22. Titian's painting for San Nicolò ai Frari, now in the Pinacoteca Vaticana (for a critical exegesis of the painting and its dating, more or less settled around the middle of the third decade, see Wethey 1969, 107-8; and Hood and Hope 1977, 534-62) and the woodcut after it by Andreani (Furlan 1959-60, 75-76), represent a text on which Jacopo reflected in 1538 and for some years afterwards. Titian's Saint Nicholas provides the model for Jacopo's figure of Saint Zeno in the Borso del Grappa altarpiece, which was to have been done by 29 September 1538, Saint Michael's Day (*Libro secondo*, fol. 14*v*), while the Saint Francis was used for the same figure in the fresco for the cloister of San Francesco in Bassano. Verci states that this painting inspired the decoration of the chapterhouse in Pove (see above ns. 3 and 17).

23. Rearick 1984, 292.

24. Compare the engraving by Marco Dente after Raphael, a replica of which was made by Francesco Villamena (Bartsch 1978, vol. 26, ii, 25-26, nos. 15/16 and 15A/16).

25. Sgarbi 1980, 201.

nose, mouth, and the light that falls across the cheek lingering on the nose, and stopping at the edges of the cheeks. But even in their Pordenonesque strength, the four saints seem to be silhouetted against the background light in the manner of Savoldo in the same way that the Virgin, Saint Joseph, the donkey, and shepherds stand out in *The Flight into Egypt*, which was done for the church of San Girolamo in Bassano.[21] This latter picture was to furnish Jacopo with the Titianesque outline of the Virgin and Child – who tries to escape from her arms – and the pronounced profile of Saint Justina in the Santa Croce Bigolina frescoes. Behind the Virgin, between two parted curtains, one can glimpse a bit of sky that is now gray.

But even in its apparent simplicity, the decoration of the apse of the church of Santa Lucia participates in the debate that was going on throughout Northern Italy over the structure of altarpieces. It was a debate that began in the second decade of the sixteenth century with Raphael's *Madonna of Foligno* and culminated in the Venetian area in the third decade with Titian's *Madonna in Glory with the Christ Child and Six Saints* of 1533 for San Nicolò ai Frari and Savoldo's altarpiece for Santa Maria in Organo in Verona. The Virgin placed above and the saints arranged in a semicircle or some other position below constitutes the basic scheme for this type of decoration. Jacopo's genius for simplifying the various cues and elements follows an innate propensity towards didacticism, which lies at the base of his idiom. The fact that Titian's painting, or the contemporary woodcut after it by Andreani, provided the compositional scheme is reconfirmed by Jacopo's conflation of Saints Nicholas and Peter in his *Saint Benedict*, who holds an open book in his hand, bows his head offering his wide forehead to the light, and has a white beard framing his face (fig. 90).[22]

But the use of graphics to derive the concept for a work is not limited to altarpieces. Rearick has, in fact, identified in the two slender profiles of the *Archangel Gabriel* and *Virgin Annunciate* on the triumphal arch the transfer onto a wall of two engravings, one by Marcantonio Raimondi and the other by Parmigianino.[23] However, the few surviving remnants of the angel's exquisite, elegantly elongated profile provide sufficient evidence to determine that the uplifted arm, which follows the movement of the body and traces an ideal line joining it to the head, is also indebted to Raphael.[24]

Very little more can be said about the exterior decoration. There is a small *Virgin and Child* on the façade and a *Virgin with Saints Lucy and Fortunato* on the south wall that is framed by a curtain of large checks outlined in red. Sgarbi's hypothesis, that stylistic elements from a later period, closer to the altarpiece for Rasai, should move the date of execution to 1542-43, is not supported by the documents concerning the placement and payment for the frescoes, cited above.[25] The little bit that is still legible of this decoration is in very bad con-

91

26. *Libro secondo*, fol. 25 v. Muraro 1982-83, 39, partially transcribed the contract.

27. The following are the conditions for the painting, frame, and tabernacle: «El quadro de la pala son alto braza 3 quarte 3 et tanta larga scarse tre deda. Comenzò a lavorar là zoxo adí 11 settembre 1537. Vene su adí 3 novembre. Item de dar per conto de l'oro. L. 10 s. o. Item de' dar per la coltrina de' la pala L. 14s. Mandai a tor l'oro per el magnifico misier Marco Pizaman, centenar 6 a L. 6 s. 15 el centenaro, monta L. 40 s. 10 [*depennati*] » (*Libro secondo*, fol. 25 v); the payments began on 19 August 1537 with a deposit of 62 Lire and two successive accounts not specified of 60 Lire for Cauzio on 7 October, for the nobleman Anton Maria da Fontaniva on 5 November. Just after is registered 7 Lire, 4 soldi «per la tela de la pala », Lire 11 «per tor le tavole del talero »... «e per la tela de la coltrina »... «do tavole per el telaro a s. 13 l'una e a farle portar a Citadela s. 5...» At the end of November, payments are registrered more consistently for the gold of the frame: «Item adí ultimo novembre ave Zanbatista da misier Baldisera Furlan per tor l'oro de contadi L. 24. Item adí 22 dicembre recevé Jacomo da ser Baldisera Furlan masaro de contadi L. 14 s. 8 ». Successive payments are annotated in 1538 and do not contain material that would allow us to reconstruct the work that was being undertaken. Alone at the end of 1538 is registered Lire 38 «... per tor pano a Vicenza ». In 1537 we have also all payments «per el zenobio del corpo de Christo », the tabernacle:... «una tola de talpon» ... «a maistro Francesco marangon L. o s. 18. Item in cornixe, zoè in murali de tejaro L. o s. 8. Item in la saradura ave Marcantonio Schiexaro con do chiave...» (*Libro secondo*, fol. 139 v). On 22 October Giacomo would pay 10 Lire for the tabernacle, and just before, on 21 September, receive accounts for parts of the altar, the columns, the ornaments of the frame: «per maistro Felipo torniero per le colone et vasi et pomi» (*Libro secondo*, fol. 43 v). Maestro Pietro, « marangon » settled on

dition, but the proportions of the figures seems to indicate an earlier date of execution than that proposed by Sgarbi. Unfortunately, the condition of the work no longer permits a reading of the actual physical materials, which could give philological support to the documented information.

Titian and Pordenone would again provide the major influence for the execution of other important fresco decoration painted by Jacopo in these same years, for example the apse of the cathedral in Cittadella, which was done between 1537 and 1539, along with the altarpiece depicting *The Supper at Emmaus* (fig. 12). The *Libro secondo* gives a daily account of the work's progress. The contract for the decoration was drawn up on 19 August 1537 between Jacopo, Pietro Cauzio, archpriest of the cathedral, and the city administrators. It included the frescoes for «la capela de la jesia catedral a l'altar grando, con figure et marmori» and «tra le colone de pria... una palla con la istoria de Luca et Cleophas, fazendo ne le colone et cornixe alcuni perfili d'oro, el resto fento de marmoro »;[26] that is, the altarpiece representing *The Supper at Emmaus*, recently restored and returned to the cathedral (fig. 12). The mention of the commencement of the work on 11 September 1537 and the notation «vene su adí 3 novembre », must, given the payments for the canvas and frame on those dates, refer to the execution of the painting.[27]

92. Jacopo Bassano, *Samson and the Philistines* and *Judith*, cathedral, Cittadella

What is more, given their iconographical and stylistic affinities, the painting must certainly have been done exactly at the same moment as *The Last Supper* now at Wormley, which was executed after September 1537 for Ambrogio Frizier de la Nave, Jacopo's paint supplier in Venice.[28] However, the frescoes that were uncovered in 1989 by the demolition of the apsidiole and adjoining wall built during the nineteenth-century renovations of the church[29] must have been done in the following months, most probably beginning in the spring of 1538, if we keep in mind the tendency not to paint frescoes during the winter months due to the dry, cold weather. The frescoes stretch along the sides of the walls next to the arch leading into the old medieval chancel.[30] In fact, between the end of the fifteenth century and 1502, Lorenzo da Bologna rebuilt the cathedral of Santi Prosdocimo e Donato, encompassing the medieval structure. Not only is this indicated by a document found in the city archives of Cittadella,[31] but by a stylistic comparison with the documented production of this prolific architect, who was active mainly in Padua and the surrounding area.[32] The sixteenth-century church consisted of four bays with barrel vaults and side chapels, a small chancel, and a sacristy on the left. Its form was recorded in a ground plan drawn by Iseppe Viani in 1746 (fig. 91).[33] All that is left of this building after the nineteenth-century renovations is one bay, the chancel, and the sacristy. In the course of the sixteenth-century rebuilding, it is possible that Maestro Lorenzo covered the cross vault of the apse, which is now once again visible. The fresco decoration of the three small vaults began at the beginning of the fifteenth-century. This can be reconstructed visually by comparing it to the vault of the contemporary sacristy constructed to its side, where a trace of the decoration remains on the right wall. This space was left without an altarpiece or wall decoration for more than thirty years, until Jacopo began his scheme, which included at the center of the side walls an illusionistic cornice in imitation white marble, supported by jutting corbels. The figures of the upper story sit on the cornice, their legs hanging over the sides, while below, the narrative scenes are set within two wide niches, open in back and constructed inside and above a high marble base enclosed by pilasters of colored marble. In the visible portion appear, on the right, *Samson and the Philistines* above and *Judith* below (fig. 92); and on the left, *Joshua* above and *David and Goliath* below (fig. 93). The metrical reconstruction done during the recent restoration[34] allows us to hypothesize that in addition to the four episodes on the two levels just described, Jacopo's decoration included another two scenes in the upper portion of each side wall. In the lower right-hand side it is possible that Jacopo painted another arch, while before finishing the work he inserted in the left wall a rectangular niche. On the sacristy wall behind the altar, there is a rapidly sketched drawing of a frame, most certainly by Jacopo (fig. 94). In a

frame similar to this, *The Supper at Emmaus* was placed. Its design is constructed perspectively following the fictive space of the Titianesque *Annunciation* in the Cappella Malchiostro in Treviso. If this reconstruction is accurate, we can visualize a one-point perspective scheme for the side wall (fig. 95), where the frescoed figures are constructed with a vanishing point in the altarpiece, and we can further hypothesize a continuity between the «architectural» decoration and the constructed space of the altarpiece. In fact, in the diminishing perspective of the altarpiece there is a precise intention to repeat the actual openings and to break through the limited space of the medieval environment. Among the surviving fragments of the decoration, a large part of which is gone, there still exist monochromatic garlands of flowers and fruit enclosed between two lateral strips of imitation marble; the fragment was found in the course of the recent restoration, but unfortunately not uncovered because of structural problems. It is difficult to say where the representation, mentioned by Ridolfi, of *Christ on Mount Tabor* could have been painted.[35] The iconographical program of the frescoes finds its conclusion and explanation in *The Supper at Emmaus* to the point that it can be considered a cycle that could only have included other episodes bearing the same message of a foreshadowing of salvation through the incarnation of Christ. A *Christ on Mount Tabor*, that is a Transfiguration, could conceivably have been a part of such a program, if the intention was to point out to the doubtful and incredulous the power of Christ, his incarnation, and the resulting salvation of mankind. Even if compatible with the iconographic program, though, a Transfiguration with six figures would have been hard to fit onto the ceiling, which was the only free space left in the chapel. We cannot help thinking that Ridolfi and Verci were mistaken, that they were remembering the exterior decoration of the chapel, with the *Transfiguration* on the triumphal arch, which was covered by plaster and stucco in the nineteenth century.[36]

The incarnation and apparition of the Savior to his incredulous disciples, illustrated in the central canvas, is prepared for by the teachings of Moses and the Prophets: every episode illustrates a book of the Bible. At bottom right, the female figure without a head[37] is the protagonist of the book of Judith, the beautiful Judaean widow who, aided by her wit and beauty, saved the city of Bethulia by cutting off the head of Nebuchadnezzar's general, Holofernes.[38] At the top is Samson, one of the twelve judges of Israel after whom the book of Judges is named, who announces that he has slain a thousand Philistines: «With the jawbone of an ass I have flayed them like asses; / with the jawbone of an ass I have slain a thousand men».[39] At the bottom of the facing wall the book of Samuel is represented by the story of David and Goliath, which captures the moment just after the giant has fallen, having been struck by one of the «smooth stones» that the young boy, «ruddy and of a

93

216

94

95

fair countenance», had picked up from the brook: «He ran to the Philistine and stood over him, and grasping his sword, he drew it out of the scabbard, dispatched him and cut off his head».[40] Above, under a great sun, the young man with a dagger in his hand represents the entire story of Joshua, savior of the Hebrew language and prefiguration of Christ. The dagger in his hand recalls the episode of the slaughter of the inhabitants of Ai: «Then the Lord said to Joshua, 'Point towards Ai with the dagger you are holding, for I will deliver the city into your hands'... Joshua held out his dagger and did not draw back his hand until he had put to death all who lived in Ai».[41] The sun high in the sky stands for Joshua's adventures against the Amorites: «On that day when the Lord delivered the Amorites into the hands of Israel, Joshua spoke with the Lord, and he said in the presence of Israel: 'Stand still, O Sun, in Gibeon; / stand, Moon, in the Vale of Aijalon'. So the sun stood still and the moon halted until a nation had taken vengeance on its enemies».[42]

These are four passages of an illustrated Bible, in which one select detail served to call up an entire episode and the significance of the book from which it was taken in a comparative reading of the Old and New Testaments: Joshua, savior of the Hebrew language, and Samson, *solis fortitudo*, prefigure Christ; David, the first king of Israel, is the Messiah-King; Judith, the Virgin Mary, succor of her people. Yet the choice of episodes that showed the fight against enemies and the conquest of Israel made Jacopo's Old and New Testament message particularly timely in those years in Cittadella. In fact, Pietro Speziale, a leading exponent of heretical thought in the Veneto region, was still living within the walled city before his imprisonment in Venice from 1541 on,[43] and the presence of a large number of his followers is emphasized in contemporary documents.[44] The commission given to Jacopo and his workshop for the frescoes, altarpiece, and a «Zenobio del Corpo di Cristo»[45] for the chancel of the cathedral thus represents a conscious attempt on the part of the Church in Cittadella to reaffirm its role in spreading the message of Christ. Nonetheless, the choice of theme and the symbolic details depicted in the painting – cherries, symbol of Christ's blood,[46] and the swallow, symbol of his incarnation[47] – reveal, more than a *captatio benevolentiae* aimed at the heretical doctrines, an attention to the elements of Catholic reform very much present in the Venetian territory[48] and taken very much to heart by the Venetian aristocracy and intelligentsia during the fourth decade of the sixteenth century.[49] This «sacrifice of Christ without a church», as Michelangelo Muraro[50] defined *The Supper at Emmaus* and as we can now read in the entire cycle, confirms the «reformed» interpretation of the Christian message offered by Jacopo and leads us to reconsider with greater attention the numerous signs given by his art, so real as to go beyond the real.[51]

Now that we have seen the significance of the cycle, we can go on to ana-
lyze the scenes in terms of the development of the artist's style.

While Giambattista was busy gilding the columns of the frame of the al-
tarpiece,[52] Jacopo was meditating on the architectonic nature of Pordenone's
frescoes in the Cappella Malchiostro,[53] and studying the ways to enlarge the
narrow space of the chancel. To reach this goal, Romanino's solution of
opening the balustrade to the sky seemed to Jacopo to be a possibility,
achievable through the astonishing and incredible figure of Samson with the
jawbone of an ass. But the steep upward thrust of the chapel[54] and the neces-
sity of giving a strong symbolical charge to the figure meant that he had to
confront for the first time those « carte di Michelangelo », that, according to
Verci, are responsible for the second phase of Jacopo's style.[55] There is no
doubt that the foreshortening, poses, and muscular frame of the *Samson* in
Cittadella (fig. 96) descend directly from Michelangelo's nudes. Even the in-
termediaries Romanino and Pordenone could not have given Jacopo the
confident draughtsmanship of the sole of the foot, perfectly foreshortened
and precisely modeled in every detail, which Romanino was not capable of
doing in his *Male Nude* in the loggia of the Castello del Buonconsiglio from
around the same period, nor Pordenone in his *Allegory of Time* (fig. 97),
whereas it is easily visible in a study by Michelangelo at Oxford (fig. 98).[56]
The striking consonance in the drawing of the flesh of *Samson* and some
Michelangelo drawings of nudes,[57] where the firm outline is accompanied
by a vigorous and powerful hatching rendering the shadows on the skin,
could lead us to believe that Jacopo, in his search for the sources of Ro-
manino and Pordenone, studied some drawings that Michelangelo left be-
hind in Venice after his brief exile there in the fall of 1529, drawings which
were evidently used by Romanino and Pordenone.[58] The drawing in the
Ashmolean could have been one of these, even more likely as it is a prepara-
tory sheet for the nudes in the New Sacristy at San Lorenzo, which were be-
ing executed in just that period. But it could very well be that this and other
sketches, which are even closer in their rendering of shadows to the Cit-
tadella figure, could have induced Jacopo to visit Florence and see for him-
self the sculptural power of Michelangelo's figures. This could have been an
occasion for him to measure his burgeoning mannerism against the develop-
ments in Michelangelo's idiom and the more striking examples of the use of
color offered by Pontormo, which went beyond the bounds of naturalistic
schemes.[59] Going beyond Michelangelo, Jacopo could also have learned to
unite elegance of line and fields of color with muscular strength. It seems
that he must have taken a trip to central Italy before the summer of 1539,
when his frescoes on the façade of the Casa dal Corno show that he had seen
Genga's Raphaelesque cherubs playing with a green curtain in the Villa Im-

96

11 October and 12 November for « la pala de
Citadela, et quela de S. Luco et per conto
d'un cenobio da tenir el corpo de Cristo, in
do volte, ave prima un mozenigo, poi L. 3,
val. L. 4 s. 4. Item ave adí 12 novembre de
contadi L. 8 s. 16 ». He came, however, to pay
for the tabernacle and for the wooden altar of
the main chapel and for the first (or last, actu-
ally the second chapel) built to the left of the
triumphal arch, devoted to Saint Luke (*Libro
secondo*, fol. 95 v).

28. Joannides and Sachs 1991, 695-98, who
have already pointed out the contemporary
execution of the two paintings. The name of
the patron is registered, along with the size of
the painting, in *Libro secondo*, fols. 1 v-2 r. For
the identification of this important person-
age, see Signori in Muraro 1992, *ad vocem*.

29. I first announced the rediscovery of
the frescoes after the removal of the walls in
Il Giornale dell'Arte, November 1989, 8. The
first renovations to the chancel area were
made during the mid-eighteenth century:

97. Pordenone, *Allegory of Time*, formerly
The Duke of Devonshire, Chatsworth

98. Michelangelo, *Study of Legs*, inv. 330v,
Ashmolean Museum of Art and Archae-
ology, Oxford

between 1741 and 1742. In fact, the high altar
was replaced (APC, *Fabbriceria*, b. XXVII, *Tab-
ernacolo, Ornamenti, Cappella del Santissimo*).
Most probably the demolition of the wall
and the sixteenth-century altar took place at
this time. In 1746 the vault appears once
again to have been remade as a cross vault
(see below n. 33). The complete restructuring
of the cathedral began in 1774 on a design by
the Cittadella architect, Domenico Bertoldo,
with the approval of Domenico Cerato, pro-
fessor of architecture at the University of
Padua (Franceschetto 1989, 125). The first
stone of the new building was laid in Decem-
ber of the following year and the inaugural
ceremony, including a new consecration of
the altar, took place on 3 September 1826
(Gloria 1862, 265). The work that would give
shape to the first bay and chancel, preceding
the most recent interventions of this decade,
began on 1 June 1864 and, as is witnessed by
the very lovely plan appended to the docu-
ment, included the construction of a brace in
front of the Cappella della Concezione,
placed between the medieval portion and
Jacopo's frescoes, connected to the older
structure by a thin wall that covered the fres-
coes and lined the entire triumphal arch
(APC, *Fabbriceria*, b. LVIII, *Cappella della Con-
cetta*). In 1868 other work, finished on 22 June
and «invoiced» on 31 December of the same
year, involved the Cappella del Battistero
(corresponding to the domed area in front of
the old chancel), the Cappella della Concezi-
one (the old chancel), the Cappella di San
Luca (last on the left) and the covering of the
areas adjoining the sacristy. The various in-
terventions are described as follows (APC,
Fabbriceria, b. VII bis, fol. 13): demolition and
reconstruction of the south wall, correspond-
ing to the current wall leading to the vaulted
area, here called the Cappella del Battistero;
demolition and reconstruction of the sloping
roof of the Cappella della Concezione, plac-
ing of tie-beams and exterior plastering; lay-
ing of the roof and placement of tie-beams in

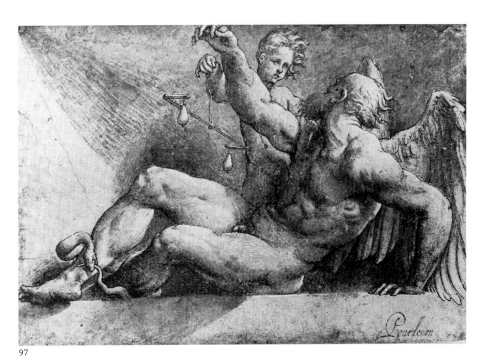

97

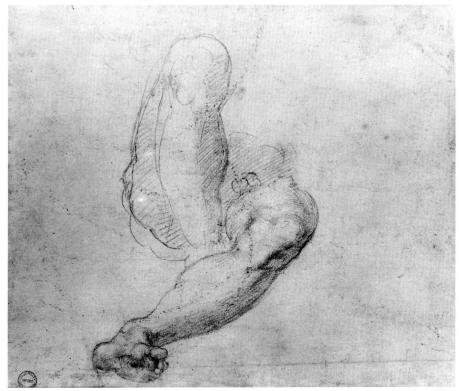

98

219

periale in Pesaro.[60] A meditation on Michelangelo's Florentine work and the foreshortened figures of the Sistine ceiling must have been part of Jacopo's « working trip », which I think must have occurred during the winter of 1537, when work was suspended in Cittadella. The figure of *Samson*, in fact, elongated in its pronounced foreshortening, unites the immediacy of the *hic et nunc* of arrested movement with an elegance of carriage and expression that seems to place it on a plane of Michelangelesque interpretation not far from some of Pontormo's results. What a distance Jacopo has traveled from his altarpiece "teetering" at the back of the apse in Santa Croce Bigolina! How much of the path has he prepared for the boy stopped in his flight by the angel in Caravaggio's *Martyrdom of Saint Matthew* in San Luigi dei Francesi in Rome!

Volpato and Verci were right about the technique used for the execution of these frescoes.[61] They were painted exactly in the same manner used by Pordenone,[62] over a primary base of thin whitewash that gives luminosity to succeeding layers. Jacopo painted his shadows, using very fine, dense hatched lines of brown earth mixed with charcoal, and on top of these lines he spread his color. The hatching of the *Samson* is identical to that of the drawing of a *Male Portrait* of 1538, in the Louvre (cat. 80). We have confirmation here, more than at Marostica, that the drawing must represent Jacopo's first idea for the fresco. The fact that the frescoed figures must have had a basis in preparatory drawings is indirectly confirmed by the absolute lack of incised lines, which carefully mark all the architectural portions, and by the fact that all the figural parts of the fresco were each done in one day's work. Just a few slight marks indicate Samson's facial features and two horizontal lines measure the distance between his head and the nose of the fallen Goliath, to aid the painter in rendering the difficult foreshortening of the figure. The paint of the *Goliath* is applied differently from that of the *Samson*, in a very liquid yellow-green layer completely homogeneous in tone, but spread over the very fine hatched lines that mold the shadows. The iconographic model for a supine figure, with its face turned upwards and large feet visible towards the back of the picture, does not derive from Pordenone's frescoes in Santo Stefano in Venice,[63] but, keeping Mantegna firmly in mind, repeats the large figure lying in the foreground of Titian's *Battle of Cadore*.[64] The female figure of *Judith*, where a loss of color in her dress permits us to read the underdrawing, quick and clear in its dark ocher brushstrokes mixed with traces of red outline, is certainly indebted in its structure to Pordenone, as exemplified by the drawing at Princeton that might be connected with the Santo Stefano frescoes in Venice.[65] It is similar in iconography to the *Judith* in form and perhaps also in subject.

The surviving fragments, then, of the Cittadella decoration allow us to re-

the Cappella della Concezione; restoration of the terra-cotta pendentives in the Baptistery, demolition of old plaster and filling in with bricks any serious cracks; and repair of the roof of the Cappella di San Luca.

30. The history of the construction of the cathedral hast not yet been the object of extensive research. Gloria (1862, 266) holds that the church was constructed in 1220 on the foundations of the old castle inside the walled city. Franceschetto (1989, 27, and 131-34) says that the current chancel belonged to the monastery of Sant'Antonio in Vienne, a theory refuted by Bortolami (1990, 104). In 1276, Pope Gregory XI united with a papal bull the titles of San Donato, patron of the small church in the territory of Padua, which up to then had served as the parish church, and San Prosdocimo, patron of the diocese in Padua, transferring the parish to the church in the city. The palimpsest discovered in the chancel, which is earlier than the layer from the second half of the thirteenth century (*Two Saints*), is composed of a layer of thin plaster, which can be dated between the twelfth and thirteenth centuries. An earlier fresco with small *Angels*, difficult to read, but probably datable between the tenth and eleventh centuries, placed above what should have been the medieval triumphal arch, is higher than the current vaulted bay, and makes us conjecture an earlier architectural space than what is now visible.

31. ACC, *Atti del Consiglio*, b. III bis, fol. 4. The document dated 12 February 1500 (*more veneto* 1501) mentions the Maestro Lorenzo da Montagnana as active in the construction of the belltower.

32. On Lorenzo da Bologna's activity, see Lorenzoni 1963. At the same time as the Cittadella work, Maestro Lorenzo was involved in the cathedral of Montagnana, consecrated in 1502 (Lorenzoni 1963, 49). On the width of the bays in Cittadella, compare also the monastery of San Giovanni da Verdara in Padua. A similar use of small vaults, such as those visible from the sacristy and originally from the apse, appears also at Montagnana and San Giovanni da Verdara. We must also point out that documentation concerning Lorenzo is particularly scarce in the last years of the quattrocento (Lorenzoni 1963, 50).

33. ASVe, *Rason vecchie*, b. 191, dis. 708. The drawing already documents a cross vault in the chancel. In 1544, the old church had seventeen altars (Gloria 1862, 266).

99. Dal Ponte Shop, *The Resurrection of Christ*, cathedral, Cittadella

99

34. Restoration of the chapel was carried out by Guido Botticelli with the collaboration of Alberto Felici in 1991-92, and was sponsored by the Società Autostrade Verona-Venezia. I wish to thank Guido Botticelli and Alberto Felici for the exchange of ideas on the characteristics of technique and execution of the Dal Ponte frescoes and Cristina Cagnoni and Gino Zanon for the graphic reconstruction of the chapel.

35. Ridolfi, 1648, I, 386; and Verci 1775, 115.

36. For the sequence of the nineteenth-century renovations, see above n. 33. The replastering and stucco work in the first bay, now the baptistery, followed immediately the architectural work done in 1868.

37. This head, like the one of Joshua in the facing panel near the top, was detached at an unknown date. These two heads, along with other fragments detached from the frescoes of the cycle of Santa Lucia in Santa Croce Bigolina, make up a corpus of Jacopo's frescoes scattered in private collections. The hope is that these pieces can be restored to the public view, perhaps even on the occasion of this exhibition.

construct a fundamental moment in Jacopo's artistic development, a moment when his «architectural» interests, understood in the widest sense, are uppermost. In fact, between the beginning of 1538 and October 1539, the date of *Christ among the Doctors in the Temple* at Oxford (fig. 18), Jacopo grappled with the problem of the relationship between figures and constructed space. It was a problem that undoubtedly was raised by his knowledge of Pordenone's work in Venice and his rethinking of the results of the competition for the *Delivery of the Ring* held by the Scuola Grande di San Marco in 1534.[66] This moment could be seen as limited to a few episodes, including the façade for Casa dal Corno in Bassano, of which we shall speak later, but which instead established a way of dealing with the construction of space that would serve him for succeeding decades. In this sense it is particularly helpful to recall the spatial solutions of Raphael to which Jacopo would remain faithful for all of his life. In *The Martyrdom of Saint Catherine* (cat. 13), in fact, he introduced for the first time the buildings from the Vatican tapestries. In particular, *The Conversion of the Proconsul* and *The Sacrifice of Lystra* would be reutilized, with modifications, in the late *Saint Roch Visiting the Plague Victims* from the Pinacoteca di Brera, Milan (cat. 47).[67] This research would lead him to some unsettling results in *The Last Supper* from the Galleria Borghese, Rome (cat. 18), or in very powerful paintings of the sixth decade such as *Lazarus and the Rich Man* in The Cleveland Museum of Art (cat. 24), *Saint Paul Preaching* in the Musei Civici, Padua (cat. 32), and *The Descent of the Holy Spirit* in the Museo Civico, Bassano del Grappa (cat. 119). It would seem from a careful reading of the descriptions in the sources and an attentive look again at the back wall of Cartigliano, that in his frescoes he constantly seems to have instinctively gone beyond the surface of the wall to incorporate architecture.

The commissions for Cittadella constitute, at least until 1541, a constant commitment for the Dal Ponte workshop. Another episode from the life of Christ is painted on the dome of the first bay of the church: *The Resurrection of Christ* (fig. 99). It is from the workshop, but in quality not ascribable to Jacopo. The picture shows an awkward woodenness in the construction of the figures that can be traced to the best efforts of Francesco il Vecchio. The shroud, arranged like a regal mantle around Christ's shoulder, reveals his upper body, which is suitably elongated given the great height of the bay, but seems out of proportion for viewing close up – a position, however, that allows us to discern the details of execution. The rosy flesh tones of Christ's stomach, accentuated by the dark line of the white linen, hint at a swelling of the belly in a manner similar to that already seen in the Christ Child in an early altarpiece by Francesco il Vecchio in the Bassano cathedral. The left arm sticks out briefly from the shroud and widens toward the large hand holding the standard of salvation. Christ's long fingers, as well as those of the

angel next to him, are the most significant passages of the entire composition. They constitute an almost unheard of, mannered, as opposed to mannerist, exasperation of anatomical traits that are found in other works of Francesco il Vecchio as well.[68] However, a flexibility unusual for Francesco il Vecchio, accentuated by the confident handling of the outline and the use of the brush tip to render the hair, ovals of the angels' faces, and outlines of the eyes and mouth of Christ prompt us to look elsewhere for the paternity of this painting. There is nothing in Francesco il Vecchio's production similar to the confident passages of the drawing of Christ's shroud and the angels' robes. Nor can we find points of contact between his art and the facial features of the angels, their bony faces elongated toward the pointed, prominent chin and characterized by a long nose, physiognomies that seem to be exaggerated versions of Jacopo's « Brescian » profiles, including *The Flight into Egypt* for San Girolamo (cat. 1) and the *Annunciation Angel* on the triumphal arch in Santa Croce Bigolina. The latter constitutes the direct antecedent for the angels in the *Noli me tangere* in Onara of 1546, a replica of the illegible painting executed by Jacopo two years earlier for Oriago (fig. 22).[69] The quality of the finishing and woodenness of the drawing in *The Resurrection* make us posit the presence of Giambattista, for whom we have already observed in the frieze of Santa Croce Bigolina a rigidity in the drawing unknown to Jacopo. The *Libro secondo* records explicit payments to Giambattista for work in the cathedral,[70] and it is Jacopo's brother who also received the money for the Onara painting.[71] I do not believe it possible, moreover, that Giambattista acted simply as a shop assistant collecting payments for such a long period, nor can we assume, after a careful reading of the account books, that he was kept in the role of simple painter of the wooden frames, a job that was his specific responsibility.[72]

From the *Libro secondo* we find that the Dal Ponte workshop was active in Cittadella already in 1525. We do not know if their first commission came from the city administrators or the Eremitani friars of the powerful convent of Santa Maria del Camposanto.[73] Francesco il Vecchio executed for the former, between 1525 and 1526, the clock for the belltower;[74] for the latter, the altarpieces and wooden altars for the chapels of Saints Augustine and Stephen in the church. In exchange for hospitality and a continuous supply of necessary goods, first Francesco il Vecchio, then Jacopo and Giambattista, executed between 1531 and 1532 the altar and altarpiece for the chapel of Saint Andrew, depicting *Saints Andrew, Peter, and Paul* and a *Pietà*;[75] between 1529 and 1534, the altarpiece for the high altar depicting *The Coronation* (perhaps *The Virgin in Glory*);[76] between 1539 and 1541 an *Annunciation*, again for the high altar; and the frescoes in the choir including « spaliere ... fente de pano d'oro », that is, backrests painted in imitation gold cloth.[77] In the early days of

38. Judith 13:6-9.
39. Judges 15:15-16.
40. I Samuel 17:51.
41. Joshua 8:18.
42. Joshua 10:12-13.
43. Pietro Speziale, born in Cittadella in 1478, lived in the city until his arrest in 1541. He was the author of *De dei gratia*, published in 1542, in six books, which contains extracts from Luther's *De servo arbitrio* and Zwinglio's *De vera e falsa religione*, the fruit of thirty years' work. His theory, based on the power of grace in the salvation of men and the negation of works, purgatory, Masses for the dead, the intercession of the saints, the primacy of the Pope, and indulgences, was already known in 1524. The text, containing two books on the passion of Christ and sermons, was dedicated to Charles V. In libel suits he defended the dogma of redempion on the authority of the Scriptures and the apostles. He abjured his doctrines and reentered Cittadella in 1550. On the figure of Pietro Speziale, his writings, and the events of his life, see De Leva 1972-73, 679-772 (particularly 684, and 688-99).
44. The parish priest Pietro Cauzio records the presence of Speziale in Cittadella during Martino Raffa's pastoral visit in 1544 (cited in De Leva 1972-73, 699), and adds: « erant nonnulli qui eius sequebantur errores, et super ipsius erant infecti, sed postquam viderunt ipsum condemnatur, cessarunt praemissis erroribus ». His disciples were Francesco Spiera and Girolamo Faccio, a lawyer, who in 1547 denied the real presence of Christ in the Eucharist, the adoration of the consecrated Host, and the power of the ministers of the church to absolve from sin (De Leva 1972-73, 701-2). In 1558 an anonymous letter denounced the fact that « in Cittadella there have been for many years continuous teachings all infected with heresy, sought and maintained with great favor by those connected and suspected in that place » (De Leva 1972-73, 737). We must also point out, although we do not have information concerning the preceding decade, that we have documentation of a substantial presence in Cittadella in 1551 of Anabaptists. The Anabaptist doctrine denied the divinity of Christ and exalted Christ's human nature, affirming the existence of a family around him, emphasized the Holy Scriptures in the churches, and denied the existence of an afterlife. In Cittadella, instead, where docu-

100. Jacopo Bassano, *Samson and the Philistines*, Gemäldegalerie Alte Meister, Dresden

100

ments record twenty Anabaptists, the doctrine of the incarnation of Christ was not accepted (Ginzburg 1970, 33-34, and 58). The topic continued to animate the life of the Cittadella community: in 1547 the preacher Giovanni Vaccaro was accused of having denied the real presence of Christ in the Eucharist (De Leva 1972-73, 721 and notes).

45. For the commission to Jacopo for the tabernacle and its execution in 1537, see above n. 27. The close relationship between the tabernacle and the fight against heresy can be deduced from the fact that Francesco Spiera and Girolamo Faccio (see above n. 44), after solemnly abjuring their doctrines publicly in Cittadella's cathedral in 1548, each had to pay the church for a tabernacle for processions and for the sick (De Leva 1972-73, 711-12).

46. On the meaning of the cherry tree and cherries, see Levi D'Ancona 1977, 89-91.

47. Ferguson 1961, 25. It does not seem possible to accept, in a highly symbolic context such as this, the naturalistic annotation made by some authors. Among these are the interpretations of Biasuz (1970, 24-25) and Rigon (1983 (A), 95 and 1983 (B), 22-24), who see in the swallow a symbol of rebirth and the relation with springtime.

48. Until 1541, when the attempt made by Cardinal Contarini to reconcile Catholics and Protestants failed at Ratisbon, adherence or an approach to Lutheran or Protestant theories had assumed, thanks also to Gritti's declared neutrality on the matter, various aspects and motivations, which in any case implied a questioning of the Roman ecclesiastical hierarchy and of certain points of Catholic doctrine, such as the existence of purgatory and the value of works in attaining salvation. Many parts of this reformed vision of doctrine had the Bible as its main text (and its use was fundamental for Jacopo, see cats. 2 and 11). In this reformed view of doctrine, great importance was given to the direct relationship between the supplicant and the sacred scene represented in real terms. In particular, the themes of the blood and passion of Christ recurred frequently in « reformed Catholic » circles. Both the *Beneficio di Cristo*, a key reformed Catholic text, and the *Sogno di Canaria* reiterate the role of the « human »

December 1539, Jacopo documents the expenses borne by the convent for his and Giambattista's board for twenty days while they were frescoing the clock on the Paduan gate,[78] where Ridolfi records instead a *Samson and the Philistines*.[79] We could conjecture that in those twenty days, certainly a long time for painting the numbers and hands of a clock, the two brothers also painted a replica of the biblical scene of *Samson and the Philistines*, which was so familiar to them in those years, having already executed, perhaps for Sebastiano Venier, the painting now in Dresden (fig. 100)[80] and the fresco on the façade of the Casa dal Corno in Bassano (cat. 116).

By that time, in fact, the great façade of the Casa dal Corno in Bassano was already finished, having been executed most probably in the months between April and August of 1539,[81] as the date read by Crivellari above the figure of *Industry* attests *ab initio*.[82] The frescoes, which were detached in 1975 and, since 1983, conserved in the Museo Civico, Bassano del Grappa, stretched along the entire length of the façade in four wide horizontal bands simulating architectural divisions. Above a dentilated cornice and under the eaves there is an illusionistic loggia supported by seven rows composed of three small banistered columns each. On this loggia nude cherubs, in every possible pose, play with a heavy green curtain closing the fictive opening. Isolated from the others, one plays a horn. The wide band above the windows is painted in a monochromatic earth-yellow similar to the garland of

223

101

flowers and fruit on the triumphal arch of the Cittadella cathedral. It depicts wind and stringed musical instruments, antique relics, books, a cherub, and a long parade of varied animals: a duck, a ram, a sheep, a bird of prey, a crouching deer, a donkey, a turkey, a goat, a monkey, an eagle with outspread wings, and a lion (fig. 101). The central band between the windows is enclosed by two large Doric columns. Marini was able to read in a photo of 1922 three female figures inside niches that are now barely visible.[83] They are recorded in the sources as *Prudence, Rhetoric,* and *Industry* (fig. 102).[84] There is also a large panel depicting *Samson and the Philistines,* which seems to copy the Venier painting (fig. 100) if we exclude one detail in the middle ground that seems to be a wind instrument. The fourth band under the windows holds four ovals with biblical scenes: *Judith and Holofernes,* structured like the scene in Cittadella, *Lot and His Daughters, The Drunkenness of Noah,* and *Cain and Abel.* The moralizing intention of the façade is confirmed by the representation under the balcony – in a position which, frankly, violates the symmetry and harmony of the rest of the composition – of a dropsical cherub, stretched out nude on top of two crossed bones with an hourglass next to them and the inscription: «Mors omnia aequat», death renders all things equal.

We shall try here to add something to the iconographical reading furnished by Marini in 1983, who, correctly in my opinion, claimed – on the basis of the coats of arms and the horn held in the hands of the flying cherub, which appeared under the plaster finish when the frescoes were detached that the cycle was commissioned by Lazzaro dal Corno.[85] The unusual nature of the representation of animate and inanimate objects in the central band should not, at any rate, be separated from the biblical matrix of the rest of the decoration. The representation of animals, in fact, in the first half of the sixteenth century always illustrated episodes from Genesis, either the *Expulsion from Paradise* or *Noah Leaving the Ark.* And in each of these cases, the choice of species is always connected with the Christological significance the animal had acquired. The pairings that Jacopo had studied in this instance have to do with the relationship between sin and redemption: the sheep and

Christ, who sheds his blood for mankind. A particular aspect, too, was the mysticism, of the *devotio moderna* in Franciscan circles, on which, see Stella 1984, 134-47. For a careful reading of contemporary information on and awareness of iconographical programs in the artistic culture of the time and in particular in Lotto and Pordenone, see Calí, 1981, 245-55; and Calí 1984, 93-101.

49. Influential members of the Venetian aristocracy participated in this impulse toward reform: Girolamo Marcello, *procuratore di San Marco* in 1537, who was in correspondence with Bartolomeo Fonzio (Stella 1984, 142); members of the Grimani, Navagerio, Soranzo, Bembo, Delminio, Amalteo, and Rosario families (Calí 1984, 100). The Anabaptist Pietro Manelfi declared during the trial of 1551 that Bernardo Navagerio and his brother Gerolamo were «Lutherans» (Ginzburg 1970, 49).

50. Muraro, 1992, 29.

51. A close analysis of the symbolic elements, numerous in his paintings up to 1542-43, especially in the various versions of *The Flight into Egypt* or other pictures in which nature plays an important role, suggests a preponderance of themes dealing with the Virgin Mary, or more precisely an attention to the role of Mary, in the events of the Incarnation and Salvation. This is not the place for such an analysis, but we will mention here the vegetable symbols in *The Flight into Egypt* for San Girolamo in Bassano (cat. 1). Numerous flowers appear at the feet of the figures: from right to left, the Christmas rose, symbol of Paradise; the columbine, symbol of the Virgin's innocence and the pains she will have to bear; daisy, representing the innocence of the Child; in back are some trees, the cherry tree symbolizing the blood of the Redeemer; the apple is the fruit of salvation;

102. Jacopo Bassano, *Industry from the Façade of the Casa dal Corno*, Museo Civico, Bassano del Grappa

102

the oak in the apocryphal Gospels is the tree of life. An investigation of later versions of the theme is more complex: a cursory analysis of *The Flight into Egypt* in Toledo (cat. 11) reveals the Marian theme with an ideological layer added to it: if it is true, as in fact it appears, that Saint Joseph is a portrait of Andrea Gritti, the identification of Mary with Venice (as in Lotto's altarpiece at Asolo, on which see the recent reading by Pozzolo 1990, 94-110), leads to a jurisdictional interpretation of the religious subject and a reaffirmation of Venetian primacy also in the matter of religious doctrine.

52. References to work of this sort entrusted to Giambattista appear in 1544 for the altarpiece at Oriago: «riceve Zuanmaria da misier pre Zuanmaria ducati sedese, quando andatte a comenzar a dorar». For payments to Giambattista in Cittadella, see *Libro secondo*, fol. 61v.

53. for the rapport between the space, the painting, and the architecture, see Cohen 1984.

the goat representing the chosen and the damned;[86] a bird, perhaps of prey, standing for the Gentiles converted to the Faith;[87] or another goat, near a monkey on a leash, symbolizing sin conquered by faith and virtue;[88] these last two near an eagle, symbol of the Resurrection, but also of the soul, elevated through the power of Grace.[89] There are also references to providence and vigilance, represented by a goose or duck,[90] next to the clypeus with Claudius, which is perhaps an emblem for the study of classical antiquity.[91] The cherub with a horn in his hand placed toward the right corner connects the meaning of the frieze with the man who commissioned it or inspired its iconographical program, Lazzaro dal Corno. Dal Corno was a philosopher who was probably educated in the Paduan school of Aristotelianism. Aristotelianism in the early years of the cinquecento tended to temper the philosophical problem of the soul with the religious exigencies of the time, while emphasizing the more canonical naturalism of Aristotle's thought.[92] The iconological program of the cycle – and this is more of a suggestion for research than a solution to the problem – should be sought within the ambit of the overall study of the prerogatives of the rational and contemplative soul, and the relationship between intellectual activity – books, music, the study of antiquity, the clypeus with the emperor – and moral actions – the *brucanio*, understood as *Virtus* – and religion, understood as the elevation of the soul towards God.

Interpretation of the meaning of the female figures would be fundamental to an understanding of the program; unfortunately, the loss of many portions of the fresco makes it very difficult to read the details of the clothing and objects accompanying the figures, which are basic to an identification of the characters. A careful analysis of the surviving details, together with Cavalcaselle's drawing (fig. 9) and a reading of the missing portions in Gaspare Fontana's tempera of 1904, can help us recognize the attributes of these figures. On the ground next to the first figure lies a book. The second figure, a woman with a book in her hand, has two heads and a snake wrapped around her arm. The third figure, a nude, holds in her right hand a rod or a stick with leaves, and in her left, a vase with either a drape or a shield. On the ground next to the third figure is a book leaning against the wall. The three women could represent, from left to right: Faith,[93] Prudence,[94] and Strength.[95] They would thus serve to evoke either the Artistotelian teaching on the prerogatives of the human soul or the virtues.

The biblical scenes could either be the usual prefigurations of Christ's sacrifice for the redemption of sinners (Abel, the naked Noah, Samson) or of Mary's role (Judith) in the salvation of mankind from sin, or each of the characters could exemplify one of the human virtues: Samson, strength; Abel, goodness; Judith, wits used for good; and the naked Noah, guiltless sin. The

meaning of the dropsical cherub and the inscription is harder to determine. They synthesize the program, just as the *Nichomachean Ethics* summarizes Aristotle's ethical philosophy. The apparently negative import of the message is overcome by a philosophical interpretation: « But it does not follow, as those who would counsel us, that because we are human we think of human things and because we are mortal we think of mortal things: on the contrary, that which we have we give back to the immortals and constrain all of our stamina to live in harmony with that which is best in us ».[96]

The figurative elements of the façade, with their complex symbolism, presuppose a repertory of models and images that have been traced only in part: by 1905, Scaffini had already linked the detail under the balcony with a print by Barthel Betham, copied precisely down to the skulls and the inscription.[97] In the scene of the killing of Abel, Marini noted the borrowing of a motif by Pordenone from the cloister of Santo Stefano.[98] Furthermore, we have already seen how Samson is a partial repetition of the Venier painting, just as the group of the *Judith* repeats the scheme from Cittadella, and how the idea for the cherubs playing with a curtain derives from a model by Raphael, taken up again by Genga in Pesaro.[99] The body structure of the cherubs, however, is not inspired by Raphael's models; rather, their postures are copied from engravings by the Master of Horseheads.[100]

Jacopo's fresco activity in these years proceeded at a steady rhythm, of which the only testimony left to us now is provided by the few traces on the Porta Dieda in Bassano. In 1539, once again with Giambattista, Jacopo frescoed scenes from the life of Saint Justina, perhaps on the exterior of some houses.[101] Between the spring and fall of the following year, he frescoed the chancel at Mussolente, following the iconographic model he had already used at Santa Maria del Camposanto and that he would continue to use up until Cartigliano. The scenes represented in this case were a Last Supper and a Last Judgment. They were placed in the center of the walls, whose lower sections were covered by false backrests and imitation gold fabric.[102] At the same time, Jacopo was also busy in Marostica, working on a large chapterhouse frescoing a Madonna and Child with six saints.[103] In 1541-42 he painted *Marcus Curtius* on the Porta Dieda. Today the scene is reduced to fragments of muscles, but its appearance was recorded in a tempera by Fontana, which indicates that Jacopo payed clear homage to Pordenone's composition painted in 1520 on a façade in Conegliano,[104] but he did not succeed in rendering the enormous vitality of the penetration of space that constitutes the principal characteristic of that fresco.

A date near the end of the fifth decade of the sixteenth century should be assigned to the detached fresco from the cloister of San Francesco in Bassano representing *The Madonna and Child with Saints Bassiano and Francis* (cat.

54. The chancel chapel, created from the space of the medieval belltower, has an original height of c. 5.3 m.

55. « Nella seconda, avendo veduto de Carte di Raffaello, e Michelangelo, si diede allo studio della costruzione de' Muscoli, tratteggiando i chiari, e gli oscuri piú fieri » (Verci 1775, 48).

56. The fact is particularly signficant that both Romanino and Pordenone and here Jacopo Bassano represent the detail of the foreshortened foot with its sole visible. For Romanino, see Chini 1988, fig. 90. For *The Allegory of Time* on the façade of the Palazzo d'Anna of 1535, see Furlan 1988, 307, with preceding bibliography. These attempts do not treat, however, the Michelangelesque solution of the figure seated on the cornice, as can be seen in two sheets from the Ashmolean Museum of Art and Archaeology, Oxford: *Study of Legs* and its verso of a *Study of a Man Rising from the Tomb* (inv. 330v, black chalk, 216×266 mm). On the recto the arm in front of the face reproposes the iconography of the *Samson*. The charcoal is applied with greater energy, see De Tolnay 1971, fig. 110; and K.T.P., n.d., figs. 20-21.

57. Numerous preparatory drawings for the figures on the Sistine ceiling and *The Battle of Cascina* show a parallel hatching using charcoal. A drawing representing a male figure with an uplifted leg and right arm on the left shoulder (Teylers Museum, Haarlem, inv. A 20v) is iconographically interesting for a study of Jacopo. For an exhaustive collection of drawings of this type, see Miller 1990, 147-74.

58. Michelangelo was in Venice from 25 September to 8 November 1529 (De Tolnay 1948, 10-11).

59. Jacopo's knowledge of Pontormo has already been suggested by Pallucchini 1944, II, XXXVI.

60. For the decoration of the Villa Imperiale, see Marchini n.d., 12-15.

61. Verci 1775, 59.

62. For Pordenone's technique, see Bonelli 1984, 249-64 (especially 250).

63. Pordenone's frescoes in the cloister of Santo Stefano were painted in 1535 immediately after his return to Venice (for this date, moved up about four years from the generally accepted date of 1532, see Furlan 1988, 229). They included a scene of *David and Goliath*, which has not survived. The iconography of the scene, which can be seen in the seven-

teenth-century engraving by Jacopo Piccin (Furlan 1984, 227), copies Michelangelo's scheme for one of the pendentives in the Sistine Chapel, where Goliath lies prone with his head down. This iconography was proposed by Pordenone in a preparatory drawing (Musée du Louvre, Département des Arts Graphiques, Paris, inv. 9918) for the oval dome of the church of Santa Maria di Campagna, Piacenza (Cohen 1980, 20-117).

64. The iconography is that of the figure lying down in the left foreground of *The Battle of Cadore*, for the Sala del Maggior Consiglio in the Palazzo Ducale, Venice, which was finished in August 1538 and destroyed by fire in 1577. For a critical exegesis, see Wethey 1975, 47-52; and Valcanover 1978, 109, no. 181. The fresco was engraved by Giulio Fontana in 1569 (Catelli Isola 1976, 49). Titian reused the type again in the canvas of the same subject, that he painted for Santo Spirito in Isola between 1542 and 1544 (Valcanover 1978, 114, no. 240; and most recently Venice 1990, 255-61).

65. Pordenone's drawing (Art Museum, Princeton University, Princeton, inv. 49-42*v*) is on the back of the preparatory study for the San Gottardo altarpiece (Museo Civico, Pordenone), which was executed in 1525-26. Cohen (1980, 120-21), while pointing out the possibility that the sheet could be related to the fresco in Venice, prefers to link it to the *Noli me tangere* in Cividale, which was executed around 1538. However, he considers it possible, given the characteristics of the *ductus*, that the drawing could be from the third decade of the sixteenth century.

66. The story of the competition for the *Delivery of the Ring* is summarized by Furlan 1988, 292-93, with preceding bibliography. For the Palazzo d'Anna, see Furlan 1988 307; Rearick 1984, 127-34; and Limentani Virdis 1984, 121-26.

67. For Raphael's tapestries, see De Vecchi 1981, 85-86, figs. 94-96. The warrior inside the niche on the first building should be compared to the figures against the left-hand pilaster in *The School of Athens* and the preparatory drawing in the Ashmolean Museum of Art and Archaeology, Oxford (see De Vecchi 1981, 40, fig. 44).

68. Compare especially the details in *The Virgin and Child with Saints Bartholomew and John the Baptist* for the cathedral in Bassano or the figure of *Saint John the Baptist* originally in Rosà, both now in the Museo Civico, Bassa-

117).[105] Only a trace remains of what must have been a refined finish obtained with earth pigments imitating the thick application of paint on canvas of the time. The loss of the top layers reveals traces of the underdrawing in dark sepia, similar to those in Cittadella. It is a drawing that highlights the movement of the folds and uses parallel hatched lines to prepare for the creation of shadows. However, as in Jacopo's drawings on paper, the dark line is accompanied by short red lines, which do not seem to be traces of a subsequent layer of paint, but part of the underdrawing itself. The breaking up of the picture plane began, then, with the preparation of the scheme of the figure. On top of this were spread the layers of paint, which were in turn animated by lines painted on the dry surface. Jacopo's technique for the execution of his frescoes is easily read in the figure of Saint Francis, which is the most well preserved. Here the surface vibrates with the lines of the underdrawing and the touches of the brush on the surface. In terms of composition, this small passage does not offer anything really new with regard to the scheme of the Rasai altarpiece, now in the Alte Pinakothek in Munich (cat. 8). Jacopo's borrowing of Titian's concept for the San Nicolò ai Frari altarpiece, which was reported by sources,[106] was instrumental in furnishing him with a model, but it did not condition the relationship between the figures, which is tense, intense, and highly charged in the same manner as his own Giusti del Giardino *Adoration of the Shepherds* and the Borghese *Last Supper* (cats. 16 and 18). More precisely, the intimate dialogue between the Virgin and Saint Francis, as well as the linear tension that defines it, is the same as that between the Virgin and the young Saint John the Baptist in the former Contini-Bonacossi picture (fig. 23), which should be dated to the end of the fifth decade, just as the sixth was beginning.

Unfortunately destroyed in 1802, Jacopo's frescoes in the chancel of Santa Giustina in Enego – executed simultaneously with the altarpiece representing *Saints Justina, Sebastian, Anthony Abbot, and Roch* (cat. 31) in 1555[107] or, perhaps, after the *Saint John the Baptist in the Wilderness* (Museo Civico, Bassano del Grappa, cat. 29)[108] – would have offered an authoritative example of his borrowing of stylistic elements from Parmigianino. Even more, the frescoes would have given us an example, fundamental for Pietro Mariscalchi from Feltre, of how to render in fresco the effect of various colors suspended in the glazes, which is the most striking characteristic of Jacopo's altarpiece in the same church. The frescoes, documented in detail by Verci,[109] covered the entire chancel. On the ceiling, among garlands of flowers, fruits, and vegetables, were the four Evangelists. On the triumphal arch, represented in the two spandrels, were, respectively, Adam next to a fruit tree and Eve with the Serpent. Below these scenes there were two portraits, identified as Antonio de Vello, the priest who commissioned the renovation of the church, and

Stefano da Romano, who commissioned the frescoes and the altarpiece.[110] On the walls to the left, a large scene depicted the Crucifixion with Christ on the cross between the two thieves, holy women, Roman soldiers on horseback, and others on the ground throwing dice to divide Christ's robes. Facing this scene, on a wall divided by a window, were two scenes depicting a Nativity with shepherds and a Flight into Egypt. In the lunette above was God the Father with angels. The back wall seems to have been structured in a manner that is similar to what we can still see in Cartigliano, which we shall discuss below, or to the central band of the Casa dal Corno. Its Corinthian columns enclosed an Annunciation with Saints Anthony of Padua and Prosdocimo, the patron saints of the diocese, on either side.

This same return to Parmigianino's style extends to the chapel in Nove that was completely frescoed following the scheme already seen in Enego. Evangelists were placed inside the spandrels, against a background of a false mosaic, in a manner that recalled Pordenone's work in Cremona. Ovals and tondi contained saints, but in 1775 the only passage still extant was a Nativity.[111]

In the eighth decade of the sixteenth century, with the assistance of his son, Francesco, Jacopo seems to have again taken up his fresco activity, a fairly exhausting technique for a painter getting on in years. Verci attributes to «his last style» the frescoes for the church of Santa Maria delle Grazie and gives a date of 1575 for a Flight into Egypt for the church of San Giuseppe.[112] For this last fresco, Rearick has recognized a drawing of the same subject in the Accademia Carrara in Bergamo as the preparatory sketch.[113] Verci also mentioned the Saint Roch for San Girolamo and the substantial fresco cycle in San Bernardino.[114]

To our great fortune, one of the cycles of his maturity, that in the old apse of the parish church in Cartigliano, has reached us practically intact, if we discount the loss of much of the finishing layers, perhaps painted a secco, and a small portion of the figures on the left wall. In 1575, as attested to by the date on the back of the apse, Jacopo worked again with his son, Francesco. The preceding year the two had already worked together on the Marostica altarpiece, in the «capela grande» of the church where, as a young man, Jacopo had taken his first steps as an artist, and where he had helped his father fresco a «Nonciata», presumably on the triumphal arch. In Cartigliano Jacopo structured the decoration following the scheme he had already used in Enego and Nove, painting The Evangelists next to The Fathers of the Church on the vault and framing the pendentives of the Gothic chapel with bands of flowers and fruit in refined natural colors, emphasizing yellows and ochers – as opposed to the monochromatic scheme of Cittadella. On the walls inside the lunettes, above a wainscot painted in imitation fabric – that «fento de pano»

no del Grappa (see Arslan 1960 (B), II, figs. 1 and 7).

69. For the Onara painting, pointed out by Muraro at the exhibition of 1957, see Zampetti 1957, 78-79, and here Rearick's essay. For an attribution of the Oriago canvas to Jacopo and its relationship with this one, see Ballarin 1967, 99, no. 13.

70. Libro secondo, fol. 61v. (dated 3 March 1538): «a Jacomo et Zuanbattista…va le spexe…per la capela de la pieve de Citadella».

71. Libro secondo, fol. 33r.

72. «Adí 9 luio 1546 / Fece mercà Zuanbatista mio fratello cum li homini de Caupo / diocexe feltrina, in casa de Francesco de la Mina de ditta villa, come masaro de la giesia di gloriosi martiri S. Vito et Modesto protetori de ditta villa…rappresentante il comun…che li dobbiamo far un adornamento sopra un quadro…» (Libro secondo, fol. 32v). In the receipts for payment this decoration is also called «fornimento» or «pala» (Libro secondo, fol. 33r). In the church at Caupo was an altarpiece by Lorenzo Luzzo (now Gallerie dell'Accademia, Venice) on which, see Moschini Marconi 1962, 133-34. Payments to Giambattista appear also in the account books of the church of Santa Maria del Camposanto in Cittadella, for which, see Libro secondo, fol. 72v.

73. The convent of Santa Maria del Camposanto was located in the territory of Bassano, in a large area to the north, adjacent to the walls of Cittadella. Formerly belonging to Benedictine nuns, in 1429 it passed into the hands of the Augustinian hermit friars of Sant'Agostino di Padova. The friars preached also in the city's cathedral. Suppressed in 1797, it was transformed into a military hospital and then a hotel. Franceschetto 1990, 145-48 furnishes some information. But see also Gloria 1868, II, 267. There does not seem to be anything left of the vast property and church furnishings (but see below n. 75). The nucleus of the church building, with a seventeenth-century door onto the street, is today part of a relief organization.

74. Work on the clock was done in 1526 (Libro secondo, fols. 22v-23r). There are no historical documents on the architectural vicissitudes of the belltower, with the exception of a recent newspaper story by Franceschetto (1992, 7), who begins her research with 1554. On the rebuilding done by Lorenzo da Montagnana or da Bologna, see above n. 31.

103. Jacopo and Francesco Bassano, *Crucifix-ion*, parish church, Cartigliano

75. *Libro secondo*, fol. 62 v. The *Pietà* could be the picture now cambered and completely repainted in the church of the Torresino in Cittadella.

76. *Libro secondo*, fol. 68 v.

77. *Libro secondo*, fols. 68 v and 72 v.

78. *Libro secondo*, fol. 72 r.

79. See above n. 2.

80. See the reference to this commission in Muraro 1992, 87, and here, Rearick's essay.

81. The contract for the frescoes was made on 19 March 1539, the last payment on 11 August (*Libro secondo*, fols. 130 v-131 r).

82. Ballarin (1967, 99, n. 4) reviews the various attempts made by art historians at dating the work and gives Crivellari's transcription of the manuscript with the exact indication of the inscription on the façade.

83. Marini 1983, 22.

84. See above ns. 2 and 3.

85. Marini (1983, 26-27) reviews the biography of Dal Corno, emphasizing his law studies and literary interests in the field of Petrarchism. She also point out that Jacopo painted portaits of Lazzaro and Giovanni dal Corno, which can no longer be traced.

86. Ferguson 1961, 19 and 21. For the contrast between sheep and goats, see Matthew 25:31-46: «He will separate men into two groups, as a shepherd separates the sheep from the goats». The sheep can also be a symbol for Christ.

87. Ferguson 1961, 18.

88. Ferguson 1961, 11.

89. Ferguson 1961, 17.

90. Ferguson 1961, 19.

91. On the frame of the portrait is the inscription « CLAUD ... Q. R. », which does not correspond to inscriptions around portraits or ancient coins. But the transposition of Claudius's image to the wall does not, in any case, originate from a coin or medal, since on them emperors are always depicted in profile. Confirmation of this fact can be found in Marcantonio Raimondi's engravings after Raphael, see Bartsch 1978, vol. 27, 177, and the ample discussion of Roman coins in Gorini 1991, 67-85. The three-quarters position and the type of pedestal link this marble to a late design in Paris by Vitellio, taken from a marble perhaps in the Grimani

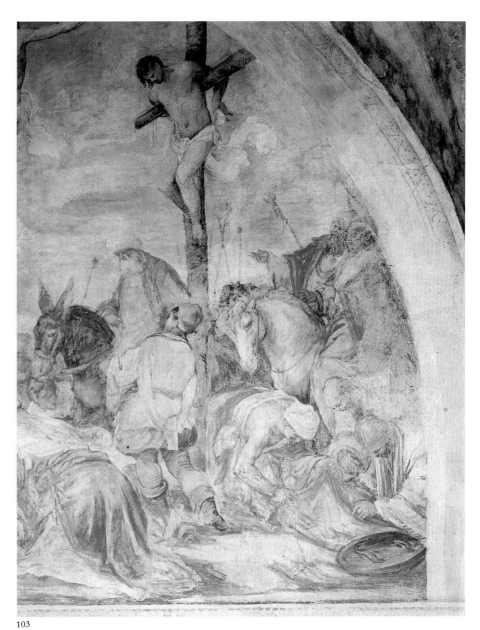

103

that we have encountered in many descriptions of Jacopo's work, beginning with the early cycle in Cittadella for Santa Maria del Camposanto – was represented on the right, the *Adam and Eve, Eve Offering the Apple to Adam*, and *The Expulsion from Paradise*, and on the left a large *Crucifixion* (fig. 103), with the three crosses, Saint John at the center of the scene, the pious women in the foreground, the Roman soldiers in the wings, and the thieves dividing Christ's robes on the right. The back wall is interrupted by a fictive pillared arcade supporting a jutting cornice, which is broken in front where the side pillars adjoin the walls. In front of these breaks are placed the figures of Saints Peter and Paul. Above the cornice is an embankment, which has no relationship with the section underneath and on which are painted two biblical scenes depicting *Moses Receiving the Law* and *The Sacrifice of Isaac* (fig. 104). In the middle of this wall is an altarpiece by Montagna, which replaced the seventeenth-century altarpiece that was removed in 1955-56.

Since 1952, the year of its first publication by Muraro,[115] the cycle has been the object of numerous studies, which for the most part concern the relationship between the sketches, preparatory drawings, and frescoes, as well as the problem of the collaboration between Jacopo and Francesco.[116] Rearick, in the recent fourth volume of the corpus of the artist's drawings,[117] brings into focus Jacopo's production around 1575 and considers the related problems of philology and attribution. Therefore, it is not necessary to go into the relationship between paintings, sketches, models, and *ricordi* in this essay. Nonetheless, we must point out that the number of preparatory drawings for this cycle is a fluke of conservation,[118] and not, as Rearick attempted to demonstrate in his essay, proof that Jacopo executed preparatory drawings before the execution of the frescoes at Cartigliano, which was not the case in his other fresco cycles. These drawings reveal not only a very close adherence to the characteristics of style and technique of the fresco medium, but correspond in subject and structure to parts of the painting itself. Four of these, a *Saint John the Evangelist* (The British Museum, London), an *Abraham*, and *A Thief on the Cross* (both Musée du Louvre, Département des Arts Graphiques, Paris), and the Saint Matthew (The J.F. Willumsen Museum, Frederikssund, cat. 108) are in fact real «models» for the same figures painted on the vault, the back wall, and the side wall. Perhaps more than ever, as Ballarin has pointed out, in these «models» we find reflected the most recondite moment of Jacopo's experimentation with language and the expressivity of the line, traced in chalk, charcoal, or pen, testifying to how his insistent meditation on the problems of form had whittled down his language to the essentials.[119] But Jacopo's paring down of his language, the result of his experience with mannerism, is legible first of all in the fresco, where the volumes are defined by the black outline, the lines of the folds, and the scratches of the

collection (Rearick 1991 (A), IV, 5, plate III, no. 5). We find it, in fact, described as in the Grimani collection in a 1587 manuscript, where it is entitled *Commodo*. It is now preserved in the Ca' d'Oro, Venice (Perry 1978, 235-36). Among other iconographic possibilities it could represent Commodius or Antinius. There is nothing to prevent us from thinking that Jacopo's interest in ancient sculpture dates from his youth. The use of clypei or coins to indicate classical antiquity must have been known in Bassano in the sixteenth century, where Alessandro Maggi was working. Maggi was the author of *Interpretatio historiarum*, a manuscript illustrated with drawings of clypei and coins of Roman emperors (Gorini 1972, 23; and Gorini 1991, 84).

92. Nardi 1958, 446-50.

93. Compare the similar subject in an engraving by Marcantonio Raimondi after Raphael, a figure wearing a long robe held up by one hand and with the other arm uplifted (Bartsch 1978, vol. 27, 79).

94. Prudence, a virtue of the soul, is always represented with two faces and a serpent. Raphael and Raimondi depict her with a mirror in hand (Bartsch 1978, vol. 27, 68), as she is described also by Ripa: « Prudence according to Aristotele is an active habit with right reason concerning things that are possible, to seek good and flee evil with a happy life as a goal, and for a happy life one must... participate in the time of the union of the soul with the body. It is distinguished by the quality of action and the diversity of goals when they accompany each other, for instance political happiness, with which one lives an orderly life, can act as a ladder to climb toward the happiness that is prepared for us in heaven...» (Ripa 1630, 599). In actuality, an absolute identification of Prudence here is hindered by the lack of a mirror, the symbol of self-awareness.

95. Strength, a virtue of the body, is associated with Prudence, virtue of the soul, in Aristotelian philosophy. Strength is represented nude with an oak branch in her hand and a shield at her side. She normally wears a helmet, which here is missing. For an iconographical identification, see Ripa 1630, 269-70.

96. Aristotle, *The Nichomachean Ethics*, 1177b.

97. Scaffini 1905, 64; and Zottman 1980, 23-24.

104. Jacopo and Francesco Bassano, *The Sacrifice of Isaac*, *Moses Receiving the Law*, and *Saints Peter and Paul*, parish church, Cartigliano

104

98. Marini 1983, 23. But see also Arslan 1960 (B), 58-59.

99. See above n. 60. Sgarbi posits the theory that Raphael's idea came to Jacopo through the Dossi brothers, who were also active in Pesaro and on the Buonconsiglio project in Trent (Sgarbi 1982, 113).

100. Compare the engraving in Bartsch 1985, vol. 23, 323.

101. *Libro secondo*, fols. 95*v*-96*r*.

102. *Libro secondo*, fols 26*v*-27*r* (contract and down payment in March 1540, payments in June, last payment in October).

103. *Libro secondo*, fols. 26*v*-27*r* (executed between August and September of 1540).

104. The theme of the rearing horse was a frequent exercise for Pordenone during the fourth decade of the sixteenth century. It is seen in a drawing for *The Conversion of Saul* (Pierpont Morgan Library, New York). See Furlan 1988, 298, and 306-7, for the preceding bibliography and an overall study of the Palazzo d'Anna. For the fresco on the Conegliano façade, which perhaps for the figurative language characteristic of Pordenone in the 1520s could most resemble the horse standing sideways on the Porta Dieda, see Furlan (1988, 356), who indicates the fresco, see Magagnato 1978, 23.

106. See above ns. 2 and 3.

107. For a description of the cycle and a history of its execution, see Bordignon Favero and Rearick 1983, 222.

108. Rearick's biographical reconstruction does not agree with the stylistic sequence of the works of the last half of the sixth decade. In fact, it is impossible to believe that the Enego altarpiece follows the now documented *Lazarus and the Rich Man* (The Cleveland Museum of Art, cat. 24) by just one year. It is easier to think that it came after the *Saint John the Baptist in the Wilderness* (cat. 29) at a moment, according to Ballarin's reading (1963, 95, 106-8, and 123, no. 20), that must have foreshadowed the *bozzetto* of *Saint Paul Preaching* (Musei Civici, Padua, cat. 32), dated 1559 by Ballarin and now also by Attardi (1991, 212-13, with previous bibliography). It is the work that best witnesses Jacopo's new

brush, with strokes separate from, but adjoining, each other, and each one different in tone and color. The touches of white lead mark the planes closest to the viewer and define the perspective. Even in this negation « of relief and in the round » that had made Boschini so enthusiastic,[120] Jacopo does not lack a profound sense of form and space. We are forced to define as an innovation – with no known precedents – the stupendous pillared arcade on the back wall, which resolves brilliantly the problem of breaking through the wall of the Gothic chapel. The hint at monochromatic decorations reveals an eye that is aware of Veronese's solutions. But how Raphaelesque is that row of pillars one next to the other![121] And what a skillful builder Jacopo shows himself to be in the solution adopted for connecting the projection of the cornice with the corner pillar. Arslan had already noted, in this eighth decade of the century, Jacopo's attention to the architectural solutions of Tintoret-

to's early period,[122] indebted, as we know, to the culture of central Italy. In fact, the attempt to break through space using foreshortened buildings is another aspect, along with the breaking up of color into light and shade, that governs some of his works of this period: *The Martyrdom of Saint Lawrence* (cathedral, Belluno, fig. 53) of 1571; *The Madonna and Child with Saints Mark and Lawrence Being Revered by Giovanni Moro and Silvano Cappello* (Museo Civico, Vicenza, fig. 54) of 1573; *Saint Paul Preaching*, in Marostica, of 1574; *Saint Roch Visiting the Plague Victims* (Pinacoteca di Brera, Milan, cat. 47) of 1573; and *Saint Lucille Baptized by Saint Valentine* (Museo Civico, Bassano del Grappa, cat. 53) of 1575. In two canvases from this decade, *The Madonna and Child with Saint Roch and Sante Moro* (Museo Civico, Bassano del Grappa, cat. 120) and *The Mystic Marriage of Saint Catherine* in Civezzano, we see a return to a more compressed space, almost a recovery of the closed space Jacopo derived from Titian in his youth. The loss of all the highlights on the *Crucifixion* in Cartigliano prevents us from capturing the other aspect of Jacopo's painting of this moment, which represents one of the crowning achievements of his career. Certainly the rendition of the horse's mane, or what we can still see of it, must have been equal in brilliance to the flickering white of Saint Martin's horse in *Saints Martin and Anthony Abbot* (Museo Civico, Bassano del Grappa, cat. 67), and the women's robes must have shown solutions to the problem of light equal to the unforgettable passage of the robe of Saint Lucille, where Boschini perceived the inner essence of an idiom that had broken through the limits of his century: « He did many white cloths, and in particular some of white satin that certainly shine and sparkle more than if they were of real silk ».[123]

attention to Schiavone and therefore to suggestions arriving from Parmigianino.

109. Verci 1775, 104-5.

110. Bordignon Favero and Rearick 1983, 222.

111. Verci 1775, 107.

112. Verci 1775, 89.

113. Rearick 1968 (A), 241. For the most recent critical analysis and preceding bibliography, see Rearick 1991 (A), IV, 9.

114. Verci 1775, 90.

115. Muraro 1952, 42.

116. Muraro 1952, 42, and on the relationship between drawings and frescoes, Ballarin 1969, 85-114; Ballarin 1971, 138-43; and for a complete bibliography, Rearick 1991 (A), IV, 9.

117. Rearick 1991 (A), IV; and Ballarin 1990 (A), 56-57.

118. All the drawings and preparatory « models » for Cartigliano come from the Sagredo collection, see Rearick 1991 (A), IV.

119. Ballarin 1971 (A), 139.

120. Boschini 1660, 346, v. 315.

121. Compare these with the pillars in *The School of Athens* (De Vecchi 1981, 40).

122. Arslan 1960 (B), I, 117-19.

123. Boschini 1674, 728.

THE PICTORIAL TECHNIQUE OF JACOPO BASSANO
AS DISCUSSED IN THE EARLY SOURCES

Maria Elisa Avagnina

With few artists more than Jacopo Bassano does a full appreciation of the work demand a thorough understanding of his technical methods and procedures.[1]

From his awkward first efforts guided by his father Francesco, a provincial painter lagging behind his time and adhering to a cultural outlook still bogged down in the quattrocento, and then on to Jacopo's winged flights of mannerism in his mature years, and thence to the works of his final period shaped by a pictorial treatment of unprecedented modernity, his astonishing capacity to renew his personal language had its roots in an uncommon flexibility and mastery of the technical means. Thanks to that firm basis, stimulated by ever new cultural impulses and pressures, Jacopo's pronounced temperament as colorist more and more shook off the « diligence » (which was not without a certain vague charm) praised in his youthful efforts, to attain finally his own extremely personal and unmatchable stylistic fingerprint, so to speak, based on the *fiero colpo di pennello* (the forceful brushstroke) and the *perfetto artificio* (perfect skill) so celebrated by the early writers, by Boschini first of all.[2]

The peculiar character of his artistic personality made Jacopo rightfully one of the most representative personages of the golden age of Venetian painting in the sixteenth century. His singularity was perspicaciously recognized in the artistic literature of the time and of later centuries as well, and much space and particular attention have been accorded the technical aspect of his painting.

Rereading the historical and critical sources that speak of Jacopo has been of considerable profit in attempting to look more deeply into his technical practice, both in itself and in relation to the practice of other Venetian artists of the time. The information thus garnered, and the more strictly technical elements set out in the texts, were subjected wherever possible to verification by a campaign of scientific analyses, including the taking of X-radiographs. In all, some twenty paintings were studied during their restoration for this exhibition.

Vasari accorded Jacopo little more than a miserly mention;[3] his Florentine chauvinism would certainly not have encouraged an objective evaluation of the eminently Venetian coloristic qualities of Jacopo's painting. The earliest source otherwise is a eulogy addressed to Jacopo by his townsman Lorenzo Marucini in his volume *Il Bassano* of 1577. Marucini, not without a dose of civic pride, hails Jacopo as « il novo nostro Apelle » (our new Apelles) and makes almost too much of his unmatchable skill in imitating in paint every manner of thing, animate or not. Further, conveniently differentiating his judgment and informing us, for the first time, of a pictorial practice both unusual and interesting, he writes: « He is in Figures most excellent, and in

1. On this subject there is an excellent university thesis by Trevisan 1990-91.
2. Boschini 1674, 725-26.
3. Vasari 1568, VII, 455. Vasari alludes only briefly to Jacopo, mentioning that Matteo Giustiniano had from him « un quadro che è molto bello: siccome anco sono molte altre opere di esso Bassano, che sono sparse per Vinezia, e tenute in buon pregio, e massimamente per cose piccole, ed animali di tutte le sorti » (a painting which is very beautiful: just as there are many other works by this Bassano, which are scattered around Venice, and held in high esteem, especially for their treatment of little things, and of animals of all kinds).

233

Landscape divine, inventor of the true painting of night-scenes on canvas and on the black stones of Verona ».[4]

Less suspect of partiality, though equally flattering, is the affirmation Raffaele Borghini made a few years later in his *Il Riposo*.[5] There, with a critical intuition as much ahead of his time as well balanced, Borghini places Jacopo alongside the great Venetian masters of the sixteenth century and praises him without reserve for his gifts as colorist, defining him as « most truly exceptional… in coloring, laying on the colors with such vividness and grace that the things painted by him appear natural, and especially the animals and the various furnishings of the household ».[6]

At the start of the new century, the Dutch biographer Karel van Mander, in his *Vita di Giacomo Bassano, pittore*, defines Jacopo as a « most pleasing and ingenious painter » and recalls in particular his skill in « representing diverse stories at night » and his « singular way of representing animals ». In addition, referring to Jacopo's vast activity for dealers, van Mander remarks on « certain small pictures by him with scenes of the Passion, all feigned as if at night », of which he provides a detailed description of great interest to our present purpose: « They were painted on small black stones, on which the rays of light, coming from torches, candles, or artificial lights, were traced on the black ground of the stone with lines of gold which were then varnished over: there were most graceful small figures, armed soldiers, and other images, and the ground was everywhere left natural, so that the black stone would simulate night ».[7]

The sources quoted so far, which on the whole offer a positive valuation of Jacopo's work, refer insistently and almost exclusively to the series of night-pieces or to pictures with numerous animals or household objects, thereby exhibiting an early and misleading tendency to class all of his work as genre painting.

Only with Ridolfi, in the mid-seventeenth century, does one finally find an organic and complete critical valuation of Jacopo's artistic personality and work. In the brief introduction to his « Vita di Iacopo da Ponte da Bassano, Pittore » in his *Le Meraviglie dell'Arte* published in Venice in 1648,[8] Ridolfi admiringly numbers Jacopo among « the excellent Painters who have been able to invent new ways of painting well » and perspicaciously singles out the peculiar character of this « new mode… in forcefulness and naturalness », the latter being particularly evident in the rendering of animals, « so that the Ox lacks only its lowing, the Sheep its bleating, the Horse its neighing… and thusly from one thing to the other ».[9]

Ridolfi was the pioneer also in characterizing the cultural factors in the young Jacopo's formation – first, in all likelihood, at Bassano in the circle of his father Francesco, then in Venice in the workshop of Bonifazio de' Pitati,

4. Marucini 1577, 59-60, « Questo è in Figure eccellentissimo, e in Paesi divino, inventore del vero pingere delle notti in tela, e sopra le pietre negre di Verona ». The black stone, or lydite, which occurs often in Paleozoic formations, derives its color from the inclusion of carbon particles. Because of its intense black coloration it is used in determining the purity of gold, whence its other name, « touchstone ».

5. Borghini 1584.

6. Borghini 1584, 563, « …rarissimo… nel colorire, il quale distende i colori con tanta vivezza e gratia, che le cose da lui dipinte paiono naturali; e spetialmente gli animali, e le varie masseritie della casa ».

7. Van Mander 1604, fol. 180. The English translation quoted here is by Robert Erich Wolf from the original Dutch. It makes the important point that the gold lines were varnished over, not the whole. The translation into Italian gives a slightly different reading, suggesting the entire surface was varnished. See the translation by G. Facchin from the original Dutch published by H. Noë. Both in Ballarin 1966-67, 151-93.

8. Ridolfi 1648, 384-402.

9. Ridolfi 1648, 384, « …gli eccellenti Pittori (che) han saputo inventar nuovi modi di ben dipingere … nuovo modo… nella forza e nella naturalezza… si che al Bue non manca, che il mugire, alla Pecora il bellare, al Cavallo il nitrire … e così di mano in mano… ».

if not directly in Titian's milieu – as well as in detecting the next source of inspiration, correctly recognized as «the drawings of Parmigianino, where he learned a certain grace in the movements of figures».[10] Further, Ridolfi was responsible for a first rudimentary subdivision of Jacopo's work into three phases, or «manners», each characterized by a different point of style, thereby anticipating the theory of the «four manners» subsequently developed by Volpato and then codified by Verci. Ridolfi's three manners are as follows: a youthful phase distinguished by paintings of «extremely lovely coloring», such as *The Supper at Emmaus* in the cathedral at Cittadella (fig. 12);[11] then a phase of more overt mannerism in which he followed «in poses the way of Parmigianino»;[12] and then the more famous «final manner of his done with forceful brushstrokes»[13] and «extremely bold patches of paint»,[14] to which Ridolfi assigned *The Adoration of the Shepherds* in the church of San Giorgio Maggiore in Venice (fig. 83) and a nocturnal *Nativity* that belonged to the Orsetti family in Venice.

In addition to his substantially convincing reconstruction of the general frame of reference and his highly detailed examination of the painter's very rich iconographic repertory, Ridolfi did not neglect to provide certain points of technical information relative to the pictorial media Jacopo used at various times or to particular procedures he used. These are so accurately described as to seem to testify to a firsthand acquaintance with the works themselves, as is the case where Ridolfi cites the lost «trophies in yellow earth color in the audience hall of Marostica, a castle in the territory of Vicenza»,[15] or the three roundels depicting «Saints Roch, Sebastian, and Donatus, made out of Mosaic» in a chapel at Nove near Bassano,[16] or, finally, when he recalls the lost frescoes depicting the Virgin with Saints Roch and Sebastian in the chapterhouse at Pove, which he says were executed «in a hatched manner»,[17] a pictorial practice derived from engravings and typical of Jacopo's manner of painting frescoes.

Consistent with his interpretation of Jacopo's life and art, Ridolfi concludes his biography with the death of the artist at eighty-two and a judgment that very effectively sums up his cultural open-mindedness and incessant stylistic and technical interest in new ways of painting that he pursued to the end: «The life of this celebrated man came to its end, having fallen ill with a rash at eighty-two, on the 13th of February, 1592; nor did he regret dying, he said, except for being unable to learn new things, commencing only now to learn the good things in Painting, knowing how difficult it is to attain to perfection in that art, since that immense ocean is not to be traversed save by long experience and with keen judgment».[18]

In order of time, Ridolfi's biography was followed in 1657 by a brief mention in Francesco Scannelli's *Il microcosmo della pittura*, which repeats the by

10. Ridolfi 1648, 386, «carte del Parmegiano, donde (Jacopo) apprese alcuna gratia negli atti delle figure».

11. Ridolfi 1648, 386, «soavissimo colorito».

12. Ridolfi 1648, 389, «nelle attitudini la via del Parmegiano».

13. Ridolfi 1648, 400, «ultima sua maniera fatta à colpi».

14. Ridolfi 1648, 394, «fierissima macchia».

15. Ridolfi 1648, 387, «trofei di terretta gialla nella sala dell' Audienza di Marostica, Castello del Vicentino».

16. Ridolfi 1648, 389, «santi Rocco, Sebastiano e Donato, cavati di Mosaico».

17. Ridolfi 1648, 386, «con maniera tratteggiata».

18. Ridolfi 1648, 402, «Terminò la vita questo huomo celebre, ammalatosi di petecchie d'anni 82 il di 13 di Febraio 1592; ne gli increbbe il morire, diceva egli, che per non poter di nuovo imparare, incominciando all'hora ad apprendere il buono della Pittura, conoscendo, quanto fosse difficile il pervenire alla perfettione di tal'arte, non varcandosi questo pelago immenso, che con lunga esperienza e con fino giudicio...».

then solidly established critical *topos* of Jacopo's singular talent « in the specialty of nocturnal works … in the reflections of fire, and other lights, as in the representation of all sorts of animals ».[19]

If, as we have seen, the first lucid critical account of Jacopo Bassano goes back to Ridolfi, Marco Boschini[20] has the merit of an intelligent and intensely enthusiastic reading of his painting in terms of form. Boschini's approach to a work of art is instinctive, based entirely on the visual aspects and not tainted with preconceptions of historical character. It proved to be a method particularly congenial to Jacopo's style, rooted as it was in the immediate suggestion of color and the skillful use of light. Moreover, Boschini's inherent interest was the more strictly technical aspects of painting, which he investigated with utter scrupulousness.[21] This makes his writings of particular interest for our present subject.

Boschini reserves for Jacopo a place in the absolute forefront of sixteenth-century Venetian painting, removing him from the sphere of genre painting where preceding historians had tended to relegate him. His *Carta del Navegar Pitoresco* is a fanciful dialogue in pseudo-Venetian dialect between a Venetian senator, who eludes precise identification, and a « professor of Painting », who is Boschini himself. The writer sings the praises of two very well-known works by Jacopo, *The Adoration of the Shepherds* in the church of San Giorgio Maggiore in Venice (fig. 83) and *Saint Lucille Baptized by Saint Valentine* (Museo Civico, Bassano del Grappa, cat. 53), which was at the time in the church of Santa Maria delle Grazie in Bassano. Here, on wings of verse and high-flown language, along with more obvious and predictable judgments, the author expresses intuitions of a far from common critical discernment in which one senses a profound spiritual and aesthetic rapport with the painter. Of particular note in that context is the interpretation of Jacopo's frank and direct way of painting in terms of « noble artifice » and of his superlative technical mastery. Nor does Boschini neglect to note that Jacopo's pictures must be looked at from an appropriate distance so as to perceive, through all the apparent confusion of the signs, their overall compositional order, as well as their harmony of color and light, and in particular the perspective intended by the artist himself. Concerning the « Natività del Signor » (*The Adoration of the Shepherds*) in the church of San Giorgio Maggiore, Boschini in fact writes:

> Questi è quei spegazzoni (sgorbi), che confonde
> tutte le diligencie de sto Mondo;
> Questi xe colpi d'un saver profondo
> Che fa le cose de rilievo e tonde.
> Vedela là quel Dio come l'è fato?
> Quela sí, che xe Imagine divina, tuta de colpi e tuta de dotrina!

19. Scannelli 1657, 84, « nel particolare d' opere notturne … ne' riflessi del fuoco, ed altri lumi, come nella rappresentazione di ogni sorte d'Animali ».

20. Boschini, one of the most celebrated and perceptive writers on art in seventeenth-century Venice, was the author of two fundamental art historical works, *La Carta del Navegar Pitoresco*, Venice 1660, and *Le Ricche Minere della Pittura veneziana*, Venice 1674. The latter is rounded out with a most interesting preface entitled « Breve Instruzione », in which the author summarizes the criteria of his work and traces the history of Venetian painting.

21. Boschini is known to have been scrupulous in seeking out technical information on the painters he wrote about, often obtaining it from the artist's relatives or pupils. He himself explains his working method in his discussion of Paolo Veronese in the « Breve Instruzione », for which see Boschini 1660, 734.

Né gh'è un contorno, un'ombra, un segno, un trato
Se vede che 'l se move e che l'è vivo;
in debita distancia el fa el so efeto;

...

Là sí se vede el nobil artificio
Del Penel venezian, che l'ochio ingana,
E dà dileto in proporcion lontana.[22]

Expressions like *franca man*,[23] *sprezzo de penelo*,[24] *colpi... machie... bote*[25] that recur in verses that have to do with Jacopo's painting technique tell us about a working procedure of great self-assuredness and vigor in which the end result is already prefigured and clear in the painter's mind, for all the seeming haphazardness and fragmentation of his way of painting.

Similar conceptions are developed in the « Breve Instruzione » with which Boschini prefaces his *Le ricche Minere della Pittura veneziana* brought out some fifteen years after the *Carta del Navegar*.[26] Here the use of prose, as well as the structure of the book itself, which is more general and systematic in character, stimulate the critic to a judgment that, whatever it may lose in picturesque imagery, gains considerably in thoroughness and lucidity.

Now Jacopo is acclaimed, with regard to the use of color and light, as the « most celebrated Apollo of Painting, because with his resplendent colors he has cast a light of glory on it in every part... [he is] arbiter of lights: for it was he who left alight an eternal artfully contrived light ».[27] With regard to style, Boschini judges him to be a « most erudite Painter »,[28] without peer in handling the brush, and he applies to him the term « great Classic »,[29] meaning a painter of great class, an epithet he never lavishes on other artists.

Repeating what he had already expressed in verse, the critic describes efficaciously Jacopo's inimitable pictorial procedure, first from within the work, as it were, and then in its final outcome, asserting: « Disdaining diligence and finished perfection, with a Chaos (so to speak) of indistinct colors and jumbles of confusion, which viewed close resemble rather an out-of-tune concert than a perfect contrivance; and yet that is a stratagem of such virtuosity that, not permitting themselves to become confused by the simple fact, but stepping back the due distance, the eye and ear of the Intellect remain well satisfied and enjoy the suavest harmony a well-tuned instrument can render when played by a master's hand, and the most sympathetic union between Art and Nature that human concert can form ».[30]

Finally, when Boschini moves from stylistic considerations of more general order to very precise and knowledgeable technical annotations with regard to the colors Jacopo used, he adds information of the greatest interest, not so much in relation to the pigments themselves – which were substantially those in general use at the time – as to how they were used. Concern-

22. Boschini 1660, 201, lines 10-24. « These are those blots and scrawls that confound / all the diligent effort of this World; / These the strong brushstrokes of a profound skill / That renders things in relief and round. / Do you behold there that God, how he is made? / That indeed is the Image of divinity done all with brushstrokes and all with doctrine! / Nor is there a contour, a shadow, a sign, a line / One sees that does not move and is not alive; / At a due distance it makes its effect;... There truly one sees the noble artificer / of the Venetian brush, who deceives the eye, / And gives delight when viewed in distant proportion ».

23. Boschini 1660, 204, line 2.

24. Boschini 1660, 299, line 6.

25. Boschini 1660, 302, line 22.

26. « Breve Instruzione », in Boschini 1660, 725-28.

27. Boschini 1660, 725, «...chiarissimo Apollo della Pittura: poiché con i suoi risplendenti colori l' ha lumeggiata di gloria in ogni parte... arbitro dei lumi: poiché è stato quello che ha lasciato acceso una lumiera eterna artificiosa ».

28. Boschini 1660, 727, « eruditissimo Pittore ».

29. Boschini 1660, 725, « gran Classico ».

30. Boschini 1660, 725-26, «...sprezzando la diligenza e la finitezza, con un Caos (per cosí dire) di colori indistinti e miscugli di confusione, che da vicino rassembrano piú tosto uno sconcerto, che un perfetto artificio; e pure quello è un inganno cosí Virtuoso, che non confondendosi sul fatto, ma scostandosi in debita distanza, l'occhio e l'orecchio dell'Intelletto restano paghi, e godono la piú soave armonia che render possa un ben accordato instrumento, tocco da maestra mano, e la piú simpatica unione tra l' Arte e la Natura che possi formare concerto umano ».

ing the flesh tones and their natural appearance, he underlines «his coloring of real Flesh, with greater relief than anyone else could achieve; and if the others made it appear as half-round, he shaped it as if elevated to two-thirds, utilizing among the other Colors a good deal of Ocher, Lake, Cinnabar, and Bitumen; the latter, mixed with Lake in the final retouchings, glazed over the dark tones for the most part equally in the flesh and fabrics and in all other things. He did not use iridescent coloring, but a good deal of fabrics in red, and frequently Lake, Azure, Yellows highlighted with Naples Yellow and shadowed with Yellow Lake; and in bringing dark parts into relief, as has been said, he used Lake and Bitumen. He also did many white fabrics, and in particular even some pure white Satins, which truly shine and glisten more than if they were of real silk: and that is how one sees Saint Lucille baptized by Saint Valentine, in a picture at Bassano, his homeplace, in the church of the Grazie».[31]

For all Boschini's merit with regard to his intuitions and his pioneering and trustworthy annotations, the fundamental early source for an acquaintance with Jacopo's painting remains Giambattista Volpato, a seventeenth-century painter and critic who lived in Bassano. In his manuscript treatise, which is written in dialogue form and titled *La Verità Pittoresca*,[32] Volpato takes up and discusses general themes regarding painting – its nature, theoretical principles, practical applications – and from time to time supports his arguments with examples drawn from the activity of noted Italian and foreign painters of past centuries, as well as the present. His own firsthand experience as a painter gives his judgments and observations notable precision and pertinence consistent with the didactic purpose of his treatise.

In the case of Jacopo Bassano, Volpato's familiarity with his work is also proven by the well-known episode of the theft and falsification of two of his paintings from churches in the Feltre area.[33] The copies that Volpato made sharpened his capacity for comprehension and analysis and thus make his writings an invaluable and irreplaceable source for understanding Jacopo's pictorial technique. Volpato's most important pronouncement concerns the so-called «four manners», which correspond to direct phases or moments in Jacopo's career, each influenced by different cultural factors and characterized by a different point of style. In this, Volpato takes up again Ridolfi's manners, making further distinctions and inaugurating an interpretation of Jacopo's painting that would later be popularized by Verci and taken over in substance by modern critics. Jacopo's first manner, we are told, was still imprinted with the «natural style» of the quattrocento models from whom he first learned. This early style was characterized by «diligence and beauty» and by «good attuning»[34] of colors and light. Broadening his cultural horizons, Jacopo then went on to a second phase, inspired by the study of Mich-

31. Boschini 1660, 728, «…il suo colorito di vera Carne, con maggior rilievo che chi si sia facesse; e se gli altri lo fecero comparire di semicircolo, questi lo formò di due terzi rilevante, adoprando tra gli altri Colori assai Ocrea, Lacca, Cinabro ed Aspalto, che mescolato con Lacca, negli ultimi ritocchi, andava velando gli oscuri per lo piú indiferentemente tanto nelle carni, come nei panni, e in ogni altra cosa. Egli non usò cangianti, ma assai panni rossi, e frequentemente di Lacca, Azuri, Gialli lumeggiati con Giallolino, e ombreggiati con Giallo Santo; e ne' ricacciamenti degli oscuri (come si è detto) si valeva della Lacca e dell'Aspalto. Fece ancora assai panni bianchi, ed in particolare alcuni pure bianchi di Raso, che certo risplendono e lucono piú che fossero di seta reale: e di questo carattere si vede vestita santa Lucilla battezzata da S. Valentino, in una Tavola a Bassano sua Patria, nella chiesa delle Grazie».

For information on the nature and characteristics of the pigments and paints cited, see *La fabbrica dei colori* 1986. Of particular interest is the use of «aspalto» (bitumen) in the finishing stages. Its use is documented in later sources as well, and it has been identified in the analysis of Jacopo's *Saint Eleutherius Blessing the Faithful* (Gallerie dell' Accademia, Venice, cat. 40), for which see Lazzarini 1983 (A), 135-44. This is a residual product after the lighter components of petrol have been evaporated away. Laid on the canvas in very thin coatings, it has a golden brown color and is transparent, and therefore particularly useful in glazings. By *giallo santo* is meant a yellow lake extracted from buckthorn berries, a plant of the Rhamnaceae family used widely in medieval manuscript illumination.

32. Volpato 1685, MS. There is another copy of the manuscript in the Biblioteca Marciana, Venice (It., IV.132) (=5069), which, however, contains only two of the seven dialogues. Annexed to the manuscript is a printed index to the work, with the title *Il vagante Corriero*, published by G. Berno in Vicenza, 1685.

33. On this subject, see Verci 1775, 251-55, and also the article by Bordignon Favero 1978-79, 129-93.

34. Volpato 1685, MS, fol. 361, «diligenza e vaghezza» and «buon accordato».

35. Volpato 1685, MS, all three passages cited on fol. 362, « costruzione de muscoli come si conosce nel martirio di S. Caterina nella chiesa di S. Girolamo in Bassano », « studio della maniera del Parmigiano, in cui si perfezionò di pratica e di teoria », and « alla quarta ultima sua maniera tutta piena di artifici... avendo in questa praticato il lume serrato ».

36. Volpato 1685, MS, fols. 66-67, « la Natività... nella chiesa di S. Giuseppe... la Venuta dello Spirito Santo... il S. Valentino ».

37. Volpato 1685, MS, fol. 362, « principio a colpeggiare con qualche franchezza ». With reference to the technique of fresco painting, on fol. 248 Volpato notes: « Bassano laid on two colors underneath, and then did his hatching, throwing into relief by hatching in the dark areas without otherwise altering the underlying color... as one recognizes clearly on the painted façade on the Piazza del Sale in Bassano ». (« Il Bassano dava due tinte di sotto e poi tratteggiava ricacciando solo de tratti negli oscuri senza altra alterazione di tinta di sotto... come chiaro si conosce nella facciata dipinta sopra la piazza del Sale in Bassano »).

38. Volpato 1685, MS, fol. 249, « composto di pratiche difficilissime ».

39. Volpato 1685, MS, fol. 53, « la pratica del Bassano fuori dalle sue mani non riuscibile, ben si può aprendere li suoi artificii e la maccia, non il colpo, la franchezza così vigorosa che non si vede un neo posto a caso tanto è l'accuratezza delle sue composizioni ».

40. Volpato 1685, MS, fol. 218, « artifici pittoreschi ».

41. The proposal of Bordignon Favero 1981, 53-82, to attribute to Volpato the additions to *The Descent of the Holy Spirit* (Museo Civico, Bassano del Grappa, cat. 119) by Jacopo, formerly in the church of San Francesco in Bassano, is, in light of the recent restoration, not without foundation. In fact, in the course of the restoration of the canvas we learned that as well as having been enlarged at the edges it had been almost totally repainted with a very tenacious and opaque layer of color by a hand that reveals a profound understanding of Jacopo's pictorial technique and deliberately imitates it (though in coloration inevitably not achieving the brilliant luminous transparency of the artist). A « restoration » similar from the point of technique and materials has also

elangelo and Raphael, with particular reference to the « construction of muscles, as is to be seen in the martyrdom of Saint Catherine in the church of San Girolamo in Bassano ». Following this, he embarked on a third phase, distinguished by the « study of the manner of Parmigianino, in which he acquired a perfect mastery of practice and theory », to arrive finally « at the fourth and last manner replete with technical skills... having in this put into practice the concentrated, delimited artificial light ».[35]

Although Volpato's proposed division into periods corresponded in effect to the obvious stylistic metamorphoses in Jacopo's art, it was not meant in rigid terms. He recognized that elements of *vaghezza*, of charm and grace and beauty, though typical of the first phase, persisted still in works of the final phase, like « the Nativity... in the church of San Giuseppe... the Descent of the Holy Spirit... the Saint Valentine ».[36] It was, however, chiefly on the fourth manner, the most complete and highly personal expression of Jacopo's singular gifts, that Volpato's admiring interest focused, citing it many times in eulogistic terms and supplying relevant technical information of utmost interest.

Among the stimuli responsible for Jacopo's passage from the « diligence » of the first manner to the frank and uninhibited approaches of the successive phases, Volpato includes the fresco painting that Jacopo practiced from his youthful years and in which he « began to wield the brush forcefully with some boldness ».[37] Along with this, from his assiduous study of prints he seems to have derived a technique of hatching that he incorporated with forceful brushwork and the use of glazing, achieving that « compound of extremely difficult techniques »[38] that characterized the last, inimitable manner Volpato so aptly summed up: « Bassano's practice in others' hands cannot succeed, though one can learn his artifices and the free application of paint but not the blow of the brush, a boldness so vigorous that one sees never so much as a dot placed haphazardly, such is the thorough carefulness in his compositions ».[39]

Volpato derived a certain competence from his own activity as a painter and his dogged study of Jacopo's work. When it comes to Jacopo's « pictorial artifices »,[40] Volpato examines the merit of precise technical procedures with an exactness one could call, within the limits of his age, scientific, which confirms his thorough and, one is tempted to say, experimental knowledge of Jacopo's paintings.[41] Among the artist's pictorial expedients, which were highly personal and astute and ensured an impressive effect – not without reason called « artifices » – was the skillful use of glazes to transform his colors in his own inimitable fashion. On that point Volpato writes: « These rubbings down or glazings in both light and dark areas alter the tints in such a way that from above they cannot be imitated, and in this Bassano was ingen-

iously artful to the highest degree ».[42]

As for the composition of those glazes, Volpato confirms what Boschini had already written and maintains that they may have involved lake colors mixed with bitumen. Elsewhere he adds: « In white cloths particularly, and in dark areas, he retouched with simple pencil and in the light parts glazed over the lead white to soften the colors, and similarly in these as in other things ».[43] Among the clever expedients typical of Jacopo's last manner, Volpato cites also the use of « *cinericij* » to soften the transitions between light and shadow on which the particular naturalness of his nudes depends, as well as the polished shaping of the forms, qualities already praised by Boschini.

The term « *cinericij* » could conceivably be a vague reference to a color (an ashen hue perhaps), but more likely it designated technically a precise pictorial substance. « The *cinericij* to blend that light tint with the dark are formed of yellow earth, lead white, and black earth, or any other black that can serve as well as black earth ».[44]

In some way connected with the use of *cinericij* are the study and rendering of light, a field in which Jacopo proved himself unrivaled, so much so as to justify fully Boschini's appellation « arbiter of lights ». Volpato went into the subject deeply and with special interest.[45]

As Volpato understands it, Jacopo used two types of lighting in the span of his long career: the « *lume aperto* » typical of works of his first period, and « *lume serrato* », which made its appearance in the works of his mature and late periods. As explained by the writer, *lume aperto* is studied directly from the natural phenomenon and is « that of the open air which renders distant things more remote but dazzling and lighter because of the air interposed between one magnitude and the other ».[46] It suffices to recall the pale blue and evanescent distances in the backgrounds of paintings such as *The Flight into Egypt* (Museo Civico, Bassano del Grappa, cat. 1), formerly in the church of San Girolamo in Bassano, which Volpato himself cites, or – we can add, as only a few of the many possible examples – *The Miraculous Draught of Fishes* (private collection, London, cat. 15) or *The Adoration of the Shepherds* (The Royal Collection, Hampton Court, cat. 17).

The ingenious device of *lume serrato* is so called because the light source is closed (*serrato*) in a paper lantern (*feràl* in Venetian). It aims for and attains exactly opposite results from « open light » because of the lack of overall lighting: « whatever things preserve their coloring prove more forceful... the color of the shadows being a lack of robust light, not of black color ».[47] As a consequence, Volpato comments, Jacopo's « coloring proves superior in forcefulness and beauty to that of any other painter, because with the beauty of the lighting and abundance of half-tints and absence of blacks it attunes all together draperies, glazes, lake colors... whites, greens, bitumens ».[48]

been noted in the garments of Saint Lucy in *The Podestà of Bassano Matteo Soranzo with His Daughter Lucia and His Brother Francesco Being Presented by Saints Lucy, Francis, and Matthew to the Madonna and Child* (Museo Civico, Bassano del Grappa, cat. 2).

42. Volpato 1685, MS, fol. 227, « questi sfregazzamenti o velamenti cosí ne' chiari come ne' scuri alterano le tinte sicché di sopra non si possono imitare ed il Bassano è stato artificiosissimo in questo ».

43. Volpato 1685, MS, fol. 230, « ne' panni bianchi particolarmente, e negli oscuri rittoccava con il lapis puro e ne' chiari velava con biacca per addolcire le tinte e cosé in queste come nelle altre cose ».

44. Volpato 1685, MS, fol. 218, « I cinericij per unire quella tinta chiara con l'oscura si formano di terra gialla e biacca, e terra nera, ovvero ogni altro nero che può servire come la terra nera ».

45. Volpato is also the author of an unpublished treatise on optics entitled *La Natura Pittrice*, Biblioteca Comunale, Bassano del Grappa (31-D-20-2). See Bordignon Favero 1977-78, 89-101.

46. Volpato 17th Cent., MS, fol. 144, « quello dell'aria aperta che rende le cose lontane piú perse abbagliate e chiare per l'aria che si frappone fra una magnitudine e altra ».

47. Volpato 1685, MS, fol. 213, « quelle che conservano il colorito riescono di maggior forza ... essendo il colore delle ombre una privazione di luce gagliarda, non di color nero ».

48. Volpato 1685, MS, fol. 362, «il colorito (di Jacopo) si rende superiore di forza e vaghezza a qual si voglia pittore perché con la vaghezza dei lumi ed abbondanza delle mezze tinte e privazione dei neri accorda panni velati lacche... bianchi, verdi, aspalti».

49. Volpato 1685, MS, fol. 259, «assai mezze tinte, lumi ed ombre piú soavi privi di riflesso con piú tondeggiamento... facendo risaltare i muscoli con oscuri senza riflessi nella parte priva di lume..., non permettendo che l'ombre e i lumi siano tra loro taglienti».

50. Volpato 1685, MS, fol. 231, «non toccava mai maggiori oscuri con termini acuti massime nei nudi, anzi con pennelli mozzi, acciò restassero piú uniti con la tinta di sotto».

51. Volpato 1685, MS, fol. 223, «Bassano fa cosí bene il nero fumo come l'oltremarino».

52. Volpato 1685, MS, fol. 330, «Il Bassano è piú forte di Paolo, di franchezza e vaghezza va del pari, di bontà supera per la composizione del nudo, e per l'accordato de' colori, ed artifizio de' lumi; di nobiltà, facilità, prestezza, e bizzaria è di gran lunga inferiore».

53. Volpato 1685, MS, fols. 388-89, «Paolo poteva insegnare al Bassano la nobiltà, il decoro, la bizzaria, e proprietà dell'invenzione... Il Bassano poi insegnar poteva a Paolo gli accrescimenti di forza, l'artifizio del lume serrato, il colpo scientifico, e ricercato, perché le sue opere sono con piú accurata inquisizione ricercate, ed ha pescato piú il fondo nella composizione del corpo umano...»

54. Volpato 1847.

The clever device of interposing a piece or cone of paper between the luminous source and the object, used by Titian as well, creates «numerous half-tints, gentler lights and shadows without reflection and with more rotundity... making the muscles stand out with dark patches without reflections in the part deprived of light..., not permitting the shadows and lights to be separated from each other by sharp edges».[49]

Without the impact of direct natural light the colors become charged with shadows, though without losing their hue, while the forms, shaped gently by the light, emerge from the penumbra that envelops them. Jacopo, to quote Volpato again, «never touched darker areas with strong measures, above all in the nudes, but rather used stumpy brushes, so as to blend in better with the underlying color».[50]

Here, then, we have the «artful lighting» of which Boschini speaks, analyzed now in the way it works and demonstrating the particular lighting conditions Jacopo recreated artificially in the studio. From it he distilled rare and highly refined coloristic effects and situations that were highly evocative, both visually and emotionally. The evocative power as such originated in the contrast between the more or less accentuated shadowy character of the spaces and the vivid prominence of colors laid on with loaded and brilliant brushstrokes.

Regarding the palette used by Jacopo, Volpato by and large repeats what Boschini said, substituting, however, in the scale of reds, red lead for cinnabar, and adding explicitly: «Bassano works as well with lampblack as with ultramarine».[51] However profound Volpato's admiration for Jacopo's excellence as a colorist, he nevertheless does not let it cloud his overall critical judgment. In comparing him with Paolo Veronese, he acknowledges that for all of Jacopo's supremacy in the use of color, there is a lesser richness of invention, a sort of compositional block, to use a modern notion: «Bassano is stronger than Paolo, they are equal in boldness and beauty, excels him in the composition of the nude and in harmonizing his colors and ingenious use of lighting; [but] in nobility, facility, celerity, and imaginative invention is by far inferior».[52] And again: «Paolo could teach Bassano nobility, decorum, imaginativeness, and appropriateness of invention ... Bassano however could teach Paolo the way to gain in forcefulness, the skillfulness of controlled light, scientific and refined brushwork, because his things are worked out with more painstaking care and he has explored more thoroughly the composition of the human body».[53]

There is further consideration of Jacopo's pictorial practice – this time in a negative sense – in Volpato's small didactic publication titled *Del preparare tele, colori od altro*,[54] a sort of manual and guide to the practice of painting. In discussing the preparation of canvases, the author insists on the importance

of using materials of good quality (plaster and fish glue made of «*varoteri*» or «*muschieri*») and in correct proportions, adding: «And I have observed in the works of Bassano that those that used little plaster have survived well, and those with too much peel away».[55]

Nothing significantly new and original was added, almost a century later, by G.B. Verci in the profile of «Giacomo Da Ponte» included in his *Notizie intorno alla vita e alle opere de' Pittori Scultori e Intagliatori della città di Bassano*.[56] While quite properly declaring his debt to the work of Volpato, this local historian nonetheless deserves credit for making known to a wider public, faithfully and without distortion, what he had learned from his predecessor. Because of the structure itself of Volpato's treatise – organized by subjects and not by authors – his great harvest of information and invaluable annotations are by necessity fragmentary and discontinuous, and often repetitive as well because of its constant reference to the more general theme of the book. Verci, by condensing all of this into a form easier to read and more consistent in its exposition, has put us all in his debt.

Here and there Verci mixes into and fills out Volpato's text with excerpts from Boschini, as, for example, in his paragraph on Jacopo's use of color, where he displays a not inestimable capacity for critical synthesis of the existing literature on the subject. Further, when it comes to listing the artist's works, he updates and gives more systematic form to what Ridolfi had supplied, organizing it in alphabetical order on a geographical basis and thereby making it easier to consult. Then, too, he publishes for the first time the inventory of pictures found in Jacopo's house dated 27 April 1592, thus two months after the painter's death. This has become a document of incomparable value for studying the organization and activity of the Dal Ponte workshop.

For these reasons, though within the limits indicated, what Verci wrote still constitutes an irreplaceable preliminary source for anyone studying the work of Jacopo Bassano, and it remains the fundamental basis for further verifications, supplements, and possible corrections. «After having described the events of the Life of Giacomo, and his way of life»,[57] Verci goes over again the passages in Volpato's treatise having to do with Jacopo. He begins by discussing his «four manners», with particular attention to the last of them in which Jacopo, «leaving aside the excessive diligence and fine finishing touches, would use only forceful brushstrokes that were massive, bold, and well thought out, with warm and clear colors, and it is all truth, nature, and picturesque fire, replete with ingenious contrivances that make the figures themselves stand out from his canvases in high relief».[58] Going on from the «artifices» of the fourth manner, he discusses the «composition of the nudes, in which he was unique»,[59] and cites as a «unique and extreme exam-

55. «Ed ho osservato nelle opere del Bassano che quelle che hanno poco gesso si conservano, e quelle che ne hanno troppo si scrostano». This observation, based as we know on accurate technical knowledge, has been substantiated by the particular kind of deterioration suffered by early works of Jacopo prior to restoration, such as the three canvases for the Sala dell'Udienza and the ex voto done for Matteo Soranzo (cat. 2). These show a distinctive craquelure, with wide channels in concentric circles, along the margins. The pictorial surface was seen to have lost fragments of color of modest proportions, but very numerous. This was evidently caused by the rigidity of the preparation.

56. Verci 1775.

57. Verci 1775, 47, «Dopo aver descritto le vicende della Vita di Giacomo, e del suo modo di vivere».

58. Verci 1775, 49-50, «lasciando da parte la soverchia diligenza, e finimento, adoperò solamente colpi massicci, franchi, e bene intesi, con calde e lucide tinte, ed è tutta verità, natura, e pittoresco foco, tutta piena d'artifizj, che con gran rilievo staccano dalle tele le medesime figure».

ple the *Saint John Baptist* in the church of San Francesco», in which, besides the use of extremely difficult expedients involving «forceful brushwork, watercolors, and hatching... there are certain scarrings on the shoulder that no one save a Bassano could have made so true to life».[60]

Verci goes on to discuss the «toning down of the highlights» and the way Jacopo imbued the figures with light, making their salient parts prominent, and speaks of draperies, of invention understood as a repertory of compositional solutions (a field in which Jacopo was in fact quite poor and repetitive), and finally of the naturalness of his coloring and the excellence of his color. Particular praise is accorded the treatment of the nude, in whose coloring, we are told, Jacopo attained unmatchable heights of naturalness «produced by the practice of forceful brushwork and the disposition of the colors».[61] He praises, too, the rendering of drapery, in particular «cloths that hang and that surround the nude... in which he saw to it that the forms of the folds were adapted to the nature of the fabrics... distinguishing silks from linens and plain cloths».[62]

As for the colors, Verci draws on the writings of Volpato and Boschini, interpreting them in his own fashion and adding observations of his own, by no means of secondary interest, about the greens used by Jacopo: «His greens are the most vivid and beautiful that can be seen in all pictures, and yet are nothing more than copper green and yellow lake, though it must be supposed that he had some particular secret for purifying those colors».[63]

With these quotations from Verci we can conclude our examination of the early sources about Jacopo's technique. Our survey has of necessity been rapid and not exhaustive.[64] We can turn now to a summary of the results of the analyses that were carried out, in connection with the restorations done for this exhibition, on a group of paintings in the Museo Civico of Bassano del Grappa. These paintings are among the most noted and important works by Jacopo and almost completely cover the entire span of his long creative activity. The results achieved by parallel investigations in the critical and historical field and in that of scientific research have confirmed – if it was necessary – the usefulness of an interdisciplinary approach to our questions. It is an approach that avails itself of the specific contributions of various sectors of inquiry, filling them out and coordinating them to a single purpose.

The conclusions reached, although interesting and significant, cannot be considered absolute and definitive, given the limited and particular character of the pictures examined. More complete and conclusive results could have been attained if the campaign of analysis had been more thorough and systematic, in particular the stratigraphy.[65] In singling out the examples to be analyzed by that method, the state of conservation of the paintings had to be taken into account, which meant that the tiny samples of paint layers could

59. Verci 1775, 50, « composizione de' nudi, in cui fu singolare ».

60. Verci 1775, 51, « unico, ed estremo esempio il S. Gio. Battista nella Chiesa di S. Francesco... colpo, acquarele, e trattizzo... vi sono certi sfregacci d'oscuro nella spalla, ch'altri ch'un Bassano non poteva fare veracemente ».

61. Verci 1775, 54, « prodotta dalla pratica del colpo, e dalla disposizione delle tinte ».

62. Verci 1775, 52, « panni che pendono, e che circondano il nudo ... in cui (Jacopo) procurò che le forme delle falde siano adattate alla qualità dei panni... distinguendo le sete da' lini, e questi da' panni ».

63. Verci 1775, 60, « I suoi verdi sono i più vivi e belli, che si vedano in tutte le Pitture, e pure altro non sono che Verde rame e Giallo santo; ma si deve supporre, che avesse qualche secreto particolare per purificare i detti colori ».

64. Among eighteenth-century critics who, apart from Verci, wrote about Jacopo Bassano, we should briefly mention Canon Francesco Memmo, author of a *Vita e macchine di Bartolomeo Ferracino*, Venice 1754, who deals only marginally with Jacopo; A.M. Zanetti, who mentions the painter in the second volume of *Della Pittura Veneziana*, Venice 1771, based on the writings of Volpato, whose theory of the « four manners » is here reduced to two; Abbé G.B. Roberti, author of a *Lettera... al signor cavalier Conte Giambattista Giovio e risposta del medesimo sopra Giacomo Da Ponte pittore detto il Bassan Vecchio*, published in Lugano in 1777; F. Algarotti, who in his *Saggio sopra la Pittura*, Venice 1784, praises Jacopo highly, though borrowing his terms from Volpato.

be taken only from areas already in some way deteriorated or damaged, adjacent to lacunae or paint losses.

On the other hand, X-radiographs[66] are not destructive and were taken of totally autograph works by Jacopo as well as others in the Museo Civico of presumed or confirmed collaboration, among the latter *The Pietà* by Francesco il Vecchio, in which the hand of the young Jacopo can be recognized alongside his father's in certain details, and *The Circumcision* (cat. 121), signed by both Jacopo and Francesco il Giovane and dated 1577. This made a better reading «from inside» of Jacopo's personal traits possible, and the evidence validated and rounded out information that can be acquired by direct observation.

In the works of the youthful period, up to around the early 1540s, X-radiographs confirmed in substance a technique of laying on paint in an orderly and precise manner and in distinct juxtaposed fields: ample evidence for the term «diligent», applied to the young painter in the sources. Contrarily, the X-radiographs of his late works – from the 1570s in particular – revealed, in contrast to the placid application of paint in his beginning years, a highly nervous and vibrant mode of painting in which much was made of the «touch» of the brush, of highlighting with lead white, and of the use of paints of different densities so as to alternate «lean» areas with fatty clots of paint. Such «artifices» stand out with incisive evidence on the black and white X-radiographic film.

Stratigraphic examination brought out, at the level of the preparatory strata, the existence of colored primings, sometimes «local», which function with the successive layers of colored pigment, confirming Volpato's indication with regard to *The Adoration of the Shepherds with Saints Victor and Corona* (cat. 46), formerly in the church of San Giuseppe in Bassano. The tonality of the priming varies from a more or less intense gray in the early works to a dark brown in the later years. The preparation of the canvas to render it impermeable was done in the youthful years and early maturity with a traditional compound of plaster and glue. Later, beginning with the San Giuseppe *Adoration of the Shepherds* of 1568, in all the samplings analyzed the plaster had been replaced with kaolin, a substance readily found in the Bassano region.

Finally, examination of the colors brought substantial confirmation to what the earlier sources report concerning the care with which Jacopo chose the pigments in making up his colors. In particular, it was verified that he used bitumen and red and yellow lake and applied them extensively in his glazings to obtain chromatic effects of luminous transparency and precious iridescence, especially in his final manner.

65. The analysis was made in the TSA laboratory, Padua, by Dr. P. Rosanò, whom I thank warmly.
66. X-radiographs were taken by the Servizio di Radiologia della Soprintendenza per i Beni Artistici e Storici del Veneto, directed by Dr. F. Pietropoli.

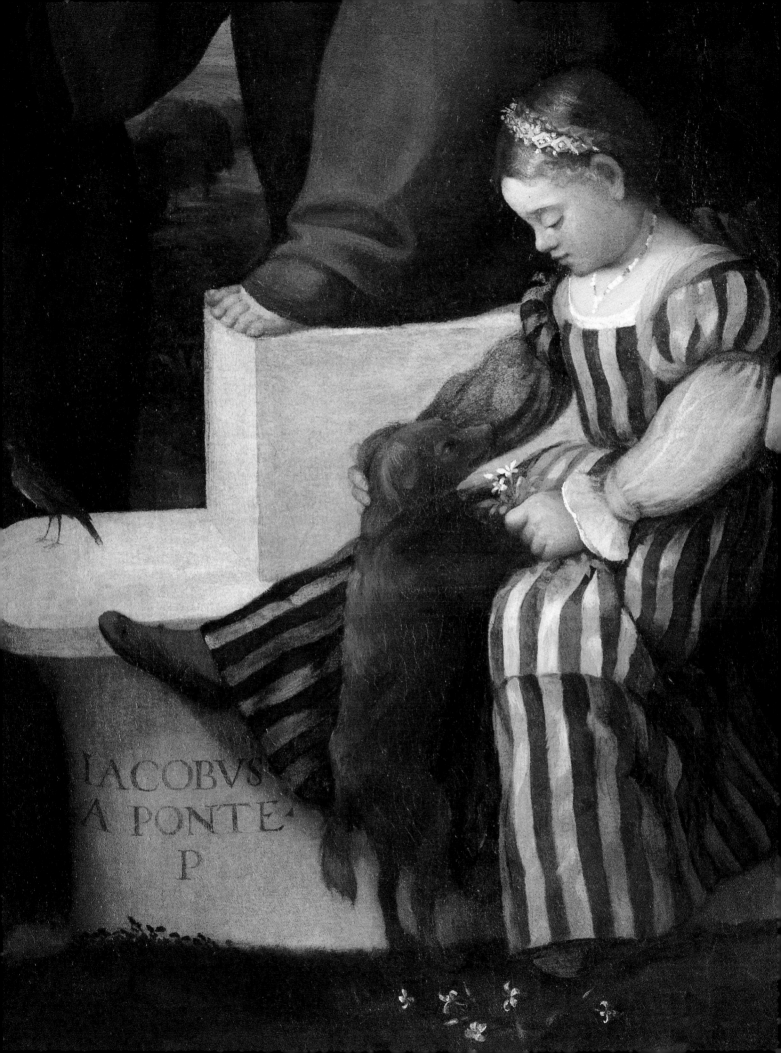

IACOBVS
A PONTE
P

CATALOGUE OF PAINTINGS

Entries by

LIVIA ALBERTON VINCO DA SESSO	(L.A.V.d.S.)
FILIPPA M. ALIBERTI GAUDIOSO	(F.M.A.G.)
MARIA ELISA AVAGNINA	(M.E.A.)
GIULIANA ERICANI	(G.E.)
PAOLA MARINI	(P.M.)
W.R. REARICK	(W.R.R.)
VITTORIA ROMANI	(V.R.)

Jacopo Bassano 1534-1544

The first ten years of Jacopo Bassano's artistic activity can be briefly defined as the years in which he achieved experience and confidence.

The ten years are marked by two dates: 1534, read by Verci before it was effaced on *The Flight into Egypt* (Museo Civico, Bassano del Grappa, cat. 1), and 1544, recorded in the *Libro secondo* as the year of the execution of *The Martyrdom of Saint Catherine* (Museo Civico, Bassano del Grappa, cat. 13); both paintings were originally in the church of San Girolamo in Bassano. This may be a casual coincidence on a path that started under the banner of naturalism, ended in a mannerist intellectualism pushed to the extreme, and along the way was marked by a sequence of irrefutable dates, especially now that the *Libro secondo*, the account book of the Dal Ponte workshop, has enabled us to resolve outstanding questions.

Accompanying him along this path was a portfolio full of engravings after Dürer, Titian, Raphael, Beham, Schiavone, Michelangelo, and Parmigianino. These furnished him ideas, compositional schemes, figures, and heads, and established from the very beginning the premises for his reworking of a vocabulary that was already «mannerist», even when it started from an observation of nature.

The first work we encounter, the 1534 *Flight into Egypt*, is a painting of great charm, suspended despite its precise indications of time and place – the light of dawn, the flowers of an early spring – in a sacred timelessness where the lessons of Brescia are filtered through the colors of Bonifazio de' Pitati. Jacopo seems to have completely overcome his concern for imitating his father's style. In the *Flight* he tempers the metallic rigidity of his father's treatment of drapery in *The Pietà* of 1534 (Museo Civico, Bassano del Grappa) as he covers the figures with fields of color blues and browns paired and contrasted with a refinement and skill that already foreshadow his later achievements as a colorist. His acquaintance with Venice and Venetian art soon afterward would arouse in him a greater interest in Lorenzo Lotto. We find important citations from Lotto's cartoons for the Bergamo intarsias in Jacopo's canvases for the Sala dell'Udienza painted for the Podestà Navagero between July 1535 and March 1536 (*Libro secondo*, fols. 92v-93r). He reveals the same concern, to define form by means of color, in the painting done in 1536 for Matteo Soranzo, *The Podestà Matteo Soranzo with His Daughter Lucia and His Brother Francesco Being Presented by Saints Lucy, Francis, and Matthew to the Madonna and Child* (Museo Civico, Bassano del Grappa, cat. 2), with its small round figure of Lucia, a true early manifesto of his carefully defined portraits and his ability with color. The influence of Pordenone, already hinted in the Soranzo *Madonna*, becomes more evident in subsequent works such as the Pove altarpiece of March 1537 (*Libro secondo*, 93v-94r) – disjointed in the two lateral figures, quite pronounced in the Saint Vigilius – representing a further exercise

in uniting Lotto's form and color with Titian's touch.

But it is in *The Supper at Emmaus* (cathedral, Cittadella, fig. 12) that the experiences of his first years in Venice reach, as never before, their first synthesis and harmony of composition, drawing, and palette. The suggestions from Michelangelo, transmitted to Jacopo through Pordenone, are legible in the frescoes painted in the chapel for which this altarpiece was destined. The frescoes were executed very soon after the autumn of 1537, the date of execution of the altarpiece iteslf (*Libro secondo*, fol. 26r), and are illuminated by the light that enters through the open arch of the chapel's entrance, which minutely describes with a delicate sensibility not only the frescoes, but also the familiar objects in the altarpiece. The particular moment in Venetian art represented by the years 1534-35 (the competition for *The Fisherman Delivering the Marriage Ring of Venice to the Doge* for the Scuola di San Marco, Pordenone's façade for the Palazzo d' Anna) inspired Jacopo to experiment in 1538-39 with formal solutions for architectural spaces, seen in his *Christ among the Doctors in the Temple* (Ashmolean Museum of Art and Archaeology, Oxford, fig. 18). His innovation in this picture, however, does not lie so much in the spatial framework as in his ability to mark off space using fields of color and to animate the narrative, which still shows the influence of Bonifazio in the psychological characterization of the faces. The influence of Titian's color appears even more strongly, albeit within a Pordenonesque framework, in *The Madonna and Child with Saints John the Baptist and Zeno* (parish church, Borso del Grappa, cat. 3). The façade of the Casa dal Corno (cat. 116) is from the same time, when the influence of Romanino's, Titian's, and Pordenone's exterior frescoes merge with echoes coming from central Italy. The high point of Jacopo's experimentation with the relationship between figures, color, and space is reached through his reconsideration at this point of the lessons of Brescian painting, as can be seen in the altarpiece depicting *The Madonna and Child with Saints Anthony Abbot and Louis of Toulouse* for the cathedral in Asolo (cat. 19), where the figures, closed within a nonexistent space, are thrown into the front of the painting.

Jacopo's return to the lessons of Brescia resulted in his masterpiece from the beginning of the 1540s, *The Adoration of the Magi* (The National Galleries of Scotland, Edinburgh, cat. 10), in which his reading of Raphael's «carte» – according to Verci, the inspiration for his second manner – allowed him to anchor in a chiasmic space his composite narrative containing the Holy Family, the Magi, their entourage, the shepherds, and all the animals. Here, the dense, compact pigment begins to dissolve, following the example set by Titian in the preceding decade, and the light enters the colored planes, «illuminating» (Verci 1775, 20) the round contours of the bodies. Jacopo's discovery of the dynamic nature of Raphael's space, and thus of the movement of fig-

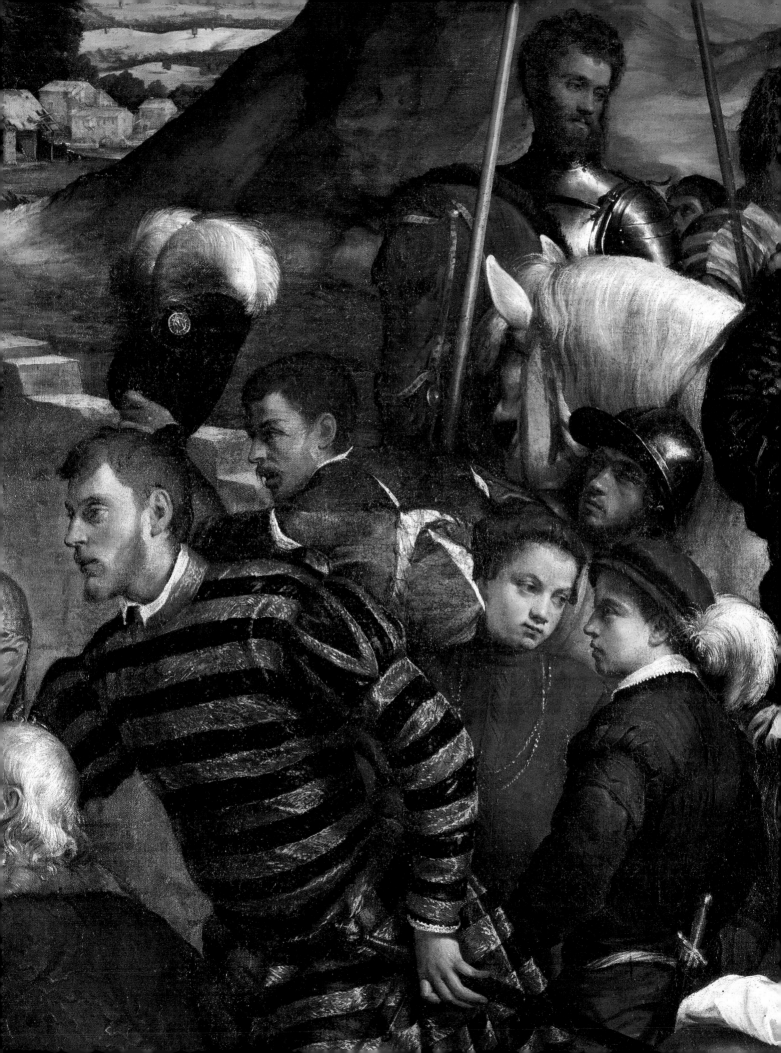

ures in that space, already evident in the central king of the Edinburgh *Adoration*, led to his keen interest in the work of Porta Salviati and Vasari, who both came to the Veneto region between 1539 and 1541. Salviati's elegance is grafted onto Jacopo's « natural propensity toward naturalism » (Ballarin 1967) in the wonderful *Flight into Egypt* (The Toledo Museum of Art, cat. 11) of about 1542, where the clearly defined fields of color and crystalline light unite the figures in a harmony never before attained. Immediately afterward, that natural harmony is broken in *The Madonna and Child with Saints Martin and Anthony Abbot* (Alte Pinakothek, Munich, cat. 8) painted for San Martino in Rasai. It is a highly refined painting executed with the tip of the brush in which Jacopo's eagerness to reread Titian in light of his new experiences with form prevails. In the early years of the 1540s, experiences with form became the central concern of artistic experimentation in Venice, and that suggested to Jacopo solutions for *The Way to Calvary* (Fitzwilliam Museum, Cambridge, cat. 12) and *The Martyrdom of Saint Catherine* for the church of San Girolamo in Bassano. In the *Martyrdom*, Jacopo's study of foreshortening becomes a way to experiment with line forcibly detached from the spatial depth created by the architecture. In the *Calvary*, instead, we can detect signs of his unease in the construction of the story, but our attention is riveted on the group of pious women, a wonderful instance of his elegance in composition, construction, and innovative color, which leads to his masterpieces of the second half of the 1540s.

GIULIANA ERICANI

I. THE FLIGHT INTO EGYPT (1534)

Museo Civico, Bassano del Grappa, inv. 6
Oil on canvas, 183×198 cm (72×78 in.)
Inscriptions: JACOBUS A PONTE on the rock at the lower left
Exhibited in Bassano del Grappa only

Provenance
Church of San Girolamo, Bassano; Municipio di Bassano, 1780; Museo Civico di Bassano del Grappa, 1840.

Exhibitions
Venice 1945; Lausanne 1947; Bassano 1952; Venice 1957; London 1983.

Bibliography
Libro secondo, fols. 121v-122r; Ridolfi 1648, I, 377; Verci 1775, 79; Lanzi 1789, 149; Paroli 1822, MS no. 18; Vittorelli 1833, 42; Brentari 1881, 195-96; Gerola 1906, 106-7; Zottmann 1908, 18-19; Lorenzetti 1911, 206; von Hadeln 1914 (C), 53; Arslan 1929 (B), 190; Venturi 1929 (B), 1118, 1121, and 1247; Venturi 1929 (C), 33; Arslan 1931, 43, 56, and 185; Berenson 1932, 47; Bettini 1933, 28 and 155; Pallucchini 1945 (A), 98; Pallucchini 1947, 83; Longhi 1948, 57; Magagnato 1952 (A), 10 and 37; Magagnato 1952 (B), 220-21; Venturi 1952, 247; Fiocco 1957, 92; Muraro 1957, 295; Pallucchini 1957, 98; Pignatti 1957 (A), 356-58; Zampetti 1957, 12; Furlan 1959-60, 72-73; Suida 1959 60, 68; Arlsan 1960 (B), I, 44-45 and 161, and II, fig. 20; Ballarin 1967, 77; Pilo 1972, 86; Gilbert 1978, 133; Magagnato and Passamani 1978, 18-19; Pallucchini 1982, 17; Sgarbi 1982 (A), 201; Muraro 1982-83, 17-21; Magagnato 1983, 146; Rearick 1986 (A), 181; Muraro 1992, 24.

This painting is the first version of a subject painted many times by the artist: the flight of the Holy Family from Bethlehem to Egypt in order to save the child Jesus from Herod's murderous fury. The scene illustrates the moment just after the angel appears to announce God's will: «When he arose, he took the young child and his mother by night, and departed into Egypt» (Matthew 2:14). In the dawn light, Joseph is leading the donkey on which the Madonna sits, struggling to hold the Child who is trying to jump out of her arms. Three shepherds, who stare fixedly, perhaps more from sleepiness than from surprise, at the divine apparition, accompany the holy group and carry their provisions, a water canteen and some goats tied to a stick. The atmosphere of unreal silence is broken by the «song» of nature: the wide landscape illuminated by the light in the background, the apple tree with its full leafy branches backlit at the center of the scene, the cherry and oak trees on the left, and the hellebore, daisy, dandelion, and fern beneath the feet of the ass and Saint Joseph.

The canvas was commissioned by the priest Evangelista, the rector of the Bassanese church of San Girolamo, in 1532 (*Libro secondo*, fol. 121v), while payments are documented from 29 August to 3 November 1537. Verci and Paroli, nonetheless, transcribed the date 1534 following the signature, which they read differently. The fact that as late as the nineteenth century some writing was still visible – «faciebat» or «pingebat» and the date, since removed – is confirmed by a lithograph made by Francesco Facci around 1835 and in Cavalcaselle's annotations of 1863. Perhaps when the painting was restored in 1904 by Corinna Gaggian Galdiolo, it was reduced to a rectangular format from its original lunette shape and was also significantly cut down by at least 5 centimeters on the left side. Probably at the same time, its lower edge was wrapped around the stretcher and thus partially hidden.

The date of 1534 was, more or less, explicitly not accepted by Arslan, Venturi, Bettini, and Magagnato (1952; and 1978), who all proposed a date around 1536-37, after the canvases for the Sala dell' Udienza and the votive painting for the Podestà Soranzo (cat. 2), and in close relationship with *The Supper at Emmaus* in Cittadella (fig. 12). Lorenzetti, Longhi, Zampetti, Pallucchini, Ballarin, and most recently Magagnato (1983) recognized Verci's authority on the question, supporting their convictions with different reasoning: Lorenzetti detected an early reflection of Bonifazio's teaching, Venturi emphasized the picture's relationship with Francesco il Vecchio's training and with Savoldo, and Longhi cited the connection with Francesco's archaic culture and the first «cultured» influences arriving from Rome, while Zampetti saw in the painting a youthful search for formal unity. Subsequent analyses followed Longhi.

To paraphrase Longhi, *The Flight into Egypt* really should not be moved away from its documented date of 1534, because it represents the first response – of great balance and charm – of a young artist trying to unite the values of form and light acquired from his father's training with influences arriving from the Venetian lagoon. These influences, however, are translated for the most part into quotations: from Titian's lunette in the Palazzo Ducale (Suida) – in the Child precariously balanced in his mother's arms and the figure of Saint Joseph who is almost copied from the old man in Titian's *Triumph of Faith* (Furlan) – or from

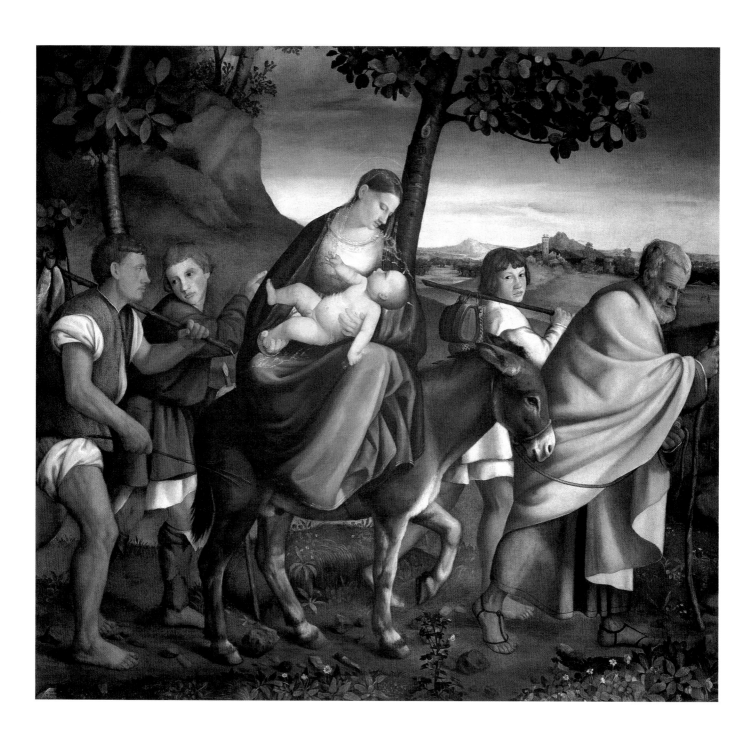

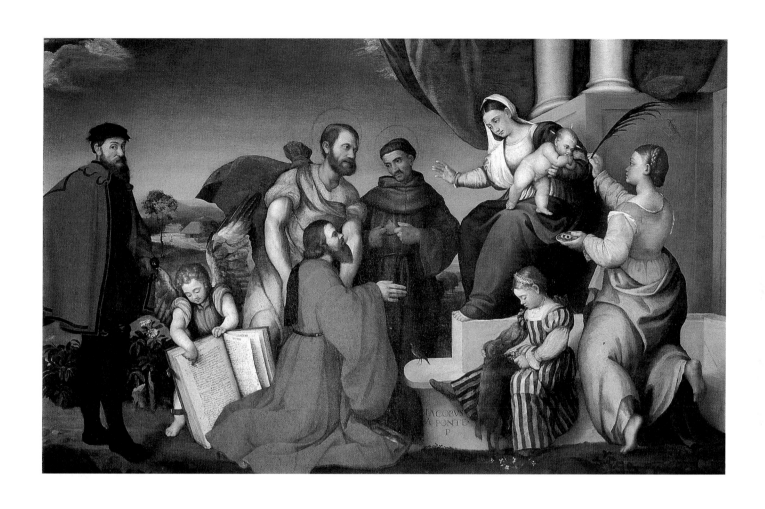

2. The Podestà of Bassano Matteo Soranzo with His daughter Lucia and His brother Francesco Being Presented by Saints Lucy, Francis, and Matthew to the Madonna and Child (1536)

Museo Civico, Bassano del Grappa, inv. 7
Oil on canvas, 153×249 cm (60 1/4×98 in.)
Inscriptions: IACOBUS / A PONTE / PINXIT on the base of the throne

Bonifazio, as is the shepherd at the left edge of the painting. But the painting's great charm, acclaimed in all the literature, lies in the essential nature of its narrative and the crystalline purity of the light, which illuminates the figures from behind and highlights, by backlighting, the flowers in the foreground, thus emphasizing their symbolic role. The « tight, firm modeling of the Flight », the « clarity of the forms like polychromed wood » (Venturi 1929 (B)) are formal elements already present in Francesco's idiom, as seen in *The Nativity* (parish church, Valstagna) of 1525-26. They are enlivened here by the molten color of Bonifazio, but mainly dependent, as both Lorenzetti and Venturi have already pointed out, on the painting tradition in Brescia, specifically the work of Savoldo. The iconography of the Madonna, with the thin transparent and luminous veil, is borrowed from Brescia and Romanino's work in Padua. These overtures toward Lombardy help us to understand Jacopo's point of departure for his exploration of the world of form, and how this research took him beyond Mantegna, studied through Montagna, even as far as Giotto in the Arena Chapel in Padua (Arslan 1960 (B), I, 45).

G.E.

Provenance
Palazzo Pretorio, Bassano del Grappa; Sala del Consiglio, Bassano del Grappa; Museo Civico di Bassano del Grappa, 1840.

Exhibitions
Venice 1946; Bassano 1952; Venice 1957.

Bibliography
Libro secondo, fols. 94*v*-95*r*; Verci 1775, 84; Vittorelli 1833, 39; Brentari 1881, 187; Gerola 1906, 107; Zottmann 1908, 20; Lorenzetti 1911, 210; Venturi 1929 (B), 1248; Venturi 1929 (C), 33; Arslan 1931, 43, 52, and 185; Tua 1932, 72; Berenson 1932, 155; Bettini 1933, 24 and 152; Pallucchini 1946, 157; Magagnato 1952 (A), 9 and 37; Pallucchini 1957, 98-99; Zampetti 1957, 18; Zampetti 1958, 16-17; Arslan 1960 (B), I, 43-44, and 161, and II, fig. 18; Rearick 1976 (A), 371-72; Magagnato and Passamani 1978, 19; Pallucchini 1982, 18; Muraro 1982-83, 33-35; Rigon 1983 (A), 13; Joannides and Sachs 1991, 697; Muraro 1992, 27.

The painting was executed for Matteo Soranzo, podestà of Bassano between February 1536 and July 1537, and was installed on 15 December 1536 (*Libro secondo*, fol. 95*r*). According to Lugo (cited by Magagnato 1952 (A)), the date of 1536 and the name of the patron appeared as part of the inscription, but are no longer legible. The donors appear in the painting, as specified in the contract: Matteo Soranzo in profile kneels at the foot of the Virgin's throne, presented by the saint whose name he bears. Behind him, a seemingly isolated small angel with multicolored wings points to a line in a book entitled « Libro VI ». In front of the Madonna, seated on the step, the podestà's little daughter Lucia is accompanied by her patron saint. Saint Francis is wedged into the group at the back, which permits us to identify the isolated figure at the left edge of the painting as Francesco Soranzo, the podestà's brother. Podestà Soranzo's act of homage to the Virgin, an apparent icon, gives Jacopo the chance to create a composition where family affections play an important, but not the only, role. Francesco Soranzo's self-contained, enigmatic expression accentuates the aura of mystery surrounding him. The book indicated by the angel does not seem to refer to any known documentary source concerning Matteo Soranzo's public office, since records neither in Venice nor in Bassano for the year 1536 bear the Roman numeral VI. Undoubtedly, the pointing finger is one of the focal points of the composition, and could very well indicate the program that the podestà intended to follow in the performance of his mandate. But it could refer, instead, to Christ's Sermon on the Mount, in chapter 6 of the Gospel according to Matthew, beginning with these words: « Beware of practicing your piety before men in order to be seen by them; for then you will have no reward from your Father who is in heaven ». If this is the correct interpretation, then we have yet another example of Jacopo's recourse to biblical authority for his subject matter (see here, Ericani's essay).

Structurally and chromatically, the painting pays homage to Titian (*The Pesaro Madonna*) and represents the most accomplished attempt in Jacopo's early works at merging his

3. The Madonna and Child with Saints John the Baptist and Zeno (1538)

Chiesa parrocchiale, Borso del Grappa
Oil on canvas, 215 × 179.5 cm (84 5/8 × 70 5/8 in.)
Inscriptions: MDXXXVIII on the first step of the throne
Exhibited in Bassano del Grappa only

investigation of form, his dominant concern during his training, with his refined innate sense of color. Compositionally more organic than the earlier canvases for the Sala dell'Udienza (1535), the Soranzo Madonna reviews all the influences of his youth: it is indebted to Bonifazio for the lengthened layout of the *historia*; to Lotto's drawing, particularly of his Bergamo phase, for the smaller, rounded shape of the figures, which are transformed into masses of color; to Titian for the rosy flesh tones and brilliant reds; to Brescian art for the deep planes of light defining the volumes; and to the first experiences of Pordenone for the rustic « deviance » of the Christ Child playing with Saint Lucy's palm frond. All these elements are brought together in a balanced measure of volumes and luminous fields of color and are synthesized in the little Lucia, who is intent on playing with the « tawny puppy » (Venturi 1929 (B)). The details, such as her diadem, necklace of pearls and corals, elegant little pink and green striped dress, and her slippers seen against the gray of the throne are all drawn with optical precision. This passage is pure Lotto, maybe transposing the *Girl with a Marten Coat* in Vienna into a more childish version, and yet in its touches of light it foreshadows Jacopo's later production and his Veronese-like achievements in the use of color (Venturi 1929 (B), 1248).

G.E.

Provenance
Chiesa parrocchiale, Borso del Grappa.

Exhibitions
Bassano 1952; Venice 1957.

Bibliography
Ridolfi 1648, I, 376; Verci 1775, 103; Federici 1803, II, 63; Zottmann 1908, 16; Lorenzetti 1911, 209 and 241-42; von Hadeln 1914 (B), II, 387; Arslan 1929 (B), 188; Arslan 1931, 66 and 187; Bettini 1933, 30 and 154; Berenson 1932, 48; Berenson 1936, 48; Longhi 1948, 44; Magagnato 1952 (A), 40; Magagnato 1952 (B), 220; Pallucchini 1957, 99; Rearick 1958, 198; Pallucchini 1959, 260-61; Arslan 1960 (B), I, 48-49 and 164, and II, fig. 29; Ballarin 1967, 77-78; Pallucchini 1977-78, 14; Rearick 1978 (A), 161; Pallucchini 1981 (A), 35; Pallucchini 1982, pl. 4; Rearick 1986 (A), 182; Rigon 1983 (A), 13; Joannides and Sachs 1991, 698.

The date 1538 painted on the circular step of the throne in the Borso altarpiece marks a precise chronological moment around which we can group several paintings that represent the transition between Jacopo's « soft manner of his Bonifazio period » (Magagnato 1952 (A)) and his acquisition of proto-mannerist stylistic elements (Pallucchini 1957). These include *The Entombment* for San Luca di Crosara, delivered 26 August 1537 (*Libro secondo*, fol. 126*v*); the Pove altarpiece, finished by Saint Michael's Day, 17 May 1537 (*Libro secondo*, fols. 93*v*-94*r*); *The Supper at Emmaus* in Cittadella (fig. 12), which we now know was begun in September 1537 (*Libro secondo*, fol. 25*v*; and see here, Ericani's essay); *The Last Supper* in the Church of Saint Lawrence, Wormley (Joannides and Sachs 1991), commissioned by Am-

brogio Frizier de la Nave (see the entries by Signori in Muraro 1992); *The Adoration of the Magi* in the Burghley House Collection, Stamford (fig. 16), commissioned 22 December 1537 (*Libro secondo*, fol. 95*v*; and Rearick 1958); and *The Supper at Emmaus* painted for the podestà of Cittadella Cosimo da Mosto after 14 October 1538 (cat. 4). In this very tight sequence of dates, which it has been possible to establish on the basis of the Dal Ponte account book, there is inserted between 9 September 1537 and 29 September 1538 (*Libro secondo* fols. 0*r*, 14*v*, and 43*v*) the Borso altarpiece, commissioned from Francesco il Vecchio by the church stewards « sul sesto de quella de S. Polo qui a S. Zuane », that is, along the lines of the altarpiece painted by Francesco in 1519 for the church of San Giovanni in Bassano (now Museo Civico, Bassano del Grappa, see Arslan 1960 (B), I, 20-22, and II, fig. 2; and Magagnato and Passamani 1978, 11-12). Some persistent archaicisms that art historians have noticed in the painting are probably due to the conditions laid out by the commission. Jacopo followed the specified model in his distribution of the figures on either side of the throne, the same scheme he used in the altarpieces for Fara (now Museo Civico, Vicenza) and Santa Caterina in Lusiana. Other old-fashioned ideas are to be seen in the suggestion of a low marble wall enclosing the holy figures, the Madonna's rich velvet robe shot with gold, and, above all, the decorative details of the pilasters on the throne, which give the painting a kind of anachronistic mountain

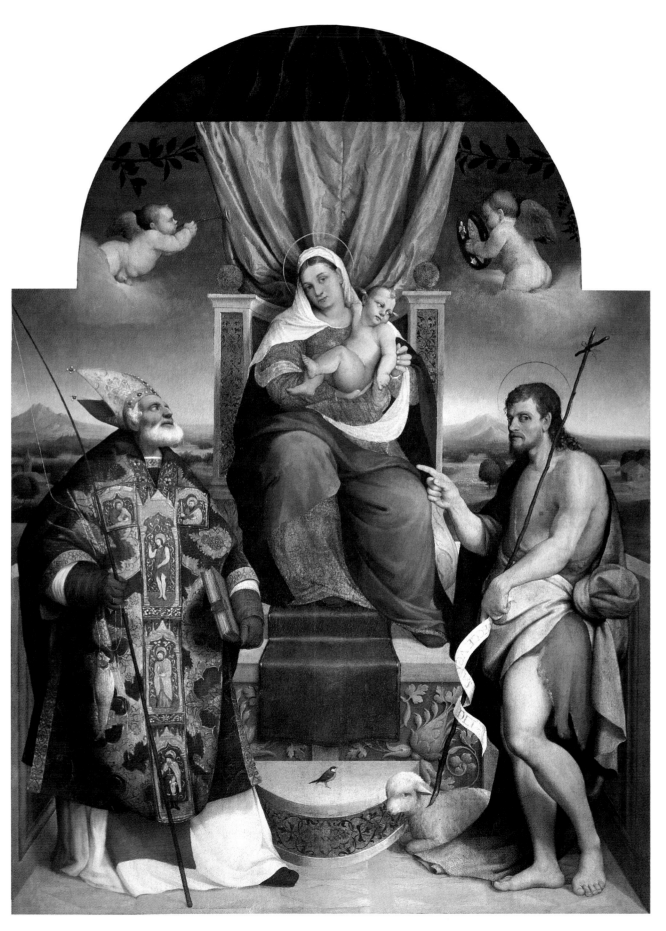

258

flavor in contrast to the structure and definition of the figures. In these figures and in Jacopo's choice of palette lies the modernity of this painting, a modernity that perhaps is not yet completely defined, but nonetheless already points toward an understanding of line and color that would characterize his full mannerist phase just a few years later. Even more than in *The Supper at Emmaus* in Cittadella, here the Pordenonesque inflation of the Madonna and Saints John the Baptist and Zeno is accompanied by a rhythmic sense of their well-drawn profiles that introduces us to the works of the early 1540s. To quote Magagnato, «the model of the forms will change, but his acute sense of the refined stylistic traits of the next decades is already born and fully formed» (Magagnato 1952 (A), 10). Nonetheless, it is true that these sharply drawn profiles furnish the «unrepeatable occasion» (Ballarin 1967, 78) for passages of color still inspired by Titian but taken almost to the extreme limits of experimentation with tonal possibilities. The symphony of reds in Saint Zeno's robe, heightened by the gold thread on his chasuble and the insets of blue embroidery on his stole – conceived «as imitation of the enamels in medieval goldwork» (Ballarin 1967, 78) – is obtained by placing a chasuble of cut velvet over a tunic of cocchineal red velvet, where the tones of the glaze leap out in brilliant flashes against the darker base. Thus the figure of Saint Zeno takes on a completely different value from that of Saint Nicholas in Titian's *Madonna in Glory with Six*

Saints (Pinacoteca Vaticana, Vatican City, fig. 90), which inspired its design (Magagnato 1952 (A), 10-11) and represents for Jacopo the synthesis of his youthful experience with Lotto and Titian in the field of color. Along with the Burghley House *Adoration of the Magi*, we see here the most extreme example of the stimuli received between 1536 and 1537 from Pordenone's Malchiostro Chapel in Treviso, which was already being superseded. In *The Supper at Emmaus* (Kimbell Art Museum, Fort Worth, cat. 4) and *Christ among the Doctors in the Temple* (Ashmolean Museum of Art and Archaeology, Oxford, fig. 18) painted immediately thereafter, Jacopo's experiments move according to the periodic «cyclical crises» we have come to expect and once again find the possibilities offered by color to construct space. The same sense of rhythm and the same intonation of color would reappear in 1539 in *Samson and the Philistines* (Gemäldegalerie Alte Meister, Dresden, fig. 100).

During the various restorations that the painting has undergone, it was returned to its original rectangular shape by Pedrocco in 1952 (Magagnato 1952 (A); and Zampetti 1957) and immediately afterwards refitted with its lunette, which matched the curved shape of its frame. However, these restorations are also responsible for a slight overall abrasion of the pigment, which is most evident in the background landscape, where the greens lack the modulation and detailed touches seen in Jacopo's best works from these years. Thus the painting now

lacks the definition of depth, which would have heightened even more our awareness of its indisputable quality.

G.E.

4. The Supper at Emmaus (1538)

Kimbell Art Museum, Fort Worth, inv. AP 1989.03
Oil on canvas, 100.6×128.6 cm (39 5/8×50 5/8 in.)

Provenance
Cosimo da Mosto collection, Cittadella; Christie's, London, 8 April 1886, lot 466 (as Marco Marziale); Christie's, London, 25 June 1887, lot 109 (as Marco Marziale); William Graham, London; Walter de Zoete, London; Christie's, London, 5 April 1935 (as Marco Marziale); art market, New York; Seligman, Rey and Co., Paris 1942; Christie's, New York, 11 January 1989, lot 91; sold to Kimbell Art Museum, Fort Worth.

Exhibitions
London 1912; Milwaukee 1935.

Bibliography
Borenius 1912, 101; Rearick 1958, 199; Arslan 1960 (B), 1, 350; Ballarin 1967, 78-79, ills.; Rearick 1968 (A), no. 20; Ballarin 1973, 91-93; Rearick 1976 (A), 104; Muraro 1982-83, 12-13; Pillsbury 1989-90, 18; Joannides and Sachs 1991, 697.

This small canvas is a variant of the painting executed in November 1537 for the high altar of the cathedral in Cittadella. It depicts the revelation of the risen Christ to two of his disciples on the road to Emmaus: « And it came to pass, as he sat at meat with them, he took bread, and blessed it, and broke it, and gave to them. And their eyes were opened, and they knew him » (Luke 24:30-31). Compared to its prototype in Cittadella, the Kimbell painting shows a significant change in the composition, with the episode set in a close, tight space, enclosed on the left side by the figure of the tavernkeeper and on the right by a servant in a plumed hat, while the low ceiling is covered by a velvet canopy. Other slight variations can be seen in the faces of the characters, the contents of the plate in front of Christ, the tablecloth that reveals more of the carpet underneath it, and the head of the cat on the right, which replaces a sleeping dog at the feet of the disciple in the Cittadella painting. The glimpse of a landscape on the left was revealed during restoration to have been cut off. A proportional comparison of the two paintings indicates that the landscape in the Fort Worth picture might have extended for 9.25 centimeters, of which only 1 centimeter is now visible.

The painting, attributed to Jacopo by Borenius in 1912, has been given various dates: 1533 (Muraro 1982-83); 1538 (Rearick 1958; and Ballarin 1967); and 1540-41 (Rearick 1976 (A)). It can be identified as « el Vanzelio de Luca et Cleophas » (the Gospel story of Luke and Cleophas) commissioned by Cosimo da Mosto, podestà of Cittadella, for the Malipiero household on 14 October 1538 and then taken instead for himself (*Libro secondo*, fol. 25v). The commission was certainly the result of the podestà's admiration for the large painting that had been hanging for almost a year in the chancel of the city's cathedral. Jacopo changed the palette completely and introduced the boy with a plumed hat from Titian's *Supper at Emmaus* (Musée du Louvre, Paris), painted for the Maffei family in Verona after 1530. Chromatic refinement is found in the velvet canopy, which is the « twin » of Saint Vigilius's robe in the Pove altarpiece (September 1537). Light breaks up on the green of the cloth and on the red and white fringe with a prismatic effect flecked with gold. Jacopo's debt to Titian's color is accompanied here by a Pordenonesque inflation of the forms, seen particularly in the apostle on the right and in the tavernkeeper, who is a close kin to the Saint Zeno in the Borso altarpiece of September 1538 (cat. 3). The smaller dimension of the painting heightens the delicate atmosphere of serenity that surrounds the sacred event set with a scene of daily life. The symbols of martyrdom – the cherries for the blood of Christ and the five eggs for the wounds of his Passion – would have caught the attention of the faithful because of their intensified color and the custom of implicitly linking common objects with the liturgy in order to render their meaning comprehensible to all. Thus the eggs – an unusual element in the treatment of this theme – which replace the more common lamb and fish, bring the episode, as Don Antonio Niero has very kindly pointed out to me, within the sphere of popular celebrations of the Easter season. « Si fuerint ova bendicenda aspersis carnibus » (Alberto da Castello [1564], fol. 202), that is, if after the benediction of the lamb and meat there were also some eggs, they too had to be blessed « ut cibus salubris fiat », so that the food would be healthy. Therefore, why not link the daily nature of this experience to the appearance of the risen Christ and to the Easter benedictions, an annual sacramental renewal, through the sprinkling of holy water on homes, persons, animals, and things?

G.E.

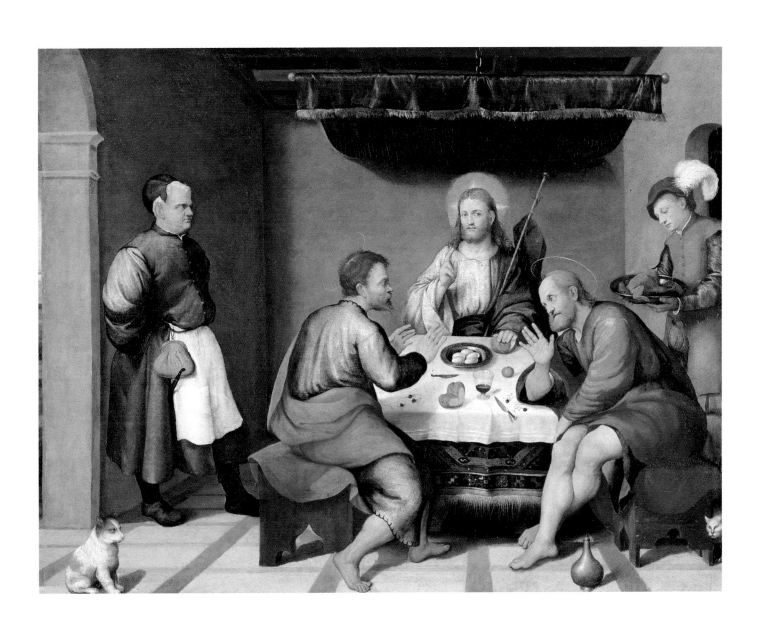

5. Portrait of a Venetian Gentleman (Giovanni Marcello?) (c. 1538-40)

Memphis Brooks Museum of Art, Memphis. Gift of the Samuel H. Kress Foundation, inv. 61.208
Oil on canvas, 76 × 65 cm (30 × 25 5/8 in.)
Inscriptions: Jac⁵ a ponte / bassanensis. p. / in... on the folded letter at the lower left

Provenance
Private English collection; Contini-Bonacossi collection, Florence; acquired by Samuel H. Kress, 1950; gift of the Samuel H. Kress Foundation to the Brooks Memorial Art Gallery, 1961.

Exhibitions
Washington 1951-57; Venice 1957; London 1983.

Bibliography
Suida 1951, 124-25, no. 52, ills.; Berenson 1952, pl. 95; Berenson 1957, I, 19; Muraro 1957, 294-95, fig. 6; Pallucchini 1957, 99 and 116; Zampetti 1957, 214-15, portraits no. 2; Zampetti 1958, 19, pl. LXXIV; Arslan 1960 (B), I, 46, 173, and pl. II, and II, fig. 26; Northrop 1961, 10, ills.; Heinemann 1962, 159; Milkovich 1966, 48-49, ills.; Ballarin 1971 (B), 269 and 271; Shapley 1973, 45, fig. 82; Rearick 1980 (B), 107-9; Pallucchini 1982, pl. 7; Magagnato 1983, 146-47; Rearick 1986 (A), 182.

Since this is the only portrait that Jacopo signed, it represents the benchmark for his production in the genre, a production that numerically was probably not very great, since the *Libro secondo* records only ten or so portraits over a period of twenty years. It was equally limited geographically, a fact that certainly did not contribute to the fortune of Jacopo's works among collectors. With the exception of the images of donors, which recur frequently in his religious or votive pictures (Pallucchini 1957, 117), his only important sitters were, according to Ridolfi (1648, I, 401), the Doge Sebastiano Venier, Lodovico Ariosto, Torquato Tasso, and other generic «letterati».

The abrasion of the paint film and general deterioration of the pigments make a stylistic reading – and, as a consequence, the dating – of the Memphis picture difficult. It also renders illegible the word at the end of the inscription, which is reported in all the literature as «Venetiis». This situation also has repercussions for the identification of the sitter.

In a comparison with the image of the donor in an early *sacra conversazione* by Tintoretto, formerly in a private collection in Lucerne, Heinemann (1962, 159) recognized the sitter, heretofore referred to simply as a «man of letters», as Girolamo Marcello. Rearick (1980 (B), 108 and n. 21) feels instead that he is Giovanni Marcello, son of Donato, on the basis of his resemblance to one of the bystanders in the Marcello altarpiece (Gallerie dell'Accademia, Venice, see Moschini Marconi 1962, 209-10, no. 368). Rearick reports that Giovanni Marcello, who was born just before 1500, was a senator and captain in Verona before his death in 1555. Here he appears in a domestic and private dimension, marked by his interests in the humanities, before embarking on his career in the service of the Venetian Republic. The intermediary for this portrait would have been Bernardo Morosini, whose image Rearick sees in the Kassel portrait (cat. 6), which would have been done just before this one. If the first one was done in 1542, the date for this one would be around 1542-43, sharing stylistic parallels with *The Adoration of the Magi* in Edinburgh (cat. 10), in particular with the figure of Caspar and his entourage, which are clearly portraits of the donor and his family.

Until further proof is found to confirm Rearick's intriguing «physiognomic» hypothesis, we can only note the artist's innate discretion as he faces his sitter. In the archaic nature of the subject's pose, beyond a parapet, one hand on an open book from which he is momentarily distracted, and a glove in the other, the artist only affirms the physical fact of his existence and subtracts his watery, vacuous gaze from any interchange with the viewer. The light is golden, still a Bonifazio light, wrapping around the round-shouldered bust that seems almost swaddled in the sitter's velvet-trimmed black damask robe, and casts a soft shadow on the olive green background, similar to the one used for the Kassel portrait. The soft, rounded facial features, a bit awkward and weak, the clear, well-drawn outlines, the shadowed, very subtle construction of the cheekbones and the eyebrow arch, as well as the three-quarter position recall works documented in 1538 and 1539 like the two versions of *The Supper at Emmaus* (cathedral, Cittadella, fig. 12; and Kimbell Art Museum, Fort Worth, cat. 4), the Borso altarpiece (cat. 3), *The Adoration of the Magi* (Burghley House Collection, Stamford, fig. 16), and *Christ among the Doctors in the Temple* (Ashmolean Museum of Art and Archaeology, Oxford, fig. 18) and support the traditional date of 1538-40 (Pallucchini 1957), which is slightly later than the date of 1536-37 proposed by Suida (1951), who was the first to notice the painting, and several years earlier than the date assigned by Rearick (1980 (B) and in

6. PORTRAIT OF A VENETIAN SENATOR (BERNARDO MOROSINI?) (c. 1540)

Staatliche Museen Kassel, Gemäldegalerie Alte Meister, Kassel, inv. L 79, lent by the Federal Republic of Germany
Oil on canvas, 86×69.5 cm (33 7/8×27 3/8 in.)

the essay published in this catalogue).

The Anatolian rug, probably one that was in the Dal Ponte studio, appears in a number of works: the *Christ among the Doctors* mentioned above; *The Beheading of the Baptist* (Statens Museum for Kunst, Copenhagen, fig. 29); *The Madonna and Child with Saints Martin and Anthony Abbot* (Alte Pinakothek, Munich, cat. 8); and *Lazarus and the Rich Man* (The Cleveland Museum of Art, cat. 24) (Shapley 1973; and Magagnato 1983).

P.M.

Provenance
Christie's, London, 16 April 1831, lot 39 (as G. Bellini); auction of Lord Vernon collection, Sotheby's, London, 12 May 1927, lot 5 (as school of Bellini); H.M. Clark; Julius Bohler, Munich, 1928; Kleinburger, New York, 1931; from the Fischer Gallery in Lucerne to the German government, 1942; depository of the Federal Republic of Germany, 1966.

Exhibitions
London 1939 (as Vincenzo Catena); Kassel 1968 (as Lorenzo Lotto).

Bibliography
Mayer 1928, 108-9, ills. (as Catena); *Altvenezianische Malerei* 1931, 4, no. 17, ills. (as Catena); Venturi 1931, pl. 315 (as Catena); van Marle 1936, 395 (as Catena); *Exhibition of Venetian Paintings* 1939, no. 17, ills. (as Catena); Robertson 1954, 35-36 and 74, no. 10 (as workshop of Catena?); Berenson 1957, 1, 62 (as Catena); Gronau and Herzog 1967, 152 (as Lotto); Herzog and Lehmann 1968, 8-9, ills. (as Lotto); Herzog 1969, 64 and 90, no. 70, ills. (as Lotto); Lehmann 1980, 34-35, ills. (as Jacopo Bassano); Rearick 1980 (B), 103 and 107, ills. (as Jacopo Bassano); Schleier 1985, 626-27; Lehmann 1986, 36, fig. 37; Rearick 1986 (A), 182; Attardi 1988, 694; Heinemann 1991, 105-6; Lehmann 1991, 36, fig. 37; Alberton Vinco da Sesso, in press.

The painting was published by Mayer (1928), as a late work by Vincenzo Catena, an attribution followed by Venturi (1931), van Marle (1936), Berenson (1957), and Heinemann (1978, oral statement quoted in Lehmann 1980; and Lehmann 1991). Robertson (1954), on the basis of the quality of the painting and its condition, preferred an attribution to a follower or collaborator of Catena. In 1966 it entered the gallery in

Kassel with an attribution to Lorenzo Lotto, accepted until Rearick's (1980 (B)) reattribution to Jacopo. Rearick dates the portrait to 1542, placing it between the portrait of a Franciscan friar (Earl of Shelburne, Bowood House, fig. 19) of 1541, which he sees as being in the style of Pordenone, and the *Portrait of a Venetian Gentleman* (Memphis Brooks Museum of Art, Memphis, cat. 5), which in his opinion dates between 1542 and 1543 during a phase when Jacopo was working with the possibilities of color inspired by Salviati, and relates it stylistically to *The Flight into Egypt* (The Toledo Museum of Art, cat. 11). He also suggests that the portrait represents Bernardo Morosini, podestà of Bassano from 1541 to 1542, who commissioned from Jacopo the frescoes on the outside of the Porta Dieda depicting *The Lion of Saint Mark* and *Marcus Curtius Throwing Himself into the Fiery Abyss*. An effigy of the « magnifico misier Bernardo Moresin podestà de Bassan » is documented in the *Libro secondo* in 1542 (fols. 16*v*-17*r*), two years after the one of Zuanne da Lugo. Also in 1542 the register of the workshop's activity records the portraits (or a double portrait) of Agostino Barbarigo, « *sinico* » of Castelfranco and his friend Maffio Girardo, and of a third gentleman, messer Alessandro Gardelin of Bassano.

The artist, rather than trying to penetrate the soul or exalt the status of his sitter, devotes his complete attention to the painterly construction of the scarlet toga made of classical damask with a « *brocone con caperi* » design, which he sets against the

7. Saint Anne and the Virgin Child with Saints Jerome and Francis (1541)

Gallerie dell'Accademia, Venezia, inv. 1041; on deposit in the Museo Civico, Bassano del Grappa, inv. 437
Oil on canvas, 144.5 × 101.5 cm (56 7/8 × 40 in.)
Inscriptions: CONCEPTIO BEATAE MARIAE / Jacobus a Ponte pinxit 1541 / die 26 settembris; iacobus a ponte bassanensis p. on the step of the throne
Exhibited in Bassano del Grappa only

brownish green background that darkens toward the edges. He sculpts the pale, slightly puffy face, floods its forehead with light outlined by the dark cloth cap, and suggests a short, light beard.

Thus Jacopo creates a very low-keyed charm, playing completely on the attractions of color, for this figure who appears to us to be suspended between *gravitas* and uncertainty. For its archaic air, still under the influence of Bonifazio, and for its affinity with the portrait in Memphis, I propose a date around 1538-40, a time by which the «Lottesque» portraits in the paintings for the Sala dell' Udienza and the Soranzo altarpiece (cat. 2), as well as in the so-called Francesco Soranzo (Musée des Beaux-Arts, Nancy, fig. 15) and in the problematic *Self-Portrait* (Kunsthistorisches Museum, Gemäldegalerie, Vienna, fig. 10) that have been linked to it (Rearick 1980 (B), 101-6), and also in the drawing depicting a *Portrait of a Young Man* (Musée du Louvre, Paris, cat. 80), were all well behind him.

The structure of the portrait is repeated unchanged in a *Portrait of a Prelate*, which was engraved by I. Troyen for the *Theatrum Pictorium* (1660, pl. 149) when it was in the collection of the Austrian Archduke, Leopold Wilhelm. The picture is now in the Kunsthistorisches Museum, Gemäldegalerie, Vienna (inv. 20), where it is attributed to Leandro Bassano and dated c. 1600-10 (Pan 1992, no. 78).

P.M.

Provenance
Church of the Padri Riformati, Asolo; Gallerie dell'Accademia, Venice, 1812; chiesa parrocchiale, Sossano 1883; Museo Civico di Bassano, 1956.

Exhibitions
Bassano 1952; Venice 1957; Venice 1981.

Bibliography
Ridolfi 1648, I, 388; Barri 1671, 87; Verci 1775, 112; Federici 1803, II, 63; Moschini 1815, II, 516; *Guida* 1828, 17; Zanotto 1847, II, 510; von Hadeln 1914 (B), I, 388 no. 5; Arslan 1929 (B), 191-92; Arslan 1931, 83; Muraro 1947, 287; Longhi 1948, 44; Magagnato 1952 (A), 38-39; Magagnato 1952 (B), 225; Fiocco 1957, 96; Muraro 1957, 295; Pallucchini 1957, 100; Zampetti 1957, 30; Arslan 1958; Zampetti 1958, 22; Pallucchini 1959, 258 ff.; Arlsan 1960 (B), I, 55 and 177, and II, fig. 32; Moschini Marconi 1962, 9-10; Ballarin 1967, 78-81; Magagnato and Passamani 1978, 21; Magagnato 1981, 166; Pallucchini 1982, 23; Rigon 1983 (A), 25-26; Rearick 1984, 296; Rearick 1986 (A), 182; Muraro 1992, 32-33.

The inscription in cursive script is reported by Verci and Federici with the date indicated as 14 September; the second inscription above it, in Sistine capital letters, which in X-radiographs appear the same, has no date (Magagnato and Passamani 1978, 21). Muraro (1947), in publishing the painting, considered the cursive writing to record not the execution but the placement of the painting on the altar. He emphasized Jacopo's borrowings from Pordenone, pointed out the similarities in style with the Borso altarpiece (cat. 3), and thus moved the date back to 1538. This earlier date was accepted by Longhi (1948) and Arslan (1931), while Magagnato (1952 (A) and 1978),

although noting the stylistic affinities with the Borso painting, proposed a date closer to 1541. Fiocco, Pallucchini, and Ballarin emphasized the stylistic differences between the two works, confirming an execution date in 1541. Zampetti posited instead an execution stretched out over time. The information available to us now reveals that the painting was commissioned on 21 February 1541 by the Padri Riformati in Asolo and placed on the altar on the date inscribed on the canvas, respecting Jacopo's contractual agreement with the stewards of the church, the notary Paolo Trevisan and Francesco Colbertaldo, that the painting be in place for the feast day of Saint Jerome, that is 30 September (*Libro secondo*, fols. 44v-45r). Pallucchini (1959) underlined, along with Pordenone's influence, the role played by engravings after Parmigianino in Jacopo's move toward mannerism at this time, an observation taken up again by Rearick (1984 and 1986 (A)), who emphasized the influence of Emilian painters, suggesting echoes from Bedoli in the treatment of the robes. Ballarin (1967) recognized instead in this Saint Anne how Jacopo had moved beyond Bonifazio's teachings, still evident in the Borso altarpiece, and was now embarking on an illusional space and fantastic palette as a result of his readings and meditations on the art of Raphael, Pordenone, and Savoldo. Giving a sensitive close reading of the painting, Ballarin pointed out the compressed and inflated space, pushed completely to the front of the painting and closed

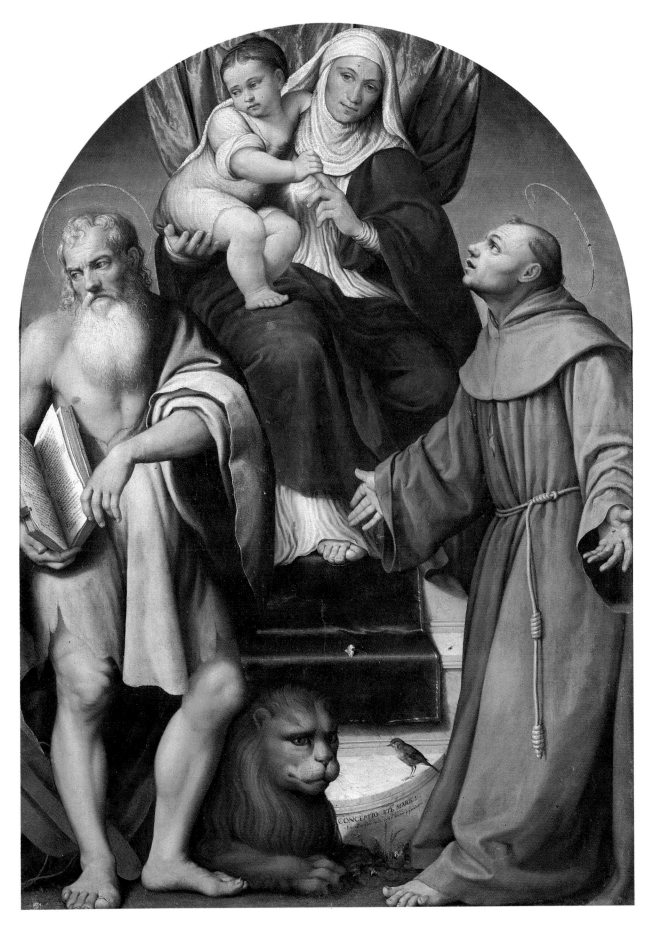

267

8. The Madonna and Child with Saints Martin and Anthony Abbot (1542)

Bayerische Staatsgemäldesammlungen, Alte Pinakothek, Munich, inv. 917
Oil on canvas, 190×121 cm (74 3/4×47 5/8 in.)
Exhibited in Bassano del Grappa only

from behind by a sheet-like blue wall with no semblance of an atmosphere. He also noted how in the background, as well as in the robes, the pigment is applied with no reference to natural appearances, but is used to construct the forms, playing on the thick planes of color and deep shadows. Furthermore, the Madonna's veil foreshadows Jacopo's touch, which nonetheless creates mass, and which would become a constant of his painting during the 1540s and of which this painting is the prelude. He further observed how Jacopo's return to Savoldo's naturalism (most evident in the folded back part of the robe and the foreshortened hand emerging from the shadow into the foreground), which had always been a part of his cultural background, occurs just at the moment of its negation, bringing about a «naturalistic vigor, a chromatic severity and an economical, yet completely constructive use of the brush, which makes us think of seventeenth-century Spanish artists».

G.E.

Provenance
Church of San Martin, Rasai (Belluno); Giambattista Volpato collection, c. 1670; Monte di Pietà, Bassano, 1682; Salvioni, Bassano, 1695; Kurfürstlichen Galerie, Düsseldorf, 1719; Schleissheim, Munich, 1806; Alte Pinakothek, Munich, 1836.

Exhibitions
Venice 1957; Washington 1988; Cincinnati 1988.

Bibliography
Dézallier d'Argenville 1745, 163; Verci 1775, 108; Eastlake 1884, 98; Bode 1892, 120; *Katalog* 1896, 253 (as Leandro); Jacobsen 1897, 441; Frizzoni 1900, 75-78; *Katalog* 1908, 245; Zottmann 1908, 31; Lorenzetti 1911, 250-51; von Hadeln 1914 (C), 58; *Katalog* 1920, 9; Venturi 1929 (B), 1262-63; *Katalog* 1930, 9; Arslan 1931, 87, 105, and 192; Berenson 1932, 58; Bettini 1933, 47 and 163; Biasuz 1933, 400 ff.; Mayer 1933, 644; Suida 1934-36, 194; *Älter Pinakothek* 1936, 14; Longhi 1948, 46; Pallucchini 1950, 53; Berenson 1957, 19; Pallucchini 1957, 53; Zampetti 1957, 48; Arslan 1960 (B), 75 and 162, and II, figs. 62 64; Kultzen and Eikemeier 1971, 41; Pallucchini 1982, 26; Kultzen 1986, 61; Brown 1988, 40; Muraro 1992, 34-35.

Jacopo executed this painting for the church of San Martino in Rasai, near Feltre, between 18 June 1542 and 22 February 1543 (*Libro secondo*, fols. 81v-82r), through the good offices of Vettor Scienza, a well-known engraver from Feltre who was living in Venice. In the 1670s Giambattista Volpato substituted in its place a copy he had painted, and pawned the original at the Monte di Pietà in Bassano to cover his debts. Despite the trial and sentencing of Volpato, the work was not redeemed, but was sold in 1695 to an administrator of the Monte, Gian

Battista Salvioni, from whom it was stolen three days later (Verci 1775, 252-53).

The triangular composition is a scheme derived from Titian. It is embellished by the large blue-veined marble throne, which stands out against the green of the curtain, and is highlighted by the white of the Madonna's veil. The entire painting quivers with color, mixing the touches of the brush and shattering the surface: the neo-quattrocentesque pattern of the carpet is rendered in white, red, and green; in Saint Martin's alb the white blends with black, gray, and violet; the border of his cope is shot through with gold flecks; and the blue of the Madonna's cloak and the cowl of Saint Francis. While the picture still recalls the inflation of the figures in the *Saint Anne* altarpiece for the church of the Padri Riformati (cat. 7), it has taken on a Titianesque profundity (Kultzen 1986, 28). The refinement of the application of the pigment by touches of the brush constitutes the great innovation of this picture, so new that some scholars felt it was the result of a later reworking by Jacopo's sons. The Alte Pinakothek catalogues of 1878 and 1879 allude to a generic collaboration on the part of the workshop, while Bettini (1933) felt that the two saints could have been finished or repainted by Leandro. Fiocco and Heinemann (verbal communication, see Kultzen 1983) thought this could be a copy by Leandro of a lost original by Jacopo. Venturi (1929 (B)) and Suida (1934-36) held that it is a copy by Francesco of the fresco depicting

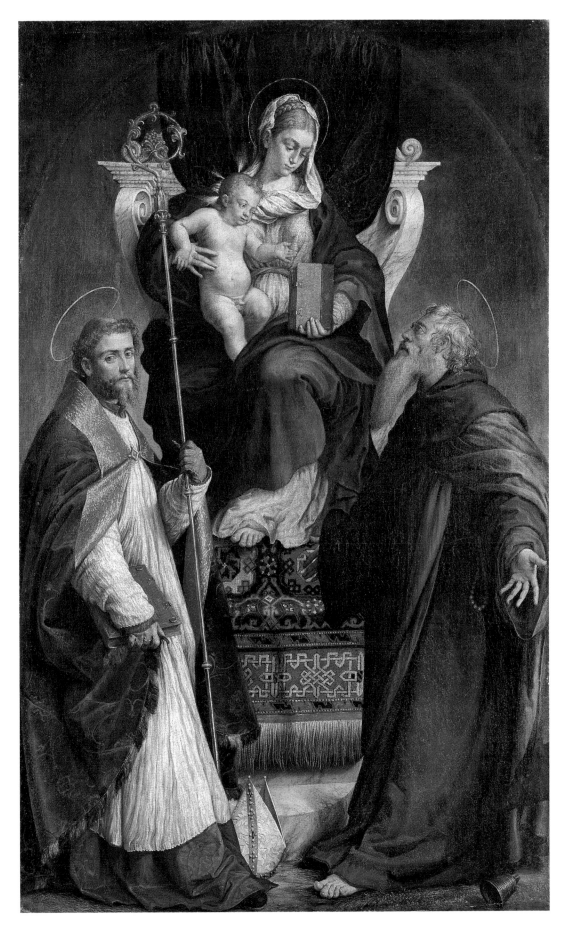

9. The Madonna and Child with the Young Saint John the Baptist (1542-43)

Accademia Cararra, Bergamo, inv. 1462
Oil on canvas, 75×64 cm (29 5/8×25 1/4 in.)

The Madonna and Child with Saints Francis and Bassiano (cat. 117), painted by Jacopo in the early years of the 1540s for the cloister of the Franciscan church in Bassano (Magagnato and Passamani 1978, 23). The date, more or less established in the 1540s, was instead moved to 1555 by Bettini (1933).

It is true that the painting fits perfectly into the moment of Jacopo's greatest mannerist crisis, when the artist's confidence in his style of figurative representation was shaken to its foundations by suggestions arriving from central Italy. What is placed in question here, however, is not so much the construction of the figures, which unites derivations from Pordenone with Parmigianesque aspirations in the throne (Pallucchini 1957; and 1982), as it is the still completely «Lombard» structure of the color similar to that of *The Adoration of the Magi* (The National Galleries of Scotland, Edinburgh, cat. 10). In this moment of crisis Jacopo turns to Titian and his use of color, citing in his throne the bluish marble of the column in the *Portrait of Benedetto Varchi* (Kunsthistorisches Museum, Gemäldegalerie, Vienna) and in Saint Martin's cope the gold flecks on the doge's hat in the *Portrait of Doge Andrea Gritti* (National Gallery of Art, Washington). Thus he reveals his continuing tribute to the Venetian master and his capacity for capturing the contemporary artistic culture, whose impulses would serve him in his ongoing effort to enlarge his own vocabulary.

G.E.

Provenance
Art market; Gustavo Frizzoni collection, 1894; Mario Frizzoni collection, 1954; Accademia Carrara, Bergamo, 1966.

Exhibitions
Never before exhibited.

Bibliography
Berenson 1894; Lorenzetti 1920, 392-94; Arslan 1931, 88 and 187; Bettini 1933, 47 and 161; Berenson 1936, 46; Zucchelli 1954, pl. xxxiii; Berenson 1957, 16; Arslan 1960 (B), 76 and 164; Ballarin 1967, 81; Ottino della Chiesa 1967, 154; Rossi 1988, 28-29.

This painting, published by Berenson in 1894, has not been the object of much scholarly analysis. Lorenzetti noticed that its structure was similar to Titian's *Pesaro Madonna* and dated it sometime near *The Rest on the Flight into Egypt* (Pinacoteca Ambrosiana, Milan, fig. 24), now established in the second half of the 1540s. Arslan, following his own chronology within that decade, linked it closely with *The Madonna and Child with Saints Martin and Anthony Abbot* painted for Rasai and now in Munich (cat. 8) because of its Titianesque elements. However, he grouped it with other works that have now been dated differently: *The Adoration of the Shepherds* at Hampton Court (cat. 17); *The Madonna and Child* (Detroit Institute of Arts, fig. 28); *The Madonna and Child* (formerly Contini-Bonacossi collection, Florence); and *The Madonna with Saints Anthony Abbot and Louis of Toulouse* in Asolo (cat. 19). Ottino della Chiesa (1967) limited himself to noting that the figure of the Virgin was a reworking of the Madonna in *The Flight into Egypt* (The Toledo Museum of Art, cat. 11). Ballarin, putting the chronology of the 1540s into proper order and giving a critical rereading of Jacopo's early mannerism, thought that this *Madonna* was painted at the beginning of the decade, just after the *Saint Anne* for the Padri Riformati in Asolo (cat. 7) and before the Edinburgh painting (cat. 10) and the Munich altarpiece (cat. 8). There can be no doubt that this very beautiful painting dates from the first four years of the 1540s. The dense impasto of the green cloth and the deep teal blue robe spread around the Virgin still belong to Jacopo's Lombard beginnings and have no connection with the flashes of light that break up the surface of the paint in the Detroit and Florence Madonnas. The thrust and lengthening of the figure of the young Saint John the Baptist in the Florentine picture are not yet seen in this canvas, where everything is static and calm. The Madonna's veil is whitened by thick brushstrokes, and her hair is streaked with gold, while a sculpted gray shadow against her cheek slims her face, which is modeled with a compact impasto. Touches of black mingle with the gold in the Christ Child's hair, in a manner similar to that seen in the Saint Anthony in the Munich altarpiece (cat. 8). But the Christ Child's facial features are not as compact nor as rounded as those in the Munich painting or in the Toledo *Flight into Egypt*. Sad and old before his time, the Christ Child has a sharper chin and thicker neck, his cheeks thinner

10. THE ADORATION OF THE MAGI (c. 1542)

The National Galleries of Scotland, Edinburgh, inv. NG 100
Oil on canvas, 183×235 cm (72 1/8×92 1/2 in.)

and drooping. This is the physiognomy drawn and shaped on different planes that initiates the moment of Jacopo's greatest range for form, after *The Martyrdom of Saint Catherine* (Museo Civico, Bassano del Grappa, cat. 13). However, this advanced treatment is not matched by other formal elements, particularly the palette, which makes us date this picture close to *The Madonna and Child with Saints Martin and Anthony Abbot* in Munich.

G.E.

Provenance
Francesco Maria Balbi collection, Genoa, 1682 (as Titian); Andrew Wilson, London, 1805; Andrew Wilson sale, Peter Coxe, London, 6 May 1907, lot 28; Lord Eldin collection, Winstanley; Lord Eldin sale, Winstanley, Edinburgh, 15 March 1833, lot 113; Neil collection, Edinburgh; Royal Scottish Academy, 1856; The National Galleries of Scotland, 1910.

Exhibitions
Edinburgh 1826; London 1906; London 1930.

Bibliography
Cochin 1758, III, 279; Ratti 1780, 186; Brusco 1788, 129; Waagen 1857, 429; Crowe and Cavalcaselle 1871, 183; Crowe and Cavalcaselle 1877, II, 468; Lorenzetti 1911, 248-49; *Catalogue* 1912, 107; *Catalogue* 1924, 100-1; Arslan 1931, 74; Bettini 1933, 39-40; *Catalogue* 1946, 72; Longhi 1948, II, 46; *Catalogue* 1957, 19-20; Rearick 1958, 197 and 199; Arslan 1960 (B), I, 62-63 and 167, and II, fig. 51; Ballarin 1967, 81 and 90; Brigstocke and Thompson 1970, 4-5; Belloni 1973, 60-70; Rearick 1978 (A), 168, n. 10; Brigstocke 1978, 12; Pallucchini 1982, 23; Boccardo and Magagni 1987, 84, no. 100.

The Adoration of the Magi in Edinburgh is a replica of a subject that Jacopo had already painted for the church in the Palazzo Pretorio in Bassano. This latter painting was commissioned on 22 December 1537 by Simone Giovanni Zorzi, podestà until November 1538 (*Libro secondo*, fol. 95v), and very probably can be identified as the canvas in the Exeter collection at Burghley House, Stamford (fig. 16; see Rearick 1958, 197-200; and Rearick 1978 (A), 168, n. 10). According to Verci (1775, 61), repeating a subject gave Jacopo the oppor-

tunity to reuse certain models by inserting them into a new scene, completely modified and treated according to new stylistic and chromatic traits he had learned in the meantime.

Abandoning the canonic and paratactical lengthening of the scene learned from Bonifazio, the episode depicted here unfolds sinuously in front of two theatrical backdrops: a building in ruins (recalling Dürer), a cherry tree, and a broken column on the left; and a mountain ridge on the right. In the center, in the blue distance, the light wedges itself between the trees and two large stacks of straw, licking the column, and defining the volumes in the foreground. Another source of light coming from the right «lightens» («alluma», according to Verci's definition of Jacopo's light tones) the pink of the large banner, highlights the dirty white coat of the horse's hindquarters, illuminates the massive shoulders of the shepherd, whitens and brightens the hair of old Melchior, and throws itself with full force onto the Madonna and Child. The forcing of the forms derived from Pordenone and so evident in the Zorzi painting here gives way in the face of Jacopo's need now to unite the chromatic values learned from Bonifazio (and elaborated under the influence of Brescian artists) with both the atmospheric values taken from Titian and the spatial schemes derived from Raphael. We find here again, as in the earlier *Martyrdom of Saint Mark* (The Royal Collection, Hampton Court), the chiasmic composition of Raphael's *Way to*

Calvary, known through Agostino Veneziano's engraving of 1517 (fig. 14). But the citation of the standard, here reversed toward the right and inserted into the group of halberdiers, furnishes the occasion for a passage of pure color, taken from Titian's *Battle of Cadore* and later introduced by Jacopo into the cloak of God the Father in *The Trinity* at Angarano (fig. 21). Another passage of color, orange this time, is provided by the muscular male figure seen from behind bent over the sheep, an act of homage to Pordenone's work in Treviso and the precursor of so many *repoussoir* shepherds in Jacopo's paintings. What strikes us most about this painting is the heights reached in the use of color, to the point of placing it in a position of transition between the works of Jacopo's youth and his mature production. The color-soaked surfaces are counterpoised in a chiasmic scheme where one color is played off against another: the deep green of the attendant with his back turned against the white of the horse; the horse's mane in contrast with the «lightened» black of the soldier's armor; the lacquer red of the little page with the violet of the male figure behind him and with the deep blue of the boy in a plumed hat in front of him; the orange of Saint Joseph's cloak with the violet of his robe; the pink worn by Balthasar with the white of Melchior's beard; and farther on, the violet brown of Melchior's robe with the pink, deep blue, and white of the Madonna's clothes. All this play of color is deepened by a new use of shadow that heightens, as never before, the sense of light and dark evidenced in the painting.

This «Lombard moment» (Ballarin 1967) represents the high point in Jacopo's treatment of color during his youthful period (Longhi 1948) and is epitomized by the remarkable passage of the king at the center of the scene. The figure is so supple as to prefigure Jacopo's later Salviatesque moments, yet he is still modeled on Raphael's *Conversion of Saint Paul*, while being dressed in a Romanino-style robe of green and gold stripes, where the touches of gold sparkle and gleam. The treatment of this figure is so realistic in its definition and richness that one is led to suppose that it could be a portrait of the donor. Perhaps Jacomo Gisi, of whom we know nothing but his name, but who immediately after 5 July 1542 ordered a painting depicting «the Story of how the three Kings went to make their offerings at the Manger» (*Libro secondo*, fol. 55r).

Lorenzetti proposed to identify this painting with one described by Ridolfi in 1648 as being in the Widmann collection, «…una historia de' Magi tocca con molta delicatezza nella quale intervengono oltre la Vergine e i Regi, servi, cavalli et altre curiose cose» (a story of the Magi touched with great delicacy in which along with the Virgin and the Kings, are present also servants, horses, and other curious things), an identification that Rearick (1958, 199) does not accept. He is convinced, on the basis of unpublished documents, that the ex-Widmann picture is the Exeter *Adoration of the Magi*, now in Burghley House, which was sold around 1680 to the senator Giacomo Vetturi and by him «at night, in a gondola, to the Fifth Earl of Exeter». Recently published inventories and letters concerning the Widmann collection (Magani 1989, 34, 40-42), which document business transactions between Venetian aristocrats and the Balbi family as early as the 1650s, confirm Rearick's hypothesis. Even though the dates of the sales to Balbi and to Vetturi are very close to each other – respectively, before 1682, the date of the first inventory of the Balbi collection, and 1680, the date of the sale to Vetturi – the inventory of the Widmann collection drawn up by Renieri and della Vecchia in 1659 records the correct attribution to Jacopo Bassano, and as such the painting passed into the Exeter collection. The *Adoration* in Edinburgh, on the other hand, carried until 1833 a seventeenth-century attribution to Titian. Della Vecchia's copy of the page at the center of the Burghley House painting (private collection, Venice; see Rearick 1958, 198) is, moreover, a direct result of his presence in the Widmann household at the time the 1659 inventory was made.

The presence of the Edinburgh painting in the Eldin collection is recorded by an engraving now in the photographic archives of Witt Library, Courtauld Institute of Art. An antique copy is in The Hermitage in Saint Petersburg, inv. 199, with a provenance from the Crozat collection.

G.E.

11. THE FLIGHT INTO EGYPT (1542)

The Toledo Museum of Art, Toledo, Ohio, inv. 1977.41. Gift of Edward Drummond Libbey
Oil on canvas, 157.5 × 203.2 cm (62 × 80 in.)
Exhibited in Fort Worth only

Provenance
Church of Santissima Annunziata, Ancona; Antonio Collamarini collection, 1801; John Donnithorne Taylor collection, Grovelands, 1840; Sotheby's, London, 24 June 1970, lot 9; gift of Edward Drummond Libbey to The Toledo Museum of Art, 1978.

Exhibitions
Never before exhibited.

Bibliography
Herrmann 1961, 465-66; Ballarin 1967, 81-83 and 88-90; Rearick 1978 (A), 166; Rigon 1983 (A), 27-28; Costanzi 1990, 35-43; Costanzi 1991, 122-28.

The painting develops the theme of the Holy Family's flight into Egypt, which the artist had already treated in the canvas painted in 1534 for the church of San Girolamo in Bassano (cat. 1). A comparison of the two paintings is illuminating as a measure of the distance Jacopo had traveled in less than ten years. The first is a silent presentation of the characters, who are united only by the relationship imposed on them by the biblical narrative, but in reality are isolated in themselves. In this second painting, the silence and self-absorption of the figures is limited to the Holy Family: Mary, Joseph, and the Christ Child. Intent on their own conversation, the two shepherds behind the donkey make up a separate group and pay no attention to the sudden movement of the third shepherd, whose voice and hands are both occupied in grabbing the horns of an ox, whose movement he is trying to stop, as well as perhaps that of the rest of the herd, who have come too close to the di-

vine group. The light of dawn marks the planes leading back to the vast blue horizon and, as in his early paintings – but with what richness of detail! – backlights and silhouettes the trees in the middle ground. Across the wide landscape closed by the peak of a mountain – perhaps Monte San Mauro remembered from Feltre? – are scattered big straw-roofed houses reminiscent of the Brenta valley; at the bottom of the valley the mills on the Pove, already seen in the 1537 *Saints Vigilius, John the Baptist, and Jerome* (parish church, Pove), draw water from a river of light; farther on, the open porches allow us a glimpse of wash hung out to dry, and a woman in front of a fire; and closer still, next to a tall leafy cypress poplar, we encounter a shepherd and a peasant couple with a goose, a group which will reappear unchanged later in *The Trinity* (parish church, Angarano, fig. 21). In the foreground, at the feet of the protagonists, the light illuminates the earth strewn with little pebbles between a daisy and some squash leaves. The light stops, however, behind the stage set formed by the trees – a cherry tree, a flowering maple, and another cypress poplar – and creates on the right a cone of shade inside of which the Madonna is lit by her own inner glow, which reflects onto and illuminates the rolled up sleeve of the shepherd and the horns of the ox. A patch of white light illuminates the Virgin's twisted veil, which is folded back on her head in the manner used already by Titian around 1530 in his *Madonna of the Rabbit* (Musée du Louvre, Paris),

and more forcefully in the votive painting for Doge Andrea Gritti (Palazzo Ducale, Venice). Compared to Jacopo's earlier *Flight*, the faces here are more elongated and sculpted by a precise and confident line. The shepherd, who opens his mouth to cry out, is also different from the type already seen in the fresco in Cittadella (see here, Ericani's essay) and in *Samson and the Philistines* (Gemäldegalerie Alte Meister, Dresden, fig. 100). The two shepherds face to face in the middle ground « molded from tanned, robust clay » with their refined, elegant faces and hands, are indebted to types used by Francesco Salviati (Ballarin 1967, 83, 88-90). The figure of Saint Joseph derives from Jacopo's earlier Titianesque version in his first *Flight into Egypt*. Titian's influence also permeates the colored chalk drawing (private collection, New York, cat. 82) that foreshadows the brown impasto of the final color used in the flesh tones. This drawing is considered a preparatory sketch for Saint Joseph's head in the Toledo picture (Rearick 1978 (A), 166; and Rearick 1986 (B), pl. III). Compared to Jacopo's earlier iconography, here Saint Joseph seems to be highly personalized, with a hooked nose and a deep furrow between his eyebrows, large eyes, high, pronounced cheekbones, and a fleshy mouth. He could be taken as a portrait of Doge Andrea Gritti, as he appears in Titian's portrait (National Gallery of Art, Washington) or the commemorative medal struck in 1534 by Andrea Spinelli (Parise Labadessa 1991, 113). The presence

of Gritti's portrait in this context and in the slightly later *Flight into Egypt* (Norton Simon Museum, Pasadena, fig. 20) could belong to the large series of acts of homage to the great doge found in Venetian painting even after his death in 1538 (Puppi 1984, 213-35). It could, however, also be due to other considerations more closely related with the painting itself, which would have to be examined in a more ample reading of the work.

Stylistically, the painting presupposes in its palette a point beyond the «completely Lombard» moment (Ballarin) of *The Adoration of the Magi* (The National Galleries of Scotland, Edinburgh, cat. 10) and the even earlier *Saint Anne* for the Padri Riformati in Asolo (Museo Civico, Bassano del Grappa, cat. 7). It has been placed chronologically by Ballarin (1967, 81) at the beginning of the 1540s, before Jacopo's «mannerist» crisis became acute – that is, before *The Martyrdom of Saint Catherine* (Museo Civico, Bassano del Grappa, cat. 13) and after the Munich altarpiece (cat. 8). According to Rearick (1978 (A), 166), it can be situated more precisely in 1542, right at that moment of transition. But in my opinion, it should, perhaps, be placed immediately before the Munich altarpiece – which we know was finished by February 1543, because of Jacopo's continued ability to insert suggestions from Titian into a prevalently Lombard pictorial fabric – that is to say, before Jacopo's further attention to Titian as a colorist provoked an explosion of touch, the results of which are visible in the

border of Saint Martin's cope in the Munich picture and the shattering of his enameled surfaces seen in paintings after 1543.

The Flight into Egypt in Toledo could be one of the canvases commissioned by the Venetian merchant-painter Alessandro Spiera between the middle of 1540 and 1543 (*Libro secondo*, 98v-99r). The existence of two copies of the painting, the first done by Carlo Maratti (formerly Manciforte collection, Ancona; now on the art market), and the second painted by Giuseppe Pallavicini for the high altar of the church of Santissima Annunziata in Ancona (Costanzi 1990, 35-37) has led to the very recent discovery that this *Flight into Egypt* was in the church during the second half of the eighteenth century with an attribution to Titian (Costanzi 1991, 122-23). From the published documents we learn that the painting left Ancona in 1801 after being sold to Antonio Collamarini (Costanzi 1990, 36-37).

Noting parallels between the years when the painting was executed and the concomitant events in the history of the church, which was annexed to a hospital for indigent unwed mothers also dedicated to the Santissima Annunziata and built at the beginning of the sixteenth century (it was considered «new» as of 11 February 1544), Costanzi formulates a hypothesis concerning the shape of the painting, although she remained perplexed about its subject. It would have presumably had an arched top or another picture above it. She also posits that the painting was executed for the high

altar of the church in Ancona, which would be the sole circumstance of finding a work by Jacopo outside his normal geographical sphere (Costanzi 1991, 125). Careful study of all the records of pastoral visits between 1592 and the end of the eighteenth century has not yielded any documentary evidence that either confirms or refutes this hypothesis. No canvas or panel is expressly mentioned as being present in the church until the survey made by Bishop Ranuzzi in 1791, and just one change in the arrangement of the church is recorded at the beginning of the eighteenth century, when two side altars appear that had not been mentioned earlier.

The documents do not give us any certain information about whether the Toledo canvas was originally placed within the church of Santissima Annunziata in Ancona, but nothing refutes it either. None of the paintings recorded in the church (Serra and Molajoli 1936, 28-29) and in part now lost have the characteristics of subject and date that would indicate they came from the high altar. However, the eighteenth-century renovations of the church could presuppose movements or removals of furnishings for which we have no documentary evidence. And yet, no matter how strange it appears to find a *Flight into Egypt* above a high altar in the sixteenth century, it would be even stranger after the Council of Trent. The theme, indeed, has direct references to Marian iconography. Both the Annunciation, which lends its name to the church, and the Flight

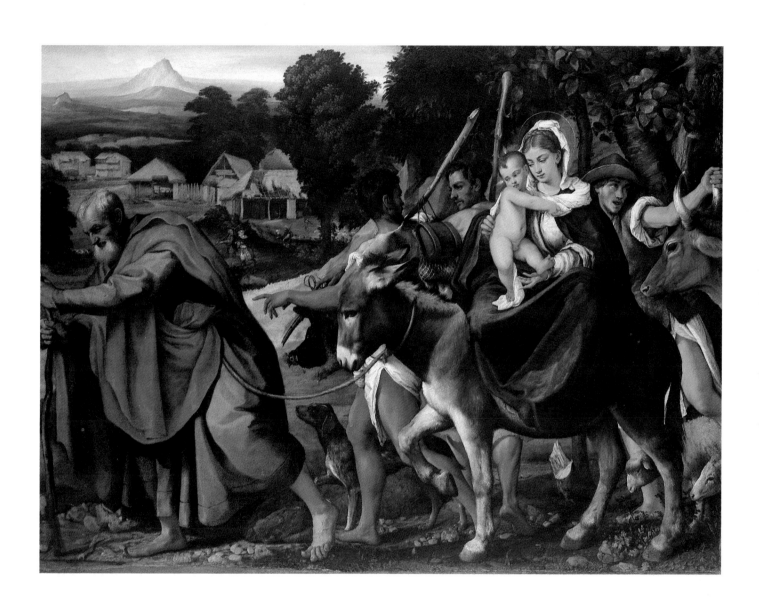

12. THE WAY TO CALVARY (1543-44)

Lent by the Syndics of the Fitzwilliam Museum, Cambridge, inv. M6
Oil on canvas, 81.9×118.7 cm (32 1/4×46 3/4 in.)

into Egypt are Gospel episodes from the infancy of Christ, which fit well with a symbolic reading of the picture that emphasizes the importance of the Madonna (see here, Ericani's essay, n. 51). Costanzi's hypothesis (1991, 126) that the painting's arrival in Ancona can be explained by a link between the members of the same confraternity in Ancona and Bassano must be rejected because the painting has no connection at all with the Confraternita di San Girolamo, which had an altar in an oratory inside the hospital of the Annunziata (*Visite pastorali* 1592, 47b). The more likely possibility, because of the artistic ties between Venice and Ancona (Polverari 1990, 15-20), is that a mediary might have been a Venetian merchant.

G.E.

Provenance
Peter Norton collection, 1857; Marlay collection, 1906; Fitzwilliam Museum, Cambridge, 1912.

Exhibitions
Manchester 1857, no. 904 (as Scarsellino); London 1906, no. 29; London 1959, no. 47; Fort Worth 1989; New York 1989; Washington 1989; Atlanta 1990; Los Angeles 1990.

Bibliography
Constable 1927, 14; Arslan 1929 (B), 190; Arslan 1931, 188, pl. XXI; Berenson 1932, 56; Berenson 1957, I, 17; Pallucchini 1957, 102; Suida 1959-60, 70-71; Arslan 1960 (B), I, 61 and 165, and II, fig. 50; Ballarin 1967, 94-95, and 98, n. 2; Goodison and Robertson 1967, II, 11-12; Hartley 1989, 59.

An unusual painting because of its fragmentary composition, *The Way to Calvary* is structured in episodes. On the left, a group of horsemen with their large banners waving in the wind looms over a barefooted rogue; the latter is depicted with a rope dragging Christ, who has fallen under the cross. On the right, in the foreground, the two Marys and a third pious woman bend over the Virgin, who is stretched out on the ground. Together their four united heads create a separate group. Behind them, Saint John the Evangelist walks in front of Herod and his soldiers, while Christ, who turns toward the group of women, is framed in the center by the wide gap opening toward Golgotha, small and alone amongst all these figures. The picture is modeled on Agostino Veneziano's engraving after Raphael's *Way to Calvary* (fig. 14), from which Jacopo took the chiasmic lay-out of the scene and some individual figures: Christ and the rogue pulling him, the horseman on the left, and the soldiers. Jacopo (and Giambattista) had already used these figures in *The Martyrdom of Saint Mark* (The Royal Collection, Hampton Court) and in another *Way to Calvary* (private collection, London; see here, Rearick's essay), where we also find the same male type with a wide square face, which here is used for Herod. This is certainly a Vitellio or Galba, taken from Roman iconography and known also through a later drawing by Jacopo (Rearick 1991, 5). The width of the painting allows Jacopo to give an important role to the natural scene, despite the crowd of figures. There is the wonderful passage of the landscape, deepened and dilated as never before, in the manner he had learned from van Scorel. The painting has been slightly abraded (Goodison and Robertson 1967, 11). There is also a disparity of treatment between the group of Marys in the foreground, which is drawn with a breadth and depth of planes and has a graceful refinement in its gleaming *changeant* colors, and the other groups, which are thinner, have sharper outlines, and are less refined in the finishing touches of the color. Excluding the possibility that they could have been painted at different times, for which no evidence exists, we must surmise that the painting also suffers in the unity of its execution because of a crisis in formal values, which, after 1541-42, was spreading through Venice. This was the result of the introduction of the mannerist idiom by Porta Salvia-

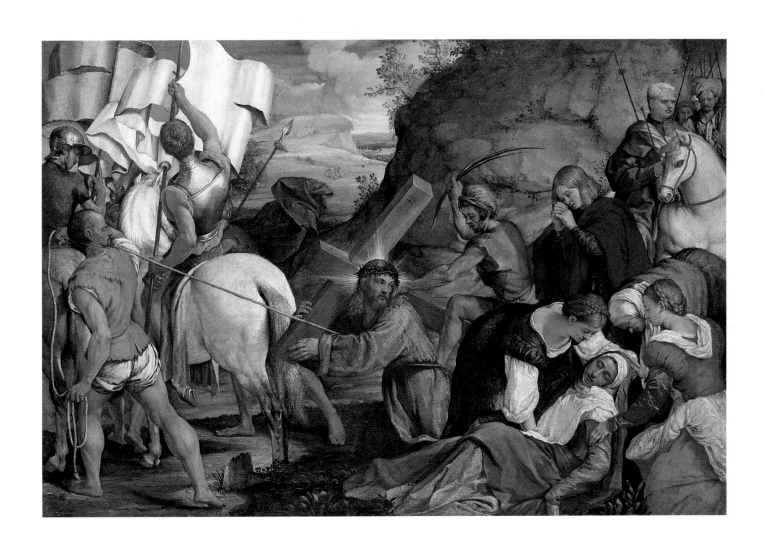

13. THE MARTYRDOM OF SAINT CATHERINE (1544)

Museo Civico, Bassano del Grappa, inv. 436
Oil on canvas, 160×130 cm (63×51 1/4 in.)

ti and Vasari, which was immediately taken up by Schiavone, Titian, and Tintoretto. It was a moment of crisis that here has already affected Jacopo's confidence in his color and places the painting chronologically alongside *The Martyrdom of Saint Catherine* (Museo Civico, Bassano del Grappa, cat. 13), as can be seen by a close comparison between Saint Catherine and these female figures. This group of pious women, the most beautiful passage in the painting – in which Pallucchini (1957, 102) saw a grace of line reminiscent of Parmigianino serves as an introduction, as has already been observed in the 1967 Fitzwilliam catalogue (Goodison and Robertson 1967, 12), to the works of the second half of the 1540s and in particular to the London *Way to Calvary* (The National Gallery, London, cat. 14). We should also point out, even if the subject does not seem to fall completely into the iconographical pattern handed down from Giovanni Bellini, that in 1543 Jacopo painted a *Christ Carrying the Cross* for Alessandro Spiera (*Libro secondo*, fol. 98*v*).

G.E.

Provenance
Church of San Girolamo, Bassano del Grappa; Compostella collection, Bassano del Grappa, 1780; Museo Civico, Bassano del Grappa, 1953.

Exhibitions
Venice 1957; Venice 1981.

Bibliography
Memmo 1754, 78; Verci 1775, 48 and 79; Ridolfi 1648, I, 397; Gerola 1905-6, 952; Magagnato 1956, 103-6; Muraro 1957, 42; Pallucchini 1957, 101-2; Zampetti 1957, 42; Arslan 1960 (B), 56, 86-87, and 163, and II, figs. 38-42; Zampetti 1964, pl. III; Ballarin 1967, 83-88 and 90; Magagnato and Passamani 1978, 22-23; Sgarbi 1980, 83; Dillon 1981, 324; Magagnato 1981, 167; Rearick 1984, 299-300; Muraro 1992, 36.

Verci speaks of *The Martyrdom of Saint Catherine* in the church of San Girolamo along with the early *Flight into Egypt* (cat. 1), highlighting the completely innovative nature of the painting: «...Stassi la Santa in mezzo ad uno stuolo di manigoldi sconpigliati e confusi dopo che per miracolo s'infranse la ruota, e si ruppero gli ordigni preparati per martirizzarla. Ammirabili si rendono le positure di essi, gli scorci e i tratti» (The saint stands in the midst of a group of rogues disconcerted and confused after the wheel was miraculously shattered, and the mechanisms broken that had been prepared for her martyrdom. Their poses are rendered admirably, as well as the foreshortening and facial features). He did not understand, however, Jacopo's new treatment of color: «Vi si potrebbe soltanto apporre non aver essa quella degradazione ne di lumi né di tinte; che si conviene» (One could only add that it did not show the shading of light or tints that is proper). Published by Magagnato in 1956, the painting immediately seemed to art historians, for its «formal daring», taken to almost unreachable extremes (Ballarin 1967, 90), to be the manifesto of Jacopo's unconditional approach to the language of central Italian mannerism. Nonetheless, with this painting we can measure the distance Jacopo has come from *Samson and the Philistines* (Gemäldegalerie Alte Meister, Dresden, fig. 100), where the interlocking bodies, still reminiscent of Michelangelo's «carte» (drawings) in both form and color, are depicted in all their density and material weight (Longhi). Here, instead, they have become pure graphic signs; with the colored squares in mauve, orange, bright red, green, and silver are enameled inlays, seemingly more parts of a tapestry than a pictorial translation of reality. In recent years, Magagnato (1981 after an initial dissension 1956; and again in 1978) has agreed with Ballarin (1967) that the work is not the result of Jacopo's study of Michelangelo as is the *Samson*, but is instead the expression of his immediate acceptance of the mannerist idiom introduced into the Veneto region by Porta Salviati in the years just after 1541-42. The Salviatesque nudes of the *Ingegnose Sorti* for Marcolini in 1541 and «i molti ignudi» (the many nudes) mentioned by Ridolfi in the fresco, now lost, of *The Fall of Manna*, painted by Porta in the Villa Priuli in Treville in 1542, must surely constitute the precedent for

this incredible figuration. The most immediate inspiration for the painting, however, are the engravings, designed by Francesco Salviati, for Pietro Aretino's *La Vita di Santa Caterina* (Dillon 1981, 324, no. 178; and Rearick 1984, 299).

The dates recorded in the *Libro secondo* (fols. 37*v*-38*r*) now confirm this chronological sequence and pinpoint the execution of the painting in the summer of 1544, between 9 June, when Jacopo received the commission from the priest Evangelista, and 11 August, when the artist's final bill was paid. This very short working time testifies to his inventive fervor and speed of execution.

G.E.

JACOPO BASSANO 1545-1555

The decade from 1545 to 1555 marks in Jacopo Bassano's development the phase of his most openly declared involvement with mannerism in all of its various aspects and nuances. The period coincides with the artist's early maturity (between the ages of 35 and 45) and represents a time in both his personal and his artistic life that was particularly full of new and diverse interests and experiences. The result was a series of masterpieces that bear witness to his astonishing capacity for renewal and the great modernity of his painting between these dates. This is the moment more or less of his « third manner » posited by Volpato (Volpato, MS, fol. 362) and Verci (1775, 49), marked by his study of Parmigianino's « carte » and characterized by an unceasing experimentation in style and technique, sometimes daring but always sustained by an exceptional mastery of the art of painting.

Beginning with Longhi's pioneering insights (1926, 143) and moving up to the most recent contributions, scholars have always paid special attention to this chapter in Jacopo's career, emphasizing the originality of his contribution to the complex phenomenon of mannerism. The important, indeed crucial, nature of a mannerist core in Jacopo's career has been particularly reiterated by Freedberg (1988, 651), who subordinates to it both the early and late phases of the artist, seeing in the former the progressive emergence of his mannerist style and in the latter his moving beyond and away from mannerism.

In these years, with the experiences of his youth under the influence of Bonifazio, Titian, Lotto, Romanino, and Pordenone behind him, Jacopo turned his attention decisively toward the most advanced areas of contemporary culture, to Salviati, Porta Salviati, Parmigianino, Schiavone, and Tintoretto. His approach to new, formal directions took place mainly through the vehicle of graphic art, which allowed him to satisfy his thirst for new experiences and his eagerness to stay abreast of current artistic trends without compromising his natural inclination toward a reserved and settled life. As his interests and experiences grew, so too did the portfolio of drawings and engravings that he kept in his workshop. These works became the object of avid study, as well as the source for ideas and compositions that he then expressed with his own innate sense of color. Echoes from Rome – from Raphael, in particular, through the prints by Agostino Veneziano, Marcantonio Raimondi, and Ugo da Carpi that were making Raphael's work known to a vast public – and from Germany, mainly from the graphic work of Dürer, were now joined with mannerist influences arriving from Tuscany and Emilia, the latter in the elegantly decorative version offered by Parmigianino and introduced very early into Venice by Schiavone's engravings, beginning in the second half of the 1530s (Rossi 1984, 189). His graphic initiation into the world of mannerism would leave visible traces on Jacopo's painting tech-

nique, especially in the clear, incisive quality of his line, a characteristic, in particular, of the works around 1545, and in his peculiar personal way of shading, rendered through thin parallel and perpendicular lines giving a crosshatched effect.

The chronology within the decade, until recently the object of controversy between the two leading Bassano scholars, Ballarin and Rearick, can now be reconstructed with a fair degree of certainty on the basis of some fundamental documentary points of reference provided by the *Libro secondo* from the Dal Ponte workshop, published posthumously by Muraro (1992). In particular, to cite the most important instance with far-reaching implications, *The Beheading of the Baptist* (Statens Museum for Kunst, Copenhagen, fig. 29), once dated 1545 by Rearick, and by Ballarin c. 1551, can now be assigned the irrefutable date of 1550 on the basis of the account book, which also gives the name of its patron, Gasparo Ottello, a notary in Padua. Together with the Copenhagen picture, the dates about which we can now finally be certain are: 1545, *The Miraculous Draught of Fishes* (private collection, London, cat. 15); 1546-48, *The Last Supper* (Galleria Borghese, Rome, cat. 18); 1546-47, *The Trinity* (parish church, Angarano, fig. 21); 1548-49, *The Madonna with Saints Anthony Abbot and Louis of Toulouse* (cathedral, Asolo, cat. 19); 1548-50, *Two Hunting Dogs* (private collection, Rome); the summer of 1551, *The Descent of the Holy Spirit* (San Giacomo, Lusiana, cat. 20); and 1554, *The Miracle of the Quails and the Manna* (private collection, Florence, fig. 33). Together these works comprise a dense network of reference points that we can then use to construct a plausible sequence for undocumented works.

Next to the small altarpiece representing *The Martyrdom of Saint Catherine* (Museo Civico, Bassano del Grappa, cat. 13) from the summer of 1544 – in its exasperated intellectuality a programmatic manifesto of Jacopo's adherence to mannerism – can be placed *The Way to Calvary* (The National Gallery, London, cat. 14), datable c. 1545. The subject is a recurrent theme in Jacopo's early work, but this particular painting is a masterpiece of chromatic preciousness that reproposes in terms of compositional concentration and the annulment of space *The Martyrdom of Saint Catherine*. The compressed space in these two paintings is instead thrown wide open and inflated in *The Miraculous Draught of Fishes*, one of the sensational new offerings of this exhibition, painted in 1545 for the Podestà Pietro Pizzamano, in which the «thundering grandeur» (Longhi 1948, 50) of the foreground with the apostles in their boat, derived from an engraving after a cartoon by Raphael of 1516, looms large against an inscrutable distance of water and landscape.

Some of the artist's best-known depictions of the Adoration of the Shepherds belong to the period just after this. Both the terse, refined example, once in the Giusti del Giardino collection and now in the Gallerie dell'Ac-

cademia, Venice (cat. 16), for which a date of c. 1545 is proposed, and the one shimmering with human affection and bucolic feeling from The Royal Collection at Hampton Court (cat. 17) of about 1546, lead directly to the triumph of naturalism in a guise of mannered elegance found in *The Rest on the Flight into Egypt* (Pinacoteca Ambrosiana, Milan, fig. 24) of c. 1546.

A mannerist sense of space and an almost abrasive realism in the figures meet in a dialectical synthesis in the Borghese *Last Supper*, a benchmark of Jacopo's production in the years between 1546-48, presenting in unprecedented terms the relationship between the artist and Tintoretto.

The progressive affirmation of Jacopo's preference for a technique of touch, as opposed to the smooth painted surfaces of his early works, would develop in the years to come into his own very personal and inimitable style. This style is convincingly represented in the exhibition by the very beautiful altarpiece from Asolo in which the pigment, whipped up by his nervous handling of the brush, tends to swell and ferment, particularly in the trembling figure of the Virgin yearning toward heaven and in the masterful passage of Saint Louis' cope.

Once past the 1550 date of *The Beheading of the Baptist*, the summit of Jacopo's mannerism interpreted in a surreal, dream-like way, we move into a phase where his stylistic development is most openly indebted to Schiavone. It is characterized by flowing, linear rhythms and allusive forms, represented by the «*pallesina*» of *The Descent of the Holy Spirit* in Lusiana, just recently added to the painter's portfolio, the very well known *Way to Calvary* (Szépmüvészeti Múzeum, Budapest, cat. 21) of about 1552, and *The Mystic Marriage of Saint Catherine* (Wadsworth Atheneum, Hartford, cat. 22), dated 1552-53.

After his return to mannerism with a Parmigianesque inflection, represented by the lovely *Adoration of the Shepherds* (Galleria Borghese, Rome, cat. 23) of c. 1553-54, the decade closes, as far as the selection in this exhibition is concerned, with a pair of paintings of disconcerting modernity, a real bridge thrown across to the artistic achievements of the next century: *Lazarus and the Rich Man* (The Cleveland Museum of Art, cat. 24), the presumed pendant to *The Miracle of the Quails and the Manna* of 1554, and *Two Hunting Dogs* (Galleria degli Uffizi, Florence, cat. 26), assigned to c. 1555. Jacopo's very special experience of light and corresponding investigation of shade that infuse the unequaled masterpiece of *Lazarus and the Rich Man* point peremptorily, as scholars have reiterated, in the direction of the greatest seventeenth-century painters, especially Velázquez at his most Caravaggesque. In a different way, the hyper-realistic naturalism of the «portrait of two dogs» in the Uffizi suggests an obvious reference to the art of reality of the seventeenth century.

MARIA ELISA AVAGNINA

285

14. The Way to Calvary (c. 1545)

The National Gallery, London, inv. 6490
Oil on canvas, 146×132 cm (57 1/2×52 in.)

Provenance
Gerrit Reynst, Amsterdam; King Charles II, 1660; King James II, 1668; the Viscount of Torrington, 1721-27; the Earl of Bradford, Weston Park; The National Gallery, London, 1984.

Exhibitions
London 1960; London 1983.

Bibliography
Arslan 1929 (A), 73-74; Longhi 1948, 46; Mahon 1950, 15; *Italian Art* 1960, 36-37, no. 64; Arslan 1960 (B), 66-67, and 179, and II, fig. 56; Ballarin 1967, 98; Ballarin 1973, 108; Magagnato 1983, 147, no. 4; Rearick 1984, 302; Rearick 1986 (A), 182; Freedberg 1988, 654-55, fig. 241.

The painting, probably acquired in Venice by the Dutch art merchant and collector Gerrit Reynst, was taken to Amsterdam and was subsequently given, together with other paintings from the Dutch States, to King Charles II of England on the occasion of his coronation. Listed in the 1668 inventory of King James II among the paintings in the custody of Catherine of Braganza between 1721 and 1727, it was in the hands of the Viscount of Torrington, from whom it was inherited by the Earl of Bradford at Weston Park. In 1984 it was sold by the earl and entered The National Gallery in London.

Beginning with an erroneous indication by Arslan (1929 (A)), the painting has been confused in the past with a copy, probably made by a Flemish artist, in the museum in York since 1955 (*Catalogue of Paintings* 1961, 1, 5-6, no. 773). Faithful to the original in the drawing but not in the dull and uniform handling of the color, this painting was presented as Jacopo's work in the exhibition in Venice in 1957 (Zampetti 1957, 46, no. 18), despite Mahon's (1950) correction of the error.

This *Way to Calvary* treats in openly mannerist terms a theme Jacopo had already approached several times, in *The Way to Calvary* (private collection, London, fig. 13) recently attributed to Jacopo by Rearick (see here, Rearick's essay), one in the Fitzwilliam Museum, Cambridge (cat. 12), and the one in the Christie collection, Glyndebourne (fig. 27), which is considered by Ballarin (1967, 98) to be an introduction to this one. Ballarin, as did Bettini (1933, 44) although he was working with the copy, finds in this picture « behind the whirling, convulsed relationship between the elements... the influence of Schiavone » in its earliest manifestation. Ballarin particularly points out that the group of Marys at the right edge of the painting, « united by the same rhythmic wave », is a derivation from an engraving by Meldolla depicting *Jesus Talking to the Women on the Stairs*. It is a motif that, in turn, seems indebted to Dürer's graphic models in the *Small Passion*, at least in the Virgin's heartfelt gesture as she presses to her face her hand hidden by a corner of her cloak, while the other hand gathers together the cloak's cascading folds. The composition is squeezed into a square canvas as if it were the blocked frame of a longer cinematic sequence and is held firmly together by the « mannerist knot [which] finally ties up the painting without dwelling any longer on illusionistic fragments » (Longhi 1948, 46), almost as though the artist had wanted to speed up the looser, slower compositional connections in the earlier versions of the *Calvary* by compressing the format in width. The figures overlap and interlock in a sort of *horror vacui*, pushed by a flow of line and a nervous wave-like rhythm that seems to move beyond the edges of the canvas. The planes of color are juxtaposed as in a marble inlay or stained glass window, in a rich and precious symphony of tones and gradations that confirm once again Jacopo's greatness as a colorist.

The painting was dated by Ballarin (1973) around 1545 and by Magagnato (1983) in a wider lapse of time, between 1545-50. Rearick (1984), like Arslan (1960 (B), 1, 66) before him, accepted this chronology and considered it immediately subsequent to *The Beheading of the Baptist* (Statens Museum for Kunst, Copenhagen, fig. 29) in a hypothesis for the reconstruction of Jacopo's activity between the mid-1540s and early 1550s that is now refuted by recently discovered documents. The date of c. 1545 convincingly places the work in a moment just after the small altarpiece depicting *The Martyrdom of Saint Catherine* (Museo Civico, Bassano del Grappa, cat. 13), a programmatic manifesto of Jacopo's adherence to mannerism, dated 1544 by the *Libro secondo*. This *Calvary* repeats, in a more narrative and fluid manner, the interlocking forms and incisive line of the *Saint Catherine*.

A reversed engraving of the painting, slightly widened at its upper edge, was made by Jeremias Falk for the volume *Varium imaginum a celeberrimis artificibus...*, published in

15. The Miraculous Draught of Fishes (1545)

Private Collection, London, Loan Arranged by Courtesy of Matthiesen Fine Arts, Ltd.
Oil on canvas, 143 × 243 cm (56.5 × 95.5 in.)
Exhibited in Fort Worth only

Amsterdam around the middle of the seventeenth century (Pan 1992, no. 54).

M.E.A.

Provenance
Pietro Pizzamano, Venice, 1545.

Exhibitions
Never before exhibited.

Bibliography
Rearick 1992 (B), in press.

On folio 99 verso of the *Libro secondo* Jacopo recorded, under the date 12 April 1545, the agreement with the Podestà Pietro Pizzamano by which he was to paint « Christ in the Boat with the Apostles » for twelve gold scudi, a value of eighty-two lire sixteen soldi. It may be assumed that the picture was finished and delivered before August of that year, when Pizzamano left office in Bassano del Grappa to return home to Venice, where *The Miraculous Draught of Fishes* was probably hung in the family palazzo on the Giudecca. There it was admired by many Venetian artists including Titian, who adapted it for the distant group in his 1547 *Virgin and Child in Glory with Saints Andrew and Peter* (cathedral, Serravalle). Its history before its reappearance in London in 1989 remains unknown. In 1990-91 it was expertly restored by Robert Shepherd; it is generally in very good condition except for a small area surrounding an old tear in Christ's mantle.

Jacopo used Ugo da Carpi's *Miraculous Draught of Fishes* woodcut (Bartsch 1803-21, XII, 19, no. 13) as his point of departure. It, in turn, was loosely based on Raphael's design for the Sistine Chapel tapestry of this subject. Jacopo reversed the print and made major revisions in the figures, especially the father of

Zebadea, who mans the oar at right. He expanded lake Geneserath into a vast seascape, bound at right by a pastoral landscape with a limpid view of Bassano in the middle distance and Monte Grappa on the horizon. The fortified town at left is topographically explicit and might represent a Dalmation outpost associated with the Pizzamano. Using his familiar unfurling cape motive to link Saint Andrew to the second boat, Jacopo here warps space to compress the dramatically looming figures into a monumental frieze that resonates against the dazzlingly luminous space behind. Color, equally, assumes a solemn gravity, a restrained harmony of strong blues, bottle green, and rose, set against accents of yellow, red, and rust in Saint Peter's jacket. Now Jacopo's exuberant preciosity of the preceding *Martyrdom of Saint Catherine* (cat. 13) takes on a mature discipline that will lead directly to the majestic *Trinity* (parish church, Angarano) of the following year.

W.R.R.

114

16. THE ADORATION OF THE SHEPHERDS (c. 1545)

Gallerie dell'Accademia, Venice, inv. 48214
Oil on canvas, 95×140 cm (37 3/8×55 1/8 in.)

Provenance
Giusti del Giardino collection, Verona, in 1934; Caracas; Verona; Onara di Tombolo; purchased by the Gallerie dell'Accademia, Venice, 1983.

Exhibitions
Amsterdam 1955; Caracas 1956; Venice 1957; Los Angeles 1979; Tokyo 1980; Venice 1981; Naples 1985; New York 1985.

Bibliography
Arslan 1934 (A), 123-24; Arslan 1938, 464; Caracas 1956, no. 67; Pallucchini 1957, 102; Zampetti 1957, 52-55, no. 21; Berenson 1957, I, 21; Zampetti 1958, 25; Arslan 1960 (B), I, 77, 93, n. 33, and 173, and II, figs. 71-73; Ballarin 1973, 108; Pignatti 1979, 136, no. 49; *Capolavori del Rinascimento* 1980, no. 19; Magagnato 1981, 171, no. 53; Pallucchini 1982, 28; Rearick 1985, 50; Rearick 1986 (A), 183; Freedberg 1988, 654; Lloyd 1991, 58.

Brought to the attention of scholars by Arslan in 1934, when it was in the Giusti del Giardino collection in Verona, the painting was recently acquired (1983) by the Gallerie dell' Accademia in Venice. In the absence of certain information about its original provenance, even taking into consideration the frequency of the subject in Jacopo's production, and despite the connection already established by Arslan with *The Adoration of the Shepherds* (Galleria Corsini, Rome, cat. 36), Ridolfi's mention (1648, I, 382) of a painting in Venice in the house of Cristoforo Orsetti, owner of other pictures by Jacopo, seems worthy of attention. His meticulous description of this piece, a «Nascita del Salvatore» (Birth of the Savior) is surprisingly appropriate for the Venetian *Adoration*: «l'altra [tela] dimostra il sorger dell'Aurora e la Vergine che raccoglie il nato figlio trà le bende, e quivi stanno altresi pastori adoranti, ed in questa volle imitare la leggiadria del Parmegiano con esquisito colorire, si che paiono vive figure e vi ritrasse al naturale alcuni giumenti» (the other [canvas] shows the rising of the Dawn and the Virgin who gathers her just born son into the swaddling clothes, and there stand also adoring shepherds, and in this he wished to imitate the lightness of Parmegiano [Parmigianino] with exquisite color, so that the figures seem alive, and he portrayed some cattle in a lifelike way).

In fact the composition, which repeats in its overall design Titianesque schemes, is remarkable for the polished enameled luminosity of its colors, enclosed within an inlay of sharp linear confines, and for the refined elegance of the figure of the Virgin, openly taken from Parmigianino's models. With mannered sweetness, the Virgin stretches to show the newborn Savior to the shepherds, who have arrived with their flocks, described in all their ordinary reality. «Manner» and truth live side by side in a subtle balance within an almost rigid division of the field, marked by the tender figure of the Christ Child and the column behind him and underscored chromatically by the contrast between the muted dark tones on the right and the precious brilliant tints on the left.

The painting has been the subject of controversy over its date. While Zampetti, Arslan, Magagnato, and Pallucchini (1982) lean toward a position around the middle of the 1540s, near *The Adoration of the Shepherds* (The Royal Collection, Hampton Court, cat. 17) and *The Rest on the Flight into Egypt* (Pinacoteca Ambrosiana, Milan, fig. 24), Ballarin (1973) and Rearick (1985; and here, Rearick's essay) tend to place it later, c. 1549-50, contemporary with a renewed interest in Schiavone's drawing style, or between 1546-48, respectively.

In reality a certain crudeness in the drawing of the work, which openly declares its graphic ascendancy, seem less like the works from the end of the decade, such as *The Madonna with Saints Anthony Abbot and Louis of Toulouse* (cathedral, Asolo, cat. 19) of 1548-49, than it finds a reference in the sharp, incisive line cutting out the figures in *The Miraculous Draught of Fishes* (private collection, London, cat. 15) documented in 1545. Likewise, the precise citation of Parmigianino leads us to think of Jacopo's early, experimental adoption of the formal idiom of the artist from Parma, which is more in keeping with a moment near the beginning of the decade. All this seems to point in the direction of a date c. 1545, just slightly earlier than the Hampton Court *Adoration*, which is a more naturalistic version of the same theme, and thus leads more openly to the masterpiece in the Ambrosiana, which art historians date c. 1546, where a mannerist suggestiveness is fully resolved in a merger with Jacopo's purest naturalistic vein.

M.E.A.

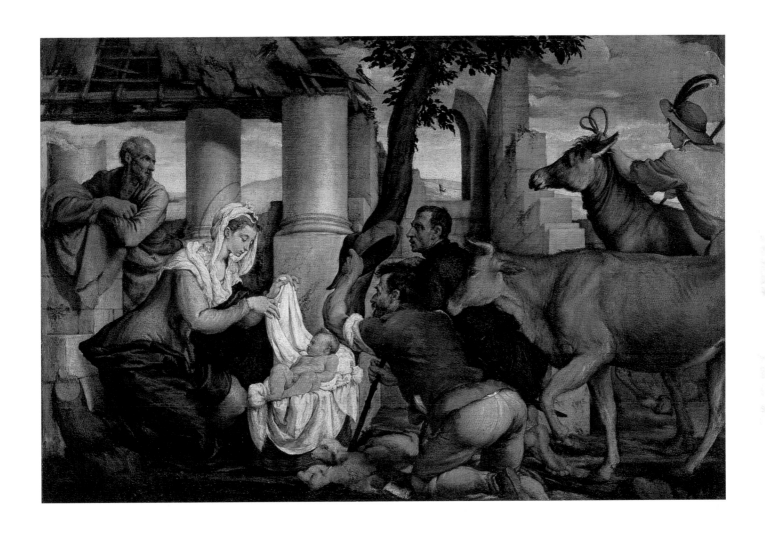

17. THE ADORATION OF THE SHEPHERDS (1546)

The Royal Collection, Hampton Court, inv. 467, Lent by Her Majesty Queen Elizabeth II
Oil on canvas, 139.5×219 cm (54 7/8×86 1/4 in.)
Exhibited in Fort Worth only

Provenance
Possibly in the collection of King Charles I at Wimbledon; very probably listed in the inventory of James II, Kensington, 1697; hanging in the King's Writing-Closet at Hampton Court, 1785-1819; in the Queen's Bedroom, mid-nineteenth century; in the King's Drawing-Room, end of nineteenth century.

Exhibitions
London 1822; Leeds 1868; London 1946; Venice 1957; London 1964; Montreal 1967; London 1991 (A).

Bibliography
Bickham 1755, 23; *Delices* 1785, 9; Pyne 1819, ii, 85; Jameson 1842, ii, 363; Powell 1853, 47; Crowe and Cavalcaselle 1871, ii, 291 and 486; Law 1881, no. 163; Berenson 1894, 83; Logan 1894, 33; Phillips 1896, 103; Law 1898, no. 163; von Hadeln 1914 (C), 58; Willumsen 1927, i, 201, and ii, 85; Arslan 1929 (B), 191; Collins Baker 1929, 5; Venturi 1929 (B), 1133-34; Arslan 1931, 75 and 190; Berenson 1932, 57; Pevsner 1932, 163-64; Spahn 1932, 134; Bettini 1933, 46-48 and 161; Pittaluga 1933, 302-3; Tietze Conrat 1936, 142-43; Nicolson 1947, 226; Longhi 1948, 46; Pallucchini 1950, 53; Magagnato 1952 (B), 225; Noë 1956, 301-2; Fiocco 1957, 96; Fröhlich-Bum 1957, 213; Pallucchini 1957, 102; Pignatti 1957 (A), 355; Zampetti 1957, 50, no. 20; Zampetti 1958, 26; Baldass 1958, 294-95; Berenson 1958, i, 18; Pallucchini 1959, 265; Furlan 1959-60, 76-78; Arslan 1960 (B), i, 75, 77-78, and 168, and ii, figs. 74-76; Ballarin 1967, 90 and 93; Freedberg 1971, 371; Pallucchini 1982, 28 and pl. 13; Shearman 1983, 21-23, no. 16; Rearick 1984, 302; Freedberg 1988, 653-54; Lloyd 1991, 58-59.

The painting probably entered the royal collections with its correct attribution to Jacopo Bassano, but subsequently, around 1700, it was assigned to Palma il Vecchio. Reclaimed for Jacopo by Powell in 1853, it was placed by Crowe and Cavalcaselle (1871) among the works of the artist's early maturity, in an intermediate position between *The Adoration of the Magi* (The National Galleries of Scotland, Edinburgh, cat. 10) and *The Rest on the Flight into Egypt* (Pinacoteca Ambrosiana, Milan, fig. 24), a chronology that has been almost unanimously accepted by later art historians.

The inspiration for the composition comes, as has been observed, from Titian's *Nativity* for the Duke of Urbino (now Galleria Palatina, Palazzo Pitti, Florence), through an engraving after it done by Giovanni Britto. The Hampton Court painting takes from this source its overall *mise en page* and certain details, such as the Virgin's gesture and the figure of the shepherd taking off his hat, this latter copied punctiliously from the engraving. Pittaluga's hypothesis (1933) that the composition is Jacopo's invention is refuted not only by the chronology, but also by the arrangement of the figures, which in the Hampton Court canvas, as in Britto's print, is reversed with respect to Titian's painting.

The canvas presents once again the theme found in the former Giusti del Giardino *Adoration of the Shepherds* (Gallerie dell'Accademia, Venice, cat. 16), in terms, however, of complete and convinced abandonment to naturalism, in which «every intellectualism has by now been left behind in a narrative once again trembling with affection» (Ballarin, 90). The Virgin's elegant but detached gesture in the Venetian picture here takes on a tender maternal dimension, epitomized by the communication between the eyes of the mother and child. The distant view of Bassano, which stands out against the blue slopes of Monte Grappa and the surrounding countryside, is captured in a warm afternoon light that places the extraordinary event in a context of real space and time and creates a passage of «Georgic poetry» so congenial to the artist (Pignatti 1957 (A), 355). «The wide solid plasticity of the forms molded of a compact *humus*» (Venturi 1929 (B), 1133) places them squarely in the luminous spotlight of the foreground, imprinting them against the precarious architecture of the stable, whose capricious design is indebted to Dürer's graphic work.

The very rich and rare range of colors, struck by a stream of warm light, designs «a large multi-colored mosaic» (Venturi, 1929 (B), 1133), in which are juxtaposed, «graduated with insuperable elegance», the violet of Saint Joseph's robe cut out against the orangish yellow of his cloak, the amaranth of the doublet and metallic blue-green of the breeches of the kneeling shepherd, and the acid sulphur yellow and bright *changeant* pink of the clothes of the man playing a bagpipe. Particularly skillful is the handling of the figure of the shepherd coming into the picture from the right and carrying a pair of hens – an example of the fragrance of daily life in Jacopo's compositions – his hot face emerging from the shadow of his hat and his silhouette, played on a subtle

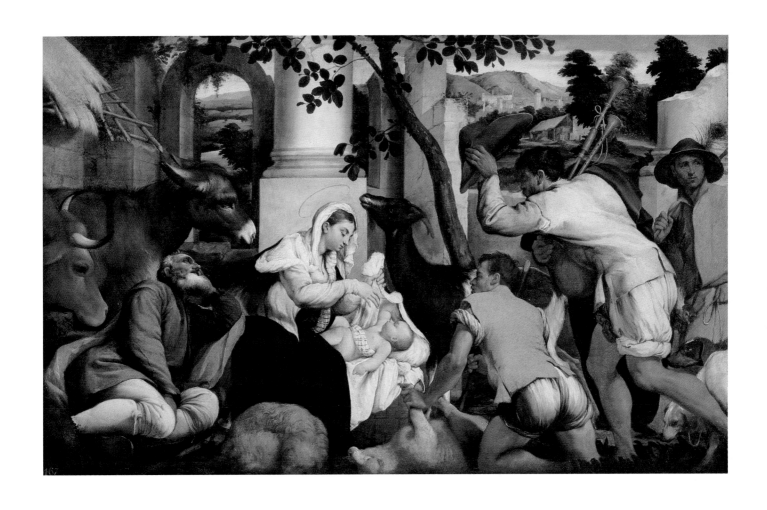

18. THE LAST SUPPER (1546-48)

Galleria Borghese, Rome, inv. 144
Oil on canvas, 168×270 cm (66 1/8×106 3/8 in.)

modulation of warm tones, standing out against the white column behind him.

A number of copies are known of the painting. Its support is a patchwork of different pieces of canvas and has an addition of about 18 centimeters on its upper edge. For this reason it was thought that the painting was originally smaller and subsequently enlarged (Nicolson 1947). Similarly, an evident pentimento in the center of the composition (the head of a man can be detected to the right of the goat's muzzle) testifies in favor of Jacopo having reworked the original design as he painted the canvas.

In light of the same observations already made concerning the Venetian *Adoration of the Shepherds*, the date of c. 1544-45 proposed for this painting by Shearman (1983), which synthesizes the opinions of earlier scholars, could be advanced slightly to c. 1546, a date closer to the Ambrosiana *Rest on the Flight into Egypt*, which it foreshadows in its naturalistic feeling, even if it does not yet share the subtle tremor of the line.

M.E.A.

Provenance
Battista Erizzo, Venice; Galleria Borghese, Rome, 1700.

Exhibitions
Venice 1957; Venice 1981.

Bibliography
Libro secondo, fol. 18*v*; *Inventario* 1700, St. III, no. 16; Rossini 1725, 38; Ramdhor 1787, I, 290; *Inventario* 1790, St. III, no. 13; *Inventario Fidecommisso* 1833, 18; Piancastelli 1891, MS, 50; Venturi 1893, 102; Berenson 1894; Berenson 1906, 85; Zottmann 1908, 35-36; Lorenzetti 1911, 256, no. 1; von Hadeln 1914 (C), 59; Willumsen 1927, I, 107-23; Delogu 1928, 25; Longhi 1928, 76 and 192; Arslan 1929 (B), 193-94; Venturi 1929 (B), 1157 60 and 1253; Arslan 1931, 194; Bettini 1933, 43 and 159; Arslan 1938, 469; Longhi 1946, 26; Longhi 1948, 50; Pallucchini 1950, 53 and 103; Della Pergola 1951, 46; Della Pergola 1955, 99-100, no. 174; Muraro 1957, 296; Pallucchini 1957, 103-4; Zampetti 1957, 64, no. 25; Zampetti 1958, 30-31; Arslan 1960 (B), 78-79 and 94, ns. 35-36, and 175, and II, figs. 78-81; Krönig 1966, 551-59; Ballarin 1973, 96; Magagnato 1981, 169, no. 52; Pallucchini 1982, 29 and pl. 17; Muraro 1982-83, 78-83; Rearick 1984, 305; Rearick 1986 (A), 183; Freedberg 1988, 654; Joannides and Sachs 1991, 695-99.

This painting is most probably the «Cena» which, according to the *Libro secondo*, was commissioned in 1546 by the Venetian aristocrat Battista Erizzo and paid for in three installments, during the following year and in the first months of 1548, for a total of 30 gold scudi. An earlier version of the same subject has recently been brought to the attention of art historians by Joannides and Sachs. It is identified in the *Libro secondo* as the «Cenaculo» and was commissioned by Ambrogio Frizier de la Nave in September 1537 (now church of Saint Lawrence, Wormley, Hertfordshire). The complexity of the composition and very high quality of the Borghese painting's technique make it one of the benchmarks in Jacopo's career around the second half of the 1540s. The information recently made available about its chronology and commission serve to accentuate the painting's importance.

Over the years, the painting has been the subject of contrasting critical opinions. It is mentioned for the first time in the Borghese *Inventario* of 1700 as the work of Titian and subsequently by Ramdhor (1787) as by Schiavone. It was finally claimed for Jacopo by Venturi in the catalogue of the Galleria Borghese drawn up in 1893. Nonetheless, Lorenzetti (1911) still tended to believe it was the «work of the school or the workshop, rather than Jacopo», while Willumsen (1927) attributed it without doubt to El Greco. Arslan (1938) compared it, because of its date, to Tintoretto's *Last Supper* for the church of San Marcuola in Venice, which had been finished on 27 August 1547 and has a more inflated and complex arrangement of space. Pallucchini (1950), restating the comparison more precisely in terms of derivation, used the date of Tintoretto's canvas as a *terminus post quem* for Jacopo's, which he placed around 1550, a date with which other art historians mainly concurred (Longhi 1948; Zampetti 1957; and Magagnato 1981). An earlier date, now supported by the documents,

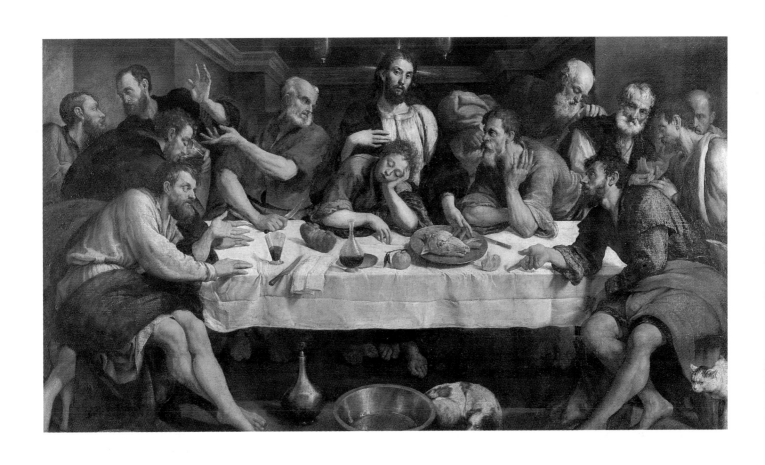

also establishes the contemporaneous, if not slightly earlier execution of Jacopo's *Last Supper* with regard to Tintoretto's. This requires a reconsideration of the relationship and exchange between the two artists, a subject on which Longhi (1948, 52), with his usual critical acumen, wrote, « One could almost say that Bassano goes beyond them [Tintoretto and Schiavone] in poetic invention ».

Jacopo's compositional structure was derived from Raphael through an engraving of *The Last Supper* by Marcantonio Raimondi (fig. 17). Onto this he grafted elements taken from Dürer's graphic production (with cross-references to the woodcuts from the *Large Passion* of 1510 and 1523). These borrowings from Dürer are evident mainly in the great compression of the composition and the positions of Christ and Saint John, as well as in the poses of some of the other figures and a few minor details, which tend to rework in mannerist terms the « classical » text. The closed space of the narrow architectural setting is compressed to the limits of claustrophobia between the architecture in the background and two apostles in front of the table in the foreground. Gathered around a forcibly foreshortened table, which is tipped toward the observer, the twelve apostles are united by an interlocking chain of studied gestures, foreshortened, agitated, and prehensile hands, and arms « fibrous... like the trunks of debarked trees » (Venturi 1929 (B), 1157). Underlying the complexity of the painting, its interpretation of space, and its strongly mannerist compositional syntax, is Jacopo's most congenial vein of pungent, almost plebeian, realism. This is evident in the rendering of the apostles' physical features, represented with no intent of idealization, as the artist draws on his already familiar repertory of figures of shepherds and ordinary people.

Considered by Venturi to be « one of the greatest examples of the possibilities offered by Jacopo's art », the Borghese *Last Supper* presents, along with its compositional daring, an attempt at a wider orchestration of chromatic values. These values are composed around the central point of the white tablecloth, which is made even more substantial by the light. Against this white, a « pre-seventeenth-century » still life stands out. The restoration currently in progress, which has already revealed enameled colors with large planes of light and shade obtained with various glazes, will inevitably lead to corrections of earlier readings of the painting that were made when it was covered by thick dark oxidized layers of varnish. These alterations of the painted surface had led Bettini (1933, 43) and Venturi (1929 (B), 1159) to see in the work a foreshadowing of the achievements of Velázquez and Ribera.

M.E.A.

296

19. THE MADONNA WITH SAINTS ANTHONY ABBOT AND LOUIS OF TOULOUSE (1548-49)

Chiesa cattedrale, Asolo
Oil on canvas, 170×155 cm (66×60 in.)
Inscriptions: IAC.⁵ BASS.⁵ P on the rock at bottom center

Provenance
Cathedral, altar of Sant'Antonio Abate, Asolo.

Exhibitions
Bassano 1952; Venice 1957.

Bibliography
Libro secondo, fols. 118*v*-119*r*; ACV Treviso, *Visite pastorali*, 1625; Ridolfi 1648, I, 377; Verci 1775, 112; Federici 1803, II, 63; von Hadeln 1914 (B), I, 388; Arslan 1931, 185; Bettini 1933, 51 and 167; Valcanover 1950, 354-55; Magagnato 1952 (A), 12, 41, and no. 20; Magagnato 1952 (B), 226; Magagnato 1956, 106; Fiocco 1957, 96; Pallucchini 1947, 104; Zampetti 1957, 112, no. 43; Berenson 1958, I, 16; Arslan 1960 (B), I, 76, 93, n. 32, and 161, and II, figs. 68-70; Ballarin 1964, 62; Dillon 1980, 125-26 and 144, ns. 4-8; Muraro 1982-83, 91-97; Rearick 1986 (A), 184; Dal Pozzolo 1990, 108 n. 24.

The altarpiece was originally placed above the first altar on the left in the Asolo cathedral, which belonged to the Confraternita dei Battuti and was dedicated to Saint Anthony Abbot. Records of the bishop's visit of 1625 report it there, as does Verci in 1775, who commented that even then it was «assai danneggiata dalla polve» (quite damaged by dust). Removed from the altar of the Battuti in 1872, the painting now hangs on the west wall of the church. It was returned to its original dimensions during the 1950 restoration (Valcanover 1950), when a large seventeenth-century addition was removed. The canvas repeats the size, the compositional scheme, and the subject of an altarpiece by Lorenzo Lotto, which had been completed a little more than forty years earlier in 1506 and was also in the cathedral. Various hypotheses have been put forward in an attempt to explain this unusual circumstance (Dillon 1980), but it seems most likely that Jacopo's painting was intended to replace Lotto's for iconographical reasons connected with the representation of the Virgin, who in Lotto's picture probably portrays Caterina Cornaro (Dal Pozzolo 1990, 180-92).

The altarpiece has generally been dated in the 1550s, whether at the beginning of the decade (Pallucchini (1947) and Ballarin (1964): 1550, or shortly thereafter); at the end (Bettini: 1558; and Magagnato: toward 1560); or even later (Zampetti: 1560-65). The sole exceptions are Valcanover and Rearick, who assigned it to the 1540s. On the basis of information in the *Libro secondo*, we can now establish definitively that the painting was done in 1548-49 and place it in a chronology that brings it close to *The Trinity* in Angarano (fig. 21) of 1546-47, to which it is very similar in style and practically identical in certain details of landscape. An unusually young and captivating Virgin rises to heaven in a mandorla of sulphureous light beneath the ecstatic gaze of Saint Louis of Toulouse (not Saint Stephen, Saint Basil the Great, or Saint Louis IX of France, as some art historians have erroneously claimed), who is wrapped in a sumptuous cope, and the incredulous curiosity of Saint Anthony, who leans lazily on his staff. Beneath the Virgin's feet, a landscape, which is highly realistic and at the same time poetic, is revealed. The scene, which translates the composi-tional scheme of the upper part of Raphael's *Transfiguration* into a language of fragrant, bucolic immediacy, is iconographically more consonant, as has been observed, with a representation of a miraculous apparition of the Virgin rather than a canonical Assumption. The composition, tightly enclosed in the almost square canvas, is traversed by a nervous shudder that finds its highest expression in the vibrant figure of the Virgin stretching toward heaven, wrapped in the arabesque of her wind-filled cloak, and in the inarrestable movement of her veil. The intimate stylistic energy that innerves the forms, derived from Jacopo's study of Parmigianesque line diffused through Schiavone, is accompanied on the level of technique by a loose, vibrant brushstroke, lifted at times by sharp irridescent streaks of light, and a palette emanating a «juicy fragrance» (Magagnato 1952 (B)). The picture gives us an immediate prelude to the technique of touch that would become Jacopo's stylistic signature in the later decades.

M.E.A.

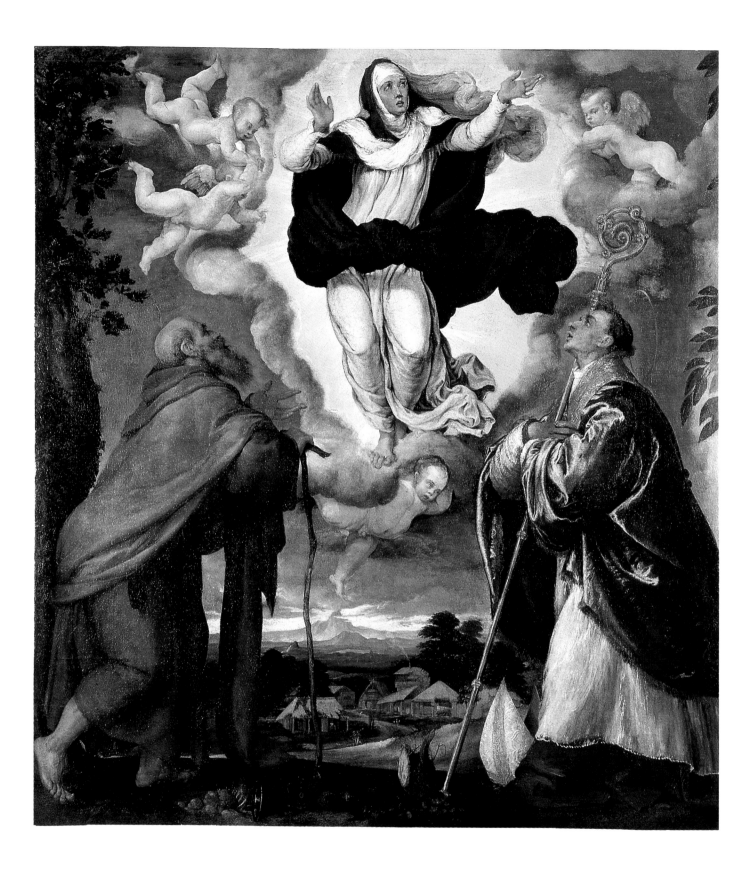

20. The Descent of the Holy Spirit (1551)

Chiesa di San Giacomo, Lusiana
Oil on canvas, 161 × 68 cm (63 3/8 × 26 3/4 in.)
Exhibited in Bassano del Grappa only

Provenance
Church of San Giacomo, Lusiana, 1551.

Exhibitions
Never before exhibited.

Bibliography
Libro secondo, fols. 120v-121r; *Notiziario veneto* 1989-90, 209-10.

This painting, hitherto unpublished, was recognized as Jacopo's by the present writer on the occasion of its recent restoration (1988-89) and mentioned in the restoration notes in *Notiziario veneto* (1989-90) as the certain work of the artist. Publication of the *Libro secondo* in the meantime has confirmed the attribution and allowed us to establish precisely the circumstances of its commission, the date, and the price of the painting. «Adí 13 zugno 1551... sier Liviero Ranzon, massaro de la schola del Spirito Santo in la giesia de S. Jacomo de Lusiana» (On 13 June 1551, Liviero Ranzon, steward of the school of the Holy Spirit in the church of San Giacomo in Lusiana) stipulated with Jacopo, for the price of 8 ducati, a contract for the execution of a «pallesina de piè 4 larga e sie alta cum la mission del Spirito Santo» (altarpiece 4 feet wide and 6 high with the mission of the Holy Spirit). According to registrations of subsequent payments, the altarpiece seems to have been already in place on 12 July of the same year, implying a very brief time of execution.

The canvas is not recorded in the *Visita pastorale* of Bishop Pisani in 1563, but does appear in the records of the following two visits by Omanetto in 1571 (AVP, VII, fol. 387) and Emo (AVP, IX, fol. 105). Strange-ly, neither Ridolfi (1646) nor Verci (1775) mention it, although they both record the early altarpiece by Jacopo in the nearby church of Santa Caterina in Lusiana, giving support to the thesis, especially in the case of Verci, that the work was removed as a result of the enlargement of the church, which took place between 1684 and 1721. The painting's modest dimensions, which do not correspond to those of the current altarpiece of the Holy Spirit, which is placed half-way down the right nave, seem to confirm that it was originally destined for a different space. Once again, this supports the theory of its substitution, and explains the silence in the sources as well as the state of abandonment in which it was found (folded over several times and forgotten in the church attic).

The painting's theme is taken from the Acts of the Apostles (2:1-4), which recounts the descent of the Holy Ghost disguised as tongues of fire onto the disciples who had met together in a house. This image is united with the representation of the Holy Spirit in the form of a dove, thus implicitly reaffirming the dogma of the Trinity, which was a very hotly debated subject in the Veneto region throughout the first decades of the sixteenth century.

The theme, not new to Jacopo, would be taken up again in his *Descent of the Holy Spirit* for the church of San Francesco in Bassano (now Museo Civico, Bassano del Grappa, cat. 119). This picture, dated around 1559, was inspired compositionally by Titian's painting of the same sub-ject of about a decade earlier done for the brothers of the Santo Spirito in Isola (now Santa Maria della Salute, Venice; see Pilo 1989, 154-69). There, however, Titian introduced a number of significant iconographical changes, such as the more centrally placed Virgin rapt in prayer and the importance given in the foreground to the figures of Peter and Luke, identified, respectively, by their attributes of keys and a pen and inkwell, which allude to *traditio* and *scriptura*. These tend to reiterate, in line with the strict orthodoxy of the Franciscans who commissioned the painting, fidelity to the tenets of the Council of Trent and the institutional aspect of the Church, founded on the event of the Pentecost.

In the Lusiana painting, on the other hand, the emphasis on books – from the closed books placed prominently on the steps in the foreground, to the half-open book held by the Madonna, to another book open on the lap of the seated apostle at the extreme right – seems to draw attention intentionally to the Scriptures, the object of reading and discussion for the gathered apostles, and the foundation of the Church's evangelical mission. Thus Jacopo consciously creates a precise iconographical link with Dürer's engraving from the Small Passion series representing the *Pentecost*.

In an ambiance defined by classical structures, whose architectural improbability creates a mannerist space, the apostles gather around the Virgin intent on her reading. Postures of meditation and debate alternate with gestures of prayer and in-

vocation, as in the figure hardly more than an adolescent seen from behind praying in the foreground, or in the one with uplifted arms framing the scene on the right edge. The latter apostle was inspired by a similar figure in an engraving after Schiavone's *Miracle of the Quails and the Manna*, which Jacopo would repeat in his painting of the same subject (private collection, Florence, fig. 33). The faces of the apostles and the Virgin, in particular, foreshadow in their allusive and abridged forms and sharp profiles the physiognomies in *The Way to Calvary* (Szépmüvészeti Múzeum, Budapest, cat. 21), painted almost immediately after this picture, or in *The Mystic Marriage of Saint Catherine* (Wadsworth Atheneum, Hartford, cat. 22), dated 1551-52. Among the other characters, the face of the apostle seated on the far right stands out for its intensity of expression, almost certainly a portrait; his handsome, strongly virile face looks squarely out of the painting, imprinting his image on the shadow created by the figure behind him.

The chromatic register, which is still notable for its timbre despite the deteriorated condition of the painting surface, plays on very few colors, variously infused with a luminous white: from intense dark blue through lighter blues, to just barely pink glazes, to moss green, to the spent tones of ocher. Everywhere, defining hair and beards, drawing shadows on the clothes or the folds of the skin, are liquid, transparent brushstrokes of bitumen, which can be related to Volpato and Verci's re-marks about Jacopo's extensive use of a material, called « *aspalto* ».

The certainty of the painting's date, when compared to the equally certain date of *The Beheading of the Baptist* (Statens Museum for Kunst, Copenhagen, fig. 29) almost immediately preceding this one at the end of 1550, is illuminating, since the Copenhagen picture is so very different in the completely fantastic and unnatural glow of its color. While these dates unarguably allow us to define some firm points of reference at the beginning of the 1550s – as exciting a moment as it is miserly with certainties – they also show the great freedom of creativity and reference that characterizes Jacopo's production, even within the same moment.

M.E.A.

300

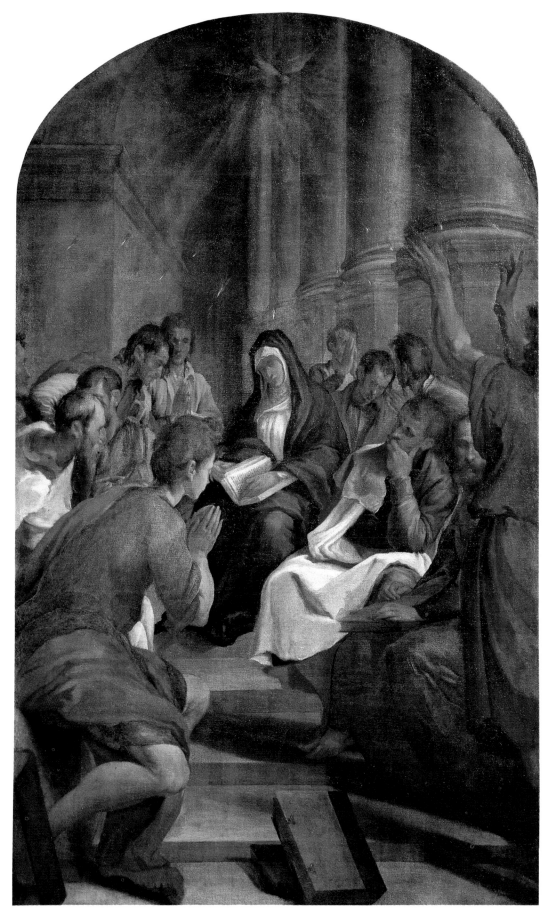

21. THE WAY TO CALVARY (c. 1552)

Szépmüvészeti Múzeum, Budapest, inv. 5879
Oil on canvas, 94×114 cm (37×44 7/8 in.)

Provenance
New York, 1922, gift of Eugen Boross to the Szépmüvészeti Múzeum, Budapest.

Exhibitions
Venice 1957; Venice 1981.

Bibliography
De Terey 1924, 80, no. 141; Venturi 1929 (A), 117 and 121; Venturi 1929 (B), 1150-53; Bettini 1930, 593; Fröhlich-Bum 1930 (A), 359; Arslan 1931, 342; Bettini 1933, 45 and 161; Longhi 1948, 48 and 52; Pallucchini 1957, 104; Zampetti 1957, 82, no. 31; Berenson 1958, I, 17; Zampetti 1958, 31 and 70; Arslan 1960 (B), I, 83-84, 94, 97, 107, 165, and 317, and II, fig. 93; Hauser 1965, 216; Ballarin 1965 (B), 66; Ballarin 1967, 98; Pigler 1967, 43; Ballarin 1973, 184; Garas 1977, 78; Magagnato 1981, 173, no. 54; Pallucchini 1982, 30, pl. 19; Garas 1985, 46; Rearick 1986 (A), 184; Freedberg 1988, 656; *Museum of Fine Arts* 1991, 5, ills.

Nothing is known about this work before 1922, when it was given by Eugen Boross to the museum in Budapest, brought there from New York.

The Way to Calvary was a theme to which Jacopo returned on various occasions – Fitzwilliam Museum, Cambridge (cat. 12); the Christie collection, Glyndebourne (fig. 27); and the one formerly in the Bradford collection, now in The National Gallery, London (cat. 14) – allowing us to measure by direct comparison the astonishing change in his style between the 1540s and the beginning of the 1550s and to observe his progressive openness toward different cultural suggestions from the Roman world and central Italian mannerism, which had already been transplanted to Venice and which he himself had already explored.

Claimed for Jacopo for the first time by Venturi (1929 (A) and 1929 (B)) and dated by Longhi (1948, 52) at the beginning of the moment when he «took up mannerism again... in a luminous and dramatic key», this *Way to Calvary* marks the point where Jacopo's art comes closest to the painting of Schiavone, to whom, not coincidentally, the work has more than once been assigned (Fröhlich-Bum 1930 (A); Arslan 1931; and Hauser 1965). Elements which recall Schiavone are – even if more plastic – the elastic, allusive forms of the figures, overwhelmed by a deforming imagination, and the fluid linear rhythm that flows across the composition from left to right, continuing beyond the physical space of the painting. Around the mute colloquium expressed in the eyes of Christ and Veronica, men and animals are piled into a crowded, depthless space, painted in fiery tones. These grieving, solicitous, and pitiless jailers reach a crescendo of anguish and allusion. Characters and figures known to us already from other pictures reappear here, sharpened by Jacopo's linear fury: the young woman kneeling in the foreground is the sophisticated cousin of the Veronica in the London *Calvary*, whose pose and pitying gesture she repeats in reverse; or the jailer bent to the ground at Christ's right, a recurring figure in Jacopo's paintings since *The Adoration of the Magi* (The National Galleries of Scotland, Edinburgh, cat. 10).

The date of c. 1552 proposed for the painting by Ballarin (1973, 97) and generally accepted by art historians seems today even more convincing since the *Libro secondo* has confirmed 1550 as the date of *The Beheading of the Baptist* (Statens Museum for Kunst, Copenhagen, fig. 29), and after the discovery of *The Descent of the Holy Spirit* in the church of San Giacomo in Lusiana (cat. 20), which is documented in the *Libro secondo* in 1551, and is thus the immediate predecessor of the painting here.

M.E.A.

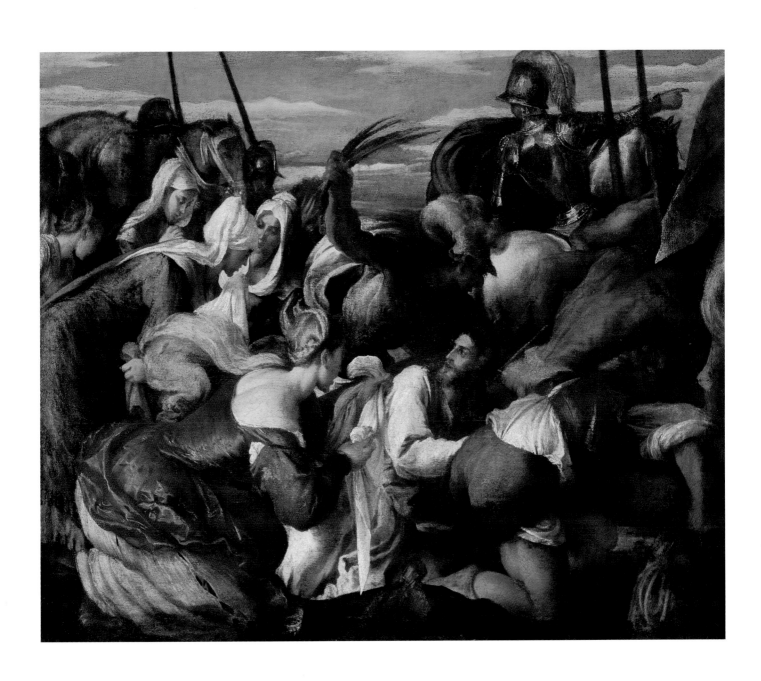

22. THE MYSTIC MARRIAGE OF SAINT CATHERINE (c. 1552-53)

Wadsworth Atheneum, Hartford, The Ella Gallup Sumner and Mary Catlin Sumner Collection, 1959.254
Oil on canvas, 90×112.5 cm (35 1/4×44 in.)
Exhibited in Fort Worth only

Provenance
Welbore Ellis Agar, London, 1806; Robert, Earl Grosvenor, London, 1806; by descent to William Grosvenor, third Duke of Westminster; Sotheby's, London, 24 June 1959, lot 2; Julius Weitzner, New York; Wadsworth Atheneum, Hartford.

Exhibitions
Hartford 1982.

Bibliography
Arslan 1960 (B), 1-3; Ballarin 1967, 98; Fredericksen and Zeri 1972, 585; Pallucchini 1982, 30, no. 20; Silk and Greene 1982, 34-35; Cadogan 1991, 58-60.

The Dal Ponte *Libro secondo* account book lists on folio 37 verso a commission from Domenico Priuli dated July 1552 for a small picture (*quadretto piccolo*) without defining its subject. Priuli paid five ducats on 20 June 1553 for a *Madonna and Child with Saints Joseph and Catherine*, which appears to be the picture ordered the previous year. Muraro did not associate this entry with the present painting. As discussed elsewhere in this catalogue, Jacopo painted two versions of this composition around 1553, of which Priuli's picture is more probably to be identified as the lost one known today from a late shop copy (formerly Brocklehurst collection, London). The Hartford picture is probably to be identified as the one in the Agar collection in 1806 as by Tintoretto. The modern literature is unanimous in accepting the attribution to Jacopo with a dating ranging from the 1550s (Arslan, Ballarin), 1550-55 (Pallucchini), or the middle 1550s (Cadogan).

This *Mystic Marriage of Saint Catherine* has been cut by about eighteen centimeters below and four at right. Although Jacopo's brushstroke was becoming broader and his finish less descriptive around 1553, many passages of this picture are evidently left in a sketched state. This is particularly evident in the saint's drapery and the landscape, where one is afforded a fascinating glimpse of Jacopo's rapidly spontaneous brush in action. No area of surface has been given its finishing glaze, but the heads approach this concluding stage of execution. The composition is a free conflation of Nicolò Vicentino's woodcut *Madonna and Saints* (Bartsch, 1803-21, XII, 64, no. 23) of c. 1550, and Antonio Campi's woodcut *Rest on the Flight* (Bartsch 1803-21, XII, 58, no. 14), which bears the date 1547. Again, these sources suggest that Jacopo's collection of graphics was kept up to date. The Madonna and Child, the Joseph, and the putto had been used, reversed in the case of the Child, in *The Adoration of the Magi* (formerly Caggioli collection, Venice) of about a year before. The style of the Wadsworth Atheneum *Mystic Marriage* develops the broad handling and more resonant color of the Budapest *Way to Calvary* (cat. 21) and looks forward to the Cleveland *Lazarus and the Rich Man* of c. 1554 (cat. 24).

W.R.R.

304

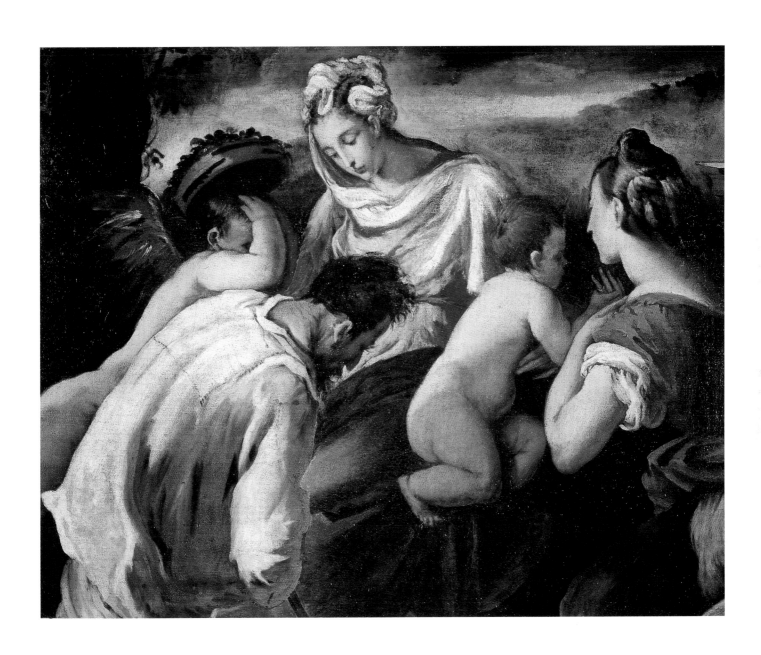

23. ADORATION OF THE SHEPHERDS (1553-54)

Galleria Borghese, Rome, inv. 26
Oil on canvas, 76×94 cm (29 7/8×37 in.)
Exhibited in Bassano del Grappa only

Provenance
Borghese collection, Rome, 1650.

Exhibitions
Never before exhibited.

Bibliography
Manilli 1650, 88; *Inventario* 1693, St. II, no. 3; *Inventario* 1700, St. II, no. 23; *Inventario Fidecommisso* 1833, 32; Piancastelli 1891, MS, 47; Venturi 1893, 41; Mayer 1914, 211; von Hadeln 1914 (A), 552; Longhi 1926, 142-43; Longhi 1928, 76 and 178; Venturi 1929 (B), 1153-54; Arslan 1931, 113, 133, 194, and 349; De Rinaldis 1948, 70; Longhi 1948, 52; Della Pergola 1950, 15; Della Pergola 1955, 100, no. 175; Zampetti 1957, 84; Berenson 1958, I, 20; Zampetti 1958, 34; Arslan 1960 (B), I, 85, 95, ns. 50-51, and 175; Della Pergola 1968, 61, no. 4; Ballarin 1973, 96; Staccioli 1981, 44; Freedberg 1988, 656.

The earliest mention of this work is by Manilli, who cites it in the Borghese collection along with other paintings by the Dal Ponte family: « Si vedono in questa camera sette quadri dei Bassani, vecchio e giovane; due de' quali, cioè la Natività e i Magi, sono del Vecchio » (In this room are seen seven paintings by the Bassano family, elder and younger; two of which, that is the Nativity and the Magi, are by the Elder). This confirms the substantial presence of works by Jacopo and his circle at that time in the most important Roman collections, a fact that had already been affirmed by Ridolfi. The attribution to Jacopo himself was questioned by Piancastelli (1891) and at first also by Venturi (1893), who assigned the painting to Jacopo's school. Despite Longhi's reclaiming of the work for Jacopo and his high opinion of it (1926 and 1928) – he called it « a truly genuine work by Jacopo » – and Venturi's acceptance of this opinion (1929 (A)), Arslan (1931) continued to maintain that it was « a copy, certainly of the seventeenth century, of another lost original ». Attribution to Jacopo, vigorously sustained in the Borghese catalogue by Della Pergola (1955), was finally recognized by Arslan (1960 (B)) and accepted by subsequent art historians.

Presenting a more open and immediate *mise en page* than either of the preceding versions of *The Adoration of the Shepherds* (Gallerie dell'Accademia, Venice, cat. 16; and The Royal Collection, Hampton Court, cat. 17), the Borghese picture charms us by the spontaneous rhythm of its composition and remarkable freshness of its color, which exudes a touching poetic intensity.

The group of the Virgin and Child surrounded by a circle of shepherds and animals, « seems to have fallen into a corner of an Orphic world » (Venturi 1929 (B), 1153). The event of the birth of the Savior and his manifestation in the world is placed in the context of a bucolic idyll, accompanied by the « rustic melodies » (Venturi 1929 (B)) that the shepherd stretched on the ground in the foreground plays on his flute. This figure, one of Jacopo's favorites, will be repeated in a reversed position in *The Annunciation to the Shepherds* (National Gallery of Art, Washington, cat. 30) and the numerous replicas of the theme. The vivid color of the sky, « shot with darts of light » (Venturi 1929 (B)), of an unusual blue-green shade, contrasts with the touches of red and orange in the faces pulled out of the shadows, especially in the summarily hinted face of Saint Joseph, which seems to reflect « all the fire of the sunset » (Venturi 1929 (B)). The light underscores the fluid rhythm of the line, and the colors change « like waves » as the light passes across the canvas, achieving a completely luministic concept of color. Formal suggestions from Parmigianino, particularly visible in the « reedlike » flexibility of the Virgin, have lost the impeccable but slightly cold elegance of their first manifestations and here yield, filtered by the superb coloristic temperament of Jacopo, to express a more truthful emotional reality.

The Borghese picture was placed by Venturi and Longhi in the interval between the masterpieces of *The Rest on the Flight into Egypt* (Pinacoteca Ambrosiana, Milan, fig. 24) and *Lazarus and the Rich Man* (The Cleveland Museum of Art, cat. 24) and dated c. 1550. In reality, the painting seems to be open to placement at a date a few years later, c. 1553-54, in a position that presupposes Jacopo's use of a Schiavone-like line in *The Way to Calvary* (Szépmüvészeti Múzeum, Budapest, cat. 21) and moves it closer to the very successful *Adoration of the Shepherds* (Nationalmuseum, Stockholm) with which it shares certain compositional elements, although the picture in Stockholm is characterized by a more allusive, looser handling of the color.

M.E.A.

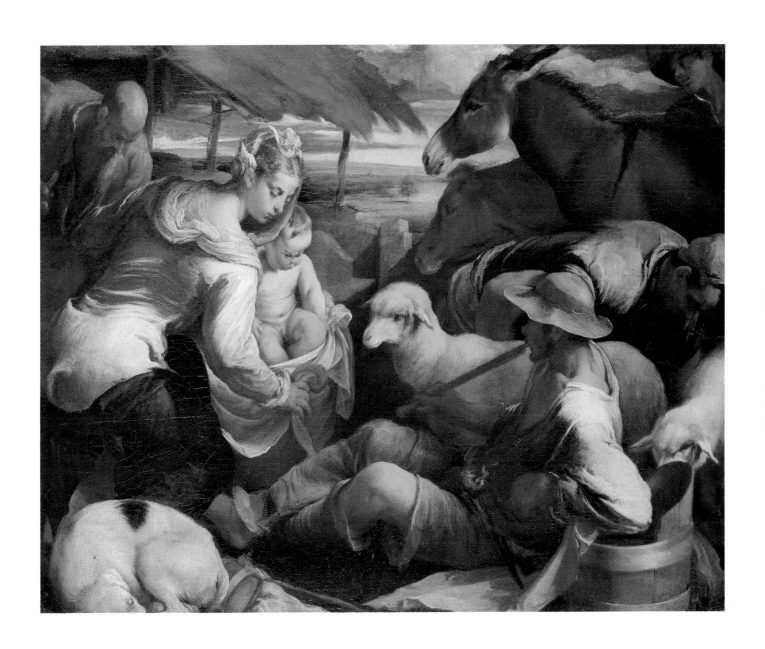

24. Lazarus and the Rich Man (c. 1554)

The Cleveland Museum of Art, Cleveland, inv. 39.68, Delia and L. E. Holden Funds
Oil on canvas, 146×221 cm (57×87 in.)

Provenance
Simonetti collection, Rome; Mr. and Mrs. Dan Fellows Platt, Englewood, New Jersey, from 1905; acquired with the Delia E. and L.E. Holden Funds, The Cleveland Museum of Art, 1939.

Exhibitions
San Francisco 1915; New York 1920-28; Los Angeles 1929; Cleveland 1936; Columbus 1938; San Francisco 1938; New York 1940; Columbus 1946; Cleveland 1956; Venice 1957; New York 1967; Naples 1985; New York 1985.

Bibliography
Mason Perkins 1911, 2, 147; Van Vechten Brown and Rankin 1914, 343; Mason Perkins 1915, 122-23; Marangoni 1927, 27; Fiocco 1929, 214; Venturi 1929 (A), 117; Venturi 1929 (B), 1147-50 and 1252; Arslan 1931, 343; Francis 1939, 155-58; Fröhlich-Bum 1948, 169; Longhi 1948, 48, 52, and 54; Magagnato 1952 (B), 226; Magagnato 1956, 106; Fiocco 1957, 96; Muraro 1957, 295-96; Pallucchini 1957, 106; Podestà 1957, 12; Weissten 1957, 16; Zampetti 1957, 90, no. 34; Berenson 1958, 1, 17; Nicolson 1958, 102; Zampetti 1958, 36; Arslan 1960 (B), I, 65-66, 84, 90, 95, n. 48, 96, n. 57, 97, 166, 168, and 317, and II, figs. 94-98; Jaffe 1963, 467; Ballarin 1964, 66-67; Tomory 1967, 185; Ballarin 1969, 104-6; Ballarin 1971 (B), 270-71; *Dizionario Bolaffi* 1972, 1, 402-3, *ad vocem*; Fredericksen and Zeri 1972, 18, 279, and 573; Ballarin 1973, 91, 96, and 108; Bialostocki 1978, 170-71; Pallucchini 1982, 32 and no. 21; *The Cleveland Museum of Art* 1982, 304-6; Magagnato 1983, 146-47 and 149; Rigon 1983 (A), 48-49; Rearick 1984, 306-7; Rearick 1985, 52; Rearick 1986 (A), 184; Freedberg 1988, 656.

One of the most controversial and unusual of Jacopo's paintings, *Lazarus and the Rich Man*, was attributed to Jacopo by Mason Perkins (1911), who called it one «of the most important sixteenth-century paintings... on the other side of the ocean». It was subsequently confirmed as Jacopo's by Venturi (1929 (A) and 1929 (B)) and Longhi (1948), but was denied to Jacopo by Arslan (1931), who called it «Bassanesque», and by Fiocco, who attributed it first to Mariscalchi (1929) and then considered it «a seventeenth-century copy, perhaps not even Italian» (1957). Following in the path of a hypothesis formulated by Longhi (1948, 52) and Arslan (1960 (B), 84), Rearick (1985) has reiterated the supposition that because of its size and style, the painting was originally the pendant of *The Miracle of the Quails and the Manna* (private collection, Florence, fig. 33) of 1554, suggesting that the paintings were hung «facing each other in the choir of the parish church of a town... near Bassano», which he did not identify further. This conflicts with Pallucchini's (1982, no. 21) identification of the painting as the «Dinner in the house of a rich man» mentioned by Verci (1775, 87) in the house of Giacomo Vittorelli in Bassano. This identification is, however, no more than conjecture, since Verci (1775, 139 and 141) himself cites two other replicas in Venice, one in the Palazzo Contarini at San Samuele and another in the Palazzo Bonfadini. Even earlier, Ridolfi (1648, I, 383) mentioned three versions in Venice: one owned by Jacopo Pighetti; another in the Casa Contarini at San Felice; and a third in the Casa Contarini at San Samuele, which would be the same one mentioned by Verci. Ridolfi (1648, I, 388) also recorded a fourth version in Antwerp, which was owned by the brothers Jan and Jacob van Buren.

The scene takes place in the half-shade of an interior, just barely open on the left to a distant landscape, that recalls *The Beheading of the Baptist* (Statens Museum for Kunst, Copenhagen, fig. 29), which is closed in the back by the same white columns on high pedestals and similarly constructed around the diagonal line of the table. Certain details, such as the Oriental rug, white tablecloth, and physiognomies also recall the *Beheading*, even though they are inserted into a different context of light and color. Here the figures emerge suddenly, struck by a light that pulls them from the darkness and gives them an ephemeral reality, like actors in the spotlight of a stage. Intervals of shadow with an almost tactile physical quality alternate with flashes of bright light, in a capricious, unsettling play that creates the dramatic tension of the scene.

Within the context of an astonishing and unprecedented modernity, which touches a «height of naturalistic violence and of the contrast of light and shade» (Ballarin 1973, 96), the work reveals accents of pure mannerism in the posture of the beggar leaning back in the foreground or the very elegant three-quarter profile of the woman. She is a more softly rounded version of Herodias in the Copenhagen painting, a fascinating female model «who unites in her being the guile of the serpent and the sinuous harmony of the swan» (Venturi 1929 (A), 117). This «sudden thirst for artistic freedom» (Venturi 1929 (B),

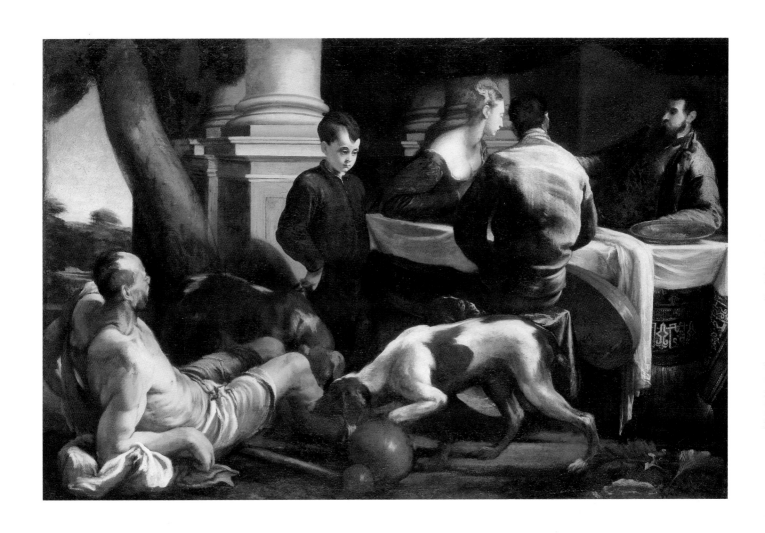

25. Portrait of a Man (c. 1554)

Collection of the J. Paul Getty Museum, Malibu, inv. 69, PA. 25
Oil on canvas, 61×53.2 cm (24×21 in.)

1147), which pervades the painting and foreshadows the new experiences of the next century, is translated into a soft, sensually robust brushstroke (as far as we can judge, given the deteriorated condition of the painting) molded directly out of the light, as in the luminous cascade of the tablecloth or the tunic of the lute player seen from behind, a passage of magisterial spontaneity and vigor worthy of Velázquez.

Dated to c. 1554 (Ballarin 1973, 91 and 108; and Rearick 1985), *Lazarus and the Rich Man* falls midway between *The Beheading of the Baptist* of 1550 in Copenhagen and *Saint John the Baptist in the Wilderness* (Museo Civico, Bassano del Grappa, cat. 29) of 1558. It represents a watershed between the moment of Jacopo's most sophisticated and diverse mannerist experiences and the phase of progressive recovery of naturalism, which was the prelude to the great season of pastoral paintings of the 1560s. Although this painting stands in a category by itself, other paintings have been grouped around it, such as the *Two Hunting Dogs* (Galleria degli Uffizi, Florence, cat. 26) of c. 1555, which carries to an extreme the naturalistic tenor of *Lazarus and the Rich Man*, or the fascinating male portrait in the J. Paul Getty Museum, Malibu (cat. 25) of these same years, which reveals very close formal and emotional ties to the awkward and stunned little page standing next to the table.

M.E.A.

Provenance
Collection of Cyril Flower, future Lord Battersea, from before 1880 to his death in 1907; inherited by his wife, who died in 1931; inherited in 1931 by Anthony de Rothschild, who kept it until 1939; sold to Singer at auction, Christie's, London, 25 May 1939, lot 251 (as Moroni); Carl Marks collection, New York, until 1964; Sotheby's, London, 2 December 1964, lot 125 (as Moretto); until 1969 in the hands of the art merchant F. Mont in New York, who sold it to the J. Paul Getty Museum in 1969.

Exhibitions
London 1880; London 1894.

Bibliography
Exhibition of Works by the Old Masters 1880, 27, no. 129 (as Venetian School); *Exhibition of Venetian Art* 1894, 50, no. 20; Berenson 1895, 5 (as Domenico Brusasorci); Berenson 1907, 178 (as Domenico Brusasorci); Ballarin 1971 (B), 268-71, ills. (as Jacopo Bassano); *Recent Accessions* 1971, 249-58, ills. (as Giovanni Battista Moroni); Fredericksen 1972, 33-34 (as Moroni); Rearick 1980 (B), 109-10, ills.; Pallucchini 1982, no. 22, ills.; Shearman 1983, 25; Attardi 1988, 694.

The painting was presented in 1880 at the Royal Academy in London with the generic indication of «Venetian School», but already by the exhibition of 1894-95 it bore the attribution to Moroni that it maintained, even if with little conviction, until after its entry into the Getty Museum (*Recent Accessions* 1971; Fredericksen 1972). As early as 1895 Berenson felt it was the work of Domenico Brusasorci, but he did not insist on this attribution. On the occasion of Sotheby's sale in 1964, the name of Moretto was put forward. In 1971 Ballarin assigned it to

the mannerist period of Jacopo Bassano, c. 1555, around the same date as *Lazarus and the Rich Man* (The Cleveland Museum of Art, cat. 24). He gave it a close formal reading, emphasizing the Tuscan, Salviatesque models for «the articulation of the bust in three-quarters profile, on which is placed the head, turned three-quarters in the other direction», and the Emilian origin for the Parmigianesque twisted movement of the bust, «crossed by a spiral motion which concludes in the ovoid shape of the head». Rearick (1980 (B)) picked up this idea and, emphasizing the luminosity of the slightly dissonant colors, translucent fluid quality of the pigment, and the particular impasto of the robe, placed it close to *The Madonna and Child* (Detroit Institute of Arts, fig. 28), which he dated c. 1551. He now, however, moves both of them to 1549 (see here, Rearick's essay).

Around twenty years after the early portraits in Bowood House (fig. 10), Kassel (cat. 6), and Memphis (cat. 5), this painting represents in Jacopo's development the first (and to date only example in those years) known return to his portrait activity, which also is only scarcely documented by the sources. The *Libro secondo* in fact records one portrait in 1540 and four in 1542 (see here, cat. 6); one of Bartolomeo Merzari, the cousin of Jacopo's wife, in 1544; one of the priest Zuanne, parish priest of Strigno, in 1545 (or 1542); one of Lazzaro Guadagnini, a textile merchant in Bassano, in 1546 (according to Muraro (1992) this may be a drawing); a down-payment for one of

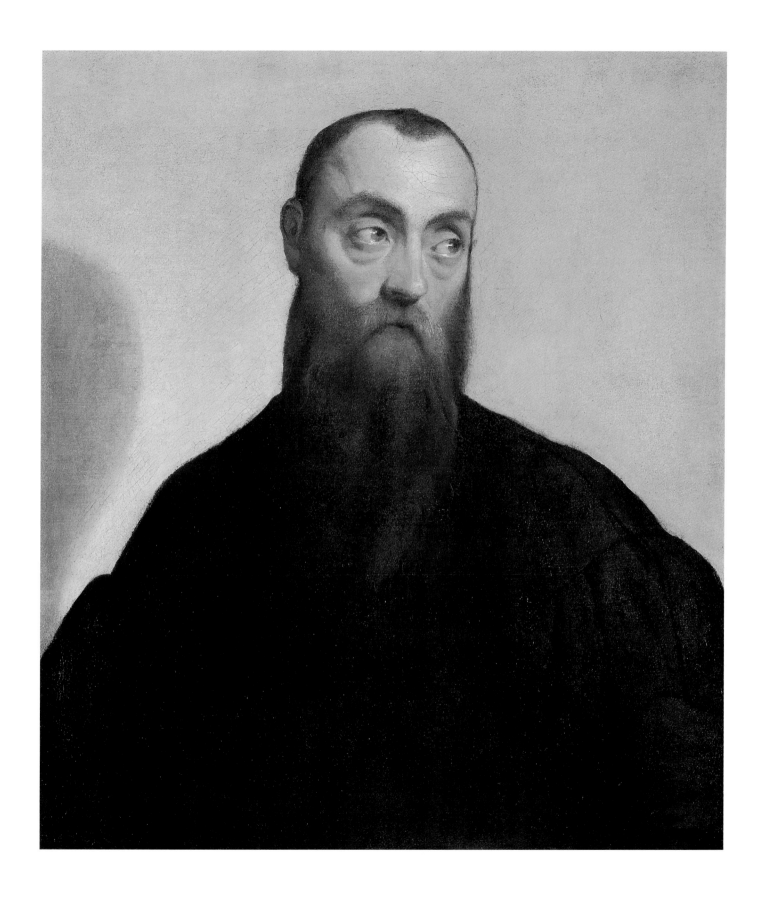

26. Two Hunting Dogs (c. 1555)

Galleria degli Uffizi, Florence, inv. 1890.965
Oil on canvas, 85×126 cm (33×49 in.)

«dottor» Alessandro Campesan in 1550; and one of Giulia, the wife of the lawyer Matteo Forcadura, represented laid out in death in her bedroom, in 1553.

Represented very close up, almost pierced by a diagonal light that strikes the rounded forehead and projects a bulbous shadow on the light olive green background, this «most mannerist portrait in Venetian painting... around mid-century» (Ballarin 1971 (B)) presents an air of resigned transitoriness. The soft circular brushstrokes define the rosy complexion, his round, bulging eyes with puffy bags under them, his arched eyebrows, and his small, half-open mouth surrounded by his soft beard. This latter passage is the part of the painting that has suffered most. However, the overall condition is really fairly good and the picture has been patiently «put back together» during the recent restoration.

The application of the pigment and type of subject lead us to reiterate the position of this sophisticated portrait in the moment of Jacopo's return to mannerism «interpreted in a luminous and dramatic key», which is also responsible for *Lazarus and the Rich Man* and *The Miracle of the Quails and the Manna* (fig. 33), documented by the *Libro secondo* in 1554.

P.M.

Provenance
Cardinal Giovan Carlo de' Medici, Castello, 1663; Leopoldo de' Medici, 1663-75; Uffizi, Tribuna, 1677; Castello (?) after 1769; Uffizi, since 1798.

Exhibitions
Florence 1978; London 1983.

Bibliography
Berenson 1894, 84; Arslan 1931, 344; Berenson 1958, I, 18; Arslan 1960 (B), I, 340; Ballarin 1964, 62-67; *Tiziano nelle gallerie fiorentine* 1978, 172-75, no. 46; *Gli Uffizi. Catalogo generale* 1979, 151; Magagnato 1983, 148, no. 6; Rearick 1984, 304, no. 20; Rearick 1986 (A), 184.

The original provenance of this painting is not known. It is mentioned for the first time without an attribution in the inventory of Cardinal Giovan Carlo de' Medici (1663), who was probably its original purchaser, among the possessions in the Medici villa at Castello. Subsequently transferred (1663-75) into the collections of his brother, Prince Leopoldo, with an attribution to Titian, the picture was moved on 2 November 1677 into the Tribuna of the Uffizi, where it is mentioned again in the 1704 inventory, assigned this time to Carracci. After several other moves it was placed definitively in the Uffizi on 21 August 1798 with the correct attribution to Jacopo Bassano.

We owe to Ballarin the critical reevaluation of the painting, which before he studied it had been neglected or misunderstood by art historians (Arslan 1931, and again 1960 (B), insisted on calling it the work of Leandro), despite Berenson's constant reference to Jacopo in the various editions of his lists of Venetian paintings. In its unusual subject and approach, the painting is a practically unique work in the panorama of sixteenth-century art. It is a preview of the seventeenth century, «comparable only to some of Savoldo's pure landscapes» (Ballarin 1964, 64). In the uncertain, milky light of dawn two stray dogs stand out in the foreground against a landscape, where in the far blue distance we see the familiar outline of Monte Grappa and Bassano, licked by the first light of the day. Jacopo's keen ability at portraiture is revealed in his treatment of the two dogs (Rearick 1984). It is accompanied by the translation into paint «of a moment of light that is as exact as it is ineffable» (Ballarin, 63). Furthermore, it is rendered with exceptional visual lucidity from which emerges an evocative poetry of time and place rarely found in art of this period. The slow narrative rhythm that ties the composition together, almost like a film in slow motion, is conveyed with an unusually fluid and careful brushstroke that limits its free touches of color to just a few details, such as the touches of red, like two commas, in the left eye of the lying dog, which accentuate his damp resigned expression, or the patches shot with tremors of color on the coat of the brown dog.

The date of c. 1555 proposed by Ballarin convincingly pairs this painting with *Lazarus and the Rich Man* (The Cleveland Museum of Art, cat. 24). They are similar both in the counterplay of light and shade and in the rendering of the shadows, which conversely make a later date

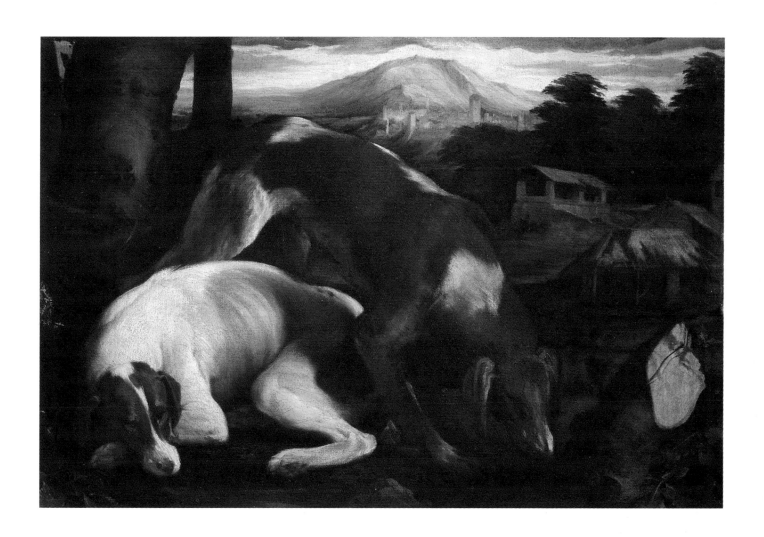

unacceptable (end of the 1550s and beginning of the 1560s, as posited by the catalogue of the exhibition in Florence (1978) and by the catalogue of the Uffizi collection (1979)). Another painting of a similar subject, formerly in the collection of the Duke of Bedford and currently in a private collection in Rome, is documented in the *Libro secondo*. It was commissioned by the Venetian gentleman Antonio Zentani in 1548, and the final payment was made in 1550.

M.E.A.

JACOPO BASSANO 1555-1568

What happened to Jacopo Bassano between 1555 and 1568 is still a controversial question open to debate in the study of his career. This was the moment when, in tune with artistic developments in Venice and throughout the Italian peninsula, he began to bring to an end his lengthy and original experience with mannerism, which had occupied the years of his first maturity, and to refine and hone his new, strongly innovative idiom. Ridolfi and Verci agreed that this new idiom characterized *The Adoration of the Shepherds with Saints Victor and Corona* (Museo Civico, Bassano del Grappa, cat. 46) of 1568, where «setting aside his excessive diligence, and finish, he worked only with heavy, straightforward, and well-placed strokes, with warm clear colors, and it is all truth, nature, and artistic fire». A definition of the outlines of this phase cannot avail itself of the tradition of his early biographers, who do not treat it as a separate period but consider it part of his Parmigianesque stage. Critics of this century, however, have recognized it as a separate phase. The first attempts at making distinctions within this long period, at the time almost devoid of documentary points of reference, and explaining the significance of the date 1562-63 for *The Crucifixion* (Museo Civico, Treviso, cat. 37) from San Paolo in Treviso – a date discovered by Federici at the beginning of the nineteenth century – were made by von Hadeln (1914 (C)) and, in a more organic and closely argued way, by Venturi (1929 (B)). At a time when scholars were debating with «the useless exchanges between Bassano and El Greco» (Longhi), Venturi saw in the «brief, agitated touches of the brush» in the Mary Magdalene of the Treviso painting «the earliest signs of that minute disintegration of color through the action of light» that would be the hallmark of Jacopo's last work. This precise diagnosis led him to assign dates around 1563 to the Enego altarpiece (cat. 31), *Saints Peter and Paul* (Galleria Estense, Modena, cat. 34), *Saint John the Baptist in the Wilderness* (Museo Civico, Bassano del Grappa, cat. 29), *The Descent of the Holy Spirit* (Museo Civico, Bassano del Grappa, cat. 119), *The Adoration of the Magi* (Kunsthistorisches Museum, Gemäldegalerie, Vienna, cat. 27), and *Jacob's Journey* (The Royal Collection, Hampton Court, cat. 33). We thus begin to see taking shape a period of «luministic intensity, highly fantastic, that uses the substance of liquid color», in the course of which light becomes an essential means of expression. The path had already been traced out and, even though «the writings that followed, from the pens of specialists, tried to cancel it out», it would be traveled by Longhi in *Calepino veneziano* (1948), from which the quotation is taken. Longhi emphasized anew the role played by the Treviso *Crucifixion* in defining Jacopo's mannerist experience, and while he clarified the two phases that had made it up, the first in an «idyllic and musical key, laminated and precious», in contrast with the second, «luministic and dramatic», he pointed out that «before leaving the luministic heights that sustain the Platt

Lazarus and the Rich Man and *The Miracle of the Manna,* Bassano tried to discern, within those zones of light and with a new optical precision, new mysterious 'quanta' of minute reality, almost as though his old naturalism had been reborn now in a microcosmic, molecular form».

This premise implied an invitation, already containing its own response, to verify if works such as *Saint John the Baptist in the Wilderness,* the Vienna *Adoration of the Magi,* or the Hampton Court *Jacob's Journey* could be placed within 1563, as Venturi had already proposed. Evidence that this direction was the right one came some time later, with Sartori's discovery (1958) of documentation allowing him to establish 1558 as the date of *Saint John the Baptist in the Wilderness.* This dating is laden with consequences. It confirmed the necessity to rethink the painter's career by moving some dates earlier and, at the same time, it provided a fixed point around which the years 1555-63 could be put into order. It also signified the precise moment that the biblical-pastoral painting mode was born. In fact, for stylistic affinities and other factors as well, *Saint John the Baptist* attracts within its immediate sphere works such as *The Good Samaritan* (The National Gallery, London, fig. 40), both versions of *The Annunciation to the Shepherds* (Accademia di San Luca, Rome; and National Gallery of Art, Washington, cat. 30), and *Moses and the Burning Bush,* an invention known today only through copies. Conversely, when placed next to *Saint John the Baptist, The Adoration of the Magi* (Galleria Borghese, Rome, inv. 234) and the very well known version of the subject in Vienna, as well as *Susanna and the Elders* (National Gallery of Canada, Ottawa, cat. 28), are seen to be earlier works, where we can still read the traces of the tapered forms taken from Parmigianino and the force of Jacopo's turn toward chiaroscuro, which had characterized his work in the early 1550s on the crest of Schiavone's «*empiastrar*», that is, scribbles. In his *Saint John the Baptist* Jacopo responds with his usual open and free mind, favored by an observation point that is far away – but not too far – from the capital, to the innovations that took place in Venice during the 1550s. The picture also marks a return to a Salviatesque style, which had been kept alive by Porta and Schiavone himself, but above all it is a very rapid affirmation of Veronese, who had just triumphantly concluded his decorations for the Libreria Marciana in Venice. The painting also signals the presence of important new factors. The twisted, sharp image of the saint is assaulted by the light, whose strength is multiplied by its artificial nature, and is set in a landscape with an importance unprecedented when compared to the flaming knots of figures seen in the pictures from the early 1550s. These two facts indicate how the painter has begun to move away from his long exchange with mannerism through a reworking of his experience of Titian: reacting to the provocation of mannerist form by «flagellating» it with light. This task is presented almost programmatically in

315

The Descent of the Holy Spirit, an act of homage to Titian's altarpiece of the same subject painted in the early 1540s for the church of Santo Spirito in Isola (now Santa Maria della Salute, Venice), offered at the moment when Titian was ending his long gestation with *The Martyrdom of Saint Lawrence* for the church of Santa Maria dei Crociferi (now Chiesa dei Gesuiti, Venice), whose nocturnal setting marks the definitive passage to his late manner. This reading of Jacopo's extraordinary altarpiece is still valid even after its recent restoration, which reveals a manner influenced less by Titian and more in line with his style in *Saint John the Baptist*. In fact, the painting now appears less to be an isolated phenomenon within the history of these years and can be seen to reflect precisely the recovery of its chromatic splendor – the blue of Saint Peter, the red of the apostle seated in the right foreground – confirming how Jacopo's experience of Titian is translated now in terms of his own personal search for a unifying and realistic rendering of light without sacrificing color. Light, imprisoned in the cold, unreal mosaic of color in the Vienna *Adoration of the Magi*, is now transformed into a luminous material capable of molding space. The accents of light and shade no longer are a function of form, as was seen a few years earlier in *Lazarus and the Rich Man* (The Cleveland Museum of Art, cat. 24), but of the attempt to give a truthful depiction of the setting. On the foundation of this new freedom of luminosity, the artist returns one last time to the forms of Parmigianino, confirming how he would cyclically go back to the sources of his mannerism but interpret them in his own free way, as in the much-discussed altarpiece depicting *Saints Justina, Sebastian, Anthony Abbot, and Roch* in Enego. Two observations might be useful concerning the question of its chronology: first of all, the Veronese-like component, which is subtly intertwined with a Parmigianesque influence that appears as the consequence of Jacopo's reapproach to Venetian art exemplified in *Saint John the Baptist*; secondly, its very close relationship, which has been recognized for some time, with the preparatory *bozzetto* for a lost altarpiece on the theme of *Saint Paul Preaching* (Museo Civico, Padua, cat. 32), to which the date of 1559 can be assigned on the strength of a payment documented in the Dal Ponte workshop's account book, the *Libro secondo*.

Saint John the Baptist, settled like a large lizard in a clearing in the woods, as Bettini so felicitously put it, documents the internal premiere of the altarpieces inspired by pastoral and landscape themes, a very important fact for clarifying the question, which scholars still have not resolved, of the birth of the biblical-pastoral painting. Beyond the stylistic reasons connecting *The Annunciation to the Shepherds* in Washington and *Jacob's Journey* at Hampton Court to the years 1557-60, there is a coexistence of an insistence on forms derived from Salviati and Parmigianino – the hipshot pose of the shepherd in the *Annunciation* and the sinuous Jacob. Furthermore, they share a search for

effects of naturalness and truth in the rendering of light and setting – the late dusk of the painting in Washington and the evening tones wrapping a silvery fog around the colors of the Hampton Court painting. Such tendencies can only be found at this point in the painter's career at the moment when he was turning upside down the premises of the mannerist aesthetic, which were based on the possibilities of a decorative manipulation of form, in order to recover and pursue more deeply his early passions: for landscape, and the truth of nature and light. In this experience as well, Jacopo's rethinking of Titian's work seems to have played an important role. He looks particularly to some drawings inspired by pastoral scenes that Titian had done for private collectors between 1520 and 1530 in which Titian relives the youthful myth of Arcadia and its roots in the art of Giorgione, but revisited now in the light of a mature classicism. In *Jacob's Journey* we see the first signs of Jacopo's familiarity with inventions such as Titian's *Shepherd with a Flute Leading his Flock*, which he would pursue more thoroughly in the next decade. If the genesis of the biblical-pastoral paintings can be considered clearer today in terms of a chronology, because of recent important discoveries such as the pastoral paintings in private collections in Turin and Budapest – which in comparison make quite evident the earlier dates of the paintings just mentioned – much still remains to be explained about the reasons, mechanisms, models, and iconography of Jacopo's invention. It is an invention that would have a resonance far beyond the sphere of the painter, his workshop, or even his century, and it would give birth to a collecting phenomenon on a very vast scale.

Around 1560, along with that of Titian, Jacopo's relationship with Paolo Veronese also gained in importance. This is the year when Veronese returned to the mainland, to Maser, after a decade of activity in Venice, while Jacopo, for the first time, was beginning to receive commissions for public works in Venice. The triptych for the church of San Cristoforo della Pace, presumably of 1558-59, of which the central section representing *Saint Christopher* still survives (Museo Nacional de Bellas Artes, Havana, fig. 35), is followed by the prestigious commission for the altarpiece depicting *Saints Peter and Paul* for the church of Santa Maria dell'Umiltà, at the time officiated by Jesuits, where Jacopo found himself associated with Veronese, who decorated the ceiling (now Cappella del Rosario, Santi Giovanni e Paolo, Venice), and Tintoretto, who painted *The Lamentation over the Dead Christ* (now Gallerie dell'Accademia, Venice). The monumentality of the painting and its new balance between figures and landscape in a vertical and decorative format, for which it is indebted to Veronese's work in the Villa Barbaro at Maser, indicate a reapproach to the Venetian tradition under the sign of Veronese's classicism, which had matured in the frescoes of the Villa Barbaro

and deepened shortly afterward in the execution of stories from the life of the Virgin on the ceiling of the church of the Umiltà. Unexpectedly reinforcing the evidence of a shared bond between two artists seemingly so different from one another are the altarpiece depicting *The Madonna and Child in Glory with Saints Anthony Abbot and Paul* (The Chrysler Museum, Norfolk) for the Benedictine abbey of San Benedetto Po, commissioned from Veronese at the end of 1561, and Jacopo's analogous one for the church of the Umiltà. We find the connection as well in Veronese's *Adoration of the Shepherds* (private collection, England), which is a version – in a format suitable for collectors – of the theme he had treated in the ceiling of the church of the Umiltà. The chromatic choices and interest in light in this picture would be difficult to justify without the example of Jacopo's inventions in works such as *The Adoration of the Shepherds* (Galleria Corsini, Rome, cat. 36). Jacopo's renewed attention to Venetian painting became richer and more multifaceted with his return to the theme of the *sacra conversazione* in *The Madonna and Child with Saints Anthony Abbot and John the Baptist* (Alvar Aalto Museum, Jyväskylä, cat. 35) and *The Parable of the Sower* (Thyssen-Bornemisza Collection, Lugano), which is almost a landscape in the tradition of Giorgione, where the biblical theme is relegated to the background, while the foreground is devoted to a solemn and silent representation of the peasants' meal as evening falls. At this point, having exhausted the residual traces of formal complications in his rethinking of the Venetian tradition and the turn toward classicism taken by Veronese, Jacopo begins definitively to minimize the unreal chromatic quality, which, beginning with the Vienna *Adoration of the Magi*, had characterized the whole period. In *The Parable of the Sower* he subordinates it to the authority and naturalness of a new concept of light – natural and transparent – that flows through the vertical canvas, which is openly indebted to the precedent set by the Umiltà altarpiece and the Treviso *Crucifixion* as the curtain of clouds lifts from the horizon.

The reaffirmation of the importance of the Treviso *Crucifixion* as a watershed in Jacopo's experience of mannerism brings, as a consequence, a reformulation of his development between 1563 and *The Adoration of the Shepherds with Saints Victor and Corona* of 1568, the date cited by his biographers as the beginning of his late manner. We are moving onto much more difficult terrain here, more controversial than what has gone before, but it is possible nonetheless to gather together a few works, many of them still fairly unknown, which, as they advance the artist's achievements in the Treviso *Crucifixion*, mark more and more clearly the distance he has traveled away from the stylistic traits of mannerism. At the same time they prepare the way, in a highly personal process, for his poetics of light that will emerge in the 1570s. The thread tying together works such as *Tamar Brought to the Stake* (Kunsthis-

torisches Museum, Gemäldegalerie, Vienna, cat. 38), *Saint Jerome in the Wilderness*, and *Saint Eleutherius Blessing the Faithful* (both Gallerie dell'Accademia, Venice, fig. 39 and cat. 40) is Jacopo's consistent, highly modern experimentation with the unifying power of light and the impressionistic construction of form that he had achieved in the Treviso *Crucifixion*. Chromatic chords are struck, and color submits increasingly to the force of the light soaking the material and shattering it in tiny, vibrant touches of the brush. Within his limpid twilight settings the shadows increase and the half-tones become more prominent, enabling a more objective rendering of the surface of things, while the silvery whites stand out in their vibrant isolation. The results in terms of naturalness and optical precision were such that for a long time perplexed scholars reacted by assigning them very late dates: see the large flame leaping into the blue air and the luminosity of Tamar's veil in the picture in Vienna; or the corpulent anatomy of Saint Jerome on which the light condenses with effects that anticipate the seventeenth century in Spain, his large head blazing with luminous touches of the brush; or the portrait from behind of the father climbing the stairs in the clear half-shade of the temple, with his little daughter by his side, in the *Saint Eleutherius* altarpiece. The « group portrait » that Jacopo painted in the foreground of the *Saint Eleutherius* altarpiece is indicative of a new narrative method based on a penetrating and affectionate observation of reality, shunning any formal or intellectualizing artifice. While it prepares the way for developments in the altarpieces of the 1570s, it openly declares its origins in the experience of biblical-pastoral paintings that begin with *Jacob's Journey* at Hampton Court. And it is just this return to the biblical-pastoral experience, after the *Saint Eleutherius* altarpiece and the few other religious subjects that can be assigned to this moment – *The Supper at Emmaus* (The Royal Collection, Hampton Court, fig. 43), *The Scourging of Christ* (Gallerie dell' Accademia, Venice, fig. 45), and the small altarpiece depicting *Saints Florian, Sebastian, and Roch* (Museo Civico, Treviso, fig. 44) – that constitutes the most significant aspect of these years. A limited but very important group of pastoral paintings returned to Jacopo's oeuvre in very recent years and some drawings document a moment that has correctly been defined as « classical » in the evolution of this genre. For stylistic reasons this moment should be pinpointed in the vicinity of Vasari's two visits to Venice in 1563 and 1566 to put the finishing touches on his new edition of the *Lives*, in which he recalled Jacopo's « many other works… that are scattered throughout Venice and held in high esteem, and mainly for small things and for animals of every sort ». In *Jacob and Rachel at the Well* (private collection, Turin, cat. 43) and its probable pendant, *Jacob's Journey* (formerly Wallraf-Richartz-Museum, Cologne), in *The Parable of the Sower* (Museum of Fine Arts, Springfield, cat. 44), and in *The Sleeping Shepherd*

(Szépmüvészeti Múzeum, Budapest, cat. 45), the artist works out a compositional structure that allows him to immerse his eye, which he had developed to a high degree of acuteness, into the depths of the landscape and to capture the variations in color and form as figures and objects are absorbed by the atmosphere. At the same time, his immediate vision focuses on the surface appearance of the herds and shepherds solemnly filling the foreground, the true protagonists of paintings in which a contemplative attitude finally conquers the demands of hierarchy and narrative. In the harmoniously fluid compositions of these paintings, where figures and landscape are in perfect balance, no trace remains of the «excessive diligence» or «finish», to use once again the words of Verci quoted earlier, which had characterized his mannerist period, while in the variety and freedom of the texture of his art, soaked in light, we discern the «mixture of very difficult practices... of touch, washes, and drawing» that Jacopo's biographer described as the distinctive traits of his fourth and last manner. And finally, without the foundation laid by this phase of pastoral painting it would be very difficult to understand fully the very special nature of *The Adoration of the Shepherds with Saints Victor and Corona*, set in an evening light with the solemn entrance on the right of a shepherd and his cow, his companion captured from behind in the immediate foreground with a dog beside him – unthinkable for the altar of a Venetian church.

VITTORIA ROMANI

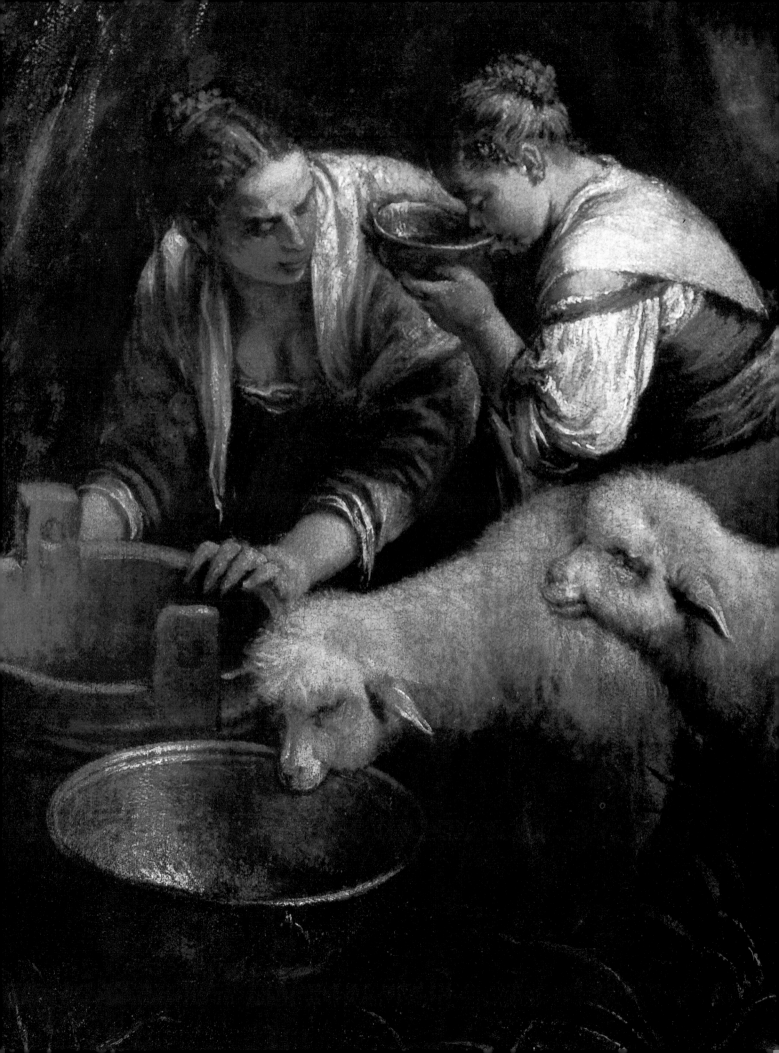

27. THE ADORATION OF THE MAGI (c. 1555)

Kunsthistorisches Museum, Gemäldegalerie, Vienna, inv. 361
Oil on canvas, 92.3×117.5 cm (36 3/8×46 1/4 in.)

Provenance

Venice, Bartolomeo della Nave (no. 84) until 1636; purchased by the English Ambassador Lord Fielding for his brother-in-law the Duke of Hamilton, London, until 1649; as a result of the revolution, it was acquired by Leopold Wilhelm, governor of the Low Countries, who moved it to Brussels and had an engraving made of it for the *Theatrum Pictorium*, and then in 1656, to Vienna (inv. 1659, no. 260: «vom dem jungen Bassan»).

Exhibitions

Paris 1947; Venice 1967; Venice 1981; Berlin 1989.

Bibliography

Boschini 1660, 60 (as Leandro); Storffer 1720, I, 223 (as Leandro); Engerth 1881, 40, no. 48 (as Leandro); von Mechel 1783, 77, no. 38 (as Leandro); Berenson 1894, 84; Berenson 1897, 78; Cossio 1908, 61 and 74 (as El Greco); Zottmann 1908, 26, 30, and fig. 12; Mayer 1911, 22 (as El Greco); von Hadeln 1914 (A), 552; von Hadeln 1914 (B), I, 394, n. 5; von Hadeln 1914 (C), 70; von Loga 1914, 43; Mayer 1914, 211 (as El Greco); Bertini Calosso 1923-24, 488-89, ills. (as Leandro); Mayer 1926, 22; Willumsen 1927, I, 178 and 259 (as El Greco); Arslan 1929 (A), 73; Venturi 1929 (B), 1191-92, 1260, and fig. 831; Arslan 1931, 114, 133, n. 8, and 196; Berenson 1932, 59; Bettini 1933, 65-66, 169, and pl. XXVII; Berenson 1936, 51; Pallucchini 1944, II, XXXVII; Longhi 1948, 54; Baldass 1955, 147; Berenson 1957, I, 21, figs. 1206-7; Fröhlich-Bum 1957, 215; Pallucchini 1957, 106; Zampetti 1957, 94, no. 35, ills.; Berenson 1958, I, 21, figs. 1206-7; Zampetti 1958, 39; Arslan 1960 (B), I, 105-6, 179, and pl. IX, and II, fig. 127; Rearick 1968 (A), 241, n. 2; Ballarin 1973, 91-92, 94, and 96-97; Smirnova 1976, 64 and fig. 65; Magagnato 1981, 177, no. 57, ills.; Pallucchini 1981, 37; Pallucchini 1982, 35, pl. 25; Pallucchini 1984, 155-60, and fig. 1; Rearick 1987, II, 8; Freedberg 1988, 657, and fig. 243; *Die Gemäldegalerie* 1991, 27, pl. 80.

Compared to its autograph replica in Birmingham (Barber Institute of Fine Arts; oil on canvas, 94.3×130 cm), the format of this painting appears to have been cut down in width. This is confirmed by comparison with the engraving in the *Theatrum Pictorium*.

Boschini was the first to publish the work, attributing it to Leandro Bassano and thus resolving the ambiguous reference to «the young Bassano» on the print and in the inventory of the collection of Leopold Wilhelm. This attribution was repeated in the historical catalogues of the royal gallery. The correct solution to the problem of attribution was first suggested by Berenson (1894), but its acceptance was delayed by the discovery of El Greco's youthful period, which was reconstructed by scholars to include a large number of works by Jacopo. Hadeln definitively proved that the Vienna *Adoration* was by Jacopo, on the basis of the work's analogies with the two compositions of similar themes engraved after designs by Raphael and Jan Sadeler, but given to Jacopo by the end of the sixteenth century, along with *The Adoration of the Shepherds* (Galleria Corsini, Rome, cat. 36). Hadeln also provided a chronology for the works, suggesting that they belonged to the artist's «second manner» – under the influence of Parmigianino and thus before the 1568 *Adoration of the Shepherds with Saints Victor and Corona* (Museo Civico, Bassano del Grappa, cat. 46) – but felt that precisely because of a comparison with this work, the date should perhaps be reconsidered with respect to the Treviso *Crucifixion* of 1562-63 (cat. 37), which provides another definitive point of reference for constructing Jacopo's chronology during these years. In his comment on Ridolfi published in that same year, Hadeln suggested a date of about 1560. Venturi agreed with Hadeln's chronological orientation, while Arslan (1931) and Bettini preferred to move the date later, closer to that of the 1568 Bassano *Adoration*. The identification of a particular moment in Jacopo's work from around 1550 of a return to mannerism «in a luministic and dramatic key» – documented by works like *Lazarus and the Rich Man* (The Cleveland Museum of Art, cat. 24) – allowed Roberto Longhi to sketch out a more coherent division of the periods comprising Jacopo's «second manner», which included the group of the Adorations, *The Annunciation to the Shepherds* (Accademia di San Luca, Rome), *Saint John the Baptist in the Wilderness* (Museo Civico, Bassano del Grappa, cat. 29), and *Jacob's Journey* (The Royal Collection, Hampton Court, cat. 33), which were placed, even if only hypothetically, between that time and the Treviso *Crucifixion*, after which the painter developed «with no other manner». This new direction, reinforced some time later by Sartori's discovery of 1558 as the date of *Saint John the Baptist in the Wilderness* (Sartori 1958 (A) and (B)), determines the position of this work between 1558 and 1562-63. Rearick, on

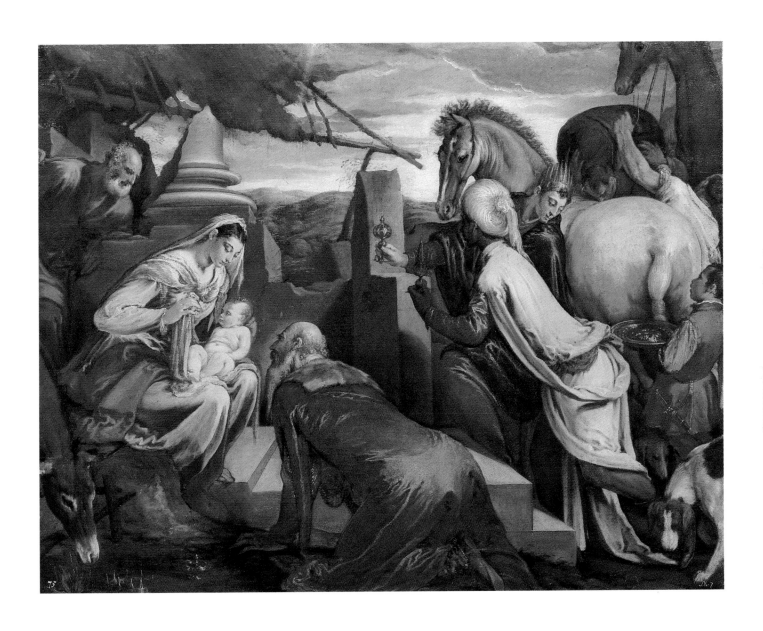

the other hand, continues to consider it later than the Treviso *Crucifixion*, dating it 1563-64, while Ballarin, pursuing the outline sketched by Longhi to reconstruct the years between 1555 and 1563, places it near the beginning, around 1555, shortly after the *Rich Man* in Cleveland.

Works like *The Adoration of the Magi* (Galleria Borghese, Rome, inv. 234), the Vienna version, and the slightly different version in the Barber Institute of Fine Arts in Birmingham, the *Susanna and the Elders* in Ottawa (cat. 28), or *The Annunciation* in Vicenza give the configuration of a very complex moment in Jacopo's career, which is characterized by a return to Parmigianesque elegance and a cold luminosity. To understand this moment, the termination points of the *Rich Man* in Cleveland and the *Saint John the Baptist* in Bassano, which were proposed by Ballarin, seem to be the most convincing. The proximity of the Vienna *Adoration* to the first of these two paintings is proven in details such as the face of the Virgin and that of the magi next to the horse, which share the same egg-shaped deformation, and the contrast between the violence of the light and the rarefaction of the shadow seen in the page at the center of the *Rich Man*. This can be understood even better when the Borghese *Adoration* (inv. 234) is seen as an intermediary picture. In it, the magi in the middle ground still belongs to the faun-like repertory of *The Miracle of the Quails and the Manna* (private collection, Florence, fig. 33), published by Longhi as the pendant to the Cleve-land picture, while the Virgin and the kneeling magi are already like those found in the Vienna picture. With respect to naturalistic and pre-seventeenth-century tendencies, the Cleveland painting signals Jacopo's return to a form more strictly faithful to Parmigianino, such as that seen in his work from around 1550, and made explicit, as Ballarin has pointed out, by recourse to Schiavone's engraving on the same theme (Bartsch 1803-21 XVI, 43, 8) that Jacopo utilized for the detail of the old magi prostrate at the feet of the Virgin. The recovery of a notion of form, more elevated and dependent on drawing, goes hand in hand with that of color, which, with difficulty, reemerges completely renewed after Jacopo's experiments with shade during the first half of the decade. The explosion of patches of color high within the encroaching shadow in the Borghese *Adoration of the Shepherds* (cat. 23) gives way to cool, clean ranges of color, which are subjugated by a twilight that bleaches out the pink of the robes and renders the face tones diaphanous and pearly. Against this background of pre-nocturnal tones, the unreal greens of the magi's loose garments and the blue of the sky stand out. They are picked up again in the foreground by the Virgin's mantle and the page's clothes. The cool, interlocking effect of the colors – underlined by an attentive, spare application of the paint and by brief passages of real light and touch, such as the muffled gleam of the crown of the magi turning toward the right, the platter offered by the page, or the gilded speckling trapped in the green robe of the kneeling elder magi – announces a reorientation of Jacopo's interests from the relationship between manner and nature that dominated his work between the fifth and the beginning of the sixth decade to that between light and color, which was central to the years of his late maturity and old age.

For a discussion of the various replicas of the painting, see the recent work done by Pallucchini (1984). However, the version in a private collection that he published should be considered as an interesting seventeenth-century copy.

V.R.

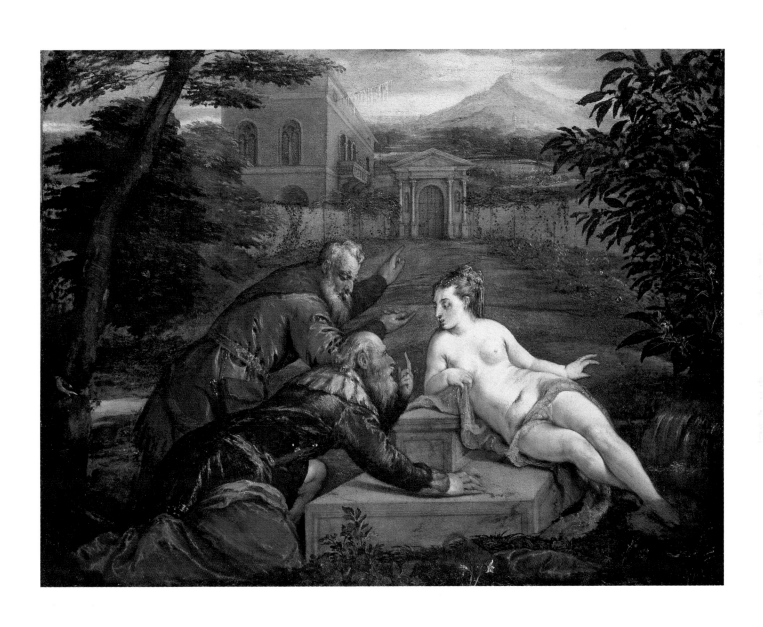

28. SUSANNA AND THE ELDERS (c. 1555-56)

National Gallery of Canada, Ottawa, Bequest of Mrs. Jeanne Taschereau Perry, inv. 14706
Oil on canvas, 89 × 114.8 cm (35 × 45 1/4 in.)

Provenance
Perhaps can be identified with the painting described by Ridolfi (1648, I, 394) in the house of Cristoforo Orsetti in Venice; London, art market, 1933; Montreal, Frederick J. Perry; bequeathed to the museum in 1965 by Mrs. Jeanne Taschereau Perry.

Exhibitions
Never before exhibited.

Bibliography
National Gallery...Report 1965-66, 5; Fredericksen and Zeri 1972, 19; Ballarin 1973, 92-94, 97, 99-100, 122, n. 5, and fig. 122; Rearick 1987 (B), 339-41, fig. 3; Laskin and Pantazzi 1987, I, 10-11, and fig. 40.

Discussed only recently in the literature, this painting is still not widely known, thus the occasion for verification offered by this exhibition is particularly valuable. When it was purchased for the Perry collection in Montreal, it was accompanied by a certificate written by Borenius attributing it to Jacopo Bassano. The attribution was changed to Leandro on Pignatti's suggestion when the painting entered the museum. It was then changed back to Jacopo by Fredericksen and Zeri. Ballarin immediately accepted this suggestion, and identified the painting as the « very fine Susanna at her bath with the two old men » painted according to « la via Parmegiano » seen by Ridolfi in Venice in the house of Cristoforo Orsetti, where there was also an *Adoration of the Shepherds* in the same style, now identified as the painting in the Galleria Corsini in Rome (cat. 36). Translating Ridolfi's critical parameters into the modern division of pe-

riods in Jacopo's career, Ballarin situated the painting between *The Adoration of the Magi* (Kunsthistorisches Museum, Gemäldegalerie, Vienna, cat. 27) of about 1555 and the *Adam and Eve after the Fall* (Galleria Palatina, Palazzo Pitti, Florence, fig. 37) of 1558. The similarity between the figures of Susanna and Eve was also pointed out by Rearick in a lecture given in Baltimore in 1974 and published a few years later (1978 (B)). He explained the similarity as a dependence of the former, painted in about 1566-67, on the latter, painted ten years earlier. On this same occasion, Rearick also proposed an iconographical reading for the *Susanna*.

A variant on the king in the foreground of the Vienna *Adoration*, the kneeling elder in the *Susanna* is defined by a Parmigianesque sharpness of the drawing and exhibits an evocative solution, whereby the figure gravitates toward his menacingly lifted finger. This gesture, as well as the tapered form that unites the nude Susanna to Eve in the Pitti painting, and the twilight tones of the light are all solutions typical of Jacopo in this period of cool luminosity. Within this period, the painting assumes particular significance for Jacopo's discovery of landscape, an innovation whose importance lies in its relationship to his imminent invention of the biblical-pastoral mode of painting, about which Ballarin has written extensively. The landscape, which is sacrificed due to Jacopo's predilection for figures composed like flaming knots in paintings of around 1550, and which is glimpsed for only a moment be-

hind the rising night vapors in the *Two Hunting Dogs* (Galleria degli Uffizi, Florence, cat. 26), now returns with a completely different morphology – that of the garden of a Venetian villa, where the only familiar element is the silhouette of Monte Grappa towering behind the classical gate. This renewed presence allows Jacopo to attenuate the cold, interlocking colors of the Viennese *Adoration* while allowing him to focus the light on the nude Susanna in a more natural manner, thus preparing the way for « the new shiver, as of shimmering silk » (Longhi) on Eve's flesh in the Florentine picture. As further evidence of Jacopo's discovery of painterly richness, alongside the veins of cold light drawn with a thin line that still clings to its graphic nature in the robes of the elders, there is an increase of passages painted with the tip of the brush. The adjoining strokes are increasingly rich in both paint and verisimilitude, as proven by a comparison of the heads of the elders with the bearded king in the Viennese *Adoration*.

V.R.

29. Saint John the Baptist in the Wilderness (1558)

Museo Civico, Bassano del Grappa, inv. 19
Oil on canvas, 114×151 cm (44 7/8×59 1/2 in.)

Provenance

Bassano del Grappa, church of San Francesco, the altar San Giovanni Battista (to the right of the high altar); moved to the Municipio, Bassano del Grappa, in 1796 as a result of the suppression of the church; reclaimed in 1831 by the Costa family, original patrons of the altarpiece; sold to Thiene, Vicenza; purchased 1863 by the canon Merlo, who donated it to the museum in 1866.

Exhibitions

Venice 1945; Bassano 1952; Venice 1957; Venice 1981.

Bibliography

Ridolfi 1648, 397; Boschini 1660, III; Memmo 1754, 78; Verci 1775, 51 and 77; Vittorelli 1833, 44; Roberti 1864 (B), 109-11; Brentari 1881, 196-97; Berenson 1894, 83; Berenson 1897, 75; Gerola 1906, III; Zottmann 1908, 34-35; Willumsen 1927, 221; Arslan 1929 (C), 408; Venturi 1929 (A), 121-22; Venturi 1929 (B), 1170-71, 1254, 1259, and fig. 821; Arslan 1931, 122 and 186; Berenson 1932, 55; Bettini 1933, 71-72 and 171; Berenson 1936, 47; Pallucchini 1944, II, XXXVIII; Pallucchini 1945 (A), 100, no. III; Longhi 1948, 54; Magagnato 1952 (A), 42, no. 21; Berenson 1957, I, 16 and fig. 1199; Pallucchini 1957, 106-7 and fig. 104, Pignatti 1957 (A), 367; Zampetti 1957, 116, no. 45, ills.; Berenson 1958, I, 16 and fig. 1199; Sartori 1958 (A), 192-93; Sartori 1958 (B), 200-1; Zampetti 1958, 36; Arslan 1960 (B), I, 87-88 and 163, and II, figs. 104-5; Ballarin 1969, 104-6; Ballarin 1973, 94, 101, 102, 123, n. 15, and fig. 127; Smirnova 1976, 55, figs. 60-61; Magagnato and Passamani 1978, 24-25, ills.; Magagnato 1981, 174, no. 55, ills.; Pallucchini 1981, 37; Pallucchini 1982, 34, pl. 24; Rearick 1986 (A), 184; Freedberg 1988, 656-57; Ballarin 1990 (B), 118.

On 27 December 1558 (1559 in the document following the *a Nativitate* style), Bartolomeo Testa, after having restored the Cappella di San Giovanni Battista in San Francesco in Bassano, decorated it with a painted altarpiece and endowed it so that Mass could be said there daily. Listed among the witnesses to the notarized document is Jacopo Bassano. The document, discovered in 1958 by Sartori, forced scholars to rethink the critical opinion of the famous *Saint John the Baptist in the Wilderness* – described from Ridolfi throughout the entire eighteenth century as being above the altar of San Giovanni in the Franciscan church – and to revise the traditional view of it as a late work in the artist's career. Both Ridolfi and Verci had sustained this view, referring to it as an example of Jacopo's late manner, an example of that « composto di pratiche difficilissime... di colpo, acquarelle e trattizzo » destined to astonish the experts, and the earliest modern studies by Zottmann, Arslan, Bettini, and Pallucchini (1944, 1945 (A)) seemed to agree. More specifically, Arslan placed the *Saint John the Baptist* within a small group of works of very high quality – Jacopo's *Descent of the Holy Spirit* (Museo Civico, Bassano del Grappa, cat. 119), the Enego altarpiece (cat. 31), *Saints Peter and Paul* (Galleria Estense, Modena, cat. 34), and the *Saint Jerome in the Wilderness* (Gallerie dell'Accademia, Venice, fig. 39) – which were characterized by a return to a Parmigianesque style, but also by greater compositional freedom and a progressive dissolving of color. These traits suggested a date after his 1568 *Adoration of the Shepherds with Saints Victor and Corona* (Museo Civico, Bassano del Grappa, cat. 46) and before that of the 1573 votive lunette in Vicenza (fig. 54). In those years, Venturi was alone in moving the date of these paintings – with the exception of the *Saint Jerome* – between *Lazarus and the Rich Man* (The Cleveland Museum of Art, cat. 24) and the Treviso *Crucifixion* (cat. 37) of 1562-63, recognizing in them a strong commitment to form and at the same time the ability to give a fantastic transfiguration to light that in the figure of Saint John « searches out every fiber of the surfaces corroded and tormented by a line drawn using the tip of his brush with cursive speed ». Longhi took up this proposal again in an essay of 1948, adding new arguments; in an overall attempt to move up the dates of all the phases of Jacopo's career, Longhi reiterated this work's position at the end of his mannerist period. The *ante quem* of 1562-63 was accepted by Magagnato, who suggested a date of around 1560, while Zampetti, on the occasion of the exhibition in Venice in 1957, preferred a later date. At this point, Sartori's research established definitively that the *Saint John the Baptist* was painted in 1558, providing a fixed date between the small altarpiece of 1541 depicting *Saint Anne and the Virgin Child with Saints Jerome and Francis* (Museo Civico, Bassano del Grappa, cat. 7) and the Treviso *Crucifixion* of 1562-63, thus initiating a process of the revision of all of Jacopo's chronology in the direction already intuited by Venturi and Longhi. Reabsorbed into his mannerist phase, the work took on a precise significance in relationship to Jacopo's career and

the last developments of Venetian painting in Ballarin's analysis, which emphasized its links with the decoration of the Libreria Marciana and Jacopo's early pastoral paintings and placed it at the center of an articulate interpretation of the years between 1555 and 1562.

The figure of the Baptist – his head turned behind him, his chest thrust forward – has its origin in a combination of various sources, prompting a comparison with the solutions imported into Venice by Paolo Veronese for ceiling decoration – a contemporaneous example of which were the series of allegorical tondi done for the Libreria Marciana in 1556-57. At the same time, however, it presents a more « forced » design that must be read in relationship to the general influence of Salviati's work in the Libreria Marciana and in other complexes, particularly those where Porta and Schiavone worked. The arrangement of the landscape is taken from Veronese as well, with its refined variations of brown in the trunks and rocks against the cold blue of the sky, striped with clouds in a skillful effect of surface decoration unusual for Jacopo. This return to complicated formal solutions, already evident in *The Good Samaritan* (The National Gallery, London, fig. 25), but here more clearly linked to his awareness of what was going on in Venetian painting, is accompanied by a renewed strength in his handling of light, which prepares the way for *The Descent of the Holy Spirit* (Museo Civico, Bassano del Grappa, cat. 119) done just afterwards, where by now

it is the artifice of light that shapes the forms. The Baptist's sharp joints are struck by the supernatural violence of a light that in the London painting assails the still integral shape of the wounded man and breaks up the smooth, cold compactness of the texture of the painting. In this sense, the passage of the face is significant, where the feverish, visionary tone of the invention arises from the aggressive light on the sharp seal of the Baptist's profile, giving rise to passages in which we can glimpse the artist's late manner, such as the ear created with touches of paint, juxtaposing informal brushstrokes of pink-ocher, a brighter, cooler pink, and wine red.

The importance reserved for the landscape, where the figure of the saint is transformed almost « into a creature of the woods » (Bettini 193), suggests a highly original interpretation of the subject taken from a passage in the Gospel of Saint Luke (3:2: « The word of God came to John son of Zachariah in the wilderness »), and makes explicit the relationship with the invention of Jacopo's first pastoral paintings, which are contemporary with this work, a relationship guaranteed also by the common stylistic matrix in the work of Salviati and Veronese.

A comparison with the engraving in reverse done by P.F. Menarola between 1684 and 1690 (Pan 1992, no. 86) shows that the painting has been cut down along the right, left, and lower borders. This is also confirmed by the seventeenth-century copy conserved in the sacristy of Il Redentore in Venice, recently ex-

hibited as autograph (oil on canvas; 128×170 cm; Gramigna Dian 1991, 57-59). In the engraving made at the beginning of the nineteenth century by Gaetano Zancon, however, the work appears as it is now. Restoration done for this exhibition freed the painting of its layers of varnish that had attenuated the cold tones of the colors and altered the chromatic chords of blue and brown in the landscape and pink and green in the saint's robes, the colors typical in this phase of Jacopo's work.

V.R.

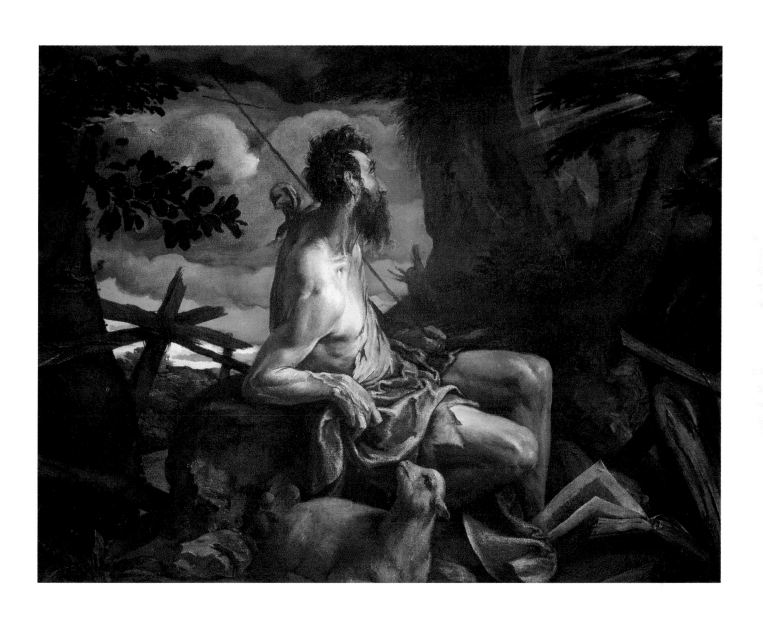

30. The Annunciation to the Shepherds (c. 1558)

National Gallery of Art, Washington, Samuel H. Kress Collection,
inv. 1939.1.126
Oil on canvas, 106×83 cm (41 3/4×32 5/8 in.)

Provenance
Charles Fairfax Murray, London; probably Sotheby's, London, 19 July 1922, lot 101, sold to J. Christie, London; Contini-Bonacossi collection, Florence; Samuel H. Kress, New York, 1933; given to the National Gallery of Art, Washington, in 1939.

Exhibitions
Seattle 1933; Charlotte 1935; San Francisco 1938; Montgomery 1938; Baltimore 1938; Toledo 1940.

Bibliography
Berenson 1957, 1, 21, fig. 93; Zampetti 1957, 128; Berenson 1958, 1, 22, fig. 93; Zampetti 1958, 37; Arslan 1960 (B), 1, 110 and 179; Rearick 1962, 525, n. 4; Ballarin 1965 (B), 66-67, and fig. 78; Ballarin 1969, 106; Fredericksen and Zeri 1972, 19; Ballarin 1973, 94-96, 100-1, 106, and fig. 126; Shapley 1973, 45-46, no. K258, fig. 83; Rearick 1978 (B), 337; Shapley 1979, 1, 30-32, and 11, figs. 19-19 a; Pallucchini 1982, 36, pl. 29; Rearick 1984, 307; Rearick 1986 (A), 184; Rearick 1987, 11, 4 and 12; Ballarin 1990 (B), 118.

This painting documents the interesting question of the genesis of the biblical-pastoral picture, which in a short period of time was to become one of the most important aspects of Jacopo and his workshop's production. Scholars agree that a version of this theme in the Accademia di San Luca, Rome (inv. 99, oil on canvas, 97×80 cm, cut along the lower border), with slight variations in the landscape and the drapery of the peasant woman's shirt, is autograph as well. The subject is also repeated in two engravings, one by Egidius Sadeler struck in reverse from a painting in the Gerolamo Giusti collection in Verona, and another, in the same direction as the paint-ing, done in Venice and bearing the inscription « Sadeler excudit Vene-tijs » (Pan 1992, no. 1).

Arslan (1931, 160) assigned the composition, which he knew only from the version in Rome, to the artist's last period between 1570 and 1580, close to pastorals on the order of the *Jacob's Journey* in the Palazzo Ducale, Venice. He distinguished it, however, from the *Jacob's Journey* at Hampton Court (cat. 33), which he felt could already have been done around 1566, when Vasari, on a trip to Venice, noted the presence of various works by Jacopo « held in high regard, and principally for small things, and animals of every sort » (1568, VII, 455). More generally, up until Longhi's contribution, pastoral painting was considered to be a late development in Jacopo's career. As we have seen, Longhi suggested that *The Annunciation to the Shepherds* in Rome – erroneously indicated as *The Adoration of the Shepherds* – and *Jacob's Journey* at Hampton Court be moved to a date earlier than the Treviso *Crucifixion* of 1562-63 (cat. 37), which would explain the mixture of formal elegance and naturalness that provides their underlying tone. This would also establish the birth of pastoral painting in the last part of Jacopo's mannerist period, at a different moment from that of the « fairs, markets, cartings, and thunderstorms of Bassano and Marostica », evocatively commented upon by Longhi some time earlier in the passage from the *Viatico* (1946), that does, in fact, represent another phase in the history of the pastoral. This hypothesis was supported with new arguments by Pallucchini (1957), who compared the two paintings to *The Parable of the Sower* (Thyssen-Bornemisza Collection, Lugano), which became known when it was exhibited in Venice in 1957 at the suggestion of Rearick. Subsequent positions on the question tend to be less definite: Arslan (1960 (B)) assigned the three paintings to the years 1565-68; Rearick proposed a date of around 1559 for the *Annunciation*, while he thinks that the Treviso *Crucifixion* and the pastorals of Lugano and Hampton Court are later; in his latest contribution, Pallucchini (1982) agreed with Arslan. Starting instead from Longhi's premises, Ballarin has convincingly demonstrated that the Washington *Annunciation* was conceived in 1558, more or less at the same time as the *Saint John the Baptist in the Wilderness* (Museo Civico, Bassano del Grappa, cat. 29). It inaugurates for Jacopo a new genre and different style and is followed by *Jacob's Journey* of 1560 at Hampton Court and the *Sower* of 1561 in the Thyssen-Bornemisza Collection.

The subject, inspired by the very familiar passage from the Gospel of Saint Luke (2:8-15), is well represented in Byzantine and medieval art, but fairly rare in the Renaissance, where it is usually relegated to the background of pictures depicting the Adoration of the Shepherds. Following a procedure that recurs throughout his career, Jacopo isolates the marginal theme and promotes it to the role of protagonist, as in his « portraits of dogs » (private collection, Rome, and Galleria degli Uffizi, Florence, cat. 26). Now, how-

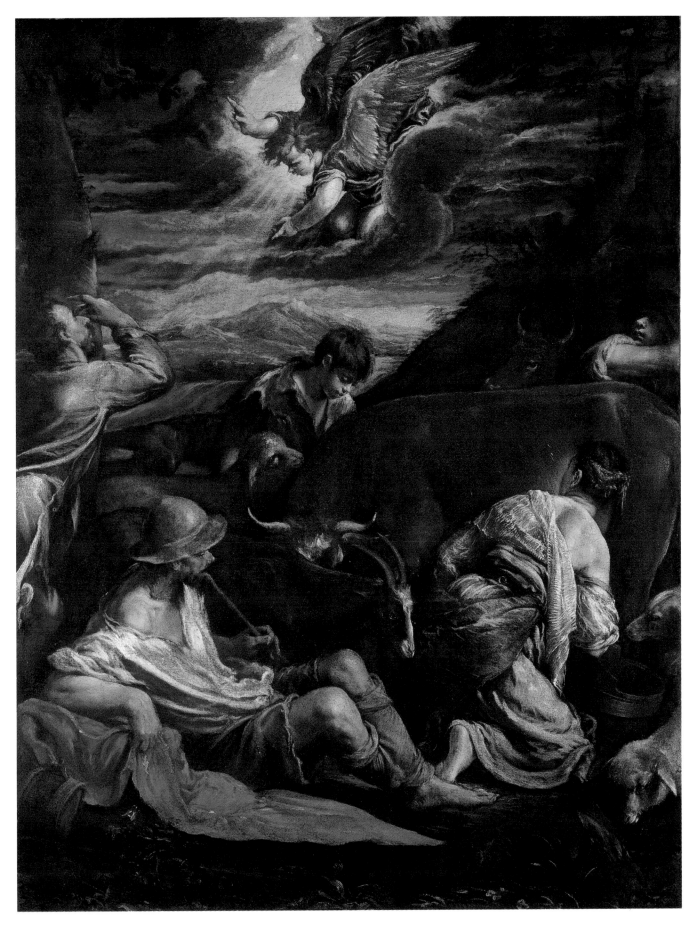

ever, this fragmentation of reality, to which Jacopo was led by the particular nature of his mannerist experience, was destined to give a new, more lasting results, since it came at a moment when the artist had abandoned his conflict between maniera and nature and was discovering a more realistic way of painting. The pastoral picture arose from these premises, and confirmation is seen in the stylistic traits of works like the *Annunciation*. The figure of a reclining shepherd – the reverse image of one in the foreground of *The Adoration of Shepherds* (Galleria Borghese, Rome, cat. 23) – finds its origin in ideas of form similar in their subtle mix of Parmigianino and Salviati to those underlying the figure of the wounded man in *The Good Samaritan* (The National Gallery, London, inv. 277; oil on canvas, 101.5 × 79.4 cm, and here, fig. 25), which also dates from the second half of the 1550s and is linked to the Washington picture through an unfinished version discovered in Prague in 1967 (Národní galerie, Prague, inv. o 129). As Ballarin has pointed out (1965 (B)), if we reverse the Prague painting, which is almost exactly the same size as the London and Washington pictures, we find that the sketched figure of the reclining shepherd is identical to the one in the Washington *Annunciation*, thus proving that the two compositions were conceived together. The landscape of the English painting – where the meeting of the backlit rocky ledge with the deep, cold blue sky shows a demand for truthfulness in the depiction of light more compelling than that found in

the Ottawa *Susanna and the Elders* (cat. 28) – is reposed here in an almost nocturnal light that lowers the chromatic tone and allows for pre-seventeenth-century effects in the progressive extinguishing of the light on the back and shirt of the shepherdess silhouetted against the brown shape of the cow. This figure is new to Jacopo's repertoire, inspired by Veronese's decorations in the Libreria Marciana in Venice, as is also the case for the figure of the saint in *Saint John the Baptist in the Wilderness* (Museo Civico, Bassano del Grappa, cat. 29), documented in 1558, whose sharp profile modeled by the supernatural light is quite similar to that of the shepherd standing on the left in the Washington picture. Another factor linking this painting to the years of the artistic exchange between Veronese and Jacopo is found in the comparison between the figure of Diana in a drawing from Christ Church, Oxford (cat. 86) and the shepherdess; seen in x-radiograph, as Shapley (1979) has proposed, it reveals not only formal analogies, but also similarities in drawing technique.

V.R.

31. SAINTS JUSTINA, SEBASTIAN, ANTHONY ABBOT, AND ROCH (c. 1560)

Chiesa di Santa Giustina, Enego
Oil on canvas, 170 × 112 cm (66 7/8 × 44 1/8 in.)

Provenance
Santa Giustina, Enego, by 1571.

Exhibitions
Bassano 1952; Venice 1957; Vicenza 1980; London 1983.

Bibliography
Ridolfi 1648, I, 389; Verci 1775, 49 and 104-6; Maccà 1812, 221; Arslan 1929 (C), 408; Venturi 1929 (A), 122; Venturi 1929 (B), 1167-69, 1259, and fig. 820; Arslan 1931, 119-20, 189, and pl. XL; Berenson 1932, 56; Bettini 1933, 92, 175, and pl. XXXVII; Berenson 1936, 49; Pallucchini 1944, II, XXXVIII; Magagnato 1952 (A), 13-14, 42-43, no. 22, and fig. 21; Magagnato 1952 (B), 226, fig. 241; Berenson 1957, I, 17, and fig. 1198; Pallucchini 1957, 108; Zampetti 1957, 120, no. 47, and 121, ills.; Berenson 1958, I, 18, and fig. 1198; Zampetti 1958, 40, pl. LVII; Arslan 1960 (B), I, 89-90, 96, n. 57, and 167, and II, figs. 109-10; Ballarin 1968 (A), 44; Ballarin 1973, 95, 105-6, 120, and figs. 133 and 137; Rearick 1976 (A), 106-7, no. 67, and fig. 67; Smirnova 1976, 63-64, and fig. 64; Rearick 1978 (B), 334-35; Mason Rinaldi 1979, 245, no. a18; Sgarbi 1980, 85, ills.; Pallucchini 1982, 34-35; Bordignon Favero and Rearick 1983, 221-23; Magagnato 1983, 148-49, no. 7, ills.; Pallucchini 1984, 155, n. 7, and 159-60.

This painting currently hangs on the west wall of the parish church of Santa Giustina in Enego. Badly damaged in a fire in 1762, the church was rebuilt beginning in 1802, erasing every trace of a large decorative program executed in various stages by Jacopo and his son, Francesco. According to Verci's analytical documentation, this included the decoration of the choir, nave, and ceiling of the church. The sixteenth-century aspect of the church constituted in 1539 and consecrated on 12 May 1552 is described in the account of the pastoral visit of the bishop Nicolò Ormanetto on 8 October 1571 (Bordignon Favero and Rearick 1983) who, after mentioning Jacopo's frescoes in the choir, recalls that on the altar « quod est adextris altaris magni in deambulatione septentrionali », and officiated by the Confraternita di Santa Giustina, there was a « palla pulchra » by the same painter that can be identified as the painting under discussion.

Although the pastoral visit of 1571 gives us important details about Jacopo's work in Enego, it does not resolve the controversial question of the date of the altarpiece, which Ridolfi included among the works realized following « la via del Parmegiano », and thus before the 1568 *Adoration of the Shepherds with Saints Victor and Corona* (Museo Civico, Bassano del Grappa, cat. 46) that he considered to come at the beginning of Jacopo's late period. This opinion was shared by Verci, who nevertheless remained ambiguous about the date. The biographer conjectured that Jacopo's undertaking in Enego was linked to the « fiera pestilenza » of 1576, a date in open contrast with the time he had indicated elsewhere as marking Jacopo's Parmigianesque phase. The error was noticed by Mason Rinaldi, who called attention to a plague of 1555-56, less famous than that of 1576, yet widespread through the Venetian territory. In the first modern studies to disagree with the very late date proposed by Arslan (c. 1570) and Bettini (c. 1574), Venturi remained isolated in dating it before the Treviso *Crucifixion* of 1562-63 (cat. 37). Venturi emphasized the strong Parmigianesque quality of the invention – the cool palette borrowed from Veronese and the application of the paint by touches of the brush, « following in flight the downpour of light ». The hypothesis of an earlier date began again with Magagnato, who proposed c. 1560, a date followed with some uncertainty by Arslan (1960 (B)) and Zampetti (1957). Pallucchini (1957) preferred to move the painting later, along with the altarpiece of *Saints Peter and Paul* (Galleria Estense, Modena, cat. 34), to a time after the Treviso *Crucifixion*. Most recently, a date of c. 1560 has been carefully argued by Ballarin in his proposal for a reconstruction of the years between 1555-63, which places the Enego altarpiece after *The Descent of the Holy Spirit* (Museo Civico, Bassano del Grappa, cat. 119). For Ballarin, the Bassano picture was conceived as an act of homage to the elderly Titian at a moment when Jacopo was returning to the more personal and anti-Titianesque problem of the unification of space through light, which meant a sacrifice of color. It also involved one last return to mannerism as practiced in Parma, before his classicism in the Modena altarpiece. Subsequent studies agree on a date around 1560, with the exception of Rearick, who, going back to the passage from Verci mentioned above, credited the hypothesis of a flight to Enego on Jacopo's part. Rearick proposed that Jacopo's flight could have taken place between March 1555 and June 1557, a period when documents do not record his presence in Bassano,

and was related to the artist's supposed Protestant sympathies. The stylistic rapport, which places this work after *Lazarus and the Rich Man* (The Cleveland Museum of Art, cat. 24) and *The Mystic Marriage of Saint Catherine* (Wadsworth Atheneum, Hartford, cat. 22), would confirm this date, and in fact allows us to narrow it down to sometime within the year 1555.

The work marks the return to an unreal, rarefied color, as though seen under water, which recalls *The Adoration of the Magi* (Kunsthistorisches Museum, Gemäldegalerie, Vienna, cat. 27). However, here the effect of cold, interlocking hues and the sharp tracing of the lines that are imprisoned on the surface of the light, yields to a rich and airy use of the brush and a new circulation of light «in rivulets, sprays, and sparkles» that exalts the Parmigianesque core of the form «moving in unison with the wind-filled curtain and ruffles of the veils» (Venturi 1929 (A)). Here, as Ballarin has pointed out, Jacopo brings to fruition his experiences between the *Saint John the Baptist in the Wilderness* (Museo Civico, Bassano del Grappa, cat. 29) and *The Descent of the Holy Spirit* toward the direction of an enrichment of the expressive possibilities of light, but without sacrificing color. Another element to be read alongside the «parallel text» of the Vienna *Adoration* is the strong presence of the Parmesan mannerism in Jacopo's style, here subtly melded with his knowledge of Veronese's work of 1557-58. For example, Saint Justina – so close in invention to the Diana of the Oxford drawing (cat. 86) – would feel quite at home among the figures on Veronese's ceilings, next to the Diana of the *Olympus* in the Villa Barbaro at Maser, and the Saint Roch, which certainly was influenced by the Titianesque woodcut of the same subject (Smirnova 1976). Jacopo explicitly refers to Veronese's anatomical constructions in the saint's head from below, leaning backwards, and his shoulder, pressed forward, tipping the entire upper body in that same direction.

An extraordinary paroxysm of Jacopo's predilection for fantasy during his long mannerist period, the painting does not offer iconographic points of departure for an interpretation in terms of Jacopo's supposed Protestant sympathies, as Rearick himself has noted. Rather, its significance as an exorcism against the plague, linked to the presence of three specifically thaumaturgical saints – Roch, Sebastian, and Anthony Abbot, who are placed next to Justina, patron saint of the church and the confraternity officiating at the altar – would bring it into the sphere of circumstances prevailing throughout the sixteenth century.

V.R.

334

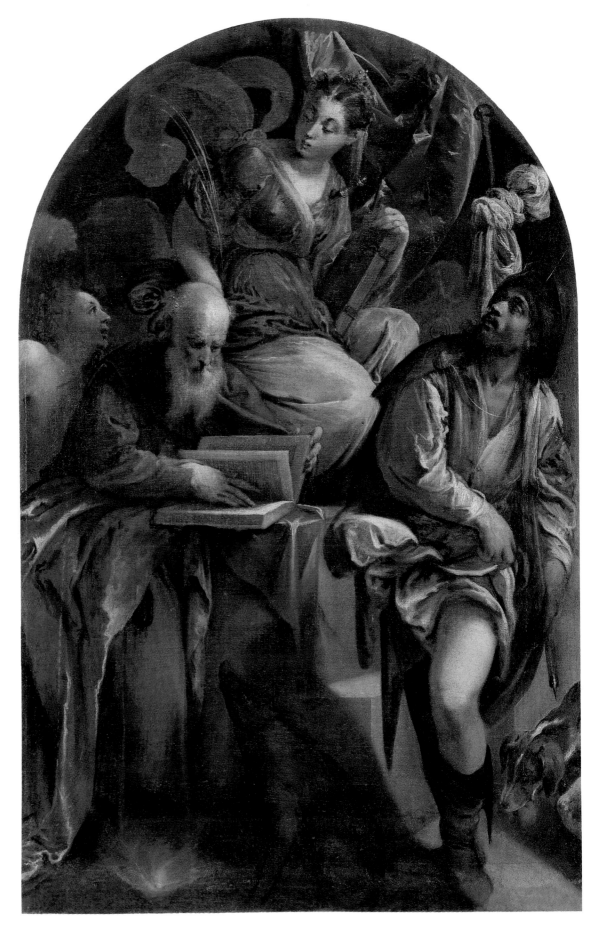

335

32. SAINT PAUL PREACHING (1559)

Musei Civici-Museo d'Arte Medievale e Moderna, Padua, inv. 897
Oil on canvas, 45×37 cm (17 3/4×14 1/2 in.)
Inscriptions: MAFEI 36 on the lower step
Exhibited in Bassano del Grappa only

Provenance

Galleria abbaziale di Santa Giustina, Padua (inv. 1689-91, no. 6, as Maffei; inv. 1697-98, no. 24, as Francesco Maffei); Museo Civico, Padua since 1857.

Exhibitions

Padua 1976; Padua 1980; Frieburg 1987; Padua 1991.

Bibliography

Ivanoff 1942, 45-46 and 60 (as Francesco Maffei); Ivanoff 1947, 42, 66, and pl. LVII (as Francesco Maffei); Zampetti 1957, 122; Ballarin 1973, 95, 106-8, 123, n. 20, fig. 135; Rearick 1976 (A), 106-7 and no. 67, fig. 67; Mariani Canova 1980 (A), 41, 55, 142, and no. 27, fig. 27; Mariani Canova 1980 (B), 323 and no. 194, fig. 193; Fomiciova 1981, 84; Meyer zur Capellen 1987, 62, no. 8, ills.; Attardi 1991, 212-13 and no. 130, fig. 130.

This is one of the artist's few surviving *bozzetti*. Jacopo's use of such models is documented not only by this piece, but also by a later model depicting *Saints Nicholas, Valentine, and Martha* (Museum of Art, Rhode Island School of Design, Providence, cat. 68) for the Valstagna altarpiece, which is no longer extant.

The original attribution to Francesco Maffei can be traced to the late seventeenth-century inventories of the collection of the abbot of Santa Giustina in Padua (Mariani Canova). Ivanoff considered it to be an unfinished sketch in the manner of Jacopo with some affinities to El Greco. The first connection came from Zampetti, who published the version in the Morandi collection in Bologna (oil on canvas, 37×52 cm), now agreed to be a copy, as an autograph work. Zampetti referred to a «replica» in the Museo Civico in

Padua, which Longhi, though it is not specified when, had attributed to Jacopo. He also mentioned a similar opinion held by Valcanover (this cannot be checked because of an error in the bibliographical citation). Ballarin considered it to be the model for a lost altarpiece and dated it slightly earlier than the Enego altarpiece (cat. 31), pointing out that it shared with this latter work a return to elements derived from Parmigianino, particularly in the handling of the light. Rearick confirmed the attribution to Jacopo and the relationship with the Enego altarpiece, but moved the date earlier, to 1555-56. Subsequent studies have concurred with the attribution to Jacopo.

The scene, inspired by a passage from the Acts of the Apostles (17:16-34), depicts Saint Paul's address to the Court of Areopagus in Athens, which resulted in the conversion of Dionysius and Damaris and the foundation of the Christian community in Greece. It is based on a free and original interpretation of a print by Schiavone of the same subject (Bartsch 1818, XVI, 53, no. 22). Here, even more than in the Enego altarpiece, we find evidence of Jacopo's return to Parmigianino's sense of form, now interpreted through his greatly increased awareness of the expressive possibilities of light, which he learned from his artistic experiments in 1557-59. This helps to explain the painting's «iridescent luminosity of pearly whites and some touches of aquamarine dropped onto the ineffable gray and pink-violet shadows, suspended at the heights of

an extremely rarefied form» (Ballarin). Significant analogies can be made with other works from 1558-59. The sharp profile of Saint Paul is close to that of Saint John the Baptist in the 1558 canvas depicting *Saint John the Baptist in the Wilderness* (Museo Civico, Bassano del Grappa, cat. 29). Saint Paul's pose has a precedent, even if less agitated, in Raphael's preparatory study for the Sistine tapestry, which also depicts Saint Paul preaching. Raphael's invention was popularized by Marcantonio Raimondi's engraving (Meyer zur Capellen). Saint Paul's profile can also be compared with that of the reclining shepherd in *The Annunciation to the Shepherds* (National Gallery of Art, Washington, cat. 30). Finally, the face seen in profile in the lower right foreground, which is foreshortened from below and illuminated by a stroke of light on the temple, is the mirror image of the apostle's head on the right in *The Descent of the Holy Spirit* (Museo Civico, Bassano del Grappa, cat. 119). The similarity is even more striking in Jacopo's preparatory study for Saint Paul (Graphische Sammlung Albertina, Vienna, cat. 85).

Another version of the painting (The Hermitage, Saint Petersburg, inv. G.E. 1389, oil on canvas, 45×38 cm, see Fomiciova) has some variations in the architecture and an additional female figure on the left. Also, the three male figures, which are barely sketched with the tip of the brush in the Paduan picture, are fully finished in the Saint Petersburg version. Attardi has correctly observed that the painting in The Her-

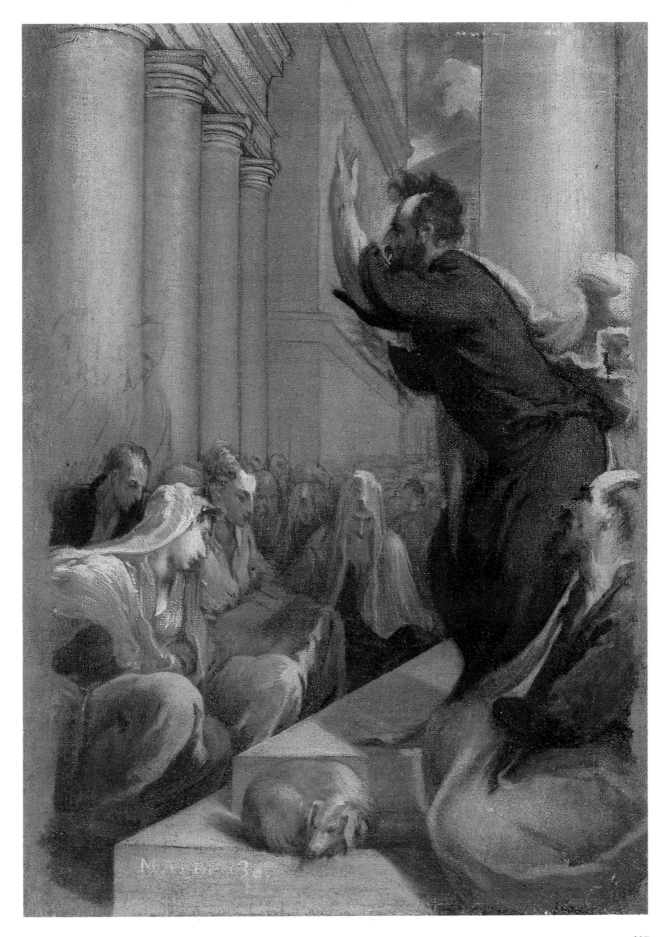

337

mitage, which is highly finished and lacks a freshness and rapidity of execution, would seem to be derived from the finished altarpiece, which was executed only after the *bozzetto* here had been approved by its patron.

The history of the altarpiece is illuminated by a late notation in the *Libro secondo* (fol. 135*v*) for the year 1559, which does not specify the month or day: « de' dar el ditto misier Zuanne da Lugo scudi d'oro n° sie de marchà fatto, d'un quadro d'un san Paolo che predica e con il cassamento tutto d'oro L. 40 s. 4 » (the above mentioned Zuanne da Lugo must give 6 gold scudi for a painting of a Saint Paul preaching and with the frame all in gold L. 40 s. 4). This must be the first payment of 6 gold scudi made by Zuanne da Lugo to Jacopo for a painting depicting *Saint Paul Preaching* whose total cost is not given. Subsequent entries confirm this; between Holy Week of 1559 and 19 December, orders for cloth from Zuanne are recorded with the notation that they were placed « monta a conto del quadro » (against the price of the painting). A similar business relationship between Jacopo and Zuanne da Lugo already existed in 1543 (fol. 132*r*) when the painter's work was paid for partly in cash and partly in cloth, a situation that was repeated in 1551 and 1552. For reasons of brevity we shall give only one example: in 1543 Zuanne delivered five and a quarter « *braccia* » of cloth for a jacket, and in the account book Jacopo noted « mi l'a datto per parte et conto de un quadro che le debo far de un Christo alla

colonna » (he gave it to me as part and on account for a painting that I have to do for him of Christ at the column). To return to the payment of 1559 mentioned above, the notation that the painting had to be furnished with a « *cassamento* » of gold, which means with an elaborate and valuable frame, leads us to think that the work was not intended for private devotional purposes, but for a church. This fact, along with the agreement between the *Libro secondo* and the date proposed for stylistic reasons for the Padua *bozzetto*, opens the way for a prudent hypothesis that the *bozzetto* could be linked with the painting commissioned by Zuanne da Lugo, which when finished must have looked similar to the copy in The Hermitage. In fact, it seems that we can exclude a reference to another *Saint Paul Preaching*, known through two very small versions (Accademia Carrara, Bergamo, inv. 58, oil on canvas, 29 × 16 cm; and art market, New York), which probably dates from some years earlier, around the time of *The Annunciation* (Museo Civico, Vicenza), and just after *The Adoration of the Magi* (Kunsthistorisches Museum, Gemäldegalerie, Vienna, cat. 27). The only reference to an altarpiece of this subject is to the very well known painting in the parish church in Marostica, which Jacopo and his son Francesco signed in 1574. Furthermore, Verci does not mention a church of San Paolo in Bassano, where such a work could have been destined. There does exist, however, a Scuola di San Paolo in Bassano. In 1519, Francesco il Vecchio had executed

an altarpiece depicting *The Virgin Enthroned with Saints Peter and Paul* for the altar of the Scuola di San Paolo in the church of San Giovanni (now Museo Civico, Bassano del Grappa), and in 1592 Leandro painted a banner depicting *The Blinding of Saint Paul* (Verci 1775, 36, 190-91). As the *Libro secondo* records, Jacopo himself had worked for the Scuola di San Paolo on more than one occasion (fols. 100*v*-101*v*, and Muraro 1992, *Catalogo*, 98-99). This, perhaps, is the proper direction to pursue in a search for the destination of the altarpiece related to the *bozzetto* under discussion here.

Perhaps we can also identify Zuanne da Lugo as the patron of another work by Jacopo, which is still not widely known: the *Ecce Homo* formerly in the Novi collection, Milan (Rearick (1976 (A), 335-36, fig. 1). It belongs to the same moment of sublime handling and luminosity as the *Lazarus and the Rich Man* (The Cleveland Museum of Art, cat. 24). The *Libro secondo* (fol. 133*v*) records on 12 December 1553 a debt in Zuanne's name « per haverli fatto un quadro d'un Christo Ecce Homo monta ducati cinque » (for having done for him a picture of Christ *Ecce Homo* for a total of 5 ducats). Once again, there is a precise agreement between the subject and date testified to in documentary sources and the date arrived at based on stylistic evidence.

V.R.

338

33. JACOB'S JOURNEY (c. 1560)

The Royal Collection, Hampton Court, inv. 103
Lent by Her Majesty Queen Elizabeth II
Oil on canvas, 127.8 × 183.5 cm (50 1/4 × 72 1/4 in.)

Provenance

Whitehall, collection of Charles I Stuart (inv. Abraham van der Doort: as Jacopo in his first manner); Somerset House, sold to Willet 7 May 1650; recovered with the Restoration (at Whitehall) in the inventory of Charles II, no. 185); at Kensington Palace under William III (inv. 1697, no. 31) until 1785; Buckingham House (inv. 1819, no. 790); Kensignton Palace by 1831 (Passavant 1836); at Hampton Court since 1839.

Exhibitions

London 1831; Leeds 1868; London 1946; London 1960; London 1983.

Bibliography

Catalogue of Pictures 1831, 16, no. 100 (as Leandro); Passavant 1836, I, 110; Waagen 1854, II, 357; *National Exhibition* 1868, no. 68; Berenson 1894, 83; Berenson 1897, 76; Jacobs 1925, 31; Willumsen 1927, I, 212; Arslan 1929 (C), 408, 413, and fig. 2; Venturi 1929 (B), 1172-74, 1259, and fig. 823; Arslan 1931, 117-18 and 190; Berenson 1932, 57; Pevsner 1932, 164; Bettini 1933, 69-71, 171, and pl. XXIX; Buscaroli 1935, 193; Berenson 1936, 49; Nicolson 1947, 226; Longhi 1948, 54; Mahon 1950, 18; Baldass 1955, 150-52 and fig. 4; Berenson 1957, I, 18; Pallucchini 1957, 106; Baldass 1958, 298-300; Berenson 1958, I, 18; Zampetti 1958, 37 and pls. XLVIII-XLIX; Arslan 1960 (B), I, 109 and 168, and II, fig. 147; Waterhouse 1960, 19, no. 11; Ballarin 1965 (B), 67, fig. 77; Rearick 1986 (A), 242; Ballarin 1969, 97-98, 106, n. 57, 114, and fig. 120; Ballarin 1973, 95-96, and fig. 138; Smirnova 1976, 62, 72-73, and fig. 83; Pallucchini 1982, 38, pl. 28; Magagnato 1983, 149, no. 8, ills.; Shearman 1983, 25-27, no. 19, and fig. 12 (with earlier bibliography relevant to the Royal Collection); Rearick 1986 (A), 184; Ballarin 1990 (B), 134 and 136.

This very beautiful pastoral was already identified as the work of Jacopo Bassano in the inventory of the collection of the Stuart king, Charles I, that was drawn up by van der Doort in the years between 1637-40. The attribution has been accepted unanimously, with the exception of the catalogue of the exhibition held in 1831 at the British Institution, which unexplainedly gives the name of Jacopo's son, Leandro. Art historians also agree in considering it among the earliest pastoral inventions of the painter. However, proposals as to a date vary widely. As for other works carried out during this phase of Jacopo's career, in the earliest modern studies we find the usual contrast between a fairly late date offered by Arslan (1931), who indicated c. 1565 and linked the painting with the passage in Vasari that mentions canvases by Jacopo in Venice depicting «animals of every sort» (1568, VII, 455). Bettini moved the date even later, to about 1568, while Venturi, on the other hand, moved the painting up to a date before the Treviso *Crucifixion* of 1562-63 for San Paolo (cat. 37) on the basis of the mixture of a decorative approach to the form and a new interest in present light, which he also found in *Saint John the Baptist in the Wilderness* (Museo Civico, Bassano del Grappa, cat. 29) and the Enego altarpiece (cat. 31). This hypothesis was shared by Longhi, who added new arguments to the thesis, and later found support, mainly from Pallucchini (1957), while Arslan remained firm in his convictions expressed in 1931. More recently Rearick, assigning the date of about 1563 to both the painting at Hampton Court and *The Parable of the Sower* (Thyssen-Bornemisza Collection, Lugano), where he recognized a subtle balance between elegant stylization and rustic simplicity, moved the question of the biblical-pastoral painting to the years after the Treviso *Crucifixion*. He was followed in this by Pallucchini (1982). Ballarin, instead, proposed to read the work as a parallel text to the Enego altarpiece of about 1560, distinguishing the birth of the pastoral painting, still linked to the last moments of Jacopo's mannerist season, from the evolution of the genre in a «classical» direction, which for Ballarin took place around the middle of the 1560s.

The new depth and width of the landscape, crossed diagonally by the flow of the procession of figures and flocks, documents an achievement that certainly comes later than *The Annunciation to the Shepherds* (National Gallery of Art, Washington, cat. 30), where the space is concentrated in the foreground and closed in by the web of the composition. It also presupposes an early attention on Jacopo's part to some of Titian's inventions of the 1520s and 1530s for pastoral themes, in particular the *Shepherd Playing a Flute with his Flock*, known through a drawing (Graphische Sammlung Albertina, Vienna) and an engraving (Ballarin 1990 (B)) that would continue to interest the artist in the following decade. The greater naturalness of the space is promoted by the quality of the light, which has abandoned the exaggerated, artificial effects of the Washington painting and the fantastic violence of the Enego altarpiece, to ac-

quire a more subtle capacity for graduating and uniting the composition. The light is shattered into minute touches in a cool range of color, those «silver tones» that Waagen has so acutely noted. The foreground of the painting is particularly enriched by this luminosity. It is painted with variations of quiet whites, grays, and browns in the sheep, and reaches the maximum concentration of light in the blouses of the women set against the dark brown background skimmed by the shade, or again, in the figure on the left, where a refined relationship is established between the ashen pink flesh of the shoulder and the faint blue-white of the blouse. The very high quality of the draughtsmanship with which the young woman's body and lost profile are traced is found also in the male figure at the center and is seen again in the detail of the mother with a small child in the foreground, where the sinuosities of the form are as though squeezed out by light, revealing a notion of form quite similar to that with which Jacopo experimented in the Enego altarpiece, whose palette is also lent to this painting. The emerald green, pink, and cobalt blue are the same as in the Enego altarpiece, yet seem less abstract due to the new atmospheric value of the light.

Identification of the subject as Jacob's journey (Genesis 29:1-8) appears today to be the most convincing, but other theories have been advanced, which are articulately discussed by Shearman (1983). An important replica of the painting, formerly belonging to Viscount Cobham at Hagley Hall (then Sotheby's, London, 10 July 1973, lot 26; Christie's, London, 10 April 1981, lot 61; oil on canvas, 132.2 × 186.6 cm), certainly a product of Jacopo's workshop and painted with a different palette, is slightly reduced in size compared to its prototype. This is particularly evident along the lower edge, where a portion of the ground, the sack, and the feet of the child seated next to the dog are all cut off.

V.R.

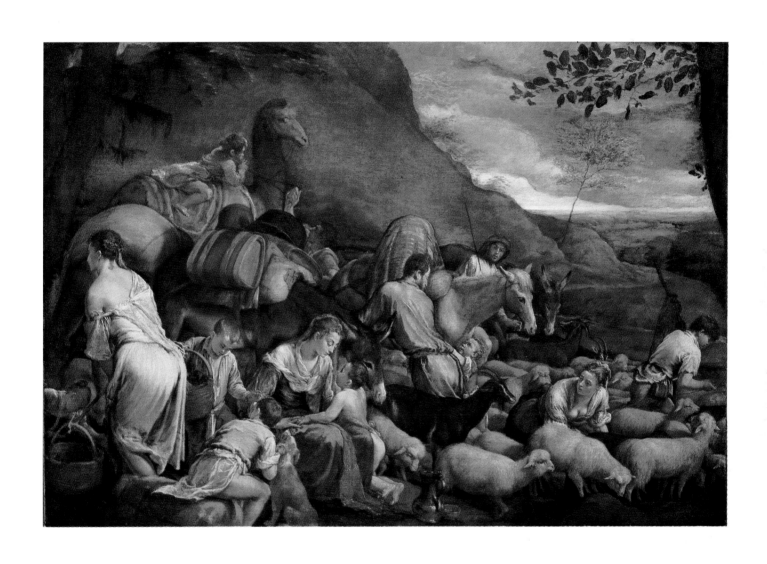

34. Saints Peter and Paul (c. 1561)

Galleria Estense, Modena, inv. 422
Oil on canvas, 288×123 cm (89 3/4×48 3/4 in.)

Provenance

Santa Maria dell'Umiltà, Venice, second altar on the right; taken from the church after its suppression in 1806, it was chosen by Edwards for the Crown and deposited in the Sala dello Scrutino of the Palazzo Ducale and from there sent to Modena, where in 1811 it entered the Galleria Estense.

Exhibitions

Venice 1957; Ferrara 1985.

Bibliography

Sansovino 1581, 98; Ridolfi 1648, I, 390; Sansovino and Martinioni 1663, I, 275; Boschini 1674, 347; Zanetti 1771, 197; Zanetti 1773, 333; Verci 1775, 138-39; Castellani Tarabini 1854, 38, no. 126 (as Veronese); Zanotto 1857, pl. II; Venturi 1878, 98; Berenson 1894, 85; Berenson 1897, 77; Gerola 1905-6, 952; Zottmann 1908, 34; Gerola 1909 (A), 6; Willumsen 1927, 177-78; Longhi 1928 (A), 79; Venturi 1929 (A), 121, fig. 10; Venturi 1929 (B), 1162-64, 1254, and fig. 818; Arslan 1931, 120, 136, n. 20, 191-92, and pl. XLI; Berenson 1932, 58; Bettini 1933, 72-73, 171, and pl. XXXII; Berenson 1936, 50; Pallucchini 1944, II, XXXVIII; Pallucchini 1945 (B), 172, no. 388, and figs. 139-40; Longhi 1946, 23; Berenson 1957, I, 19; Pallucchini 1957, 108-9; Zampetti 1957, 124, no. 49 and 125, ills.; Berenson 1958, I, 19; Zampetti 1958, 40; Arslan 1960 (B), I, 88-89 and 171, and II, figs. 106-8; Rearick 1968 (A), 241, n. 2; Smirnova 1976, 65, figs. 62-63; Ballarin 1973, 95, 108-9, fig. 144; Pallucchini 1981, 37; Pallucchini 1982, 34; Rearick 1984, 308; Rearick 1986 (A), 184; Rearick 1987, II, 6; Freedberg 1988, 656-67.

This is one of the rare public works executed by Jacopo for an important Venetian church. It was commissioned for Santa Maria dell' Umiltà, located along the Rio della Salute, not far from the Dogana (Corner 1758, 524-25; and Zorzi 1972, II, 362-63). At one time the church belonged to the order of the Teutonic Knights, but it was ceded in 1550 to one of the first Jesuit communities established in Italy, which held it until 1606, when the order was forced by interdiction to leave the city. The Jesuits renovated the church «in a comfortable and beautiful form», as Sansovino writes in 1581, mentioning for the first time the altarpiece by Jacopo, which was placed above the second altar on the right. The prestige of the commission is best understood in relation to the «many works of beautification» and in particular to the ceiling, decorated with canvases by Paolo Veronese depicting *The Annunciation, The Assumption of the Virgin,* and *The Adoration of the Shepherds* (now Santi Giovanni e Paolo, Venice; Pignatti 1976, I, 78-79 and 213-14). Other works in the church included Tintoretto's *Deposition from the Cross* (now Gallerie dell'Accademia, Venice; Pallucchini and Rossi 1982, I, 61, fig. 297) and the precious wooden tabernacle with canvases by Veronese, Jacopo Palma il Giovane, and Francesco Bassano, which was being built in 1581, the year Sansovino's guide was published (Mason Rinaldi 1982).

The altarpiece has been attributed to Jacopo continuously since 1581, when the artist was still alive, with the sole exception of Castellani Tarabini, who assigned it to Paolo Veronese. Its critical history runs parallel to that of works such as *Saint John the Baptist in the Wilderness* (Museo Civico, Bassano del Grappa, cat. 29) and the Enego altarpiece (cat. 31). Considered to be slightly earlier than the Treviso *Crucifixion* (cat. 37) by Venturi, who along with Longhi detected a Titianesque heroism in the two saints, the painting was moved back to around 1570 by Arslan (1931) and Bettini. After the monographic exhibition of 1957, in which the altarpiece appeared with the date of 1565, Venturi's date prevailed, and was narrowed to around 1561 with new, closely argued observations offered by Ballarin, with whom Rearick dissents, holding that it was executed in 1564.

Although belonging to the phase begun by the Viennese *Adoration of the Magi* (cat. 27), in which there is a marked abstraction of the color and tension between light and shade, the Modena altarpiece takes on a solemn, monumental air and achieves a new balance between formal refinement and a landscape background, preparing the way for a turning point in Jacopo's career, which is represented by the Treviso *Crucifixion.* Furthermore, the work places Jacopo squarely within the Venetian tradition, justifying critical references to Titian. In reality, the artist to whom Jacopo looks in this painting is Veronese, not the Veronese of the ceiling of the Libreria Marciana, who had interested Jacopo at the time of *Saint John the Baptist,* but rather the «classical» Veronese of the Maser frescoes (Ballarin), who suggested to Jacopo the solemn design of the figures and the vertical and decorative structure of the landscape. The three stories from the life of the Virgin painted by Veronese

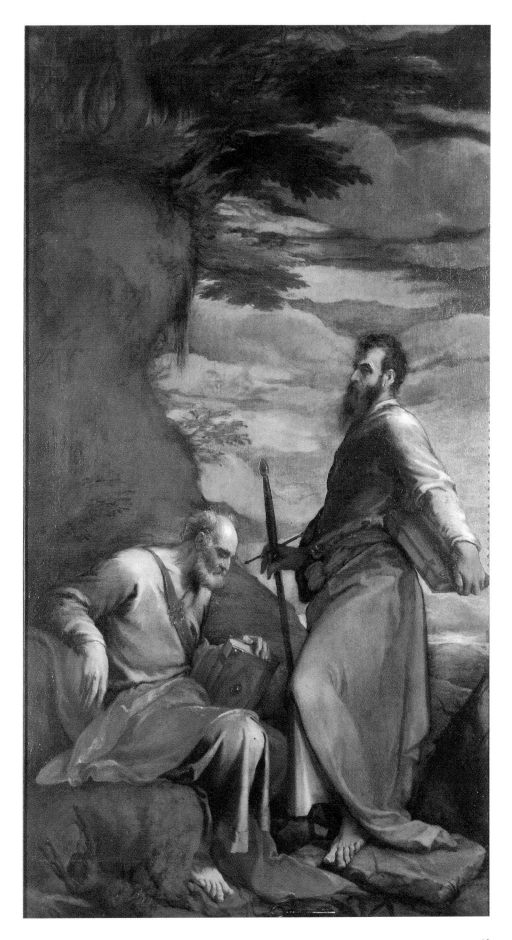

for the ceiling of the same church were already *in loco* by 1566 when Vasari saw them. Chronologically, they are probably not too distant from Jacopo's contribution to the church, given their stylistic dependence on the decoration for the Villa Barbaro at Maser. These paintings are extremely helpful for understanding the complexity of the relationship between the two artists at this particular moment, especially since Veronese's *Adoration of the Shepherds* – from which derives the smaller version of the same subject in a private English collection (Ballarin 1968 (A), 42) – reveals a familiarity with works by Jacopo like *The Adoration of the Shepherds* (Galleria Corsini, Rome, cat. 36). Another important comparison for understanding the aspects of Veronese's painting that interested Jacopo as he was about to conclude his mannerist phase is with the fine altarpiece representing *The Virgin Appearing to Saints Anthony Abbot and Paul*, destined for an altar in the Benedictine abbey at Polirone (now The Chrysler Museum, Norfolk; Pignatti 1976, I, 73 74, and II, fig. 366), commissioned in December 1561 and finished the following March. Beyond these Veronese-like innovations, the links between this painting and the Enego altarpiece can also be seen in the unreal tension of the light and color, particularly evident in the detail of the skull of Saint Peter, which is sketched against the point where the brown backdrop of the rock meets the lapis lazuli of the sky by a ray of light that emphasizes its egg-shaped form – a passage closer to the head of Saint Anthony Abbot in Enego than to the Saint Jerome of the *Crucifixion* of 1562-63, where the temple is constructed following the principle of an impressionistic shattering of the form. This passage is nevertheless not so far away, as becomes evident as we approach the horizon, where the high, uniform tone of the color of the sky yields to a new transparency of atmosphere, and the pearly light comes in to disperse the dark shadow enveloping the bust of Saint Paul and to fleck the violet pink of the robe, which in the sleeve reaches tones of silver.

A preparatory study (Hazlitt, Gooden and Fox, London, cat. 87) – in which we can still detect some traces of a robustness of form deriving from Salviati – is linked to the figure of Saint Paul (Rearick 1987).

V.R.

344

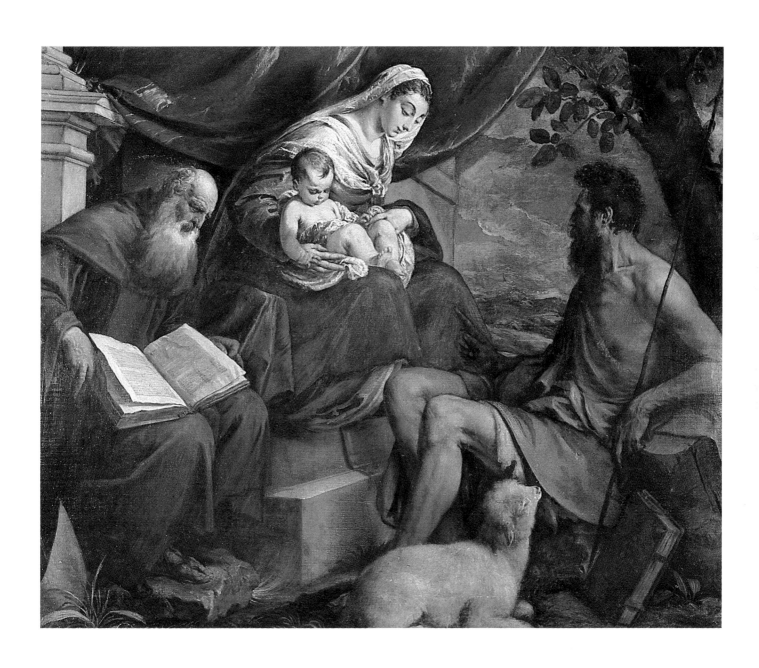

35. The Madonna and Child with Saints Anthony Abbot and John the Baptist (c. 1561)

Alvar Aalto Museum, Jyväskylä, The Collection of the Ester and Jalo Sihtola Fine Arts Foundation, inv. 320
Oil on canvas, 108×130 cm (42 1/2×51 1/8 in.)

Provenance
Frohsdorf Castle (Austria), collection of the royal branch of the Bourbons of France; sold Sotheby's, London, 20 July 1938, lot 3; Louis Richter, Helsingfors; Jalo Sihtola collection.

Exibitions
Stockholm 1944; Stockholm 1962; Helsinki 1992.

Bibliography
Sirén 1944, 55, no. 89; Berenson 1958, I, 18; Pallucchini 1958, 235; Zampetti 1958, 43; Arslan 1960 (B), I, 169; *Konstens Venedig* 1962, 100, no. 102, fig. 23; Ballarin 1968 (A), 44; Ballarin 1969, 106; Ballarin 1973, 95, 108-9, and fig., 145; Rearick 1987, II, 8; Rearick 1991 (A), IV, 9; Eskelinen 1992, 45-47, fig. 25; *Italianska Maalauksia* 1992, 41, ills.; Nurminen 1992, 47-48.

Although it was shown as the work of Jacopo in the exhibition of Italian art held in Stockholm in 1944, this painting gained the attention of Bassano scholars only after the publication of Zampetti's monograph, where it was assigned to the artist's late maturity, that is, after the 1568 *Adoration of the Shepherds with Saints Victor and Corona* (Museo Civico, Bassano del Grappa, cat. 46), an opinion also held by Pallucchini and Arslan. The most recent literature, however, compares it to the *Saints Peter and Paul* (Galleria Estense, Modena, cat. 34), thus moving the date earlier. There is, however, a significant discrepancy of opinion between those who interpret the classicism of the composition as a preparation for the turning point represented by the Treviso *Crucifixion* (cat. 37; Ballarin: around 1561) and those who read it instead as the re-

sult of that experience (Rearick: 1563-64). A very recent contribution by Eskelinen, on the occasion of an exhibition of Italian paintings in Finnish collections, called attention to the distinguished provenance of the painting, which was sold in London in 1938 with a group of works belonging to the royal house of France from Frohsdorf Castle in Austria, where Henry V, comte du Chambord, son of the duc de Berry, and grandson of Charles X, had lived from 1844 on. It does not seem possible, however, to establish with any certainty the date when the work entered the collection. The seal and coat of arms on the frame belong to the royal branch of the Bourbons, which leaves open the alternatives of Louis XVIII, Charles X, or the comte du Chambord. On this same occasion an X-radiograph of the canvas was made, revealing several pentimenti in the figures of the two saints.

It was unusual for Jacopo to paint a *sacra conversazione*. This fact alone is indicative of the return to the Venetian tradition that marked his activity at the beginning of the 1560s, when he received the commission for the *Saints Peter and Paul* altarpiece, at one time in Santa Maria dell'Umiltà in Venice, and is witness to his rethinking of the classicism of Paolo Veronese. There is evidence of this in the carefully balanced composition placed inside a solemn triangle, set against a diagonal architectural framework that is partially covered by a large curtain on the left and closed by a tree on the right. The glimpse of a landscape,

with a deep blue sky striped with clouds rising from the low horizon, recalls the Umiltà altarpiece, as does the monumental drawing of the figures. Saint John the Baptist, similar to Saint Paul in the Umiltà altarpiece, shows traces of Jacopo's absorption of Salviati's example in the years 1557-59, and could indicate a date close to that period. A comparison with the 1558 *Saint John the Baptist in the Wilderness* (Museo Civico, Bassano del Grappa, cat. 29), however, shows how quickly the painter was moving away from that world of impossibly strained drawing. As in the *Saints Peter and Paul*, here too Jacopo uses more severe, lower chromatic tones, abandoning the fantastic tension of the Enego altarpiece (cat. 31). The same retrenchment is seen in his handling of the light, which takes on greater importance in the construction of the figures according to the new monumentality of the design, leaving behind all decorative extravagance. The juxtaposition of brown and plum in Saint Anthony Abbot's robes echoes the refined combination of mauve and burnt gold in the robes of the Modena Saint Peter, while the robes of Saint John the Baptist repeat the chromatic chord of pink and green in Saint Paul's robes.

V.R.

346

36. The Adoration of the Shepherds (c. 1562)

Galleria Corsini, Rome, inv. 649
Oil on canvas, 105×157 cm (41 3/8×61 3/4 in.)

Provenance
Probably identifiable as the painting described by Ridolfi (1648, I, 394) in Venice in the house of Cristoforo Orsetti; Corsini collection, Rome (inv. 1750, no. 54: as Giacomo da Bassano); in the Gallery since 1908.

Exhibitions
Venice 1957.

Bibliography
De la Lande 1769, IV, 493; Verci 1775, 132; Jahn Rusconi 1908, 136; Mayer 1911 (as El Greco); von Hadeln 1914 (B), 65-68, and fig. 11; Bertini Calosso 1923-24, 489, ills. (as Leandro?); Hermanin 1924, 39 no. 649 (as El Greco); Longhi 1928, ed. 1967, 294; Fröhlich-Bum 1930 (B), 237 (as El Greco); Arslan 1931, 194, pl. xxxiv; Berenson 1932, 58; De Rinaldis 1932, II, ills.; Berenson 1936, 50; Berenson 1957, I, 20, and fig. 1209; Pallucchini 1957, 109; Zampetti 1957, 126, no. 50, and 127, ills.; Berenson 1958, I, 20, and fig. 1209; Zampetti 1958, 42; Arslan 1960 (B), I, 107-8 and 176, and II, figs. 133-35; Moschini Marconi 1962, 14-15, no. 5; Ballarin 1968 (A), 42; Ballarin 1973, 92, 95, 110-11, and fig. 147; Smirnova 1976, 62, 74-75, and figs. 84-85; Magnanimi 1980, 101; Pallucchini 1982, 36; Rearick 1982 (A), 22, n. 3, and 23, fig. 1; Rearick 1986 (A), 184; Freedberg 1988, 657; Ballarin 1990 (B), 118.

There exists in the Reinhardt collection in Winterthur (oil on canvas, 102×152 cm) another version of this painting, with some variations and different lighting to give it a nocturnal setting, which scholars are almost unanimous in attributing to Jacopo. Rearick (1982 (A), 23, n. 4) thinks it is a replica done by Jacopo's son, Francesco, at a very early age and later retouched by his father. This second composition was engraved in Venice in 1559 by Jan Sadeler and carries the inscription «I. Ponte Bassa pix» (Pan 1992, no. 8). A seventeenth-century copy in the Gallerie dell'Accademia in Venice (inv. 793; oil on canvas, 111×160 cm) repeats the composition of the Roman painting and, like it, was attributed first to El Greco and then to Jacopo (Moschini Marconi).

Hadeln was the first to propose that the painting presented here is the *Adoration* described by Ridolfi in the Venetian house of Cristoforo Orsetti, which «shows the rising Dawn and the Virgin, who gathers her newborn son into swaddling clothes, and here also are shepherds in adoration», and is a work in which Jacopo «wished to imitate the light of Parmegiano [sic] with exquisite color, so that the figures appear to be alive, and he portrayed some lifelike calves». The precise reference to the light and the influence of Parmigianino evident in the painting make this identification quite convincing.

Like *The Adoration of the Magi* (Kunsthistorisches Museum, Gemäldegalerie, Vienna, cat. 27), *The Adoration of the Shepherds* was attributed to El Greco at the beginning of the twentieth century and reclaimed for Jacopo by Hadeln and Longhi. After Hadeln's proposal of a date prior to the termination of the Treviso *Crucifixion* (cat. 37), the painting was for the most part considered to have been done after 1565, very close to *The Adoration of the Shepherds with Saints Victor and Corona* (Museo Civico, Bassano del Grappa, cat. 46), which is documented 1568. Although chronologically too late, this hypothesis did lead to an opportune comparison with *The Parable of the Sower* (Thyssen-Bornemisza Collection, Lugano; Pallucchini 1957; Arslan 1960 (B)), repeated recently by Ballarin in the context of a date moved up to about 1562, more or less the one also proposed by Rearick (1982: around 1559; 1986 (A): around 1560).

The composition recalls older versions of the same theme now in The Royal Collection, Hampton Court (cat. 17) and in the Gallerie dell'Accademia, Venice (cat. 16), not only in its overall structure, but also in particular figures, such as the shepherd holding a sheep in the foreground, or in gestures like that of the shepherd doffing his hat and the Virgin's stretch to lift the linen in which the Christ Child is wrapped. But Jacopo also adds a new invention, that of a crouching child blowing on a glowing ember. In the Corsini picture, the artist brings to fruition his earlier experiences in the painting of pastoral scenes. The balanced composition and nobility of draughtsmanship in figures like the shepherd in the center bring this painting close to the Jyväskylä altarpiece (cat. 35) and to the figures in the Lugano picture, revealing Jacopo's move towards classicism, mediated by his reflections on the work of Paolo Veronese, which characterizes his work in the early 1560s and prepares the way for his definitive abandonment of mannerism. A useful comparison in this instance can be made with Veronese's *Adoration of the Shepherds* in an English private collection (Ballarin 1968 (A), 42-43,

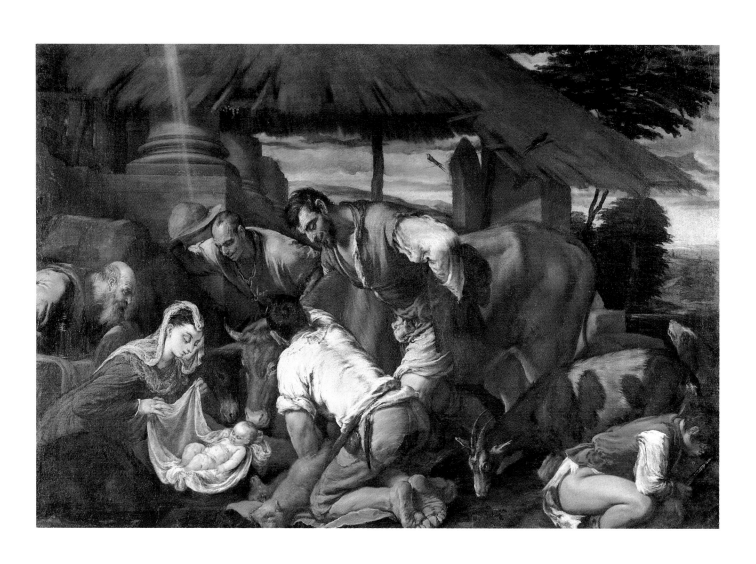

37. The Crucifixion with the Virgin and Saints Mary Magdalene, John the Evangelist, and Jerome (1562-63)

Museo Civico di Treviso, inv. P 109
Oil on canvas, 300×157 cm (118×61 7/8 in.)

fig. 52), which is an smaller version, more suitable for a private collection, of the same episode he had painted for the ceiling of Santa Maria dell'Umiltà in Venice. It gives evidence of the exchange between the two painters just after 1560. The monumentality of the group of figures and the architectural framework of the Veronese reveals a classicizing intent that is expressed to its utmost in his Villa Barbaro project at Maser. It must have stimulated reflection in Jacopo, while the interest in light and the choices of color manifested in the English painting – the yellow of the shepherd's robe against the brown of the cow – are new to Veronese and document suggestions offered to him by Jacopo in works like the *Adoration* presented here. Jacopo's setting in the earliest light of dawn with a cold, clear atmosphere determines a refined modulation of color and gives rise to passages that foreshadow the Treviso *Crucifixion*. Saint Joseph's head, with its effect of fragmented light, shows a strong affinity with that of Saint Jerome kneeling at the foot of the cross; the scarf around the Virgin's neck, with its scattered silver droplets, recalls that of Mary Magdalene, while the blending and shadowing of the white of the sheet on which the Christ Child lies gives an early indication of the new unifying force of light in Jacopo's art.

V.R.

Provenance
High altar of San Paolo, Treviso; transferred to the high altar of San Teonisto, Treviso after the Napoleonic suppression of 1810; in the Museo Civico di Treviso since 1946.

Exhibitions
Venice 1945; Venice 1946; Lausanne 1947; Venice 1957; Venice 1981.

Bibliography
Ridolfi 1648, I, 397; Cima 1699, fol. 261; Rigamonti 1744, 19; Rigamonti 1767, 38; Verci 1775, 133; Rigamonti 1776, 41; Federici 1803, II, 63 and 84; Crico 1822, 32-33; Crico 1829, 70; Crico 1833, 44-45; Fapanni 1844, 5; Sernagiotto 1871, 97; Bailo 1872, 82; Agnoletti 1897, I, 453 (as Veronese); Gerola 1905-6, 950; Zottmann 1908, 33; Gerola 1909 (A), 6; von Hadeln 1914 (C), 54 and 67; Longhi 1918, 47; Willumsen 1927, 139; Longhi 1928, 79; Venturi 1929 (A), 122, fig. 13; Venturi 1929 (B), 1192-95 and 1255-59, fig. 832; Arslan 1931, 100-1, 105-6, and 195, n. 32; Berenson 1932, 59; Brizio 1932, 57; Bettini 1933, 53-54, 63-65, and 169, pl. xxvi; Arslan 1934, 123; Coletti 1935, 266-67; Berenson 1936, 51; Liberali 1940, 258; Pallucchini 1944, II, xxxvii; Pallucchini 1945, 99, no. 109; Pallucchini 1946, 144, no. 256; Longhi 1946, 23; Fiocco 1947, 97 and 107; Pallucchini 1947, 40, no. 59; Liberali 1950, 10-12; Pallucchini 1950, 29 and 53; Magagnato 1952 (A), 14; Magagnato 1952 (B), 227-28; Liberali 1953, 171-72, fig. 150; Berenson 1957, I, 20, and fig. 1201; Pallucchini 1957, 107-8; Pignatti 1957 (A), 364-69; Zampetti 1957, 104, no. 40, ills.; Zampetti 1958, 39, and pls. LIII-LIV; Arslan 1960 (B), I, 97-98, III, n. 2-3, and 177, and II, figs. 113-17; Menegazzi 1964, 21-26, ills.; Ballarin 1973, 95 and 112; Rearick 1976 (A), 373; Smirnova 1976, 61 and 65-66, figs. 66-69; Rearick 1980 (C), 373; Magagnato 1981, 175, no. 56, ills.; Pallucchini 1982, 35, pl. 26; Rearick 1986 (A), 184; Torresan 1986-87, 173-76; Torresan 1987, 201; Ballarin 1990 (B), 118-20.

The painting is described as being on the high altar of the Dominican convent of San Paolo in Treviso, no longer extant, from Ridolfi to Crico, who records its transfer to the church of San Teonisto. The sources agree in indicating Jacopo as the artist, as traced in documents published by Federici and later added to by Liberali and Torresan. Evidence of payments recorded in the *Quaderno della Procuratora* and a notation made in 1563 by Cornelia Meolo, prioress of the convent, allow us to fix the date of the official commission as 29 November 1561, the day on which Jacopo received a payment on account for the execution of the altarpiece. On 8 November 1562 five people received payments for moving the painting from Bassano, and it is recorded that on 12 November the painting had been in Treviso, accompanied by Jacopo, for three days. Almost a year later, the picture was briefly taken back to Bassano, where according to the prioress it was «returned to perfection» on 22 September 1563. It was solemnly unveiled in its place on the altar on 24 September. The execution of the altarpiece can thus be narrowed down to the period between November 1561 and November 1562. Its brief return to Bassano at the end of the summer of 1563, the circumstances of which are not clear in the documents, seems to have been motivated by the necessity of some restoration work or maintenance while the altar was being constructed. Payment for the altarpiece was made on the same day of its unveiling, according to a document discovered by Torresan.

This painting, for a long time the only work dated between Jacopo's youthful period and the 1568 *Adoration of the Shepherds with Saints Victor and Corona* (cat. 46) for San Giuseppe in Bassano, has become the fixed point for the various proposals concerning the artist's mature period, the most convincing of which remains the one put forward by Venturi. He was the first scholar to indicate that the most innovative aspect of the altarpiece was its «first signs of that minute decomposition of color through the action of the light», evident in the figure of Mary Magdalene, which introduces the painter's late manner. As a consequence Venturi suggested that the work be placed at the end of a sequence of pieces, including *Saint John the Baptist in the Wilderness* (cat. 29), *The Descent of the Holy Spirit* (Museo Civico, Bassano del Grappa, cat. 119), the Enego altarpiece (cat. 31), *Saints Peter and Paul* (Galleria Estense, Modena, cat. 34), *The Adoration of the Magi* (cat. 27), and *Jacob's Journey* (cat. 33), in which the freedom of his painting style and treatment of light gained from his experience of painting *Lazarus and the Rich Man* (The Cleveland Museum of Art, cat. 24). Jacopo had managed to prevail over the interest in form borrowed from Parmigianino, thus marking the end of his mannerist period. In 1948 Longhi reiterated that after the *Crucifixion* Jacopo «develops with no other 'manner' now than what he finds inside himself, content by this point to accompany in silence his greater companion Titian to the most remote inns of Emmaus of Ve-

netian painting», adding new evidence to support the chronology proposed by Venturi. Later research has agreed with this only in part, as is indicated by the fact that some of the works mentioned above have been moved to after 1563, thus jeopardizing the position of this painting as a watershed for Jacopo's mannerist phase, a position that today is fully accepted only by Ballarin.

The altarpiece is at the pivot between the two periods marking Jacopo's development in the years 1555-68. In one sense it represents the conclusion of the period that began with the Vienna *Adoration of the Magi*, based on the expressive qualities of color and the very free use of a formal repertoire that is still mannerist, even though around 1560, under the influence of Veronese, he was beginning to move toward a robust classicism. Now, within the severe, solemn compositional scheme taken from Titian's *Crucifixion* (San Domenico, Ancona) – a painting no longer as markedly mannerist as his *Descent of the Holy Spirit* for Santo Spirito (Santa Maria della Salute, Venice), which Jacopo had used as a model for his own altarpiece of the same subject (Museo Civico, Bassano del Grappa, cat. 119), but rather an example of Titian's late style – the last remnants of formal loftiness, resulting from his long confrontation with mannerist aesthetics, and the intensity of color, still too strong in the Modena *Saints Peter and Paul*, meld in an equilibrium based on the new value of the quality of the light. The light pervades the landscape, which explicitly recalls the Ver-

onese-like solution adopted in the Modena painting, flowing with unprecedented authority and naturalness, and inaugurates his concern with impressionistic construction of form, which he would consistently explore more and more thoroughly in subsequent years, up to the epilogue of the 1568 *Adoration of the Shepherds*. In this context, the importance has already been noted of passages like the head of Mary Magdalene, imprinted in light against the luminous profundity of the sky, or Saint Jerome's temple, shattered by the juxtaposition of filaments ranging from a cool pink to ocher and yellow, finally to fade out in the gray of his eyebrow (Ballarin 1973). We could also add the detail of the face of Saint John the Baptist, seen in profile against the gray of the clouds, where the sharpness of Salviati's effects (compare this figure to the apostle bringing his hand toward his breast in the middle ground on the right in Jacopo's *Descent of the Holy Spirit*) is softened by a hand that is by now more natural in the movement from the ash gray shadows of the jaw and temple to the increasingly vibrant pinks of the cheek and nose, to the spike of white light striking the temple and black pupil of the eye, bright with tears.

V.R.

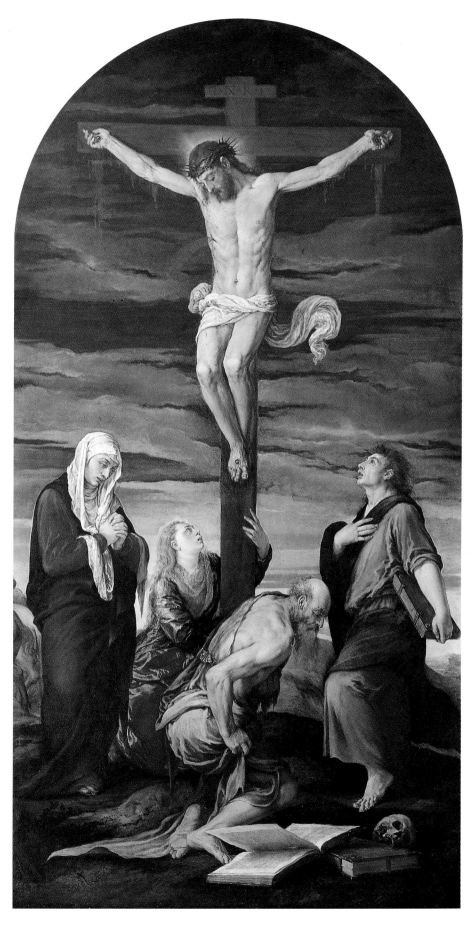

38. Tamar Brought to the Stake (c. 1563)

Kusthistorisches Museum, Gemäldegalerie, Vienna, inv. 9
Oil on canvas, 55 × 116 cm (oval format) (21 5/8 × 45 3/4 in.)

Provenance
Mentioned for the first time in the 1730 inventory of the imperial collections.

Exhibitions
Venice 1957.

Bibliography
Storffer 1730, 207; von Mechel 1783, 69, no. 8; Engerth 1881, I, 34, no. 35; Würzbach 1882, 289; Berenson 1894, 84; Berenson 1897, 78; Zottmann 1908, 43; Willumsen 1927, 165; Arslan 1931, 170, 178, 196, n. 35, and pl. LX; Berenson 1932, 59; Bettini 1933, 96-97, 179, and pl. XLIII; Arslan 1936 (A), 102; Berenson 1936, 51; Berenson 1957; Pallucchini 1957, 109; Zampetti 1957, 144, no. 58, ills.; Berenson 1958, I, 21, and fig. 1212; Zampetti 1958, 43-44, fig. 9, and pl. LXIV; Arslan 1960 (B), I, 142, 151, n. 23, and 179, and II, figs. 186-88; Ballarin 1971 (A), 143; Ballarin 1973, 110, fig. 145; Rearick 1986 (A), 184; Rearick 1987, II, 11; Ballarin 1990 (B), 120; *Die Gemäldegalerie* 1991, 28, pl. 80.

Attribution of this painting to Jacopo dates from at least the beginning of the eighteenth century, when it was exhibited in the Stallburg in Vienna, and has been reconfirmed in the modern literature, with admiration for the freedom of its impressionistic handling. The handling led scolars, at first, to date the work at the end of the 1570s, in the phase then considered to be the end of the artist's career. Particular insistence was made on its relationship with *Saint Lucille Baptized by Saint Valentine* (Museo Civico, Bassano del Grappa, cat. 53), because of the luminosity of the whites and the wonderfully subtle technique with which Jacopo breaks up the color into small dots. In the monographic exhibition of 1957, the work was dated c. 1570, making it one of the earliest examples of Jacopo's late manner «supported by a luminosity that does not extinguish, but renders more precious the tonal qualities of his color» (Pallucchini 1957, 109). Most recent studies have moved the date even earlier, inserting the work into a different period in Jacopo's career; in Rearick's opinion, around 1565, before the *Saint Eleutherius Blessing the Faithful* (Gallerie dell'Accademia, Venice, cat. 40). Ballarin, instead, thinks it was done around 1563, since, like the *Saint Jerome in the Wilderness* (Gallerie dell'Accademia, Venice, fig. 39), it experiments with the «synthetic construction of form through light, patches of color, and touches of the brush» achieved in the Treviso *Crucifixion* (cat. 37). Rearick further suggested that the painting should be linked to two other episodes in the life of Tamar (Genesis 38:12-26), known today only through replicas done in his workshop, in particular the two in the Uffizi representing, respectively, *Jude and Tamar* (inv. 927; 40 × 95 cm) and *Hirah Searching for Tamar* (inv. 920; 40 × 96 cm), to which we can add a drawing by Jacopo in the Uffizi (cat. 88) showing the left-hand side of the *Jude and Tamar*. The two works would have been created as a series with the one in Vienna, perhaps to decorate an alcove. The iconographical links and homogeneity of style – even though for the Florentine works this can be judged only on the basis of replicas – make this hypothesis quite logical. However, it is contradicted by a difference in format, the relationship between the figures and the frame, and the use of light, as noted by Ballarin (1990 (B)). Ballarin has also drawn attention to a panel fragment representing the same part of *Jude and Tamar* seen in the Uffizi drawing, published as Jacopo by Sirén (1933, pl. IIIa; 34.5 × 43 cm), and known today only through photographs.

The originality of the painting lies in the remarkable idea of placing at the center of the composition as protagonist a great cloud of smoke rising from the fire, which with great optical precision mixes with and disappears into the blue of the cold, clear evening air. Just as innovative is the solution for the right-hand section of the painting, where the small procession leading Tamar in chains advances against the architectural backdrop. The procession's various colors – red, cobalt blue, and green – are highlighted by the contrast with the shining silver of the armor and Tamar's veil. It is a passage that already hints at the style of the *Saint Lucille*, even though these two paintings are separated by, among other things, Jacopo's sacrifice of color resulting from his experiments with painting nocturnal scenes in intervening years. In the background a few synthetic brushstrokes break up the two figures in a dialogue within the paler, more transparent light of the sky near the horizon. It is a foretaste of Jacopo's impressionistic manner, whose premise lies in the new unifying force of light just achieved in his Treviso *Crucifixion* for the church of San Paolo, and which is repeated in the detail of the crucifix sketched in the stretch of

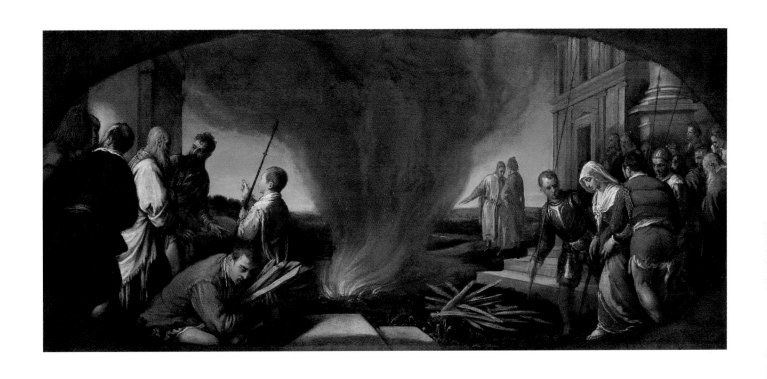

39. The Israelites Drinking the Miraculous Water (c. 1563-64?)

Museo del Prado, Madrid, inv. 6312
Oil on canvas, 146×230 cm (57 1/2×90 1/2 in.)
Exhibited in Bassano del Grappa only

night sky lit by the moon in the *Saint Jerome*, for which a date contemporaneous with the *Tamar* has rightly been claimed by Ballarin (1973, 110; 1990 (B), 118). On the left, a light that has lost all traces of artificiality constructs the head of the page who brings Jude his pledges, imprinting it against the luminous sky – as Jacopo did with Mary Magdalene in the Treviso *Crucifixion* – and bleaches out the chromatic accord between the blue and cool yellow of the tunic. The transparent shadow, which is thrown onto the step in the foreground by the man bringing firewood, anticipates those shadows stretching across the stairs of the porch in *Saint Eleutherius Blessing the Faithful*, which was painted very soon after this work; further links can be seen in the studied effects of the heads, painted in half-shade against the background of the halo of light illuminating the architecture on the far right.

V.R.

Provenance
Royal collection; on deposit at the Museo de Murcia from 1882 to 1969.

Exhibitions
Never before exhibited.

Bibliography
Pérez Sánchez 1965, 552 (as workshop of Jacopo); Ballarin 1990 (B), 145; *Museo del Prado* 1990, 213, no. 757, ills.; Rearick 1991 (A), IV, 7 (as Jacopo and Giambattista); Rearick 1992 (B), in press.

The painting is listed in the inventory of the Spanish royal collection with an attribution to Jacopo Bassano. Pérez Sánchez mentions it in his inventory of Italian seventeenth-century paintings in Spain as having been in the Museo de Murcia, where it was on deposit from 1882 to 1969. He calls it an interesting work from Jacopo's *bottega*. Only recently, after it was restored and hung in the Prado, have scholars given it their attention. In 1990 Ballarin declared that it was a previously unknown version of the theme and attributed it to Jacopo, dating it before 1568, or perhaps even earlier. He declared that it should be studied in relationship with Jacopo's production of biblical-pastoral scenes during the period 1566-67, and stated that he would make further observations on the work in another publication. For Rearick, however, the work was laid out by Jacopo's son, Giambattista, who took many elements from his father, including the female figure with her back turned in the foreground that appears in a study (Staatliche Museen Preussischer Kulturbesitz, Kupferstichkabinett, Berlin, inv. KdZ 5121) originally con-

ceived for the scene of the *Crucifixion* in the fresco cycle of 1575 for the parish church in Cartigliano. From this Rearick deduced a later date, which in his most recent work on the artist's drawings (in press) he narrows down to 1576-78, also linking this composition to *A Page Seen from Behind* (Fitzwilliam Museum, Cambridge, cat. 101). The Cambridge drawing is considered to be a preparatory study for the young man in the middle ground on the right, who offers drink to the old man on horseback in this version or another earlier version (now lost), which would have been done by Jacopo alone and used as a point of departure by Giambattista.

The painting, which is noteworthy for its size, has suffered extensive damage to its surface. Nevertheless, some passages are in quite good condition, of undeniably high quality, and realized with an unusual palette. These factors would seem to point towards an attribution to Jacopo himself, which then raises the question of the work's chronology. Comparison with a completely autograph version of this theme (Gemäldegalerie Alte Meister, Dresden, inv. 273), dated 1573 for its stylistic analogies with the lunette depicting *The Madonna and Child with Saints Mark and Lawrence Being Revered by Giovanni Moro and Silvano Cappello* (Museo Civico, Vicenza, fig. 54) – which is signed and dated in that year – gives strong evidence that the Prado painting belongs to the preceding decade and may be the oldest version of the subject discovered until now. The solution of a space di-

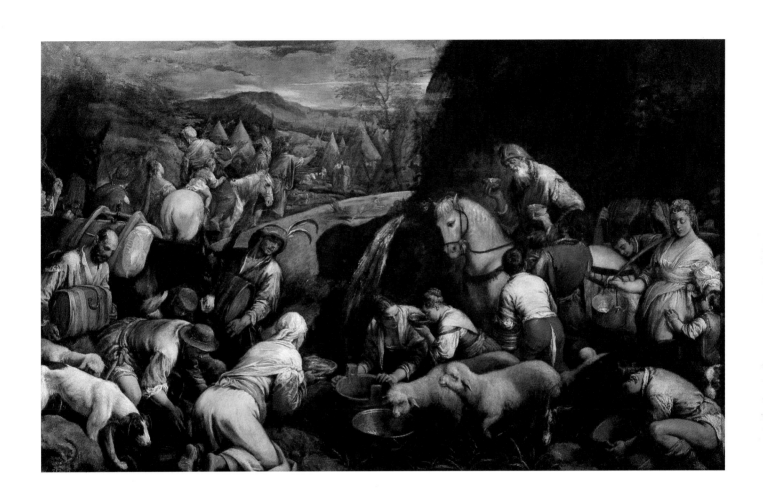

vided between the rocky backdrop on the right and the open landscape on the left, the close-up, monumental treatment of the objectively rendered figures and animals in the foreground, and the balance and solemnity of the composition place this picture within the sphere of Jacopo's pastoral paintings of 1566-67. Particularly significant for the dating are two other versions of the same subject. One is known through copies in Vaduz (Liechtensteinische Staatliche Kunstsammlung, inv. 958; oil on canvas, 146×213 cm) and formerly at Winterthur in the Reinhardt collection (Sotheby's, London, 6 December 1967, lot 32). The second is known through a workshop version, probably by Francesco (Gallerie dell'Accademia, Venice, inv. 402, oil on canvas, 108×158 cm), which has been convincingly assigned to these years by Ballarin (1990 (B), 142-43). In them we find analogous compositional solutions and very similar motifs, such as the detail of the sheep drinking in the foreground, the young boy kneeling with a tub, who is present with some variation in all three paintings, or the child seen from the back carrying a copper pot, represented only in the canvases in Venice and Madrid. An early date is also favored due to certain motifs reworked with slight variations from Jacopo's inventions of 1561-62: the boy kneeling with the tub in the right corner is taken from the young man blowing on the ember in *The Adoration of the Shepherds* (Galleria Corsini, Rome, cat. 36), from which also derives the goat with white patches on its face, while

the natural and solemn woman kneeling with her back turned in the foreground is similar in pose and conception to the peasant woman preparing breakfast in *The Parable of the Sower* (Thyssen-Bornemisza Collection, Lugano). The resemblance, noticed by Rearick, of this last figure to the one in the Berlin drawing should not impede an acceptance of an early date, since the drawing presents a formal handling and cool light, which distinguishes it from the colored chalk figure studies of the 1570s and, in particular, from the preparatory drawings for the frescoes in Cartigliano, where Rearick includes it. Instead, the handling and light indicate a date of around 1567, as suggested by Ballarin (1971 (A), 143-44). In the last analysis, it is above all the quality of the color, still high yet already unifying, and the effort to subject the color to the effect of light – which is evident in this painting – that orient us toward the moment in Jacopo's career just after the Treviso *Crucifixion* (cat. 37), and more or less at the same time as *Tamar Brought to the Stake* (Kunsthistorisches Museum, Gemäldegalerie, Vienna, cat. 38). The luminosity of the whites, shot with blue highlights, the chord struck by the light blue and cool yellow, and the pink and cobalt blue vibrating in the sharp, clear atmosphere evoke the particular palette of the canvas in Vienna and would seem to precede the experience of the *Saint Eleutherius* altarpiece (Gallerie dell'Accademia, cat. 40), where the greater authority of the light forces the color into a lower register and towards unifying effects

that are still absent here. If these observations are correct, the work would document a moment in the development of pastoral painting halfway between the early experiments at the end of the sixth and beginning of the seventh decade, and the «classical» phase of the years 1565-68.

V.R.

40. SAINT ELEUTHERIUS BLESSING THE FAITHFUL (c. 1565)

Gallerie dell'Accademia, Venice, inv. 301, cat. 401
Oil on canvas, 280×174 cm (110 1/4×68 1/2 in.)
Exhibited in Bassano del Grappa only

Provenance
High altar of Sant'Eleuterio, Vicenza; it became the property of the state after the Napoleonic suppression; delivered to the Gallerie dell'Accademia on 17 May 1829.

Exhibitions
Never before exhibited.

Bibliography
Borghini 1584, 563; Ridolfi 1648, 1, 389; Scannelli 1657, 254; Barri 1671, 90; Boschini 1676, 35; Bertotti Scamozzi 1761, 76; Verci 1775, 145; Baldarini 1779, 1, 36-37; Zanotto 1833, 1, fol. 30; Veronese 1860, 2; Berenson 1894, 84; Berenson 1897, 77; Zottmann 1908, 30; Arslan 1930, 565; Arslan 1931, 168, 170-73, 189, 195, and pl. LXII; Berenson 1932, 59; Bettini 1933, 180; Berenson 1936, 51; Tietze and Tietze-Conrat 1944, 50, no. 130; Barbieri, Cevese, and Magagnato 1953, 132; Berenson 1957, 1, 20, and fig. 1215; Pallucchini 1957, 116 annd 118; Zampetti 1957, 238, n. 3, and 249, n. 31; Berenson 1958, 1, 21, and fig. 1215; Zampetti 1958, 54; Arslan 1960 (B), 1, 140 and 177, and 11, fig. 180; Moschini Marconi 1962, 11-12, no. 11; Ballarin 1969, 94-95, 102, and fig. 111; Rearick 1980 (B), 111, 113-14, and fig. 13; Rearick 1986 (A), 185; Rearick 1987, 11, 10; Ballarin 1990 (B), 120-21, ills.

There is a long tradition beginning with Borghini, who wrote while Jacopo was still alive, describing this painting on the high altar of Sant'Eleuterio in Vicenza and ascribing it to Jacopo. The church was located near Piazza dei Signori, where the Bombardieri had their headquarters and it was to this company of warriors that the high altar belonged. It was the first of a series of important commissions that Jacopo would receive in Vicenza, and was followed by the large lunette depicting *The Madonna and Child with Saints Mark and Lawrence Being Revered by Giovanni Moro and Silvano Cappello* (Museo Civico, Vicenza, fig. 54), *Saint Roch Visiting the Plague Victims* (Pinacoteca di Brera, Milan, cat. 47), and *The Entombment*, painted for Santa Croce in Vicenza (Museo Civico, Vicenza).

This painting is listed as by Jacopo in all the editions of Berenson's catalogue, while Arslan (1931; 1960 (B)) considered it the result of a collaboration with his son, Gerolamo, assigning it a rather late date because of a comparison with the *Paradiso* (Museo Civico, Bassano del Grappa, cat. 123), and Bettini thought it was almost completely the work of the shop. The absence of the altarpiece from the monographic exhibition of 1957 was regretted by Pallucchini, who emphasized the high quality of the invention and innovative scheme – «very adventurous» – and moved its execution up to around 1570, but considered it only partially by Jacopo's hand. More recently, the importance of the work has been pointed out by Ballarin, who studied the drawings connected with it (1971 (A)). He posited an intervention on the part of Jacopo's son, Francesco, both in the preparation of the preliminary materials and in the actual execution of the work, which was, however, limited to the figure of Christ in the arch (1990 (B)). He also moved the date up to the middle of the seventh decade. In Ballarin's view, the painting is a keystone in his proposal for a new reconstruction of the painter's development between 1563 and 1568 and for a res-

toration to Jacopo of important works such as *The Supper at Emmaus* (The Royal Collection, Hampton Court, fig. 43). Rearick agrees with the necessity for a reevaluation of the work and suggests a date of around 1567.

The conservation work carried out for this exhibition and the restoration of the canvas to its original arched format has improved the picture's legibility. The condition of the painting has been seriously compromised by a deterioration of the pigments that have resulted in a loss of the surface modeling and an alteration of colors, with an increase in dark tones against which the whites stand out in isolation. This does not, however, prevent an appreciation of the quality and great innovation demonstrated in the work, evident in the twilight sky seen through an open portico. The sky is crossed by a streak of light coming from the left, which follows the progress up the stairs of the figures of the faithful, who are depicted from the back with their shadows lengthened along the ground. This solution foreshadows the structure of the altarpieces of the 1570s and marks Jacopo's early experiments with a new narrative method in the sphere of sacred painting. It is even and objective, as his pastoral paintings would be, and is based on a penetrating and affectionate observation of reality. It strongly establishes a distance between the intellectualistic, formal range of his mannerist phase and points toward the direction that Jacopo's experiments would take him in the eighth decade. The im-

portance of passages such as the father, who protectively puts his arm around his little daughter, has already been noted (Ballarin 1990 (B)), and the pungent vein of portraiture has also been emphasized. The latter is particularly evident in the young man praying, where Rearick (1980 (B)) has convincingly recognized the features of Jacopo's son, Francesco. Ridolfi, however, had already pointed out the presence of «individual heads and very natural dogs». The concentration on the ray of light that shines on the armor of the soldiers in the foreground, then slowly dies out in increasingly subtle stages as it moves back through the shadows of the portico, gives an early anticipation of the conception of space organized by gradations of light that will infuse Jacopo's altarpieces of the 1570s. What places such a modern painting in the period around 1565 is the careful attention to the drawing, which still belongs to Jacopo's long season of measuring himself against mannerist aesthetics as well as certain significant references to his other works of the same period. In particular, it recalls *Tamar Brought to the Stake* (Kunsthistorisches Museum, Gemäldegalerie, Vienna, cat. 38), evoked by the detail of the woman veiled in white leaning before Saint Eleutherius, whose luminosity is also linked to a study for *Jude and Tamar* (Gabinetto Disegni e Stampe degli Uffizi, Florence, cat. 88) and *Saint Jerome in the Wilderness* (Gallerie dell' Accademia, Venice, fig. 39), where it is echoed in the effects of the light on the bodies of the two cherubs in flight. The altarpiece comes exactly halfway between the Treviso *Crucifixion* of 1562-63 (cat. 37) and *The Adoration of the Shepherds with Saints Victor and Corona* (Museo Civico, Bassano del Grappa, cat. 46) of 1568, since it brings to fruition the equilibrium between light and color that Jacopo had achieved with great effort in the Treviso painting and inaugurates, also in terms of the *Tamar*, a new chromatic range resulting from a great unifying power of the light, which points toward the pastoral paintings of 1566-67 and the 1568 *Adoration*. In this sense, the depiction of the deacon's clothing on the right of Saint Eleutherius is particularly meaningful. The light catches the embroidery on the background of the damask with a flame-like effect, and in the saint's sleeve the light ripples along the white robe folded back to the elbow and is temporarily extinguished in ashen tones, until it meets the red of the cuff and picks up strength again in the cool yellow of the gloved hand that introduces the gold of the monstrance. The quality of the painting is homogeneous, with the exception of the arch where Christ appears among the clouds, which is painted in a poorer, simplified style that reveals the hand of a collaborator, probably Francesco.

For a discussion of the drawings connected with the painting, see catalogue entry 89.

V.R.

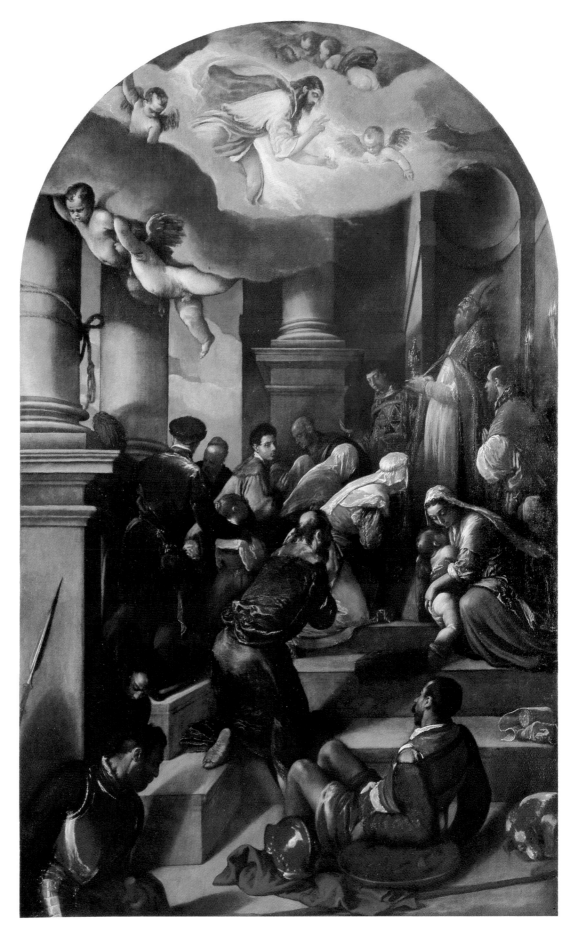

41. TORQUATO TASSO (1566)

Sammlung Heinz Kisters, Kreuzlingen
Oil on canvas, 62×46 cm (24 3/8×18 1/8 in.)
Inscriptions: In the cartouche of the frame, in the center at the bottom: NON TROVO TRA GLI AFFANI / ALTRO RICOVERO; on the back, on the relining: T. TASSO. / ANNO. ÆTATIS. SUÆ. XXII. / 1566 / G. BASSAN P.ᵗ X. On the back, on the lower left of the stretcher, there is a printed note that reads: « 43. Portrait of Tasso... G. Bassan 2 0 16. The originality of this picture is well ascertained; it was taken out of a pannel in an apartment belonging to the Society of *Ricovrati* at Padua. Beneath, a comet or evil star appears to be da[rt?]ing its rays on a laurel tree with this inscription, 'non trovo fra gli affani altro ricovero'. On the back his age appears, 22. This portrait is not inferior to Titian in peint of colour and effect. From Sasso, Venice ». On the back, at the bottom of the stretcher to the right of the first note there is a second printed label reading: HUME COLLECTION. No 22. 3. Portrait of Tasso G. Bassano.
Exhibited in Bassano del Grappa only

Provenance
Accademia dei Ricovrati, Padua (?); Sasso, Venice; Abraham Hume collection, no. 22; Holdford collection, England, until 1925; auction of the Hans Wenland collection, Ball and Graupe, Berlin, 24-25 April 1931; Heinz Kisters collection, Kreuzlingen (probably from about 1963).

Exhibitions
Ferrara 1985 (B).

Bibliography
Ridolfi 1648, 1, 401; Emiliani 1966, ills. between 720-21; Emiliani 1967, 200-3; Emiliani 1968, 131-36, ills.; Emiliani 1985, 207-8, ills.; Ballarin 1990 (B), 130-31 and 133, ills.; Alberton Vinco da Sesso, in press.

The portrait of the twenty-two-year-old Torquato Tasso was published as a work of Jacopo Bassano from 1566 by Emiliani (1966), after Federico Zeri brought it to his attention. The sitter, attribution, and date are mentioned in an inscription on the back of the picture, which was probably recopied from an earlier one when the canvas was relined. The information was confirmed in an expert opinion by Voss in 1963, which is now in the archives of the Kisters collection. Emiliani (1967, 1968, and 1985) studied the work further, gathering together all the information, which we shall discuss later, below. His proposal was refuted by Pallucchini (typewritten opinion dated 10 December 1985 in the Kisters archives), while Ballarin agrees completely (1990 (B)), and Rearick (1980 (B); and 1986 (B)), who had not been aware of the picture when he published his study on Jacopo's portraits, is in agreement.

Jacopo's portrait activity, which was limited, was confined mainly to local personages and occasionally extended to some Venetian administrator in Bassano or nearby town. Ridolfi reports what appear to be the only exceptions: the portrait of the Doge Sebastiano Venier, Lodovico Ariosto, Torquato Tasso, and other « *letterati* ». It could very well be that these last three were a series of decorative images, not all, or perhaps not any, of them done from life. Ariosto, in fact, died in 1533. The organization of the Tasso painting, inside an oval frame like the frontispiece of a book, ornamented by elegant scrolls enclosing at bottom center an emblem – a flowering bush and comet – and the motto « Non trovo tra gli affani / altro ricovero », as well as its provenance from an apartment belonging to the Società dei Ricovrati in Padua (witnessed by one of the labels on the stretcher), would seem to support the hypothesis that it was part of a decorative series for some academic building. However, fur-

ther information is needed in order to confirm this.

The Accademia dei Ricovrati in Padua was founded on 25 November 1599, but Tasso's biographers do not report that he was a member. He was, in fact, twenty-two years old in 1566. Emiliani (1967) therefore conjectures that this indication erroneously confuses the Accademia dei Ricovrati with the Accademia degli Eterei, to which Tasso did belong from its conception in January of 1564, taking the name of Pentito. When Tasso left Bologna for Padua he moved into the house of his friend, Scipione Gonzaga, who was related to the dukes of Sabbioneta. Scipione's house, which has not yet been identified more specifically, was also the site of the Accademia. The emblem inside the cartouche could thus allude to the line « Tasso arbore del suo cognome » (Tasso the tree of his surname) cited in the index to the *Rime degli Academici Eterei dedicate alla Serenissima Madama Margherita di Vallois, Duchessa di Savoia* and to the cordial hospitality he found within the Accademia, but it could also explain, along with the verse quoted, the painting's supposed provenance from the headquarters of the Ricovrati.

Within an oval *trompe l'oeil* frame of greenish brown scrolls, highlighted by the thin lines of green and gold, there is a lively portrait of the poet set against an emerald green ground. In a three-quarters position, he looks beyond us with an oblique, but alert and sharp gaze. His rosy complexion is framed by the brown shadow of his dark cap, his strong

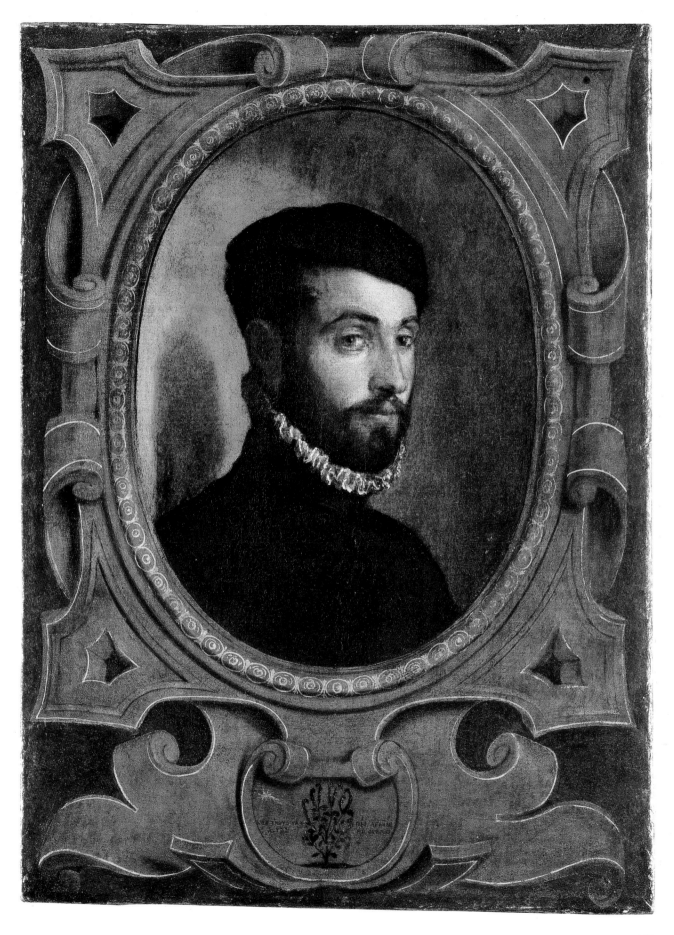

361

42. PORTRAIT OF A MAN IN PRAYER (c. 1570)

Civica Galleria di Palazzo Rosso, Genoa, inv. 96
Oil on canvas, 78×65 cm (30 3/4×25 5/8 in.)

hairline, and trim beard, which is separated from the dark ruff of his suit only by a luminous white zig-zag brushstroke. On the right a sharp dark brown line defines the contour of his face. Small touches of a brighter pink enliven his nose, his cheeks, his young, fleshy, and faintly smiling mouth, the inside of his eye, his forehead, and his nostrils. A dense, velvety gray-black shades the network of veins at his temple. The noble, sensitive face is finished by the strong black line of the long eye-lashes, placed over the softer circular movement of the entire eye socket.

This small *Torquato Tasso* maintains the shape and spirit of Jacopo's early portraits done almost thirty years before (cats. 5 and 6), but intensifies, with extraordinary results, the psychological portrayal, which here is on the same level as the pictorial effects. A distant echo of Jacopo's mannerist spirit, intellectual choice, and chromatic abstraction still inform the picture, recovering completely the experience of the *Portrait of a Man* (J. Paul Getty Museum, Malibu, cat. 25). Apt comparisons (Ballarin 1990 (B)) with *Saint Eleutherius Blessing the Faithful* (Gallerie dell'Accademia, Venice, cat. 40) and the more problematic *Supper at Emmaus* (fig. 43) and *Portrait of a Man Holding Gloves* (both The Royal Collection, Hampton Court, invs. 75 and 438) bring into focus the strong, sequential links with the works of the mid-1560s.

P.M.

Provenance
Brignole-Sale collection, Genoa; Civica Galleria di Palazzo Rosso after 1874.

Exhibitions
Never before exhibited.

Bibliography
Alizeri 1847, 391 (as Jacopo Bassano); *Catalogo* 1861, 14, no. 62 (as Jacopo Bassano); *Atto di cessione* 1874, 44, no. 64; Alizeri 1875, 167 (as Jacopo Bassano); Jacobsen 1896, 102 (as Jacopo Bassano); Suida 1906, 143 (as Alessandro Buonvicino, called Il Moretto); Berenson 1907, 284 (as Romanino); Grosso 1909, 76 (as Jacopo Bassano); Grosso 1910, 126 (as Jacopo Bassano); Jacobsen 1911, 196-97 (as Brescian painter, perhaps Savoldo); Grosso 1912, 40 (as Alessandro Buonvicino); Nicodemi 1925, 197 (as Romanino); Venturi 1928, 855 (as Romanino); Grosso 1931, 65 (as mid-sixteenth-century Brescian school); Berenson 1932, 487 (as Romanino); Berenson 1936, 419 (as Romanino); Arslan 1960 (B), I, 343 (as early seventeenth-century Genoese school); Ferrari 1961, 50, pl. 99 (as Romanino); Rearick 1980 (B), 109-12 (as Jacopo Bassano); Ballarin 1990 (B), 131.

Listed as the work of Jacopo Bassano by Genoese nineteenth-century sources when it was in the Brignole-Sale collection, the painting was subsequently attributed to the Brescian school, with some oscillation between the name of Moretto (Suida 1906) and Romanino, who was preferred by most scholars (Berenson 1907, 1932, and 1936; Nicodemi 1925; Venturi 1928; Ferrari 1961). Finally Rearick (1980 (B)) proposed an attribution to Jacopo, which was seconded by Ballarin (1990 (B)).

The difference in dating between these last two scholars is slight. Rear-

ick thinks it was done in 1567, immediately after *Saint Eleutherius Blessing the Faithful* (Gallerie dell'Accademia, Venice, cat. 40) of 1566. These two pictures share a subtle attention to drawn details as well as a shade of gray twilight, where a limited range of blacks, grays, and browns predominate, lifted only by the cold blue of the sky, which in the portrait is seen on the right through the iron bars. Ballarin, instead, compared this portrait to those of *Torquato Tasso* (Sammlung Heinz Kisters, Kreuzlingen, cat. 41) and the *Portrait of a Man Holding Gloves* (The Royal Collection, Hampton Court), both of which date from 1566. In Ballarin's opinion, this portrait marks an advancement in the direction of the images of Giovanni Moro and Silvano Cappello as they appear in the large 1573 lunette depicting *The Madonna and Child with Saints Mark and Lawrence Being Revered by Giovanni Moro and Silvano Cappello* (Museo Civico, Vicenza, fig. 54). For this reason, he dates the *Man in Prayer* c. 1570.

The unusual nature of the iconography is commented upon by Rearick, who suggests that the painting could be the portrait of a prisoner, whose elevated social status is indicated by the fur trim on his cloak, or perhaps more likely, an ex voto painted once the man was released from prison. The plain cross, without the figure of the crucified Christ to which the man prays, is a sign of his Protestant sympathies, which were probably the cause of his imprisonment. This very attractive hypothesis should be approached cau-

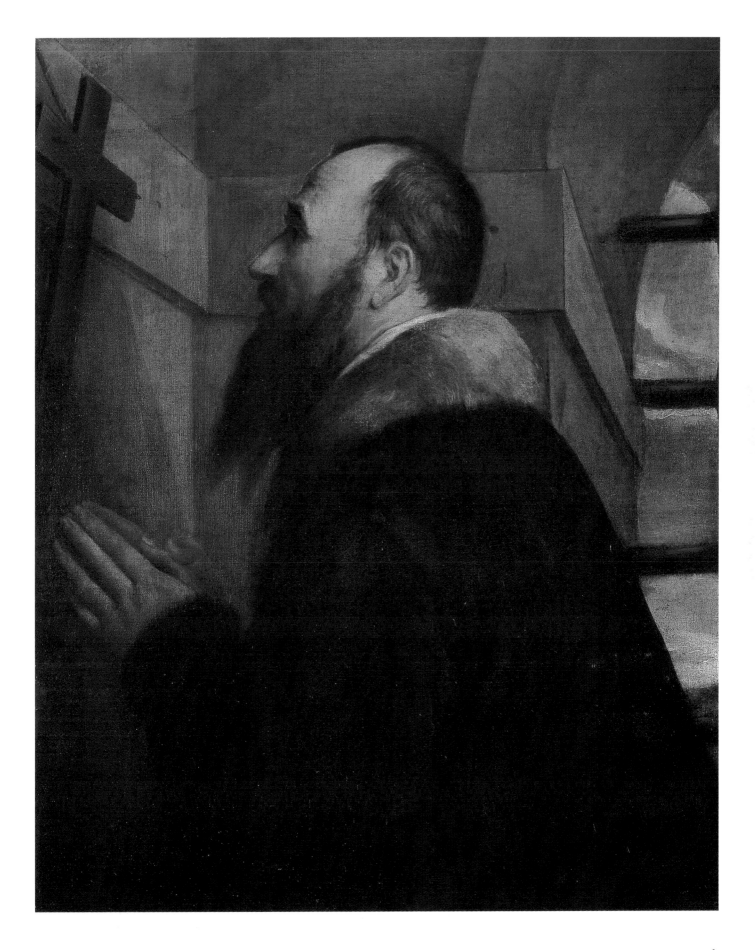

tiously, especially if one were tempted to extend the heretical leanings of the subject to the painter. According to the testimony of the *Libro secondo*, Jacopo's Catholic faith, even though oriented toward the Reformation, never appears to have been in doubt.

The possibility that this is a fragment of a larger canvas is suggested by the «drop» in perspective in the window opening's depth, which is so steep as to project a focal point well beyond the painting's surface. This possibility, however, seems to be contradicted by the tacking edges of the canvas, which have remained intact. We should point out that the painting was relined at some point in the past.

The sources are ambiguous about the painting's provenance. Sansovino and Martinioni (1663, 377-78), followed by Verci (1775, 141), speak of a «Vergine con un ritratto di huomo divoto» (Virgin with a portrait of a devout man) in the possession of the Franco-Flemish painter Nicolas Renier in Venice. This work appears again in 1666 in the inventory of the sale of his collection (Savini Branca 1964, 264) and once again among the paintings purchased in Venice in 1670 by the Retani brothers for Giuseppe M. Durazzo, for whom they served as agents: «9. Madonna con il bambino un ritratto del Bassan vecchio» (Lot 9. Madonna and Child a portrait by the elder Bassano; Puncuch 1984, 204, no. 146; and Boccardo 1988, 102). It can next be traced in the catalogue of paintings exhibited in the mid-eighteenth century in the Palazzo Brignole, called the Palazzo Rosso (*Pitture e quadri* 1756). These included the paintings inherited from their father by Giovanni Francesco III Brignole-Sale and his brother Gio. Giacomo Brignole-Sale and divided between them in 1717, as well as those left to only Giovanni Francesco by their grandmother Maria Durazzo, who had married Giovanni Francesco II (Boccardo 1988, 102 and 105, n. 43). Ratti as well (1780, 260) cites a «quadro di N. Signora col Bambino, ed una mezza figura in atto di adorazione, del Bassano vecchio» (picture of Our Lady with the Child, and a half figure in adoration, by the elder Bassano).

A picture without the Virgin and Child or the name of the donor, a «carcerato che prega del Bassano» (prisoner praying by Bassano), appears about sixty years later in the guide by Alizeri (1847) to the painting gallery of the Palazzo Rosso, which became the property of the city of Genoa in 1874 as a result of a donation by Maria Brignole-Sale De Ferrari.

The serene application of the pigment (which was flattened by a relining at some point in the past), the subtle design of the drawing, the light shadows obtained by the use of bitumen, and the sober golden intonation suggest to us a date of c. 1570. That is, between *The Adoration of the Shepherds with Saints Victor and Corona* (Museo Civico, Bassano del Grappa, cat. 46) of 1568 and the large lunette with the portraits of Giovanni Moro and Silvano Cappello, which is signed and dated 1573.

P.M.

364

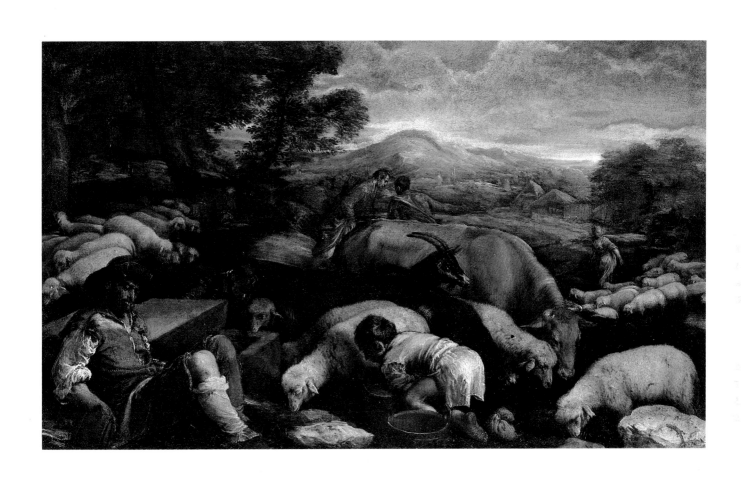

43. Jacob and Rachel at the Well (c. 1566)

Private collection, Turin
Oil on canvas, 58.6×99.1 cm (23 1/8×39 in.)
Exhibited in Bassano del Grappa only

Provenance
Durazzo Pallavicini Negrotto Cambiasso collection, Genoa; Cesano Maderno, Christie's, Milan, 5-6 October 1979, lot 516 (as workshop of Jacopo Bassano); Galleria Caretto, Turin; Antichi Maestri Pittori, Turin.

Exhibitions
Milan 1986; Turin 1986; Turin 1990.

Bibliography
Antiquariato internazionale 1986, ills; *Mostra di importanti dipinti europei* 1986, no. 4, ills.; Ballarin 1990 (B), 117, and 134-42, no. 11, ills.

The painting first became known in 1979, when it was entitled *Annunciation to the Shepherds* and attributed to Jacopo's workshop, in the auction catalogue of the Durazzo collection, which also noted that the canvas had been enlarged (110×133 cm). In 1986 it was exhibited at the international antique show in Milan as a work of Jacopo's from around 1550, with the same erroneous indication of the subject, but returned to its original dimensions and partially cleaned of extensive overpainting. It later appeared in Turin at the Galleria Caretto, where on the basis of a written communication by Mason Rinaldi, the subject was correctly identified and the date moved to about 1567. Purchased by the gallery Antichi Maestri Pittori, the canvas was once again restored (1989), recovering its true light values and giving it an extraordinary legibility, despite some losses in areas such as the mass of trees on the left and the top part of the sky. The picture had been altered by additions and repainting in the sky and landscape, probably carried out in the eighteenth century when the canvas was enlarged, and these additions had not been removed during the first restoration. Ballarin described the work as an example of a new, very fertile phase in the history of pastoral painting that followed, in about 1566, the experience of the *Saint Eleutherius* altarpiece (cat. 40), where the artist, freed by now of all mannerist artifice, achieved a «classical» formulation of the genre, linked to fluid, harmonious forms, a perfect balance between figures and landscape, and a new awareness of the unifying power of light. We must, however, point out that the composition had already been known for some time through a version formerly in the von Auspitz collection in Vienna (now private collection, Baltimore), which was published by Bettini (1936, 145-46, fig. 4; oil on canvas, 62×101 cm) as a work of the middle of the eighth decade, subsequently catalogued by Arslan (1960 (B), I, 383-84) as among the works considered generically from Bassano circles, and restored to Jacopo by Rearick (1968, 242, fig. 8), with a date of about 1567. X-radiographs of the painting reveal significant pentimenti in the position of the legs of the sleeping shepherd and also in his head, which originally lay on the arm propped against the stone of the well. These changes lead us to believe that this picture is the prototype of the theme. Other replicas from the workshop are known (Accademia di San Luca, Rome, inv. 409; Kunsthistorisches Museum, Gemäldegalerie, Vienna, inv. 5284, oil on canvas, 61×100 cm) and a version with variations painted by Jacopo's son, Francesco (Fitzwilliam Museum, Cambridge, inv. 114, oil on canvas, 65.7×93.7 cm). Comparison of the measurements of these versions indicates that the painting discussed here has lost about two to three centimeters in height and width.

Compared to early pastoral experiments, this painting takes an unprecedented approach to a lowered and looming composition. It permits Jacopo to portray the figures and animals close up, while opening up backwards to take in the forms of the landscape. The protagonists of the story (Genesis 29:1-12) are relegated to the middle ground. This new structure, developed from Jacopo's reworking of Titian's innovations – such as those in his drawing and engraving of *A Shepherd Playing a Lute with his Flock* – and prepared, as Ballarin indicates, by a painting known only through a replica by his workshop, *Hirah Searching for Tamar* (Galleria degli Uffizi, Florence, inv. 920), is functional for his mode of observation and natural narration. After the abstractions of his mannerist phase, this period is free of artifice and culminates in the detail of the sleeping shepherd in this picture. The new balance between light and color, with which Jacopo experimented in the *Saint Eleutherius* altarpiece, is now translated into an exterior landscape scene, subjugating the entire composition to one range of cool, violet twilight tones. The results foreshadow the scarcity of light and abundance of half-tones described by Verci in *Saint Lucille Bap-*

44. The Parable of the Sower (c. 1567)

Museum of Fine Arts, Springfield, The James Philip Gray Collection, no. 55.05
Oil on canvas, 61 × 50.8 cm (24 × 20 in.)
Exhibited in Fort Worth only

tized by Saint Valentine (Museo Civico, Bassano del Grappa, cat. 53). The foreground is handled with very few points of light, which are concentrated in the shepherd's sleeve and the child's skirt. It is rich in silver vibrations that stand out against the subdued whites in shadow in the coats of the sheep, and should be compared to the similar passage in *Jacob's Journey* (The Royal Collection, Hampton Court, cat. 33) to see how far Jacopo has traveled in terms of naturalness. The comparison becomes even more instructive in the middle ground, where the conscious sharpness of the drawing and unreal saturation of color in the figures in the English painting yields to a veiled atmosphere that «wraps the figures of Rachel and Jacob in a fringed cocoon of air... [figures that are] masterpieces of Jacopo's 'impressionist' manner» (Ballarin), which appeared for the first time in the Treviso *Crucifixion* (cat. 37).

The hypothesis offered by Ballarin (1971 (A), 142-43; 1990 (B)) and accepted by Rearick (1986 (A), 184) that the painting was conceived in tandem with a *Jacob's Journey* (formerly Wallraf-Richartz-Museum, Cologne, inv. 699) appears convincing. Not only does this picture furnish further data for a resolution of the problem of chronology for the pastoral paintings of the 1560s, but it gives us a document concerning the practice that would develop in relationship to the exigencies of art collections.

V.R.

Provenance
Galleria degli Uffizi, Florence (on loan to the Italian Embassy in Warsaw prior to 1945); Museum of Fine Arts, Springfield, 1955.

Exhibitions
Winnipeg 1953; Vancouver 1953; Pittsburgh 1954; Cleveland 1956.

Bibliography
Arslan 1931, 278 and 344; Berenson 1957, I, 20; Muraro 1957, 299; Arslan 1960 (B), I, 269 and 375; Ballarin 1990 (B), 133; Rearick 1992 (A), in press.

Arslan reported (1960) that this picture is identical with one lent by the Galleria degli Uffizi, Florence (no. 1359) to the Italian Embassy in Warsaw prior to 1939. That work disappeared during World War II. The present painting was exhibited by the Knoedler Gallery, New York, in 1953-54, and was acquired by the Springfield Museum of Fine Arts the following year. Since Arslan (1931) confused it with two other versions of this theme from the Uffizi and the Galleria Palatina, Palazzo Pitti, Florence, a margin of doubt remains regarding the history of the Springfield picture.

Like *The Parable of the Sower* (Thyssen-Bornemisza Collection, Lugano) of c. 1564, the Springfield picture is primarily an illustration of the biblical passage from Saint Matthew that describes the sower whose seed is about to be devoured by the birds. It might, equally, have a secondary theme taken from the passage on grain sowing in Virgil's *Georgics*. For it, Jacopo not only reduced the scale and staffage from the earlier treatment, but also restudied

all of its components. Equally, its pictorial character is metamorphosized from a dusky chiaroscuro to the clean light of day, and from sharp color to a more somber harmony of rose, gray, tan, and oyster white. This restrained severity and the charming emphasis on naturalistic peasant life places it in relation to such works as the *Tamar* cycle (see cat. 38) and *The Scourging of Christ* (Gallerie dell'Accademia, Venice, fig. 45), and suggests a date close to 1567. A *ricordo* drawing (private collection, Brunswick, Maine), possibly by Giambattista, seems to have served the shop for numerous replicas and variants (Gallerie dell'Accademia, Venice; Galleria degli Uffizi, Florence; Galleria Palatina, Palazzo Pitti, Florence, etc.).

W.R.R.

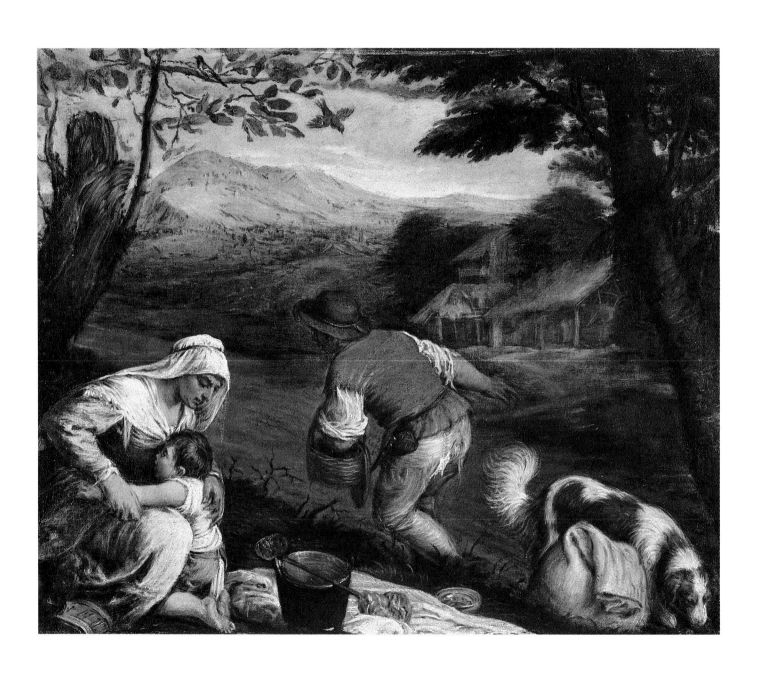

368

45. SLEEPING SHEPHERD (c. 1568)

Szépmüvészeti Múzeum, Budapest, inv. 119
Oil on canvas, 99.5×137.5 cm (39 1/8×54 1/8 in.)

Provenance
Esterházy collection; in the Szépmüvés-
zeti Múzeum since 1871.

Exhibitions
Never before exhibited.

Bibliography
Venturi 1900, 236; Arslan 1931, 303 (as
Gerolamo); Berenson 1957, II, fig. 1220
(as Gerolamo); Berenson 1958, II, fig.
1220 (as Gerolamo); Arslan 1960 (B), I,
287 (as Gerolamo); Donzelli and Pilo
1967, 72 (as Gerolamo); Pigler 1968, I, 46,
and II, fig. 101 (as Gerolamo), Ballarin
1990 (B), 144, ills; *Museum of Fine Arts*
1991, 5, ills.

This painting represents one of the most recent and interesting proposals for an addition to Jacopo's oeuvre, just how important can be evaluated within the context of this exhibition. In the inventories and early catalogues of the museum the attribution to Jacopo, which had been listed in the inventory of the Esterházy collection, was set aside in favor of an attribution to his workshop or school. Furthermore, no weight was given to the fact that an authority of Venturi's stature attributed it to Jacopo in his essay on Italian paintings in Budapest. Soon thereafter, Arslan assigned the work to the artist's son Gerolamo, who had been born in 1566. This resulted in the painting's being neglected by art historians and critics, until recently when Ballarin returned the authorship of the painting to Jacopo and proposed an affinity with *The Adoration of the Shepherds with Saints Victor and Corona* (Museo Civico, Bassano del Grappa, cat. 46) of 1568. He considered it the last work in the phase of pastoral painting that Jacopo had begun immediately after the execution of *Saint Eleutherius Blessing the Faithful* (Gallerie dell'Accademia, Venice, cat. 40), a phase characterized by a «classical, monumental style, purified of the inflections derived from Parmigianino and Salviati». He also suggested, in referring scholars to a closer analysis of the work, that it illustrated the mythological episode of Mercury stealing the herds from Argus.

The canvas is constructed once again with the same *mise en page*, «ingenious and functional to the expression of an authentic pastoral vein» (Ballarin), with which Jacopo had already experimented in *Jacob and Rachel at the Well* (private collection, Turin, cat. 43) and its pendant, *Jacob's Journey* (formerly Wallraf-Richartz-Museum, Cologne). In these pictures the flocks and shepherds in the foreground are depicted from a very close and lowered viewpoint, revealing only a glimpse of the horizon above the animals' backs. The composition is very similar to that of a lost painting, *Abraham's Journey* (formerly Count Agostino Giusti collection, Verona), which is known through an engraving by Jan Sadeler (Pan 1992, no. 3). In the engraving the figure of the sleeping shepherd leaning back appears on the left. The same figure recurs throughout this phase of Jacopo's pastoral painting not only in the *Jacob and Rachel* just mentioned, but also in two drawings from the same moment, *Jacob's Ladder* (Stiftung Ratjen, Vaduz, cat. 91) and *Resting Shepherd* (Städelsches Kunstinstitut, Frankfurt, cat. 90). It is also translated into the sacred iconography of Saint Roch cared for by an angel in the small altarpiece formerly in the church of Ognissanti in Treviso that depicts *Saints Florian, Sebastian, and Roch* (Museo Civico, Treviso, fig. 44). These comparisons give some measure of the concentration of formal and inspirational themes during the years 1565-68. The most important aspect of Jacopo's work during these years was his exploration of the effects of light in open air, which achieved its highest results in this canvas and the 1568 *Adoration of the Shepherds* with its serene, yet solemnly monumental composition. The narrative line of the work seems almost overcome by Jacopo's new capacity for observation, or rather for portrayal, something which was already evident in the *Saint Eleutherius* altarpiece. Here it is manifest in the center of the painting, where the golden blond patches on the cow's coat are juxtaposed with the cool white and silver highlights of the horse's mane. This passage demonstrates a remarkably keen visual sense, capable of capturing with a touch of white paint the reflection of the light on the black pupil of the horse's eye, which is realized using a very liquid mixture, almost the consistency of watercolor, and barely visible brushstrokes – now lighter, now darker – yielding a highly finished surface and at the same time placing every detail within the register of light contained in the painting. The sleeping figure, like the shepherd on the left in the *Jacob and Rachel at the Well* and the kneeling shepherd seen from behind

in *The Adoration of the Shepherds*, illustrates how the palpable sense of the materials and thickness of the pigments found in Jacopo's earlier paintings have been consumed and dissolved into the atmosphere by the fragmentation of his touch. This is especially evident in the figure's pink bodice, which is consumed by touches of gray and brown and gives way to the passage of muffled gold cloth lying on his lap. In this costume Jacopo has created a web of half tones, against which the vertex of light on the sleeve of his ripped blouse and the glimpse of the pink flesh underneath stand out. The landscape is treated in an unusual way, with the space closed off in the center by a hillock crowned with a group of trees and open toward the left rear where the slopes of Monte Grappa can be seen encircled by pink clouds. On the left through a backdrop of the trees, brief glimpses of the sky can be seen. These are painted with touches of blue on top of the brown tangle of the branches. The same is true of the green grass that peeps through the bushes at the bottom. The passage of the hill at the center is painted with a very soft pigment, practically without modeling, which suggests the effect of atmospheric haze in the middle ground. Jacopo's technique in this painting is a testament to his modernity during these years.

The painting's subject does not fit into the biblical themes most often represented in Jacopo's pastoral paintings, of which Ridolfi gave a very full list, and is still difficult to identify. Ballarin's recent proposal of Mercury stealing the oxen from Argus is not convincing, since it does not seem to have a figurative tradition. In his essay in this catalogue, Rearick has proposed that the picture represents the month of August. Another version of the work appeared on the art market (Stalker and Boos Inc., Birmingham, Michigan, ills., *Apollo*, July 1975, 57) with an attribution to Francesco Bassano.

V.R.

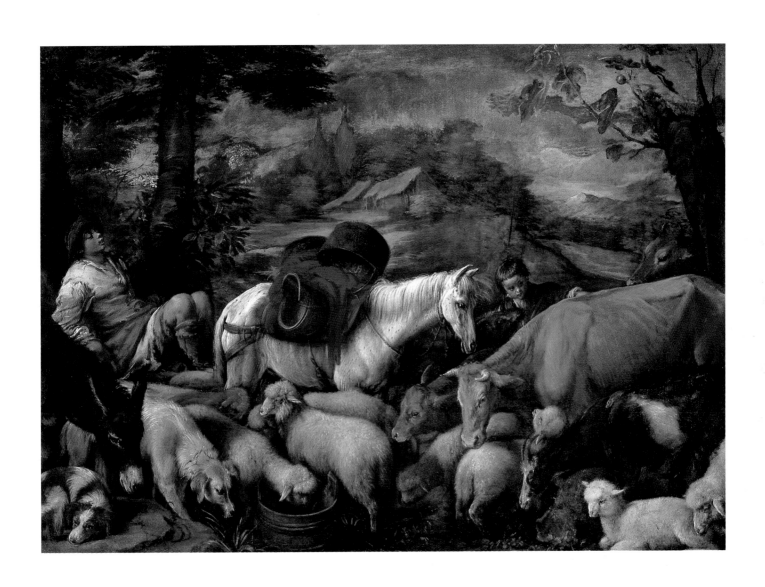

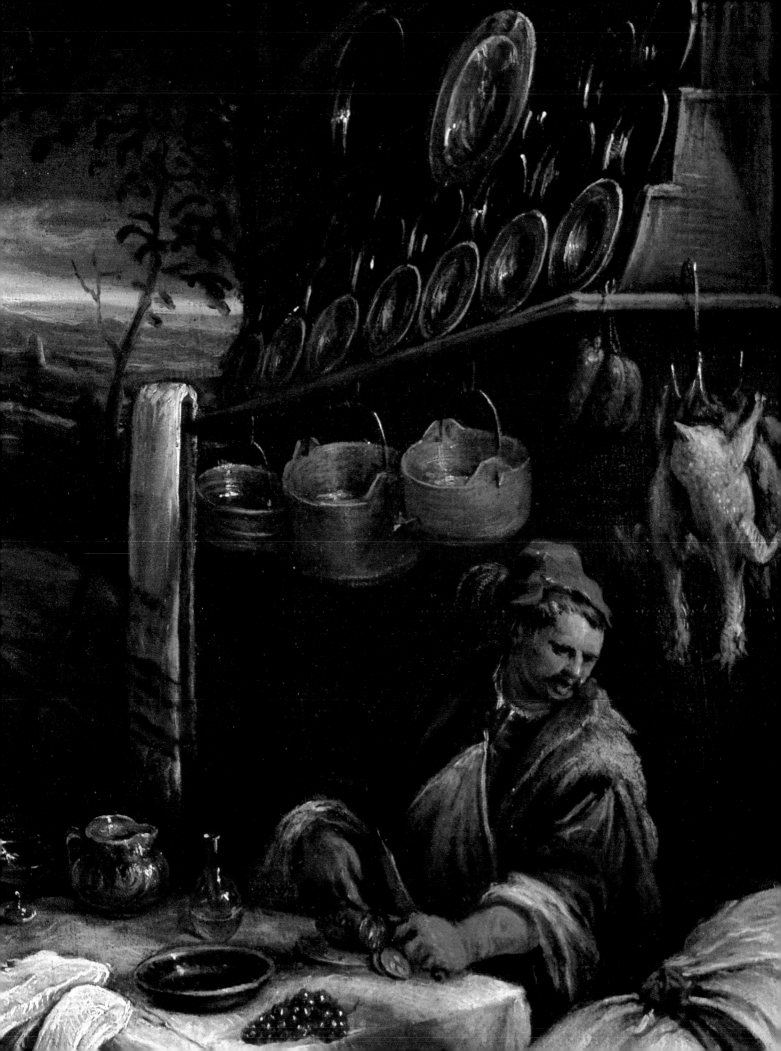

JACOPO BASSANO 1568-1578

The years between 1568 and 1578 are characterized by Jacopo Bassano's collaboration with his sons: first Francesco, then to a much lesser degree Giambattista, whose modest contribution merges with that of the workshop assistants, and later Leandro. At the end of 1568 Jacopo painted *The Adoration of the Shepherds with Saints Victor and Corona* (Museo Civico, Bassano del Grappa, cat. 46) for the small church of San Giuseppe in Bassano, in which he achieved a perfect synthesis of sacred and pastoral themes, as well as demonstrated his technical maturity. Immediately afterward, around 1569, we find some of his biblical compositions, such as *Noah Gathering the Animals into the Ark* (Museo del Prado, Madrid, fig. 51) and *Abraham's Journey* (private collection, Canada), which reveal his predilection for a naturalistic representation of human and animal types positioned within the diminishing perspective of a landscape. This interest in perspective becomes more vivid in the course of the 1570s, especially in the altarpieces, almost all of them monumental, that he painted for churches and convents in the towns and cities of the Veneto and Trentino regions. In these works the hand of Francesco can also often be discerned. Since some of these works are dated, we can establish a chronology into which others can be inserted on the basis of style: *The Martyrdom of Saint Lawrence* (cathedral, Belluno, fig. 53) of 1571; *The Martyrdom of Saint Sebastian* (Musée des Beaux-Arts, Dijon, fig. 55), signed by Jacopo and his son, Francesco, *The Entombment* (Santa Maria in Vanzo, Padua, cat. 52), and *Saint Paul Preaching* (Sant'Antonio, Marostica), all three dated to 1574; in 1575 he painted the frescoes in the parish church in Cartigliano (figs. 103 and 104), and around that same year the cycle of canvases in Civezzano (fig. 59) and *Saint Lucille Baptized by Saint Valentine* (Museo Civico, Bassano del Grappa, cat. 53). An important civic work of 1572-73 was the votive painting for the Sala del Consiglio in Vicenza that depicts *The Madonna and Child with Saints Mark and Lawrence Being Revered by Giovanni Moro and Silvano Cappello* (Museo Civico, Vicenza, fig. 54). The group in the foreground showing the rectors Silvano Cappello and Giovanni Moro thanking the Virgin for saving the city from the plague is masterfully coordinated with the group on the stairs representing the freeing of prisoners pardoned on the occasion of the miracle. Biblical stories in a large format dominated by an evening light, such as *The Return of Tobias* (fig. 57) and *The Israelites Drinking the Miraculous Water* (both Gemäldegalerie Alte Meister, Dresden) or *Jacob's Journey* (Palazzo Ducale, Venice), show similar characteristics with paintings from this period, but scholars do not agree on their dating: for Ballarin (1988) they are of c. 1573-74, while for Rearick the first two are of c. 1576 and the last of c. 1579.

Toward the middle of the 1570s Jacopo organized his workshop for the production in series of « *quadri campestri* » (paintings set in the country), which he had invented for collectors and refined with the assistance of Francesco.

These were the allegories of the *Seasons* and the cycle with stories from the life of Noah, of which a large number of replicas were made. A few years later (c. 1577) Jacopo would revise their compositions. His invention of «nocturnes» dates from 1575, at the time of the Cartigliano frescoes painted by Jacopo with Francesco's collaboration. The two years of 1576 and 1577, those of the most fervent activity for Jacopo and his workshop, saw the production of the allegories of the *Elements* and biblical stories elaborated as genre scenes, such as *The Supper at Emmaus* (private collection, cat. 62) and *Christ in the House of Mary, Martha, and Lazarus* (Sarah Campbell Blaffer Foundation, Houston, cat. 61). Among the last works signed jointly by the father and son before Francesco moved to Venice (1578) is *The Circumcision* (Museo Civico, Bassano del Grappa, cat. 121), painted in 1577 for the Bassano cathedral. After 1578 Leandro would be his father's most valid assistant, but we do not see his hand in that extraordinary masterpiece, *Saints Martin and Anthony Abbot* (Museo Civico, Bassano del Grappa, cat. 67), painted c. 1578 for the church of Santa Caterina in Bassano. And we can only hypothesize a collaboration on his part in the execution of the altarpiece depicting *Saints Nicholas, Valentine, and Martha* for Valstagna of about 1578, which is now lost, but for which the *bozzetto* survives (Museum of Art, Rhode Island School of Design, Providence, cat. 68).

LIVIA ALBERTON VINCO DA SESSO

46. The Adoration of the Shepherds with Saints Victor and Corona (1568)

Museo Civico, Bassano del Grappa, inv. 17
Oil on canvas, 240×151 cm (94 1/2×59 1/2 in.)
Inscriptions: Jac.ˢ A. Ponte / Bassan.ˢ P. on the base of the crib

Provenance
Church of San Giuseppe, Bassano, from 18 December 1568 to the closing of the church in 1859, when it passed to the Museo Civico.

Exhibitions
Venice 1945; Venice 1946; Lausanne 1947; Bassano 1952; Venice 1957; London 1983; Rome 1988.

Bibliography
Ridolfi 1648, I, 396; Memmo 1754, 78; Verci 1775, 50, 53, 56, 79, and 80-81; Roberti 1777, 26 and 42; Lanzi 1818, 152; Vittorelli 1833, 28; Brentari 1881, 202; Crivellari 1893, 10; Gerola 1906, 110; Zottmann 1908, 27; Willumsen 1927, II, 201; Venturi 1929 (B), 1195-96, ills.; Berenson 1932, 48; Bettini 1933, 66, 170, ills.; Pallucchini 1944, II, xxxvii, ills.; Pallucchini 1946, 144; Pallucchini 1947, 84, no. 60; Magagnato 1952 (A), 14, 44, no. 25, ills.; Baldass 1955, 148; Fröhlich-Bum 1957, 215, ills.; Pallucchini 1957, 108; Zampetti 1957, 136, no. 55, ills.; Arslan 1960 (B), I, 113-15 and 162-63, and II, figs. 150-51; Rearick 1962, 526, ills.; Bialostocki 1978, 170; Magagnato and Passamani 1978, 27; Pallucchini 1982, 40, pl. 33; Magagnato 1983, 149, no. 9, ills.; Rearick 1984, 310; Rearick 1986 (A), 185; Russo 1988, 135-36, cat. 87, ills.; Rearick 1989, III, 5; Ballarin 1990 (B), 138, 141, and 144.

On 18 December 1568 the altarpiece, which is sometimes called «Il Presepe di San Giuseppe», was placed above the high altar of the church of San Giuseppe in Bassano, where the confraternity of that name met (Gerola 1906, 110; the date of 1568 is given also by Verci 1775, 80). Ridolfi (1648) reports that from the beginning it was widely admired, to the point that many «have even tried with large offers to purchase it», but the people of Bassano never wanted to give it up, «so that it is kept there as testimony to the virtue of such a citizenry». Verci (1775, 81) tells of a resolution on 26 March 1674 by the Confraternita di San Giuseppe, which established that «such a treasure» never for any reason be removed from its location «and this with a fine of 500 ducati, giving authority to the stewards to fortify it both in front and behind, for its conservation».

Numerous replicas of the picture were made, among which we might mention the one, with some variations and a smaller format, signed by Gerolamo (Kunsthistorisches Museum, Gemäldegalerie, Vienna, inv. 2022), and datable c. 1592-94. There are an infinite number of copies, especially from the seventeeth century. Verci (1775, 81) lists all those found in Bassano and the surrounding area during his lifetime. Among these paintings, we can recognize the faithful reproductin, mentioned as being in the church of San Giovanni, still belonging to the parish of Santa Maria in Colle, and the one in the church of Santa Croce in Campese, which was the work of G.B. Volpato and was lost in a fire about twenty years ago. Among the copies, those noteworthy for their own intrinsic value include one by Scarsellino (Pinacoteca Nazionale, Bologna) and one by Dorigny in the cathedral of Castelfranco Veneto. Engravings of the altarpiece were made by Pietro Menarola (c. 1680) and Teodoro Viero (mid-eighteenth century, Pan 1992, nos 89 and 129).

In his analysis of Jacopo's style, Verci often cites this *Adoration of the Shepherds* as an example of the artist's achievement in his «fourth manner», of which it seems to be the manifesto. In the painting, characterized by a remarkable naturalness, the painter seems to have absorbed into a style all his own the suggestions as to form and color coming from mannerism and Venetian art, particularly that of Veronese. It is thus a point of arrival, yet also one of departure, for the innovations he would make in the eighth decade in his altarpieces and pastoral scenes. His fervor for experimentation toward the end of the 1560s finds expression in his brief and touching comment written on a drawing in charcoal and colored chalk of 1569, «nil mihi / placet», where he reworked the composition of this picture (the notation is on the recto of sheet no. KdZ 24630, Staatliche Museen Preussischer Kulturbesitz, Kupferstichkabinett, Berlin, figs. 48 and 49; the same theme is also treated on the verso; see Rearick 1989, III 5).

In this *Adoration of the Shepherds* Jacopo again takes up the same subject as the one in the Galleria Corsini in Rome (cat. 36), but with a vertical format and various other modifications. The compositional scheme «on the surface describes two intersecting triangles, and on the plane is set up in a circle» (Verci 1775, 53). The scene is placed between two theatrical wings composed of architectural ruins with the characteristic thatched roofs, beyond which unfolds the landscape bathed in the cool light of twilight. The lowered point of view captures the sacred event close-up. The Virgin is

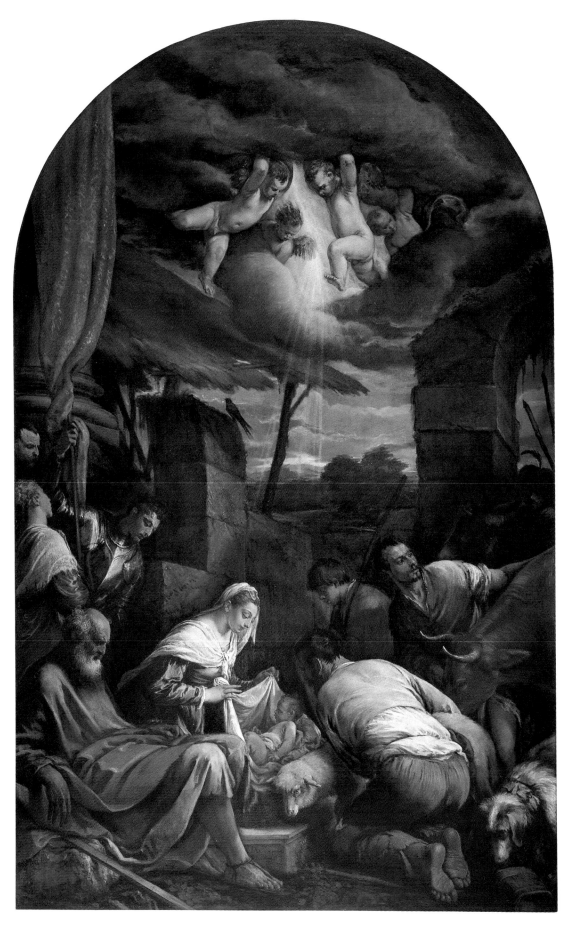

47. SAINT ROCH VISITING THE PLAGUE VICTIMS (c. 1573)

Pinacoteca di Brera, Milan, inv. 625
Oil on canvas, 350×210 cm (137×82 in.)
Inscriptions: JAC^s A PŌTE / BASS^{is} / PINGEBAT on the step on lower right
Exhibited in Bassano del Grappa only

represented in the act of uncovering the Christ Child, who sleeps in a curled position. On the left, behind Saint Joseph, who seems to have dozed off, Saints Victor and Corona, patrons of the church of San Giuseppe, look on, and a third figure – which is certainly a portrait, given the characteristic facial features – also appears. On the right is the group of shepherds with their animals, copies from everyday life. The light coming from the opening in the sky, in which hover little angels in flight, and the cloudy horizon unifies the composition magisterially and gives it an air of classical solemnity. The painting technique and the *mise en page* emphasizing the foreground can be seen, again very similarly, in *The Sleeping Shepherd* (Szépművészeti Múzeum, Budapest, cat. 45), which Ballarin (1990 (B), 142) considers autograph and also dates 1568. A curious similarity is the sheep dog, which is identical in both paintings, with its "anti-wolf" collar of thorns.

The literature on this painting is extensive, and all agree in praising the great poetry of the scene, which was captured eloquently by Ridolfi in 1648 (I, 396): « The pen cannot describe the beauty and purity of that Virgin, in the composition of which it seems that the Angels worked harder than the Painter, so that everyone in admiring that divine mystery, expressed with such naturalness, would swear that they were in the hut in Bethlehem with Mary, Joseph, and the Shepherds ».

L.A.V.d.S.

Provenance
Church of San Rocco, Vicenza, until 25 January 1807; entered the Pinacoteca di Brera, Milan, on 30 July 1811, from the state depository.

Exhibitions
Venice 1957; Venice 1979.

Bibliography
Borghini 1584, 563; Ridolfi 1648, I, 378; Boschini 1676, 115-16; Bertotti Scamozzi 1761, III; Verci 1775, 145; Baldarini 1779, part I, 116; Lanzi 1795, III, 96; Gironi 1812, I, XXXIX (engraving by I. Fumagalli); Zottmann 1908, 28-29; Rumor 1915, 16 and 26-27; Willumsen 1927, II, 189-99 and pl. XL; Venturi 1929 (B), IX/IV, 1196-1200, 1255-56, and fig. 834; Arslan 1931, 151, 153, 160-62, 191, and pl. LIV; Bettini 1933, 96, 176-77, and pl. XLII; Berenson 1936, 49; Morassi 1942, 8, 43, and 53, ills.; Pallucchini 1944, II, XXXIX, pl. 106-7; Magagnato 1952 (A), 49-50; Arslan 1956, 150, no. 1018; Berenson 1957, 18; Pallucchini 1957, 110 and 113; Zampetti 1957, 178, no. 72, ills.; Zampetti 1958, 44-46, pl. LXVI-LXVII; Arslan 1960 (B), I, 116-18, 122-24, 132, 171, and pl. X, and II, fig. 129; Rearick 1962, 530; Bialostocki 1978, 171; Mason Rinaldi 1980 (B), 220, fig. 14; Brera 1980, 98; Sgarbi 1980, 24, 80, and 86; Pallucchini 1982, 42; Rearick 1986 (A), 186; Ballarin 1988, I, 2, 6, and 10; Humfrey 1990, 195-98; Noè 1990, 32-34, ills.; Rearick 1991 (A), IV, 10.

This altarpiece was executed for the high altar of the church of San Rocco in Vicenza, which was served by the congregation of the Canonici secolari (secular canons) of San Giorgio in Alga (suppressed in 1668). This same order also officiated at the church of Santa Maria in Vanzo, Padua, for which Jacopo painted *The Entombment* dated 1574 (cat. 52). San Rocco later passed into the hands of the nuns of Santa Teresa di Venezia.

The altarpiece was removed on 25 January 1807, when Napoleon confiscated the convent and its property, and sent to the Brera (Rumor 1916, 13 and 16).

Verci (1775) was the first to address the problem of the picture's chronology and style. Following the opinion of G.B. Volpato, he assigned it to Jacopo's last or « fourth manner », which, for him, was characterized by a complete maturity of form and technique. In the absence of any documentation concerning its date (my research in the Archivio Segreto Vaticano proved fruitless), art historians of this century have put forth several theories justifying its chronological position, from 1568, as proposed by Willumsen (1927) and Venturi (1929 (B)), to 1575-76, suggested by Arslan (1931), who linked its commission to the first signs of plague in Vicenza in the fall of 1575. Other authoritative art historians, including Bettini (1933), Pallucchini (1944 and 1982), Zampetti (1957 and 1958), and Rearick (1986 (A)) tended to agree with this later date. Ballarin (1988) has recently offered valid historical and stylistic arguments for connecting the picture with Jacopo's pivotal artistic experience in 1573. He places it after the large lunette depicting *The Madonna and Child with Saints Mark and Lawrence Being Revered by Giovanni Moro and Silvano Cappello* (Museo Civico, Vicenza, fig. 54) from the winter of 1572-73 and alongside the two large canvases depicting *The Return of Tobias* (fig. 57) and *The Israelites Drinking the Miraculous Water* (both Gemäldegalerie Alte Meister, Dresden), which he

377

believes were painted at this time by Jacopo.

Here, as in the large lunette in Vicenza and in all the large altarpieces from the first half of the 1570s, including *The Martyrdom of Saint Lawrence* (cathedral, Belluno, fig. 53), dated 1571, and *The Entombment* mentioned above, Jacopo shows a tendency to impart monumentality to his composition through the use of perspective. He often sets the scene at twilight and moves the viewer toward a distant landscape along a diagonal line of architectural elements placed like a series of stage backdrops. By adopting this scheme, which reveals «a recognition of Tintoretto's syntax, and a concept of architecture reflecting Palladio» (Sgarbi 1980, 86), the artist limits his narrative freedom in favor of a spatial order that lends verisimilitude to his representation.

This altarpiece is divided into two areas: heaven, with the Virgin suspended between clouds and three-dimensional angels, and earth, with Saint Roch bending down to bless the plague victims, who are arranged in various groupings. The narrative continues along the diagonal created by the buildings, with the figures reduced in scale as dictated by the laws of perspective. In the far distance, the landscape is positioned against a twilight sky.

The naturalism of the figures, which has been emphasized by all the scholars, is not the most important element of the composition according to Mason Rinaldi (1980 (B)), who instead sees the accent placed on a sublimation of the event. From the point of view of technique, we have here an example of Jacopo's «impressionism»: an abbreviated brushwork, using touches that «create sparkles of light on the 'muted' half tones, using a drawing structure of great nobility and a cool palette» (Ballarin 1988, 6). The refinement and vigor of its execution leave no doubts as to Jacopo's authorship, which has by now been unanimously recognized.

Arslan (1960 (B)), without considering the innovation of altarpieces like this one, compared it to pictures from the end of the 1560s such as *The Adoration of the Shepherds with Saints Victor and Corona* (Museo Civico, Bassano del Grappa, cat. 46). He perceived a dualism between the «pictorial postulates» and the rhythm of the composition, and judged the figures to be academic exercises that had lost their original reason for being, merely becoming part of Jacopo's visual vocabulary. It is true that some of the figures are closely related to those in other paintings. For example, the plague victim on the right is a mirror image of Saint Sebastian in the little altarpiece depicting *Saints Florian, Sebastian, and Roch* of the preceding decade (formerly in the church of the Ognissanti, Treviso; now Museo Civico, Treviso, fig. 44); the postulant in the center is the same figure as the one on the right in the Dresden *Miraculous Water* and repeats, in reverse, the Virgin from *The Adoration of the Shepherds with Saints Victor and Corona*. We can see, however, that when Jacopo reuses figures from the iconographical repertory he worked out during his long mannerist experience, he chose figures consistent with the theme of the work: the poses of the participants in the drama are either *accoudée* (leaning on their elbows) or *accroupie* (kneeling or bending forward), to use the terms coined by Bialostocki (1978), and express suffering or protection, respectively, as befits the scene. In some passages, such as the one on the right where the *monatto* (the public servant who during plagues carried away the sick and dying) bends over the nude child, we find a mannerist counterbalancing of two poses that follows a pattern already established in subjects like the Good Samaritan or the Expulsion of the Merchants from the Temple.

No preparatory drawings exist for this altarpiece, and the chiaroscuro drawing in Florence (Gabinetto Disegni e Stampe degli Uffizi, Florence, no. 13063 F) for the lower half of the composition is a *ricordo* sketched by Jacopo and then finished by Francesco (Rearick 1962; and 1991 (A)). *Saint Roch Visiting the Plague Victims* (parish church, Cavaso del Tomba) is a reversed and reduced replica from Jacopo's workshop, dated c. 1578 by Ballarin (1988) and in the 1580s according to Rearick (1986 (A)). A copy of smaller dimensions with some variations is attributed to Francesco (64.8 × 47.8 cm, Staatliche Museen Kassel, Gemäldegalerie Alte Meister, Kassel, inv. no. GK 518).

L.A.V.d.S.

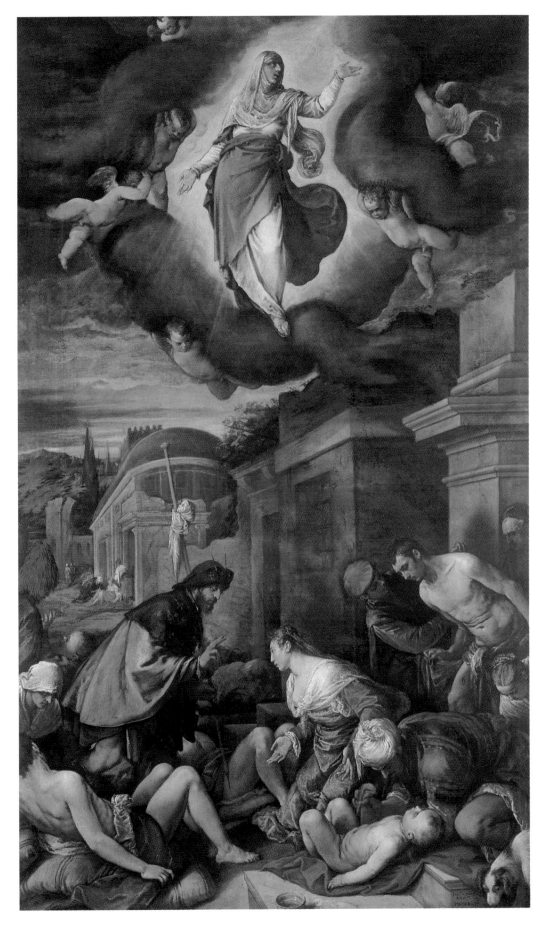

379

48. ADAM AND EVE IN THE EARTHLY PARADISE (c. 1570-75)

Galleria Doria Pamphilj, Rome, inv. 230
Oil on canvas, 77×109 cm (30 1/4×42 7/8 in.)
Exhibited in Bassano del Grappa only

Provenance
Galleria Doria Pamphilj, Rome, before 1929.

Exhibitions
Venice 1957.

Bibliography
Arslan 1929 (C), 410 (as Jacopo); Venturi 1929 (B), 1179 82 and 1259, ills. (as Jacopo); Arslan 1931, 194 (as Jacopo); Fröhlich-Bum 1932, 58; Buscaroli 1935, 193; Muraro 1952, 58 (as not Jacopo); Fokker 1954, 4 (as Jacopo); Berenson 1957, I, 20; Muraro 1957, 292 (as not Jacopo); Pallucchini 1957, 114 (as Jacopo and Francesco); Zampetti 1957, 194, 238 no. 81, ills. (as Jacopo and Francesco); Arslan 1960 (B), I, 108 and 175, and II, fig. 139 (as Jacopo); Ballarin 1969, 92-93 (as Jacopo); Pallucchini 1982, 46 (as Jacopo and Francesco); Safarik and Torselli 1982, no. 177, ills. (as Jacopo); Rigon 1983 (A), 74, ills. (as Jacopo); Rearick 1986 (A), 185 (as Jacopo and Francesco); Safarik 1991, 33, no. 194 (as Jacopo); Rearick 1992 (B), in press.

The painting is not mentioned in the literature on Jacopo before its publication in 1929 by Arslan, who saw it as Jacopo's invention and posited a date of c. 1568. Most scholars believe that it is by Jacopo: from Venturi (1929 (B)), who in particular judged the landscape to be of very high quality, «all flowering with light, vaster and deeper than any other by Jacopo»; to Berenson (1932 and 1957); from Buscaroli (1935), who pointed out the work's importance in the development of landscape painting in Italy, to Zampetti (1957) and Pallucchini (1957). In his monograph on Jacopo (1933), Bettini did not list it among the artist's works, and Muraro (1952; and 1957)

did not attribute it to Jacopo, comparing it with the 1575 Cartigliano frescoes on the same theme, which were a collaborative effort between Francesco and Jacopo. For the most part one can discern the assistance of one of the artist's sons, either Francesco or Leandro. Scholars agree on assigning to Jacopo the figures of Adam and Eve. He made a drawing of them in red chalk that coincides exactly with the composition (Staatliche Museen Preussischer Kulturbesitz, Kupferstichkabinett, Berlin, inv. 5109), which Rearick, however, omits from his corpus of Jacopo's graphic work. In his essay in this catalogue, he considers the drawing to be a *ricordo* by Leandro of his father's invention. Rearick also changes his earlier (1986 (A)) attribution of the painting to Francesco, assigning it instead to Leandro c. 1577.

Other Bassano scholars have recognized in the execution of the landscape the more or less consistent intervention of a different hand: Arslan (1929 (C) and 1960 (B)) saw the hand of one of the sons, perhaps Leandro; Zampetti (1957) and Pallucchini (1957 and 1982) thought it was Francesco. In the Venetian exhibition of 1957 the painting was dated c. 1576, an opinion accepted by Zampetti (1957) and Pallucchini (1982). Arslan (1960 (B)) maintained that the picture dated a little before 1570 and compared it to the version in Florence (Galleria Palatina, Palazzo Pitti, Florence, inv. 170, and here, fig. 30), which, evidently, was done at an earlier date.

Accepting an opinion expressed orally by Ballarin, the work can be

placed at the beginning of the 1570s, at a time when Francesco played a primary role in the workshop and could have participated in the execution of the scene. Compositions like this one are probably the antecedent for the allegories of the *Seasons* such as those in Vienna (cats. 50-51) of c. 1574, which have a very similar *mise en page* and where the same unifying power of light dominates the composition.

This earthly paradise is the landscape around Bassano at dawn in the spring and is very similar to the one in the background of *Spring* (Kunsthistorisches Museum, Gemäldegalerie, Vienna, no. 4303), where we find some of the same iconographical details (Venturi 1929 (B), 1270). The eastern light illuminates the bluish bulk of Monte Grappa, settling more brightly on the southern slopes. The observation point from which the lanscape is depicted, obviously with no houses or signs of the city, is quite far away, and can still today be identified in the area southwest of Bassano, between the convent of San Fortunato and the locality called Lazzaretto. The diagonal movement of the complex landscape setting – with a perspective similar to that of the buildings in the large altarpieces of the early 1570s – is given by the valley that runs from left to right toward the place where Bassano should rise. Here, though, the city's place is taken by a wooded area described with a rapid line and touch, which delineates the various types of recognizable trees. In the clearing in the foreground, Jacopo's impressionistic brushstroke describes

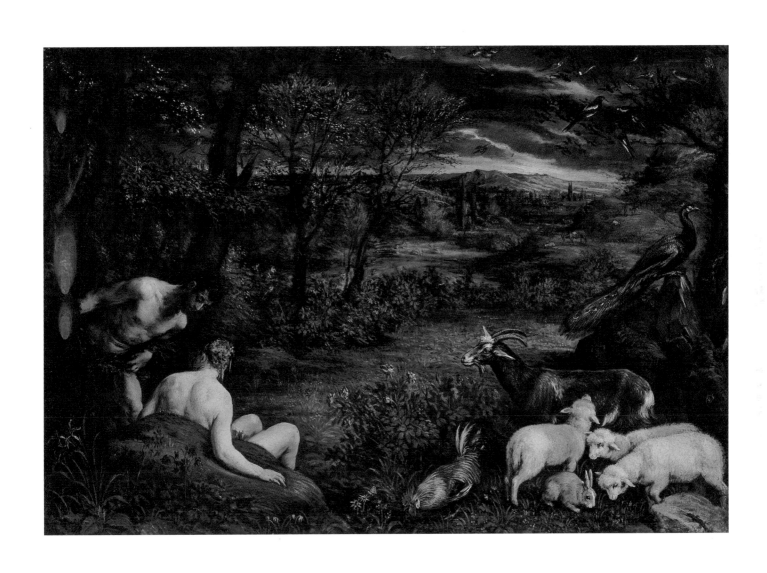

49. THE SACRIFICE OF NOAH (c. 1574)

Stiftung Schlösser und Gärten Potsdam-Sanssouci, Potsdam, inv. GKI 5265
Oil on canvas, 100×168 cm (39×66 in.)
Inscriptions: IAC.ˢ / BASSANESI / [PIN]GEBAT on the rock in the center, where the third line is incomplete, having been partially cut off by the addition of about 5 centimeters along the entire lower edge; «41» on lower left, a number, not completely clear, from the old inventory
Exhibited in Bassano del Grappa only

the flowers, leaves, and grass. The animals palpitate with life in «a limited, but comprehensive sampling» (Rigon 1983 (A), 74), which ranges from domestic pets to birds, and a lizard, symbol of vanitas, on the rock in the right corner. The figures of Adam and Eve, with their soft modeling and warm flesh tones, stand out against the rich gradations of the dominant greens. Around this meeting of our progenitors «the painter hangs his holiday luminaries on the branches of the trees, on the feathers of the birds trimmed with fire, and the petals of the flowers; with his magic virtuoso touch he ruffles the hair of Eve into falls of yellow and pink; and in the blue green sky he opens pathways for currents of phosphorous green and sudden rapids of light, which descend obliquely from above» (Venturi 1929 (B), 1180). And it is the light that transforms the meticulously rendered variety of beings into an extraordinary vision.

L.A.V.d.S.

Provenance
Neue Palais Potsdam-Sanssouci, 1794; storerooms of the Neue Palais Potsdam-Sanssouci, 1930; U.S.S.R., 1945-48; since 1963, Bildergalerie Potsdam-Sanssouci.

Exhibitions
Never before exhibited.

Bibliography
Nicolai 1779, 667; Rumpf 1794, 216; Parthey 1863, 1, 70, no. 2; Arslan 1960 (B), 1, 364 (as workshop); Die Gemälde in der Bildergalerie 1962-63, no. 102; Eckardt 1975, 15; Ballarin 1988, 2 and 12, n. 6; Eckardt 1990, 15 (as Jacopo).

In reviewing the history of this painting, Eckardt (1975; and 1990, 15), does not go back beyond 1794, but mentions the possibility that it could be the one identified as «Ein Viehstück von Bassano» (Nicolai 1779, 667) present since 1779 in the castle in Berlin, where another painting from the cycle of the Flood is mentioned by Puhlmann (1790, no. 86): an *Animals Entering the Ark* now in the castle in Homburg vor der Höhe. Ballarin (1988, 2 and 12) considers the Potsdam painting to be certainly autograph and one of the four original stories from the life of Noah series created by Jacopo in 1574. He feels it is very close in style to *The Entombment* (Santa Maria in Vanzo, Padua, cat. 52), which is signed and dated 1574. Other scenes from the Noah cycle have not survived, or at least have not yet come to light. According to Ballarin (1988, 2), the autograph fragment with the right half of *Noah Giving Thanks to God* (Walker Art Gallery, Liverpool, fig. 64) represents, with minimal variations, a second stage of the Pots-

dam composition. The Liverpool picture (Arlsan 1960 (B), 11, fig. 203) then becomes the original for subsequent versions, many with some variations in composition and format, such as the one painted entirely by the workshop, although signed by Jacopo, which appeared on the art market around 1968 (Knoedler, New York; and Weitzner, London; see Ballarin 1988, 12, who dates it c. 1568), and the one from the complete cycle in the Archbishop's Palace in Kroměříž (*Noah Building the Ark, The Animals Entering the Ark, The Flood*, and *The Sacrifice of Noah*, cats. 63-66) of 1578-79, signed only by Jacopo, but clearly done in collaboration with his sons: Francesco, according to Ballarin; Leandro, according to Rearick (1986 (A), 186). Rearick (see his essay in this catalogue) feels that the invention of the successful stories from the life of Noah, in a medium-sized format intended for collectors, dates from around 1576-77, and that the Liverpool fragment belongs to the original series, since numerous pentimenti are visible – including the addition of a wooden box above the tools on the left – an indication that this is an invention *in fieri*, almost an artist's proof, not yet completely defined as the model for the workshop replicas.

The Potsdam painting illustrates the moment in which Noah renders thanks to God after the Flood: «Then Noah built an altar to the Lord, and took of every clean animal and of every clean bird, and offered burnt offerings on the altar» (Genesis: 8:20). The sacrifice does not oc-

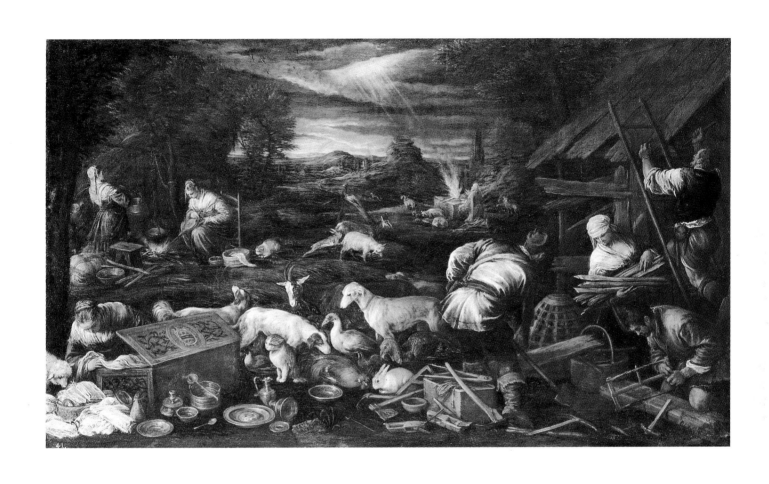

cupy the foreground, but an area to the right, behind the hut that is being built. Beyond a dip in the hills, the Ark has come to rest on Mount Ararat. Farther back, against the backdrop of the mountain, we see a rainbow, symbol of the divine promise: « When the bow is in the clouds, I will look upon it and remember the everlasting covenant between God and every living creature of all flesh that is on the earth » (Genesis: 9:16). In the center, the rays of a supernatural light stream down onto the sacrificial flames. The actual story, narrated faithfully following the biblical text, does not take place in the foreground, where instead we find the return to daily life on the earth, which the artist portrays in a pastoral vein. The protagonists are the animals saved from the Flood, Noah's wife, and three sons intent on constructing a hut at the right of the picture. On the left, one of Noah's three daughters-in-law bends over to take some linens from a chest, while behind her the other two attend to cooking the food over a fire. Set in the earliest, or last, light of day, the composition is structured in a wedge shape along two diagonal lines originating in the right corner from the beam being sawed and in the left from the open chest. They meet in the depth of the landscape, which is accentuated by the shape of the canvas. Ballarin (1988, 2-3) observed that inventions like this one presuppose the experience of *The Return of Tobias* (Gemäldegalerie Alte Meister, Dresden, fig. 57) and *Jacob's Journey* (Palazzo Ducale, Venice), both of which

he dates to 1573. The elegant shattered line with which the Potsdam picture is painted and the landscape unified by the light are also seen in the predellas in Civezzano and the *Seasons* in Vienna (cats. 50 and 51).

The coat of arms on the cover of the chest is important for understanding the taste of the collectors who ordered works from Jacopo. The precision with which the painter has reproduced it (six black beards on a silver ground, blue band with three gold lions *passant*: design in *Il Campidoglio Veneto*, sec. XVIII, MS, fols. 89*v*-89*r*) has made it possible to identify it as the arms of the Venetian family Barbarigo della Terrazza, who had a palace on the Rio San Polo and from the fifteenth century on collected works by various artists, including Titian. Among the 102 paintings listed in the inventory of the Pinacoteca Barbarigo, which was sold as a block in 1850 to Czar Nicholas I (Levi 1900, 281), there is no mention of a *Sacrifice of Noah*. The picture had evidently left the collection at an earlier date, as is indicated by its presence at Potsdam-Sanssouci already in 1794. Among the members of the Barbarigo family, most probably Nicolò, son of Giambattista, commissioned the painting. In 1574 he was podestà of Verona, well educated, an excellent speaker, and a refined man of letters (*Il Campidoglio Veneto*, sec. XVIII, MS, fol. 91*v*).

L.A.V.d.S.

384

50. SUMMER (c. 1574-75)

Kunsthistorisches Museum, Gemäldegalerie, Vienna, inv. 4302
Oil on canvas, 78.5 × 110.5 cm (30 7/8 × 43 1/2 in.)

Provenance
Collection of the Archduke Leopold Wilhelm, Brussels, before 1659; Prague Castle 1660-1894; Kunsthistorisches Museum, Vienna, since 1894.

Exhibitions
Never before exhibited.

Bibliography
Ridolfi 1648, I, 398; *Inventario* 1659; Teniers 1660, pl. 159; *Inventarium* 1685, no. 369; *Inventarium* 1737, no. 422; Dézallier d'Argenville 1745, I, 162 (as Jacopo); Zottmann 1908, 54 (as Francesco); Venturi 1929 (B), 1270-99, ills. (as Francesco); Arslan 1931, 355; Baldass 1949, 214 (as Francesco); Baldass 1955, 154-55, ills. (as Francesco); Isarlo 1956, 54, fig. 44; Zampetti 1957, 152; Arslan 1960 (B), I, 187 and 381, and II, fig. 213 (as the circle of Francesco and workshop); *Katalog der Gemäldegalerie* 1965, no. 438 (as Francesco); Smirnova 1971, 131; Rearick 1986 (A), 186 (as Jacopo and Francesco); Ballarin 1988, 2 and 12 (as Jacopo); *Die Gemäldegalerie* 1991, 26, no. 296, ills. (as Francesco).

It is not known when this painting, along with two others from the same series of *Seasons* (now all in the Kunsthistorisches Museum, Gemäldegalerie, Vienna: *Autumn*, inv. 4304, cat. 51; and *Spring*, inv. 4303) entered the collection of Archduke Leopold Wilhelm in Brussels, where they are mentioned for the first time in the inventory of 1659 with an attribution to Jacopo. The inventory grouped together the *Seasons* and two biblical-pastoral scenes from the Dal Ponte workshop, one of which Safarik (1962) identifies as *The Meeting between Ruth and Boaz* (now Národní galerie, Prague). The *Seasons* in the collection of the Hapsburg Arch-

duke, who was governor of the Low Countries, were faithfully reproduced in reverse by Teniers, in the *Theatrum Pictorium* (1660, pl. 157-60, drawn by Hoÿ and engraved by J. van Ossenbeck). The series is mentioned under Jacopo's name by Dézallier d'Argenville (1747) as in the Hapsburg royal collections in Prague. However, since 1894, when it passed into the Kunsthistorisches Museum in Vienna (Gemäldegalerie: *Spring*, inv. 277; *Summer*, inv. 296; *Autumn*, inv. 295; for the missing *Winter*, there is a variant attributed to Francesco, inv. 2869), it has always been assigned to Francesco, including the latest edition of the catalogue, *Die Gemäldegalerie* (1991), and dated c. 1576. Most art historians have agreed with this attribution. Only von Hadeln in his commentary on Ridolfi (1914 (B), I, 378) recognized these three paintings as originals by Jacopo. Baldass (1949; and 1955) calls them early works by Francesco, very close to the style of Jacopo. Arslan felt that they were done by Francesco with workshop assistance or even by someone in the workshop who was repeating « early Francesco compositions with strong reminiscences of Jacopo ». Smirnova reasoned along these same lines (1971), connecting the series in Vienna and a similar one in the Castello Sforzesco in Milan (which she attributed to the workshop, perhaps Gerolamo) to a prototype by Jacopo, which was probably invented in the years 1574-76. This prototype for the *Seasons* (very similar, as Baldass has noted, to the cycle described by Ridolfi in the house of the painter Ni-

colas Renier in Venice) then served as the model for the numerous workshop replicas (among those that Smirnova mentioned as very close to the painting under discussion, there is a *Summer* in the Galleria Estense, Modena, attributed to Francesco) and copies. Further copies, mainly by seventeenth-century artists, were evidently derived from engravings after the series made by Hendrik Hondius (1601) and the brothers Jan and Raphael Sadeler (between 1598 and 1601). These engravers, in an effort to give greater weight to the landscape and genre aspects of the original paintings, made some modifications: for instance, the Sadeler brothers eliminated the biblical scenes in the middle distance, and Hondius added the signs of the zodiac in the sky (Pan 1992, nos. 9-12).

Satisfactory attribution of the Vienna paintings has long been hindered in this century by the conviction of most scholars that Francesco was the inventor of the pastoral scenes. Ballarin (1966-67), putting the early sources into focus, noticed that all of them recognized Jacopo's extraordinary ability to render « reality », particularly in the pastoral subjects inspired by stories from the Bible. Even the Viennese *Seasons*, which, according to Ballarin are by Jacopo and belong to the original series invented in the workshop around 1574, contain a biblical motif, albeit relegated to the background or the left-hand corner: the expulsion of Adam and Eve in *Spring*; the sacrifice of Isaac in *Summer*; Moses receiving the tablets of the Law in

Autumn; and Christ bearing the cross in *Winter*. Rearick (1986 (A)) believes that these paintings are the result of a collaboration between Jacopo and Francesco, and dates them c. 1575, pointing out that the biblical episodes should be understood as moralizing comments on each season. In his essay here, Rearick revises the date to 1577.

Summer describes the labors done mainly in June: in the middle ground, the cutting and threshing of wheat; in the foreground, the shearing of sheep and the preparation of a rustic meal; and halfway up the high ground on the left, a summarily painted shepherd boy, *accoudé*, roping a horse. The low, wide format of the canvas permits an open *mise en page* for the pastoral episodes and a lyrical depiction of the landscape around Bassano and Monte Grappa, which is seen in the distance. Berenson (1948) must have had pictures like this in mind when he defined Jacopo as «the first modern landscape painter».

Here, as in the other *Seasons*, the artist achieves an astonishingly wide-open panorama by adopting a high, distant observation point and using for his perspective a diagonal moving back through the landscape from the lower right corner. All the elements of the composition meld together within the register of the summer light, a light that saturates the lovely color spread with an elegant and tiny brushstroke. Jacopo draws on his repertory of prototypes for the figures, principally from the biblical-pastoral scenes of the 1560s, but also from some paintings closer

in time to this one, such as *The Israelites in the Desert* (Gemäldegalerie Alte Meister, Dresden) of c. 1573, where we find the old man who shears the sheep. We can discern an emotional participation in the daily life of the countryside on the part of the artist. Jacopo never yields to a purely descriptive realism, which would, in fact, become a characteristic of these paintings in the hands of his sons, who turned them into genre scenes. We cannot accept Longhi's definition (1946) of Jacopo as a «peasant for fun», that is, someone who painted country scenes as entertainment for rich people. Certainly the innovative value of these pictures, created for collectors, was perceived immediately in Venice, and the admiration of his contemporaries echoes through the words of Marucini (1577): «Questo [Jacopo] è in Figure eccellentissimo e in Paesi divino... inganna quando vuola, e gli huomeni, e gl'animali, con ritrar dal naturale quello che piú li piace, hor cose animate, e hor inanimate, cosí ben rassomiglia, che da tutte le parti concorrono gl'uomini ad ammirar le cose sue» (This man [Jacopo] is in Figures most excellent and in Landscapes divine... he alludes, whenever he wants, to both men and animals, by portraying from nature what they are most like, now animate things, now inanimate, and they resemble so well that men run from every direction to admire his things).

L.A.V.d.S.

386

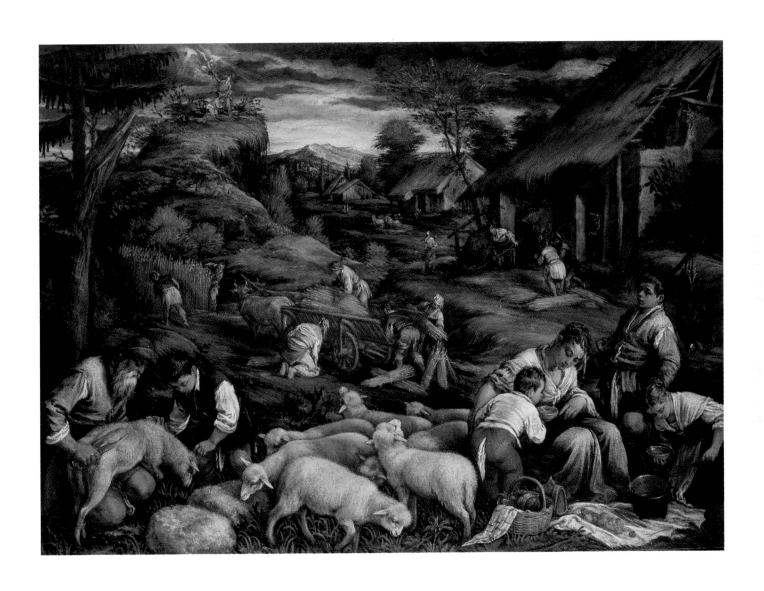

387

51. Autumn (c. 1574-75)

Kunsthistorisches Museum, Gemäldegalerie, Vienna, inv. 4304
Oil on canvas, 75.5×109 cm (29 3/4×42 7/8 in.)

Provenance
Collection of Archduke Leopold Wilhelm, Brussels, before 1659; Prague Castle 1660-1894; Kunsthistorisches Museum, Vienna, since 1894.

Exhibitions
Never before exhibited.

Bibliography
Ridolfi 1648, 1, 398; *Inventario* 1659; Teniers 1660, pl. 158; *Inventarium* 1685, no. 208; *Inventarium* 1737, no. 32; Dézallier d'Argenville 1745, 1, 162 (as Jacopo); Zottmann 1908, 54 (as Francesco); Arslan 1931, 355; Baldass 1949, 214, fig. 16 (as Francesco); Baldass 1955, 154-55 (as Francesco); Isarlo 1956, 54, fig. 14; Arslan 1960 (B), 1, 187 and 381 (as Francesco's workshop); *Katalog der Gemäldegalerie* 1965, no. 439 (as Francesco); Smirnova 1971, 131; Rearick 1986 (A), 186; Ballarin 1988, 2 and 12; *Die Gemäldegalerie* 1991, 26, no. 295, ills. (as Francesco).

In 1659 *Autumn*, together with the other allegories of the seasons from the same series, was in the collection of Archduke Leopold Wilhelm in Brussels (see *Summer*, cat. 50). We accept Ballarin's (1988) proposal that this is the prototype invented in the workshop by Jacopo around 1574. It was engraved, in reverse, by J. van Ossenbeck as plate 158 of *Theatrum Pictorium* (Pan 1992, no. 83), and by Raphael Sadeler in a print that eliminates the biblical episode of Moses receiving the tablets of the Law (Pan 1992, no. 11). A large number of replicas of this *Autumn* are known (Smirnova 1971, 131, lists some), and two drawings derived from it are now in The Hermitage, Saint Petersburg (Smirnova 1971). In his essay in this catalogue, Rearick maintains that this *Autumn* and the *Summer*

(cat. 50) are the only two surviving Seasons from the original series, which he dates 1577.

The figures, busy at their autumnal work – harvesting grapes, making wine, and sowing grain – have their prototypes in paintings more or less distant in time. For example, the sower in the middle ground is the same as in *The Parable of the Sower* (Thyssen-Bornemisza Collection, Lugano) of around 1561, while the woman leaning over to lift the baskets on the right has the same pose as the figure toward the left in *Jacob's Journey* (Palazzo Ducale, Venice) of c. 1573-74. But in this atmosphere of a bucolic idyll, the figures become part of a new type of composition, which Jacopo had already explored in his large altarpieces beginning with *The Martyrdom of Saint Lawrence* (cathedral, Belluno, fig. 53) of 1571. The diagonal recession that moves back from the right-hand corner gives a larger breadth to the landscape without reducing the role of figures as the protagonists of the painting, as is also the case in the contemporaneous *Sacrifice of Noah* (Stiftung Schlösser, Potsdam, cat. 49).

The scene is unified by a melancholy autumnal light, which mutes the greens in the valley leading up to a view of Monte Grappa and suffuses an intimate poetry throughout the painting. It is a feeling we will encounter again in the pastoral pictures in Civezzano of about 1575.

L.A.V.d.S.

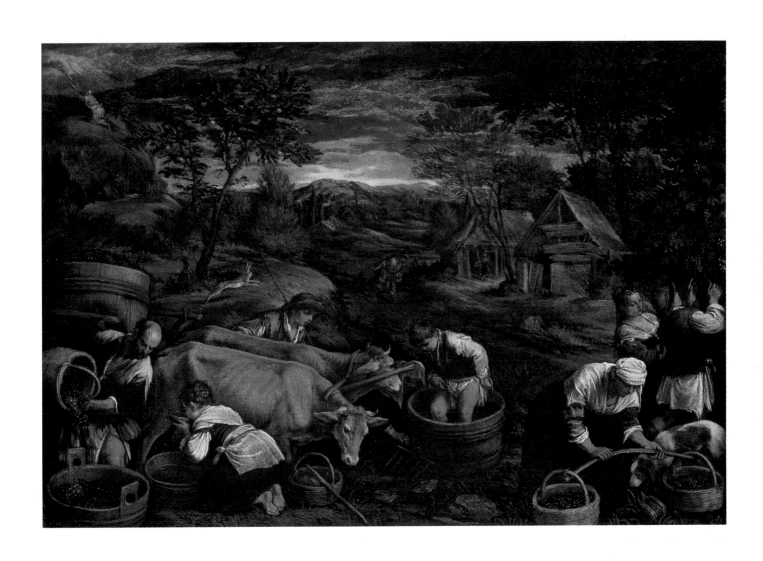

52. THE ENTOMBMENT (1574)

Chiesa di Santa Maria in Vanzo, Padua
Oil on canvas, 270×180 cm (106 1/4×70 7/8 in.)
Inscriptions: JAC.BASSANE / FACIEBAT / MDLXXIV on the stone at bottom center; the final E of the first line is partially covered by a leaf

Provenance
In the church of Santa Maria in Vanzo since its execution in 1574.

Exhibitions
Venice 1957; Padua 1976.

Bibliography
Ridolfi 1648, I, 396; Verci 1775, 126-28; Lanzi 1818, 152; Donati 1888, 25; Berenson 1894, 84; Gerola 1905-6, 951; Zottmann 1908, 37; Venturi 1929 (B), 1259; Arslan 1931, 141, 147-48, 151, 153, and 193; Fröhlich-Bum 1931, 122; Berenson 1932, 58; Bettini 1933, 90-92 and 174; Arslan 1936 (B), 171; Berenson 1936, 58; Pallucchini 1944, XXXVIII; Magagnato 1949, 193; Baldass 1955, 148; Arslan 1956, 72; Alce 1957, 175; Berenson 1957, I, 19; Pallucchini 1957, 112; Pignatti 1957 (A), 373; Zampetti 1957, 172, no. 69, ills.; Zampetti 1958, 52; Arslan 1960 (B), I, 113, 116, 120, 122-23, 126, 128, 137, 139, and 174, and II, fig. 167; Guzzi 1960, 83; Rearick 1976 (A), 107-8; Bialostocki 1978, 171; Sgarbi 1980, 87-88; Pallucchini 1982, 42 and 47, pl. 35; Rigon 1983 (A), 74, figs. 39 a-b; Rearick 1986 (A), 185; Attardi 1988, 693; Ballarin 1988, 2; Freedberg 1988, 658; Avagnina 1989, 28-29.

The altarpiece, which has always remained in its original position, was painted for the last altar on the left wall of Santa Maria in Vanzo, a church served by the Canonici secolari (secular canons) of San Giorgio in Alga, who also officiated at the church of San Rocco in Vicenza, for which Jacopo painted *Saint Roch Visiting the Plague Victims* (Pinacoteca di Brera, Milan, cat. 47) of c. 1573. After the suppression of the congregation in 1670, the church and its art treasures were incorporated into the chapel of the seminary of the diocese, which was transferred to the adjacent monastery. There is proba-bly a connection between the two commissions awarded to Jacopo by the same congregation. A sign of the success of the Paduan piece is the replica, with some variations, which Jacopo then had to do for the church of Santa Croce in Vicenza (now the church of the Carmini; according to Magagnato (1949): mid-1570s, by Jacopo; for Ballarin (1988, 2): c. 1574, by Jacopo; for Rearick (1976 (A), 108): 1578-79, by Jacopo in collaboration with Francesco; for Rearick now (see his essay in this catalogue): c. 1582, in collaboration with Leandro; for Avagnina (1989): within 1580, by Jacopo). The smaller version (Kunsthistorisches Museum, Gemäldegalerie, Vienna, inv. 5680; from the royal collection, Prague, where it was already listed in the 1685 inventory, brought to the attention of scholars by Baldass in 1924), which had always been attributed to Jacopo, appears in the latest catalogue of the museum (*Die Gemäldegalerie* 1991) as the work of Leandro, following a suggestion by Rearick (1976 (A)); he lists some of the numerous repetitions of the theme painted by Jacopo's sons and the workshop). Engravings after the altarpiece in Padua were made by Cochin and Jackson. Art historians, beginning with Ridolfi (1648), have generally recognized the work as one of the masterpieces painted completely by Jacopo himself, but Pallucchini continued to see Francesco's hand in the landscape.

In the silence of a very late twilight Joseph of Arimathea and Nicodemus tenderly carry the body of Christ, while on the left Saint John and the grieving Marys come to the aid of the Virgin, who has fainted. On the right, Mary Magdalene is carefully preparing the perfumes for Christ's embalming. In the distant left, three crosses rise over Calvary. The dual illumination – the natural twilight and the artificial light of the torches – plays across the group of mourners and the gray body of Christ. Christ's body is placed along a diagonal line, at the top of which, as Rearick observes (1976 (A)) «Jacopo has placed – in skillful allusion the symbol of death and resurrection – the broken tree from which a new branch is shooting». The majestic landscape participates in the drama, taking up almost half the composition. It is enlivened by the luminous flickers of the torches. «In no other work of Jacopo's do the figures, nature, light, and symbol fuse so effectively».

The certainty of the date and signature make it possible to analyze the artist's actual achievements at this point, and even more than *Saint Paul Preaching* (Sant'Antonio, Marostica), also of 1574, but painted with Francesco's assistance, allows us to bring together other important paintings in Jacopo's development, including *The Sacrifice of Noah* (Stiftung Schlösser, Potsdam, cat. 49) and the *Seasons* in Vienna (cats. 50 and 51).

L.A.V.d.S.

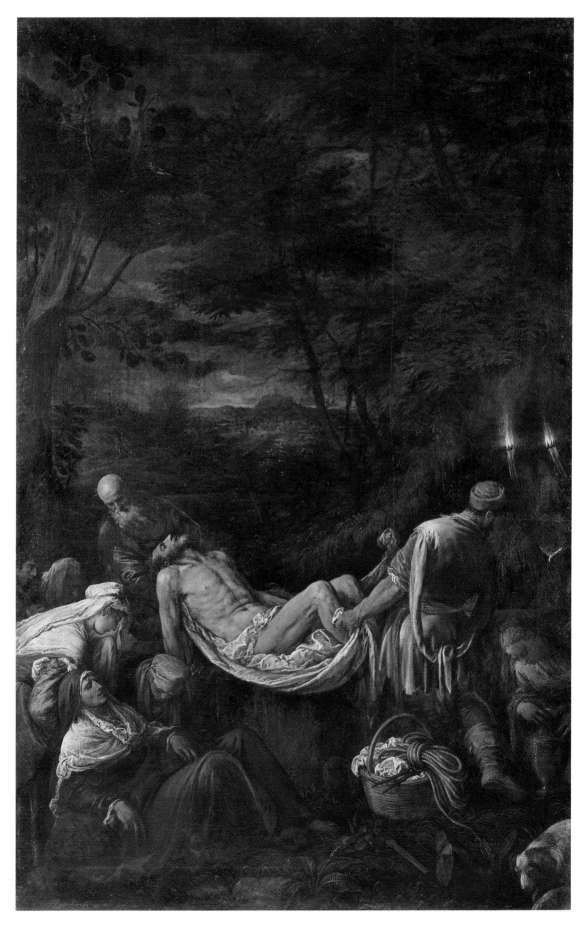

53. Saint Lucille Baptized by Saint Valentine (c. 1575)

Museo Civico, Bassano del Grappa, inv. 15
Oil on canvas, 183.5×129.5 cm (72 1/4×51 in.)
Inscriptions: Jac. A. Ponte / Bassanensis F. on the riser of the lower step

Provenance
Church of Santa Maria delle Grazie, Bassano, where it remained after 1667, when the church passed into the hands of the Danieli family of Bassano; in 1842 deposited in the Museo Civico in Bassano by Don Antonio Danieli.

Exhibitions
Venice 1946; Lausanne 1947; Bassano 1952; Venice 1957; Los Angeles 1979.

Bibliography
Ridolfi 1648, I, 397; Boschini 1660, 299-302; Memmo 1754, 78; Verci 1775, 52, 57, 60, and 82-83; Roberti 1777, 28; Vittorelli 1833, 13; Brentari 1881, 197; Donati 1894, 21; Gerola 1906, 109; Zottmann 1908, 28; Venturi 1929 (B), 1218-20 and 1257, ills.; Arslan 1931, 168 and 186; Bettini 1933, 100-2 and 179, ills.; Pallucchini 1944, xxxix, ills.; Pallucchini 1946, 142-43, no. 253; Pallucchini 1947, 85, no. 62; Magagnato 1952 (A), 15, 45, no. 27, ills.; Pallucchini 1957, 112; Pignatti 1957 (A), 373; Zampetti 1957, 154, no. 62, ills.; Arslan 1960 (B), I, 141, pl. XI, and 162, and II, pl. XIII, and fig. 185; Ballarin 1966, 132-34; Magagnato and Passamani 1978, 28, ills.; Rigon 1978, 177; Pignatti 1979, 140, no. 51, ills.; Bordignon Favero 1981, 72, 75, and 77; Pallucchini 1982, 42, pl. 36; Rearick 1986 (A), 187; Ballarin 1988, 3-4; Lugato Giupponi 1992 (B), in press.

Ridolfi (1648) was the first to mention this altarpiece, painted by Jacopo «for the Fathers of the Graces». The small church of Santa Maria delle Grazie, built against the city walls of Bassano, is given as its location in the writings of Boschini (1660), Memmo (1754), Verci (1775), Roberti (1777), and Vittorelli (1833), all witnesses to the admiration the painting enjoyed in various epochs. An engraving was made of it in the eighteenth century by Filippo Ricci

(Pan 1992, no. 128). Among the copies («a great many», according to Verci), the most noteworthy is by G.B. Zampezzi (Palazzo Avogadro, Calstelfranco Veneto).

Verci places the work among the masterpieces of Jacopo's «fourth manner», but does not give documentary information on the commission or date, nor do the other very early authors, Ridolfi and Boschini, treat the problem of chronology. This problem is debated by twentieth-century scholars, who also discuss the possible collaboration of his sons. Before Magagnato offered his hypothesis (1952) – that the work was autograph and dated from 1573-74 (for the «flickering light and verdant, precious intensity of touch») before *Saint Paul Preaching* (Sant'Antonio, Marostica), which is dated 1574 – the commonly accepted date was around 1580 (Arslan 1931; Bettini 1933; Pallucchini 1944 and 1946), at a time then considered to be the end of the artist's career. Since the exhibition in Venice in 1957, the tendency has been to date the altarpiece to 1575 (Zampetti 1957; Pallucchini 1957 and 1982; Pignatti 1957 and 1979; Ballarin 1966 and 1988); Arslan, however, maintained his earlier opinion. Rearick (1986 (A) and in the essay here) considers it to be from 1578-79, after the Dolzoni altarpiece in San Giacomo dell'Orio in Venice, which he sees as a collaboration between Francesco and Jacopo and dates to 1578, and also later than the *bozzetto* for *Saints Nicholas, Valentine, and Martha* (Museum of Art, Rhode Island School of Design, Providence cat. 68), because he

feels that Saint Valentine has the same stylistic characteristics in both compositions. Rearick also finds in *Saint Lucille* the hand of Leandro, who after Francesco's departure played an important role in his father's workshop. Ballarin (1966 and 1988) dates it precisely 1575, before the canvases in Civezzano, and detects a particular luminosity resulting from his experience that same year painting nocturnal scenes like *The Annunciation to the Shepherds* (Narodní galerie, Prague, cat. 54). In these two «stories», according to Ballarin, Jacopo uses the same language distinguished by great, formal elegance, changing only the setting, which in the *Saint Lucille* altarpiece is twilight. The figure types are also the same, as Ballarin demonstrates in a close comparison (1966, 133-34).

The subject, the only example known in paintings of the period from the Veneto, is inspired in part by the chapter on Saint Valentine in *The Golden Legend* and in part by the hagiography of Saint Lucille. Valentine, «a priest held in great esteem», was subjected to questioning by the emperor Claudius II, a fierce persecutor of Christians. As Valentine was about to convert Claudius, the prefect, in alarm, recalled the emperor to his duty. The priest was then handed over to the custody of a high-ranking officer, Nemesius, who had a blind daughter named Lucille. It should be noted that the name is a diminutive of Lucy, which derives from the Latin *lux*, meaning light. Valentine prayed to «Christ, the true light», and gave the girl not only the physical light of her eyes,

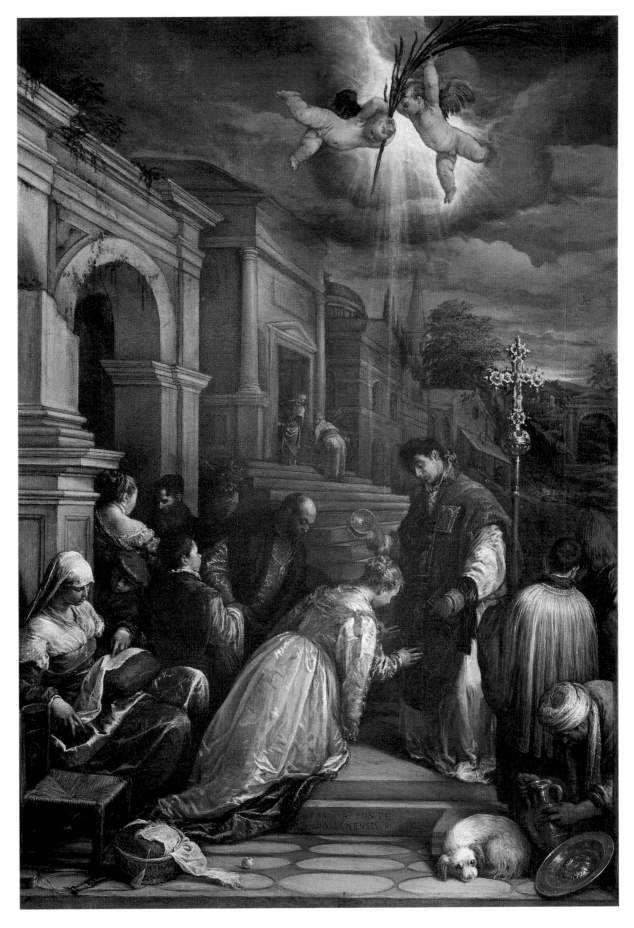

but also, after converting her and her father, the supernatural light of the soul, imparted through baptism. When the emperor heard of this, he had Valentine beheaded. His martyrdom, according to *The Golden Legend*, occurred around 280 A.D. Some time later, both Nemesius and Lucille met the same fate.

Like the other altarpieces of the eighth decade, this too is constructed around a framework of buildings positioned diagonally in perspective, giving the illusion of a penetration of depth into the landscape, which is once again that of the area near Bassano. In the solemn classical architecture, Jacopo may have wanted to evoke Imperial Rome. However, he portrays the figures in modern dress and reinforces this sense of contemporaneity by having the acolyte carry Filarete's crosier, which since 1449 had been a part of the liturgical trappings of the cathedral in Bassano and was used for centuries in rituals (now Museo Civico, Bassano del Grappa). Valentine is captured at the moment when he pours the baptismal water over the head of the kneeling Lucille, next to whom kneels her father Nemesius, almost as though he, too, wished to submit to the sacrament. Other characters are present and participate to varying degrees in the ceremony: the page carrying Lucille's veil over his arm, the two noblemen talking together under the arch, and the man peeking around the pillar, perhaps the prefect who will then carry the tale to the emperor. The outcome for the three protagonists is suggested by the appearance of two angels hovering in the sky with a martyr's palm. The supernatural light, pouring down from above, is at the same time a symbol of the glory awaiting the martyrs and of the spiritual rebirth imparted to Lucille through baptism. Even if they are not part of the main episode, the two groups on the sides, placed a bit towards the interior of the scene, do not disturb the intimate atmosphere: in the left foreground, the woman embroidering and the little boy curious about her work; and on the right, the Turk, maybe a merchant, turning a copper vase around in his hands, next to a curled-up dog. This example of everyday life « represents one of the most moving concessions to genre painting that can be found in an altarpiece » (Arslan).

The stylistic analysis of the painting made by Verci, who it is known used as a base the critical observations of G.B. Volpato, maintains its validity today (Bordignon Favero 1981 identifies some of the passages from Volpato's manuscripts *La verità pittoresca* and *La natura pittrice*, regarding the *Saint Lucille* altarpiece used by Verci). He inserts the work among those in which the technique of « agreement », similar to the manner of the « enclosed » light source, demonstrates all the possibilities of the half-tones, and in which the extreme degree of artifice is masked by naturalness. The minute, nervous touch vitalizes the colors and works the miracle of the « black drape that seemed white » (this admiring phrase, mentioned by Roberti in 1777, was written by Giambattista Tiepolo in a letter to his son, Domenico, after having seen the *Saint Lucille* during a trip to Bassano).

Recent restoration (1992) has made apparent the rather poor quality of some of the passages, such as the architecture painted in drab, lifeless color (Pallucchini 1957 and 1982 had already noticed this and attributed it to an intervention by Francesco) and certain details painted with a descriptive brushstroke, not from the hand of Jacopo. But the cleaning has also brought to its original state the luminous tones of the whites, which move toward silver, and the preciousness of certain passages like the cross and Lucille's dress. « Lucille, more shining and celestial/ Than any sparkling diamond », wrote Boschini in 1660 (he wrote more than 100 lines of poetry to the saint). Boschini, who knelt before the painting continued: « to touch with my hands/ Those touches, those patches, those blows,/ That I value as precious fine pearls/ pearls, rubies, emeralds, turquoises/ Diamonds that shine even at night ».

L.A.V.d.S.

54. The Annunciation to the Shepherds (c. 1575)

Národní galerie, Prague, inv. o 9026
Oil on canvas, 126×175 cm (49 5/8×68 7/8 in.)
Exhibited in Bassano del Grappa only

Provenance
Prague Castle, 1718; Národní galerie, Prague, since 1960.

Exhibitions
Prague 1962.

Bibliography
Safarik 1962, 12-13 (as Francesco); Ballarin 1966, 131-34, 136, and figs. 149-51 and 153 (as Jacopo); Smirnova 1971, 137 (as Jacopo); Smirnova 1976, 115, fig. 143 (as Jacopo); Pallucchini 1981, 273 (as Jacopo); Ballarin 1988, 3 (as Jacopo); Ballarin 1990 (A), 56; Ballarin 1990 (B), 144; Attardi 1991, 217; Rearick 1992 (B), in press.

It is not known when and how this painting entered the royal collection in the castle in Prague, from which it passed in 1960 into the Národní galerie. Safarik, who published it in 1962, attributing it to Francesco and comparing it with another picture in Cracow also attributed to Francesco, believed it was certainly *The Annunciation to the Shepherds* cited in 1718 in the inventories of the royal collection as by «Bassan» (inv. 305) and then in 1737 as by «Giacomo Bassano» (inv. 221).

Nor is it known whether, like the *Seasons* now in Vienna (cats. 50-51), it was part of the group of paintings acquired by Archduke Leopold Wilhelm. It is not among the works examined by Neumann (1964) in his study of the inventories of the Hapsburg collection in Prague (in particular, the inventory of 1685 based on the one of 1663, which is now lost). Safarik proposed that this *Annunciation*, set at night, was the source for Jan Sadeler's print, whose details are very close to this work (in his inscription Sadeler states that the pic-

ture he engraved, formerly the property of Count Agostino Giunti, was by Jacopo, see Pan 1992, no. 2). Arslan (1960 (B)), who did not know the painting in Prague, thought that the engraving was taken from the version attributed to Francesco in Vienna (Kunsthistorisches Museum, Gemäldegalerie, Vienna, inv. 5734). It is Ballarin's opinion that, in the absence of documentary proof, these identifications are not justified. In fact, it is very difficult to establish precise relationships, since these compositions, set both in the daytime and at night and very often practically identical, survive in a fairly large quantity (Rearick 1992 (B); in all there are about twenty-eight of them). Since none of those set at night are signed by Jacopo, most art historians in this century have felt that the invention of the biblical-pastoral scene was not his. Arslan felt that the prototype could be the picture – whose whereabouts are unknown – formerly in the De Nemes collection, but which was sold in Paris in 1913 (lot 2). It is the only one signed by Francesco. (Arslan listed the following versions under Francesco's name: the version in Dresden, inv. 259, destroyed during the war; the painting mentioned above in Vienna; Wawel Castle, Cracow, inv. 115, which is the most representative of Francesco's style; Bogstadt collection, Norsk Folkemuseum, Oslo; Statens Museum for Kunst, Copenhagen, inv. 31; Musei Capitolini, Rome, inv. 233). A painting signed by Leandro – whose whereabouts are unknown – formerly in the Doria Pamphilj collec-

tion in Rome, follows the same scheme. Accepting the working hypothesis suggested by Ballarin (1966-67) for a plausible attribution in cases like this one, when one theme is treated in many replicas signed by either Francesco or Leandro, I think it is logical to assume that both brothers were working from an original by their father. Without saying whether or not *The Annunciation to the Shepherds* in Prague represents the original invention, Ballarin (1966; and 1988) compared its quality to that of the above-mentioned versions signed by Francesco and Leandro and with others that can be linked to them on the basis of style. He saw in the Prague picture a masterpiece from the hand of Jacopo dating from the 1570s – more precisely c. 1575, the year in which he places the *Saint Lucille Baptized by Saint Valentine* (Museo Civico, Bassano del Grappa, cat. 53) and some nocturnes, such as the Barcelona *Crucifixion* (Museu Nacional d'Arte de Catalunya, cat. 55), *The Nativity at Night* (private collection, Padua), and the two versions of *Christ Praying in the Garden of Gethsemane* (Burghley House Collection, Stamford; and Galleria Estense, Modena). Marucini (1577) testified that by the middle of the 1570s Jacopo had already produced such creations in his workshop, calling him «inventore del vero pinger delle notti in tela e sopra le pietre negre di Verona» (the inventor of the true painting of nights on canvas and on the black stones of Verona). Van Mander (1604) in his *Vita di Giacomo da Bassano pittore*, referring to his trip to Italy between

1574 and early 1576, praised Jacopo for his skill in creating the illusion of night and cites as an example an *Annunciation to the Shepherds*. Convinced of the attribution to Jacopo, Smirnova (1971; and 1976) dates the work c. 1585, Pallucchini (1981) to the 1580s, and Rearick (1992 (B)), saying that most probably the drawing of the *Sleeping Shepherd* (Graphische Sammlung Albertina, Vienna, cat. 85) is a preparatory sketch for the painting, dated them both c. 1579-81. In his essay in this catalogue, Rearick points to Leandro's collaboration in some passages of the painting.

The event takes place in a clearing among the trees on a very dark night. It is illuminated by a stream of light moving obliquely into the scene from the outside, pouring from above onto the angel of the Annunciation, and grazing the leaves, animals, and shepherds – those that are awake, those that are thunderstruck by the miraculous apparition, and those deep in sleep. The men and the animals are arranged in two lateral groups, leaving the center of the composition almost empty. Of the three types of light sources codified by Lomazzo (1584), here Jacopo seems to be using mainly the «supernatural», because there is no «artificial» light and the only «natural» light comes from the moon that barely illuminates the clouds in the far background. The light effects, which the artist manages to create in this way, are as artful as those in the *Saint Lucille* altarpiece, or even superior to them, as Ballarin (1966) observed. He considered the two works to be contemporaneous and

pointed out precise iconographical parallels, noting that the only difference between them was their settings: twilight for the painting in Bassano, which emphasizes the half tones; night for the Prague painting, where «the light condenses into large beads like pearls», so that the lifted hands of the shepherds seem to be «treasure chests holding collections of very precious stones» and the faces are «soaked in light, roughened by the dense blows of the brush». The figure types and their poses can be found in earlier compositions, beginning with *The Annunciation to the Shepherds* (National Gallery of Art, Washington, cat. 30) of c. 1558, where we find the shepherd leaning back. In the Prague painting, he is placed to the right of the canvas on a slight slant, but a revised version of this figure is typical of Jacopo's pastoral epics (Ballarin 1990 (B), 144). The animals are depicted with an affectionate attention to reality, which won Van Mander's praise: Jacopo knew how to «render animal pelts in an exquisite manner: the sheep and lambs appeared so soft and wooly that it seemed that if one touched the painting he would have the sensation of touching wool, and also all the lumps and furrows were admirably observed».

L.A.V.d.S.

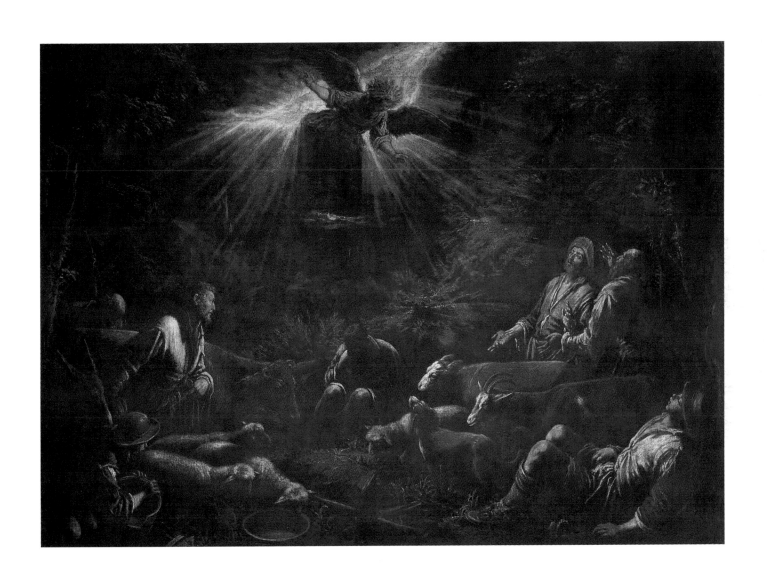

55. THE CRUCIFIXION (c. 1575)

Museu Nacional d'Arte de Catalunya, Barcelona, inv. 108373
Oil on slate, 49.4×29.8 cm (19 1/2×11 3/4 in.)
Exhibited in Bassano del Grappa only

Provenance
Purchased from the Jesuit Father Fabre-
gas Cami, 20 October 1966.

Exhibitions
Rome 1990 (B).

Bibliography
Ballarin 1988, 3; Ballarin 1990 (A), 56,
figs. 13 and 13 a.

The painting was attributed to
Jacopo by Ballarin, who brought it
to the attention of scholars in 1988
and published it in the catalogue
(1990 (B)) of the exhibition in Rome
entitled *Capolavori dal Museo d'Arte
della Catalogna*. The date proposed is
1575, the same year as the Cartigliano
frescoes, done by Jacopo with the as-
sistance of his son Francesco, and the
year, according to Ballarin, of the in-
vention of a series of nocturnes, of
which this *Crucifixion* is one of the
rare ones from the hand of Jacopo
himself, along with a few others,
such as *The Annunciation to the Shep-
herds* (Národní galerie, Prague, cat.
54), also of about 1575. Ballarin (1990
(A)) pointed out the closely corre-
sponding formal and compositional
characteristics of this painting and
the scenes from the Passion of
Christ, which, like this picture, were
painted on slate, set at night, and lit
by an artificial light source. Van
Mander (1604) described these pic-
tures with great admiration after
having seen them in the house of a
merchant during his stay in Rome
between mid-1574 and the early
months of 1576.

The story is narrated with a very
tight rhythm. In the foreground
there is the group of pious women,
while the cross of Christ rises high in
the center middle ground, surround-
ed by a bristle of pikes, banners, and
ladders placed on a diagonal, creat-
ing a sense of depth into the solid
darkness of the night, which is rep-
resented by the bare slate. Figures
on horseback crowd in on all sides.
At the foot of the cross, Saint John
turns toward the crucified Christ,
and in the right-hand corner two
soldiers are gambling for Christ's
robe.

Ballarin (1990 (A)) observed that
this painting is a reworking in a ver-
tical format and nocturnal setting of
the large frescoed *Crucifixion* in Car-
tigliano of 1575 (fig. 103), and con-
cluded that it is probably a deriva-
tion of that work done in the same
year. For this smaller format the two
thieves have been eliminated, as
well as some intermediate figures
like the old man on the donkey and
the young man seen from behind on
the right. Here there are only two
pious women; the lateral episodes of
the horsemen and the division of the
robe are compressed into the space
around the single cross, making the
representation more dramatic. We
are « at the height of the artist's poet-
ic and technical skill » (Ballarin 1990
(A)), especially for the masterful use
of artificial light, accentuating the
contrast between the black back-
ground of the slate and the warm
tones of red and golden yellow. The
painting's surface alternates passages
of thick, broken pigment, as in the
Virgin's shawl, with « skeins of lumi-
nous white and ocher threads that
evoke only by their luster the armed
soldier on horseback with his back
turned, the elegant and mysterious
filigree of the background, and the
subtle web of golden light that every-
where draws together the most art-
fully created light ».

L.A.V.d.S.

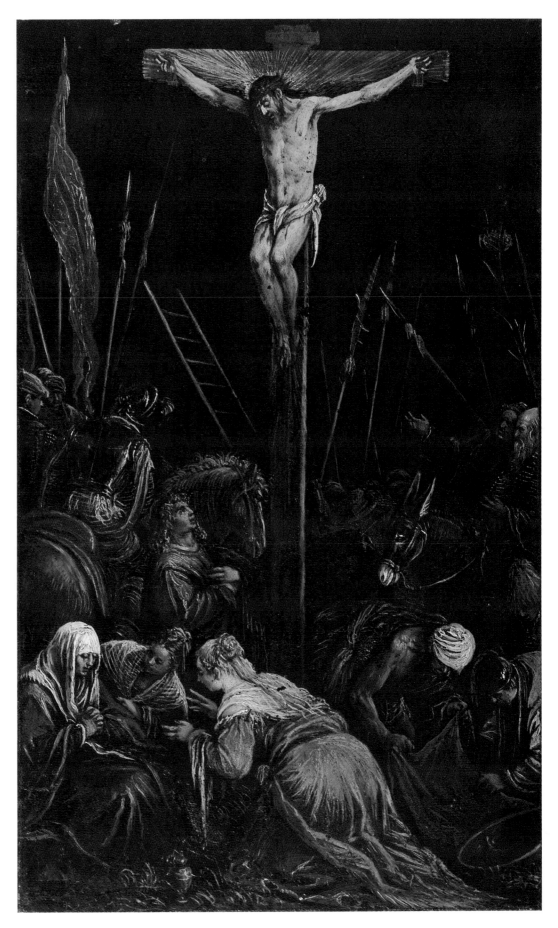

56. THE ADORATION OF THE MAGI (c. 1576)

Galleria Borghese, Rome, inv. 150
Oil on canvas, 126×140 cm (49×55 in.)
Exhibited in Bassano del Grappa only

Provenance
In the Borghese collection by 1650.

Exhibitions
Rome 1990 (A).

Bibliography
Manilli 1650, 88, 113 (as Bassano family); Venturi 1893, 105 (as Jacopo); Venturi 1889, 450 (as Jacopo); Lafenestre and Richtenberger 1905, 11 (as Jacopo); von Hadeln 1914 (B), 394; Longhi 1928, 75 and 192; Venturi 1929 (B), 1280-82; Fröhlich-Bum 1930 (B), 233-34, fig. 242; Arslan 1931, 205 and 231; Shilenko-Andreeyeff 1933, 128; De Rinaldis 1939, 44 (as Francesco); Della Pergola 1951, 53; Magagnato 1952 (A), 50; Della Pergola 1955, 98, fig. 172 (as Francesco); Arslan 1960 (B), I, 189 and 221, and II, fig. 221 (as Francesco); Alberton Vinco da Sesso 1986, 174 (as Francesco); Ballarin 1988, 4 and 6 (as Jacopo); Rearick 1992 (B), in press (as Leandro).

This painting can be identified as one of the two *Adoration of the Magi* mentioned in the Borghese collection with a generic attribution to the Bassano family as early as 1650 (see Manilli 1650). Venturi (1893) first attributed it to Jacopo and then (1929 (B)) to Francesco. Longhi (1928) noticed Francesco's extensive collaboration with his father and dated the picture c. 1577, and Fröhlich-Bum (1930 (B)) agreed. Arslan (1931; and 1960 (B)) assigned the painting to Francesco only and placed it among his earliest attempts at creating an autonomous style before his transfer to Venice in 1578. De Rinaldis (1948) and Della Pergola (1955) also attributed it to Francesco.

The present writer accepted Arslan's opinion in 1986, but has now removed the painting from Franc-esco's production (Alberton Vinco da Sesso, in press). Most recently, Ballarin (1988) reassigned it to Jacopo, dating it 1576, while Rearick (1992 (B)) gives it to Leandro with a date c. 1580.

This painting presents a revised version of a theme that Jacopo had treated numerous times in the preceding decades. Here it takes place on a stage that has been enlarged and enriched with genre episodes, using a formal vocabulary that by this date had been widely tested. Jacopo still uses the backwards diagonal movement of the architecture to create depth and open up the landscape. On the horizon is the familiar view of Bassano and the blue shape of Monte Grappa in the cold light of evening. Jacopo, however, has tempered this standard formula with his new concern for pushing certain figures towards the edges of the canvas, thus emphasizing its two-dimensionality. The entire scene is wrapped in a twilit luminosity. A harmonious chain of movement links the various groups together: the central group with the sacred scene, and the one on the left with the members of the entourage, who have already arrived with their animals and various gifts, including the beautifully decorated ceramic basin. The last part of the entourage, briefly described with rapid strokes, is entering through an opening in the architecture, which iconographically is very similar to the one in *The Meeting of Joachim and Anna* (parish church, Civezzano).

As mentioned above, Ballarin (1988, 4) sees the hand of Jacopo in the painting, «which shows remarkable resemblance to passages from *Saint Lucille Baptized by Saint Valentine* and to the episode of *The Meeting of Joachim and Anna* in the upper section of the canvas in Civezzano, which is by Jacopo». Within the context of his proposed chronology for works of the 1570s, Ballarin placed the Borghese picture in the early months of 1576, between the cycle in Civezzano (1575) and the small votive altarpiece depicting *The Madonna and Child with Saint Roch and Sante Moro* (Museo Civico, Bassano del Grappa, cat. 120), painted for the Podestà Sante Moro in 1576, to which it is linked by the new, larger treatment of the figures and by Jacopo's «Titianesque» color, slightly softened through the precious transparent effects obtained by the skillful application of glazes. This painting shares with *Saint Lucille Baptized by Saint Valentine* (Museo Civico, Bassano del Grappa, cat. 53) some iconographical and formal details. It is sufficient to mention here the virtuoso creation of the various shades of white through differing applications of lead white. The Borghese version is most probably the prototype of the new scheme for the Adoration of the Magi, which became very popular, to judge by the dozen or so replicas executed with some variation by Jacopo's sons and his workshop – Pinacoteca Capitolina, Rome, no. 232; cathedral, Sacrestia dei Canonici, Padua; Kunsthistorisches Museum, Gemäldegalerie, Vienna, no. 4311, all for the most part attributed to Francesco and his shop – and a later pic-

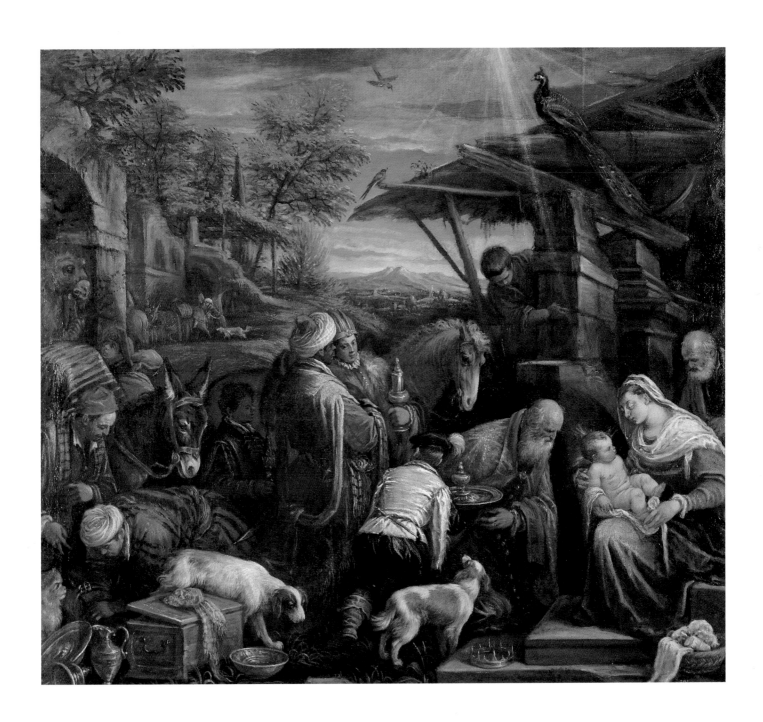

57. PORTRAIT OF A PRELATE (c. 1576)

Museum of Fine Arts, Boston, gift of Ernest Wadsworth Longfellow, Alice M. Longfellow, and Mrs. Annie A. Longfellow Thorp, inv. 21.2285

Oil on canvas, 81×62 cm (31 7/8×24 1/2 in.)

ture, Szépművészeti Múzeum, Budapest, inv. 121, which is, perhaps, by Gerolamo.

Rearick, as we have said, attributed the Borghese version to Leandro, where he sees (verbal communication) a rather unfocused brushstroke, sparkling color, and a taste for precision. He also noticed (1992 (B)) that the silken jacket of the servant seen from behind has its antecedent in the one worn by the page in a drawing by Jacopo (Gabinetto Disegni e Stampe degli Uffizi, Florence, cat. 102), which Ballarin (1971 (A)) saw as a study done in 1575 for the lost *Return of the Prodigal Son* known through Pietro Monaco's print (Pan 1992, no. 122).

L.A.V.d.S.

Provenance
Gift of Ernest Wadsworth Longfellow, Alice M. Longfellow, and Annie A. Longfellow Thorp to the Museum of Fine Arts in Boston, 27 October 1921.

Exhibitions
New York 1940.

Bibliography
Catalogue 1940, 6-7, ills.; Berenson 1957, I, 16; Arslan 1960 (B), I, 143 and 164, and II, fig. 193; Fredericksen and Zeri 1972, 18; Rearick 1980 (B), 112-13, ills.; Attardi 1988, 694.

The painting's attribution to Tintoretto was corrected in favor of Jacopo by Berenson (letter of 1939); Morassi, Suida, and Sterling all agreed. Rearick (1980 (B)) inserted it into his systematic treatment of Jacopo's portraits, with a date of c. 1570, which he now moves, in agreement with Ballarin's opinion, to at least five years later. A letter in the museum files, dated 5 April 1951, from Erica Tietze to W.G. Constable, curator of paintings at the Museum of Fine Arts, Boston, in which she claimed to have identified both the artist and the subject on the basis of an engraving, seems not to have been followed up.

The old prelate, with his rosy face, sits erect with astonished pride against a plain dark brown background, marked only by the faint trace of a Saint Andrew's cross. As was usual in Jacopo's portraits, the man is depicted in a three-quarters position. His alert, restless gaze, lowered to our right, is attracted by something outside the painting. His arms and hands are eliminated in this close-up view. His wide forehead, bared beneath his tilted three-cornered hat, is sculpted by the light, and on the left the arteries in his temple almost the painter's signature spread out, thrown into relief by the shadows. Beneath his soft beard, painted with the same blue tones of his robe, his mouth is closed. Above the strong nose, his eyes are wide open, yet filmy, rimmed by a reddish brown stroke and capped by his bushy, lifted eyebrows. With a great economy of pictorial means, using a palette playing essentially on the darker range and brightened only by the reddish flesh tones, and through an extraordinarily vibrant application of the paint, Jacopo approaches his subject in his frightened, but proud old age with disarming humanity. In the many details just described, in the turning of the head with respect to the body, and in the rendering of the area around the eyes, the connection of this splendid painting can clearly be seen – even if separated in time – with *Torquato Tasso* (Sammlung Heinz Kisters, Kreuzlingen, cat. 41) as well as with the earlier *Portrait of a Man* (J. Paul Getty Museum, Malibu, cat. 25).

Compared to other presumably contemporaneous works, the Boston *Prelate* reveals a painting texture that is richer and more modulated than the portrait of Sante Moro in the votive altarpiece of *The Madonna and Child with Saint Roch and Sante Moro* (Museo Civico, Bassano del Grappa, cat. 120) of 1576 and closer to the portrait of *Doge Sebastiano Venier* of 1577. This latter painting, mentioned by Ridolfi (1648, I, 401) and

58. SPRING (c. 1576)

Galleria Borghese, Rome, inv. 3
Oil on canvas, 141×186 cm (55 1/2×73 1/4 in.)
Exhibited in Bassano del Grappa only

probably lost, survives in a smaller version painted on copper, which was in the Giusti collection in Verona at the beginning of the seventeenth century (Pona 1620, 30; now private collection, Stuttgart, fig. 67). The portrait was repeated in *The Circumcision* (Museo Civico, Bassano del Grappa, fig. 121), which is signed by Jacopo and his son Francesco (see here, Rearick's essay).

The Boston painting concludes our exhibition's review of Jacopo's portrait activity. The portraits in the Národní galerie, Prague, inv. DO 4299, and in the Museo Civico, Vicenza, inv. A30, attributed to Jacopo by Rearick (1980 (B), 113), are not in good condition. *The Portrait of an Old Man* (National Gallery of Victoria, Melbourne) has been convincingly assigned to Palma il Giovane (Rearick 1980 (B), 100, n. 4; Rearick 1981 (B); Mason Rinaldi 1984, 91, no. 144). To complete the history of this fascinating and very successful, although marginal, aspect of Jacopo's career, we should mention the portrait of Brandolino V Brandolini in the *Saint Martin* (Castello di Valmarino, Cison, fig. 71; see also cat. 67) and the *Portrait of an Old Man* (Nasjonalgalleriet, Oslo, fig. 80; see Venturi 1929 (B), 1224, fig. 847; and Zampetti 1957, portrait no. 9), from the late 1580s, as well as the *Portrait of the Architect Antonio dal Ponte* and the drawing in colored chalks of an *Old Man*, which only Ballarin (1971 (A); and 1971 (B), 146) attributes to Jacopo.

P.M.

Provenance
In the Borghese collection by 1650.

Exhibitions
Never before exhibited.

Bibliography
Ridolfi 1648, 1, 398; Manilli 1650, 88 (as Francesco); Venturi 1893, 22 (as Jacopo's workshop); Longhi 1928, 74 and 176 (as Francesco); Arslan 1931, 349 (as Jacopo's workshop); De Rinaldis 1939, 9 and 17; Della Pergola 1951, 24; Della Pergola 1955, 101-2, fig. 178 (as follower of Jacopo); Arslan 1960 (B), 1, 365 (as Jacopo's workshop); Smirnova 1971, 136; Ballarin 1988, 5-6, 10, and 13 (as Jacopo).

Manilli (1650) mentions, among the thirteen works in the Borghese collection that he refers to as by members of the Dal Ponte family, four *Seasons* by «giovane Bassano», that is, Francesco, including this *Spring*, an *Autumn* (cat. 59), and a *Winter* (inv. 9). Venturi (1893) attributed them to Jacopo's workshop, and Longhi (1928) returned them to Francesco. Arslan, who in 1931 leaned only partially toward acceptance of Venturi's hypothesis (in fact, he felt that the *Autumn* was by a follower of Francesco), in 1960 listed all four among the works by Jacopo's shop. Della Pergola (1951 and 1955) assigned them generically to followers of Jacopo and does not distinguish between the hands. Smirnova mentioned them only in passing and without dealing with problems of attribution (1971, 135-36: she considered *Winter* to be very close to the version in the Palazzo Spinola, Genoa, and this *Spring* to be identical with the version in The Hermitage, Saint Petersburg, inv. 1623), in an at-

tempt to establish a hierarchy in the various series of *Seasons* produced by the Dal Ponte shop.

Two of the Borghese paintings (invs. 11 and 9) correspond, with some variations, to the replicas signed by Francesco in the Kunsthistorisches Museum, Vienna.

Ballarin (1988) recently attempted to put Jacopo's activity during the 1570s into chronological order, and also to assess the assistance Jacopo received from his workshop. He considered these three Borghese pieces to be largely by Jacopo himself and probably to have been executed between the end of 1576 and the beginning of 1577. He traced the artist's stylistic development between the biblical-pastoral scenes of around 1573 (such as *The Return of Tobias*, Gemäldegalerie Alte Meister, Dresden, fig. 57) or from 1574 (such as the first cycle of *Seasons* in the Kunsthistorisches Museum, Gemäldegalerie, Vienna, included here – cats. 50 and 51 – or *The Sacrifice of Noah* in the Stiftung Schlösser, Potsdam, cat. 49) and this revision of the *Seasons*. A new sense of space, more balanced between the different planes of the scene, is related through the introduction of certain elements along the edges of the canvas such as, in this *Spring*, the old man on the right shearing the sheep.

A closer comparison of the versions of *Spring* in Rome and Vienna does not yield great differences in their motifs or iconography. Just as in the Vienna painting, we find here: the kneeling woman milking a goat held by a little peasant boy; the greyhounds walking beside a young man

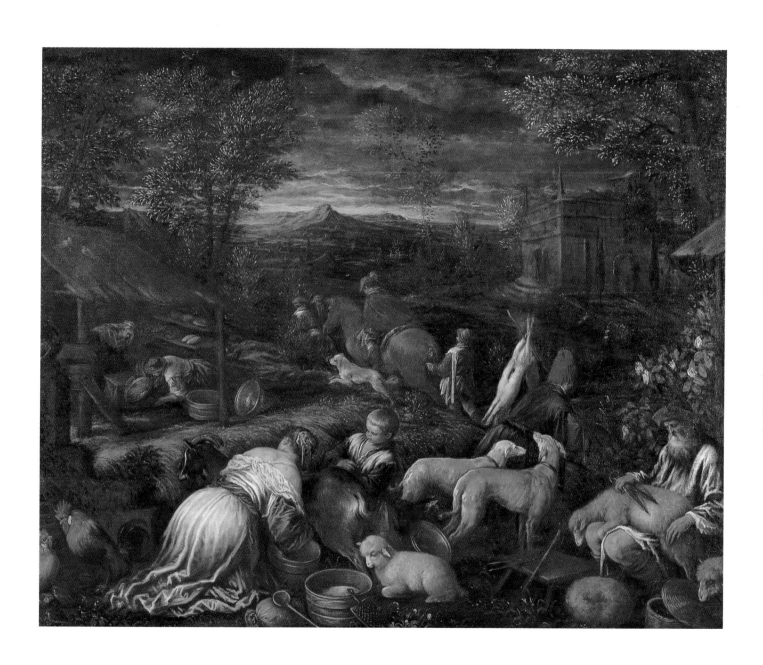

Galleria Borghese, Rome, inv. 11
Oil on canvas,
133×185 cm (52 3/8×72 7/8 in.)
Exhibited in Bassano del Grappa
only

with a hare slung over his shoulder; and a horseman in the background setting off on a hunt. The scene in the left middle ground is also similar, but the shearing scene reappears here not from *Spring*, but from the Vienna *Summer*. A deeper analysis reveals that Jacopo's language has changed. His prevailing concern of a few years earlier to represent genre scenes has now given way to a preoccupation with landscape, as can be seen in the small altarpiece dated 1576 depicting *Saints Anthony and Crescenzio Interceding with the Virgin on Behalf of the Flood Victims* (Santa Maria degli Angeli, Feltre).

It is certainly Jacopo, albeit with some help from Francesco, who presides over this renewal of pastoral themes, which encompass the whole structure of the painting, not just its syntax. As Ballarin (1988) notes, we find here an echo of neo-Giorgionism, which shows Jacopo once again looking toward the traditions of Venice.

The forms are no longer drawn in first, but created exclusively with paint, and they are immersed in the landscape without any artificial perspective. Depth is no longer suggested by the diminishing scale of the various elements, but by a difference in chromatic tone. The pigment, mixed with air and light and applied using impressionistic touches of the brush, reflects Jacopo's experience with the nocturnal scenes of 1575 (see, for example, cat. 54) « which has strengthened light's capacities for construction and diminished that of the half-tones. The next step is the discovery of a warmer palette and

the enticing brushwork of the *Seasons* » (Ballarin).

The series to which the Borghese paintings belong is the model for the replicas signed by Francesco, which can be dated just slightly later, around 1577 (Kunsthistorisches Museum, Gemäldegalerie, Vienna: *Summer*, inv. 4289; *Autumn*, inv. 4287; *Winter*, inv. 4288). The date of 1585-90 proposed for these Viennese pictures in the catalogue of the museum (*Die Gemäldegalerie* 1991) does not seem plausible. In his variation of the motifs of the original invention (for example, he adds the signs of the zodiac in the sky), Francesco organizes the Elements in quite an arid manner, which reveals how little he understood the reform of the linguistic structure found in those works, on which he himself had collaborated not so long before in his father's workshop.

L.A.V.d.S.

Provenance
In the Borghese collection by 1650.

Exhibitions
Never before exhibited.

Bibliography
Ridolfi 1648, 1, 398; Manilli 1650, 88; Venturi 1893, 22 (as Jacopo's workshop); Longhi 1928, 74 and 176 (as Francesco); Arslan 1931, 349 (as follower of Francesco); De Rinaldis 1939, 9 and 17; Della Pergola 1951, 24; Della Pergola 1955, 101-2, fig. 179 (as follower of Jacopo); Arslan 1960 (B), 1, 365 (as follower of Francesco); Ballarin 1988, 5-6, 10, and 13 (as Jacopo).

The painting belongs to the same series, along with *Spring* (inv. 3) and *Winter* (inv. 9), in which according to Ballarin (1988) Jacopo revises his earlier (c. 1574) invention of the *Seasons*. Here too, as has already been observed for *Spring* (cat. 58), when compared to the similar composition in the earlier cycle (Kunsthistorisches Museum, Gemäldegalerie, Vienna, cat. 51), we see a verisimilitude in Jacopo's perspective and in the balance he achieves between the various planes, the depiction of the landscape, and the scenes of seasonal labors. A slightly veiled light pervading the picture, similar to that found in *The Adoration of the Magi* (Galleria Borghese, Rome, cat. 56), does not subtract from the color, which is applied with « striated touches of the brush » (Ballarin), or the warmth that characterizes, in particular, *Spring*. The narrative is richer here than in the Vienna *Autumn*: the preparation of the wine barrels and the picking of fruit are represented in the midst of a wealth of tools.

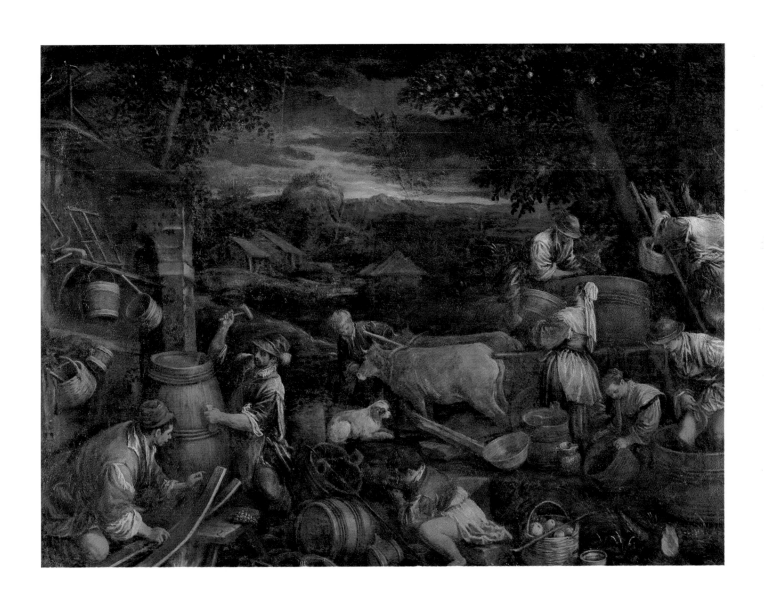

60. ABRAHAM'S JOURNEY (c. 1576-77)

Staatliche Museen Preussischer Kulturbesitz, Gemäldegalerie, Berlin, inv. 4/60
Oil on canvas, 93×115.5 cm (36×45 in.)
Inscriptions: JAC.ˢ ET. / FRAN.ˢ / FIL. P. on the bundle at the lower right

In the replica (Kunsthistorisches Museum, Gemäldegalerie, Vienna) of c. 1577, which is signed by Francesco, the scene is repeated with some small variations. It demonstrates the diligence with which the scene was put together, like a puzzle, using the various figurative patterns whose success was already well proven.

L.A.V.d.S.

Provenance
Acquired by the museum in 1960.

Exhibitions
Never before exhibited.

Bibliography
Ballarin 1966-67, 180; Rearick 1968 (A), 245, fig. 9; Ballarin 1969, 112; *Pictures Gallery Berlin* 1978, 46, ills.; Pallucchini 1982, 50; Ballarin 1988, 4 and 12; Noè 1990, 30; Attardi 1991, 213-14.

Published by Rearick (1968 (A), 245), this version of *Abraham's Journey*, the only one known so far bearing the signatures of both Jacopo and Francesco, stands out above the others for its quality. The other versions are for the most part by Francesco and can be dated in the 1570s. According to Ballarin (1988, 4), this revision of the biblical story, which Jacopo had treated numerous times earlier in his career, was done in the 1570s with a new structure and medium-sized format that can be attributed to Jacopo. Among the many replicas, one that Jacopo painted immediately after this picture (Rijksmuseum, Amsterdam, inv. 434 D 1) and another, with some variations (Kunsthistorisches Museum, Gemäldegalerie, Vienna, inv. 1550), deserve special mention.

It is Ballarin's opinion (quoted by Attardi 1991, 214) that a workshop copy (The National Gallery, London, inv. 2148), which can be linked to another version attributed to Francesco (Museo Civico, Padua, inv. 2485), derives from a lost prototype by Jacopo, which is known through an engraving by Pietro Monaco of the painting formerly in the Savorgnan collection in Venice

(Pan 1992, no. 121).

The theme of this painting is often interpreted as *Jacob's Return to Canaan* (Genesis 31:17-18). As Rearick pointed out (1968 (A), 245), the two subjects lend themselves to confusion because both patriarchs, Abraham and Jacob, set out on journeys with their families, household goods, and animals. Here Abraham, commanded by God – who appeared before him in the clouds – leaves for the land of Canaan, followed by his brother's son, Lot, and his wife, Sarah, on horseback. They leave through the city gate of Haran with «all their possessions which they had gathered, and the persons that they had gotten in Haran» (Genesis 12:1-5).

The journey moves from right to left along a diagonal line that diverges slightly from the other diagonal created by the wall and grassy bank leading back into the landscape.

The painting can be dated c. 1576-77 (Rearick 1968 (A), 245; and Ballarin 1988, 4). Although the iconographical repertory is the same one used for other paintings of about the same time, especially the cycle in Civezzano, the space is structured in a new way with respect to similar compositions of several years earlier, such as the 1569 *Abraham's Journey* (private collection, Canada; see Ballarin 1969, figs. 116-18). The space also differs from works closer to it in time, such as *The Meeting of Joachim and Anna* in Civezzano, where Jacopo reduces the scale of the figures in the background in an attempt to render a sense of perspective. Here,

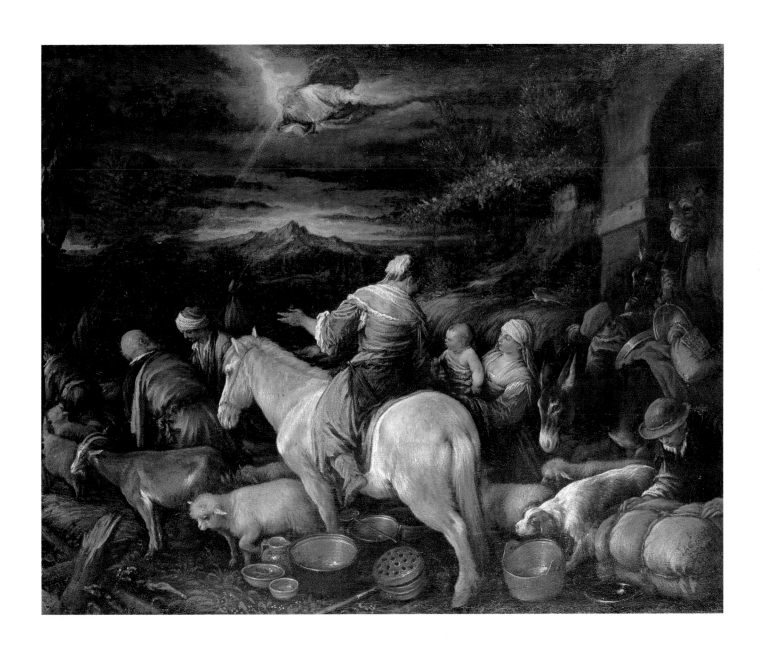

61. CHRIST IN THE HOUSE OF MARY, MARTHA, AND LAZARUS (c. 1576-77)

Sarah Campbell Blaffer Foundation, Houston, inv. 79.13
Oil on canvas, 98×126.5 cm (38×49 in.)
Inscriptions: JAC. ET FRAC. FILIUS F. on the base of the column on the left

instead, he moves them more freely throughout the landscape and suggests depth by varying the tonal intensity of the color.

Rearick (1968 (A), 245) observed that the painting was drawn by Jacopo, but painted almost completely by Francesco, whose hand can be seen particularly in Abraham's cloak, the figure of Sarah on horseback, the horse itself, the donkey's head, the distant landscape, and the figure of God. A drawing (Crocker Art Museum, Sacramento), closely corresponding to the woman on horseback, is a *ricordo* probably done by Francesco from the above-mentioned painting in Amsterdam (Rearick, verbal communication).

L.A.V.d.S.

Provenance
Private collection, England; Julius Weitzner, New York, until 1959; Bob Jones University Collection, Greenville, S.C., until 1974; purchased from M. Knoedler and Co., New York, for the collection of the Sarah Campbell Blaffer Foundation, Houston.

Exhibitions
Milwaukee 1977; Los Angeles 1979; Leningrad 1980; Moscow 1980; Kiev 1980; Columbus 1983; Winston-Salem 1984.

Bibliography
Havens 1961-62, 112; *The Bob Jones University Collection* 1962, 105, ills.; Ballarin 1966-67, 167; Rearick 1968 (A), 245-46, fig. 13; Fredericksen and Zeri 1972, 18; Fredericksen and Zeri 1977, 105; Pignatti 1979, 142, no. 52, ills.; Pallucchini 1982, 48, fig. 12; Shearman 1983, 31; Pignatti 1985, 104-6, ills.; Alberton Vinco da Sesso 1986, 7; Rearick 1986 (A), 186; Ballarin 1988, 4; Aikema 1989, 76-77, fig. 39.

The first scholars to study this painting were Ballarin (1966-67) and Rearick (1968 (A)), who published it. Rearick suggested that it is the picture attributed to Jacopo by Ridolfi (1648, I, 394), who had seen it in Venice in the Palazzo Contarini at San Samuele. Ballarin (1966-67; and 1988) and Rearick (1968(A); and 1986 (A)), as opposed to earlier art historians, agreed that it was by Jacopo at a time when he was still closely collaborating with Francesco, who invented, especially for collectors, this type of medium-sized composition, where the biblical subject is treated like a genre scene. These include scenes from the life of Christ or parables set between a kitchen and a courtyard, with a wealth of domestic objects, copper and pewter utensils, as well as pottery set on high shelves or the floor, and still lifes. These scenes are constructed along a diagonal wall and populated by figures that belong to a repertory that, by this time, was well tested. A number of them survive, signed by both Jacopo and Francesco, in evident recognition of the part played by the younger artist. They can be dated in the years around 1576-77, a period of fervent activity for the workshop.

Several replicas exist of *Christ in the House of Mary, Martha, and Lazarus*, including one in Zagreb (Strossmayerova galerija), one signed by Francesco (Staatliche Museen Kassel), and others in Saint Petersburg (The Hermitage) and Florence (Galleria Palatina, Palazzo Pitti).

The story is taken from the gospel according to John (12:1-2): «Six days before the Passover, Jesus came to Bethany, where Lazarus was, whom Jesus had raised from the dead. There they made him a supper; Martha served, but Lazarus was one of those at table with him». The entire episode is summarized on the left middle ground in the postures of the figures: Martha's reverent bow and Mary's intention to anoint Christ's feet with «ointment of pure nard», which she will then dry with her long blond hair. Leaning on the left side of the door frame is Judas Iscariot, who made the malicious comment about the waste of the perfume that could have been sold for 300 denari and the money given to the poor. Christ, however, approved of her gesture, saying: «Let her keep it for the day of my burial.

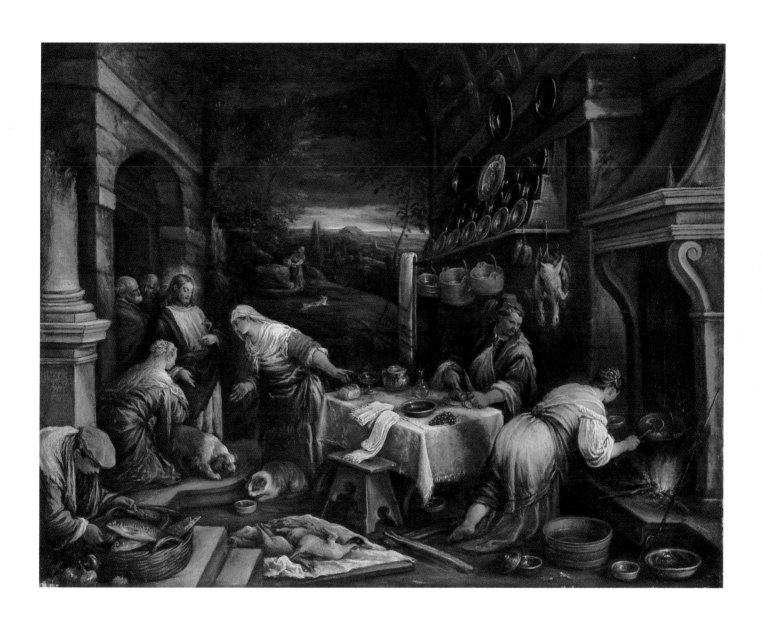

62. THE SUPPER AT EMMAUS (c. 1576-77)

Private collection
Oil on canvas, 95×124 cm (37 3/8×48 7/8 in.)
Inscriptions: JAC⁵ ET / FRANC⁵ FIL on the step on lower left

The poor you always have with you, but you do not always have me» (John 12:7-8).

The episode takes place inside a lively country kitchen. In the foreground the cook is busy at the hearth and a boy sets down a basket of fish. Numerous still-life elements are strewn everywhere and a dog and cat are in attendance. There is no clean break between the interior and the exterior. Lit by the distant sunset, the story continues to unfold at a well in the background, where a woman is drawing water.

Ballarin (1988) placed the invention of paintings on this scheme in the year 1576 and proposed the same date for the Houston picture, which he felt was a replica done largely by Francesco. Rearick (1968 (A); and 1986 (A)) considered it to be the original version of about 1577 and observed that, more than in similar pictures, here Francesco did the actual painting, although following, as was the usual practice, a drawing by Jacopo. Jacopo then added the finishing touches, painting in a thin layer the highlights and adding details, for the most part, in the foreground.

Other compositions from the same time and stylistically similar to this one are signed by Jacopo and his son Francesco, with the predominant hand of one or the other discernible: *Joachim's Vision* (The Methuen Collection, Corsham Court, fig. 62), *The Supper at Emmaus* (private collection, cat. 62), and *The Return of the Prodigal Son* (Galleria Doria Pamphilj, Rome, fig. 61).

L.A.V.d.S.

Provenance
Nicolas Renier (active in Venice 1626-40)?; Earl of Erne, Crom Castle, through an inheritance.

Exhibitions
Enniskillen 1944; Belfast 1961.

Bibliography
Crookshank 1961, 12, no. 16; Ballarin 1966-67, 168; Rearick 1968 (A), 245, ills.; Rearick 1986 (A), 186; Ballarin 1988, 4.

The painting appeared in two exhibitions. The catalogues of these exhibitions published the inscription, but the painting was ignored in the literature until Ballarin (1966-67) brought into focus the problem of the relationship between Jacopo and his son Francesco during the decade of their close collaboration. The canvas was published by Rearick (1968 (A)) in a study where he presented a series of paintings from 1576-77 that were started by Jacopo, then worked on by Francesco, and signed jointly by both. These are horizontal compositions depicting stories from both the Old and New Testaments, some of which were new to the Dal Ponte workshop, while others, like *The Supper at Emmaus*, were revised with respect to earlier versions.

The Supper at Emmaus is represented here following a scheme that Arslan believed to have been Francesco's, with the left half of the painting reserved for the kitchen of the inn, and the right half for the table spread under the arbor. It is not possible to establish precisely if this painting is the original depiction of what we now know to have been the final version of the subject. It is a subject that Jacopo had treated from

the very beginning of his career (the picture in the cathedral in Cittadella dates from 1537, fig. 12). Rearick (1968 (A)) pointed out that the picture here presents the same composition as *The Supper at Emmaus* that Ridolfi (1648, I, 395; see also Verci 1775, 141) saw in the house of the painter Nicolas Renier in Venice and identified as Jacopo's. In his essay in this catalogue, Rearick mentions a version on the art market in New York, which shows some variations and is signed only by Jacopo. Rearick feels that the New York picture is a replica painted with the collaboration of Leandro, who was too young to be allowed to sign pictures with his father.

The new *mise en scene* for *The Supper at Emmaus* was made very popular through Raphael Sadeler's engraving (Pan 1992, no. 6), which shows some modifications on the right. The theme of the painting, Christ's supper with his disciples Luke and Cleophas in the village of Emmaus (Luke 24: 28-31), is staged in the middle ground on an outdoor terrace, under a «*frascata*», or shelter made of branches (Ridolfi). In the foreground there is a dog and cat as well as an array of household utensils. On the left a diagonal wall, with a hutch exhibiting a beautiful arrangement of dishes and copper pails, leads to the interior of the kitchen, where women are busy at various tasks. The innkeeper sits on a chair in the center, just between the kitchen and the terrace, and looks out toward the diners, to whom a servant is bringing a dish. This kitchen scene shows a number

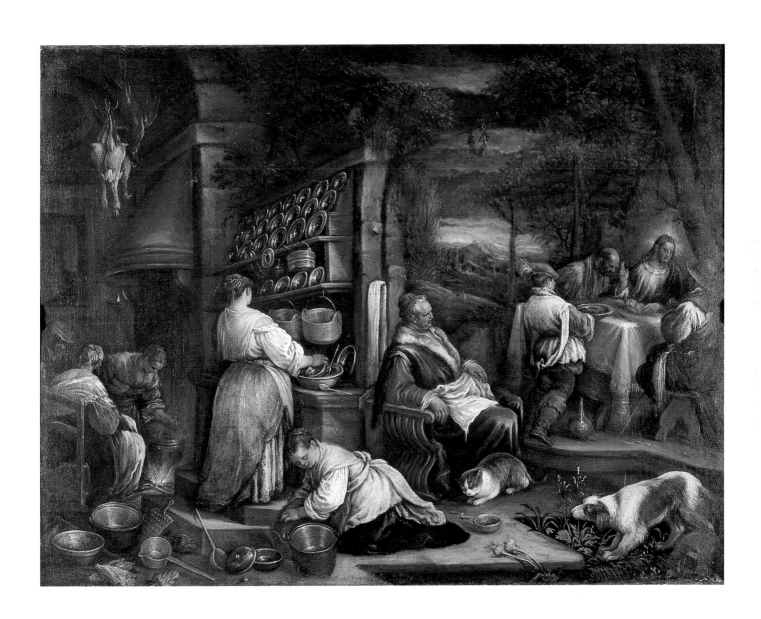

63. NOAH BUILDING THE ARK (c. 1578-79)

Arcibiskupský Zámek a Zahraóy, Kroměříž, no. 054
Oil on canvas, 133×187 cm (52 3/8×73 5/8 in.)
Inscriptions: JAC. BASS.
Exhibited in Fort Worth only

of similarities, including the iconography of the figures, with *Christ in the House of Mary, Martha, and Lazarus* (Sarah Campbell Blaffer Foundation, Houston, cat. 61). However, here the division between interior and exterior is orchestrated more skillfully. The actual biblical episode, to which only a bare third of the canvas is given, seems to play a subordinate role to the larger genre scene, as was the case with *The Return of the Prodigal Son* (Galleria Doria Pamphilj, Rome, fig. 61), which was also signed by Jacopo and Francesco. The realism seen here was very much to the taste of Jacopo's patrons, but it also answered his own need to root sacred scenes in everyday life in order to make their message more easily understood.

Rearick (1968 (A)) has observed that the painting was executed – and this is true also for the other paintings in the series – by Francesco following an invention of his father. After Jacopo had drawn the design on the canvas, Francesco completed the composition and Jacopo returned to add finishing touches. Here these finishing touches are considerably more than in *Christ in the House of Mary, Martha, and Lazarus* and involve the horizon, enlivened with loose blue brushstrokes, and almost all the figures, especially Christ, the apostles, and the servant. However, the innkeeper is completely Francesco's.

L.A.V.d.S.

Provenance
Archbishop's Palace, Kroměříž, 1667.

Exhibitions
Never before exhibited.

Bibliography
Mitteilungen der Zentral Kommission 1885, 185; *Blätter für Gemäldekunde* 1910, 143; Breitenbacher 1932, unpaged; Arslan 1960 (B), I, 146-47 and 169; Pallucchini 1982, 50; Rearick 1986 (A), 186; Ballarin 1988, 10.

According to Breitenbacher, this picture and its three companion canvases (cats. 64-66) were offered to Leopold I in 1667. Recorded in the 1691 inventory, and again in the 1885 and 1910 accounting of paintings at Kroměříž, they did not enter the Bassano literature until Arslan published them as a set executed subsequent to the original cycle (see cat. 49), which he dated to about 1574. Pallucchini and Ballarin saw the extensive collaboration of Francesco in the Kroměříž cycle, and the latter dated it to c. 1577.

Of the first Noah series, only a fragment of the *Noah Giving Thanks to God* (Walker Art Gallery, Liverpool) survives, but other sets, at least two (cat. 49, and formerly art market, London) partly preserved and signed by Jacopo alone, intervened before Jacopo undertook the Kroměříž suite. Only one prior version of *Noah Building the Ark* is securely identifiable, a replica (formerly Mildmay collection, London) done by Francesco of Jacopo's lost original with corrections by the master himself. That picture corresponds in almost all details with the present Kroměříž composition. Virtually all surviving replicas produced subsequently by the Bassano shop follow the present format even in details and color. For this version Jacopo followed his familiar sequence of sketching the composition onto the primed canvas, but he then proceeded to lay in a significant portion of the painted forms before turning it over to an assistant for further work. That associate brought passages to a complete state before Jacopo returned to add corrections and finishing touches over much of its surface. His fluent touch and transparent glazes are most evident in the woman to the left of center, the man sawing at center, and a scattering of details. Leandro was clearly Jacopo's collaborator in this cycle. His bright sharp color accents, the thready paint texture, the minute attention to descriptive detail, and the abrupt contrast between highlights and black shadow are all hallmarks of Leandro's style in his early maturity. Although Francesco surely performed this role earlier, after his departure for Venice late in 1577 or in early 1578 that role was assumed primarily by Leandro. It is, in fact, to about 1579 that we would date the Kroměříž Noah suite. Leandro would repeat it alone many times over the following decades, but Jacopo seems not to have participated in these mechanical replications. The Kroměříž cycle assumes especial importance as the only surviving complete set of Noah pictures in which Jacopo himself participated. It is, indeed, the only complete survivor among the various famous sets of paintings in which Jacopo specialized during his later years.

W.R.R.

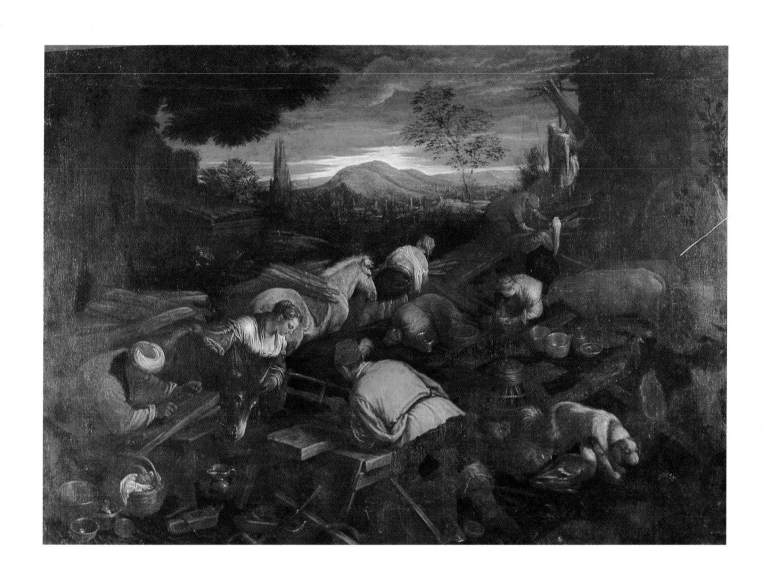

64. The Animals Entering Noah's Ark (1578-79)

Arcibiskupský Zámek a Zahraóy, Kroměříž, no. 065
Oil on canvas, 133×186 cm (52 3/8×73 1/4 in.)
Inscriptions: JAC.US BASS.
Exhibited in Fort Worth only

Provenance
Archbishop's Palace, Kroměříž, 1667.

Exhibitions
Never before exhibited.

Bibliography
Mitteilungen der Zentral Kommission 1885, 185; *Blätter für Gemäldekunde* 1910, 143; Breitenbacher 1932, unpaged; Arslan 1960 (B), I, 146-47 and 169; Pallucchini 1982, 50; Rearick 1986 (A), 186; Ballarin 1988, 10.

The critical history of *The Animals Entering Noah's Ark* is the same as that for the *Noah Building the Ark* (cat. 63). Jacopo's growing popularity as a painter of animals led him, at a date close to 1569, to treat this subject independently in a monumental canvas (Museo del Prado, Madrid) conceived to stand alone. Only subsequently, around 1576-77, did Jacopo and Francesco revise this subject as part of a suite of four, or occasionally five canvases, but in this instance the original is lost. It was, however, replicated in at least two pictures that Jacopo signed alone (lost), and a very fine set by Francesco with corrections by Jacopo. Of this group, the present subject survives (formerly Mildmay collection, London). That version would, in turn, be subjected to several modifications, including one by Francesco (private collection, Florence) in which Jacopo added finishing touches. It was only after Francesco's departure for Venice in 1578 that Jacopo turned to Leandro to assist him in the present set of Noah pictures. In the same sequence we have described for the *Noah Building the Ark*, Jacopo sketched the composition onto the canvas, brought the broadly painted passages to a half-finished state, and turned the project over to young Leandro for development. The twenty-two-year-old youth seems to have been allowed to clarify the design of some of the animals, as his detailed study (Walker Art Gallery, Liverpool, no. 8) for the hunting dog at center attests. Jacopo's third son finished many passages such as Noah, the animals, and the landscape, but here Jacopo returned to add more extensive revisions and finishing touches than in the three companion pictures. His nervously expressive touch is evident in the kneeling woman in front left, the horse, the woman at the Ark door, and elsewhere. His most decisive addition is the youth at right, whose richly luminous red brown hat is deftly set with a few transparent swaths of paint. The deer next to him are by Jacopo and look forward to the visionary expression of the 1585 *Susanna* (cat. 72). This formulation of *Noah's Ark* would henceforth become the standard one to be repeated dozens of times, in particular by Leandro, who recorded his first impression in a characteristically splintered black chalk drawing (Staatliche Museen Preussischer Kulturbesitz, Kupferstichkabinett, Berlin, no. KdZ 15664). Leandro, Francesco, and their shop associates produced so many replicas that today well over fifty are still in existence.

W.R.R.

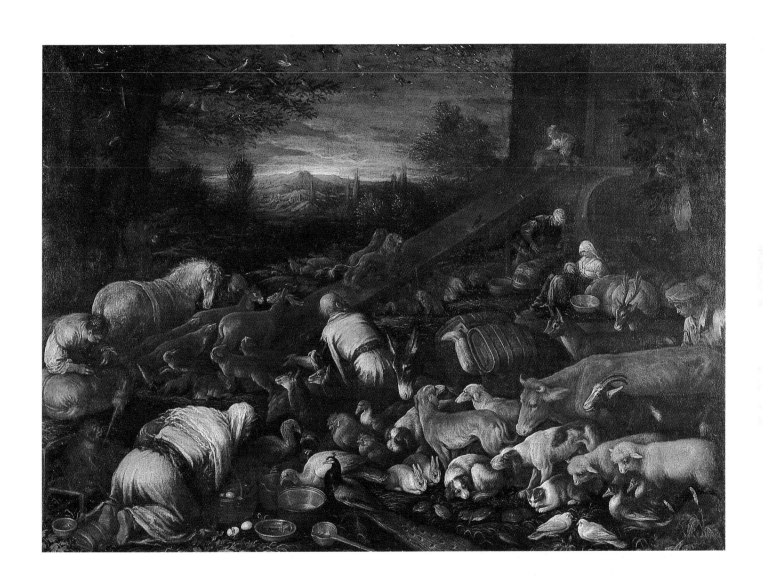

65. THE FLOOD (1578-79)

Arcibiskupský Zámek a Zahraóy, Kroměříž, no. 070
Oil on canvas, 132×178 cm (52×70 in.)
Inscriptions: JAC. BASS.
Exhibited in Fort Worth only

Provenance
Archbishop's Palace, Kroměříž, 1667.

Exhibitions
Never before exhibited.

Bibliography
Mitteilungen der Zentral Kommission 1885, 185; *Blätter für Gemäldekunde* 1910, 143; Breitenbacher 1932, unpaged; Arslan 1960 (B), 1, 146-47 and 169; Pallucchini 1982, 50; Rearick 1986 (A), 186; Ballarin 1988, 10.

Like its companion pictures (cats. 63, 64, 66) in this set, *The Flood* bears Jacopo's signature but has been seen recently as a collaboration with his son Francesco. Of the four compositions that normally make up the Noah cycle, this one would prove the least popular, perhaps because of its darkly tragic theme. Certain figures as well as the general effect were adapted from the lower part of the altarpiece (Santa Maria degli Angeli, Feltre), where he depicted the flood of the Colmeda river in 1576. Jacopo's first suite of Noah pictures seems, in fact, to date from about 1576-77. Although the original of this subject is lost, Francesco's replica, made shortly afterward with Jacopo's participation (formerly Mildmay collection, London), corresponds closely with the Kroměříž format. This suggests that about 1578-79, when Jacopo turned to Leandro for assistance in painting the present picture, he followed his prototype closely, sketching it onto the canvas and then allowing Leandro to develop forms to a nearly finished state before returning to make corrections and additions. Jacopo's hand is most evident in the boy with a dog at left, the woman with a child at center, and the woman with raised arms in the middle distance at right. He added accents elsewhere, but Leandro's dry and thready touch, harsh contrast of acid color against a black environment, and attention to descriptive detail predominates. A drawing (private collection, Venice) for the supine child at front left is by Leandro, done from the painting in preparation for a replica. Another study (Gabinetto Disegni e Stampe degli Uffizi, Florence, no. F 13050) of the boy in the tree at top right corresponds more closely with that figure in the large replica (The Royal Collection, Hampton Court) painted by Gerolamo for the Gonzaga court at Mantua about 1584. Volpato (1685, 286) reported that the Duke's agent gave Jacopo the commission, that Gerolamo executed the pictures, and that the patron was entirely taken in by the subterfuge. Several later replicas are signed by Leandro, and all members of the shop shared in reproducing the Kroměříž original.

W.R.R.

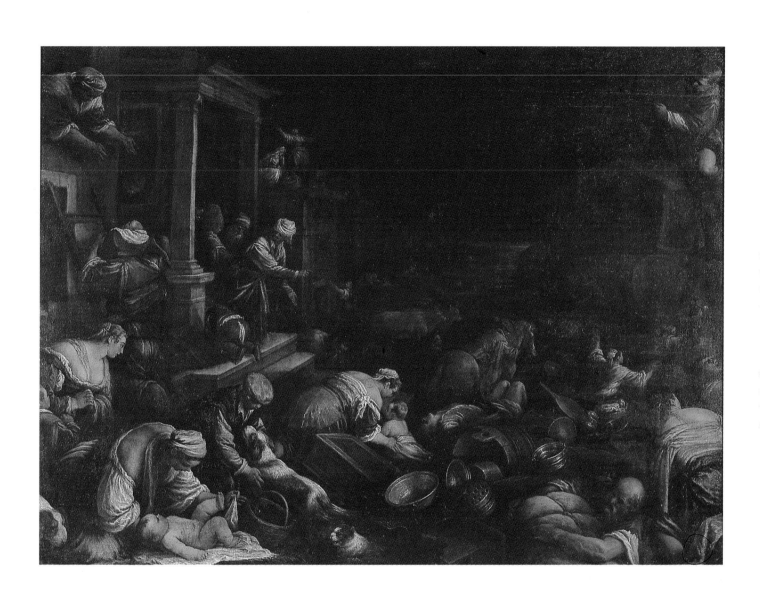

66. Noah Gives Thanks to God (c. 1578-79)

Arcibiskupský Zámek a Zahraóy, Kroměříž
Oil on canvas, 134×179 cm (52 3/4×70 1/2 in.)
Inscriptions: jac. bass.
Exhibited in Fort Worth only

Provenance
Archbishop's Palace, Kroměříž, 1667.

Exhibitions
Never before exhibited.

Bibliography
Mitteilungen der Zentral Kommission 1885, 185; *Blätter für Gemäldekunde* 1910, 143; Breitenbacher 1932, unpaged; Arslan 1960 (B), 1, 146-47 and 169; Pallucchini 1982, 50; Rearick 1986 (A), 186; Ballarin 1988, 10.

Of the four pictures that form the earliest complete set of the Noah cycle to survive intact, *Noah Gives Thanks to God* is the only one for which we have the original version (Walker Art Gallery, Liverpool) of about 1576-77, albeit in fragmentary form. That work is in large measure by Jacopo with some assistance from Francesco. It was soon followed by a repetition signed by only Jacopo, but with a greater participation by Francesco (Stiftung Schlösser, Potsdam, cat. 49). The replica (formerly art market, London), signed again by Jacopo alone, is preponderantly by an assistant, probably already Leandro. Finally, around 1578-79, Jacopo undertook the present set, sketching the design onto the canvas, allowing Leandro to develop much of it to a finished state, and returning at the end to make corrections and add finishing touches. His hand is evident in highlights and accents in the group at right foreground and the woman at left, but it is less dominant than in the first three canvases. Perhaps Leandro, despite his dryly detailed brushwork and sharp color against an almost black preparation, was now sufficiently experienced to require less revision. Changes between the various treatments are minimal, a curious one being Leandro's misinterpretation of the knot of drapery at the hip of the man on the ladder; he has here transformed it into a pouch of nails.

W.R.R.

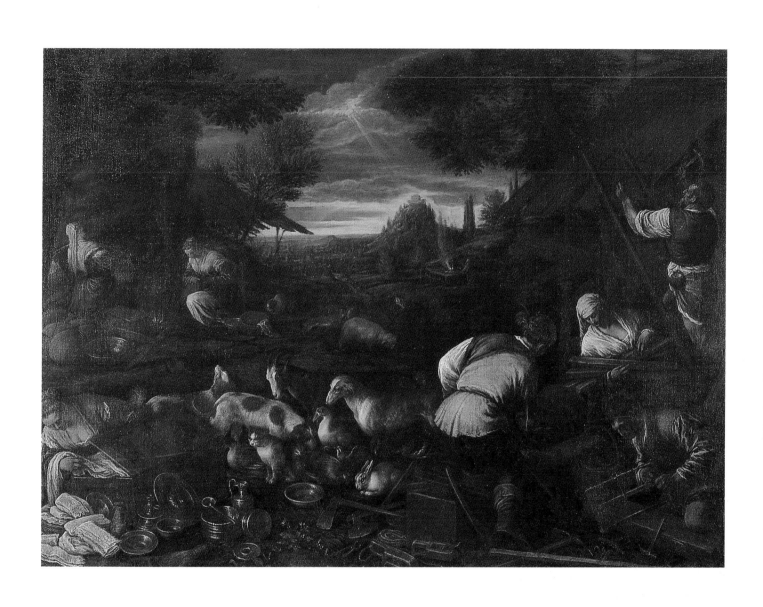

67. Saints Martin and Anthony Abbot (c. 1578)

Museo Civico, Bassano del Grappa, inv. 25
Oil on canvas, 167×105 cm (65×41 in.)

Provenance
Church of Santa Caterina, Bassano del Grappa, until the suppression in 1772 of the convent and church, when it was purchased along with all the church furnishings by the Verci family of Bassano; sold by G.B. Verci in 1783 to Count Giuseppe Remondini, who donated it in 1785 to the city of Bassano del Grappa, as documented in the Atti Consigliari of that year.

Exhibitions
Venice 1945; Bassano 1952; Venice 1957; London 1983.

Bibliography
Ridolfi 1648, 1, 397; Memmo 1754, 78; Verci 1775, 56, 75, and 82; Brentari 1881, 205; Crivellari 1893, 10; Gerola 1906, 113; Zottmann 1908, 32; Venturi 1929 (B), 1164-67, ills.; Arslan 1931, 186; Berenson 1932, 48; Bettini 1933, 97, 178, and pl. XLIV; Arslan 1936 (A), 102; Pallucchini 1945 (A), 100; Magagnato 1952 (A), 16, 46, and no. 28; Pallucchini 1957, 114; Pignatti 1957 (A), 373; Zampetti 1957, 198, no. 82, ills.; Arslan 1960 (B), 1, 140 and 163, and 11, figs. 182-83; Ballarin 1966, 114, 118, and 119; Magagnato and Passamani 1978, 28-29, ills.; Pallucchini 1982, 52 and pl. 37; Magagnato 1983, 150, no. 10, ills.; Rearick 1986 (A), 187; Ballarin 1988, 3, 7, 8, and 11; Freedberg 1988, 658.

The *terminus ante quem* for dating the painting is 3 March 1580, when in a contract (published by Crivellari 1893, 10) Jacopo agreed to furnish the Confraternita di San Giuseppe with an altarpiece of *The Virgin in Glory with Saints Agatha and Apollonia* (Museo Civico, Bassano del Grappa, cat. 122) by Saint Martin's Day of that year with the understanding that it be of a « forma simile » (similar form) to the one he had done « de S.n Martin in S.ta Catt.a » (of Saint Martin in Santa Caterina).

The hand of Jacopo is recognized here in all the literature beginning with Ridolfi (1648, 1, 397), who defined it as « della piú forte sua maniera » (in his strongest manner). This expression was also used by Verci (1775, 75), who added that a large number of copies were made of it. A similar subject is treated in *Saint Martin with Brandolino V Brandolini* (Castello di Valmarino, Cison, fig. 71), variously judged by art historians, who, for the most part, consider it to be a shop reworking of this *Saint Martin*. However, Rearick (1986 (A); and his essay here) thinks it is a replica done largely by Leandro around 1582, and Ballarin (1988) thinks it is an early formulation of the theme done by Jacopo around 1575. A drawing, without the figure of the Virgin (The Hermitage, Saint Petersburg), has been attributed to Leandro (Dobroklonski, 1940) and was exhibited as Jacopo's in the exhibition in Venice in 1957 (no. 87). All three figures from the Santa Caterina altarpiece reappear in the right corner of *Paradiso* (Museo Civico, Bassano del Grappa, cat. 123), executed, according to Ballarin, in 1579. *Saints Martin and Anthony Abbot* was engraved by P.F. Menarola in 1685 (Pan 1992, no. 88).

Art historians in this century have tried to assign a precise date to the *Saint Martin*. Except for Venturi (1929 (B)), who placed it with *Saints Peter and Paul* (Galleria Estense, Modena, cat. 34) in the early 1560s, thus moving it much earlier than the 3 March 1580 date of the document mentioned above, all the others have tended to give it a date c. 1580. Until Jacopo's late career was clarified in a fundamental essay by Ballarin (1966), the picture was unanimously considered to be the last masterpiece entirely by Jacopo, executed just before 1580, after which he was thought to be totally or almost totally inactive. Pallucchini (1957, 114) saw in it a new orientation on Jacopo's part after Francesco's move to Venice, and Rearick (1986 (A); and his essay here) agreed, dating it 1579. Ballarin (1988) brought it into greater focus, placing it after the *bozzetto* depicting *Saints Nicholas, Valentine, and Martha* (Museum of Art, Rhode Island School of Design, Providence, cat. 68) for the lost Valstagna altarpiece dated 1578; after the small painting on copper showing *The Miracle of Saint Peter Curing the Cripple* (private collection, Turin); and before *The Lamentation over the Dead Christ* (Lansdowne collection, London), once again done in 1578. Ballarin finds stylistic and iconographical similarities among the three paintings: for example, the head of Saint Martin is the same as Saint Valentine's, while the head of Saint Anthony Abbot is the same as that of Saint Nicholas, the grandfather in *The Miracle of Saint Peter*, and Joseph of Arimathea in *The Lamentation*.

At this point Jacopo takes another step forward in the process of his reinvention of the altarpiece. Even when compared to *The Circumcision* (Museo Civico, Bassano del Grappa, cat. 121), which is close in date – 1577 – and signed by Jacopo and Francesco, we find that he has emphasized, in a completely personal way,

422

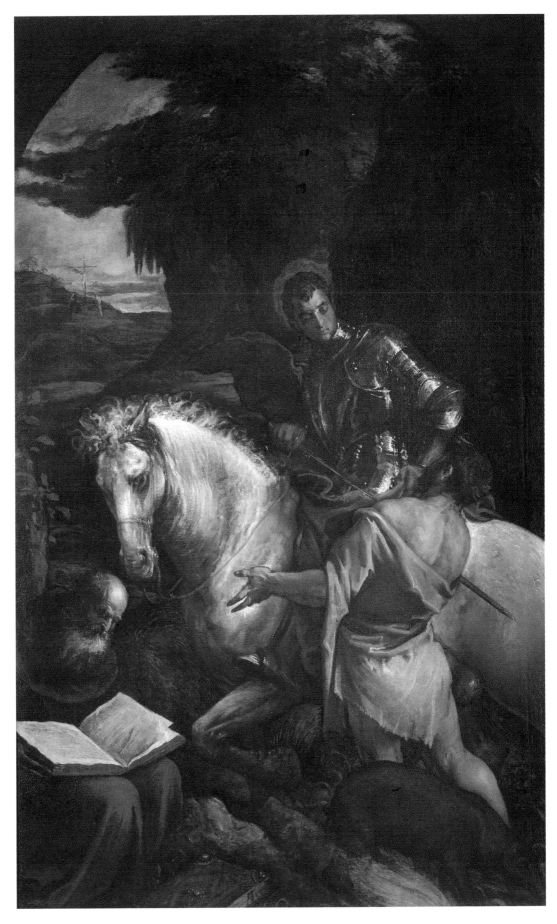

the two-dimensionality of the *Saint Martin* canvas. Freed from the problems of perspective he had faced in the large altarpieces up to 1575 and in his landscapes and genre scenes of 1576-77 during the period of his most active collaboration with Francesco, Jacopo now prefers an elliptical syntax for the structure of his paintings. This can be seen in the extraordinary foreshortening of the excited meeting of Saint Martin and the beggar, to whom the saint gives half his cloak, and in the free manner with which he relates this main group to the solitary figure of Saint Anthony Abbot, who is oblivious to the event. What is represented is a fantastic apparition, and so too does the background shun any naturalistic or descriptive intent. The unforgettable sunset, woven of pink and blue against the whitish clouds, contrasts with the dark mountain spur to the right and Golgotha to the left, where the figures of the crucified Christ, the Virgin, and Saint John are rendered with a few essential brushstrokes dipped in evanescent light.

The skillful use of light manages to hold the various planes of the picture together in an ordered space. A trait made more evident after the picture's recent restoration, when certain details that had not been clearly legible were brought to light: in the foreground the fire and the pig, attributes of Saint Anthony Abbot, on whose knees a pentimento is now more visible (the book has been moved); Saint Martin's halo, earlier just a blur of an undetermined color, and the various shades of red in his cloak; the green of the field and valley leading toward Calvary; and the second natural backdrop, which is lighter than the preceding one.

Upon close analysis, Jacopo reveals here an eagerness for pictorial experimentation similar to the ones that in the past had led him to offer «passages of incandescent color that would have pleased Rembrandt» (Pallucchini 1982, 52). The robust, energetic brushwork forces the viewer to step back in order to synthesize the image, which otherwise could not be read. In some cases, as in the beggar's flesh tones near the edge of his robe, the shadows are obtained by letting the warm gray ground show through. Defining the form is the extraordinary force of the light, which catches the red reflections of the fluttering cloak on the saint's armor and soaks the ruffled mane of the white horse and the pink robe of the beggar. By accentuating the expressive qualities of light, Jacopo shows his affinity with Venetian painting, especially Titian. But, at the same time, he returns to the fantastic tension of his maturity: «The heraldic arching of the crested neck of the horse and the backwards arch of the beggar's back represent two last gasps of his mannerist education» (Magagnato 1952 (A), 46).

L.A.V.d.S.

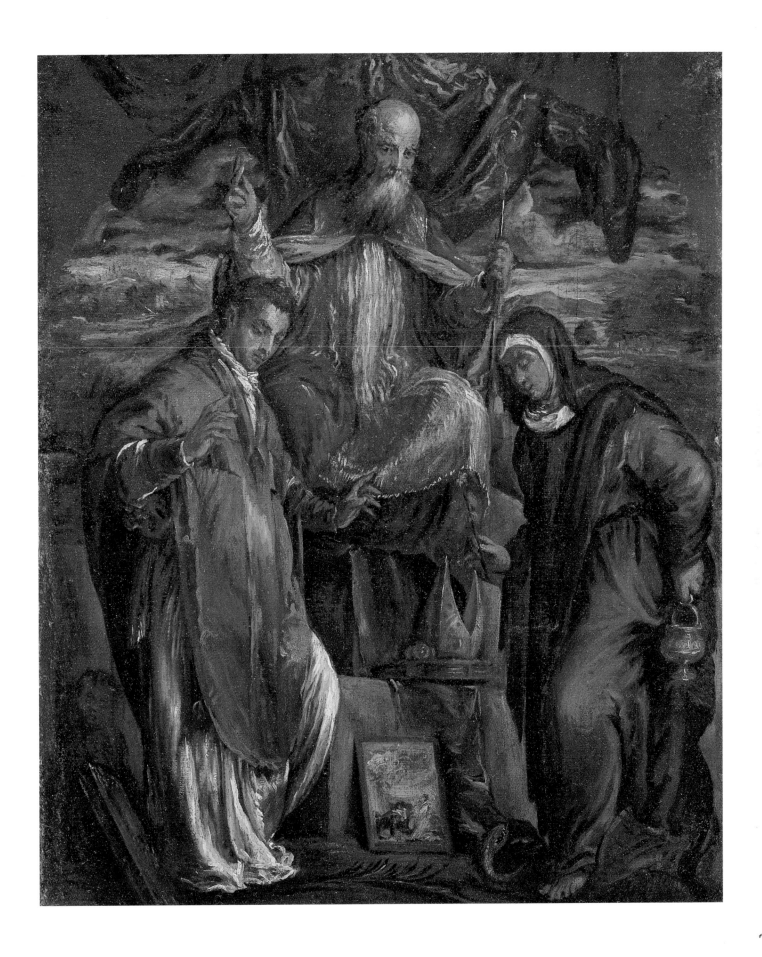

68. SAINTS NICHOLAS, VALENTINE, AND MARTHA (1578)

Museum of Art, Rhode Island School of Design, Providence, no. 57.158
Oil on canvas, 45.7×36.8 cm (18×14 1/2 in.)

Provenance
Museum of Art, Rhode Island School of Design, Providence, 1957.

Exhibitions
Never before exhibited.

Bibliography
Arslan 1960 (B), I, 364; Rearick 1976 (A), 106; Rearick 1982, 22; Ballarin 1988, 8.

Although it was purchased by the Museum of Art, Rhode Island School of Design as by Jacopo Bassano, Arslan called it the work of Pietro Mariscalchi. The present writer identified it as Jacopo's *modello* for the altarpiece (formerly parish church, Valstagna) after which Giambattista drew the *ricordo* (Staatliche Museen Preussischer Kulturbesitz, Kupferstichkabinett, Berlin, no. KdZ 22720), which bears the date 1578.

Verci (1775, 109-10) described an altarpiece of this subject, attached to the wall over the door to the sacristy in the parish church at Valstagna, calling it a work in Jacopo's latest style. That picture was sold at a comparatively recent date and cannot be traced. The Providence picture is evidently its *modello*, perhaps prepared for the approval of the patron. It must have been intended as an ex voto, since the little panel propped against Nicholas's throne represents what is probably a mother kneeling before a child's crib giving thanks before a miraculous apparition of the Virgin. *Modello* paintings by Jacopo are extremely rare, but most of them are included in the present exhibition (cats. 32, 69, and 75). Jacopo assigned the execution of *ricordo* drawings to the shop in his later years, and the date *1578* on Giambattista's crude drawing after the finished picture records its completion. It might have been begun, together with the present *modello*, at a slightly earlier date. It is possible that the shop, and in particular Giambattista, might have participated in painting the altarpiece on the basis of Jacopo's oil sketch. The fresh and improvisational handling of the present painting is, however, exclusively characteristic of Jacopo and reflects on an intimate scale the technique of the nearly contemporary *Saint Lucille Baptized by Saint Valentine* (cat. 53). It must have remained with the Dal Ponte shop material since Giambattista, Luca Martinelli, and other late associates used its figures in several later altarpieces (parish church, Rosà, etc.).

W.R.R.

426

JACOPO BASSANO 1580-1592

Reconstruction of the final phase of Jacopo's career (1580-1592) has been made possible by research carried out in the last thirty years, even though some exciting and very perceptive ideas had already been offered by Venturi (1929), Bettini (1933 and 1936) and Arslan (1931 and 1933) in their work on the artist. An important milestone was marked in 1957 by the exhibition curated by Zampetti. The catalogue entries brought into focus connections between *Susanna and the Elders* (Musée des Beaux-Arts, Nîmes, cat. 72), *The Flagellation of Christ* (The J.F. Willumsen Museum, Frederikssund, cat. 69), and *Christ Crowned with Thorns* (private collection, Rome, cat. 77), which, along with *Diana and Actaeon* (The Art Institute of Chicago, cat. 72), were linked to a group of works characterized by a similar treatment of light, such as the fragment of the Suida *Sacrifice of Isaac* (Zampetti 1957, no. 61), *The Entombment* in the Kunsthistorisches Museum, Vienna (Zampetti 1957, no. 68), the altarpiece with the same subject in the church of Santa Maria in Vanzo in Padua (Zampetti 1957, no. 69, and here, cat. 52), the Agnew *Christ Praying in the Garden of Gethsemane*, and the Lansdowne *Deposition* (Zampetti 1957, no. 70). Pallucchini (1957, fig. 115) added to these *The Lamentation* (Museu Nacional de Arte, Lisbon, and here, fig. 76). This first nucleus of works was generally dated before 1581, the year in which it was thought that Jacopo's painting activity ended.

Rosenberg's correct reading of the date 1585 on the *Susanna and the Elders* in Nîmes after its restoration presented the possibility of moving into the last decade of the painter's life a group of highly significant works that differed stylistically from those of the 1570s.

Taking as a point of reference the date of the *Susanna*, Ballarin in 1966 brought this last phase into focus, calling it Jacopo's «fifth and last manner», after the four manners identified by Volpato (c. 1685) and reported by Verci (1775, 47ff.). Ballarin's two fundamental studies, coupled together under the title *Chirurgia bassanesca*, were published in 1966-67. The first serves as an introduction to the second with a complete, meticulous analysis of all the historical and critical literature on the subject. Ballarin approached the problem of the complex relationship between Jacopo and his sons, particularly Francesco. He started with a careful reading of the inventory of the works found in the artist's house just after his death, drawn up on 27 April 1592, and proceeded to draw some very interesting conclusions about the possibility of attributing to Jacopo himself works that were classified generically as «Bassanesque» and of distinguishing finished works from unfinished ones and from those that were just «sketched in» (unfinished? or simple sketches that were then used by the master or someone in his workshop? or sketches that Jacopo considered to be artistically complete?). An appendix, finally, provides a reprint of Marucini's praise of Jacopo (1577) and the Italian translation

of Van Mander's biography of the artist (1604), both contemporary sources that speak of his «nocturnes» and «Scenes of the Passion, all imitating night». In the second essay, the reconstruction of Jacopo's career during the 1580s and up to 1592, the year of his death, is substantiated by new attributions around the benchmark of *Susanna and the Elders* in Nîmes. His «last manner» was thus delineated, and his new iconographical and technical experiments were examined, with particular attention to an analysis of his «innovations in the structure of color and touch» and in light «perceived as color and material». The aging artist's extraordinary capacity for renewal was highlighted as he meditated on the last work of Titian and Tintoretto, reaching the point of extreme fantastic and visionary tension that at the end takes on an expressionist dimension.

In this way, the idea that Jacopo was practically inactive after 1581 was definitively laid to rest. It was an idea that had been suggested by a passage in a letter from his son Francesco to the Florentine merchant Pietro Gaddi (Bottari and Ticozzi 1822, III, 265ff.) stating that «Jacopo ormai non disegna piú» (Jacopo by now doesn't draw anymore). The statement testifies, as Zampetti had noted, to Jacopo's technique in his last years, when he constructed his forms with paint rather than drawing. This practice did not escape the notice either of his biographers or of later students of his work.

Just after Ballarin's two essays, Rearick's important contributions of 1967 and 1968 reopened the discussion with *Jacopo Bassano's Later Genre Paintings* (1968) and enriched our knowledge of the artist's late period with provocative observations, connections, and distinctions, which have now been further revised and added to in the essay published in this catalogue. The 1968 study in particular drew attention to the problem of the responsibility of Jacopo and Francesco respectively in the biblical-pastoral paintings, which came out of the workshop signed either by Jacopo or «JAC.ᔆ ET FRANC.ᔆ FILIUS», and to the wide circulation of this type of painting throughout all of Europe through the numerous workshop replicas, for which the working methods and procedures were described. His essay of 1967, presenting *The Baptism of Christ* (private collection, cat. 79) and giving the history of its recognition (already mentioned by Ballarin), constituted another important and meaningful episode in the critical recovery of Jacopo's late period.

Pallucchini's monograph, which appeared in 1982, utilized in its last chapter, «L'ultima fase luministica» (The Last Luministic Phase), research carried out by Ballarin and Rearick, and reinserted into the group of late paintings *The Deposition* (Musée du Louvre, Paris), which Pallucchini (1959-60) himself had earlier reclaimed for Jacopo as a prototype for paintings of the same subject in a smaller format.

Closing the last chapter of the exhibition, which opens with the Wil-

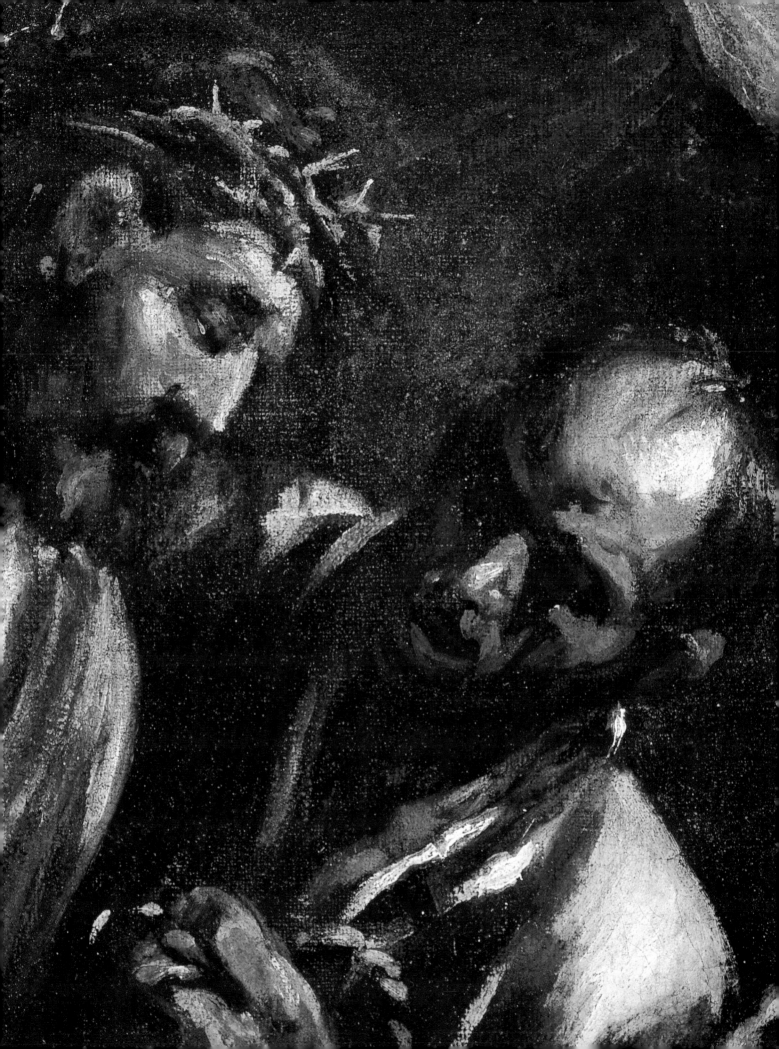

lumsen *Flagellation*, is *The Baptism of Christ*, which concludes the period 1580-92. The succession of the last eleven works exhibited unfolds between these two dates, documenting Jacopo's painting practices in the last years of his life. During this last phase, marked by an intense and vibrant fantasy of invention which, we reiterate, was never interrupted (Arslan as late as 1960 assumed as a given that the artist stopped working almost completely in the decade after 1581), Jacopo painted with «stylistic furor». Through physical contact with the pigment itself, spread it seems even with his fingers now that his sight was leaving him, Jacopo created the lights of faraway sunsets that mark the depth of his landscapes, the nights illuminated by rays of moonlight, and the flickering flames of torches that reveal in the darkness of his interiors, figures and objects with sudden flashes of lead white and rapid phosphorescent stripes. From a rethinking of the late Titian his painting moves, as we have already noted, toward Rembrandt.

Evaluation of his last period is still marked by differing opinions regarding the works where participation of his sons can be detected, especially of Francesco, even if some of the deductions that can be made from the biographical information on his sons (see here, Rearick's essay), chemical and physical analyses of his painting technique, and especially a thorough understanding of Jacopo's art, have set scholars more securely on the path toward a correct distinction between their hands. «Flickering» and «inexpressive stammering of languid lights» (Bettini 1936, 146) are two of the phrases used to define Francesco's «*colpizar*», or touch, while in Jacopo's paintings the structure of the bodies is always solid and sure, where the dynamic function of touch and abbreviated brushstrokes soaked in color and light does not annihilate the forms, but rather heightens their eruptive, expressive force.

The installation of the exhibition as seen in Bassano del Grappa, with the sections dedicated to Jacopo's technique and to X-radiographic analyses of his works, gives a very useful space to this area of research, to which new data could be added if it were possible to make X-radiographs of some emblematic paintings included in the exhibition on which scholars still have not reached a consensus of opinion.

<div align="right">Filippa M. Aliberti Gaudioso</div>

69. The Flagellation of Christ (c. 1580)

The J.F. Willumsen Museum, Frederikssund, inv. G.S. 26
Oil on canvas, 139 × 100.2 cm (54 3/4 × 39 1/2 in.)
Exhibited in Bassano del Grappa only

Provenance

Hamilton collection, Stockholm; at the auction of the Hamilton collection it was bought by Karl Madsen (1855-1938), director of the Königliche Gemälde und Skulpturensammlung, Copenhagen 1911-38; purchased by J.F. Willumsen through the auction house Winkel and Magnussen, which on 28 September 1938 sold the collection of Italian and Dutch paintings of Karl Madsen, but this painting was not listed in the collection; The J.F. Willumsen Museum, Frederikssund, since 1947.

Exhibitions

Copenhagen 1947.

Bibliography

Willumsen 1927, I, 551 52, ills. (as Jacopo Bassano or El Greco); Venturi 1929 (B), 1200-3, 1259, and fig. 835; Bettini 1933, 93, 177, and pl. xxxix; Zampetti 1957, 170; Zampetti 1958, 50; Arslan 1960 (B), I, 343 (among works by or thought to be by Jacopo); Olsen 1961, 38; Ballarin 1967, 159; Shapley 1973, 48-49, fig. 88; Pallucchini 1977-78, 8; Pallucchini 1982, 52.

This picture has never been very highly considered by critics, despite its exceptional quality. It was brought to the attention of scholars by Willumsen (1927) with an attribution to either Jacopo or El Greco. Venturi (1929 (B)) saw it as one of Jacopo's rare *bozzetti*, chronologically close to *Saint Roch Visiting the Plague Victims* (Pinacoteca di Brera, Milan, cat. 47) and the *Susanna and the Elders* (Musée des Beaux-Arts, Nîmes, cat. 72). Bettini (1933) thought it was the fruit of Jacopo's late-blooming love, never really dormant, for Titian. Zampetti (1957; and 1958) mentioned it in passing, in the context of Titian, among Jaco-

po's last works, placing it between the end of the 1570s and the beginning of the 1580s, next to the two versions of *The Entombment* (Kunsthistorisches Museum, Gemäldegalerie, Vienna; and Santa Maria in Vanzo, Padua, cat. 52), the *Susanna* in Nîmes, and *Christ Crowned with Thorns*, at the time in the Tinozzi collection (now private collection, Rome, cat. 77). Although considering it «remarkable for its seemingly effortless air», Arslan (1960 (B)) excluded it from the catalogue of works by Jacopo and his sons and listed it among «Bassanesque» works.

According to Olsen (1961), the execution of this large sketch should be linked to the commission for the cycle of nine canvases with episodes from the Passion of Christ for the choir of the Jesuit church in Brescia, Sant' Antonio Abate, now scattered among various public and private collections (Ridolfi 1648, I, 390; Averoldo 1700, 85 ff.; Arslan 1960 (B), I, 195-96, and 207, n. 38). Under Jacopo's direction the undertaking involved, to varying degrees, all the members of the workshop and was presumably carried out between the end of the 1570s and beginning of the 1580s (see here, Rearick's essay). In particular it can be thought of as a kind of trial for *The Flagellation of Christ* (Civiche Raccolte d'Arte Castello Sforzesco, Milan, inv. 715), thought by Arslan (1960 (B), I, 195-96, and II, fig. 241) to be by Francesco and by Rearick to be by Leandro. Even though this one, like its pendant in Milan from the same series, *Christ Crowned with Thorns*, is about

40 centimeters shorter than the other canvases, nonetheless the composition of the Willumsen sketch is strongly vertical. Jacopo's canvas thus seems to be an intermediate size meant to be used according to the exigencies of the various interpretations given it by the workshop: square in the painting for the church of the Maddalene in Vicenza (now Museo Civico, Vicenza), assigned to Giambattista by Arslan (1960 (B), I, 232, and II, fig. 268) but more probably by Francesco (Cevese 1954; and Lugato 1990-91, 188-90); horizontal for the painting formerly in the Demotte collection, Paris, and the Kress collection, New York, and now in the North Carolina Museum of Art, Raleigh (inv. GL. 60.17.50), placed by Arslan, on the basis of an examination only of its photograph, in the catalogues of both Giambattista and Leandro (Arslan 1960 (B), I, 232 and 267) and attributed to Giambattista by Shapley (1973, 48-49, fig. 88).

In a complex and improbably narrow architectural space, moving back diagonally toward deep dark distances in the back of the painting, beneath the gaze of a woman looking out of the window «like in a seventeenth-century Dutch painting» (Venturi), the martyrdom of Christ is drawn out from the shadows in all its violence. Its execution is very free, with energetic blows of the brush leaving thick lumps of color next to thinner waving lines, and interrupted, nervous touches, as in the loincloth of Christ. Christ's snow-white, trembling form, almost like a ghostly apparition in the blind-

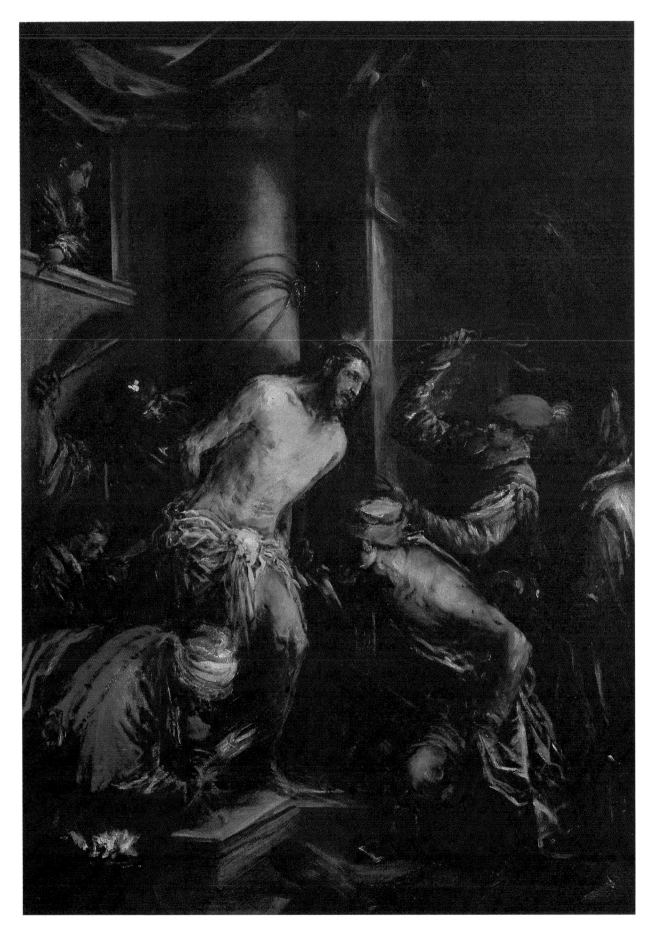

The John and Mable Ringling Museum of Art, Sarasota, inv. SN 87
Oil on canvas, 139.7 × 182 cm (55 × 77 5/8 in.)

ing light, seems to be physically pulled out from the gray ground and lit by flashes of light that touch his shoulder and temple. His eyes and mouth are shot with blood, and the executioners « drawn into the silver current of a ray that slants down from on high... are flashes of light in human form » (Venturi). The fury of their gestures, arranged along two lines crossing diagonally, creates a void in the center. This dynamic vortex condenses into luminous and material highlights on the helmet and turban of the two rogues on the left and the burning brazier in the foreground, then slides in the direction of the jailer draped in lacquer pink kneeling on the right.

The solidity of the composition, the balanced relationship between the figures and the space, and the quality of the material – which recall *Saints Martin and Anthony Abbot* (Museo Civico, Bassano del Grappa, cat. 67) and *The Virgin in Glory with Saints Agatha and Apollonia* (Museo Civico, Bassano del Grappa, cat. 122) of 1580 – lead us to place this painting not too far beyond the end of the 1570s. It is a painting that reveals at the same time, to cite again the acute reading of Venturi, the « prodigious technical daring » and « lyrical impulse » of Jacopo Bassano.

P.M.

Provenance
Liechtenstein collection, Vienna (before 1920-25); Count Alessandro Contini-Bonacossi, Florence; J. Böhler, Munich; John Ringling collection, Sarasota.

Exhibitions
Never before exhibited.

Bibliography
Description des tableaux 1780, no. 239; Buscaroli 1935, 194; Arslan 1936 (A), 110; Suida 1949, 86; Berenson 1957, I, 20; Arslan 1960 (B), I, 187-88 and 222; Fredericksen and Zeri 1972, 18; Tomory 1976, 73-75, no. 69; Janson 1986, no. 12; Rearick 1986 (A), 186; Ballarin 1988, 5-6.

Arslan (1936 (A)) tentatively attributed this canvas to Gerolamo, but Suida called it largely Jacopo, and Berenson illustrated it as by Francesco. Later Arslan (1960 (B)) shifted it to Francesco, but thought that Gerolamo might have assisted his brother in the execution. Tomory gave its history and suggested the dual iconography of Elements/Temperaments. Janson returned it to Jacopo; Rearick saw some participation by Gerolamo; and Ballarin clarified the complex group of related pictures from the Liechtenstein collection, assigning this one to Jacopo with a date early in the 1580s.

Although it is true that during the cinquecento the elements and the temperaments were regarded as parallel Water/Phlegmatic, Fire/Choleric, Air/Sanguine, Earth/Melancholic here the Dal Ponte simply depicted the emblematic human activities associated with the elements and made no overt allusion to the temperaments. The classical deities associated with each element – in the present case, Neptune in his chariot drawn by winged sea horses – are seen above in celestial radiance.

The *Elements* was the last of several cycles of four subjects invented by Jacopo and reproduced in quantity by his shop. Like the analogous *Seasons* and *Noah* series (see cats. 50- 51, 58-59, and 63-66), which originated in the years around 1576-77, the *Elements* began with successive suites produced by Jacopo in collaboration with his sons. At least three such sets are known. Of the first, painted in large measure by Francesco, with Jacopo's intervention in the foreground figures, the one representing *Air* survived (formerly Kaiser Friedrich Museum, Berlin), until it was burned in 1945. It may be dated to about 1577. This set was followed by an amplified treatment in about 1579-80 in which Leandro's hand predominated, with Jacopo's contribution limited to finishing touches. Again, only one of the four canvases, *Earth* (Walters Art Gallery, Baltimore), is known in the original. The last set, of which the present canvas and its pendant *Fire* (cat. 71) survive, recast with major changes the two earlier cycles. Reconstructing the earlier treatments of *The Element of Water* is complicated not only by the loss of the originals, but also because of the absence of shop replicas, unless the present version was repeated with little variation from one or both of the prototypes. This, however, is unlikely since, as Ballarin observed, the format and style of the prior suites is in marked contrast with the present pair.

Just as the earlier *Elements* share a

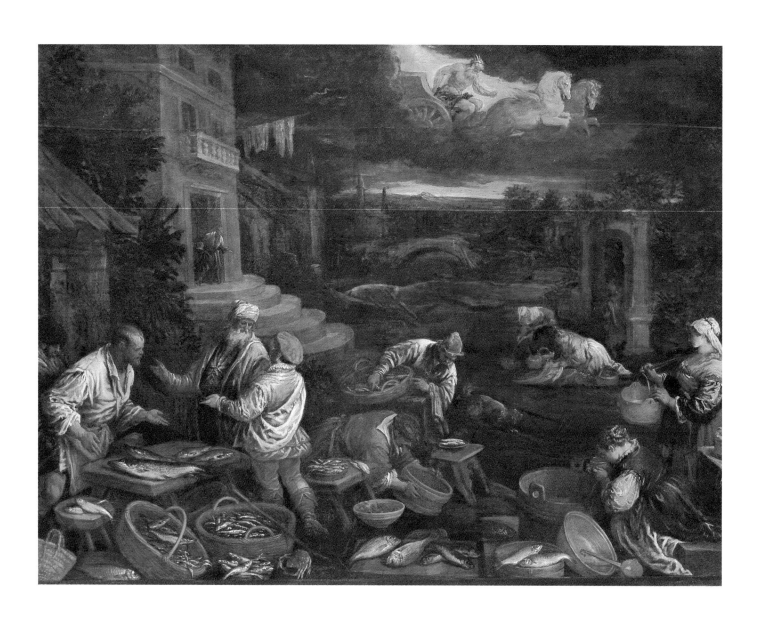

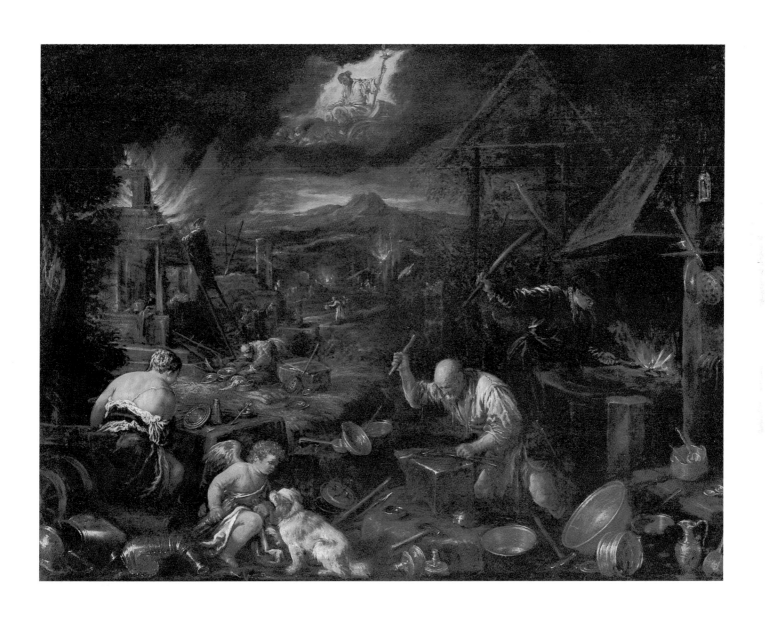

435

71. THE ELEMENT OF FIRE (c. 1584-85)

The John and Mable Ringling Museum of Art, Saratosa, inv. SN 86
Oil on canvas, 139.7×182 cm (55×77 5/8 in.)

cheerfully decorative evocation of country life with the peasant genre compositions of the later 1570s, this revision of the suite is cast in the same somber mode as *Susanna and the Elders* (Musée des Beaux-Arts, Nîmes, cat. 72) of 1585. Against a dark and stormy setting, sober accents of wine red, saffron, and silver gleam in the twilight. A wide range of seafood, including certain species found in Venice but not in Bassano, is disposed along the foreground, while other activities requiring water, such as laundry and ferrying, are pursued glumly in the middle distance. The brushstrokes are broad and dappled with highlights, but the presence of a second, more cautious hand is evident in much of the intermediated stage of painting. Although even here a slightly woolly lack of focus suggests Gerolamo's more approximate touch, it was most probably Francesco who collaborated with his father. It would, in fact, be Francesco who made use of this composition in the production of replicas, some of which he signed (Musée des Beaux-Arts, Angoulême), while in others (Trafalgar Gallery, London) a slight intervention by Jacopo may be detected.

W.R.R.

Provenance
Liechtenstein collection, Vienna (before 1920-25); Count Alessandro Contini-Bonacossi, Florence; J. Böhler, Munich; John Ringling collection, Sarasota.

Exhibitions
Never before exhibited.

Bibliography
Descriptions des tableaux 1780, no. 239; Buscaroli 1935, 194; Arslan 1936 (A), 110; Suida 1949, 86; Berenson 1957, I, 20; Arslan 1960 (B), I, 187-88 and 222; Fredericksen and Zeri 1972, 18; Tomory 1976, 73-75, no. 68; Janson 1986, no. 11; Rearick 1986 (A), 186; Ballarin 1988, 5-6.

The critical history of this *Element of Fire* is the same as that of its pendant, *The Element of Water* (cat. 70). Like Neptune in *Water*, the classical symbol of fire, Vulcan, appears in a dog-drawn chariot in the sky above. Unlike the more prosaic activity of the country folk in *Water*, the *Fire* contains a mythological allusion in the left foreground, where Venus gazes into a convex silver mirror and Cupid plays with a dog. This implies that the smith who works at the anvil is Venus's husband, Vulcan. The useful production of Vulcan's forge is scattered about the foreground, while in the middle distance fire's destructive potential is suggested as people try to save what they can from a burning villa.

As in the case of *The Element of Water*, both presumed earlier treatments of *Fire* are lost and seem not to survive in shop replicas. Nonetheless, this third and last cycle of *Elements* provided Jacopo with an especially congenial theme in which a nearly nocturnal setting served to set off the pyrotechnic effects of flame, smoke, and burnished metal. This flickering illumination is seconded by a paler, celestial gleam that permits Jacopo to describe the smith with skeins of nervously phosphorescent highlight. This spectral evocation extends to much of the transfigured pictorial surface, achieving in the bellows boy an almost caricatured abbreviation of form. Jacopo would voyage into even more visionary pictorial realms with subsequent works such as *The Martyrdom of Saint Lawrence* (parish church, Poggiana, fig. 81) and the even later *Christ Crowned with Thorns* (private collection, Rome, cat. 77), and with Francesco he adapted it for an oval ceiling depicting *Venus at the Forge of Vulcan* (Muzeum Narodowe, Poznan). Francesco took full advantage of the success of *The Element of Fire*, painting numerous replicas, several of which he signed (private collection, Bassano del Grappa; Walker Art Gallery, Liverpool; Liechtenstein collection, Vaduz; Muzeum Narodowe, Warszawie W Warsaw; etc.). Of these the version in Liverpool is the last and demonstrates how Francesco had forgotten the expressive touch of Jacopo's brushwork from around 1585.

W.R.R.

72. Susanna and the Elders (1585)

Musée des Beaux-Arts, Nîmes, inv. 241
Oil on canvas, 85 × 127 cm (33 1/2 × 50 in.)
Inscriptions: J.B.f. 1585
Exhibited in Bassano del Grappa only

Provenance
Gower collection (inv. 580); in the Musée des Beaux-Arts, Nîmes, since 1875.

Exhibitions
Amsterdam 1953; Bordeaux 1953; Brussels 1953; Venice 1957; Paris 1965; Nice 1979; London 1983.

Bibliography
Catalogue Musée 1911, no. 241; Longhi 1926, 143; Longhi 1928, 79; Venturi 1929 (B), 1202, 1259, and fig. 836; Arslan 1931, 141-42, 193, 353, and pl. 48; Berenson 1932, 58; Bettini 1933, 92-93, 175, and pl. 38; Gillet 1934, 255; Berenson 1936, 50; *Catalogue Musée* 1940, no. 241, ills.; Pallucchini 1944, ii, 38; Tietze and Tietze-Conrat 1944, 53, no. 194; Isarlo 1950, i, ills.; Alazard 1955, 223; Pigler 1956, i, 219; Berenson 1957, i, 19; Florisoone 1957, 31-32 and 51, ills.; Isarlo 1957, 2; Mariacher 1957, 27-28, no. 661; Muraro 1957, 296; Pallucchini 1957, 115; Pignatti 1957 (A), 372-73; Arslan 1958, 477; Zampetti 1958, 50 and pls. 72-73; Pallucchini 1959, 266; Arslan 1960 (B), i, 119-20, 173, and 377, and ii, figs. 163-64; Mellini 1961, 24, fig. 42 detail; Manning 1963, no. 19; Zampetti 1964, i, 231-32; Ballarin 1965 (A), 239; Rosenberg 1965, 33; Ballarin 1966, 112, 116, and figs. 131 and 134; Freedberg 1971, 374; Rheims 1973, 134, ills.; Pallucchini 1981 (B), 272; Pallucchini 1982, 52-53, no. 38, ills.; Magagnato 1983, 150-51, no. 11, fig. 11; Nîmes 1988, 8-10; Freedberg 1988, 658.

« There is a very wonderful Susanna at her bath with two old men ». This brief note by Ridolfi (1648, i, 394) informs us of the existence of this subject among Jacopo's works.

Described by Venturi (1929 (B), 1202) as « one of the most daringly improvised and blazing works of Jacopo's whole life », it is likened to *The Flagellation of Christ* (The J.F. Willumsen Museum, Frederikssund, cat. 69), where the figures « are flashes of light in human form ». Bettini (1933, 92) pointed out how much the two works, along with others from the 1570s, owe to « the elderly, elated Titian, drunk with color, of the *Flagellation* in Munich and the *Pietà* in Venice ».

The illegibility of the date before the picture was restored and the widespread conviction that Jacopo was inactive after 1581 (see here, Rearick's essay) kept hypotheses about the date within a range from 1571 to 1579 (Bettini 1933; Pallucchini 1944; Zampetti 1957; Berenson 1957; and Arslan 1960 (B)) until restoration revealed the complete inscription at the bottom of the painting: « J.B.f. 1585 » (communicated by Rosenberg to Ballarin). From that moment the Nîmes painting became the hinge around which are gathered all the works of the 1580s before, during, or after 1585. The painting gave Ballarin the key for reconstructing the last years of Jacopo's career. His most detailed analysis of the work was made in *Chirurgia bassanesca* (1966, 114 ff.), where he took on the problems and themes that characterize what he called « Jacopo's fifth and last manner », after the four manners indicated by Volpato: « This *Susanna* returns to the painter ten years of activity... among his most inspired » (Ballarin 1966, 116).

Unfortunately, the painting has reached us with its surface compromised by large abraded areas, to the point that we can barely intuit the extraordinary quality of the original pigment. Nonetheless, we can still fully perceive the poetry that pervades this masterpiece of Jacopo's last years. The painting brings to its culmination the process of rarefaction that Jacopo was pursuing in his increasingly urgent search for a figurative synthesis and a composition reduced to its essentials. The viewer's attention is concentrated on the three figures in the foreground, placed along three diagonal lines, as Magagnato observed (1983, 11), diverging from the center toward the edges of the canvas, in a dynamic action of attraction and repulsion. Susanna leans against a low wall that is wedged right into the center of the painting between the woman and the elders and seems to mark the boundary between the two impulses. On the right, the second elder peeps furtively from behind a tree. In the foreground there is a lemon tree, which seems to have been taken from the greenhouse of the Palladian style villa at the left in the park. All are wrapped in the evening shadows. Under the branches of the tree, whose leaves are flecked with the reddish light of the far-off sunset, crouches a rabbit, and a deer stretches out his neck. The light moves across the figures and the few objects in the foreground with phosphorescent stripes on Susanna's cloak and veils, drawing its greatest intensity from the pink robe of the first elder, modulated by thin layers of glaze. An atmosphere of suspension and mystery hangs over the landscape, veiled by that particular luminous haze that settles as the day ends and evening begins. The

mountain against the background of the sky, gathering the final rays of the setting sun, is the landscape *leitmotiv* in many of Jacopo's pastoral paintings.

In his representation of this biblical story, Jacopo seems to evoke the ghosts of some dream world, which would soon yield to more agitated atmospheres in the works of the end of the decade, such as *Christ Crowned with Thorns* (Christ Church, Oxford, cat. 78) and *The Baptism of Christ* (private collection, cat. 79). Rosenberg (1965, no. 33), in his discussion of the variations on the Nîmes *Susanna* in a painting in the Museo Correr and in the version signed by Leandro in the Brass collection, Venice, posited that the Nîmes canvas might have been cut along the left side and at the bottom, since it is missing certain details present in those pictures. Evidence of these cuts should have come to light during the painting's restoration. As this was not the case, we tend to think that the picture, so effective in its essence, represents the reworking of a *bozzetto* that Jacopo prepared for his own use and that of his shop. In the *Inventario* (1592), no. 35 is listed as a painting « della Susanna sbozzato vecchio, di lunghezza braccia due ed altezza due e mezzo » (of Susanna, sketched out elder, two *braccia* long and two and a half higher). The sketched picture, larger than ours here, could have included those details that are seen in the replicas in Venice, but missing from the Nîmes canvas. The Nîmes picture, in fact, does not contain the two rabbits in the foreground and the silhouette of a fountain on the left, which appear in another replica assigned to Leandro (Christie's, London, 19 March 1965, lot 99). The omission of these details would serve once again as witness to the search for synthesis and essentiality that characterizes the artist's last work.

F.M.A.G.

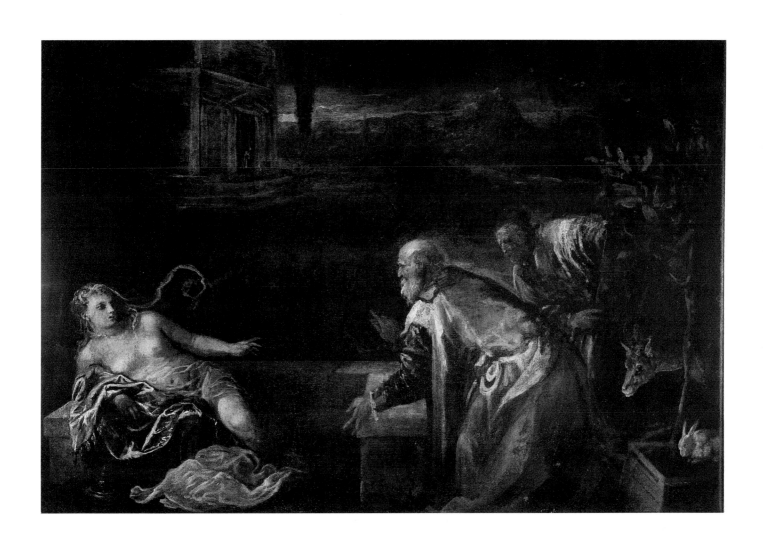

73. Diana and Actaeon (1585)

The Art Institute of Chicago, Chicago, inv. 1939-2239, Charles H. and Mary F.S. Worcester Collection
Oil on canvas, 63.6 × 68.7 cm (25 × 27 in.)
Exhibited in Bassano del Grappa only

Provenance

Perhaps in the inventory of pictures found in Jacopo's studio at his death in 1592 (*Inventario* 1592, 97, no. 130); documented in the Dupille collection in Paris 1742-63; E. and A. Silberman, New York, before 1939; sold by Silberman to Charles H. Worcester, Chicago; donated to the Art Institute of Chicago in 1939.

Exhibitions

Venice 1957; Peoria 1970.

Bibliography

Recueil 1729-42, II, ills. (as Jacopo Bassano); Crozat 1763, *L'école venitienne*, no. XII, ills. (as Jacopo Bassano); Fröhlich-Bum 1932, 114 (as Leandro Bassano); Sweet 1940, 94-96, ills. (as Jacopo); Longhi 1948, 55, fig. 65 (as Jacopo); Berenson 1957, I, 17 (as Jacopo); Muraro 1957, 292, n. 13-a (as not by Jacopo); Pallucchini 1957, 115 (as Francesco); Zampetti 1957, 150-51, ills. (as Jacopo); Zampetti 1958, 57, pls. LXXV-LXXVI (as Jacopo); Arslan 1960 (B), I, 259 (as perhaps an early Leandro); Ballarin 1966, 116 and 121 (as Jacopo); Ballarin 1967, 160 (as Jacopo); Fredericksen and Zeri 1972, 18, 469, and 571 (as Jacopo); Magagnato 1983, 151 (as Jacopo); Ballarin 1988, 5; Pan 1992, no. 114; Lloyd, unpublished entry for the catalogue of Italian paintings in the Art Institute of Chicago, in press (as Jacopo).

An etching by Etienne Fessard for the second volume of the *Recueil d'estampes d'après les plus beaux tableaux et d'après les plus beaux desseins qui sont en France dans le cabinet du Roy, dans celuy de Monseigneur le Duc d'Orléans, et dans d'autres cabinets*, published in Paris in 1742 (Pan 1992, no. 114), documents the paintings of «Diane et Acteon changé en Cerf» as in the Dupille collection. The painting remained in the collection for at least twenty years, but was not listed in the Dupille sale held in Paris in 1780 (Lloyd, n. 4). The measurements indicated on the engraving, «haut de deux pieds, large de deux pieds cinq pouces,» correspond to 64.8 × 78.3 cm. A comparison of the engraving and the painting shows that the reduction of the canvas, confirmed also by its cut edges, consisted in a loss of about 10 centimeters, 5 centimeters off the left side, where a wooded landscape stretched beyond the full-length figure of the standing nymph, and 5 centimeters off the right, where the group of two horsemen and a page was more fully realized.

Attribution of the work is still under discussion: Sweet, Longhi, Berenson, Zampetti, Ballarin, Fredericksen and Zeri, Magagnato, and Lloyd are of the opinion that it is the work of Jacopo Bassano. Muraro excluded it from the list of the master's works, without proposing other authorship. Pallucchini thought it was by Francesco. Fröhlich-Bum and Arslan assigned it to Leandro. For Ballarin (1988) the painting is a reworking of *The Death of Actaeon* of. c. 1576 (formerly Kaiser Friedrich Museum, Berlin; *Die Gemäldegalerie* 1930, 8, as Francesco, with the title *Allegory of Autumn*, see here, fig. 79). Rearick (see his essay in this catalogue, n. 374) now gives the Chicago picture to Gerolamo with a date of c. 1594. He feels it is based on the prototype formerly in Berlin, which he dates c. 1585 and attributes to Leandro with some minor intervention from Jacopo.

As had been observed, «*L'Istoria d'Ateo, d'un braccio d'ogni banda*» appears as no. 130 in the *Inventario* of the pictures found in Jacopo's house on 27 April 1592, two months after his death (letter from Erica Tietze-Conrat to E. and A. Silberman, 11 September 1939, quoted by Lloyd, n. 3). The very effective synthesis of the composition, which unites different moments of Ovid's *Metamorphoses* (II, 138-252), the quality and application of the pigment, even if by now badly deteriorated and damaged, as well as the size of the Chicago canvas all lead us to believe that it can well be identified with the picture mentioned in the inventory.

In this painting there are no narrative or descriptive elements from Ovid's story. Diana, surrounded by her nymphs, is surprised at her bath by Actaeon, who was guided there by fate, but Actaeon's image has already been transformed into a stag and is the prey of his pack of dogs and hunting companions. The midday sun has burned out the range of colors: standing out against the silver-gray tones of the deep green setting are only the white female flesh draped in ice blue robes on the left and the warm yellows and browns of the hunters and animals on the right. The elements in common between this *Diana and Actaeon* and the contemporaneous *Susanna and the Elders* (Musée des Beaux-Arts, Nîmes, cat. 72), dated 1585, include not only the structure, arranged along two diagonal lines, but also the «carbon copy» of Jacopo's two rare nudes: Diana and Susanna. There is also a very similar treatment in the form of the hands. The application of the paint seems

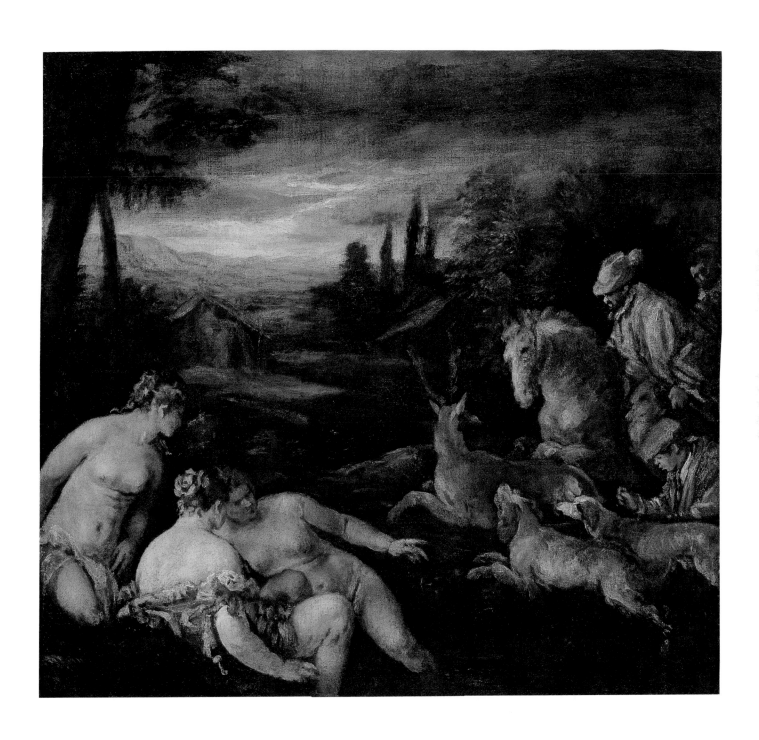

74. THE ADORATION OF THE MAGI (early 1580s)

Private collection, Rome
Oil on canvas, 36×31.2 cm (14 1/8×12 1/4 in.)
Exhibited in Bassano del Grappa only

«thrown» onto both canvases in small informal lumps with feathered contours. But even more than these similarities there is the renewed experience of a meditation on the last work of Titian and Tintoretto that characterizes Jacopo's «fifth manner», in which «the supremacy of color shatters the gradations of light» and «light is... perceived as both color and matter» (Ballarin 1966, 119 and 131). And then that sense of astonished surprise, of disarming poetry, that inspired the masterful pen of Longhi (1948): «A fable of *Acteaon*, thematically reworked as though by a Watteau from the Venetian countryside, steeps, almost groping, in a stew of faded corn poppies. It almost makes us think that the elderly Jacopo, like the elderly Renoir, was by this point painting with the brush tied to his fingers, dipped in the juices of flowers and grass, and dripping from it a clear-eyed memory of places, women, hunters, in a fable that is almost unrepeatable and by now nameless.»

A copy of the painting, attributed to Leandro, recently appeared on the art market (Sotheby's, London, 12 December 1990, lot 168). A variant with a vertical format, where the two groups are inverted, is characterized by a punctilious attention to decorative details. It was published by Fröhlich-Bum (1932) as being in a private collection in Vienna and cited again by Berenson (1957) and Arslan (1960 (B), I, 275, and II, fig. 311).

P.M.

Provenance
Early history unknown.

Exhibitions
Never before exhibited.

Bibliography
Unpublished.

This painting, heretofore unpublished, will appear in Ballarin's forthcoming catalogue, where it is assigned to the beginning of the 1580s, between *Saints Martin and Anthony Abbot* (Museo Civico, Bassano del Grappa, cat. 67) of c. 1579 and *Susanna and the Elders* (Musée des Beaux-Arts, Nîmes, cat. 72) of 1585.

It moves away from the iconography of all the preceding *Adorations* painted by Jacopo, showing a relationship only with *The Adoration of the Magi* in the Galleria Borghese, Rome (cat. 56). But of this latter it repeats almost in a mirror image some of the elements on the right of the composition. The time of day is different: the cold evening light in the Borghese *Adoration* here is warmed by the lively flashes of nighttime illumination. It is precisely this nocturnal setting that distinguishes the painting and associates it with Jacopo's last works, his most intensely dramatic. From the deep darkness of the night emerge, traced by the light, the essential passages of an architectural backdrop: the edge of a thatched roof leaning on a ruined arcade and a broken column on a high pedestal, reminiscent of Codussi and acting as a central pivot for the scene of adoration.

Jacopo's luministic technique reaches in this small painting one of its most sublime effects of chromatic splendor. The canvas is primed as for a nocturne, dark brown mixed with red earth, helping to calibrate the general tone of the work, against which vibrate the silvered whites, ruby reds, deep emerald greens, and golden yellows. Boschini's celebrated verses (1660, 273, lines 22-25) lend themselves well to a reading of this work: «Quei colpi, quele macchie e quele bote / Che stimo preciose piere fine, / Perle, rubini, smeraldi e turchine, / Diamanti, che resplende fin la note» (Those touches, patches, and strokes / That I hold as precious fine stones / Pearls, rubies, emeralds, and turquoises / Diamonds that brighten even the night).

The models for the figures are among the most well known ones in Jacopo and his shop's repertory. The Madonna and Child are taken from a model used repeatedly, beginning with the large lunette for Vicenza depicting *The Madonna and Child with Saints Mark and Lawrence Being Revered by Giovanni Moro and Silvano Cappello* (Museo Civico, Vicenza, fig. 54). The page with a plumed beret, foreshortened in the foreground, is the same as the boy blowing on the fire with a bellows in *The Martyrdom of Saint Lawrence* (cathedral, Belluno, fig. 53). We find him again in one of Jacopo's very last works, *Christ Crowned with Thorns* (Christ Church, Oxford, cat. 78). Also, the group of participants on the right appears in numerous works on various themes. Especially frequent is the man with a headdress of cascading red feathers. The repeated use of the same models prepared by the master

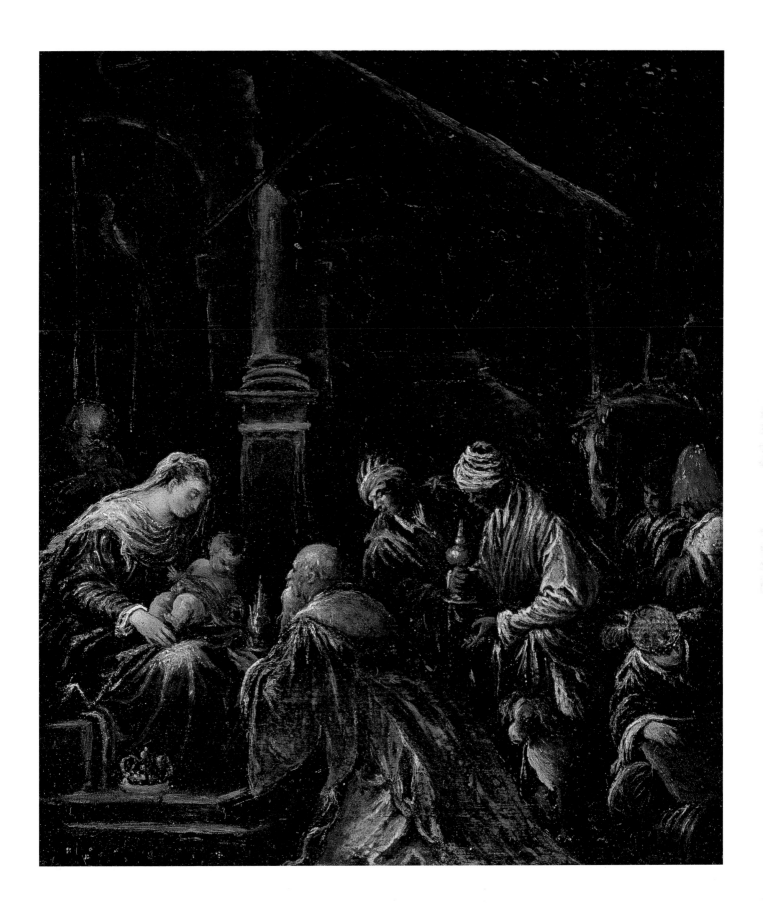

75. The Birth of the Virgin (c. 1588)

Museum of Art, Rhode Island School of Design, Providence, Mary B. Jackson Fund, no. 52.318
Oil on canvas, 82.9×100.7 cm (32 5/8×39 5/8 in.)
Exhibited in Bassano del Grappa only

was part of the organization of the workshop, but every time that Jacopo reuses them he gives them new life as his painting technique varies according to the evolution of his style.

In this painting, distinguished by the richness of the luminous pigment applied with rapid strokes, by bursts of light, and by surprising touches of lead white and red that give an expressive vitality to the faces of the characters, we can already perceive the strong, essential language of Jacopo's last works, even if here he still lingers over descriptive details and notations of costume.

F.M.A.G.

Provenance
Sir Joshua Reynolds Collection, London, before 1792; Museum of Art, Rhode Island School of Design, Providence, 1952.

Exhibitions
Waltham 1963.

Bibliography
Fröhlich-Bum 1948, 170; Berenson 1957, I, 19; Arslan 1960 (B), I, 364; Gilbert 1963, no. 17, 24-25; Maxon 1963, 1-4; Rearick 1982 (A), 22.

Fröhlich-Bum first published this small picture as a sketch by Jacopo for an unexecuted *Birth of the Virgin*. Berenson accepted this attribution, but Maxon and, hesitantly, Gilbert assigned it to Francesco. Arslan merely listed it among products of the Bassano workshop with a warning that loose brushwork did not necessarily mean that it was a *bozzetto* by either Jacopo or Francesco. The present author returned it to Jacopo.

This rapidly sketched little canvas is evidently a *modello* for a larger picture, although none survives that is based directly on it. Its subject might be equally the birth of the Virgin or the birth of the Baptist, but the comparative rarity of the latter subject in the Veneto and certain details such as the bathing of the baby suggest that it is the Virgin and that the figures at top right are Anna and Joachim. Jacopo and Francesco had jointly created one of their most innovative nocturnes around 1576 in the *Joachim's Vision* (The Methuen Collection, Corsham Court). Both in subject and handling the Providence picture might have been pre-

pared as a pendant to that work, a painting that was still being reproduced in the Bassano shop more than a decade later as an unfinished replica (private collection, Bassano del Grappa) painted by Gerolamo with significant corrections by Jacopo in about 1589-91. *The Birth of the Virgin* modello fits well in these last years. Against an almost black bedroom environment, a phosphorescent light lends the figures a spectral aura evocative of a tremulous emotion bordering on dread, hardly to be expected of an event so filled with hope and joy. In this it most closely resembles *The Martyrdom of Saint Lawrence* (parish church, Poggiana), *The Annunciation to the Shepherds* (private collection, Padua), and *Christ Crowned with Thorns* (private collection, Rome, cat. 77), all visionary evocations of supernatural luminosity. Although neither Jacopo nor his shop seem to have developed this sketch in finished form, it appears to have remained in the family shop, since Leandro made free use of its components for several works such as *The Birth of the Virgin* altarpiece (parish church, Merlara), the *Portrait of an Elderly Woman* (Earl of Crawford and Balcarres collection, Balcarres), and the very late *Birth of the Baptist* (San Cassiano, Venice). None, predictably, captured or even aspired to the expressive depth of the present painting.

W.R.R.

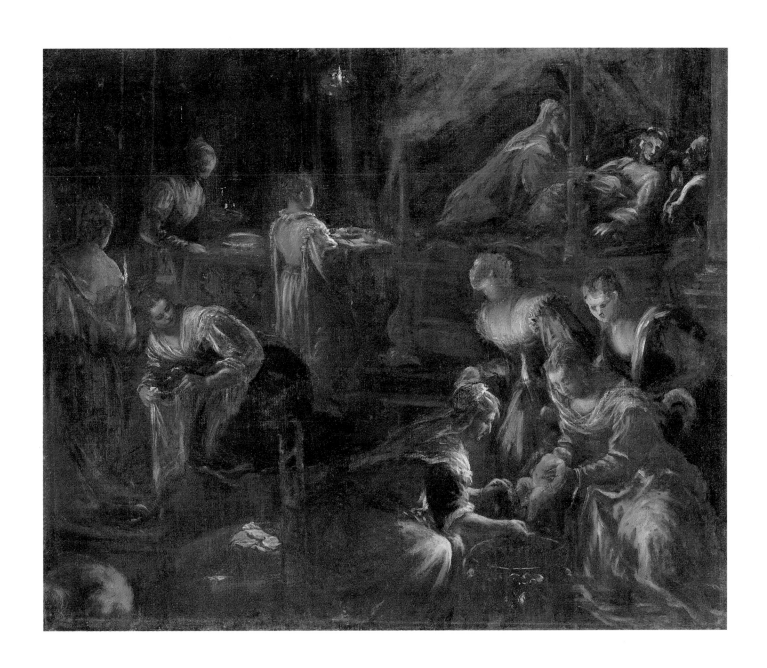

76. The Return of the Prodigal Son (c. 1585)

Private collection, Bassano del Grappa
Oil on canvas, 76×100.5 cm (29 7/8×39 1/2 in.)
Exhibited in Bassano del Grappa only

Provenance
Mr. and Mrs. Arthur Wisemburg, New York; Rose Art Museum, Brandeis University, Waltham, Massachusetts, 1960, inv. 99; sold Sotheby's, New York, 7 June 1978, lot 57.

Exhibitions
Never before exhibited.

Bibliography
Fredericksen and Zeri 1972, 19 and 643.

Indicated under the name of Jacopo Bassano in the census of Italian paintings in North American public collections edited by Fredericksen and Zeri in 1972 (19, 643), the painting returned to Italy after its sale at Sotheby's in 1978 (New York, 7 June 1978, lot 57). The auction catalogue lists it as the work of the circle of Jacopo and Francesco dal Ponte, derived from a similar painting in the Galleria Doria Pamphilj in Rome (fig. 61).

The Doria painting is signed by Jacopo and Francesco, but the feeling is that it was done largely (Arslan 1938, 469 ff.) or completely by Francesco (Sestieri 1942, 103; Rearick 1968 (A), 245, fig. 7; and Ballarin 1988, 4) in the second half of the 1570s.

Both compositions present the same architectural and spatial *mise en page*, and both use the same elements with some variations, in particular the servant quartering the calf hung by a hook from the fireplace wall and the meat on the stool being sniffed at by the cat. The canvas in the collection in Bassano, whose painting surface is slightly abraded, is about 25 centimeters smaller in both height and width, and also omits cer-

tain details, the most significant being the group of an old woman with a child behind the woman seated on the right.

While the Doria painting is characterized by a clearer definition of the drawing and colors of the architecture, figures, and objects, which are the hallmarks of Francesco's style, the one examined here reveals a painting style whose outlines are more blurred by the light, closer to the works of Jacopo in the 1580s. Here the pattern invented by the artist in the mid-1570s for his biblical scenes, such as *Christ in the House of Mary, Martha, and Lazarus* (Sarah Campbell Blaffer Foundation, Houston, cat. 61) and *The Supper at Emmaus* (private collection, cat. 62), is reproposed in a less descriptive, more «internalized» manner. Its synthetic and sketchy technique can be compared with works like *Susanna and the Elders* (Musée des Beaux-Arts, Nîmes, cat. 72) of 1585 and the contemporaneous *Diana and Actaeon* (The Art Institute of Chicago, cat. 73). The refined intonation of the color, in which the reds and the precious, light-soaked pink of the figure seen from behind stand out, is heightened by the last moments of twilight. The setting seems to be tied by silver filaments of light, reaching heights of great elegance, as in the detail at the upper right where, with the tip of his brush, Jacopo has outlined the arch of the barrel vault with a luminous thread against the darkness of the background, and the iron rod from which the barely sketched game has been hung.

That this is an autograph revision

of the subject done by Jacopo in the 1580s is given support by the presence of some pentimenti in the position of the face of the woman seated in front of the fireplace and in the servant in the foreground, who is seen from behind. We should also note that X-radiographs reveal the very beautiful movement in the highly expressive application of the paint, which can hardly be attributed to the assistants in his shop.

Finally, the inventory of the works present in Jacopo's studio at his death (Verci 1775, 96) lists as number 110 «Il figlio Prodigo, alto quarti cinque, e lungo quarti sete in circa» (The Prodigal son, five *quarti* high and about seven *quarti* long).

A comparison with the numerous works from Jacopo's last manner, united in this exhibition for the first time, gives us the opportunity to verify this hypothesis, with which Ballarin agrees (oral statement). In Rearick's opinion, this is the work of Leandro or, perhaps, Luca Martinelli (see here, Rearick's essay, especially n. 290).

P.M.

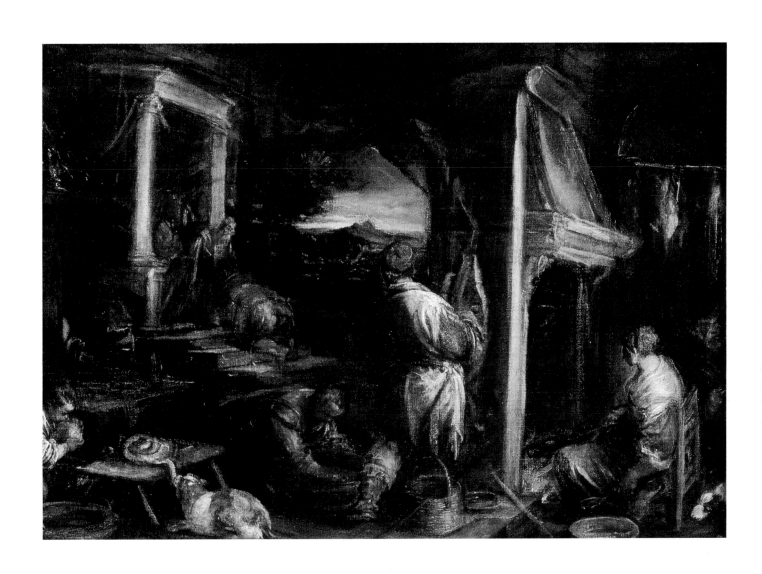

77. CHRIST CROWNED WITH THORNS (1589-90)

Private collection, Rome
Oil on canvas, 107×138 cm (42 1/8×54 3/4 in.)
Exhibited in Bassano del Grappa only

Provenance
Tinozzi collection, Bologna.

Exhibitions
Cleveland 1936; Venice 1957.

Bibliography
Bettini 1936, 146; Tietze and Tietze-Conrat 1944, 49; Pallucchini 1957, 114-15; Zampetti 1958, 50, fig. 15; Ballarin 1966, 130; Ballarin 1966-67, 159 ff.; Pallucchini 1981 (B), 271; Pallucchini 1982, 52; Penny 1990, 43, fig. 21.

The painting was published in 1936 by Bettini, who considered it one of Jacopo's last works. It was shown in the 1957 Venetian exhibition as an unpublished work by Jacopo (Zampetti 1957, 176, fig. 71), with its date moved earlier because of the impasse in which Bassano scholars found themselves as a result of neglecting or not recognizing the artist's activity after 1581. Pallucchini (1957, 114-15), who was aware of Bettini's attribution, repeated his observations that emphasized the evident relationship between Jacopo's work and Titian's *Crowning with Thorns* (Alte Pinakothek, Munich). A bit later Arslan (1960 (B), I, 332), denying any connection between this painting and Jacopo's other work, assigned it to the school of Bassano.

In the reconstruction of the final phase of Jacopo's activity, ably delineated by Ballarin (1966-67), *Christ Crowned with Thorns* occupies a very distinct place, which leads to «the final result of the *Christ Mocked at Night* in Oxford» (see here, cat. 78). We are already well into the 1580s, after 1585, the year of *Susanna and the Elders* (Musée des Beaux-Arts, Nîmes, cat. 72), in which we can de-

tect the passages – as in *The Flagellation of Christ* (The J.F. Willumsen Museum, Frederikssund, cat. 69) – from a «dream dimension...to the terrible thoughts, where all that can be felt is the urgency of a feeling of anguish» (Ballarin), which would dominate the «many actions of the passion of the Redeemer» represented «at night, with little light and vigorous shadows illuminated by flames and torches» (Ridolfi 1648, I, 394-95).

In this *Christ Crowned with Thorns* all the elements work together to take the dramatic tension to its highest pitch. Out of the dark shadows of a porticade emerge the figures of Christ and his torturers, struck by the reddish light shed by the two torches on the upper right and the brazier on the lower left. The light from the two sources meets and coagulates in the knot formed by the figures of the soldier, Christ, and the executioner. His lifted arm, innervated with blood, dominates the pyramid of the composition and, isolated from its dark surroundings by the light, becomes a symbol of brutal violence. This is a painting of great dramatic effect, obtained with very few colors, dominated by cadmium red, lead white with thin layers of glaze, and bitumen black. They are molded and mixed together with the artist's fingers, palette knives, and large brushes, and vigorously applied in a manner that heightens the tension of the gestures. Light takes on a determining role in this painting, «a light similar...to Rembrandt's, a light about which we can say only that it is the essence of the

life itself of the picture» (Bettini 1936, 147). The dog and objects in the foreground, evidence of Jacopo's undying attention to things, would be a superfluous intrusion if they were not absorbed into the shadows.

The marks of Titian's inspiration on this work are recognized universally and there is no need to comment here. But we can note how, beginning with the *modello* for the *Flagellation* in Frederikssund, Jacopo moves toward a different situation: while in Titian the ruffians are fiercely beating Christ, Jacopo blocks the violent gestures in midair and once again creates that climate of suspension and dramatic expectation that distinguishes his last works.

Tietze and Tietze-Conrat (1944, 49) have indicated in the Monachie collection in Camerton near Bath a drawing representing, with some variations, the figure of the executioner and the head of Christ. Rearick (1989) and Ballarin (1990 (B), 128 and 131) instead think it is a preparatory sketch for the earlier version of *Christ Mocked* (Gallerie dell'Accademia, Venice). A copy of the painting, with some variations, attributed to Leandro, is in the Museo del Prado, Madrid.

F.M.A.G.

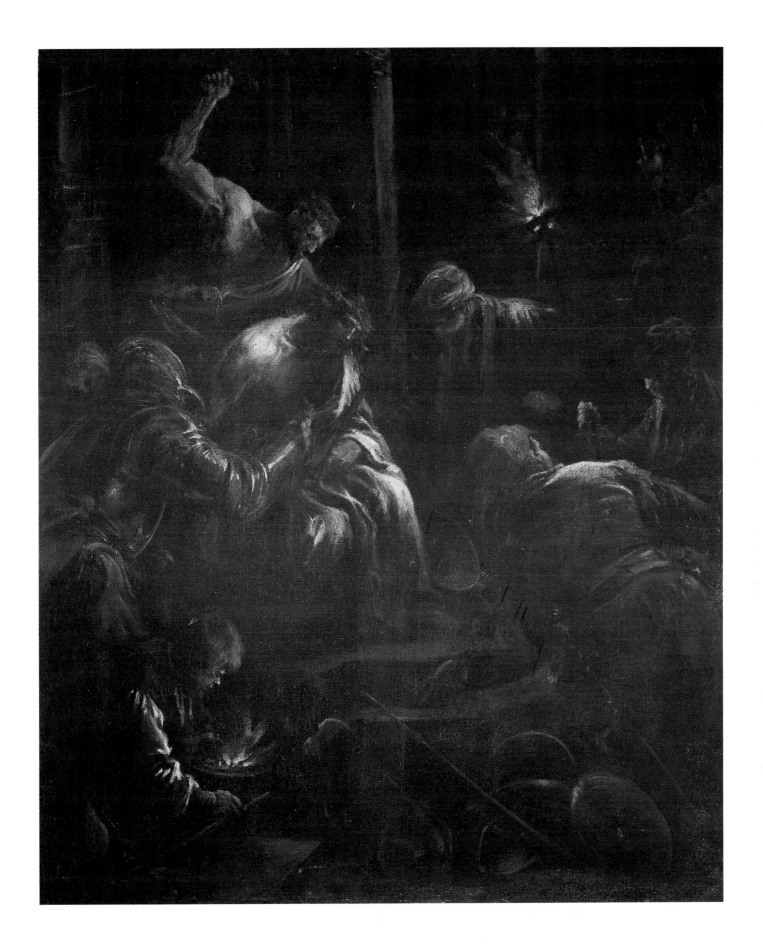

78. CHRIST CROWNED WITH THORNS (after 1590)

The Governing Body of Christ Church, Oxford
Oil on canvas, 107 × 138.5 cm (42 1/8 × 54 1/2 in.)
Exhibited in Bassano del Grappa only

Provenance
Guise Bequest, 1765, probably from the sale by Stephen Rougent, 1755, third day, lot 49.

Exhibitions
Never before exhibited.

Bibliography
Berenson 1911; Borenius 1916, no. 209; Arslan 1931, 347; Arslan 1960 (B), I, 359; Ballarin 1966, 124-31 and figs. 142-47; Byam Shaw 1967, 74, no. 92, fig. 77; Pallucchini 1982, 54.

The painting, after an attribution to Francesco by Borenius (1916, no. 209), with which Arslan did not agree (1960 (B), I, 359), was listed in the catalogue of the painting gallery at Christ Church, drawn up by Byam Shaw (1967, 74, no. 92) with an attribution to Jacopo(?). Although Byam Shaw had based this attribution on the certainty expressed by Ballarin (1966, 124-31) as to the presence of Jacopo's own hand, he preferred to remain cautious, stating that he was « still inclined to suspect that our picture, though perhaps representative of Jacopo's latest style, is no more than a product of the Bassano studio ». Pallucchini (1982, 54), instead, agreed unreservedly with the attribution to Jacopo.

This exhibition presents an exceptional occasion to work out a solution to this problem. The painting can be studied here more easily than has been possible up to now at Christ Church, where it is hung very high on the wall above a door. It can also be compared with another *Christ Crowned with Thorns* (private collection, Rome, cat. 77).

Ballarin subjected the Oxford *Christ Crowned with Thorns* to a very close and detailed analysis, in which he indicated its connections with other works of the artist's maturity, such as the Lehman drawing and *Lazarus and the Rich Man* (The Cleveland Museum of Art, cat. 24). He found closer and more direct links with the works from the second half of the 1580s, such as *Susanna and the Elders* (Musée des Beaux-Arts, Nîmes, cat. 72), the above-mentioned *Christ Crowned with Thorns* in Rome, and *Christ Praying in the Garden of Gethsemane* (formerly Agnew collection, London; present whereabouts unknown), which was shown in the 1957 Jacopo Bassano exhibition in Venice.

These works represent the results of Jacopo's last study of the possibilities of light. In them he dramatically exalts forms and colors through sudden contrasts of light, with unexpected flashes of color, thickening dark shadows and rapid streaks of lead white. These are the means and materials he uses in this new « expressionist dimension » of his art to which the scenes of the Passion of Christ belong. Their strong visual impact, in which the signs of a spiritual unease and interior anguish erupt, was probably fed by the climate of the Counter-Reformation in the years after the Council of Trent.

The inventory dated 27 April 1592, which lists the paintings found in Jacopo's house after his death, frequently records images of the *Ecce Homo*, Christ mocked at night, the flagellation, the « molte attioni della passione del Redentore » (many actions of the passion of the Redeemer). Ridolfi (1648) would later define them as « setting the subjects in the night time, with very few light sources and vigorous shadows, illuminated by flames and torches... ». This description is particularly apt for the Oxford picture, where the figure of the derided Christ is placed in the center of the composition, struck by the gleams of light from the torch on the upper right. He is surrounded and crowded by those who would do him harm, squeezed into a space, where there is no more room for objects, only for the contorted masks of the faces and the crudely ferocious gestures. This painting, when compared with the one in a private collection in Rome, has eliminated all the descriptive details (the boy blowing on the brazier, the dog, the basket with Christ's robes, the lance, and the second torch on the right side of the painting). In this tight circle of suffocating space, a fury of brushstrokes are concentrated, the only marks and movements of the violent act. Jacopo's consummate skill as a painter has allowed him to achieve a result of astonishing technical freedom and great consistency of expression. Those strokes of the brush dipped in red, yellow, and « mud », skillfully flung onto the surface of the finished painting, when seen up close could appear to be arbitrary, but from the proper distance seem to be an integral part of the unified chromatic economy of the work.

His meditation on the works of Titian's last years, as has been ob-

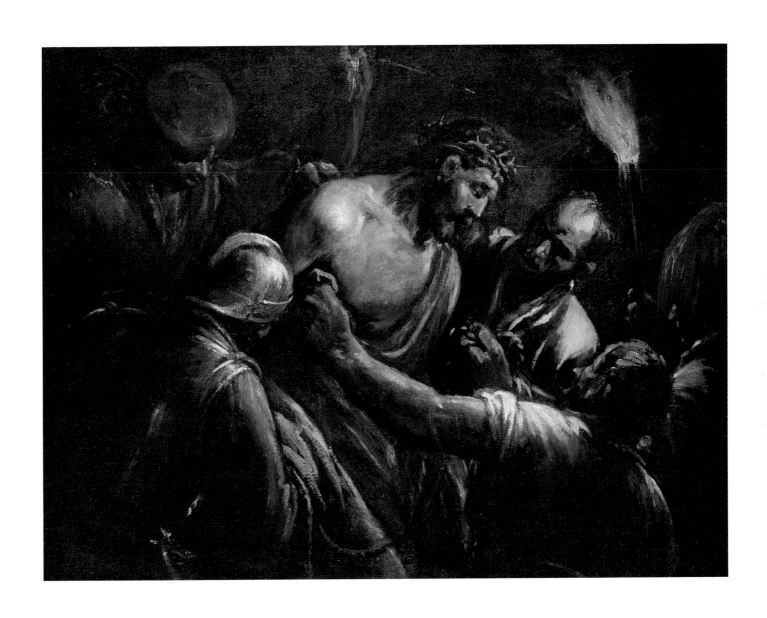

79. THE BAPTISM OF CHRIST (1592)

Private collection
Oil on canvas, 110×90 cm (43 3/8×35 1/2 in.)

served many times, certainly played a determining role in the evolution of Jacopo's late style. It is a style that already foreshadows the seventeenth century, and particularly, as far as this picture is concerned, shows a pre-Caravaggesque sensibility.

Another version of *Christ Crowned with Thorns* (Galleria Palatina, Palazzo Pitti, Florence, inv. 40) is signed by Jacopo and Francesco and dated to the 1570s (Ballarin 1966, 130). A seventeenth-century drawing is derived from the Oxford painting (The Art Institute of Chicago, Drawings Documentation Project, Department of Prints and Drawings, inv. 1922, 1056).

F.M.A.G.

Provenance

Estate of Jacopo dal Ponte, Bassano del Grappa, 1592; by descent to Carlo dal Ponte, Bassano del Grappa, 1648; art market, Munich, 1931.

Exhibitions
Never before exhibited.

Bibliography
Ridolfi 1648, 1, 389; Verci 1775, 94; Fröhlich-Bum 1931, 121-22; Fiocco 1931, 159; Benesch 1936, 60; Arslan 1960 (B) 1, 357; Rearick 1967, 104-7; Pallucchini 1982, 54-55; Rearick 1986 (A), 187.

Verci transcribed the inventory, now lost, made of the contents of Jacopo dal Ponte's studio in Bassano del Grappa on 27 April following the artist's death on 13 February 1592. Under no. 64 was recorded «The Baptism of Our Lord by Saint John the Baptist, which is an unfinished altarpiece» (*Il battesimo di N. S. da S. Gio. Battista, cioè una Tavola d'altare sbozzata*). Athough works left incomplete at the time of Jacopo's death seem for the most part to have been finished by his heirs and consigned to the clients who had commissioned them, this unfinished canvas was kept by the family as a revered relic of the old master's final creative effort. Gerolamo used it as the model for a replica that was doubtless delivered to the original patron, probably a provincial church to the southwest, since it is now on deposit at the Museo di Castelvecchio in Verona. The original remained in the Dal Ponte house, where Ridolfi saw it and subsequently described it as one of Jacopo's last, unfinished works. In Verci's time it had been dispersed, and it

would reappear only in 1931 in Munich, where Fröhlich-Bum published it as a finished work close in style to the Padua *Entombment* (cat. 52) of 1574. Fiocco shifted its date to late in Jacopo's career. Benesch accepted the attribution. Arslan preferred to list it among shop and wrongly attributed works. The present author confirmed that it was Jacopo's last, unfinished altarpiece. Pallucchini stressed its dramatic illumination.

Jacopo is known to have painted *The Baptism of Christ* (lost) in 1541 for the parish church at Foza, but it did not form a familiar or recurrent part of his later thematic repertory. Even his sons seem not to have treated it until after 1592, and Leandro's altarpiece (Oratorio dei Catecumini, Venice) betrays scarcely any allusion to his father's composition. It is characteristic of the isolation in which old Jacopo passed his last years that *The Baptism* altarpiece shows almost no awareness of the treatment of the theme by such contemporaries as Veronese and Tintoretto, but, instead, recalls with solemn restraint works of almost a century earlier, such as Giovanni Bellini's picture (Santa Corona, Vicenza). New, however, is the nocturnal setting, a deep night just broken by the first rays of the red sun rising on the horizon. Loosely sketched in parts such as the awe-stricken angels, but firm and assured in the blocking out of forms such as the Baptist's head and upraised arm, Jacopo's final effort is at once artless and powerfully evocative.

W.R.R.

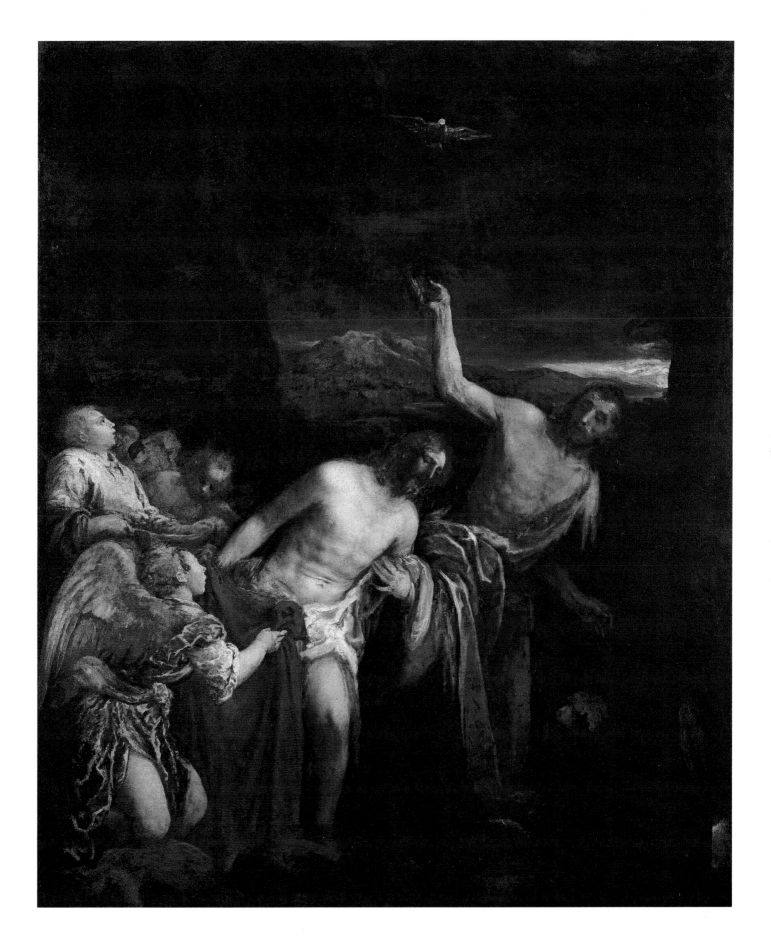

CATALOGUE OF DRAWINGS

80. Portrait of a Young Man in Profile (1538)

Musée du Louvre, Département des Arts Graphiques, Paris, inv. 5679
Black chalk with traces of red chalk in the eye sockets, nostrils and mouth, and white chalk on the collar, on beige paper, glued to a backing
339 × 244 mm
Inscriptions: on recto at bottom center in pen and brown ink two sixteenth-century inscriptions in two different hands, next to each other: « 1538 », probably in the handwriting of the artist, and on the right: « 21 »; below, in pen: « 63 »
Exhibited in Fort Worth only

Provenance
Glued on the backing are the collectors' marks of Alfonso III d'Este (L. 112) and Francesco II d'Este (L. 1893).

Exhibitions
London 1983.

Bibliography
Von Hadeln 1925, 21, pl. 15 (as Bernardo Licinio); Tietze and Tietze-Conrat 1944, 47-48 and 53, no. 192, pl. CXLI; Pallucchini 1957, 99; Zampetti 1957, 242, no. 13; Rearick 1958, 199-200; Arslan 1960 (B), I, 49 and 174, and II, fig. 31; Pignatti 1970, 9; Ballarin 1973, 92; Rearick 1978 (A), 162-63 and 168, n. 8; Rearick 1980 (A), 8 and 28; Pallucchini 1982, under no. 7; Scrase 1983, 246, no. D2, fig. D2; Rearick 1986 (B), I, 2, pl. I.

Among the few drawings that can be assigned to Jacopo's early activity, this impressive portrait can claim the longest tradition of attribution to the artist and the greatest critical acclaim. Assigned to Bernardo Licinio by von Hadeln, it was attributed to Jacopo verbally by Linzeler, who felt it was a study for one of the portraits in *The Adoration of the Magi* (The National Galleries of Scotland, Edinburgh, cat. 10). This opinion is cited by the Tietzes, who seemed inclined to accept it, albeit with some reservations, noting the combination between formal simplicity and psychological self-possession typical of the artist's early paintings. After this the attribution was no longer placed in doubt, nor was its debt to Pordenone's formal vision questioned after Pallucchini (1957) first pointed it out. Rearick (1958) pro-posed that the sheet could be linked to the figure of the page holding a platter of food in *The Supper at Emmaus* (Kimbell Art Museum, Fort Worth, cat. 4), thought to be of the same year. More recently, Rearick (1978 (A); and 1986 (B)) has moved the date of the drawing later, to about 1540, interpreting the drawing as a portrait from life, perhaps of one of Jacopo's brothers.

Pordenone's influence can be seen in the integral volumes and plasticity of the figure. This influence is expressed more explicitly in the altarpiece depicting *The Madonna and Child with Saints John the Baptist and Zeno* (parish church, Borso del Grappa, cat. 3), also dated 1538. In the drawing, the plastic vigor is used to establish the direction of the light and to render the material texture of the surfaces. With variety and richness, the chalk creates the densely hatched network of the right profile, which is cast in shadow, and the softer surface of the cheek, giving it a grainy appearance where the light strikes it, and finally, with a few summary strokes, indicates the right arm set back. Carefully graduated shadows highlight the volume of the cheek and the collar, which stands out slightly from the jacket, and define almost geometrically the faceted structure of the sleeve and the rough roundness of the subject's cap. This keen attention to the behavior of light combined with a subtle naturalistic observation harks back to Jacopo's interest, which he had man-ifested many times as a young man, in the artistic developments of the Po valley, Lorenzo Lotto, and the painters of Brescia. Signs of this interest are certainly seen in the detail of the lip shadowed with a light moustache, the acute definition of the lock of hair escaping along the boy's cheek, the tasseled collar highlighted in white, and the traces of red chalk on the eye sockets, nostrils, and mouth.

Attribution of the drawing to Jacopo, whose vocation for portrai-ture is already evident in the small votive altarpiece depicting *The Podestà of Bassano Matteo Soranzo with His Daughter Lucia and His Brother Francesco Being Presented by Saints Lucy, Francis, and Matthew to the Madonna and Child* (Museo Civico, Bassano del Grappa, cat. 2) and the canvases with stories from the Old Testament painted for the Palazzo Pretorio in Bassano (now Museo Civico, Bassa-no del Grappa; see cat. 115 and fig. 11), finds support in a comparison with the *Portrait of a Venetian Gentle-man* (Memphis Brooks Museum of Art, cat. 5), signed by the artist and of just a slightly later date, where the treatment of the face shows a simi-larly acute awareness of light.

V.R.

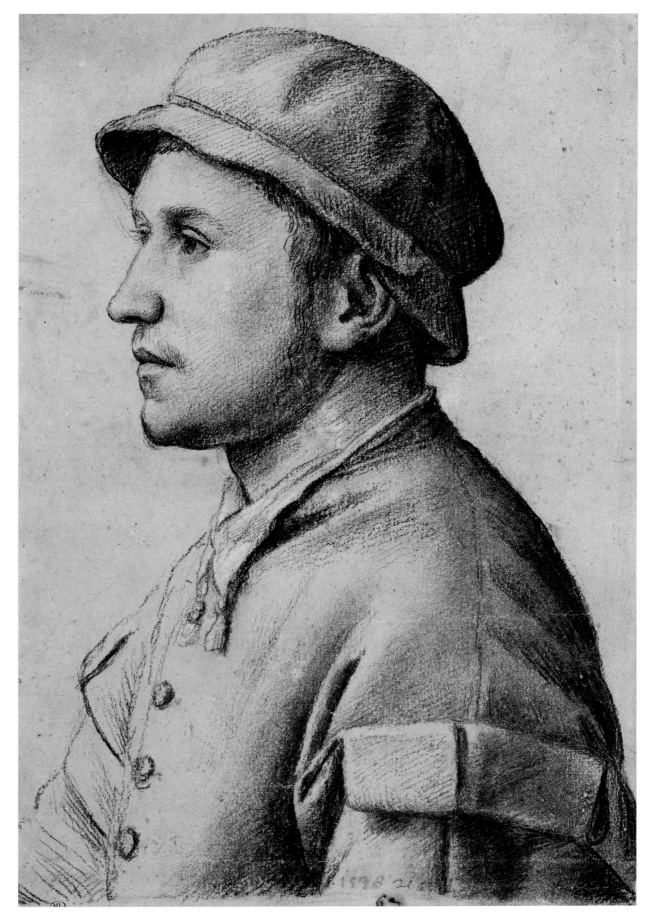

457

81. Six Studies of Male Heads (1539)

The Duke of Devonshire and the Chatsworth Settlement Trustees, Chatsworth, inv. 56
Black chalk on apricot prepared paper; the six drawings are glued and mounted on one backing
58 × 49 mm; 56 × 45 mm; 59 × 50 mm; 50 × 50 mm; 55 × 49 mm; 55 × 50 mm
Exhibited in Bassano del Grappa only

Provenance
Early history unknown.

Exhibitions
Never before exhibited.

Bibliography
Rearick 1978 (A), 163-64 and 168, figs. 4 a-f; Rearick 1986 (B), 1, 3, pl. 1.

These six studies, originally done on the same sheet, were discussed by Rearick with regard to the problem of reconstructing Jacopo's early graphic activity. He confirmed the attribution to the artist, which had been expressly questioned in an anonymous notation written on the mount. Rearick pointed out a series of links with works datable around 1538 or soon thereafter, in particular the *Samson and the Philistines* (Gemäldegalerie Alte Meister, Dresden, fig. 100), the frescoes on the façade of the Casa dal Corno (cat. 116), the earliest version of *The Martyrdom of Saint Catherine* (known through a copy, Museo Civico, Bassano del Grappa, inv. 326), and *The Adoration of the Magi* (Burghley House Collection, Stamford, fig. 16). The only cases in which the correspondence between these paintings and the Chatsworth drawings appears to be exact are: the Philistine to Samson's left in the Dresden canvas and the Chatsworth boy with the lock of hair on his forehead; and the young groom next to the horse in the Burghley House *Adoration* and the Chatsworth boy with his mouth open. In the other cases the resemblance seems more generic.

The unusual technique of using black chalk on paper prepared with an apricot-colored wash and the modest quality of the drawings gives me some reservations about the attribution to Jacopo. I would leave open the hypothesis that the heads could be copies, rather than preparatory sketches.

V.R.

458

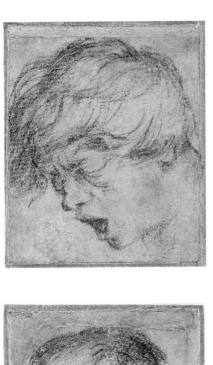
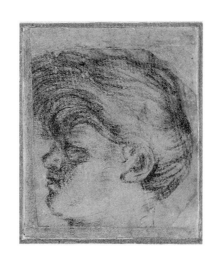
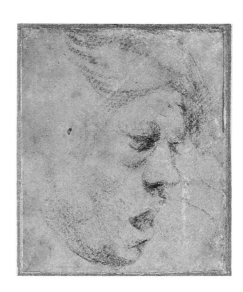
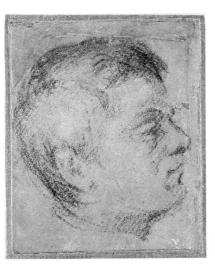
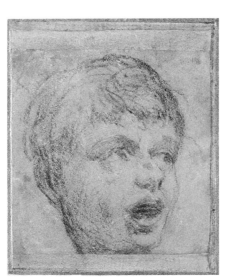
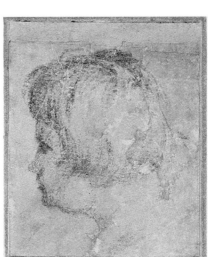

82. SAINT JOSEPH (c. 1542-43)

Private collection, New York
Black, white, and red chalk, washed slightly in the red area on faded blue paper, glued to a backing
156 × 130 mm
Inscriptions: in pen on the mat: « Tiziano Vecelli fece »
Exhibited in Fort Worth only

Provenance
Unidentified collector's mark consisting of the letter M inside an oval.

Exhibitions
New York 1973.

Bibliography
Stampfle and Denison 1973, 31, no. 27, pl. 27 (as attributed to Jacopo Bassano); Rearick 1978 (A), 166 and 168 n. 14; Rearick 1986 (B), 1, 4, pl. III.

This drawing was first published with a tentative attribution to Jacopo Bassano by Stampfle and Denison, who compared the head with that of Saint Joseph in Jacopo's early *Flight into Egypt* (Museo Civico, Bassano del Grappa, cat. 1) and that of Saint Joseph of Arimathea in *The Pietà* (parish church, San Luca di Crosara). The drawing was then linked by Rearick to the profile of Saint Joseph in *The Flight into Egypt* (The Toledo Museum of Art, cat. 11), for which it is a preparatory study, eliminating any doubt as to its authorship. The connection with the painting makes this sheet one of the few certain drawings from the artist's early years.

The Flight into Egypt was painted in the early 1540s, after 1541 when Jacopo had finished the small altarpiece depicting *Saint Anne and the Virgin Child with Saints Jerome and Francis* (Museo Civico, Bassano del Grappa, cat. 7), and at a moment when his style was particularly close to the naturalism of Lorenzo Lotto and the Brescian painters. At the same time, he was experimenting with the first mannerist constructs being offered by Salviati, but had not yet reached the crisis marked by *The Martyrdom of Saint Catherine* (Museo Civico, Bassano del Grappa, cat. 13). Even though the head of Saint Joseph in the Toledo *Flight into Egypt* does not reach the heights of originality represented by the faces of the two shepherds behind the Virgin, which are characterized by a harsh naturalism, it is made of the same thick, rough material and given density by the sharp contour lines sculpted by the light. These traits are foreshadowed in the drawing by the vigorous strokes in red and black chalk, which are gone over again several times in an attempt to adjust the outlines, by the hard lines of the facial features, seen especially in the wrinkle in his cheek, and by the intense shading around the temple in contrast with the dense, vaporous treatment of the beard and hair.

V.R.

460

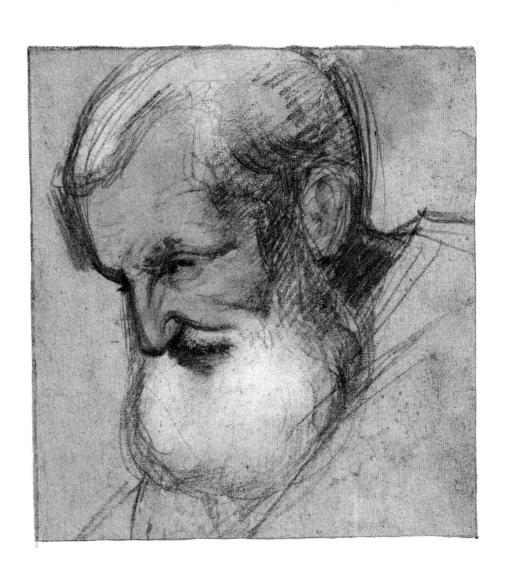

461

83. Bearded Male Head in Profile (c. 1550)

Museo Civico, Bassano del Grappa, inv. 111578
Pen and brown ink on white paper; slightly irregular edges, horizontal fold fairly close to the upper edge
137×90 mm (maximum dimensions)
Exhibited in Bassano del Grappa only

Provenance
Private collection, Bassano del Grappa; gift of the API di Mussolente to the Museo Civico, Bassano del Grappa, 1990.

Exhibitions
Never before exhibited.

Bibliography
Rearick 1986 (B), 1, 7, fig. c; Puppulin in Muraro 1992, appendix VII.

This sheet, evidently a scrap, was originally inserted between the pages of the *Libro secondo*, which was recently acquired by the Museo Civico, Bassano del Grappa. The *Libro secondo* records the accounts of the Dal Ponte workshop up to the beginning of the 1550s. This drawing is on a different kind of paper from the pages of the *Libro secondo*. The head shown in profile is drawn in brown ink of a cool tone, identical to that used for the numbers and letters that also appear on the sheet. The verso consists of a series of notations of expenses written in pen and a brown ink of a warmer shade. They are transcribed in the appendix of the recently published edition of the *Libro secondo* (Muraro 1992), where the handwriting on both sides of the sheet is identified as that of Giambattista, Jacopo's brother. On the basis of some notations concerning the purchase of soap and the mention of a « messer Zuanne », who may be the cloth merchant Zuanne da Lugo, Puppulin suggests that the notes were made in 1542, but does not offer other evidence to support this hypothesis. In attributing the drawing to Jacopo, Rearick felt that it was inspired by Niccolò Vicentino's woodcut of *Christ Calling the Apostles* – could this be *Christ and His Apostles Healing the Lepers* (Bartsch 1803 21, XIV, 39, no. 15), a chiaroscuro woodcut derived from a drawing by Parmigianino now at Chatsworth (inv. no. 335)? – and proposed a date of c. 1549.

The mannerist nature of the hand revealed in this quick sketch makes the attribution to Jacopo plausible. The head can be compared with the faces of the wounded man in *The Good Samaritan* (The Royal Collection, Hampton Court, fig. 25) and of Saint John the Baptist in *The Beheading of the Baptist* (Statens Museum for Kunst, Copenhagen, fig. 29), which would limit the date to the end of the 1540s.

V.R.

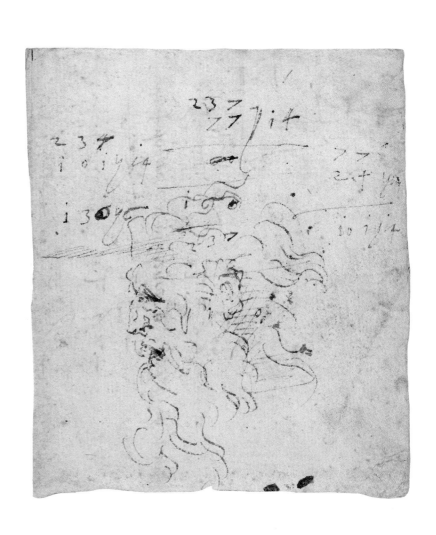

84. STUDY FOR THE GOOD SAMARITAN (c. 1557)

Private collection, Chicago
Black chalk, colored chalks (pink, violet, brown), heightened with white chalk, pen and brown ink on blue paper; irregular edges and the slight trace of a vertical fold in the center
271 × 354 mm (maximum dimensions)
Inscriptions: on recto in pen, on lower right, in a seventeenth-century hand: « Giacomo Bassano »
Exhibited in Fort Worth only

Provenance
The drawing was originally glued to a paper mount with a pen inscription in a seventeenth-century hand: « B.B. n° 23 » and was mounted on a larger sheet of paper with a pen inscription in a seventeenth-century hand: « B.B. n° 74 ». This type of mount and the inscriptions indicate a provenance which is currently thought to be either the Borghese or Sagredo collection; private collection, Lyons; Hazlitt, Gooden and Fox, London and New York.

Exhibitions
London 1991 (B); New York 1992.

Bibliography
Rearick 1987, II, 4, pl. III; Scarpa 1987, 394, fig. 12; *Italian Drawings* 1991, no. 9, ills.

Added just recently to Jacopo's corpus of drawings, this preparatory study for the figure of the wounded man in *The Good Samaritan* (The National Gallery, London, fig. 40; see Ballarin 1973, 94 and 100, fig. 123, who dates it c. 1557; and Rearick 1987, II, 4, who dates it c. 1560-61) makes a fundamental contribution toward the reconstruction of his career as a draughtsman before 1568. The task for the moment rests with just a few drawings on which critics do not all agree. As one of the earliest known examples of Jacopo's figure studies in colored chalks, this sheet serves as an introduction to his graphic production in this medium.

At first the artist seems to have explored with a light, but precise black chalk line the idea of a figure lying back with his legs bent and close together, so that the right knee was higher than the left one. The result recalls the pose of figures that recur throughout Jacopo's paintings of the second half of the 1550s, such as Adam in *Adam and Eve after the Fall* (Galleria Palatina, Palazzo Pitti, Florence, fig. 37) or the shepherd in the foreground of *The Annunciation to the Shepherds* (National Gallery of Art, Washington, cat. 30). The pose must not have satisfied him here, because he went on to revise his first idea by articulating the legs in a scissors effect, following a more openly artificial and ornamental concept of form, which he would complete by letting the right arm dangle toward the exterior of the scene. This arm is bent slightly around what seems to be a summary sketch of the Samaritan's knee. Although this was still not the final solution he would adopt in the painting, where the position of the figure's right leg, arm, and head would be modified, Jacopo makes the unusual choice of going over the figure's outlines in pen and brown ink, which he also uses to define more amply the head and muscles of the back. He goes on to study the play of light through the use of colored chalks. The white chalk with silver overtones gives a marbled effect foreshadowing the cold, thin sheath of light surrounding the figure in the painting, then thickens at the joints of the shoulder and knee to emphasize the mannerist articulation of the form. It is blended with pink, violet, and brown to render the opalescent surface of the flesh of the thigh and ribs. Touches of black, brown, and violet chalk sculpt the shadows, giving them an ashen tonality that recurs in other paintings of this period, especially *Saint John the Baptist in the Wilderness* (Museo Civico, Bassano del Grappa, cat. 29) of 1558. This picture is very closely related to the Chicago drawing, which gives new support to the affinities linking it with the painting in London.

Because it is easy to date, this drawing is extremely helpful for understanding the painter's orientation in the second half of the 1550s. A comparison with a *Figure Study* (private collection, Paris; see Ballarin 1973, 112 and 117-22, fig. 140) allows us to date the second drawing to the same phase in Jacopo's career. The drawing in Paris reveals the same attention to the definition of the figure's elongated structure, dwelling on the dynamism of the joints, and a robust construction of the form achieved through the use of colored chalks only in certain areas. It also shows the same violent contrast between the idea of a cold light blocked at the surface and the areas of violet-colored shadow.

V.R.

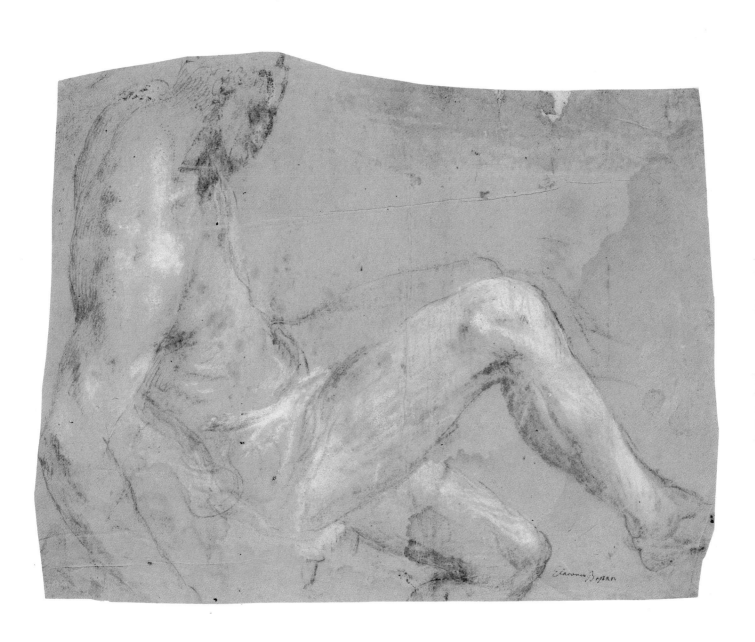

465

85. SAINT PAUL (c. 1559)

Graphische Sammlung Albertina, Vienna, inv. 1553 (Ven. 72)
Black and colored chalks (brown, pink, ocher, violet) on blue paper, glued to a backing
132 × 132 mm
Inscriptions: on the recto in lower left corner in pen and brown ink in an eighteenth-century hand: « Bassano »
Exhibited in Fort Worth only

Provenance
Albert von Saxe-Teschen (L. 174).

Exhibitions
Venice 1957; Venice 1961; Paris 1975.

Bibliography
Wickhoff 1891, no. 138; von Hadeln 1926, 17, pl. 76; Stix and Fröhlich-Bum 1926, 46; Arslan 1931, 196, pl. xcvi; Fröhlich-Bum 1931, 125; Bettini 1933, 127; Tietze and Tietze-Conrat 1944, 48 and 54, no. 200; Zampetti 1957, 250, no. 17; Muraro 1957, 296; Pallucchini 1957, 118; Zampetti 1958, 242, no. 17; Arslan 1960 (B), I, 178; Benesch 1961, 37 38, no. 40; Pignatti 1970, 9 and 83; Koschatzky, Oberhuber, and Knab 1972, no. 64; Ballarin 1973, 107, 112, and 119 20; Oberhuber 1975, 128, no. 56; Rearick 1978 (A), 161 and 168, n. 4; Rearick 1980 (A), 29 and 31; Pallucchini 1982, no. 31; Rearick 1987, II, 2, pl. II-a; Attardi 1991, 213; Birke 1991, 105-6, fig. 127.

The traditional attribution to Jacopo is attested to by an eighteenth-century inscription. It was confirmed by Wickhoff at the end of the nineteenth century, but only in the early 1930s did Fröhlich-Bum establish a connection between this drawing and the head of the first apostle on the left in *The Descent of the Holy Spirit*, which was painted for the altar of the Holy Spirit in the church of San Francesco in Bassano (now Museo Civico, Bassano del Grappa, cat. 119). As early as Verci (1775), the altarpiece was considered an example of the artist's late manner. For a long time, it was thought to have been painted around 1570. Only recently have scholars moved its dating to c. 1559 on the basis of its Salviatesque treatment of the form and the violence with which the

light assaults the surface (Ballarin 1973, 101-5; and Rearick 1978 (A)). Both of these aspects fit well into Jacopo's development after *Saint John the Baptist in the Wilderness* (Museo Civico, Bassano del Grappa, cat. 29), which we now can document in 1558 (Sartori 1958 (A); and 1958 (B)), as Venturi (1929 (B), 1182-85, had intuited some time earlier. The establishment of this earlier date and the discovery of a series of drawings, which are usually said to come from the Borghese collection, have allowed us to begin to fill in the lacunae in our knowledge of the artist's graphic activity between the *Portrait of a Young Man in Profile* (Musée du Louvre, Département des Arts Graphiques, Paris, cat. 80) dated 1538 and the studies of the 1570s. Ballarin (1973) assigned to the period between 1555-62 not only this drawing, but two unpublished drawings, the study of a reclining figure (private collection, Padua) and a study of a figure (private collection, Paris). These joined *Diana in the Clouds* (Christ Church, Oxford, cat. 86), which previously had been dated c. 1558; Ballarin also dated a study of a male figure (Hessisches Landesmuseum, Darmstadt, inv. AE 1432) around 1561. Two important preparatory studies, one (cat. 84) for *The Good Samaritan* (The National Gallery, London, fig. 40), and another for Saint Paul (cat. 87) in the Santa Maria dell'Umiltà altarpiece depicting *Saints Peter and Paul* (Galleria Estense, Modena, cat. 34), first published by Rearick (1987, II, 4 and 6), belong to this period as well.

The drawing is thus one of the

earliest known colored chalk studies. The ovoid shape of the balding head and the sharp profile of the face, recurrent elements in Jacopo's paintings during the second half of the 1550s, take shape through abbreviated, interrupted strokes of black and red-brown chalk, pressed forcefully into the blue paper, in contrast with the light, transparent movement of the chalk over the flesh tones. In the same way rapid, dense strokes of black chalk create the locks of hair and the goatee beard on a gray shaded ground. This handling of his materials, besides accentuating the febrile nature of the sketch, effectively foreshadows the expressive tension and anti-naturalistic attitude of the painting. Equally evocative is the study of the behavior of light. On the neck and head, struck by the light, the red brightens and bleaches toward yellow, then cools into violet in the profile immersed in shadow and the ashen gray of the beard. A similar result of a luminous synthesis of the form can be seen in the seated figure in the right foreground of the *modello* for *Saint Paul Preaching* (Musei Civici, Padua, cat. 32) from around the same year. The facial type and even the handling of the brushwork are so similar to this drawing as to posit, as Ballarin correctly did, that the sketch was used again, reversed, for the *modello* in Padua. Connections have also been established between *The Descent of the Holy Spirit*, a drawing of *Saint Peter* (Royal Library, Windsor Castle, cat. 93), and a study for Saint Peter in black and white chalk on blue paper, formerly in the Russel collection

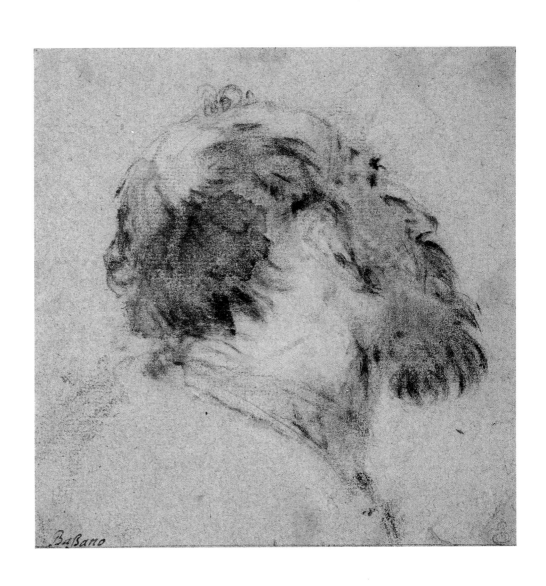

Bassano

467

86. THE LADY OF THE APOCALYPSE (DIANA IN THE CLOUDS) (c. 1558-60)

The Governing Body of Christ Church, Oxford, inv. 1341
Black chalk, heightened with white and gray wash, on blue paper
508 × 379 mm
Inscriptions: on the eighteenth-century mat: «Giacomo Pontormo»
Exhibited in Fort Worth only

and mentioned in 1976 as being in a private collection in Montreal. Beginning with von Hadeln (1926, 17, pl. 74), it was considered to be autograph, but recently Rearick (1978 (A), 168, n. 4) has placed the attribution in doubt. However, until he can study the drawing directly, he prefers to consider it a copy made by Jacopo's son Francesco at the beginning of his apprenticeship.

V.R.

Provenance
Sir Peter Lely (L. 2092); General John Guise.

Exhibitions
Washington 1972; Philadelphia 1972; New York 1972; Cleveland 1972; Saint Louis 1972; London 1983; Ingelheim am Rhein 1987.

Bibliography
Ballarin 1969, 104-8, 113, n. 51, and fig. 121; Byam Shaw 1972, 16, no. 4; Ballarin 1973, 93; Byam Shaw 1976, I, 202, no. 751, and pl. 464; Pignatti 1977, no. 44; Scrase 1983, 246, no. D I, ills.; Whistler 1987, 82, no. 27; Rearick 1989, III, 13, pl. VI.

The drawing was attributed to Jacopo by Philip Pouncey in a handwritten note on the mat. Its technique, careful finish, and large size all lead Ballarin to classify this sheet as Jacopo's earliest *modello*. In this time, making *modelli* or cartoons in order to test the invention in its definitive form before going on to the actual painting was not yet part of the organization of the workshop. The making of *modelli*, frequent among painters of central Italy and Venetian artists most aware of central Italian practice, is documented in Jacopo's later years by sheets such as *The Archangel Gabriel* (Christ Church, Oxford, cat. 99) and *The Virgin Annunciate* (Gabinetto Disegni e Stampe degli Uffizi, cat. 98), both dated 1569, or the *Woman and Child* (Musée Fabre, Montpellier, cat. 89), which is linked to *Saint Eleutherius Blessing the Faithful* (Gallerie dell'Accademia, Venice, cat. 40). It is a procedure that would be adapted by Jacopo to meet the needs of his shop as a work progressed. Rearick, too,

agreed that the Oxford sheet was a preparatory study, but felt that the other drawings mentioned above were *ricordi* done once the painting was finished. He also suggested that the subject here might be the Lady of the Apocalypse and connected the drawing with a painting, known only from an old photograph, attributed to Francesco Bassano during his Venetian period, around 1583, representing *The Vision of Saint John the Evangelist on Patmos*. Perhaps the painting can be identified as the altarpiece for San Giovanni Nuovo, Venice, where the saint sees the Lady of the Apocalypse seated on clouds with a crescent moon under her feet. It seems to have been inspired, with some variations, by this drawing. On this occasion, Francesco could have reused a study done by his father sometime around 1570-72 as he worked to invent a prototype for the same subject, or less likely, a story from the myth of Diana. As I was not able to find documentation concerning the painting mentioned by Rearick, the question of Francesco's reutilization of the drawing a good number of years after it was done must remain suspended for the moment.

Viewed from below and arranged with regard to the picture plane in «forklike» movements enclosed within an undulating contour line that bends her robust shape into an impossible, but elegant position, the figure declares its origin at a moment when Jacopo was responding to impulses coming from both Salviati and Veronese, which would culminate in Venice around the end of

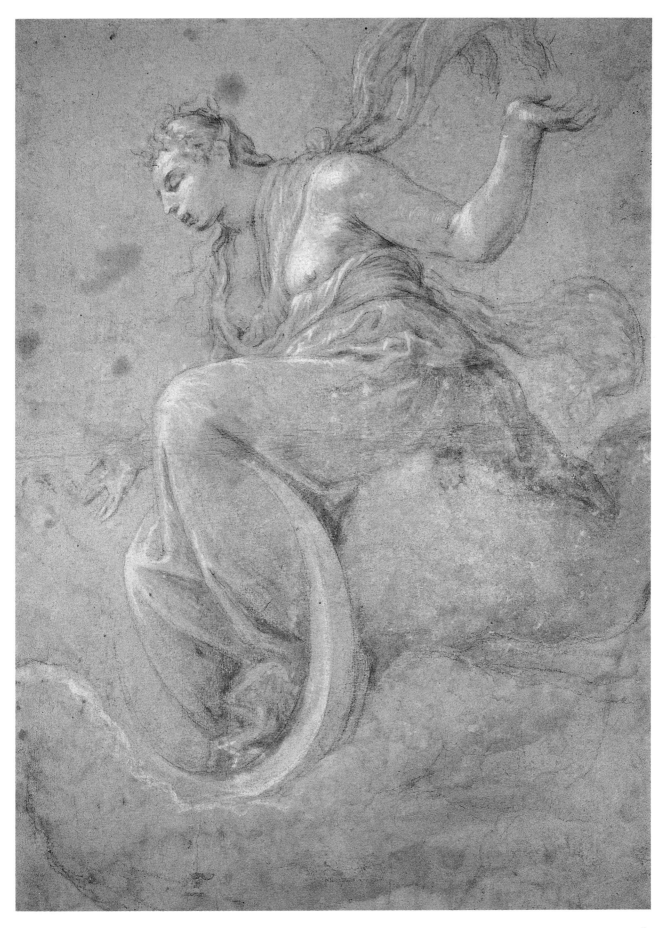

87. SAINT PAUL (c. 1561)

Hazlitt, Gooden and Fox, London
Black chalk heightened with white on blue paper, irregular edges, some paint spots and the slight trace of a horizontal fold in the bottom half of the sheet
208 x 193 mm (maximum dimensions)
Inscriptions: on the recto in the upper right-hand corner in pen and brown ink in a seventeenth-century hand: « Giacomo Bass…/ all'Umiltà »; on the verso in pen and brown ink: « B.B. n° 7 »
Exhibited in Fort Worth only

the 1550s with their decoration for the Libreria Marciana. Formal affinities can be found with: the figure of the wounded man in *The Good Samaritan* (The National Gallery, London, fig. 40); *Saint John the Baptist in the Wilderness* (Museo Civico, Bassano del Grappa, cat. 29) of 1558; Saint Justina in the Enego altarpiece (cat. 31); *The Madonna and Child with the Baptist* (Galleria Palatina, Palazzo Pitti, Contini-Bonacossi bequest, Florence, fig. 23); the Madonna in a private collection in Milan (Ballarin 1968 (A), 43-45, figs. 53 and 55); and the Madonna in *The Madonna and Child with the Infant Baptist* (formerly the Earl of Spencer, Althorp House, London, fig. 36) dated c. 1558-59, which represent the theme of the Virgin and Child with the young Saint John the Baptist. The latter is linked to the figures of the mother and child in the left foreground of *Jacob's Journey* (The Royal Collection, Hampton Court, cat. 33). All of these pictures help place this sheet at the final moments of Jacopo's mannerist season. The concept of suggesting light by scattered touches of white and bursts of light that underline the elegance of the form recalls the Saint Justina in the Enego altarpiece, while in a more general way the handling of the drawing can be compared to *Saint Paul Preaching* (Galleria Estense, Modena, cat. 32), which by virtue of being a *bozzetto* is closer in technique to drawing. This can be seen especially in the detail of the two women in front of the saint.

V.R.

Provenance
The inscription on the verso and the original mounting on an album page with the indication « B.B. 101 » in pen and brown ink designate a provenance conventionally called Borghese or Sagredo collection.

Exhibitions
London 1991 (B); New York 1992.

Bibliography
Rearick 1987, II, 6, pl. IV; *Italian Drawings* 1991, no. 8, ills.

An old inscription on the recto of the drawing, recently brought to light by Rearick, gives the correct indication of its authorship and destination. This is a study for the figure of Saint Paul, who appears in Jacopo's first important public commission in Venice, the altarpiece at one time in the church of Santa Maria dell'Umiltà depicting *Saints Peter and Paul* (Galleria Estense, Modena, cat. 34), whose date oscillates in the opinion of modern scholars within the first five years of the 1560s. The abrupt interruption of the figure at the hips and the irregularly cut lower edge with signs of a fold near the bottom suggest that the sheet originally included the full figure. The elegantly tapered form, with the hint of a twisting motion, reappears unchanged in the painting. The form shows signs of Jacopo's debt to Salviati and Parmigianino during this, his mannerist, season. This is also evident in the insistent modeling of the figure using shadows and by the claw-like appearance of the hand on the hilt of the sword. The white chalk, applied with a light marbleized effect, slides across the surface

in a refined, cool light that checks the pictorial qualities of the black chalk. Jacopo obtains from this technique a result different from Titian's tonalism, more comparable to the effect in the drawings of Paolo Veronese, whose influence is easily perceived in the sheet. This technique can be compared to that in a study of a reclining figure (private collection, Padua; see Ballarin 1973, 91-92, fig. 121; and Rearick 1986 (B), I, 6, pl. V), which is done in white and black chalk on blue paper. It is slightly less finished and is dated earlier, around the mid-1550s.

V.R.

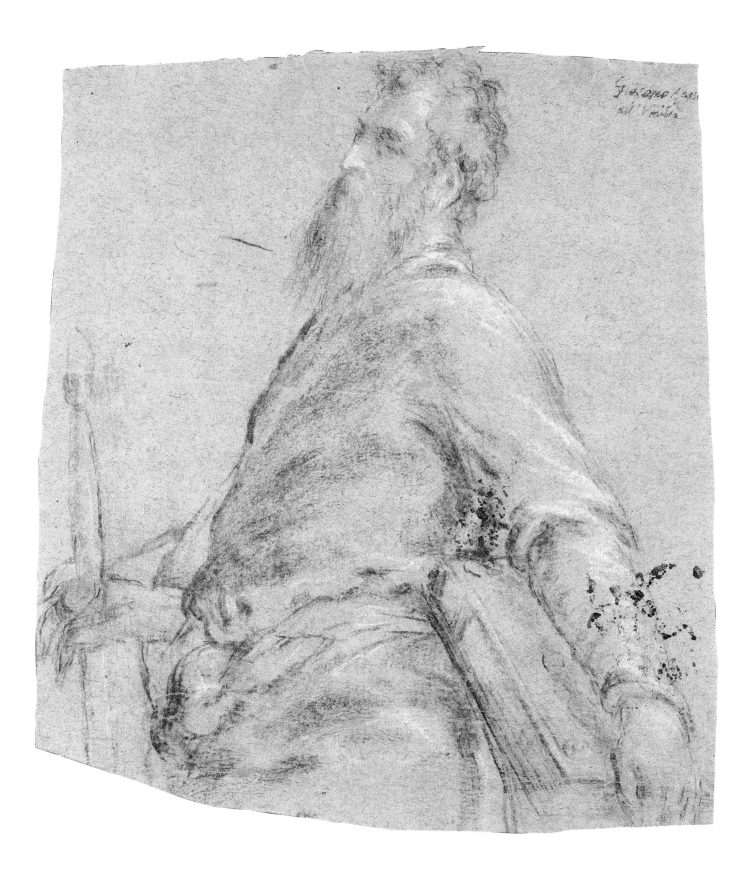

471

88. Jude and Tamar (c. 1563)

Gabinetto Disegni e Stampe degli Uffizi, Florence, inv. 13073 F
Brown wash, heightened with white over black chalk, on completely faded blue
paper, glued to a backing, some spots and signs of a vertical fold near the center
300 × 429 mm
Exhibited in Bassano del Grappa only

Provenance
Early history unknown.

Exhibitions
Never before exhibited.

Bibliography
Tietze and Tietze-Conrat 1944, 45, no.
93 (as workshop of Francesco Bassano);
Arslan 1960 (B), I, 217 (as Francesco Bassano?); Rearick 1987, II, II, pl. VI; Ballarin
1990 (B), 124, ills.

The sheet illustrates the left side
of a scene representing the meeting
between Jude and Tamar, known
today through the many workshop
versions including one in the
Galleria degli Uffizi, Florence (inv.
927), to which two other episodes
from the same biblical story can be
linked, *Hirah Searching for Tamar*,
known only from workshop replicas, and *Tamar Brought to the Stake*,
documented by the autograph canvas in the Kunsthistorisches Museum, Vienna (cat. 38). The date of
these canvases oscillates between
1563 and 1567. Jacopo's authorship of
the drawing first was proposed by
Rearick, who moved it from Francesco's portfolio to that of the father.
Ballarin agreed. More controversial
is the question of the role played by
sheets like this one, which are quite
frequent in Jacopo's corpus. They
are generally of a large size, executed with a black chalk outline, brown
wash, and highlights of lead white
on blue paper. They are very carefully finished and often coincide exactly with the painted version of the
same subject. According to Rearick,
Jacopo started making drawings of
this type around the middle of the
1560s, copying the composition from
the finished painting in order to record and save the invention, or parts
of it, so that it could be used again by
the workshop, which was beginning
to take shape as Francesco began his
apprenticeship. Later on this task of
copying would fall to his sons, but in
cases like this one and the drawing
of a *Woman and Child* (Musée Fabre,
Montpellier, cat. 89), which is linked
to *Saint Eleutherius Blessing the Faithful*
(Gallerie dell'Accademia, Venice,
cat. 40), from more or less the same
time, the older artist started the
practice as an example for his son,
who was just beginning his training.
For Ballarin, instead, the high degree
of finish and correspondence with
the painted version cannot be explained, at least in these two cases, as
ricordi, or records, but rather are instances of a fully realized drawing,
ready for transfer onto the canvas,
that is a *modello* or cartoon typical of
the graphic production of central Italy.

The poor condition of the drawing, which is stained in several places
and no longer offers its original pictorial effect – where vivid, fresh luminosity of the lead white would
have been set against the blue paper
– still does not completely hinder an
appreciation of its high quality. The
meeting of the two figures leaning
toward each other in complementary postures is evoked with great
confidence and fluidity of line. In
Tamar's dress the movement of the
light is traced with a subtlety that is
neither mechanical nor summary.
Light striations of lead white highlight the surface of the robe and condense on the edges of the deeper
folds, in contrast with the brown
wash that marks their depths. A very
delicate relationship is established
between the low neckline of Tamar's dress, which is caressed by the
light and the diaphanous shadow of
her neck, and her cheek and emerging profile. This passage, as well as
the detail of the veil lit by a shattered
light, can be very closely compared
with the head of Tamar in *Tamar
Brought to the Stake*, with which it
shares also an intensity of execution.
In this case, then, the artist's involvement in an investigation of light,
which represents the central element of his idiom around the mid-
1560s, can perhaps be best explained
in the context of a preparatory study
for a painting. This is true even if the
drawing was done at a very late stage
in the process, when the image was
completely defined. Here, contact
has not been lost with the expressive
experimentation of the invention, as
it would have in a drawing made
only to record an image for the
workshop's files.

V.R.

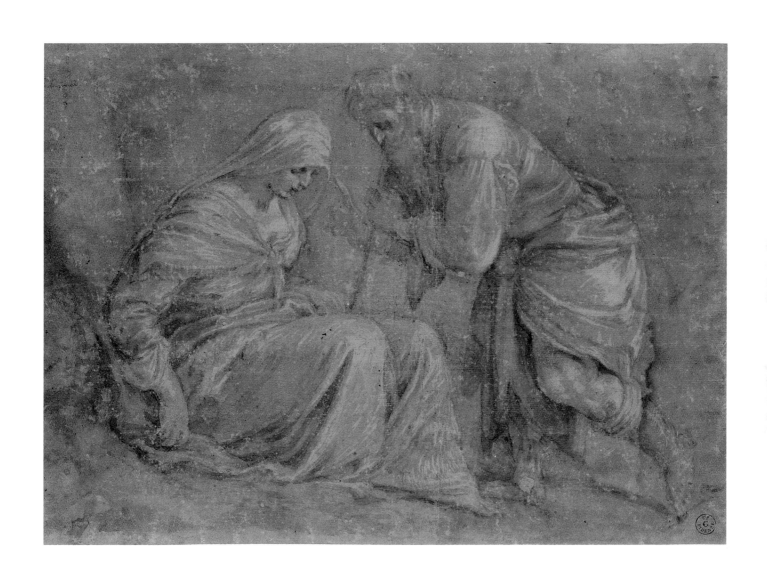

473

89. WOMAN AND CHILD (c. 1565)

Musée Fabre, Montpellier, inv. 837.I.281
Traces of black chalk, brown wash, heightened with lead white, on paper prepared with light gray wash
300 × 240 mm
Exhibited in Fort Worth only

Provenance
François-Xavier Fabre bequest, 1837.

Exhibitions
Venice 1957; Paris 1965; Nice 1979.

Bibliography
Lafenestre and Michel 1878, no. 735; Arslan 1931, 304 (as Gerolamo Bassano); Tietze and Tietze-Conrat 1944, 46, no. 109 (as Gerolamo Bassano); Zampetti 1957, 241, no. 10, ills.; Zampetti 1958, 54, fig. 19; Arslan 1960 (B), I, 289 (as Gerolamo Bassano); Coulanges Rosenberg 1965, 25, no. 36, fig. 36; Ballarin 1969, 94, 101, and 111, n. 24, fig. 107; Provoyeur 1979, 37, no. 17, fig. 17; Rearick 1980 (A), 9 and 29-30; Rearick 1987, II, 10, fig. d.

Traditionally attributed to Paolo Veronese, the drawing was given to Gerolamo Bassano by Arslan (1931), who described the subject as the Virgin embracing the Christ Child. This attribution, with which the Tietzes agreed, was repeated in the re-edition of Arslan's monograph on the Dal Ponte family (1960 (B)). Later, on the occasion of the exhibition in Venice in 1957, Zampetti gave the sheet to Jacopo with a very interesting proposal of a date around 1568. At that time, however, the connection had not yet been noted with the group in the middle ground on the right in the altarpiece depicting *Saint Eleutherius Blessing the Faithful* (Gallerie dell'Accademia, Venice, cat. 40). The following year, Zampetti reiterated Jacopo's authorship, indicating the sheet as a preparatory study for the *Saint Eleutherius* altarpiece, which was considered to date from about 1580.

The most recent studies, while agreeing that the drawing was done by Jacopo, have posed the problem of its relationship to the *Saint Eleutherius* altarpiece, which is now assigned a date around or just after the mid-1560s. The technique and high degree of finish of the sheet, which corresponds in every way with the details in the painting, lead Rearick to consider it a *ricordo* done by Jacopo after the work was finished as a record for his file of the inventions, which could be used again or referred to by the workshop. Ballarin, on the other hand, placed it in the category of highly finished *modelli* or cartoons used to prepare sections of a painting, as was the tradition in central Italy. Thus the choice is proposed here again, as in the case of *Judé and Tamar* (Gabinetto Disegni e Stampe degli Uffizi, Florence, cat. 88), between *ricordo* or *modello*. It is complicated in this instance by the existence of three other drawings connected to the altarpiece, two on the theme of the soldier in the foreground (Nasjonalgalleriet, Oslo; and Chatsworth, inv. 271) and a third reproducing the central section of the composition (private collection, Switzerland), which do not equal the quality of the sheet examined here, but raise the question, still unresolved, of the collaboration of Jacopo's son, Francesco, even at the level of planning the design of a painting (see Ballarin 1969, 94-96; and Rearick 1980 (A), 29-30).

Certain elements synthetically indicated by the wash seem important in defining its purpose, such as the profile of the step in the foreground or the outline of the drapery above the woman's head, which establish this group's connection with the overall composition. The very careful representation of these links, which characterizes a large number of the sheets in the Dal Ponte workshop, seems significant when placed in relationship with the process of preparing a painting, because they fix the detail's exact position in the overall compositional scheme. It is more difficult to justify their presence if the drawing is interpreted as a *ricordo*. If this were the case, the purpose of the drawing would be to record a detail of a painting in order to use it again on other occasions, and thus references to how it should be inserted into the context for which it was originally created would have no reason for being.

Support for the hypothesis that this is a fully finished *modello* is given, aside from the drawing's spontaneity and immediacy of execution, by Jacopo's attention to the behavior of light. The passage of the woman's dress, where fluid strokes of lead white render the vibrations of light striking the folds, in contrast to the half-tones created with a light wash that thickens in the areas of shadow, or the roundness of the child's body emerging from the lead white applied with thick touches of the brush, announce Jacopo's experimentation with precise aspects of his idiom in this phase of his career. These aspects can best be justified in the instance of a preparatory study, and, in fact, are integral to a reading that is disturbed by the drawing's imperfect condition.

V.R.

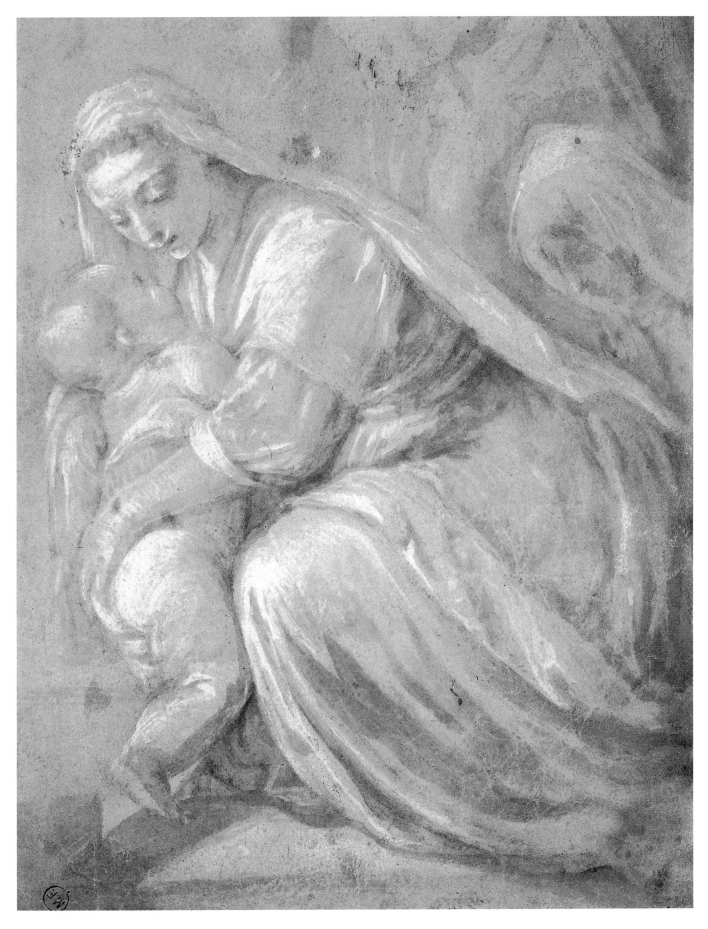

90. RESTING SHEPHERD (c. 1565-67)

Städelsches Kunstinstitut, Frankfurt, inv. 15216
Black and colored chalks (orange, yellow, pink), heightened with white chalk, on rough brown paper, cut irregularly
269 × 328 mm
Exhibited in Bassano del Grappa only

Provenance
Early history unknown.

Exhibitions
Never before exhibited.

Bibliography
Tietze and Tietze-Conrat 1944, 51, no. 148; Arslan 1960 (B), I, 168; Rearick 1962, 525, n. 4; Ballarin 1971 (A), 138, 143, and 149, ns. 6 and 7, fig. 1; Ballarin 1973, 112; Rearick 1980 (A), 31; Rearick 1987, II, 12, pl. VII; Ballarin 1990 (B), 145, ills.

Assigned by the Tietzes to Jacopo Bassano, this splendid figure study belongs to the category of colored chalk drawings in which the painter «with very few marks, traced with an elemental force accompanied by a *fauve* burst of color, is concerned with fixing the structure, the essential articulation of the figure» (Ballarin). It is similar to the study of a male figure (Hessisches Landesmuseum, Darmstadt, inv. AE 1432) and the sheet with *Saint Gregory the Great* (Musée du Louvre, Département des Arts Graphiques, Paris, cat. 109), which is a preparatory study for the vault of the Cappella del Rosario in Cartigliano.

Rearick (1980 (A); and 1987) first interpreted this sheet as a revision of the figure of a shepherd with a flute in the foreground of *The Adoration of the Shepherds* (Galleria Borghese, Rome, cat. 23), done with a view to using the same figure reversed in *The Annunciation to the Shepherds* (National Gallery of Art, Washington, cat. 30) of about 1557. He suggested, albeit prudently, that it could be a preparatory study for Saint Roch in the small altarpiece at one time in the church of the Ognissanti in Tre-

viso that depicts *Saints Florian, Sebastian, and Roch* (Museo Civico, Treviso, fig. 44), which he dates about 1567, correctly moving the date earlier than the traditional one of around 1575. Ballarin (1971 (A)) proposed a date for the Frankfurt sheet within 1569 as the result of a comparison he made with *The Presentation of the Virgin* (National Gallery of Canada, Ottawa, cat. 95) of that same year, and linked the drawing with the biblical-pastoral paintings of the mid-1560s. He also observed that the connection between the sheet and the Treviso painting posited by Rearick could not be a direct one, even though the idea of the saint yielding himself up to the care of the angel is undoubtedly very close to the figure in the Frankfurt sheet, since the tunic worn by the figure clearly indicates he is a shepherd. The resemblance thus should be explained in the context of the osmosis of Jacopo's inventions between ecclesiastical paintings and pastoral pieces that characterizes the period between 1563-68. Although for the moment we cannot establish a precise link between this study and a specific painting, it does reveal an affinity with the repertory of figures that populate the Dal Ponte production of pastoral scenes in the mid-1560s, of which the shepherd leaning back in the foreground could be seen as a symbol. The drawing is in perfect harmony with Jacopo's artistic experiments of these years, when the consistency of the pigment of his earlier period is recovered and submitted to a new luministic reality. Here this coloristic experimentation

is found in the burst of orange liberated from the feverish tangle of black contour lines, but consumed by the gray and black shadows, and burned out in the areas struck by the light, indicated by strokes of white chalk. Ballarin's comparison with the resting shepherd on the left of *Jacob and Rachel at the Well* (private collection, Turin, cat. 43) is particularly convincing. The face, realized with intense, vibrant touches of pink, red, black, and gray, with a few scattered touches of light, is the equivalent in painting of the handling of the chalk in the head and neck here. A similarly close comparison can be made with the medley of pink, white, and black in the foreground leg of the two figures.

V.R.

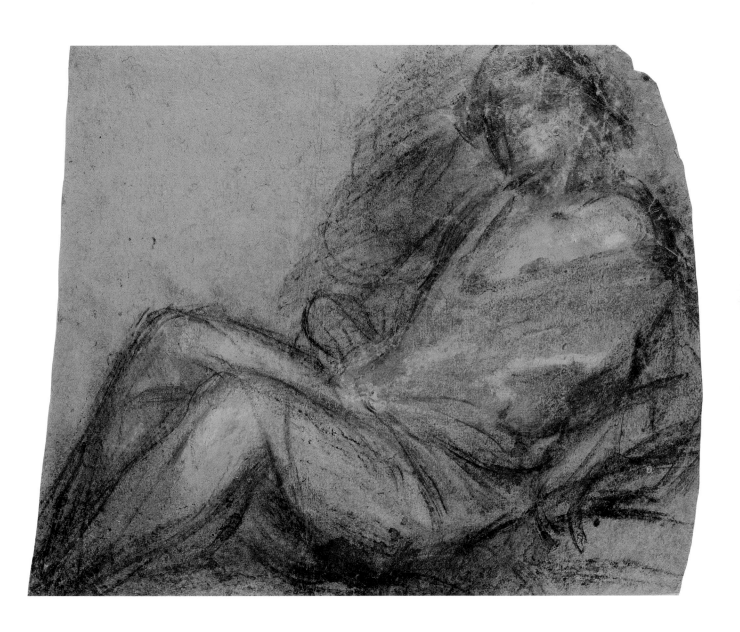

477

91. JACOB'S LADDER (c. 1565-68)

Stiftung Ratjen, Vaduz, inv. 584
Black chalk, brown wash, heightened with lead white, on blue paper
395 × 523 mm
Exhibited in Fort Worth only

Provenance
Giorgio Neerman, Florence; Herbert List collection, Munich.

Exhibitions
Never before exhibited.

Bibliography
Ballarin 1973, 91 and 122, n. 2; Ballarin 1990 (B), 144-45, ills.; Rearick 1992 (B), in press.

This important compositional study represents an episode from the life of Jacob for which we do not at the moment know of any painted version. Mentioned as the work of Jacopo by Ballarin in 1973, it was examined more thoroughly in his recent study of Jacopo's biblical-pastoral works of the years 1563-68, a period that would encompass this drawing, as it represents the graphic equivalent of paintings such as *Jacob and Rachel at the Well* (private collection, Turin, cat. 43) of about 1565. For Rearick, instead, the sheet is datable c. 1578 based on a comparison with *The Flight into Egypt* on the verso of a study for *Saint Jerome* (Accademia Carrara, Bergamo, inv. 294) of 1575 and *The Presentation of the Virgin* (Muzeum Narodowe W Warszawie, Warsaw, cat. 100). Furthermore, he suggested that the sheet could be linked to the painting of the same subject indicated as no. 69 in the inventory of works left in the shop after Jacopo's death and transcribed by Verci (1775, 94). Ridolfi, too, (1648, 1, 393) recalls the theme as one treated by Jacopo.

The landscape setting opens on the left in a panorama that stretches back to the horizon and is closed on the right by the backdrop of a hill. The harmonious flow of the composition, the forms constructed with generous contour lines, the more insistent modeling using wash and lead white for the figure of Jacob in the foreground, and the light, open line in the angels on the ladder point to the most «classical» moment of Jacopo's biblical-pastoral production, around 1565 (see Ballarin 1990 (B)). The sleeping Jacob is closely related to the shepherd in the Frankfurt sheet (cat. 90), the sleeping figures in *Jacob and Rachel at the Well* in Turin, and the *Sleeping Shepherd* (Szépmüvészeti Múzeum, Budapest, cat. 45). In the handling of the line, especially in its most finished sections, this drawing can be compared to the one depicting *The Mystic Marriage of Saint Catherine* (Gabinetto Disegni e Stampe degli Uffizi, Florence; see Ballarin 1969, 98, 102-4, and 113, n. 48, fig. 110; and Rearick 1987, 11, 9, pl. v), which has the date 1567 written on its verso.

V.R.

478

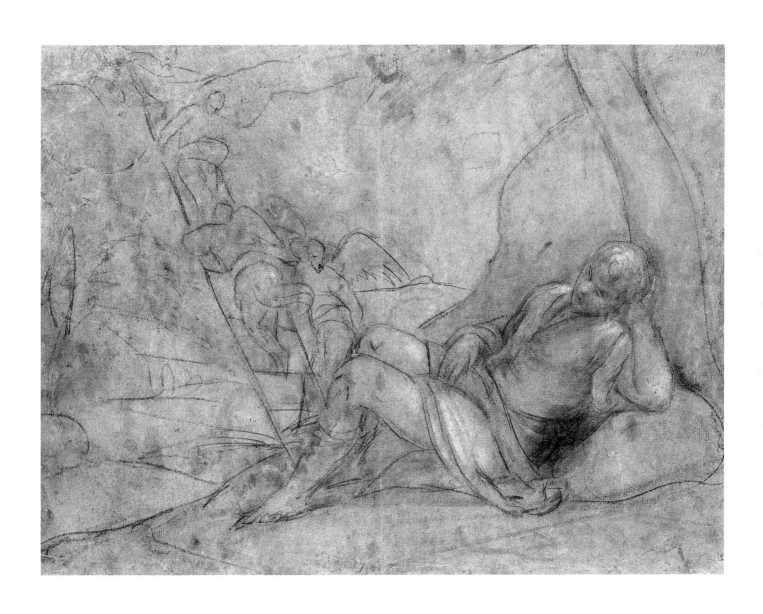

92. YOUNG SHEPHERD (c. 1566)

Museo Horne, Florence (on deposit at the Gabinetto Disegni e Stampe degli Uffizi), inv. 5663 Horne
Black chalk, heightened with white, on blue paper
197 × 135 mm
Inscriptions: on the recto along the bottom edge on the right, in pen: « Bassano »
Exhibited in Bassano del Grappa only

Provenance
Early history unknown.

Exhibitions
Florence 1963.

Bibliography
Tietze and Tietze-Conrat 1944, 51, no. 147; Arslan 1960 (B), I, 168 (as possibly Jacopo Bassano); Ragghianti Collobi 1963, 36, no. 112, pl. 4 (as Jacopo Bassano?); Rearick 1987, II, 7, fig. b; Ballarin 1990 (B), 141-42 and 144-45, ills.

This very fine, evocative drawing is a preparatory study for the figure of the young shepherd leading his flock in the background of *Jacob's Journey* (formerly Wallraf-Richartz-Museum, Cologne, inv. 699; sold by the museum in 1943 and no longer traceable). The Tietzes confirmed the traditional attribution to Jacopo, which recently has been reiterated by Rearick and Ballarin, after Arslan had expressed some doubt about Jacopo's authorship.

The black chalk, set down in light, feathered strokes, seems to float on the blue paper, creating a rarefied, incorporeal form, constructed of glimmers of light, that almost has no outline. Jacopo's « impressionistic » creation of figures inserted into distant landscapes in the pastoral paintings of 1563-68, is one of the most modern achievements of his career. This new awareness of the unifying power of light comes just after the turning point represented by the Treviso *Crucifixion* (cat. 37). As it is no longer possible to compare this study directly with the painting formerly in Cologne, a useful comparison could be made with *Jacob and Rachel at the Well* (private collection, Turin, cat. 43) of about 1566, for which the Cologne picture could plausibly have been a pendant. Particularly close are the figures of Jacob and Rachel, whose structure is similarly consumed and blurred along the outlines by the atmospheric haze in the middle distance. This comparison underscores the notion of an elongated, slightly twisting form, which very elegantly evokes the earlier ideal of formal refinement typical of Jacopo's mannerist period.

V.R.

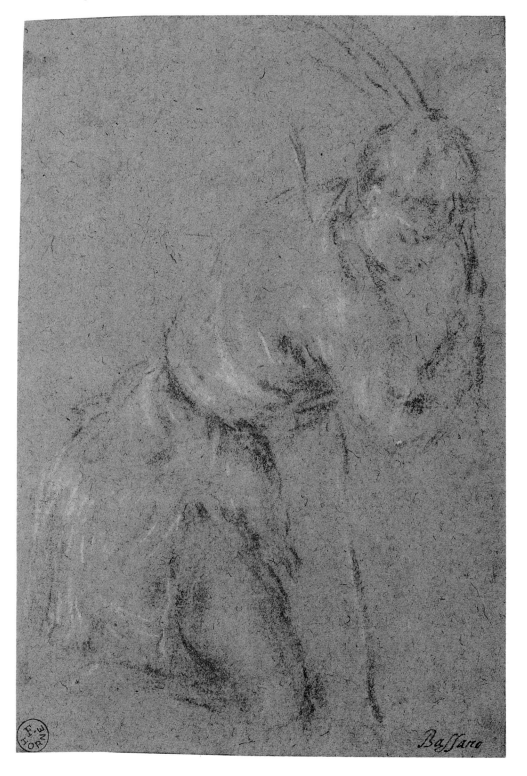

93. Saint Peter (c. 1563-68)

Royal Library, Windsor Castle, Berkshire, inv. 0835, Lent by Her Majesty Queen Elizabeth II
Black chalk, heightened with white chalk, on blue or green paper, now completely faded
415 × 266 mm
Exhibited in Fort Worth only

Provenance
Early history unknown.

Exhibitions
Never before exhibited.

Bibliography
Popham and Wilde 1949, 196, no. 121; Arslan 1960 (B), I, 179; Rearick 1980 (A), 29; Rearick 1987, II, I, pl. I; Ballarin 1990 (B), 138-39 ills.

Even though today the original effect of this drawing is quite compromised by the faded paper, which is also spotted with oil in various places, and by the loss of white highlights that earlier must have been more plentiful, its high quality and subtlety are still notable. The sheet is a fragment, as can be seen by the black chalk marks along the right edge, which most probably indicated the hair of a third head, besides the two that are visible, and the study for the detail of an ear.

The attribution to Jacopo made by Popham was accepted by Arslan and by Rearick, who feels that these are preparatory studies for the third apostle from the left in *The Descent of the Holy Spirit* (Museo Civico, Bassano del Grappa, cat. 119), which was painted for the church of San Francesco in Bassano. Rearick dated the sheet around 1558 and grouped it with the more famous head in colored chalks depicting *Saint Paul* (Graphische Sammlung Albertina, Vienna, cat. 85), which can be linked with certainty to the first apostle in the same area of the painting. In this larger sheet the black chalk moves over the paper with a fluid and wide gesture unprecedented for Jacopo.

He constructs the shape still slightly elongated, but remote from any suspicion of forcing of the vanishing profile and renders with a keen sense of observation the disorderly locks of hair escaping from the collar and the thicker, shaggier hair along the edges of the head, erupting in the soft shading of the beard. The result is distinctly different from the concentrated, summary, febrile strokes delineating the head in the sheet in Vienna, which along with the different technique, also demonstrates a luministic tension absent from this page. Details like the ear, delicately highlighted with white chalk, or the touch of light that burrows in between the head and beard, emphasizing the round contour of the neck, as well as the observations made above, point in the direction of the new spirit of naturalism and an equilibrium between color, light, and form attained by Jacopo in the years between 1563-68. This is the opinion of Ballarin, who compared the study to the reversed profile of the figure behind Tamar in *Tamar Brought to the Stake* (Kunsthistorisches Museum, Gemäldegalerie, Vienna, cat. 38). At the same time, he refuted the connection to the apostle in *The Descent of the Holy Spirit* because the head in the drawing appears to be less balding and oriented differently than the one in the painting.

Analyzing the smaller Albertina sketch, which Rearick interpreted as an alternative solution for the same head, we can note the suggestion of a lifted arm, which Ballarin commented would definitively exclude the figure from being related to the altarpiece.

V.R.

482

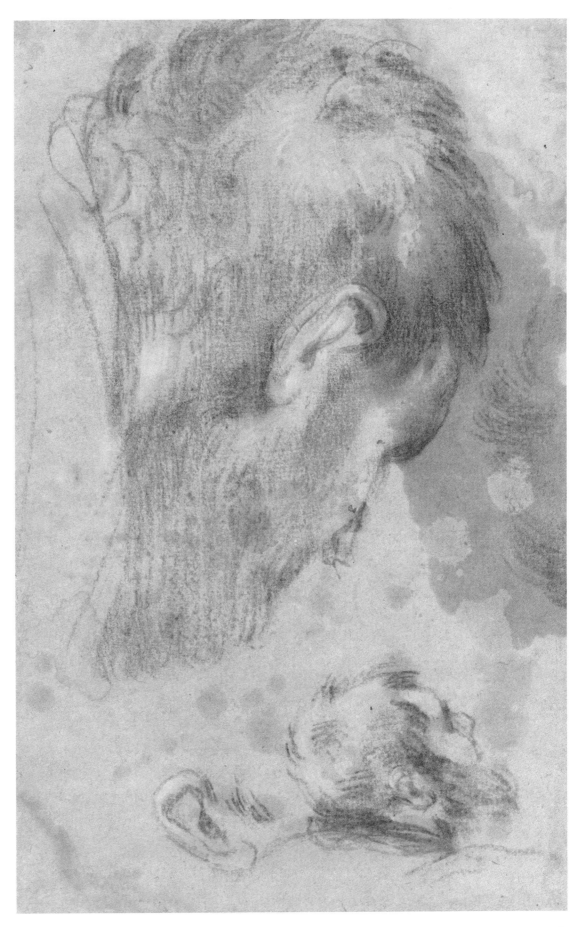

94. THE SCOURGING OF CHRIST (1568)

National Gallery of Art, Washington, inv. 1980.3.1
Black and colored chalks (pink, red, green, brown, yellow), heightened with
white chalk, on gray-green faded paper, stained in several places
407×535 mm (slightly irregular edges)
Inscriptions: on the recto, in black chalk, on the pilaster in the upper right hand
corner, probably in the artist's hand, the date « 1568 da agosti (?) »
Exhibited in Fort Worth only

Provenance
Sagredo collection (?); Marignane collection, Marseilles; Hans Calmann collection, London; acquired by the National Gallery of Art, 1980.

Exhibitions
Stockholm 1962.

Bibliography
Tietze and Tietze-Conrat 1944, 52, no. 163; Arslan 1960 (B), I, 170; *Konstens Venedig* 1962, 190, no. 228; Rearick 1962, 525-26; Ballarin 1969, 96, 98, and 100; Ballarin 1971 (A), 138; Dreyer 1983, 146; Rearick 1989, III, 2, pl. I; Ballarin 1990 (B), 129.

The two year period, 1568-69, is documented by two dated altarpieces, *The Adoration of the Shepherds with Saints Victor and Corona* (Museo Civico, Bassano del Grappa, cat. 46), and *The Virgin in Glory with the Penitent Saint Jerome* (Gallerie dell' Accademia, Venice; fig. 15), as well as a spectacular series of drawings, in which an important role is played by the compositional studies in colored chalk. Due to some recent additions to Jacopo's corpus of drawings, this particular aspect of his graphic production is beginning to be rather well documented. *The Capture of Christ* (Musée du Louvre, Département des Arts Graphiques, Paris, inv. RF 38.815) in a nocturnal setting, dated 1568 (Rearick 1989, III, 4, pl. III, with bibliography), and the two studies of 1569 for *The Adoration of the Shepherds* (Staatliche Museen Preussischer Kulturbesitz, Kupferstichkabinett, Berlin, inv. KdZ. 24630 recto and verso, and here, figs. 48 49), published by Dreyer (1983, 145-46), have been added to the two

sheets already noted by the Tietzes, the one being considered here, and *The Presentation of the Virgin* (National Gallery of Canada, Ottawa, cat. 95) from 1569. The undated *Expulsion of the Merchants from the Temple* (The J. Paul Getty Museum, Malibu, cat. 96) should not be excluded from this group of drawings. *The Archangel Gabriel* (Christ Church, Oxford, cat. 99) and *The Virgin Annunciate* (Gabinetto Disegni e Stampe degli Uffizi, Florence, cat. 98), although executed in a different technique – black chalk with brown wash and heightened with white – also date from 1569.

The Scourging of Christ was first noticed by the Tietzes. Arslan compared it to *The Presentation of the Virgin* in Ottawa and the drawing of the same subject in Warsaw (Muzeum Narodowe W Warszawie, cat. 100). Rearick connected it to the painting of the same subject in the Gallerie dell' Accademia, Venice (fig. 47). Two other drawings, which can be related to this one are: *The Study of an Executioner* in the Goldman collection, New York (copied from Titian's *Saint Peter Martyr* altarpiece), and *The Study of an Executioner and a Head of Christ*, formerly in the Maconochie collection, Bath, and now in a French private collection. Ballarin pointed out the existence of a copy of the Accademia painting in a private collection in Madrid, which is close in style to the young Maffei. It has the same composition, but treats the clothing of the executioner with more detail, changing the style of his trousers. This copy, characterized by a greater vitality in the

figures and a higher register of color, could document an earlier, first version of the theme of the scourging of Christ, later repeated, around 1565, in the Venetian painting, executed in a somber color scheme that presupposes the experience of *Saint Eleutherius Blessing the Faithful* (Gallerie dell'Accademia, Venice, cat. 40). Consequently, Ballarin proposed to associate it with the study depicting *The Capture of Christ*, in the Louvre.

In the drawing, the concentrated monumentality of the scene, where the large gestures of the tormentors, arranged around Christ, give a circular movement to the composition – which is closed on the left by the figure with a tall red hat and on the right by a young boy playing a horn – is the result of a rethinking of the painting of *The Scourging of Christ* in the Accademia. In this painting the more horizontal extension of the composition depends on the degree of classicism reached in the Bassano *Adoration of the Shepherds*. We know that the Accademia painting was originally placed on the altar of the small church of San Giuseppe in December 1568. The drawing is inscribed August of the same year. The Louvre drawing of *The Capture of Christ* appears so close in style that Ballarin's hypothesis, that Jacopo was involved in designing a cycle of the Passion of Christ, seems convincing. In both studies black chalk lines define forms with authority and close contours in a way that differs from the more synthetic and contracted manner typical of Jacopo's work in the seventies. While

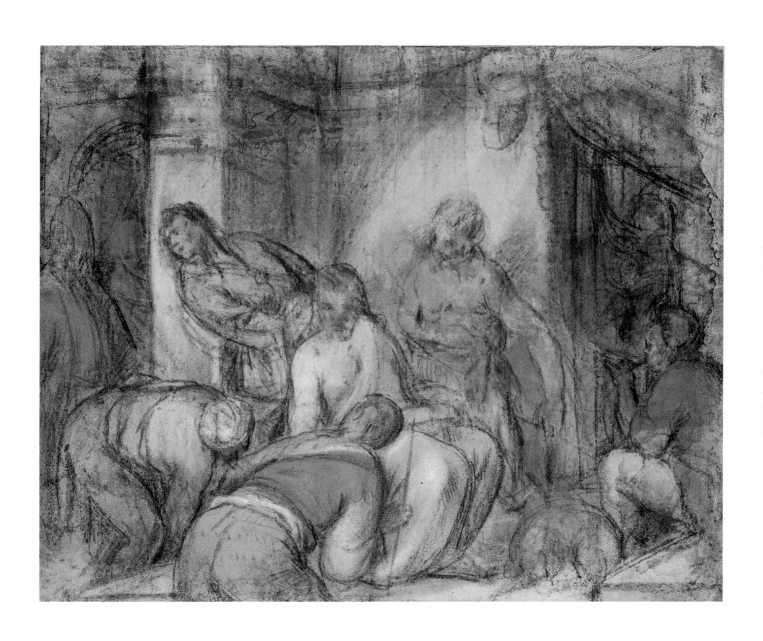

95. The Presentation of the Virgin (1569)

National Gallery of Canada, Ottawa, inv. 4431 (Oppé 66)
Black, white, and colored chalks (pink, red, yellow, lilac, green, blue) on blue-gray paper that is slightly faded and stained in the upper part
516 × 378 mm (irregular edges)
Inscriptions: on the recto, along the top left-hand edge, probably in the artists's own hand, « de lano 1569 »; on the steps at the center of the drawing « del 1569 »; also on the recto, in the center, in pen and ink: « B.B. nº: 88 »; the drawing is mounted on a sheet of heavy white paper upon which is written, in pen and ink, near the bottom: « B.B. nº: 23 »
Exhibited in Fort Worth only

color has lost the unrealistic and violent character it had in earlier drawings, it still maintains its importance and is applied in patches that are subject to the overall design. While our sheet can easily be compared to the equilibrium of color and light achieved in the 1568 *Adoration of the Shepherds*, the color tones in *The Capture of Christ* seem brighter. In the latter case one must take into account the nocturnal setting of the scene, which is unique in the pictorial production of the artist in these years. The studies from 1568, and more clearly those of 1569 (see cat. 95), seem to belong to a transitional period. Having abandoned the stylistic characteristics of the fifties, which Ballarin (1973, 112-22) carefully singled out in sheets such as *The Study of a Reclining Figure*, in a French collection, and the similar subject in the Hessisches Landesmuseum in Darmstadt (inv. AE 1432), and to which can be added the preparatory study (private collection, Chicago, cat. 84) for the injured person in *The Good Samaritan* (The National Gallery, London, fig. 40), the painter returned to a dissonant and forceful use of color and conceded a new authority to light, while definitively leaving behind him the manipulation of forms that he had learned from Salviati and Parmigianino. This is the beginning of a process that will result in the preparatory studies for the frescoes in Cartigliano, where a light, iridescent web, consisting more of light than of color, envelopes the figures.

V.R.

Provenance

Sagredo collection (see the inscriptions); Marignane collection, Marseilles; A. de Havesy (?); Hans Calmann collection, London; acquired by the National Gallery in 1938.

Exhibitions

Indianapolis 1954; Venice 1957; New York 1961; Toronto 1968; Florence 1969.

Bibliography

Mongan and Sachs 1940, 1, 52, no. 64; Oppé 1941, 55; Tietze and Tietze-Conrat 1944, 52, no. 177, pl. CXLIII; Muraro 1952, 54; Parks 1954, no. 52. ills.; Muraro 1957, 296; Zampetti 1957, 241, no. 11; Mrozinska 1958, 22; Zampetti 1958, 44, pl. LXXXIII; Arslan 1960 (B), 1, 113 and 173; *Bassano Drawings* 1961, no. 6, ills.; Rearick 1962, 529-30, fig. 12; Popham and Fenwick 1965, no. 25, 19, ills.; *Master Drawings* 1968, no. 4; Ballarin 1969, 96, 100, and 111, n. 28; Cazort Taylor 1969, 22-23, no. 2, fig. 2; Witzthum 1969, 11 12; Ballarin 1971 (A), 138 and 149, n. 2; Ballarin 1973, 118; Rearick 1980 (A), 9 and 30-31; Pallucchini 1982, no. 32, ills.; Dreyer 1983, 146; Rearick 1989, III, 6, fig. c.

Although this is one of the best known drawings by Jacopo, its purpose has never been explained. Probably a study for an altarpiece, it has been associated, because of compositional similarities, with *The Circumcision* (Museo Civico, Bassano del Grappa, cat. 121), signed by Jacopo and his son Francesco in 1577. Some scholars (Oppé, Tietze and Tietze-Conrat, Parks, and Rearick) think that this painting reuses ideas experimented with in the drawing. Subsequent scholarship emphasized a re-

lationship with the study of the same subject in Warsaw (Muzeum Narodowe W Warszawie, cat. 100), and Popham proposed that the two sheets could be connected to the same commission. The elegantly balanced composition organized along the diagonal of the temple staircase, which the Virgin climbs towards the altar at the top, presents solutions not far from those used in the *Saint Roch Visiting the Plague Victims* (Pinacoteca di Brera, Milan, cat. 47) and *The Martyrdom of Saint Lawrence* (cathedral, Belluno, fig. 53). The drawing does not yet show the perspective penetration into space, evident in the Warsaw *Presentation*, and the descriptive naturalism, so characteristic of the 1570s, a period not preoccupied with formal concerns, which do appear, however, in the refined intertwining of the figures in the frontal plane of the drawing. Outlines define the forms and their inter-relationships with continuous adjustments. The handling is looser than that found in the colored chalk compositional studies of 1568, such as *The Scourging of Christ* (National Gallery of Art, Washington, cat. 94) and *The Capture of Christ* (Musée du Louvre, Département des Arts Graphiques, Paris, inv. RF 38.815; see Rearick 1989, III, 4, pl. III, with earlier bibliography). The application of color, in compact patches that respect the outlines, begins to give way to a scheme that seems like an entangled black chalk web, animated

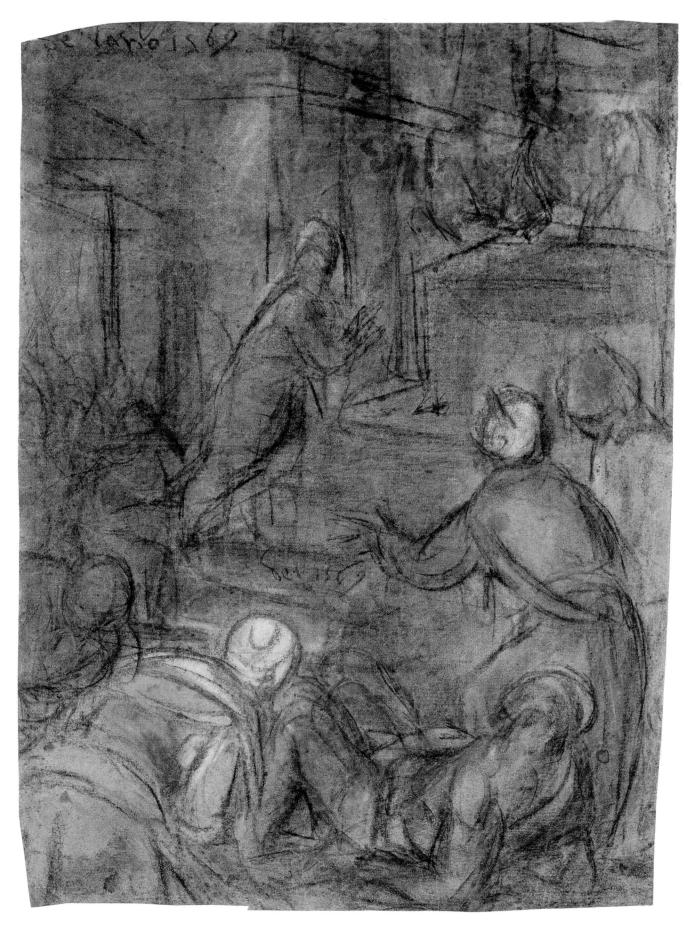

487

96. The Expulsion of the Merchants from the Temple (c. 1568-69)

Collection of the J. Paul Getty Museum, Malibu, inv. 8.9.GB.63
Black and colored chalks (yellow, pink, red, violet, brown, blue, green), heightened with white, on blue paper; upper right hand corner missing, stained on the left
418×531 mm
Exhibited in Fort Worth only

by iridescent effects that tend to deaden the colors, as the two studies for *The Adoration of the Shepherds* (Staatliche Museen Preussischer Kulturbesitz, Kupferstichkabinett, Berlin, inv. KdZ. 24630 recto and verso, and here, figs. 48-49) so clearly show. In the drawings of 1569, that process of reducing the role of color in favor of effects of light, which prepares the way for the preparatory studies for the Cartigliano frescoes, is already making headway.

V.R.

Provenance
Collection of the Marquis Jacopo Durazzo, Genoa (1717-94); Sotheby's, London, 4 July 1988, lot 62.

Exhibitions
Never before exhibited.

Bibliography
Rearick 1992 (B), in press.

This spectacular drawing joined a small group of colored chalk compositional studies by Jacopo, dated between 1568 and 1569, only a few years ago. Rearick (1992 (B)), in the last volume of his corpus of the artist's drawings, points out strong compositional similarities between this drawing and the painting of *The Expulsion of the Merchants from the Temple*, which used to belong to the Marquis of Lansdowne and is now in a private collection in Bassano (fig. 69). According to Rearick, the painting is Jacopo's second version of the theme. The first version (Museo del Prado, Madrid, fig. 50) was done in collaboration with his son, Francesco, in 1569, and the second was started by Leandro and then taken up again by Jacopo around 1578, using the studies in the Hessisches Landesmuseum, Darmstadt (inv. AE 1432), which were formerly in a private collection in Stockholm (Tietze and Tietze-Conrat 1944, no. 198), for the two seated figures in the right foreground. The drawing examined here, which, according to Rearick, was executed between 1574 and 1581, represents a very experimental revision, full of ambiguities and unresolved problems, of the painting. Nothing quite like it was produced later by the master or the

shop. Rearick, therefore, denies a relationship, which would seem obvious, between this drawing and other studies executed in the same technique on large format sheets of blue paper: *The Capture of Christ* (Musée du Louvre, Département des Arts Graphiques, Paris, inv. RF 38.815; Rearick 1989, III, 4, pl. III, with earlier bibliography); *The Scourging of Christ* (National Gallery of Art, Washington, cat. 94) from 1568; the two studies for *The Adoration of the Shepherds* (Staatliche Museen Preussischer Kulturbesitz, Kupferstichkabinett, Berlin, inv. KdZ. 24630 recto and verso, and here, figs. 48-49); and *The Presentation of the Virgin* (National Gallery of Canada, Ottawa, cat. 95) from 1569. In the drawing under examination, as in these other drawings, colored chalk appears only in certain areas and almost seems to comment on the structural forms that are outlined in black chalk. The figures have the same slightly elongated forms and oval heads. Finally, the colors are typical of this period; the pale rosy lilac of the robe of the merchant who flees through the door, and the red and bitter yellow, which, as in the drawings of 1569, create iridescent effects. Moreover, the relationship with the former Lansdowne *Expulsion of the Merchants*, strongly suggested by the detail of the two figures in the left foreground, would call for an earlier dating than the one proposed by Rearick, certainly within the seventh decade, as other scholars have postulated. On the basis of a photograph, Ballarin (1973, 113-15) proposed that the painting now in Bassano was a

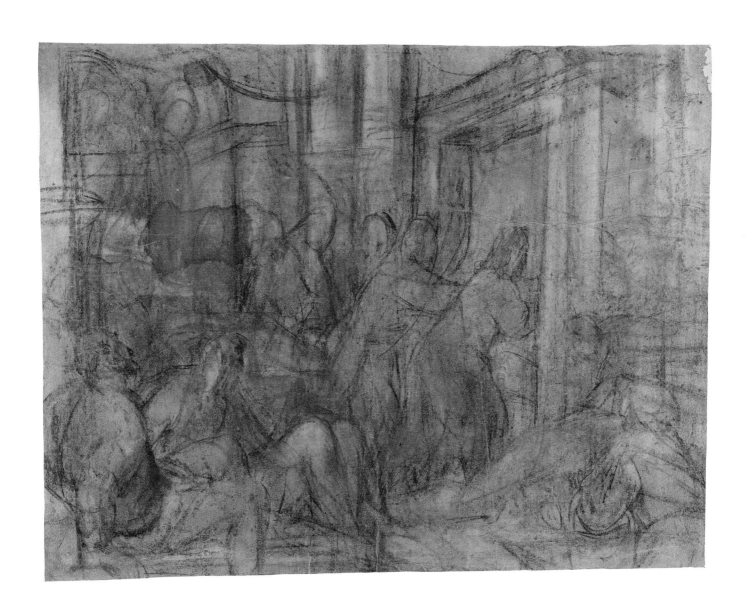

97. The Visitation (1569)

Gabinetto Disegni e Stampe degli Uffizi, Florence, inv. 13953 F
Bistre wash, heightened with white, over black chalk on faded blue paper
530×398 mm
Inscriptions: by the artist in bistre, on the recto in the upper right hand corner,
«Nil mihi place(t) / Del 1569»; on the verso, probably in the seventeenth century, on what remains of an old backing, «Bassan»
Exhibited in Fort Worth only

product of the shop based on Jacopo's original of about 1561, known through a seventeenth-century copy in the Bayerische Staatsgemäldesammlungen, Munich. Pallucchini (1982, 38, pl. 30) published the painting, after it was restored, as an autograph work from around 1565.

The relationship with the painting of the same subject in the Prado (inv. 28), which Rearick reevaluated and dated c. 1569, is more difficult to understand. The naturalism of the Prado painting seems to have more in common with the works from the 1570s, while in the drawing there are still signs of an elegance and affectation that belong to Jacopo's earlier mannerist period and that reappear in the other studies dated 1569. Of these, *The Presentation of the Virgin* in Ottawa offers the most pertinent comparison with the drawing being considered here.

V.R.

Provenance
Medici collection.

Exhibitions
Venice 1957; Florence 1976.

Bibliography
Willumsen 1927, 535-42 (as El Greco); Fröhlich-Bum 1931 32, 124-25, ills.; Bettini 1933, 130; Tietze and Tietze-Conrat 1944, 48, 51, no. 146, and pl. cxlv, 1; Muraro 1952, 54; Muraro 1957, 292; Zampetti 1957, 246, no.4; Arlsan 1960 (B), 1, 168; Rearick 1962, 530, fig. 17; Ballarin 1969, 86, 102, and 113, n. 49; Rearick 1976 (B), 162 64, no. 118, fig. 92; Dreyer 1983, 146; Rearick 1989, III, 7, pl. v.

The drawing was given back to Bassano by Fröhlich-Bum after having been attributed to El Greco by Willumsen, who proposed that the artist made it during a hypothetical apprenticeship to Jacopo. It is one of the better known drawings by Jacopo and belongs to an especially well documented period of the artist's graphic production, together with a series of sheets dated 1568-69, executed in diverse techniques (cats. 94, 95, 98, and 99). Critics agree about the free experimental character of this study, an evaluation that the painter seemed to share. In an autograph annotation he indicated the date of execution and expressed a feeling of dissatisfaction with the results. A similar annotation, proof of the private nature of these sheets, occurs on another drawing dating from the same year, which experiments in colored chalk with two different solutions for *The Adoration of the Shepherds* (Staatliche Museen Preussischer Kulturbesitz, Kupferstichkabinett, Berlin, inv. KdZ.

24630 recto and verso, and here, figs. 48-49; see Dreyer 1983, 145-46). In *The Visitation*, the encounter of the two figures is arranged in a slightly diagonal composition with one figure facing forward and the other with her back to the viewer. Their movements are linked and balanced by large curves according to a taste for harmonious monumentality, which is found in the mature style of the artist and is exemplified by works like *The Adoration of the Shepherds with Saints Victor and Corona* (Museo Civico, Bassano del Grappa, cat. 46). Forms are feverishly explored by the black chalk, with continuous adjustments of the contours and with a dynamism that leads to the chalk studies of the 1570s such as *A Page Seen from Behind* (Fitzwilliam Museum, Cambridge, cat. 101), *The Sacrifice of Abraham*, and *The Good Thief* (both Musée du Louvre, Département des Arts Graphiques, Paris), and preparatory studies for the fresco cycle in the parish church of Cartigliano (see cat. 108). Bistre wash and white heightening are used to create volume and to study light effects with free yet concise touches that effectively conjure up the faintly lighted settings and the light buoyant forms characteristic of the works produced in these years. One notices, in particular, the refinement of the use of the white heightening on the Virgin's back and the rarefied touches that pick out her ear and veil, setting them off against the oval of her face, which is cast in shadow.

V.R.

491

98. The Virgin Annunciate (1569)

Gabinetto Disegni e Stampe degli Uffizi, Florence, inv. 13061 F
Bistre wash, heightened with white, over black chalk on faded blue-green paper, damaged along the edges with extensive staining
539×375 mm
Inscriptions: with a brush in bistre wash, in the lower left corner «1569»
Exhibited in Bassano del Grappa only

Provenance
Early history unknown.

Exhibitions
Never before exhibited.

Bibliography
Arslan 1931, 278 (as Leandro Bassano); Tietze and Tietze-Conrat 1944, 56, no. 216 (as shop of Leandro Bassano); Arslan 1960 (B), I, 342 (as shop of Leandro Bassano); Rearick 1962, 530-33; Ballarin 1969, 85-86 and 93-94; Byam Shaw 1976, I, 202; Rearick 1989, III, 9, fig. e.

This drawing was included in the Bassano literature before its pendant, *The Archangel Gabriel* (Christ Church, Oxford, cat. 99). Arslan first assigned it to Leandro (1931) and then to the Bassano workshop (1960 (B)) in agreement with the position expressed by the Tietzes. Rearick refused to call it a product of the shop. In connecting the sheet with its companion, mentioned above, he proposed that the finished and slightly academic character of the drawing was not due to the intervention of another hand, but to the different purpose of the drawing: that is, to record and not to work out an invention. This was the first attempt to put together a category of «*ricordi*», or records, large scale, very finished drawings executed in bistre wash and white heightening over a black chalk underdrawing, which start appearing in Jacopo's corpus at the beginning of the 1560s. This type of drawing filled a need for an archive of the master's inventions from which the workshop could draw. Traces of glue and fabric on the back of some of these sheets, which is the case of the one in ques-

tion, proved, according to the hypothesis of Rearick, that they were originally glued onto the fabric of «tredici rodoli di diversi disegni» (thirteen rolls of various drawings) mentioned in the inventory of the painter's workshop (Verci 1775, 533). Starting at the end of the 1560s, the practice of making «*ricordi*» would have become the task of the shop and would have represented the first exercises in painting for Jacopo's sons. Jacopo could have reused these drawings many years later, as is the case with the drawing of *The Madonna and Child* (Hamburger Kunsthalle, Kupferstichkabinett, Hamburg, cat. 113). The figures in both the drawing in Florence and in Oxford are cut off at one side by a vertical line parallel to the edge of the sheet. In the Oxford sheet the angel's leg and one wing are cut off and in the Florentine sheet the Virgin's back and feet are cut off. According to Rearick, this is because the drawings are copies after finished paintings.

This theory of the role of a certain type of drawing, heavily represented in Jacopo's corpus, did not convince Ballarin. In particular, two arguments in Rearick's article of 1969 reveal the problematic aspects of the question. First, there is the fact that drawings like the Oxford *Angel* and others classified as «*ricordi*» by Rearick are of a rather high quality and do not just repeat details of paintings but, instead, seem to look forward to the particular nature of the artistic language found in them. Also, the drawings are interrupted along a line drawn parallel to the edge of the sheet. This is a characteristic that

becomes a common feature of the drawing style of Jacopo's sons and occurs in drawings that are definitely experimental in nature, like the ones in colored chalk, as well as the oil sketch for *Saint Paul Preaching* (Musei Civici, Padua, cat. 32). The interruption could refer to the presence of architectural backdrops or other compositional devices that framed the detail studied in the drawing. This leads one to interpret the Oxford *Angel* as a very finished preparatory study worthy of the late Veronese. As for a derivation of the drawing from the painting formerly in Lugano depicting *The Archangel Michael*, which was proposed by Rearick and with which Ballarin concurred, we feel judging from a photograph that the painting seems inferior in quality to the drawing and does not show the same refined distribution of light. One must be more cautious in appraising *The Virgin Annunciate*, where the lower quality could be explained by a different hand, rather than a different purpose.

A better understanding of the graphic production of Jacopo's sons and a clearer definition of the category of «*ricordi*» would help solve the complicated problem of defining the character and role of drawings like the ones in question. Rearick has referred several times to the presence of sheets of this type in the catalogues of Giuseppe Porta and of Veronese, but the question needs further investigation. In this specific case, while it is perhaps prudent to maintain some doubt about the authorship of the Uffizi drawing –

493

99. The Archangel Gabriel (1569)

The Governing Body of Christ Church, Oxford, inv. 1416
Bistre wash, heightened with white, over black chalk on brown paper, faded from blue, which has been glued to a backing; there is a fold line across the center and a stain on the left
535 × 327 mm
Inscriptions: on the recto, in the lower left-hand corner in bistre wash « 1569 »; on the backing in a seventeenth-century (?) hand: « Basano langelo de la famosa anonziata di Milano », and beside this annotation the « illiterate connoisseur » added « Copia »
Exhibited in Bassano del Grappa only

which here can be examined next to its companion – the quality of the Oxford drawing, with its careful attention to the distribution of light, lead one to categorize it as a very finished preparatory study. Despite the damage due to poor conservation, the drawing can be associated with *The Mystic Marriage of Saint Catherine* (Gabinetto Disegni e Stampe degli Uffizi, Florence, inv. 727 E) from 1567, which no one doubts is a preparatory study. Finally, regarding this problem, one needs to point to a passage in the *Libro Secondo*, where on 25 January 1569 a payment is registered from the Scuola di San Paolo in Bassano for « two figures based on his cartoons, that is to say the Annunciation of the Angel and the Madonna, over life-size ». The document does not say whether the figures were on canvas or in fresco, nor does it say where they were placed. The over life-size dimensions would exclude the above-mentioned canvas of *The Archangel Michael* (91 × 46 cm). However, the coincidence of the date and the subjects suggests a connection with the drawings discussed here. Further research needs to be done on the circumstance of the commission and on the use of the term « cartoon ».

V.R.

Provenance
General John Guise.

Exhibitions
Ingelheim am Rhein 1987.

Bibliography
Rearick 1962, 530, fig. 18; Ballarin 1969, 85-86, 93-94, 96, 102, 108, and fig. 96; Byam Shaw 1976, I, 202, no. 752, pl. 463; Whistler 1987, 82, no. 26; Rearick 1989, III, 8, fig. d.

This drawing was attributed to Jacopo by Rearick who, in an important article of 1962, connected it with *The Virgin Annunciate* (Gabinetto Disegni e Stampe degli Uffizi, Florence, cat. 98), also dated 1569. Contrasting the highly finished character of the two sheets with the experimental spontaneity of drawings such as the Uffizi *Visitation* (cat. 97), executed in the same year and in the same technique, the critic suggested that they should be interpreted as « *ricordi* » – in other words, drawings made after a finished painting as records for a later reuse by the workshop. Confirmation for this theory is provided, in this case, by the existence of a painting once on the art market in Lugano and first published by Fröhlich-Bum (1931, 123). It corresponds in every detail to the drawing, but the figure was transformed into the Archangel Michael, at a later date, by the addition of his attributes of a sword and scales. This interpretation, repeated by Rearick in several subsequent publications and applied by him to a number of other sheets associated with Jacopo

and executed in the same technique (see here, cats. 88, 89, 106, and 114), was accepted as plausible, with respect to the present drawing, by Byam Shaw. Ballarin, on the other hand, argued that this drawing and the Florentine *Virgin Annunciate* should be regarded as preparatory studies.

V.R.

494

100. THE PRESENTATION OF THE VIRGIN (recto)
THE PRESENTATION OF THE VIRGIN (verso) (c. 1570-75)

Muzeum Narodowe W Warszawie, Warsaw, inv. rys ob.d III
Bistre wash, heightened with white chalk, over black chalk on faded blue paper; stained; the sheet is composed of two smaller ones glued together
546×616 mm
Exhibited in Bassano del Grappa only

Provenance
The drawing has been in the museum collection since 1946; it had been in an eighteenth-century album, where it was numbered 176 and attributed to Jacopo with some reservations.

Exhibitions
Venice 1958; Warsaw 1962; London 1980; Braunsweig 1981.

Bibliography
Byam Shaw 1958, 395; Mrozinska 1958, 21-22; Pallucchini 1958 (B), 258-59; Arslan 1960 (B), I, 170 and 177; Mrozinska 1961, 397; Rearick 1962, 524; Popham and Fenwick 1965, 19; Ballarin 1969, 96 and 100; Mrozinska 1980, no. 2, pl. 8; Rearick 1980 (A), 30; Turner 1980, 213; Mrozinska 1981, 24-26, no. 3, fig. 3.

This compositional study first became known to scholars when it appeared in the exhibition of Venetian drawings from Polish collections held in Venice in 1958. Mrozinska attributed it to Jacopo and associated it with the colored chalk drawing of the same subject in the National Gallery of Canada, Ottawa (cat. 95), dated 1569, and with the figure of the Virgin in *The Visitation* in the Gabinetto Disegni e Stampe degli Uffizi, Florence (cat. 97) from the same year. He also pointed out compositional similarities with the altarpiece depicting *The Circumcision* (Museo Civico, Bassano del Grappa, cat. 121), which is signed by Jacopo and his son, Francesco, and dated 1577. Arslan and Popham agreed with his proposal, emphasizing the resemblance to the Ottawa drawing. They felt that both were preparatory studies for the same composition. Rearick rejected this hypothesis. At first, he favored a dating around 1575

for the drawing, but now he places it during the last period of the painter's activity. According to Rearick, the sheet inspired several motifs in the altarpiece of the same subject painted by Francesco for the church of the Zittelle in Venice around 1586. Ballarin dated the drawing in the 1570s. The verso of the sheet contains a first rapid sketch for the scene. In the upper part, a few lines define the compositional solution for the Virgin ascending the stairs and being received by a group of figures at the entrance to the temple. In the rest of the drawing nervous lines work out, with numerous pentimenti, the group watching the event from below. On the recto the composition is firmed up and is given an architectural setting. When compared with the version of the subject in the colored chalk sheet in Ottawa, dated 1569, the architectural framework, here, appears wider and deeper. This type of setting is characteristic of Jacopo's altarpieces executed in the first half of the 1570s, from *The Martyrdom of Saint Lawrence* (cathedral, Belluno, fig. 53) to the votive lunette in Vicenza depicting *The Madonna and Child with Saints Mark and Lawrence Being Revered by Giovanni Moro and Silvano Cappello* (Museo Civico, Vicenza, fig. 54). The groups of foreground figures reinterpret, with some changes, ideas experimented with in those works, but they move back into space more convincingly and are interconnected in a more naturalistic manner. One notes, for instance, the two figures in conversation at the bottom of the stairs, and the motif of the boy with

a dog that recalls the large canvas from Vicenza. No paintings by Jacopo of this subject are known.

V.R.

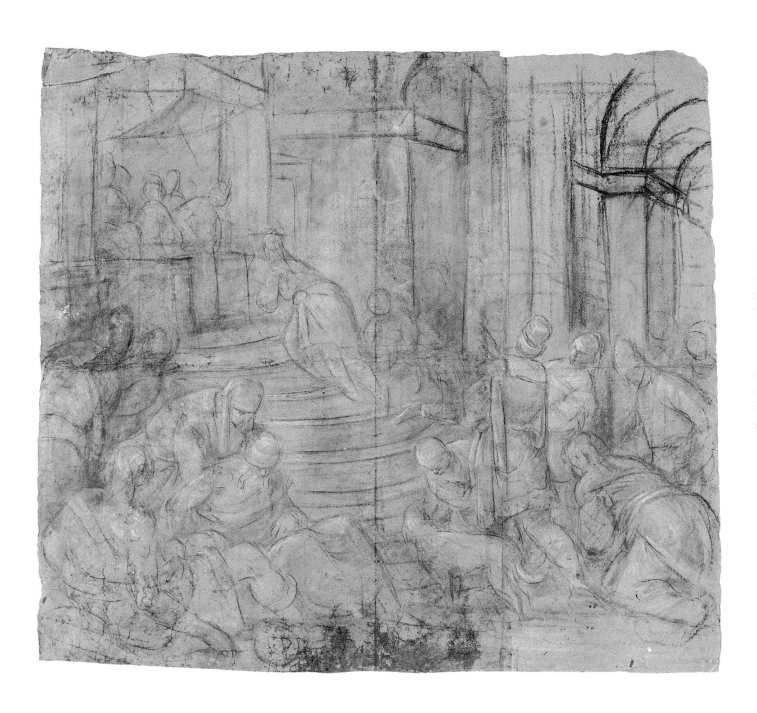

497

101. A Page Seen from Behind (c. 1570-75)

Lent by the Syndics of the Fitzwilliam Museum, Cambridge, inv. 1980
Black chalk, heightened with white, on blue paper
192 × 162 mm
Exhibited in Fort Worth only

Provenance
Charles Ricketts and Charles Shannon; Charles Haslewood Shannon bequest, 1937.

Exhibitions
Cambridge 1960; New York 1976; Fort Worth 1976; Baltimore 1976; Minneapolis 1976; Philadelphia 1976; Venice 1992.

Bibliography
Tietze and Tietze-Conrat 1944, 49, no. 120, pl. CXLII, 3; D'Albanella 1950, 65; Arslan 1960 (B), I, 165; Van Hasselt 1960, II 12, n. 16; Ballarin 1969, 103; Ballarin 1971 (A), 140-41 and 150, n. 13; Jaffé 1976, 5-6, no. 6; Rearick 1982 (B), 38; Scrase 1992, 56, no. 19; Rearick 1992 (B), in press.

The traditional attribution to Jacopo was confirmed by the Tietzes and has found unanimous critical acceptance ever since. Considerable disagreement has remained, however, about the purpose of the drawing. Van Hasselt connected it with the page who appears on the right in *The Return of the Prodigal Son*, formerly in the collection of Francesco Savorgnan in Venice, and known from a seventeenth-century engraving by Pietro Monaco (Pan 1992, no. 122). This hypothesis was endorsed by Jaffé, and very recently also by Scrase. Ballarin thinks that the figure of the page in the Savorgnan painting should be connected with the colored chalk study of *A Page Seen from Behind* (Gabinetto Disegni e Stampe degli Uffizi, cat. 102), whereas the figure in this drawing, while not definitely connectable with any painting, is perhaps closest to the page in *The Crucifixion* in the parish church of Cartigliano (fig. 103). Rearick, on

the other hand, suggested that this sheet is a preparatory sketch for the figure of the boy offering water to the old man on horseback, at the right in *The Israelites Drinking the Miraculous Water* (Museo del Prado, Madrid, cat. 39), which he considered a collaboration between Jacopo and his son, Giambattista, and dated around 1576-78. It could also be for an earlier version (now lost) of the same composition by Jacopo himself. Of these various theories, the one that connects the drawing with the page in the Savorgnan picture is the most convincing, since it best accounts for the pose with which Jacopo is experimenting here.

The figure is seen close up, and slightly from below, in a way that emphasizes the sudden, backwards movement of the head and shoulders. This pose of a figure with outstretched arms recurs frequently, either as seen here or in reverse, in the works of the early 1570s. Note, for example, the figure of Abraham in *Abraham's Journey*, a picture by Jacopo and Francesco dated to c. 1569, formerly in the collection of the Duke of Hamilton and now in a private collection, Canada (see Sotheby's, London, 2 December 1964, lot 97, ills.; Ballarin 1969, 101, 112, n. 46, and figs. 116-18; and here, fig. 60, for another version in a private collection, Bassano del Grappa). The pose is used again for the small child next to the mother on the extreme right of *The Israelites Drinking the Miraculous Water* (Gemäldegalerie Alte Meister, Dresden) of c. 1573 (Ballarin 1988, 1-2). The latter picture was painted about the same time as the

lunette depicting *The Madonna and Child with Saints Mark and Lawrence Being Revered by Giovanni Moro and Silvano Cappello* (Museo Civico, Vicenza, fig. 54), in which the figure of the page at the base of the steps is again very similar to the one in this drawing. The dynamic energy and synthetic draftsmanship are typical of Jacopo's figure studies from the 1570s. The black chalk, sometimes applied with thin, incisive strokes, other times with more blunted ones blended into the blue background, and the very light, nervous white heightening work together to create a light, airy network of light effects that defines form. The final result is in perfect harmony with this phase of Jacopo's painting style.

V.R.

499

102. A Page Seen from Behind (c. 1575)

Gabinetto Disegni e Stampe degli Uffizi, Florence, inv. 13053 F
Black and colored chalks (red, orange, yellow, brown), with touches of white
heightening, on faded blue paper
283×198 mm
Inscriptions: on the verso in pen, in an eighteenth-century hand: « Rocco Bassano » and « 6 »
Exhibited in Fort Worth only

Provenance
Medici-Lorraine collection.

Exhibitions
Florence 1961; Florence 1976.

Bibliography
Tietze and Tietze-Conrat 1944, 50, no. 139, pl. CXLI-4; Zampetti 1957, 241, no. 8; Arslan 1960 (B), I, 217 (as Francesco Bassano?); Forlani 1961, 20, no. 105; Ballarin 1971 (A), 139-40, 141, and 150, n. 12, fig. 5; Petrioli Tofani 1972, no. 67, ills.; Rearick 1976 (B), 164, no. 119, fig. 94; Rearick 1982, 38; Rearick 1992 (B), in press.

Listed in the 1793 manuscript inventory of the Uffizi collection and first published by the Tietzes with an attribution to Jacopo Bassano, this drawing has been accepted as autograph by all critics except Arslan, who tentatively suggested the name of Jacopo's son Francesco. The figure is in the same pose as the page in the drawing in the Fitzwilliam Museum, Cambridge (cat. 101), but is drawn in a different technique. While this is a fairly common motif in Jacopo's graphic repertory of the 1570s, attempts to connect this sheet with a specific painting have been unsuccessful. Petrioli Tofani associated it with the page in *Tamar Brought to the Stake* (Kunsthistorisches Museum, Gemäldegalerie, Vienna, cat. 38), which is certainly an earlier work. Ballarin related it to the boy with his back to the viewer in *The Return of the Prodigal Son*, formerly in the Savorgnan collection in Venice and known through an eighteenth-century engraving by Pietro Monaco (Pan 1992, no. 122). He pointed out that there also exists a rapid sketch for the raised right hand. However, in this drawing the page looks up towards a point higher than the one in the print, causing the head to tip back more sharply. Rearick's hypothesis, that the study could be a first idea, considerably altered subsequently, for the page with a tray who appears in a series of drawings of the Adoration of the Magi, is no more convincing. Jacopo developed this theme during the 1570s, but only shop replicas of it are known. The most important copy is the canvas in the Galleria Borghese, Rome (cat. 56), which Rearick considers a work by Leandro from c. 1580.

The effectiveness of the Uffizi drawing depends on the relationship between the chromatic brightness of the face and hat, executed in a mixture of rich luminous red and pink blended with touches of yellow and violet, and the soberness of the clothing, executed in a combination of thin and broad strokes of black chalk and touches of white heightening that create a sort of transition to the blue paper, barely touched by white in the area of the shoulder and the collar. A connection with other sheets done in colored chalks in the seventies, especially with the group of preparatory drawings for the frescoes in the parish church in Cartigliano (cats. 108 and 109), is evident, but the originality of the result achieved here should be pointed out. The harmony of the colors is warmer, fuller, and more resonant than the studies for *The Sacrifice of Abraham* (Musée du Louvre, Département des Arts Graphiques, Paris) and *Saint John the Evangelist* (The British Museum, London), where the chalks are applied in a more rarefied manner and there is a refined play of chromatic effects using cold iridescent colors.

V.R.

103. HALF-LENGTH FIGURE LEANING FORWARD (c. 1570-75)

Galleria Estense, Modena inv. 1956, no. 1507 (inv. 1884, no. 1101)
Black and colored chalks (pink, red, brown, lemon yellow, yellow ocher),
heightened with white, on faded blue paper with a watermark showing a
long-necked bird in a circle (not in Briquet)
161.5 × 187 mm
Exhibited in Bassano del Grappa only

Provenance
Early history unknown.

Exhibitions
Modena 1989.

Bibliography
Palluchini 1938, 81; Tietze and Tietze-Conrat 1944, 52, no. 171; Arslan 1960 (B), 1, 355 (as close to Jacopo Bassano); Ballarin 1971 (A), 139, 141, and 150, n. 11, fig. 4; Saccomani 1989, 114, pl. XXIV; Rearick 1992 (B), in press.

The faded blue paper and slightly rubbed colored chalks take something away from the freshness of this study, which was first published by Pallucchini in 1938. It joined what was then a small group of colored chalk drawings by Jacopo, which included the sheets in the Graphische Sammlung Albertina, Vienna (cat. 107) and Hessisches Landesmuseum, Darmstadt. While the autograph quality of the drawing has rarely been disputed – only Arslan expressed some doubts – the drawing was ignored until Ballarin republished it and compared it to the drawings of the early 1570s, in particular the study for *Saint John the Evangelist* (The British Museum, London) frescoed on the vault of the Cappella del Rosario in the parish church of Cartigliano. While Ballarin (1971 (A)) first published this connection, it had already been pointed out by Rearick in a note on the mat. Saccomani (1989) agreed with Ballarin. Rearick (1992 (B)), on the other hand, in an addendum to the last volume of his corpus of Jacopo's drawings, now proposes that the drawing is a preparatory study for the shepherd standing in the center of *The Adoration of the Shepherds* (Galleria Corsini, Rome, cat. 36), consequently moving the date back to the first years of the 1560s. However, the two figures look quite different. Not only is there a difference in the position of the right arm – pointed out by Rearick – but also in the position of the whole figure. In the drawing it appears parallel to the background, while in the painting it is in a three-quarters view and the left shoulder is pulled forward. The posture of the figure in the painting is executed with more care, and an attempt is made to endow the figure with elegance by elongating it and giving it a slightly twisting movement. Similar handling can be found in a black and white chalk drawing on blue paper depicting *Saint Paul* (Hazlitt, Gooden and Fox, London, cat. 87), which is a study for *Saints Peter and Paul* (Galleria Estense, Modena, cat. 34). The London drawing is more or less contemporaneous with the Corsini *Adoration of the Shepherds*, rather than with the Modena drawing examined here. The Modena drawing is executed with a brisk, abbreviated draftsmanship more typical of the seventies. Furthermore, the use of chalk «to work out the whole network of pictorial and luminescent passages, which will constitute the figure when it occupies its space in the painting» by means of «a subtle modulation of his earlier palette» (Ballarin), links the drawing to the group of preparatory studies for the cycle of frescoes in the parish church in Cartigliano of 1575. In particular, the cold yellow highlights on the gray right shoulder and those interrupted by heavy strokes of reddish-brown and black, which define the shape of the left sleeve, clearly recall the drawing mentioned above in The British Museum. A convincing parallel to the handling of the drawing can be found in the detail of the young boy with a stick of charcoal, kneeling at the right in the painting of *The Martyrdom of Saint Lawrence* (cathedral, Belluno, fig. 53), on which we can now read the date «1571». The drawing from Modena should, therefore, be dated c. 1570-75.

A pentimento in the position of the head, which at first was higher and pulled further back, is revealed by the double profile of the neck and the top of the head and in the retouching of the contours of the face.

V.R.

104. TWO RABBITS (c. 1570-75)

Gabinetto Disegni e Stampe degli Uffizi, Florence, inv. 811 Orn
Black and colored chalks (brown, violet, pink, ocher) with touches of white
chalk on brownish-gray paper, mounted on a backing
159 × 241 mm
Exhibited in Fort Worth only

Provenance
Medici collection by 1793.

Exhibitions
Florence 1914; Florence 1953; Florence 1961; Florence 1976.

Bibliography
Ferri, Gamba, and Loeser 1914, 34, no. 114 (as Francesco Bassano); Muraro 1953, 10-11, no. 4, fig. 5; Forlani 1961, 44-45, no. 66, fig. 51; Ballarin 1964, 67; Rearick 1976 (B), 165, no. 120; Rigon 1983 (A), 54; Rearick 1989, III, 10, fig. f.

The attribution to Francesco Bassano found in the Uffizi inventory of 1793 was reproposed at the beginning of this century (Ferri, Gamba, and Loeser 1914) when the drawing was in the exhibition dedicated to Venetian drawings of the Renaissance. While the Tietzes left it out of their inventory, Muraro gave the study to Jacopo, basing his attribution on its strongly naturalistic character, and he compared it with the study for a head of a donkey (formerly in the Geiger collection, now Staatliche Museen Preussischer Kulturbesitz, Kupferstichkabinett, Berlin, inv. KdZ. 15655). This proposal was accepted by Ballarin (1964) in his study on Jacopo as an animal painter. In this article Ballarin refocused attention on the study for a greyhound (Walker Art Gallery, Liverpool, inv. 1216), already known to Arslan and the Tietzes and exhibited in Venice in 1957. Emphasizing the emotional veracity of these drawings done from life, Ballarin suggested a date in the 1570s, when the painter was particularly occupied with paintings that included this type of subject matter. He as-

signed to Jacopo, around 1560, two studies of oxen (Det kongelige Bibliotek Kobberstiksamling, Copenhagen), which later proved to be by Carletto Caliari. Finally, Rearick connected the Uffizi drawing to the preparation of the painting depicting *Noah Gathering the Animals into the Ark* (Museo del Prado, Madrid, inv. 22 and here, fig. 51), which is considered to be the earliest version of this well-known subject and was executed in collaboration with the workshop around 1569-70. Rearick suggested that the drawing of a donkey's head in Berlin was also used for this painting. He does not agree about the attribution to Jacopo of the greyhound in Liverpool, which he feels is a copy by Francesco Bassano made after the later version of *The Animals Entering Noah's Ark* (Arcibiskupský Zámek a Zahraóy, Kroměříž, cat. 64).

Starting in the first years of the 1570s, Jacopo experimented with a new type of spatial construction for his biblical-pastoral paintings. The landscape is viewed sharply from above. It takes over the pictorial plane and is populated by an exodus of biblical figures that move across it in a diagonal, accompanied by a new and varied collection of animals. Paintings important for the evolution of this genre are: *Abraham's Journey* (private collection, Canada, formerly Duke of Hamilton, Sotheby's, London, 2 December 1964, lot 97, ills.; and Ballarin 1969, 101, 112, n. 46, and figs. 116-18: as Jacopo and Francesco, c. 1569) and the Prado canvas, mentioned above, depicting *Noah Gathering the Animals into the Ark*

(Rearick 1968 (A), 242, fig. II: c. 1570; Ballarin 1969, 112, n. 46: c. 1570). It is quite likely that the study in question was executed during this period. In fact, as Rearick observed, it recalls the pair of rabbits that appear in the front plane of the painting in the Prado, although there is not an exact correspondence. In the tightness of the handling in the painting – a strong indication of shop participation – one cannot find that striking sense of veracity that appears in the drawing, which was certainly executed from life. Soft, closely aligned strokes of black and violet chalk describe the two rabbits hidden in the grass: one crouching against the background, with its ears held straight up, and the other curled up next to it, with its raised muzzle and a defenseless expression. The fur is rendered in soft varied passages of the chalk, which range from a cold tonality along the contours of the figure to warmer reds and ochers. White touches illuminate the chest and snout. Similar pictorial subtleties, rather common in the colored chalk drawings of the 1570s, are also found in the study for a greyhound in Liverpool. Executed with a great economy of color, its autograph quality is confirmed by passages such as the smooth-flowing, almost shiny effect of the hair on the slender body of the animal and by the dark modeling of the stomach in black and brown chalks, contrasted with the back-lighted outlines of the back paw. The attribution of the *Head of a Donkey* in Berlin, memorable for its mild submissive expression and for the dull, disheveled tex-

504

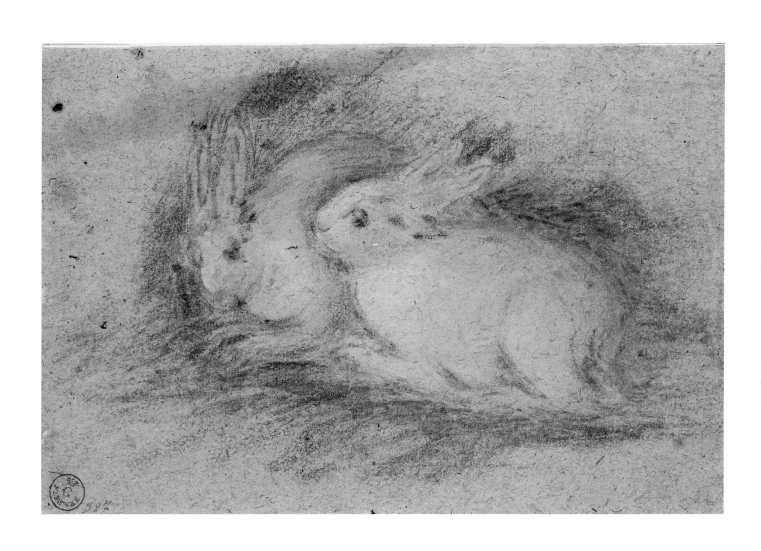

505

105. Lion's Head (c. 1570-1575)

Private collection, England
Black and colored chalks (red, ocher, yellow) with touches of white chalk on faded blue paper; the lower left corner has been replaced, and a horizontal tear on the left edge has been repaired
405 × 270 mm
Inscriptions: on the recto along the lower left edge: « R ... s 30 »; the annotation is in very pale chalk and difficult to read; it could refer to an attribution to Rubens, repeated on a small piece of paper glued onto the verso of the drawing in a brief printed text: «... n leeuwenkop, door P.P. Rubens »
Exhibited in Fort Worth only

ture of its coat, seems more convincing when it is compared to the engraving dated 1649, recently brought to light by Pan (1992, no. 48), which was executed by Hollar after Jacopo's drawing of a donkey.

V.R.

Provenance
Early history unknown.

Exhibitions
Never before exhibited.

Bibliography
Rearick 1989, III, 12, fig. h.

This astonishing study for the head of a lion has recently enriched the small collection of animal «portraits» painted and drawn by Jacopo. This is an aspect of his production that is still poorly documented and one that seems more modern, as an old attribution to Rubens proves. When Rearick published this drawing he emphasized that it had the character of a life-study, rich in expressiveness and surface texture, and he proposed a date around 1573. He compared it with the lion depicted next to *Saint Mark in Glory with Saints John the Evangelist and Bartholomew*, which decorates the high altar of the parish church in Cassola – consecrated on 21 December 1573 – without, however, implying that there is a precise correspondence between the drawing and the painting.

The drawing is executed with that attention to luminescent and pictorial effects that characterizes the major part of the colored chalk studies done by Jacopo in the 1570s. The warm register of the tawny brown chalk turns into golden ocher and yellow in the mane framing the animal's face. A rich, yet, dissolving network of color almost cancels itself in some places to allow the blue of the

paper to show through. The eye socket is set off with touches of white heightening. A speck of yellow flashes in the right pupil. Soft white heightening appears on the forehead, on the cheeks, and on the nose and around the mouth, where the application of color becomes thinner. The painter enters into an extraordinarily syntonic relationship with the animal, giving the lion an almost human personality. This is achieved by elongating the muzzle, giving the head a slight three-quarters turn, just barely tipped towards the right, and endowing the eyes with a melancholy, detached gaze. Keeping in mind the difficulty of finding a precise placement for a drawing of this kind, one could try to date it within the first half of the 1570s, near studies such as the *Two Rabbits* (Gabinetto Disegni e Stampe degli Uffizi, Florence, cat. 104), the *Greyhound* (Walker Art Gallery, Liverpool, inv. 1216), and the *Head of a Donkey* (Staatliche Museen Preussischer Kulturbesitz, Kupferstichkabinett, Berlin, inv. KdZ. 15655).

V.R.

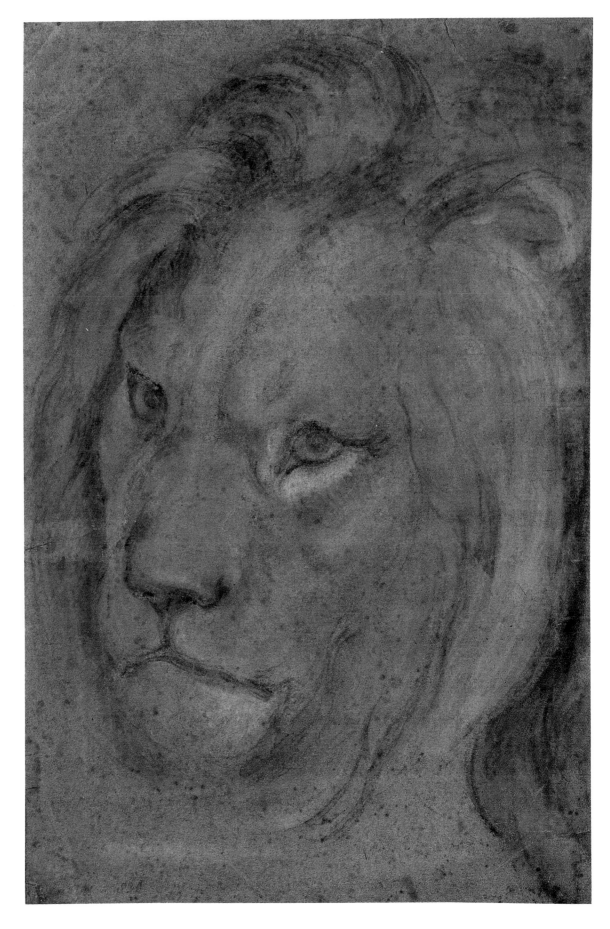

106. The Martyrdom of Saint Sebastian (1574)

Royal Library, Windsor Castle, Berkshire, inv. 6673, Lent by Her Majesty
Queen Elizabeth II
Black chalk with light brown wash on blue slightly faded paper
346×505 mm
Inscriptions: the date « 1574 », in brown wash on the base of the column just to
the right of the center
Exhibited in Fort Worth only

Provenance
Eary history unknown.

Exhibitions
Never before exhibited.

Bibliography
Popham and Wilde 1949, 196-98, no. 122
(as after Jacopo Bassano); Arslan 1960
(B), I, 385 (as after Jacopo Bassano); Re-
arick 1962, 530, n. 23 (as Jacopo and
Francesco); Ballarin 1969, 113, n. 50; Bé-
guin 1979, 14; Guillaume 1980, 7-8; Rear-
ick 1989, III, 14, fig. i (as Jacopo and
Francesco Bassano).

The drawing has long been con-
sidered a copy of a painting in the
collection of the Archduke Leopold
Wilhelm, which was mentioned in
the catalogue of the Viennese collec-
tion by von Mechel (1783, 75, no. 30)
and attributed to « old Bassano ». It
was engraved by Ossenbeck in the
Theatrum Pictorium. The painting was
considered lost until the Paris exhi-
bition of 1965 (Rosenberg 1965, 25,
no. 34, fig. 34: as Jacopo and Franc-
esco), when it was identified with
the small picture in Dijon (Musée
des Beaux-Arts, no. 41; oil on canvas,
65.5×76 cm, and here, fig. 55) signed
« IAC. BASSANEN / FACIEBAT / AN /
MDLXXIV ». The autograph quality of
this painting has been doubted
(Guillaume 1980, 7-8, no. 13, fig. 13)
and often denied, in favor of an attri-
bution to Leandro or Gerolamo.
Rearick looked at the drawing in a
new light and decided it was not a
mere copy, but a « *ricordo* », or record,
of the whole composition. He gave
the part in chalk to Jacopo and the
part in wash to Francesco and com-
pared it to other drawings of the
same type, such as *The Martyrdom of*
Saint Lawrence (Gabinetto Disegni e
Stampe degli Uffizi, Florence, inv.
13065), which is connected with the
altarpiece of the same subject in the
cathedral in Belluno (fig. 53). By this
point in his career the artist had
turned over to his sons the task of
making records of paintings that
could be referred to by the shop at
a later moment. Occasionally he
would have intervened by tracing
the general outlines in chalk. Re-
cently, while confirming the pres-
ence of Francesco's hand in the
Windsor *Saint Sebastian*, Rearick
seemed inclined to give the light ex-
pressive touches of the wash model-
ing to Jacopo, as well as the chalk
underdrawing.

The questions posed about the
nature of this drawing are the same
as those concerning sheets such as
The Archangel Gabriel (Christ Church,
Oxford, cat. 99) and *The Virgin An-
nunciate* (Gabinetto Disegni e Stam-
pe degli Uffizi, Florence, cat. 98).
Are they part of the preparatory
process for a painting in its final
stage, or are they records of details
derived from the finished work and
made to form part of the shop ar-
chive of visual sources? Of course,
in this case there is a difference; the
drawing treats the whole composi-
tion – not just one figure. Sheets of
this type are quite common in Jaco-
po's oeuvre (see the list of examples
in Ballarin 1969, 113, n. 50). Even
among those executed in brown
wash and heightened with white
over black chalk, we find noticeable
differences in handling. These range
from the painstakingly finished
character of the drawing in question
to the more cursive and approxima-
tive execution of *The Expulsion of the
Merchants from the Temple* (Musée du
Louvre, Département des Arts Gra-
phiques, Paris, inv. 5280), which re-
cords a lost composition and is dated
1570. The dimensions vary greatly as
well. Two examples of large draw-
ings are the Uffizi *Martyrdom of Saint
Lawrence*, mentioned above, and
Saint Roch Visiting the Plague Victims
(Gabinetto Disegni e Stampe degli
Uffizi, Florence), which reproduces
the bottom half of the altarpiece in
the Pinacoteca di Brera, Milan (cat.
47). They are executed on pieces of
paper glued together. In order to de-
termine the real role of these draw-
ings in the creative process of the
Dal Ponte workshop, it will be nec-
essary to reevaluate all the known
information and to do more research
on the working procedures of Jaco-
po's sons. Each case will have to be
studied as it comes up.

The painting in Dijon belongs to
the same year, 1574, as the altarpiece
of *The Entombment* from the church
of Santa Maria in Vanzo, Padua (cat.
52). It reproduces that picture's dra-
matic intensity, but reduces it to a
more intimate dimension, concen-
trating on the solitary relationship
between the defenseless figure of
the young martyr and the impassive
cruelty of the archer, caught in the
act of pulling back the arrow in his
bow. Below, a boy, indifferent to
the torture, leans on one of the steps
and reaches for an arrow. In the
Windsor drawing, the composition,
slightly cut along all four sides, is
first sketched in light, sure strokes of
chalk, which are then reinforced by

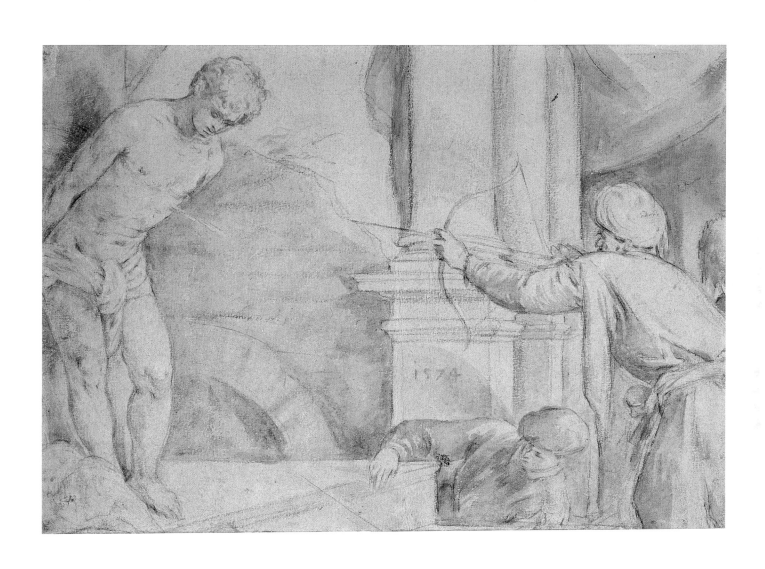

107. Sleeping Figure and a Shepherd with a Basket (recto)
Sleeping Shepherd (verso) (c. 1575)

Graphische Sammlung Albertina, Vienna, no. 23642 (Ven. 76)
recto: black chalk and brown wash on blue paper
verso: black chalk on blue paper
264×369 mm
Exhibited in Fort Worth only

shorter strokes and pale brown wash used to create volume. White wash, cleverly graduated in its intensity and calculated in its relationship with the blue paper, helps give transparency to the twilight atmosphere that invades the depth of the portico and casts shadows that become elongated on the architecture, due to the effect of the beam of light coming in from the right. Despite the economy with which it is realized, the drawing does not seem executed in an abbreviated or mechanical manner, which would suggest it was a copy. To the contrary, there are a few slight differences between it and the painting, which previously have not been noted. In the drawing, the drapery abandoned on the steps to the left completely hides the right foot of the saint, while in the painting the saint stands on top of it. In the painting, the piece of drapery, which falls from the shoulder of the archer, has been given more folds, thus creating a richer play of chiaroscuro. A few other small changes can be seen; in the painting the illumination on the saint's loincloth is sharper and more lively, while in the drawing the play of light on the shoulder of the boy is more pronounced. These changes in the composition and light make the hypothesis that this sheet is a very finished study for the painting in Dijon seem more plausible.

V.R.

Provenance
Early history unknown.

Exhibitions
Venice 1957.

Bibliography
Stix and Fröhlich-Bum 1926, I, 50, no. 76, fig. 76; Arslan 1931, 286 (as not by Jacopo Bassano); Tietze and Tietze-Conrat 1944, 54, n. 204 (as workshop copy); Zampetti 1957, 246, n. 29; Arslan 1960 (B), I, 380 (as workshop of Jacopo Bassano, Francesco?); Rearick 1992 (B), in press (as recto: Gerolamo Bassano?; verso: Jacopo Bassano).

The proposal by Fröhlich-Bum to attribute this drawing to Jacopo as a study for the nocturnal *Annunciation to the Shepherds* (formerly in Dresden, inv. 259) did not have much following. Arslan rejected the hypothesis, tentatively suggesting an attribution to Francesco. The Tietzes felt it was a shop copy. Rearick now proposes to connect the verso, illustrated here, with the nocturnal *Annunciation to the Shepherds* (Národní galerie, Prague, cat. 54), a picture published by Ballarin (1966, 112-36). Rearick considers the Albertina drawing to be an autograph preparatory study, executed between 1579-81, for the figure of the shepherd in the center of the painting. The recto, which is of lower quality, is, in his opinion, by another hand, perhaps that of the young Gerolamo, who would have copied from the painting, as a «*ricordo*», or record. It shows the same figure prepared by his father on the verso, as well as the figure of the shepherd kneeling in the left corner of the painting. Therefore, we have a case of a draw-ing used for two purposes: a preparatory study on the verso and a «*ricordo*» on the recto.

On the verso the rounded forms of the sleeping, curled up shepherd emerge from a cocoon of black chalk lines. The dynamism and the decisiveness, typical of the studies of the 1570s, are substituted here with a more cautious and tranquil handling, which effectively renders the idea of a figure immersed in the numbness of sleep. In the Prague canvas, the immobility of the youth, enveloped in the darkness, is contrasted with the teeming, luminous animation of the landscape filled by divine light. In the drawing, black chalk lines make continuous adjustments and corrections to the contours. A more significant change occurs in the realization of the right arm, bent to hold up the head, which is first given a lower position and then raised. In the painting, the figure gravitates more towards the left, a solution already experimented with in the drawing, where the profile of the left shoulder, arm, and hand are moved upward. Finally the diagonal position of the legs in the drawing is slightly straightened in the painting.

This version of a nocturnal *Annunciation to the Shepherds* should date around 1575, together with other paintings with analogous night settings, such as *The Adoration of the Shepherds* (private collection, Padua) and the two versions of *The Agony in the Garden* (Burghley House Collection, Stamford; and Galleria Estense, Modena). The Modena version can be connected with two studies that

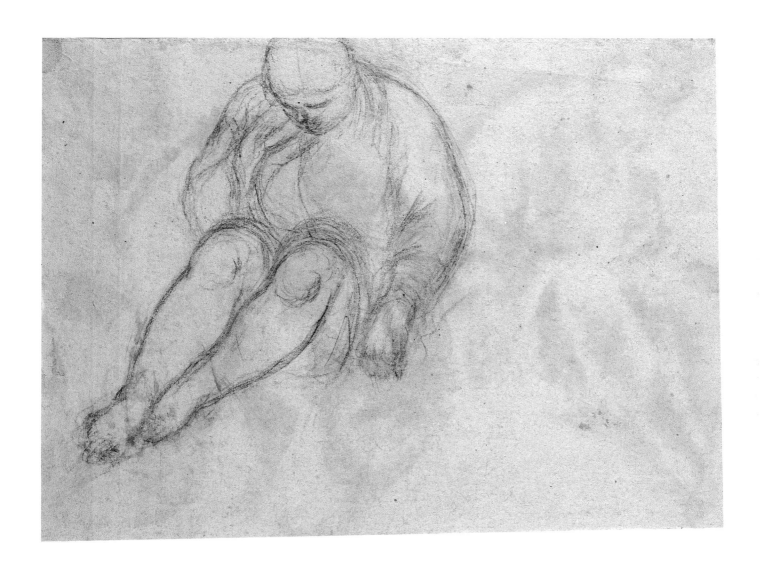

appear on the same sheet as *The Good Thief* (Musée du Louvre, Département des Arts Graphiques, Paris, inv. RF 2897) for the 1575 cycle of frescoes in Cartigliano: *The Mocking of Christ* (formerly Morandotti collection) and *The Crucifixion* (Museu Nacional d'Arte de Catalunya, Barcelona, cat. 55).

One must use greater caution in evaluating the recto, where the brown wash gives the forms a rather heavy quality. The juxtaposition of two figures from the same composition, without paying any attention to their original spatial relationship, is characteristic of Francesco's and Leandro's graphic work.

V.R.

108. SAINT MATTHEW (1575)

The J. F. Willumsen Museum, Frederikssund, inv. G.S. 1308
Black and colored chalks (violet, pink, orange, yellow, ocher), heightened with white, on faded blue-green paper, upper corners replaced
357×409 mm
Inscriptions: on the recto, on the lower right, in pencil by a modern hand: «San Matthew»; in the upper right, in pencil by Willumsen: «1308»; on the verso of the mat, in pen and brown ink, in the hand of J. Richardson Senior: «nei primi tempi colori con grazia con dolcezza e con movimenti parmigianeschi, ma nel ultimo con quel tignere di macchia a colpi, e di forza rese stupita l'arte ammiratrice di una tanta franchezza. Orlandi di Ridolfi which last says that in the Vicentino he coloured in Fresco the figures of the Four Evangelists. One of which probably was the Present S. Matthew. Sagredo Coll.»; in a modern hand, in pencil: «From the Sagredo Collection / Richardson collection? 1772 and Sharp collection 1878» again in a modern hand similar to the one on the recto; in the hand of Willumsen: «1308 / Francesco Bassano / The Heavenly Paradise / c. 1574»
Exhibited in Bassano del Grappa only

Provenance
Sagredo Collection; J. Richardon Senior (L. 2184); William Sharp (L. 2650); acquired by J. F. Willumsen before 1 October 1927.

Exhibitions
Copenhagen 1988.

Bibliography
Fischer 1988, no. 1, 13, pl. 1; Byam Shaw 1989, 493; Rearick 1991 (A), IV, 4.

The drawing is related to the frescoes in the Cappella del Rosario in the parish church in Cartigliano, which is one of the most complete and best preserved of Jacopo's fresco cycles. We now know that he worked there in 1575 because that date has been found in the scene of Moses receiving the tablets of the Law (fig. 104). Ridolfi (1648, I, 397) and Verci (1775, 102 and 162-63) attest to the collaboration of his son, Francesco. After being ignored by modern scholars, the frescoes were published in detail by Muraro, who focused attention on the newly discovered date and on two drawings that Van Regteren Altena had noticed in the Département des Arts Graphiques of the Musée du Louvre, Paris, among the Barocci drawings. One is a preparatory study for the figure of Abraham (inv. 2913) in the scene of the sacrifice of Isaac, painted on the back wall of the chapel (here, fig. 104). The other is a study for the Good Thief (inv. 2897) in The Crucifixion (here, fig. 103) on the left wall (see Rearick 1991 (A), IV, 5-6). Because the execution is extremely free and innovative, these frescoes have an expressive power and spontaneity unlike that of the fresco tradition associated with Veronese and Zelotti, which dominated the Veneto in the 1550s and 1560s. One of the interesting aspects of this fresco cycle is the fact that, of all of Jacopo's undertakings, it is the best documented by preparatory drawings. This spectacular group of colored chalk studies on blue paper, which can be dated 1575, constitutes a useful starting point for understanding Jacopo's development in this medium. We can add to the two drawings mentioned above three studies for the vault, which was divided into four sections by garlands of fruit and flowers. In each section an evangelist and a doctor of the church were paired. The Willumsen drawing is for Saint Matthew. The one in The British Museum, London, is for Saint John (inv. 1943-11-13-2; see Ballarin 1971 (A), 139-40; and Rearick 1991 (A), IV, 3, fig. a). The other shows Saint Gregory the Great (Musée du Louvre, Département des Arts Graphiques, Paris, cat. 109). Rearick proposed to connect the study for a *Reclining Figure* (private collection, Paris) and the study for a *Kneeling Female Figure Seen from Behind* (Staatliche Museen Preussischer Kulturbesitz, Kupferstichkabinett, Berlin, inv. KdZ. 5121) to the cycle. Ballarin (1971 (A), 141-42, fig. 8; and 1973, 112 and 117-22, fig. 140), instead, maintained that they are examples of Jacopo's colored chalk style from an earlier period, dating them c. 1560 and c. 1567, respectively.

The drawing shares with the *Saint John* in The British Museum a provenance from the Sagredo collection, attested to not by the usual collector's mark followed by a number but by an annotation on the old mat. The inscriptions on the two drawings are different in content, but by the same hand, which has been identified with that of Richardson Senior. In addition to giving the correct attribution, the collector proposed to connect the *Saint Matthew* drawing to the four figures of evangelists painted by Jacopo in the environs of Vicenza and mentioned by Ridolfi. These could not refer to Cartigliano because the sources describe the doctors of the church on the vault there. They could, however, be those recorded in a chapel «in the Villa delle Nove in the Vicenza area» (Ridolfi 1648, I, 389), which are now lost. Despite the authoritative opinion of Richardson, Willumsen, in his annotation on the mat, assigned the drawing to Francesco, around 1574, and related it to the al-

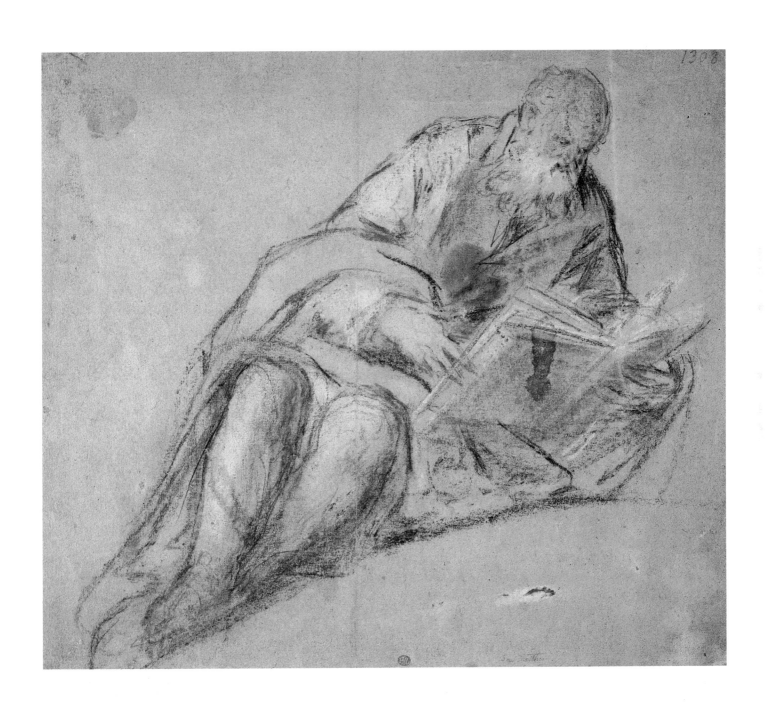

Musée du Louvre, Département des Arts Graphiques, Paris, inv. R.F. 38936
Black and colored chalks (brown, pink, yellow, red) with traces of white chalk
on blue paper, irregularly cut along the edges
346×267 mm (maximum measurements)
Inscriptions: on the verso, in pen: «B.B. no 65»
Exhibited in Bassano del Grappa only

tarpiece depicting *Paradiso* in the Museo Civico in Bassano del Grappa (cat. 123). In a recent publication Fischer correctly returns the drawing to Jacopo and reassociates it with its proper destination.

While in the Louvre studies for Abraham and the Good Thief, Jacopo attempts to give a monumental presence to the figures by tracing and retracing their contours with dynamic strokes of black chalk, in the *Saint Matthew* drawing he uses short decisive lines to define form in an economic way and seems more concerned with achieving, through a light application of colored chalk, the refinement of lighting effects and the transformations of color that are characteristic of his style around the mid-1570s. The evangelist's violet clothing is modeled with substantial touches of brown and black in the folds and shaded areas, and with yellow and white heightening in the illuminated points, culminating in iridescent effects of color in the right sleeve. The results were carried over into the fresco with a few exceptions; the color of the drapery was changed to green and the position of the figure was moved slightly towards the right. A striking feature of the drawing is the pair of large knees pushed into the front of the pictorial plane by the foreshortening of the legs. A mixture of red, ocher, brown, yellow, and black chalks combine to produce a pictorialism and a naturalistic impetuosity that are characteristic of the Cartigliano cycle.

V.R.

Provenance
The inscription on the verso and the mat with onglets on a piece of paper bearing the annotation, in pen, «B.B. n° 65», found on many Bassano drawings, indicates a so-called Borghese or Sagredo provenance; acquired by the museum in 1982.

Exhibitions
Paris 1984.

Bibliography
Goguel 1984, 14, no. 11, ills.; Bacou 1987, 106 7, fig. 3; Rearick 1991 (A), IV, 2, pl. I.

Recently acquired by the Louvre, together with a study depicting *The Capture of Christ* and other important drawings from the Dal Ponte workshop (Bacou 1987), this spectacular sheet comes from an important collection about which little is known. It is sometimes identified with the Borghese collection, other times with the Venetian collection of Zaccaria Sagredo. In the past, but especially in recent years, numerous drawings have emerged from this collection to enrich and transform the physiognomy of Jacopo as a draughtsman, which previously had been traced by the Tietzes (1944) and Arslan (1960 (B)). Goguel published this sheet as a preparatory study by Jacopo for Saint Crescenzio, depicted to the right in the altarpiece of *Saints Anthony and Crescenzio Interceding with the Virgin on Behalf of the Flood Victims* (Santa Maria degli Angeli, Feltre), which is signed and dated 1576. Bacou then related the sheet to the figure of Saint Gregory the Great, frescoed next to Saint John the Evangelist on the vault of the Cappella del Rosario in the par-

ish church of Cartigliano in 1575. Rearick accepted this connection and agreed with Bacou that the drawing was subsequently reused for the altarpiece in Feltre.

The figure is economically studied with a few decisive strokes of black and brown chalk that define the contours. Foreshortened and viewed from below, it is seated on an arch barely indicated along the lower edge of the sheet. The mass of the body, which tapers rapidly upward to the conically shaped tiara, is described with an intentionally brutal simplicity. Within the geometric framework of the planes, in abbreviated bold passages, the chalk liberates the violence of the color: the red mantle is illuminated by a golden yellow along the borders of the cope, which are juxtaposed to the luminous silvery alb. In transferring the design to the vault, the unbalanced tipping of the figure towards the left is accentuated, but the liberty and arrogance of the conception are preserved intact. The effect is completed by the bold, fleshy features that characterize the face, squeezed between the shoulders and the miter. Wisps of white hair stick out from under the miter. The appearance of this drawing differs from the other two studies in the same technique, *Saint John the Evangelist* (The British Museum, London) and *Saint Matthew* (The J.F. Willumsen Museum, Frederikssund, cat. 108), and shows that Jacopo used two diverse approaches in his colored chalk figure study. It is the basic articulation of the figure, captured by the violent planes of color, that

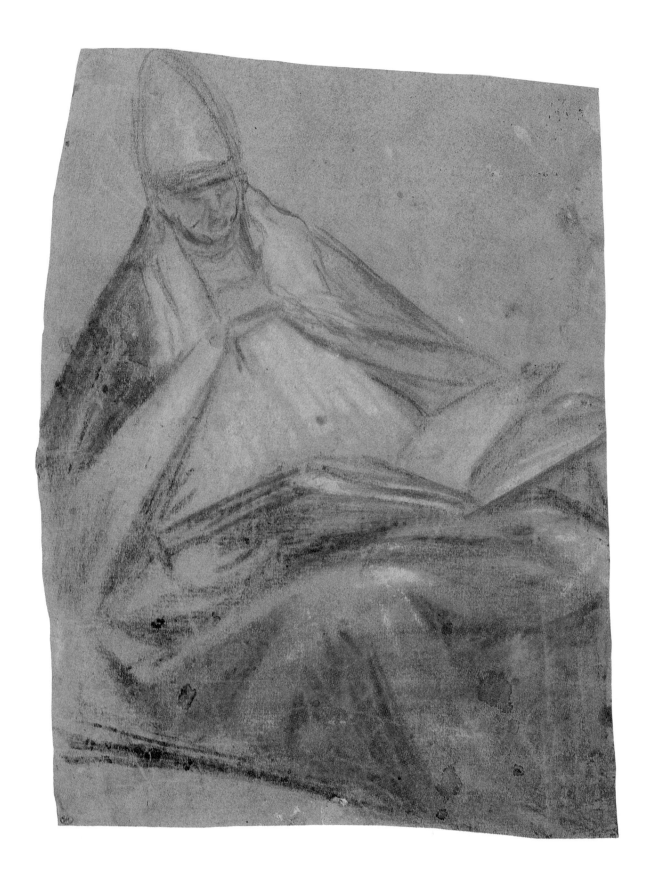

110. BEARDED MALE HEAD WITH A TURBAN (c. 1575)

Museum Boymans-van Beuningen, Rotterdam, inv. I-516
Black and colored chalks (pink, red, brown, blue) heightened with white on faded blue paper, mounted on a backing
174 × 143 mm
Inscriptions: on the verso in pen: « B.B. n° 45 »
Exhibited in Bassano del Grappa only

interests the painter in *Saint Gregory the Great*. In the other two studies he seems more concerned with working out the chromatic and luminous texture, which will give form to the figures when they are inserted into the space of the painting.

V.R.

Provenance
Sagredo collection? (see the inscription on the verso); M. de Marignane; F. Koenigs (L. 1023); acquired in 1930; donated by D.G. van Beuningen to the museum in 1940.

Exhibitions
Amsterdam 1929; Venice 1985.

Bibliography
Catalogue 1929, 48, no. 168 (as Francesco Bassano); Tietze and Tietze-Conrat 1944, 51, no. 153; Arslan 1960 (B), I, 176 (as either Jacopo or Francesco Bassano); Ballarin 1971 (A), 141 and 150, n. 19, fig. 7; Rearick 1980 (C), 373; Aikema and Meijer 1985, 51, no. 32; Rearick 1987, II, 3, pl. II-b.

While this drawing was initially attributed to Francesco Bassano, the Tietzes included it in their catalogue as by Jacopo, comparing it with a study for a head in the Albertina, Vienna (cat. 85), which is a preparatory drawing for the apostle to the left in *The Descent of the Holy Spirit* (Museo Civico, Bassano del Grappa, cat. 119). Their attribution has been accepted by subsequent scholars with the exception of Arslan, who seemed unsure about whether it is by the father or the son.

Ballarin saw stylistic similarities with the group of preparatory studies for the fresco cycle in the parish church of Cartigliano and, therefore, dated it around the middle of the 1570s. He suggested that it may be a study for the head of the oriental at the foot of the crucifix or for the bust of a prophet, meant to be placed, following an old-fashioned custom, in the decorative frieze of some chapel. Rearick recognized that the motif derived from the King

David depicted in the procession of Titian's *Triumph of the Faith*, a print known to Jacopo from his youth. He used the figure for the prophet David in one of the roundels on the intrados of the arch leading into the choir of the small church of Santa Lucia in Santa Croce Bigolina (Muraro 1960, 113-14; and Sgarbi 1982 (A), 200-4). It is part of the fresco cycle – in a very damaged state and presently being restored – which the *Libro Secondo* places in the year 1536. The graphic style of the drawing led Rearick to propose a date for it a few years earlier than the above-mentioned study of a head in the Albertina, around 1555-57.

While Rearick's comparison shows how much the study in the Albertina, which is dated c. 1559, anticipates certain aspects of the Rotterdam drawing, it also underscores a tension in handling and a luminous violence in the Albertina sheet, which are foreign to the interests of the artist in the seventies, the period in which this head of a man in a turban should be placed. Here the lines move in a slower, more descriptive way, and the network of colored chalk creates subtle transitions of light. These are the stylistic traits which we associate with the preparatory sheets for the fresco cycle in Cartigliano (cats. 108 and 109). The figure's clothing is outlined in black chalk and modeled with a few nuances of blue, hardly darker than the blue paper. The full beard is delineated with fine strokes of black chalk laid over a halo of smudged brown that creates a transition to the brighter tonality of the face. There

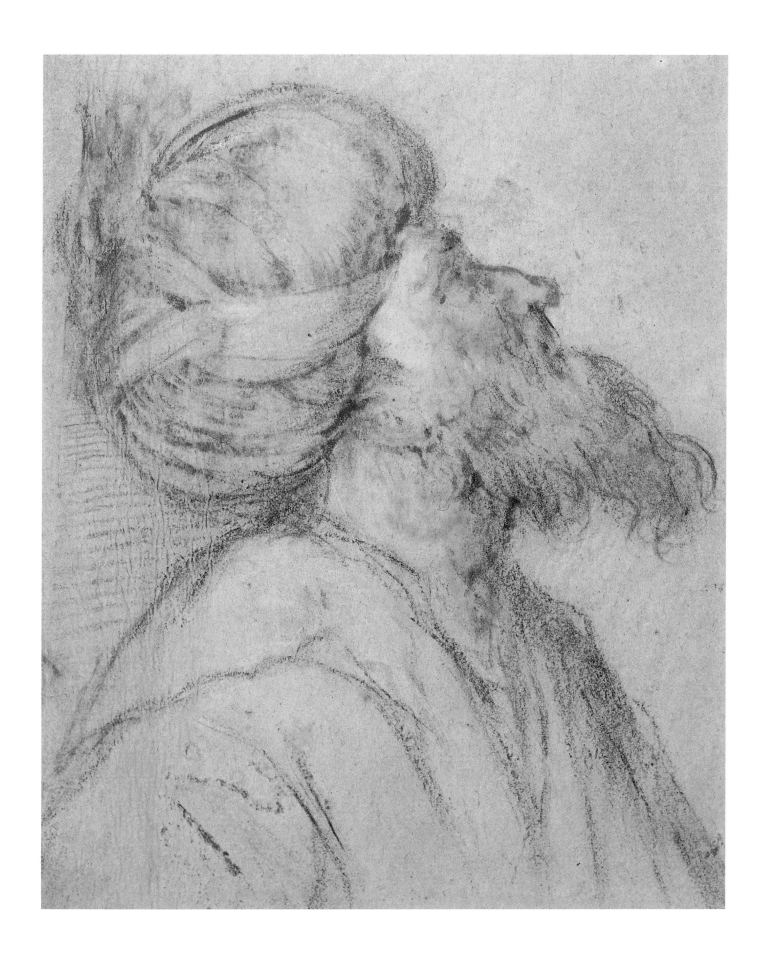

III. OLD MAN WITH A TURBAN (late 1570s-early 1580s)

Fondazione Museo Miniscalchi-Erizzo, Verona, inv. 35
Black and colored chalks (pink, ocher, yellow, red), with white heightening, on faded blue-gray paper, stained in upper right corner
240×195 mm
Exhibited in Bassano del Grappa only

pink is modeled with red on the old patriarch's ruby-colored cheeks, and the bridge of his nose is reinforced with a line of red chalk. Jacopo's reuse of a motif by Titian, which he had known since his youth, should not surprise us in a painter who worked in cycles and often turned back to earlier periods of his career in order to rethink old themes and working procedures in terms of new demands.

V.R.

Provenance
Moscardo collection.

Exhibitions
Never before exhibited.

Bibliography
Cuppini 1962, 61-62, fig. 27 (as Guercino?); Marchini 1984, 44-45, ills.; Marchini 1990, 84, ills.

This study is in a collection of predominately Venetian drawings, which until recently belonged to a private collector and is still not well known. It was first published by Cuppini in 1962, who pointed out its high quality. Although with some doubts, he proposed an attribution to Guercino, a conclusion which, to some extent, was in contradiction with his assessment of the drawing. He deemed its handling of colors «kindling sparks of yellow, white, and red which sizzle like the head of a match when it is struck», worthy of a Venetian. Marchini recognized that the drawing belonged to Jacopo when he did the catalogue entries for the Soprintendenza per i Beni Artistici e Storici del Veneto, and recently he reiterated this attribution in his guide to the museum. The drawing does not appear in Rearick's corpus of Jacopo's graphic work. Ballarin, in a conversation, said that he feels it is without doubt by Jacopo.

The figure is caught in a wide gesture of movement towards the left, which is emphasized by the unfurling of the generous sleeves. An orangey-red lights up the fabric that covers his shoulders and chest, and is parted to reveal a shirt, upon which rest a necklace and his full beard. It is described by a layer of white chalk so thin that it lets the blue of the paper show through, and by touches of red and ocher chalk. The head energetically turns in the opposite direction of the chest. Its modeling, in a mixture of red, pink, and ocher-colored chalks, is partially damaged by a large stain that covers part of his turban.

The stately stance and countenance of the old man, who seems to look forward to Rembrandt's biblical protagonists, and the color scheme of the yellow and red juxtaposed with the white highlighted drapery place this drawing in the 1570s. Still, there are significant differences between it and the group of better known and better documented drawings (cats. 108 and 109) related to the frescoes in the parish church of Cartigliano, from 1575. The execution of the drawing is based on the contrast between the refined framework, more evocative than descriptive, suggested by a few flat strokes of black chalk and light white heightening on the chest, and the sudden combustion of the red laid down with strong, dense strokes and touched up with traces of yellow ocher. The subtle alchemy of light and the cold chromatic tones, which are characteristic of the studies made during the mid-1560s, are missing. Instead the drawing looks forward to the warmer, more brilliant, fantastically conceived color, filled with unexpected outbursts, of Jacopo's late style. The figure can be effectively compared, as Ballarin suggested to me, with the old man who walks up to the fish stand in *The Ele-*

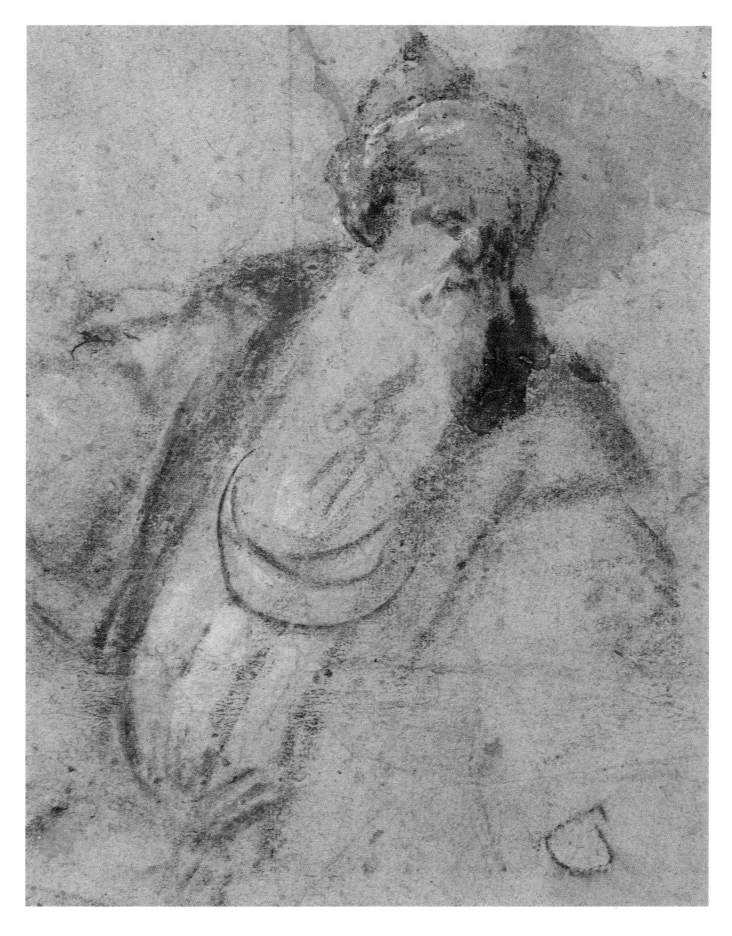

ment of Water (The John and Mable Ringling Museum of Art, Sarasota, cat. 70), a painting which belongs to the beginning of the 1590s.

V.R.

112. THE MADONNA AND CHILD (1573)

Private collection
Red and black chalk on paper
284 × 224 mm
Inscriptions: on the mat in an eighteenth-century(?) hand: «Bassan»; in a more recent hand «Jacopo da Ponte called il Bassano»; in the lower right «ex collectione de Segrada» and in the center «also from the collection of John Barnard Esq.»
Exhibited in Bassano del Grappa only

Provenance
Sagrado collection(?); John Barnard (L. 1419); Parsons and Sons (L. 2881); Sotheby's, London, 28 November 1962, lot 24; Sotheby's, New York, 16 January 1986, lot 156.

Exhibitions
Never before exhibited.

Bibliography
Rearick 1991 (A), IV, II, pl. VI.

This lovely drawing, which appeared on the art market in 1962, has recently been studied by Rearick. It is a preparatory study for the figure of the Madonna and Child in the small votive painting of *The Madonna and Child with Saint Roch and Sante Moro* (Museo Civico, Bassano del Grappa, cat. 120). Ridolfi (1648, I, 397) mentioned it among the artist's late works and Verci (1775, 84) recorded it on the altar of the chapel in the Palazzo Pretorio in Bassano, from which it entered the Museo Civico. The painting was probably ordered by the patron as an ex voto after he survived the danger of the plague of 1575 (Mason Rinaldi 1979, 247 48, no. 20a, ills.). It must have been executed between August 1575 and January 1577, the period of Sante Moro's term as podestà, and probably by 1576, the date found in the dedicatory inscription of the chapel that the podestà paid to have constructed. These dates fit the style of the work well. While the painting derives from works executed in the years 1574-75, in particular *Saint Lucille Baptized by Saint Valentine* (Museo Civico, Bassano del Grappa, cat. 53) and the altarpieces from the parish church in Civezzano, such as

Saints Anthony Abbot, Virgil, and Jerome (fig. 59) and *The Mystic Marriage of Saint Catherine*, it also introduces a new figural module that is more expansive and less refined. It is a prelude to the developments at the end of the 1570s, with its interest in Titian.

The drawing is one of the few red chalk studies in Jacopo's corpus. Its appeal derives not only from the painterly effects that Jacopo is able to achieve through this technique, but also from the refined relationship between the warm, luminous tonality of the medium and the white, almost pale pink paper. With great delicacy the red chalk brings to life the wide oval of the Virgin's face, her heavy eyelids, and her tiny mouth. It gives roundness to her cheek with a thin film of shadow that then moves down her neck and sets it off against the bright transparent veil. The drawing achieves a level of quality that does not seem to be sustained in its translation into paint. Repetition of chalk lines along the Christ Child's back creates shading that moves with a timorous naturalness into the shadow under the Virgin's breast as she holds the child in front of her. In her drapery, an effect of luminous leavening is obtained by allowing the paper to show through the color. Tiny, closely aligned, blended strokes of chalk etch out her ample, rounded forms. This handling resembles the way violet glazes shimmer over the wine pink of her drapery in the painting. Rearick thinks that Jacopo wet his chalk so that it would leave a less sharp mark on the paper, in order to

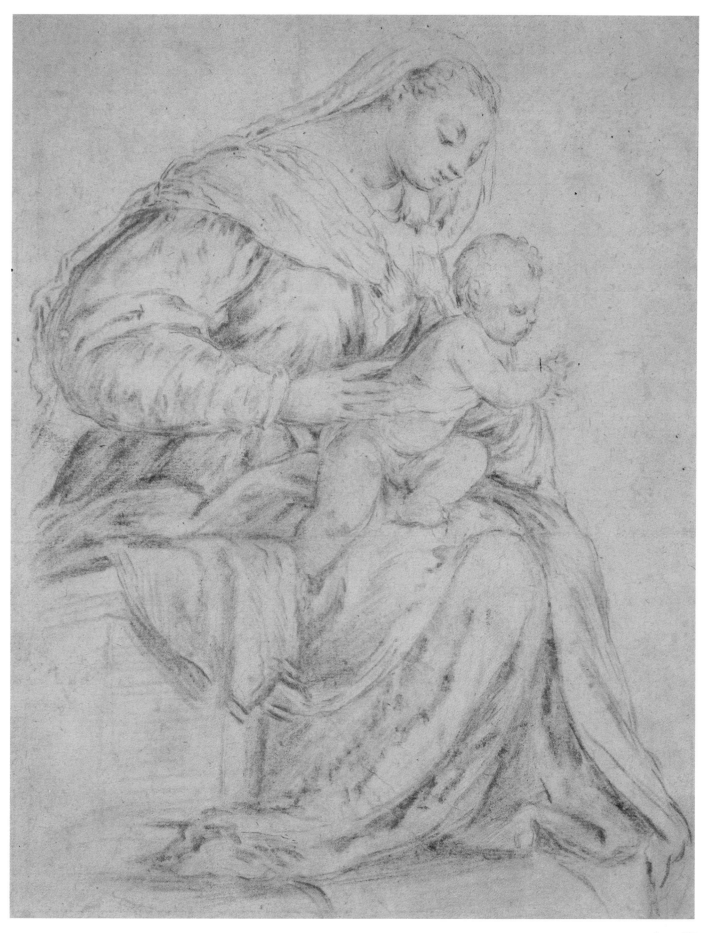

113. The Madonna and Child (1581)

Hamburger Kunsthalle, Kupferstichkabinett, Hamburg, inv. 21360
Bistre wash, heightened with white, on faded blue paper
290 × 216 mm
Exhibited in Bassano del Grappa only

achieve this painterly effect.

Another red chalk study of clearly inferior quality exists. It too depicts the theme of the Virgin and Child, but adds a curtain in the background (Scarpa 1987, 395, fig, 12: Jacopo Bassano). Rearick thinks this drawing is a copy by Jacopo's son, Leandro, who, according to Rearick, collaborated with his father on the execution of the altarpiece.

V.R.

Provenance
Early history unknown.

Exhibitions
Never before exhibited.

Bibliography
Rearick 1967, 103-4, fig. 116; Ballarin 1969, 85-86; Rearick 1992 (A), in press.

The drawing can be related to the small altarpiece depicting *The Virgin in Glory with Saints Agatha and Apollonia* (Museo Civico, Bassano del Grappa, cat. 122). It was commissioned from Jacopo by the Confraternita di San Giuseppe on 3 March 1580, and final payment was made on 21 January of the following year. Difficulty in understanding the stylistic novelty of the painting and the fact that the son of the painter, Gerolamo – then only fourteen years old – received two of the payments for it, led scholars starting with Arslan (1930, 554-57) to give it substantially to Gerolamo. In 1967, however, Rearick pointed out what he felt was the quality of the work and its role in the introduction of Jacopo's late style. This late style was further defined by the correct reading of the date «1585» on *Susanna and the Elders* (Musée des Beaux-Arts, Nîmes, cat. 72; see Ballarin 1966, 112-36). Rearick published the sheet as a «*ricordo*», or record, of the top part of the *Saints Agatha and Apollonia* altarpiece, made to preserve the image for later use by the workshop. It would be, therefore, the last example by Jacopo of a practice he started around the mid-1570s and then largely turned over to his sons (see here, cats. 88, 89, 98, 99, and 106). This «*ricordo*» drawing appears

at such a late stage in Jacopo's career because he needed to teach this task to the young Gerolamo. Previously the sheet had been assigned to the shop; Morassi, in a note written on the mat, gave it to Leandro or Francesco, and Tietze-Conrat, in a note written on the photograph in the Frick Reference Library, to the Bassano family. Ballarin (1969) has also pointed out the modest quality of the drawing. He maintains that one of the dangers in applying the «*ricordo*» drawing category in a very strict and extensive manner is that too little attention may be given to an evaluation of quality. It seems prudent to maintain these reservations about an attribution of the drawing to Jacopo, himself. However, the drawing does seem to belong to the Dal Ponte workshop. Executed in a cursive and approximate manner, it gives a rather exaggerated breadth to the figure of the Virgin and displays a handling of white heightening that we associate with the style of Leandro. When the drawing is compared with the painting in the Museo Civico in Bassano del Grappa, we find a series of small variations in the treatment of the faces of the Virgin and Child and in the drapery.

V.R.

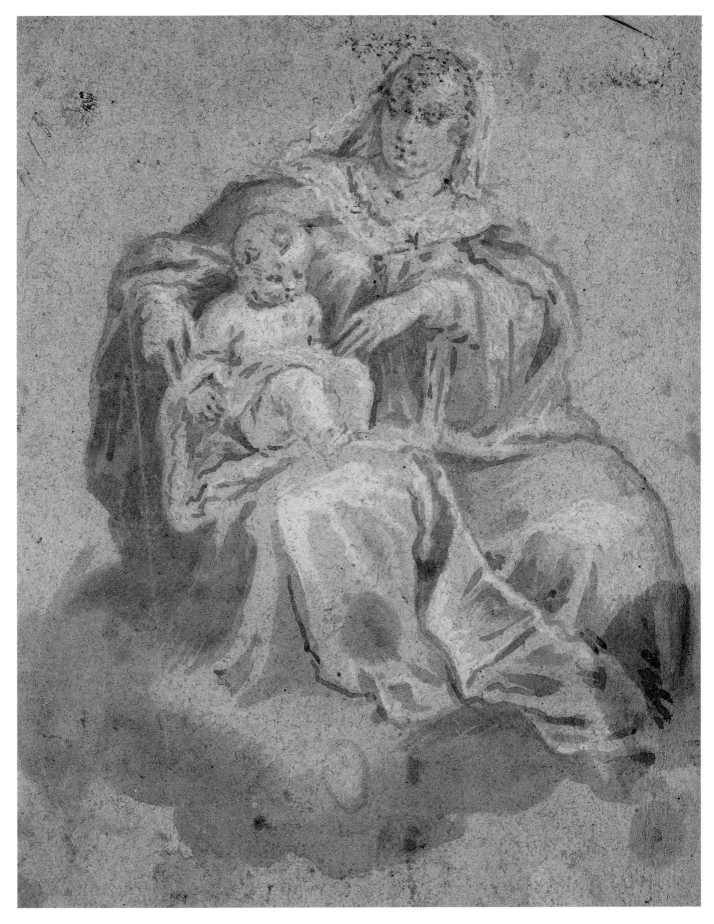

114. Head of the Madonna (1591-92)

Courtauld Institute Galleries, Witt Collection, London, inv. 3299
Black chalk, heightened with white, on buff paper, a stain and an abrasion of the chalk in the upper right, on the Virgin's veil
216 × 274 mm
Inscriptions: on the recto, along the lower margin in brown ink: « n° »; on the mat: « n° 44, Gia.ᵐᵒ Bassano. in Chiesa a San Giorgio Maggiore di Venezia »; the 44 is then corrected to 29
Exhibited in Bassano del Grappa only

Provenance
Sir Robert Witt (L. 2286); donated to the Courtauld Institute in 1952.

Exhibitions
Never before exhibited.

Bibliography
Blunt 1956, 62; Arslan 1960 (B), I, 350 (as Giambattista Bassano?); Attardi 1991, 215 (as Francesco Bassano); Rearick 1992 (B), in press.

The traditional attribution of the drawing to Jacopo was reconfirmed by Blunt in his handlist of drawings in the Witt Collection. Arslan had doubts about the attribution to Jacopo and, instead, gave the drawing to his son Giambattista. Attardi, in his discussion of the nocturnal *Adoration of the Shepherds* (Museo Civico, Padua), went over the whole history of the evolution of this theme. It started with a prototype made by Jacopo around 1575, now in a private collection in Padua (Ballarin 1988, 3), and was followed by a revision of the subject by Francesco, in which the Holy Family was moved to the left. Francesco used this version for the large canvases (cathedral, Toledo; and Galleria Doria Pamphilj, Rome, inv. 524) that he completed before he moved to Venice. Ballarin suggested that the drawing examined here is related to these two pictures. Later Leandro used the same composition, with a few changes, in the nocturnal *Adoration of the Shepherds* (church of Cristo Re, Saint Symphorien-sur-Loire). The attribution to Jacopo and the connection with the Madonna in *The Adoration of the Shepherds* (San Giorgio Maggiore, Venice, fig. 83), mentioned in the annotation on the mat, were re-proposed by Rearick. He pointed out the abstract idealization of the forms and the delicate treatment of light in the sheet. While he agreed that there is a resemblance between the drawing and the heads of the Madonnas in the above-mentioned canvases in Toledo and Rome, he maintained that they were by Leandro and executed c. 1590-92, and, therefore, dependent on the paternal version in the Venetian canvas.

This drawing is executed with wide, frugal strokes that give a rather astonishing material presence to the broad face illuminated from below. Although the drawing is of discreet quality, an attribution to Jacopo is not altogether convincing. The black chalk lines appear a little too simplified and describe the arched eyebrow, the pointed nose, the small oval mouth, and the round chin in a dry manner, which produces a stylization of the facial features rather similar to those found in the Virgin of the Doria nocturnal *Adoration of the Shepherds*. Ballarin's attribution to Francesco for this painting, which he places in the period just before the painter left for Venice, seems the most probable one.

V.R.

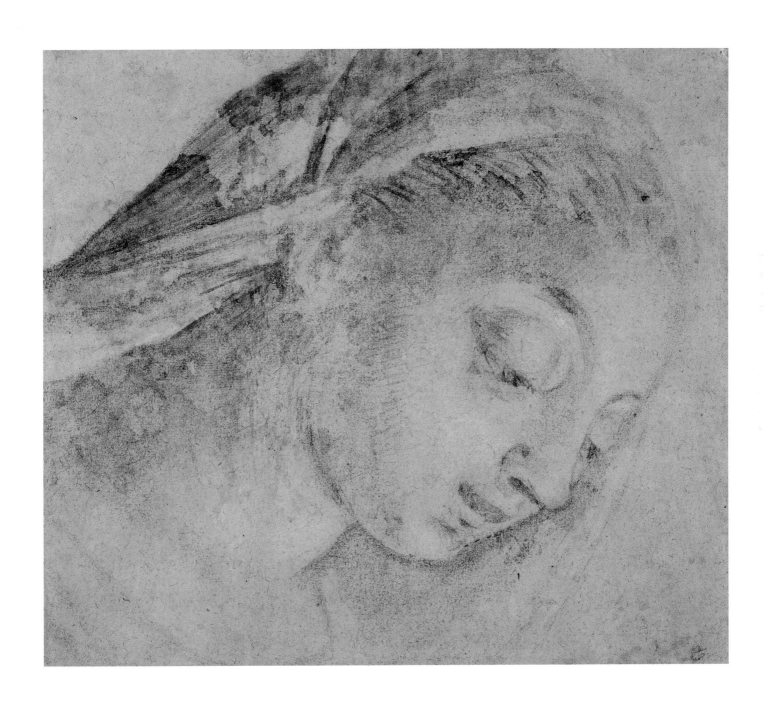

APPENDIX

This appendix presents some important paintings by Jacopo dal Ponte that are part of the permanent collection of the Museo Civico, Bassano del Grappa.

115. CHRIST AND THE ADULTERESS (1536)

Museo Civico, Bassano del Grappa, inv. 9
Oil on canvas, 141×225 cm (55 1/2×88 5/8 in.)
Inscription: ALOY⁵. SUPER⁵. / RESARC CUR on the first column on the left and
ANNO / MDC on the first column on the right

The work was originally in the Sala dell'Udienza of the Palazzo Pretorio in Bassano del Grappa, from which it was transferred to the Municipio in 1781 and in 1840 to the Museo Civico (Magagnato and Passamani 1978, 20-21, with complete bibliography up to that date).

This painting is part of a cycle that also includes *The Fiery Furnace* (Museo Civico, Bassano del Grappa, inv. 8, and here, fig. 11) and *Susanna and the Elders* (Museo Civico, Bassano del Grappa, inv. 10) and has always been considered to date from the earliest moments of Jacopo's career. The *Libro secondo* (fols. 92v-93r) has now made it possible for us to assign it a precise date. On 20 July 1535, the *Libro* records the commission from the podestà of Bassano, Luca Navagero, to Francesco il Vecchio for a series of decorations for the «camara granda in palazzo» (large bedroom of the palace), including three «quadri istoriati» (pictures with stories) to be placed above the bedstead. Final payment of 225 lire and 14 soldi was made on 8 February 1536. However, it was Jacopo who signed the first painting, and Ridolfi (1648, I, 377) already speaks of them as being in the Sala dell'Udienza, that is, the room where the podestà carried out his judicial duties. In fact, the theme of a higher justice triumphant over all – treated in the three canvases – leads us to believe that this was their original destination.

The precise architectural structure given to the space and, even more, Jacopo's faithful adaptation of the model offered to him by Bonifazio de' Pitati's treatment of a similar subject contribute to make this work the most successful of the series. The background furnishes a solid framework for the passages in a more naturalistic or portrait vein that are typical of Lombard painting – the cripple, the falconer – and for those moments where his treatment of the material and color – the dress of the adulteress – foreshadow the direction that his development would later take. Jacopo was a relaxed and good-natured narrator (Venturi 1929 (B), 1125-26), whose translation into painting of the episode from the Gospel of Saint John (8:2-11) has a didactic precision and spirit that seems to echo Lorenzo Lotto. Even at this point, Jacopo drew on the graphic sources that would sustain him in the early years of his «diligent self-education» (Rearick 1986 (A), 182): in this case Titian, Dürer, and Raphael (Furlan 1959-60, 74; and Rearick 1984, 292).

The tormented history of the conservation of this and the other paintings in the series – due probably to the technique used by the painter, who was still experimenting – recurs throughout the earlier sources. An early restoration carried out for the Podestà Alvise Soranzo in 1600 is referred to in the inscription on the columns, which can be interpreted as «Aloysius Superantius resarcendum curavit anno MDC». Verci (1775, 83) speaks explicitly of the painting's bad condition. Zuliani (MS 1826) and Brentari (1881, 190) mention a restoration undertaken in 1826. In 1965 Tiozzo intervened and in 1990 Bacchin again worked on the painting. The citizens of Bassano reacted strongly against the request of the Doge Alvise Mocenigo in 1725 to move the canvases to Venice to decorate the Libreria Marciana. They requested an ordinance to protect those works of Jacopo remaining in his city (see here, the Chronological Register of Documents).

P.M.

528

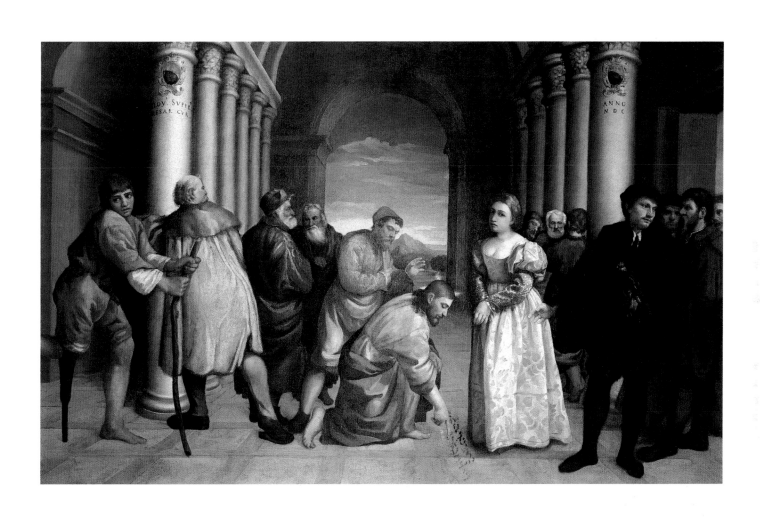

529

116. The Façade from the Casa Dal Corno in Bassano (1539)

Museo Civico, Bassano del Grappa
Detached fresco, 610×1190 cm (240 1/8×468 1/2 in.)

This large fresco originally decorated the façade of the house on the east side of the Piazzotto del Sale in Bassano, belonging to the Dal Corno family. It later passed into the hands of the Michieli and Bonato families. In 1975 it was detached in an attempt to save it from deterioration and in 1982 was installed in the Museo Civico.

Even though its legibility has been seriously compromised, the wall constitutes a valuable document. It is one of the few surviving examples of Jacopo's extensive fresco production that was recorded by Ridolfi and Verci. Among the other extant works are the frescoes in Santa Lucia in Santa Croce Bigolina near Tezze sul Brenta (figs. 85-88), the practically illegible *Marcus Curtius* on the exterior façade of the Porta Dieda in Bassano, *The Madonna and Child with Saints Bassiano and Francis* (Museo Civico, Bassano del Grappa, cat. 117), the badly damaged *Crucifixion* in the small church of the Madonna delle Grazie in Bassano, and the larger and better preserved cycle in Cartigliano (figs. 103-4).

Beneath a double frieze – one of cherubs playing with a curtain between balusters placed in diminishing perspective and one of animals and musical instruments – the «story» unfolds in two bands. The main band, enclosed on either side by Doric columns and placed asymmetrically between the windows of the *piano nobile*, contains a depiction of *Samson and the Philistines* preceded by three female figures in niches, traditionally identified as *Prudence, Rhetoric*, and *Industry* (Ridolfi 1648, I, 376).

Below, four ovals hold, from left to right: *Judith and Holofernes, Lot and His Daughters, The Drunkenness of Noah*, and *Cain and Abel*. In the space under the balcony a dropsical cherub lies on crossed bones near an hourglass, while an inscription warns: «Mors omnia aequat».

The «frescoed Samson above Piazza del Sale» is mentioned by Verci (1775, 48) along with *The Martyrdom of Saint Catherine* (Museo Civico, Bassano del Grappa, cat. 13), formerly in the church of San Gerolamo, and the *Curtius Rufus* as one of the basic texts of Jacopo's «second manner», when he «having seen the graphic work ("carte") of Raphael and Michelangelo, gave himself up to the study of the construction of Muscles».

The account book of the Dal Ponte family now gives us definite information for dating the work. It registers on 19 May 1539 a down payment to Francesco il Vecchio and on 11 August of the same year the final payment to Jacopo in the amount of 50 lire. The patron, Zanetto or Zuanne dal Corno, was the authorized seller of salt in Bassano. He also commissioned the Dal Ponte workshop, where Francesco il Vecchio's other son Giambattista was also active at the time, to repaint the outer shutters of his windows in white and blue, and to make the family's coat of arms in carved wood with gold and silver gilt (*Libro secondo*, fols. 130v-131r). This latter commission was probably to replace the frescoed coat of arms painted by the shop a few years earlier. This fresco emerged when the 1539 façade was

detached and is still *in situ*. It is quite likely that the idea for the rich pictorial program received a contribution from his nephew, Lazzaro dal Corno, certainly the most illustrious member of the family (Marini 1983, 26). For a thorough iconographical and stylistic analysis of the decoration, see Ericani's essay in this catalogue.

Deterioration of the façade was already evident in the nineteenth century, when steps were taken to save it. In 1883 the painter Alessandro Müller experimented with removing the dropsical cherub. Various restorations were carried out by Giuseppe Cherubini (1922), Mauro Pellicciolo (after World War II), Leonetto Tintori (1959), and finally the painful decision to detach the frescoes (Ottorino Nonfarmale 1975-82). The technical and civic debate accompanying these restorations constitute an exemplary episode in the history of the conservation of exterior frescoes in Italy (see the archives of what was then the Soprintendenza alle Gallerie del Veneto, now in the Soprintendenza ai Beni Ambientali e Architettonici di Verona, Vicenza, Rovigo; the essays by Nonfarmale, Passamani, and Marini in *Il restauro ed il recupero* 1983; and Sgarbi 1982 (B)). Some small drawings of heads, which can be related to the fresco, are in the collection of the Duke of Devonshire, at Chatsworth (cat. 81).

P.M.

530

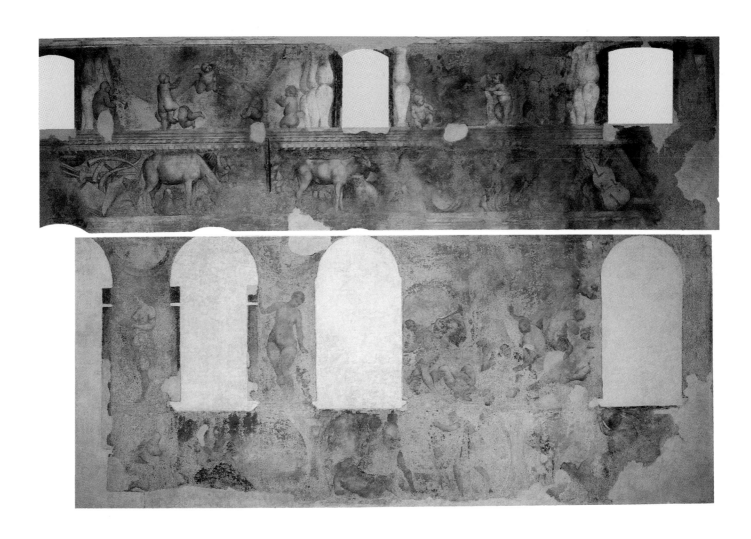

117. THE MADONNA AND CHILD WITH SAINTS BASSIANO AND FRANCIS (1542-43)

Museo Civico, Bassano del Grappa, inv. 432
Detached fresco, 112×128 cm (44 1/8×50 3/8 in.)

Originally in the cloister of the church of San Francesco in Bassano, this fresco was detached by the painter Alessandro Müller in the second half of the nineteenth century and placed in the museum (Vinco da Sesso 1982).

Beginning with the earliest sources (Ridolfi 1648, I, 376-77; and Verci 1775, 89-90), the saint on the Virgin's left has always been identified as Saint Anthony Abbot. Recently, however, Magagnato (1952 (A), 41), followed by Rearick and Ericani in their essays in this catalogue, has identified the figure as Saint Bassiano. As the early sources also pointed out, Saint Francis is derived from the image of the same saint in Titian's *Madonna in Glory with Six Saints* for San Nicolò dei Frari (now Pinacoteca Vaticana, Vatican City, fig. 90).

Even though some art historians (Bettini 1933, 47; and Longhi 1948, 50) have noticed its evident formal and stylistic references to *The Madonna and Child with the Young Saint John the Baptist* (Accademia Carrara, Bergamo, cat. 9), and *The Madonna and Child with Saints Martin and Anthony Abbot* (Alte Pinakothek, Munich, cat. 8), scholars have tended to date this work around 1550 (Magagnato and Passamani 1978, 23, with bibliography up to that date). The date of 1542-43, which the *Libro secondo* gives for the Munich altarpiece mentioned above, is also a sure point of reference for this fresco, where Jacopo's experience of Parmigianino was once again filtered through Schiavone. Both Rearick (see his essay in this catalogue) and Ballarin (oral communication) agree on this « earlier » date. The painting is in an unfortunate state, due to the loss of the final details, which were painted *a secco*, and perhaps also as a result of an experimental detaching. This worn state, however, reveals the underdrawing and a technique of shading employing parallel lines, similar to that used for drawings and engravings (Bettini 1933, 47).

P.M.

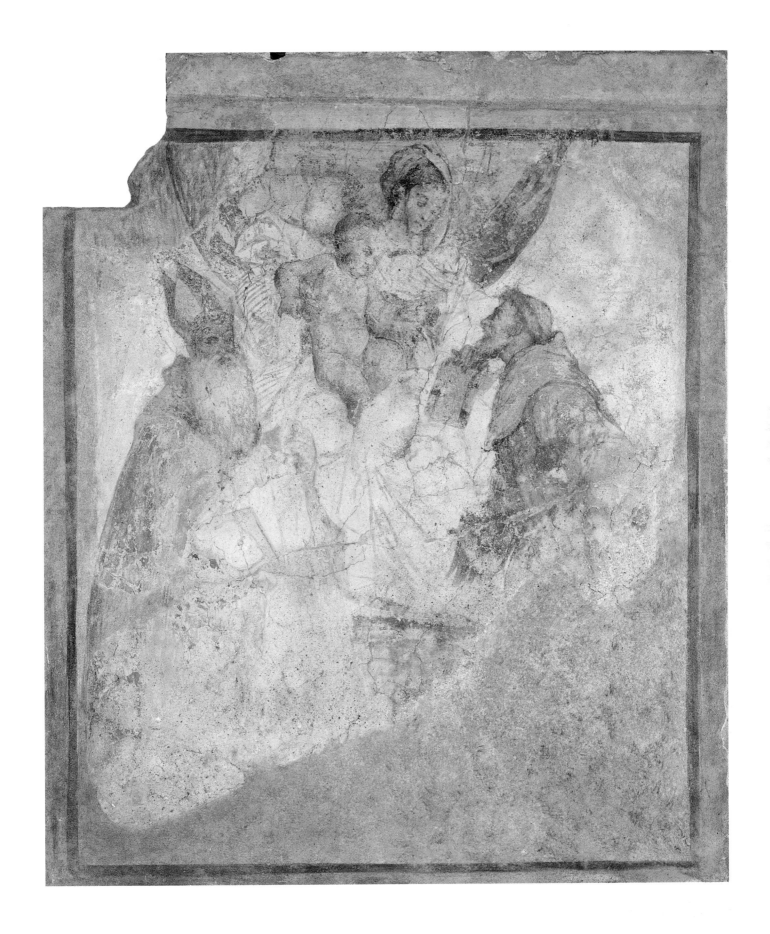

533

118. Saints Ursula, Valentine, and Joseph (1542-43)

Museo Civico, Bassano del Grappa, on deposit from the the parish church, Mussolente
Oil on canvas, 168 × 106 cm (66 1/8 × 41 3/4 in.)

The *Libro secondo* (fols. 49*v*-50*r* and 51*r*) reveals that in September 1541 a contract was stipulated between Jacopo and the priest and stewards of the parish church in Mussolente for the execution of an altarpiece depicting « Saint Ursula in the middle, Saint Valentine on one side, and on the other Saint Joseph ». The painter also agreed to build a platform behind the painting to protect it from dampness, for a total compensation of 142 lire and 12 soldi. We also learn (fol. 98*v*) that Jacopo entrusted to Piero Marangon the carving of the frame. The payments go forward until 6 August 1543, when final payment was made. The Dal Ponte workshop had done numerous jobs for the church in Mussolente, but to date none of them have been traced (Muraro 1992).

This work was first brought to the attention of scholars on the occasion of the 1957 exhibition in Venice (Zampetti 1957, 34). It had been identified by Muraro (1957, 295), who had found it by following the indications given in the account book. Even though he did not have the definite chronological data we have today, Arslan (1960 (B), 1, 56; followed by Sgarbi 1980, 82) refuted the relationship with *Christ among the Doctors in the Temple* (Ashmolean Museum of Art and Archaeology, Oxford, fig. 18) proposed by Pallucchini (1957, 100) and perceived the painting as foreshadowing Jacopo's experience with mannerism, which officially began with *The Martyrdom of Saint Catherine* (Museo Civico, Bassano del Grappa, cat. 13). Despite the almost total loss of the blue background, the precise elegant line, brilliant enameled colors, and chromatic richness make this painting an important milestone on Jacopo's path toward Parmigianesque mannerism. It is a style that would be mediated through Jacopo's knowledge of Schiavone and Salviati, and echoed and confirmed, as Rearick has suggested (see his essay in this catalogue), in the very beautiful *Flight into Egypt* (Norton Simon Museum, Pasadena, fig. 20).

P.M.

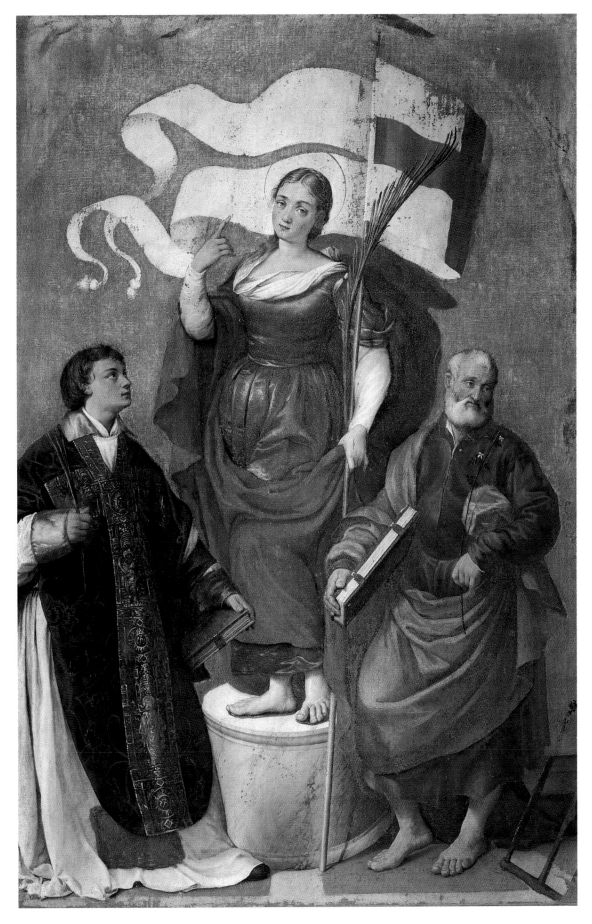

119. THE DESCENT OF THE HOLY SPIRIT (c. 1559)

Museo Civico, Bassano del Grappa, inv. 16
Oil on canvas, 311.5 × 172.5 cm (122 5/8 × 67 7/8 in.)

This painting originally hung over the altar of the Holy Spirit in the church of San Francesco in Bassano, where it faced the slightly earlier *Saint John the Baptist in the Wilderness* (Museo Civico, Bassano del Grappa, cat. 29). When the church's property passed to the State, the picture was placed in the Municipio and then in 1840 in the Museo Civico.

Although he assigned this altarpiece to the artist's late manner, Verci (1775, 77-78) acutely defined its stylistic traits, referring to Parmigianino for the drawing and to Veronese for its palette. This implicitly placed it in a transitional position between Jacopo's mannerist phase and the greater formal openness and breadth that began with the Treviso *Crucifixion* (cat. 37) of 1562-63, foreshadowed by the « Veronesian » *Saints Peter and Paul* (Galleria Estense, Modena, cat. 34). A proposal to date it in the 1560s (von Hadeln 1926, 17; Arslan 1931, 124, 137, and 186; and Bettini 1933, 87-89 and 173) was, albeit with some uncertainty, rapidly discarded (Magagnato 1952 (A), 14-15; Pallucchini 1957, 108; and Zampetti 1957, 138) as a result of Venturi's suggestion (1929 (A), 122; 1929 (B), 1182-85) that, along with the *Saint John the Baptist*, the Enego altarpiece (cat. 31), and *Saints Peter and Paul*, it anticipated the Treviso painting. Ballarin (1973, 101 and 105) has amply demonstrated how for the second time Jacopo takes up *The Descent of the Holy Spirit* painted by Titian just after the middle of the 1540s for the Venetian church of Santo Spirito in Isola (now Santa Maria della Salute,

Venice; see Pilo 1990, 280-83). Here he has reworked it in the context of a neo-Salviatesque style, which characterizes his work in the years 1557-59. But under the influence of Titian's more recent works, such as *The Martyrdom of Saint Lawrence* painted for the church of Santa Maria dei Crociferi (now Chiesa dei Gesuiti, Venice), Jacopo tends to replace formal concerns by a preoccupation with light. The very close vicinity of the dates, despite the long time Titian spent on the Crociferi canvas, which we now know had not yet been delivered in 1557 and was put in place only in 1559 (Sponza in *Tiziano* 1990, 308-13), leads us to reconsider Venturi's comment (1929 (B), 1182) that, looking at the two paintings together, it is very difficult to say which came first and « to decide who in Venetian painting was the first to establish the technique of touch ». Nonetheless, as Ballarin (1973, 105) maintained, *The Descent of the Holy Spirit* risks appearing at that date as an isolated case, without immediate consequences for the problem of the unification of space through light and the luminosity of touch. Rearick agreed on dating the picture very near the *Saint John the Baptist* of 1558.

The painting takes up again the theme that Jacopo had already treated in a very different religious and stylistic spirit less than ten years earlier for San Giacomo in Lusiana (cat. 20). It was retouched and enlarged with the addition of the apostle who clasps his hands together at the left. This must have taken place at a very early date, since an engraving of 1687 by Crestano Menarola (Pan 1992, no.

90) reproduced it as it now appears. The author of the « restoration » was probably Giambattista Volpato, but this did not stop Verci from voicing a negative opinion of it, even though, as is known, he worked from manuscripts by Volpato, who praised very enthusiastically Jacopo's chromatic technique in this painting (Bordignon Favero 1981).

There are preparatory drawings for the heads of the apostles in the Graphische Sammlung Albertina, Vienna (cat. 85) and the Royal Library at Windsor Castle (cat. 93).

P.M.

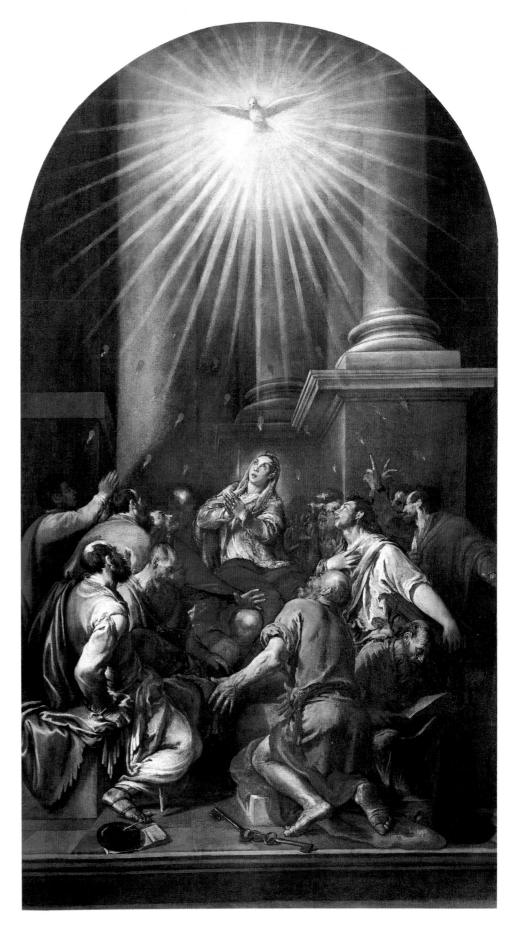

120. The Madonna and Child with Saint Roch and Sante Moro (1576)

Museo Civico, Bassano del Grappa, inv. 23
Oil on canvas, 130×103 cm (51 1/8×40 1/2 in.)

Originally in the chapel of the Palazzo Pretorio in Bassano, the painting was moved to the Municipio in 1781 and the Museo Civico in 1840.

Sante Moro was podestà of Bassano from August 1575 until 24 January 1577. He built the chapel in the Palazzo Pretorio for which this painting was destined and where his name appeared on a commemorative plaque along with the date 1576 (Brentari 1881, 206; and Brentari 1884, 469). The saint who presents Moro to the Virgin is not Saint Mark, as Verci claimed (1775, 84), but appears to be Saint Roch, as Ridolfi correctly indicated (1648, 1, 385). Thus both the building of the chapel and the commission for the altarpiece should be considered an ex voto after the plague of 1575-76 (Magagnato and Passamani 1978, 29-30, with a general bibliography on the painting; and Mason Rinaldi 1979, 247).

The motif of the podestà kneeling before the Madonna and Child, who are seated beneath a canopy, is taken from the large lunette of 1573 depicting *The Madonna and Child with Saints Mark and Lawrence Being Revered by Giovanni Moro and Silvano Cappello* (Museo Civico, Vicenza, fig. 54; see Pallucchini 1977-78, 64-65; and Mason Rinaldi 1979, 248).

The date is certain, but the same certainty does not extend to the appreciation of the painting, which has gathered some dissenting votes (Venturi 1929 (B), 1236-37; and Bettini 1933, 94-95 and 176). The early sources were silent on the problem, limiting themselves simply to a mention of the painting. In other cases, emphasis has been placed on the subtle sensibility demonstrated in the use of color, which shows the clear influence of Titian in its strongly Venetian interplay of deep glossy enameled colors soaked in light (Magagnato 1952 (B), 47; and Zampetti 1957, 180). Still others have commented on virtuoso passages such as the glass globe in the veiled light of dusk or the « silver white veil vaporous as a cloud tied to Saint Roch's staff » (Venturi 1929 (B), 1236-37; Pallucchini 1957, 113; Arslan 1960 (B), 1, 139; and Ballarin 1966, 114).

Rearick (1986 (A), 187; and in his essay in this catalogue) detects a small intervention on the part of Leandro in the execution of the figure of the saint, and points out a preparatory drawing in a private collection (cat. 112).

P.M.

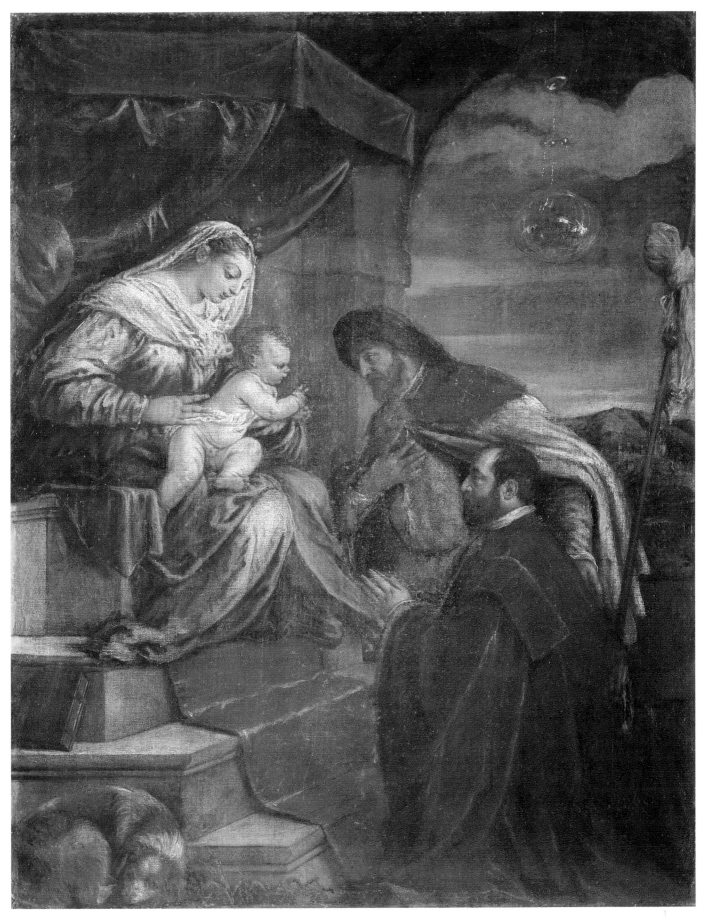

539

121. The Circumcision (1577)

Museo Civico, Bassano del Grappa, inv. 21
Oil on canvas, 320×211 cm (126×83 1/8 in.)

On 17 February 1576, the Confraternita del Nome di Gesú asked the city council for a contribution toward the payment of an altarpiece that had already been commissioned for its altar in the church of Santa Maria in Colle in Bassano (Alberton Vinco da Sesso 1991, 64 n. 6). The painting can definitely be identified as the *Presentation in the Temple* described by Verci (1775, 75) on the altar of the Nome di Gesú in the Bassano cathedral. An inscription on the plinth of the column on the left gives the signature and date: IAC.s A PŌTE / BAS.s ET FRĀC.s / FILIUS FACIE.nt / MDLXXVII. When it was moved to the Museo Civico in 1870, it was substituted by an exact copy (still *in loco*) painted that same year by Giustiniano Vanzo Mercante (Brentari 1881, 215). A picture with the same subject and also signed and dated, but in a horizontal format, which eliminated the upper and lower zones with angels and devils, was in the church of Santa Maria della Misericordia in Venice and has since been lost. An outline engraving by G. Bernasconi illustrated Francesco Zanotto's *Pinacoteca Veneta ossia raccolta dei migliori dipinti delle chiese di Venezia* (Venice 1858-40). Zanotto analyzed the subject of the picture in Venice very thoroughly, interpreting it as the foundation of the Monastero delle Vergini in Venice in the presence of Doge Sebastiano Ziani, Pope Alexander III, and the Emperor Federico Barbarossa (see also Pan 1992, no. 177). Quoting Zanotto's long text, Brentari (1881, 214) maintained that the figure in front of the inscription was a portrait of Jacopo and that the

one behind it was Francesco. This opinion was shared by Gerola (1906, 111-12), who, however, did not accept the identification of the subject.

The work was quite highly appreciated by early critics: Verci (1775, 76) considered it one «of the most beautiful and pleasing for its loveliness, nobility, strength, and boldness properly distributed», while scholars in this century have reduced its importance, limiting the role played by Jacopo and increasing that of Francesco, who at that time was preparing to leave his father's workshop in order to start his own career in Venice (Bettini 1933, 117; Magagnato 1952 (A), 51; Arslan 1960 (B), 1, 188, 213; and Magagnato and Passamani 1978, 31, with bibliography). Recently, Rearick has studied the many portraits contained in the painting and recognized the doge as Sebastiano Venier, who was elected in 1577, the year the picture was painted. (Rearick 1980 (B), 1, 114; and Rearick 1986 (A), 186). Ballarin (1988, 10) saw it in the context of the collaboration between the master and his workshop. For him it was a moment in Jacopo's process of revising the concept of an altarpiece. He emphasized the innovations in the organization of space, which no longer moves back in a diagonal direction, but now is dilated frontally with the figures in the upper and lower registers moved to the edges of the picture, forming a decorative frame.

P.M.

540

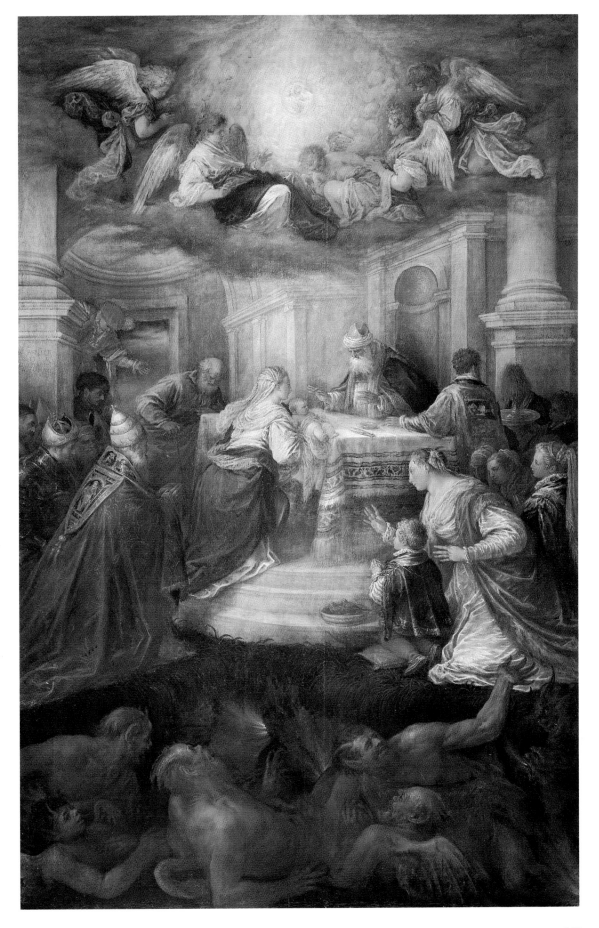

122. THE VIRGIN IN GLORY WITH SAINTS AGATHA AND APOLLONIA
(1580)

Museo Civico, Bassano del Grappa, inv. 24
Oil on canvas, 185.5 × 112 cm (73 × 44 1/8 in.)

The painting was originally in the church of San Giuseppe in Bassano (no longer extant), for which in 1568 Jacopo had painted *The Adoration of the Shepherds with Saints Victor and Corona* (Museo Civico, Bassano del Grappa, cat. 46). When the church was suppressed in 1859, the picture passed to the Museo Civico.

On 3 March 1580 the Confraternita di Santa Maria e San Giuseppe commissioned from Jacopo an altarpiece similar to « quella de S.ⁿ Martin in S.ᵗᵃ Catt.ᵃ » (the one of Saint Martin in Santa Caterina) to be placed above the altar of Santa Apollonia, with the proviso that it be delivered by Saint Martin's Day of 1580. The compensation agreed upon was 150 lire. Partial payments were made to Jacopo on 8 March and 14 September of that year and on 19 September to his son Girolamo, who received the final payment on 21 January 1581 (Crivellari 1893, 10). Verci (1775, 82) was the first to mention the great difference between the *Saints Martin and Anthony Abbot* (Museo Civico, Bassano del Grappa, cat. 67) and this altarpiece, due to the low price paid for this one. But he did not seem to doubt its authorship, nor do any other of the early sources (Ridolfi 1648, I, 384; and Brentari 1881, 216). On the contrary, Verci (1775, 50-51) pointed out its high technical quality, citing it – along with *The Adoration of the Shepherds* from the same church and *Saint John the Baptist in the Wilderness* (Museo Civico, Bassano del Grappa, cat. 29) – as one of the masterpieces of those « practices made up of touch and drawing » that characterized Jacopo's fourth and last manner. He

went on to describe in particular « the heads defined by drawing, the hands by touch, the Baby Jesus in the Virgin's arms by drawing, the face and hands of the Virgin by touch » (Verci 1775, 50-51).

Venturi (1929 (B), 1231-34) felt that the greatness of the painting lay in its landscape abandoned by the light, in the varying planes of ocher, violet, and blue, and the « mysterious effervescence of the leaden sky », while he considered the saints to be « chubby and clumsy » and found in the Virgin the signs of the presence of a collaborator, who he thought might be Leandro. On the basis of a document already known to Verci and published by Crivellari, Arslan (1931, 292-93 and 303) hypothesized the authorship of Gerolamo, which was promptly accepted (Bettini 1933, 180; Magagnato 1952 (A), 18, 20, and 53-54; Pallucchini 1957, 116; and Magagnato and Passamani 1978, 14-15). Zampetti, however (1957, 204), followed by Sgarbi (1980, 98), continued to believe that Jacopo's hand was the prevalent one. Along this line, Rearick (1967, 102-3) even saw here the « prototype » of Jacopo's late style « so completely dissolved as to reach points of incoherence » (Rearick 1986 (A), 187), and refuted any intervention on the part of Gerolamo (see his essay in this catalogue). Most recently, new documentation and the results of the restoration carried out for this exhibition have substantiated Rearick's thesis. The *Libro secondo* in fact, shows that the price of 150 lire for an altarpiece of this size – although cited with regard to earlier pictures,

the stability of prices at this time is well known – is anything but modest. Examination of the painting during the removal of the yellowed varnishes revealed the consistent presence of one hand, very confident and quick as it achieved with essential strokes a result of great liberty and painterly effectiveness. A drawing of the same subject, which Rearick thinks is a *ricordo* done by Jacopo himself, is in the Kupferstichkabinett of the Hamburger Kunsthalle (cat. 113).

P.M.

123. PARADISO (c. 1580)

Museo Civico, Bassano del Grappa, inv. 18
Oil on canvas, 237×156 cm (93 1/4×61 3/8 in.)

The canvas was originally over the high altar in the Capuchin church of the Ognissanti in Bassano. When the convent was suppressed in 1812, the picture passed into the Municipio and later to the Museo Civico in 1840.

With its more than fifty « very beautiful figures », this Glory of Paradise is a sort of compendium of all the poses Jacopo used in his various works (Verci 1775, 75), some of them, according to Ridolfi (1648, I 386), taken from Titian. Arranged in wide circles around a triangular grouping of Christ, the Virgin, and Saint John the Baptist are angels, the evangelists, and fathers of the Church, popes, bishops, founders of religious orders and, finally, male and female saints, including on the left Saints Catherine and Veronica (Brentari 1881, 197), and on the right Saints Anthony Abbot and Martin, as well as a figure seen from behind who guides and introduces the vision. The latter's pose is taken from the altarpiece of *Saints Martin and Anthony Abbot* (Museo Civico, Bassano del Grappa, cat. 67).

It follows that 1579, the probable year of execution for *Saints Martin and Anthony Abbot*, constitutes a *terminus post quem* for the painting discussed here (Venturi 1929 (B), 1230-31; and Ballarin 1988, 8). Rearick (see his essay in this catalogue) tends to move its execution to after 1580, the year of the small altarpiece depicting *The Virgin in Glory with Saints Agatha and Apollonia* (Museo Civico, Bassano del Grappa, cat. 122), as he sees the same Saint Agatha in this painting, and even after 1582, when Jaco-po and his son Leandro signed *Saint Roch in Glory with Saints Job and Sebastian* (Palazzo della Provincia, Vicenza, fig. 72), which would have provided the figures of Saint Roch and Saint Sebastian. However, these citations are not so exact as to constitute proof for establishing a precise date. Rearick also links the canvas in Bassano to a competition held in 1577 in Venice after the fire in the Palazzo Ducale destroyed the *Paradiso* by Guariento in the Sala del Maggior Consiglio. Thus the Ognissanti painting would have been a kind of model sketched out by the elderly artist for his son Francesco, who was participating in the competition. The actual execution, according to Rearick, would have fallen to Leandro, whose hand was also detected by Venturi (1929 (B)), while Pallucchini (1957, 116) speaks of a prevailing collaboration on the part of the school. Instead, for Bettini (1933, 103-5 and 179), this is one of the works in which the artist's style reaches its greatest heights of expression. For Magagnato (1952 (A), 16 and 47), Zampetti (1957, 200), and Arslan (1931 and 1960 (B), I, 140), whatever intervention there was on the part of the workshop would have fallen within the limits of normal loyal assistance.

The very loose composition, in which the figures « float on the surface, composing garlands of splendor » (Venturi), and the brief, quick, confident touch, interwoven with gold flecks, lead us to agree that this altarpiece is substantially the work of Jacopo himself.

P.M.

CHRONOLOGICAL REGISTER OF DOCUMENTS

Edited by Livia Alberton Vinco da Sesso

Note to the Reader:

The indication *Libro secondo* refers to the information contained in *Libro secondo di dare e avere della famiglia Dal Ponte con diversi per pitture fatte*, edited by Michelangelo Muraro and published in 1992. The following excerpts from this publication record only the data relevant to the Dal Ponte family and to the paintings identified by Muraro listed in the *Catalogo*.

Many heartfelt thanks to Giuseppina Menin Muraro, Antonio Trevisan, and Daniela Puppulin for supplying information about the notation found in the *Libro secondo*.

I express my gratitude to Renata Del Sal for facilitating my research in the Archivio Comunale di Bassano del Grappa.

Abbreviations:

ACB: Archivio Comunale di Bassano del Grappa
AP: Archivio Parrocchiale
APSM: Archivio Parrocchiale di Santa Maria in Colle
ASBas: Archivio di Stato di Bassano del Grappa
ASTv: Archivio di Stato di Treviso
ASVe: Archivio di Stato di Venezia
BBVi: Biblioteca Bertoliana di Vicenza

1517, January 1
Contract between Francesco il Vecchio and the Confraternita di San Paolo
for the following works to decorate the altar of San Paolo in the church of
San Giovanni Battista in Bassano: an altarpiece representing *The Madonna
and Child Enthroned between Saints Peter and Paul*; a lunette with *God the Father*;
an architectural frame in gilded and painted wood. All that remains is the al-
tarpiece, signed and dated Francesco 1519, in the Museo Civico, Bassano del
Grappa (inv. 2).
ASBas, not. Giovanni Pietro Uguccioni, b. 61 (Brotto Pastega 1991, 10-11 and
40-41).

1521, 1523, 1524, 1528, 1529, 1533
Contract with Francesco il Vecchio (16 August 1521) for the «painting of the
Holy Spirits on the high altar» of the parish church in Oliero. Payments to
Francesco ending on 24 April 1533. This *Descent of the Holy Spirit* is *in situ*.
Libro secondo, fols. 14*v*, 42*v*, and 56*v*-57*r* (Muraro 1992, *Catalogo*, no. 6).

1521, 1524, 1533, 1534
Commission to Francesco il Vecchio from the priest Lovixe, chaplain of the
Confraternita del Corpo di Cristo, and payments for the altarpiece with the
Lamentation over the Body of Christ, to be placed in the church of San Giovanni
Battista in Bassano. The work is now in the Museo Civico, Bassano del
Grappa (inv. 5).
Libro secondo, fols. 62*v* and 69*v*-70*r* (Muraro 1992, *Catalogo*, no. 7).

1522, April 4 and 28
Francesco il Vecchio, father of Jacopo, appears as one of the city councillors
of Bassano.
ACB, *Atti del Consiglio*, under the dates 4 and 28 April 1552 (Gerola 1907 (A),
84 and 86).

1523, September 11
Baptism of Caterina Angelica, Jacopo's half-sister and daughter of Francesca,
Francesco il Vecchio's second wife.
APSM, *Atti battesimali*, 11 September 1523 (Gerola 1907 (A), 82-83).

1524, 1529, 1530, 1531
Commission to Francesco il Vecchio from Fra Marco Bassanin, Fra Andrea
Guarniero, and the stewards of San Donato, and payments for the altarpiece
with *The Madonna and Child Enthroned with Saints Donato and Michael and a
Donor* in the church of San Donato in Bassano (*in situ*).

Libro secondo, fols. 55*v*-56*r* and 59*r* (Muraro 1992, *Catalogo*, no. 13).

1525, 1526, 1527
On 23 April 1525, it is noted that Francesco il Vecchio is owed money by the « Scuola de S. Antonio » in Valstagna for a painting already placed on the altar of San Giuseppe in the parish church. Payments to Francesco until 5 November 1527. The altarpiece, which depicts *The Nativity*, is *in situ* in the parish church.
Libro secondo, fols. 109*v*-110*r* (Muraro 1992, *Catalogo*, no. 18).

1529, 1539
Contract between Francesco il Vecchio and Alessio Alessi (8 February 1529) for « a painting depicting Saint Sebastian » with its frame (*caxamento*) for the parish church in Rosà (*in situ*).
Libro secondo, fols. 0*v*-1*r* (Muraro 1992, *Catalogo*, no. 30).

1529, 1530, 1531, 1532, 1533, 1534, 1535, 1536, 1537, 1538, 1539
On 24 January 1529, a contract between Francesco il Vecchio and the stewards of the church of Santo Spirito in Oliero and the Confraternita di San Sebastiano for a painting depicting *The Pietà with Saints Sebastian and Roch* (*in situ*). Payments in various years.
Libro secondo, fols. 14*v*, 39*v*-41*r*, and 42*v*-43*r* (Muraro 1992, *Catalogo*, no. 33).

1530, 1531
Commission and payments to Francesco il Vecchio from the priest Ercules and stewards of the Scuola di Santa Maria in Rosà for the polyptych (including friezes and frames) with *The Madonna, Saints Peter, John the Baptist, Sebastian, and God the Father* for the parish church in Rosà. The two panels with *Saint John the Baptist* and *Saint Peter* are now in the Museo Civico, Bassano del Grappa (invs. 3 and 4).
Libro secondo, fols. 41*v*-42*r*, 43*r*, and 59*v*-60*r* (Muraro 1992, *Catalogo*, no. 37).

1532, 1537, 1538, 1539
Contract with Francesco il Vecchio for *The Deposition of Christ* and *The Resurrection* (lunette?), and payments to Francesco and Jacopo from Zuan Gregorio Nichele, the priest of San Luca, and from the stewards of the church and the city. Of the two compositions destined for the church of San Luca in Marostica, the *Deposition* is still conserved *in situ*.
Libro secondo, fols. 95*v*, 126*v*-127*r*, and 139*v* (Muraro 1992, *Catalogo*, no. 55).

1532, 1537
Contract with Francesco il Vecchio and payments from the priest Evangelista for *The Flight into Egypt* (cat. 1) for the monastery of San Girolamo in Bassano (Museo Civico, Bassano del Grappa, inv. 6).
Libro secondo, fols. 121v-122r (Muraro 1992, *Catalogo*, no. 48).

1533, 1546, 1547, 1548
Contract and payments to Francesco il Vecchio, and later Jacopo, from the archpriest Zuan Brevio, his chaplain, priest Egidio, and various representatives of the city of Angarano for the altarpiece of *The Holy Trinity* for the church of the Santa Trinità in Angarano (*in situ*).
Libro secondo, fols. 24v-25r and 35r (Muraro 1992, *Catalogo*, no. 59).

1534, 1535
Francesco il Vecchio declares on 17 November 1534 that Jacopo has made a contract with the priest Jacomo da Fara for a painting depicting *The Madonna Enthroned with the Christ Child and Saint Mary Magdalene and Donors*. The painting, executed by Jacopo, was in the parish church of Fara Vicentino (now Museo Civico, Vicenza, inv. A-354).
Libro secondo, fols. 60v-61r (Muraro 1992, *Catalogo*, no. 67).

1535, January 15
The Venetian Senate grants Jacopo dal Ponte, Jacomo Antonio da Trento, and Jacomo da Trento the patent for a hydraulic invention.
ASVe, *Senato Terra*, xxxv, 176 (Gerola 1907 (B)).

1535
Contract with Francesco il Vecchio for a fresco depicting the *Dead Christ with Angels* for the Scuola del Corpo di Cristo in Marostica. The fresco is still visible.
Libro secondo, fol. 110v (Muraro 1992, *Catalogo*, no. 69).

1535, 1536
On 20 July 1535, Francesco il Vecchio makes a contract with the podestà of Bassano, Luca Navagero, for «three history paintings to go above a bed alcove». Payments are made in 1535 and 1536. The three paintings, depicting *The Fiery Furnace* (fig. 11), *Christ and the Adulteress* (cat. 115), and *Susanna and the Elders*, were in the Palazzo Pretorio and are now in the Museo Civico, Bassano del Grappa (invs. 8, 9, and 10).
Libro secondo, fols. 92v-93r (Muraro 1992, *Catalogo*, no. 70).

1536, 1537, 1538, 1540 Contract of 26 January 1536 between Francesco il Vec-

chio and Bernardin de la Rea and Zuan de Caron, the stewards of the city of Pove, Andrea d'Alberton, and Bianco de Caron for a picture for « the high altar, including the colors, woodwork, and gold ». Payments in 1537 and 1538 to Francesco, and on 5 January 1540 to Jacopo for the remainder. The picture depicting *Bishop Saint Vigilius in Glory with Saints John the Baptist and Jerome* is placed above the high altar of the parish church of Pove del Grappa.
Libro secondo, fols. 93v-94r (Muraro 1992, *Catalogo*, no. 85).

1536, March 12
Contract with Francesco il Vecchio and payment from the Podestà Matteo Soranzo for a votive canvas depicting *The Podestà of Bassano Matteo Soranzo with His Daughter Lucia and His Brother Francesco Being Presented by Saints Lucy, Francis, and Matthew to the Madonna and Child* (cat. 2). The work, signed by Jacopo, is in the Museo Civico, Bassano del Grappa (inv. 7).
Libro secondo, fols. 94v-95r (Muraro 1992, *Catalogo*, no. 79).

1536, April 2
The city of Angarano hires Francesco il Vecchio to draw a map of a mountain that was being disputed between the cities of Angarano and Valstagna. ACB, *Angarano, Liti*, parte III, fasc. 3 (Gerola 1907 (A), 84 and 97; and Muraro 1992, *Catalogo*, no. 83).

1536, October 17
The Dal Ponte family, in an agreement with Father Mattia, prior of the monastery of San Fortunato in Bassano, begins the frescoes in the church of Santa Lucia in Cittadella (now Santa Croce Bigolina) with the following representations: a frieze with eighteen figures of saints in round frames, *The Annunciation* on the choir façade, and thirteen prophets in round frames in the archivault.
Libro secondo, fols. 94v-95r (Muraro 1992, *Catalogo*, no. 76).

1537, April 12
Contract with Francesco il Vecchio and payment from Father Mattia, prior of the monastery of San Fortunato in Bassano, for frescoes in the church of Santa Lucia in Cittadella (now Santa Croce Bigolina). The representations to be added to those already painted (see above, 17 October 1536) are: a frescoed altarpiece in the apse depicting *The Madonna and Saints*; on the vault, *God the Father* and a decoration of imitation marble; on the exterior façade above the door, *Saint Lucy*; and along the side, above the exterior altar, *The Madonna between Saints Lucy and Lawrence*. This decoration, although damaged, is still visible.

Libro secondo, fols. 94v-95r (Muraro 1992, *Catalogo*, no. 87).

1537, September 9
Contract with Francesco il Vecchio and payments from the administrators of the city of Borso del Grappa for the altarpiece of the high altar depicting *The Madonna and Child with Saints John the Baptist and Zeno* (*in situ*, cat. 3).
Libro secondo, fols. 0r, 14v, 15r, and 43v (Muraro 1992, *Catalogo*, no. 86).

1537, 1538
Contract with Francesco il Vecchio and payments to Jacopo from Ambrogio Frizier de la Nave for a *Last Supper* (church of Saint Lawrence, Wormley, Hertfordshire).
Libro secondo, fols. 1v-2r (Muraro 1992, *Catalogo*, no. 89).

1537, 1538, 1539
Contract with Francesco il Vecchio and payments to Francesco and Jacopo from the archpriest and the city administrators of Cittadella for an altarpiece depicting *The Supper at Emmaus* (now in the cathedral sacristy, fig. 12) and «figures and marbles» in the chapel of the cathedral's high altar. These are the frescoes, now partially recovered, depicting *Samson and the Philistines* (fig. 92) and *David and Goliath* (fig. 93).
Libro secondo, fols. 25v-26r, 43v, 95v, and 139v (Muraro 1992, *Catalogo*, no. 90).

1538, October 14
Contract with Francesco il Vecchio and payment to Jacopo from Cosmo da Mosto, podestà of Cittadella, on behalf of a gentleman of the Malipiero household, for a *Supper at Emmaus* (Kimbell Art Museum, Fort Worth, cat. 4).
Libro secondo, fol. 25v (Muraro 1992, *Catalogo*, no. 95).

1539, March 19
Contract with Francesco il Vecchio and payments to Jacopo from Zaneto dal Corno to fresco the façade of his house in Bassano (cat. 116). The detached frescoes are now in the Museo Civico, Bassano del Grappa.
Libro secondo, fols. 130v-131r (Muraro 1992, *Catalogo*, no. 106).

1539, August 21
Terminus ante quem for the death of Francesco il Vecchio. On this date it is written in the *Libro secondo*: «quondam maestro Francesco».
Libro secondo, fol. 21v.

1539

Contract and payments to Jacopo in October 1539 for a commission from Marco Pizzamano of Venice for a picture depicting *Christ among the Doctors in the Temple* (Ashmolean Museum of Art and Archaeology, Oxford, fig. 18).

Libro secondo, fols. 69*v*-70*r* (Muraro 1992, *Catalogo*, no. 102).

1541, May 27

Jacopo is exempted from payment of both ordinary and special taxes «because of the excellence of his art».

ACB, *Atti del Consiglio*, 27 May 1541 (Verci 1775, 43; and Crivellari 1893, 10).

1541, 1542, 1543

Contract and payments to Jacopo from the stewards of the Confraternita della Concezione di Asolo for the altarpiece for the church of San Girolamo in Asolo depicting *Saint Anne and the Virgin Child with Saints Jerome and Francis* (cat. 7). The work, signed and dated 1541 by Jacopo, is now in the Museo Civico, Bassano del Grappa, on deposit from the Gallerie dell'Accademia, Venice (inv. 437).

Libro secondo, fols. 44*v*-45*r* (Muraro 1947, 287-88; and Muraro 1992, *Catalogo*, no. 121).

1541, 1542, 1543

Commission and payments from the stewards of the church in Mussolente and the priest Antonio Maria di Cesana of Asolo for an altarpiece depicting *Saints Ursula, Valentine, and Joseph* (on loan to the Museo Civico, Bassano del Grappa, cat. 118).

Libro secondo, fols. 49*v*-50*r*, 51*r*, and 98*v* (Muraro 1992, *Catalogo*, no. 126).

1542, 1543

Contract with the priest Natale Moreo of Feltre for the altarpiece in Rasai depicting *The Madonna and Child with Saints Martin and Anthony Abbot* (Bayerische Staatsgemäldesammlungen, Alte Pinakothek, Munich, cat. 8).

Libro secondo, fols. 81*v*-82*r* (Muraro 1992, *Catalogo*, no. 135).

1542

Contract and payment from Bernardo Morosini, podestà of Bassano, for his portrait (Staatliche Museen Kassel, Gemäldegalerie Alte Meister, Kassel, cat. 6).

Libro secondo, fols. 5*r* and 16*v*-17*r* (Muraro 1992, *Catalogo*, no. 131).

1543, April 30

Contract with Jacopo from Baldissera Moro and the Oriago parish priest

Zuan Maria for the altarpiece depicting the *Noli me tangere* for the parish church in Oriago (*in situ*, fig. 22). Payments followed in 1544.
Libro secondo, fols. 16*v*-17*r* (Muraro 1992, *Catalogo*, no. 142).

1543, November 29
Jacopo, on behalf of himself and his brothers, assigns a dowry to his sister Anna, who married Valentino Baroncelli.
ASBas, not. Filippo Angelini, b. 100 (Brotto Pastega 1991, 47-48).

1544, June 9
Contract with the priest Evangelista and a payment on 11 August 1544 for an altarpiece depicting *The Martyrdom of Saint Catherine* for the monastery of San Girolamo in Bassano (Museo Civico, Bassano del Grappa, inv. 436, cat. 19).
Libro secondo, fols. 37*v*-38*r* (Muraro 1992, *Catalogo*, no. 148).

1544, November 22
Jacopo, on behalf of himself and his brothers, assigns a dowry to his sister Caterina, who married Andrea Baroncelli.
ASBas, not. Filippo Angelini, b. 100 (Brotto Pastega 1991, 51-52).

1545, April 12
Commission and payments from the Podestà Piero Pizzamano for the « story when Christ was in a boat with the disciples », *The Miraculous Draught of Fishes* (private collection, London, cat. 15).
Libro secondo, fols. 99*v*-100*r* (Muraro 1992, *Catalogo*, no. 154).

1546, September 6
To Elisabetta Merzari, bride of Jacopo, a dowry is assigned by her father, Giovanni Battista.
ASBas, not. Madio di Bartolomeo, b. 113 (Brotto Pastega 1991, 53-54).

1546, 1547, 1548
In 1546 Jacopo receives a deposit by letter from Battista Erizzo of Venice for « a picture of the Last Supper of Christ ». Payments were made in 1547 and 1548. This picture can be identified as *The Last Supper* (Galleria Borghese, Rome, cat. 18).
Libro secondo, fol. 18*v* (Muraro 1992, *Catalogo*, no. 163).

1546, 1550
Contract with Jacopo, signed at his house in Bassano, from the stewards « de la vila de Honara » and payments for an altarpiece depicting « the story

where our Savior in the guise of a gardener appears to the Magdalene », that is, the *Noli me tangere* (parish church, Onara di Tombolo).
Libro secondo, fols. 32v-33v (Muraro 1992, *Catalogo*, no. 166).

1547, January 21
Francesco Alessandro, son of Jacopo and Elisabetta Merzari, born on 15 January, is baptized.
APSM, *Atti battesimali*, 21 January 1547.
Libro secondo, fol. 136v (Gerola 1905, 103).

1547, May
Francesco Alessandro dies.
Libro secondo, fol. 136v.

1547, 1548
Contract and payments from the city administrators of Castello di Godego for a sculptural group depicting *The Crucifixion with the Madonna and Saint John the Evangelist* to be placed in the parish church. Muraro has identified this with fragments of an inlaid wooden crucifix and a plaster Saint John (ex-church of San Pietro, Castello di Godego).
Libro secondo, fols. 35v-36r (Muraro 1992, *Catalogo*, no. 167).

1548, June 5
Terminus ante quem for the death of Giambattista, brother of Jacopo. On this date it is written in the *Libro secondo*: « quondam Zuan Baptista suo fratello ».
Libro secondo, Appendix XII.

1548, 1549
Contract with Antonio and Pasquale Zatta and payments for the altarpiece in the parish church of Tomo depicting *The Madonna and Child with Saints James and John the Baptist* (Bayerische Staatsgemäldesammlungen, Alte Pinakothek, Munich, fig. 26).
Libro secondo, fols. 7v-8r (Muraro 1992, *Catalogo*, no. 176).

1548, 1549
Contract and payments from the stewards and overseers of the Scuola della Madonna, in the parish church of Asolo, for an altarpiece representing *The Madonna with Saints Anthony Abbot and Louis of Toulouse* (*in situ*, with « its ornament », cat. 19).
Libro secondo, fols. 118v-119r (Muraro 1992, *Catalogo*, no. 177).

1548, 1550
Contract on 31 October 1548 between Jacopo and the priest Nicola da Pesaro of Cittadella, who was acting on behalf of Antonio Zentani in Venice. Payments are made for a picture «of his pointers, that is, only dogs». This can be identified as *Two Hunting Dogs* (private collection, Rome).
Libro secondo, fols. 6*v*-7*r* (Ballarin 1964, 55-61; and Muraro 1992, *Catalogo*, no. 173).

1549, January 7
Francesco, son of Jacopo and Elisabetta Merzari, is born on 7 January and baptized on 13 January with the name Francesco Giambattista.
Libro secondo, fol. 136*v*.

1549, August 10 and 17
Jacopo is elected consul for the neighborhood of Margnan in the city of Bassano but requests and is granted dispensation from the office, from which he resigns on 17 August.
ACB, *Atti del Consiglio*, 10 and 17 August 1549 (Memmo 1754, 79; Verci 1775, 44; and Gerola 1909 (A), 4).

1550, October 12
Giacomo Rosso of Valstagna reports to Pietro Venier in Venice that Jacopo has «rinfrescà», or restored, a large painting depicting the story of Samson, that is, *Samson and the Philistines* (Gemäldegalerie Alte Meister, Dresden, fig. 100). The subject is the same as that frescoed on the façade of the Casa dal Corno (cat. 116).
Libro secondo, fol. 98*v* (Muraro 1992, *Catalogo*, no. 190).

1550
Contract and payment from Gasparo Ottello of Padua for *The Beheading of the Baptist* (Statens Museum for Kunst, Copenhagen, fig. 29) and a «paese», or landscape, in the lunette (now lost).
Libro secondo, fols. 52*v*-53*r* (Muraro 1992, *Catalogo*, no. 189).

1551, February 6
Girolamo, brother of Jacopo, is named as a priest in a notarized act.
ASBas, not. Giambattista Ottello, b. 6, February 1551 (Gerola 1907 (A), 82).

1551, February 22
Jacopo is exempted from payment of personal property taxes, but not taxes on cash (*reali*).
ACB, *Atti del Consiglio*, 22 February 1551 (Verci 1775, 43; and Crivellari 1893, 10).

1551
Contract with Liviero Ranzon, steward of the Scuola dello Spirito Santo in the church of San Giacomo in Lusiana, for *The Descent of the Holy Spirit* (*in situ*, cat. 20).
Libro secondo, fols. 120*v*-121*r* (Muraro 1992, *Catalogo*, no. 195).

1551, December 27
Birth of Giustina, daughter of Jacopo and Elisabetta Merzari.
Libro secondo, fol. 136*v*.

1553, March 4
Giambattista, son of Jacopo and Elisabetta Merzari, is born in Bassano on 4 March and baptized on 9 March by his paternal uncle Girolamo, a priest.
Libro secondo, fol. 136*v*.

1554, January 19
Jacopo assigns a dowry to his sister Franceschina, who married Giovanni Miazzi of Cittadella.
ASBas, not. Filippo Angelini, b. 100 (Brotto Pastega 1991, 55-56).

1554, August 26
Jacopo records in the *Libro secondo* the destruction of four battlements in the city walls, torn down, he affirms, «for half of our house».
Libro secondo, fol. 136*r*.

1554
Contract and payments from Domenico Priuli for *The Miracle of the Quails and the Manna* (private collection, Florence, fig. 33).
Libro secondo, fols. 37*v*-38*r* (Muraro 1992, *Catalogo*, no. 211; and Longhi 1948, 52).

1554
Girolamo, brother of Jacopo, is elected chaplain of the Confraternita del Santissimo.
ACB, *Estimo de' Beni Affitti e Livelli*, 1554, fol. 199 (Gerola 1907 (A), 82).

1554
Jacopo acquires from the builder Paolo a small house, located next to the small wooden house, which he will restructure and enlarge.
Libro secondo, fol. 79*v*.

1555, March 24
Marina Benedetta, daughter of Jacopo, is baptized; born on 21 March, she would be married on 23 July 1576 to Apollonio Apolloni.
APSM, *Atti battesimali*, 24 March 1555; and *Libro secondo*, fol. 136*v* (Gerola 1905, 111).

1557, June 10
Leandro, son of Jacopo and Elisabetta Merzari, is born on 10 June and baptized on 26 June by his paternal uncle Girolamo.
Libro secondo, fol. 137*r*.

1558, July 22
Giustina, Jacopo's daughter, dies.
Libro secondo, fol. 136*v*.

1558, December 27
Jacopo is present as witness of a notarized act in which Bartolomeo Testa endows the Cappella di San Giovanni Battista in the church of San Francesco in Bassano, after having had it restored and decorated with a new altarpiece. This is evidently the little altarpiece of *Saint John the Baptist in the Wilderness* (Museo Civico, Bassano del Grappa, inv. 19, cat. 29).
ASBas, not. Giulio Gosetti, b. 117, fols. 174*v*-175*v*. There also exists a faithful transcription made in the eighteenth century: ASVe *Dep. ad Pias Causas*, fasc. Bassano, b. 43 (Sartori 1958 (B), 200-1).

1560, February 5
Jacopo and his brother Girolamo, the priest, assign a dowry to their sister Elisabetta, who married Baldassare de Mundo.
ASBas, not. Madio di Bartolomeo, b. 113 (Gerola 1907 (A), 83; and Brotto Pastega 1991, 57-59).

1560, April 17
Silvia Giustina, daughter of Jacopo and Elisabetta Merzari, is born on 17 April and baptized on 26 April by the priest Vidal.
Libro secondo, fol. 137*r*.

1561, February 24
Jacopo receives a payment of L. 15,8 on account for a ciborium ordered by the priest Lunardo of Mussolente. A payment of L. 7,14 is made on 25 October 1561, and the final payment of L. 69,17, upon completion of the work, is made on 9 March 1562.
APMussolente, *Libro della fabbrica / che incomincia l'anno 1559 / e termina / l'*

anno 15/72 (Rigon 1978, 174; and Bonaldi 1982, 237).

1561
In the census of 1561, Jacopo is listed as being 45 years old and his wife, 36; he has «tre puti», or little boys (Francesco, Giambattista, and Leandro) and «due pute», or little girls (Marina and Silvia). His brother Girolamo, the priest, is 36 years old.
ACB, *Censi della popolazione*, vol. 2, fasc. 26 (Gerola 1905, 103; and Gerola 1907 (A), 82).

1561, 1562, 1563
On 29 November 1561, Cornelia Meolo, prioress of the convent of the Dominican nuns of San Paolo in Treviso, commissions from Jacopo a *Crucifixion with the Virgin and Saints Mary Magdalene, John the Evangelist, and Jerome* (Museo Civico, Treviso, cat. 37). From the prioress' *Memoirs* we learn of the painting's fate: on 9 November 1562 it is accompanied to Treviso by Jacopo himself; after almost a year it is taken back to Bassano to be restored or adapted to the altar; payment for the altarpiece, according to a document (Torresan 1986-87; and Torresan 1987), was made on 24 September 1563, the same day as the solemn inauguration of the painting. The annals of the prioress record the painting on fol. 313: «24 September 1563. The singing of a man by the cathedral choir for the placement of the altarpiece of the holy crucifixion». Jacopo was present at this ceremony, according to the *Memoirs*, and received a compensation of L. 544.
ASTv, *Corporazioni Religiose Soppresse*, San Paolo, Quaderno della Procuratoria, b. 31 (Federici 1803, ii, 63-64; Liberali 1940, 258; Liberali 1950, 95-108; Liberali 1953, 171-72; Torresan 1986-87, 173-76; and Torresan 1987, 201).

1566, February 8
Cornelia Gosetti, who will marry Leandro on 22 May 1587, is baptized in Bassano.
APSM, *Atti battesimali*, 8 February 1566 (Gerola 1905, 114).

1566, May 27
The Bassano City Council confirms Jacopo's exemption, previously granted, from all «ordinary and special» taxes.
ACB, *Atti del Consiglio*, 27 May 1551 (Verci 1775, 43-44).

1566, June 3
Girolamo, last son of Jacopo and Elisabetta Merzari, is born on 3 June and baptized on 8 June by his paternal uncle, the priest Girolamo.
Libro secondo, fol. 137r (Gerola 1905, 105).

1568, December 18
The Confraternita di San Giuseppe, under the guidance of master Bastian Polonio, master Soranzo Lorenzon, and ser Lion Chaxolin, administrator and steward, places on the high altar of the small church of San Giuseppe in Bassano (no longer extant) an altarpiece depicting *The Adoration of the Shepherds with Saints Victor and Corona* (Museo Civico, Bassano del Grappa, inv. 17, cat. 46). For this altarpiece he was paid 50 ducati, at a rate of 6 Lire 4 soldi per ducat. The chapters of the Confraternita di San Giuseppe, from 1521 through 1613 (as listed in ACB), record Jacopo's agreements with the brothers from 9 April 1553. In following years, various transactions occurred with the administrator and steward.
ACB, *Maneggio della Confraternita di Santa Maria e San Giuseppe*, fol. 102v (Gerola 1906, 110).

1573, December 21
The altarpiece depicting *Saint Mark in Glory with Saints John the Evangelist and Bartholomew* (*in situ*) is placed on the altar of the parish church of Cassola.
APCassola, in a note in the *Libro dei Battezzati* of 1573, reported by Magagnato and now lost (Magagnato 1952, 45; and Brotto Pastega 1991, 29-30).

1576, February 17
The Confraternita del Nome di Gesú asks the city council for a contribution toward the price of an altarpiece that had already been commissioned (it is not specified from whom) for their altar in the church of Santa Maria in Colle in Bassano. The altarpiece can be identified as *The Circumcision*, dated 1577 and signed by Jacopo and Francesco (Museo Civico, Bassano del Grappa, inv. 21, cat. 121).
ACB, *Atti del Consiglio*, 17 February 1576 (Alberton Vinco da Sesso 1991, 64).

1577, February 18
Jacopo assigns a dowry to his daughter Marina, bride of Apollonio Apolloni on 23 July 1576.
ASBas, not. Giulio Gosetti, b. 120 (Verci 1775, 93; and Brotto Pastega 1991, 60-63).

1578, February 10
Francesco, son of Jacopo, marries Giustina Como in Bassano; she died and was buried in Bassano on 14 November 1607.
APSM, *Atti matrimoniali*, 10 February 1578 (Gerola 1905, 104).

1580, March 3
The Confraternita di Santa Maria e di San Giuseppe in Bassano commissions

from Jacopo an altarpiece representing *The Virgin in Glory with Saints Agatha and Apollonia* (Museo Civico, Bassano del Grappa, inv. 24, cat. 122) to be placed on the altar of Saint Apollonia in the church of San Giuseppe (no longer extant). On 21 January 1581, the altarpiece was already in place. (Crivellari 1893, 10).

1581, May 25
Francesco sends a letter from Venice to the merchant Niccolò Gaddi in Florence. In it he speaks of the many trials and tribulations he has had from his father Jacopo and of his father's diminished capacity to work.
(Bottari and Ticozzi 1822, 265-66).

1585, October 28
A contract is drawn up in Bassano between Jacopo and representatives of the Confraternita di Santa Maria Rossa in Paderno for a banner representing on one side the *Madonna della Misericordia*, gathering the brothers under her mantle, and on the other a *Crucifixion*. Payments for the work were made periodically up to the final payment on 21 December 1585.
ASTv, *Corporazioni Religiose Soppresse*, Cantone di Asolo, b. 20 (Bordignon Favero 1992, in press).

1587, May 22
Leandro, son of Jacopo, marries Cornelia Gosetti in Bassano; her dowry was established on 6 October 1587 (ACB, *Pergamene*, 872).
APSM, *Atti matrimoniali*, 22 May 1522 (Gerola 1905, 105).

1587, November 10
Francesco, son of Jacopo, dictates his will in Venice at his house at San Canziano ai Biri, which had belonged to Titian.
ASVe, not. Ottavio Novello, b. 751 (Gerola 1905, 103-7).

1589, October 26
In the census of 26 October 1589, Jacopo is listed as being 70 years old.
ACB, *Censi della popolazione*, vol. 1, fasc. 6 (Gerola 1905, 104).

1589
Jacopo is listed as a brother of the Scuola del Santissimo Sacramento, which patronized the church of San Giovanni Battista in Bassano. The codex with the *Matricola* (immatriculation) of the school and lists of the brothers was conserved in the school's archives, now lost, and was transcribed and published in 1822 by an anonymous brother.

(*Matricola della veneranda Scuola del Santissimo Sacramento...*, Bassano 1822, 45).

1591, November 6
Jacopo assigns two farms to his son Leandro and his wife, one at Casoni di Mussolente and the other «in the Rambolini area» near Bassano, as completion of the dowry established at 1,000 ducati in the marriage contract drawn up on 6 October 1587 (Gerola 1905, 106).
ASBas, not. Nicolò Apollonio, b. 110 (Alberton Vinco da Sesso and Signori 1979, 163).

1592, February 10
In his house on the other side of the bridge in Bassano, Jacopo dictates his will to the notary Bernardino dalla Porta in the presence of seven witnesses.
ASBas, not. Bernardino dalla Porta, b. 154 (Alberton Vinco da Sesso and Signori 1979, 161 and 163-64).

1592, February 11
To his will Jacopo adds a codicil, which he dictates to the notary Bernardino dalla Porta in the presence of six witnesses, one of whom is the archpriest of Santa Maria in Colle, Girolamo Compostella.
ASBas, not. Bernardino dalla Porta, b. 154 (Alberton Vinco da Sesso and Signori 1979, 161 and 164).

1592, February 14
Jacopo is buried in the church of San Francesco in Bassano. He most probably died the preceding day, 13 February. He had dictated his will on 10 and 11 February 1592 in his house on the other side of the bridge.
APSM, *Necrologi*, vol. I, 14 February 1592 (Gerola 1905, 104; and Brotto Pastega 1991, 73).

1592, April 27
Court records entitled *Inventario delli Beni del quondam Eccellentissimo Signor Giacomo dal Ponte, Pittor celeberrimo* (Inventory of the Goods of the Deceased Most Excellent Giacomo dal Ponte, Celebrated Painter), once existing in the Cancelleria Civile of Bassano and now lost, were used by Memmo to prepare an inventory of the paintings found in the houses of Jacopo and his son Leandro; Verci transcribed it.
(Memmo 1754, 82; and Verci 1775, 91-102).

1592, July 3
Francesco, son of Jacopo, dies in Venice «for having thrown himself from a

balcony, for madness» eight months before, in November 1591. He was buried in the family tomb in San Francesco in Bassano.
APSan Canziano di Venezia, *Necrologi*, 3 July 1592 (Gerola 1905, 103).

1593, May 29
Jacopo's widow, Elisabetta Merzari, requests and obtains the return of her nuptial dowry.
ASBas, not. Alessandro Como, b. 160 (Verci 1775, 42-43; and Gerola 1905, 104).

1594, July 18
Jacopo's sons – Giambattista and Girolamo on one side, Leandro on the other – reach a compromise concerning the inheritance from their father, regarding in particular the house across the bridge in Bassano.
ASBas, not. Bernardino dalla Porta, b. 155 (Alberton Vinco da Sesso and Signori 1979, 163).

1594, August 13
Jacopo's sons Giambattista and Girolamo divide the portion of the house they had inherited together from their father.
ASBas, not. Bernardino dalla Porta, b. 155 (Alberton Vinco da Sesso and Signori 1979, 163).

1600, May 27
Elisabetta Merzari, Jacopo's widow, dictates her will in the house near the bridge, where she lived with her son Girolamo.
ASBas, not. Nicolò Apollonio, b. 112 (Mantese 1974, 1271; and Brotto Pastega 1991, 26).

1601, September 5
Elisabetta Merzari, Jacopo's widow, is buried in the family tomb in San Francesco in Bassano.
APSM, *Necrologi*, 5 September 1601 (Brotto Pastega 1991, 73).

1613, February 1
Jacopo's son Girolamo restores a painting of *The Madonna with Saints Roch and Sebastian*, the property of Paolo Gualdo of Vicenza.
BBVi, E146, *Paolo Gualdo, Lettera a Emilio Gualdo*, in *Autografi vicentini illustri*, s.s. (Dalla Pozza 1943, 37-38).

1622, April 15
Leandro, son of Jacopo, dies in Venice and is buried in the church of San Salvatore.
APSan Salvatore di Venezia, *Necrologi*, 15 April 1622 (Gerola 1905, 106).

1672, February 4
At the request of the Bassano City Council, the Venetian Senate decrees that the paintings of the Dal Ponte family existing in the churches and public buildings of the city not be moved or sold.
ACB, *Atti del Consiglio*, 4 February 1672.

1674, March 26
The Confraternita di Santa Maria e San Giuseppe in Bassano decrees that the altarpiece depicting *The Adoration of the Shepherds with Saints Victor and Corona* (cat. 46) not be moved from its location for any reason « and this on pain of payment of 500 ducati, granting authority to the stewards to fortify it both in front and behind for its conservation ».
ACB, *Libro de' Capitoli della Scola di San Iseppo di Bassano*, vol. B, fols. 122v-123r (Verci 1775, 81).

1678, April 29
The city council decides to insure against the theft of the altarpiece of *Saint Lucille Baptized by Saint Valentine* (cat. 53) in the church of Santa Maria delle Grazie by means of « an iron grating with chains and locks ».
ACB, *Atti del Consiglio*, 29 April 1678.

1725, December 20
A ducal decree of 20 December 1725 concedes that the three canvases by Jacopo in the Sala dell'Udienza in the Palazzo Pretorio, requested by a ducal decree of 6 November 1725 for the purpose of decorating the public library in Venice, remain untransferrable and unmovable from their location in Bassano, in response to a supplication to the Doge on the part of the Bassano City Council.
ACB, *Ducali che li tre quadri in Camera Audienza del Palazzo Pretorio di Bassano opera di Giacomo da Ponte siano ivi conservati da Commune* (Verci 1775, 84; and Crivellari 1893, 10).

BIBLIOGRAPHY

ABBREVIATIONS

ACB	Archivio Comunale di Bassano del Grappa	APC	Archivio Parrocchiale di Cittadella	ASTv	Archivio di Stato di Treviso
ACC	Archivio Comunale di Cittadella	APSM	Archivio Parrocchiale di Santa Maria in Colle	ASVe	Archivio di Stato di Venezia
ACV	Archivio Curia Vescovile	ASBas	Archivio di Stato di Vicenza, Sezione Bassano del Grappa	AVP	Archivio Visite Pastorali
AP	Archivio Parrocchiale			BBVi	Biblioteca Bertoliana Vicenza

MANUSCRIPTS

Il Campidoglio Veneto sec. XVIII
G.A. Cappellari Vivaro. *Il Campidoglio Veneto.* 4 vols., MS, sec. XVIII, Biblioteca Nazionale Marciana di Venezia, I T. VII, 15 (8304).

CIMA 1699
N. Cima. *Le tre Faccie di Trevigi, Secolo, Chiesa e Chiostro…* MS, 3 vols., 1699, Biblioteca Civica di Treviso.

CRIVELLARI
G. Crivellari. *Antichi affreschi in Bassano: elenco e descrizione.* MS, n.d. Biblioteca Civica di Bassano, 30-C-10-6.

Inventario 1693
Inventario di tutti li mobili che sono nell'appartamento Terreno che gode il Sig.ᵣ Prencipe di Rossano. MS, Archivio Segreto Vaticano di Roma, Fondo Borghese, busta n. 7504.

Libro secondo
Libro secondo di dare e avere della famiglia Dal

Ponte con diversi per pitture fatte. MS, sec. XVI, Biblioteca Civica di Bassano.

PAROLI 1822
C. Paroli. *Sopra i quadri che ornano la Sala della Congregazione Municipale della R. Città di Bassano.* MS, 1822, Biblioteca Civica di Bassano, 30-A-20-8-B.

PINCASTELLI 1891
Istituzione Fidecommissaria fatta dal Principe Francesco Borghese, con le modifiche e sistemazione posteriori. Annotated by Piancastelli, MS, 1891, Archivio Galleria Borghese di Roma.

STORFFER 1720
F. Storffer. *Neu eingerichtes Inventarium der Kayl. Bilder Gallerie in der Stallburg…* MS, vol. I, 1720, Kunsthistorischen Museum di Vienna.

STORFFER 1730
F. Storffer. *Neu eingerichtes Inventarium der Kayl. Bilder Gallerie in der Stallburg…* MS, vol.

II, 1730, Kunsthistorischen Museum di Vienna.

TRISSINO
L. Trissino. *Notizie per una guida artista del territorio vicentino.* MS, n.d. Biblioteca Bertoliana di Vicenza, 3158-C-58.

VOLPATO 1685
G.B. Volpato. *La Verità pittoresca svelata a' dilettanti.* MS, 1685 ca., copia apografa di G.B. Roberti, 1827, Biblioteca Civica di Bassano, 31-A-25.

VOLPATO 17th Century
G.B. Volpato. *La Natura Pittrice.* MS, sec. XVII, copia apografa di G.B. Roberti, sec. XIX, Biblioteca Civica di Bassano, 31-D-20-2.

ZULIANI 1826
Zuliani. *Il Forestiero a Bassano e i suoi contorni.* MS, 1826, Biblioteca Civica di Bassano, 46-D-3006.

BIBLIOGRAPHY

ACKERMAN 1967
J.S. Ackerman. « Palladio's Vicenza: A Bird's-Eye Plan of c. 1571 ». In *Studies in Renaissance and Baroque Art Presented to Anthony Blunt.* London 1967, 54-61.

AGNELLI 1734
J. Agnelli. *Galleria di pitture del Card. Tomm. Ruffo vescovo di Ferrara.* Ferrara 1734.

AGNOLETTI 1897
F. Agnoletti. *Treviso e le sue Pievi: Illustrazione storica el XV centenario dalla istituzione del Vescovato trivigiano (CCCXCVI-MDCCCXCVI).* 2 vols., Treviso 1897.

AIKEMA 1989
B. Aikema and D. Meijers. « L'immagine della carità veneziana ». In *Nel Regno dei Poveri: Arte e storia dei grandi ospedali veneziani in*

età moderna 1474-1797. Venice 1989, 71-96.

AIKEMA AND MEIJER 1985
Disegni veneti di collezioni danesi. Exhibition catalogue edited by B. Aikema and B.W. Meijer, Vicenza 1985.

ALAZARD 1955
J. Alazard. *L'art italien au XVIᵉ siècle.* Paris 1955.

ALBERTO VINCO DA SESSO 1986
L. Alberton Vinco da Sesso. « Dal Ponte Francesco, il Giovane, detto Bassano ». In *Dizionario Biografico degli Italiani,* XXXII. Rome 1986, 173-77.

ALBERTON VINCO DA SESSO 1991
L. Alberton Vinco da Sesso and F. Signori. « Gli altari ». In *Il Duomo di Santa Maria in*

Colle di Bassano del Grappa. Vicenza 1991, 60-82.

ALBERTON VINCO DA SESSO
L. Alberton Vinco da Sesso. « Jacopo dal Ponte ». In *The MacMillan Dictionary of Art.* London (in press).

ALBERTON VINCO DA SESSO AND SIGNORI 1979
L. Alberton Vinco da Sesso and F. Signori. « Il testamento di Jacopo dal Ponte detto il Bassano ». *Arte Veneta* XXXIII (1979), 161-64.

Album bassanese 1988
Album bassanese: Stampe e disegni di Bassano e dintorni. 3rd. edition, Bassano del Grappa 1988.

ALCE 1957
V. Alce. « L'arte religiosa di Jacopo Bassano ». *Arte Cristiana* XLV (1957), 173-76.

ALCOLEA 1980
S. Alcolea. *Pinturas de la Universitat de Barcelona: Catàleq.* Barcelona 1980.

ALGAROTTI 1784
F. Algarotti. *Saggio sopra la pittura* Venice 1784.

ALIZERI 1847
F. Alizeri. *Guida artistica per la città di Genova.* 3 vols. Genoa 1846-47.

ALIZERI 1875
F. Alizeri. *Guida illustrativa del cittadino e del forastiero per la città di Genova e sue adiacenze.* Genoa 1875.

Altvenezianischer Malerei 1931
Altvenezianischer Malerei. Exhibition catalogue, Munich 1931.

AMBROSINI 1990
F. Ambrosini. «Tendenze filoprotestanti nel patriziato veneziano». In *La Chiesa di Venezia tra riforma protestante e riforma cattolica.* Venice 1990, 155-59.

Antiquariato internazionale 1986
Antiquariato internazionale: 248 opere scelte all'Internazionale dell'Antiquariato di Milano. Exhibition catalogue, Turin 1986.

ARSLAN 1929 (A)
W. Arslan. «A Bassano Picture and a Teniers Copy». *The Burlington Magazine* LIV (February 1929, no. 311), 73-74.

ARSLAN 1929 (B)
W. Arslan. «Contributo a Jacopo Bassano». *Pinacoteca* I (1929), 178-96.

ARSLAN 1929 (C)
W. Arslan. «Un nuovo dipinto di Jacopo Bassano». *Bollettino d'Arte* VII (1929), 407-13.

ARSLAN 1930
W. Arslan. «Gerolamo da Ponte». *Dedalo* X (1929-30), 551-66.

ARSLAN 1931 (A)
W. Arslan. *I Bassano.* Bologna 1931.

ARSLAN 1934 (A)
W. Arslan. «An Unknown Painting by Jacopo Bassano». *Art in America* XXII (4 October 1934), 123-24.

ARSLAN 1934 (B)
W. Arslan. *La Pinacoteca Civica di Vicenza.* Rome 1934.

ARSLAN 1936 (A)
W. Arslan. «Bassanesca». *Studi Trentini di Scienze Storiche* XVII (1936), 100-15.

ARSLAN 1936 (B)
W. Arslan. *Inventario degli oggetti d'arte d'Italia, VII: Provincia di Padova, Comune di Padova.* Rome 1936.

ARSLAN 1938
E. Arslan. «Nuovi dipinti dei Bassano». *Bollettino d'Arte* (April 1938), 462-74.

ARSLAN 1946
W. Arslan. *Il concetto del luminismo e la pittura veneziana barocca.* Milan 1946.

ARSLAN 1956
W. Arslan. *Vicenza, I: Le chiese: Catalogo delle cose d'arte e di antichità d'Italia.* Rome 1956.

ARSLAN 1958
W. Arslan. «Bassano». In *Enciclopedia Universale dell'Arte.* vol. II (1958), 471-79.

ARSLAN 1959
E. Arslan. «A Portrait by Jacopo Bassano in the Melbourne Gallery». *Annual Bulletin of the National Gallery of Victoria* I (1959), 18-19.

ARSLAN 1960 (A)
E. Arslan. «A Painting by Jacopo Bassano». *Bulletin of the Wadsworth Atheneum* (Winter 1960, no. 6), 1-3.

ARSLAN 1960 (B)
E. Arslan. *I Bassano.* 2 vols., Milan 1960.

ARSLAN 1967
E. Arslan. «Due storie dell'Arca di Francesco e Jacopo Bassano». *Antichità Viva* VI (1967, no. 3), 3-7.

ATTARDI 1987
L. Attardi. «Dal Ponte, Jacopo detto Bassano». *La Pittura in Italia: Il Cinquecento*, II. 1st edition, Milan 1987.

ATTARDI 1988
L. Attardi. «Dal Ponte, Jacopo detto Bassano». In *La pittura in Italia: Il Cinquecento.* New and revised edition. Edited by Giuliano Briganti, Milan 1988, II, 693-94.

ATTARDI 1991
L. Attardi. *Da Bellini a Tintoretto: Dipinti dei Musei Civici di Padova dalla metà del Quattrocento ai primi del Seicento.* Exhibition catalogue edited by A. Ballarin and D. Banzato, Rome 1991.

Atto di cessione 1874
Atto di cessione del Palazzo Rosso fatta al Municipio di Genova dalla famiglia Galleria. Genoa 1874.

AVAGNINA 1989
E. Avagnina. «Jacopo dal Ponte. Trasporto di Cristo al Sepolcro». In *Restituzione: 10 Opere Restaurate.* Exhibition catalogue, Vicenza 1989, 28-30.

AVEROLDO 1700
G. Averoldo. *Le scelte pitture di Brescia additate al forestiere.* Brescia 1700.

Älte Pinakothek 1936
Älte Pinakothek München. Munich 1936.

BACOU 1987
R. Bacou. «Pastels de Jacopo Bassano au Cabinet des Dessins». In *Hommage à Hubert Landais: Art, Objects d'Art, Collections. Etudes sur l'art du Moyen Age et de la Renaissance sur l'histoire du goût et des collections.* Paris 1987, 104-9.

BAILO 1872
L. Bailo. *Guida della città di Treviso.* Treviso 1872.

BALDARINI 1779
P. Baldarini. *Descrizione delle Architetture, Pitture e Sculture di Vicenza con alcune osservazioni. Parte prima: Delle Chiese e degli Oratori, Umiliata alli Nobiliss. Signori Deputati della magnifica città. Parte seconda: Degli edifizi ed altre opere pubbliche e private.* 2 vols., Vicenza 1779.

BALDASS 1949
L. Baldass. «Some Remarks on Francesco Bassano and His Historical Function». *The Art Quarterly* XII (Summer 1949, no. 3), 199-219.

BALDASS 1955
L. Baldass. «Les Tableaux champêtres des Bassano et la peinture réaliste des Pays-Bas au XVIᵉ siècle». *Gazette des Beaux-Arts* I (March 1955), 143-60.

BALDASS 1958
L. Baldass. «Les Tableaux champêtres des Bassano et la peinture réaliste des Pays-Bas au XVIᵉ siècle». In *Essays in Honor of Hans Tietze* Paris (1958), 291-308.

BALLARIN 1964
A. Ballarin. «L'orto del Bassano (a proposito di alcuni quadri e disegni inediti singolari)». *Arte Veneta* XVIII (1964), 55-72.

BALLARIN 1965 (A)
A. Ballarin. «I veneti all'esposizione *Le Seizième Siècle Européen* del Petit Palais». *Arte Veneta* XIX (1965), 238-40.

BALLARIN 1965 (B)
A. Ballarin. «Osservazioni sui dipinti ven-

eziani del Cinquecento nella Galleria del Castello dei Praga ». *Arte Veneta* XIX (1965), 59-82.

BALLARIN 1966
A. Ballarin. « Chirurgia bassanesca, I ». *Arte Veneta* XX (1966), 112-36.

BALLARIN 1966-67
A. Ballarin. « La vecchiaia di Jacopo Bassano: le fonti e la critica (Nota introduttiva alla *Chirurgia bassanesca*), con in appendice la ristampa dell'elogio del Marucini e la traduzione italiana della *Vita* del van Mander ». *Atti del R. Istituto Veneto di Scienze Lettere ed Arti* CXXV(1966-67), 151-93.

BALLARIN 1967
A. Ballarin. « Jacopo Bassano e lo studio di Raffaello e dei Salviati ». *Arte Veneta* XXI (1967), 77-101.

BALLARIN 1968 (A)
A. Ballarin. « Aggiunte al catalogo di Paolo Veronese e Jacopo Bassano ». *Arte Veneta* XXII (1968), 39-46.

BALLARIN 1968 (B)
A. Ballarin. « Pittura veneziana nei Musei di Budapest, Dresda, Praga e Varsavia ». *Arte Veneta* XXII (1968), 237-55.

BALLARIN 1969
A. Ballarin. « Introduzione ad un catalogo dei disegni di Jacopo Bassano, I ». *Arte Veneta* XXIII (1969), 85-114.

BALLARIN 1971 (A)
A. Ballarin. « Introduzione a un catalogo dei disegni di Jacopo da Bassano, II ». In *Studi di Storia dell'Arte in onore di Antonio Morassi*. Venice 1971, 138-51.

BALLARIN 1971 (B)
A. Ballarin. « Un ritratto inedito del Bassano ». *Arte Veneta* XXV (1971), 268-71.

BALLARIN 1973
A. Ballarin. « Introduzione a un catalogo dei disegni di Jacopo Bassano, III ». *Arte Veneta* XXVII (1973), 91-124.

BALLARIN 1988
A. Ballarin. « Jacopo Bassano. S. Pietro risana lo storpio ». In *Pittori Padani e Toscani tra Quattro e Cinquecento*. Exhibition catalogue, Antichi Maestri Pittori, Vicenza 1988, 1-13.

BALLARIN 1990 (A)
A. Ballarin. « Jacopo Bassano. Crocifissione ». In *Capolavori al museo d'Arte della Catalogna: Tredici opere dal Romanico al Barocco*. Exhibition catalogue, Rome 1990, 56-62.

BALLARIN 1990 (B)
A. Ballarin. « Jacopo Bassano, Incontro di Giacobbe Rachele al Pozzo ». In *Biduino ad Algardi: Pittura e scultura a confronto*. Exhibition catalogue edited by G. Romano, Turin 1990, 117-45, no. II.

BANTI 1953
A. Banti. *Lorenzo Lotto*. Florence 1953.

BANZATO 1988
D. Banzato. *La quadreria Emo Capodilista: 543 dipinti dal '400 al '700*. Exhibition catalogue by D. Banzato, Padua 1988.

BARBIERI 1823
G. Barbieri. « Elogio di Jacopo da Ponte, detto il Bassano ». In *Discorsi dell'Accademia di Belle Arti in Venezia*. Venice 1823, 50-58.

BARBIERI 1973
F. Barbieri. *La pianta prospettica de Vicenza del 1580*. Vicenza 1973.

BARBIERI, CEVESE, AND MAGAGNATO 1953
F. Barbieri, R. Cevese, L. Magagnato. *Guida di Vicenza*. Vicenza 1953.

BARRI 1671
G. Barri. *Viaggio pittoresco in cui si notano tutte le pitture famose de' più celebri Pittori che si conservano in qualsivoglia città d'Italia descritto da G. Barri pittore in Venetia*. Venice 1671.

BARTSCH 1803-21
A. Bartsch. *Le peintre graveur*. 21 vols., Vienna 1803-21.

BARTSCH 1818
A. Bartsch. *Le peintre graveur*, XVI. Vienna 1818.

BARTSCH 1978
see Oberhuber 1978.

BARTSCH 1985
M. Wolff. *German and Netherlandish Masters of the Fifteenth and Sixteenth Centuries*. In *Illustrated Bartsch*, XXIII. New York 1985.

BASEGGIO 1847
G.B. Baseggio. « Della pittura e dell'intaglio in rame in Bassano ». *Di Bassano e dei Bassanesi illustri*. Edited by G. Ferrazzi, Bassano 1847, 51-85.

Bassano Drawings 1961
Bassano Drawings. Exhibition catalogue, New York, Seiferheld Gallery, New York 1961.

BÉGUIN 1979
L'Art religieux à Venise 1500-1600: Tableaux, dessins et gravures des collections publiques et privées en France. Exhibition catalogue edited by S. Béguin, Nice 1979.

BELLONI 1973
V. Belloni. *Penne, pennelli e quadrerie*. Genoa 1973.

BELLORI 1672
G.P. Bellori. *Le vite de' pittori, scultori e architetti moderni…* Rome 1672. Edited by E. Borea, Turin 1976.

BENEDETTI 1571
R. Benedetti. *Ragguaglio delle Allegrezze, Solennità, e Feste fatte in Venetia per la felice Vittoria al Clariss. Sig. Girolamo Diedo, digniss. Consigliere di Corfú*. Venice 1571.

BENESCH 1936
O. Benesch. « Meisterzeichnungen aus dem oberitalienische Kunstkreis ». *Die Graphische Kunste* II (1936), 60.

BENESCH 1961
Disegni veneti dell'Albertina di Vienna. Exhibition catalogue by O. Benesch, Vicenza 1961.

BERENSON 1894
B. Berenson. *The Venetian Painters of the Renaissance*. New York and London 1894.

BERENSON 1895
B. Berenson. *The Venetian Painting, Chiefley before Titian, at the Exhibition of Venetian Art: The New Gallery, 1895*. London 1895.

BERENSON 1897
B. Berenson. *The Venetian Painters of the Renaissance with an Index to Their Works*. New York and London 1897.

BERENSON 1906
B. Berenson. *The Venetian Painters of the Renaissance with an Index of their Works*. New York and London 1906.

BERENSON 1907
B. Berenson. *The North Italian Painters of the Renaissance*. New York and London 1907.

BERENSON 1911
B. Berenson. *The Venetian Painters of the Renaissance*. New York and London 1911.

BERENSON 1932
B. Berenson. *Italian Pictures of the Renaissance: A List of Principal Artists and Their Works with an Index of Places*. Oxford 1932.

BERENSON 1936
B. Berenson. *Pitture Italiane del Rinascimento:*

Catalogo dei principali artisti e delle loro opere con indice dei luoghi. Milan 1936.

BERENSON 1948
N. Berenson. *I pittori italiani del Rinascimento.* Milan 1948.

BERENSON 1952
B. Berenson. *Italian Painters of the Renaissance.* London 1952.

BERENSON 1953
B. Berenson. *Lorenzo Lotto.* Milan 1953.

BERENSON 1955
B. Berenson. *Lorenzo Lotto.* London 1955.

BERENSON 1957
B. Berenson. *Italian Picture of the Renaissance: A List of the Principal Artists and Their Works with an Index of Places, Venetian School.* 2 vols., London 1957.

BERENSON 1958
B. Berenson. *Pitture italiane del Rinascimento: Scuola Veneta.* 2 vols., London 1958.

BERENSON 1968
B. Berenson. *Pitture italiane del Rinascimento: Elenco dei principali artisti e delle loro opere con un indice dei luoghi: La scuola veneta.* 2 vols., Florence 1968.

BERTINI CALOSSO 1923-24
A. Bertini Calosso. « Un quadro giovanile del Greco ». *Bollettino d'Arte* III (1923-24), 481-90.

BERTOTTI SCAMOZZI 1761
O. Bertotti Scamozzi. *Il forestiere istruito delle cose piú rare di architettura e di alcune pitture della città di Vicenza.* Vicenza 1761.

BETTINI 1930
S. Bettini. « Wart Arslan, I Bassano ». *Rivista d'arte* XII (1930), 588-97.

BETTINI 1933
S. Bettini. *L'arte di Jacopo Bassano.* Bologna 1933.

BETTINI 1936
S. Bettini. « Quadri dei Bassano ». *La Critica d'Arte* I (1936), 143-47.

BIALOSTOCKI 1978
J. Bialostocki. « Le vocabulaire visuel de Jacopo Bassano e son stilus humilis ». *Arte Veneta* XXXII (1978), 169-73.

BIASUZ 1933
G. Biasuz. « La falsificazione di due celebri tele di Jacopo Bassano ». *Archivio Storico di Belluni, Feltre e Cadore* V (1933, no. 26), 400 ff.

BIASUZ 1970
G. Biasuz. « La rondine sotto l'arco nella Cena in Emmaus di Jacopo Bassano ». *Padova e la sua provincia* XVI (1970, no. 3), 24-25.

BICKHAM 1755
G. Bickham. *Deliciae Britannicae; or the Curiosities of Kensington, Hampton Court and Windsor Castle.* London 1755.

BIERENS DE HAAN 1948
J.C.J. Bierens de Haan. *L'oeuvre gravé de Cornelis Cort, graveur hollandais.* The Hague 1948.

BIRKE 1991
V. Birke. *Die Italienischen Zeichnungen der Albertina: Zur Geschichte der Zeichnungen in Italien.* Munich 1991.

Blätter für Gemäldekunde 1910
Blätter für Gemäldekunde, I. Vienna 1910.

BLUNT 1956
A. Blunt. *Handlist of the Drawings in the Witt Collection.* London 1956.

Bob Jones University Collection 1962
The Bob Jones University Collection of Religious Paintings. 2 vols., Greenville 1962.

BOCCARDO 1988
P. Boccardo. « Le *rotte mediterranee* del collezionismo genovese. Vicende della Caduta di San Paolo di Caravaggio, di un inedito di Pietro Novelli, della Giuditta di Veronese e di altre opere delle quadrerie di Francesco M. Balbi e Guiseppe M. Durazzo ». *Bollettino dei Musei Civici Genovesi* X (January-December 1988, nos. 29-30), 99-108.

BOCCARDO AND MAGNANI 1987
P. Boccardo and L. Magnani. « La committenza ». In *Il palazzo delle università: Il collegio dei gesuiti nelle strade dei Balbi.* Genoa 1987.

BODE 1892
W. Bode. « Ein Altpersischer teppich in Besitz der Koniglichen Museen zu Berlin ». Jahrbuch der Königlich Preuszischen Kunstsammlungen 13 (1892), 120.

BONALDI 1982
M. Bonaldi. « Pieve e chiese ». In *Mussolente, Casoni: Terra di Misquile.* Bassano 1982, 229-37.

BONELLI 1982
M. Bonelli. « Dentro la pittura. Stile e tecnica negli affreschi del Pordenone a Vacile ». In M. Bonelli and C. Furlan. *Il Pordenone a Vacile.* Spilimbergo 1982, 63-62.

BONELLI 1984 (A)
M. Bonelli. « Gli affreschi del Pordenone a Travesio. Tecniche d'esecuzione ». In *Il Pordenone: Atti del Convegno Internazionale di Studi.* (Pordenone, 23-25 August 1984), edited by C. Furlan, Pordenone 1985, 19-26.

BONELLI 1984 (B)
M. Bonelli. « Gli affreschi. Itinerario attraverso la tecnica pittorica ». In *Il Pordenone.* Exhibition catalogue edited by C. Furlan, Milan 1984, 249-64.

BOORSCH AND LANDAU 1992
S. Boorsch and D. Landau. *Andrea Mantegna.* Exhibition catalogue edited by J. Martineau, London 1992.

BORDIGNON FAVERO 1977-78
E. Bordignon Favero. « La *Natura Pittrice* di Giovan Battista Volpato: nota su un trattato di ottica per pittori della seconda metà del Seicento ». *Atti e Memorie dell'Accademia Patavina di Scienze, Lettere ed Arti.* XC (1977-78, no. 3), 89-101.

BORDIGNON FAVERO 1978-79
E. Bordignon Favero. « Il processo per furto e falso contro G.B. Volpato pittore del '600 ». *Atti e Memorie dell'Accademia Patavina di Scienze, Lettere ed Arti.* XCI (1978-79), 129-93.

BORDIGNON FAVERO 1981
E. Bordignon Favero. « La *Pentecoste* di G.B. Volpato e il *lume serrato* di Jacopo Bassano ». *Atti e Memorie dell'Accademia Patavina di Scienze, Lettere ed Arti.* XCIII (1980-81, no. 3), 53-82.

BORDIGNON FAVERO 1983-84
E. Bordignon Favero. « Carlo Osti in Villa Rinaldi a Casella d'Asolo (1686) ». *Atti e Memorie dell'Accademia Patavina di Scienze, Lettere ed Arti,* XCVI, (1983-84), 355-72.

BORDIGNON FAVERO 1992
E. Bordignon Favero. « I Frizier 'De la Nave' e un affresco inedito di Jacopo Bassano ». *Arte Veneta* XLIV (1992) (in press).

BORDIGNON FAVERO AND REARICK 1983
E. Bordignon Favero and W.R. Rearick. « Per la datazione delle opere di Jacopo dal Ponte a Enego ». *Arte Veneta* XXXVII (1983) 221-23.

BORENIUS 1912
T. Borenius. *The Painters of Vicenza 1480-1550.* London 1909.

BORENIUS 1912
T. Borenius. « Exhibition of Pictures of the Early Venetian School at the Burlington Fine Arts Club-III ». *The Burlington Magazine* XXI (April-September 1912), 95-101.

BORENIUS 1916
Pictures by the Old Masters in the Library of Christ Church, Oxford. Edited by T. Borenius, Oxford 1916.

BORGHINI 1584
R. Borghini. *Il Riposo.* Florence 1584.

BORGO 1975
L. Borgo. «Jacopo Bassano's *Temptation of Saint Anthony*». *The Burlington Magazine* CXVII (1975) 603-7.

BORTOLAMI 1990
S. Bortolami. «Alle origini di Cittadella: la città *di pietra* e la *città vivente*». In *Cittadella città murata.* Cittadella 1990, 96-123.

BOSCHINI 1660
M. Boschini. *La Carta del Navegar Pitoresco: Dialogo tra un Senator venezian deletante, e un Professor de Pitura, soto nome d'Eccelenza e de Compare.* Venezia 1660, edited by A. Pallucchini, Venice and Rome 1966.

BOSCHINI 1664
M. Boschini. *Le miniere della pittura: Compendiosa informazione di Marco Boschini, non solo delle pitture publiche di Venezia, ma delle isole ancora circonvicine.* 1st edition, Venice 1664.

BOSCHINI 1674
M. Boschini. *Le ricche minere della pittura veneziana: Compendiosa informazione non solo delle pitture publiche di Venezia, ma dell'isole ancora circonvicine.* 2nd edition, Venice 1674.

BOSCHINI 1676
M. Boschini. *I Gioielli pittoreschi virtuoso ornamento della Città di Vicenza, cioè l'endice di tutte le pitture publiche della stessa Città.* Venice 1676.

BOSELLI 1957
C. Boselli. «Le storie della passione dei Bassano di Sant'Antonio in Brescia». *Arte Veneta* XI (1957), 208-11.

BOTTARI AND TICOZZI 1822
C. Bottari and S. Ticozzi. *Raccolta di lettere sulla Pittura, Scultura ed Architettura.* 8 vols., Rome 1822.

BRAMBILLA BARCILON AND AVAGNINA GOSTOLI 1982-83
P. Brambilla Barcilon and M.E. Avagnina Gostoli. *Pordenone e Tiziano nella Cappella Malchiostro: problemi di restauro.* Treviso 1982-83.

BRANDOLINI D'ADDA 1945
A. Brandolini d'Adda. *I Brandolini da Bagnacavallo.* Venice 1945.

BREITENBACHER 1932
A. Breitenbacher. «Kdejinam arcibiskupske obrazny v Kromerizi». *Casopis vlast spolku musejniho v Olomuci.* XLV (1932), n.p..

BRENTARI 1881
O. Brentari. *Il Museo di Bassano illustrato.* Bassano 1881.

BRENTARI 1884
O. Brentari. *Storia di Bassano e del suo territorio.* Bassano 1884.

Brera 1980
Brera, Milano. Edited by C. Bertelli, Milan 1980.

BRIGSTOCKE 1978
H. Brigstocke. *Italian and Spanish Paintings in the National Gallery of Scotland.* Edinburgh 1978.

BRIGSTOCKE AND THOMPSON 1970
H. Brigstocke and C. Thompson. *National Gallery of Scotland, Shorter Catalogue.* Edinburgh 1970.

BRIZIO 1932
A.M. Brizio. «Il Greco a Venezia». *L'Arte* XXXV (January 1932, no. 1), 51-69.

BROTTO PASTEGA 1991
A. Brotto Pastega. *Piccola raccolta di Atti notarili dalpontiani dagli archivi di Stato di Bassano del Grappa e di Venezia.* Bassano del Grappa 1991.

BROWN 1988
Masterworks from Munich: Sixteenth-to Eighteenth-Century Paintings from the Alte Pinakothek. Exhibition catalogue by B.L. Brown and A. Wheelock, Washington 1988.

BRUSCO 1788
G. Brusco. *Description des beautés de Gênes.* Genoa 1788.

BUSCAROLI 1935
P. Buscaroli. *La pittura di paesaggio in Italia.* Bologna 1935.

BYAM SHAW 1958
J. Byam Shaw. «Venetian Drawings from Poland at the Fondazione Cini». *The Burlington Magazine* C (1958, no. 688), 395.

BYAM SHAW 1967
J. Byam Shaw. *Paintings by Old Masters at Christ Church, Oxford.* London 1967.

BYAM SHAW 1972
Old Master Drawings from Christ Church, Oxford. Exhibition catalogue by J. Byam Shaw, Washington 1972.

BYAM SHAW 1976
J. Byam Shaw. *Drawings by Old Masters at Christ Church, Oxford.* 2 vols., Oxford 1976.

BYAM SHAW 1989
J. Byam Shaw. «Italian Drawings in the J.F. Willumsen Collection». *The Burlington Magazine* CXXXI (July 1989, no. 1036), 493.

CADOGAN 1991
J.K. Cadogan and M.R.T. Mahoney. *Wadsworth Atheneum Paintings, II: Italy and Spain: Fourteenth through Nineteenth Centuries.* Hartford 1991.

CALÍ 1981
M. Calí. «La *Religione* di Lorenzo Lotto». In *Lorenzo Lotto: Atti del Convegno Internazionale di Studi per il V Centenario della nascita.* (Asolo, 18-21 September 1980), edited by P. Zampetti and V. Sgarbi, Treviso 1981, 243-77.

CALÍ 1984
M. Calí. «Patroni, committenti, amici del Pordenone fra religione e storia». In *Il Pordenone: Atti del Convegno Internazionale di Studi.* (Pordenone, 23-25 August 1984), edited by C. Furlan, Pordenone 1985, 93-101.

CAMON AZNAR 1950
J. Camon Aznar. *Domenico Greco.* Madrid 1950.

CANTALAMESSA 1902
G. Cantalamessa. *Le Gallerie Nazionali Italiane.* Rome 1902.

CANTALAMESSA 1916
G. Cantalamessa. «Tre quadretti delle Gallerie Borghese». *Bollettino d'Arte* (1916, no. 10), 266-72.

Capolavori del Rinascimento 1980
Capolavori del Rinascimento italiano. Exhibition catalogue, Tokyo 1980.

CAPUCCI 1970
M. Capucci. In L. Lanzi. *Storia pittorica dell'Italia dal Risorgimento delle Belle Arti fin presso la fine del XVIII secolo.* 3 vols., Florence 1968-74.

CARACAS 1956
Obras de antiguos maestros italianos en colleciones privades de Caracas. Exhibition catalogue, Caracas 1956.

CASTELLANI TARABINI 1854
Cenni storici e descrittivi intorno alle pitture della Reale Galleria Estense. Edited by F. Castellani Tarabini, Modena 1854.

Catalogo 1861
Catalogo dei quadri ed altri oggetti d'arte della Galleria di S.E. il Marchese Antonio Brignole Sale nel di lui palazzo di Genova, detto il Palazzo Rosso in Via Nuova. Genoa 1861.

Catalogo dei quadri 1785
Catalogo dei quadri raccolti dal fu signor Maffeo Pinelli ed ora in vendita in Venezia. Venice 1785.

Catalogue 1912
Catalogue of the National Gallery of Scotland. Edinburgh 1912.

Catalogue 1924
Catalogue of the National Gallery of Scotland. Edinburgh 1924.

Catalogue 1929
Catalogue van de tetoonstelling van Oude Kunst door de vereninging van handelaren in Oude Kunst in Nederland. Exhibition catalogue, Amsterdam 1929.

Catalogue 1940
Catalogue of European and American Paintings 1500-1900. Exhibition catalogue edited by Walter Pack, New York World's Fair, New York 1940.

Catalogue 1946
Catalogue of the National Gallery of Scotland. Edinburgh 1946.

Catalogue 1957
Catalogue of Paintings and Sculpture. Edinburgh 1957.

Catalogue Musée 1911
Ville de Nîmes: Musée des Beaux-Arts. Catalogue. Nîmes 1911.

Catalogue Musée 1940
Ville de Nîmes: Musée des Beaux-Arts. Catalogue. Nîmes 1940.

Catalogue of Paintings 1961
Catalogue of Paintings: City of York Art Gallery. Catalogue, I. York 1961.

Catalogue of Pictures… 1831
Catalogue of Pictures by Italian, Spanish, Flemish, Dutch and French Masters. Exhibition catalogue, London 1831.

CATELLI ISOLA 1976
Immagini da Tiziano: Stampe dal sec. XVI al sec. XIX. Exhibition catalogue edited by M. Catelli Isola, Rome 1976-77.

CAZORT TAYLOR 1969
Da Dürer a Picasso: Mostra di disegni della Galleria del Canada. Exhibition catalogue edited by M. Cazort Taylor, Florence 1969.

CEVESE 1954
R. Cevese. « Ricchezze pittoriche vicentine: Chiesa delle Maddalene ». *Vita vicentina* IV (August 1954).

CHASTEL 1975
A. Chastel. « L'ardita capra ». *Arte Veneta* XXIX (1975), 146-49.

CHIARI 1982
M.A. Chiari. *Incisioni da Tiziano.* Venice 1982.

CHINI 1988
E. Chini. « Gli affreschi di Girolamo Romanino nella loggia del Castello del Buoncosiglio dopo il restauro ». In *Romanino a Trento: Gli affreschi nella Loggia del Buonconsiglio.* Milan 1988.

CHIUPPANI 1904
G. Chiuppani. « Le piante storiche della città di Bassano ». *Bollettino del Museo Civico di Bassano* I (1904), 55-64.

COCHIN 1758
C.N. Cochin. *Voyage d'Italie, ou Recueil de Notes sur les Ouvrages de Peinture et de Sculpture, qu'on voit dans les principales villes d'Italie.* 3 vols., Paris 1758.

COHEN 1980
C.E. Cohen. *Giovanni Antonio da Pordenone.* Florence 1980.

COHEN 1984
C.E. Cohen. « Observations on the Machiostro Chapel ». In *Il Pordenone: Atti del Convegno Internazionale di Studio* (23-25 August 1984). Edited by C. Furlan, Pordenone 1985, 27-33.

COLETTI 1935
L. Coletti. *Catalogo delle cose d'arte e di antichità d'Italia: Treviso.* Rome 1935.

COLLINS BAKER 1929
C.H. Collins Baker. *Catalogue of the Pictures at Hampton Court.* Glasgow 1929.

CONFORTI CALCAGNI 1987
A. Conforti Calcagni. « La casa agli Orti di Spagna ». *Annuario storico Zenoniano* (1987), 33-61.

CONSTABLE 1927
W.G. Constable. *Catalogue of Pictures in the Marlay Bequest.* Cambridge 1927.

CORNER 1758
F. Corner. *Notizie storiche delle chiese e monasteri di Venezia, e di Torcello tratte dalle chiese veneziane e torcellane illustrate da Flaminio Corner.* Padua 1758.

COSSIO 1908
M.B. Cossio. *El Greco.* Madrid 1908.

COSTANZI 1990
C. Costanzi. « Per un Tiziano in più ». In *Ancona e le Marche per Tiziano 1490-1990.* Ancona 1990, 35-43.

COSTANZI 1991
C. Costanzi. « Ipotesi e considerazioni sulla presenza di una *Fuga in Egitto* di Jacopo Bassano ad Ancona ». *Notizie di Palazzo Albani* (1991), 121-28.

COULANGES ROSENBERG 1965
Le XVIe Siècle Européen: Peintures et Dessins dans les Collections Publiques Françaises. Exhibition catalogue by F. Coulanges Rosenberg, Paris 1965.

COX REARICK 1964
J. Cox Rearick. *The Drawings of Pontormo.* 2 vols., Cambridge, Massachusetts, 1964.

CRICO 1822
L. Crico. *Viaggetto pittorico da Venezia a Possagno.* Venice 1822.

CRICO 1829
L. Crico. *Indicazioni delle pitture ed altri oggetti di Belle Arti degni d'osservazione esistenti nella R. città di Treviso.* Treviso 1829.

CRICO 1833
L. Crico. *Lettere sulle Belle Arti Trivigiane.* Treviso 1833.

CRIVELLARI 1893
G. Crivellari. « Spigolature dapontiane ». In *Bassano e Jacopo da Ponte.* Bassano 1893, 10 ff.

CROOKSHANK 1961
A Crookshank. *Pictures from Ulster Houses.* Exhibition catalogue, Belfast 1961.

CROWE AND CAVALCASELLE 1871
J.A. Crowe and G.B. Cavalcaselle. *A History of Painting in North Italy; Venice, Padua, Vicenza, Verona, Ferrara, Milano, Friuli, and Brescia from the Fourteenth to Sixteenth Century.* 2 vols., London 1871. Edited by T. Borenius, 3 vols., London 1912.

CROWE AND CAVALCASELLE 1876
J.A. Crowe and G.B. Cavalcaselle. *Geschichte der Italienischen Malerei.* Leipzig 1876.

CROWE AND CAVALCASELLE 1877
J.A. Crowe and G.B. Cavalcaselle. *Tizian: Le-*

ben und Werke. 2 vols., 1st edition, London 1877.

CROZAT 1763
P. Crozat. *Recueil d'estampes d'après les plus beaux tableaux et d'après les plus beaux desseins qui sont en France*. 2 vols., Paris 1763.

CUPPINI 1962
M.T. Cuppini. « Alcune opere del Museo Miniscalchi Erizzo ». In *La Fondazione Miniscalchi Erizzo*. Edited by P. Gazzola, Verona 1962.

D'ALBANELLA 1950
G. d'Albanella. *Venetian Drawings XV-XVIII Centuries*. London 1950.

DAL POZZOLO 1990
E.M. Dal Pozzolo. « Lorenzo Lotto 1506: la pala di Asolo ». *Artibus et Historiae* (1990, no. 21), 89-110.

DALLA POZZA 1943
A. Dalla Pozza. *Palladio*. Vicenza 1943.

DE LA LANDE 1769
De La Lande. *Voyage d'un François in Italie fait dans les années 1765 et 1766...* 8 vols., Venice 1769.

DE LEVA 1972-73
G. De Leva. « Degli eretici di Cittadella. Appendice alla storia del movimento religioso in Italia nel secolo decimosesto » *Atti del R. Istituto Veneto di Scienze, Lettere ed Arti*, series IV (1972-73, nos. 1-2), 720-54.

Delices 1785
Les delices des Châteaux Royaux: or a Pocket Companion to the Royal Palaces of Windsor, Kensington, Kew and Hampton Court. Edited by C. Knight, London 1785.

DELLA PERGOLA 1950
P. Della Pergola. *La Galleria Borghese a Roma*. Milan 1950.

DELLA PERGOLA 1951
P. Della Pergola. *La Galleria Borghese in Roma*. Rome 1951.

DELLA PERGOLA 1955
P. Della Pergola. *Galleria Borghese: I dipinti*. 2 vols., Rome 1955.

DELLA PERGOLA 1968
Musei. Galleria Borghese. Presented by P. Della Pergola, Milan 1968.

DELOGU 1928
G. Delogu. *G.B. Castiglione detto il Grechetto*. Bologna 1928.

DE RINALDIS 1932
A. De Rinaldis. *La Galleria Nazionale d'Arte Antica in Roma*. Rome 1932.

DE RINALDIS 1939
A. De Rinaldis. *La Galleria Borghese in Roma*. Rome 1939.

DE RINALDIS 1948
A. De Rinaldis. *Catalogo della Galleria Borghese*. Rome 1948.

Description des tableaux 1780
Description des tableaux [...] que referme la Galeria [...] Prince Regnant du Liechtenstein. Liechtenstein 1780.

DE TEREY 1924
C. De Terey. *Budapest Museum of Fine Arts: Catalogue of the Paintings by Old Masters*. Budapest 1924.

DE TOLNAY 1948
C. De Tolnay. *Michelangelo III: The Medici Chapel*. Princeton 1948.

DE TOLNAY 1971
C. De Tolnay. *Michelangelo V: The Final Period*. Princeton 1971.

DE VECCHI 1981
P. De Vecchi. *Tintoretto: L'opera completa*. Milan 1981.

DÉZALLIER D'ARGENVILLE 1745
A.J. Dézallier d'Argenville. *Abregé de la vie des plus fameux peintres*. vol. 1, Paris 1745.

Die Gemäldegalerie 1930
Staatliche Museen Berlin, *Die Gemäldegalerie: Die italienischen Meister 16, bis 18, Jahrhundert. 300 Abbildungen*. Berlin 1930.

Die Gemäldegalerie 1991
Die Gemäldegalerie des Kunsthistorischen Museum in Wien Verzeichnis der Gemälde Edited by S. Ferino-Pagden, W. Prohaska, and K. Schütz, Vienna 1991.

Die Gemälde in der Bildergalerie 1962-63
Die Gemälde in der Bildergalerie von Sanssouci: Hrsg von der Generaldirektion der Staatliche Schlösser und Gärten Potsdam-Sanssouci. Potsdam 1962-63.

DILLON 1980
G.V. Dillon. « La pala di Asolo ». In *Lorenzo Lotto a Treviso: Ricerche e restauri*. Exhibition catalogue, Treviso 1980, 125-46.

DILLON 1981
G.V. Dillon. In « *Da Tiziano a El Greco: Per la storia del Manierismo a Venezia 1540-1590*. Exhi-

bition catalogue edited by R. Pallucchini, Milan 1981.

DILLON 1991
G.V. Dillon. « Il Parmigianino di Agostino Giusti ». *Verona Illustrata* IV (1991), 51-54.

Dizionario Bolaffi 1972
« Bassano, Jacopo da Ponte detto ». In *Dizionario Enciclopedico Bolaffi dei Pittori e degli Incisori italiani dal XI al XX secolo*. Turin (1972), I, 402-3.

DOBROKLONSKI 1940
M.B. Dobroklonski. *I disegni della scuola Italiana del XV e XVI secolo all'Ermitage*. Moscow 1940.

DONATI 1888
C. Donati. « Il Bassano ». *Atti dell'Accademia Olimpica di Vicenza* LXXVII (1888), 23-48.

DONATI 1894
C. Donati. *Di Jacopo da Ponte*. Florence 1894.

DONZELLI AND PILO 1967
C. Donzelli and G.M. Pilo. *I Pittori del Seicento veneto*. Florence 1967.

DREYER 1983
P. Dreyer. « Ein Blatt von Jacopo Bassano aus dem Jahre 1569 ». *Pantheon* XLI (1983), 145- 46.

EASTLAKE 1884
C. Loch Eastlake. *Principal Pictures in the Old Pinakothek at München*. London 1884.

ECKARDT 1975
G. Eckardt. *Die Gemälde in der Bildergalerie von Sanssouci*. 1st edition, Potsdam-Sanssouci 1975.

ECKARDT 1990
G. Eckardt. *Die Gemälde in der Bildergalerie von Sanssouci*. 2nd edition, Potsdam-Sanssouci 1990.

EDINBURGH 1989
El Greco: Mystery and Illumination. Exhibition catalogue National Galleries of Scotland, Edinburgh 1989.

EMILIANI 1966
A. Emiliani. « Ricerca iconografica ». In *Storia della Letteratura Italiana*. Edited by E. Cecchi and N. Sapegno. *Il Cinquecento*. Milan 1966.

EMILIANI 1967
A. Emiliani. « Un'ipotesi per il vero ritratto di Torquato Tasso ». In *Padova: I secoli, le ore*. Edited by D. Valeri, Bologna 1967, 200-3.

EMILIANI 1968
A. Emiliani « Un'ipotesi per il vero ritratto di

Torquato Tasso ». *Bergomum* xli (1968, no. 3), 131-36.

EMILIANI 1985
A. Emiliani. « Jacopo Bassano, Ritratto di Torquato Tasso ventiduenne ». In *Torquato Tasso tra letteratura, musica, teatro e arti figurative*. Exhibition catalogue edited by A. Buzzoni, Bologna 1985, 207-8, no. 66.

EMMENS 1973
J.A. Emmens. « Ein aber ist nötig-Zu Inhalt und Bedeutung von Marktund Küchenstücken des 16. Jahrhunderts ». In *Album amicorum J.G. van Gelder*. L'Aja 1973, 93-101.

ENGERTH 1881
E.R. von Engerth. *Kunsthistorischen Sammlungen des Allerhöchsten Kaiserhauses, Gemälde. Beschreibendes Verzeichnis, I: Band Italienishe, Spanische und Französische Schulen*. Vienna 1881.

ESKELINEN 1992
K. Eskelinen. « Jacopo Bassano, Virgin and Child with John the Baptist, and St. Antony Abbot (Sacra Conversazione) ». *Ateneum: Valtion Taidemuseon Vuolsijukaisu. The Finnish National Gallery Bulletin* (1992), 45-47.

Exhibition of Venetian Art 1894
Exhibition of Venetian Art. Exhibition catalogue, London 1894.

Exhibition of Venetian Paintings 1939
Exhibition of Venetian Paintings and Drawings Held in Aid of Lord Baldwin's Fund for Refugees. London 1939.

Exhibition of Works by the Old Masters 1880
Exhibition of Works by the Old Masters. Exhibition catalogue, London 1880.

FABRIS 1991
O. Fabris. « Conciati per le feste... » *Idee* (Spring 1991), 33-36.

FAGGIN 1963
G. Faggin. « Bonifazio ai Camerlenghi ». *Arte Veneta* xvii (1963), 79-95.

FAGGIN 1969
G.T. Faggin. *Memling: L'opera completa*. Milan 1969.

FAPANNI 1844
F.S. Fapanni. *La Chiesa e il Collegio di S. Teonisto*. Venice 1844.

FARINATI 1968
P. Farinati. *Giornale (1573-1606)*. Edited by L. Puppi, Florence 1968.

FASOLI AND MANTESE 1980
G. Fasoli and G. Mantese. « La vita religiosa dalle origini al XX secolo ». In *Storia di Bassano*. Bassano 1980, 435-65.

FAVERO 1975
E. Favero. *L'Arte dei Pittori in Venezia e i suoi statuti*. Florence 1975.

FEDERICI 1803
D.M. Federici. *Memorie Trevigiane sulle opere di disegno dal mille e cento al mille ottocento per servire alla storia delle Belle Arti d'Italia*. Venice 1803.

FERGUSON 1961
G. Ferguson. *Signs and Symbolism in Christian Art*. New York and Oxford 1961.

FERRARI 1961
M.L. Ferrari. *Il Romanino*. Milan 1961.

FERRARI 1971
G. Ferrari. *Il breviario Grimani*. Milan 1971.

FERRI 1890
P.N. Ferri. *Catalogo riassuntivo della Raccolta di disegni antichi e moderni posseduta dalla R. Galleria degli Uffizi di Firenze*. Rome 1890.

FERRI, GAMBA, AND LOESER 1914
Mostra di disegni e stampe di scuola veneziana dei secoli XV e XVI nel Gabinetto dei disegni della R. Galleria degli Uffizi. Exhibition catalogue, edited by P.N. Ferri, C. Gamba, and Ch. Loeser, Bergamo 1914.

FIOCCO 1929
G. Fiocco. « Pietro Marescalchi detto lo Spada ». *Belvedere* viii (1929), 211-24.

FIOCCO 1931
G. Fiocco. « Austellung Venezianischen Kunst in München ». *Zeitschrift für Bildenden Kunst* lxv (1931), 155-60.

FIOCCO 1953
G. Fiocco. « A proposito di Francesco Vecellio. » *Arte Veneta* vi (1953), 44-45.

FIOCCO 1957
G. Fiocco. « Francesco Vecellio e Jacopo Bassano ». *Arte Veneta* xi (1957), 91-96.

FIOCCO 1958
G. Fiocco. « Seicento europeo e Seicento veneziano ». In *Atti del R. Istituto Veneto di Scienze, Lettere ed Arti*. cxvii (1958-59), 203-11.

FISHER 1988
Italian Drawings in the J.F. Willumsen Collection. Exhibition catalogue edited by C. Fischer, Copenhagen 1988.

FLORISOONE 1954
M. Florisoone. « Le salon des Bassans à Versailles ». *La Revue des arts* iv (1954, no. 2), 93-102.

FLORISOONE 1956
M. Florisoone. « Jacopo Bassano portraitiste de Jean de Bologne et d'Antonio dal Ponte ». *Arte Veneta* x (1956), 107-18.

FLORISOONE 1957
M. Florisoone. « Jacopo Bassano ». *L'Oeil* (1957, nos. 31-32), 49-52.

FOGOLARI 1937
G. Fogolari. « Lettere pittoriche del gran principe Ferdinando di Toscana a Niccolò Cassana (1698-1709) ». *Rivista del R. Istituto d'Archeologia e Storia dell'Arte* vi (1937, nos. 1-2), 145-86.

FOKKER 1954
H. Fokker. *Galleria Doria Pamphilj in Roma*. Rome 1954.

FOMICIOVA 1981
T. Fomiciova. « I dipinti di Jacopo Bassano e dei suoi figli Francesco e Leandro nella collezione dell'Ermitage ». *Arte Veneta* xxxv (1981), 84-94.

FONTANA 1981
R. Fontana. « Solo senza Fidel Governo et molto inquieto de la mente ». In *Lorenzo Lotto: Atti del Convegno Internazionale di Studi per il V Centenario della nascita. (Asolo 18-21 September 1980)*, edited by P. Zampetti and V. Sgarbi, Treviso 1981, 279-97.

FORLANI 1961
A. Forlani. In *Mostra del disegno italiano di cinque secoli*. Exhibition catalogue edited by P. Barocchi, A. Forlani, and M. Fossi Todorow, Florence 1961.

FRANCESCHETTO 1989
G. Franceschetto. *Cittadella: Saggi storici*. Cittadella 1989.

FRANCESCHETTO 1990
G. Franceschetto. *Cittadella: Saggi storici*. Cittadella 1990.

FRANCESCHETTO 1992
G. Franceschetto. « Il campanile, le campane, l'orologio ». *Cittadella comunità parrocchiale* (1992), 7.

FRANCIS 1939
H.S. Francis. « *Lazarus and the Rich Man* by Jacopo Bassano ». *The Bulletin of The Cleveland

Museum of Art XXVI (December 1939, no. 10), 155-58.

FREDERICKSEN 1972
B.B. Fredericksen. *Catalogue of the Paintinngs in the J. Paul Getty Museum.* Malibu 1972.

FREDERICKSEN AND ZERI 1972
B.B. Fredericksen and F. Zeri. *Census of Pre-Nineteenth-Century Italian Paintings in North American Public Collections.* Cambridge, Massachusetts, 1972.

FREDERICKSEN AND ZERI 1977
Collecting the Masters. Exhibition catalogue edited by B.B. Fredericksen and F. Zeri, Milwaukee 1977.

FREEDBERG 1971
S.J. Freedberg. *Painting in Italy 1500-1600.* Harmondsworth 1971.

FREEDBERG 1975
S.J. Freedberg. *Painting in Italy 1500-1600.* 2nd edition, Harmondsworth 1975.

FREEDBERG 1988
S.J. Freedberg. *La pittura in Italia dal 1500 al 1600.* Revised Italian edition, Bologna 1988.

FRESCOT 1707
D.C. Frescot. *La nobiltà veneta...* Venice 1707.

FRIZZONI 1900
G. Frizzoni, « Nuovi acquisti della R. Pinacoteca di Monaco in Baviera ». *L'Arte* III (1900), 75-78.

FRIZZONI 1901
G. Frizzoni. « Ricordi di un viaggio artistico Oltralpe ». *L'Arte* IV (1901), 221-38.

FRÖHLICH-BUM 1930 (A)
L. Fröhlich-Bum. « Meldola, Andrea detto Schiavone ». In *Allgemeines Lexikon der bildenden Künstler.* Edited by U. Thieme and F. Becker. Leipzig 1930, XXVI, 357-59.

FRÖHLICH-BUM 1930 (B)
L. Fröhlich-Bum. « Neue aufgetauchte Gemälde des Jacopo Bassano ». *Jahrbuch der Kunsthistorischen Sammlungen in Wien* IV (1930), 231-44.

FRÖHLICH-BUM 1931
L. Fröhlich-Bum. « Unbekannte Gemälde des Jacopo Bassano ». *Belvedere* X (1931), 121-25.

FRÖHLICH-BUM 1931-32
L. Fröhlich-Bum. « Zeichnungen des Jacopo Bassano » *Zeitschrift für Bildende Kunst* LXV (1931-32), 121-28.

FRÖHLICH-BUM 1932
L. Fröhlich-Bum. « Some Original Compositions by Francesco and Leandro Bassano ». *The Burlington Magazine* LXI (September 1932, no. 354), 113-14.

FRÖHLICH-BUM 1948
L. Fröhlich-Bum. « Some Sketches by Jacopo Bassano ». *The Burlington Magazine* XC (June 1948, no. 543), 169-70.

FRÖHLICH-BUM 1957
L. Fröhlich-Bum. « Some *Adorations* by Jacopo Bassano ». *Apollo* LXV (June 1957), 213-17.

FURLAN 1959-60
I. Furlan. « La componente tizianesca nella formazione di Jacopo Bassano ». *Arte Veneta* XIII-XIV (1959-60), 72-78.

FURLAN 1984
Il Pordenone. Exhibition catalogue by C. Furlan, Milan 1984.

FURLAN 1988
C. Furlan. *Il Pordenone: L'opera completa.* Milan 1988.

FURLAN AND BONELLI 1984
C. Furlan and M. Bonelli. *Il Pordenone a Travesio.* Travesio 1984.

GABRIELLI 1971
N. Gabrielli. *Galleria Sabauda: Maestri Italiani.* Turin 1971.

GALLO 1953
R. Gallo. « Note d'Archivio su Francesco Guardi ». *Arte Veneta* VI (1953), 153-56.

GARAS 1977
K. Garas. *The Budapest Gallery: Paintings in the Budapest Museum of Fine Arts.* Budapest 1977.

GARAS 1985
K. Garas. *The Budapest Museum of Fine Arts.* Budapest 1985.

GARLICK 1976
K.J. Garlick. *A Catalogue of Pictures at Althorp House.* Walpole Society, vol. XLV, 1976.

GEROLA 1905
G. Gerola. « I testamenti di Francesco il giovane e di Gerolamo da Ponte ». *Bollettino del Museo Civico di Bassano* II (1905), 103.

GEROLA 1905-6
G. Gerola. « Per l'elenco delle opere dei pittori da Ponte ». *Atti dell'Istituto Veneto* LXV (1905-6), 945-62.

GEROLA 1906
G. Gerola. « Catalogo dei dipinti del Museo. Sezione bassanese ». *Bollettino del Museo Civico di Bassano* III (1906) 105-32.

GEROLA 1907 (A)
G. Gerola. « Il primo pittore bassanese. Francesco Da Ponte il Vecchio ». *Bollettino del Museo Civico di Bassano* IV (1907), 77-98.

GEROLA 1907 (B)
G. Gerola. « Un'invenzione di Jacopo Da Ponte e di due Pittori Trentini ». *Tridentum* X (1907), 167-70.

GEROLA 1909 (A)
G. Gerola. « Bassano Giacomo ». In *Allgemeines Lexikon der bildenden Künstler.* Edited by U. Thieme and F. Becker, Leipzig 1907, III, 4-7.

GEROLA 1909 (B)
G. Gerola. « La pittura a Bassano ». *Nuovo Archivio* XVIII (1909), 406.

GEROLA 1909 (C)
G. Gerola. « Un nuovo libro sull'arte dei Bassani » *Bollettino Museo Civico di Bassano* V (1909), 30-37.

GILBERT 1963
Major Masters of the Italian Renaissance. Exhibition catalogue edited by C. Gilbert. Brandeis University, Waltham 1963.

GILBERT 1978
C. Gilbert. « Bonifacio and Bassano ca. 1533 ». *Arte Veneta* XXXII (1978), 127-33.

GILLET 1934
L. Gillet. « Le Musée Jacquemart-André. Les Ecoles Du Nord et l'Ecole Espagnole ». *La Revue de L'Art Ancien et Moderne* II (1934), 255.

GINZBURG 1970
C. Ginzburg. *I costituiti di don Pietro Manelfi.* Florence and Chicago 1970.

GIRONI 1812
R. Gironi. *Pinacoteca del Palazzo Reale delle Scienze e delle Arti di Milano.* 3 vols., Milan 1812-33.

Gli Uffizi: Catalogo Generale 1979
Gli Uffizi: Catalogo Generale. 1st edition, Florence 1979.

Gli Uffizi: Catalogo Generale 1980
Gli Uffizi: Catalogo Generale. 2nd edition, Florence 1980.

GLORIA 1862
A. Gloria. *Il territorio padovano illustrato.* 4 vols., Padua 1862.

GOFFEN 1990
R. Goffen. « Tiziano, i donatori e i soggetti religiosi ». In *Tiziano.* Exhibition catalogue, Venice 1990, 85-93.

GOGUEL 1984
C. Goguel. In *Acquisitions du cabinet des Dessins, 1973-1983.* Exhibition catalogue edited by R. Bacou, Paris 1984.

GOMBRICH 1967
E. Gombrich. « Celebrations in Venice of the Holy League and of the Victory of Lepanto ». In *Studies in Renaissance and Baroque Art.* London 1967, 62-68.

GOODISON AND ROBERTSON 1967
J.W. Goodison and G.H. Robertson. *Fitzwilliam Museum Cambridge. Catalogue of Paintings, II: Italian School.* Cambridge 1967.

GORINI 1972
G. Gorini. *Monete antiche a Padova.* Padua 1972.

GORINI 1991
G. Gorini. « Le monete greche e romane nell'arte rinascimentale veneta ». In *A testa o croce: Immagini d'arte nelle monete e nelle medaglie del Rinascimento. Esempi dalle collezioni del Museo Bottacin.* Exhibition catalogue edited by G. Gorini and A. Saccocci, Padua 1991, 67-85.

GRAMIGNA DIAN 1991
S. Gramigna Dian. In *Restituzioni '91: Quattordici Opere Restaurate.* Exhibition catalogue, Vicenza 1991, 57-59.

GRONAU AND HERZOG 1967
G. Gronau and E. Herzog. *Meisterwerke hessischer Museen, Die Gemäldegalerien in Darmstadt, Kassel und Wiesbaden.* Hannover 1967.

GROSSO 1909
O. Grosso. *Catalogo delle Gallerie di Palazzo Bianco e Palazzo Rosso.* Genoa 1909.

GROSSO 1910
O. Grosso. *Catalogo descrittivo ed illustrato dei quadri antichi e moderni delle Gallerie di Palazzo Bianco e Palazzo Rosso.* Genoa 1910.

GROSSO 1912
O. Grosso. *Catalogo delle Gallerie di Palazzo Rosso.* Milan 1912.

GROSSO 1931
O. Grosso. *Catalogo della Galleria di Palazzo Rosso, della Pinacoteca di Palazzo Bianco e delle Collezioni di Palazzo Comunale.* Genoa 1931.

GUIDA 1828
Guida per la Regia Accademia delle Belle Arti in Venezia, con alcune notizie riguardanti lo stabilimento stesso. Venice 1828.

GUILLAUME 1980
M. Guillaume. *Catalogue raisonné du Musée des Beaux-Arts de Dijon: Peintures italiennes.* Dijon 1980.

GUZZI 1960
V. Guzzi. « Jacopo Bassano ». In *Amore degli Antichi.* Caltanissetta and Rome 1960.

HARTLEY 1989
C. Hartley. In *Treasures from the Fitzwilliam.* Exhibition catalogue, Washington 1989, 59.

HARTT 1958
F. Hartt. *Giulio Romano.* 2 vols., New Haven 1958.

HARTT 1971
F. Hartt. *The Drawings of Michelangelo.* London 1971.

HASKELL 1980
F. Haskell. *Patrons and Painters: A Study in the Relations Between Italian Art and Society in the Age of the Baroque.* New Haven and London 1980, 1st edition, London 1963.

HAUSER 1965
A. Hauser. *Mannerism: The Crisis of the Renaissance and the Origin of Modern Art.* London 1965.

HAVENS 1961-62
M. Havens. « Collection of Religious Art at the Bob Jones University ». *Art Journal* XXI (1961-62, no. 2), 108-14.

HEINEMANN 1962
F. Heinemann. « Nachtraege zu Jacopo Bassano ». *Arte Veneta* XVI (1962), 159.

HEINEMANN 1991
F. Heinemann. *Giovani Bellini e i Belliniani, III: Supplemento ampliamenti.* Hildesheim, Zürich, and New York 1991.

HERMANIN 1924
F. Hermanin. *Catalogo della R. Galleria d'Arte Antica nel Palazzo Corsini.* Rome and Bologna 1924.

HERRMANN 1961
L. Herrmann. « A New Bassano *Flight into Egypt* ». *The Burlington Magazine* CII (November 1961, no. 704), 465-66.

HERZOG AND LEHMANN 1968
E. Herzog and J. Lehmann. *Unbekannte Schätze der Kasseler Gemäldegalerie.* Kassel 1968.

HERZOG 1969
E. Herzog. *Die Gemäldegalerie der Staatlichen Kunstsammlungen Kassel, Geschichte der Galerie.* Edited by G. Gronau and E. Herzog, Hannover 1969.

HILLER 1986
G.S. Hiller. *Ikonographie der christlichen Kunst.* Kassel 1986.

HOOD AND HOPE 1977
W. Hood and C. Hope. « Titian's Vatican Altarpiece and the Pictures Underneath ». *The Art Bulletin* LIX (December 1977, no. 4), 534-52.

HOPE 1990
C. Hope. « Tiziano e la committenza ». In *Tiziano.* Exhibition catalogue, Venice 1990, 77-84.

HUMFREY 1990
P. Humfrey. *La Pittura Veneta del Rinascimento a Brera.* Florence 1990.

HÜTTINGER 1968
E. Hüttinger. « Zur Porträtmalerei Jacopo Tintorettos. Aus Anlass eines unbekannten Bildnisses ». *Pantheon* XXVI (November-December 1968, no. 6), 467-73.

Il restauro e il recupero 1983
Il restauro e il recupero degli affreschi di Jacopo Bassano al Piazzotto Montevecchio ed altri restauri 1977-1982. Exhibition catalogue, Bassano del Grappa 1983.

Imago Mariae 1988
Imago Mariae: Tesori d'arte della civiltà cristiana. Exhibition catalogue edited by P. Amato, Rome 1988.

Inventario 1592
Inventatio de' quadri di Pittura ritrovati nella Casa del q. Eccellente Sig. Giacomo da Ponte, 27 April 1592. In G.B. Verci. *Notizie intorno alla Vita e alle Opere de' Pittori, Scultori e Intagliatori della Città di Bassano.* Venice 1775, 91-188.

Inventario 1659
A. von Berger. « Inventarium aller vnndt jeder Ihrer hochfürstlichen Durchleücht Herrn Leopold Wilhelmen... Zue Wienn Vor Handenen Mahllereyen... Ehem. Krumau,

Fürstl. Schwarzenbergsches Centralarchiv. »
*Jahrbuch der Kunsthistorischen Sammlungen des
Allerhöchsten Kaiserhauses* I (1883), LXXXVI-
CLXXVII.

Inventario 1700
*Nota alli Quadri dell'Appartamento terreno di
S.E. il Sig. Pñpe Borghese.* Pamphlet n.d. in the
Archivio della Galleria Borghese.

Inventario Fidecommisso 1833
*Fidecommisso Artistico nella Famiglia Borghese,
1883.* Pamphlet in the Archivio della Galleria
Borghese.

Inventarium 1685
*Inventarium der Röm Kayserl. Maytt. Mahlerey
auff dem Königl. Praager Schloss.* Ao. 1685 (pho-
tocopy in the library of the Kunsthistorisches
Museum in Vienna from the Inventariazione
nell'Archivio di Stato di Praga).

Inventarium 1737
K. Köpl. « Ehem. Prag, K.K. Statthalterei-
Archiv ». *Jahrbuch der Kunsthistorischen Samm-
lungen des Allerhöchsten Kaiserhauses* X (1889),
CXLII-CLXXI.

ISARLO 1950
G. Isarlo. « Bassano le révolutionnaire ». *Arts*
(April 1950), 1 ff.

ISARLO 1956
G. Isarlo. « Bassano est un réaliste d'avant-
garde ». *Connaissance des arts* LVI (October
1956), 54 ff.

ISARLO 1957
G. Isarlo. « Les fantaisies de l'exposition Bas-
sano et leur raison ». *Combat-Art* XLI (1957).

Italian Art 1960
Italian Art and Britain. Exhibition catalogue
edited by E.K. Waterhouse, London 1960.

Italian Drawings 1991
Italian Drawings. Exhibition catalogue, Haz-
litt, Gooden and Fox, London 1991.

Italialaisia Maalauksia 1992
*Italialaisia Maalauksia Suomessa. Italian Paint-
ings in Finland 1300-1800.* Exhibition cata-
logue edited by M. Supinen, Helsinki 1992.

IVANOFF 1942
N. Ivanoff. *Francesco Maffei.* 1st edition, Padua
1942.

IVANOFF 1947
N. Ivanoff. *Francesco Maffei.* 2nd edition, Pad-
ua 1947.

IVANOFF 1957
N. Ivanoff. « Le copie bassanesche di Giam-

battista Zampezzi ». *Arte Veneta* XI (1957), 211-
13.

JACOBOWITZ 1981
E.S. Jacobowitz. « Lucas van Leyden Engrav-
ings and Etchings ». In *The Illustrated Bartsch*,
XII. New York 1981, 131-334.

JACOBS 1925
E. Jacobs. « Das Museo Vendramin und die
Sammlung Reynst ». *Repertorium für Kunstwis-
senshaft* XLVI (1925) 15-38.

JACOBSEN 1896
E. Jacobsen. « Le Gallerie Brignole Sale
Deferrari in Genova ». *Archivio Storico dell'Arte*
II (1896), 88-129.

JACOBSEN 1897
E. Jacobsen. « Uber einige italienische Ge-
mälde der älteren Pinakothek zu München ».
Repertorium für Kunstwissenschaft XX (1897),
425-30.

JACOBSEN 1911
E. Jacobsen. « Gemälde und Zeichnungen in
Genua ». *Repertorium für Kunstwissenschaft*
XXXIV (1911, no. 3), 185-223.

JAFFÉ 1963
M. Jaffé. « Cleveland Museum of Art: The
Figurative Arts of the West c. 1400-1800 ».
Apollo LXVIII (December 1963), 457-67.

JAFFÉ 1976
*European Drawings from the Fitzwilliam, Lent by
the Syndics of the Fitzwilliam Museum, University
of Cambridge.* Exhibition catalogue edited by
M. Jaffé, New York 1976.

JAHN RUSCONI 1908
A. Jahn Rosconi. « Il rinnovamento della
Galleria Nazionale Corsini ». *Emporium* XXVII
(February 1908, no. 158), 122-40.

JAMESON 1842
A. Jameson. *A Handbook to the Public Galleries
of Art in and near London.* 2 vols., London 1842.

JANSON 1986
A. Janson. *Great Paintings from the John and
Mable Ringling Museum of Art.* New York 1986.

JOANNIDES AND SACHS 1991
P. Joannides and M. Sachs. « A *Last Supper* by
the Young Jacopo Bassano and the sequence
of His Early Work ». *The Burlington Magazine*
CXXXII (October 1991, no. 1063), 695-99.

KARPINSKI 1983
C. Karpinski. « Italian Chiaroscuro Wood-
cuts ». In *The Illustrated Bartsch*, XLVIII. New
York 1983.

Katalog 1896
*Katalog der Gemälde Sammlung der Koningler
Älteren Pinakothek in München.* Munich 1896.

Katalog 1908
*Katalog der Gemälde Sammlung der Koningler
Älteren Pinakothek in München.* Munich 1908.

Katalog 1920
*Katalog der Älteren Pinakothek zu München,
Amtliche Ausgabe.* Munich 1920.

Katalog 1930
Katalog der Älteren Pinakothek zu München.
Munich 1930.

Katalog der Gemäldegalerie 1965
*Katalog der Gemäldegalerie, I: Teil. Italiener,
Spanier, Franzosen, Engländer.* Edited by G.
Heinz and F. Klauner, Vienna 1965.

Konstens Venedig 1962
*Konstens Venedig: Utställning anordnad med an-
ledning av Konung Gustaf VI Adolf åttioårsdag.*
Exhibition catalogue, introduction by R. Pal-
lucchini, Stockholm 1962.

KOSCHATZKY, OBERHUBER, AND KNAB 1972
W. Koschatzky, K. Oberhuber, and E. Knab.
I grandi disegni italiani dell'Albertina di Vienna.
Milan 1972.

KRÖNIG 1966
W. Krönig. « L'*Ultima Cena* di Jacopo Bassa-
no ». In *Arte in Europa: Scritti di storia dell'arte in
onore di Edoardo Arslan.* Milan 1966, 551-59.

K.T.D.
K.T.D. *A Selection of Drawings by Michelangelo
in the Ashmolean Museum.* Oxford n.d.

KULTZEN 1986
R. Kultzen. *Bayerische Staatsgemälde-
sammlungen, Alte Pinakothek, München: Ven-
ezianische Gemälde des 17. Jahrhunderts, vollstau-
diger Katalog.* Munich 1986.

KULTZEN AND EIKEMEIER 1971
R. Kultzen and P. Eikemeier. *Bayerische
Staatsgemälde Sammlung Alte Pinakothek.* Mu-
nich 1971.

La fabbrica dei colori 1986
La fabbrica dei colori. Rome 1986.

LAFENESTRE AND MICHEL 1878
G. Lafenestre and E. Michel, *Inventaire des
richesses d'art de la France: Musée de Montpellier.*
Paris 1878.

LAFENESTRE AND RICHTENBERGER 1905
G. Lafenestre and E. Richtenberger. *La pein-*

ture en Europe, Rome: Les Musées, les Collections particulieres, les Palais. Paris 1905.

LANZI 1789
L. Lanzi. *Storia pittorica della Italia*. Bassano 1789.

LANZI 1795
L. Lanzi. *Storia pittorica della Italia dal Risorgimento delle Belle Arti fin presso al fine del XVIII secolo*. Bassano 1795, edited by M. Capucci, 3 vols., Florence 1968-74.

LANZI 1818
L. Lanzi. *Storia pittorica della Italia*. 3rd edition, Bassano 1818.

LANZI 1988
L. Lanzi. *Viaggio nel Veneto*. Edited by D. Levi, Florence 1988.

LASKIN AND PANTAZZI 1987
Catalogue of the National Gallery of Canada, Ottawa: European and American Painting, Sculpture and Decorative Arts. 2 vols. Edited by M. Laskin Jr. and M. Pantazzi, Ottawa 1987.

LAW 1881
E. Law. *A Historical Catalogue of the Pictures in the Royal Collection at Hampton Court*. London 1881.

LAW 1898
E. Law. *The Royal Gallery of Hampton Court Illustrated*. London 1898.

LAZZARINI 1983 (A)
L. Lazzarini. « Il colore nei pittori veneziani tra 1480 e 1580 ». *Bollettino d'Arte* suppl. 5 (1983), 135-44.

LAZZARINI 1983 (B)
L. Lazzarini. « Esame Tecnico-Scientifico ». In *Il restauro ed il recupero degli affreschi di Jacopo Bassano al Piazzotto Montevecchio ed altri restauri 1977-1982*. Exhibition catalogue, Bassano del Grappa 1983, 28-30.

LEHMANN 1980
J.M. Lehmann. *Staatliche Kunstsammlungen Kassel, Gemäldegalerie Alte Meister, Schloss Wilhelmshöhe. Katalog, I: Italienische, französische und spanische Gemälde des 16. bis 18. Jahrhunderts*. Fridingen 1980.

LEHMANN 1986
J.M. Lehmann. *Italienische, französische und spanische Meister in der Kasseler Gemäldegalerie*. Melsungen 1986.

LEHMANN 1991
J.M. Lehman. *Italienische, französische und span-ische Meister in der Kasseler Gemäldegalerie Staatliche Kunstsammlungen Kassel*. Melsungen 1991.

LEVI 1900
C.A. Levi. *Le collezioni veneziane d'Arte e d'Antichità dal secolo XIV ai nostri giorni*. Venice 1900.

LEVI D'ANCONA 1977
M. Levi D'Ancona. *The Garden of the Renaissance: Botanical Symbolism in Italian Painting*. Florence 1977.

LIBERALI 1940
G. Liberali. « Originali inediti di Paolo Veronese, Iacopo Palma, Antonio Fumiani, Gerolamo Campagna, Antonio Zucchi e altri minori nella chiesa di S. Teonisto a Treviso ». *Rivista d'Arte* XXII (1940), 254-71.

LIBERALI 1950
G. Liberali. « La Memoria Meolo sul *Crocifisso* di Jacopo Da Ponte di Bassano in S. Teonisto di Treviso ». *Archivio Veneto* XLVI-XLVII (1950), 96-108.

LIBERALI 1953
G. Liberali. « Precisazioni e ricerche sul *Calvario* di Jacopo da Ponte di Bassano in San Teonisto di Treviso ». *Arte Veneta* VII (1953), 171-72.

LIMENTANI VIRDIS 1984
C. Limentani Virdis. « La famiglia d'Anna a Venezia. Contatti col Pordenone, Tiziano e Tintoretto ». In *Il Pordenone: Atti del Convegno Internazionale di Studi* (Pordenone, 23-25 August 1984). Edited by C. Furlan, Pordenone 1985, 121-26.

LLOYD 1991
C. Lloyd. *The Queen's Pictures: The Royal Collection through the Centuries*. Exhibition catalogue, London 1991.

LOGAN 1894
M. Logan. *Guide to the Italian Pictures at Hampton Court*. London 1894.

LOGAN 1979
A.M. Logan. *The « Cabinet » of the Brothers Gerard and Jan Reynst*. Amsterdam, Oxford, and New York 1979.

LOMAZZO 1584
G.P. Lomazzo. *Trattato dell'Arte de la Pittura*. Milan 1584.

LONGHI 1918
R. Longhi. « Bollettino Bibliografico. n. 19, D.F. von Hadeln Uber die Zweite Manier des Jacopo Bassano ». *L'Arte* XXI (1918), 44-48.

LONGHI 1926
R. Longhi. « Precisioni nella gallerie italiane. Galleria Borghese: il gruppo delle opere bassanesche e in particolare il n. 26 ». *Vita Artistica* I (1926), 142-43.

LONGHI 1928
R. Longhi. « Precisioni nelle Gallerie italiane. La Galleria Borghese ». *Pinacotheca* (1928), 1-254 (Reprinted in *Saggi e Richerche, 1925-1928: Edizione delle opere complete di Roberto Longhi, II*. 2 vols., Florence 1967, 1, 265-366).

LONGHI 1946
R. Longhi. *Viatico per cinque secoli di pittura veneziana*. Florence 1946 (Reprinted in R. Longhi, « Ricerche sulla pittura veneta: 1940-1949 ». *Edizione delle opere complete di Roberto Longhi, x*. Florence 1978, 3-63).

LONGHI 1948
R. Longhi. « Calepino Veneziano: XIV-Suggerimenti per Jacopo Bassano ». *Arte Veneta* II (1948), 43-55.

LORENZETTI 1911
G. Lorenzetti. « De la giovinezza artistica di Jacopo Bassano ». *L'Arte* XIV (1911), 198-210.

LORENZETTI 1920
G. Lorenzetti. « Un nuovo dipinto di Jacopo Bassano ». *Dedalo* I (1920-21), 392-94.

LORENZONI 1963
G. Lorenzoni. *Lorenzo da Bologna*. Preface by G. Fiocco, Venice 1963.

LOTTO 1969
L. Lotto. *Il « Libro di spese diverse » con aggiunte di lettere e altri documenti*. Edited by P. Zampetti, Venice and Rome 1969.

LUGATO 1990-91
F. Lugato. *Per un catalogo dell'opera pittorica di Francesco dal Ponte il Giovane detto Bassano*. Thesis, Università degli Studi di Venezia, Facoltà di Lettere e Filosofia, 1990-91.

LUGATO GIUPPONI 1992 (A)
F. Lugato Giupponi. « Francesco dal Ponte il Giovane ». *L'Illustre bassanese* 15 (1992), 4-12.

LUGATO GIUPPONI 1992 (B)
F. Lugato Giupponi. « Sui dipinti di Francesco dal Ponte il giovane nella chiesa di San Giacomo dell'Orio a Venezia ». *Bollettino del Museo Civico di Bassano* 1992 (in press).

MACCÀ 1812
G. Maccà. *Storia del territorio vicentino*. 14 vols., Caldogno 1812-16.

MAGAGNATO 1949
L. Magagnato. « Recensione alla mostra del restauro a Vicenza ». *Arte Veneta* III (1949), 193.

MAGAGNATO 1952 (A)
Dipinti dei Bassano recentemente restaurati. Exhibition catalogue edited by L. Magagnato, Venice 1952.

MAGAGNATO 1952 (B)
L. Magagnato. « In margine alla mostra dei Bassano ». *Arte Veneta* VI (1952), 220-29.

MAGAGNATO 1952 (C)
L. Magagnato. « Una mostra di Jacopo Bassano ». *Comunità* (December 1952), 72-73.

MAGAGNATO 1956
L. Magagnato. « Jacopo Bassano intorno al 1540 ». *Critica d'arte* (January-March 1956, nos. 13-14), 103-6.

MAGAGNATO 1974
L. Magagnato. In *Cinquant'anni di pittura veronese 1580-1630.* Exhibition catalogue, Verona 1974.

MAGAGNATO 1981
L. Magagnato. In *Da Tiziano a El Greco: Per la storia del Manierismo a Venezia 1540-1590.* Exhibition catalogue edited by R. Pallucchini, Milan 1981, 164-79.

MAGAGNATO 1983
L. Magagnato. « Jacopo da Ponte, called Jacopo Bassano ». In *The Genius of Venice 1500-1600.* Exhibition catalogue edited by J. Martineau and C. Hope, London 1983, 146-51.

MAGAGNATO AND PASSAMANI 1978
L. Magagnato and B. Passamani. *Il Museo Civico di Bassano del Grappa: Dipinti dal XIV al XX secolo.* Vicenza 1978.

MAGANI 1989
F. Magani. « Il collezionismo e la committenza artistica della famiglia Widman, patrizi veneziani dal Seicento all'Ottocento ». *Memorie dell'Istituto Veneto di Scienze, Lettere ed Arti* XLI (1989, no. 3), 79-118.

MAGNANIMI 1980
G. Magnanimi. « Inventari della collezione romana dei principi Corsini ». *Bollettino d'arte* LXV (July-September 1980, no. 7), 91-126, (October-December 1980, no. 8), 73-114.

MAHON 1950
D. Mahon. « Notes on the 'Dutch Gift' to Charles II ». *The Burlington Magazine* XCII (January-December 1950, no. 562), 12-18.

MANILLI 1650
J. Manilli. *Villa Borghese fuori di Porta Pinciana.* Rome 1650.

MANNING 1963
R. Manning. *A Loan Exhibition of Venetian Paintings of the Sixteenth Century, Finch College Museum of Art.* New York 1963.

MANTESE 1974
G. Mantese. *Memorie storiche della Chiesa Vicentina.* Vicenza 1974.

MANTESE 1980
G. Mantese. *Bassano nella storia: La Religiosità.* Bassano 1980.

MARANGONI 1927
M. Marangoni. *Arte Barocca.* Florence 1927.

MARCHINI 1984
G.P. Marchini. In *Immagini dei musei in Italia dagli elenchi telefonici 1984.* Turin 1984.

MARCHINI 1990
G.P. Marchini. *Il Museo Miniscalchi Erizzo.* Verona 1990.

MARCHINI
G. Marchini. *La villa imperiale di Pesaro.* Milan n.d.

MARIACHER 1957
G. Mariacher. *Il Museo Correr di Venezia: Dipinti dal XIV al XVI secolo.* Venice 1957.

MARIANI CANOVA 1980 (A)
G. Mariani Canova. « Alle origini della Pinacoteca Civica di Padova: i dipinti delle corporazioni religiose soppresse e la galleria abbaziale di S. Giustina ». *Bollettino del Museo Civico di Padova* LXIX (1980), 3-221.

MARIANI CANOVA 1980 (B)
G. Mariani Canova. « Tracce per una storia del patrimonio artistico dei monasteri benedettini padovani durante l'Ottocento ». In *S. Benedetto e otto secoli (XII-XIX di vita monastica nel padovano).* Padua 1980, 225-70

MARINI 1983
P. Marini. « Gli affreschi di Jacopo Bassano ». In *Il restauro ed il recupero degli affreschi di Jacopo Bassano di Piazzotto Montevecchio ed altri restauri 1977-1982.* Exhibition catalogue, Bassano del Grappa 1983, 20-23.

MARUCINI 1577
L. Marucini. *Il Bassano.* Venice 1577.

MASON PERKINS 1911
F. Mason Perkins. « Dipinti italiani nella raccolta Platt ». *Rassegna d'Arte* XI (1911, no. 9), 147-52.

MASON PERKINS 1915
F. Mason Perkins. « Miscellanea ». *Rassegna d'Arte* XV (1915), 122-25.

MASON RINALDI 1965
S. Mason Rinaldi. « Appunti per Paolo Fiammingo ». *Arte Veneta* XIX (1965), 95-107.

MASON RINALDI 1979
S. Mason Rinaldi. « Le immagini della peste nella cultura figurativa veneziana ». In *Venezia e la Peste: 1348-1797.* Exhibition catalogue, 1st edition, Venice 1979.

MASON RINALDI 1980 (A)
S. Mason Rinaldi. « Francesco Bassano e il soffitto del Maggior Consiglio in Palazzo Ducale ». *Arte Veneta* XXXIV (1980), 214-19.

MASON RINALDI 1980 (B)
S. Mason Rinaldi. « Le immagini della peste nella cultura figurativa veneziana ». In *Venezia e la Peste: 1348-1797.* Exhibition catalogue, 2nd edition, Venice 1980.

MASON RINALDI 1982
S. Mason Rinaldi. « Il Tabernacolo della chiesa dei *Gesuiti* alla Dogana di mare ». *Arte Veneta* XXXVI (1982), 211-16.

MASON RINALDI 1984
S. Mason Rinaldi. *Palma il Giovane: L'opera completa.* Milan 1984.

Master Drawings 1968
Master Drawings from the Collection of the National Gallery of Canada. Exhibition catalogue, introduction by K. Fenwick, Toronto [1968].

Matricola... del Santissimo Sacramento 1822
Matricola della veneranda Scuola del Santissimo Sacramento avente Jus. Patronato nella chiesa di S. Giovanni Battista di Bassano. Bassano 1822.

MAXON 1963
J. Maxon. « A Picture from the Collection of Joshua Reynolds ». *Bulletin of Rhode Island School of Design: Museum Notes* (1963), 1-4.

MAYER 1911
A.L. Mayer. *El Greco.* Monaco 1911.

MAYER 1914
A.L. Mayer. « Greco und Bassano. Ein Beitrag zu ihren Künstlerischen Beziehungen ». *Monatshefte für Kunstwissenschaft* VII (June 1914), 211-13.

MAYER 1926
A.L. Mayer. *El Greco.* Monaco 1926.

MAYER 1928
A.L. Mayer. « Kunstliteratur, München ». *Pantheon* (February 1928, no. 1), 99-114

MAYER 1933
A.L. Mayer. « La pittura italiana nella Pinacoteca antica di Monaco di Baviera ». *Le vie d'Italia e del mondo* 1 (1933), 629-51.

MAYER 1939
A.L. Mayer. « Notes on the Early El Greco ». *The Burlington Magazine* LXXIV (January 1939, no. 430), 28-33.

MEIJER 1985
B.W. Meijer. « Cremona e i Paesi Bassi ». In *I Campi e la cultura artistica cremonese del Cinquecento*. Exhibition catalogue, Milan 1985, 25-32.

MELLINI 1961
G.L. Mellini. « I Bassano ». *Sele-Arte* L (1961), 24-39.

MEMMO 1754
F. Memmo. *Vita e Macchine di Bartolomeo Ferracino*. Venice 1754.

MENEGAZZI 1964
L. Menegazzi. *Il Museo Civico di Treviso: Dipinti e sculture dal XII al XIX secolo*. Venice 1964.

MEYER ZUR CAPELLEN 1987
J. Meyer Zur Capellen. « Malerei in Venetien vom 16. Bis 18 Jahrhundert aus dem Museo Civico zu Padova. La Pittura nel Veneto dal 16° al 18° secolo nel Museo Civico di Padova ». In *Malerei in Venetien: 50 Werke des Museo Civico in Padua. Pittura nel Veneto 1500-1800: 50 opere del Museo Civico di Padova*. Exhibition catalogue, Freiburg 1987, 29-45.

MICHIELI 1893
P. Michieli. *Cenni storici della chiesa suburbana di San Vito di Bassano e di fra' Antonio Eremita*. Bassano 1893.

MILKOVICH 1966
M. Milkovich. *The Samuel H. Kress Collection*. 2nd edition, Memphis 1966.

MILLAR 1965
O. Millar. *Italian Drawings and Paintings in the Queen's Collection*. London 1965.

MILLER 1990
M. Miller. « A Michelangelo Drawing ». *The Bulletin of The Cleveland Museum of Art* (May 1990), 146-74.

Mitteilungen der Zentral Kommission 1885
Mitteilungen der Zentral Kommission zur Erforschungen und Erhaltung der Kunst und Historischen Deukmaeler. Vienna 1876-93.

MORASSI 1942
A. Morassi. *La Regia Pinacoteca di Brera*. Rome 1942.

MORASSI 1956
A. Morassi. *Tiziano: Gli affreschi della scuola del Santo a Padova*. Milan 1956.

MORETTI 1983
L. Moretti. « Portraits ». In *The Genius of Venice 1500-1600*. Exhibition catalogue edited by J. Martineau and C. Hope, London 1983.

MONGAN AND SACHS 1940
A. Mongan and P. Sachs. *Drawings in the Fogg Museum of Art: Italian, German, Flemish, Dutch, French, Spanish, Miscellaneous Schools*. 2 vols., Cambridge, Massachusetts, 1940.

MOSCHINI 1815
G.A. Moschini. *Guida per la città di Venezia all'amico delle Belle Arti*. 2 vols., Venice 1815.

MOSCHINI MARCONI 1962
S. Moschini Marconi. *Gallerie dell'Accademia di Venezia: Opere d'Arte del secolo XVI*. Rome 1962.

Mostra 1956
Disegni del Museo Civico di Bassano. Exhibition catalogue edited by L. Magagnato, Venice 1956.

Mostra di importanti dipinti europei 1986
Mostra di importanti dipinti europei del '500 e '600. Exhibition catalogue, Turin 1986.

MOXEY 1977
K.P.F. Moxey. *Pieter Aertsen, Joachim Beuckelaer, and the Rise of Secular Painting in the Context of the Reformation*. New York and London 1977.

MROZINSKA 1958
Disegni veneti in Polonia. Exhibition catalogue edited by M. Mrozinska, Vicenza 1958.

MROZINSKA 1961
M. Mrozinska. « L'exposition des dessins italiens des collections polonaises en Italie ». *Biuletyn Historii Sztuki* XXIII (1961, no. 4), 391-411.

MROZINSKA 1980
M. Mrozinska. In *One Hundred of the Finest Drawings from Polish Collections: A Loan Exhibition under the Patronage of S. Lorentz and K. Robinson*. Exhibition catalogue, introduction by J. Bialostocki, preface by M. Mrozinska, London 1980.

MROZINSKA 1981
M. Mrozinska. In *Zeichnungen älter Meister aus polnischen Sammlungen*. Exhibition catalogue, Braunsweig 1981.

MURARO 1947
M. Muraro. « Ritrovamento di un'opera di Jacopo Bassano ». *Arte Veneta* I (1947), 287-88.

MURARO 1949
Mostra del restauro di monumenti e opere d'arte danneggiate dalla guerra nelle Tre Venezie. Exhibition catalogue edited by M. Muraro, Vicenza 1949.

MURARO 1952
M. Muraro. « Gli affreschi di Jacopo e Francesco da Ponte a Cartigliano ». *Arte Veneta* VI (1952), 42-62.

MURARO 1953
Mostra dei disegni veneziani del Sei e Settecento. Exhibition catalogue edited by M. Muraro, Florence 1953.

MURARO 1956
M. Muraro. *Affreschi di Jacopo e Francesco da Ponte a Cartigliano*. Vicenza 1956.

MURARO 1957
M. Muraro. « The Jacopo Bassano Exhibition ». *The Burlington Magazine* XCIX (September 1957, no. 654), 291-99.

MURARO 1960
Pitture murali nel Veneto e tecniche dell'affresco. Exhibition catalogue edited by M. Muraro, Venice 1960.

MURARO 1982-83
M. Muraro. *Pittura e società: il libro dei conti e la bottega dei Bassano*. Offprint from the Università di Padova, Facoltà di Magistero, Storia dell'Arte Veneta, 1982-83.

MURARO 1992
M. Muraro. *Il Libro Secondo di Francesco e Jacopo dal Ponte*. Bassano 1992.

MURARO AND ROSAND 1976
Tiziano e la xilografia veneziana del Cinquecento. Exhibition catalogue edited by M. Muraro and D. Rosand, Venice 1976.

Museo del Prado 1990
Museo del Prado: Inventario General de Pinturas, I: La Coleccion Real. Introduction by A. Pérez Sánchez, Madrid 1990.

Museum of Fine Arts 1991
Museum of Fine Arts Budapest, Old Masters Gallery: A Summary Catalogue of Italian, French,

Spanish, and Greek Paintings. Edited by V. Tatrai, London and Budapest 1991.

MÜLLER HOFSTEDE 1964
H. Müller Hofstede. « Ein Frühwerk Jacopo Bassanos und eine Komposition Raffaels ». *Münchner Jahrbuch der Bildenden Kunst* XV (1964), 131-44.

NARDI 1958
B. Nardi. *Saggi sull'aristotelismo padovano dal secolo XIV al XVI.* Florence 1958.

National Exhibition 1868
National Exhibition of Works of Art. Exhibition catalogue, Leeds 1868.

National Gallery... Report 1965-66
National Gallery of Canada Annual Report. Toronto 1965-66, 5.

NEUMANN 1962
J. Neumann. *The Picture Gallery of Prague Castle.* Prague 1962.

NEUMANN 1964
J. Neumann. *Obrazórna Prazského Hradu.* Prague 1964.

NEUMANN 1967
J. Neumann. *The Picture Gallery of Prague Castle.* Prague 1967.

NICODEMI 1925
G. Nicodemi. *Gerolamo Romanino.* Brescia 1925.

NICOLAI 1779
F. Nicolai. *Beschreibung der königlichen Residenzstädte Berlin und Potsdam...* Berlin 1779.

NICOLAI 1768
F. Nicolai. *Beschreibung der königlichen Residenzstädte Berlin und Potsdam...* 3rd edition, Berlin 1786.

NICOLSON 1947
B. Nicolson. « Di alcuni dipinti veneziani nelle collezioni reali d'Inghilterra ». *Arte Veneta* I (1947), 222-26.

NICOLSON 1958
B. Nicolson. *Hendrick Terbrugghen.* The Hague 1958.

NÎMES 1988
Nîmes, Musée des Beaux-Arts: Nouvelle presentation des collections anciens. Nîmes 1988.

NOË 1956
H. Noë. « Annotazioni sui rapporti fra la pittura veneziana e olandese alla fine del Cinquecento ». In *Venezia e l'Europa: Atti del*

XVII Congresso Internazionale di Storia dell'Arte. (Venice 12-18 September 1955), Venice 1956, 299-302.

NOÈ 1990
E. Noè. In *Pinacoteca di Brera: Scuola Veneta.* Milan 1990.

NORTHROP 1961
M. Northrop. « Fine Portrait by Jacopo Bassano Takes its Position in Kress Collection ». *The Commercial Appeal* (February 1961, no. 12), 10.

Notiziario Veneto 1989-90
« Notiziario Veneto ». *Arte Veneta* XLIII (1989-90), 191-211.

NURMINEN 1992
S. Nurminen. « Conservator's Report ». *Ateneum: Valtion Taidemuseon Vuolsijukaisu. The Finnish National Gallery Bulletin* (1992), 47.

OBERHUBER 1975
Dessins italiens de l'Albertina de Vienne. Exhibition catalogue edited by W. Koschatzky, E. Knab, and K. Oberhuber, Paris 1975.

OBERHUBER 1978
K. Oberhuber. *The Works of Marcantonio Raimondi and His School.* In *The Illustrated Bartsch* XXVI, part I, and XXVII, part II. New York 1978.

OLIVATO 1974
L. Olivato. « Gli affari sono affari: Giovan Maria Sasso tratta con Tomaso degli Obizzi ». *Arte Veneta* XXVIII (1974), 298-304.

OLIVIERI 1981
A. Olivieri. « Fra collettività urbane e rurali e 'colonie' mediterranee: l' 'eresia' a Venezia ». In *Storia della cultura veneta* III, part 3. Vicenza 1981, 467-512.

OLSEN 1961
H. Olsen. *Italian Paintings and Sculpture in Denmark.* Copenhagen 1961.

OPPÉ 1941
P. Oppé. « Drawings at the National Gallery of Canada ». *The Burlington Magazine* LXXIX (August 1941, no. 461), 50-56.

OTTINO DELLA CHIESA 1967
A. Ottino della Chiesa. *Accademia Carrara.* Bergamo 1967.

PADOVA 1991-92
Da Bellini a Tintoretto: Dipinti dei Musei Civici di Padova dalla metà del Quattrocento ai primi del Seicento. Exhibition catalogue edited by A. Ballarin and D. Banzato, Rome 1991.

PAGNOTTA 1987
L. Pagnotta. *Giuliano Bugiardini.* Preface by M. Gregori, Turin 1987.

PALLUCCHINI 1938
R. Pallucchini. « Opere bassanesche nella R. Galleria Estense ». *Le Arti* I (October-November 1938), 81-84.

PALLUCCHINI 1944
R. Pallucchini. *La pittura veneziana del Cinquecento.* 2 vols., Novara 1944.

PALLUCCHINI 1945 (A)
Cinque secoli di pittura veneziana. Exhibition catalogue edited by R. Pallucchini, Venice 1945.

PALLUCCHINI 1945 (B)
R. Pallucchini. *I dipinti della Galleria Estense di Modena.* Rome 1945.

PALLUCCHINI 1946
I capolavori dei Musei Veneti. Exhibition catalogue edited by R. Pallucchini, Venice 1946.

PALLUCCHINI 1947
Trésors de l'art Vénitien. Exhibition catalogue edited by R. Pallucchini, Milan and Brussels 1947.

PALLUCCHINI 1948
R. Pallucchini. « Una nuova *Adorazione dei Pastori* di Jacopo Bassano ». *Arte Veneta* II (1948), 51.

PALLUCCHINI 1950
R. Pallucchini. *La giovinezza del Tintoretto.* Milan 1950.

PALLUCCHINI 1957
R. Pallucchini. « Commento alla mostra di Jacopo Bassano ». *Arte Veneta* XI (1957), 97-118.

PALLUCCHINI 1958 (A)
R. Pallucchini. « Bassano a colori ». *Arte Veneta* XII (1958), 235.

PALLUCCHINI 1958 (B)
R. Pallucchini. « Disegni oxfordiani e polacchi a San Giorgio ». *Arte Veneta* XII (1958), 258-59.

PALLUCCHINI 1959
R. Pallucchini. « Jacopo Bassano e il Manierismo ». *Studies in the History of Art Dedicated to W.E. Suida* (London 1959), 258-66.

PALLUCCHINI 1975
R. Pallucchini. « Per gli inizi veneziani di Giuseppe Porta ». *Arte Veneta* XXIX (1975), 159-66.

PALLUCCHINI 1977-78
R. Pallucchini. *Jacopo Bassano e il Manierismo.* Thesis, Università degli Studi di Padova, Facoltà di Lettere e Filosofia, 1977-78.

PALLUCCHINI 1981 (A)
R. Pallucchini. « Per la storia del Manierismo a Venezia ». In *Da Tiziano a El Greco: Per la storia del Manierismo a Venezia 1540-1590.* Exhibition catalogue, Milan 1981.

PALLUCCHINI 1981 (B)
R. Pallucchini. « Aggiunte all'ultimo Bassano ». In *Ars Auro Prior: Studia Johanni Bialostocki sexagenario dicata.* Warsaw 1981, 271-77.

PALLUCCHINI 1982
R. Pallucchini. *Bassano.* Bologna 1982.

PALLUCCHINI 1984
R. Pallucchini. « Una nuova redazione dell'*Adorazione dei magi* viennese di Jacopo Bassano ». *Arte Veneta* XXXVIII (1984), 155-60.

PALLUCCHINI 1987
R. Pallucchini. « Una *Parabola del buon Samaritano* di Jacopo Bassano ». *Arte Veneta* XLI (1987), 135-38.

PALLUCCHINI AND ROSSI 1982
R. Pallucchini and P. Rossi. *Tintoretto: Le opere sacre e profane.* 2 vols., Milan 1982.

PAN 1992
E. Pan. *Jacopo Bassano e l'incisione: La fortuna dell'arte bassanesca nella grafica di riproduzione dal XVI al XIX secolo.* Exhibition catalogue, Bassano del Grappa 1992.

PANOFSKY 1948
E. Panofsky. *Albrecht Dürer.* London 1948.

PARISE LABADESSA 1991
R. Parise Labadessa. « L'arte della medaglia rinascimentale italiana ». In *A testa o croce: Immagini d'arte nelle monete e nelle medaglie del Rinascimento, esempi dalle collezioni del Museo Bottacin.* Exhibition catalogue edited by G. Gorini and A. Saccocci, Padua 1991, 87-114.

PARKS 1954
Pontormo to Greco, the Age of Mannerism: A Loan Exhibition of Paintings and Drawings of the Century 1520-1620. Exhibition catalogue edited by R.O. Parks, Indianapolis 1954.

PARTHEY 1863
G. Parthey. *Deutscher Bildersaal, Verzeichniss der in Deutschland vorhandenen Oelbilder verstorbener Maler aller Schulen.* 2 vols., Berlin 1863.

PASSAVANT 1836
J.D. Passavant. *Tour of a German Artist in England...* 2 vols., 1836.

PENNY 1990
N. Penny. In *Italy by Moonlight: The Night in Italian Paintings 1550-1850.* Exhibition catalogue, Rome 1990.

PÉREZ SÁNCHEZ 1965
A.E. Pérez Sánchez. *Pintura italiana del siglo XVI en España.* Madrid 1965.

PERRY 1978
M. Perry. « Cardinal Domenico Grimani's Legacy of Ancient Art to Venice ». *Journal of the Warburg and Courtauld Institutes* XLI (1978), 215-44.

PETOELLO AND RIGON 1980
G. Petoello and F. Rigon. « Sviluppo urbanistico dal X secolo ai nostri giorni ». In *Storia di Bassano.* Bassano 1980, 389-434.

PETRIOLI TOFANI 1972
A.M. Petrioli Tofani. *I grandi disegni Italiani degli Uffizi.* Introduction by A. Forlani Tempesti, Milan 1972.

PEVSNER 1932
N. Pevsner. Review of: « W. Arslan, I Bassano ». *Zeitschrift für Kunstgeschichte* I (1932, no. 2), 163-64.

PHILLIPS 1896
C. Phillips. *The Picture Gallery of Charles I.* London 1896.

Picture Gallery Berlin 1978
Picture Gallery Staatliche Museen Preussischer Kulturbesitz Berlin: Catalogue of Paintings 13th-18th Century. Berlin 1978.

PIGLER 1956
A. Pigler. *Barockthemen.* 2 vols., Budapest 1956.

PIGLER 1967
A. Pigler. *Budapest Szépmüvészeti Múzeum: Katalog der Galerie Alter Meister.* Budapest 1967.

PIGLER 1968
A. Pigler. *Museum der Bildenden Künste Szépmüvészeti Múzeum Budapest: Katalog der Galerie Alter Meister, I.* Tübingen 1968.

PIGNATTI 1957 (A)
T. Pignatti. « L'itinerario di Jacopo Bassano ». *Nuova Antologia* XCII (November 1957), 355-74.

PIGNATTI 1957 (B)
T. Pignatti. *Pittura veneziana del Cinquecento.* Bergamo 1957.

PIGNATTI 1970
T. Pignatti. « La scuola veneta ». *I disegni dei maestri.* 2 vols., Milan 1970.

PIGNATTI 1976
T. Pignatti. *Veronese.* 2 vols., Venice 1976.

PIGNATTI 1977
T. Pignatti. *I grandi disegni italiani nelle collezioni di Oxford, Ashmolean Museum e Christ Church Picture Gallery.* Milan 1977.

PIGNATTI 1979
The Golden Century of Venetian Painting. Exhibition catalogue edited by T. Pignatti and K. Donahue, Los Angeles 1979.

PIGNATTI 1985
Five Centuries of Italian Painting, 1300-1800, from the Collection of the Sarah Campbell Blaffer Foundation. Exhibition catalogue, by T. Pignatti, Houston 1985.

PILLSBURY 1989-90
E.P. Pillsbury. « Jacopo Bassano and the Origins of European Genre Painting. A Rediscovered Masterpiece of Venetian Renaissance Painting ». *Calendar. Kimbell Art Museum* (August 1989-January 1990), 18-19.

PILO 1972
G.M. Pilo. « Due opere recuperate e qualche osservazione sulla giovinezza di Jacopo Bassano ». *Paragone* XXIII (May 1972, no. 267), 82-88.

PILO 1989
G.M. Pilo. « Sulla *Pentecoste* di Tiziano per Santo Spirito in Isola ». *Arte Documento* III (1989), 154-69.

PILO 1990
G.M. Pilo. « Pentecoste ». In *Tiziano.* Exhibition catalogue, Venice 1990, 280-83.

PITTALUGA 1930
M. Pittaluga. *L'incisione italiana nel Cinquecento.* Milan 1930.

PITTALUGA 1933
M. Pittaluga. « Un Tiziano di meno ». *Dedalo* XIII (1933, no. 2), 297-304.

Pitture e quadri 1756
Pitture e quadri del Palazzo Brignole detto volgarmente il Palazzo Rosso di Strada Nuova in Genova. Genoa and Tarigo 1756.

PODESTÀ 1957
A. Podestà. « La mostra di Jacopo Bassano ». *Emporium* CXXVI (July 1957), 3-23.

POLVERARI 1990
M. Polverari. *Tiziano: La Crocifissione di Ancona*. Ancona 1990.

PONA 1620
F. Pona. *Sileno, overo delle Bellezze del Luogo dell'Ill.^mo Sig. Co. Gio. Giacomo Giusti*. Verona 1620.

POPHAM 1971
A.E. Popham. *Catalogue of the Drawings of Parmigianino*. 3 vols., New Haven and London 1971.

POPHAM AND FENWICK 1965
A.E. Popham and K.M. Fenwick. « European Drawings (and Two Asian Drawings) in the Collection of The National Gallery of Canada ». In *The National Gallery of Canada Catalogue, IV*. Toronto 1965.

POPHAM AND WILDE 1949
A.E. Popham and J. Wilde. *The Italian Drawings of the XV and XVI Centuries in the Collection of His Majesty the King at Windsor Castle*. London 1949.

POWELL 1853
W. Powell. *An Account of the Palace and Picture Galleries of Hampton Court*. East Moulsey 1853.

PREDELLI 1908
R. Predelli. « Le memorie e le carte di Alessandro Vittoria ». *Archivio Trentino* XXIII (1908), 1-280.

PRETO 1978
P. Preto. « Peste società a Venezia nel 1576 ». In *Studi e testi veneziani*, 7. Vicenza 1978.

PROVOYEUR 1979
P. Provoyeur. In *L'Art religieux à Venise 1500-1600: Tableaux, dessins et gravures des collections publiques et privées en France*. Exhibition catalogue, Nice 1979.

PUHLMANN 1790
J.G. Puhlmann. *Beschreibung der Gemälde, welche sich in der Bildergalerie, den daranstossenden Zimmern, und den weissen Saale im Königlichen Schlosse zu Berlin befinden*. Berlin 1790.

PUNCUCH 1984
D. Puncuch. « Collezionismo e commercio di quadri nella Genova sei-settecentesca. Note archivistiche dai registri contabili dei Durazzo ». *Rassegna degli Archivi di Stato* XLIV (January-April 1984), 164-218.

PUPPI 1960
L. Puppi. « Francesco Verla ». *Rivista dell'Istituto Nazionale di Archeologia e Storia dell'Arte* XVIII (1960), 267-97.

PUPPI 1962
L. Puppi. *Bartolomeo Montagna*. Venice 1962.

PUPPI 1967
L. Puppi. *Francesco Verla pittore*. Trent 1967.

PUPPI 1984
L. Puppi. « Iconografia di Andrea Gritti ». In *Renovatio Urbis: Venezia nell'età di Andrea Gritti*. Edited by M. Tafuri, Rome 1984, 216-35.

PYNE 1819
W.H. Pyne. *The History of the Royal Residences*. 3 vols., London 1819.

RAGGHIANTI COLLOBI 1963
Disegni della Fondazione Horne in Firenze. Exhibition catalogue edited by L. Ragghianti Collobi, Florence 1963.

RAMA 1990
E. Rama. « Giovanni Speranza ». In *La pittura nel Veneto: Il Quattrocento*. Edited by M. Lucco, Milan 1990, II, 767.

RAMDHOR 1787
F.W.B. van Ramdhor. *Ueber Mahlerei und Bildhauerarbeit in Rom für Liebhaber der Schönen in der Kunst*. Leipzig 1787.

RATTI 1780
C.G. Ratti. *Instruzione di quanto può vedersi di più bello in Genova in pittura, scultura, ed architettura…* 2nd edition, Genoa 1780 (1st edition, Genoa 1766).

REARICK 1958
W.R. Rearick. « The Burghley House *Adoration* of Jacopo Bassano ». *Arte Veneta* XII (1958), 197-200.

REARICK 1962
W.R. Rearick. « Jacopo Bassano 1568-69 ». *The Burlington Magazine* CIV (December 1962, no. 717), 524-33.

REARICK 1967
W.R. Rearick. « Jacopo Bassano's Last Paintings: *The Baptism of Christ* ». *Arte Veneta* XXI (1967), 102-7.

REARICK 1968 (A)
W.R. Rearick. « Jacopo Bassano's Later Genre Paintings ». *The Burlington Magazine* CX (May 1968, no. 782), 241-49.

REARICK 1968 (B)
W.R. Rearick. *The Paintings of Jacopo Bassa-

no*. Ph.D. dissertation, Harvard University, 1968.

REARICK 1976 (A)
W.R. Rearick. In *Dopo Mantegna: Arte a Padova e nel territorio nei secoli XV e XVI*. Exhibition catalogue, Milan 1976.

REARICK 1976 (B)
Tiziano e il disegno veneziano del suo tempo. Exhibition catalogue by W.R. Rearick, Florence 1976.

REARICK 1978 (A)
W.R. Rearick. « Early Drawings of Jacopo Bassano ». *Arte Veneta* XXXII (1978), 161-68.

REARICK 1978 (B)
W.R. Rearick. « Jacopo Bassano and Religious Imagery ». In *Essays Presented to Myron P. Gilmore*. Edited by J. Bertelli and G. Ramakus, 2 vols., Florence 1978, I, 331-43.

REARICK 1980 (A)
W.R. Rearick. « Maestri veneti del Cinquecento ». In *Biblioteca dei disegni*, VI. Florence 1980, 8-32.

REARICK 1980 (B)
W.R. Rearick. « The Portraits of Jacopo Bassano ». *Artibus et Historiae* I (1980), 99-114.

REARICK 1980 (C)
W.R. Rearick. « Tiziano e Jacopo Bassano ». In *Tiziano e Venezia: Atti del Convegno Internazionale di Studi, Venezia 1976*. Vicenza 1980, 371-74.

REARICK 1981 (A)
W.R. Rearick. « The *Rape of the Sabines* as Conceived by Jacopo Bassano and Executed by Francesco ». In *Per A.E. Popham*. Parma 1981, 83-91.

REARICK 1981 (B)
W.R. Rearick. « Circle of Jacopo Palma il Giovane. Portrait of a Venetian Procurator ». In *Italian Paintings XIV-XVIIIth Centuries from the Collection of the Baltimore Museum of Art*. Baltimore 1981, 128-47.

REARICK 1982 (A)
W.R. Rearick. « Leandro Bassano. *Adoration of the Shepherds* ». *Bulletin of Rhode Island School of Design*. LXIX (October 1982, no. 2), 22-27.

REARICK 1982 (B)
W.R. Rearick. In *Nel disegno: 1450-1950*. Exhibition catalogue, Spilimbergo 1982, 36-38.

REARICK 1984
W.R. Rearick. « Jacopo Bassano and Manner-

ism ». In *Cultura e Società nel Rinascimento tra riforme e manierismo*. Edited by V. Branca and C. Ossola, Florence 1984, 289-311.

REARICK 1985
W.R. Rearick. In *Caravaggio e il suo tempo*. Exhibition catalogue, Milan 1985, 50-52.

REARICK 1986 (A)
W.R. Rearick. « Dal Ponte, Jacopo detto Bassano ». In *Dizionario Biografico degli Italiani*. Rome 1986, XXXII, 181-88.

REARICK 1986 (B)
W.R. Rearick. *Jacobus a Ponte Bassanensis: Disegni giovanili e della prima maturità (1538-1548)*, I. Bassano del Grappa 1986.

REARICK 1987
W.R. Rearick. *Jacobus a Ponte Bassanensis: Disegni della maturità (1549-1567)*, II. Bassano del Grappa 1987.

REARICK 1987-88
W.R. Rearick. « Jacopo Bassano e Paolo Veronese ». *Bollettino del Museo Civico di Bassano*. Nuova Serie, nos. 3-6 (1987-88), 31-40.

REARICK 1988 (A)
Paolo Veronese: Disegni e dipinti. Exhibition catalogue by W.R. Rearick, Vicenza 1988.

REARICK 1988 (B)
The Art of Paolo Veronese: 1528-1588. Exhibition catalogue by W.R. Rearick, Washington 1988.

REARICK 1989
W.R. Rearick. *Jacobus a Ponte Bassanensis: I disegni della tarda maturità (1568-1574)*, III. Bassano del Grappa 1989.

REARICK 1991 (A)
W.R. Rearick. *Jacobus a Ponte Bassanensis: Da Cartigliano a Civezzano (1575-1576)*, IV. Bassano del Grappa 1991.

REARICK 1991 (B)
W.R. Rearick. « The *Twilight* of Paolo Veronese ». In *Crisi e rinnovamenti nell'autunno del Rinascimento a Venezia*. Florence 1991, 237-53.

REARICK 1991 (C)
W.R. Rearick. « Titian Drawings: A Progress Report ». *Artibus et Historiae* XXIII (1991), 9-37.

REARICK 1992 (A)
W.R. Rearick. « From Arcady to the Barnyard ». *Studies in the History of Art* (in press).

REARICK 1992 (B)
W.R. Rearick. *Jacobus a Ponte Bassanensis: I*

disegni della vecchiaia (1577-1592), v. Bassano del Grappa 1991 (in press).

REARICK 1992 (C)
W.R. Rearick. « La *Pesca Miracolosa* di Jacopo Bassano ». *Arte Veneta* XLIV (1992), (in press).

RÉAU 1955-59
L. Réau. *Iconographie de l'art chrétien*. 6 vols., Paris 1955-59.

Recent Accessions 1971
« Recent Accessions of American and Canadian Museums ». *Art Quarterly* XXXIV (October-December 1971, no. 2), 249-58.

Recent Acquisitions 1969
Recent Acquisitions, 26th March 1969-12th April 1969. Exhibition catalogue, London 1969.

Recueil 1729-42
Recueil d'estampes d'aprés les plus beaux tableaux et d'aprés les plus beaux desseins qui sont en France dans le Cabinet du Roi, dans celui de Monseigneur le Duc d'Orléans, et dans d'autres cabinets. 2 vols., Paris 1729-42.

Renovatio Urbis 1984
Renovatio Urbis: Venezia nell'età di Andrea Gritti (1523-1538). Edited by M. Tafuri, Rome 1984.

RHEIMS 1973
Rheims. *Musées de France*. Paris 1973.

RICHARDSON 1980
F.L. Richardson. *Andrea Schiavone*. Oxford 1980.

RIDOLFI 1648
C. Ridolfi. *Le maraviglie dell'arte ovvero le vite degli illustri pittori veneti e dello stato descritti da Carlo Ridolfi*. Venice 1648; edited by D. von Hadeln, 2 vols., Berlin 1914-24.

RIGAMONTI 1744
A. Rigamonti. *Giornale per l'anno 1744*. Treviso 1744.

RIGAMONTI 1767
A. Rigamonti. *Descrizione delle pitture più celebri che si vedono esposte nelle chiese, ed altri luoghi pubblici di Trevigi*. Treviso 1767.

RIGAMONTI 1776
A. Rigamonti. *Descrizione delle pitture più celebri che si vedono esposte nelle chiese, ed altri luoghi pubblici di Trevigi*. Treviso 1776.

RIGON 1978
F. Rigon. « Taccuino bassanesco ». *Arte Veneta* XXXII (1978), 174-181.

RIGON 1982
F. Rigon. « Dopo Bassano. Origini ed aspetti del bassanismo ». *Studi Trentini di Scienze Storiche* LXI (1982, no. 1), 53-80.

RIGON 1983 (A)
F. Rigon. « Gli animali di Jacopo Bassano ». *Quaderni Bassanesi*. Bassano and Vicenza 1983.

RIGON 1983 (B)
F. Rigon. « Le rondini di Bassano », in *Arte di terra vicentina*. Vicenza 1983, 86-97.

RIPA 1630
C. Ripa. *Della più che novissima iconologia di Cesare Ripa perugino*. Padua 1630.

ROBERTI 1777
G.B. Roberti. *Lettera del Signor Conte Abate Giambatista Roberti al Signor Cavalier Conte Giambatista Giovio e risposta del medesimo sopra Giacomo Da Ponte Pittore*. Lugano 1777.

ROBERTI 1864 (A)
T. Roberti. *Considerazioni storico-critiche sulla scuola dei Bassani*. Bassano 1864.

ROBERTI 1864 (B)
T. Roberti. *Sopra un quadro di Jacopo da Ponte: Lettera all'abate Filippo Draghi*. Bassano 186.

ROBERTSON 1954
G. Robertson. *Vicenzo Catena*. Edinburgh 1954.

ROSENBERG 1965
P. Rosenberg. In *Le XVIᵉ Siècle Européen: Peintures et Dessins dans les Collections Publiques Françaises*. Exhibition catalogue, Paris 1965.

ROSSETTI 1776
G.B. Rossetti. *Descrizione delle Pitture, Sculture, ed Architetture di Padova, con alcune Osservazioni intorno ad esse, ed altre curiose Notizie: Edizione Seconda accresciuta e migliorata*. Padua 1776.

ROSSI 1984
P. Rossi. « Andrea Schiavone e l'introduzione del Parmigianino a Venezia ». In *Cultura e società nel Rinascimento tra Riforma e manierismi*. Edited by V. Branca and M. Ossola, Florence 1984, 189-205.

ROSSI 1988
F. Rossi. *Accademia Carrara, I: Catalogo dei dipinti sec. XV-XVI*. Milan 1988.

ROSSINI 1725
P. Rossini. *Il Mercurio errante*. Rome 1725.

RUMOR 1915
S. Rumor. *La chiesa votiva di San Rocco eretta*

dalla città di Vicenza per decreto 11 maggio 1485. Vicenza 1915.

RUMPF 1794
J.F.D. Rumpf. *Beschreibung der äussern und innern Merkwürdigkeiten der Königlichen Schlösser in Berlin, Charlottenburg, Schönhusen, in und bei Potsdam.* Berlin 1794.

RUSSO 1988
L. Russo. «Jacopo da Ponte detto Jacopo Bassano». *Imago Mariae: Tesori d'arte della civiltà cristiana.* Exhibition catalogue edited by P. Amato, Rome 1988, 135-36.

RYLANDS 1988
P. Rylands. *Palma il Vecchio.* Milan 1988.

SACCOMANI 1989
E. Saccomani. In *Disegni della Galleria Estense di Modena.* Exhibition catalogue edited by J. Bentini, Modena 1989.

SAFARIK 1962
Vystava Prirustku 1957-1962 Obrazy. Exhibition catalogue edited by E.A. Safarik, Prague 1962.

SAFARIK 1991
E.A. Safarik. *Breve Guida della Galleria Doria Pamphilj in Roma.* Rome 1991.

SAFARIK AND TORSELLI 1982
E.A. Safarik and G. Torselli. *La Galleria Doria Pamphilj a Roma.* Rome 1982.

SALMINA 1964
L. Salmina. *Disegni veneti del Museo di Leningrado.* Venice 1964.

SANSOVINO 1581
F. Sansovino. *Venetia, città nobilissima et singolare, descritta in XIII libri da M. Francesco Sansovino.* Venice 1581.

SANSOVINO AND MARTINIONI 1663
F. Sansovino and G. Martinioni. *Venetia, città nobilissima et singolare, descritta dal Sansovino con nove e copiose aggiunte di D. Giustinian Martinioni.* Venice 1663.

SARDELLA 1986
A. Sardella. *Francesco e Leandro Dal Ponte: la veduta di Bassano 1583-1610.* Thesis, Università degli Studi di Padova, Facoltà di Lettere, 1986-87.

SARTORI 1894
F. Sartori. *Giacomo Da Ponte detto il Bassano ed albero genealogico della sua famiglia.* Padua 1894.

SARTORI 1958 (A)
A. Sartori. *La provincia del Santo dei Frati Minori Conventuali: Notizie storiche.* Padua 1958. Republished in *Archivio Sartori: Documenti di storia e arte francescana,* II, part I. Edited by P. Giovanni Luisetto, Padua 1983-86.

SARTORI 1958 (B)
A. Sartori. «Il San Giovanni Battista nel deserto del Bassano». *Arte Veneta* XII (1958), 200-1.

SAVINI BRANCA 1964
S. Savini Branca. *Il collezionismo veneziano nel '600.* Padua 1964.

SCAFFINI 1905
G. Scaffini. «Un affresco bassanese ed un'incisione tedesca». *Bollettino del Museo Civico di Bassano* II (1905), 64-67.

SCANNELLI 1657
F. Scannelli. «Il Microcosmo della Pittura. Overo Tratto diviso in due Libri». Cesena 1657 (reprinted with Saggio Bibliografico, Appendice di lettere dello Scannelli, and Indice analitico). In *Gli storici della letteratura artistica italiana,* XV. Edited by G. Giubbini, Milan 1966.

SCARPA 1987
P. Scarpa. «A Venetian Seventeenth-Century Collection of Old Master Drawings». In *Drawings Defined.* Edited by W. Strauss and T. Felker, New York 1987.

SCHLEIER 1985
E. Schleier. Review of: «Italienische, französische und spanische Gemälde des 16. bis 18. Jahrhunderts. Staatliche Kunstsammlungen Kassel; Gemäldegalerie Alte Meister Schloss Wilhelmshöhe. By Jürgen M. Lehmann». *The Burlington Magazine* CXXVII (September 1985, no. 990), 626-28.

SCHLOSSER 1964
J. Schlosser Magnino. *La letteratura artistica: Manuale delle fonti della storia dell'arte.* 3rd edition, Florence 1964 (1st edition 1935; 2nd edition 1956).

SCRASE 1983
D.E. Scrase. In *The Genius of Venice, 1500-1600.* Exhibition catalogue edited by J. Martineau and C. Hope, London 1983, 246.

SCRASE 1992
Da Pisanello a Tiepolo: Disegni veneti dal Fitzwilliam Museum di Cambridge. Exhibition catalogue edited by D. Scrase, Milan 1992.

SCREMIN 1976-77
P.F. Scremin. *Francesco Negri Bassanese da Bassano e San Benedetto Polirone a Santa Giustina (1500-1525).* Thesis, Università degli Studi di Padova, 1976-77.

SEIBERT 1980
J. Seibert. *Lexikon christlicher Kunst.* Freiburg 1980.

SERNAGIOTTO 1871
M. Sernagiotto. *Terza ed ultima passeggiata per la città di Treviso verso l'anno 1600 e illustrazione di cose e fatti anteriori.* Treviso 1871.

SERRA AND MALAJOLI 1936
L. Serra and B. Malajoli. *Inventario degli oggetti d'arte d'Italia, VII: Provincia di Ancona ed Ascoli Piceno.* Rome 1936.

SESTIERI 1942
Catalogo della Galleria ex Fidecommissaria Doria-Pamphilj. Edited by E. Sestieri, Spoleto 1942.

SGARBI 1980
Palladio e la Maniera: I pittori vicentini del Cinquecento e i collaboratori del Palladio, 1530-1630. Exhibition catalogue edited by V. Sgarbi, Venice 1980.

SGARBI 1982 (A)
V. Sgarbi. «Gli affreschi di Jacopo Bassano a Santa Croce Bigolina». *Arte Veneta* XXXVI (1982), 200-4.

SGARBI 1982 (B)
V. Sgarbi. «Gli affreschi di Jacopo da Ponte in Ca' Bonato Michiel a Bassano». In *Urbs picta: La città affrescata nel Veneto. Omaggio a Luigi Coletti: Atti del convegno di studi.* (Treviso, 10-12 June 1982). Treviso 1982, 113-20.

SHAPLEY 1973
F.R. Shapley. *Paintings from the Samuel H. Kress Collection: Italian Schools XVI-XVIII Century.* London 1973.

SHAPLEY 1979
F.R. Shapley. *National Gallery of Art, Washington: Catalogue of Italian Paintings.* 2 vols., Washington 1979.

SHEARMAN 1983
J. Shearman. *The Early Italian Pictures in the Collection of Her Majesty the Queen.* Cambridge 1983.

SHILENKO-ANDREYEFF 1933
V. Shilenko-Andreyeff. «The Romantic Current in Italian Art and Some Venetian Paintings in Moscow and Leningrad». *Art in America* XXI (October 1933), 122.

SIGNORI 1992
F. Signori. « Notizie storiche sui personaggi citati nel manoscritto ». In *Libro Secondo di Francesco e Jacopo dal Ponte*. Edited by M. Muraro, Bassano 1992.

SILK AND GREENE 1982
G. Silk and A. Greene. *Museums Discovered: The Wadsworth Atheneum*. Fort Lauderdale 1982.

SIMONETTI 1986
S. Simonetti. « Profilo di Bonifacio de' Pitati ». *Saggi e memorie di Storia dell'Arte* XV (1986), 83-134.

SIRÉN 1944
O. Sirén. *Äldre Italiensk Konst Italienska Tavlor Teckningar ock Skulpturer ur Svenska ock Finska Samlingar*. Exhibition catalogue, Stockholm 1944.

SMIRNOVA 1971
I. Smirnova. « Due serie delle *Stagioni* bassanesche e alcune considerazioni sulla genesi del quadro di genere nella bottega di Jacopo da Ponte ». In *Studi di Storia dell'Arte in onore di Antonio Morassi*. Venice 1971, 129-37.

SMIRNOVA 1976
I. Smirnova. *Jacopo Bassano i pozdnee Vozrozdenie v Venecii*. Moscow 1976.

SPAHN 1932
A. Spahn. *Palma Vecchio*. Leipzig 1932.

STACCIOLI 1981
Le collezioni della Galleria Borghese. Edited by S. Staccioli, Milan 1981.

Staatliche Museen Berlin 1930
Staatliche Museen Berlin, Die Gemäldegalerie: Die italienischen Meister 16. bis 18. Jahrhundert. 300 Abbildungen. Berlin 1930.

STAMPFLE AND DENISON 1973
Drawings from the Collection of Lore and Rudolf Heinemann. Exhibition catalogue edited by F. Stampfle and C. Denison. Introduction by J. Byam Shaw, New York 1973.

STELLA 1969
A. Stella. *Anabattismo e antitrinitarismo in Italia nel XVI secolo: Nuove ricerche storiche*. Padua 1969.

STELLA 1983
A. Stella. « Movimenti di riforma nel Veneto nel Cinquecento ». In *Storia della cultura veneta*, IV, part I. Vicenza 1983, 1-21.

STELLA 1984
A. Stella. « Tensioni religiose e movimenti di riforma ». In *Renovatio Urbis: Venezia nell'età di Andrea Gritti (1523-1538)*. Edited by M. Tafuri, Rome 1984, 134-47.

STELLA 1989
A. Stella. « Le minoranze religiose ». In *Storia di Vicenza*, III, part I. 1989, 199-219.

STIX AND FRÖHLICH-BUM 1926
A. Stix and L. Fröhlich-Bum. *Beschreibender Katalog der Handzeichnungen in der Graphischen Sammlung Albertina, I: Zeichnungen der Venezianischen Schule*. Vienna 1926.

SUIDA 1906
W.E. Suida. *Genua*. Leipzig 1906.

SUIDA 1934-36
W.E. Suida. « Studien zu Bassano ». *Belvedere* IX-XII (1934-36), 194-98.

SUIDA 1949
W.E. Suida. *The John and Mable Ringling Museum of Art*. Sarasota 1949.

SUIDA 1951
W.E. Suida. *Paintings and Sculptures from the Kress Collection*. Washington 1951.

SUIDA 1959-60
W.E. Suida. « Tiziano e Raffaello fonti d'ispirazione per Jacopo Bassano ». *Arte Veneta* XIII-XIV (1959-60), 68-71.

SWEET 1940
F.A. Sweet. « Actaeon and the Nymphs by Jacopo Bassano ». *Bulletin of the Art Institute of Chicago* (November 1940, no. 34), 94 ff..

TANZI 1990
M. Tanzi. « Vicenza ». In *La pittura nel Veneto: Il Quattrocento*, II. Edited by M. Lucco, Milan 1990, 599-621.

TAFURI 1985
M. Tafuri. *Venezia e il Rinascimento*. Turin 1985.

TARGHETTA 1990
R. Targhetta. « Appunti su una famiglia patrizia veneziana: I Morosini detti da Bassano » (Sec. XV-XVIII), *Archivio Veneto* CXXXIV (1990), 45-66.

TENIERS 1660
D. Teniers. *Theatrum Pictorium*. 2nd edition, Brussels 1660 (1st edition 1658; 3rd edition 1684).

The Cleveland Museum of Art 1982
European Paintings of the 16th, 17th, and 18th Centuries: The Cleveland Museum of Art Catalogue of Paintings. Cleveland 1982.

The Index of Paintings... 1801-5
The Index of Paintings Sold in the British Isles During the Nineteenth Century: I (1801-1805). Edited by B.B. Fredericksen, Oxford 1988.

The Index of Paintings... 1806-10
The Index of Paintings Sold in the British Isles During the Nineteenth Century: II (1806-1810). Edited by B.B. Fredericksen, Oxford 1990.

TIETZE AND TIETZE-CONRAT 1936
H. Tietze and E. Tietze-Conrat. « Tizian Studien ». *Jahrbuch der Kunsthistorischen Sammlungen in Wien* X (1936), 137-92.

TIETZE AND TIETZE-CONRAT 1944
H. Tietze and E. Tietze-Conrat. *The Drawings of the Venetian Painters in the XVth and XVIth Century*. New York 1944.

Tiziano 1990
Tiziano. Exhibition catalogue, Venice 1990.

Tiziano nelle gallerie fiorentine 1978
Tiziano nelle gallerie fiorentine. Exhibition catalogue, introduction by M. Gregori, Florence 1978.

TOMORY 1967
P.A. Tomory. « Profane Love in Italian Early and High Baroque Painting: The Transmission of Emotive Experience ». In *Essays in the History of Art Presented to Rudolf Wittkower*. New York 1967, 182-87.

TOMORY 1976
P. Tomory. *Catalogue of the Italian Paintings Before 1800: The John and Mable Ringling Museum of Art*. Sarasota 1976.

TORRESAN 1986-87
C. Torresan. *Treviso scomparsa: il patrimonio artistico delle chiese degli ordini religiosi*. Thesis, Università degli Studi di Padova, Facoltà di Lettere e Filosofia, 1986-87.

TORRESAN 1987
C. Torresan. « Per *Treviso scomparsa*: nuovi documenti su artisti sei-settecenteschi attivi nelle chiese conventuali ». *Arte Veneta* XLI (1987), 199-201.

TREVISAN 1990-91
M.C. Trevisan. *Aspetti dell'evoluzione tecnica della pittura ad olio di Jacopo da Ponte nei dipinti del Museo Civico di Bassano*. Thesis, Università degli Studi di Udine, Facoltà di Lettere e Filosofia, Storia delle tecniche artistiche, 1990-91.

TUA 1932
P.M. Tua. *Inventario dei monumenti iconografici d'Italia, I: Bassano del Grappa*. Trent 1932.

TURNER 1980
N. Turner. «One Hundred of the Finest Drawings from Polish Collections, Birmingham, City Museum and Art Gallery». *The Burlington Magazine* CXXII (March 1980, no. 924), 213-14.

VACCARI 1900
G. Vaccari. «Un capolavoro di Jacopo da Ponte (S. Valentino che Battezza Lucilla)». *Emporium* XII (1900, no. 67), 77-79.

VALCANOVER 1950
F. Valcanover. «Nuovi restauri nelle provincie venete, IV: L'Assunta di Jacopo Bassano nel Duomo di Asolo». *Bollettino d'Arte* XXXV (October-December 1950, no. 4), 350-58.

VALCANOVER 1978
F. Valcanover. *Tiziano: L'opera completa*. Milan 1978.

VAN HASSELT 1960
Exhibition of 15th- and 16th-Century Drawings. Exhibition catalogue edited by C.C. van Hasselt, Cambridge 1960.

VAN MANDER 1604
K. van Mander. *Het Schilder-Boeck*. Haarlem 1604, reprinted in H. Noë, *Karel van Mander en Italië*. The Hague 1954.

VAN MARLE 1936
R. van Marle. *The Development of the Italian Schools of Painting*, XVIII. The Hague 1936.

VAN VECHTEN BROWN AND RANKIN 1914
A. van Vechten Brown and W. Rankin. *A Short History of Italian Painting*. London and Toronto 1914.

Variarum imaginum a celeberrimis artificibus 1660-71
Variarum imaginum a celeberrimis artificibus pictarum caelaturae elegantissimis tabulis repraesentatae. Ipsae picturae partim extant apud viduam Gerardi Reynst, quondam huius urbis senatoris ac scabini, partim Carolo II. Britanniarum Regi a Potentissimis Holandiae West-Frisiaeque Ordinibus dono missae sunt. Amsterdam [1660-71].

VASARI 1568
G. Vasari. *Le vite de' più eccellenti Pittori Scultori e Architettori scritte e di nuovo ampliate da M. Giorgio Vasari Pittore et Architetto Aretino co' ritratti loro, e con le nuove Vite dal 1500 in sino al 1567*. (Florence 1568). Edited by G. Milanesi, 9 vols., Florence 1878-85, reprinted in 1906.

VENDRAMINI MOSCA 1779
F. Vendramini Mosca. *Descrizione delle Architetture, Pitture e Scolture di Vicenza, con alcune osservazioni. Parte prima: Delle Chiese e degli Oratori, Umiliata alli Nobiliss. Signori Deputati della magnifica città. Parte seconda: Degli edifizj ed altre opere pubbliche e private*. 2 vols., Vicenza 1779.

Venezianische Gemälde 1971
Venezianische Gemälde des 15. und 16. Jahrhunderts Alte Pinakothek. Munich 1971.

VENTURI 1878
A. Venturi. *Le Belle Arti di Modena*. Modena 1878.

VENTURI 1893
A. Venturi. *Il Museo e la Galleria Borghese*. Rome 1893.

VENTURI 1899
A. Venturi. «Bartolomeo Veneto». *Archivio Storico dell'Arte* IV (1899), 432-62.

VENTURI 1900
A. Venturi. «I quadri di scuola italiana nella Galleria Nazionale di Budapest». *L'Arte* III (1900), 185-240.

VENTURI 1928
A. Venturi. In *Storia dell'Arte italiana, IX: La pittura del Cinquecento*, part III. Milan 1928.

VENTURI 1929 (A)
A. Venturi. «Jacopo Bassano». *L'Arte* XXXII (1929), 107-25.

VENTURI 1929 (B)
A. Venturi. In *Storia dell'Arte italiana, IX: La pittura del Cinquecento*, part IV. Milan 1929.

VENTURI 1929 (C)
A. Venturi. «Un'ignota opera giovanile di Jacopo Bassano nella chiesa di Sant'Antonio Abate a Marostica». *L'Arte* XXXII (1929), 33-34.

VENTURI 1930
A. Venturi. «Pitture di Pietro di Cosimo e di Jacopo Bassano». *L'Arte* XXXIII (January 1930, no. 1), 46-51.

VENTURI 1931
A. Venturi. *Pitture Italiane in America*. Milan 1931.

VENTURI 1952
A. Venturi. «Mostre d'arte. Bassano». *Commentari* IV (October-December 1952), 247.

VERCI 1775
G.B. Verci. *Notizie intorno alla Vita e alle Opere de' Pittore, Scultori e Intagliatori della Città di Bassano*. Venice 1775.

VINCO DA SESSO 1980
G.B. Vinco da Sesso. «Scuola e cultura». In *Storia di Bassano*. Bassano 1980, 541-614.

VINCO DA SESSO 1982
G.B. Vinco da Sesso. «La tormentata storia del *Putto idropico*». *Il Gazzettino* (8 July 1982).

VITTORELLI 1833
D. Vittorelli. *Viaggio o guida di Bassano, Possagno ed Oliero diviso in tre giornate*. Bassano 1833.

VOLPATO 1847
G.B. Volpato. *Del preparare tele, colori od altro spettante alla pittura*. Bassano 1847.

VON HADELN 1914 (A)
D. von Hadeln. «Bassano und nicht Greco». *Kunstkronik* XXV (1914), 552 ff..

VON HADELN 1914 (B)
C. Ridolfi. *Le maraviglie dell'arte ovvero le vite degli illustri Pittori veneti e dello stato descritti da Carlo Ridolfi*. Venice 1648. Edited by D. von Hadeln. 2 vols., Berlin 1914-24.

VON HADELN 1914 (C)
D. von Hadeln. «Uber die zweite Manier des Jacopo Bassano». *Jahrbuch der Königlich Preuszischen Kunstsammlungen* XXXV (1914), 52-70.

VON HADELN 1925
D. von Hadeln. *Venezianische Zeichnungen der Hochrenaissance*. Berlin 1925.

VON HADELN 1926
D. von Hadeln. *Venezianische Zeichnungen der Spätrenaissance*. Berlin 1926.

VON LOGA 1914
V. von Loga. «Grecos Anfänge». *Jahrbuch der Königlich Preuszischen Kunstsammlungen* XXXV (1914), 43-51.

VON MECHEL 1783
C. von Mechel. *Verzeichnis der Gemälde der Kaiserlich Königlichen Bilder Gallerie in Wien verfast... jahre 1781 gemachten neuen Einrichtung*. Vienna 1783.

WAAGEN 1854
G.F. Waagen. *Treasures of Art in Great Britain: Being an Account of the Chief Collections of Paintings, Drawings, Sculptures, Illuminated Manuscripts, etc....*. 3 vols., London 1854.

WAAGEN 1857
G.F. Waagen. *Galleries and Cabinets of Art in Great Britain: Being an Account of More Than*

Forty Collections of Paintings, Drawings, Sculptures, Manuscripts, Visited in 1854 and 1856 and Now For the First Time Described. London 1857.

WATERHOUSE 1952
E.K. Waterhouse. « Paintings from Venice for Seventeenth-Century England: Some Records of a Forgotten Transaction ». *Italian Studies* (1952), 1-23.

WATERHOUSE 1960
E.K. Waterhouse. « A Note on British Collecting of Italian Pictures in the Later Seventeenth Century ». *The Burlington Magazine* CII (February 1960, no. 683), 54-58.

WEISSTEN 1957
U. Weissten. « Jacopo Bassano in Venice ». *Arts* XXXI (September 1957, no. 16), 16.

WESTPHAL 1931
D. Westphal. *Bonifazio Veronese.* Munich 1931.

WETHEY 1969
H.E. Wethey. *The Paintings of Tiziano, I: The Religious Paintings.* London 1969.

WETHEY 1975
H.E. Wethey. *The Paintings of Titian, III: The Mythological and Historical Paintings.* London 1975.

WHISTLER 1987
C. Whistler. In *Arte a Venezia XVI-XVIII secolo: Dipinti e disegni. Kunst in Venedig 16.-18 jh: Gemälde und Zeichnungen.* Exhibition catalogue, Ingelheim am Rhein 1987.

WICKHOFF 1891
F. Wickhoff. « Die Italienischen Handzeichnungen der Albertina, I Theil: Die venezianische, die lombardische und die bolognesische Schulen ». *Jahrbuch der Kunsthistorischen Sammlungen des allerhöchsten Kaiserhauses* XII (1891), CCV-CCXIV.

WILKS 1989
T. Wilks. « The Picture Collection of Robert Carr, Earl of Somerset (c. 1587-1645), Reconsidered ». *Journal of the History of Collections* I (1989, no. 2), 167-78.

WILLUMSEN 1927
J.F. Willumsen. *La Jeunesse du peintre El Greco.* 2 vols., Paris 1927

WINKLER
H.F. von Winkler. *Dürer des Meisters Gemälde Kupferstiche und Holzschnitte.* Berlin and Leipzig n.d..

WITZTHUM 1969
W. Witzthum. « Dessins d'Ottawa ». *L'Oeil* 179 (November 1969), 10-18.

ZAMPETTI 1953
P. Zampetti. *Lorenzo Lotto nelle Marche.* Urbino 1953.

ZAMPETTI 1957
P. Zampetti. *Jacopo Bassano.* Exhibition catalogue edited by P. Zampetti. Venice 1957.

ZAMPETTI 1958
P. Zampetti. *Jacopo Bassano.* Rome 1958.

ZAMPETTI 1964
P. Zampetti. « Jacopo Bassano ». In *Kindler Malerei Lexikon,* I. 1964, 231-33.

ZANETTI 1733
A.M. Zanetti. *Descrizione di tutte le pubbliche pitture della città di Venezia e isole circonvicine o sia Rinnovazione delle Ricche Minere di Marco Boschini.* Venice 1733.

ZANETTI 1771
A.M. Zanetti. *Della Pittura Veneziana e delle Opere Pubbliche de' Veneziana e delle Opere Pubbliche de' Veneziana Maestri, Libri V.* Venice 1771.

ZANOTTO 1833
F. Zanotto. *Pinacoteca dell'I.R. Accademia di Belle Arti.* 2 vols., Venice 1833-34.

ZANOTTO 1847
F. Zanotto. *Venezia e le sue lagune.* Venice 1847.

ZANOTTO 1857
F. Zanotto. *Pinacoteca Veneta, ossia i migliori dipinti delle chiesa di Venezia.* 2nd edition, Venice 1857.

ZAPPA 1990
G. Zappa. « I committenti vicentini di Andrea Palladio ». In *Storia di Vicenza,* III, part 2. Vicenza 1990, 311-25.

ZERI 1976
F. Zeri. *Italian Paintings in the Walters Art Gallery.* 2 vols., Baltimore 1976.

ZERNER 1979
H. Zerner. *Italian Artists of the Sixteenth-Century School of Fontainbleau.* In *The Illustrated Bartsch,* XXXII. New York 1979.

ZONTA 1916
G. Zonta. « Francesco Negri l'eretico e la sua tragedia *Il libero arbitrio* ». *Giornale storico della letteratura italiana* LXVII-LXVIII (1916), 275-318.

ZORI 1972
A. Zori. *Venezia scomparsa.* 2 vols., 1st edition, Milan 1972 (2nd edition 1984).

ZOTTMANN 1908
L. Zottmann. *Zur Kunst der Bassani.* Strasbourg 1908.

ZUCCHELLI 1954
N. Zucchelli. *Capolavori d'arte in Bergamo.* Bergamo 1954.

ZUCKER 1980
M. Zucker. *Early Italian Masters.* In *The Illustrated Bartsch,* XXIV. New York 1980.

EXHIBITIONS

Amsterdam 1929
Catalogue van de tetoonstelling van Oude Kunst door de vereniging van handerlaren in Oude Kunst in Nederland. Exhibition catalogue. Amsterdam.

Amsterdam 1953
De Venetiaanse Meesters. Exhibition catalogue, introduction by R. Pallucchini, Rijksmuseum, Amsterdam.

Amsterdam 1955
De Triomf van het Maniërisme. De Europese Stijl van Michelangelo tot el Greco. Exhibition catalogue. Rijksmuseum, Amsterdam.

Atlanta 1990
Treasures from the Fitzwilliam. Exhibition catalogue. High Museum of Art, Atlanta.

Baltimore 1938
Religious Art: An Exhibition of Fourteenth, Fifteenth, Sixteenth and Seventeenth Century Paintings, Sculpture, Illuminated Manuscripts, Metalwork, Rosaries, Textiles, Stained Glass and Prints. Exhibition catalogue. Baltimore Museum of Art, Baltimore.

Baltimore 1976
European Drawings from the Fitzwilliam. Exhibition catalogue edited by M. Jaffé. Baltimore.

Bassano 1952
Dipinti dei Bassano. Exhibition catalogue edited by L. Magagnato. Museo Civico, Bassano del Grappa.

Belfast 1961
Pictures from Ulster Houses. Exhibition catalogue edited by A. Crookshank. Belfast.

Berlin 1989
Europa und der Orient 800-1900. Exhibition catalogue. W. Gropius Bau, Berlin.

Bordeaux 1953
Le Greco de la Crète a Tolède par Venise. Exhibition catalogue edited by G. Martin-Méry, introduction by R. Pallucchini. Bordeaux.

Braunsweig 1981
Zeichnungen alter Meister aus polnischen Sammlungen. Exhibition catalogue. Braunsweig.

Brussels 1953
La peinture venitienne. Exhibition catalogue. Palais des Beaux-Arts, Brussels.

Cambridge 1960
Exhibition of 15th and 16th Century Drawings. Exhibition catalogue edited by C.C. van Hasselt. Cambridge.

Caracas 1956
Obras de antiguos maestros italianos en coleciones privadas de Caracas. Exhibition catalogue. Caracas.

Charlotte 1935
An Exhibition of Italian Paintings Lent by Mr. Samuel H. Kress of New York. Exhibition catalogue. Mint Museum of Art, Charlotte.

Cincinnati 1988
Masterworks from Munich: Sixteenth- to Eighteenth-Century Paintings from the Alte Pinakothek. Exhibition catalogue edited by B.L. Brown and A. Wheelock. Cincinnati Art Museum, Cincinnati.

Cleveland 1936
Catalogue of the Twentieth-Anniversary Exhibition of The Cleveland Museum of Art. The Official Art Exhibit of the Great Lakes. Exhibition catalogue. The Cleveland Museum of Art, Cleveland.

Cleveland 1956
Venetian Tradition. Exhibition catalogue, introduction by H.S. Francis. The Cleveland Museum of Art, Cleveland.

Cleveland 1972
Old Master Drawings from Christ Church, Oxford. Exhibition catalogue edited by J. Byam Shaw. The Cleveland Museum of Art, Cleveland.

Columbus 1938
Exhibition of Four Outstanding Venetian Canvases. Columbus. No catalogue.

Columbus 1946
The Age of Titian. Columbus. No catalogue.

Columbus 1983
Italian Masters 1400-1800. Exhibition catalogue. Columbus Museum, Columbus.

Copenhagen 1947
Mostra della collezione di J.F. Willumsen. Exhibition catalogue. Copenhagen.

Copenhagen 1988
Italian Drawings in the J.F. Willumsen Collection. Exhibition catalogue edited by C. Fischer. Copenhagen.

Edinburgh 1826
Royal Institution for the Encouragement of the Fine Arts in Scotland: Third Exhibition of Ancient Pictures. Exhibition catalogue. Edinburgh.

Enniskillen 1944
Fermanagh Old Masters. Exhibition catalogue. Enniskillen.

Ferrara 1985 (A)
Bastianino e la pittura a Ferrara nel secondo Cinquecento. Exhibition catalogue edited by J. Bentini. Palazzo dei Diamanti, Ferrara.

Ferrara 1985 (B)
Torquato Tasso tra letteratura, musica, teatro e arti figurative. Exhibition catalogue. Ferrara.

Florence 1914
Mostra di disegni e stampe di scuola veneziana dei secoli XV e XVI nel Gabinetto dei Disegni della R. Galleria degli Uffizi. Exhibition catalogue edited by P.N. Ferri, C. Gamba, and C. Loeser. Gabinetto Disegni e Stampe degli Uffizi, Florence.

Florence 1953
Mostra dei disegni veneziani del Sei e Settecento. Exhibition catalogue edited by M. Muraro. Gabinetto Disegni e Stampe degli Uffizi, Florence.

Florence 1961
Mostra del disegno italiano di cinque secoli. Exhibition catalogue edited by P. Barocchi, A. Forlani, and M. Fossi Todorow. Gabinetto Disegni e Stampe degli Uffizi, Florence.

Florence 1963
Disegni della Fondazione Horne in Firenze. Exhibition catalogue edited by L. Ragghianti Collobi. Palazzo Strozzi, Florence.

Florence 1969
Da Dürer a Picasso: Mostra di disegni della Galleria del Canada. Exhibition catalogue. Gabinetto Disegni e stampe degli Uffizi, Florence.

Florence 1976
Tiziano e il disegno veneziano del suo tempo. Exhibition catalogue, introduction by M. Gregori. Palazzo Pitti, Florence.

Fort Worth 1976
European Drawings from the Fitzwilliam. Exhibition catalogue edited by M. Jaffé. Kimbell Art Museum, Fort Worth.

Fort Worth 1989
Treasures from the Fitzwilliam. Exhibition catalogue. Kimbell Art Museum, Fort Worth.

Freiburg 1987
Malerei in Venetien: 50 Werke des Museo Civico in Padua. Pittura nel Veneto 1500-1800: 50 Opere

del Museo Civico di Padova. Exhibition catalogue. Augustinermuseum, Freiburg.

HARTFORD 1982
Framing Art: Frames in the Collection of the Wadsworth Atheneum. Exhibition catalogue edited by J. Cadogan, L. Howitz, and S. LaFrance. Wadsworth Atheneum, Hartford.

HELSINKI 1992
Italialaisia Maalauksia Suomessa: Italian Paintings in Finland 1300-1800. Exhibition catalogue edited by M. Supinen. Sinebrychoff, Helsinki.

INDIANAPOLIS 1954
Pontormo to Greco: The Age of Mannerism. A Loan Exhibition of Paintings and Drawings of the Century 1520-1620. Exhibition catalogue edited by R.O. Parks. The John Herron Art Museum, Indianapolis.

INGELHEIM AM RHEIN 1987
Arte a Venezia XVI-XVIII secolo: Dipinti e disegni. Kunst in Venedig 16.-18. Jh: Gemälde und Zeichnungen. Exhibition catalogue. Museum Altes Rathaus, Ingelheim am Rhein.

KASSEL 1968
Unbekannte Schätze der Kasseler Gemälde-Galerie. Exhibition catalogue edited by E. Herzog and J. Lehmann. Kassel.

KIEV 1980
The Golden Century of Venetian Painting. Exhibition catalogue. Museum of Western and Eastern Art, Kiev.

LAUSANNE 1947
Trésor de l'art Venitien. Exhibition catalogue edited by R. Pallucchini. Musée Cantonal des Beaux-Arts, Lausanne.

LEEDS 1868
National Exhibition of Works of Art. Exhibition catalogue. Leeds.

LENINGRAD 1980
The Golden Century of Venetian Painting. Exhibition catalogue. The Hermitage, Leningrad.

LONDON 1822
A Catalogue of Pictures of Italian, Spanish, Flemish and Dutch Schools. Exhibition catalogue. British Institution, London.

LONDON 1831
Catalogue of Pictures by Italian, Spanish, Flemish, Dutch and French Masters. Exhibition catalogue. British Institution, London.

LONDON 1880
Exhibition of Works by the Old Masters. Exhibition catalogue. The Royal Academy of Arts, London.

LONDON 1894
Exhibition of Venetian Art. Exhibition catalogue. New Gallery, London.

LONDON 1906
Burlington Fine Arts Club. Exhibition catalogue. London.

LONDON 1912
Exhibition of Pictures of the Early Venetian School at the Burlington Fine Arts Club-III. Exhibition catalogue edited by T. Borenius. London.

LONDON 1930
Exhibition of Italian Art 1200-1900. Exhibition catalogue. The Royal Academy of Arts, London.

LONDON 1939
Exhibition of Venetian Paintings and Drawings Held in Aid of Lord Baldwin's Fund for Refugees. Exhibition catalogue. Matthiesen Gallery, London.

LONDON 1946
The King's Pictures. Exhibition catalogue. The Royal Academy of Arts, London.

LONDON 1959
Treasures of Cambridge. Exhibition catalogue. The Burlington Fine Arts Club, London.

LONDON 1960
Italian Art and Britain. Exhibition catalogue edited by E.K. Waterhouse. The Royal Academy of Arts, London.

LONDON 1964
Italian Art in the Royal Collection. Exhibition catalogue. The Queen's Gallery, Buckingham Palace, London.

LONDON 1980
One Hundred of the Finest Drawings from Polish Collections: A Loan Exhibition under the Patronage of S. Lorentz and K. Robinson. Exhibition catalogue. Heim Gallery, London.

LONDON 1983
The Genius of Venice 1500-1600. Exhibition catalogue edited by J. Martineau and C. Hope. The Royal Academy of Arts, London.

LONDON 1991 (A)
The Queen's Pictures: The Royal Collection through the Centuries. Exhibition catalogue. The National Gallery, London.

LONDON 1991 (B)
Italian Drawings. Exhibition catalogue. Hazlitt, Gooden and Fox, London.

LOS ANGELES 1929
American Art Dealers Association Exhibition. Los Angeles. No catalogue.

LOS ANGELES 1979
The Golden Century of Venetian Painting. Exhibition catalogue edited by T. Pignatti. Los Angeles County Museum of Art, Los Angeles.

LOS ANGELES 1990
Treasures from the Fitzwilliam. Exhibition catalogue. Los Angeles County Museum of Art, Los Angeles.

MANCHESTER 1857
Art Treasures Exhibition. Exhibition catalogue. Manchester.

MILAN 1986
Antiquariato internazionale: 248 opere scelte all'Internazionale dell'Antiquariato di Milano. Exhibition catalogue. Milan.

MILWAUKEE 1935
Picture of the Month on Loan from A. Seligmann, Rey and Co., New York. Milwaukee Art Institute, Milwaukee. No catalogue.

MILWAUKEE 1977
Collecting the Masters. Exhibition catalogue. Milwaukee Art Center, Milwaukee.

MINNEAPOLIS 1976
European Drawings from the Fitzwilliam. Exhibition catalogue edited by M. Jaffé. Minneapolis.

MODENA 1989
Disegni della Galleria Estense di Modena. Exhibition catalogue edited by J. Bentini. Galleria Estense, Modena.

MONTGOMERY 1938
Exhibition of Venetian Paintings from the Fifteenth Century through the Eighteenth Century. Exhibition catalogue.

MONTREAL 1967
Terre des Hommes: Exposition internationale des beaux-arts (expo 1967). Exhibition catalogue. National Gallery of Canada, Montreal.

MOSCOW 1980
The Golden Century of Venetian Painting. Exhibition catalogue. Pushkin Museum, Moscow.

NAPLES 1985
Caravaggio e il suo tempo. Exhibition catalogue. Naples.

NEW YORK 1920-28
Exhibition at The Metropolitan Museum of Art, New York. No catalogue.

NEW YORK 1940
Catalogue of European and American Paintings, 1500-1900: Masterpieces of Art. Exhibition catalogue edited by W. Pack. New York World's Fair, New York.

NEW YORK 1961
Bassano Drawings. Exhibition catalogue. Seiferheld Gallery, New York.

NEW YORK 1967
The Italian Heritage: An Exhibition of Works of Art Lent from American Collections for the Benefit of CRIA (Committee to Rescue Italian Art). Exhibition catalogue. New York.

NEW YORK 1972
Old Master Drawings from Christ Church, Oxford. Exhibition catalogue edited by J. Byam Shaw. The Pierpont Morgan Library, New York.

NEW YORK 1973
Drawings from the Collection of Lore and Rudolf Heinemann. Exhibition catalogue edited by F. Stampfle and C. Denison, introduction by J. Byam Shaw. The Pierpont Morgan Library, New York.

NEW YORK 1976
European Drawings from the Fitzwilliam. Exhibition catalogue edited by M. Jaffé. New York.

NEW YORK 1985
Caravaggio e il suo tempo. Exhibition catalogue. New York.

NEW YORK 1989
Treasures from the Fitzwilliam. Exhibition catalogue. The National Academy of Design, New York.

NEW YORK 1992
Italian Drawings. Exhibition catalogue. Hazlitt, Gooden and Fox, New York.

NICE 1979
L'Art religieux à Venise 1500-1600: Tableaux, dessins et gravures des collections publiques et privées en France. Exhibition catalogue. Musée National Message Biblique Marc Chagall, Nice.

PADUA 1976
Dopo Mantegna: Arte a Padova e nel territorio nei secoli XV e XVI. Exhibition catalogue. Padua.

PADUA 1980
I Benedettini a Padova. Exhibition catalogue edited by A. de Nicolò Salmazo and F. Trolese. Abbazia di Santa Giustina, Padua.

PADUA 1991
Da Bellini a Tintoretto: Dipinti dei Musei Civici di Padova dalla metà del Quattrocento ai primi del Seicento. Exhibition catalogue edited by A. Ballarin and D. Banzato. Musei Civici, Padua.

PARIS 1947
Trésor des Musées de Vienne. Exhibition catalogue. Petit Palais, Paris.

PARIS 1965
Le XVI Siècle Européen: Peintures et Dessins dans les Collections Publiques Françaises. Exhibition catalogue. Petit Palais, Paris.

PARIS 1975
Dessins italiens de l'Albertina de Vienne. Exhibition catalogue edited by W. Koschatzky, E. Knab, and K. Oberhuber. Musée du Louvre, Paris.

PARIS 1984
Acquisitions du Cabinet des Dessins, 1973-1983. Exhibition catalogue edited by R. Bacou. Musée du Louvre, Paris.

PEORIA 1970
The Grand Tour. Exhibition catalogue. Lakeside Center for the Arts and Sciences, Peoria.

PHILADELPHIA 1972
Old Master Drawings from Christ Church, Oxford. Exhibition catalogue edited by J. Byam Shaw. Philadelphia Museum of Art, Philadelphia.

PHILADELPHIA 1976
European Drawings from the Fitzwilliam. Exhibition catalogue edited by M. Jaffé. Philadelphia.

PITTSBURGH 1954
Pictures of Everyday Life: Genre Painting in Europe 1500-1900. Exhibition catalogue. Carnegie Institute, Pittsburgh.

PRAGUE 1962
Vystava Prirustku 1957-1962 Obrazy. Exhibition catalogue edited by E.A. Safarik. Prague.

ROME 1988
Imago Mariae: Tesori d'arte della civiltà cristiana.

Exhibition catalogue edited by P. Amato. Palazzo Venezia, Rome.

ROME 1990 (A)
Temporary exhibition of works from the Galleria Borghese held in the Palazzo Venezia, Rome. No catalogue.

ROME 1990 (B)
Capolavori dal Museo d'Arte della Catalogna: Tredici opere dal Romanio al Barocco. Exhibition catalogue. Accademia Spagnola di Storia, Archeologia e Belle Arti, Rome.

SAINT LOUIS 1972
Old Master Drawings from Christ Church, Oxford. Exhibition catalogue edited by J. Byam Shaw. The Saint Louis Art Museum, Saint Louis.

SAN FRANCISCO 1915
Catalogue de luxe of the Department of Fine Arts, Panama-Pacific International Exposition. Exhibition catalogue. San Francisco.

SAN FRANCISCO 1938
Exhibition of Venetian Paintings from the Fifteenth Century through the Eighteenth Century. Exhibition catalogue. The California Palace of the Legion of Honor, San Francisco.

SEATTLE 1933
An Exhibition of Italian Paintings Lent by Mr. Samuel H. Kress of New York. Exhibition catalogue. Seattle.

STOCKHOLM 1944
Äldre Italiens Konst: Italienska Tavlor, Teckningar och Skulpturer ur Svenska ock Dinska Samlingar. Exhibition catalogue edited by O. Sirèn. Nationalmuseum, Stockholm.

STOCKHOLM 1962
Konstens Venedig: Utställning anordnad med anledning av Konung Gustaf VI Adolf åttiårsdag. Exhibition catalogue, introduction by R. Pallucchini. Nationalmuseum, Stockholm.

TOKYO 1980
Capolavori del Rinascimento italiano. Exhibition catalogue. Tokyo.

TOLEDO 1940
Four Centuries of Venetian Painting. Exhibition catalogue, introduction by H. Tietze. The Toledo Museum of Art, Toledo.

TORONTO 1968
Master Drawings from the Collection of the National Gallery of Canada. Exhibition catalogue, introduction by K. Fenwick. Toronto.

TURIN 1986
Mostra di importanti dipinti europei del '500 e '600. Exhibition catalogue. Galleria Caretto, Turin.

TURIN 1990
Da Biduino ad Algardi: Pittura e scultura a confronto. Exhibition catalogue edited by G. Romano. Galleria Antichi Maestri Pittori, Turin.

VANCOUVER 1953
Great Masters of the Italian Renaissance, 1400-1600. Exhibition catalogue. Vancouver Art Gallery, Vancouver.

VENICE 1945
Cinque secoli di pittura veneziana. Exhibition catalogue edited by R. Pallucchini. Procuratie Nuove, Venice.

VENICE 1957
Jacopo Bassano. Exhibition catalogue edited by P. Zampetti. Palazzo Ducale, Venice.

VENICE 1958
Disegni Veneti in Polonia. Exhibition catalogue edited by M. Mrozinska. Fondazione Giorgio Cini, Venice.

VENICE 1961
Disegni veneti dell'Albertina di Vienna. Exhibition catalogue edited by O. Benesch. Fondazione Giorgio Cini, Venice.

VENICE 1979
Venezia e la peste, 1348/1797. Exhibition catalogue. Palazzo Ducale, Venice.

VENICE 1981
Da Tiziano a El Greco: Per la storia del Manierismo a Venezia 1540-1590. Exhibition catalogue. Palazzo Ducale, Venice.

VENICE 1985
Disegni veneti di collezioni olandesi. Exhibition catalogue edited by B. Aikema and B.W. Meijer. Fondazione Giorgio Cini, Venice.

VENICE 1992
Da Pisanello a Tiepolo: Disegni veneti dal Fitzwilliam Museum di Cambridge. Exhibition catalogue edited by D. Scrase. Fondazione Giorgio Cini, Venice.

VICENZA 1980
Palladio e la Maniera: I pittori vicentini del Cinquecento e i collaboratori del Palladio, 1530-1630. Exhibition catalogue edited by V. Sgarbi. Chiesa di Santa Corona, Vicenza.

WALTHAM 1963
Major Masters of the Italian Renaissance. Exhibition catalogue edited by C. Gilbert. Brandeis University, Waltham.

WARSAW 1962
Muzeum Narodowe W Warszawie, Warsaw. No catalogue.

WASHINGTON 1951-57
Paintings and Sculpture from the Kress Collection. Exhibition catalogue edited by W.E. Suida. National Gallery of Art, Washington.

WASHINGTON 1972
Old Master Drawings from Christ Church, Oxford. Exhibition catalogue edited by J. Byam Shaw. National Gallery of Art, Washington.

WASHINGTON 1988
Masterworks from Munich: Sixteenth- to Eighteenth-Century Paintings from the Alte Pinakothek. Exhibition catalogue edited by B.L. Brown and A. Wheelock. National Gallery of Art, Washington.

WASHINGTON 1989
Treasures from the Fitzwilliam. Exhibition catalogue. National Gallery of Art, Washington.

WINNIPEG 1953
Great Masters of the Italian Renaissance, 1400-1600. Exhibition catalogue. Winnipeg Art Gallery, Winnipeg.

WINSTON-SALEM 1984
Treasures of Italian Painting from the Sarah Campbell Blaffer Foundation. Exhibition catalogue. Wake Forest University, Winston-Salem.

Photographic Credits